THE BOTTLE BOOK

THE BOTTLE BOOK

A COMPREHENSIVE GUIDE TO HISTORIC, EMBOSSED MEDICINE BOTTLES

RICHARD E. FIKE

The Bottle Book

ISBN-13: 978-1-932846-15-7
ISBN-10: 1-932846-15-8

Library of Congress Control Number: 2006922434

THE BLACKBURN PRESS
P. O. Box 287
Caldwell, New Jersey 07006
U.S.A.
973-228-7077
www.BlackburnPress.com

CONTENTS to the 2006 Printing

PREFACE to the 2006 Printing

This volume is an illustrated guide and reference to the identification of embossed medicinal containers designed to assist the cultural historian in the interpretation and dating of archaeological sites and their components.

This volume does not discuss the evolution of bottle making, nor does it describe the many intricate technological changes, general functional applications of vessels, or the history and application of medicine as these subjects have been carefully examined by other scholars. This volume was designed solely as a reference to identify, describe, and date not only the individual medicine bottles but the products they contained as well. It is considered a useful, functional tool for typing sherds, dating and describing the vessels from which the sherds are derived, and producing more meaningful site interpretations.

Over the years, as the research progressed, I found many ways to improve or simplify the identification process. Unfortunately, relocating the bottles made it impossible to include or incorporate the evolving changes. In using this information, you will observe that attributes are occasionally missing, e.g. dimensions. Also many of the vessels were incomplete, making it impossible to note all the attributes.

Nearly two decades have passed since the first printing of *The Bottle Book*. When first approached about updating and reprinting this reference, I thought, What a horrendous task!

Over the years, numerous colleagues and collectors shared their knowledge and information with me. The letters and data had accumulated. However, as I began sorting through this information, I found few changes or corrections were actually needed.

In addition to several new bottles or variants, I found that the majority of the correspondence dealt with expansion of histories, attributes, or the clarification of old data. The new information can be found at the back of the book in a new index entitled, "Errata." Some of the additions in the Errata are complete by themselves; others will need to be compared with the original entry. **Asterisks in the General Index indicate that changes or additions were made. Those changes can be found in the Errata section.**

As I stated before, there are undoubtedly many ways to improve, describe, and organize this information. I know of colleagues that have created databases that now are invaluable to scholars in their continued research of an interesting component of historical archaeology.

Richard E. Fike

Editor's Note: The author and the publishers welcome any *verifiable* additions, corrections or updates to any of the information in this book. Please address all correspondence to: The Blackburn Press, PO Box 287, Caldwell, NJ 07006.

ACKNOWLEDGEMENTS
to the 2006 Printing

In the original printing I wrote, *"...that the completion of this volume would be the reward for these multiple years of labor leading up to the moment of writing "The End," but now, in retrospect, I find the effort and eventual completion are not the real achievement; my ultimate compensation has been — and is now — simply to recall the meeting, working with, and acquiring of new and old friends, colleagues, and associates along the way. I remember the total strangers who shared their collections, the harried colleagues and peers who compressed their own schedules in order to give me some help, and all the many others, friends, co-worker, known and unknown at the start, who made an impression on me and a contribution to this book. I recall you all with pleasure and my gratitude is heartfelt."*

Since the book has been on the market for nearly two decades, I find those original words have even more importance. Not only did I meet new friends and colleagues when gathering data for the first printing, but now have met so many more that I cannot begin to recall and thank all of you. I apologize for this omission and, hopefully, when you run into me, you will remind me of this oversight. Years take their toll.

Again, I must single out certain individuals for their crucial advice and direction in the beginning. Jim Ayers, Stanley South and Olive Jones provided not only their constructive criticisms, but their support as well. Peregrine Smith Books not only provided crucial direction but took a gamble in printing a technical book, not knowing what direction its future would hold. I must acknowledge Laura Haggert who spent many hours typing and retyping drafts on a typewriter. Unfortunately, I have lost track of many of the individuals cited below. I apologize for that. Credits in bold are new:

Dale L. Berge, Marley R. Brown III, Elizabeth O. Bush, Caroline D. Carley, David B. Cook, Gardiner Dalley, Mike and Colleen Empey, B. J. Earle, Helene Fairchild, Carol Fenichel, Roy Goodman, Ben Greenbalm, **Carol A. Harris-Fike**, Bruce Hawkins, **Jon Horn, Bill Hunt, Gwen Hurst,** Thorn Kuhl, Las Vegas Antique Bottle Club, Alan Lichty, **Bill Lindsey,** LaMar Lindsay **(deceased),** David B. Madsen, James Mayfield, Joel McNamara, George L. Miller, Charlotte Moulton, Rebecca A. Perry, Carol Pine, Carlyn Ring, Christine Ruggere, Stan Sanders, Peter D. Schulz, Robert H. Schmidt, Jacqueline Norgren, Glenn Sonnedecker, Roderick Sprague, Bob Toynton, Nancy Weinstock, Jerry Wylie, and Betty Zumwalt. My sincere appreciation is extended to the people at The Blackburn Press who provided direction and guidance in reprinting this volume.

Again, beyond all citations above, I must credit Ron and Smitty Fike, now deceased, who nurtured my interest in history and made this goal possible.

PREFACE

This volume is an illustrated guide and reference book to the identification of embossed medicinal containers, designed to assist the cultural historian in his interpretation of historic archaeological sites and their components. Represented in this volume are nearly ten years of intensive and sometimes arduous study. This labor, inclusive within over twenty years of active study on bottles, has often been highly satisfying, but has also left a sense of frustration. If goals are attainable, what is a reasonable end? When is enough, enough? I began to realize that this volume could never be complete, and as I proceeded, my study nurtured my frustration. Reaching the threshold where I have felt totally comfortable with this data, and satisfied that one more entry is not essential to the success of the volume, has been difficult at best. It was with reluctance then, that I chose to terminate this study; a decision based in part, on making a personal commitment to more fully share this portion of my life with family and friends.

During the evolutional years as the research progressed, methods for improving or simplifying the identification process became apparent but the difficulty in relocating the bottles made it impossible to include or incorporate the changes; therefore, in using the information you will observe that attributes are occasionally missing, e.g., dimensions. Also many of the vessels were incomplete, making it impossible to note all attributes.

In preparing the volume, I had no intentions of discussing the evolution of bottle making or describing the intricate technological differences and general functional applications of containers or the history and application of medicine; these subjects have been carefully examined by other scholars. My sole purpose was to compile and provide a reference that could identify, describe, and date not only the individual medicine bottles but the products they contained as well. However, if this reference becomes a functional tool for typing sherds, dating and describing the vessels from which the sherds are derived, and producing a more meaningful site interpretation, then my frustrations and labors have served me well. There are undoubtedly ways to improve, describe, and organize this information, and I hope this material will create, in you, a challenge to gain a more thorough familiarity and understanding of historic glass medicinal containers.

Richard E. Fike

Editor's Note: The author and the publishers welcome any *verifiable* additions, corrections or updates to any of the information in this book. Please address all correspondence to Peregrine Smith Books, P.O. Box 667, Layton, Utah 84041. Please include your complete source of information.

ACKNOWLEDGEMENTS

I had anticipated that the completion of this volume would be the reward for these multiple years of labor leading up to the moment of writing "The End," but now, in retrospect, I find the effort and eventual completion are not the real achievement; my ultimate compensation has been—and is now—simply to recall the meeting, working with, and acquiring of new and old friends, colleagues, and associates along the way. I remember the total strangers who shared their collections, the harried colleagues and peers who compressed their own schedules in order to give me some help, and all the many others, friends, co-workers, known and unknown at the start, who made an impression on me and a contribution to this book. I recall you all with pleasure and my gratitude is heartfelt. But some I must single out. First and foremost is my wife, Laura, who patiently put up with my frustrations, tantrums, moods, and neglect over the years, and has given generously countless hours in typing, editing, and arranging numerous drafts, versions, and updates. This volume is dedicated to her, with love and gratitude.

It is impossible to remember and thank all of the people to whom appreciation should be extended, especially the many individuals who patiently allowed me to catalog their collections. I must particularly thank James Ayres for his crucial direction at the start, Stanley South and Olive Jones for their constructive criticisms and support and Helene Fairchild who graciously reviewed and edited the introductory material. Thanks also to Leslie Cutler Stitt of Peregrine Smith Books for her careful editing and proofreading. Special appreciation is also extended to B. J. Earle, John Nielsen, and David B. Cook who penned the illustrations found throughout the volume and to William H. Helfand, of Merck & Co., Inc., for use of his extensive, personal collection of rare pharmaceutical manufacturers' and wholesalers' catalogs. Other individuals deserving note and credit are:

Dale L. Berge, Brigham Young University, Provo, UT

Marley R. Brown, III, Office of Excavation & Conservation, Colonial Williamsburg Foundation, Williamsburg, VA

Elizabeth O. Bush, Office of Excavation & Conservation, Colonial Williamsburg Foundation, Williamsburg, VA

Caroline D. Carley, University of Idaho, Moscow, ID

Gardiner Dalley, Bureau of Land Management, Cedar City, UT

Mike and Colleen Empey, Ogden, UT

Carol Fenichel, Philadelphia College of Pharmacy & Science, Philadelphia, PA

Roy E. Goodman, American Philosophical Society, Philadelphia, PA

Ben Greenbalm, Philadelphia College of Pharmacy & Science, Philadelphia, PA

Michael R. Harris, Medical Sciences Div., Smithsonian Institution, Washington, DC

Bruce Hawkins, Rochester, MI

Thorn Kuhl, Warner-Lambert Company, Morris Plains, NJ

Las Vegas Antique Bottle Club, Las Vegas, NV

Alan Lichty, University of Utah, Salt Lake City, UT

LaMar W. Lindsay, Utah State Division of History, Salt Lake City, UT

David B. Madsen, Utah State Division of History, Salt Lake City, UT

James L. Mayfield, Lone Pine, CA

Joel McNamara, University of Utah, Salt Lake City, UT

George Miller, Office of Excavation & Conservation, Colonial Williamsburg Foundation, Williamsburg, VA

Charlotte J. Moulton, National Library of Medicine, Betheseda, MD

Rebecca A. Perry, Lloyd Library, Cincinnati, OH

Carol Pine, Countway Library, Boston, MA

Carlyn Ring, Portsmouth, NH

Christine Ruggere, College of Physicians, Philadelphia, PA

Stan Sanders, Salt Lake City, UT

Peter Schulz, California Division of Parks & Recreation, Sacramento, CA

Robert H. Schmidt, Las Vegas, NV

Jacqueline Soderquist, Bureau of Land Management, Salt Lake City, UT

Glenn Sonnedecker, University of Wisconsin & Director of the American Institute of History of Pharmacy, Madison, WI

Roderick Sprague, University of Idaho, Moscow, ID

Bob Toynton, Santee, CA

Nancy L. Weinstock, Philadelphia College of Pharmacy & Science, Philadelphia, PA

Jerry Wylie, U. S. Forest Service, Ogden, UT

Betty Zumwalt, Sandpoint, ID

Beyond all citations above, I would especially like to credit Ron and Smitty Fike, Ogden, Utah, who made this goal possible.

INTRODUCTION

Since the early 1960s, bottle collecting has been one of the leading family-oriented recreational activities. Unfortunately, this hobby is responsible for an appreciable loss of data since the bottles and other artifacts now reside in widely dispersed personal collections all over the world. The information these materials and the displaced fragments could have provided to cultural historians is virtually lost. In addition, and even more serious, is the destruction of the context and archaeological record of the sites from which they were taken. Collectors obtain substantial monetary rewards and personal satisfaction in turning over a layer of the past in search of interesting coins, beads, buttons, military relics, or glass bottles and even strengthened state and federal legislation has helped little in abating this activity. While not advocating, condoning, or denouncing bottle collecting, I must give credit to these amateurs since it is their enthusiasm, research, and publications that form the basis of much current historical research.

Collector data, while informative, is often unsubstantiated and their descriptions pertain only to complete vessels. Such information provides little substance for the archaeologist who deals with sherds. This book attempts to bridge that gap by providing a correlation between fragmentary evidence and the complete specimen. It is not only an aid to the descriptive reconstruction of vessel form from sherds, but includes a careful examination of individual containers, their products and chronologies, and corporate histories. This is not a price guide to determine the value of historic bottles. It is like a dictionary, designed to help identify, describe, and date individual, embossed medicine bottles and hopefully give historical sites and their components more meaningful interpretations.

Within this volume are descriptions of several thousand medicinal containers with emphasis on patent and proprietary medicines from the mid-nineteenth century to the end of the second decade of the twentieth century. Such medicinals were chosen as the focus of this study because of their relative abundance in historic archaeological sites. The containers are categorized and discussed by medicinal subfunction (cures, remedies, pills, tonics, etc.) and attributes such as design, finish, and color are discussed within these categories.

Thousands of bottles, primarily in unprovenienced private collections, were located, measured, and described. Histories were obtained from public records, city directories, gazetteers, newspapers, journal advertisements, pharmaceutical manufacturers' and wholesalers' catalogs, and other sources.[1] The compilation of a comprehensive list of *all* medicine bottles, including those of a patent and proprietary nature, is nearly impossible. To obtain all of the descriptions and histories, including dates of manufacture and use of each individual container represented herein is equally out of reach.

Use the volume in the same manner you would use any reference book or field guide, but don't consider it all-inclusive. Literally hundreds of thousands of brands and variations of vessels were manufactured and all could obviously not be included. The exclusion of some, however, was intentional. Pharmaceutical and local embossed drugstore containers (prescription bottles) would require a separate study and considerable research, if only because they are so prolific. Furthermore, several references are available on bitters (Ring 1980; Watson 1965, for example), sarsaparilla (Shimko 1969; De Graft 1980), and other products, and to redescribe or extensively list them here is unnecessary in view of the adequate work of other researchers. Some vessels containing questionable products were not

omitted even after research determined that the contents were not for medicinal application. The information they provide is considered important to the reader and they were, for that reason, left in.

Finally, this book can be a great aid in dating individual containers. For best results, the manufacturing dates or chronological parameters of the products should be compared to the technological attributes of vessel manufacture.

1. It is worthy to note that the Genealogical Department, Church of Jesus Christ of Latter-Day Saints, Salt Lake City, UT, is in possession of numerous county histories, gazatteers, and directories. This consolidated availability made my research much easier.

PATENT MEDICINE AND THE EMBOSSED BOTTLE ERA

Drugs are primarily grouped as proprietary or ethical. Drugs of an ethical nature are those restricted to sale by doctor's prescription, and proprietary drugs are generally protected by secrecy, copyright, or patent against free competition by name, product, composition, or manufacturing process.

"Patent Medicine" has become the common, generic term applied erroneously to all remedial agents sold without prescription (Munsey 1970). Although over 1,500 "proclaimed-to-cure" patents were issued in the United States by the late 1850s (Index of Patents, United States Patent Office), medicinal products were seldom patented.[1] Then, as now, a patent had to show a product to be new and useful and required the disclosure of formulas and contents. So manufacturers chose other forms of governmental protection instead to safeguard their legitimate and illegitimate secrets and interests by registering brand names or distinctive bottle shapes or designs as trademarks (Hechtlinger 1970; Carson 1961), and labels and promotional literature as copyrights (Young 1962). Trademarks were issued for twenty years, were renewable and were not subject to government scrutiny. Registered, these brands became known as proprietary medicines. Copyrights, according to a federal law of 1831, lasted for twenty-eight years and were renewable for fourteen more (Young 1962).

Prior to the twentieth century shrewd opportunists took advantage of the lack of federal drug controls. The period of 1850 to 1900 is considered the peak era of fraud and misrepresentation. The medicine business was lucrative and the public was ready and vulnerable. Anything could be bottled, advertised, and sold. Manufacturers swindled the public with medicines claiming extravagant therapeutic results and guarantees. Besides the fact that many patent and proprietary medicines provided no medicinal relief, the majority were foul tasting (until and even after introduction of taste-improving additives); however, the psychological advantages may have been positive. Products were advocated to cure from twenty to thirty ailments; one even claimed equal relief from both diarrhea and constipation. Bottled as tonics, killers, bitters, and liniments, many of these cures and remedies consisted of nothing more than alcohol, sugar and water. Some cure-alls even contained narcotics. Opium, for example, was often added not only for its pain-numbing characteristics, but because heavy consumption could lead to addiction, and subsequently increased sales.

The false truths became apparent to the public on 7 October 1905, when Samuel Hopkins Adams, of *Collier's, The National Weekly*, began his bold series of ten articles entitled, "The Great American Fraud." Although Adam's articles exposed 264 products, individuals and firms, only two lawsuits resulted (Young 1962). Federal investigations intensified, resulting in passage of the Pure Food and Drug(s) Act of 1906 (Wiley and Heyburn Bill). Created was "An Act for preventing the manufacture, sale, or transportation of adulterated or mis-branded or poisonous or deleterious foods, drugs, medicines, and liquors, and for regulating traffic therein, and for other purposes" (U. S. Dept. of Agriculture, Kebler 1909). The Act of 30 June 1906, effective January 1907, was the culmination of nearly twenty years of crusading by Dr. Harvey Washington Wiley, Chief of the Bureau of Chemistry, U. S. Department of Agriculture. The Bureau of Chemistry ensured that foods and drugs conformed to high standards of purity. Misbranding or formula adulterations were unlawful, even use of certain words was forbidden, like "cure" (Holcombe 1979). Drug companies were forced to improve, change, and properly label their products by displaying the presence and amounts of certain harm-

ful drugs; the naming of other ingredients was not necessary.

Hundreds of companies were forced out of business, lessening competition among the surviving firms. Those still in business were required to re-label or place a sticker on or near the old label stating "This product guaranteed under Pure Food and Drug(s) Act, June 30, 1906." The surviving firms, now well established, continued to grow, and prosperity was common. The flaws and limitations of the act were soon discovered, however, and false label claims continued. Use of the banned word, "cure," for example, persevered, and in 1910, nearly 1,400 such products were on the market (*American Druggist* 1910). The government, cognizant of the problem, strengthened the legislation in 1913 and passed the Sherley Amendment, which prohibited any false and fraudulent curative or therapeutic claims on labels. Again, drug companies found a weakness in the law and anyone caught paid only a minimal fine. In 1938, a major overhaul and rewrite brought an end to most of this deception with the signing of the Food, Drug, and Cosmetic Act on 25 June 1938 (Richardson 1979). The Cancer Act in 1939 and the Pharmacy and Medicines Act of 1941 at last made it illegal to advertise cures for cancer, Bright's disease, cataract, fits, diabetes, epilepsy, tuberculosis, etc. and misleading or other exaggerations by advertisement were further curtailed by a Code of Standards in 1950 (Turner 1953).

Throughout all these years, increased demands were continually being placed on the glass container manufacturers. Prospering medicine companies desired (or patented) their own designs and shapes; laws such as the Poisons and Pharmacy Act of 1908 contributed by requiring that liquid poison containers be distinguishable by shape and feel (Morgan 1979). Demands prompted technological change and improvement. For example, the use of more sophisticated molds expanded and popularized the use of raised, embossed lettering, virtually replacing the use of appliqued seals and etching or engraving on containers. Rarely were the latter applications used on medicine bottles; however, etching was occasionally applied to pharmaceutical containers. The versatility of molds also made possible the development of indented panels and other personalized, aesthetic and purposeful innovations. The combined use of molds with lettering occurred early; examples include Turlington Balsam, 1750 (Noël Hume 1969), Essence of Peppermint, prior to 1790 (Jones 1981), J. Tice's Liquid Blacking, 1804 (Putnam 1968); and Dr. Robertson's Family Medicines prepared by T. W. Dyott, 1809 (Nielsen 1978). Plate molds, patented in 1867 but probably used prior to 1860, permitted lettered paneling and even greater versatility (Toulouse 1969b). In general, embossing was not a common practice until the mid-nineteenth century and even by the 1890s, less than 40 percent of all glass bottles were embossed.

The last years of the nineteenth century are considered the era of semi-automation or period of greatest mechanical innovation. By the late 1880s, semi-automatic machines such as the one developed by Philip Arbogast (patented in the United States in 1881) and that of Howard Ashley (patented in England in 1886) allowed for substantial changes in the manufacture of bottles. The Arbogast machine, in use after 1893, allowed for mass production of wide-mouth vessels, including petroleum jelly and fruit jars. The Ashley machine, capable of manufacturing small-mouthed containers, saw little commercial use until 1899. Despite the new technology, the majority of all manufactured bottles in the United States in the early 1890s continued to be made by hand (Davis 1970; Miller and Sullivan 1981).

The years 1903–1904 must be considered the era of crowning achievement in the development and manufacture of glass containers. Even though other equipment had been in use for a few years, the Owens Fully Automatic Bottle Machine revolutionalized the industry. Although the machine started production in 1903, Michael J. Owens did not receive patent rights until 8 November 1904 (Toulouse 1967). Not until 1909 was Owen's machine capable of making small medicine bottles (Kendrick 1971). The unit was so expensive that the gradually improved semi-automatic machines

continued in use. The machine saw substantial improvements for many years and was the only extensively used automatic machine. Other machines were becoming available by 1917 (Kendrick 1971). Production figures show that in 1917 total automation, or use of the Owens machine, accounted for only 50 percent of all containers manufactured; roughly 5 to 10 percent were still produced by hand-blowers, the rest by semi-automatic machines (Davis 1970; Miller and Sullivan 1981). By 1924–25, 90 percent of all manufactured containers were completely machinemade (Davis 1970). Some containers were still handblown in the United States as late as 1938 (Toulouse 1967).

Technological advancements, volume production, and inflation all contributed to the slow decline of individualism in container manufacture, and by the 1920s, embossing and other unique traits were nearly extinct. Plastic bottles were introduced in the early 1950s and by the mid-1960s had become the most prevalent type of container due to factors such as weight, breakage, cost, mass production, automatic packaging, handling, and transportation.

1. In 1796 the first medicine patent was issued in the United States to Samuel Lee, Jr. of Windham, Connecticut for "bilious pills" (Young 1962), six years after the doors opened at the U.S. Patent Office (Munsey 1970).

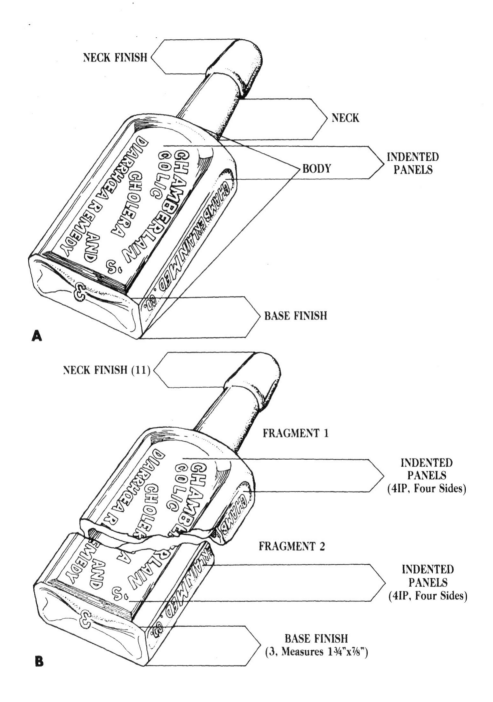

NECK FINISH

NECK

BODY

INDENTED
PANELS

BASE FINISH

A

NECK FINISH (11)

FRAGMENT 1

INDENTED
PANELS
(4IP, Four Sides)

FRAGMENT 2

INDENTED
PANELS
(4IP, Four Sides)

BASE FINISH
(3, Measures 1¾"x⅞")

B

FIG. 1

USER'S GUIDE

It is assumed that users of this book will generally have a particular vessel or vessel fragment in mind, if not in hand, that they are trying to research and interpret. This chapter will therefore explain how the book is to be used in order to research particular embossed patent and proprietary medicine bottles, especially vessel fragments or sherds which can be visually reconstructed and then further interpreted. Mechanisms are provided to help the user not only locate a vessel within the book, but also interpret the data available with each bottle entry.

BOTTLE CHAPTER HEADINGS AND INDEXES

The chapter headings in the main reference section of the book identify how the bottles have been categorized. Bottles are categorized by commonly used and applied words embossed within the glass. Most bottles have been grouped according to the medicinal product which they contained. However, others are classified by the firm or company name. The chapter headings are organized as follows:

- **Products:** Product chapters such as Balm, Balsam, Bitters, and Cure, etc., and product association chapters such as Hair and Cough list bottles under the product name.

Spelling variations are included in their related chapter, i.e., Balsamic with Balsam and Baume with Balm. The exclusion of some product categories is due to scarcity; anodyne, drops and embrocation, for example, are listed in the chapter entitled Miscellaneous.

- **Companies:** These chapters, including Chemical, Company, Drug, and Manufacturer, alphabetize a bottle by the firm or company name rather than the product name.

- **Miscellaneous:** This chapter exists for containers lacking common words, those which could not conveniently be placed in the other chapters.

Within each chapter, the bottles are listed alphabetically according to the actual name of the product or company. Titles and their variations, e.g., Doctor., Dr., Docᵗ.,Mr., Mrs., and Professor, and first names or initials are not used in alphabetizing.

In addition, there are three indexes in the back of the book to aid the user in locating information about partial or whole containers.

- **Place Name Index:** An index of cities, towns and states embossed within the glass. This index also includes the base shape identification number (see Figure 3) of each vessel to assist in scrutinizing sherds, and also refers the researcher to the primary name on the bottle and the chapter where it can be found.

- **Secondary Name Index:** An index of embossed alternate names such as agents, formula originators, proprietors and promoters and/or additional brand names. This index refers the researcher to the primary name on the bottle and the chapter where the information is located.

- **General Index:** An alphabetical index of containers, although not every variant is included. The user is referred to the page where the bottle is listed.

It is possible for one container to be located in several chapters. The Chamberlain's bottle in Figure 1, for example, has several common embossed words and can be found in the *Remedy*, Medicine, and Company chapters, as well as in the General Index, as CHAMBERLAIN'S COLIC CHOLERA AND DIARRHOEA REMEDY, and the Place Name Index under DES MOINES, IA. (The embossed city and state are not shown in the illustration.) The detailed histories, chronologies and labels

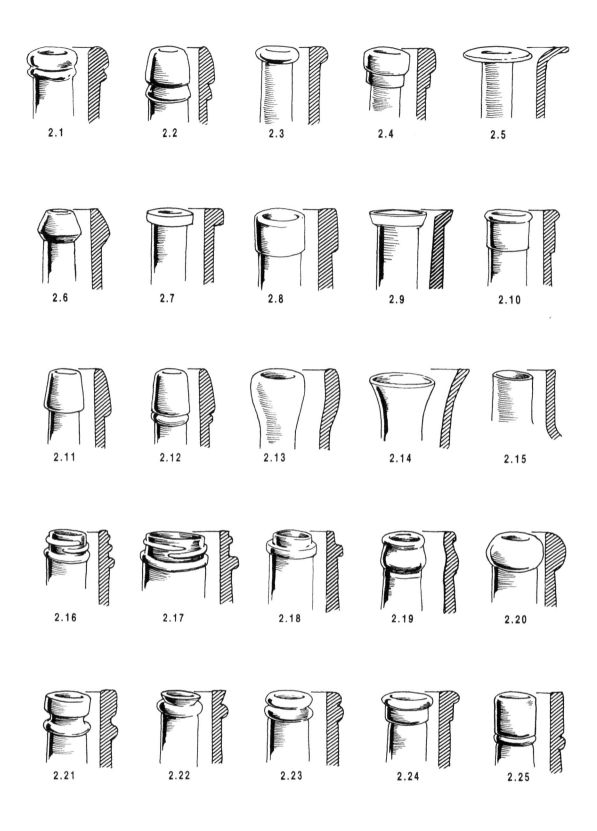

Fig. 2 – NECK FINISHES: 2.1 Double Ring; 2.2 Double Oil or Mineral; 2.3 Bead; 2.4 Stove Pipe; 2.5 Wide Prescription; 2.6 Sheared Ring (occasionally ground); 2.7 Flat or Patent; 2.8 English Ring, Deep Lip or Packer; 2.9 Prescription; 2.10 Reinforced Extract; 2.11 Ring or Oil; 2.12 Wine or Brandy; 2.13 Globular Flare; 2.14 Flare or Trumpet; 2.15 Sheared or Blow Over (usually ground); 2.16 Small Mouth External Thread; 2.17 Wide Mouth External Thread; 2.18 Champagne; 2.19 Crown; 2.20 Blob; 2.21 Grooved Ring; 2.22 Flared Ring; 2.23 Stacked Ring; 2.24 Collared Ring; 2.25 Straight Brandy or Wine. *Shapes and names are compiled from information from Cumberland Glass Co. Catalog, 1911; Dominion Glass Co. Catalog, n.d.; Illinois Glass Co. Catalog, 1911 (Putnam 1965); Whitall Tatum Glass Co. Catalog, 1880 and 1902 (James 1967); Whitney Glass Co. Catalog, 1904 (Lohman 1972).*

are not replicated if a bottle or company is listed in more than one chapter. The chapter containing the complete information appears in bold italics in the cross-referencing material following the physical attributes description. The full information, then, about the Chamberlain's bottle appears in **Remedy**.

DATA INTERPRETATION

Once the correct vessel has been located, the data describing the bottle will need to be interpreted. Each container description provides the following information: (1) The actual embossed words on the bottle; (2) The label, history and/or chronology of the company and product, if available and, (3) The physical attributes of the particular vessel, and cross-referencing information. The abbreviations used in the book are explained in this section.

Embossed Words

Embossed lettering is shown as close to the original as possible, i.e., upper and lower case, and if in script, so identified in the attribute data. Misspellings on the bottle are also replicated. Information in brackets [] does not appear on the bottle, but is given to help clarify the embossing. See "Embossing Scheme" for abbreviations. The following codes are used to denote embossing line and side changes:

| (/) **Single slash** | Line change |
| (//) **Double slash** | Side change |

Historic Data

The descriptive information may include the medicinal applications, label information, company histories, and individual container and product chronologies. Advertising dates usually cover the marketing range for each product, but they may not completely coincide with the vessel described, due to variations of bottles through the years or the change to label-only containers. Advertising dates are listed only for the earliest and latest dates that could be found. Not all city directories were checked or were available for every year, so some corporate and product information is incomplete. The addresses are listed exactly as they appear in the cata-

logs and directories; thus, the states' names are occasionally inconsistent. Ohio might be listed as O., Oh., or OH. Primary citations, e.g., trade catalogs, journals and city directories are cited similar to the following example: Adv. 1876, *WHS*; 1881, Gopsills' Philadelphia City Directory. Abbreviations used for the trade catalogs accompany the references in the bibliography. Parenthetical citations are derived from secondary sources, i.e., Adv. 1873 (Baldwin 1973); these data, however, are usually the results of other authors' use of primary sources of information (see annotated bibliography). Occasionally letters or symbols on bottle bases, representing bottle-makers, are discussed because of the additional chronological information. As a matter of interest, isolated numbers and/or letters on the base usually indicate design, mold control or batch number; they seldom provide chronological information (Toulouse 1972). The following abbreviations are used in the descriptive data:

Adv.	advertised
ca.	about or approximately
unk.	unknown
WHS, etc.	The abbreviations of trade catalogs (see bibliography for the complete name.)

Physical Attributes and References

The physical attributes of each vessel appear in bold type to assist the researcher in scanning the information.

- **Color** – self explanatory

- **Bottle dimensions** (height × width × breadth). Dimensions are in inches rather than metric because most vessels were designed and manufactured using the English system of measurement.

 | **dimens.** | dimensions |

- **Neck finish** (See Figure 2)[1]

 | **n** | neck |
 | **sp** | spool. A molded ring or ridge below the neck finish, above the shoulder. Often referred to as a ball neck. |

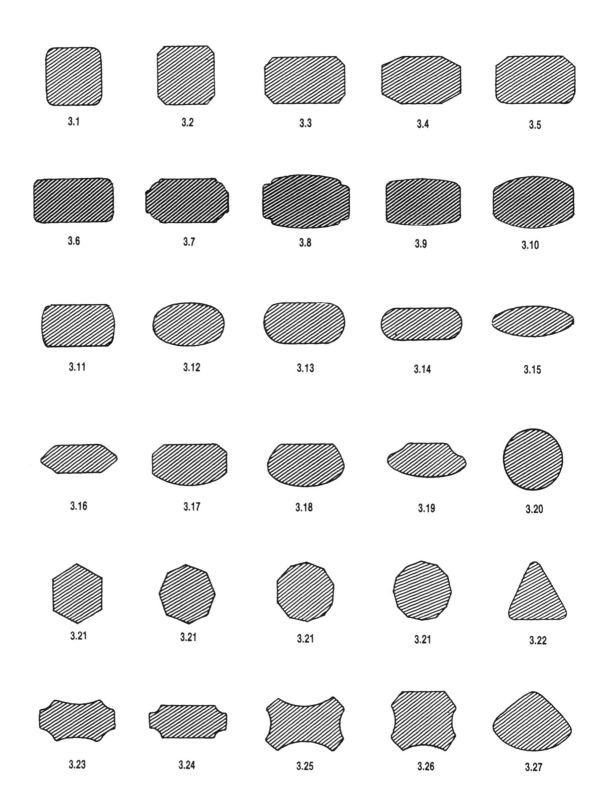

Fig. 3 – BASE PROFILES: 3.1 Hopkins Square; 3.2 French Square; 3.3 Blake (variant 1); 3.4 Blake (variant 2); 3.5 Beveled Ideal; 3.6 Excelsior, Windsor Oval or Round Cornered Blake; 3.7 Oblong Prescription; 3.8 Union Oval; 3.9 Crown Oval; 3.10 Salamander Oval; 3.11 Monarch or Erie Oval; 3.12 Plain Oval; 3.13 Elixir or Handy; 3.14 Slender Handy; 3.15 Oval; 3.16 Irregular Polygon; 3.17 Hub or Golden Gate Oval; 3.18 Buffalo or Philadelphia Oval; 3.19 Clamshell; 3.20 Round; 3.21 Polygon; 3.22 Triangle; 3.23 Fluted Oblong (variant 1); 3.24 Fluted Oblong (variant 2); 3.25 Concave; 3.26 Fluted Square; 3.27 Spherical Triangle. *Shapes and names taken from information from Berge (1980); Dominion Glass Co. Catalog, n.d.; Illinois Glass Co. Catalog, 1911 (Putnam 1965); Peter Van Schaak & Sons Drug Catalog, 1907; Whitall Tatum Glass Co. Catalog, 1902 (James 1967).*

- **Base profile** (See Figure 3)

b	base
rect.	rectangular base profile (specifics unknown)

Rare variations and modifications of the neck finishes and base profiles are either described or noted. It is recommended that Figures 2 and 3 be reproduced to save flipping back and forth to the front of the book.

- **Sides or panels**

pl	plain (not recessed)
ip	indented panels. The number preceding ip, for example, 4ip, indicates how many panels are indented.

- **Embossing scheme.** Historically, when the product was on the market, the unembossed back panel normally represented the front and contained the label. For our purposes, the embossed panel will be considered the front. Where no letter designating the sides is given, the embossing occurs on just the front panel, or remains the same on all panels. Embossing may occur in other areas, however, only the following are abbreviated.

b	back
c	corner
d	diagonal
f	front
h	horizontal
s	side
v	vertical

- **Other characteristics**

ABM	Automatic Bottle Machine.[2] All containers were mold blown and hand or mechanically finished (semi-automatically) unless specified ABM.
p	pontiled[3]

- **References.** The cross-referencing information follows the physical attribute data. The primary name on the bottle is followed in parentheses by the chapters in which further related information can be found. The chapter in bold italics identifies where the full historical data (label, corporate history, advertising chronology) is found. If a bottle does not list any attributes, it will refer the user to the chapter where the attributes are listed.

Let's walk through an example. The bottle in Figure 1 occurs in the text as:

CHAMBERLAIN'S/COLIC/CHOLERA/ AND/DIARRHOEA REMEDY// CHAMBERLAIN MED. CO.//DES MOINES, IA. U.S.A.
Aqua; $4^{1}/_{2}$″ × $1^{3}/_{4}$″ × $^{7}/_{8}$″; 11n; 3b; 4ip; v, fss. See CHAMBERLAIN'S *(Remedy).*

As previously mentioned, the common words embossed on this vessel mean that it is categorized in the **Remedy**, Company, and Medicine chapters, with **Remedy** containing the complete historical information. The primary name under which it is alphabetized in each section is CHAMBERLAIN'S. The interpretation of the physical attributes is as follows: The color is aqua. The bottle is $4^{1}/_{2}$″ high, $1^{3}/_{4}$″ wide and $^{7}/_{8}$″ thick. The neck finish is #11 (See Figure 2) and the base profile is #3 (See Figure 3). There are four indented panels, one on each of the four sides. The embossing is vertical with CHAMBERLAIN'S/COLIC/ CHOLERA/AND/DIARRHOEA REMEDY on the front panel, CHAMBERLAIN'S MED. CO. on a side panel and DES MOINES, IA. U.S.A. on the other side panel.

1. The neck finishes and base profiles were derived from a classification by Berge (1980); however, names for the neck finishes and base profiles vary. Those used were compiled from a variety of sources. Many of the names, from glass manufacturers' catalogs, reflect the overall vessel shape rather than neck or base designs. No standard nomenclature for all designs was found.

2. Bottles manufactured completely automatically (ABM) generally possess a mold seam characteristically different from those of mold-blown, hand-finished bottles. As a standard rule, mold seams in ABM bottles run vertically the full length of the container over the lip or top. Occasionally, this seam may be offset. Another seam will run horizontally around the base of the lip finish. The outer side of the base of ABM bottles usually possesses a filamented ring or heal seam. In the 1930s, 1940s, and later, valve marks, usually from $^{1}/_{2}$″ to $^{7}/_{8}$″, often off center, occur on the base (see Toulouse 1969b for a thorough discussion). Unless obliterated by turn molding, the vertical seams of mold-blown, hand-finished bottles stop just below or barely into the base

of the laid-on-ring or neck finish (Toulouse 1969a).

3. A pontil mark (resulting from the method of manufacture) often occurs on the base of bottles manufactured prior to ca. 1870. Pontils are usually visible and sometimes occur as rough protrusions of glass. A holding device, called a snap case, was introduced in America in the 1850s and replaced the pontil rod, thus eliminating the mark (Munsey 1970). Occasionally some free-blown speciality items are manufactured today using the pontil rod (Toulouse 1969a).

INTERPRETATION BY COLOR, DESIGN AND SHAPE

There are several documents currently available which contain classification schemes and functional discussions for historic artifacts in general. However few are substantive and/or pertinent solely to the categorical classification of nondescript glass bottles or sherds. Publication of such a document would satisfy a critical need and would be widely accepted as an invaluable tool for professional use. However, that is not the intent of this section and I wish here only to share with the reader a few observations by comparisons of medicinal products to common attributes of color, design, and shape. This information should place some vessels in better perspective and hopefully will be of assistance in identification and interpretation.

Medicinal containers were not only designed to be serviceable and practical but were occasionally manufactured with individuality, for a specific purpose, product, or client, and thus were instantly identifiable by color, design, or shape. Other vessels, designed to be multi-functional and more likely to contain a number of similar products, lacked the universal recognition value of "one design-one purpose." Prior to mechanization more variety and liberal individuality occurred; mechanization, unfortunately, produced standardization in color, design, and shape. Thus, it is with difficulty that unembossed and many embossed sherds, or even complete specimens can be placed into any specific category and dated with any confidence. Also the purpose for which a vessel was originally designed should not be confused with commercial and individual re-use since re-use is unpredictable depending upon the vessel's availability and convenience, popularity, and the individual's self needs.

COLOR

Firing and combinations of compounds affect color and hue intensity. Standard glass ingredients produce light green and aqua.[1] But some compounds are expensive. For example, it takes one ounce of gold to produce sixty pounds of ruby glass (Texaco Inc. 1962; Munsey 1970). Color was not necessarily indicative of use and rarely of time. However, the following general analogies can be posited.

Amber or brown glass had a general application, including use for alcoholic beverages such as beer and whiskey. It was used widely after ca. 1860.

Aqua glass had a general and very versatile application. It was commonly used in nearly all the product categories since the introduction of glass bottles.

Black glass[2] was mostly used for alcoholic beverages such as stout, ale, and wine, and mineral water, prior to ca. 1870.

Blue or cobalt glass was used for medicines, cosmetics, soda water, and for specialty use from the 1890s to the 1960s.

Clear glass[3] had a general application, especially after 1875.

Green glass had general, versatile use, including use for wine and mineral water vessels, from ca. 1865 or earlier.

Milk glass was used for medicines, cosmetics, toiletry, food, and specialty items from the 1890s to the 1960s.

Red glass was used for rare, specialty items.

DESIGN

Designs can be artistic, or individualistic, functional or utilitarian, or be the result of techniques employed in manufacture. Descriptive or functional embossing, mold seams, etching and applique seals, and even vessel shape, are forms of design (Munsey 1970). Designs can often be classified and dated. This reference helps serve that purpose for embossed medicinal containers.

SHAPE

Vessel shape, often analogous to design, is more diagnostic of specific use than is color. The function of many bottles with traditional shapes is well known, medicines being no exception. As an example, liquids were not drunk from a wide-mouthed bottle any more than a salve or ointment was extracted from a narrow-mouthed one. Alcohol bottles, by tradition, were obviously distinguishable from medicine bottles and so forth. Early trade catalogs showed the variety of containers that were available and often categorized them by function. In such catalogs, the medicine, liquor and household bottles, for example, were described and/or displayed by sub-function such as prescription, pharmaceutical, tablets, extracts, or brandy, gin, whiskey, and schnapps. Containers were usually designed to be practical and versatile and as such saw many functional uses. The exceptions were the traditionally well-known brand-name vessels, designed and often trademarked for individual use, i.e., Turlington Balsam, the Keeley Cure, various bitter figurals, etc. Some shapes, considered commercially competitive, were rarely used for more than one product. For example, the cylindrical, tapered vessel or vial (Figure 4), of English origin was exclusively used for Godfrey's Cordial or Dalby's Carminative. The bottle for Godfrey's Cordial was never embossed, and the product was eventually also bottled

Fig. 4

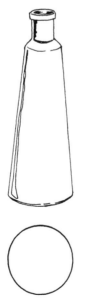

in American-manufactured vessels. First advertised in 1721, the product was still available in 1931. Dalby's Carminative was introduced in England in the 1780s, and subsequently imported to the United States. Dalby's Carminative was the subject of one of the first legal actions under the 1906 Act, a case concluded in 1940. Embossed variants of the bottle were manufactured and the product was on the market in 1940 or later (Griffenhagen and Young 1959). The vessels were small in stature, (ca. 5¼″ high, 1³⁄₈″ diameter at the base, ⁷⁄₈″ diameter at the shoulder), clear or aqua, and included neck finishes as shown in Figures 2.7 and 2.13.

The profiles and base shapes illustrated in Figures 5 through 10 represent vessels that were available to all users and are discussed because of solid evidence that they had particular medicinal use or application. Descriptions include the variations found in finishes, base profiles, and color, by descending order of popularity. Although attributes may vary slightly, the overall appearance generally remains about the same. In the main, dimensions are not provided in these discussions, since such attributes are covered in the reference section of this book. The trade catalogs are very helpful and should be consulted to gain familiarity with the general shapes and applications.

Figures 5.1–5.3 represent vessels manufactured exclusively for prescription use, and were popular during the latter nineteenth and early twentieth centuries. The form shown in Figure 5.4, while used for prescriptions, was versatile and also contained chemical and household products. The earlier drug or prescription bottles were generally round, often possessed pontils, and were usually aqua or pale blue. The slight variances found in shape, profile, and design are still easily recognized as representative of this particular group of medicines. The most dramatic changes were the finishes and basal profiles. Variations in finishes are shown in Figures 2.9, 2.5, 2.7, 2.3, 2.24, and 2.16 (the latter post-1910); that of basal profiles in Figures 3.18, 3.17, 3.20, 3.13, 3.3, and 3.2. Predominant colors were clear, aqua, amber, cobalt, and

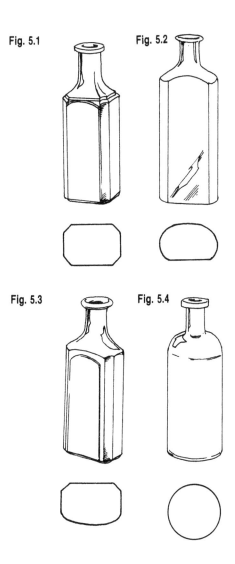

Fig. 5.1 Fig. 5.2

Fig. 5.3 Fig. 5.4

were given to the Enterprise Glass Company, the first to produce vessels of this kind (Davis 1970; Toulouse 1967). The predominant finishes are typified by Figures 2.17, 2.7, and 2.3 with base profiles 3.20 and occasionally 3.12. Colors varied from clear and aqua to rarely used amber and cobalt.

Bitters and tonics and occasionally compounds, cordials and schnapps were bottled in a variety of styles and shapes of containers. Figures 7.1 and 7.2 depict forms almost exclusively reserved for these products during the years ca. 1860 to ca. 1920. The majority of these products contained high percentages of alcohol and gained popularity with the advent of the temperance movement. Prior to enforcement of the Pure Food & Drug(s) Act, these products were recognized in abstinence societies as both curative and socially acceptable beverages (Deiss 1981). Additionally, producers could avoid the high revenue taxes imposed on liquors after 1862 (Munsey 1970). Descriptively, the finishes,

green in descending order of popularity.

Tablets and/or salts were bottled in a variety of containers. Figures 6.1 and 6.2 merely represent vessels most commonly used for these purposes. Finishes included 2.16, 2.7, and 2.3, of which the first two were occasionally ground. Colors generally varied from clear, aqua, and amber to an occasional emerald green, with extensive use of cobalt for salts, the latter popular during the first two decades of the twentieth century.

Paste medicines (creams and pomades), were bottled in a variety of wide-mouthed containers or jars (Figures 6.3 and 6.4). The illustrations shown approach nearly exclusive use, with exception of the Figure 6.4 variant, which was occasionally used for tablets. The commercial mass production of wide-mouthed, screw-capped paste jars, i.e., the Vaseline® jar, became possible with the introduction of Philip Arbogast's semi-automatic machine. Exclusive rights

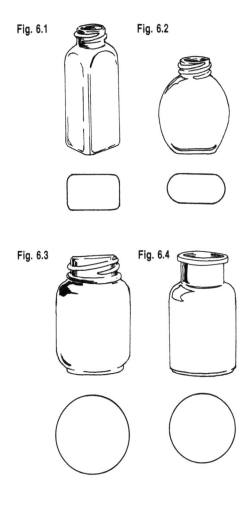

Fig. 6.1 Fig. 6.2

Fig. 6.3 Fig. 6.4

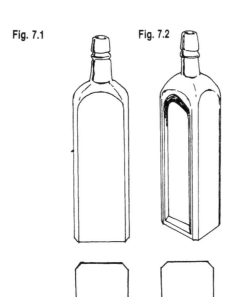

Fig. 7.1 Fig. 7.2

in descending order of popularity were 2.11, 2.12, 2.2, 2.25, 2.16, and 2.7; basal profiles were 3.2 and 3.1. Colors were amber, olive green, clear, light blue, and cobalt.

Liquids were available in a variety of bottles. Extracts were medicinal, such as compound extract of sarsaparilla, or household, e. g., vanilla extract. Liquid medicinal preparations included elixirs, liniments, mixtures, nervines, pectorals, pepsins, remedies, specifics, and syrups. Syrups were often bottled in containers with three and four indented panels, kickup bases, and spool or ball neck finished necks (Figures 8.1 and 8.2). Such features were functional, since they could conceal slight amounts of sediment and reduce volume;

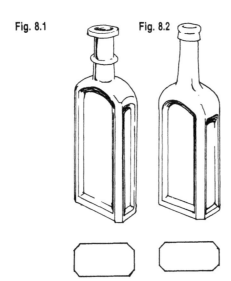

Fig. 8.1 Fig. 8.2

the latter, of course, saved the company money. Common neck finishes were 2.1, 2.3, 2.4–2.11, 2.13–2.16, and 2.24. Numerous bases and common colors were utilized.

Jamaica Ginger, popular during the last half of the nineteenth century, was seldom bottled in any shape other than that depicted in Figure 9.1. It was particularly popular as an alcohol substitute on "off-limits" military posts (Arthur Woodward, personal communication, 1964). The product was an alcoholic extract of ginger used for flavoring and medicinal infusion. Popular neck finishes included 2.11, 2.7, and 2.1. Colors were aqua, light blue, and clear.

Shown in Figure 9.2 is the common form traditionally and exclusively used for Florida

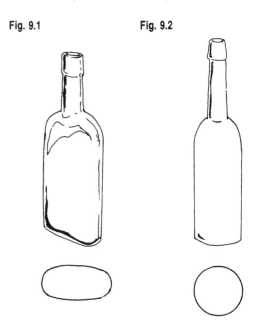

Fig. 9.1 Fig. 9.2

water and castor oil after ca. 1850. A variant used today for Florida water differs visually only in neck finish. Dimensions varied from about 5″ to 7″ inches in height and from 1³⁄₈″ to 2¹⁄₂″ in diameter. Color was the only distinguishing variable between Florida water and castor oil: cobalt blue for castor oil, aqua or pale blue, clear, and occasionally amber for Florida water.

The Hutchinson shape (Figure 10.1) is included here only because it was occasionally used for mineral water or citrate of magnesia. The vessel was used, almost exclusively, for soda water and is a result of the "Patent Spring Stopper" introduced by the W. H. Hutchinson Company,

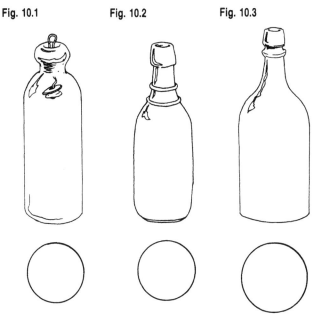

Fig. 10.1 Fig. 10.2 Fig. 10.3

Green or Yellow Green--copper, chromium, iron

 Milk or Opal--tin, zinc
 Opalescent--calcium phosphate
 Opaque--barium
 Red or Ruby--gold, copper, selenium
 Yellow--iron, antimony, silver, uranium, selenium.

2. The introduction of certain ingredients produced dark, olive-green or olive-amber glass, so nearly opaque that it became commonly referred to as "black glass" (Kendrick 1971; Munsey 1970).

3. The increased demand for clear glass containers became readily apparent by 1880. The growing food-preservation industry was forced to package products in clear vessels by the shopper who demanded to see, without distortion, what was being purchased (Kendrick 1971).

4. The company operates today, making closures as a division of the National Can Corporation.

Chicago in 1879 (Lief 1965),[4] and discontinued in 1912 (Riley 1958). Colors varied, the most common being aqua and clear.

Citrate of magnesia bottles, particularly popular during the first three decades of this century, were easily recognized, and the shape, depicted in Figure 10.2, was exclusively used for this purpose. Minor design differences occurred but were readily apparent. Often embossed, the average height was about 8″, diameter about 3″. Neck finishes of 2.1, 2.7, 2.11, 2.19, and 2.22 were possible as well as a three-ringed variant; colors were clear, aqua, light blue, and, rarely, amber or cobalt.

Mineral water, available in a variety of containers, consisted of a combination of gases and dissolved salts and was medicinal. The vessel depicted in Figure 10.3 probably contained only mineral water (ca. 1840 to ca. 1890). Dark colors predominated: olive green (black glass), olive amber, and emerald green.

1. Combinations of other compounds produce the following colors:
 Amber and Brown--carbon, nickel, iron
 Black--iron, carbon, or other metals
 Blue--cobalt, copper
 Clear--manganese, selenium, arsenic. When exposed to ultra-violet rays, manganese turns clear glass amethyst or purple (depending upon the amount); selenium turns the glass straw color or yellow. Arsenic has no obvious effect.

Fig. 11

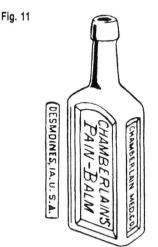

Lotion, Miscellaneous, *(Remedy)*, VON HOPF (Bitters), W. WARNER *(Company)*.

CHAMPION/EMBALMING FLUID/ THE CHAMPION/CHEMICAL CO./ SPRINGFIELD/OHIO
See CHAMPION *(Company)*.

I. COVERT'S//BALM OF LIFE
". . . Remedy for all diseases of the windpipe and lungs." Product of I. Covert, Auburn, NY. Adv. 1839 (Baldwin 1973); 1841 (Putnam 1968).
Olive; 6″ × 2¹⁄₂″ × 1⁵⁄₈″; 11n; 4b; pl; v, fb; p.

DILL'S/BALM OF LIFE// THE DILL MEDICINE CO.// NORRISTOWN, PA.
See DILL *(Company)*.

DURFEE/EMBALMING/FLUID CO/ GRAND RAPIDS/MICH.//POISON/ [graduated markings] **8 OZ to 64 OZ**
Clear; 8¹⁄₂″ × 4⁵⁄₈″ × 4⁵⁄₈″; 9n; 2b; pl; h, fb. See DURFEE (Miscellaneous).

[h] A. D./ELMERS/[v] IT CURES/ LIKE/A CHARM//PAIN KILLING// BALM
Manufactured in Northfield, MA, as a cure for everything from diptheria to toothache, and for wounds by glass, scythe and rusty nails. Adv. 1890, *W & P*; 1910, *AD*.
Aqua; 4⁷⁄₈″ × 1¹⁄₂″ × 1³⁄₁₆″; 7n; 3b; 4ip; arched front; h, v, fss.

ELY'S/CREAM/BALM/CO./ OWEGO/N.Y.//HAY FEVER// CATARRH
Label: . . . *Application for Catarrh, Hay Fever, and Cold In The Head* . . . Product of Charles, Fred and Alfred Ely, Owego, NY, introduced in 1878 (Wilson and Wilson 1971). *The Historical Gazetteer of Tioga Co., NY,*

BALM

BAUME UNICA/SECRET INDIAN REG᷎ᴰ/MOUTREAL
Aqua; 5³⁄₄″ × 1⁷⁄₈″ × 1¹⁄₈″; 7n; 3b; 4ip, v.

BLODGETT'S/PERSIAN BALM// THE GREAT/HOME LUXURY
Aqua, teal blue; 4⁷⁄₈″ × 1⁹⁄₁₆″ × 1″; 11n; 3b; 4ip, arched; v, fb; p. See PERSIAN *(Balm)*.

BOGLES//QUAKER BALM
San Francisco directories listed the Quaker Medicine Company, founded by Joseph H. Bogle, in 1886. Bogle retired in 1890, due to poor health, and was succeeded by his wife Christina (Wilson and Wilson 1971). Christina was still operating the firm in 1897. Product adv. 1912 (Devner 1968).
Aqua; 6″ × ? × ?; 7n; 3b; 3 or 4ip; v, ss.

BRANT'S/SOOTHING BALM// J. W. BRANT//HILLSDALE, MICH
Adv. 1871, *VSS & R*; 1912, by the J. W. Brant Co., Ltd., Albion, MI (Devner 1968).
Color and dimens. unk.; 1n; 3 or 6b; 3ip; v, fss. See BRANT *(Balsam, Extract)*.

D᷎ᴿ E. C. BALM
Aqua; 5″ × 1¹⁄₁₆″ × 1″; 11n; 3b; 4ip; v; p.

CHAMBERLAIN'S/PAIN-BALM// CHAMBERLAIN MED. CO//DES MOINES, IA. U.S.A. [See Figure 11]
Adv. 1889, *PV & S*; 1923, *SF & PD*.
Aqua; 5¹⁄₄″ × 1⁷⁄₈″ × 1″; 11n; 3b; 4ip; v, fss; 3 sizes. See CHAMBERLAIN, (Liniment, Lotion, Miscellaneous, *(Remedy)*, VON HOPF (Bitters), W. WARNER *(Company)*.

CHAMBERLAIN'S/PAIN-BALM// CHAMBERLAIN MED. CO.// DES MOINES, IA. U.S.A.
Aqua; 7¹⁄₈″ × ? × ?; 11n; 3b; 3ip; v, fss. See CHAMBERLAIN (Liniment,

1875–1888, showed the firm had moved to New York City by 1888; the business was purchased by Wyeth Chemical Co. in 1913 (Devner 1968). Balm adv. 1941–42 by Wyeth Chem. Co., New York City, *AD*.
Amber; 2¹⁄₂″ × 1³⁄₈″ × 1″; 15n; 3b; pl; h, f; v, ss.

ELY'S/CREAM/BALM/ELY BRO'S/ NEW YORK//HAY FEVER// CATARRH
Amber; 2¹⁄₂″ × 1⁵⁄₈″ × ⁷⁄₈″; 15n; 3b; 2ip, arched front; h, f; v, ss.

ELY'S/CREAM/BALM/ELY BROS./ OWEGO/N.Y.//HAY FEVER// CATARRH [See Figure 12]
Amber; 2¹⁄₂″ × 1³⁄₈″ × 1″; 15n; 3b; pl; arched front; h, f; v, ss; several embossing orders.

Fig. 12

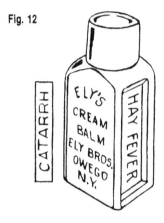

ELY'S/CREAM/BALM/LIQUID/ ELY BRO'S/NEW YORK// HAY FEVER//CATARRH
Amber; 3³⁄₁₆″ × 1⁹⁄₁₆″ × 1¹⁄₄″; 9n; 3b; 2ip; h, f; v, ss.

95-F.F.F.-95/BALM OF GILEOD/ EMBROCATION. 1889
Product of San Jose, CA.
Aqua; 6¹⁄₄″ × 2″ × 1¹⁄₄″; 7n; 3b; 4ip; v.

BALM//OF//THOUSAND/ FLOWERS//FETRIDGE & C᷎ᴼ// NEW YORK
"Dr. Fontaine's Balm of a Thousand Flowers, For the Toilet, The Nursery, For Bathing, has many medicinal purposes and remedies every defect of the complexion, Fetridge & Co." Adv. 1851 (Singer 1982). Produced as Fetridge's Balm in 1865, *GG*, and without a brand name in 1877, *McK & R*; manufactured also by J. Hauel.
Aqua; 5″ × 1³⁄₄″ × 1″; 9n; 4b; pl; v, scfcs. See CUTICURA *(Cure)*, HAUEL (Balm), POTTER (Drug), SANFORD *(Invigorator)*.

PROF. H. K. FLAGGS//BALM OF EXCELLENCE//[6-point star monogram]
Bottled and sold by H. K. Flagg, Worcester, MA. Adv. 1865, *GG*; 1895, *McK & R*.
Aqua; 5⅞″ × 1⅝″ × 1″ (also in other heights); 1n; 3b; ip; v, ssf; p.

FORSHA'S//ALTERATIVE/BALM
Cincinnati city directory, 1864: "Forsha's Alterative Balm—A Balm for every wound—For Internal or External use. Laboratory and depot, No. 415 Fifth Street, Cincinnati, Ohio." Balm adv. 1854 (Baldwin 1973); 1916, *MB*.
Aqua; 4⅛″ × 1¾″ × ⅞″; 13n; 3b; 2ip; v, fb; p. See FORSHA (Balsam).

HAGAN'S/MAGNOLIA/BALM
Introduced ca. 1850 and marketed by Demas Barnes; distributors included the P. H. Drake Lab, 1860 to 1870; J. F. Henry, 1870 to ?; and Wm. E. Everson, New York (Wilson and Wilson 1971). Adv. 1900 by the Lyon Mfg. Co, 43 S. Fifth St., Brooklyn, N.Y., *EBB*; 1941–42 Lyon Mfg. Co., 41 S. Fifth St., *AD*.
Aqua; 2½″ × 1¹/₁₆″ × ⁹/₁₆″; 7n; 3b; pl; v. See DRAKE (*Bitters*), WYNKOOP (*Pectoral*).

HAGAN'S/MAGNOLIA/BALM
[See Figure 13]
Label: *HAGAN'S MAGNOLIA BALM for Beautifying the Complexion, Eradicating Freckles, Erruptions, Sunburn and Tan. Wm. E. Everson, New York, Sole Agent.*
Milk glass, clear; 5″ × 2⅛″ × 1½″; 7 or 3n; 3b; pl; v. See DRAKE (*Bitters*), WYNKOOP (*Pectoral*).

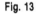

Fig. 13

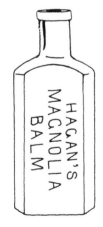

HAGAN'S/MAGNOLIA/BALM
Label: *HAGAN'S MAGNOLIA BALM for Beautifying the Complexion. Made in four colors, this is White. Tones down dark complexion instantly. An Excellent Face Powder in Liquid Form. Lyon Mfg. Co.,*

Inc., Brooklyn, N.Y., New Label Adopted Jan. 1919.
Clear; 5⅛″ × 2⅛″ × 1½″; 3n; 3b; pl; v. See DRAKE (*Bitters*), WYNKOOP (*Pectoral*).

NASAL BALM/W. T. HANSON CO/ PROPRIETORS/SCHENECTADY/ N.Y.//CATARRH// COLD IN THE HEAD
Willis T. Hanson, Schenectady, NY, apparently founded his medicine manufacturing business in the 1890s; the firm was still operating in 1939 according to Schenectady city directories. Adv. 1895, *PVS & S*; 1921, *BD*.
Clear; 4⅜″ × 1⅝″ × 1⅛″; 15n; 3b or 6b; pl, h, f; v, ss.

DR. HARTER'S/LUNG BALM// Sᵀ LOUIS Mᵒ
Adv. 1872, *F & F*; 1921, *BD*.
Color unk.; 6″ × ? × ?; 7n; 3b; 3ip; v, sfs. See HARTER (*Bitters*, Elixir, Miscellaneous, Tonic), HOOD (Company).

THE ORIGINAL//BALM OF// THOUSAND/FLOWERS// JULES HAUEL//PHILADᴬ
Clear; 5″ × 1¾″ × 1⅛″; 5n; 4b; pl; v, scfcs; p. See FETRIDGE (Balm), HAUEL (*Company*, Miscellaneous).

[h] Dᴿ McLEAN'S/[d] LIVER/&/ KIDNEY/[h] BALM/Sᵀ LOUIS
Label: *. . . Reliable Remedy For Diseases of the Liver, Kidney & Urinary Organs . . .* In 1851 James H. McLean and Addison G. Bragg were listed as wholesale druggists on the corner of Third & Market Streets, St. Louis. In 1854–55, Bragg became affiliated only with Mexican Mustang Liniment, and McLean with Volcanic Oil Liniment, although both were located at the same address. Demas Barnes eventually acquired the Mustang Liniment and by 1864, Bragg had moved and established another firm at 61 Market St. In 1867, McLean moved to 314 Chestnut St. The first reference to McLean as being a manufacturer of drugs was in 1873. In 1883, McLean moved to the southeast corner of Broadway and Biddle streets, and the firm soon became the Dr. J. H. McLean Medicine Company (Holcombe 1979). In the 1900 *Era Blue Book* and 1929–30 *American Druggist*, the Company was located at 3114 Franklin Ave.; in 1981, 1 W. 37th St., New York City, *AD*. Liver & Kidney Balm adv. 1889, *PVS & S*; 1923, *SF & PD*. Products were still being manufactured as of 1983, *AD*.

Aqua; 8¾″ × ? × ?; 11n; 12b; pl; h, d. See McLEAN (Miscellaneous, *Oil*, Purifier, Sarsaparilla), MEXICAN (*Liniment*).

DR. J. H. McLEAN'S/TAR WINE LUNG/BALM/ST. LOUIS, MO.
Adv. 1889, *PVS & S*; 1929–30, *AD*. McLean's Tar Wine Compound adv. 1935, *AD*; 1983, *RB*.
Aqua; 7¼″ × 2⁷/₁₆″ × 1⅜″; 1n or 11n; 12b; pl; h; also ABM. See McLEAN (Miscellaneous, *Oil*, Purifier, Sarsaparilla).

MILLER'S BALM
Label: *Miller's Magnetic Balm . . . A Universal Remedy and Instantaneous Specific for Cholera, Cholera Morbus, Diarrhoea, Colic, and All Pains in the region of the Stomach or Bowels (Alcohol 56%).* Product was introduced in the 1860s by Dr. J. R. Miller, Syracuse, NY. The sole agent has continuously been David Ransom or D. Ransom & Sons (Holcombe 1979; Wilson and Wilson 1971). Adv. 1948, *AD*.
Aqua; 3½″ × ? × ?; 7n; 3b; 3 or 4ip; arched front; v. See ANDERSON (Miscellaneous), RANSOM (*Company*), TRASK (*Ointment*).

DR. J. R. MILLER'S// MAGNETIC BALM
Aqua; 4¾″ × 1¾″ × ⅞″; 7n; 3b or 6b; 3 or 4ip; v, ss. See ANDERSON (Miscellaneous), RANSOM (*Company*), TRASK (*Ointment*).

MODJESKA DERMA-BALM// Larkin Soap Co.//Larkin Soap Co.
See LARKIN (*Company*).

NORWEGIAN BALM/ FOR CATARRH/N. B. PHELPS PROPRIETOR/NEW YORK
Directories have Napoleon B. Phelps as proprietor of the Norwegian Balm from 1879 to 1885, subsequent owner(s) are unknown. The product was available in 1900, *EBB*.
Clear; 5¼″ × 2″ × ?; 9n; 3 or 6b; ip; v.

OLDRIDGES/BALM/OF COLUMBIA//FOR RESTORING/ HAIR/PHILADELPHIA
Product of J. Oldridge, Philadelphia. Adv. 1823, introduced in England, 1824, *CC*; 1851, *JSH*.
Aqua; 5⅛″ × 2½″ × 1⅝″; 6n; 23b; pl; v, fb; p.

[v] OLDRIDGE'S/BALM/ OF COLUMBIA//FOR RESTORING/ HAIR/PHILADELPHIA/[horizontally above base:] ENLARG'D 1826
Cornflower blue; 5⁵/₁₆″ × 2⅜″ × 1¾″; 2n; 23b; pl; v, h, fb.

**PATTON'S/ [arched] FLORAL BALM/
CURES/CHAPPED/HANDS & C./
McCLELLAN/AND/PATTON/
NEW YORK**
Directories for 1893–1894 show Leslie
C. McClellan and John G. Patton, 508
Manhattan Ave., New York City, as
druggists. In 1895 the pair were listed
as brokers.
Clear; 5″ × 2³/₄″ × 1³/₁₆″; 9n; 17b,
with rounded corners; pl; h.

PAWNEE/INDIAN BALM
Probably the product of the Pawnee
Indian Medicine Co., San Francisco.
Charles A. Burgess purchased the
company of Giesue Rottanzi, manufac-
turer of Pawnee Long Life Bitters and
others, in the 1890s, and established his
own laboratory on Howard Street
(Wilson and Wilson 1971). The San
Francisco directory for 1891 listed the
Pawnee Indian Med. Co. at 2476
Howard, with Charles A. and William
Burgess as proprietors. Frank, son of
Charles, assumed the business in 1903
(Wilson and Wilson 1971). In 1923,
Mrs. F. P. Burgess is listed as proprie-
tor (Ring 1980). In 1929–30, the
Pawnee Indian Med. Co. dispensed
Pawnee Cough Balsam from 3542
Mission St.; in 1935, from 244 Taylor
Street, *AD*. Pawnee Indian Pain Balm
adv. 1896–97, *Mack*; 1923, *SF & PD*.
Clear; 4⁹/₁₆″ × 1⁵/₈″ × 1″; 9n; 3b; pl; v.
See PAWNEE (Bitters, Miscellaneous).

**PERSIAN/BALM//
S. S. BLOODGETT [sic]/
OGDENSBURGH NY**
Blodgett's Persian Balm, The Great
Home Luxury; note embossing error.
Persian Balm (brand name unk.) adv.
1860, *CNT*; 1871, *WHS*; Blodgett's Per-
sian Balm, 1887, *WHS*; 1910, *AD*.
Aqua, teal blue; 5″ × 1³/₄″ × 1¹/₈″; 9n
or 11n, 3b; 4ip, arched; v, fb; p. See
BLODGETT (Balm).

**PRETZINGER'S/CATARRH BALM/
DAYTON, OHIO**
Product of Pretzinger Bros., Chemists,
Dayton, OH, in 1898 (Baldwin 1973).
Adv. as Pretzinger's Nasal Balm, 1948,
AD.
Clear; 2″ × 1¹/₄″ diameter; 17n; 20b;
pl; v.

**RUSH'S//LUNG//BALM//
A. H. FLANDERS M.D.**
Introduced by Abraham Hilliard
Flanders, Boston, MA, in 1866 or 1867.
Flanders moved to New York City ca.
1872 and also introduced a Pain Cure
and Restorer (Wilson and Wilson 1971).
Balm adv, 1910, *AD*.
Aqua; 7¹/₈″ × 2¹/₄″ × 1¹/₂″; 1n; 3b; 4ip;
v, fssb. See RUSH (Bitters, Miscellaneous,
Sarsaparilla).

**SEMINOLE INDIAN MED. CO./
LUNG BALM/BOONE, IOWA**
See SEMINOLE *(Company)*.

**UNIVERSAL/EMBALMING/FLUID/
COMPANY/ST. LOUIS, MISSOURI**
See UNIVERSAL *(Company)*.

**VAN WERT'S/GOLDEN BALM/
VAN WERT CHEMICAL CO/
WATERTOWN, N.Y.**
Adv. 1887 (Baldwin 1973); 1910, *AD*.
Aqua; 2⁷/₈″ × 1¹/₈″ diameter; 9n; 20b;
pl; v. See VAN WERT *(Balsam)*.

BALSAM

ABEL'S WHITE PINE/BALSAM/ LOS ANGELES, CAL
Adv. as Horne & Abel's White Pine Balsam, 1896–97, *Mack*; as Abel's White Pine Balsam, 1897, *L & M* and 1923, *SF & PD*.

Clear, aqua; 5⅝″ × 2¹/₁₆″ × 1⅛″, also 4⅝″ × 1¾″ × 1″; 7n; 3b; 4ip; v.

ABIETENE/COUGH BALSAM
Introduced ca. 1885 by R. M. Green and A. J. Jones, Oroville, CA (Blasi 1974); adv. 1923, *SF & PD*.

Clear; 6⅞″ × ? × ?; 1n, sp; 3 or 6b; ip; v. See ABIETENE (Company), GREEN (Restorer).

DR. A. L. ADAM'S// LIVER BALSAM
Aqua; 7¼″ × 2½″ × ?; 1n; 3 or 6b; 3ip; v, sf; p.

ALLEN'S/LUNG/BALSAM//DAVIS & LAWRENCE CO. LIM.// NEW YORK
Label: *Allen's Cough Balsam*. Lung Balsam adv. 1859 (Baldwin 1973); 1910, *AD*. Cough Balsam adv. 1922, *RD*; 1929–30 by Davis & Lawrence Co., Bronx Blvd. and 238th St., New York City. Cough Compound adv. 1935 from Bronx and 238th; 1948 by Davis & Lawrence Co., 75 Main St., Dobbs Ferry, N.Y., *AD*.

Aqua; 6¾″ × 2½″ × ⅞″; 11n; 3b; 3ip; v, fss.

ALLEN'S/LUNG/BALSAM// J. N. HARRIS & CO// CINCINATTI [sic]
Bottle manufactured ca. 1886; oldest variants without J. N. HARRIS & CO date to 1871 (Wilson and Wilson 1971). The balsam, formulated by Dr. William Allen of Fort Edwards, NY, was introduced by J. N. Harris in 1863 (Blasi 1974; Wilson and Wilson 1971). Adv. 1923, *SF & PD*.

Aqua; 8″ × 2¾″ × 1½″, also 6¾″ × 2¼″ × 1″; 11n; 3b; 4ip; v, fss; also other sizes. See ALLEN (Jamaica Ginger).

Mʀˢ S. A. ALLEN'S//WORLDS HAIR/BALSAM/355 BROOME Sᵗ// NEW YORK
Adv. 1900, *EBB*; possibly Mrs. Allen's Zylo Balsamum, adv. 1840 (Holcombe 1979), 1907, *PVS & S*.

Aqua; 6¾″ × 2¼″ × 1⅜″; 1n; 3b; 4ip; v, sfs. See MRS. ALLEN (Miscellaneous, *Restorer*).

ALLISON'S CHERRY BALSAM/ LINCOLN
Other products adv. 1900: Chalybeate Tonic, Diarrhoea Cure, Iceland Balsam, Pectoral Troches of Wild Cherry, Peristaltic Lozenges & Pile Ointment, *EBB*.

Light blue; 5⁷/₁₆″ × 2″ × 1⅛″; 7n; 3b; 3ip; v.

AMERICAN/PULMONARY/ BALSAM
Possibly American Balsam, an English product formulated by John Hill, the creator of Hill's Balsam of Honey. American Balsam was introduced in England in 1770 (Young 1962); and made available in the United States in 1790 (penciled entry in *John Day & Co.* catalog.

Aqua; 5¼″ × 1⅛″ diameter; 5n; 20b; pl; v. See BALSAM OF HONEY (Balsam).

AMERICAN//RHEUMATIC/ BALSAM//BUFFALO, N. Y.
Product of R. Turner, Buffalo. Adv. 1850 (Blasi 1974).

Aqua; 6⅜″ × ? × ?; 11n; 3 or 4ip; v, sfs; p. See TURNER (Jamaica Ginger).

Dʀ SETH ARNOLD'S//BALSAM// GILMAN BROS./BOSTON
A diarrhoea remedy introduced by Seth Arnold, New London, CT in 1840s (Blasi 1974). Owned by Gilman Bros., Boston, in 1866 (Singer 1982). Adv. 1848 (Putnam 1968); 1910, *AD*. Directories first include Gilman Bros. (G.D., J.A., and S.K. Gilman) in 1863. The firm still existed in 1986.

Aqua; 7″ × ? × ?; 7n; 3b; 3ip; v, ssf; several variants. See ARNOLD (Cough, Pills), PAGE (Syrup).

A. DAVIS ASHLEY'S/HONEY BALSAM/NEW BEDFORD, MASS.
Adv. 1890, *W & P*; 1900 at 947 Acushnet Ave., *EBB*.

Aqua; 6⅛″ × ? × ?; 7n; 3b; 3 or 4ip; v.

A. D. ASHLEY'S//RED SEA BALSAM//NEW BEDFORD, MASS.
Adv. 1890, *W & P*.

Aqua; 4¼″ × 1¼″ diameter; 7n; 21b; 12 sides; pl; v, sss. Also ABM variant with Red Sea Balsam in quotes.

Dʀ H AUSTIN'S//GENUINE/ AGUE BALSAM//PLYMOUTH, O.
Austin's Ague Drops, adv. 1879, *VSS & C*; 1900, *EBB*.

Aqua; 7″ × ? × ?; 11n; 3b; 3 or 4ip; v, sfs, p.

TRY BAKERS 5 MINUTE/ BALSAM 10ᶜᴱᴺᵀˢ
Product of Johnson, Nelson & Co., Detroit, incorporated in 1889; the firm operated as Nelson Baker & Co. from 1891 to 1951; then as Nelson Chemical Co. (Blasi 1974). Balsam adv. 1900, *EBB*.

Light green, 5⁷/₁₆″ × ? × ?; 7n; 3 or 6b; ip; v.

BALSAM/OF/HONEY
Embossed bottles introduced ca. late 1830s (Wilson and Wilson 1971). Bottle contained either Cundell's or Hill's Balsam of Honey; Cundell's adv. 1810 (Putnam, 1968); 1834, *S & S*. Hill's adv. 1790, *JD*; 1901, *HH & M*.

Aqua; 3″ × ?; 13n; 20b; pl; v; p. See AMERICAN PULMONARY (Balsam).

BALSAM/OF/HONEY
Aqua; 3⅛″ × 1⅛″ diameter; 5n; 20b; pl; v. See AMERICAN PULMONARY (Balsam).

BARCLAY'S/AMERICAN/BALSAM
[George] Barclay's, [New York] American Balsam of Spikenard, Blood Root, Wild Cherry, Comfrey, and Elecampane, adv. 1845 (Blasi 1974).

Aqua; 5¾″ × ? × ?; 2n; 3 or 6b; pl; v; p. See BARRY (Hair).

BARNES & PARK/NEW YORK// BALSAM OF WILD// CHERRY AND TAR
Product of Demas Barnes and John D. Park ca. 1855 to 1868 (Shimko 1969).

Aqua; 7½″ × ? × ?; 11n; 3b; 3 or 4ip; v, fss; p. See GUYSOTT (Sarsaparilla), WYNKOOP (Pectoral).

BEGGS/DIARRHOEA BALSAM
Charles W. Beggs, Elk Point, South Dakota Territory, was in partnership with Eldin C. DeWitt, Sioux City, IA, ca. 1884 to 1886. Beggs also established a separate business in Chicago in 1886 (Blasi 1974). Products included Blood Purifier, Dandelion Bitters, Cherry Cough Syrup, Eye Water, IXL Bitters,

Knoxit, Soothing Syrup, etc. Balsam adv. 1895, *PVS & S*; 1916, *MB*.

Aqua; 5¾″ × ? × ?; 7n; 3 or 6b; pl, v. See BEGGS (Syrup), KNOXIT (Miscellaneous).

DR. BELL'S//BALSAM OF/ ALPINE MOSS,// FOR CONSUMPTION// NEW YORK & LONDON/ CHEMICAL CO./NEW YORK

Product adv. 1875 (Baldwin 1973); 1879 by G. L. Bell, *VSS & C*; 1910, *AD*. Bell's Lung Balsam adv. 1935 by Claude A. Bell, Lowell, Mass., *AD*. These may or may not be same product.

Aqua; 7¾″ × 2⅝″ × 1½″; 7n; sp; 3b; ip; v, sfsb; back embossing order indeterminate. See BELL *(Manufacturer)*.

BENJAMIN'S LUNG BALSAM/ P. A. BENJAMIN CHEMIST/ KINGSTON, JA.

Aqua, clear; 6¼″ × ? × ?; 7n; 3 or 6b; ip; v.

Dr BLACKMAN'S//GENUINE// HEALING//BALSAM

Adv. 1857 (Baldwin 1973); 1935 by Filkins & Bros., 352 Hayward Ave., Rochester, N.Y., *AD*.

Aqua, clear; 5⅝″ × 1½″ diameter; 13n; 21b, 8 sides; pl; v, ss: also without p.

Dr. M. BOWMAN'S//GENUINE// HEALING//BALSAM

Adv. 1852 (Baldwin 1973); 1890, *W & P*.

Clear; 5¾″ × ?; 14n; 21b, 8 sides; pl; v, ssss; p.

BRANT'S//INDIAN//BALSAM

Brant's Indian Pulmonary Balsam, the product of M. [Matthew] T. Wallace, Brooklyn, NY, adv. 1847 (Blasi 1974; Wilson and Wilson 1971); 1901 by H. Planten & Son, New York City, *HH & M*; 1910, *AD*.

Aqua; 7″ × 2⅜″ diameter; 11n; 21b, 8 sides; pl; v, sss; p. See BAKER (Miscellaneous), BRANT (Balm, Extract).

BRANT'S INDIAN//PULMONARY BALSAM//M. T. WALLACE/ PROPRIETOR

Aqua; 7″ × ?; 11n; 21b; pl; v, sss; p. See BRANT (Extract).

BRANT'S/PULMONARY/ BALSAM//J. W. BRANT CO.// ALBION, MICH.//BRANTS

The firm apparently was established in Hillsdale, MI many years before its incorporation in 1896. Directories list

the company until 1933 (Blasi 1974). Adv. 1879, *VSS & C*; 1929–30 by J. W. Brant Co., Albion, Mich., *AD*.

Aqua; 6¼″ × ? × ?; 1n; 3 or 6b; ip, small arched, indented panel on back; v, fss; h, b. See BRANT (Balm).

BRUNKER'S/CARMINATIVE/ BALSAM

Adv. 1889, *PVS & S*; 1948 by Mooney-Mueller-Ward Co., 501 Madison Ave., Indianapolis, Ind., *AD*.

Clear; 4¾″ × ? × ?; 9n; 3b; ip; v.

BUCHAN'S//HUNGARIAN// BALSAM OF LIFE//LONDON

Adv. 1843 (Putnam 1968); 1910, *AD*.

Aqua; 5⅝″ × 1¹⁵⁄₁₆″ diameter; 5n; 20b; pl; v, fsbs.

BURK'S/WHITE PINE/BALSAM

Product of Burk's Medicine Co., Chicago, IL, adv. 1889, *PVS & S*; 1915 (Blasi 1974).

Clear; 6″ × 2¼″ × 1⅛″; 7n, sp; 3b; 3ip, arched; v; several variants. See BURK *(Medicine)*.

BURR'S//HEALING BALSAM

Adv. 1879 (Blasi 1974).

Clear; 4⅛″ × ?; 7n; 21b, 8 sides; pl; v, ss.

BURRILLS COMPOUND/ CHERRY BALSAM

Product of H. L. Burrill & Co., Weedsport, NY. Adv. 1877 (Blasi 1974).

Aqua; 5″ × 1⅝″ × 1″; 7n; rect.; ip, v.

BUTLERS//BALSAM//OF// LIVERWORT

An English product, adv. ca. 1804 to ca. 1900 (Wilson and Wilson 1971).

Aqua; 4¼″ × 1¼″ × 1¼″; 13n; 2b; pl; v, fsbs.

Dr CARTER'S/COMPOUND/ PULMONARY/BALSAM

Product of Wm. Henry Carter, Newbury, VT introduced in 1840; F. H. Keyes Company, Newbury, became proprietors in 1841 (Blasi 1974). Adv. 1895, *M & R*.

Aqua; 5¼″ × ?; 6n; 20b; pl; v.

CHEESEMAN'S/ARABIAN/BALSAM

Adv. 1839 by E. Cheeseman, Richfield Springs, NY (Blasi 1974); late 19th century by T. H. Robinson Co., New York (source unk.); 1910, *AD*.

Aqua; 4″ × 1⅜″ diameter; 5n, crude; 20b; pl; v; p.

Dr J. S. CLARK'S//BALSAM FOR THE//THROAT & LUNGS

Aqua; 8½″ × ? × ?; 1n; 3b; 3 or 4 ip, arched front; v, fss.

CLIFTON'S/BALSAMIC COUGH/ MIXTURE

Light green; 5³⁄₁₆″ × 1¹³⁄₁₆″ × 1⅛″; 7n; 3b; 3ip; v.

CONGREVE'S//CELEBRATED/ BALSAMIC//ELIXIR// FOR COUGH/& ASTHMA

[George T.] Congreve's Elixir for Consumption, of English origin, was imported by E. Fougera & Co.; adv. 1880 (Blasi 1974); 1900, *EBB*; 1935, *AD*.

Clear; 4⅞″ × 1⅞″ × 1⅛″; 7n; 3b; pl; v, sfsb; several sizes.

CRUMPTON'S//STRAWBERRY// BALSAM//ATTICA, INᴰ

Product of William Crumpton, adv. 1862 (Baldwin 1973; Blasi 1974); 1910, *AD*.

Aqua; 4⅞″ × 1⅜″ × 1⅜″; 5n; 1b; 4ip; v, fsbs, p.

DR. DENIG'S/COUGH BALSAM

Adv. 1887, *M & K*; 1929–30, 1935 by Owl Medicine Co., 35 Rodgers Ave., Columbus, Oh.; *AD*.

Aqua; 6¼″ × 2¼″ × 1¼″; 11n; 3b; 3ip; v; graphite p.

B. DENTON'S//HEALING BALSAM

"For Man or Beast"; a product of Barton Denton, New York, Hall & Ruckel, New York, agents. Adv. 1847 (Baldwin 1973); 1912 (Blasi 1974).

Aqua; 4″ × 1⅛″ diameter; 10 and 11n; 21b, 8 sides; pl; v; with and without p.

GEO. K. DICKINSON/ALTERATIVE BALSAM/HARTFORD CONN.

Adv. 1872 (Blasi 1974); 1900 from 67 Evergreen Ave., *EBB*.

Aqua; 7″ × ? × ?; 7n; 3b; ip; v.

M. DIMMITT/Sᵀ. LOUIS//COUGH// BALSAM [See Figure 14]

Marcellus Dimmitt, "wholesale and retail dealer in drugs, patent medicines,

Fig. 14

chemicals & c.," established his business in 1864; this firm became M. Dimmitt & Bro. in 1870 and was unlisted in directories after 1874. Dimmitt was also associated with Robert S. Hale, Dimmitt, Hale & ˙ Co., 1870–1874. Balsam adv. 1869, St. Louis city directory; 1900, *EBB*.
Aqua; 4¹³⁄₁₆″ × 2″ × 1⁵⁄₁₆″; 1n; 3b; 3ip; v, fss. See DIMMITT (Hair).

MRS. DINSMORE'S/ COUGH & CROUP/BALSAM
English product distributed by L. M. Brock, Lynn, MA (Devner 1968). Introduced ca. 1875 (Blasi 1974); adv. 1910, *AD*.
Clear; 6″ × 2¹⁄₈″ × 1″; 7n; 3b; 1ip, oval; v.

REV. N. H. DOWNS'// VEGETABLE//BALSAMIC//ELIXIR
See DOWNS' (Elixir).

DRAKE'S/CHERRY BALSAM
Aqua; 6¹⁄₄″ × ? × ?; 7n; 3 or 6b; ip; v.

DUCONGE'S/PECTORAL BALSAM SYRUP/NEW ORLEANS
Francois P. Duconge, a New Orleans druggist, first promoted the balsam in 1871. The last listing in directories was by family members in 1895–1896 (Blasi 1974).
Aqua; 6¹⁄₂″ × ? × ?; 7n; 3b; ip; v.

EGYPTIAN/COUGH BALSAM
A product of Frank Hadley, New Bedford, MA. Product trademarked 1885 (Blasi 1974); adv. 1900, *EBB*.
Clear; 6⁵⁄₈″ × ? × ?; 7n; 3 or 6b; ip, oval; v.

Dr. ENGLES'/BALSAM OF/LIFE
Aqua; 8″ × ? × ?; 11n; 3 or 6b; ip; v; p.

FATHER'S BALSAM/H. H. HAINES/ FT. WAYNE, IND. U.S.A.
Product of Henry H. Haines, Ft. Wayne, IN, 1888 to ca. 1919 (Blasi 1974).
Clear; 5¹⁄₂″ × ? × ?; 11n; 12b; pl; v.

Dʳ S. FELLER'S/LUNG BALSAM
Aqua; 6⁵⁄₈″ × ? × ?; 11n; rect.; ip; v; p.

Dᴿ FILKINS BROS//GENUINE// HEALING BALSAM//ALBANY N. Y.
Directories indicate that Filkins was an Albany, NY druggist who entered the wholesale drug business in 1871. Adv. 1900, *EBB*; 1910, *AD*.
Clear; 5³⁄₄″ × 1³⁄₄″ diameter; 7n; 21b, 8 sides; pl; v, ssss, embossed on alternate sides.

FORSHA'S//ALTERATIVE/ BALSAM
Aqua; 4¹⁄₄″ × 1³⁄₄″ × ³⁄₄″; 13n; 3b; 2ip; v, fb; p. See FORSHA (Balm).

MRS. M. N. GARDNER'S/INDIAN BALSAM/OF LIVERWORT
Adv. 1835, *JH*; 1910, *AD*.
Aqua; 5″ × 2¹⁄₈″ diameter; 5n; 20b; pl; v; p. See CUTICURA (Cure).

J. H. GAYLORD/PINE TREE/ BALSAM
A Schenectady, NY product (Blasi 1974); adv. 1910, *AD*.
Clear, aqua; 4³⁄₄″ × 2¹⁄₈″ × 1¹⁄₄″; 7n; 17 or 18b; pl; v.

GERMAN BALSAM BITTERS/ W. M. WATSON & CO./ SOLE AGENTS FOR U.S.
See GERMAN (Bitters).

J. E. GOMBAULT'S/ CAUSTIC BALSAM// THE LAWRENCE–WILLIAMS CO./ SOLE PROP'S FOR U.S.A. AND CANADA//THE LAWRENCE– WILLIAMS CO./SOLE PROP'S FOR U.S.A. AND CANADA
A French preparation, introduced in Cleveland, OH, ca. 1860s (Wilson and Wilson 1971). Adv. 1948 as "The safe, reliable liniment, counter-irritant or blister used by horsemen, breeders and veterinarians for over 71 years. Also remarkably effective for the relief of human strains and pains. Gombault's Products Corporation, 511 Fifth Ave., New York City," *AD*.
Aqua; 6¹⁄₂″ × 2⁷⁄₁₆″ × 1⁷⁄₁₆″; 11n; 4b; pl; v, fss.

J. E. GOMBAULTS/ CAUSTIC BALSAM// THE LAWRENCE WILLIAMS CO.// THE LAWRENCE WILLIAMS CO.
Aqua; 6¹⁄₂″ × 2¹⁄₂″ × 1¹⁄₄″; 11n; 4b; pl; v, fss.

J. E. GOMBAULT'S/CAUSTIC BALSAM/COMPOUND// THE LAWRENCE WILLIAMS CO.// THE LAWRENCE WILLIAMS CO.
Aqua; 6¹⁄₄″ × ? × ?; 11n; 4b; pl; v, fss.

GRAY'S BALSAM/BEST COUGH CURE//S. K. PIERSON// LEROY, N.Y.
Product of Stanley K. Pierson, LeRoy, NY. Adv. 1910, *AD*.
Aqua; 6¹⁄₂″ × 2¹⁄₈″ × 1¹⁄₈″; 11n; 3b; 3 or 4ip; v, fss.

GRAY'S BALSAM/CURES COUGHS//S. K. PIERSON//

LEROY, N. Y.
Clear; 5⁵⁄₁₆″ × 2″ × 1″; 11n; 6b; 4ip; v, fss.

HALL/BALSAM/FOR THE LUNGS//NEW YORK
A William S. Hall product introduced ca. 1850. Amon L. Scovill soon acquired the product (Wilson and Wilson 1971). John F. Henry acquired A. L. Scovill & Co. in 1873 (Holcombe 1979). Adv. 1874 by John F. Henry, Curran & Co., 8 & 9 College Pl., New York, (Fike 1967); 1923, *SF & PD*, proprietor unk.
Aqua; 5¹⁄₄″ × ? × ?; 11n; 3b; 4ip; v, fs. See BAKER (Miscellaneous), BENNETT (Cure), J. F. HENRY (Company), SCOVILL (Company, Syrup), WARREN (Cordial, Remedy).

HALL'S/BALSAM/FOR THE LUNGS//DR. W. HALL CO// NEW YORK
Aqua; 6¹⁄₂″ × ? × ?; 11n; 3b; 4ip; v, fss. See BAKER (Miscellaneous), BENNETT (Cure), J. F. HENRY (Company), SCOVILL (Company, Syrup), WARREN (Cordial, Remedy).

HALL'S BALSAM/FOR THE LUNGS//JOHN F. HENRY & Co// NEW YORK
See J. F. HENRY (Company).

HALL'S BALSAM/FOR THE LUNGS//A. L. SCOVILL & CO// CIN'TI & N. Y.
See SCOVILL (Company).

HALL'S/PULMONARY/BALSAM// J. R. GATES & CO.// PROPRIETORS S.F.
Unrelated to Hall's Balsam For The Lungs, Hall's Pulmonary Balsam was labeled a . . . *Safe and Speedy Cure for Diseases of the Throat and Lungs* Introduced ca. 1855 by Richard Hall; then acquired by J. R. Gates. J. R. Gates & Co. became Shepardson & Gates in 1867 (Blasi 1974). Adv. 1921, *BD*.
Aqua; 6³⁄₈″ × 2″ × 1¹⁄₈″; 11n; 3b; 4ip; v, fss. See BARNES (Jamaica Ginger), HALL (Sarsaparilla).

HAMLIN'S/COUGH BALSAM// CHICAGO//U.S.A.
Label: *WIZARD COUGH CORDIAL – Contains 2% Alcohol – For Coughs & Colds. Hamlins Wizard Oil Co., Chicago, Ill., Toronto, Can. Guaranteed Under Food & Drugs Act, June 30, 1906 – No-2035.* Adv. 1871, *WHS*; 1923, *SF & PD*.
Clear; 6¹⁄₁₆″ × 1⁷⁄₈″ × ⁷⁄₈″; 1n; 6b; 4ip; v, fss. See HAMLIN (Oil).

**REV. W. HARRISON/ROME N.Y.//
COUGH//BALSAM**
Adv. 1863 (Baldwin 1973).
Aqua; 7$\frac{1}{8}$" × 2$\frac{1}{2}$" × 1$\frac{1}{4}$"; 7n; 3 or
6b; 3 or 4ip; v, fss.

**DR. HARVEY'S/ALPINE BALSAM/
A. W. DOBBS ITHACA, N. Y.**
Albert Dobbs manufactured medicines
from 1888 to 1910 (Blasi 1974).
Aqua; 5$\frac{3}{4}$" × 2" × 1"; 11n; 3 or 6b;
ip; v.

**DR. HAYNES//ARABIAN BALSAM/
E. MORGAN & SONS/
PROVIDENCE, R.I.**
A product for pain and inflammation.
Advertisement in 1858: "DR.
HAYNES' ARABIAN BALSAM.
40,000 Bottles Sold In Less Than Two
Years Without Advertising. Prepared
and sold by the inventor, A. Haynes,
M.D., South Braintree, Mass." (Singer
1982). Trademark was acquired by J.
Austin Rodgers in 1877. E. Morgan &
Sons was established in 1885 (Blasi
1974). Balsam adv. 1948 by E. Morgan
& Sons, 350 Weybosset St., Provi-
dence, RI, AD.
Aqua; 4$\frac{1}{8}$" × 1$\frac{1}{4}$" diameter; 7n; 21b;
pl; v.

**Dr HOOFLAND'S/BALSAMIC
CORDIAL//C. M. JACKSON/
PHILADELPHIA**
C. M. Jackson was an agent for this
product ca. 1850 to 1863, when all
rights transferred to Charles Evans and
R. S. Jones. By 1873, rights belonged
to Johnson & Holloway, Philadelphia
(Blasi 1974). Adv. 1900, EBB.
Aqua; 6$\frac{7}{8}$" × 3" × ?; 9n; 3b; 4ip; v, fb;
p. See HOOFLAND (*Bitters*, Tonic).

**DR. HOUGH'S/COUGH & LUNG/
BALSAM//DR. H. G. HOUGH//
PROVIDENCE, R.I.**
1872 directories refer to an H. C.
Hough, so the bottle was probably
embossed incorrectly. H. C. Hough
died in 1885 (Blasi 1974). The product
was adv. in 1900 by H. I. Hough, Provi-
dence, RI, EBB, and in 1935, AD.
Aqua; 6$\frac{3}{4}$" × ? × ?; 1n; 4b; v, fss.

**HUNTER'S/PUL. BALSAM/
or COUGH SYRUP//J. CURTIS/
PROP.TR/BANGOR ME.**
Adv. 1858 (Baldwin 1973). This was
probably a product of Jeremiah Curtis
who apparently retained proprietorship
of this product after the merger of Curtis
& Perkins. Bottle may predate Curtis's
move to New York in 1854.

Aqua; 6" × 2" × 1$\frac{3}{8}$"; 7 or 9n; 4b; pl;
v, fb; p. See CURTIS (Miscellaneous,
Syrup), CURTIS & PERKINS (Bitters,
Killer), WINSLOW *(Syrup)*.

HURD'S COUGH/BALSAM
Aqua; 4$\frac{1}{2}$" × 1$\frac{13}{16}$" × 1$\frac{1}{16}$"; 13n; 3b;
1ip; v, arched panel; p.

**HYATT'S//AB/DOUBLE
STRENGTH//LIFE BALSAM/N.Y.**
William Hyatt produced three different
Life Balsams and established his patent
medicine business in 1849 according to
Doggett's New York City directory.
Hyatt's Double Strength Balsam adv.
1864 (Blasi 1974, Putnam 1968);
1929–30 by Century National Chemi-
cal Co., 86 Warren St., New York City,
AD.
Aqua; 9$\frac{3}{4}$" × ? x?; 2n; 3b; ip; v, sfs.

**HYATT'S//INFALLIBLE//
LIFE BALSAM/N.Y.**
Hyatt's Infallible Balsam adv. 1849
(Blasi 1974); 1910, AD; Hyatt's Balsam
adv.1935 by Century Nat'l|Chem.Co.,
Ward & Cross Streets, Paterson,
N.J., AD.
Green; 9$\frac{1}{2}$" × 3$\frac{7}{8}$" × 2$\frac{7}{8}$", 6 or so
variants; 11n; 3b; ip; v, sfs; p.

**HYATT'S//PULMONIC//
LIFE BALSAM/N.Y.**
Hyatt's Pulmonic Balsam adv. 1857
(Baldwin 1973); 1891, WHS.
Aqua; 11" × 3" × ?; 12n; 3b; ip; v, sfs;
graphite p.

**DR D. JAYNE'S/CARMINATIVE/
BALSAM/PHILAD$^\triangle$**
Adv. 1837 (Singer 1982); 1948 by
Dr. D. Jayne & Son, Inc., 2 Vine St.,
Philadelphia, Pa., AD.
Aqua; 4$\frac{3}{4}$" × 1$\frac{1}{8}$" diameter, also
variant 5$\frac{1}{4}$" diameter; 7n; 20b; pl; v;
several styles, with and without p.
See JAYNE (Expectorant, Liniment,
Miscellaneous, Tonic).

KEMP'S BALSAM [See Figure 15]
Bottle manufactured after 1900 (Wilson
and Wilson 1971). Orator Frank Wood-
ward was born in 1856 and moved to
LeRoy, NY in 1860. "In 1883 he
commenced the manufacture of Kemp's
balsam, in which he has secured a large
trade," *Beers Gazetteer and Biographical
Record of Genesee Co., N.Y., 1788–1890.*
Woodward acquired Jell-O in 1890, died
in 1906 and was succeeded in business
by the family. In 1920, son Donald,
purchased all interests and incorporated
as Kemp & Lane, Inc.; in 1929 the
company purchased S. B. Goff & Son.

The firm was still in business in 1964
(Shimko 1969). Balsam adv. 1935 by
Kemp & Lane, Inc., LeRoy, N.Y., AD.
Aqua; 2$\frac{7}{8}$" × 1$\frac{3}{8}$" × $\frac{11}{16}$"; 7n; 12b;
pl; v. See GOFF (Bitters), KEMP
(Sarsaparilla), WESTLAKE (Ointment).

Fig. 15

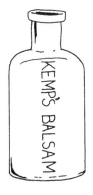

**KEMP'S BALSAM/FOR THAT
COUGH//KEMP'S BALSAM/
FOR THAT COUGH** [Base: O in a
square]
Label: *KEMP'S BALSAM For Coughs,
Colds and Sore Throat, Kemp and Lane,
Inc., LeRoy, N.Y.* Bottle manufactured
by the Owens Bottle Co., Toledo, O,
1911 to 1929 (Toulouse 1972).
Clear; 5$\frac{1}{2}$" × 1$\frac{7}{8}$" × 1"; 8n; 3b; v, ss.
See KEMP (Sarsaparilla).

**KEMP'S BALSAM/FOR THAT
COUGH//KEMP'S BALSAM/
FOR THAT COUGH** [Base: O
superimposed over a diamond]
Label: *KEMP'S BALSAM For Coughs,
Sore Throat due to Colds. Kemp and Lane
Inc., LeRoy, N.Y.* Bottle manufactured
by Owens Illinois Glass Co., 1932 to
1943 (Toulouse 1972).
Clear; 6$\frac{1}{8}$" × 2$\frac{1}{4}$" × 1$\frac{3}{8}$"; 8n; 3b; pl;
v, ss, ABM. See KEMP (Sarsaparilla).

**KEMP'S BALSAM/FOR/THROAT
AND LUNGS//O. F. WOODWARD//
LEROY, N.Y.**
Bottle manufactured ca. 1900 (Wilson
and Wilson 1971).
Aqua; 5$\frac{1}{2}$" × ? × ?; 7n; 3b; 3ip; v, fss.
See KEMP (Sarsaparilla).

**KEMP'S BALSAM/FOR/THROAT
AND LUNGS//O. F. WOODWARD//
LEROY, N.Y.**
Bottle manufactured ca. 1896 (Wilson
and Wilson 1971).
Clear, aqua; 6$\frac{3}{4}$" × 2$\frac{1}{4}$" × 1$\frac{1}{4}$"; 11n;
3b; 3ip; v, fss. See KEMP (Sarsaparilla).

**DR. B. J. KENDALL'S/
BLACKBERRY BALSAM**
Introduced ca. 1872 (Blasi 1974); adv.
1929–30 by Kimball Bros. & Co., Inc.,

Enosburgh Falls, Vt.; 1948 as Blackberry Compound, *AD.*

Clear, aqua; 5″ × ? × ?; 1n, modified; 3 or 6b; ip; v. See HAMILTON (Oil), HUTCHINSON (Company), KENDALL (Cure, **Miscellaneous**).

DR. KENNEDY'S//CHERRY BALSAM/FOR THE LUNGS// RONDOUT N.Y. U.S.A.

Product of Dr. David Kennedy. Adv. 1887, *WHS;* 1910, *AD.*

Aqua; 5³⁄₄″ × 1¹³⁄₁₆″ × ⁷⁄₈″; 11n; 3b; 4ip; v, sfs. See KENNEDY **(Remedy).**

DR. M. G. KERR/&/BERTOLET// COMPOUND/ASIATIC BALSAM// NORRISTOWN PA

Product of Marcus G. Kerr, adv. 1837 to 1854. Kerr established a brief partnership with Amos Bertolet from ca. 1849 to 1854 (Blasi 1974).

Aqua; 4⁵⁄₈″ × 1⁵⁄₈″ × ³⁄₄″; 5n; 3b; 4ip; v, fbs.

KIRK'S IRISH MOSS/ COUGH BALSAM

Adv. 1898 (Baldwin 1973); 1923, *SF & PD.*

Clear; 5⁷⁄₈″ × 2″ × 1″; 7n, sp; 3b; 4ip; v.

LOUDEN & CO'S/CARMINATIVE/ BALSAM/PHILAD.△

Introduced by George Louden ca. 1849. Louden apparently sold the business in the 1860s (Blasi 1974). Product adv. 1910, *AD.*

Aqua; 5¹⁄₄″ × 1³⁄₈″ diameter; 5n; 20b; pl; v. See LOUDEN (Company, **Elixir**).

Dᴿ. MANN'S//CELEBRATED/ AGUE BALSAM//GALION, OHIO

"Unrivalled in the History of Medicine." Product of S. K. Mann & Co., Galion, OH, 1859, 1892 (Blasi 1974); adv. 1900, *EBB.*

Aqua; 6³⁄₄″ × ? × ?; 1n; 3 or 6b; ip; arched front; v, sfs.

MASTA'S/INDIAN//PULMONIC// BALSAM//LOWELL/MASS.

Product of Joseph A. Masta (Blasi 1974). Adv. 1857 (Baldwin 1973); 1900, *EBB.*

Aqua; 5¹⁄₂″ × ? × ?; 1n; 3b; 3ip; h, f, v, ssb.

MASTEN'S BALSAM/ OF HOREHOUND/FOR THROAT, LUNGS & ETC.//ALBANY, N.Y.// ALBANY, N.Y.

Willard E. Masten operated the Masten Drug Store in Albany, NY from 1875 until his death in 1904 (Blasi 1974).

Light green; 6¹⁄₄″ × ? × ?; 1n; 3 or 6b; ip, arched front; v, fss. See MASTEN (Water), ELMENDORF (Water).

McANDREWS/COUGH BALSAM

[See Figure 16]
Label: *McANDREWS TAR & CHERRY COMPOUND—Recommended as a Safe Remedy for Coughs, Sore Throat, Hoarseness, Whooping Cough, and all Ailments of the Throat and Lungs. Contains no Opiates or Other Harmful Drugs. Prepared by Dolan & Furnival Co., Portland, Maine.* Balsam adv. 1880 (Blasi 1974).

Clear; 5″ × ? × ?; 7n; rect.; pl; v.

Fig. 16

DR. CHAS. MEYER'S//LUNG BALSAM//MACUNGIE, PENN.

Aqua; 6¹⁄₄″ × ? x?; 7n; 3 or 6b; ip; v, sfs.

MINGAY'S/COUGH BALSAM

Adv. 1887, *M & K;* 1910, *AD.*

Aqua; 4¹⁄₄″ × ? × ?; 7n; 3b; ip; v. See MINGAY **(Miscellaneous).**

DR. NUNN'S/BLACK OIL/ HEALING BALSAM

Clear; 5¹⁄₄″ × ?; 7n; 20b; pl; v. See NUNN **(Compound).**

DR. OTTO'S/SPRUCE GUM/ BALSAM

Product of the Carlstedt Medicine Co., Evansville, IN from 1892 to 1903 and the American Pharmacal Co., Evansville, IN, same address, from 1904 to 1915 (Blasi 1974; Devner 1968). Balsam adv. 1916, *MB.*

Clear; 3″ × 1³⁄₈″ × ³⁄₄″; 7 or 9n; 12b; pl; v.

JOHN PALMER'S/BALSAM

Aqua; 7″ × 2³⁄₈″ × 1¹⁄₄″; 11n; 3 or 6b; ip; v.

PARKER'S//HAIR/BALSAM// NEW YORK

[See Figure 17]
Label: *PARKER'S HAIR BALSAM, A Toilet Preparation of High Standard, Used for Restoring the Natural Color, etc.,*

HISCOX CHEMICAL WORKS, PATCHOGUE, N.Y. David Hiscox established Hiscox & Co. in 1875, and began producing the balsam in 1876 (Blasi 1974; Wilson and Wilson 1971). Adv. 1879, *VSS & C;* 1948 by Hiscox Chemical Works Inc., 52 Rider Ave., Patchogue, NY, *AD.*

Amber; 6³⁄₄″ × 2³⁄₈″ × 1¹⁄₄″; 1n; 3b; 4ip, oval panels; v, sfs. See PARKER (Tonic).

Fig. 17

PARKER'S//HAIR/BALSAM// NEW YORK

[Base: embossed diamond] Bottle manufactured by the Diamond Glass Company, Royersford, PA, symbol used after 1924 (Toulouse 1972).

Olive; 7¹⁄₂″ × 2⁷⁄₈″ × 1³⁄₄″; 1n; 3b; 4ip, oval panels; v, sfs; ABM. See PARKER (Tonic).

Dr J. PETTITS/CANKER/BALSAM

Balsam introduced in Fredonia, NY, ca. 1844. By the 1890s, Pettit Medicines were manufactured in Buffalo, NY and included Pettit's American Cough Cure, Eye Salve, Blood Purifier, Pile Remedy and Worm Honey (Wilson and Wilson 1971). Pettit's Eye Salve and Canker Balsam were controlled or owned by W. H. Schieffelin in 1891, *WHS.* Balsam adv. 1929–30 by Howard Bros. Chemical Co., 457–459 Washington St., Buffalo, N.Y.; 1941–42 by Smith, Carroll Dunham Pharmacal Co., Orange, N.J., *AD.* Pettit's Eye Salve manufactured by Medtech Labs, Cody, WY, 1985, *AD.*

Clear; 3¹⁄₄″ × 1¹⁄₂″ × ⁷⁄₈″; 7n; 12b; pl; v. See PETTIT (Cure).

GOLDEN BALSAM/RICHARD'S/ SAN FRANCISCO

C. French Richards, San Francisco, obtained the balsam trademark in 1865. C. F. Richards & Co., Wholesale Druggists, was established in 1868 and was still operating in 1904 (Blasi 1974).

Aqua; 5⁵⁄₈″ × 2¹⁄₈″ diameter; 1n; 20b; pl; v.

**[h] 3³/₄ OZ/[v] RODERIC/
WILD CHERRY/COUGH BALSAM**
Label: . . . *Prepared by The Roderic
Extract Co. Portland, Maine.* The trade-
mark was obtained by Chas. S. Foss,
Deering, MI, in 1885 (Blasi 1974). Adv.
1910, *AD.*
Clear; 5¹/₄″ × ? × ?; 9n; 4b; pl; h, v;
also ABM.

**DR. RUSSELL'S/BALSAM OF
HOREHOUND/AND/
SARSAPARILLA**
See RUSSELL *(Sarsaparilla).*

DR. SAWEN'S//COUGH BALSAM
Introduced ca. 1850s, in Watertown,
NY. Product of W. Sawens & Co.,
Utica, NY from 1868 to 1885 (Blasi
1974). Adv. 1910, *AD*, manufacturer
unknown.
Aqua; 7³/₈″ × 2¹/₂″ × 1³/₈″; 11n; 3b; 3
or 4ip; v, ss; also with p. See SAWEN
(Company).

**DR. SCOTT'S ELECTRIC/COUGH
BALSAM/G. M. GROSSE, PROPᴿ**
Aqua; 6⁵/₈″ × ? × ?; 7n; 3b; ip, oval
front panel; v.

SEABURY'S//COUGH BALSAM
Adv. 1871, *WHS*; 1910, *AD.*
Aqua; 4³/₄″ × 1¹/₄″ diameter; 3n; 20b;
pl; v, fb. See SEABURY (Miscellaneous).

**Dᴿ SEYMOUR'S//BALSAM OF//
WILD CHERRY//& COMFREY**
Aqua; 6¹/₂″ × 2¹/₂″ diameter; 11n;
21b; pl; v, ssss, 8 sides, embossed on
4 consecutive sides; p.

**SKELTON'S//PECTORAL BALSAM/
OF LIFE/FOR//LUNG DISEASES**
Adv. 1854 (Baldwin 1973).
Aqua; 7″ × ? × ?; 11n, 3 or 6b; 4ip; v,
sfs; p.

**SPILLER'S GOLDEN BALSAM//
SPILLER'S GOLDEN BALSAM**
[See Figure 18]
Label: *SPILLER'S GOLDEN BALSAM.
For the Relief and Cure of Coughs, Colds,
Croup, Hoarseness, Inflammation of the
Lungs and La Grippe. Prepared by the
GOLDEN TONIC CO., WESTBROOK,
MAINE. Price 25 cents.* Adv. 1900, *EBB*;
1910, *AD.*
Aqua; 6″ × 2¹/₈″ × 1″; 7n; 3b; ip; v, ss.

**Dᴿ SQUIRES//BALSAMIC/
EXPECTORANT//
SPRINGFIELD, OHIO**
Dr. John R. Squire & Company is
included in Springfield directories from
1874 to 1881 (Blasi 1974).
Aqua; 5³/₈″ × ? × ?; 7n; 3 or 6b; ip; v,
sfs.

Fig. 18

**H. R. STEVENS.//FAMILINE/
FAMILY BALSAM//
BOSTON, MASS.**
Trade card: "FAMILINE. For External
and Internal Use. A Quick and Thor-
ough Cure for such Complaints as Pains
in the Chest, etc., Chilblains, Corns,
Poisoning by Dogwood, Ivy, Bites, etc.,
Worms, Earache, Coughs and Croup."
Adv. 1889, *PVS & S*; 1901, *HH & M.*
Aqua; 6¹/₄″ × ? × ?; 1n; 3 or 6b; ip,
arched front panel; v, sfs. See
CUMMINGS *(Miscellaneous).*

**STRICKLANDS/MELLIFLUOUS//
COUGH BALSAM**
Label: *STRICKLAND'S MELLIFLUOUS
COUGH BASLAM. This is a Rich and
Pectoral Balsam of the most Healing,
Softening, and Expectorating Qualities, etc.*
Product of William W. Strickland, New
York City, introduced ca. 1851. Strick-
land sold out within a few years to one
of his agents (Wilson and Wilson 1971).
Adv. 1855 (Singer 1982); 1895, *PVS
& S.*
Aqua; 6¹/₄″ × ? × ?; 11n; 3b; 3 or 4ip;
v, fs.

**[Embossed sun]/SUN RISE/
COUGH BALSAM**
Product of the Dr. A. P. Sawyer Med.
Co., Chicago. Adv. 1900, *EBB*; 1910,
AD.
Color and dimens. unk.; ?n; 3b; ip; v.
See SAWYER (Cure, Miscellaneous,
Sarsaparilla).

TAYLOR'S/HOREHOUND BALSAM
Label: *TAYLOR'S HOREHOUND
BALSAM, Alcohol 10%, for Coughs,
Croup, Whooping Cough. Made in Tren-
ton, N.J. for 35 years. Prepared only by
W. Scott Taylor. Registered 1885.*
Introduced in 1875 (Blasi 1974). Adv.
1948 by W. Scott Taylor, 11 W. State
St., Trenton, N.J., *AD.*
Clear; 6¹/₄″ × 2¹/₈″ × 1¹/₁₆″; 7n; 3b;
4ip; v; ABM.

TUR/LING/TON'S/BALSAM
Robert Turlington's Balsam, a cure-all
of English origin, was patented in 1744
(Alpe 1888; Noël Hume 1969). Patent
specifications claimed numerous botan-
icals originating from England and the
Orient (Young 1962). The balsam was
available in bottles by 1750 with
introduction of the popular vial in 1754.
The shape was an unsuccessful attempt
to eliminate re-use and forgery of the
bottles and reduce competition (Noël
Hume 1969). In spite of Turlington's
efforts, counterfeiting continued.
Turlington's Balsam was available in the
United States by 1768 (Young 1962)
and possibly earlier, as noted by a pen-
cil entry in the ca. 1760 *John Tweedy*
catalog; eventually many of the
containers were also manufactured in
the United States (Blasi 1974). Adv.
1923, *SF & PD.*
Clear; 3″ × 1¹/₁₆″ × ³/₄″; 3n; 3b; 1ip; h.
Embossing and body styles varied;
imitations were also produced.
Distinctive pear shape.

**BY/THE/KINGS/ROYAL/PATENT/
GRANTED/TO//ROBᵀ/TURLI/
NGTON/FOR HIS/INVENTED/
BALSAM/OF/LIFE//
JANUᵛ 26 1754//LONDON**
Clear; 2¹/₂″ × ? × ?; 5n; 6b; pl; h, fb; v,
ss; p, also without p and patent dates;
distinctive pear shape.

**BY THE/KING'S/ROYAL/PATENT/
GRANTED/TO//ROBT./TURLI/
NGTON/FOR HIS/INVENTED/
BALSAM/OF LIFE//JANY//
LONDON/[Base:] WT & CO**
[See Figure 19]
Bottle manufactured by Whitall-Tatum,
Millville, NJ, symbol used 1857 to 1935
(Toulouse 1972).
Clear; 2¹¹/₁₆″ × 1″ × ¹³/₁₆″; 3n; 6b; pl;
h, fb; v, ss; also with p.

Fig. 19

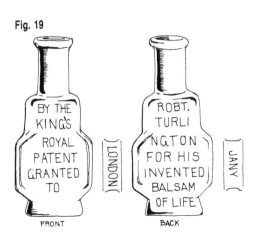

FRONT BACK

27

**DR. VAN WERT'S/BALSAM//
VAN WERT CHEMICAL CO.//
WATERTON, N.Y.**

Samuel Felt formed the Samuel Felt Drug Company in 1885. The Van Wert Chemical Company appears to be a subsidiary and Samuel Felt was proprietor (Blasi 1974). Listings for Van Wert Chemical Company appear in 1900, *EBB* and 1916 (Blasi 1974). Balsam adv. 1888 (Baldwin 1973); 1929–30 by Felt Drug Co. Inc., 242 Factory St., Watertown, N.Y.; as Van Wert's Balsamated Compound, 1941–42, *AD*.
Aqua; 8″ × 2¾″ × 1½″; 1n; 3b; 3 or 4ip; v. **several sizes.** See VAN WERT (Balm).

**VEGETABLE/PULMONARY/
BALSAM**

Advertising (Singer 1982) indicates the balsam was introduced in 1826. Abraham Lowe and Sampson Reed were Boston druggists from 1826 to 1837, Lowe having "discovered" the formula. Lowe sold his rights to the formula to Sampson Reed, who joined in a partnership with William J. Cutler (Wilson and Wilson 1971). City directories indicate that union was in existence in 1844. Reed left the business in the 1860s and Cutler Bros. was established by 1870, with William J., George, and E. Waldo Cutler and C. E. Barker. The firm's last directory listing was 1899. Adv. 1910, *AD*.
Aqua; 5″ × 1″ diameter; 5n; 20b; pl; v; p. See BERRY (Cure).

**VEGETABLE/PULMONARY/
BALSAM//REED CUTLER & Cᵒ/
BOSTON MASS**

Aqua; 7¼″ × ? × ?; 9n; 3b; 3 or 4ip; v, fs; p. See previous entry.

VITAL/BALSAM

Aqua; 4⅛″ × 1¼″ diameter; 7n, crude lip finish; 20b; pl; v; p.

**WAKEFIELD'S/BLACK BERRY/
BALSAM**

Introduced in Bloomington, IL in 1846 (White 1974) as the product of Cyrenius Wakefield (Blasi 1974). Directories list the C. Wakefield & Co. from 1855 (earliest available) to 1969. The firm resided in New York City in 1980, *RB*. The product was being manufactured in 1984 by the J. H. McLean Med. Co., Garden City, NY, according to Richard Stessel, J. H. McLean Med. Co. (personal communication, 1984).
Aqua; 4⅞″ × 2″ × 1¼″; 7n; 3b; 3ip; v. See J. H. McLEAN (*Balm*), WAKEFIELD (Cure, Liniment).

**WAKEFIELD'S/BLACKBERRY/
BALSAM COMPOUND**

Color & dimens. unk.; 7n; 3b; ip; v; also ABM. See J. H. McLEAN (*Balm*), WAKEFIELD (Cure, Liniment).

**DR. WARREN'S//BOTANIC/
COUGH BALSAM//S. F. CAL.**

[See Figure 20]
Product distributed by Homer Williams (Wilson and Wilson 1971). Adv. 1870s (Devner 1968); 1910, *AD*.
Aqua; 6¾″ × 2⁵⁄₁₆″ × 1⅜″; 7n; 3b; 4ip; v, sfs. See YERBA BUENA (*Bitters*), WARREN (Cordial, *Remedy*).

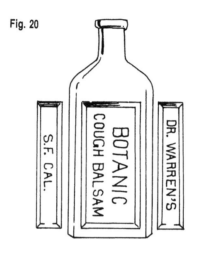

Fig. 20

**FAITH WHITCOMBS/BALSAM//
CURES COUGHS AND COLDS//
CURES CONSUMPTION**

Whitcombs Asthma Remedy adv. 1901, *HH & M*.
Aqua; 9″ × 2⅝″ × 1½″; 1n; 3b; 3ip; v, fss; inset above base.

**WILLIAMS/BALSAMIC/
CREAM OF ROSES**

Product of John Williams, Stockton, CA, introduced in 1880 (Blasi 1974); trademarked 1881 (Wilson and Wilson 1971); adv. 1899 (Devner 1968).
Cobalt; 5″ × ? × ?; 9n; 3b; pl; v. A variant of 1890s has SF & PGW embossed on the base. See H. H. H. (*Medicine*), NATIONAL (*Liniment*).

**WILLSON'S/MONARCH/BALSAM/
FOR/COUGHS/AND/COLDS//
WILLSON BROS./EDGERTON/
WIS. U.S.A.**

Product of Willson Monarch Laboratories which operated from 1882 to 1961 (Blasi 1974). Balsam adv. 1907, *PVS & S*; 1910, *AD*.
Aqua; 9″ × ? × ?; 1n; sp; 3 or 6b; ip; h. See WILLSON (Remedy).

**WILSONS//PULMONARY//
CHERRY BALSAM//
J. W. BRAYLEY//PROPRIETOR**

Adv. 1880s (Blasi 1974); 1900, *EBB*.
Aqua; 4⅜″ × 1⅜″ diameter; 7n; 21b; 12 sides; pl; v, sssss, embossed on consecutive sides.

**JOHN M. WINSLOW//
COMPOUND/BALSAM OF/
HOARHOUND//COLDS COUGHS/
AND/CONSUMPTION**

Adv. 1839 by John M. Winslow, Rochester, NY (Baldwin 1973); 1855 by Winslow & Young, Successors to J. M. Winslow (Blasi 1974).
Aqua; 5¼″ × 2″ × 1¼″; 13n; 6b; pl; v, sfs; p.

**DR. WISTAR'S//BALSAM OF//
WILD CHERRY//SETH W.
FOWLE//& SONS//BOSTON**

"The Great Remedy for Consumption of the Lungs, Natures Own Prescription." The product was adv. by Williams & Co., Philadelphia, in 1841 (Blasi 1974) and was purported to have been available for forty years when adv. in 1875 (Singer 1982). Isaac Butts, NY, became sole owner and maker in December 1843 (Blasi 1974). Butts was succeeded by Seth W. Fowle shortly thereafter who subsequently became the proprietor and manufacturer. Seth W. Fowle & Co. was still producing the Balsam in 1883 (Holcombe 1979). Agents included Sanford & Park and John D. Park in the 1840s and 1850s (Blasi 1974), and A. B. & D. Sands. Adv. 1929–30 by John D. Park & Sons Co., Ltd., 515 Sycamore St., Cincinnati, O; 1941–42 by Brewer & Co., Inc., 12 E. Worcester St., Worcester, MA, *AD*.
Aqua; 3½″ × ?; 7n; 21b; 12 sides; pl; v, ssssss. See GUYSOTT (*Sarsaparilla*), OXYGENATED (*Bitters*).

**DR. WISTARS//BALSAM OF//
WILD CHERRY//JOHN. D. PARK,
CINCINNATI, OHIO**

Aqua; 6½″ × ?; 11n; 21b; 8 sides; pl; v, ssss. See GUYSOTT (*Sarsaparilla*).

**Dᴿ WISTAR'S//BALSAM OF//
WILD CHERRY//PHILADᴬ**

Aqua; 4¹⁄₁₆″ × 1½″ diameter; 11n; 21b; 8 sides; pl; v, ssss.

**DR. WISTAR'S//BALSAM OF//
WILD CHERRY//PHILADᴬ**

Aqua; 5″ × ?; 11n; 21b; 8 sides; pl; v, ssss; p.

**DR WISTAR'S//BALSAM OF//
WILD CHERRY//PHILADA//I. B.**
Bottles bearing the initials "I. B." (for
Isaac Butts) continued to be produced
years after his association with the prod-
uct (Blasi 1974).
Aqua; 6½" x 2⅜" diameter; 11n;
21b, 8 sides; pl; v, ssssb, with and
without p. Embossed on consecutive
panels with exception of initials;
several variants.

**P. T. WRIGHT & Co/PHILADA //
CARMINATIVE//BALSAM**
Product of Peter T. Wright & Co.,
Philadelphia. Adv. 1854 (Blasi 1974) to
1869. In 1859 Wright moved from 241
Market St. to 609 Market St., accord-
ing to Philadephia city directories.
Light green; 4¾" x 1⅝" x ⅞"; 13n;
3b; 3ip; v, fss.

**WRIGHT'S INDIAN/
COUGH BALSAM**
Adv. ca. 1900, E. E. Anthony (Blasi
1974); 1935 by C. E. Anthony, 155 E.
Ferry St., Buffalo, NY, *AD*.
Aqua; 4⅞" x ? x?; 7n; 4b; pl; v.

**DR R. WRIGHT'S//DANDELION//
BALSAM**
Aqua; 8½" x ? x ?; 1n; 3b; ip, arched
front panel; v, fss.

BITTERS

AFRICAN/STOMACH/BITTERS
Product of Spruance, Stanley and
Company, San Francisco, established in
1872; formerly J. & J. Spruance Com-
pany, founded by James and John
Spruance, Folsom, CA, in 1862. The
Celebrated African Stomach Bitters,
trademarked in 1881, was produced
until 1898 (Schulz, et al. 1980). The
bitters were bottled in unembossed
bottles after 1887 (Wilson and Wilson
1969).
Light amber; 9⅝" x 3" diameter; 11n;
20b; pl; h. See CATAWBA *(Bitters)*,
MOTT *(Tonic)*.

**AFRICAN/STOMACH/BITTERS//
SPRUANCE STANLEY & CO**
Red amber; 9½" x 3" diameter; 11n;
20b; pl; h, fb. See CATAWBA *(Bitters)*,
MOTT *(Tonic)*.

**AFRICAN/STOMACH/BITTERS/
SPRUANCE STANLEY & CO**
Light amber; 9⅝" x 3" diameter; 11n;
20b; pl; h. See CATAWBA *(Bitters)*,
MOTT *(Tonic)*.

ALPINE/HERB BITTERS//TT & C.
[monogram]
Embossed bottle manufactured only in
1888. Thomas Taylor (note monogram)
of San Francisco established a whole-
sale liquor company in 1864 after
acquiring the business of J. G. Frisch.
Frisch and Taylor were also both
producers of Hufeland Bitters. After
Taylor's death in 1874, the business was
moved to Virginia City, NV, and was
operated by Bertha Taylor. In 1883 a
move was made back to San Francisco
(Wilson and Wilson 1969).
Amber; 10" x 2¾" x 2¾"; 11n; 2b;
pl; v, f; h, b. See HUFELAND *(Mis-
cellaneous)*.

[In circle:] **AMERICAN LIFE BITTERS**//[in circle:] **AMERICAN LIFE BITTERS**//**P.E. ILER/ MANUFACTURER/OMAHA NEB**

Directories indicate Peter E. Iler moved to Omaha from Tiffin prior to 1874 and established Iler & Co. and the Willow Springs Distilling Co. with Joseph D. Iler. American Life Bitters was produced in Tiffin and Omaha from 1867 (Wilson and Wilson 1971) until ca. 1876. Both companies became branches of the Standard Distilling & Distributing Co., and operated in the twentieth century; the Willow Springs Bottling Co. until the 1960s. Joseph was also affiliated with Storz & Iler, Distillers, with offices in Omaha and Kansas City, MO.

Amber, green; 9″ × 3⅛″ × 2¼″; 11n; 6b, bulbous corners; distinctive, log cabin shape; h, ssf, part circular and arched; also variant with Tiffin, Ohio. See KENNEDY *(Bitters)*.

PEPSIN BITTERN/[monogram cross]/**E. L. ARP KIEL** [See Figure 21]
Clear; 11½″ × 2¾″ diameter; 23n; 20b; pl; h, in shoulder seal. See ARP *(Miscellaneous)*.

Fig. 21

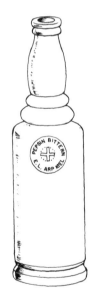

[Shoulder:] **N. WOOD SOLE PROPRIETOR** [Base:] **ATWOOD'S GENUINE BITTERS**
Nathan Wood, Portland, ME, a dealer of botanic medicines in 1845 and agent for the bitters, purchased the brand in 1863 (Wilson and Wilson 1971). Nathan Wood & Son, Portland, Me. is also on bottles embossed Atwood's Jaundice Bitters, Formerly Made By Moses Atwood, Georgetown, Mass.

This latter affiliation is unknown. Genuine Bitters adv. 1845 (Wilson and Wilson 1971); 1910, *AD*.
Aqua; 6¾″ × 2″ diameter; 7n; 20b; pl; h. See ATWOOD'S JAUNDICE *(Bitters)*, N. WOOD *(Miscellaneous)*.

FREE SAMPLE//**ATWOOD'S**//**JAUNDICE**//**BITTERS**
Alcohol content 25.6%. Moses Atwood, Georgetown, MA introduced his famous "Genuine Vegetable Physical Jaundice Bitters" in 1840 (Ring 1980). The relationship between Moses Atwood, Georgetown, MA, producer of Atwood's Jaundice Bitters and Chas. H. Atwood, Boston, MA, producer of Atwood's Quinine Bitters is not fully understood. Labels noting worthless imitations are found. Often confused, the pair were evidently competitors. M. Carter & Sons, Georgetown, acquired rights to the Jaundice Bitters in 1855 (Singer 1982). Carter & Son owned and manufactured this product until ca. 1875 when the newly established Manhattan Medicine Co., New York City, began manufacturing the acquired bitters (Holcombe 1979; Ring 1980). In 1877 John F. Henry purchased the Manhattan Medicine Co. and apparently acquired sole agency for the Jaundice Bitters (Holcombe 1979). Adv. 1900 by Manhattan Medicine Co., *EBB*; 1929–30 by O. H. Jadwin & Sons, New York City, sole agents for the Manhattan Medicine Co., *AD*. About 1940, Jaundice was apparently changed to Jannaice, and the product was sold by the Wyeth Chemical Company, successors to the Manhattan Medicine Co. (Holcombe 1979). Adv. 1948 as Atwood's Jannaice Laxative Bitters by Whitehall Pharmacal Co., 22 E. 40th St., New York City, *AD*.
Aqua; 3⅜″ × 1¼″ diameter; 1n; 21b, 12 sides; pl; v, ssss, embossed on consecutive sides, ABM. See ATWOOD'S GENUINE *(Bitters)*, ATWOOD'S QUININE *(Bitters)*, TOMS *(Liniment)*.

ATWOOD'S//**JAUNDICE BITTERS**//**MOSES ATWOOD**//**GEORGETOWN**//**MASS.**
Label: *ATWOOD'S VEGETABLE PHYSICAL JAUNDICE BITTERS. This is an effective cure for jaundice, headache, dyspepsia, worms, dizziness, loss of appetite, darting pains, colds and fevers. It cleanses the blood from humors and moistens the skin. It is also good for liver complaints, strangury, dropsy, croup and phthisic. Formerly manufactured by Moses*

Atwood, Georgetown, Mass. and sold by agents throughout the United States. Manhattan Medicine Co., Prop's., New York. Variant label: *ATWOOD'S JANNAICE BITTERS—Established in 1840 at Georgetown, Mass. by Moses Atwood and now manufactured by Wyeth Chemical Co., Successor, Detroit, Mich.*
Aqua; 6 1/16″ × 2¼″ diameter; 1n; 21b; pl; v, sssss; also variant with JAUNDICE spelled JANNAICE. See ATWOOD'S QUININE *(Bitters)*.

ATWOOD's//**QUININE/TONIC**//**BITTERS**
Alcohol content 40%. Atwood's Quinine Tonic Bitters were advertised 1860–1869 by Chas. H. Atwood, Boston, MA; in 1871 by Alvah Littlefield, Boston; and in 1872 by A. Littlefield & Co. (Singer 1982). The corporate name, Alvah Littlefield & Co., was retained after the death of Alvah in 1871 by his eldest son, H. L. Littlefield. Demas Barnes, New York City, was the most lucrative of the Littlefield sales outlets. John F. Henry acquired the business from Barnes in 1868 and continued to act as agent, acquiring sole agency in 1877 (Holcombe 1979). Apparently John F. Henry was affiliated with both the Jaundice and Quinine Bitters after 1877. Quinine Bitters adv. 1860 (Singer 1982); 1910, *AD*.
Aqua; 8¾″ × 2¼″ × 2¾″; 1n; 3b; 3ip; v, sfs. See ATWOOD'S JAUNDICE *(Bitters)*.

AUGAUER BITTERS//**AUGAUER BITTERS CO./CHICAGO**
Label: *AUGAUER BITTERS, Contains 35% Alcohol. This preparation is offered to the public as a palatable and Wholesome Remedy For the Mitigation of the Stomach, Sleeplessness, Loss of Appetite, Chronic Diarrhoea and Light Attacks of Dyspepsia or Indigestion. Manufactured By Augauer Bitters Company, Formerly the Dr. Russell Med. Co., Chicago. Established 1890.* Variant label (Ring 1980): *. . . this valuable compound has been on the market since 1890 and was originally known as Dr. Russell's PEPSIN CALISAYA BITTERS.*
Green; 7⅞″ × 4¼″ × 2⅝″; 11n; 3b; ip; v, ss. See SUN *(Bitters)*.

AYALA/MEXICAN BITTERS//**M. ROTHENBERG & CO./SAN FRANCISCO, CAL.**
Bottle manufactured ca. 1910–1919. A product of Mendel Rothenberg, who left the employ of S. B. Rothenberg & Co., Oakland, CA, to establish his own

firm in 1895. The company survived until prohibition (Wilson and Wilson 1969).

Amber; 9³/₈″ × 2³/₄″ × 2³/₄″; 12n; 1 or 2b; pl; v; ABM.

E. L. BAILEY'S KIDNEY/AND LIVER BITTERS//BEST/ BLOOD PURIFIER

Product of Edwin Bailey, Sacramento, CA, ca. 1905 only (Wilson and Wilson 1969).

Amber; 9⁷/₈″ × 2³/₄″ × 2³/₄″; 11n; 2b; 2ip; v, fb.

BAKER'S/HIGH/LIFE/BITTERS// THE/GREAT/NERVE/TONIC

Manufactured in 1917 only for the Owl Drug Co., San Bernardino, CA, apparently by the Baker-Lane Med. Co., San Diego, CA (Ring 1980; Wilson and Wilson 1969).

Amber; dimens. unk.; 11n; 2b; pl; v, fb; ABM.

BAKER'S/ORANGE GROVE// BITTERS

Label: *. . . a pleasant tonic and analyzed to be free of deleterious substances by S. Dane Hays, State Assayer, Mass. Feb. 15, 1869. C. & J. F. Baker Co., 107 Commercial St., Boston, Mass* (Ring 1980). Adv. 1871, *WHS*; 1902 (Ring 1980).

Amber; 9¹/₄″ × 2⁷/₈″ × 2⁷/₈″; 11n; 1b; 4ip; v, fb; ribbed corners.

DR BANKER'S//HOME BITTERS// NEW YORK

Introduced in 1872 (source unk.); adv. 1910, *AD*.

Aqua; 9″ × 3″ × 2″; 11n; 3b; 3ip; v, sfs.

DR. BAXTER'S//MANDRAKE BITTERS//LORD BROS// PROPRIETORS//BURLINGTON, VT.

[See Photo 1]

Label: *DR. BAXTER'S MANDRAKE BITTERS, Henry, Johnson & Lord, Proprietors, Burlington, Vt., Successors to Dr. Henry Baxter.* Adv. 1881, *New Hampshire Register, Farmers Almanac & Business Directory*; 1929–30 and 1941–42 by Burlington Drug Co., Burlington, Vt., *AD*.

Clear, aqua, amber; 6⁵/₁₆″ × 2¹/₈″ diameter; 1n; 21b, 12 sides; pl; v. See BOYCE *(Bitters)*, DOWN'S *(Elixir)*, J. F. HENRY *(Company)*.

BENNET'S/CELEBRATED/ STOMACH BITTERS.// JOS. N. SOUTHER & CO./ SOLE PROPRIETORS/ SAN FRANCISCO

Bennet's Wild Cherry Bitters became Bennet's Celebrated Stomach Bitters in 1880. The product was embossed until 1882 and was followed by paper-labeled bottles only (Wilson and Wilson 1969). Adv. 1890 (Ring 1980).

Amber; 9″ × 2³/₄″ × 2³/₄″; 12n; 2b; pl; v, fb.

BENNET'S/WILD CHERRY/ STOMACH BITTERS//CHENERY, SOUTHER & CO./SOLE AGENTS/ SAN FRANCISCO, CAL.

Bottle manufactured ca. 1871 to 1879 (Wilson and Wilson 1969).

Amber; 9″ × 3″ × 3″; 12n; 2b; pl; v, fb.

BIG/BILL/BEST/BITTERS//BIG/ BILL/BEST/BITTERS

Labels: *Big Bill Stomach Bitters* . . . and *Big Bill Magen Bitters* Both variants contained 21% alcohol and were guaranteed Under the National Pure Food Law by Liebenthal Bros. & Co., U.S. Serial No. 2521 (Ring 1980).

Amber; 12″ × 3″ × 3″; 12n; 1b; 2ip; h, fb; tapered body, double rings on shoulder.

BISMARCK/BITTERS/ W. H. MULLER, NEW YORK, U.S.A. [Base:] W. T. & Co/U.S.A.

Bottle manufactured by Whitall-Tatum, 1857 to 1935 (Toulouse 1972). City directories show William H. Muller, Druggist, at 62 Seventh Ave. from 1883 to 1893; and at 45 University from 1893 to 1899. Adv. 1900 by W. H. Muller, 74 University, *EBB*; 1910, *AD*.

Amber; 6¹/₈″ × 2¹/₂″ × 1³/₄″; 11n; 3b; pl; v.

DR. BLAKE'S//AROMATIC/ BITTERS//NEW YORK

Adv. 1848; 1855 (Ring 1980). Directories indicate that Thomas Blake operated a porterhouse and a malt liquor store from 1846 to 1848 and was a physician from 1849 to 1862. The only mention of Aromatic Bitters occurred in 1859.

Aqua; 6⁷/₈″ × 2⁷/₈″ × 1³/₄″; 11n; 4b; pl; v, sfs; p.

DR. BOERHAAVE'S/STOMACH BITTERS.

Embossed in 1868 and 1869 only; a product of Siegfried and Philip Wertheimber and Louis Waterman, San Francisco. The firm was out of business by 1874 (Ring 1980; Wilson and Wilson 1969).

Light amber; 8⁷/₈″ × 2¹/₈″ × 2¹/₈″; 11n; 2b; 2ip, 2 small ip's on panel opposite embossing; v.

BOERHAVES/HOLLAND BITTERS//B. PAGE Jᴿ & CO// PITTSBURGH PA

Adv. 1857 (Ring 1980); 1907, *PVS & S.* Directories show Benjamin Page Jr. & Company at the corner of Smithfield & Third from 1856 until 1862. In 1862 Benjamin entered the Navy. Subsequent owners of the bitters are unknown.

Aqua; 7¹/₂″ × 2¹¹/₁₆″ × 1⁵/₈″; 1n; 3b; 3ip; v, fss.

BOTANIC/STOMACH BITTER'S// BACH MEESE & CO/ SAN FRANCISCO.

Bottle manufactured ca. 1885 to 1889. John Bach and Hermann Meese were liquor wholesalers from 1879 to 1890. Bach's son, Frank and Frank H. Eckenroth produced the product until 1902 when the company was dissolved (Wilson and Wilson 1969). Product adv. 1890, *W & P.*

Amber; 9¹/₂″ × 2³/₄″ × 2³/₄″; 11n; 2b; pl; v, fb.

BOTANIC/STOMACH BITTERS// BOTANIC/STOMACH BITTERS

Bottle manufactured from 1890 to 1896 at which time embossing was terminated.

Amber; 9″ × 2³/₄″ × 2³/₄″; 11n; 2b; pl; v, fb.

[h] 21 OZ./[v] BOWE'S/CASCARA/ BITTERS/HAS NO/EQUAL// P.F. BOWE/WATERBURY/ CONNECTICUT, U.S.A.

Clear; 9⁵/₈″ × 1³/₄″ × 1³/₄″; 11n; 1 or 2b; pl; h, v, fb.

DR BOYCE'S//TONIC BITTERS// HENRY & CO//PROPRIETORS

Introduction of embossed bottles ca. 1850s (Wilson and Wilson 1969). Series of producers included Fenn & Tuttle in 1868; Henry & Co. in 1869; Wells, Richardson & Co. in 1873–74; Francis Fern, Rutland in 1881–82; Henry, Johnson & Lord in 1882 and the Tuttle Elixir Company (Ring 1980). Adv. 1910, *AD*.

Aqua; 7¹/₂″ × 2³/₄″ diameter; 11n; 21b, 12 sides; pl; v, ssss. See J. F. HENRY *(Company)*.

F BROWN BOSTON/ SARSAPARILLA/& TOMATO BITTERS

Boston directories show Frederic Brown was a Boston druggist from 1837 to 1867. Bitters adv. 1851, *JSH*; 1856 (Ring 1980).

Aqua; 9″ × 3¹/₂″ × 2″; 12n; 12b; pl; v.

**BROWN'S IRON BITTERS//
BROWN CHEMICAL CO.**
Label: *BROWN'S IRON BITTERS, A
True Tonic, A Sure Appetizer – A Complete
Strengthener, A Valuable Family Medicine.
Not a substitute for whiskey, Not sold as a
beverage, Not composed mostly of spirits,
Not sold in bar-rooms. Registered May 21,
1878 by the Brown Chemical Co., Balti-
more, Md.* Adv. 1900 by Brown's Iron
Bitters Co., 306 Water, Baltimore,
EBB; 1935 by James F. Ballard Inc.,
500 N. Second St., St. Louis, Mo., *AD*.
Amber; 8½" × 2¼" × 2¼"; 12n; 2b;
3ip; v, fb.

BRYANT'S//STOMACH BITTER'S
Bottle manufactured ca. 1857. Andrew
Jackson Bryant and George W. Ches-
ley, Sacramento, CA established a
wholesale liquor business in 1853.
Bryant moved to San Francisco in 1859
and soon sold the business to Chesley
(Wilson and Wilson 1969). Adv. 1860
(Ring 1980).
Olive; 14" × 2⅞" diameter; 18n; 21b,
8 sides; pl, tapered body; v, ss,
embossed on 2 consecutive side
panels; p.

BRYANT'S//STOMACH//BITTERS
Bottle manufactured ca. 1858 to 1861
(Wilson and Wilson 1969).
Olive; 12⅝" × 3½" diameter; 12n,
lady's leg shape; 21b, 8 sides; pl; v,
sss, embossed on consecutive side
panels; p.

**BURDOCK/BLOOD/BITTERS//
FOSTER MILBURN CO//
BUFFALO, N.Y.** [Base: R in triangle]
Label: *BURDOCK BLOOD BITTERS
(contains no alcohol), contents, 9¾ Ounces.
Formulated by James I. Fellows, Saint
John, N.B. Trade mark, No. 8632, Sept.
1881* (Ring 1980). Bottle manufactured
by the Reed Glass Co., Rochester, NY,
1927 to 1956 (Toulouse 1972). Adv.
1882, addendum to *VSS & C*; 1929–30
and 1935 by Foster Milburn Co.,
Buffalo, N.Y., *AD*.
Clear; 7¾" × 2¾" × 1¾"; 1n; 3b; 3ip;
v, fss; ABM. See FELLOW (Chemical,
Syrup, Tablet), FOWLER (Extract),
THOMAS *(Oil)*, WOOD (Syrup).

**BURDOCK/BLOOD/BITTERS//
FOSTER MILBURN & CO//
BUFFALO N.Y.**
Aqua; 8½" × 2¾" × 1⅞", also 9¼"
high square variant; 1n; 3b; 3ip; v, fss.
Variant embossed The T. Milburn Co.
Ltd., Toronto, Ont. Other variants,
i.e., 4⅛" high. See FELLOW (Chemical,
Syrup, Tablet), FOWLER (Extract),
THOMAS *(Oil)*, WOOD (Syrup).

**CALIFORNIA/FIG/BITTERS//
CALIFORNIA EXTRACT OF
FIG CO/SAN FRANCISCO, CAL.**
Bottle manufactured ca. 1897 to 1903.
A product of William H. Briggs
introduced in 1892, the bitters were
originally called Hierapicra Bitters,
dated ca. 1878 to 1892. California Fig
Bitters was paper-labeled until 1897. B.
R. Kieth, San Francisco, became the
owner in 1903 and the company was
destroyed by the earthquake and fire in
1906 (Wilson and Wilson 1969). Adv.
1921, *BD*.
Light amber; 9½" × 2¹¹⁄₁₆" × 2¹¹⁄₁₆";
12n; 2b; 2ip; v, fb. See HIERAPICRA
(Bitters).

**CALIFORNIA FIG & HERB
BITTERS//CALIFORNIA FIG
PRODUCTS CO./SAN FRANCISCO,
CAL.**
Bottle manufactured ca. 1903 to 1906
(Wilson and Wilson 1969).
Amber; 9⅞" × 2¾" × 2¾"; 12n; 1 or
2b; 2ip; v, fb; Variant: 4½" × 1½" ×
1½". See HIERAPICRA *(Bitters)*.

**CAPITOL/BITTERS//DR M M
FENNER'S//FREDONIA, N.Y.**
Bottle manufactured ca. 1887 (Wilson
and Wilson 1971). Trademark issued to
Rudolph Sternsdorff, Buffalo, NY, July
1885 (Ring 1980). Adv. 1883 (Ring
1980); 1910, *AD*.
Aqua; 10⅛" × 3⅜" × 2"; 11n; 3b;
3ip; v, fss. See FENNER (Cure, Medi-
cine, Miscellaneous, *Remedy,* Specific).

**CARTER'S/LIVER BITTERS/C.M.
CO. NEW YORK** [Base:] WT&CO/
U.S.A.
Bottle manufactured by Whitall-Tatum
Glass Co., 1857 to 1935 (Toulouse
1972). John S. Carter, Erie, PA, per-
fected Carter's Little Liver Pills in the
1880s and established the Carter Medi-
cine Co. Carter sold all interests in the
company to a New York syndicate in
the 1890s (Shimko 1969). Bitters adv.
1873 (Ring 1980); 1921, *BD*.
Amber; 8¼" × 3¼" × 2"; 11n; 18b;
pl; v. See CARTER (Cure, Extract).

CATAWBA/WINE//[cluster of
grapes]//**BITTERS**//[cluster of grapes]
Introduced ca. 1860, J. C. Horan &
Co., San Francisco, agents. The com-
pany was absorbed by J. & J. Spruance
& Co. in 1867. Bottles were embossed
until 1867. Spruance, Stanley & Co.,
produced a variant embossed with
CHALMER'S CATAWBA WINE
BITTERS from 1872 to 1874 (Wilson

and Wilson 1969). Adv. 1860–66 (Ring
1980).
Emerald green; 9⅜" × 2⅜" × 2⅜";
12n; 2b; pl; v, fsss; p. See AFRICAN
(Bitters), MOTT (Tonic).

**CELEBRATED/CROWN BITTERS//
F. CHEVALIER & CO/
SOLE AGENTS**
Bottle manufactured ca. 1880–1886
(Wilson and Wilson 1969).
Amber; 8⅞" × 2¾" × 2¾"; 11n; 2b;
2ip; v, fb.

**CLARK'S GIANT/BITTERS/
PHILADᴬ PA.**
Adv. 1910, *AD*.
Light green; 6¾" × 2¼" × 1⅜"; 7n;
3b; 3ip, front oval panel; v.

**CLARKE'S/SHERRY WINE/
BITTERS/ROCKLAND/ME**
Aqua; 9⅝" × 3½" × 2½"; 11n; 3b;
pl; v.

**CLARKE'S/SHERRY WINE/
BITTERS/SHARON/MASS**
Dr. Clarke's Vegetable Sherry Wine Bit-
ters, adv. 1853 (Ring 1980); 1897,
L & M.
Aqua; 9½" × 3½" × 2½"; 11n; 3b; pl;
v, sfs; many variants in size and
embossing.

**CLARKE'S/VEGETABLE/SHERRY
WINE/BITTERS/SHARON MASS.**
Aqua; 14" × 5⅞" × 4"; 11n; 3b; pl; v.

**E. R. CLARKE'S//SARSAPARILLA/
BITTERS//SHARON, MASS.**
Aqua; 7⅜" × 3¼" × 2"; 11n; 4b; pl;
v, sfs; p.

**CLIMAX BITTERS//SAN
FRANCISCO CAL.**
Bottle manufactured ca. 1887 to 1890
(Wilson and Wilson 1969). Product of
Justin Gates Jr., and Alonzo Van
Alstine, introduced in 1884. Justin died
in 1888 and the firm was dissolved in
1890 (Wilson and Wilson 1969). The
bitters were apparently acquired by
another firm and sold for a few years.
Adv. 1896–97, *Mack*; 1897, *L & M*.
Amber; 9¾" × 2½" × 2½"; 11n; 2b;
pl; v, fb.

**COLBURG/STOMACH BITTERS/
FOR/LIVER, STOMACH &
BOWELS//GENUINE GERMAN/
STYLE CATHARTIC/AND BLOOD
PURIFIER**
Amber; 10" × 2¾" × 2¾" at bottom,
3" × 3" at shoulder; 2n; 2b; pl, case
gin-shaped; v, fb.

COLUMBO/PEPTIC BITTERS//
L. E. JUNG/NEW ORLEANS, LA.
[Base:] **S.B.&G. CO.**
Label: *COLUMBO PEPTIC BITTERS ,*
L. E. JUNG, SOLE PROPRIETOR and
MANUFACTURER, 317 and 319 Maga-
zine St., New Orleans. Awarded Gold
Medal at Louisiana Purchase Exposition,
St. Louis, 1904, also the Lewis & Clark
Exposition, Portland Oregon, 1905. Trade
Mark No. 28,712 filed May 8, 1896 and
Registered August 4, 1896. Bottle
manufactured by Streator Bottle &
Glass Co., Streator, IL, 1881 to 1905.
Amber; 9″ × 2¾″ × 2¾″; 11n; 2b; pl;
v, fb. Several variants. See PEYCHAUD
(Bitters).

JOSIAH COSBYS/VIRGINIA/
COMPOUND/VEGETABLE/
BITTERS/1834//B. R. LIPSCOMB,
AGᵀ//RICHMOND, Vᴬ
Aqua; 7″ × 3¼″ × 2″; 9n; 8b; pl; h,
fss.

CURTIS & PERKINS/WILD
CHERRY/BITTERS
Adv. 1860, New England business
directory.
Aqua; 6⅞″ × 2⅞″ diameter; 11n;
20b; pl; v, p. See CURTIS (Miscellane-
ous, Syrup), CURTIS & PERKINS (Killer),
WINSLOW *(Syrup).*

[Shoulder; h] **MANUF'R/**[v]
DAMIANA BITTERS//[shoulder; h]
LEWIS HESS/[v] **BAJA**
CALIFORNIA [Base: 8-point star]
[See Figure 22]
Bottle manufactured ca. 1877 to 1885;
shoulder embossing was terminated
between 1886 and 1890. Henry Weyl
(location unk.) produced the bitters for
three years before selling the brand to
Lewis Hess in 1876. Offices were
located at 317 Broadway, New York,

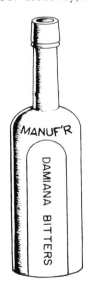

Fig. 22

and in San Francisco. Hess sold the firm
to Naber, Alfs and Brune of San Fran-
cisco in 1890 (Ring 1980; Wilson and
Wilson 1969). Adv. 1917, *BD.*
Aqua; 11⅝″ × 2¾″ diameter; 12n;
20b; pl; v,h, fb.

DAVIS'S KIDNEY AND/
LIVER BITTERS//BEST
INVIGORATOR/AND CATHARTIC
Amber; 9¾″ × 2⁹⁄₁₆″ × 2⁹⁄₁₆″; 11n; 2b;
2ip; v, fb.

DIAMOND/STOMACH/BITTERS/
DETROIT/MICH.//B [in diamond]**//**
B [in diamond]
Bottle manufactured ca. 1889.
Amber; 9¾″ × 3″ × 3″; 2n; 2b; pl; h,
fss.

DOYLES//HOP//BITTERS//1872/
[Hop plant] [See Photo 2]
Label: . . . *For General Debility, Bilious-*
ness, Nervousness, Neuralgia, Indigestion,
Fever and Ague, Liver Complaint, Mental
Depression and all Diseases of the Kidneys
and Urinary Organs. John D. Doyle,
Rochester, N.Y. registered the brand in
1872. In 1874 proprietorship of the
brand, and the Hop Bitters Manufac-
tury, was assumed by Asa T. & Wilson
Soule. The last directory listing for the
firm was 1881, subsequent owners are
unknown. Offices included Rochester,
N.Y., Toronto and London, Eng.
(Schulz, et al. 1980). Adv. 1910, *AD.*
Amber; 9½″ × 2¾″ × 2¾″; 12n; 1b;
8ip, 4ip on the body and 4ip on
tapered shoulders; h, bsfs.

ST/DRAKE'S/1860/PLANTATION/
X/BITTERS//X/BITTERS//
PATENTED/1862
Bottle design patented in 1862. Label:
. . . *Alcohol 38.2%. Contents St. Croix*
Rum from the Carribean [note ST
& X embossing], *Calisaya Bark Roots &*
Herbs. An effectual Tonic, Appetizer &
Stimulant. Patrick Henry Drake of New
York formed a partnership with Demas
S. Barnes in 1861 and established the
P. H. Drake Co. In 1870 another part-
ner, William P. Ward, was added.
Drake died in 1883 (Ring 1980). The
Lyon Mfg. Co. was established in 1871
or 1872 taking over ". . . proprietaries
previously manufactured and sold by P.
H. Drake & Co." P. H. Drake & Co.,
however, continued alongside the Lyon
Mfg. Co., at the same address until ca.
1884. The Lyon Mfg. Co. was located
in Brooklyn, NY in 1948 according to
the *American Druggist.* Products of the
P. H. Drake Lab and the Lyon Mfg.
Co. included Hagans Magnolia Balm,

Lyon's Kathairon and Mexican Mustang
Liniment (Wilson and Wilson 1971).
Addresses of the Drake Lab included
202 Broadway, 1862 (Singer 1982); 105
Liberty and 21 Park Row, 1867 to
1869; 53 Park Pl., 1869 to 1878; and
144 Duane according to the New York
business directories. Adv. 1910, *AD.*
Amber, green, clear; 9¾″ × 2¾″ ×
2¾″; 11n; 1b, recessed base; 2ip, log
cabin shape; h, fb, embossed front &
back shoulder or cabin roof. See
HAGAN (Balm), LYON (*Hair*, Jamaica
Ginger, Miscellaneous), MEXICAN (*Lini-*
ment), WYNKOOP (*Pectoral,*
Sarsaparilla).

"ELECTRIC" BRAND/BITTERS//
H. E. BUCKLEN & CO./CHICAGO,
ILL. [See Figure 23]
Label: *"ELECTRIC" BRAND BITTERS,*
18% alcohol. The Great Family Remedy
For all Diseases of the Stomach, Liver and
Kidneys. Guaranteed under the Pure Food
and Drug Act of 1906. . . . Introduced
in 1880 (Wilson and Wilson 1971). An
1888 advertisement states "Mr. D. I.
Wilcoxson, of Horse Cave, Ky., adds
a testimonial saying he positively
believes he would have died had it not
been for Electric Bitters." Adv. 1923,
SF & PD.
Amber; 8⅝″ × 2⁵⁄₁₆″ × 2⁵⁄₁₆″, at least
2 sizes; 11n; 2b; 4ip; v, fb. See KING
(Discovery, Pill).

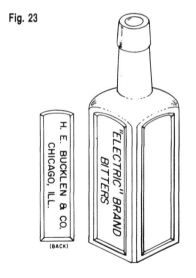

Fig. 23

GWILYM EVAN'S/QUININE
BITTERS
Adv. 1887, *WHS;* 1910, *AD.*
Aqua; 8¼″ × 2⅜″ × 2⅜″; 9n; 2b;
pl; v.

**FERRO QUINA/BITTERS/
D. P. ROSSI/DOGLIANI/ITALIA &/
S.F. CAL.**

Sample bottle manufactured ca. 1890. The Angelo Rossi family were distributors for Ferro China Bisleri Bitters and introduced their own brand, Ferro Quina Stomach Bitters in 1895 (Wilson and Wilson 1969). Adv. 1923, *SF & PD.*
Amber; $3^5/8'' \times 1^5/8'' \times 1^5/8''$; 7n; 1b; 1ip; h. See FERRO CHINA (Miscellaneous).

**FERRO QUINA BITTERS/
D. P. ROSSI/1400 DUPONT STR/
SAN FRANCISCO/CAL./SOLE/
PROPRIETOR**

Bottle manufactured ca. 1895 to 1900 (Wilson and Wilson 1969).
Light amber, amber; $9'' \times 4'' \times 4''$; 1n; 1b; 1ip; h. See FERRO CHINA (Miscellaneous).

**FERRO QUINA/KIDNEY/AND/
LIVER/BITTERS/D. P. ROSSI/
SAN FRANCISCO/CAL.**

Bottle manufactured ca. 1907 to 1908 (Wilson and Wilson 1969).
Amber; $10'' \times 2^3/4'' \times 2^3/4''$; 1 and 11n; 1b; 1ip; v. See FERRO CHINA (Miscellaneous).

**FERRO QUINA/STOMACH
BITTERS/BLOOD MAKER/
DOGLIANI ITALIA/D. P. ROSSI/
1400 DUPONT STR. S.F./
SOLE AGENT/U.S.A. AND
CANADA**

Bottle manufactured ca. 1901 to 1905 (Wilson and Wilson 1969).
Amber; $9'' \times 4'' \times 4''$; 12n, bulbous; 1b; 1ip; h. See FERRO QUINA (Miscellaneous).

**FERRO QUINA/STOMACH
BITTERS/BLOOD MAKER/
MNFG. BY/D. P. ROSSI/
SAN FRANCISCO/CAL.**

[See Photo 3]
Amber; $9^1/8'' \times 4'' \times 4''$; 12n; 1b; 1ip; h. See FERRO QUINA (Miscellaneous).

**GARNETT'S/COMPOUND/
VEGETABLE BITTERS/
RICHMOND, VA.**

Adv. 1871 (Ring 1980).
Amber; $6^3/8'' \times 2^3/4'' \times 1^3/4''$; 7n; 12b; pl; v.

**GERMAN BALSAM BITTERS/W. M.
WATSON & CO./SOLE AGENTS
FOR U.S.**

Bottle manufactured ca. 1900 to 1904. A product of Warren M. Watson, Oakland, CA, a wholesale liquor dealer from 1880 until 1905, when the business was sold to the Winedale Co., headed by T. W. Sigourney. Brand was continued in paper-labeled bottles only (Wilson and Wilson 1969).
Milk glass; $9'' \times 2^7/8'' \times 2^7/8''$; 11n; 2b; pl; v.

**GILBERT'S//SARSAPARILLA//
BITTERS//N. A. GILBERT &
CO.//ENOSBURGH FALLS VT.**

Labeled as a specific . . . *for loss of appetite, indigestion, constipation, etc., and all diseases such as ring worms, boils, pimples, cancerous humors, etc.* Adv. 1882–83, Stetson & Gilbert (Ring 1980); 1891, *WHS.* N. A. Gilbert & Co., Enosburgh Falls, VT, was established in 1886 by Nathan A. Gilbert and J. W. Beatty as an ". . . outgrowth of a drug and medicine business formerly established by H. D. Kendall. . . ." In 1891 the firm was manufacturing Scotch Oil, Lung Balsam and the Sarsaparilla Bitters according to the *History of Franklin and Grand Isle Counties Vermont,* (Syracuse, N.Y.: 1891).
Amber; $8^3/4'' \times 2^7/16''$ diameter; 7n; 21b, recessed base; 1ip; v, sssss. See KENDALL *(Miscellaneous).*

[Script:] **Goff's Bitters**
Label: *Goff's Herb Bitters, 12½% alcohol, S. B. Goff & Sons, Camden, N.J.* Bottle manufactured ca. 1906. The company was established in 1872 and incorporated in 1900 (Watson 1965). Adv. 1872 (Devner 1968); 1935 by S. B. Goff & Sons Co., LeRoy N.Y., 1948 by Kemp & Lane Inc., LeRoy, N.Y., *AD.*
Clear; $5^1/2'' \times 1^{15}/16'' \times {}^{15}/16''$; 24n; 17b; pl; v; script. See GOFF (Liniment, Miscellaneous, Sarsaparilla, Syrup), KEMP *(Balsam).*

**S. B. GOFF'S//HERB BITTERS//
CAMDEN, N.J.**

Aqua; $5^3/4'' \times 2^1/8'' \times 1^1/8''$; 1 and 7n; rect.; 3ip; v, sfs. See GOFF (Liniment, Miscellaneous, Sarsaparilla, Syrup), KEMP *(Balsam).*

GRAND PRIZE [in arc]/**BITTERS**
Label: *Dr. Cooper's Celebrated Grand Prize Bitters, Recommended as an appetizer, Tonic and Stomach Regulator, Louis Taussig & Co. Sole Agents, 205–207 Battery St., San Francisco, Cal.* Bottle manufactured ca. 1880–84 (Wilson and Wilson 1969).
Amber; $9^1/4'' \times 3'' \times 3''$; 7n; 2b; 1ip; h.

**GRANGER BITTERS//BOYKIN
CARMER & Co//BALTIMORE**

Adv. 1900 by Boykin & Carmer Co., 11 N. Liberty, Baltimore, *EBB.*
Amber; $8^1/2'' \times 2^1/2'' \times 2^1/2''$; 11n; 2b; 3 or 4ip; v, sbs.

**DR. JAS. GRAVES//TONIC
BITTERS//LOUISVILLE KY.**

James A. Graves was a patent medicine manufacturer in 1865 and was joined by son James Jr. in 1866, thus Graves & Son. John B. Graves became the agent in 1869. James Sr. was unlisted after 1882. In 1888 James Jr. and John McKelvey were shown as affiliated with Graves & Co., patent medicines; James Jr. was unlisted after 1889. Directories showed Graves (John B.) & Son (Charles L.) in 1890 as manufacturers of bitters. No reference is made after 1899 according to Louisville city directories. The *Era Blue Book* catalog lists Graves & Son in 1900.
Aqua; $10'' \times 2^3/4'' \times 2^3/4''$; 11n; 1b; 3ip; v, sfs; flat tapered shoulders; also variant embossed GRAVES & SON. See GRAVES (Cure).

GREELEY'S BOURBON/BITTERS
Label: *Greeley's Bourbon Bitters, W. F. & A. W. Greeley, Boston, Mass.* Bitters adv. 1871, *WHS;* 1890 (Ring 1980).
Amber; $9^1/8'' \times 2^3/8''$ diameter; 7n; 20b; pl; h; barrel-shaped, tapered body.

**DOCTOR GREGORYS/SCOTCH
BITTERS** [Base:] **IGCO**
Bottle manufactured by the Ihmsen Glass Co., Pittsburgh, 1870–95 (Toulouse 1972). Producers or dealers included Spink & Co. and Young Patterson & Co., Minneapolis, MN. Product adv. 1875–85 (Ring 1980).
Amber; $9^1/2'' \times 2^3/8'' \times 2^3/8''$; 11n; 1b; pl; v.

**THE DR. H. F. WEIS
MEDICINE CO./GUARD ON THE
RHINE/STOMACH BITTERS/
DAYTON, OHIO** [Base:] **W.T.
CO/U.S.A.**

Bottle manufactured by Whitall-Tatum, Millville, NJ, 1857 to 1935 (Toulouse 1972). Introduced ca. 1870 by Dr. Henry F. Weis. Son Henry L. joined the business ca. 1900 and the family continued operating the firm until ca. 1950.
Amber; $9'' \times 2^7/8'' \times 2^7/8''$; 7 and 12n; 2b; pl; v.

**HAIR "BITTERS//HAIR "BITTERS//
Beriault/LABORATORIES** [Base:] **PC**
Label on an unembossed variant: *Beriault's Hair Bitters, A Remedy for Dandruff, Falling Hair, Scalp Disease. A Delightful Dressing. Copyright 1919, Hair Bitters*

Mfg. Co., Seattle, Wash. Bottle manufactured by the Pacific Coast Glass Co., San Francisco, 1925 to 1930 (Toulouse 1972).

Clear; 6″ × 2½″ × 1¹¹/₁₆″; 10n; 6b; 2ip; v, ss; h, f; ABM; crown-shaped stopper.

DR THOS HALL'S/CALIFORNIA/ PEPSIN WINE BITTERS

Product of Thomas Hall, San Francisco. Thomas produced the bitters from ca. 1875 until his retirement in 1880 (Wilson and Wilson 1969). His successor is unknown. Adv. 1915, *SF & PD.*

Amber; 9″ × 2¾″ × 2¾″; 11n; 2b; pl; v.

HART'S//VIRGINIA/AROMATIC// BITTERS

Emerald green; 7½″ × ? × ?; 11n; 3b, concave beveled corners; pl; v, sfs; p.

DR HARTER'S/WILD CHERRY/ BITTERS/DAYTON, O. [Base:] DESIGN/PATENTED

Although Milton G. Harter established his business in 1855, he did not introduce his famous bitters until 1885 (Wilson and Wilson 1971). A trademark was issued in July 1887. Harter died in 1890 and his daughter married Mr. Hayner, Troy, OH, a manufacturer of whiskey. At that time the sales operation moved to Dayton, near Troy. In 1901 the company was sold to the C. I. Hood Co., Boston (Ring 1980). Adv. 1923, *SF & PD.*

Amber; 4⅝″ × 2⅞″ × 1½″; 11n; 6b; 4ip; h. See HARTER (Balm, Elixir, Miscellaneous, Tonic), HOOD (Company).

DR HARTER'S/WILD CHERRY/ BITTERS/ST LOUIS [Base:] DESIGN/ PATENTED

Amber; 3¾″ × 2⅛″ × 1⅛″; 11n; 6b; 4ip; h. See HARTER (Balm, Elixir, Miscellaneous, Tonic), HOOD (Company).

DR HARTERS/WILD CHERRY/ BITTERS/ST LOUIS [Base:] DESIGN/ PATENTED

Amber; 7¾″ × 4½″ × 2⅜″; 11n; 6b; 4ip; h. See HARTER (Balm, Elixir, Miscellaneous, Tonic), HOOD (Company).

HECTAR/HB [monogram in center]/ BITTERS

Light amber; 12½″ × 3¼″ diameter; 18n, lady's leg shape; 20b; pl; base.

DR HENLEY'S/WILD GRAPE ROOT [in arc]/IXL/BITTERS

Dr. Henley's Wild Grape Root Bitters were introduced in 1866 by Louis Gross & Company, San Francisco, a firm with which Dr. William A. Henley was associated. Several management changes and reorganizations culminated in the establishment of Henley Brothers. Sons Alexander and Walter formed the firm in 1888 when the elder Henley died. In 1905 the product reportedly contained 52% alcohol (Shulz, et al. 1980). Adv. 1915, *SF & PD.*

Olive green, blue green; 12″ × 3⅜″ diameter; 18n; 20b; pl; h. See C. B. & I. (Company), HENLEY (Miscellaneous).

DR HENLEY'S/WILD GRAPE ROOT [in arc]/IXL [in oval]/BITTERS

Aqua, light blue; 12⅜″ × 3⅜″ diameter; 18n; 20b; pl; h; embossing varies in size. See C. B. & I. (Company), HENLEY (Miscellaneous).

FREE SAMPLE/HENTZ'S CURATIVE/BITTERS [Base:] 43

Light green, aqua; 4⅛″ × 1⅜″ × 1⅜″; 25n; 2b; pl; v.

HENTZ'S//CURATIVE/BITTERS// PHILADELPHIA

Light green; 9⅝″ × 2¾″ × 2¾″; 12n; 2b; 3ip; v, sfs.

HIBERNIA [in arc]/BITTERS

Bottle manufactured 1886–91. Product of (Hermann) Braunschweiger & Co., Importer & Wholesale Dealer of Wine & Liquor, San Francisco. The last available directory listing is 1900. See the following entry.

Amber; 9¾″ × 2¾″ × 2¾″; 11n; 2b; pl; h.

HIBERNIA BITTERS/ BRAUNSCHWEIGER & BUMSTEAD/ SAN FRANCISCO

Bottle manufactured 1883–84. Herman Braunschweiger and Edward H. Bumstead established a wholesale liquor business in San Francisco in 1883; Braunschweiger purchased Bumstead's interests in 1884 (Wilson and Wilson 1969).

Light amber; 10″ × 2¾″ × 2¾″; 12n; 2b; pl; v.

HIERAPICRA BITTERS/EXTRACT OF FIGS//BOTANICAL SOCIETY// CALIFORNIA [Base:] FIG

Bottle manufactured 1890–91 (Wilson and Wilson 1969). Adv. 1880 (Ring 1980).

Aqua; 9⅜″ × 2⅞″ × 2″; 11n; 3b; 3ip; v, fss. See CALIFORNIA FIG *(Bitters).*

HOLTZERMANNS/PATENT/ STOMACH/BITTERS

Label states the product was established in 1836. The bitters were probably bottled in unembossed containers until patented for J. F. Holtzermann, Piqua, OH, 7 May 1867 (Ring 1980). After the death of Holtzermann ca. 1880, business was carried on by his widow, Johanna, Moses E. Flesh and Adam Kraymer until 1886, when sold to William L. Ahrendt and Sons, Toledo, Ohio (Wilson and Wilson 1971). Adv. 1910, *AD.*

Amber; 9¾″ × 3½″ × 2¾″; 11n; 6b; ip; h, cabin-shaped, embossed on roof.

HOME BITTERS//JAS A. JACKSON & Co./PROPRIETORS// SAINT LOUIS. MO

Adv. 1870–1873 by James A. Jackson & Co., 105 & 107 N. Second St., St. Louis, MO (Ring 1980) and by Jackson, Pfouts & Douglas in 1874. From 1877 to 1880 the bitters were a product of the Home Bitters Co., G. Shryock, Sec. & Treas., 213 N. Second St. The last reference in directories was 1881 with Shryock as Sec., 24 & 26 N. Main (Holcombe 1979). Home Bitters adv. 1896–97, proprietor unknown, *Mack.*

Amber; 9″ × 2¾″ × 2¾″; 11n; 2b; 3ip; v, fsb.

[Shoulder:] HOME BITTERS/ ST LOUIS MO//PREPARED BLACK/BERRY BRANDY

Bottle universal for Home Bitters or Blackberry Brandy. Advertisement, 1870s: "THE CELEBRATED HOME STOMACH BITTERS–THESE CELEBRATED BITTERS Are a Certain Preventative of FEVER and AGUE INTERMITTENTS, INDIGESTION, DYSPEPSIA, And a sure cure for FEMALE SICKNESS. . . ." Also same advertisement: "PROF. CAMERON'S BLACKBERRY BRANDY, This celebrated Prepared Blackberry Brandy has long been a standing remedy with all Physicians in the UNITED STATES and CANADA, as a certain and speedy cure for Cholera, Summer Complaint in children, Dysentary, Chronic and Acute Diarrhoea, Bloody Flux. . . ."

Amber; 11½″ × 3¼″ diameter; 12n; 20b; pl; h, fb.

DR HOOFLAND'S/GERMAN BITTERS//LIVER COMPLAINT// DYSPEPSIA & c//C. M JACKSON/ PHILADELPHIA

Introduced in 1842 (Ring 1980). In 1863 C. M. Jackson was bought out by Charles Evans and R. S. Jones. In 1873 heirs sold to Johnson, Holloway & Co.,

Philadelphia (Ring 1980). Adv. 1916 *MB*.

Aqua; 7$^{15/16}$″ × 2$^{1/2}$″ × 1$^{5/8}$″; 1n; 3b; 4ip; v, fssb. See HOOFLAND (Balsam, Tonic).

HOP//BITTERS//1884

[Embossed torch]//T. T. & CO

A Hop Bitters was being advertised in 1877, *McK & R*; 1910, *AD*.

Aqua; 9$^{1/2}$″ × ? × ?; 11n; rect.; pl; h, sfsb.

[Shoulder:] HOPS/&/MALT/ BITTERS/[body:] HOPS & MALT/ TRADE-MARK/BITTERS//[shoulder:] HOPS/&/MALT/BITTERS// [shoulder:] HOPS/&/MALT/ BITTERS//[shoulder:] HOPS/&/ MALT/BITTERS

Label: *HOPS AND MALT BITTERS, the Best Combination of Remedies, Purely Medicine, Hops & Malt Bitters Co., Detroit, Mich. U.S.A.* Also apparently manufactured by the Rochester Med. Co., Rochester, NY (Ring 1980). The relationship between the Rochester Med. Co. and the Hop Bitters Mfg. Co., Rochester, which advertised the Hop Bitters in 1880–81 is unknown (Singer 1982). Hops & Malt Bitters adv. 1876–77 (Ring 1980); 1910, *AD*.

Amber; 9″ × 2$^{9/16}$″ × 2$^{9/16}$″; 11n; 2b; 4ip; h, fsbs.

[Arched within embossed horseshoe:] HORSE SHOE BITTERS// [below embossed horseshoe:] HORSE SHOE MEDICINE CO/[embossed running horse]/COLLINSVILLE/ILLS [Base:] PATENT APPLIED FOR

Clear; 8$^{1/2}$″ × 4$^{1/4}$″ × 2″; 11n; distinctive rect. shape; 2ip; h, fb.

DR J. HOSTETTERS/ STOMACH BITTERS

These common bitters varied in percentages of alcohol up to 47%. Bottlemakers included several Pittsburgh glass houses: S. McKee & Co. (S. McK & Co.), ca. 1860–85; A. & D. H. Chambers (A & DHC), ca. 1865; Thomas Wightman (TW & Co.), ca. 1870s; Ihmsen Glass Co. (I.G. Co.), ca. 1870–95; W. McCully (W. McC & Co.), ca. 1886 (Toulouse 1972). David Hostetter, Pittsburgh, PA, assumed the formula developed by his father, and in 1853, began manufacturing this famous bitters with George W. Smith (Young 1962). In 1858 bottles were embossed (Schulz, et al. 1980). Hostetter & Co. was established in 1884 after the death of Smith and became The Hostetter Co. in 1888 after the death of David.

The family continued to operate the business. The alcoholic content was reduced to 25% after passage of the 1906 Act and during prohibition the medication was increased, making the taste unbearable, thus the product didn't sell well. After prohibition its formula was restored (Holcombe 1979). From 1954 until its demise in 1958, this product was known as Hostetter Tonic (Schulz, et al. 1980).

Amber; 9$^{1/2}$″ × 3″ × 3″; 11n; 2b; pl; v; many variants & colors, recent variants were amber, short, round and unembossed. See HOSTETTER (Jamaica Ginger), REDINGTON *(Company)*.

HUNKIDORI/BITTERS// H. B. MATTHEWS/CHICAGO

Directories have Henry B. Matthews as the proprietor of patent medicines and stomach bitters from 1869 through 1876. In 1876 the firm became H. B. Matthews & Sons Company (Edwin, Daniel & H. B. Jr.), Manufacturing Chemists. From 1881 until the last entry in 1885, Edwin was proprietor. Hunkidori Bitters adv. 1870, Chicago city directory; 1878 (Ring 1980).

Amber; 9″ × 2$^{3/4}$″ × 2$^{3/4}$″; 11n; 2b; pl; v, fb.

JOHN FEASTER & CO/PROP'S INDIAN HEMP BITTERS/ GREEN CREEK, N.J.

Aqua, clear; 7$^{3/4}$″ × 2$^{1/2}$″ × 1$^{7/8}$″; 9n; 13b; pl; v.

INDIAN/RESTORATIVE/ BITTERS//DR GEO PIERCE'S// LOWELL MASS

Product of George Pierce introduced ca. 1857, possibly as early as 1849. Pierce moved to Boston in 1859 or 1860. After Pierce's retirement in the 1870s, managers included J. B. Hamblin and Adams & Couch. In 1885 the company purchased Dr. Cummings Vegetine from Henry R. Stevens (Ring 1980; Wilson and Wilson 1971). Information partially substantiated by Boston city directories. Adv. 1889, *PVS & S*.

Aqua; 8$^{7/8}$″ × 3$^{1/2}$″ × 2″; 11n; 3b; pl; v, fss. See CUMMINGS *(Miscellaneous)*.

INDIAN/RESTORATIVE/ BITTERS//DR GEO. PIERCE'S// LOWELL, MASS.

Aqua; 8$^{3/4}$″ × 3$^{7/16}$″ × 2″; 1n; 3b; 3ip; v, fss. See CUMMINGS *(Miscellaneous)*.

DR H. A. JACKSON'S//BITTERS

Dr. Jackson's Vegetable Bitters adv. 1849 (Ring 1980); 1853 (Singer 1982).

Aqua; 7$^{1/2}$″ × 2$^{3/4}$″ × 1$^{3/4}$″; 11n; 3b; 2ip; v, ss; p.

JEWEL BITTERS//JOHN S. BOWMAN & CO

Embossed in 1886 only (Wilson and Wilson 1969). Jewel Bitters were manufactured by John S. Bowman & Co., San Francisco from 1886 to 1892 at which time the company was sold to junior partners, J. Coblenz and B. Pike (Wilson and Wilson 1969). In later years the product was produced by A. Forticus & Co., San Francisco (Ring 1980).

Amber; 9$^{7/8}$″ × 3$^{1/4}$″ × 2$^{1/2}$″; 11n; 4b; 2ip; v, ss.

DR STEPHEN JEWETT'S// CELEBRATED HEALTH/ RESTORING BITTERS// RINDGE, N.H.

Wilson and Wilson (1971) suggest that Rev. Stephen Jewett, or his father, formulated the bitters in the 1820s as J's American Vegetable Bitters, letting a relative, J. P. Jewett, Rindge, NH, bottle and sell it. About 1854 the plant was moved to Boston; J. P. Jewett sold the brand about 1864; subsequent owners used paper-labeled bottles only. Patented 6 Dec. 1849 (Ring 1980). Adv. 1830; 1852 (Singer 1982); 1912 (Devner 1968), proprietor unk.

Aqua; 7$^{1/4}$″ × 3$^{1/4}$″ × 2″; 9n; 4b; pl; v, cfc. See JEWETT (Elixir).

JOHNSON'S//INDIAN// DYSPEPTIC//BITTERS

Light green; 6$^{1/2}$″ × 2$^{1/2}$″ × 1$^{1/2}$″; 11n; 4b; pl; v, fsbs; p.

STOMACH BITTERS/ FRED. KALINA/409 WATER STREET/PITTSBURGH, PA.// DEVIL-CERT

Pittsburgh city directories list Fred Kalina Liquors from 1909 to 1917.

Clear; 9″ × ?; 7n; 20b; pl; h, f; v, b.

KELLYS/OLD CABIN/BITTERS// PATENTED/1863

Depots included New York and St. Louis. Design patented 22 March 1870. Adv. 1864; 1878 (Ring 1980).

Amber, green, aqua; 9$^{1/8}$″ × 3$^{7/16}$″ × 2$^{3/4}$″; 11n; 6b; distinctive log cabin shape; h, fb; roof embossed only.

KENNEDYS/EAST INDIA/ BITTERS/ILER & CO./ OMAHA, NEB.

Label front and back: *KENNEDY'S EAST INDIAN BITTERS or Nervine Invigorator. A Botanic Distillation that will not Injure the most Delicate Organization. Compounded with Mineral Water. Best*

Remedy in the World for Rheumatism, Constipation, Biliousness, Lung Diseases, Dyspepsia, Sedentary Diseases, Kidney Complaint, Impure Blood, etc. ILER & CO., Proprietors and Sole Manufacturers, Omaha, Neb. Label Registered ?, re-registered in 1882. Kennedy's East India Bitters was introduced by Peter E. Iler in 1860 (Wilson and Wilson 1971), trademarked July 1882 (Ring 1980) and adv. 1901, *HH & M.*

Clear, amber, green; 9″ × 2⅞″ × 2⅞″; 7n; 2b; 1ip, embossed above and below ip; h; several sizes including miniature. See AMERICAN *(Bitters).*

KIMBALL'S/JAUNDICE// BITTERS//TROY. N. H.

Label: *Kimball's Roots and Herb Jaundice Bitters. These Bitters are Purely Vegetable and Safe to be Taken by All, Both Young and Old. They are the Best Article in the World for the Jaundice and all Kindred Complaints, and for Worms in Children* (Ring 1980).

Green, amber; 6¾″ × 2¾″ × 1¾″; 11n; 4b; pl; v, fss; p; backward S on Kimball's.

KIMBALL'S/JAUNDICE// BITTERS//TROY N. H.

Olive, amber; 7″ × 2¾″ × 1¾″; 11n; 13b; pl; v, fss; p.

KING SOLOMON'S BITTERS// SEATTLE, WASH. [See Figure 24]

Bottle manufactured ca. 1908–1912 (Wilson and Wilson 1969).

Amber; 8⅜″ × 4¼″ × 2½″, also 7½″ × 3¾″ × 2″; 12n; 6b; pl; v, ss. Also ABM unembossed variant.

Fig. 24

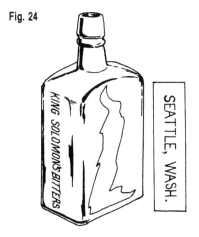

LACOUR'S BITTERS// SARSAPARIPHERE

Louis Lacour, San Francisco, was producing this sarsaparilla bitters in 1866. The term *sarsapariphere* was trademarked in 1867; the bottle design, patent 2,915, on 4 Feb. 1868. Lacour retired in 1869 and died in 1873. Manufacture of the bitters may have been continued to 1873 or may have been assumed by Weil Bros., coincidentally formed the year of Lacour's retirement. The product apparently disappeared from the market in the 1870s (Ring 1980; Schultz, et al. 1980; Wilson and Wilson 1969).

Green, amber, aqua, olive green; 9″ × 3³⁄₁₆″ diameter; 4n, with extra ring; 20b, distinctive appearance; ip; v, ss.

DR LANGLEY'S/ROOT & HERB/ BITTERS/76 UNION Sⱦ/BOSTON

Bottle addresses included 76 Union St., ca. 1845–1853; 99 Union St., 1854–ca. 1857. Boston city directories located John O. Langley at 99 Union St., 1854–1856; and sporadically at 11 or 12 Marshall St., from 1857–1871. George C. Goodwin, who operated a small sales agency at 76 Union St., Boston, convinced J. O. Langley, a country doctor, to concoct the bitters, marketing the product first in 1845 (Wilson and Wilson 1971). In 1854, Langley moved to Boston and apparently around 1857 left the business to compound and market other prescriptions. William B. Hibbard became Goodwin's partner in the 1850s and was the general manager by 1859. Goodwin retired in 1859 and was succeeded by his son Charles C., who with Hibbard, developed one of Boston's largest wholesale drug companies. Goodwin apparently operated out of several addresses including 76 and 99 Union Streets and 38 Hanover Street. Bitters adv. 1901, *HH & M.*

Aqua; 6¾″ × 2⅞″ diameter; 6n; 20b; pl; h; p, also without p. See CUTICURA *(Cure).*

DR LANGLEY'S/ROOT & HERB/ BITTERS/99 UNION Sⱦ/BOSTON

Aqua; 8½″ × 2⅞″ diameter; 11n; 20b; pl; h; 99 embossed backwards. See CUTICURA *(Cure).*

SAMPLE/LASH'S BITTERS

[See Figure 25 and Photo 4]

Bottle manufactured ca. 1890s. John Spieker and Tito Lash began the manufacture of proprietary medicines, including Homer's Ginger Brandy and various bitters, in San Francisco in 1883. Lash's Bitters were introduced in 1884. Lash, bought out by Spieker ca. 1890, produced Dr. Webb's and Webb's Stag Bitters until prohibition. Spieker died in 1914 and was succeeded by his wife (Ring 1980; Wilson and Wilson 1969). Lash's Bitters adv. 1935 by Hahn & Wessel, 316–324 E. 21st Street, New York, N.Y., *AD.*

Amber; 4³⁄₁₆″ × 1⁵⁄₁₆″ × 1⁵⁄₁₆″; 11n; 2b; pl; v.

Fig. 25

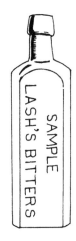

LASH'S BITTERS [Base: H in triangle]
Label: *LASH'S NATURAL LAXATIVE BITTERS. New Label Adopted May 1913. Alcohol 18% by Volume. Contents 1 pt. 6 Fld. Oz. Known and Used For Over 50 Years. Manuf. Lash Inc., Clifton, N.J., Anaheim, Cal., Chicago, Ill.* Bottle manufactured by the Hamilton Glass Company, Pittsburgh, PA, ca. 1900 to 1943 (Toulouse 1972).

Amber; 9″ × 2¼″ × 2¼″; 16n; 1b; pl; v; ABM.

LASH'S/BITTERS CO./N.Y.– CHICAGO/S.F.

Bottles contained products other than bitters, e.g., label: *HOMER'S GINGER BRANDY.*

Amber; 11¼″ × 3″ diameter; 12n; 20b; pl; h.

LASH'S/BITTERS CO./NEW YORK CHICAGO/SAN FRANCISCO [Base:] 7 [See Photo 5]

Label: *CLARK'S CORDIAL – Non-Alcoholic – Manufactured by Lash's Bitters Co., Laboratories New York, Chicago, San Francisco.* Amber variant label: *HOMER'S GINGER BRANDY.*

Clear; 10¾″ × 3″ diameter; 12n; 20b; pl; h; ABM; Also amber variant. See CLARK (Cordial).

LASH'S KIDNEY AND/ LIVER BITTERS//THE BEST CATHARTIC/AND BLOOD PURIFIER

Bottle manufactured ca. 1884 to 1893 (Wilson and Wilson 1969).

Light amber; amber; 9″ × 2¾″ × 2¾″; 11n; 2b; 2ip; v, fb.

LASH'S/KIDNEY [embossed in arc]/AND/LIVER [in arc]/BITTERS// THE BEST CATHARTIC/ AND BLOOD PURIFIER

Label: *LASH'S CALIFORNIA KIDNEY & LIVER BITTERS is Composed from the Bark Rhamnus Purshiana. Address all Orders: Lash's Bitters Co., 63 Varick St., New York; 149–151 E. Huron St., Chicago; 416 Second St., San Francisco.* Bottle manufactured ca. 1894 to 1905 (Wilson and Wilson 1969).
Amber; 9¹/₁₆″ × 2⅝″ × 2⅝″; 11n; 2b; pl; v, fb.

LASH'S BITTERS//NATURAL/ TONIC LAXATIVE

Bottle manufactured ca. 1910 to 1912 (Wilson and Wilson 1969).
Amber; 9½″ × 2¾″ × 2¾″; 12n; 1b; pl; v, fb; also ABM and also screw-capped variant.

LASH'S LIVER BITTERS// NATURAL/TONIC LAXATIVE

Bottle manufactured ca. 1908 to 1909 (Wilson and Wilson 1969).
Amber; dimens. unk.; 12n; 1b; pl; v, fb.

LASH'S LIVER BITTERS// NATURE'S/TONIC LAXATIVE

Label: *LASH'S NATURAL TONIC LAX-ATIVE BITTERS. New Label Adopted May 1913. Alcohol 21% by Volume. Net Contents 1 pt. 6 Fld. Oz. Lash's Bitters—Introduced in 1884—Has Become Celebrated For Its Medicinal Value Manuf. by Lash's Bitters Co. Incorporated New York, Chicago, San Francisco.*
Amber; 9⁹/₁₆″ × 2⅝″ × 2⅝″; 12n; 1b; pl; v, fb; ABM.

LEAK'S/KIDNEY [embossed in arc]/ AND/LIVER [in arc]/BITTERS

[Base:] **2777**
Bottle manufactured ca. 1906–1907. In 1908, a recessed paneled bottle was utilized with a 12 neck enclosure. Product of Leak's Bitters Co., Oakland, Cal., produced about two and one-half years (Wilson and Wilson 1969).
Amber; 9¾″ × 2⅝″ × 2⅝″; 11n; 2b; pl; v.

LIFE OF MAN//BITTERS// C. GATES & Cᵒˢ

Label: *Gates Life of Man Bitters, Registered 1877. A Vegetable Compound, Ladies will find this a Boon at the Turn of Life. Manufactured by C. Gates, Son & Co., Middleton, N.S.*

Aqua; 8⅛″ × 2⅞″ × 1¹¹/₁₆″; 1n; 3b; 3ip; v, ssf.

Litthauer Stomach Bitters/invented 1864 by/Josef Loewenthal, Berlin

Label: *Litthauer Stomach Bitters—Invented 1864 by Josef Loewenthal—Bottled under Supervision of S. Loewenthal, Son of Sole Inventor and Former Proprietor. Made in Cleveland, O. U.S.A. Medals awarded, 1879, 1891, Berlin; 1880, Melbourne. Guaranteed Under the Federal Food and Drugs Act, June 30th, 1906.*
Milk glass; 9½″ × 2¼″ × 2¼″; 8n; 1b; pl; v; tapered body. See KANTORO-WICZ **(Miscellaneous)**.

Litthauer Stomach Bitters/ invented 1864/by Josef Loewenthal

Clear; 7″ × 1¾″ × 1¾″; 11n; 1b; pl; v; tapered body. See KANTOROWICZ **(Miscellaneous)**.

Dᴿ LOEW'S CELEBRATED/ STOMACH BITTERS & NERVE TONIC//THE/LOEW & SONS CO./ CLEVELAND, O.

Green; 9⅜″ × 3⅛″ × 3⅛″; 12n, distinctive; 1b; ip; v, fb.

MARSHALL'S BITTERS//THE BEST LAXATIVE/AND BLOOD PURIFIER

Embossed 1902–1908 (Wilson and Wilson 1969). Label: *MARSHALL'S SARSAPARILLA BITTERS—An effective Blood Purifier, Kidney and Liver Cure and Regulator For the Stomach and Bowels. Prepared by KIRK, GEARY & CO. SACRAMENTO, CAL.* An unembossed variant label reads the same except *Prepared by MARSHALL MFG. CO. SACRAMENTO, CAL.* Product of Harry Kirk and William Geary, Sacramento (Wilson and Wilson 1969, 1971). The *Era Blue Book* lists the company in 1900. Adv. 1888 (Ring 1980).
Amber; 9″ × 2¹¹/₁₆″ × 2¹¹/₁₆″; 11n; 2b; pl; v, ss; also ABM.

MISHLER'S HERB BITTERS// Dᴿ S. B. HARTMAN & CO// TABLESPOON GRADUATION/

[graduation marks embossed] [Base:] **PAT FEB 6 66**
Product of Benjamin Mishler, Reamstown, PA. introduced ca. 1857. Mishler moved to Lancaster, PA in 1859 and expanded his business. In 1867 Samuel Brubaker Hartman, Lancaster, became the owner of the bitters and established S. B. Hartman & Co.; a sales office was also opened in Pittsburgh. In 1879 the Mishler Herb Bitters Co. was formed. Hartman left the company in 1888, moved to Columbus,

OH and soon thereafter established the Peruna Co. Mishler died in 1882, Hartman in 1918 (Holcombe 1979). Bitters adv. 1901 by Mishler Herb Bitters Co., Philadelphia, *HH & M*; 1916, *MB*.
Amber; 8¾″ × 2¾″ × 2¾″; 11n; 2b; 3ip, arched front; v., fss. See S. B. H. [Hartman] **(Company)**.

MORNING DEW/BITTERS//VAN OPSTAL & CO//NEW YORK

See VAN OPSTAL **(Company)**.

Dr. MOWE'S//VEGETABLE/ BITTERS//LOWELL MASS

Bottle manufactured ca. 1860s (source unk.).
Aqua; 10″ × 4″ × 2½″; 12n; 3b; 3ip; v, sfs.

NATIONAL/BITTERS [Base:] PATENT 1867

Product of Walton & Co., 9 N. 7th St., Philadelphia. The design (shaped like an ear of corn) was patented by Henry Schlichter and H. A. Zug, 22 Oct. 1867 (Ring 1980). The bitters were compounded by J. H. Kurtz (Watson 1965). Adv. 1866 (Ring 1980); produced until 1873 (Wilson and Wilson 1971).
Amber, aqua, clear; 13″ × 2¾″ diameter; 12n, variant; 20b; h.

NIBOL/KIDNEY AND LIVER/ BITTERS//THE BEST TONIC/ LAXATIVE & BLOOD PURIFIER

[See Figure 26]
Label: *NIBOL TONIC LAXATIVE, Contains 10% Alcohol By Volume, Nibol Mfg. Co., St. Louis, Mo. Copyrighted June 24, 1912 by NIBOL MFG. CO.* Three sizes of Nibol Tonic Laxative adv. 1935 by Nibol Mfg. Co., 25 S. 4th St., St. Louis, *AD*.
Amber; 9½″ × 2¾″ × 2¾″; 11n; 2b; pl; v, fb.

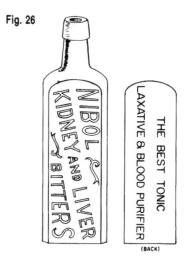

Fig. 26

**NORMAN BITTERS//
DOCTOR BOHLIN'S**
Bottle manufactured ca. 1889–1890. A
product of Louis Gairaud, Santa Clara,
CA. Introduced in 1870; discontinued,
1890 (Wilson and Wilson 1969).
Clear; 8⅞″ × 2¾″ × 2¾″; 11n; 2b;
pl; v.

**OLD/HOMESTEAD/WILD
CHERRY/BITTERS//PATENT**
Product of T. B. Slingerland & Co.,
No. 69 Beekman St., New York City.
The trademark (3307) was issued June
1863 to George Scott, Rome, NY; the
cabin-shaped design was patented in
1864 (Ring 1980).
Amber; 9½″ × 2⅞″ × 2⅞″; 11n; 1b;
h, fb, embossed on roof.

OREGON/GRAPE ROOT/BITTERS
Product of George and August Wolters
of Wolters Bros. & Co., San Francisco,
CA, manufactured in 1885 only (Wilson
and Wilson 1969).
Clear; 9½″ × 3″ diameter; 11n; 20b;
pl; h.

ORRURO//BITTERS
Olive; 10⅝″ × 2⅞″ diameter; 25n;
20b; pl; h, fb, shoulder embossed;
ABM.

**GARRY.OWEN/STRENGTHENING/
BITTERS//BALL & LYONS/
NEW ORLEANS. LA.//
SOLE PROPRIETORS** [Base:]
W. MᶜC & CO. PITTS.
William Ball and Isaac L. Lyons were
partners in the wholesale drug business
from 1869 to 1875. Isaac Lyons was
listed as an accountant in 1867; how-
ever, the firm of I. L. Lyons & Co., "A
Gulf Coast Institution Since 1866"
apparently began with Tucker &
Lyons. The 1875 directory identified I.
L. Lyons as the ". . . successor to Ball
& Lyons, Importer, Wholesale and
Retail Druggist Proprietor of Garry
Owen Bitters, Abram's Chill Tonic,
Brodie's Cordial, Locock's Cough
Elixir" The bitters were included
until 1893. Although the proprietaries
varied, Isaac was listed as president until
1924. The business was operating in
1985.
Amber; 9″ × 2⅝″ × 2⅝″; 11n; 2b; pl;
v, fsb; also embossed I. L. LYONS &
CO./NEW ORLEANS, LA. See
I. L. LYONS (Company).

**OXYGENATED//BITTERS//
FOR DYSPEPSIA ASTHMA/AND/
GENERAL DEBILITY**
Label: *Celebrated Oxygenated Bitters,
Dr. George B. Green, Inventor, John F.*

Henry, Sole Prop., New York – 1871
(Watson 1965). Green's Bitters were
formulated and controlled by G. B.
Green, Windsor, VT from ca. 1847
(Wilson and Wilson 1971) until owner-
ship transferred to S. W. Fowle & Co.,
Boston, sometime prior to 1858 (Singer
1982). After 1859 the Green surname
was apparently not always used, a
Wistar prefix was used. By 1871, John
F. Henry was sole proprietor (Watson
1965). Adv. 1848 (Putnam 1968);
1907, *PVS & S.*
Aqua; 6⅛″ × 2½″ × 1¾″; 11n; 3b; pl;
v, ssf. See J. F. HENRY *(Company)*,
WISTAR (Balsam).

**OXYGENATED//BITTERS//
FOR DYSPEPSIA/ASTHMA
& GENERAL DEBILITY**
Label: *WISTAR'S OXYGENATED
BITTERS – Seth W. Fowle & Co., Bos-
ton, Mass.* (Ring 1980). Bottle manufac-
tured ca. 1858 (Wilson and Wilson
1971).
Aqua; 7½″ × 2⅝″ × 1⅝″; 11n; 3b;
4ip; v, ssf; p. See J. F. HENRY
(Company), WISTAR (Balsam).

PARKERS/CELEBRATED/JCP
[monogram in circle]/**STOMACH/
BITTERS** [Base:] I G Co
Bottle manufactured either by Ihmsen
Glass Co., Pittsburgh, PA, 1885 to
1896 or later; or Illinois Glass Co.,
Alton, IL, ca. 1880 to 1900 (Toulouse
1972). Product of John C. Parker, St.
Louis, Copyright No. 2300, June 1880.
Adv. 1887 (Ring 1980).
Amber; 9⅛″ × 2⅝″ × 2⅝″; 11n; 2b;
pl; v.

**PAWNEE BITTERS/PAWNEE/
INDIAN MEDICINE CO./S. F.**
Bottle manufactured ca. 1910 (Wilson
and Wilson 1969).
Amber; 8⅝″ × 4⅞″ × 1¾″; 12n; 6b;
pl; h. See PAWNEE (*Balm,*
Miscellaneous).

**PAWNEE LONG LIFE/BITTERS/
NET CONTENTS 1 PINT 3 OZ.**
Bottle manufactured ca. 1911–1912.
Product manufactured in San Francisco
from the early 1870s to 1914.
Embossed bottles introduced ca. 1910
(Wilson and Wilson 1969).
Amber, aqua; 8″ × 3″ × 1⅝″; 12n; 4b;
pl; h. See PAWNEE (*Balm,*
Miscellaneous).

**PERUVIAN/BITTERS//
WK & C** [monogram]
Bitters produced ca. 1869 to 1906.
Label: *. . . a Positive Remedy for
Dipsomania, Chills and Fever and All*

*Malarial Diseases . . . Wilmerding &
Co., Sole Agents, 214 & 215 Front St.,
San Francisco. Alcohol 22.4%.* Product
of Wilmerding & Kellogg, San Fran-
cisco, introduced ca. 1869. This firm
was reorganized as Wilmerding, Kellogg
& Co. in 1874 or 1875; Wilmerding &
Co. in 1879 or 1880; Wilmerding-
Loewe Co., Inc., in 1895 and was out
of business by 1918 or 1919. The
bitters, however, were advertised by
Lash's Bitters Co. after 1900 until its
apparent demise ca. 1906 (Schulz, et al.
1980).
Amber; 9″ × 2¾″ × 2¾″; 7n; 2b; 1ip;
h, fb.

**PEYCHAUD'S/AMERICAN/
AROMATIC/BITTER/CORDIAL/
L. E. JUNG/SOLE PROPRIETOR/
29 CAMP &/116 COMMON STS./
NEW ORLEANS/LA.**
Label: *PEYCHAUD'S AMERICAN ARO-
MATIC BITTER CORDIAL, Diploma of
Honor Awarded at the Grand Exhibition
of Altona-Germany 1869. About 33% Alco-
hol.* Many embossing variants, e.g.
BEAUMAN & JUNG/29 CAMP &
116 COMMON STS./NEW
ORLEANS, LA.; L. E. JUNG/SOLE
PROPRIETOR/23 CAMP & 116
COMMON STS./NEW ORLEANS/
LA; L. E. JUNG/SOLE PROPRIE-
TOR/317 AND 319 MAGAZINE
ST./NEW ORLEANS/LA; L. E.
JUNG/SOLE PROPRIETOR/37/
TCHOUPITOULAS ST./NEW
ORLEANS/LA; L. E. JUNG/SOLE
PROPRIETORS/319/MAGAZINE
ST/NEW ORLEANS/LA. Also labels:
*PEYCHAUD'S AMERICAN AROMATIC
COCKTAIL BITTERS, Manufactured and
Bottled by Many Blanc & Co., Chicago and
PEYCHAUD'S AROMATIC COCKTAIL
BITTERS, L. E. Jung & Wulff Co., New
Orleans – Gold Medal Grand Exhibit
Altona, Germany 1869, New Orlean's
1884-5, Bronze Medal Atlanta, Georgia
1895, St. Louis 1904, Portland, Oregon
1905.* Also variant with embossed seal:
P E Y C N A U D ' S / A M E R I C A N /
BITTERS/NEW ORLEANS (Note
spelling of Peychaud) (Ring 1980).
Amber; 8⅞″ × 2½″ diameter; 12n;
20b; pl; h. See COLUMBO (Bitters).

**PEYCHAUD'S/AMERICAN/
AROMATIC/BITTER/CORDIAL/
L. E. JUNG/SOLE PROPRIETOR/
NEW ORLEANS**
Amber; 10½″ × 3″ diameter; 12n;
20b; pl; h. See COLOMBO (Bitters).

PHOENIX/BITTERS//JOHN/ MOFFAT//NEW YORK// PRICE $1.00

Product adv. 1837; patented 29 Dec. 1862 (Ring 1980). Property of William B. Moffat after 1862 according to New York City directories. Adv. 1907, *PVS & S.*

Aqua, olive; 5¼″ × 2½″ × 1¹¹⁄₁₆″; 3 and 11n; 4b; pl; v, fbss.

POND'S/BITTERS// AN UNEXCELLED/LAXATIVE

[Base: I in diamond]
Label: *POND'S BITTERS – A Vegetable Preparation Acting on the Bowels with no Harmful After Effect, removing the causes that usually produce Constipation, Biliousness, Dyspepsia, Indigestion, Upset Stomach, Malaria. No family should be without it. POND'S BITTERS CO., CHICAGO, ILL.* Bottle manufactured by the Illinois Glass Works, Alton, IL, 1916–1929 (Toulouse 1972).

Amber; 9½″ × 2⅝″ × 2⅝″; 12n; 1b; pl; v, fb; ABM.

POORMAN'S/FAMILY BITTERS

Label: *POOR MAN'S FAMILY BITTERS – Poor Man's Bitters Co., Oswego, N.Y. Entered According to the Act of Congress in 1870.* In the 1870s the company was acquired by Mead Drug Store, Oswego, and Darwin M. Mead began promoting the bitters via medicine shows. In 1918 George Bush and the Bush Pharmacy, Oswego, purchased the bitters and Donald H. Burnside soon became proprietor. Production ceased in the 1930s (Ring 1980).

Aqua; 6¼″ × 2¾″ × 1¾″; 7n; 3b; 1ip; v.

PRICKLY ASH/BITTERS C⁰.

[See Figure 27 and Photo 6]
Label from unembossed, ABM variant: *DR. B. F. SHERMAN'S COMPOUND*

Fig. 27

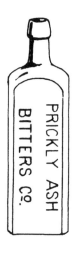

PRICKLY ASH BITTERS WITH BUCHU, BUTTON SNAKE, SENNA, SODIUM ACETATE and other Drugs. Contains 22 Percent Alcohol. Recommended For Such Disorders in the STOMACH AND BOWELS as Constipation and Flatulence . . . MEYER BROTHERS DRUG CO. PROPRIETOR' ST. LOUIS, MO. Adv. 1885 (Ring 1980); 1935 by Meyer Bros. Drug Co., St. Louis, *AD.*

Amber; 9⅝″ × 2¹³⁄₁₆″ × 2¹³⁄₁₆″; 11n; 2b; pl; v..

QUAKER BITTERS//D⁅ FLINT'S/ PROVIDENCE, R. I. [See Figure 28]

Adv. 1872, *F & F;* 1910, *AD.*

Aqua; 9¼″ × 3¼″ × 2⅛″; 7n; 4b; pl; v, fss; indented base.

Fig. 28

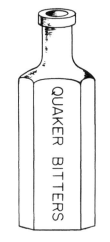

QUAKER BITTERS

THE QUININE BITTERS CO/ 184 TO 196 CONGRESS ST/ CHICAGO, ILL., USA

Clear; 8¾″ × 2¾″ × 2¾″; 12n; base diamond shape with concave sides; pl; v.

RED JACKET/BITTERS//BENNETT PIETERS & CO [Base:] M⁅C & CO

Bottle manufactured by Wm. McCully & Co., Pittsburg, PA from 1841 to ca. 1886 (Toulouse 1972). The bitters were patented in 1864 (Ring 1980). The company was called Bennett Pieters & Co., Chicago, 1864–1866; Schwab, Pieters & Co. in 1869 with Charles H. Schwab, Bennett Pieter, Edward McQuaid and L. Monheimer as proprietors. Bennett Pieters retired ca. 1872 (Holcombe 1979). When the bitters were discontinued is uncertain as embossing variants include Schwab, McQuaid & Co. and Monheimer & Co., the later a slug plate over Schwab, McQuaid & Co. Ring provides advertising dates of 1901–02, however, several other Red Jacket Bitters were

produced, suggesting the dates are not totally reliable.

Amber; 9⅛″ × 2¹¹⁄₁₆″ × 2¹¹⁄₁₆″; 11n; 2b; pl; v, fb.

KOEHLER & HINRICH/RED STAR/ STOMACH BITTERS/ST. PAUL. MINN.

Bottle manufactured ca. 1908–1913. This distinctive bottle was patented 10 April 1900 (Ring 1980).

Clear; 11½″ × 3⅜″ diameter; 12n; 20b; pl; embossed in a circle.

REED'S/BITTERS// REED'S BITTERS

New York directories list W. Reed, Distiller and Liquors, 27 Spring St. in 1850; and a W. Reed, Liquors & Bitters, 19 Bleeker St. in 1880 (Watson 1965).

Amber; 12½″ × 3¾″ diameter; 12n; 20b; pl; v, f; h, b, on shoulder; lady's leg shape. Possibly a relationship to REED *(Tonic).*

D⁅ RENZ'S/HERB BITTERS

Embossed prior to 1882 (Wilson and Wilson 1969). Product of John Renz, Sacramento, later San Francisco. Adv. 1857 (Watson 1965); 1897, *L & M.* John Renz died in 1897 and apparently so did the bitters (Schulz, et al. 1980).

Amber, olive; 9¾″ × 2¾″ × 2¾″; 12n; 2b; pl; v.

REX/BITTERS/CO./CHICAGO

Adv. 22 April 1909, *The Pharmaceutical Era;* 1916, *MB.*

Amber, clear; 11¼″ × 3″ diameter; 12n; 20b; pl; h; ABM.

REX/KIDNEY/AND/LIVER/ BITTERS//THE BEST LAXATIVE/ AND BLOOD PURIFIER

Label: *REX KIDNEY AND LIVER BITTERS, Alcohol 22%. Prepared from Cascara Sagrada Bark and Wine. No. 3329 Guaranteed By REX BITTERS CO. (Not Inc.) Under the Food and Drugs Act, June 30, 1906. Rex Bitters Company, 1712-14 Michigan Ave., Chicago, Ill.*

Amber; 9⁹⁄₁₆″ × 2¾″ × 2¾″; 12n; 1b; pl; v, ss.

D⁅ C. W. ROBACKS/STOMACH BITTERS/CINCINNATI. O

[See Figure 29]
Partial label: *Dr. C. W. Robacks Unrivalled Stomach Bitters, Cincinnati – Jan. 1861.* Patented 1855 (Ring 1980). Adv. 1907, *PVS & S.*

Amber; 9″ × 2½″ diameter; 11n; 20b; barrel shape; h. See ROBACK *(Purifier).*

Fig. 29

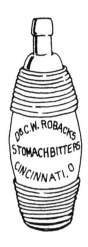

ROCKY MOUNTAIN//TONIC BITTERS//1840 TRY ME 1870
Product of Langley Hurd & Co., 96 & 98 Broad St., Boston, MA. Adv. 1867 (Singer 1982).
Amber; 9¾″ × 2¾″ × 2¾″; 11n; 2b; 3ip; v, fsb.

E. J. ROSE'S/MAGADOR BITTERS/ FOR STOMACH, KIDNEY & LIVER//SUPERIOR TONIC, CATHARTIC/AND BLOOD PURIFIER [See Figure 30]
Amber; 8⁹/₁₆″ × 2¾″ × 2¾″; 11n; 2b; pl; v, fb.

Fig. 30

FRONT BACK

ROSENBAUM'S/BITTERS// N. B. JACOBS & C°// SAN FRANCISCO
Adv. 1858 (Ring 1980); ca. 1870 (Wilson and Wilson 1969).
Amber, green; 9½″ × 2¾″ × 2¾″; 12n; 2b; pl; v, fss.

RUSH'S//BITTERS//A. H. FLANDERS. M.D./NEW YORK
Label: *RUSH'S BITTERS—For The Stomach's Sake And All Purposes For Which Any Bitters Can Be Used. . . .* Product

was introduced in 1866 by A. H. Flanders, Boston, along with such products as a Sarsaparilla, Buchu and Iron, and Pills. Flanders moved to New York City ca. 1872 and added Rush's Restorer and Pain Cure (Wilson and Wilson 1971). Adv. 1907, *PVS & S.*
Amber; 9⅛″ × 2⅞″ × 2⅞″; 1n; 2b; 3ip; v, fsb. See RUSH (Balm, Miscellaneous, Sarsaparilla).

S͈ᵀ GOTTHARD HERB BITTERS/ METTE & KANNE PRO͢S/S͈ᵀ LOUIS, Mͦ [Base:] MGC Cͦ
Bottle manufactured by the Modes Glass Co., Cicero, IN, ca. 1895 to 1904 (Toulouse 1972). Adv. 1895 (Ring 1980).
Amber; 8¾″ × 2¾″ × 2¾″; 11n; 2b; pl; v.

SANBORN'S/KIDNEY/AND/LIVER/ VEGETABLE/LAXATIVE/BITTERS
Amber; 9⅞″ × 3⁷/₁₆″ × 2½″; 12n; 3b; pl; h; distinctive shape, tapered at shoulder, 4″ wide.

SARASINA/STOMACH BITTERS
Amber; 4″ × 1¼″ × 1¼″; 11n; 2b; pl; v; sample size.

SARRACENIA/LIFE BITTERS// [monogram in circle]/TUCKER/ MOBILE ALᴬ
Product of Joseph Tucker. Adv. 1871, 1883 (Ring 1980).
Amber; 9¼″ × 2⅝″ × 2⅝″; 12n; 2b; pl; v, fb.

SAXLEHNER/HUNYADI/JANOS/ BITTERQUELLE
Label: *Hunyadi Janos, Budai Keseruviz Forras, Hunyadi Janos Mineral Spring. Proprietor: Andreas Saxlehner in Pest.* [Budapest, Hungary]. *Merit Medal, Vienna Exhibition, 1873; Bronze Medal, Lyons Exhibition, 1872. The Appollinaris Company, Limited, London, Sole Exporters.* A "Natural Aperient Water" with gentle laxative properties, named Hunyadi Janos after a Hungarian national hero of the fourteenth or fifteenth century. The bottle was in use after 1863 (Toulouse 1972). Adv. 1923, *SF & PD.* Bottles were also used by others, e.g. *PERUVIAN TONIC, The Greatest Of All Modern Tonics. A decided specific for Malaria, Chronic Catarrh, Influenza, Coughs, Dyspepsia, Heart Trouble, Loss of Appetite . . . PREPARED ONLY BY THE SCOTT MEDICINE CO. ST. LOUIS, MO.*
Olive green; 9¼″ × 2¹⁵/₁₆″ diameter; 20n; 20b; pl; base.

SCHROEDER'S/BITTERS/ LOUISVILLE, KY. [Base:] SB & G CO [See Figure 31]
Bottle manufactured by the Streator Bottle & Glass Co., Streator, IL, from 1881 to 1905. Bottles were also manufactured by the Kentucky Glass Works, Louisville; the symbols, KYGW or KYGWCO, were used from 1849 to 1855 or later. This firm became the Louisville Glass Works in 1855, the symbol LGW was used from ca. 1870 to 1886 or later (Toulouse 1972). John H. Schroeder established his business in 1845, and was joined by his son in 1859. John retired in the 1870s and the son was joined by a partner from Cincinnati. Bottles were embossed Louisville & Cincinnati from ca. 1878 to 1884 when the brand was sold to Pearce, Hurt & Co., Louisville. In 1889 the brand was sold to H. H. Shufeldt & Co., Peoria, IL (Wilson and Wilson 1971). When the bitters and the distinctive shaped bottle were terminated is unknown.
Amber; 9″ × 2⁷/₁₆″ diameter; 12n; 20b; pl; h; lady's leg shape.
See SCHROEDER (Miscellaneous), WOODCOCK (Bitters).

Fig. 31

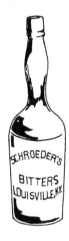

SCHROEDER'S/SPICE/BITTERS
Bottle manufactured ca. 1864 (source unk.).
Amber; 11¹⁵/₁₆″ × 3⅜″ diameter; 18n; 20b; pl; h; lady's leg shape.
See SCHROEDER (Miscellaneous), WOODCOCK (Bitters).

SHEDDS/SPRING BITTERS// SHEDDS/SPRING BITTERS
Bottle manufactured ca. 1888 to 1900 (source unk.). Adv. as . . . *an Elegant Bitter much used in Dyspepsia.* Product of W. D. Shedd, Jamestown, NY (Ring 1980).
Amber; 9½″ × 2⅝″ × 2⅝″; 11n; 2b; 3ip; v, fb.

D^R JGB SIEGERT & SONS
[Base:] ANGOSTURA BITTERS
Dr. Johann Gotlieb Benjamin Siegert
introduced his popular bitters in
Angostura, Venezuela in 1824 and
began exporting the brand, except in
the United States, as Angostura Bitters,
in 1830. Siegert's sons joined the busi-
ness, Carlos in 1867 and Alfredo in
1872. The elder Siegert died in 1870
and the brothers re-established the busi-
ness in Trinidad in 1875. The firm was
changed from Dr. J. G. B. Siegert &
Hijos to Angostura Bitters, Dr. J. G. B.
Siegert & Sons, Ltd., in 1909. The
company was still in business in 1958
(Schulz, et al. 1980). The product was
adv. in the U.S. in 1872, *F & F.* Adv.
1880 by J. W. Hancox, Sole Agent, 51
Broadway, New York City (*Harper's
Weekly* 3 July 1880); 1887 by J. W.
Wupperman, 51 Broadway, New York
City, Sole Agent, *McK & R*; 1958
(Schulz, et al. 1980).
Green; 4⁷/₈″ × 1³/₈″ diameter; 12n;
20b; pl; h, embossed around shoulder
and base; many variants. See SIEGERT
(Miscellaneous).

D^R W. SIMON'S/INDIAN BITTER
Green; 5¹/₄″ × 1¹/₄″ diameter; 7n; 20b;
pl; v.

**SOLOMON'S/STRENGTHENING
&/INVIGORATING BITTERS//
SAVANNAH/GEORGIA**
Adv. ca. 1850 (Ring 1980); 1890;
W & P.
Cobalt; 9⁵/₈″ × 2¹¹/₁₆″ × 2¹¹/₁₆″; 11n;
2b; 3ip; v, fb. See HOFFMAN (Mixture),
SOLOMON (Drug).

**INDIAN WINE BITTERS/
OLD D^R SOLOMON'S**
Trade card adv.: "Old Dr. James M.
Solomon's Indian Wine Bitters, the
Greatest Blood Purifier and Liver Cure
in the World, Attleboro, Mass." Adv.
1885, *GG*; 1900, *EBB.*
Aqua; 8⁷/₁₆″ × 2¹³/₁₆″ × 1¹¹/₁₆″; 7n; 3b;
3ip; v.

**DR. STANLEY'S/SOUTH
AMERICAN/INDIAN BITTERS**
Produced 1878–1913, Dr. A. G. Stan-
ley, proprietor, Cor. Main & Market
Streets, Lykens, Penn. (Ring 1980).
Amber, aqua; 8³/₄″ × 2⁹/₁₆″ × 2⁹/₁₆″;
11n; 2b; pl; v.

**STAR ANCHOR BITTERS//W. L. B.
JACK./PORTSMOUTH OHIO**
Production ca. 1872–ca. 1885 (source
unk.).
Amber; 8³/₄″ × 2⁵/₈″ × 2⁵/₈″; 11n; 2b;
3ip; v, fss.

**[v] STAR KIDNEY/[d] AND/
[v] LIVER BITTERS**
Label on unembossed variant: *STAR
KIDNEY AND LIVER BITTERS, Alcohol
19 percent. A Purely Vegetable Compound,
A Remedy for Diseases Arising From a Dis-
ordered Condition of the Stomach, Liver or
Bowels such as Dyspepsia, Indigestion, Sick
& Nervous Headache and as a Relief for
Constipation . . . Purely Vegetable. A
Combination of Roots, Herbs, & Barks,
Star Bitters Co., San Francisco, U.S.A.*
Bottle manufactured ca. 1902–1916
(Wilson and Wilson 1969). Bottled first
ca. 1900 in unembossed bottles. The
product was manufactured at some
point at 415 19th St., Sacramento (Ring
1980).
Amber; 8⁷/₈″ × 2³/₄″ × 2³/₄″; 11n; 2b;
pl; v, d.

**STOCKTON'S/PORT WINE/STW
[monogram] TRADE MARK/BITTERS**
Label: *Stockton's Celebrated Malvoise
Bitters*; a product of W. W. Stockton,
Santa Clara, CA, ca. 1882 to ca. 1900
(Wilson and Wilson 1971).
Amber; 9¹/₂″ × 3″ × 2¹/₄″; 11n; 6b;
pl; h.

**SUN/KIDNEY/AND/LIVER/
BITTERS//VEGETABLE
LAXATIVE/BOWEL REGULATOR/
AND BLOOD PURIFIER**
A product of the Augauer Bitters Co.,
Chicago, established 1890 (Ring 1980).
The Augauer Bitters Co. was formerly
known as the Dr. Russell Medicine
Company (Fike 1967).
Amber; 9⁵/₈″ × 2⁹/₁₆″ × 2⁹/₁₆″; 12n; 1b;
pl; v, fb; ABM. See AUGAUER (Bitters).

**DR J. SWEET'S//
STRENGTHENING//BITTERS**
Product of Dr. J. Sweet, New Bedford,
MA (Ring 1980). Adv. 1890, *W & P.*
Aqua; 8¹/₂″ × 2¹/₄″ × 2¹/₄″; 1n; 2b; pl;
v, fsb.

**[h] 1PT. 3OZ./[d] Toneco/
[h] BITTERS [Base:] FGW**
[See Figure 32 and Photo 7]
Label: *APPETIZER TONIC Toneco BIT-
TERS, LASH'S BITTERS COMPANY,
NEW YORK CHICAGO SAN FRAN-
CISCO, EST. 1884.* Bottle manufactured
by Fairmount Glass Works, Indi-
anapolis, IN, 1898–1930 (Toulouse
1972). Produced 1908–1917 (Wilson
and Wilson 1969).
Clear; 10″ × 2⁵/₈″ × 2⁵/₈″; 12n; 1b; pl;
v, d, h; ABM. See LASH (Bitters).

Fig. 32

**TONECO/STOMACH BITTERS//
APPETIZER & TONIC** [See Photo 7]
Label: *TONECO STOMACH BITTERS,
ALCOHOL 30%, IS COMPOUNDED
WITH THE FINEST HERBS, ROOTS,
BARKS AND GUM UPON SCIENTIFIC
PRINCIPLES AND GUARANTEED
ABSOLUTELY PURE. Guaranteed by
Lash's Bitters Co. Under the Food and
Drugs Act, June 30, 1906, Serial Number
2079. LASH'S BITTERS COMPANY 721
Washington St., New York; 319–331 W.
Ohio St., Chicago; 1721 Mission St.,
San Francisco.*
Clear, aqua; 9″ × 2⁵/₈″ × 2⁵/₈″; 11n; 1;
pl; v, ss. See LASH (Bitters).

**DR. A. S. HOPKINS/UNION
STOMACH BITTERS/F. S.
AMIDON, SOLE PROP./
HARTFORD, CONN. U.S.A.**
[See Photo 8]
Label: *DR. HOPKINS' CELEBRATED
UNION STOMACH BITTERS
CONTAINS 20 LIQUID OUNCES
CONTAINS 15½% ALCOHOL ABSO-
LUTE SERIAL No. 1030. Guaranteed by
F. S. Amidon under the Food and Drugs
Act, June 30, 1906. SARSAPARILLA
AND OTHER ROOTS AND BARKS
Compounded so as to act in concert, and
assist nature in ERADICATING DISEASE
. . . For Purifying the Blood. Prepared
exclusively by the Subscriber from the Origi-
nal Formula, as compounded by the late
DR. A. S. HOPKINS, by his successor-
F. S. AMIDON, SOLE PROPRIETOR.*
According to Hartford directories A. S.
Hopkins controlled the bitters from
1882 until his death in 1899; F. S.
Amidon purchased the business in 1901
and was last listed in 1919 (Ring, 1980).
Amber; 9³/₈″ × 2¹¹/₁₆″ × 2¹¹/₁₆″; 11n;
2b; 2ip; v. See HOPKINS (Sarsaparilla).

UNIVERSE BITTERS/
MANUFACTURED BY/AUG.
HORSTMAN/SOLE AGENT/
F. J. SCHAEFER/231 MARKET ST./
NASHVILLE KY
Green; 12″ × 3½″ diameter; 25n; 20b;
pl, lady's leg shape; h; also variant
LOUISVILLE KY.

VER = MUTH/STOMACH/
BITTERS//TONIC/AND/
APPETIZER [Base: F in circle]
Clear; 9⅜″ × 2¾″ × 2¾″; 11n; 1b; pl;
v, fb.

DR VON HOPF'S//CURACOA
BITTERS//CHAMBERLAIN & CO/
DES MOINES/IOWA
Adv. 1878 (Ring 1980); 1907, *PVS &
S*; changed to Tonic, 1910, *AD*.
Amber; 7½″ × 3¼″ × 1½″; 11n; 3 or
6b; pl; v, ssf. See CHAMBERLAIN
(Balm, Liniment, Lotion, Miscellaneous,
Remedy).

DR VON HOPF'S/CURACO
BITTERS//CHAMBERLAIN & CO/
DES MOINES/IOWA
Amber; 9⅛″ × 2¹¹⁄₁₆″ × 2¹¹⁄₁₆″; 11n;
2b; 2ip; v, fb; an early variant reads:
MARION, IOWA. See CHAMBERLAIN
(Balm, Liniment, Lotion, Miscellaneous,
Remedy).

ALEX VON HUMBOLDTS//
STOMACH BITTERS
Bottle embossed 1868–1872 only.
Agents apparently included Henry
Buneman, San Francisco (Wilson and
Wilson 1969), and Hazlett & Miller,
location unknown (Ring 1980). Adv.
1872, *F & F*; 1901, *HH & M*.
Amber; 9½″ × 2⅝″ × 2⅝″; 11n; 2b;
pl; v, fb.

[h] WAHOO/&/CALISAYA/
BITTERS/[shoulder:] Y!!//[v] JACOB
PINKERTON/[shoulder, h] O.K.//[v]
JACOB PINKERTON/[shoulder, h]
Y!!!//[shoulder, h] I. M.
Product of Jacob Pinkerton, Nos. 14 &
16 James St., Syracuse, NY (Watson
1965). Adv. 1865, *GG*; 1872, *VHS*.
Light amber; 9¾″ × 2⅞″ × 2⅞″; 11n;
2b; 2ip; h, v, fssb.

WAIT'S/KIDNEY AND/LIVER
BITTERS//CALIFORNIA'S OWN/
TRUE LAXATIVE/AND BLOOD
PURIFIER [Base:] PCGW [See Photos
9 and 10]
Label: *WAIT'S LIVER AND KIDNEY
BITTERS, A Purely Vegetable Compound
For All Diseases Arising From A Disordered
Condition of the Stomach, Liver or Bowels.
MANUFACTURED BY GEORGE Z.
WAIT WHOLESALE & RETAIL*

*DRUGGIST 531 J STREET SACRA-
MENTO $1.00 per Bottle*. Sticker added,
*Guaranteed Under the Food and Drugs Act,
June 30, 1906 No 3104*. Additional label:
*Wait's HOREHOUND IRISH MOSS
HONEY & BALSAM TOLU For Coughs,
Colds, Hoarseness and All Bronchial
Affections. PREPARED ONLY BY
GEORGE Z. WAIT WHOLESALE AND
RETAIL DRUGGIST, SACRAMENTO.*
Label over embossed Hostetter's bot-
tle: *WAIT'S LIVER AND KIDNEY BIT-
TERS. Alcoholic Strength not over 13%.
Guaranteed by the Geo. Z. Wait Co. Under
Food and Drugs Act of June 30, 1906 Serial
No 3104. . . . $1.00* Bottle manufac-
tured by the Pacific Coast Glass Works,
San Francisco, 1902–24.
Amber; 8⅝″ × 2⅝″ × 2⅝″; 11n; 2b;
pl; v, fb. See WAIT (Tonic).

DR. WALKINSHAW'S//CURATIVE
BITTERS//BATAVIA N. Y.
Product of Walkinshaw, Hewitt & Co.,
Batavia, NY. Adv. 1880 (Ring 1980).
Maxwell G. Walkinshaw, a Batavia phy-
sician, compounded the product in
1879 and apparently marketed the
bitters through his brother James's drug-
store, Baker & Walkinshaw; Henry
Hewitt was apparently the financial
backer for the business (Wilson and
Wilson 1971). Lucius Baker and James
M. Walkinshaw were Batavia druggists
from 1874 until ca. 1897 according to
directories and *Beers Gazetteer and
Biographical Record of Genesee Co., N.Y.,
1788–1890*.
Amber; 10″ × 2⅛″ × 2⅛″; 11n; 2b;
3ip; v, sfs.

WAMPOO BITTERS//
BLUM SIEGEL & BRO
New York directories listed Jonas N.
Blum and Lewis and Gabriel Siegel as
separate wine and/or bitters merchants
during the period 1867–1879; only the
Siegels were listed until the 1890s.
Wampoo Bitters were specifically
named by the Siegels in 1870–71, and
they listed a bitters in 1874, the brand
name not given. The Blum association
is unclear.
Amber; 10″ × 2⅝″ × 2⅝″; 2n; 2b;
3ip; v, also variants: BLUM SIEGEL
& BRO/NEW YORK And SIEGEL
& BRO/NEW YORK.

WARNER'S/SAFE/BITTERS/
TRADE/MARK [on embossed safe]/
ROCHESTER, N.Y.
Introduced ca. 1880 (Seeliger 1974).
Adv. 1882, *VSS & C*; 1897, *L & M*.
Amber; 7¼″ × 2¾″ × 1½″; 7n; 12b;

pl, h, the words TRADE MARK are
embossed on safe. See LOG CABIN
(Extract, Remedy, Sarsaparilla), H.
WARNER (Company, *Cure*, Nervine,
Remedy).

WEST INDIA/STOMACH
BITTERS//ST. LOUIS MO.
[Base:] WIMCo
The West India Manufacturing
Company was established in 1876 and
succeeded Moody, Michel & Co.,
Wholesale Grocers, Wines, Liquors &
Cigars (Holcombe 1979). Adv. 1882,
VSS & C; 1916, *MB*.
Amber; 8⅝″ × 2¾″ × 2¾″; 11n; 2b;
pl; v, fb.

WHEAT//BITTERS
Advertisement: ". . . THE ROYAL
APPETIZER! FOOD for the Blood,
Brain and Nerves. A Nutritive, Medic-
inal Tonic for the Entire System. A
Corrective for the Digestive and Urinary
Organs. A Cure for Debility and all
Malarial Diseases. TRY IT AND BE
CONVINCED . . . Wheat Bitters Co.,
19 Park Place, New York City" (Fike
1966). Adv. 1882 (Ring 1980); 1910,
AD.
Amber; 9½″ × 3½″ × 2⅛″; 11n; 3b;
3ip; v, ss.

[Base:] WHITES ANGOSTURA
BITTERS [shoulder, h] MIGUEL
BETHENCOURT CURACAO
Label: *WHITE'S BITTERS Trade Mark
Prepared by Miguel Bethencourt Curacao.
D.W.I.*
Dark olive; 8⅛″ × 2⅜″ diameter; 2n;
20b; pl; base, h.

WHITWELL'S TEMPERANCE//
BITTERS BOSTON
Bottle manufactured ca. 1848 (source
unk.). John P. Whitwell operated a
drugstore on 48 Newbury St., Boston,
from 1810, or before, until ca. 1816
when he began working at the Boston
Infirmary. From 1821 to 1849 Whitwell
again operated a drugstore, the latter
years with son J. George. Adv. 1814
(source unk.); 1848 (Singer 1982).
Aqua; 7¾″ × 3″ × 1¾″; 11n; 4b; pl;
v, ss.

WILD CHERRY BITTERS/
MANUFACTURED BY/C. C.
RICHARDS & Co/YARMOUTH,
N. S. [Base:] L. G. Co. N. S.
Aqua; 6¼″ × 3″ × 1½″; 3n; rect.;
2ip; v.

H. N. WINFREE'S/AROMATIC/
STOMACH/BITTERS/CHESTER, VA.
Aqua; 6⅜″ × 2¾″ × 1¾″; 7n; 12b;
pl; v.

WINTER'S/STOMACH BITTERS

[Base:] **S B & G Co** [See Figure 33]
Bottle manufactured by the Streator Bottle & Glass Co., Streater, IL between 1881 and 1905 (Toulouse 1972).

Amber; 9½″ × 2⅞″ × 2⅞″; 11n; 2b; pl; v.

Fig. 33

DR. WONNE'S/ GESUNDHEITS BITTERS

Product of J. D. Meimsoth, Chicago (Ring 1980).

Amber; 9½″ × 2¾″ × 2¾″; 11n; 2b; pl; v.

DR. WONSER'S/U.S.A./ INDIAN ROOT/BITTERS

Bottle manufactured ca. 1871. Square variant made in 1875. A product of William M. Hawkins, San Francisco, CA; the company was sold to McMillan & Kester in 1874. McMillan & Kester sold the product for maybe another 15 years in unembossed bottles (Wilson and Wilson 1969).

Aqua; 10½″ × 3″ diameter; 1n, 1ip has 2 rings; 20b, with kickup; pl; h; distinctive shape, 16 flutes on shoulder. See McMILLAN & KESTER (Jamaica Ginger).

DR. WONSER'S/U.S.A./ INDIAN ROOT/BITTERS

Bottle manufactured ca. 1872–1873.

Olive, green; 11″ × 3″ diameter; 11n, with 2 rings; 20b; pl; h; distinctive shape, 16 flutes on shoulder. See McMILLAN & KESTER (Jamaica Ginger).

DR WOOD'S//SARSAPARILLA/&/ WILD CHERRY//BITTERS

Adv. 1847, a product of Wyatt & Ketcham, 121 Fulton St., New York City (Shimko 1969). Advertised 1844–1845 (Singer 1982); 1851, *JSH*.

Aqua; 9″ × 3″ × 2″; 11n; 4b; pl; v, cfc.

WOODCOCK/PEPSIN BITTERS// SCHROEDER'S MED. C°

Product of John H. Schroeder, Louisville, KY.

Amber; 8″ × 4¼″ × 2½″; 11n; 4b; 2ip; v, ss. See SCHROEDER (Bitters).

YERBA BUENA// BITTERS S.F. CAL.

Label: *DR. WARREN'S YERBA BUENA BITTERS . . . H. WILLIAMS & CO. PROPRIETORS SAN FRANCISCO, CAL.* Product of Homer Williams and Alfred Wright, San Francisco, CA, introduced in 1870. Homer became sole owner and wealthy with the bitters, Homer's Ginger Brandy and Warren's Botanic Cough Balsam. In 1880 Homer retired and in the mid 1880s the Paul O. Burn Co., San Jose, CA, purchased Yerba Buena Bitters; the Lash's Bitters Co. purchased Homer's Ginger Brandy. Yerba Buena variants with No. 2 on the back were introduced in 1886 (Wilson and Wilson 1969). Bitters adv. 1921, *BD*.

Amber; 9½″ × 3½″ × 2″; 12n; 13b, with slightly flattened ends; pl, coffin-shaped flask; v, ss; several colors and variants. See WARREN (Balsam, Cordial, Remedy).

CHEMICAL

AMERICAN PEROXIDE/AND/
CHEMICAL CO/NEW YORK
Amber; 7″ × 2″ × 2″; 3n; 1b; pl; v.

PEPTONOIDS/THE ARLINGTON
CHEMICAL CO/YONKERS, N.Y.
Introduced in 1881, adv. 1948 by
Arlington Chemical Co., 26 Vark St.,
Yonkers, N.Y.), *AD.*
Amber; 7½″ × 2½″ × 2½″; 7n; 1b;
1ip; v. See LACTOPEPTINE (Miscellane-
ous, Remedy), REED & CARNRICK
(Oil).

PHOSPHO-CAFFEIN COMP./
ARLINGTON CHEMICAL CO./
YONKERS, N.Y. [See Figure 34]
Adv. 1895, *M & R*; 1941–42, *AD.*
Amber; 3¹⁵⁄₁₆″ × 1³⁄₈″ × 1³⁄₈″; 7n; 1b;
1ip; v. See LACTOPEPTINE (Miscellane-
ous, Remedy), REED & CARNRICK
(Oil).

Fig. 34

PHOSPHO-CAFFEIN COMP/
ARLINGTON CHEMICAL CO./
YONKERS, N.Y.
Amber; 4⅞″ × 1¹³⁄₁₆″ × 1¹³⁄₁₆″, also
4⅛″ × 1⁷⁄₁₆″ × 1⁷⁄₁₆″; 7n; 1b; 1ip; v.
See LACTOPEPTINE (Miscellaneous,
Remedy), REED & CARNRICK *(Oil).*

LESOEN OF ORME/
ANESTHESIQUE GENERAL/
AROUSSEAU CHIMISTE
BORDEAUX
Emerald green; 4⅝″ × 1½″ diameter;
18n, squared off; 20b; pl; v.

THE BAKER-LEVY/CHEMICAL
CO./CHICAGO
See BAKER-LEVY *(Company).*

BENJAMIN'S LUNG BALSAM/
P. A. BENJAMIN CHEMIST/
KINGSTON, JA.
See BENJAMIN'S *(Balsam).*

BILLINGS CLAPP & C⁰//
CHEMISTS//BOSTON
See BILLINGS *(Company).*

[Script:] Boots THE CHEMISTS
Jesse Boot, Nottingham, England,
inherited a combined herbalist and
grocer's shop and was calling himself a
druggist in 1877 and a 'Cash Chemist'
in 1880. He had ten shops by 1883
(Jefferys 1954). Boots are still in
business and in the 1980s have moved
into the Canadian market (Olive Jones,
personal communication, 1983).
Emerald green; 4⅜″ × 1⅝″ × 1⅛″;
7n; 12b; lip, embossed indented panel;
v, part script.

[Script:] Boots CASH/CHEMISTS
Clear; 5½″ × 1¹⁵⁄₁₆″ × 1″; 7n; 3b; pl;
v, part script.

BOSTON CHEMICAL CO./
RICHMOND, VA
Clear; 5½″ × 2″ × 1⅜″; 9n; 17b; pl; v.

BROWN CHEMICAL CO//
BROWN'S IRON BITTERS
See BROWN *(Bitters).*

CELERY-VESCE/CENTURY/
CHEMICAL CO./INDIANAPOLIS,
IND/USA
See CENTURY *(Company).*

CHAMPION/EMBALMING FLUID/
THE CHAMPION/CHEMICAL CO./
SPRINGFIELD/OHIO
See CHAMPION *(Company).*

CHELF'S/CELERY-CAFFEIN/
COMP'd/CHELF CHEM. CO/
RICHMOND, VA.
See CHELF *(Compound).*

CHELF/CELERY-CAFFEIN/
COMP'D/CHELF CHEM. CO./
RICHMOND, VA. [Base:] 5
See CHELF *(Compound).*

R. C. & C. S. CLARK/CHEMISTS
Label: *Clarks Anti-Bilious (ABC)
Compound for Diseases of the Liver. Cleve-
land, Ohio.* The 1871 Cleveland city
directory lists the proprietors of the
compound as Rollin C. and Curtis S.
Clark. After Curtis left the business in
1878, and Rollin in 1880, the firm was
managed by E. L. Rich and was known
as the Clark ABC Med. Co. (Holcombe
1979). Adv. 1910, *AD.*
Aqua; 9⅛″ × 2¾″ × 1⅝″; 11n; 3b;
3ip; v.

THOMAS. B. CORNER/CHEMIST/
WHITBY [Base: monogram]
Clear; 4¹³⁄₁₆″ × 1¹³⁄₁₆″ × 1⅛″; 5n; 3b;
pl; v.

[Script:] Rubi-Formol/THE DE PREE
CHEMICAL CO./HOLLAND, MICH.
WINDSOR, ONT. [Base: I in diamond]
See DE PREE *(Company).*

F. C. DETTMERS/CHEMIST/
FLATBUSH, L.I.
Clear; 5⁹⁄₁₆″ × 1¹⁵⁄₁₆″ × 1⁵⁄₁₆″; 9n; 5b;
pl; v.

DICKEY/[embossed mortar and pestle]
PIONEER/1850 [embossed within]/
CHEMIST/S.F. [See Photo 11]
Label on amber variant, manufactured
ca. 1900: *Dickey Creme de Lis, For the
Complexion. Manufactured by E. B.
Harrington & Co., Los Angeles, Ca.* This
was a universal container but also
housed the big seller, Creme de Lis.
George S. Dickey and Charles Hodge,
San Francisco, opened a drugstore in
1850. In 1860 Hodge left the business,
moved to Portland and established his
own drug concern. Dickey was semi-
retired by 1867 and William T. Wen-
zell ran the business and ca. 1870,
bought Dickey out. It is believed that
all embossed bottles were manufactured
after Wenzell acquired the business
(Wilson and Wilson 1971). Adv. 1923,
SF & PD.
Cobalt, amber; 5⅝″ × 1¾″ × 1⅜″;
7n; 3b; pl; h. See W *(Miscellaneous),*
WENZELL (Miscellaneous).

G. DUTTON & SON//COUGH
& BRONCHITIS MIXTURE/OR/
SYRUP OF LINSEED &
LIQUORICE//CHEMISTS BOLTON
See DUTTON *(Syrup).*

[Script:] Egyptian Chemical Co./
Boston, Mass. U.S.A.//Alco-form/
PATENT APPLIED FOR//
[graduated in ounces]
See EGYPTIAN *(Company).*

[Monogram]/ELYSIAN MFG. CO./
CHEMISTS & PERFUMERS/
DETROIT, U.S.A.
See ELYSIAN (Company).

THE EVANS/CHEMICAL/
COMPANY/CINCINNATI/
OHIO/U.S.A.
See EVANS (Company).

THE EVANS/CHEMICAL/
COMPANY/PROPRIETORS/BIG
[superimposed over G]/
CINCINNATI, O/U.S.A.
See EVANS (Company).

FERRO-CHINA-/[arched] EXCELSIOR
CHEMICAL CO./[h] N.Y.//
EXCELSIOR
Label: *FERRO-CHINA EXCELSIOR
BITTER TONIC AND RECONSTRUC-
TIVE. This Ferro-China is strickly Pure
without any Injurious Ingredients and Fully
In Compliance with the National and State
Pure Food Law. Excelsior Chemical Co.,
New York.*
Amber; 9″ × 3⁹/₁₆″ diameter; 23n,
modified; 20b; pl; h, bf. See FERRO-
CHINA (Miscellaneous).

FELLOW & Cᵒ/CHEMISTS/
Sᵀ JOHN, N.B.
Aqua; 7³/₄″ × 3¹/₂″ × 2³/₁₆″; 7n; 12b;
1ip; v. See BURDOCK (Bitters),
FELLOW (Syrup, Tablet), FOWLER
(Extract), THOMAS (Oil).

FISCHER CHEMICAL IMP'T CO/
NEW YORK
See FISCHER (Company).

C. D. FRAZEE/CHEMIST/
SANTA ROSA/[monogram] [Base:]
WT & CO
Bottle manufactured by Whitall-Tatum,
1857 to 1935 (Toulouse 1972).
Clear; 4³/₄″ × 2″ × 1¹/₄″; 9n; 18b; pl;
v; several variants.

GARDEN CITY/
CHEMICAL WORKS
Aqua; 5⁵/₁₆″ × 1⁵/₈″ × ³/₄″; 1n; 3b;
4ip; v.

HEGEMAN & CO/CHEMISTS
& DRUGGISTS/NEW YORK
[See Figure 35]
Florida water. From the 1 Nov. 1891
Pharmaceutical Era: "Sixty-five years ago
William Hegeman began his career as
a lad with the firm of Rushton & Aspin-
wall, later Rushton, Clark & Co., and
finally Hegeman & Co. From the lad
in the store was thus evolved the clerk,
partner and head of the house." Rushton
& Aspinwall date ca. 1830s; Rushton
& Clark, ca. 1840s; and Hegeman &

Clark ca. 1850s. William Hegeman
became president of Hegeman & Clark
ca. 1862 and the name became Hege-
man & Co. J. Niven Hegeman assumed
management in the 1870s (Wilson and
Wilson 1971). The business was oper-
ating in 1903 (Shimko 1969). Florida
water adv. 1875, 1899 (Devner 1970).
Aqua; 8⁷/₈″ × 2¹/₈″ diameter; 11n;
20b; pl; v.

Fig. 35

HEGEMAN & CO//CHEMISTS//
NEW YORK
Cod Liver Oil. Adv. ca. 1851 (Shimko
1969); 1860, *CNT*; 1910, *AD*.
Aqua; 10¹/₄″ × 3″ × 1⁷/₈″; 11n; 3b;
3ip; v, fss.

THE/CORPORATION OF/
HEGEMAN & CO./CHEMISTS/
SARSAPARILLA/(ARTHUR
BRAND)/200 BROADWAY/
NEW YORK
Clear; 8¹/₄″ × 3″ × 2″; 7n; rect.; pl; h.

[h] HOYT'S/POISONED BLOOD/
CURE/[arched] THE HOYT
CHEMICAL/[h] CO./INDIANAPOLIS
See HOYT (Company).

IMPERIAL/CHEMICAL
MANUFACTURING CO.//
NEW YORK//IMPERIAL HAIR/
TRADE MARK/REGENERATOR
See IMPERIAL (Company).

IMPERIAL/CHEMICAL
MANUFACTURING CO//
IMPERIAL HAIR/TRADE/[embossed
crest]/MARK/REGENERATOR
See IMPERIAL (Company).

JAQUES'/CHEMICAL WORKS/
CHICAGO
Aqua; 4¹/₂″ × 1³/₄″ × 1″; 11n; 12b;
pl; v. See JAQUE (Company).

JAQUES'/CHEMICAL WORKS/
CHICAGO
Clear; 4³/₄″ × 1³/₄″ × ⁷/₈″; 7n, sp; 3b;
4ip; v. See JAQUE (Company).

KALMUS CHEMICAL CO./
CINCINNATI.//DR. GUERTIN'S//
NERVE SYRUP [Base: I in diamond]
See GUERTIN (Syrup).

KALMUS CHEMICAL CO./
CINCINNATI & NEW YORK//
DR. GUERTIN'S//NERVE SYRUP
See GUERTIN (Syrup).

KATHARMON CHEMICAL CO./
ST. LOUIS, MO.//
HAGEE'S CORDIAL
See HAGEE (Cordial).

KEASBEY & MATTISON/
CHEMISTS/PHILADELPHIA
Label: *Pil. Antifebrin and Chocolate—
Compressed by John Wyeth & Brother,
Philadelphia.* Henry Keasbey and
Richard Mattison, Philadelphia, began
manufacturing chemicals in 1870 (Fike
1965) and moved to Ambler, PA ca.
1882 according to the Philadelphia city
directory. The company discontinued
the manufacture of medicinals in the
early 1930s (Fike 1965).
Amber, 5³/₄″ × 1³/₄″ × 1³/₄″; 7n; 2b;
pl; v. See KEASBEY (Company,
Miscellaneous).

KEASBEY & MATTISON CO./
CHEMISTS/AMBLER, PA.
Cobalt; 5″ × ? × ?; 7n; 3b; 1ip; v.
See KEASBEY (Company, Miscellaneous).

LAVORIS/CHEMICAL CO//
LAVORIS [Base:] MINNEAPOLIS
See LAVORIS (Company).

LEIS CHEMICAL MFG. CO./
LAWRENCE KAS.
See LEIS (Company).

LORRIMER & CO./
MANUFACTURING CHEMISTS/
LABORATORY/BALTIMORE, MD.
[See Figure 36]
The 1914 Baltimore city directory

Fig. 36

locates the Lorrimer Hair Tonic Co. at 319 N. Howard.

Amber; 6³/₈″ × 2³/₄″ × 1¹/₂″; 11n; 9b; pl; v.

CHEMIST/JOHN LUNN/SANDGATE [Base:] M

Aqua; 6″ × 2¹/₈″ × 1¹/₂″; 9n; 17b, front base has rounded corners; 1ip; v.

MALLINCKRODT/CHEMICAL WORKS/ST. LOUIS

G. Mallinckrodt & Co., manufacturing chemists, was established by Gustave and Otto Mallinckrodt in 1867. Edward Mallinckrodt was listed with the firm in 1872 and as sole proprietor in 1879. Mallinckrodt Chemical Works, manufacturers of chemicals for medicine, photography and the arts, was established in 1883, according to St. Louis city directories. It was still operating as of 1983, *AD*.

Light blue; 7³/₈″ × 2⁷/₈″ diameter; 7n; 20b; pl; v.

THE/MALTINE/MF'G CO/ CHEMISTS/NEW YORK

See MALTINE *(Company)*.

DR. J. A. McARTHUR'S// SYRUP OF/HYPOPHOSPHITES// CHEMICALLY/PURE

See McARTHUR *(Syrup)*.

W. A. McGUFFIE & CO./ CHEMISTS/BRISBANE [Base:] W.T. & CO/U.S.A.

Clear; 3³/₄″ × 1⁷/₁₆″ × 1³/₁₆″; 7n; 19b; pl; v.

G. W. MERCHANT/CHEMIST/ LOCKPORT, N.Y.

Bottle dates ca. 1857 (Wilson and Wilson 1971).

Green, cornflower blue; 7″ × 3¹/₄″ diameter; 11n; 20b; pl; v, with and without p. See GARGLING *(Oil)*, MERCHANT (Miscellaneous).

FROM THE/LABORATORY// OF G. W. MERCHANT/ CHEMIST//LOCKPORT/N.Y.

Bottle manufactured ca. 1860-1861 (Wilson and Wilson 1971).

Green; 5³/₄″ × ? × ?; 11n; 3b; pl; v, sfs. See GARGLING *(Oil)*, MERCHANT (Miscellaneous).

H. K. MULFORD & CO/CHEMISTS/ PHILADELPHIA [Base:] C

Label: *Friable Triturates, Calomel with spearmint. Guaranty No. 172.* Harry K. Mulford was with L. E. Sayre & Co., Philadelphia, prior to the establishment of H. K. Mulford Co. in 1887, according to Gopsill's Philadelphia city direc-

tories. Mulford Lab., in operation in 1968 (Devner 1968), was owned and operated by Sharp & Dohme since 1929 according to William H. Helfand of Merck & Co., Inc., Rahway, NJ (personal communication, 1983).

Amber; 2⁵/₈″ × ?; 16n; 1b; pl; v; ground top; variant has embossed B on base. See MULFORD (Laxative).

H. K. MULFORD CO/CHEMISTS/ PHILADELPHIA [Base:] R.C.S.

Amber; 3³/₈″ × 1¹/₂″ × 1¹/₂″; 3n; 1b; v. See MULFORD (Laxative).

NEW YORK & LONDON/ CHEMICAL CO./NEW YORK// DR. BELL'S//BALSAM OF/ALPINE MOSS,//FOR CONSUMPTION

See BELL *(Balsam)*.

J. R. NICHOLS & CO//CHEMISTS// BOSTON

Aqua; 10¹/₈″ × 3″ × 2″; 11n; 3b; 3ip; v, fss. See BILLINGS *(Company)*.

[Script:] Nontoxo/CHEMICAL CO./ SO. BEND, IND.

Amber; 2⁵/₈″ × 1¹/₄″ × 1¹/₄″; 9n; 2b; pl; v, partial script; tapered bottom edge.

THE OAKLAND CHEMICAL COMP'Y/H₂ [monogram] OC OZ

Bottle contained several products including dioxygen (hydrogen peroxide). Adv. 1907; 1929–30, 1948 by Oakland Chem. Co., 59 Fourth Ave., N.Y., N.Y., *AD*.

Amber; 4³/₄″ × 1¹⁵/₁₆″ diameter; 1n; 20b; pl; circular embossing. See DIOXYGEN *(Miscellaneous)*.

OD CHEM CO/NEW YORK

Labeled as Sanmetto, a product composed of harmonizing drugs, including sandalwood and palmetto berries (thus the name). Sanmetto, containing 20.6% alcohol, was billed as a healing agent for "Genito-Urinary" disorders. The product was acquired by McDougald Haman, New York, in 1891, at which time the OD Chem. Co. was formed. Haman claimed the product had been on the market for thirty years (Holcombe 1979). Adv. 1929 by OD Chem. Co., 61 Barrow St., New York City; 1948 by OD Peacock Sultan Co., 4500 Parkview Pl., St. Louis; 1984–85 by Medtech Labs., Cody, WY, *AD*.

Amber; 6¹/₄″ × 2″ × 2″; 9n; 2b; pl; h. See O. P. S. *(Company)*.

OMEGA/OIL/IT'S GREEN [all in embossed leaf]/TRADE MARK/

THE OMEGA/CHEMICAL CO./ NEW YORK

See OMEGA *(Oil)*.

CASWELL/HAZARD/& Cᵒ/ [embossed in circle:] OMNIA VINCAT LABOR/CHEMISTS/NEW YORK/ &/NEWPORT

See CASWELL *(Company)*.

PARKE DAVIS & Cᵒ/CHEMISTS/ DETROIT

See PARKE *(Company)*.

E. M. PARMELEE// MANUFACTURING/CHEMIST// DANSVILLE N.Y.

See PARMELEE *(Manufacturer)*.

PFEIFFER CHEMICAL Co./ NEW YORK/& ST. LOUIS

See PFEIFFER *(Company)*.

PHALON & SON'S/CHEMICAL HAIR/INVIGORATOR// NEW YORK

See PHALON *(Invigorator)*.

PHENIQUE CHEMICAL COMPANY ST LOUIS MO

Label: *Campho-Phenique, Non-Irritant, Germicide, Antiseptic For Internal & External and Hypodermic Administration. Campho-Phenique Co., St. Louis.* Adv. 1889, *PVS & S*; 1929–30, 1941–42 by James Ballard Inc., 500 N. Second St., St. Louis; 1948 by Dr. W. B. Caldwell Inc., Div. of Sterling Drug Inc., Monticello, Ill.; 1983 by Winthrop Labs., 90 Park Ave., New York City, *AD*. Directories list the Phenique Chem. Co. from 1888 to 1905, followed by the Campho-Phenique Co. to ca. 1920s.

Clear; 4³/₄″ × 1³/₄″ diameter; 7n; 20b; pl; h, embossed around shoulder.

MILK OF/[in circle] TRADE MARK/ MAGNESIA/REG'D IN U.S. PATENT OFFICE/AUG. 21, 1906/ THE CHAS. H. PHILLIP'S/ CHEMICAL COMPANY/ GLENN BROOK, CONN.

See PHILLIPS *(Magnesia)*.

THE CHAS. H. PHILLIPS/ CHEMICAL CO./NEW YORK

See PHILLIPS *(Company)*.

THE CHAS. H. PHILLIPS/ CHEMICAL CO.//NEW YORK

See PHILLIPS *(Company)*.

POTTER DRUG & CHEMICAL/ CORPORATION/BOSTON, MASS. U.S.A.//THE CUTICURA SYSTEM/

OF CURING/CONSTITUTIONAL HUMORS
See CUTICURA *(Cure)*.

POTTER DRUG & CHEMICAL/ CORPORATION/BOSTON, U.S.A.//CUTICURA SYSTEM OF/ BLOOD AND SKIN/PURIFICATION
See CUTICURA *(Cure)*.

POTTER DRUG & CHEMICAL/ CORPORATION/BOSTON, U.S.A.//CUTICURA TREATMENT/ FOR AFFECTIONS/OF THE SKIN
See CUTICURA *(Cure)*.

POTTER DRUG & CHEM. CORP.// BOSTON, MASS. U.S.A.// GENUINE SANFORD'S GINGER/ A DELICIOUS COMBINATION OF/ GINGER FRENCH BRANDY AND/ CHOICE AROMATICS, REG'D 1876
See POTTER *(Drug)*.

POTTER DRUG & CHEM. CORP.// BOSTON, MASS. U.S.A.// SANFORD'S JAMAICA GINGER/ THE QUINTESSENCE OF JAMAICA/ GINGER, CHOICE AROMATICS &/ FRENCH BRANDY, REGISTERED 1876
See POTTER *(Drug)*.

POTTER DRUG & CHEMICAL CORPORATION BOSTON MASS USA//SANFORD'S// RADICAL CURE
See SANFORD *(Cure)*.

J. R. RAYMOND/CHEMIST/ ROCKHAMPTON
Light blue; 4⁷/₁₆″ × 1⁵/₈″ × ¹⁵/₁₆″; 7n; 6b; 1ip; v.

FOR/EXTERNAL/USE ONLY/ PRESCRIPTION/REESE CHEM. CO.
[superimposed over] **1000/ EXTERNAL/USE 4 TIMES DAILY/ MFG. BY/REESE CHEM. CO./ CLEVELAND/O.** [See Figure 37]

Fig. 37

Label: . . . *a Prophylactic against Gonorrheal Infections in the Anterior Urethra, an external product not for syphilis.* Adv. 1917, *BD*.
Cobalt; 5½″ × 2″ × 1¼″; 10n; 17b; pl; h; ABM; ribbed sides.

RESINOL/CHEMICAL/CO./ BALT'O MD
See RESINOL *(Company)*.

RIO CHEMICAL CO.//NEW YORK [Base: I in diamond]/MADE IN U.S.A.
See RIO *(Company)*.

RIO CHEMICAL CO. ST. LOUIS
See RIO *(Company)*.

ROCHESTER/CHEMICAL/WORKS
Available Rochester NY directories of 1913, 1916, 1918, list the Rochester Chem. Co. as manufacturers of polishes; possibly the same company as the Chemical Works.
Clear; 3³/₄″ × 2¹/₄″ × 1³/₈″; 7n; 12b; pl; h.

DR. LISTER'S/FAMOUS ANTISEPTIC/TOOTH POWDER/ PREPARED SOLELY BY/ROGER, SON & CO./CHEMISTS/LONDON, E. C. [Base:] **W. B. M. CO./903**
Adv. 1910, *AD*.
Clear; 3½″ × 2¹/₄″ × 1″; 16n; 6b; pl; h; recessed near base; ABM.

[h] W/[v] **RUMFORD/CHEMICAL WORKS** [Base:] **PATENTED MARCH 10 1868** [See Figure 38]
Label: *Horsford's Acid Phosphate Tonic & Nerve Food.* 1880 ad: "Horsford's Acid Phosphate is more convenient for making 'lemonade' than lemons or limes, and it is healthier than either." Adv. 1884 (Baldwin 1973); 1935, *AD*. Eben N. Horsford, appointed professor at Harvard University by Benjamin Count Rumford, established the business with George Wilson in Providence, RI in

Fig. 38

1855; the firm was incorporated as Rumford Chemical Works in 1857. In 1966 the company was purchased by the Essex Corporation; in 1975 the firm was closed (Holcombe 1979; Zumwalt 1980).
Blue; clear; 5½″ × 2⁵/₁₆″ diameter, also 7½″ × 2¹³/₁₆″ diameter with no base embossing; 7n; 21b, 8 sides; 1ip; h, v.

SCHLOTTERBECK & FOSS CO./ MANUFACTURING CHEMISTS/ PORTLAND, ME.
See SCHLOTTERBECK *(Company)*.

[In circle:] **HOPE IS THE ANCHOR OF THE SOUL/T. A. SLOCUM CO/ MANFG. CHEMISTS/NEW YORK– LONDON//FOR CONSUMPTION AND LUNG TROUBLES//PSYCHINE**
See SLOCUM *(Company)*.

G. S. STODDARD & CO./M'F'G. CHEMISTS/NEW YORK// G. S. STODDARD & CO./ M'F'G. CHEMISTS/NEW YORK
See STODDARD *(Company)*.

SULPHUME CHEMICAL CO.// NEW YORK
Label:. . . *The Great Cure, Skin & Blood Purifier.* . . . Adv. 1897, *L & M*; 1921, *BD*.
Clear; 8″ × 2⁵/₈″ × 1³/₄″; 7n; sp; 3b; 4ip; v, ss.

THE TARRANT CO./CHEMISTS/ NEW YORK
Ad: "Tarrant's Effervescent Seltzer Aperient, a 'tried by time' Cure for Costiveness, Biliousness, Constipation, Dyspepsia, Headache, and Sick Stomach," was introduced in 1844. Although directories first include James Tarrant, Druggist, in 1836–1837, a gilt sign on the building stated: "Established 1834." Son John assumed control in 1853. Henry Billings controlled the company after the death of John in 1866 and James Littell took control in 1880 after the death of Billings (Holcombe 1979). The business operated as Tarrant & Co. from 1859 to 1906, and as The Tarrant Co. from 1906 until sometime between 1925 and 1933 according to Ed Sudderth of the National Park Service (personal communication, 1984). In the late 1930s the product was being produced and sold by the American Druggists Syndicate, Inc., Long Island, NY (Holcombe 1979). Adv. 1948 by Consolidated Royal Chem. Corp., 544 S. Wells St., Chicago, IL, *AD*. Other products

included Tarrant's Hair Dye, Sarsaparilla, Extract of Cubebs and Thorn's Compound Extract of Copaiba.
Clear; $5^{1}/_{8}'' \times 2^{1}/_{2}'' \times 1^{9}/_{16}''$; 7n; 3b; 1ip; v. See TARRANT (Drug).

O. TOMPKINS//CHEMIST/271 WASHINGTON ST.//BOSTON
Bottles contained several products including a Pile Cure adv. 1887, *WHS*; 1910, *AD*. Orlando Tompkins, druggist, is listed in Boston directories from 1840 until ca. 1873. Prior to his death on 29 Nov. 1884, Tompkins was also proprietor of the Boston Theatre. Subsequent manufacturers of the products are unknown.
Milk glass; $7'' \times ?$; 5n; ?b; pl; sfs.

SAVE-THE-HORSE/TRADE MARK/ SPAVIN CURE/TROY CHEMICAL CO. TROY, N.Y.
See SAVE-THE-HORSE *(Cure)*.

SAVE-THE-HORSE/REGISTERED TRADE MARK/SPAVIN CURE/ TROY CHEMICAL CO. BINGHAMPTON N.Y.
See SAVE-THE-HORSE *(Cure)*.

VAN WERT'S/GOLDEN BALM/ VAN WERT CHEMICAL CO/ WATERTOWN, N.Y.
See VAN WERT *(Balm)*.

DR. VAN WERT'S/BALSAM// VAN WERT CHEMICAL CO.// WATERTOWN, N.Y.
See VAN WERT *(Balsam)*.

W.& H. WALKER/CHEMISTS/AND/ PERFUMERS/PITTSBURG, PA.
Label: *WALKER'S BEEF, IRON AND WINE, A Valuable Nutritive Tonic, Combining the Stimulating Properties of Superior Sherry Wine with an Assimilable Form of Iron and a Suitable Proportion of Predigested Beef. Valuable in Treatment of Debility.* Adv. 1907, *PVS & S*; 1910, *AD*. The firm was included in Pittsburgh directories from 1876 to 1886 and listed as a soap manufacturer from 1887 to 1910. Producers of product after 1886 are unknown.
Clear; $8^{5}/_{8}'' \times 3'' \times 1^{7}/_{8}''$; 7 or 9n; 12b; pl; h; recessed base, strap sides.

WOODWARD/CHEMIST/ NOTTINGHAM
Products imported and adv. by E. Fougera, 1897, *EF*.
Cobalt; $6'' \times ? \times ?$; 10n; 15b; pl.

WOODWARD/CHEMIST/ NOTTINGHAM
Blue; $6^{1}/_{16}'' \times 2^{3}/_{8}'' \times 1^{7}/_{16}''$; 12n; 10b; pl; v.

WOODWARD, CLARKE & CO/ CHEMISTS/PORTLAND, OR. [Base:] W T & CO U.S.A.
Cobalt; $5'' \times 2'' \times {}^{15}/_{16}''$; 9n; 3b; pl; v. See COOPER *(Sarsaparilla)*.

WYETH CHEMICAL CO./18
Label: *Rowles Mentho Sulphur Compound, For the Relief of Rash, Itching, Ivy Poisoning. By Wyeth Chem. Co.* Adv. 1935 by Wyeth Chem. Co., 257 Cornelison Ave., Jersey City, N.J.; 1941–42 by Wyeth Chem. Co., 578 Madison Ave., New York City, *AD*.
Milk glass; $2^{3}/_{8}'' \times 1^{3}/_{4}''$ diameter; 17n; 20b; pl; base. See WYETH *(Extract, Miscellaneous, Oil)*.

THE ZEMMER CO./ MANUFACTURING CHEMISTS/ PITTSBURG, PA.
See ZEMMER *(Company)*.

age." The last reference to the company occurs in 1956 (Schulz, et al. 1980). Because C. W. Abbott was the proprietor and manufacturer of Angostura Bitters by 1883 (Ring 1980), Abbott apparently acquired the product from C. A. Richards. Adv. 1850, 1956 (Schulz, et al. 1980).

Amber; 3⁹/₁₆″ × 1³/₁₆″ diameter; 12n; 20b; pl; h, fb, on shoulder. See DINGLEY *(Company)*, RICHARDS *(Company)*.

C. W. ABBOTT & CO.// BALTIMORE [Base:] C. W. ABBOTT & CO/BALTIMORE

Amber; 8″ × 2¼″ diameter; 12n; 20b; pl; h, fb; embossed on shoulder.

THE ABBOTT/ALKALOIDAL COMPANY/CHICAGO

Label: *Gelatine Coated Phosphorous & Strychinine, Parke, Davis & Co., Detroit.* The Parke Davis relationship is unk. Directories establish The Abbott Alkaloidal Co. in 1896. By 1929–30, 1948, the firm was known as Abbott Laboratories, North Chicago, Ill., *AD.*

Amber; 2⁹/₁₆″ × 1³/₁₆″ × 1³/₁₆″; 9n; 2b; pl; v.

THE ABBOTT/ALKALOIDAL COMPANY/CHICAGO [Base: star and] WT & CO. U.S.A.

Bottle manufactured by Whitall-Tatum, 1857 to 1935 (Toulouse 1972).

Clear; 2⁵/₈″ × ¹⁵/₁₆″ × ¹⁵/₁₆″; 9n; 2b; pl; v.

ABBOTT ALKALOIDAL CO/ CHICAGO

Label: *Calomel with Aromatics. Guaranteed Serial No 656. Calomel is considered a Purgative, Vermifuge and syphilitic.*

Clear; 4¹/₂″ × 1¹/₂″ × 1¹/₂″; 7n; 2b; pl; v.

THE/ABBOTT ALKALOIDAL CO./ CHICAGO

Label: *Rheumatic Candler, An Eliminative Anti-rheumatic.*

Clear; 6¹/₄″ × 2″ × 2″; 9n; 2b; pl; v.

ABIETINE MEDICAL CO// OROVILLE, CAL. U.S.A.// GREEN'S LUNG RESTORER/ [d] SANTA/[v] ABIE

See GREEN *(Restorer).*

ABIETINE MEDICAL CO// OROVILLE, CAL. U.S.A.// SANTA ABIE

Aqua; 6¹/₄″ × 2¹/₈″ × 1¹/₄″; 1n; 3b; 3ip; v. See ABIETINE *(Balsam)*, GREEN *(Restorer).*

THE P. L. ABBEY CO./ KALAMAZOO, MICH.

Label: *CELERY TONIC BITTERS – It is a valuable tonic, reviving the energies and faculties which makes it one of the best medicines for aged people. CELERY MEDICINE CO., KALAMAZOO, MICH.* (Watson 1965). Trademark No. 4719 issued Feb. 1886 (Ring 1980). Kalamazoo city directory of 1897 listed Celery Med. Co. and Perley L. Abbey. The 1899 directory listed P. L. Abbey Co., Mfg. Pharmacists, Celery Preparations, Perley L. Abbey, Propr. (Shimko 1969). The company was acquired by Nelson Baker & Co., Detroit, ca. 1900 and the product changed to Celery Nervine (Devner 1968); both firms are included in the 1900 *Era Blue Book.*

Clear; 8³/₄″ × 2⁵/₈″ × 2⁵/₈″; 12n; 2b; 3ip; v.

C. W. ABBOTT & CO.// BALTIMORE [Base:] C. W. ABBOTT & CO/BALTIMORE

Label on C. W. Abbott variant: *ANGOSTURA BITTERS. . . For the cure of indigestion, C. A. Richards, sole proprietor, sold by all the dependable apothecaries and grocers, "None genuine without signature C. A. Richards"* (Ring 1980). In 1873, directories showed Cornelius Webster Abbott and Cornelius F. Abbott associated with Morning Star Bitters; in 1880, C. W. Abbott & Co. were the manufacturers of Morning Star Bitters; in 1886, C. W. Abbott & Co., Wholesale Druggists were dealers in Angostura Bitters and extracts; in 1893, the manufacturers of the original Angostura Bitters were located at 302 S. Charles, also the residence for C. F. and C. W. Abbott. In the 1940s, C. W. Abbott Jr. was president of the firm. In 1942 Angostura Bitters were advertised as "A Condiment for Food and Bever-

ACKER REMEDY CO./ PROPRIETORS//ACKER REMEDY//FOR THROAT & LUNGS

See ACKER *(Remedy).*

[v] PREPARED FOR THE U.S./ BY. L. AND N. ADLER MEDICINE CO./READING PA. U.S.A.// HERMANUS/GERMANY'S/ INFALLIBLE/DYSPEPSIA CURE//

[h: soldier standing over a dead bird] See HERMANUS *(Cure).*

ALLAIRE, WOODWARD & CO./ PEORIA, ILL. [Base:] WT & CO./ U.S.A.

Label: *500 pills, Quinine Sulphate 2 GRS.* Allaire, Woodward & Co. was listed as a Chemist & Manufacturing Pharmacist in 1882 and the 1950s (Devner 1970). Bottle manufactured by Whitall-Tatum, 1857 to 1935 (Toulouse 1972).

Amber; 5¹/₂″ × 1⁷/₈″ × 1⁷/₈″; 3n; 2b; pl; v.

ALLAIRE, WOODWARD & CO./ PEORIA, ILL. [Base:] W. T. & CO./ U.S.A.

Label: *Allaire, Woodward & Co's, Tonic Phosphate, A Powerful Aphrodisiac.* Adv. 1895, 1907, *PVS & S.*

Amber; 7³/₄″ × 2³/₈″ × 1³/₈″; 9n; 6b; pl; v; recessed above base.

THE ALLEN/SARSAPARILLA CO// WOODFORDS//MAINE

See ALLEN *(Sarsaparilla).*

AMERICAN APOTHECARIES CO./ NEW YORK, U.S.A.//JARABE DE AMBROZOIN

Label: *Syrup of Ambrozoin, Relieves Coughs & Colds* Adv. 1917, *BD;* 1929–30 by American Apoth. Co., 299 Ely Ave., Long Island, N. Y., 1948 from 28–29 41st Ave., Long Island, N.Y., *AD.*

Clear; 8″ × ? × ?; 8n; 6b; 2ip; v, ss; ABM.

AMERICAN DRUG CO/NEW YORK

See AMERICAN *(Drug).*

AMERICAN PEROXIDE/AND/ CHEMICAL CO/NEW YORK

See AMERICAN PEROXIDE *(Chemical).*

THE AMERICAN REMEDY CO./ OGDEN, UTAH, U.S.A.

Amber; 8″ × 2¹/₂″ × 2¹/₂″; 9n; 2b; pl; v.

ANCHOR MED. CO// WEAKNESS CURE

This Chicago company was listed in

1892 only; Orlando D. Orvis, Pres., according to Lakeside Chicago city directory.
Amber; 7½" × ?; 7n; ?b; pl; v, ss.

ANDREWS MFG CO/ BRISTOL, TENN.
Label: *Aunt Dinah's Egg Cream Liniment, The Poor Man's Friend − − The Rich Man's Comforter. Good For Man or Beast "The Greatest Pain Killer for External Use now on the Market".* Adv. 1910, *AD*.
Aqua; 8" × 3⅝" × 1⅜"; 11n; sp; 12b; pl; h.

PEPTONOIDS/THE ARLINGTON CHEMICAL CO/YONKERS, N.Y.
See ARLINGTON (Chemical).

PHOSPHO-CAFFEIN COMP./ ARLINGTON CHEMICAL CO./ YONKERS, N.Y.
See ARLINGTON (Chemical).

[Monogram in circle:]/CREME/Luxor
[Base, script:] **Armour & Company/ CHICAGO/U.S.A.**
Armour & Co. was founded in 1867 by Philip D. Armour (Periodical Publishers Association, 1934). As of 1986, the firm was very diversified. Creme Luxor adv. 1923, *SF & PD*; 1948 by Luxor Ltd., 1355 W. 31st St., Chicago, Ill., *AD*.
Milk glass; 3" × 1¹⁵⁄₁₆" × 1¹⁵⁄₁₆"; 17n; distinctive square base with bulbous corners; 3ip; h.

[h, in embossed shield] ARMOUR/ & CO/[d] Digestive Ferment/Chicago
Label: *Glycerine Extract of Red Bone Marrow.* Adv. 1901, *HH & M*; 1935, *AD*.
Amber; 7¼" × 2½" × 2½"; 9n; 1b; pl; h, d, embossed in shield.

B. F. ARTHUR & CO/SOLE AGENTS/NORTH & SOUTH AMERICA//ACKER'S ENGLISH REMEDY//FOR ALL THROAT & LUNG DISEASES
Label: *Acker's Celebrated English Remedy, Warranted to Cure All Throat & Lung Diseases, Coughs, Colds. . . . W. H. Hooker & Co., New York, U.S.A. Sole Agents No. & So. America.*
Cobalt; 6¾" × 2⅝" × 1⁷⁄₁₆"; 9n; 3b; 3ip; v, fss. See ACKER (Remedy),) HOOKER (Company).

ACM [monogram]/ATLAS MEDICINE CO./HENDERSON, N.C. U.S.A.
See ATLAS (Medicine).

AUGAUER BITTERS CO./ CHICAGO//AUGAUER BITTERS
See AUGAUER (Bitters).

B. P. Co./[backward P P in circle]
[See Figure 39]
Label: *JOHNSON'S DIGESTIVE TABLETS − For Dyspepsia and Indigestion − Papoids − JOHNSON & JOHNSON, New Brunswick, N.J. U.S.A. Successors To The Brunswick Pharmacal Co.* Adv. by Johnson & Johnson, 1889, *PVS & S*; 1929−30, *AD*; 1935 by The Kells Co., Newburgh, N.Y., *AD*.
Cobalt; 2⅞" × 1¾" × ¾"; 3n; oval base, will not stand; pl; h; also flat bottomed and threaded variants.

Fig. 39

MENTHO-LAXENE B. P. CO.// MENTHO-LAXENE B. P. CO.
[Base: P in circle]
Label: *B. P. Compound Essence Mentho-Laxene. Contains Alcohol 35% By Volume. Concentrated to Make One Pint Cough Syrup. Marketed Only By Blackburn Products, Dayton, Ohio.* Bottle manufactured by the Pierce Glass Co., 1905 to 1917 (Toulouse 1972). Adv. 1916, *MB*; 1941−42 from 312 College, *AD*.
Clear; 6" × 1¹⁵⁄₁₆" × 1¹⁄₁₆"; 16n; 3b; 3ip; v, ss; ABM.

A. P. BABCOCK CO./PERFUMER/ NEW YORK
Products adv. 1913 from 116 W. 14th, according to Trow's New York City directory; 1929−30 from 501 Fifth Ave., 1941−42 and 1948 from 50 Patterson Ave., East Rutherford, N.J., *AD*.
Clear; 6" × 1¹³⁄₁₆" × 1⅜"; 3n; 6b; pl; v; tapered body, smaller at base.

BACH MEESE & CO/ SAN FRANCISCO//BOTANIC/ STOMACH BITTER'S
See BOTANIC (Bitters).

JNo. C. BAKER & Co//100 N 3d St// PHILAD.A//B. L.
Company was a producer of cod liver oil, adv. 1864 in McElroy's Philadelphia city directory; 1941−42, *AD*. Locations included 154 N 3rd, in 1859 and 718 Market, in 1864, 1871, and 1873. The information concerning 100 N. Third is unknown.
Color unk.; 4¾" × ? × ?; ?n; 3b; ip; v, fssb; p. See J. BAKER (Sarsaparilla).

S. F. BAKER & CO.//KEOKUK, IOWA.//DR. BAKER'S/HEMATONE
Silas Baker & Co., manufacturers of patent medicines, pills, liniments and conditional powders, were located at 5th and Blondeau in 1871. In 1879, son Eugene S. was with the firm, located at 8th and Main. In 1931, S. F. Baker & Co., producers of "Proprietary Medicines, Extracts & Spices," was located at 410 Johnson, Keokuk city directories. Hematone adv. 1907, *PVS & S*.
Aqua; 8⅝" × 2⅞" × 1¾"; 7n; 3b; 3ip; v, ssf. See BAKER (Liniment).

S F BAKER & CO.//KEOKUK, IOWA//DR BAKER'S/PAIN RELIEF
Adv. 1887, *MP*; 1919 (Devner 1968). The company also produced a Pain Panacea, adv. 1901, *HH & M*; note competitor, A. R. Baker's Pain Panacea, (Miscellaneous).
Aqua; 8¾" × 2⅞" × 1¾"; 7n; 3b; 4ip; v, ssf. See BAKER (Liniment).

S. F. BAKER & CO.//KEOKUK, IOWA//DR BAKER'S/ PLANTATION/COUGH SYRUP
[See Figure 40]
Aqua; 8½" × 2⅞" × 1¾"; 7n; 3b; 4ip; v, ssf. See BAKER (Liniment).

Fig. 40

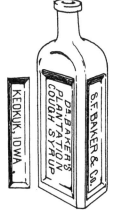

DR. BAKERS/TURKISH LINIMENT//S. F. BAKER & CO.// KEOKUK, IA.
See BAKER (Liniment).

**THE BAKER-LEVY/
CHEMICAL CO./CHICAGO**
F. Wilford Baker and Henry Levy operated from 167 Wabash Ave. from 1892 until 1899, at which time Levy (Baker is unlisted) moved to 209 State. The following year the company was located at 134 Van Buren, according to the Lakeside city directories of Chicago. Products adv. 1900, *EBB*.
Clear; 3¹⁵/₁₆″ × 1³/₈″ × 1³/₈″; 9n; 2b; pl; v.

**BALDPATE/HAIR TONIC/
BALDPATE CO./NEW YORK/
8 OZ. CONTENTS**
Adv. 1917 (Devner 1968); 1921, *BD*.
Clear; 6¹/₄″ × 2¹/₈″ × 1⁷/₁₆″; 3n; 8b, with square corners; pl; h; distinctive shape, recessed just above base.

**BALLARD SNOW/LINIMENT CO./
ST. LOUIS, MO.**
See BALLARD *(Liniment)*.

**THE BARKER/MOORE & MEIN/
MEDICINE COMPANY**
See BARKER *(Medicine)*.

**THE BARKER/MOORE & MEIN/
MEDICINE COMPANY//
PHILADELPHIA**
See BARKER *(Medicine)*.

**DR: BELDING MEDICINE. CO//
MINNEAPOLIS, MINN.//
DR. BELDING'S/SKIN REMEDY**
See BELDING *(Remedy)*.

**BELL & CO INC/ORANGEBURG/
NEW YORK USA//PA·PÁY·ANS/
BELL**
Pa-Páy-Ans-Bell, Acidity Tablets, adv. 1909 (Devner 1968) and 1915, *SF & PD*. The name apparently changed to Bell-Ans in 1914 (Devner 1968) and was still adv. 1984–85 by C. S. Dent & Co., Cincinnati, O., *AD*.
Amber; 2¹/₂″ × 2³/₄″ × 1″; 3n; 11b; pl; v, ss. See PA-PÁY-ANS BELL *(Miscellaneous)*.

**THE BELL MFG. COMPANY/
[monogram]/PERTH AMBOY, N.J.**
Amber; 4⁹/₁₆″ × 2¹/₁₆″ × 1⁷/₁₆″; 9n; 8b; pl; embossed in an oval.

**BENNETT PIETERS & CO//
RED JACKET/BITTERS** [Base:]
M⸦C & CO
See RED JACKET *(Bitters)*.

**BENTON HOLLADAY & CO./
CHICAGO**
Clear; 4³/₄″ × 2¹/₈″ × 1³/₁₆″; 3n; 4b; 1ip; v.

**BERKSHIRE SPRING WATER/
FROM THE/BERKSHIRE HILLS/
[monogram]/BERKSHIRE SPRINGS
CO./579 & 581 E 133 ST NEW
YORK/THIS BOTTLE NOT SOLD**
Product postdates 1899 and predates 1913 when the firm was located at 517 E. 132nd St. according to New York City directories.
Aqua; 13″ × ?; 11n; 20b; pl; h.

**BILLINGS CLAPP & C⸰//
CHEMISTS//BOSTON**
Label: *ELIXIR PERUVIAN BARK— Billings, Clapp & Co., Successors to Jas. R. Nichols & Co., Boston—Registered 1875. Also NICHOLS PERUVIAN BARK & IRON—Alcohol 18%. Proprietors, Brewer & Co., Worcester, Mass.* J. R. Nichols & Co. operated from 1857 (Shimko 1969) to 1872 when Billings, Clapp & Co. was established. Charles E. Billings, formerly of J. R. Nichols & Co., was joined by Albion R. Clapp. Directories include the business until 1912. Adv. 1871, *VSS & R*; 1923, *SF & PD*.
Aqua; 10³/₁₆″ × 3″ × 2″; 11n; 3b; 3ip; v, fss.

**PHIL BLUMAUER & CO/
PORTLAND, OR.//CELRO-KOLA**
Phil Blumauer, previously with the Blumauer-Frank Drug Co., operated Blumauer's Pharmacy in 1895 at 275 Morrison, and in 1898, established Phil Blumauer & Co. with Moses B. Blumauer at 271¹/₂ Morrison. Blumauer & Co. produced Celro-Kola from 1898 until 1900. Directories don't include the firm after 1900. Several other members of the Blumauer family were also successful manufacturers of patent medicines. The 1881 Oregon state directory listed L. Blumauer & Co. as sole agents for the Rose Pill, a "Strickley Vegetable Blood Purifier," at 165 1st St., the original store, and 1st and Stark. Louis operated this business from the 1870s until 1890, at which time the Blumauer-Frank Wholesale Drug Co. was established, with Emil Frank. In 1938 the company was absorbed by McKesson & Robbins Inc.; however, the firm operated until the 1940s under the original name, according to Portland city directories.
Color unk.; 10″ × ?; 11n; 2b; ip; v or h, sf. See CELRO *(Company)*, PUROLA *(Trade Mark)*, WISDOM *(Miscellaneous)*.

BOERICKE & RUNYON/COMPANY
[See Figure 41]

Amber; 2¹/₂″ × ³/₄″ × ³/₄″; 3n; 2b; pl; v. See BOERICKE & RUNYON *(Miscellaneous)*, C. C. C. *(Tonic)*.

Fig. 41

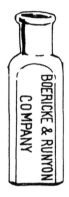

**BOERNER-FRY COMPANY/
IOWA CITY, IOWA**
Emil L. Boerner and William A. Fry established their perfume and toilet article business in 1899. In 1934 the Iowa City directory referred to Boerner's Prescription Pharmacy, with Helen, the widow of Emil, Proprietor.
Clear; 4⁹/₁₆″ × 1¹¹/₁₆″ × 1¹/₁₆″; 7n; 17b; 1ip; v.

**BOERNER-FRY CO./
IOWA CITY, IOWA**
Milk glass; 5¹/₄″ × ? × ?; 9n; 4b; pl.

**THE BORADENT CO. INC./
SAN FRANCISCO & NEW YORK//
CREME DE CAMELIA/
FOR THE COMPLEXION**
Label: *Boradent—Creme De Camelia, Alcohol 2%. For Beautifying the Complexion. Perfectly Harmless—The Boradent Co., Inc., Distributors, San Francisco and New York.* City directories indicate the company was in business in 1901. Adv. 1915, 1923, *SF & PD*.
Cobalt; 5″ × 2¹/₁₆″ × 1³/₈″; 7 or 9n; 3b; pl; v, ss.

**GUNN'S/ONION SYRUP/
DR. BOSANKO MED CO/
PHILADA. P.A.**
The company was established in Piqua, OH, ca. 1884, and moved to Philadelphia after 1890. The John O. Gunn medicine line was introduced in 1887 (Wilson and Wilson 1971). Products adv. 1923, *SF & PD*.
Light green; 4³/₄″ × 1³/₄″ diameter; 1n; 20b; pl; h. See BOSANKO *(Remedy)*, GUNN *(Syrup)*.

**DR. GUNN'S/ONION SYRUP/
PREPARED BY/THE
DR. BOSANKO MED. CO/
PHILADELPHIA, PA.**

Label: *ONION SYRUP from a prescription by Dr. Gunn. The Great Cure For Consumption, Coughs, Colds and All Affections of the Throat and Lungs. Manufactured by the Dr. Bosanko Med. Co., Philadelphia.*
Aqua; 5⅝″ × 2⅜″ × 1⅜″; 7n; 3b; 4ip; v. See BOSANKO (Remedy), GUNN (Syrup).

BOSTON CHEMICAL CO./ RICHMOND, VA
See BOSTON (Chemical).

BOTHIN/M'F'G. Co./S.F.
Directories first mention the Bothin Manufacturing Co. in 1884, as producers of baking powders, flavoring extracts, spices and coffee, but not medicine. Henry M. Bothin manufactured coffee and spice mills in the 1870s and was simultaneously in partnership with Albert Dallemand in the 1880s as an importer and wholesaler in coffee, tea, spices and wholesale liquor. The Bothin Mfg. Co. operated into the twentieth century.
Clear; 5⅞″ × 1¾″ diameter; 7n; 20b; 1ip; h.

JOHN S. BOWMAN & CO// JEWEL BITTERS
See JEWEL (Bitters).

BOYKIN CARMER & Co// BALTIMORE//GRANGER BITTERS
See GRANGER (Bitters).

BRADFIELD REG'L CO.// ATLANTA. GA.//THE MOTHER'S/ FRIEND [See Figure 42]
Adv. 1876, *WHS*; 1983 by S.S.S. Co., Atlanta, Ga., *AD*.
Aqua; 6⅞″ × 2⁵⁄₁₆″ × 1½″; 1n; 3b; 3ip; v, ssf.

Fig. 42

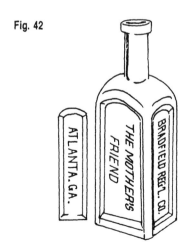

BRADFIELD REG'L CO// ATLANTA, GA.//THE MOTHERS/ FRIEND
Label: *DR. J. BRADFIELD'S FEMALE REGULATOR, a Tonic For Women and a Relief of Irregularities of the Menstrual Functions when not caused by malformation or that do not require surgical treatment, especially for use during last two months of pregnancy, at puberty and at the change of life. 89½ S. Forsyth St., Atlanta Ga. Only to be used externally.*
Aqua; 8⅛″ × 2⅜″ × 1½″; 1 and 7n; 3b; 3ip; v, ssf.

MINNEQUA WATER/ BRADFORD C⁰/P^Δ
See MINNEQUA (Water).

BRANICA Co/REGD LHR [Base:] B
[See Figure 43]
Cobalt; 2⅝″ × 1¹⁄₁₆″ diameter; 7n; 20b; pl; v.

Fig. 43

[v] J. W. BRANT CO.// ALBION, MICH.//BRANT'S/ PULMONARY/BALSAM// [h] BRANTS
See BRANT (Balsam).

BRO. MED. CO.//D. K. & B. CURE
See D. K. & B. (Cure).

BROWN CHEMICAL CO.// BROWN'S IRON BITTERS
See BROWN (Bitters).

RAMON'S PEPSIN CHILL TONIC/ MADE BY BROWN MF'G CO.// GREENVILLE, TENN.//NEW YORK, N.Y. [Base: diamond]
See RAMON (Tonic).

BROWN MF'G CO. NEW YORK// RAMON'S/SANTONINE/ WORM SYRUP
See RAMON (Syrup).

BROWN MED. CO.//ERIE, P. A.// CARTER'S EXT/OF SMART/WEED
See CARTER (Extract).

THE BROWN MEDICINE CO.// ERIE PA.//CARTER'S COUGH, AND/CONSUMPTION CURE
See CARTER (Cure).

DR. BROWNLOW & CO// GLYCERINE/JELLY
Clear; 5½″ × 2″ × 2″; 3n; 2b; 4ip; v, fb. See BROWNLOW (Tonic).

H. E. BUCKLEN & CO./CHICAGO, ILL.//"ELECTRIC" BRAND/ BITTERS
See ELECTRIC (Bitters).

H. E. BUCKLEN & CO//CHICAGO, ILL.//DR. KING'S/NEW DISCOVERY
See KING (Discovery).

H. E. BUCKLEN & CO.// H. E. BUCKLEN & CO.// DR. KING'S/NEW DISCOVERY/ FOR COUGHS AND COLDS
See KING (Discovery).

H. E. BUCKLEN & CO.// CHICAGO, ILL.//DR KING'S/ NEW DISCOVERY/FOR COUGHS AND COLDS
See KING (Discovery).

H. E. BUCKLEN & CO//CHICAGO, U.S.A.//DR. KING'S/NEW LIFE PILLS
See KING (Pills).

BURK'S MED. CO./NEW YORK/ & CHICAGO
See BURK (Medicine).

[Script:] **Burma-Shave** [Base:] BURMA VITA COMPANY MINNEAPOLIS, MINN./H A [monogram]/MADE IN U.S.A./ONE POUND/NET/8
Bottle manufactured by the Hazel-Atlas Glass Co., Wheeling, WV, 1920 to 1964 (Toulouse 1972). Adv. 1935 from 2019 E. Lake, 1941–42, 1948 from 2318 Chestnut, *AD*. This product was popular in the 1950s and classic passages and phrases could be found on billboards throughout the United States.
Clear; 4⅝″ × 3⅝″ diameter; 17n; 20b; pl, numerous vertical ridges along body of vessel; part script; ABM.

BURNETT AND CO/APOTHECARY/ NO 327 MONTGOMERY ST/ SAN FRANCISCO// DR. ROWELL'S//FIRE OF LIFE
Product of Dr. Charles Rowell, introduced ca. 1875 (Wilson and Wilson 1971). Adv. 1923, *SF & PD*.
Aqua; 5⅞″ × 2″ × 1⅛″; 7n; 3b; 4ip; v.

TRADE MARK/[monogram]/THIS BOTTLE/IS NOT SOLD/BUT REMAINS/PROPERTY OF/SIR ROBT. BURNETT/& C°/LONDON/ENGLAND

Label: *SIR ROBT. BURNETT & CO'S ORANGE BITTERS.* This product was made from Seville oranges and was an "excellent appetizer when used with sherry."

Aqua; 11½″ × 2¾″ × 2¾″; 22n; 20b; pl; h; with glass stopper. Also clear variant, 5¾″ × 1½″ diameter; 12n, 1ip.

[Script:] **The Dr. D. M. Bye/Combination Oil Cure Co./316 N. ILLINOIS ST, INDIANAPOLIS, IND./THE ORIGINATOR (COPYRIGHTED)**

See BYE *(Cure)*.

C & CO [monogram] [Base:] **Colgate & Co./NEW YORK**

Label: *Colgates Violet Water.* Adv. 1877, *MCK & R;* 1935, *AD.*

Clear; dimens. unk.; 7n; ?b; h. See COLGATE *(Company)*.

C. B. & I. EXTRACT CO/S.F. CAL.//DR. HENLEY'S/CELERY, BEEF AND IRON

Adv. 1867 (Wilson and Wilson 1971); 1923, *SF & PD.*

Amber; 9⁵/₁₆″ × 3¹/₁₆″ × 2⁵/₁₆″; 11n; 3b; 2ip; v, ss. See HENLEY *(Bitters,* Miscellaneous).

CARTER'S/LIVER BITTERS/C.M.CO. NEW YORK [Base:] WT&CO/U.S.A.

See CARTER *(Bitters)*.

CALIFORNIA EXTRACT OF FIG CO/SAN FRANCISCO, CAL.//CALIFORNIA/FIG/BITTERS

See CALIFORNIA *(Bitters)*.

CALIFORNIA FIG PRODUCTS CO./SAN FRANCISCO, CAL.//CALIFORNIA FIG & HERB BITTERS

See CALIFORNIA *(Bitters)*.

CALIFORNIA FIG SYRUP CO/CALIFIG/STERLING PRODUCTS (INC.)/SUCCESSOR

See CALIFORNIA *(Syrup)*.

CALIFORNIA/FIG SYRUP CO/SAN FRANCISCO, CAL

See CALIFORNIA *(Syrup)*.

CALIFORNIA FIG SYRUP CO/SAN FRANCISCO, CAL/SYRUP OF FIGS//SYRUP OF FIGS

See CALIFORNIA *(Syrup)*.

CALIFORNIA/FIG SYRUP CO.//WHEELING, W. VA.

See CALIFORNIA *(Syrup)*.

California Perfume Co./FRUIT/FLAVORS

David H. McConnell, San Francisco, established the California Perfume Co. in 1886, now known as the Avon corporation located in New York City. The first Avon lady was Mrs. P. F. E. Albee, and the product was Little Dot Perfume.

Clear; 5½″ × 1¹⁵/₁₆″ × ¹⁵/₁₆″; 7n, sp; 3b; 4ip; v.

[Script:] **Orange Flower Cream/THE CANN DRUG CO./RENO, NEV.** [Base:] W. T. Co./U.S.A.

See ORANGE FLOWER *(Cream)*.

Carbona Products Co.//CARBONA//CARBONA

[See Figure 44]

Not a medicine. Label: *CARBONA — Unburnable Cleaning Fluid, Removes Grease Spots Instantly, Without Injury to the Most Delicate Fabrics or Color. Price, – 15 Cents. Prepared solely by CARBONA PRODUCTS CO., NEWARK, N.J.* Backside: *This article is one of a series of Unburnable products made by the Carbona Products Co., under U.S. Patent No. 733, 591; July 14, 1908, including: White Satin, A Polish For Silver; Red Satin, A Polish For Brass; Black Satin, A Polish For Stoves and Iron; Carbona Cream, A Polish For Furniture; Carbona Liquid Soap (Carbonola) For Washable Fabrics, Curtains, Carpets, Etc.* . . . An advertisement in the *New York Times,* 10 April 1923, established the firm over 25 years earlier. Besides the Newark, NJ, address, "We were also located at 304 W. 26th Street, Manhattan, in N.Y.C., until 1947. From then until 1979 we were located at 30–50 Greenpoint Ave. in Long Island City, NY. Since then we have been located at 330 Calyer Street, Brooklyn, N.Y." (Joseph A. Corradeno, Carbona Products Co., Brooklyn, NY, personal communication, 1984.) The firm had no record of when the embossing on the vessels was terminated.

Aqua; 7″ × 2¹/₈″ diameter; 7n; 21b; 12 sides; pl; v, sss.

CAREY & CO.//GREAT ENGLISH/SWEENY//SPECIFIC

Daniel G. Carey, was listed as a patent medicine manufacturer in Waverly, NY in 1888, according to Gay's *History Gazette of Tioga Co.;* as proprietor of the G.E.S.S. Med. Co., Middletown, NY, in the 1890s (Blasi 1974). Information about the Binghampton location, in the following entry, is unk. Adv. 1877, *McK & R;* 1910, *AD.*

Aqua; 5⁵/₈″ × 2″ × 1¾″; 7n; rect.; ip; v, sfs.

THE CAREY/G. E. S. S./MEDICINE CO.//BINGHAMPTON N.Y.//BINGHAMPTON N.Y.

Label: *Carey's Great English Sweeny Specific.*

Aqua; 5¾″ × 1¾″ × 1″; 11n; 3 or 6b; pl; v, fss.

CARPENTER-MORTON CO/COLORITE/BOSTON, MASS.

[See Figure 45]

The medicinal-looking bottle contained a hair dye, also used as a general dye for straw hats, belts, shoes, wood, metal, etc. Adv. 1916, *MB;* 1929–30 and 1941–42 by Carpenter-Morton Co., 77 Sudbury St., Boston, *AD.* Directories list the company from 1892 to 1953.

Clear; 4¹/₈″ × 1³/₈″ × 1³/₈″; 3n, modified; 1b; pl; v; ABM.

Fig. 44

Fig. 45

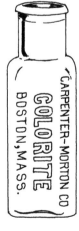

CASWELL/HAZARD/& C⁰/
[in circle:] OMNIA VINCAT LABOR/
CHEMISTS/NEW YORK/&/
NEWPORT
Label: *Mensman's Peptonized Beef Tonic*;
adv. 1879, *VSS & C*; 1910, *AD*. New
York directories show Caswell, Hazard
& Co., 1099 Broadway and 673 Sixth
Ave., operating from 1868 to 1888; the
Newport relationship is unknown. The
firm was apparently founded by John R.
and Philip Caswell Jr., and Henry Q.
Mack as Caswell, Mack & Co. in 1861.
Mack left and Rowland N. Hazard
joined the firm in 1868. In 1878 John
R. Caswell left Caswell, Hazard & Co.
and with a Mr. Massey, established
Caswell, Massey & Co., also a drug
firm, which was still operating in 1913.
W. M. Caswell joined the latter firm in
1888. Hazard & Co. succeeded
Caswell, Hazard & Co. and continued
to operate from 1099 Broadway and
673 Sixth Ave. after 1888.
Amber; $7^{1}/_{2}'' \times 2^{3}/_{4}'' \times 2^{3}/_{4}''$; 7 or 8n;
1b; pl; h.

DE TREY'S/SYNTHETIC/
PORCELAIN/MED.
[monogram] **BY/THE L. D. CAULK**
CO. [Base:] **89**
Clear; $1^{7}/_{8}'' \times 1^{3}/_{16}''$ diameter; 3n; 20b;
1ip; h. See CAULK (Manufacturer, *Mis-cellaneous*).

CELRO-KOLA CO/PORTLAND,
ORE.//[script:] Celro-kola//
Celro-kola [Base: diamond]
Bottle manufactured by the Diamond
Glass Company after 1924 (Toulouse
1972). Celro-Kola was adv. 1898,
according to Portland city directories;
1910, *AD*, and apparently in the 1920s.
Amber; $8^{3}/_{4}'' \times 2^{3}/_{4}'' \times 2^{3}/_{4}''$; 11n; 2b;
pl; v, sfs, part script; ABM. See
BLUMAUER (*Company*).

CELERY-VESCE/CENTURY/
CHEMICAL CO./INDIANAPOLIS,
IND/USA
A cure-all for headache, neuralgia, and
depression. Adv. 1880s, 1916, by
Century Chem. Co. (Devner 1968);
1935 by Celery-Vesce Co.,
Indianapolis; 1941–42 by Celery-Vesce
Sales, Indianapolis, *AD*.
Amber; $4'' \times ?$; 3n; 20b; pl.

CHAMBERLAIN & CO./
DES MOINES, IOWA
Aqua; $6^{1}/_{2}'' \times 2^{3}/_{8}'' \times 1^{1}/_{4}''$; 11n; 3b;
4ip; v. See CHAMBERLAIN (Balm,
Liniment, Lotion, Medicine, Miscellaneous,
Remedy), VON HOPF (Bitters).

CHAMBERLAIN & CO/
DES MOINES, IOWA
Aqua; $8^{3}/_{4}'' \times ? \times ?$; 11n; 3b; 4ip; v.
See CHAMBERLAIN (Balm, Liniment,
Lotion, Medicine, Miscellaneous,
Remedy), VON HOPF (Bitters).

CHAMBERLAIN & CO/DES
MOINES/IOWA//DR. VON
HOPF'S//CURACOA BITTERS
See VON HOPF (*Bitters*).

CHAMBERLAIN MED. CO.//
DES MOINES, IA. U.S.A.//
CHAMBERLAIN'S/COLIC/
CHOLERA/AND/
DIARRHOEA REMEDY
See CHAMBERLAIN (*Remedy*).

CHAMBERLAIN MED. CO.//
DES MOINES, IA. U.S.A.//
CHAMBERLAIN'S/
COUGH REMEDY
See CHAMBERLAIN (*Remedy*).

CHAMBERLAIN MED. CO.//
DES MOINES, IA. U.S.A.//
CHAMBERLAIN'S/PAIN-BALM
See CHAMBERLAIN (*Balm*).

CHAMBERLAIN MEDICINE CO//
DES MOINES, IA//
CHAMBERLAIN'S/LINIMENT
See CHAMBERLAIN (*Liniment*).

CHAMPION/EMBALMING FLUID/
THE CHAMPION/CHEMICAL CO./
SPRINGFIELD/OHIO
The Champion Chemical Co. was listed
in Springfield city directories in 1904
and 1930. The following vessel entry
indicates the firm was still operating
after 1938.
Clear; $8^{3}/_{8}'' \times 4^{5}/_{8}'' \times 4^{5}/_{8}''$; 7n; 1b;
pl; h.

THE/CHAMPION/COMPANY/
SPRINGFIELD/OHIO/LEASIDE/
ONTARIO//THE/CHAMPION/
COMPANY/SPRINGFIELD/OHIO/
LEASIDE/ONTARIO//COMPLIES
WITH ALL STATE LAWS/
[graduated marks] [Base:] **MADE IN**
USA/[Anchor Hocking monogram]
Bottle manufactured after 1938
(Toulouse 1972).
Clear; $7^{3}/_{4}'' \times 2^{1}/_{2}'' \times 2^{1}/_{2}''$; 16n; 26b;
pl.

TWITCHELL CHAMPLIN & CO//
NEURALGIC ANODYNE
See TWITCHELL (*Company*).

CHATTANOOGA MEDICINE CO.//
CARDUI THE WOMAN'S TONIC
Rev. R. I. McElree learned of an herbal
concoction used by Indian women to
relieve menstrual pain. McElree
introduced his Cardui in 1879 and sold
the product to the Chattanooga Medi-cine Company, now Chattem Labs, in
1882. Chattem Labs discontinued the
product around 1982. L. D. Ward
purchased the trademark in 1984, refor-mulated the product using drugs rather
than herbs, and began shipping it in
plastic bottles in August 1985 (Dave
Ward, L. D. Ward, Chattanooga, TN,
personal communication, 1986).
Aqua, clear; $8^{3}/_{8}'' \times 2^{13}/_{16}'' \times 1^{9}/_{16}''$;
11n; 3b; 4ip; v, ss; ABM.

THE CHATTANOOGA MEDICINE
CO//MᶜELREE'S CARDUI
[Base: C in circle]
Label: . . . *As a Bitter Tonic and*
Stomachi from Puberty through the Meno-pause and as an Anti-spasmodic on Painful
Periods. Bottle manufactured by the
Chattanooga Glass Co. after 1927
(Toulouse 1972).
Light aqua; $7^{3}/_{8}'' \times 2^{11}/_{16}'' \times 1^{1}/_{2}''$; 15n,
threaded; 9b; 2ip; v, ss; ABM.

CHATTANOOGA MEDICINE CO.//
MᶜELREE'S WINE OF CARDUI
[See Figure 46]
Label: *McElree's Wine of Cardui, Womans*
Relief, A Certain Cure for Menstrual Dis-turbances of Women such as Irregularity,
Exaggeration, Suppression. . . .
Aqua, clear; $8^{1}/_{2}'' \times ? \times ?$; 11n; 3b; 4ip;
v, ss.

Fig. 46

CHELF/CELERY-CAFFEIN/
COMP'D/CHELF CHEM. CO./
RICHMOND, VA. [Base:] **5**
See CHELF (*Compound*).

CHELF'S/CELERY-CAFFEIN/
COMP'd/CHELF CHEM. CO/
RICHMOND, VA.
See CHELF (*Compound*).

CHENERY, SOUTHER & CO./
SOLE AGENTS/SAN FRANCISCO,
CAL.//BENNET'S/WILD CHERRY/
STOMACH BITTERS
See BENNET (Bitters).

CHESEBROUGH MFG. CO./
VASELINE
In 1859, Robert A. Chesebrough, a
22-year-old New York chemist, discov-
ered that "rod wax," a sticky, black goo
generated from oil drilling operations,
was useful in the treatment of minor
wounds and bruises. After refining the
material, Chesebrough made it availa-
ble in the 1860s on a limited basis,
promoting the balm as "effective for
man or beast." By 1879, Blue Seal
Vaseline Petroleum Jelly was available
nationwide. In 1880, Chesebrough Mfg.
Co. Consolidated was founded.
Chesebrough died in 1933. In 1955, the
company merged with Pond's Extract
Company. The cork enclosures were
replaced by the threaded cap in 1908.
Blue Seal Vaseline is still available.
(Joseph C. Coen, Chesebrough-Pond's
Inc., Greenwich, CT, personal commu-
nication, 1985).
Amber, clear; 2³⁄₄″ × 1⁵⁄₈″ diameter;
3n; 20b; pl; h; many variants. See
VASELINE (Miscellaneous).

F. CHEVALIER & CO/
SOLE AGENTS//CELEBRATED/
CROWN BITTERS
See CELEBRATED (Bitters).

CIMONA/COUGH ASTHMA &
CROUP CURE/PREPARED BY
CIMONA MEDICINE CO./
INDIANAPOLIS, U.S.A.
See CIMONA (Cure).

THE C. G. CLARK Co//
NEW HAVEN Cᵀ [See Figure 47]
Aqua; 5³⁄₈″ × 1⁵⁄₈″ diameter; 7n; 21b;
12 sides; 2ip; v. See COE (Cure).

Fig. 47

C. G. CLARK & Cᵒ//
NEW HAVEN Cᵀ//COE'S/
DYSPEPSIA CURE
See COE (Cure).

THE C. G. CLARK CO.//
NEW HAVEN, CONN.//COE'S/
DYSPEPSIA/CURE
See COE (Cure).

N. L. CLARK & CO//
PERUVIAN//SYRUP
See PERUVIAN (Syrup).

CLARKE & CO
Bottle manufactured ca. 1847 to 1865.
Dark green; 7¹⁄₄″ × ?; 2n; 20b; pl; h,
embossed around shoulder. See
CLARKE (Miscellaneous), LYNCH
(Miscellaneous), CONGRESS (Water).

CLAY, WHOLESALE & CO./MFG
PHARMACISTS/ELMIRA N.Y.//
SELLECK'S GINGER//
TOLU COUGH SYRUP
Aqua; 5⁷⁄₁₆″ × 1³⁄₄″ × ¹⁵⁄₁₆″; 7n; 3b;
3ip; v, fss.

FLORIDA WATER/
COFFIN-REDINGTON CO./
SAN FRANCISCO
See COFFIN-REDINGTON (Water).

C & CO [monogram] [Base:] Colgate
& Co./NEW YORK
See C (Company).

COLGATE & CO/PERFUMERS/
NEW YORK
Label: Bandoline Moss Rose, 6% Ethyl
Alcohol, For Dressing the Hair, and Keep-
ing It in Place. Bandoline adv. 1915, SF
& PD; 1941–42, AD. Colgate & Co.
was established in 1806 as a soap and
candle factory and merged with B. J.
Johnson & Palmolive Peet in 1928
(Devner 1970).
Clear; 3⁵⁄₈″ × 2″ × 1⁵⁄₁₆″; 7n; 6b; pl; h.

COLGATE & CO./TRADE C & C
[monogram] MARK/NEW YORK
Clear; 7″ × 2³⁄₁₆″ diameter; 3n; 20b;
pl; h; tapered body.

COLUMBIAN OPTICAL CO/
CLENAL [Base:] W. T. & CO/U.S.A.
Bottle manufactured by Whitall-Tatum,
1857–1935 (Toulouse 1972).
Clear; 4¹⁄₄″ × 1¹⁄₂″ × 1¹⁄₄″; 14n; 11b;
pl; v.

CONGRESS & EMPIRE SPRING
CO/[h] E/SARATOGA N.Y.//
[in oval:] EMPIRE/WATER [Base:
4-point star]
See EMPIRE (Water).

CONGRESS SPRING CO./C/
SARATOGA, N.Y.//
CONGRESS/WATER
See CONGRESS (Water).

THE CONVERSE TREATMENT
COMPANY/COLUMBUS OHIO
The 1940 directory listed the Converse
Company, products unknown.
Clear, 5⁷⁄₈″ × 2¹⁄₄″ × 1¹⁄₂″; 9n; 4b;
pl; v.

CORONA DISTEMPER TONIC/
MANUFACTURED ONLY BY/
THE CORONA MFG. COMPANY/
KENTON, OHIO
See CORONA (Tonic).

R. COTTER & CO//
HOUSTON TEXAS//
IXL SARSAPARILLA/&/
IODIDE POTASSIUM
See IXL (Sarsaparilla).

[v] CRAB ORCHARD/[d] GENUINE
[embossed crabapple & leaves]
GENUINE/[v] TRADE MARK/
SALTS/BOTTLED BY/
CRAB ORCHARD WATER CO./
LOUISVILLE, KY.
See CRAB ORCHARD (Water).

WM. CRAEMER MED. CO.//
ST. LOUIS, U.S.A.
Label: CRAEMER'S CELEBRATED
COMPOUND C.C.C. For use in cases of
Stomach and Bowel Complaints due to
Biliousness, Sallow Complexion, Dizziness,
Loss of Appetite, Bad Taste, Belching and
Accumulation of Gases in the Intestines.
WM. CRAEMER MED. CO., 3212
Hebert St., St. Louis. St. Louis city
directories include the firm in 1884 and
1942, the last available directory. The
Hebert address on the label was the
latest location, established sometime
between 1905 and 1917.
Clear; 7⁵⁄₈″ × 3″ × 1¹⁄₄″ 9n; 3b; pl;
v, ss.

CRAIG'S KIDNEY/&/LIVER/
CURE/COMPANY
See CRAIG (Cure).

CRESCENT DRUG CO.//
NEWARK, N.J.//CRESCENT/
SARSAPARILLA/100 DOSES
50 CENTS
See CRESCENT (Sarsaparilla).

THE CROWN/PERFUMERY/
COMPANY/LONDON [Base:]
C. P. C. O. [in diamond with crown]/
NO. 160745
Ad: "CROWN LAVENDER SMELL-
ING SALTS. SPECIAL PRODUC-

TIONS OF THE CROWN PER-
FUMERY CO., 177 New Bond Street,
London." Adv. June 1892, *Harper's
Weekly*; after 1900 by W. H. Schieffelin,
New York. Adv. 1929–30, 1948 by
Schieffelin & Co., 16 Copper Sq., New
York, *AD*. A similar vessel with a
smaller mouth contained several
products including Crab-Apple Blossom
Perfume.
Emerald green; 4″ × 1⅞″ diameter;
7n; 20b; pl; h; large salt mouth with
crown-shaped stopper.

**DR. CUMMINGS' CO/EXT. OF
SARSAPARILLA & DOCK/
PORTLAND, ME. [Base:] W.T. & Co.**
See CUMMINGS (*Sarsaparilla*).

**CURO/MINERAL SPRINGS/CO./
SOUTH OMAHA/NEB. [Base:]
CURO/CAP 8 OZ**
Directories first mention the company
in 1896, with Richard O'Keeffe, Pres.
The firm was still included in the 1900
directory.
Clear; 7¾″ × 2⅜″ diameter; 19n;
20b; pl; h.

**CURTIS & BROWN//MFG. CO. LD.
NEW YORK//BROWN'S/
HOUSEHOLD PANACEA/
AND FAMILY LINIMENT**
See BROWN (*Liniment*).

**CUTLER BROS. & CO.//BOSTON//
BERRY'S CANKERCURE**
See BERRY (*Cure*).

**FELLOWSHIP/CEMENT/
D. P. S. CO./CHICAGO**
Tooth cement.
Clear; 2¹/₁₆″ × 1″ diameter; 3n; 20b;
pl; h.

D·S·CO//D·S·CO
Label: *GENTIAN COMPOUND C.C.T.
TABLETS. Manufactured by DIRECT
SALES CO. INC., BUFFALO, N.Y.*
Clear; 5⁹/₁₆″ × 1⅞″ × 1⅞″; 7n; 2b; pl;
v, ss.

**DAVIS & LAWRENCE CO. LIM.//
ALLEN'S/LUNG/BALSAM//
NEW YORK**
See ALLEN (*Balsam*).

[Script:] **Rubi-Formol/THE DE PREE
CHEMICAL CO./HOLLAND, MICH.
WINDSOR, ONT. [Base: I in diamond]**
[See Figure 48]
Bottle manufactured by the Illinois
Glass Co., Alton, IL, 1916 to 1929
(Toulouse 1972).
Clear; 8″ × 2″ diameter; 22n,
modified; 20b, recessed body; pl,

horizontally embossed graduated OZ
measurements 1-11 on right side of
embossed panel; v; part script; ABM.

Fig. 48

**E. C. DEWITT & CO. CHICAGO//
KODOL DYSPEPSIA CURE**
See KODOL (*Cure*).

**[Base:] E. C. DEWITT/& CO./
CHICAGO [f] KODOL/NERVE/
TONIC**
See KODOL (*Tonic*).

**E. C. DEWITT & CO.//
CHICAGO, U.S.A.**
Label: *DEWITTS GOLDEN LINIMENT
OF KODOL, a cure for dyspepsia.*
Aqua; 6¾″ × 2½″ × 1³/₁₆″; 11n; 3b;
4ip; v, ss. See DEWITT (*Cure,
Sarsaparilla, Syrup*), KODOL (*Cure,
Tonic*), ONE MINUTE (*Cure*).

**E. C. DEWITT & CO./CHICAGO.
U.S.A.//ONE MINUTE/
COUGH CURE**
See ONE MINUTE (*Cure*).

**THE DILL MEDICINE CO//
NORRISTOWN PA**
Label: *DILL'S BLOOD AND NERVE
TONIC, Alcohol 20%* William W.
Dill founded the company in 1872; it
was still in business in 1971 (Wilson and
Wilson 1971). Adv. 1887, *WHS*; 1910,
AD.
Clear; 7¼″ × ? × ?; 7n; 3b; 4ip; v, ss.

**THE DILL MEDICINE CO./
NORRISTOWN, PA.//DILL'S/
BALM OF LIFE**
Adv. 1900, *EBB*; 1916, *MB*.
Aqua; 6⅝″ × 2⅜″ × 1⅛″; 1n; 3b; 4ip;
v, ssf.

**DILL MEDICINE CO.//
NORRISTOWN, PA.//ROYAL/
COUGH CURE**
Clear; 6¾″ × 2¼″ × 1⅛″; 7n; 3b; 4ip;
v, ssf.

**GERMAN FIR COUGH CURE/
DILLARD REMEDY CO./
EAST BANGOR, PA. [Base:] 225A**
See GERMAN FIR (*Cure*).

**JAMES DINGLEY & CⱰ//
99 WASHINGTON Sᵀ/
BOSTON MASS.**
Bottle contained such products as
Sonoma Wine Bitters, gin and possibly
Dr. Abbott's Bitters. James Dingley
acquired C. A. Richards & Co. in 1872;
directories thereafter list Richards as a
seller of real estate. Although the last
directory listing is 1872, Dingey appar-
ently sold out in 1877 (Wilson and
Wilson 1971).
Amber; 9½″ × ?; 11n; 2b; pl; v. See
ABBOTT (*Company*), RICHARDS
(*Company*).

**J. C. DODSON MEDICINE CO/
STERLING PRODUCTS (INC)/
SUCCESSOR/DODSON'S**
See DODSON (*Medicine*).

**MELLIN'S/INFANT'S FOOD/
DOLIBER-GOODALE CO/
BOSTON//[shoulder:] LARGE SIZE**
Label: *MELLIN'S FOOD FOR INFANTS
AND INVALIDS – originated by GUSTAV
MELLIN, LONDON-DOLIBER-GOOD-
ALE CO., BOSTON, MASS. This Label
Registered in U.S. Patent Office, Doliber-
Goodale Co., 1888.* Gustav Mellin, West
London, England, supposedly copied a
formula of the famous Dutch chemist,
Justus Von Liebig, and introduced the
food in 1868 (Turner 1953; Wilson and
Wilson 1971). The product was first
produced in the United States on 1 Jan
1882 by Metcalf & Co., Boston, under
sole supervision of Thomas Doliber, a
junior member of the firm; who joined
the firm 1 Jan 1863. On 1 August 1883
Doliber left Metcalf & Co. and with
Thomas Goodale became proprietors of
Mellins Food; the firm was incorporated
in 1888 as the Doliber-Goodale Co.
(*Pharmaceutical Era*, 1 Nov 1891).
Offices included Portland, ME. The
company became the Mellin Food Co.
in mid-1898 (Peter Schulz, personal
communication 1985). 1913 London
advertisements illustrate a threaded cap
(*The London Illustrated News*, 7 June
1913). Adv. 1948 by Mellin Food Co.,
41 Central Wharf, Boston, Mass., *AD*.
Aqua; 6¼″ × 3⅛″ diameter; 11n,
large mouth; 20b; pl; h. See MELLIN
(*Company*), METCALF (*Company*).

**DONNELL'S/RHEUMATIC
LINIMENT//J. T. DONNELL
& CO//ST. LOUIS, MO.**
See DONNELL *(Liniment).*

**DURFEE/EMBALMING/FLUID CO/
GRAND RAPIDS/MICH.//
POISON/**[graduated markings 8 OZ
to 64 OZ]
See DURFEE *(Balm).*

E. R. DURKEE & Cº/NEW YORK
Contained essence of mustard or
vermifuge. E. (Eugene) R. Durkee &
Co. was first mentioned in New York
City directories in 1855. Glidden pur-
chased the company in 1929, and
merged with SCM in 1967; Durkee is
a division of that merger (Zumwalt
1980). The mustard or vermifuge was
manufactured until the 1880s (Wilson
and Wilson 1971).
Aqua; 4³/₄″ × 1¹/₂″ × ¹⁵/₁₆″; 5n; 15b;
pl; v; p.

**J. D. EASTMAN & CO./
DEER LODGE, MONTANA** [Base:]
I. G. CO
Products included Eastman's Oregon
Grape Root Tonic and the Great Pacific
Coast Remedy. Adv. 1887 (Ring 1980).
Amber; 8⁷/₈″ × 2⁵/₈″ × 2⁵/₈″; 11n; 2b;
pl; v.

**EATON DRUG CO. ATLANTA,
GA.//ROYAL FOOT WASH**
See EATON *(Drug).*

**C. H. EDDY & CO./JAMAICA/
GINGER/BRATTLEBORO, VT.**
See EDDY *(Jamaica Ginger).*

[Script:] **Egyptian Chemical Co./
Boston, Mass. U.S.A.//Alco-form/
PATENT APPLIED FOR//**
[graduated in ounces]
From 1883 to 1926 the company
manufactured chemicals and disinfec-
tants; from 1926 to 1955, undertaker's
supplies and embalming fluid.
Clear; 5¹⁵/₁₆″ × 2″ × 2″; 3n; 1b; pl; v,
bfs, partial script.

[shoulder:] **CHARLES. ELLIS SON
& Cº PHILᴬ**
Probably contained Ellis' Calcined
Magnesia, adv. 1853 (Baldwin 1973)
and 1873, *VSS & R.* Ellis' Citrate and
Dry Magnesia adv. 1890, *W & P;* Ellis'
Citrate Magnesia Granules, 1900, *EBB.*
Charles Ellis Son & Co. was listed in
Gopsill's Philadelphia city directory,
1871, having been preceded by Charles
Ellis & Co. The last reference, possi-
bly subsequent to a city move, was

1875, with Charles & Evan T. Ellis,
William Ellicott Jr., and Wellington
Boyle.
Aqua; 5⁵/₈″ × 2⁵/₁₆″ diameter; 3n; 20b;
pl; h.

**ELY'S/CREAM/BALM/CO./
OWEGO/N.Y.//HAY FEVER//
CATARRH**
See ELY *(Balm).*

[Monogram]/**ELYSIAN MFG. CO./
CHEMISTS & PERFUMERS/
DETROIT, U.S.A.**
Company adv. 1899 (Devner 1970).
Clear; 5⁵/₈″ × 1⁷/₈″ × 1¹/₄″; 9n; 3b;
pl; v.

**BROMO-SELTZER/EMERSON/
DRUG CO./BALTIMORE, MD.**
See EMERSON *(Drug).*

**EMERSON'S/RHEUMATIC CURE/
EMERSON/PHARMACAL
COMPANY/BALTIMORE MD**
See EMERSON *(Cure).*

**EMMERT/PROPRIETARY CO/
CHICAGO ILL//UNCLE SAMS/
NERVE & BONE/LINIMENT**
See UNCLE SAM *(Liniment).*

**DR. WINCHELL'S/TEETHING
SYRUP/EMMERT/PROPRIETARY
CO/CHICAGO, ILLS'**
See WINCHELL *(Syrup).*

**EMPRESS JOSEPHINE TOILET CO./
NEW YORK/LABORATORY
= DAYTON, OHIO** [Base:]
PAT DEC 13/87 CLC.C [?]
Milk glass; 6¹/₄″ × ? × ?; 9n; 5b; 1ip;
illegible base embossing.

**THE EVANS/CHEMICAL/
COMPANY/CINCINNATI/OHIO/
U.S.A.** [See Figure 49]
Label: *BIG G, Compound of Borated
Golden Seal, to Remedy Catarrh, Hay
Fever, Irritations, Inflammation, Ulcera-
tions of Mucous Membranes on Linings of
the Nose, Throat, Stomach and Urinary
Organs. Cure for Social Diseases.* Adv.
1887, *WHS;* 1929–30 by P.D.Q.
Specialty Co., 214 Main St., Cincinnati,
O.; 1948 by Evans Chem. Co., 215 E.
Pearl, Cincinnati, O., *AD.* Directories
establish the Evans Chemical
Company, manufacturers and dealers in
chemicals and proprietary medicines, in
1885.
Clear; 5″ × 2¹/₄″ × 1¹/₄″; 8n; 18b;
pl; h.

Fig. 49

**THE EVANS/CHEMICAL/
COMPANY/PROPRIETORS/**[G with
BIG superimposed horizontally over it]/
CINCINNATI, O/U.S.A.
Clear; 5″ × 2¹/₄″ × 1¹/₄″; 8n; 18b;
pl; h.

[h] **FERRO-CHINA/**[arched]
EXCELSIOR CHEMICAL CO./[h]
N.Y.//EXCELSIOR
See EXCELSIOR *(Chemical).*

**PREPARED BY/DR PETER
FAHRNEY & SONS Co/CHICAGO,
ILL. U.S.A.//Fornis/Heil-Oel** [Base:]
PAT APPLIED FOR
Possibly all of the embossed bottles date
to after 1900. Dr. Peter Fahrney,
Chicago, began bottling the Blood
Clenser & Vitalizing Panacea in the late
1860s and by the 1880s had simplified
the name to Blood Panacea. During the
1880s, Fahrney let pharmaceutical
houses like George G. Shively Co.
manufacture his products (Wilson and
Wilson 1971). His sons were managing
the extensive business by 1891 accord-
ing to the 1891 Chicago city directory.
Fahrney's Kuriko, Hoboko, Gomozo,
Lozogo del Pietro, Novoro, and Zokoro
are all international variants of the Blood
Vitalizer (Devner 1968). *Farm Field &
Fireside Magazine,* 22 Feb 1896, states:
"Dr. Peter's Blood Vitalizer, The Old
Swiss German Remedy has proved its
worth in over 100 years of popularity."
Produced at 112 and 114 So. Horne
Ave., Chicago. Products were still being
produced in 1984 by the J. H. McLean
Medicine Co., Garden City, NY,
according to Richard Stessel, J. H.
McLean Med. Co. (personal communi-
cation, 1984).
Clear; 5³/₈″ × 1⁵/₈″ × 1⁵/₈″; 7n; 1b; 4ip;
v, bf. See FAHRNEY (Miscellaneous),
PETER (Miscellaneous).

PREPARED BY/DR PETER FAHRNEY & SONS CO/CHICAGO, ILL. U.S.A.//Fornis/Mageustarcker
Stomach tonic.
Clear; 5³/₈″ × 1⁵/₈″ × 1⁵/₈″; 7n; 1b; 4ip; v, bf. See FAHRNEY (Miscellaneous), PETER (Miscellaneous).

PREPARED BY/DR PETER FAHRNEY & SONS CO/CHICAGO, ILL. U.S.A.//DR PETER'S/OLEOID [Base:] **PAT. APPLIED FOR**
Clear; 5³/₈″ × 1⁵/₈″ × 1⁵/₈″; 7n; 1b; 2ip; v, bf; ABM. See FAHRNEY (Miscellaneous), PETER (Miscellaneous).

PREPARED BY/DR PETER FAHRNEY & SONS CO./CHICAGO, ILL. U.S.A.//THE RELIABLE/ OLD-TIME PREPARATION/FOR HOME USE [Base:] **FAHRNEY/ CHICAGO**
Clear; 9″ × 2¹¹/₁₆″ × 2¹¹/₁₆″; 7n; 1b; 2ip; v, bf; ABM. See FAHRNEY (Miscellaneous), PETER (Miscellaneous).

JOHN FEASTER & CO/PROP'S INDIAN HEMP BITTERS/GREEN CREEK, N.J.
See INDIAN HEMP *(Bitters)*.

FELLOW & Cᵒ/CHEMISTS Sᵀ JOHN, N.B.
See FELLOW *(Chemical)*.

FELTON GRIMWADE & CO./ MELBOURNE//KRUSES/ PRIZE MEDAL/MAGNESIA [Base:] **K**
See KRUSES *(Magnesia)*.

FETRIDGE & Cᵒ//NEW YORK// BALM//OF//THOUSAND/ FLOWERS
See FETRIDGE *(Balm)*.

FISCHER CHEMICAL IMP'T CO/ NEW YORK
A French preparation. Label: *Blaud's Pills, Pilulae Ferri Carb. U.S.P.* Adv. 1887, *McK & R*; 1929–30, *AD*. Clear; 6″ × 2″ × 2″; 3n; 2b; pl; v.

THIS BOTTLE IS/LOANED BY THE/ FITCH/DANDRUFF CURE CO.
Products adv. prior to 1906, from Boone, IA (Devner 1968); 1948 by F. W. Fitch Co., 304 15th St., Des Moines, Ia., *AD*. Company was sold ca. 1955, information courtesy of Weeks & Leo, Inc., Des Moines, IA.
Clear; 7⁷/₈″ × 2³/₈″ diameter; 7n; 20b; 1ip; h. See F. W. FITCH (Miscellaneous).

[Script:] **The F. W. Fitch Co**
[Base:] **4** [O in square] **4**
Bottle manufactured by the Owens

Bottle Co., 1911 to 1929 (Toulouse 1972).
Clear; 5³/₈″ × 2¹/₈″ diameter; 7n; 20b; pl; d, script; pewter cap reads: F. W. FITCH CO./DES MOINES IOWA. See F. W. FITCH (Miscellaneous).

[Script:] **The F. W. Fitch Co./ Boone, Ia.** [Base: diamond]
Bottle manufactured by the Diamond Glass Company after 1924 (Toulouse 1972).
Clear; 7³/₄″ × 2⁵/₈″ diameter; 7n; 20b; pl, tapered body; d, script; pewter cap & pour spout. See F. W. FITCH (Miscellaneous).

F. W. FITCH'S//IDEAL DANDRUFF CURE CO
Clear; 5⁵/₈″ × 2¹¹/₁₆″ × 1³/₁₆″; 7n; 6b; 1ip; v, ss. See F. W. FITCH (Miscellaneous).

F. W. FITCH'S//IDEAL/DANDRUFF CURE CO
Clear; 6⁷/₈″ × 2¹⁵/₁₆″ × 1⁵/₈″; 7n; 6b; 1ip; v, ss. See F. W. FITCH (Miscellaneous).

FOLEY & CO. [Base: B8 in diamond]
Directories show (John B.) Foley & Co., Chicago, was established in 1890. Locations included 110 Randolph in 1891 (Shimko 1969); 230, 232 Kenzie in 1892; 92 Ohio St. in 1900, *EBB*, and 945 W. George St. in 1956 (Shimko 1969). The Kidney & Liver Cure was introduced ca. 1891, the Diarrhoea and Colic Cure ca. 1898 (Wilson and Wilson 1971).
Clear; 2⁹/₁₆″ × 1¹/₁₆″ diameter; 7n; 20b; pl; v; ABM.

FOLEY & CO.//CHICAGO, U.S.A.
[Base: 868 in diamond]
Clear; 4″ × 1¹/₄″ × ⁹/₁₆″; 7n; 3b; 2ip; v, ss.

FOLEY & CO.//CHICAGO, U.S.A.
Label: *ORINO LAXATIVE, Expectorant and Demulcent for Coughs, Colds, Hoarseness & Children's Cough. No Opiates, 7% Alcohol* Adv. 1910, *AD*; 1921, *BD*. Also labeled: *FOLEY'S HONEY AND TAR COMPOUND—Contains 7% Alcohol. An Expectorant and Demulcent for Coughs, Colds, Hoarseness, and Children's Coughs which should not be neglected. Contains no Opiates. Prepared only by Foley & Company, Chicago. In Three Sizes.* Adv. 1895, *PVS & S*; 1929–30 and 1948 from 945 George St., Chicago, *AD*.
Aqua; 5¹/₂″ × 1¹³/₁₆″ × ⁷/₈″; 1n; 3b; 4ip; v, ss; ABM.

FOLEY & CO.//CHICAGO, U.S.A.
Label: *FOLEY'S KIDNEY REMEDY, Contains Five Per Cent Alcohol. A Safe Remedy for Incipient Bright's Disease, Chronic Bladder & Gravel, Irritation of the Kidneys, Diabetes and Nervous Exhaustion. Prepared only by Foley & Company, Chicago. Guaranteed by Foley & Co., 1906.* Adv. 1925, *BWD*.
Aqua; 9¹/₈″ × 2³/₄″ × 1³/₄″; 11n; 3b; 3ip; v, ss.

FOLEY & CO.//CHICAGO. U.S.A.// FOLEY'S/SAFE DIARRHOEA/ & COLIC CURE
Adv. 1899 (Devner 1968); 1900, *EBB*.
Aqua; 4¹/₂″ × 1³/₄″ × 1⁵/₁₆″; 11n; 3b; 4ip; v, ssf.

SAMPLE BOTTLE/FOLEY'S KIDNEY CURE./FOLEY & CO./ CHICAGO U.S.A.
Product introduced, ca. 1891 (Wilson and Wilson 1971). Adv. 1895, *PVS & S*; 1921, *BD*.
Clear; 4¹/₈″ × 1″ diameter; 7n; 20b; pl; v.

SAMPLE BOTTLE/FOLEY'S KIDNEY CURE/FOLEY & CO. CHICAGO, U.S.A.
Label: *Free Sample FOLEY'S KIDNEY CURE, Cures All Kidney and Bladder Diseases. The Most Successful Remedy for Incipient Bright's Disease, Chronic Inflammation of the Bladder, Gravel, Irritation of the Kidneys, Diabetes and Nervous Exhaustion. Two Sizes, 50 cents and $1.00.*
Aqua; 4¹/₄″ × ¹⁵/₁₆″ diameter; 7n; 20b; pl; v.

FOLEY & CO//CHICAGO, U.S.A.// FOLEY'S KIDNEY/ & BLADDER CURE
Amber; 7¹/₂″ × 2¹/₂″ × 1¹/₂″, also 9¹/₂″ high variant; 1 and 11n; 3b; 3ip, v, ssf.

FOLEY & CO.//CHICAGO, U.S.A.// FOLEY'S/HONEY AND TAR
Adv. 1899 (Devner 1968); 1941–42, *AD*.
Aqua; 4¹/₄″ × ¹⁵/₁₆″ × ⁵/₈″; 7n; 3b; 4ip; v, ssf.

FOLEY & CO.//CHICAGO, U.S.A.// FOLEY'S/HONEY AND TAR
Aqua; 6⁵/₈″ × 2¹/₄″ × 1¹/₈″; 7n; 3b; 4ip; v, ssf.

FOLEY'S KIDNEY PILLS/FOLEY & CO., CHICAGO
Foley's Family Pills adv. 1895 and 1907, *PVS & S*; Foley's Kidney Pills, adv. 1913, *SN*; 1921, *BD*. Foley's

Diuretic Pills (possibly same product), adv. 1929–30 and 1948, *AD*.
Aqua; 2¼″ × ?; 7n; 20b; pl; v.

FOLEY & CO.//CHICAGO, U.S.A.//
FOLEY'S/PAIN RELIEF
Adv. 1907, *PVS &S*; 1948, *AD*.
Aqua; 4½″ × 1¾″ × 1⅞″; 11n; 3b;
4ip; v, ssf.

FOLEY & CO//CHICAGO USA.//
FOLEY'S SARSAPARILLA/
MFD. BY/FOLEY & CO. CHICAGO.
Adv. 1900, *EBB*; 1910, *AD*.
Amber; 9″ × 2¾″ × 1¾″; 11n; 3b;
3ip; v, ssf; also clear variant, 1n,
arched front panel.

FOLEY'S KIDNEY & BLADDER
CURE/MFD BY FOLEY & CO/
CHICAGO
Amber; 7⅛″ × 2⁷⁄₁₆″ × 1⁷⁄₁₆″; 1n; 3b;
4ip; v.

M'F'R'D BY FOLEY & CO./
STEUBENVILLE O. & CHICAGO//
THE CLINIC/KIDNEY
& LIVER CURE
Amber; 9¼″ × 2¾″ × 1¾″; 11n; 3b;
2ip; v, bf.

M'F'R'D BY FOLEY & CO./
STEUBENVILLE O. & CHICAGO//
THE CLINIC/BLOOD PURIFIER
Adv. 1895, *PVS & S*; 1910, *AD*.
Amber; 9⅛″ × 2¾″ × 1¾″; 11n; 3b;
2ip; v, bf.

J. A. FOLGER & CO/ESSENCE OF/
JAMAICA GINGER/
SAN FRANCISCO
See FOLGER (*Jamaica Ginger*).

FORT BRAGG/HOSPITAL & DRUG
CO. [Base:] WT & CO/USA
See FORT BRAGG (*Drug*).

THE/FOSO COMPANY//FOR THE
HAIR AND SCALP//CINCINNATTI,
O. U.S.A.
Light green; 7⅞″ × 2¹³⁄₁₆″ × 1⁹⁄₁₆″; 1n;
3b; 4ip; v, fss. See ALTENHEIM
(*Medicine*).

FOSTER MILBURN CO//
BURDOCK/BLOOD/BITTERS//
BUFFALO, N.Y. [Base: R in triangle]
See BURDOCK (*Bitters*).

FOSTER, MILBURN & CO.//
BUFFALO, N.Y.//DR. FOWLER'S
EXTRACT/OF/
WILD STRAWBERRY
See FOWLER (*Extract*).

FOSTER, MILBURN & CO.//
THOMAS/ECLECTRIC OIL//
INTERNAL & EXTERNAL
See THOMAS (*Oil*).

FOSTER, MILBURN & CO.//
DR. S. N. THOMAS/ECLECTRIC
OIL//INTERNAL//EXTERNAL
See THOMAS (*Oil*).

FOSTER MILBURN & CO//
BUFFALO, N.Y.//
WOOD'S NORWAY/PINE SYRUP
See WOOD (*Syrup*).

FRANCO-AMERICAN//
HYGIENIC//CO. CHICAGO//
TOILET//REQUISITES
The Franco-American Hygienic Co.
(Toilet Supplies), William M. Chase,
Manager, was first mentioned in
Chicago directories in 1892.
Depilagiene, adv. in 1918 for eczema,
sun spots, redness, etc. (Devner 1968).
Clear; 1¹⁵⁄₁₆″ × ½″ diameter; 3n; 21b,
6 sides; 3ip; v, sssss.

FRANCO-AMERICAN HYGIENIC
CO./CHICAGO//TOILET.
REQUISITES//FRANCO-AMERICAN
[See Figure 50]
Clear; 6″ × 1½″ × 1⅜″; 3n; 13b, inset
just above base; 3ip; v, fss.

Fig. 50

QUEEN FLORIDA WATER/
FRENCH RICHARDS & CO/
PHILADELPHIA
See FRENCH (*Water*).

FRENCH'S/TRADE/[crown]/
MARK/KIDNEY/&/DROPSY CURE
CO/PRICE 1.00
See FRENCH (*Cure*).

FRIGID FLUID CO./CHICAGO.
[See Figure 51]
Clear; 7¼″ × 2⁷⁄₁₆″ × 2⁷⁄₁₆″; 9n; 2b,
tapered; pl; v, horizontal graduated
OZ measurements 1-14 right side of
embossed panel.

Fig. 51

FURST-McNESS CO/FREEPORT,
ILL. [Base: I in diamond]
Label: *F. W. McNess' Pain Oil, Alcohol
63%. Apply as a liniment for Rheumatic
Pains, Neuralgia, Headache, Sprains,
Wounds, etc. . . .* Bottle manufactured
by the Illinois Glass Co., Alton, IL,
1916 to 1929 (Toulouse 1972).
Aqua; 7¾″ × 2⅝″ × 1⅝″; 24n; 3b;
1ip, indented panel embossed; v;
ABM.

C. GATES & Cᵒˢ//LIFE OF MAN//
BITTERS
See LIFE (*Bitters*).

Dᴿ BARNES/Eˢˢ JAMAICA
GINGER/J. R. GATES & CO/
PROPRIETORS
See BARNES (*Jamaica Ginger*).

J. R. GATES & CO.//PROPRIETORS
S.F.//HALL'S/PULMONARY/
BALSAM
See HALL (*Balsam*).

J. R. GATES & CO.//
PROPRIETORS, S.F.//
HALL'S/SARSAPARILLA
See HALL (*Sarsaparilla*).

GERSTLE MEDICINE CO.//
CHATTANOOGA, TENN.//S J S/
FOR THE/BLOOD
See GERSTLE (*Medicine*).

MEYER'S SARSAPARILLA/MANF'D
BY/GIANT MEDICINE CO./
HELENA. MONT.
See MEYER (*Sarsaparilla*).

[h] GIFFORD/& CO/[v] H. H. H./
MEDICINE/[h] CHICAGO//
THE CELEBRATED//D. D. T. 1868
See H. H. H. (*Medicine*).

GILBERT BROS & CO/
BALTIMORE, MD.
Label: *. . . a Cream Chloroform Liniment
For Man or Beast.* Firm was also a

producer of Anti-Fag and Gilbert's Lax-atol, adv. 1900, *EBB*; 1910, *AD*. Directories listed the firm from 1896 through 1930 (Shimko 1969).
Aqua; 8¼″ × ? × ?; 11n, sp; 6b; pl; h.

**N. A. GILBERT & CO.//
ENOSBURGH FALLS VT.//
GILBERT'S//SARSAPARILLA//
BITTERS**
See GILBERT *(Bitters)*.

**GILES & CO/IODIDE AMMONIA/
LINIMENT**
See GILES *(Liniment)*.

**PARISIAN SAGE/A HAIR TONIC/
GIROUX MFG. CO./BUFFALO**
See PARISIAN *(Tonic)*.

**GIROUX. MFG. CO./BUFFALO.
FORT ERIE//PARISIAN SAGE//
A HAIR TONIC**
See PARISIAN *(Tonic)*.

**THE GLESSNER MED. CO.//
FINDLAY, OHIO//DR. DRAKE'S/
GERMAN/CROUP REMEDY**
See DRAKE *(Remedy)*.

**GLOBE/HAIR RESTORATIVE AND
DANDRUFF CURE/GLOBE MFG.
CO. GRINNELL, IA**
See GLOBE *(Restorer)*.

H. CLAY GLOVER CO./NEW YORK
Amber; 5″ × ? × ?; 1n; 3b; pl; v. See GLOVER *(Cure*, Medicine, Remedy).

[v] **H. CLAY GLOVER CO.//
NEW YORK**//[h on shoulder]
6½ FL. OZ./[v] **GLOVERS
IMPERIAL/MANGE MEDICINE**
[Base: O in square]
See GLOVER *(Medicine)*.

GODBE & COˢ**/ESS OF/
JAMAICA GINGER/
SALT LAKE CITY**
(William S.) Godbe & Co. near Main & 1st. So., was established prior to 1869. The firm became Godbe, Pitts & Co. in 1877 and operated as the Godbe Pitts Drug Co. from 1888 until 1910.
Aqua; 5½″ × 2¼″ × 1⅛″; 7 and 1n; 12b; pl; v.

**FREAR'S AMBER OIL/MFG. BY/
GOLD MEDAL FOOD CO./
TUNKHANNOCK, PA.**
See FREAR *(Oil)*.

**GOODRICH DRUG CO.//ANOKA,
MINN//HOFF'S GERMAN
LINIMENT** [Base: I in diamond]
See HOFF *(Liniment)*.

**RESORCIN/HAIR/TONIC/
GOODRICH/**[embossed pyramid]/
**QUALITY/TRADE MARK/
GOODRICH/DRUG CO./OMAHA**
See GOODRICH *(Drug)*.

[Script:] **Velvetina/REG. U.S. PAT.
OFF./RESORCIN/HAIR TONIC/
GOODRICH/DRUG CO. OMAHA**
[Base: embossed diamond]
See GOODRICH *(Drug)*.

**GOODRICH DRUG CO./
OMAHA, U.S.A.**//[Script:] **Velvetina/
CREAM/LOTION** [Base: embossed diamond]
See GOODRICH *(Drug)*.

[Script:] **Velvetina/SKIN/Beautifier/
GOODRICH/DRUG/COMPANY/
OMAHA, U.S.A.**
See GOODRICH *(Drug)*.

RICE'S [within figure of goose]/
**GOOSE GREASE LINIMENT/
MANF'D ONLY BY THE/GOOSE
GREASE LINIMENT CO./
GREENSBORO, N.C.**
See RICE *(Liniment)*.

Graefenberg Cᵒ**//Childrens/
Panacea//New York** [See Figure 52]
Introduced ca. 1847 (Wilson and Wilson 1971). Adv. 1929–30 and 1948 by Graefenberg Co., Newburgh, N.Y., *AD*.
Clear, aqua; 4½″ × 1¾″ × 1¼″ 7n; 3b; 3ip; v, sfs. See GRAEFENBERG (Sarsaparilla, *Syrup*).

Fig. 52

**GRAEFENBERG CO//DYSENTERY/
SYRUP//NEW YORK**
See GRAEFENBERG *(Syrup)*.

Graefenberg Cᵒ**//DYSENTERY/
SYRUP//NEW YORK**
See GRAEFENBERG *(Syrup)*.

Graefenberg Cᵒ**//SARSAPARILLA/
COMPOUND/NEW YORK**
See GRAEFENBERG (Sarsaparilla).

**GRAFTON MEDICINE/Co//
S**ᵀ **LOUIS, M**ᵒ**//MRS. WHITCOMBs//
SYRUP FOR CHILDREN**
See WHITCOMB *(Syrup)*.

**Greenhalgh Remedy Co./28 EAST
FOURTH SOUTH/SALT LAKE CITY**
See GREENHALGH *(Remedy)*.

**GREENHALGH'S/BLOOD
PURIFIER/PREPARED BY/
GREENHALGH REMEDY CO./
SALT LAKE CITY, UTAH**
See GREENHALGH *(Remedy)*.

**GREGORY MED. CO.//LITTLE
ROCK, ARK.//GREGORY'S/
ANTISEPTIC OIL**
See GREGORY *(Oil)*.

**GRIGGS & CO OTTAWA, ILLS.//
DR JONE'S/RED/CLOVER/TONIC**
[embossed clover]
See JONES *(Tonic)*.

**GUARANTY/RHEUMATIC
REMEDY/COMPANY**
See GUARANTY *(Remedy)*.

PEPTO-MANGAN "GUDE" [Base:]
DR. A GUDE & CO/TRADE/[raised heart with] **ME/P/MARK/G & CO**
[See Figure 53]
Aqua; 6⅞″ × 2⁷⁄₁₆″ diameter, also 3¾″ × 1⁷⁄₁₆″ diameter; 7n; 21b, 6 sides; pl; v. See PEPTO-MANGAN *(Miscellaneous)*.

Fig. 53

**GUGGENHEIM MF'G CO/
ROCHESTER, N.Y.** [Base:] **FER & CO**
Clear; 4¼″ × 1⅞″ × 1″; 9n; 18b; pl; v.

H. W. & CO. NEW YORK//
COD LIVER OIL//
WARRANTED PURE
Aqua; 10¼″ × 3″ × ?; 12n; 3b; 3 or
4ip; v, sfs; p.

H T & CO
Clear; 2⅝″ × 1¼″ diameter; 3n; 20b;
pl; h; embossing within a diamond.

DR. S. B. H. & CO./MIL.
Label: *PE-RU-NA, a Cure for Catarrh of
the Head, Lungs, Stomach, Liver & Kid-
neys, Bladder, Pelvic Catarrh and
Systematic Catarrh, Alcohol 28%, Water
70%, 1% Cubebs for Flavor, 1% Burnt
Sugar for Color—Introduced in 1879.* Also
labeled: *MAN-A-LIN "Is a Unequaled
Remedy for Dyspepsia, Liver Complaint,
and Constipation" Peruna Medicine Co.,
Columbus, Ohio. Successors to Dr. S. B.
Hartman & Co.—Introduced in 1879.*
Samuel Hartman also introduced
La-Cu-Pi-A, a blood medicine, in 1877.
All three medicines originated with
companies with which Hartman was
affiliated before he formed the Peruna
Medicine Company in Columbus, OH,
in 1888 (Holcombe 1979). In 1867, Dr.
Samuel B. Hartman purchased a bitters
from Benjamin Mishler, Lancaster, PA;
in 1869 Hartman turned over manage-
ment of the medicine business to Henry
Lehman and Julius Kauffman and
resumed his medical practice (Wilson
and Wilson 1971); and in 1879, Hart-
man apparently started his Peruna busi-
ness. Hartman moved to Columbus,
OH, in 1888. Peruna, Man-A-Lin, and
Lacupia were all adv. 1935 by United
Remedies Inc., 544 S. Wells St.,
Chicago, *AD*, and Peruna was adv. 1948
by Consolidated Royal Chemical Corp.,
544 S. Wells St., Chicago, *AD*. What
the embossed MIL. stands for is
unknown.
Aqua; 7⅛″ × 2⅝″ diameter; 11n;
20b; pl; circular embossing on base.
See HARTMAN (Company), MISHLER
(Bitters).

W. E. HAGAN & CO.//TROY. N.Y.
The History of the City of Troy, by A. J.
Weise, A.M., 1876, mentions W. E.
Hagan, but information about his busi-
ness is not provided.
Cobalt; 6¾″ × 2¾″ diameter; 9n;
21b; pl; v, ss.

Dᴿ BARNES/Eˢˢ OF JAMAICA
GINGER/R. HALL & Cº/
PROPRIETORS
See BARNES *(Jamaica Ginger).*

R. HALL & Cº//PROPRIETORS//
CROCKETTS/AMYGDALINE
A hair dressing, hand and face lotion.
R. Hall & Co. apparently distributed
the product only in 1866, Shepardson
& Gates thereafter (Wilson and Wilson
1971).
Aqua; 4½″ × ?; 11n; 3 or 6b; 3 or
4ip; v, ssf. See HALL *(Balsam,
Sarsaparilla),* BARNES (Jamaica
Ginger).

DR. W. HALL CO//NEW YORK//
HALL'S/BALSAM/FOR THE LUNGS
See HALL *(Balsam).*

THE HALLER PROPRIETARY
CO.//BLAIR, NEBR.
Products included Sarsaparilla, Barb
Wire Liniment, Cough Syrup, Corn
Cure, Condition Powders, Headache
Cure, Tonic Bitters, Pain Paralyzer,
Vienna Female Tea, Pills and Balsam.
Adv. 1900, *EBB*; 1901, *HH & M.*
Clear; 7¼″ × 2¼″ × 1¹³⁄₁₆″; 7n; 3b;
v, ss.

D. C. HALLOCK & CO/
RHEUMATAZI/PORT JERVIS N.Y.
U.S.A.
Adv. 1910, *AD.*
Color unk.; 7⅛″ × 2¼″ × 1¼″; 1n; 3
or 6b; ip; v.

MAGNETIC//AETHER BY//
HALSTED & Co
Label: *Magnetic Aether or Fluid of Resto-
ration. No. 3 for Liver Complaints. H.
Halsted & Co., Physicians & Chemists,
Rochester, N.Y.* (Nielsen 1978).
Aqua; 4¼″ × 1⅞″ diameter; 5n; 21b,
9 sides; pl; v, sss, embossed on
consecutive sides; p.

HAND MED. CO./PHILADELPHIA
See HAND *(Medicine).*

NASAL BALM/W. T. HANSON CO/
PROPRIETORS/SCHENECTADY/
N.Y.//CATARRH//
COLD IN THE HEAD
See NASAL *(Balm).*

J. N. HARRIS & CO//
CINCINATTI//ALLEN'S/
LUNG/BALSAM
See ALLEN *(Balsam).*

HART'S SWEDISH ASTHMA CURE
CO/BUFFALO, N.Y.//4 FL. OZ.
See HART *(Cure).*

Dᴿ S. B. HARTMAN & CO//
TABLESPOON GRADUATION/
[graduation marks] [Base:]
PAT FEB 6 66

Amber; 8¾″ × 2¾″ × 2¾″; 11n; 2b;
3ip; v, ssf. See S. B. H. (H)
(Company), MISHLER *(Bitters).*

HASKIN MEDICINE CO.//
BINGHAMPTON, N.Y.//
HASKIN'S/NERVINE
See HASKIN *(Nervine).*

EMRY DAVIS SUCCESSOR TO
D. W. HATCH & CO. JAMESTOWN,
N.Y.//UNIVERSAL//COUGH
SYRUP//EMRY DAVIS/SOLE
PROPRIETOR/NEW YORK
See UNIVERSAL *(Syrup).*

JULES HAUEL & Cº/PHILADᴬ//
AWARDED//PREMIUM
Products introduced in 1828. Vegeta-
ble Hair Dye adv. 1846 (Putman 1968);
French Hair Dye; 1851, *JSH*; Eau Lus-
trale Hair Renovator, adv. 1859
(*Harper's Weekly,* 10 Dec 1859). The
last reference to Jules Hauel & Co. in
Gopsill's Philadelphia city directory is
in 1865, Perfumers & Importers of
Fancy Goods, 930 Arch, Philadelphia,
PA.
Clear; 6¼″ × 2″ × 1¼″; 11n; 3b; 3ip;
v, fss; p. See HAUEL (Balm,
Miscellaneous).

THE HAWKER MEDICINE Cº LTD/
HAWKER'S DYSPEPSIA CURE/
ST. JOHN. N.B.
The 1908 directory lists the firm as
William Hawker & Son [Samuel H],
Chemists and Druggists; 1923 as Wm.
Hawker & Son, Ltd; 1931 the same,
although William was retired; and 1936,
as Hawker & Son.
Clear 4⅛″ × 1⅝″ × 1⅛″; 7n; 3b;
pl; v.

HAZELTINE & CO.//
PISO'S CURE//FOR/
CONSUMPTION
See PISO *(Cure).*

HAZELTINE & CO.//
TRADE-PISO'S-MARK//
THE/PISO COMPANY
See PISO *(Company).*

HEGEMAN & CO/
CHEMISTS & DRUGGISTS/
NEW YORK
See HEGEMAN *(Chemical).*

HEGEMAN & CO//CHEMISTS//
NEW YORK
See HEGEMAN *(Chemical).*

THE/CORPORATION OF/
HEGEMAN & CO./CHEMISTS/
SARSAPARILLA/(ARTHUR

BRAND)/200 BROADWAY/
NEW YORK
See HEGEMAN (Chemical).

C. HEIMSTREET & CO.//
TROY, N.Y.
A hair product manufacturer established in 1834; the firm became C. Heimstreet & Co. in 1852 (Wilson and Wilson 1971). Products adv. 1900, EBB.
Cobalt; 7″ × 1¹³/₁₆″ diameter; 1n; 21b, 8 sides; pl; v, ss; p.

HEMLOCK OIL CO.,/DERRY, N.H.
Clear; 5¹¹/₁₆″ × 1″ × 1″; 22n, variant; 1b; pl; v.

W. HENDERSON & Cº//
EXTRACT OF/SARSAPARILLA//
PITTSBURGH
See HENDERSON (Sarsaparilla).

HENRY & CO//PROPRIETORS//
Dᴿ BOYCE'S//TONIC BITTERS
See BOYCE (Bitters).

JOHN F. HENRY & Co//
NEW YORK//HALL'S BALSAM/
FOR THE LUNGS [See Figure 54]
John M. Henry & Sons, predecessors to John F. Henry & Co., was established in Waterbury, VT in 1855. John F. Henry, with his brother William W., and Eli B. Johnson, assumed his father's business ca. 1862. John M. Henry & Co., possibly briefly called John F. Henry & Co., moved from Waterbury to Burlington in March 1867, and in 1870 the company divided, making a distinction between the wholesale and retail trades. Henry & Co. assumed the wholesale trade under the partnership of Edward Wells, A. E. Richardson and W. J. Van Patten, and in 1873 the firm became Wells, Richardson & Co. Although primarily wholesalers, this firm also manufactured various oils and chemicals, in addition to Diamond Dyes. In 1891 the wholesale aspects of Wells, Richardson & Co. were sold to a Mr. Herrington and Mr. Miller and they renamed the business Burlington Drug Co. The manufacturing business became Wells & Richardson Co., which was reincorporated in the 1920s as Wells-Richardson Co., Inc. This firm closed its doors in 1942. The second firm created as a result of the 1870 division was Henry & Johnson, which manufactured proprietary medicines. In 1877 Loren B. Lord joined the business and the firm became Henry, Johnson & Lord. The 1900 Era Blue Book indicated this firm was operating in 1900, but how

long thereafter is unknown. While all of this was taking place in Vermont, John Henry was extending his interests in New York City. In 1865, John, while retaining his Vermont business, traveled to New York City and went to work for Demas Barnes & Co.; he purchased a part of this business in 1868. After purchasing A. L. Scovill & Co. in October 1873, the John F. Henry Medicine Warehouse became John F. Henry, Curran & Co.; in 1880 the New York business became John F. Henry & Co. John F. Henry died in 1893 and directories last included a reference to the New York firm in 1895, operated by the estate. References: Childs Gazetteer & Business Directory of Chittenden County, Vermont, 1882–1883; Rann's History of Chittenden County Vermont (Syracuse, N.Y.: 1886); The New Hampshire Register and Business Directory (advertisements), 1884; (Fritschel 1974; Holcombe 1979; Ring 1980; Shimko 1969).
Aqua; 7³/₄″ × 2¹/₂″ × 1¹/₂″; 11n; 6b; 4ip; v, ssf. See BAKER (Miscellaneous), BAXTER (Bitters), BENNETT (Cure), DOWN'S (Elixir), HALL (Balsam, Company), PAINE (Compound), SCOVILL (Company, Syrup), WARREN (Cordial, Remedy), WYNKOOP (Pectoral), VERMONT (Liniment).

Fig. 54

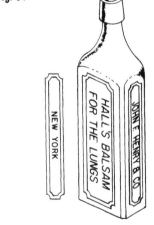

HERB MEDICINE CO.//
SPRINGFIELD, OHIO//LIGHTNING
HOT DROPS/NO RELIEF NO PAY
See HERB (Medicine).

HERB MEDICINE CO//WESTON
W. VA//LIGHTNING BLOOD
ELIXIR/NO RELIEF NO PAY
See HERB (Medicine).

HERB MEDICINE CO//WEST. W.
VA//LIGHTNING KIDNEY AND
LIVER CURE/NO RELIEF, NO PAY!
See HERB (Medicine).

HERBINE//HERBINE CO.//
ST. LOUIS [See Figure 55 and Photo 12]
Label: HERBINE For Liver Complaint, Biliousness, Dyspepsia, Constipation and Bilious Sick Headache, Chills, Fever and Ague and Dumb Ague. BALLARD SNOW LINIMENT CO., Successors to the Herbine Co., Sole Proprietors & Manufacturers, St. Louis, Mo. Directories list the Herbine Co., 1604 Market, in 1891 only; James F. Ballard began manufacturing medicines in 1885. Herbine adv. 1895, PVS & S; 1941–42 by James F. Ballard Inc., St. Louis, AD.
Aqua; 6³/₄″ × 2¹/₈″ × 1¹/₈″; 11n; 3b; 3ip; v, fss. See BALLARD (Liniment).

Fig. 55

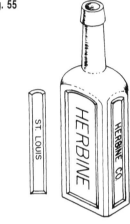

HERBINE//HERBINE CO.//
ST. LOUIS.
Label: Herbine, 20% Alcohol—For Biliousness, Costiveness, Indigestion, Bloated Abdomen, Wind in the Bowels, Foul Breath. By Jas. F. Ballard, St. Louis.
Clear; 6⁷/₈″ × 2¹/₈″ × 1¹/₄″; 11n; 3b; 3ip; v, fss; ABM. See BALLARD (Liniment).

HERNIA CURE CO.//
WESTBROOK MAINE//
RUPTURINE//CURES RUPTURE
Clear; 6″ × 1¹/₂″ diameter; 7n; 21b, 8 sides; pl; v, ssss.

HERRIOTT BROS & CO.
Aqua; 4³/₄″ × 1¹¹/₁₆″ × 1¹¹/₁₆″; 7n; 2b; pl; v.

F. J. HILL & CO/CITRATE/OF/
MAGNESIA/SALT LAKE CITY
[Base:] WT & CO/USA
Bottle manufactured by Whitall-Tatum,

1857 to 1935 (Toulouse 1972). Frederick J. Hill was listed as a druggist in 1888, established F. J. Hill & Co. in either 1894 or 1895 and operated under that name until 1903 when the company became F. J. Hill Drug Co. Frederick was president until 1908. In 1909 the motto was "The Never Substitutors." The firm was unlisted by 1910 according to R. L. Polk & Co.'s Salt Lake City directories.

Clear; 6⅞″ × 2¹¹/₁₆″ diameter; 1n; 20b; pl; h.

A. S. HINDS CO/PORTLAND/ MAINE/U.S.A.//HIND'S/HONEY &/ ALMOND/CREAM/ALCOHOL 7%
See HINDS (Cream).

A. S./HINDS CO/PORTLAND/ MAINE/U.S.A.//HINDS/HONEY/ AND/ALMOND/CREAM// IMPROVES THE/COMPLEXION// ALCOHOL 7%
See HINDS (Cream).

[Script:] Holbert & CO/MILWAUKEE
Clear; 5¼″ × 2¼″ × 2¼″; 9n, salt mouth with tear-drop shaped stopper; 1b; pl; d, partial script.

THE HOLDEN DRUG CO// STOCKTON CAL//ETHEREAL/ COUGH SYRUP
See ETHEREAL (Syrup).

HOLDEN DRUG CO// STOCKTON CAL.//HOLDEN'S/ ETHEREAL COUGH SYRUP
See HOLDEN (Syrup).

HOME MEDICINE CO./CHICAGO ILLS. [Base:] W.T. & CO./USA
See HOME (Medicine).

THE HONDURAS CO'S// COMPOUND EXTRACT// SARSAPARILLA// ABRAMS & CARROLL/SOLE AGENTS/S.F.
See HONDURAS (Sarsaparilla).

C. I. HOOD & C⁰// LOWELL, MASS.//HOOD'S/ COMPOUND/EXTRACT/SARSA/ PARILLA
See HOOD (Sarsaparilla).

C. I. HOOD & C⁰//LOWELL, MASS.//HOOD'S/SARSA/PARILLA
See HOOD (Sarsaparilla).

C. I. HOOD & CO.//LOWELL MASS//TUS SANO/CURES/ COUGHS/AND/COLDS [Base:] 4
See TUS (Cure).

C. I. HOOD & CO/U.S.A./ LOWELL, MASS//HOODS PILLS/ DOSE/TO/CURE LIVER ILLS
See HOOD (Pills).

HOOD'S/TOOTH POWDER/ C. I. HOOD & CO/LOWELL, MASS.
Adv. 1895, PVS & S; 1915, SF & PD.
Clear; 3⅜″ × 2⅛″ × 1³/₁₆″; 3n, sp; 12b; pl; h. See HARTER (Balm, Bitters, Elixir, Miscellaneous, Tonic), HOOD (Pills, Sarsaparilla), TUS (Cure).

ACKER'S/BABY SOOTHER/ W. H. HOOKER & CO
Introduced in the 1890s (Wilson and Wilson 1971). Adv. 1895, McK & R; 1910, AD.
Aqua, clear; 5½″ × ?; 1n; 20b; pl; v. See ACKER (Remedy),) ARTHUR (Company).

W. H./HOOKER/& CO./BUFFALO/ N.Y.//ACKER'S/DYSPEPSIA/ TABLETS
Label: ACKER'S DYSPEPSIA TABLETS for Dyspepsia, Indigestion, Flatulence, Heartburn, Headache, Constipation, Watery Risings. Adv. 1895, McK & R; 1935 by McCullough Drug Co., 30–34 E. High St., Lawrenceburg, Ind., AD.
Clear; 4¾″ × 2″ × 1¼″; 3n; 3b; 4ip; d, ss. See ACKER (Remedy), ARTHUR (Company).

W. H. HOOKER & CO/LONDON ENG/NEW YORK U.S.A.// ACKERS ELIXIR//ACKERS ELIXIR
Label: ACKER'S BLOOD ELIXIR, A Guaranteed Specific, The Greatest Blood Purifier known, W. H. Hooker & Co., New York, Sole Proprietors. Adv. 1887, WHS; 1935, AD.
Amber; 7¼″ × 2½″ × 1½″; 7n; 3b; 3ip; v, fss. See ACKER (Remedy), ARTHUR (Company).

W. H. HOOKER & CO./ PROPRIETORS/NEW YORK, U.S.A.//ACKER'S ENGLISH REMEDY//FOR THE THROAT & LUNGS
See ACKER (Remedy).

W. H. HOOKER & CO/SOLE AGENTS/NORTH & SOUTH AMERICA//ACKER'S ENGLISH REMEDY//FOR THE THROAT & LUNGS
See ACKER (Remedy).

HORSE SHOE MEDICINE CO/ [embossed running horse]/ COLLINSVILLE/ILLS//W/ [arched in embossed horseshoe]

HORSE SHOE BITTERS [Base:] PATENT APPLIED FOR
See HORSE SHOE (Bitters).

W. E. HOUCK REMEDY CO.// SEDALIA MO.//DR. F. A. WOOD'S/ SARSAPARILLA
See F. WOOD (Sarsaparilla).

HOWES & CO./PROPRIETORS// CLEM'S/SUMMERCURE
Aqua; 5″ × 1⅞″ × 1″; 7n; 3b; pl; v, bf.

[h] HOYT'S/POISONED BLOOD/ CURE/[arched h] THE HOYT CHEMICAL/[h] CO./INDIANAPOLIS
Adv. 1907, PVS & S.
Clear; 8⁵/₁₆″ × 2⅞″ × 1½″; 1n; 6b; pl; v.

HOYT'S/GERMAN/COLOGNE/ E. W. HOYT & CO./LOWELL/ MASS. [See Figure 56]
E. W. Hoyt's German Cologne was advertised in 1877 as being the genuine cologne, with ". . . the name blown in the bottle, and the signature of the proprietors printed in red across the label. Beware of Imitations." McK & R. Both a nickel and dime bottle were adv. 1914, HD; 1948 as Hoyt's Eau de Cologne by E. W. Hoyt & Co., Lowell, Mass., AD. Its competitor was Hoyt & Co.'s, "Dime Cologne," established in 1868 and adv. in the Pharmaceutical Era (1 Nov 1891) as a product of Philadelphia. The competitive cologne was apparently never embossed. Information from Mildred B. Long, president of J. Strickland, Memphis, TN (1982), indicates that E. W. Hoyt's cologne was introduced in 1871. Both products were acquired in the 1960s by J. Strickland & Co. and were combined and sold, as of 1986, as Hoyt's Cologne.
Clear; 3½″ × 1¼″ diameter; 9n; 20b; 1ip; h. See HOYT (Miscellaneous).

Fig. 56

**HOYT'S/GERMAN/COLOGNE/
E. W. HOYT & CO/LOWELL/
MASS.**

Clear; 5³/₄″ × 1¹/₂″ diameter; 9n; 20b;
1ip; h. See HOYT (Miscellaneous).

**E. W. HOYT & CO./
HOYT'S GERMAN COLOGNE/
LOWELL MASS.**

Clear; 7¹/₂″ × 1¹³/₁₆″ diameter; 9n;
20b; 1ip; v?. See HOYT (Miscellaneous).

**SAMPLE/OF/RUBIFOAM/FOR THE
TEETH/E. W. HOYT & CO./
LOWELL, MASS.**

Label: . . . *Liquid Dentrifice Alcohol
45%, Contains No Grit, No Acid or Any-
thing Injurious.* . . . Adv. 1889, *PVS &
S*; 1925, *BWD*.

Color unk.; 2¹/₂″ × ? × ?; 3n; 18b; pl;
h. See HOYT (Miscellaneous).

**RUBIFOAM/FOR THE/TEETH/
PUT UP BY/E. W. HOYT & CO/
LOWELL, MASS.**

Clear; 4″ × 2¹/₄″ × 1″; 7n; 17b,
modified; pl; h. See HOYT
(Miscellaneous).

HUMPHREY'S/HOMEO MED CO

See HUMPHREY (Medicine).

**HUMPHREYS' MEDICINE CO/
[embossed horse in circle]/
TRADE MARK/NEW YORK**

See HUMPHREY (Medicine).

**J. L. HUNNEWELL/& CO./
BOSTON, MASS//UNIVERSAL/
COUGH REMEDY**

See UNIVERSAL (Remedy).

**DR. F. S. HUTCHINSON CO//
ANTI-APOPLECTINE//THE ONLY/
APOPLEXY PREVENTIVE/AND/
PARALYSIS CURE** [Base:]
ENOSBURGH FALLS/VT.

Label: *Dr. F. S. Hutchinson's Anti-
Apoplectine! The only Apoplexy Preventive
and Paralysis Cure. Price $1.00 per Bot-
tle, Registered 1886. Prepared only by
Dr. F. S. Hutchinson & Co., Enosburgh
Falls, VT.* Product of B. J. Kendall, adv.
1890, *W & P*; 1916 *MB*.

Aqua; 8⁵/₈″ × 2⁵/₈″ × 1³/₄″; 1n; 3b; 3ip;
v, ssf. See KENDALL (Balsam, Cure,
Miscellaneous).

**IMPERIAL/CHEMICAL/
MANUFACTURING Co.//
NEW YORK//IMPERIAL HAIR/
TRADE MARK/REGENERATOR**

Patented Sept. 16, 1884. Adv. 1894 by
Imperial Chemical Manufacturing Co.,
135 W. 23rd St., New York City
(Devner 1968); 1900 (with seven

colors), *EBB*; 1929–30, *AD*.

Aqua; 4³/₈″ × 1¹⁵/₁₆″ × 1¹/₈″; 9n; 3b;
pl; v, ssf.

**IMPERIAL/CHEMICAL
MANUFACTURING CO//
NEW YORK//IMPERIAL
HAIR/TRADE/[embossed crest]/
MARK/REGENERATOR**

Aqua; 5⁵/₈″ × 2³/₈″ × 1¹/₂″; 9n; 3b; pl;
v, ssf.

**IMPERIAL HAIR/REGENERATOR
CO./NEW YORK/PAT SEPT 16TH
1884** [Base:] **W T & CO**

Bottle manufactured ca. 1890 (Wilson
and Wilson 1971).

Aqua; 4″ × ? × ?; 7n; 3b; pl; v.

**IMPERIAL/PERFUMERY CO/
PERFUMERS/NEW YORK**

Bottle manufactured ca. 1889 (Wilson
and Wilson 1971).

Aqua; 3″ × 1¹/₈″ diameter; 7n; 20b; pl;
h.

**HILLS/[embossed H with arrow]/
TRADE/MARK/DYS PEP CU/
CURES/CHRONIC/DYSPEPSIA/
INDIANA DRUG/SPECIALTY CO/
Sᵀ. LOUIS &/INDIANAPOLIS**

Company located at 302 S. 4th, St.
Louis, 1900, *EBB*.

Amber; 8³/₁₆″ × 3¹/₈″ × 1¹/₂″; 11n;
24b; 2ip; h.

**INTERNATIONAL FOOD CO.//
MINNEAPOLIS, MINN.//
SILVER PINE/HEALING OIL**

Label: *SILVER PINE HEALING OIL
FOR HUMAN USE—For Burns, Bruises,
Sprains, Scalds, Sores, Ulcers, All Flesh
Wounds, External Inflammation, Swell-
ings, Lame Back, Injuries Made by Nails,
etc. International Stock Food Co.,
Minneapolis, Minn.* Adv. 1907, *PVS &
S*; 1923, *SF & PD*. The International
Food Co., Marion W. Savage, Pres.,
operated from 1889 or 1890 to 1942.
Early in the twentieth century the name
was changed to the International Stock
Food Company. The Belding Medicine
Co. apparently was a division of this
firm operating out of the International
Stock Food Bldg., also with M. W. Sav-
age as Pres., from 1908 to 1918,
according to Davison's Minneapolis city
directories.

Aqua; 6″ × 2″ × 1¹/₈″; 7n; 3b; 3ip; v,
ssf. See BELDING (Remedy, Sarsaparilla).

**JAˢ. A. JACKSON & Co./
PROPRIETORS//
SAINT LOUIS. Mᵒ //
HOME BITTERS**

See HOME (Bitters).

**N. B. JACOBS & Cᵒ//
SAN FRANCISCO//
ROSENBAUM'S/BITTERS**

See ROSENBAUM (Bitters).

**JAQUES' ATWOOD/& CO./
CHICAGO**

Frank F. Jaques and Myron W. Atwood
(business unknown) established their
Chicago business in 1881; whether they
manufactured medicinals is uncertain. In
1889 the firm became Atwood &
Steefe, according to Lakeside city direc-
tories of Chicago.

Aqua; 6³/₁₆″ × 2³/₁₆″ diameter; 7n;
20b; pl; h. See JAQUE (Chemical).

**JEWETT & SHERMAN CO./
MILWAUKEE, WIS.**

Label: *Jamaica Ginger*. Directories listed
the firm as producers of teas, coffees,
spices and mills in 1918 and 1958.

Clear; 6³/₈″ × 2¹/₄″ × 1³/₁₆″; 7n; sp; 3b;
4ip; v, ss.

**PALMOLIVE/SHAMPOO/
B. J. JOHNSON/SOAP CO./
MILWAUKEE,/WIS. U.S.A./
TORONTO, ONT/CANADA** [Base:
embossed diamond] [See Figure 57]

Bottle manufactured by the Diamond
Glass Co. after 1924 (Toulouse 1972).
Adv. 1914 for 50 cents, *HD*; 1941–42,
AD.

Clear; 7″ × 2⁵/₁₆″ × 1⁵/₈″; 3n; 6b,
tapered bottom edge; distinctive
shape, pewter pour spout; h, fb; ABM.

Fig. 57

**GREAT BLOOD & RHEUMATISM
CURE/NO. 6088/MATT J.
JOHNSON CO./ST. PAUL, MINN.**

See GREAT BLOOD (Cure).

**JONES & PRIMLEY CO./ELKHART,
IND.//PRIMLEY'S/IRON &/
WAHOO/TONIC**

See PRIMLEY (Tonic).

JONES & PRIMLEY CO.//
ELKHART, IND.//PRIMLEYS/
SPEEDY/CURE/FOR/COUGHS/
AND/COLDS
See PRIMLEY *(Cure).*

[d] THE/JONES-THIERBACH/
CO/[v] SAN FRANCISCO [Base:]
117 H
Not a medicine. Webster Jones and
George C. Thierbach, Importers and
Dealers in teas, coffee, spices, extracts
and baking powder were successors to
Jones-Paddock Co. in 1913 (Zumwalt
1980). Directories included the firm in
1956.
**Clear; 7¹/₂″ × 2³/₈″ × 1¹/₄″; 7n; 3b; pl;
d, v.**

JORDAN'S/COUGH SYRUP/
JORDAN MARSH DRUG CO./
COXSACKIE, N.Y.
See JORDAN *(Syrup).*

K. K. MEDICINE CO//
NEW JERSEY//K. K./CURES/
BRIGHT'S/DISEASE/AND/
CYSTITIS
**Aqua; 7¹/₂″ × 2¹/₂″ × 1¹/₄″; 11n; 3b;
4ip; v, ss; h, f.**

KKK//KKK MEDICINE CO.//
KEOKUK, IOWA
Pectus Balm, adv. 1900, *EBB.*
**Color & dimens. unk.; 1n; 3 or 6b; ip;
v, fss.**

KALMUS CHEMICAL CO./
CINCINNATI.//DR. GUERTIN'S//
NERVE SYRUP [Base: I in diamond]
See GUERTIN *(Syrup).*

KALMUS CHEMICAL CO./
CINCINNATI & NEW YORK//
DR. GUERTIN'S//NERVE SYRUP
See GUERTIN *(Syrup).*

KASKARA/MEDICINE CO./
CHICAGO
**Amber; 10¹/₂″ × ?; 11n; 20b; pl; circu-
lar embossing.**

KATHARMON CHEMICAL CO./
ST. LOUIS, MO.//
HAGEE'S CORDIAL
See HAGEE *(Cordial).*

KEARNEY & Cº//NEW YORK
[See Figure 58]
**Aqua; 6⁷/₈″ × 2⁵/₁₆″ × 1³/₈″; 7n; 3b;
4ip; v, ss.**

KEASBEY & MATTISON Co
AMBLER PA
**Blue; 5¹⁵/₁₆″ × 2¹/₈″ diameter; 3n; 20b;
pl; h, embossed around shoulder. See
KEASBEY, (Chemical, Miscellaneous).**

Fig. 58

KEASBEY & MATTISON CO./
CHEMISTS/AMBLER, PA.
See KEASBEY *(Chemical).*

L.E.K./MANUFACTURED/BY/
THE LESLIE E. KEELEY CO./
LABORATORY/DWIGHT,
ILLINOIS/U.S.A.//[shoulder script:]
Leslie E. Keeley M.D.
**Clear; 5³/₄″ × 2³/₄″ × 1³/₈″; 9n, with
pour spout; distinctive shape in cross
section, with inset base; pl; h, fb,
partial script. See KEELEY (Cure,
Remedy).**

W. H. KEITH & Cº/SAN FRANCISCO
William Keith, with a partner, estab-
lished an apothecary business, in San
Francisco about 1851; by 1857 the
name was Wm. H. Keith & Co. (Wilson
and Wilson 1971). Directories showed
the firm out of business in 1870.
**Clear; 4¹/₂″ × 1³/₄″ diameter; 5n; 20b;
pl; v.**

WM H KEITH & Cº/
APOTHECARIES/SAN FRANCISCO
Possibly contained citrate of magnesia.
**Aqua; 7¹/₂″ × 3″ diameter; 1n; 20b;
pl; v.**

KELLER-BOHMANSSON/DRUG CO.
[Base:] W.T. Co./U.S.A.
See KELLER-BOHMANSSON *(Drug).*

DR. DANA'S SARSAPARILLA/
L. N. KEMPTON & CO./
CLAREMONT, N.H.
See DANA *(Sarsaparilla).*

KENNEDY & Co. GEN'L AGENTS//
CARBOLINE/FOR THE HAIR//
PITTSBURGH PA.
Carboline, the . . . *Petroleum Hair
Renewer* . . ., was a product of R.
Monroe Kennedy & Co. Adv. 1881
(Holcombe 1979); 1923, *SF & PD.*
Pittsburgh city directories have R.
Monroe Kennedy & Co. in stationary

supplies in 1868; as a Goods Agent, in
1869–70; and first in Patent Medicines
in 1873; the firm was unlisted in Pitts-
burgh by 1887.
**Clear; 8¹/₄″ × 2⁷/₁₆″ × 1⁵/₁₆″; 7n, sp;
3b; 4ip; v, sfs.**

SEVEN SEALS/OR/GOLDEN
WONDER//KENNEDY & CO
PROP'S//PITTSBURGH PA
Label: *Dr. Radcliff's Seven Seals or Golden
Wonder . . . R. Monroe Kennedy & Co.,
Sole Proprietors.* Adv. 1875 (Holcombe
1979); 1921, *BD.*
**Clear; 7¹/₈″ × 2¹/₄″ × 1¹/₄″; 7n; sp; 3b;
4ip, oval panels; v, fss. See previous
entry.**

BROWNATONE/KENTON PHARM
CO/COVINGTON, KY.
[Base: diamond] [See Figure 59]
Bottle manufactured by the Diamond
Glass Co., Royersford, PA, after 1924
(Toulouse 1972). Product adv. 1915,
SF & PD; 1941–42, *AD.*
**Amber; 2¹/₂″ × 1¹/₈″ diameter; 3n;
20b; pl; v; ABM.**

Fig. 59

BROWNATONE/KENTON
PHARMACAL CO./
COVINGTON, KY. [Base: diamond]
**Amber; 4⁵/₈″ × 1⁵/₈″ diameter; 3n;
20b; pl; v; ABM.**

DR. KILMER & CO//CATARRH/
[in indented lung:] DR KILMER'S/
COUGH-CURE/CONSUMPTION
OIL/[below lung, in panel:]
SPECIFIC//BINGHAMTON, N.Y.
See KILMER *(Cure).*

DR. KILMER & CO//THE BLOOD/
[in indented heart:] DR. KILMER'S/
OCEAN WEED/HEART/REMEDY/
[below heart, in panel:] SPECIFIC//
BINGHAMTON, N.Y.
See KILMER *(Remedy).*

F. W. KINSMAN &
CO./DRUGGISTS/
AUGUSTA, ME./AND/
NEW YORK CITY

Kinsman Asthma Cure, two sizes, adv. 1901, *HH & M.* Augusta city directories included the company, established by Francis W. Kinsman, in 1867 and 1911–12; New York City directories included the business, the Kinsman Co., operated by Frank W., son of Francis, & Frank W. Jr., in 1884–85 and 1913. The stores were eventually sold to the Hegeman Co., New York City (Blasi 1974).

Aqua; 4 11/16" × 2 1/8" × 1 7/16"; 7n; 8b; pl; h.

GUARANTEE/DANDRUFF/CURE/ THE/HOMER KIRK/CO [Base:] **A.M.F. & CO.**
See GUARANTEE *(Cure).*

ED. PINAUD/PARIS//NAJOUTER FOIQUALA SIGNATURE/[script:] **Ed. Pinaud** [Base:] **BOTTLE PROPERTY/ OF H. & C. KLOTZ CO. REGISTERED** [See Figure 60]
Labels indicate products since 1810. Adv. 1929–30, 1948 by Pinaud Inc., 220 E. 21st. St., New York City), *AD.* Products still available in 1984.

Aqua; 6 1/16" × 2 1/8" × 1 11/16"; 7n; 25b; pl; h; s; v; s; some script; tapered body.

Fig. 60

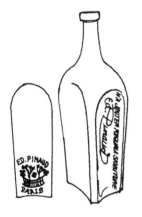

GLYCO-THYMOLINE [Base:] **KO & CO/NEW YORK**
Clear; 7 7/8" × 3 1/8" × 2 1/16"; 9n; 12b; pl; h. See GLYCO-THYMOLINE *(Miscellaneous).*

DR KOCH VEG. TEA CO// WINONA, MINN.//TRADE MARK/ DR. KOCH'S/REMEDIES/ EXTRACTS & SPICES
See KOCH *(Remedy).*

DR. KOCH VEGETABLE TEA CO.//WINONA, MINN.// DR. KOCHS/TRADE MARK/ REMEDIES/PURELY VEGETABLE
See KOCH *(Remedy).*

ONE NIGHT COUGH CURE/ KOHLER M'F'G. CO./ BALTIMORE, MD.
See ONE NIGHT *(Cure).*

Koken/BARBERS' SUPPLY/CO/ ST. LOUIS, U.S.A.
Ernest E. Koken was a druggist and distributor of barber supplies on 318 Chestnut in 1877 and formed a brief partnership with Louis Boppert in the 1880s. The firm was still in business in 1893 (Zumwalt 1980).

Clear; 9 1/2" × 3 1/8" × 3 1/8"; 9n; 1b; pl; h, d.

[Base:] **THE L. CO/PHILADA.** [f] **THE/**[script:] **Lycosine/INSTANTLY/ RELIEVES/ALL/SUPERFICIAL/ PAIN**
An inhaler with internal glass tubes.

Clear; 3 5/8" × 1 7/16" diameter; 17n, ground and threaded; 20b; pl; h, part script.

LISTERINE/LAMBERT/ PHARMACAL COMPANY
[Base: N in circle] [See Figure 61]
Bottle manufactured by the Obear-Nester Glass Co., East St. Louis, IL, 1894 to 1915 (Toulouse 1972). Listerine was introduced by Jordan Lambert in 1879. The product was named after Sir Joseph Lister, who popularized the use of antiseptics in 1865. The Lambert Pharmacal Company was founded in St. Louis, in 1878. Listerine is currently manufactured by the Warner-Lambert Company, Morris Plains, NJ, according to Thorn Kuhl, Warner-Lambert Company, (personal communication, 1982). Listerine was available by prescription only until 1914 (Devner 1968).

Clear; 4 1/4" × 1 3/4" diameter; 7n; 20b; pl; h; 4 sizes. See W. WARNER *(Company).*

Fig. 61

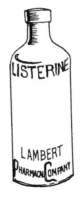

P. R. LANCE & CO/NEW YORK// SPARKLING//APERIENT [Base:] **W. McC. & CO**
Bottle manufactured by Wm. McCulley & Co, Pittsburgh, 1841 to ca. 1886 (Toulouse 1972).

Clear; 6" × 2 1/2" × 1 9/16"; 7n; rect.; ip; v, fss.

LANE'S MEDICINES ARE GOOD/ CHAS. E. LANE & CO./ ST. LOUIS, MO.
See LANE *(Medicine).*

DEAN'S/KIDNEY CURE/THE LANGHAM MED. CO/LEROY, N.Y.
See DEAN *(Cure).*

Larkin Co./BUFFALO
From 1909 to 1920 the Larkin bottles were manufactured by the company-owned Greensburg Glass Co., Greensburg, PA. Buffalo directories and advertisements establish the firm of John D. Larkin, soap manufacturers, in 1875. The company was very diversified and manufactured pottery, furniture, clothing, paint and even some food products. The firm liquidated most of its holdings in 1942.

Clear, 2 1/2" × ?; 3n, salt mouth; 20b; pl; h.

LARKIN CO./BUFFALO
Clear; 4 1/8" × 1 1/2" diameter; 8n; 20b; pl; h.

Larkin Co.//BUFFALO [Base:] **15/ C P/GLYCERINE**
Clear; 5 3/4" × 1 5/8" diameter; 7n; 20b; pl; h.

Larkin Co/[monogram]**/BUFFALO**
[See Figure 62]
Label: *Bay Rum.* Adv. 1898, *CHG.*

Clear; 5 1/2" × 1 3/4" diameter; 3n; 20b; pl; h; pewter pour spout closure.

Fig. 62

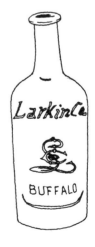

Larkin/Soap Co./BUFFALO
Emerald green; 2³/₄″ × ? × ?; 3n, salt mouth; 3b; tapered bottom edge; pl; h; distinctive shape.

Larkin Soap Co.//MODJESKA DERMA-BALM//MODJESKA DERMA-BALM
Clear; 4³/₄″ × 1⁹/₁₆″ × 1⁹/₁₆″; 9n, modified with flat top and no taper; 1b; 2ip; v, sbf.

LASH'S/BITTERS CO./ N.Y.–CHICAGO/S.F.
See LASH (Bitters).

LASH'S/BITTERS CO/NEW YORK CHICAGO/SAN FRANCISCO
[Base:] 7
See LASH (Bitters).

LAVORIS//LAVORIS/CHEMICAL CO [Base:] MINNEAPOLIS
Product of the Lavoris Chemical Company, Minneapolis, introduced in 1902; at first for local distribution only and by mail order. Richardson-Merrell Inc., Wilton, CT, purchased the product from Clarke-Cleveland, Buffalo, NY, in 1958. Adv. 1983, Richardson-Vicks Inc., successors to Richardson-Merrell, according to Kathi Davis, Richardson-Vicks Inc. (personal communication, 1983).
Clear; 4⁵/₈″ × 1³/₄″ diameter; 9n; 20b; pl; h, fb; ABM.

THE LAWRENCE WILLIAMS CO.// THE LAWRENCE WILLIAMS CO.// J. E. GOMBAULT'S/CAUSTIC BALSAM/COMPOUND
See GOMBAULT (Balsam).

THE LAWRENCE WILLIAMS CO.// THE LAWRENCE WILLIAMS CO.// J. E. GOMBAULTS/ CAUSTIC BALSAM
See GOMBAULT (Balsam).

THE LAWRENCE–WILLIAMS CO./ SOLE PROP'S FOR U.S.A. AND CANADA//THE LAWRENCE– WILLIAMS CO./SOLE PROP'S FOR U.S.A. AND CANADA//J. E. GOMBAULT'S/CAUSTIC BALSAM
See GOMBAULT (Balsam).

LAXAKOLA CO.//NEW YORK & CHICAGO//LAXAKOLA/ THE GREAT/TONIC LAXATIVE
See LAXAKOLA (Tonic).

FLORIDA WATER/LAZELL DALLEY & CO./NEW YORK
See LAZELL (Water).

LEIS CHEMICAL MFG. CO./ LAWRENCE KAS.
In business in 1887 (Devner 1970).
Aqua; 6¹/₈″ × 2⁷/₁₆″ × 1³/₁₆″; 7n; 12b; pl; v.

LEONARDI'S BLOOD ELIXIR/ THE GREAT BLOOD PURIFIER/ S. B. LEONARDI & CO./ NEW YORK & TAMPA, FLA.
See LEONARDI (Purifier).

A. H. LEWIS MEDICINE CO./ ST. LOUIS, MO.
See LEWIS (Medicine).

KURAKOFF/C. A. LEWIS & CO/ PROPR'S
A cure for asthma and catarrh. Adv. 1883 (Baldwin 1973); 1912 by Charles Lewis, Somerville, MA (Devner 1968).
Aqua; 5¹/₂″ × 1⁵/₈″ × 1⁵/₈″; 7n; 2b; 1ip; v.

E. N. LIGHTNER & CO/ DETROIT, MICH·// SARSAPARILLA//& STILLINGIA
See LIGHTNER (Sarsaparilla).

LIQUOZONE/MANUFACTURED ONLY BY/THE LIQUID OZONE Co/ CHICAGO USA
Originally Powley's Liquified Ozone, manufactured in Canada. Labeled as a "Cure for Everything," from dysentery to dandruff, containing 99% water and 1% acid. The product was introduced in the mid 1890s by Douglas Smith (Wilson and Wilson 1971; Young 1962). Adv. 1921, BD.
Amber; 8″ × ? × ?; 9n; 3b, the sides of the base on late variants are more rounded; pl; h.

LIQUOZONE/MANUFACTURED ONLY BY/THE LIQUOZONE CO./ CHICAGO, U.S.A. [Base:] 1078/18
Amber; 7¹/₂″ × 3″ diameter; 9n; 20b; pl; h.

THE/LOEW & SONS CO./ CLEVELAND, O.//Dᴿ LOEW'S CELEBRATED/STOMACH BITTERS & NERVE TONIC
See LOEW (Bitters).

LONG'S/STANDARD/MALARIA/ CURE Co/ROCHESTER/N.Y.
See LONG (Cure).

BAKER'S/VEGETABLE/BLOOD & LIVER/CURE/LOOKOUT/ MOUNTAIN/MEDICINE CO/ MANUFACTURERS/&/ PROPRIETORS/GREENEVILLE/ TENN.
See BAKER (Cure).

J. J. LORD & CO./SPRINGFIELD ILL//Dᴿ TOPPING'S/ALTERATIVE &/CATHARTIC SYRUP
See TOPPING (Syrup).

LORENTZ MED. CO.// TRADE "TO-NI-TA" MARK
See LORENTZ (Medicine).

LORRIMER & CO./ MANUFACTURING CHEMISTS/ LABORATORY/BALTIMORE, MD.
See LORRIMER (Chemical).

LOUDEN & Cᵒ/ALTERATIVE// PHILAD.A
Adv. 1854 (Baldwin 1973); 1910, AD.
Aqua; 6¹/₂″ × 2³/₄″ × 1³/₈″; 11n; 12b; pl; v, fb; p. See LOUDEN (Balsam, Elixir).

LOUDEN & CO'S/CARMINATIVE/ BALSAM/PHILAD.ᴬ
See LOUDEN (Balsam).

LOUDEN & CO'S/FEMALE ELIXIR
See LOUDEN (Elixir).

BOHEMIAN/CATARRH CURE/ D. D. LUCAS CO./VINELAND N.J.
See BOHEMIAN (Cure).

LUCKY TIGER/DANDRUFF CO/ KANSAS CITY, MO.// LUCKY TIGER/FOR SCALP/ ECZEMA & DANDRUFF
Clear; 7″ × 2³/₄″ × 2″, with recessed base 2¹/₄″ × 1¹/₂″; 4n; 6b, tapered bottom edge; pl; v, ss; ABM; also a smaller size.

LUCKY TIGER/MFG CO./K C MO
Label: LUCKY TIGER VEG-E-LAY, A Real Hair Dressing for Men. Alcohol 78%. Lucky Tiger Mfg. Co., Kansas City, Mo. This label adopted March 1, 1939. Adv. 1918 (Devner 1968); 1980 by L. T. York Co., 440 E. Helm, Brookfield, Mo., RB.
Clear; 7⁵/₈″ × 2⁵/₈″ diameter; 16n; 20b; pl; base; ABM.

LUCKY TIGER/REMEDY CO./ KANSAS CITY, MO.// LUCKY TIGER/FOR SCALP/ ECZEMA & DANDRUFF
[Base: N in square]
Bottle manufactured by the Obear-Nester Glass Co., East St. Louis, IL, after 1915 (Toulouse 1972).
Clear; 5¹/₈″ × 2″ × 1¹/₁₆″; 7n; 6b, recessed above the base; pl; v, ss; ABM

LUNDIN & CO./CHICAGO, ILLS.
Label: KIDNEY CURE – For the permanent cure of all kidney and bladder diseases, as gravel, painful micturition, difficult

urination, swelling of limbs, dropsy . . . Prepared by LUNDIN & CO., 2443, 2445, 2447 W. Kinzie St., CHICAGO, ILL.

Aqua; 5¼″ × 1⅝″ × 1⅝″; 9n; 2b; pl; v.

LUNDIN & CO. SOLE
MANUFACTURERS CHICAGO, ILL.
U.S.A.//LUNDIN'S CONDENSED
JUNIPER-ADE//MAKES 5
GALLONS OF A HEALTHFUL
BEVERAGE//LUNDIN'S
KONDENSERADE ENBARS SIRUP
[Base:] A3
The company was apparently in existence from 1889 through 1918 (Shimko 1969). Lundin's Syrup adv. 1895, 1907, *PVS & S.*

Clear; 5⅛″ × 1⁹⁄₁₆″ × 1⁹⁄₁₆″; 7n; 2b; pl; v, sfbs.

LUNG SAVER/THE GOOD COUGH
SYRUP/THE LUNG SAVER CO.
PHILA. PA. U.S.A.
City directories list the company in 1926, at 1418 N. Front, Harry H. Kelly, Proprietor; in 1936 at 1236 N. Front.

Color & dimens. unk.; 7n; rect.; pl; v; ABM.

MEXICAN/MUSTANG/LINIMENT/
LYON MFG CO/NEW YORK
See MEXICAN (*Liniment*).

E. G. LYONS & CO/ESS./
JAMAICA GINGER/S. F.
See LYON (*Jamaica Ginger*).

[Script:] I. L. Lyons & Co.//
New Orleans, La. [See Photo 13]
Label: *LYONS' LAXATIVE TASTELESS CHILL & FEVER CURE For CHILLS and FEVER, MALARIA, BILIOUSNESS, LOSS of APPETITE, LASSITUDE, SICK HEADACHE, ANEMIA and GENERAL DEBILITY. A true Blood Purifier and Tonic. PRICE 50 CENTS. I. L. LYONS & CO. LTD., PROPRIETORS, NEW ORLEANS.*

Clear; 6¼″ × 2⁵⁄₁₆″ × 1¼″; 9n; 6b; inset ca. ³⁄₈″ above base; pl; v, script. See OWEN (*Bitters*).

[h] NONE GENUINE/WITHOUT
OUR/[v] TRADE/[embossed bottle]/
MARK/[h] DAMONIA/M. M. CO./
CHICAGO, ILL.
See DAMONIA (*Trade Mark*).

M. P. & CO./CHICAGO
Label: *Dosimetric Granules.* Product of Morrison, Plummer & Co., wholesalers and manufacturers, 1876 (Devner 1970); 1900, *EBB.*

Amber; 5⅝″ × 2¼″ × 1⅝″; 7n; 3b; pl; v.

DR FLINT'S/REMEDY/MACK
DRUG CO PROP'S/NEW YORK
See FLINT (*Remedy*).

DR. A. E. FLINT'S/HEART
REMEDY/J. J. MACK & CO.,
PROP'S/SAN FRANCISCO
See FLINT (*Remedy*).

J. J. MACK & CO.//
SAN FRANCISCO, CAL.//INDIAN/
SARSAPARILLA//[embossed Indian]
See INDIAN (*Sarsaparilla*).

J. J. MACK & CO./WHOLESALE/
DRUGGISTS/SAN FRANCISCO,
CAL.
Amber, 5″ × 1⅝″ × 1⅝″; 9n; 2b; pl; v. See CIRCASSIAN (Miscellaneous), FLINT (Remedy), INDIAN (*Sarsaparilla*), MACK (*Water*).

J. J. MACK & CO/WHOLESALE
DRUGGISTS/SAN FRANCISCO,
CAL.
Clear, aqua; 5⅛″ × 1¾″ × 1″; 7n; sp; 3b; 4ip; v. See FLINT (Remedy), INDIAN (*Sarsaparilla*), MACK (*Water*).

MACKS/BRIGHTON/COLOGNE/
MACK & CO/PROPRIETORS/
SAN FRANCISCO
Aqua; 6¾″ × ?; 11n; 20b; pl; v; Florida water shape. See MACK (*Water*).

R. M. MACY & CO./[embossed star]/
NEW YORK
Milk glass; dimens. unk.; 1n; rect.; pl; h.

MAGUIRE/MEDICINE/COMPANY/
Sᵀ LOUIS. MO.
See MAGUIRE (*Medicine*).

J & C MAGUIRE/MEDICINE C./
Sᵀ LOUIS.
See MAGUIRE (*Medicine*).

J. & C. MAGUIRE'S/FAMILY
MEDICINES/MAGUIRE MEDICINE
CO./SOLE PROPRIETORS/
ST. LOUIS.
See MAGUIRE (*Medicine*).

THE MALTINE MF'G CO/
NEW YORK
John Carnrick introduced Maltine in 1875 and established the Maltine Manufacturing Company in 1878. There were at least 14 different Maltines including: Hops, with Beef & Iron; Hypophosphites; Cod Liver Oil and Peptones (Wilson and Wilson

1971). Carnrick sold the company in the 1890s (Nelson 1983). Offices included 54 Warren St., New York, with the lab located in Yonkers on the Hudson. In 1929–30 the offices were located at 8th Ave. & 18th St., Brooklyn; in 1948 at 745 5th Ave., New York City, *AD.* A label only, threaded variant, ca. 1920, reads: *MALTINE, Malto Yerbine. Ext. of Malted Barley, Wheat & Oats. An ideal stimulating expectorant. Alcohol 3 88%. New Label Adopted Sept. 7, 1909. Maltine 100 Manuf. Co., New York.* In 1952 the Maltine Manufacturing Company became Chilcott Laboratories and merged with Warner-Hudnut, Inc. Later the firm became Warner-Lambert, according to Thorn Kuhl, Warner-Lambert Company (personal communication, 1982).

Amber; 6½″ × 2⅝″ × 1¾″; 3n; 11b; 1ip, arched; v; also ABM. See REED & CARNRICK (*Oil*), W. WARNER (*Company*).

THE/MALTINE/MF'G CO/
CHEMISTS/NEW YORK
Amber; 7⅜″ × 3⁵⁄₁₆″ × 2⁵⁄₁₆″; 3n; 11b; pl; h. See REED & CARNRICK (*Oil*), W. WARNER (*Company*).

THE/MALTINE/MF'G CO/
CHEMISTS/NEW YORK
This distinctive shape was introduced ca. 1900 (Wilson and Wilson 1971).

Amber; 8¾″ × ? × ?; 7n, distinctive shape, tapered body and bulbous neck; 11b; pl; h. See REED & CARNRICK (*Oil*), W. WARNER (*Company*).

MALTO IRON TONIC CO./
[monogram]/BALTO. & LOUISVILLE
[Base:] G. L. ? CO.
Clear; 8³⁄₁₆″ × 3¼″ × 2¹⁄₁₆″; 10n; 18b; pl; circular embossing around monogram.

[Script:] Mastico Medicine Co/
Danville, Ills.// Gladstone's Celery/
And Pepsin Compound
See GLADSTONE (*Compound*).

MAYOR WALNUT-OIL CO/
KANSAS CITY, MO.//HAIR DYE//
HAIR DYE//NONE BETTER
[Base: diamond]
See MAYOR (*Oil*).

J. D. MᶜCANN CO./
HORNELLSVILLE, N.Y.
Products unknown. In 1929–30 and 1948 the offices were located at 26 Forbes St., Rochester, NY, *AD.*

Clear; 2½″ × 1¼″ diameter (base), shoulder ca. 1⅝″ diameter; 3n; 20b; pl.

Mc CONNON & CO.//
WINONA, MINN.
Clear; 9¼″ × 3″ × 1¹¹⁄₁₆″; 11n; 3b; 3ip; v, ss.

Mc CONNON & CO./WINONA,
MINN.//DR. MALAKOFF'S/
CONSUMPTION CURE
Color & dimens. unk.; 11n; 3b; 3ip; v, ssf.

McCONNON & CO.//WINONA,
MINN.//DR. TOLSTOIS/
CAUCASIAN LINIMENT
Color & dimens. unk.; 11n; rect.; 3ip; v, ssf.

Mc CONNON'S/FACE CREAM/
Mc CONNON & COMPANY/
WINONA, MINN. [See Figure 63]
Clear; 5⁵⁄₁₆″ × 2¼″ × 1½″; 7n; 6b; 1ip; v.

Fig. 63

THE McDERMOTT CO/BOTTLERS/
FAYWOOD, HOT SPRINGS/N. MEX.
Label: *Faywood Hot Springs Mineral*
Water.
Aqua; 10¼″ × 4¹¹⁄₁₆″ diameter; 20n; 20b; pl; h.

W. A. McGUFFIE & CO./
CHEMISTS/BRISBANE [Base:] W T
& CO/U.S.A.
See McGUFFIE (*Chemical*).

M. T. MEAD & CO./
APOTHECARIES/FAIRHAVEN
VERMONT//MEAD'S//
SARSAPARILLA
Aqua; 9″ × 3″ × 1¾″; 1n; 3b; 3ip; v, fss.

NONE GENUINE/WITHOUT THE/
NAME/[script:] Liebigs/**BEEF/WINE**
& IRON/PREPARED BY/THE
MEDICATED TABLET CO./
CHICAGO, ILL.
See MEDICATED (*Tablet*).

MELLINS FOOD CO/BOSTON USA
Light green; 3½″ × ?, also 5″ height; 11n; 20b; pl; h. See DOLIBER-GOODALE (*Company*).

J. C. MENDENHALL & CO./
EVANSVILLE, IND//C.C.C.//
[Left side embossing unknown]
Products included: Certain Chill Cure, adv. 1889, *PVS & S* and 1900, *EBB*; Certain Catarrh Cure, adv. 1900, *EBB* and 1929–30, *AD*; Certain Cough Cure and Certain Corn Cure, adv. 1895, *PVS & S* and 1900, *EBB*.
Aqua; dimens. unk.; 11n; 3b; ip; v, fss.

MENTHOLATUM/TRADE MARK/
MENTHOLATUMCO/BUFFALO
N.Y./WICHITA KAN
See MENTHOLATUM (*Trade Mark*).

MERTEN MFG CO/S. F. CAL.
Merten, Moffitt & Co. was established in 1880. Merten became sole owner in 1889 (Wilson and Wilson 1971). Products included a Jamaica Ginger adv. in 1900, *EBB*.
Aqua; 6″ × ? × ?; 11n; 15b; 1ip; v.

MERTEN, MOFFITT & CO./
SAN FRANCISCO [See Figure 64]
Aqua; 5⅞″ × 2¼″ × 1³⁄₁₆″; 11n; 12b; pl; v.

Fig. 64

FLORIDA WATER/MERTEN
MOFFITT & CO/SAN FRANCISCO
Aqua; 8⅞″ × 2³⁄₁₆″ diameter; 11n; 20b; 1ip; v.

METCALF CO//BOSTON, MASS.
Theodore Metcalf & Company was established in 1837 (*Pharmaceutical Era*, 1 Nov 1891). Products adv. 1941–42 by Theo. Metcalf Co., Boston, *AD*. Directories included the company until 1943.
Milk glass; 4¼″ × ?; 9n; ?b, ip; v, ss. See BURNETT (*Miscellaneous*),

DOLIBER-GOODALE (*Company*), MELLIN (*Company*).

BURNETT'S/COD LIVER OIL/BY/
T. METCALF & Cᵒ/BOSTON
The 1861 San Francisco city directory notes the product's agent as Wm. H. Keith & Co., San Francisco. Adv. 1923, *SF & PD*. Joseph Burnett was a teenage apprentice and partner to Theodore Metcalf & Co. (Holcombe 1979) prior to establishment of his own business in 1845 according to the Boston city directory. Metcalf continued to use the Burnett surname on this product and was probably sole owner.
Aqua; 8″ × 2¼″ × 2¹⁄₁₆″; 9n; 12b; pl; v. See BURNETT (*Miscellaneous*), DOLIBER-GOODALE (*Company*,) MELLIN (*Company*).

MEXICAN AMOLE SOAP CO/
PEORIA, ILL.
Products included Hair Tonic, Carbolic, Amole, and Pulque, adv. 1889, 1916, *MB*.
Aqua; 3¾″ × 1⅜″ × 1″; 3n; 25b; 4ip; v.

TO-KA//BLOOD/TONIC [Base:]
MEX. MED. CO.
Aqua; 8½″ × 3¼″ × 1½″; 1n; 14b; pl; h, fb.

VANS MEXICAN HAIR
RESTORATIVE/MANUFACTURED
ONLY BY THE/MEXICAN
MEDICINE CO./CHICAGO, U.S.A.
Adv. 1895, *PVS & S*; 1923, *SF & PD*.
Clear; 9″ × 3¹⁄₁₆″ × 1¾″; 7n, sp; 3b; 3ip; v.

COUGH SYRUP/A. C. MEYER
& CO.//BALTIMORE, MD. USA//
DR. J. W. BULL'S
See BULL (*Syrup*).

A. C. MEYER & CO. BALTO. MD.
U.S.A.//DR. J. W. BULLS COUGH
SYRUP [Base:] W
See BULL (*Syrup*).

SALVATION/TRADE OIL MARK/
A. C. MEYER & CO/BALTIMORE,
M. D. U.S.A.
See SALVATION (*Oil*).

MICHIGAN DRUG CO.//
DETROIT, MICH.
See MICHIGAN (*Drug*).

DR. MILES/MEDICAL CO.
[Base: P in circle]
See MILES (*Medicine*).

LACTOSAL/JNO. T. MILLIKEN
& CO./ST. LOUIS, MO.

Adv. 1910, *AD*; 1921, *BD*.
Amber; 5″ × 1¾″ diameter; 7n, large mouth; 20b, recessed above base; pl; h.

PASTEURINE/JNO T. MILLIKEN & CO/ST. LOUIS, MO./U.S.A.
[See Figure 65]
Adv. 1895, *PVS & S*; 1923, *SF & PD*.
Clear; 5″ × 1¾″ diameter; 7n, sp; 20b, inset; pl; h.

Fig. 65

THE MOREY/MERCANTILE CO./ DENVER, COLO.
Bottle manufactured by the Illinois Glass Co., symbol and dates unknown. Apparently not a medicine. Chester S. Morey, Denver, CO, a travel agent in 1879, established C. S. Morey, Grocers' Supplies & Sundries at 367 Blake, in 1880. After a brief term as Sprague, Warner & Co., 1881–1884, Morey established the C. S. Morey Mercantile Co., southeast corner of 19th and Wazee. From 1897 to ca. 1912 the firm operated from 16th and Wynkoop; in 1912 or 1913 the company became the Morey Mercantile Co., with John W. Morey, President; Chester was listed as president of the Great Western Sugar Co. Morey Mercantile Co. became a division of Consolidated Foods in 1958; W. Wesley Taylor Jr. was president in 1960; A. W. Nelson was manager in 1961, the last year of reference.
Clear; 5⅝″ × 1⅞″ × ⅞″; 8n; 3b; 3ip; v; ABM.

MORRIS-MORTON DRUG CO.// FORT SMITH, ARK.//SWAMP/ CHILL/AND/FEVER/CURE
Adv. 1916, *MB*.
Light aqua; 6¾″ × 2⅛″ × 1⁵⁄₁₆″; 11n; 3b; 3ip; v. See SWAMP (*Tonic*).

H. K. MULFORD & CO/CHEMISTS/ PHILADELPHIA [Base: C (also with B)]
See MULFORD (*Chemical*).

H. K. MULFORD CO/CHEMISTS/ PHILADELPHIA [Base:] R.C.S.
See MULFORD (*Chemical*).

MURINE/EYE/REMEDY CO./ CHICAGO, U.S.A.
See MURINE (*Remedy*).

NATIONAL PHARMACY Co/ SAN FRANCISCO, CAL [See Figure 66 and Photo 14]
Directories included the firm in the late 1930s, 1940 and 1951.
Amber; 2¾″ × 1⅛″ × ⅝″; 9n; 5b, with round corners; pl; v.

Fig. 66

NATIONAL REMEDY/COMPANY/ NEW YORK
See NATIONAL (*Remedy*).

NADINOLA CREAM/ A COMPLEXION BEAUTIFIER/ NATIONAL TOILET CO/PARIS TENN·U.S.A.
See NADINOLA (*Cream*).

NAYEAU TONIC CO/TRADE/ MARK/CHICAGO, ILL. USA
Amber; 9³⁄₁₆″ × 2⅝″ diameter; 11n; 20b; pl; v.

NELATION REMEDY CO./ BALTIMORE, MD.
Vessel contained a remedy for rheumatism, adv. 1910, *AD*; 1923, *SF & PD*.
Clear; 4½″ × 1½″ × 1½″; 9n; 2b; pl; v.

NEW SKIN CO. [See Figure 67]
New Skin adv. 1910 as Douglas' Liquid Court Plaster, *AD*; 1929–30, 1935 by Newskin Co., Bush Terminal Bldg., Brooklyn, N.Y., *AD*; 1948 by New Skin Co., 882 Third Ave., Brooklyn, N.Y., 1980–81 by New Skin Co., Plainview, N.Y., *AD*.
Cobalt; 2⁵⁄₁₆″ × 1¹⁄₁₆″ diameter; 16n; 20b; pl; v; ABM.

Fig. 67

NEW·SKIN CO.
Amber; 2⅜″ × 1⅛″ diameter; 3n; 20b; pl; v; ABM.

NEW YORK & LONDON/ CHEMICAL CO./NEW YORK// DR. BELL'S//BALSAM OF/ALPINE MOSS,//FOR CONSUMPTION
See BELL (*Balsam*).

V–O/EUCALYPTUS/OIL/THEO. NOEL Cº/CHICAGO/U.S.A.
See V-O (*Oil*).

[Script:] **Nontoxo/CHEMICAL CO./ SO. BEND, IND.**
See NONTOXO (*Chemical*).

T. NOONAN & CO. BOSTON// ZEPP'S DANDRUFF CURE
See ZEPP (*Cure*).

T. NOONAN & CO. BOSTON// ZEPP'S/LUSTRA/FOR/DANDRUFF
Adv. 1929–30, *AD*.
Clear; 6½″ × 2¹¹⁄₁₆″ × 1¼″; 3n; 4b; pl; v, ss. See ZEPP (*Cure*).

NORTHROP &/LYMAN CO/ TORONTO, ONT.// Dᴿ S. N. THOMAS/ECLECTIC OIL//INTERNAL,//EXTERNAL
See THOMAS (*Oil*).

THE NU-TO-NA REMEDY CO// BINGHAMTON, N.Y.//NU/TO/NA/ THE GREAT/SYSTEM/BUILDER
See NU-TO-NA (*Remedy*).

NYE BROTHERS & CO./ DERMATINE/ZANESVILLE, OHIO
Adv. 1895, *PVS & S*; 1910, *AD*; then not again until 1948 by Lavell Labs., 6 River St., Dundee, Ill., *AD*.
Clear; 6¼″ × 2¼″ × 1⅜″; 7n; 18b; 1ip; v.

O. P. S. CO.//ST. LOUIS, U.S.A.
[Base: O superimposed over diamond]
Label: *CHIONIA, A Preparation of Fringe Tree Based on the Eclectic Principles of Medicine. For Cramps of Abdomen, a Laxative. Made by O D Peacock Sultan*

Co., St. Louis. Bottle manufactured by Owens Illinois Glass Co. after 1929 (Toulouse 1972). Adv. 1887, *McK & R*; 1900 by Od. Chemical Co., 15 Cedar, St. Louis, *EBB*; 1929–30 by Peacock Chemical Co., 112 N. Second St., St. Louis; 1948 by O D Peacock Sultan Co., 4500 Parkview Pl., St. Louis, *AD*. Clear; 6″ × 2⅜″ diameter; 16n; 20b; pl; h, fb, on shoulder; ABM. See OD *(Chemical)*, SULTAN *(Drug)*.

THE OAKLAND CHEMICAL COMP'Y/H₂ [monogram] OC OZ
See OAKLAND *(Chemical)*.

FLORIDA WATER/THE OAKLEY SOAP & PERFUMERY CO N. Y.
See OAKLEY *(Water)*.

OD CHEM CO/NEW YORK
See OD *(Chemical)*.

W. OLMSTED & CO// NEW YORK//CONSTITUTION BEVERAGE
Adv. 1865 to 1867. Directories for 1865 and 1867 show Waller Olmsted as a manufacturer of a cordial. In 1866, the entry read: "Information Refused." Amber; 10½″ × ? × ?; 7n; 3b; 4ip; ssf; p; cabin shaped.

OLYMPIA WATER CO./MINERAL WELLS/TEX.
See OLYMPIA *(Water)*.

OMEGA/OIL/IT'S GREEN [within embossed leaf]/**TRADE MARK/ THE OMEGA/CHEMICAL CO./ NEW YORK**
See OMEGA *(Oil)*.

A. P. ORDWAY & CO.
Label: *DR. KAUFMANN'S SULPHUR BITTERS—Contains 22.30% Alcohol. Guaranteed by A. P. Ordway & Co., Under the Food and Drugs Act June 30th, 1906. Prepared by A. P. Ordway & Co., Mfg. Chemists, New York.* Copyright No. 1473 was acquired by Aaron P. Ordway, Lawrence, MA in 1878. Offices were also located in Boston (Ring 1980). Adv. 1948 by A.P. Ordway & Co., 343 W. 37th, New York City, *AD*. Clear; 8⅛″ × 3¼″ × 1½″; 3n; 13b; pl; base; rib on each side.

[Script:] **The Owl Drug Co**/[owl on monogrammed mortar and pestle]/[d] **TODCO//POISON** [See Figure 68]
Label: *TINCT. IODINE POISON. Alcohol 83 per cent. From the Laboratories of the Owl Drug Co., San Francisco, Chicago, New York.* Bottle manufactured ca. 1920. Numerous bottles and products

were manufactured. The Owl Drug Company, 1128 Market St., San Francisco, was established in 1892 by Richard Elgin Miller. The original office building was destroyed by the earthquake and fire of 1906. Other locations included 80 and 82 Geary St., San Francisco, opened in 1904; 320 So. Spring St., Los Angeles; 718–720 K Street in Sacramento and Broadway and Thirteenth in Oakland. The stores eventually went nationwide (Shimko 1969). In 1919 the Owl Drug business became affiliated with Rexall and went out of business ca. 1930–1933. Paper-labeled only bottles were in use by this time. Cobalt; 3¹⁵⁄₁₆″ × 1¾″; 9n; 22b; pl; h, d, f; v, s; part script; ABM. See IRA BAKER *(Sarsaparilla)*.

Fig. 68

[Script:] **The Owl Drug Co**//[owl on monogrammed mortar and pestle]/ [d] **TODCO**
Label: *Ameroil, A Pure and Superior Paraffin Oil (Liquid Petrolatum). Ameroil is Successfully Prescribed in the Treatment and Correction of Persistent Constipation and as a Preventive against Auto-intoxication, also Appendicitis. From the Laboratory of the Owl Drug Co., Chicago, San Francisco, New York.* Clear; 9¾″ × 3⅞″ × 2⅝″; 9n; 9b; pl; h, fb, script; ABM. See IRA BAKER *(Sarsaparilla)*.

THE OWL DRUG CO.//[owl on monogrammed mortar and pestle]/ [d] **TODCO**
Bottle manufactured ca. 1895 to 1910. Milk glass; 4″ × ?; 9n; ?b; pl; h, fb. See IRA BAKER *(Sarsaparilla)*.

THE OWL DRUG CO/ SAN FRANCISCO, CAL.
Florida water.

Aqua; 6⅛″ × 1½″ diameter, also 7¼″ × 1¹¹⁄₁₆″ diameter, also 8⅞″ × ?; 11n; 20b; pl; v. See IRA BAKER *(Sarsaparilla)*.

THE OWL DRUG CO.//THE OWL DRUG CO.
Aqua; 9½″ × 3³⁄₁₆″ × 1¾″; 7n; 3b; 4ip; v, ss. See IRA BAKER *(Sarsaparilla)*.

[h: Embossed bird]/**TRADE MARK/ [v] OZARK EYE/STRENGTHENER/ OZARK MED. CO./SPRINGFIELD, MO.**
Clear; 2⅞″ × 1¹⁄₁₆″ × ⅝″; 7n; 17b; with round corners; pl; h, v.

P. P. M. CO.
Aqua; 7″ × 2⅝″ × 1³⁄₁₆″; 6n; 24b; pl; h.

PACIFIC MEDICAL COMPANY/ SHELTON, NEB.
See PACIFIC *(Medicine)*.

PACIFIC//SELF HELPER CO.// LADIES [embossed 6-point star] **STAR**
Label: *Ladies Star For the Cure of Leugorrhoea and other Female Diseases. Prepared by The Pacific Self-Helper Co. $1.50.* Clear; 6⅛″ × 2⅛″ × 1½″; 9n; 3b; pl; v, ssf.

B. PAGE Jᴿ & CO// PITTSBURGH PA//BOERHAVES// HOLLAND BITTERS
See BOERHAVES *(Bitters)*.

[In circle:] **PAGEMATIC/TRADE MARK/FOR THE RHEUMATIC/ , Manufactured by/The Pagematic/ Co of Texas/DALLAS, TEXAS.**
Color & dimens. unk.; 10n; 7b; pl; circular embossing.

THE PALISADE/MFG CO./ YONKERS N.Y.//BOROLYPTOL// BOROLYPTOL
See PALISADE *(Manufacturer)*.

PALMER DRUG CO/SANTA CRUZ, CAL. [Base:] **WT CO/U.S.A.**
See PALMER *(Drug)*.

GROVES TASTELESS/CHILL TONIC PREPARED BY/PARIS MEDICINE CO./ST. LOUIS.
See GROVES *(Tonic)*.

PARKE DAVIS & Cᵒ/ CHEMISTS/DETROIT
Hervey C. Parke and Samuel P. Duffield, Detroit, began manufacturing pharmaceutical products in 1866. George S. Davis joined the firm the following year; Duffield soon retired. In

1875 the firm was incorporated and in 1881 the first sales office was opened in New York City. One controversial product, Liquor Ergotae Purificatus, introduced in 1879, was a crude drug derived from rye infected by a fungus. This product was used to control conditions associated with childbirth. Too much of the product caused circulatory problems and impairment of the central nervous system. Company expansions included Walkerville, Ontario in 1887; London in 1891; Montreal in 1898; and Sydney, Australia in 1902. Parke Davis was acquired by Warner-Lambert in 1970 and in 1985 was still a subsidiary of that firm. The divisional headquarters were moved to Morris Plains, NJ in 1978 according to Thorn Kuhl, Warner-Lambert Company (personal communication, 1982).
Clear; $2^7/8'' \times {}^{15}/_{16}'' \times {}^{15}/_{16}''$; 7n; 2b; pl; v. See W. WARNER (Company).

SILMERINE/PARKER/BELMONT/ & CO./CHICAGO
Label: *LIQUID SILMERINE, Prepared by Parker & Co., 134 W. Madison St., Chicago.* Adv. 1917, *BD*; 1929–30, 1948 by Dearborn Supply Co., 2350 Clybourne Ave., Chicago, *AD*.
Clear; $5'' \times 2''$ diameter; 3n; 20b; pl; h.

DR. DEWITTS/ECLECTIC/CURE/ W J PARKER/& CO/ BALTIMORE/MD
See DEWITT (Cure).

Dᴿ DEWITTS LIVER BLOOD/ & KIDNEY CURE/W. J. PARKER & CO BALTO MD [Base:] WPG CO
See DEWITT (Cure).

PARKER'S/BEEF/WINE/AND/ IRON/PARKER-BROWN CO./ PITTSBURG/PA.
The company was listed for one year only, 1911, at 305 Scotland, according to Pittsburgh city directories.
Clear; $8'' \times 3^1/4'' \times 1^5/8''$; 9n; 12b; pl; h.

Dᴿ PARKER'S SONS/SURE CURE FOR HEADACHE/ MANUFACTURED BY Dᴿ PARKER'S SONS CO./BATAVIA, N.Y. [Base:] W. T. CO./U.S.A.
Label: *. . . A physicians Prescription, Guaranteed to Cure Sick and Nervous Headache without after effects.* Bottle manufactured by Whitall-Tatum, 1857 to 1935 (Toulouse 1972). Adv. 1900, *EBB*; 1910, *AD*.

Clear; $4'' \times 1^5/8'' \times 1^1/8''$; 3n; 3b; pl; v. See PARKER (Miscellaneous).

"RED CHERRY COUGH CURE"/ FOR CONSUMPTION/ DR. PARKER'S SONS CO./ BATAVIA. N.Y.
Light blue; $7'' \times 2^1/8'' \times 1''$; 7n; 3b; 4ip; v. See PARKER (Miscellaneous).

PAWNEE BITTERS/PAWNEE/ INDIAN/MEDICINE-CO./S.F.
See PAWNEE (Bitters).

PAXTON TOILET CO BOSTON// MRS K. S. MASON// OLD ENGLISH//REGISTERED
Directories list the Paxton Toilet Co. from 1907 to 1922; earlier the company was called R. Paxton & Co. Product adv. 1907, *PVS & S*.
Clear; $6^7/8'' \times 2^5/8'' \times 1^5/16''$; 7n; 3b; 3ip; v, ssfb, embossing on the front and back occurs above the indented panels.

OLD ENGLISH MRS. K. S. MASON REGISTERED PAXTON TOILET CO BOSTON
Clear; $7'' \times$? \times ?; 8n; 3b; pl.

PEET BROS./MANFG. CO./ KANSAS CITY, U.S.A. [See Figure 69]
The 1897 Kansas City directory listed the firm as Peet Bros., Soap, William Peet, Pres., Albert W. Peet, V. Pres.
Clear; $5'' \times 1^7/8'' \times 1^5/16''$; 9n; 6b; 1ip; v.

Fig. 69

CALDWELL'S SYRUP PEPSIN/ MF'D. BY/PEPSIN SYRUP COMPANY/MONTICELLO, ILLINOIS
See CALDWELL (Syrup).

PEPSIN SYRUP COMPANY// MONTICELLO, ILLINOIS// DR. W. B. CALDWELL'S/ SYRUP PEPSIN
See CALDWELL (Syrup).

PERUVIANA/NATURES KIDNEY CURE/PERUVIANA HERBAL REMEDY CO./CINCINNATI, OHIO
See PERUVIANA (Cure).

PFEIFFER CHEMICAL Co./ NEW YORK,& ST. LOUIS
Label: *Dr. Hobson's Wire Fence Liniment.* Adv. 1929–30 by Wm. R. Warner & Co., 113 W. 18th St., New York City, *AD*. The date when Henry Pfeiffer opened his pharmacy in Cedar Falls, IA is unknown, but after ten years there, he was manufacturing drugs. Eventually the operations were moved to St. Louis where, with brother Allan, the Pfeiffer Chemical Company was established. Within a few years, brother Gustavus also became a partner. In 1907 the firm was merged with W. R. Warner & Co. Corporate offices were moved to New York a few years later and the St. Louis plant expanded according to Thorn Kuhl, Warner-Lambert Company (personal communication, 1982). In 1891 the firm was located in St. Louis and until 1900 was called the Allen-Pfeiffer Chemical Company, Henry Pfeiffer, Pres. Directories did not list the firm in 1901 or 1902 but the Pfeiffer Chemical Company was listed from 1903 through 1942.
Clear; $10^1/4'' \times$? \times ?; ln; 3b; ip. See HUDNUT (Miscellaneous), W. WARNER (Company).

PHENIQUE CHEMICAL COMPANY ST. LOUIS MO
See PHENIQUE (Chemical).

THE CHAS. H. PHILLIPS/ CHEMICAL CO./NEW YORK
The Charles H. Phillips Chemical Company was founded in 1849 and the name has remained unchanged since 1885 (Periodical Publishers Association, 1934). Phillips introduced his Cream of Magnolia in 1877, the Cod Liver Oil ca. 1880, and Phospho-Nutrine and Milk of Magnesia in 1873 (Wilson and Wilson 1971); Sterling Drug acquired ownership in 1923. Milk of Magnesia, Tablets and Tooth Paste adv. 1983 by Glenbrook Laboratories, 90 Park Ave., New York City, *AD*.
Amber; $4^{11}/16'' \times 1^7/16'' \times 1^7/16''$; 7n; 2b; pl; v. See PHILLIPS (Magnesia, Miscellaneous, Oil, Trade Mark).

THE CHAS. H. PHILLIPS/ CHEMICAL CO.//NEW YORK
Label: *Phillips' Phospho-Muriate of Quinine Compound, a Non-Alcoholic Tonic and Reconstructive. Made in Glen Brook, Conn.* Adv. 1887, *WHS*; 1941–42, *AD*.

Clear; 7³⁄₈″ × 2³⁄₄″ × 1³⁄₄″; 7n; 3b; 3ip; v, ss. See PHILLIPS (Magnesia, Miscellaneous, Oil, Trade Mark).

MILK OF/[in circle:] TRADE MARK/ MAGNESIA/REG'D IN U.S. PATENT OFFICE/AUG. 21, 1906/ THE CHAS. H. PHILLIP'S/ CHEMICAL COMPANY/ GLENN BROOK, CONN.
See PHILLIPS (*Magnesia*).

THE PILLOW-INHALER CO/ PHILADELPHIA
Listed in the 1886, Gopsill's Philadelphia city directory; 1900, *EBB*.
Light green; 7¹⁄₂″ × 1¹¹⁄₁₆″ diameter; 9n; 20b; pl; v.

FRITOLA//PINUS MEDICINE CO.// MONTICELLO, ILL. U.S.A. [Base: embossed diamond]
Label: *FRITOLA – Active Ingredients: OILS: Olive, Peanut, Corn, Patua (a species of Palm oil) – Contents 4 FL. OZ. For women and men – manufactured by Pinus Medicine Company – FRENCH LICK, INDIANA.* This product was also promoted as FRUITOLA (rather than Fritola), a laxative and cure for gallstones and stomach disorders. Bottle manufactured by the Diamond Glass Company after 1924 (Toulouse 1972). Offices in early years included Los Angeles (Devner 1968). Directories indicate a Chicago office in 1889. Adv. 1906 (Devner 1968); 1948 by Pinus Med. Co., 118 E. Washington St. Monticello, Ill., *AD*.
Clear; 6⁷⁄₁₆″ × 2″ × 1⁵⁄₁₆″; 3n; 3b; pl; v, fss.

TRAXO//PINUS MEDICINE CO// MONTICELLO, ILL. U.S.A. [Base: P in circle]
Label: *TRAXO – A Compound of Herbal Extracts, A Stomachic. Alcohol 20%* Bottle manufactured by the Pierce Glass Co., either in St. Mary's, PA, 1905 to 1912; or in Hamburg, NY, from 1912 to 1917 (Toulouse 1973). Product unavailable before 1900. Adv. 1910 (Devner 1968); 1948, *AD*.
Clear; 6¹⁄₂″ × 2¹⁄₂″ × 1¹⁄₂″; 3n; 4b; pl; v, fss; ABM.

THE/PISO COMPANY// HAZELTINE & CO.// TRADE-PISO'S-MARK
Emerald green; 5¹⁄₈″ × 1¹⁵⁄₁₆″ × 1³⁄₁₆″; 7n; 3b; 4ip; v, fss. See PISO (*Cure*).

THE/PISO COMPANY// HAZELTINE & CO.// TRADE-PISO'S-MARK [See Photo 15]

Amber; 5¹⁄₂″ × 1¹⁵⁄₁₆″ × 1¹⁄₈″; distinctive neck finish; 3b; 4ip; v, fss; ABM. See PISO (*Cure*).

PISO CO. WARREN, PA. U.S.A.// TRADE PISO'S MARK
Amber; 5⁷⁄₁₆″ × 2″ × 1¹⁄₈″; distinctive neck finish; 3b; 4ip; v, ss; ABM. See PISO (*Cure*).

[d] BORTON CURE/[v] PLYMOUTH INSTITUTE CO./WARSAW, IND. U.S.A.
See BORTON (*Cure*).

[Script:] Mrs. Potters/HYGIENIC SUPPLY C⁰/CINCINNATI, OHIO. № 2 [Base:] B № 2 [See Figure 70]
Mrs. Potter's Walnut Juice Hair Stain, adv. 1907, *PVS & S.* Directories listed the company in business only one year, 1907.
Amber; 3¹³⁄₁₆″ × 1⁹⁄₁₆″ × 1⁵⁄₁₆″; 7n; 3 or 4b; pl; v, some script.

Fig. 70

DR. MOTT'S/WILD, CHERRY TONIC/A. H. POWERS & CO
See MOTT (*Tonic*).

S. A. PRATT & CO./LINCOLN, NEB.//PRATT'S TREATMENT/ FOR THE SCALP
Label: *Pratt's Treatment For the Scalp, S. A. Pratt & Co. Proprietors, Lincoln, Nebr. 2$ per bottle.*
Clear; 7³⁄₄″ × 2⁵⁄₈″ × 1¹⁄₂″; 7n, sp; 3b; 4ip; v, ss.

PRICKLY ASH/BITTERS C⁰ .
See PRICKLY ASH (*Bitters*).

16 OZ/DR. E. E. BURNSIDES/ PURIFICO/P/THE PURIFICO CO/ BUFFALO, N.Y.
"The greatest remedy known for cancers & tumors" was adv. 1885 (Baldwin 1973). Dr. Elinor E. Burnsides was listed in Buffalo directories as a physi-

cian from 1885 to 1912 or later; in 1917 she was not listed.
Aqua, clear; 9³⁄₈″ × ? × ?; 7n; 13b; pl; h.

THE QUININE BITTERS CO/ 184 to 196 CONGRESS ST/ CHICAGO, ILL., USA
See QUININE (*Bitters*).

JUNIPER BERRY GIN/BOTTLED BY/QUININE WHISKEY CO./ LOUISVILLE, KY.//JUNIPER BERRY GIN/A DIURETIC/ CURES KIDNEY TROUBLE
Orville Sercombe and William Williamson, 227 6th, Proprietors of The Quinine Whiskey Company were listed in directories from 1891 to 1893, and O. G. Sercombe & Co., 332 W. Main, from 1893 to 1898.
Light blue; 9³⁄₄″ × 3¹⁄₁₆″ × 3¹⁄₁₆″; 25n; 2b; pl; v, bf.

R. R. R./RADWAY & CO/ NEW YORK//ENTD ACORD TO// ACT OF CONGRESS
Contained Radway's Ready Relief, an Anodyne Nervine and Pain Killer. John and Richard Radway formed J. & R. G. Radway & Co., New York City, in 1848 to promote R.R.R. (Radway's Ready Relief). After various family changes the firm became known as Radway & Company ca. 1877. The family was still operating the firm in 1942 (Holcombe 1979). Radway's Ready Relief adv. 1948 by Radway & Co., Inc., 208 Center St., New York, *AD*.
Aqua; 4³⁄₄″ × ? × ?; 5n; 3b; pl; v, fss; p; crude. See RADWAY (*Sarsaparilla*).

R. R. R./RADWAY & CO./ NEW YORK [Base: 0 superimposed over diamond]
Label: *Radway's Ready Relief. Alcohol 27 Per Cent. For Internal and External Pain.* Bottle manufactured by the Owens-Illinois Glass Company after 1929 (Toulouse 1972).
Aqua; 5³⁄₄″ × 1⁷⁄₈″ × ³⁄₄″; 1n; 6b; pl; v; ABM. See RADWAY (*Sarsaparilla*).

R. R. R./RADWAY & CO./ NEW YORK [Base: P in circle]
Label: *Radway's Ready Relief – Alcohol 27 Per Cent. Mfg. Since 1847 by Radway & Co., New York.* Bottle manufactured by the Pierce Glass Co., Port Allegany, PA, from 1905 to 1917 (Toulouse 1972). Unusual that this screw-capped variant would have been manufactured before the previous bottle, which was capped by cork.

Clear; $5^{3}/_{4}'' \times 1^{7}/_{8}'' \times ^{3}/_{4}''$; 16n; 6b; pl; v; ABM. See RADWAY *(Sarsaparilla)*.

R. S. CO ROCHESTER, N. Y.//
RHEUMATIC/[embossed tree]/
TRADE MARK/SYRUP/1882
See RHEUMATIC *(Syrup)*.

D. RANSOM & CO//KING/OF THE
BLOOD//BUFFALO, N.Y.
Dr. David Ransom began his practice in Buffalo, NY, in 1846 and soon began manufacturing medicines, one of the first being King of the Blood. About 1860–62 the rapidly expanding business became D. Ransom & Co. and in 1873, D. Ransom, Son & Co. (Holcombe, 1979). The 1948 *American Druggist* included Ransom products. King of the Blood adv. 1923, *SF & PD.*
Aqua; $8^{1}/_{4}'' \times 3^{1}/_{8}'' \times 1^{3}/_{4}''$; 11n; 3b; 3ip; v, sfs. See ANDERSON (Miscellaneous), MILLER (Balm), RANSOM (Syrup), TRASK *(Ointment)*.

W. T. RAWLEIGH CO//
FREEPORT, ILL.//[script:]
Rawleigh's/TRADE MARK
See RAWLEIGH *(Trade Mark)*.

W. T. RAWLEIGH MED CO//
FREEPORT, ILL.//[script:]
Rawleigh's/TRADE MARK
See RAWLEIGH *(Trade Mark)*.

FLORIDA WATER/RAYMOND
& Co/NEW YORK [Base:] J/11
See RAYMOND *(Water)*.

FRANK O. REDDISH & CO//
LEROY, N.Y.//PARKS/LIVER
& KIDNEY/CURE
See PARK *(Cure)*.

FLORIDA WATER/REDINGTON
& CO/SAN FRANCISCO
John Hobby Redington formed many interesting partnerships and business ventures, including a wholesale drug business with E. S. Holden in 1849 and with C. R. Story from 1851 to 1856 (Zumwalt 1980). According to an early San Francisco city directory, Redington & Co., "The great drug & patent medicine depot," was operating in 1860, possibly as early as 1855; associates included Andrew G. & Issac S. Coffin, New York City. Between 1869 and 1876 the company was in partnership with David Hostetter (Wilson and Wilson 1971). During the 1860s–1870s products distributed included Hostetter's, Drake's and Walker's Vinegar Bitters. Directories showed William P. Redington succeeding John in the 1880s. Coffin, Redington & Co. oper-

ated in New York City under that name from 1860 (Zumwalt 1980) to 1930 or later. In San Francisco, Redington & Co. was changed to Coffin, Redington & Co. in 1908 (Zumwalt 1980) and as such was operating in 1949. Florida Water adv. 1868, 1930 according to Peter Schulz (personal communication, 1985).
Light blue; $9'' \times 2^{1}/_{4}''$ diameter; 11n; 20b; pl; v; several variants. See COFFIN-REDINGTON (Water), HOSTETTER *(Bitters)*, REDINGTON (Jamaica Ginger).

REDINGTON & CO./ESS OF/
JAMAICA GINGER/
SAN FRANCISCO
See REDINGTON *(Jamaica Ginger)*.

REDINGTON & C\underline{o}//NEWELL'S//
PULMONARY/SYRUP
See NEWELL *(Syrup)*.

REED CUTLER & C\underline{o}/
BOSTON MASS//VEGETABLE/
PULMONARY/BALSAM
See VEGETABLE *(Balsam)*.

FOR/EXTERNAL/USE ONLY/
PRESCRIPTION/REESE CHEM. CO.
[superimposed over 1000]/**EXTERNAL/**
USE 4TIMES DAILY/MFG. BY/
REESE CHEM. CO./CLEVELAND O.
See REESE *(Chemical)*.

RESINOL/CHEMICAL CO./
BALT'O MD
For skin disease, inflammation and irritation. Adv. 1897, *L & M;* 1948 by Resinol Chemical Co., 517 W. Lombard St., Baltimore, Md., *AD;* 1983 by The Mentholatum Co., Buffalo, N.Y., *RB.*
Milk glass; $2'' \times 1^{3}/_{4}''$ diameter; 17n; 20b; pl; base; ABM. See YUCCA *(Company)*.

ROSEWOOD/DANDRUFF CURE/
PREPARED BY/J. R. REEVES CO./
ANDERSON, IND.
Clear; $6^{3}/_{8}'' \times 2^{3}/_{8}'' \times 1^{7}/_{8}''$; 9n; 6b; pl; v; fluted shoulders.

ROSEWOOD/DANDRUFF
REMEDY/THE J R REEVES CO./
ANDERSON, IND.
Clear; $6^{3}/_{8}'' \times 2^{7}/_{16}'' \times 1^{15}/_{16}''$; 9n; 6b; pl; v; fluted shoulders.

REX/BITTERS/CO./CHICAGO
See REX *(Bitters)*.

C. A. RICHARDS & CO/99
WASHINGTON St/BOSTON MASS
Label: *SONOMA WINE BITTERS,*

Made from the rich ripe grapes that grow on the vine clad hills of California and bittered with aromatic and healthful plants. Copyright and Trade Mark secured; entered according to the Act of Congress in the year 1867 by C. [Calvin] *A. Richards in the Clerk's Office of the District Court of Massachusetts.* Richards was in partnership with James Dingley (Ring 1980). Dingley purchased the business in 1873 (Wilson and Wilson 1971).
Amber; $9^{1}/_{2}'' \times 2^{3}/_{4}'' \times 2^{3}/_{4}''$; 11n; 2b; pl; v. See DINGLEY *(Company)*.

WILD CHERRY BITTERS/
MANUFACTURED BY/
C. C. RICHARDS & CO/
YARMOUTH, N.S. [Base:] L. G.
Co. N.S.
See WILD CHERRY *(Bitters)*.

A. RICHTER & CO INC.//
NEW YORK
Clear; $5'' \times 1^{3}/_{4}'' \times ^{3}/_{4}''$; 1n; 3b; pl; v, ss; ABM.

F. A\underline{d} RICHTER & CO//NEW
YORK//[embossed anchor]
PAIN-EXPELLER/REG. U.S. PAT.
OFF./FOR/RHEUMATISM, GOUT,/
NEURALGIA, COLDS, ETC.
[See Figure 71 and Photo 16]
Anchor Pain Expeller, adv. as the "Best Remedy for Rheumatism, Gout, Influenza, Backache, Pains in the Side, Chest and Joints, Neuralgia, Sprains, etc." Product of Friederich A. Richter; products trademark 16,853, issued 23 July 1889, used since 1 March 1869 (Shimko 1969). Pain Expeller adv. 1887, *WHS;* 1948 by F. AD Richter & Co., 338 Berry St., Brooklyn, N.Y., *AD;* 1982, observed by the author in a New Jersey drugstore.
Aqua; $4^{7}/_{8}'' \times 1^{5}/_{8}'' \times ^{5}/_{8}''$; 1n; 3b; pl; h, ssf.

Fig. 71

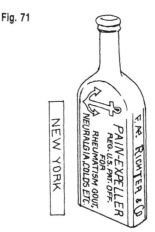

F. A.ᵈ RICHTER & CO. INC.//
NEW YORK
Label: *LOXOL PAIN EXPELLER. 49%
Alcohol. Capsicum, Ammonia, Camphor
Soap, Essential Oils. Use Externally as a
Liniment. Manufactured by F. AD Richter
& Co., Inc., Berry & S. Fifth Sts., Brook-
lyn, N.Y.*
Aqua; 6¹/₁₆″ × 2″ × ¹⁵/₁₆″; 1n; 3b; pl; v,
ss; ABM.

RIO CHEMICAL CO.//NEW YORK
[Base: I in diamond]/MADE IN U.S.A.
Label: *ALETRIS CORDIAL – 7 Fluid
Ounces – 27.8% Alcohol For Use In
Functional Derangements of the Female
Generative Organs.* Bottle manufactured
by the Illinois Glass Co., Alton, IL,
from 1916 to 1929 (Toulouse 1972).
Adv. 1884 (Devner 1968); 1948 by Rio
Chemical Company, 79 Barrow St.,
New York City, *AD*. St. Louis directo-
ries include the company at 401 N.
Main from 1884 until their move to
New York City in 1902.
Amber; 5⁵/₈″ × 2³/₈″ diameter; 16n;
20b; pl; h, on shoulder; ABM.

RIO CHEMICAL CO. ST. LOUIS
Label: *ACID MANNATE, a Palatable,
Painless Purgative. Indispensable as an
Aperient For Women During Pregnancy and
For Nursery Use.* Adv. 1887, *WHS*; 1907,
PVS & S. Also *Celerina – For Use in Func-
tional Disorders – Alcohol 42%* Adv.
1887, *WHS*; 1929–30 by Rio Chemi-
cal Company, New York City, *AD*.
Amber; 5¹/₂″ × 2³/₈″; 7n; 20b; pl; h,
on shoulder.

DR. LISTER'S/FAMOUS
ANTISEPTIC/TOOTH POWDER/
PREPARED SOLELY BY/ROGER,
SON & CO./CHEMISTS/LONDON,
E. C. [Base:] W. B. M. CO./903
See ROGER (*Chemical*).

LA SANDORA/ROMERO
DRUG CO.
Originally the firm was established in
Las Vegas, NM, ca. 1880. La Sandora
was adv. in 1880 as an effective liniment
for rheumatism, cholera, twitching eye-
brows, rump ache, etc. (Devner 1968);
1948 by Romero Drug Co., San
Antonio, Tex., *AD*.
Clear, light blue; dimens. unk.; 7n; 3b;
ip, oval front; v.

C. J. ROOSEVELT & Cᵒ/
NEW YORK//Dᴿ LARDOR'S
EXTRACT/OF LUNG WORT
Adv. 1844 (Putnam 1968); 1845 (Bald-
win 1973).
Aqua; 7″ × 3″ × 2″; 11n; 4b; pl; v,
ss; p.

ZEMO/MFG. BY E. W. ROSE CO./
CLEVELAND, O.//ZEMO/
ANTISEPTIC LOTION/FOR SKIN
& SCALP [Base: W over T in triangle]
See ZEMO (*Lotion*).

ZEMO CURES ECZEMA/E. W.
ROSE MEDICINE CO./
ST. LOUIS//ZEMO CURES
PIMPLES/AND ALL DISEASES
OF THE/SKIN AND SCALP
See ZEMO (*Cure*).

M. ROTHENBERG & CO./
SAN FRANCISCO, CAL.//AYALA/
MEXICAN BITTERS
See AYALA (*Bitters*).

JOHN STERLING/ROYAL REMEDY
CO./KANSAS CITY, MO. [Base:]
W.T. & Co.
See ROYAL (*Remedy*).

S & Co̲ BLOOD//PURIFIER
See S (*Purifier*).

WHS [monogram] CO
Label: *Phosphori Cantharicis Pills, W. H.
Schieffelin & Co., New York.*
Clear; 3⁵/₁₆″ × 1³/₈″ × ¹⁵/₁₆″; 7n; 3b;
pl; h.

SAGE BRUSH/SAGE BRUSH/
TONIC CO. LTD./HAIR TONIC
[Base:] I. G. & CO.
See SAGE (*Tonic*).

SALLADE & CO./MAGIC
MOSQUITO/BITE CURE/
& INSECT/DESTROYER/N.Y.
See MAGIC MOSQUITO (*Cure*).

SALLADE & CO/MAGIC
MOSQUITO BITE CURE/
& INSECT/EXTERMINATOR/N.Y.
See MAGIC MOSQUITO (*Cure*).

SARGENT & CO//AMERICAN/
CANCHALACOGUE//NEW YORK
Espes W. Sargent began selling do-it-
yourself drugs for home mixing ca. 1851
and began bottling some of his products
in 1854. The business apparently wasn't
lucrative because in the late 1850s
Sargent became a general merchant
(Wilson and Wilson 1971).
Aqua; 9³/₄″ × 3¹/₂″ × ?, also
7⁵/₈″ × 2³/₄″ × ?; 1n; 3b; 3 or 4ip; v,
sfs; p.

W. SAWENS & CO//UTICA, N.Y.
Label: *Sawen's Magic Balm* Adv.
1876, *WHS*; 1910, *AD*.
Aqua; 5″ × 1⁷/₈″ × 1″; 7n; 3b; 3 or
4ip; v, ss. See SAWEN (*Balsam*).

[Arched:]VERMONT SPRING/
[h] SAXE & CO./SHELDON, VT.
Green; 9″ × 3⁷/₈″ diameter; 2n; 20b;
pl; h.

SCARLESS LINIMENT CO./
WINTERSET, IA.
See SCARLESS (*Liniment*).

SCARLESS REMEDY CO./
WINTERSET, IA.
Clear; 6¹⁵/₁₆″ × 2¹⁵/₁₆″ × 1¹¹/₁₆″; 9n;
18b; pl; v. See SCARLESS (*Liniment*).

SCHLOTTERBECK & FOSS CO./
MANUFACTURING CHEMISTS/
PORTLAND, ME.
Augustus G. Schlotterbeck (Schlotter-
beck Inc.), Apothecaries & Surgical
Instruments, preceded Schlotterbeck &
Foss (Charles S.) Co., "Manufacturers
of Foss's Pure Flavoring Extracts and
Proprietors of Schlotterbeck's Phar-
maceuticals" established in 1890 (Zum-
walt 1980). Schlotterbeck & Foss was
still operating in 1942 according to the
Portland city directory. The 10 Sept.
1892 *Medical Record* advertises Schlot-
terbeck's Mistura Helonin Compound
as the women's "Standard Remedy for
the Treatment of Dysmenorrhoea,
Amenorrhoea and Menorrhagia." Adv.
1887, *WHS*; 1916, *MB*.
Clear; 4⁷/₈″ × 1³/₄″ × 1³/₄″; 9n; 2b;
pl; v.

Schlotterbeck & Foss Co./(ONE
FLUID PINT)/PORTLAND, MAINE.
Amber; 7¹/₂″ × 2⁹/₁₆″ × 2⁹/₁₆″; 9n; 1b;
1ip; v; ABM.

PAN-TINA/COUGH &
CONSUMPTION CURE/
E. SCHMIDT & CO. BALTO.
See PAN-TINA (*Cure*).

SCHROEDER'S MED. Cᵒ//
WOODCOCK/PEPSIN BITTERS
See WOODCOCK (*Bitters*).

SCOVILL MFG CO/NO 4/
BEEKMANS/NEW YORK
A. L. Scovill & Co. had offices in New
York City from 1849 until 1873, and in
Cincinnati from 1857 until 1881. Scovill
does not appear to be affiliated with the
Cincinnati operation after 1862. A. L.
Scovill & Co., New York, was
purchased by John F. Henry, Curran &
Co. in 1873 (Holcombe 1979).
Aqua; 5³/₄″ × 2³/₈″ diameter; 1n; 20b;
pl; v. See BAKER (*Miscellaneous*),)
BENNETT (*Cure*), HALL (*Balsam*),
J. F. HENRY (*Company*), ROGER'S
(*Miscellaneous*), SCOVILL (*Syrup*),
WARREN (*Cordial, Remedy*).

A. L. SCOVILL & Cº//
Dʀ BENNETT'S//QUICK CURE
See BENNETT (Cure).

A. L. SCOVILL & CO/CINTI.
& N.Y.//Dʀ WARREN'S/
PILE REMEDY
See WARREN (Remedy).

A. L. SCOVILL & CO//
CIN'TI & N.Y.//HALL'S BALSAM/
FOR THE LUNGS
Aqua; 7¹/₂″ × 2¹/₂″ × 1¹/₂″; 11n; 6b;
4ip; v, fss. See BAKER (Miscellaneous), BENNETT (Cure), HALL
(Balsam), J. F. HENRY (Company),
ROGER'S (Miscellaneous), SCOVILL
(Syrup), WARREN (Cordial, Remedy).

A. L. SCOVILL & Cº//
NEW YORK//DR. A. ROGERS/
LIVERWORT TAR &/
CANCHALAGUA
Adv. 1847 (Singer 1982); 1913, SN.
Aqua; 7³/₁₆″ × 2⁷/₈″ × 1³/₄″; 11n; 6b;
4ip; v, ssf. See BAKER (Miscellaneous), BENNETT (Cure), HALL
(Balsam), J. F. HENRY (Company),
ROGER'S (Miscellaneous), SCOVILL
(Syrup), WARREN (Cordial, Remedy).

SECURITY REMEDY CO./
MINNEAPOLIS, MINN.//
ANTISEPTIC HEALER 50 CENTS//
ANTISEPTIC HEALER 50 CENTS
[Base:] **B 96** [See Photo 17]
Label on variant embossed 4 OZ.
FULL MEASURE: . . . VETERI-
NARY REMEDIES INCLUDING SECU-
RITY DISTEMPER, EPIZOOTIC,
CHRONIC COUGH AND PINK EYE
REMEDY FOR ALL DOMESTIC
ANIMALS Producers were The
Security Remedy Co. with Wm.
McCann, proprietor, and the Security
Stock Food Co. Directories for 1917
and 1942 included Security Remedy
Co., Fred J. McCann, proprietor.
Aqua; 6³/₄″ × 2¹/₁₆″ × 1³/₁₆″; 7n; 3b;
3ip; v, fss. Variant embossed 4 OZ.
FULL MEASURE: Clear; 6³/₄″ × 2¹/₄″
× 1¹/₄″; 7n; 3b; 3ip; v, ss.

A. B. SEELYE & CO.//ABILENE,
KANSAS//NER-VENA
Clear; 8¹/₂″ × 2¹/₄″ × 2¹/₄″; 12n; 2b;
3ip; v, ssf.

A. B. SEELYE & CO.//ABILENE
KANSAS//DR. SEELYE'S/MAGIC/
COUGH AND/CONSUMPTION/
CURE
Color unk.; 7″ × 2³/₈″ × 1¹/₄″; 1n; 3b;
3 or 4ip; v, ssf; 2 known sizes.

THE MOTHER SEIGEL'S//
SYRUP CO
See SEIGEL (Syrup).

SEMINOLE INDIAN/MEDICINE
CO./BOONE, IA.
Clear; 6⁷/₈″ × 2¹/₄″ × 1¹/₄″; 7n; 3b; 3ip,
embossed panel, arched; v. See next
entry.

SEMINOLE INDIAN MED. CO./
LUNG BALM/BOONE, IOWA
Product of W. B. Montgomery,
introduced in 1899, apparently avail-
able until the mid-1910s.
Aqua; 4″ × ? × ?; 7n; rect.; ip; v. Also
clear variants with heights of 6 and
7 inches.

SHAW PHARMACAL CO//
OFFICE 66 LIBERTY ST
NEW YORK//[woman's head]/
[d] CLEWLEY'S/MIRACU-
LOUS/CURE FOR/RHEUMATISM
See CLEWLEY (Cure).

THE KIND YOUR/GRANDMOTHER
USED/SHERER-GILLETT CO./
CHICAGO
The relationship of Sherer to the Gillett
Chemical Works, Chicago, is unk.;
nothing was found in Chicago
directories.
Clear; 5⁵/₈″ × 1⁷/₈″ × 1⁵/₁₆″; 1n; sp; 3b;
1ip; v. See GILLETT (Jamaica Ginger,
Miscellaneous).

SHORES–M CO./CEDAR RAPIDS,
IOWA.
Shore's Kidney & Liver Cure, Shores
Mueller Co., Cedar Rapids, IA, adv.
1911 (Devner 1968).
Clear; 7″ × 2³/₈″ × 1⁵/₁₆″; 1n; 6b; 4ip;
v, ss; ABM.

SIEGEL COOPER/& Co. CHICAGO
[See Figure 72]
Siegel Cooper & Co., 205 State St.,
Chicago, IL, was established in 1887 by
Henry Siegel, Frank H. Cooper and
Isaac Keim. The firm was operating in
1901, according to the Lakeside city
directory of Chicago.
Clear; 2⁷/₈″ × 1¹/₁₆ × ¹¹/₁₆″; 7n; 11b;
pl; v.

Fig. 72

SI-NOK//THE SI-NOK CO./
INDIANAPOLIS/-INDIANA-
Label: SI-NOK, A Scientific Preparation
For Head Colds Adv. 1929–30
from 3413 N. Illinois St., AD; 1948 by
Kiefer-Stewart Co., 141 W. Georgia St.,
Indianapolis, Ind., AD.
Clear; 4¹/₈″ × 1³/₄″ × 1¹/₄″; 16n; 3b; pl;
v, ss; ABM.

SKABCURA/DIP CO./CHICAGO,
ILL./U.S.A.
The company manufactured patent
medicines in 1895 and 1896 with Fred
D. Banning, Pres., 11 Exchange,
Chicago. In 1901 the firm was appar-
ently only producing nicotine liquid
insecticides. Trade journals indicate the
firm also manufactured animal dips.
Sheep dip adv. 1900, EBB.
Aqua; 5¹/₄″ × 3¹/₄″ × 3¹/₄″; 11n; 1b;
pl; h.

[arched] CHARLES F. SLADE CO/
[h]10 OZ./BUFFALO, N.Y.//[arched]
SLADE'S AMMONIA/[h] PEAR/
TRADE MARK
The company was included in Buffalo
city directories from 1894 to 1912. In
1911 the firm was listed as the manufac-
turer of ammonia and extracts; the com-
pany was out of business ca.
1912–1916.
Clear; 8¹/₂″ × 3³/₈″ × 1³/₈″; 11n; 12b;
pl; h, bf. See SLADE (Miscellaneous).

[In circle:] HOPE IS THE ANCHOR
OF THE SOUL/T. A. SLOCUM CO/
MANFG. CHEMISTS/NEW YORK–
LONDON//FOR CONSUMPTION
AND LUNG TROUBLES//PSYCHINE
Label: PSYCHINE, An Infallible Remedy
for Consumption and all Disorders of the
Throat, Lungs and Heart. Branch Offices
in London, Paris, Karlsbad, Montreal,
Havana, Rome, Madrid, City of
Mexico. . . .
Aqua; 9¹/₂″ × 3¹/₄″ × 2″; 12n; 4b; 1ip;
v, fss, part in circle. See OZOMUL-
SION (Miscellaneous), PSYCHINE
Miscellaneous), SLOCUM (Expectorant,
Oil).

SMITH'S/GREEN MOUNTAIN/
RENOVATOR//REMEDY
COMPANY//ST. ALBANS, VT.
See SMITH (Remedy).

SODERGREN & CO//
MINNEAPOLIS, MINN.
A balsam containing 50% alcohol and
ether.
Aqua; 5¹/₄″ × 1⁷/₈″ × ¹⁵/₁₆″; 1n; sp; 3b;
4ip; v, ss. See SODERGREN (Mis-
cellaneous).

SODERGREN & CO.//
MINNEAPOLIS, MINN.
Bottle manufactured later than previous
entry.
Clear; 5¹¹/₁₆″ × 1⁷/₈″ × 1¹/₁₆″; 1n; sp;
rect.; 4ip; v, ss. See SODERGREN
(*Miscellaneous*).

HOFFMAN'S MIXTURE/FOR/
GONORRHEA GLEET & C/
SOLOMONS & CO/SAVANNAH,
GEO. [Base:] 3 ᴼZ/[monogram]
See HOFFMAN (*Mixture*).

A. A. SOLOMONS & CO/
DRUGGIST/MARKET SQUARE/
SAVANNAH GA
See SOLOMON (*Drug*).

JOS. N. SOUTHER & CO.//SOLE
PROPRIETORS/SAN FRANCISCO//
BENNET'S/CELEBRATED/
STOMACH BITTERS.
See BENNET (*Bitters*).

HOSPITAL/SOUTHERN
PACIFIC CO./DEPARTMENT
Clear; 4¹⁵/₁₆″ × 1¹⁵/₁₆″ × 1¹/₂″; 9n; 5b;
pl; v, d.

THE SPEEDWAY REMEDY CO//
SHELBY, OHIO
See SPEEDWAY (*Remedy*).

SPOHN'S DISTEMPER CURE/
SPOHN MEDICAL CO./
GOSHEN, IND.
See SPOHN (*Cure*).

SPOHN'S DISTEMPER COMP./
SPOHN MEDICAL COMPANY/
GOSHEN, INDIANA, U.S.A.
[Base: I in diamond]
See SPOHN (*Compound*).

SPRUANCE STANLEY & CO//
AFRICAN/STOMACH/BITTERS
See AFRICAN (*Bitters*).

AFRICAN/STOMACH/BITTERS/
SPRUANCE STANLEY & CO
See AFRICAN (*Bitters*).

DR. MOTT'S/WILD CHERRY
TONIC/SPRUANCE STANLEY
& CO
See MOTT (*Tonic*).

F. E. SUIRE & CO/CINCINNATI//
WAYNE'S/DIURETIC ELIXIR
See WAYNE (*Elixir*).

[h] 16 OZ./[v] STANDARD
HOMOEOPATHIC/PHARMACY
COMPANY/LOS ANGELES
This firm was apparently established

between 1901 and 1910 and was oper-
ating in 1942.
Clear; 8¹/₈″ × 2⁷/₁₆″ × 2⁷/₁₆″; 9n; 2b;
pl; h, v.

FREDERICK STEARNS & CO./
DETROIT, MICH. U.S.A.
Frederick Stearns & Co. was estab-
lished in 1855 and incorporated in
1882. Son Fred. K. succeeded his father
as president in 1887 (Shimko 1969).
The business was acquired by Sterling
Products in 1944 (Devner 1968).
Amber; 4¹/₄″ × 1¹¹/₁₆″ diameter; 7n;
20b; pl; v. See EXTERNAL
(*Miscellaneous*).

FREDERICK STEARNS & CO.
DETROIT, MICH. [See Figure 73]
Label: *WINE OF COD LIVER OIL AND
PEPTONATE IRON, a clean, grateful
tonic and tissue builder, and an admirable
tonic in the declining years of life*
Adv. 1894 (Devner 1968); 1941–42,
AD.
Amber, clear; 10¹/₈″ × 2¹¹/₁₆″, also
heights of 4³/₄″ and 6¹/₄″; 8n; 3-sided
with flat corners; pl; v, c. See
EXTERNAL (*Miscellaneous*).

Fig. 73

[d] OPTIMUS/[v] STEWART
& HOLMES/DRUG CO/
SEATTLE, WASH.
Company referenced in Nov. 1891,
Pharmaceutical Era, and in 1900 from
703 Front St., *EBB.*
Aqua; 6³/₈″ × 2″ × 1¹/₈″; ?n; 6b; 3ip; d,
v.

G. S. STODDARD & CO./M'F'G.
CHEMISTS/NEW YORK//
G. S. STODDARD & CO./
M'F'G. CHEMISTS/NEW YORK
Label: *SALCETOL, G. S. Stoddard &
Co., Manufacturing Chemists, 88–90
Reade St., N.Y.* Adv. 1929–30 and
1948 from 121 E. 24th St., *AD. The*

Delineator, August 1892, advertised the
products of Geo. S. Stoddard & Co.;
the first reference in directories was in
1893.
Green; 3¹/₄″ × 2¹/₄″ × 1¹/₈″; 3n; 6b; pl;
v, ss.

SULPHUME CHEMICAL CO.//
NEW YORK
See SULPHUME (*Chemical*).

SULTAN/DRUG CO./ST. LOUIS
See SULTAN (*Drug*).

SULTAN DRUG CO//ST. LOUIS
& LONDON
See SULTAN (*Drug*).

SUTCLIFFE/McALLISTER/& Cᴼ//
DRUGGIST'S//LOUISVILLE
See SUTCLIFFE (*Drug*).

THE E. E. SUTHERLAND/
MEDICINE CO./PADUCAH, KY.//
DR. BELL'S//PINE, TAR, HONEY
Aqua; 5¹/₂″ × 1⁷/₈″ × 1″; 1n; sp; 3b;
4ip; v, ssf. See BELL (*Cough*),
WALKER (*Tonic*).

THE E. E. SUTHERLAND/
MEDICINE CO./PADUCAH, KY//
DR. BELL'S//PINE-TAR-HONEY
Aqua; 6⁷/₈″ × 2³/₈″ × 1⁵/₁₆″; 7n; sp; 3b;
4ip; v, ssf. See BELL (*Cough*),
WALKER (*Tonic*).

SWAMP A. MED. CO//WASH. D.C.
See SWAMP (*Medicine*).

SYLVAN REMEDY CO./PEORIA,
ILL.//REID'S/GERMAN COUGH/&/
KIDNEY CURE//NO DANGER
FROM OVERDOSE//CONTAINS
NO POISON
See REID (*Cure*).

T CO./N.Y.
Clear; 3³/₄″ × 1¹¹/₁₆″ × 1″; 7n; sp; 3b;
pl; v.

T. T. & CO//HOP//BITTERS//
1884 [embossed torch]
See HOP (*Bitters*).

[v in circle:] ESTABLISHED 1873/
TRADE/MARK [superimposed over
elephant]/REGISTERED/[d] THE/[v]
U. P. T. Co./N.Y.
Clear; 6¹/₂″ × 2³/₈″ × 1¹¹/₁₆″; 9n; 4b;
pl; v, d.

THE/TABER FOOD CO. BOSTON,
MASS. U.S.A.
Label: *TABERS FOOD. Concentrated
Extract Beef & Vegetables. Tabers Food is
endorsed by the best physicians for
Insomnious Exhausted Vitality, Nervous
Prostration, Bad Blood, General Decline*

and Physical Debility, etc. Food contains 15.9% Soluble Albumen. Adv. 1890, *W & P.* No reference to the company was found in Boston directories.
Amber; 9⅝″ × 2¼″ diameter; 12n; 20b; pl; v.

THE TARRANT CO./CHEMISTS/ NEW YORK
See TARRANT *(Chemical).*

TARRANT & CO/DRUGGISTS/ NEW YORK
See TARRANT *(Drug).*

H. W. TAYLOR & CO// COROLLAS//NEW YORK
Corollas Hair Tonic Ointment, adv. 1887, *McK & R*; 1910, *AD.* Henry W. Taylor, Tonic Manufacturer, was located at 23 E. 20th in 1886; H. W. Taylor & Co., Dermatologists at 44 W. 56th in 1913, according to Trow's New York City directories.
Aqua; 7¹³⁄₁₆″ × 2½″ × 1½″; 7n; 3b; 3ip; v, sfs.

THOMAS DRUG CO./THE REXALL STORE/SAN JOSE, CAL. [Base:] W T CO/U.S.A.
Bottle manufactured by Whitall-Tatum, 1857 to 1935 (Toulouse 1972).
Clear; 6¹⁄₁₆″ × 2¹⁄₁₆″ × 1¼″; 7n; 3b; 1ip; v.

THOMPSON MFG. CO.// SAN FRANCISCO, CHICAGO & N.Y.//HYGEIA/WILD
[monogram] TMCO CHERRY/ PHOSPHATE
Label: . . . *Hygeia Wild Cherry Phosphate. For Headache, Gas, Colds* Introduced ca. 1890, product of Amund G. Thompson (Wilson and Wilson 1971). Adv. 1895, *PVS & S*; 1921, *BD.*
Aqua; 6⅛″ × 2″ × 2⅛″; 7n; 5b; pl; v, ss; h, f; unique front.

THOMPSON PHO'S CO. CHICAGO// WILD CHERRY PHOSPHATE// + // DIRECTIONS/ONE TEASPOONFUL EXTRACT, THREE OF SUGAR, ONE GLASS/WATER, HOT OR COLD. DRINK FREELY
Clear; 5³⁄₁₆″ × 1¼″ × 1¼″; 6n; 6b; pl; v, ssfb; unique front.

[h] THOMPSON'S/ORIGINAL/ -HYGEIA-/WILD/CHERRY/ PHOSPHATE/DIRECTIONS/ USE ONE TEASPOONFUL/ EXTRACT THREE OF/SUGAR ONE GLASS/WATER USE HOT/ OR COLD DRINK FREELY/AS YOU WOULD/LEMONADE/THOMPSON/ PHOSPHATE CO./CHICAGO//

THOMPSON'S/WILD CHERRY/[v] HYGEIA PHOSPHATE CHICAGO
Aqua 8″ × 2¾″ × 1½″; 11n; 6b; pl; h, f; v, b; side embossing unk.

THOMPSON STEELE/AND PRICE/ MANUFACTURING CO.// CHICAGO//Sᵀ. LOUIS [Base:] W. MᶜC & CO
Bottle manufactured by William McCully & Co., Pittsburgh, PA, 1841 to ca. 1886 (Toulouse 1972). This bottle contained a flavoring extract, not medicine. Thompson Steele & Price, Manufacturers of Dr. Price's Cream Baking Powder and Flavoring Extracts, advertised in Gould's St. Louis city directory in 1872 only; in prior years the firm was Thompson & Steele and subsequent years it was known as Steele & Price.
Clear; 5⅜″ × 1⅞″ × ⅞″; 7n; 3b; 3ip, oval front; v, fss.

PROFESSOR BYRNE'S/ = GENUINE = /FLORIDA WATER/ PREPARED FOR/H. K. & F. B. THURBER & CO./NEW YORK
See BYRNES *(Water).*

TILDEN & CO,// NEW LEBANON/N.Y.
Elam Tilden, previously associated with the Shakers, established the company in 1824. In 1848 the firm introduced the first alcoholic fluid extract. Other associations included a glass house where they produced the first blue glass bottles in the country. Products included tinctures, infusions, syrups, wines, mixtures, pills and all forms of fluid and solid extracts. The business was closed in 1963 (Shimko 1969).
Amber; 7″ × 2½″ × 2½″; 11n; 2b; 2ip; v, fb.

TONTO/COMPANY/PROVIDENCE/ RHODE ISLAND
Directories in 1912 and 1930 listed Daniel J. Mahler as general manager of both the D. J. Mahler Co. and Tonto Co., the latter, manufacturers of shaving and massage creams. Advertisements indicate the D. J. Mahler Co. was established in 1880.
Aqua; 2¾″ × 2½″ diameter; 17n; 20b; pl; h; ABM.

TROMMER/EXTRACT OF MALT CO./FREMONT OHIO
Adv. 1877, as the "IMPROVED TROMMER'S EXTRACT OF MALT for Treatment of Impaired, Difficult and Irritable Digestion, Loss of Appetite, Sick Headache, Chronic Diarrhoea, Cough, Bronchitis, Asthma, Consumption, the Debility of Females and Aged . . . Trommer Extract of Malt Co., Fremont, Ohio" *McK & R.* Adv. 1929–30 by The Trommer Co., 117 S. Arch St., Fremont, O.; 1948 by Trommer Malt Co., 225 N. Park Ave., Fremont, O., *AD.*
Amber; dimens. unk., 3 sizes; 7n; 15b; pl, v.

SAVE-THE-HORSE/REGISTERED TRADE MARK/SPAVIN CURE/ TROY CHEMICAL CO. BINGHAMPTON N.Y.
See SAVE-THE-HORSE *(Cure).*

SAVE-THE-HORSE/TRADE MARK/ SPAVIN CURE/TROY CHEMICAL CO. TROY, N.Y.
See SAVE-THE-HORSE *(Cure).*

TRUE'S PIN WORM ELIXIR/ ESTABLISHED 1851/DR. J.F. TRUE & CO/AUBURN, MAINE
See TRUE *(Elixir).*

Dᴿ TRUE'S ELIXIR/ESTABLISHED 1851/DR. J.F. TRUE & CO/ AUBURN, MAINE//WORM EXPELLER//FAMILY LAXATIVE
See TRUE *(Elixir).*

DR. TRUE'S ELIXIR/ESTABLISHED 1851/DR. J. F. TRUE & CO. INC/ AUBURN, ME
See TRUE *(Elixir).*

TUCKER PHARMACAL CO./ NEW YORK, N.Y. [Base: diamond]
Label: *Bromo Adonis Seconl* Bottle manufactured by the Diamond Glass Co. after 1924 (Toulouse 1972). Adv. 1910, *AD*; 1929–30 by Tucker Pharmacal Co., 182 Duane St., Brooklyn, N.Y.; 1941–42 and 1948 from 221 E. 38th St., New York City, *AD.*
Clear; 6⅜″ × 2″ × 2″; 9n; 2b; pl, v.

TUTTLE'S ELIXIR CO.// BOSTON, MASS.
See TUTTLE *(Elixir).*

HONDURAS/TONIC/W. E. TWISS & Co/MFR.
See TWISS *(Tonic).*

TWITCHELL CHAMPLIN & Co// NEURALGIC ANODYNE
[See Photo 18]
Label: *TWITCHELL, CHAMPLIN & CO'S STANDARD NEURALGIC ANODYNE – A Valuable Remedy for the Cure of Neuralgia, Headache, Rheumatism, Colds, Sore Throat, Colic, Cramps, Dysentery, Diarrhoea, Sea Sickness, Bruises,*

Sprains, Cuts, Chilblains, & c – Copyrighted July 17th 1883 – Portland, ME. Price 25 Cents. Adv. 1929–30 by Twitchell Champlin Co., 252 Commercial St., Portland, Me., *AD*.
Aqua; 6″ × 1¹³/₁₆″ × 1¹/₁₆″; 7n, sp; 3b; 2ip; v, ss.

U D CO/130/R.023
Product of United Drug Co., Boston; became Rexall Laboratory in 1903 and Rexall Drug Co. in 1920 (Devner 1970).
Amber; 3³/₄″ × 1¹/₂″ diameter; 9n; 20b; pl; base.

UNITED STATES/MEDICINE CO/ NEW YORK [See Figure 74]
Dr. Dunlop's Cascara Compound, adv. 1891, *WHS*; 1929–30 by U. S. Med. Co., 106 Sixth Ave., New York City, *AD*.
Aqua; 6¹/₈″ × 2¹/₁₆″ × 1¹/₄″; 7n; 3b; 3ip; v.

Fig. 74

UNIVERSAL/EMBALMING/FLUID/ COMPANY/ST. LOUIS, MISSOURI
[Base: O over diamond] [See Figure 75]
Bottle manufactured by the Owens-Illinois Glass Co. from 1932 to 1943 (Toulouse 1972).
Clear; 7⁷/₈″ × 2¹/₂″ × 2¹/₂″; 16n; 1b; pl; v, with horiz. graduations, 1 to 16, on right side of embossed panel; ABM.

UTE CHIEF/MINERAL/ WATER CO./MANITOU, COLO.// THIS BOTTLE/NEVER SOLD
[Base:] U. C.
See UTE CHIEF *(Water)*.

VAN OPSTAL & CO// NEW YORK//MORNING DEW/ BITTERS
(John) Van Opstal & Co., Liquors, was apparently established in 1860 at 408 Madison and was operating in 1913 according to New York City directories.

Amber; 10¹/₂″ × 2¹/₂″ × ?; 12n; 3b; 3ip; v, ssf.

Fig. 75

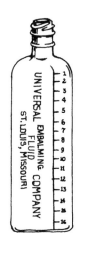

VAN SCHAACK/STEVENSON & CO/CHICAGO [Base:] R
A medicinal supply company formed in 1870 as Van Schaack, Stevenson & Reid. Before 1879 the name became Van Schaack, Stevenson & Co., and ca. 1887, Peter Van Schaack & Sons. (Information courtesy of Special Collections, University of Wisconsin Pharmaceutical Library.)
Clear; 4¹/₈″ × 1³/₈″ × 1³/₈″; 9n; 2b; pl; v; also variant: PETER VAN SCHAACK/&/SONS/[eagle on pestle]/CHICAGO. See BURNHAM (Cure, *Miscellaneous*).

VANVLEET-MANSFIELD DRUG CO//MEMPHIS, TENN.
See VANVLEET *(Drug)*.

VAN WERT'S/GOLDEN BALM/ VAN WERT CHEMICAL CO/ WATERTOWN, N.Y.
See VAN WERT *(Balm)*.

DR. VAN WERT'S/BALSAM//VAN WERT CHEMICAL CO.// WATERTOWN, N.Y.
See VAN WERT *(Balsam)*.

VAPO-CRESOLENE CO.//PATD US JUL 17 94 ENG JUL 23 94 [Base: O in square] [See Photo 19]
Bottle manufactured by Owens Bottle Co. from 1911 to 1929 (Toulouse 1972). Introduced in 1879 by E. Carpenter, Providence, RI (Wilson and Wilson 1971). By 1894 a special lamp or burner provided the means to displace Cresolene Vapor, a powerful germicide (White 1974). Offices were located in New York City in 1900, *EBB*; 1948, *AD*. The product was removed from the market in 1983 according to Benjamin Pritz, Vapo-Cresolene Co.,

Cincinnati, OH, (personal communication, 1984).
Aqua; 3⁷/₈″ × ¹⁵/₁₆″ × ¹⁵/₁₆″; 24n; 2b; pl; v, fs; embossing occurs between vertical rows of dots.

VAPO-CRESOLENE CO.//PATD US JUL 17 94 ENG JUL 23 94
[Base, script: Duraglas O over diamond]
Bottle manufactured by the Owens-Illinois Glass Co. after 1929 (Toulouse 1972).
Clear; 3⁷/₈″ × 1³/₈″ × 1³/₈″; 24n; 2b; pl; v, fs; embossing occurs between vertical rows of dots.

FLORIDA WATER/VENNARD & COMPANY/NEW YORK
See VENNARD *(Water)*.

THE CHAS. A. VOGELER Cº// LONDON & PARIS
Aqua; 7¹/₄″ × 1³/₄″ × ¹⁵/₁₆″; 8n; 3b; 2ip; v, ss. See BULL (Pectoral, *Syrup*), REDSTAR (Cure), ST. JACOB *(Oil)*, SALVATION *(Oil)*.

THE CHARLES A. VOGELER CO.//REDSTAR [embossed star] COUGH CURE [Base:] BALTIMORE/ U.S.A.
See REDSTAR *(Cure)*.

ST. JAKOBS OEL/THE CHARLES A VOGELER COMPANY/ BALTIMORE, MD. U.S.A.
See ST. JACOB *(Oil)*.

WHS [monogram] CO
Clear; 3⁵/₁₆″ × 1³/₈″ × ¹⁵/₁₆″; 7n; 3b; pl; h. See WH(S) *(Company)*.

[Base:] W.M.S.CO/SAN FRANCISCO [shoulder:] WITTER/SPRING/WATER
See WITTER *(Water)*.

M. T. WALLACE & Cº/ PROPRIETORS// BROOKLYN. N.Y.//BRANT'S/ PURIFYING EXTRACT
See BRANT *(Extract)*.

HENRY K. WAMPOLE & CO. PHILADA.
Label: *WAMPOLE'S CONCENTRATED EXTRACT of MALT.* . . . Before 1876, Henry Wampole was associated with Ziegler and Smith. Philadelphia directories reference the company first in 1876. The business was acquired by the Denver Chem. Mfg. Co. in 1958. A 1901 price list contained 2,000 preparations, including elixirs, salts, extracts, syrups, wines and tablets (Devner 1968). Malt Extract adv. 1890, *W & P*; 1917, *BD*.

Amber; 9″ × ?; 12n; 20b; pl; h, on shoulder. See LEON *(Hair)*, WAMPOLE (Syrup).

HENRY K. WAMPOLE & CO.// PHILADELPHIA

Wampole's Pyralgesic Compound, adv. 1907, *PVS & S*; 1915, *SF & PD*.
Blue; 5¼″ × 2″ × 1¼″; 7n; 3b; pl; v, ss. See WAMPOLE (Syrup).

HENRY K. WAMPOLE & CO.// PHILADELPHIA

Amber; 9½″ × ? × ?; 11n; rect., tapered bottom edge; pl; v, ss. See WAMPOLE (Syrup).

HENRY K. WAMPOLE & CO./ PHILADELPHIA//WAMPOLE'S/ LIQUID WHEAT [Base:] 103

Label: . . . *an efficient aid to the digestion of meat, egg-milk and other nitrogenous foods.* Adv. 1897, *L & M*; 1921, *BD*.
Amber; 6½″ × 2⅛″ × 1⅞″; 8n; 6b; pl; v, ss. See WAMPOLE (Syrup).

HENRY K. WAMPOLE & COMPANY//HENRY K. WAMPOLE

[Base: W in circle]
Label: *WAMPOLE'S PERFECTED AND PALATABLE PREPARATION. Originated in 1880. Alcohol 12%. Contains a Solution of an Extractive from Fresh Cod Livers, the Oily or Fatty Portions being eliminated. Copyright 1930* Bottle manufactured by T. C. Wheaton Co., Millville, NJ after 1946 (Toulouse 1972). Adv. 1948, *AD*.
Clear; 8¼″ × 3″ × 2″; 9n; 4b; pl; v, ss; ABM. See WAMPOLE (Syrup).

DR. WARD'S/MEDICAL COMPANY//5 OZ. FULL MEASURE//WINONA, MINN.

Products included Vegetable Anodyne Liniment, Walnut Oil, Cathartic & Liver Pills, Kidney Compound, Headache Powders, Rosaline, Condition Powder, Cattle Spice, Cream of Chalk and Jersey Corn Salve. Products adv. 1879, *VSS & C*; 1916, *MB*.
Clear; 7⅛″ × 2⅜″ × 1³⁄₁₆″; 25n; 3b; 3ip; v, fss.

WARING & CO//NEW YORK// KENDALL'S/AMBOLINE/ FOR THE HAIR

See KENDALL *(Hair)*.

H. H. WARNER & CO// TIPPECANOE/[embossed canoe] [Base:] ROCHESTER/N.Y.

[See Figure 76 and Photo 20]
Label: *TIPPECANOE BITTERS, THE BEST STOMACH TONIC . . . H. H. Warner & Co., ROCHESTER,*

TORONTO & LONDON. Introduced ca. 1883 (Holcombe 1979); adv. in later years as: "TIPPECANOE, The Best For Dyspepsia, Mal-Assimilation of Food, Stomach Disorders, General Disorders, General Debility . . . After Once Using Our 'TIPPECANOE', You Will Use No Nostrums Nor Preparations Called Bitters" Adv. 1910, *AD*.
Amber; 9″ × 2⅞″ diameter; inverted rolled lip; 20b; pl, distinctive shape with log and bark design; v. See LOG CABIN (Extract, Remedy, Sarsaparilla), H. WARNER (Bitters, *Cure*, Nervine, Remedy).

Fig. 76

H. H. WARNER & CO. LTD./ MELBOURNE [Base: monogram]

Amber; 9½″ × 3½″ × 1⅝″; 12n; 20b; pl; v; several shapes and variants. See LOG CABIN (Extract, Remedy, Sarsaparilla), H. WARNER (Bitters, *Cure*, Nervine, Remedy).

FREE SAMPLE/WARNER'S SAFE CURE CO./ROCHESTER, N.Y.

See H. WARNER *(Cure)*.

12½ FL. OZ./WARNER'S/SAFE/ REMEDIES CO./TRADE/MARK

[on embossed safe]/ROCHESTER, N.Y. U.S.A. [Base:] 488
See H. WARNER *(Remedy)*.

WARNER & COS/TABLETS/ PHILADA

W. Warner produced a variety of tablets including Formin Lithia, Lithia, and Tono Nervine. Tablets adv. 1941–42, *AD*.
Clear; 2½″ × ?; 16n; 20b; pl; h; slug plate circle. See WARNER (Miscellaneous), next entry.

SAMPLE/Wᴹ. R. WARNER & CO/ BOTTLE

William R. Warner established his Philadelphia based business in 1866 after being a pharmacist for 10 years.

Warner's interests had included the manufacture of sugar-coated pills, which he sold in bulk to Bullock & Crenshaw, same city; they in turn marketed them under their own name. Many claimed invention of the sugar-coated pills, including Warner (Sonnedecker & Griffenhagen 1957). After his death, control passed on to William R. Warner, Jr., and in 1907 the Philadelphia firm was acquired and merged with the Pfeiffer Chemical Company, St. Louis. In 1908 the headquarters were moved back to Philadelphia; in 1916 to New York City. In 1916, the Richard Hudnut Corporation was purchased and in 1950 the name became Warner-Hudnut, Inc. Acquisitions included the Earl S. Sloan Co., the Waterbury Chem. Co. and the Chamberlain Med. Co. (1930). With acquisition of Chilcott Labs., formerly the Maltine Co., in 1952, the firm became known as Warner-Chilcott Labs. Division and similarly in 1955, with acquisition of the Lambert Co., the Warner-Lambert Pharmaceutical Co. Acquisitions continued with the Emerson Drug Co. in 1956; Lactona, Inc. in 1961; the American Chicle Co. in 1962; the American Optical Co. and Texas Pharmaceutical in 1966; Parke Davis and Schick in 1970, Smith Bros. (cough drops) in 1977, and others. In 1970 the name of the parent company was shortened to the Warner-Lambert Co. because the descriptive "Pharmaceutical" tended to underestimate the diverse product line. Information furnished by Thorn Kuhl, Warner-Lambert Co. (personal communication, 1982). Products for 1900 included Tono Sumbul Cordial, a Tonic & Heart Stimulant, Hydrobromate Caffeine, Bronchial Throat Tablets, Effervescent Salts, Lithia & Vichy Tablets, etc., *EBB*. Some bottles found with dose caps.

Aqua; 5¾″ × 1⅝″ × ⅞″; 14n?; rect.; tapered inset base; v. See CHAMBERLAIN *(Remedy)*, EMERSON *(Drug)*, HUDNUT *(Miscellaneous)*, LAMBERT *(Company)*, MALTINE *(Company)*, PARKE DAVIS *(Company)*, PFEIFFER *(Company)*, SLOAN *(Liniment)*, WARNER (Miscellaneous).

Wᴹ R. WARNER & CO./[monogram]/ NEW YORK ST. LOUIS

Among its contents, Infant Anodyne with 13% alcohol.
Clear; 7⅝″ × 3⅜″ × 2¼″; 9n; 12b; pl; h, embossed ovally. See WARNER (Miscellaneous).

WM R. WARNER & CO./PHILADA.
[See Figure 77]
Cobalt; 4″ × 1³/₈″ diameter; 3n; 20b;
pl; v. See WARNER (Miscellaneous).

Fig. 77

[v] WM. R. WARNER & CO./[d]
PHILADA/NEW YORK/CHICAGO
Clear; 3³/₈″ × 1¹/₄″ × 1¹/₄″; 17n; 1b; pl;
v, d. See WARNER (Miscellaneous).

WM R. WARNER & CO./[monogram]/
PHILADELPHIA [See Figure 78]
Cobalt; 5⁷/₈″ × 2¹/₈″ diameter; 3n;
20b; pl; v. See WARNER
(Miscellaneous).

Fig. 78

[arched] WM R. WARNER & CO/
[h] PHILADELPHIA/
LABORATORIES/PHILADELPHIA/
AND/ST. LOUIS [Base:]·120·
Bottle manufactured ca. 1907–1915.
Clear; 3³/₈″ × 1¹/₂″ × 1¹/₂″; 3n; 1b; pl;
h. See WARNER (Miscellaneous).

WASHINGTON MANF'G CO/
SAN FRANCISCO//[monogram]
Coffee and pickle manufacturers, not
medicine. Directories list the firm with
Messrs Adeledorfer and M. J. Branden-
stein as proprietors from 1887 to 1901.
Brandenstein eventually established M.
J. Brandenstein & Co., proprietors of
MJB Coffee (Zumwalt 1980).
Clear; 7¹/₂″ × 2¹/₄″ × 1¹/₄″; 7n; 3b; 4ip;
v, fb; distinctive, tapered shape.

WATKINS FACE CREAM/
J. R. WATKINS MED. CO./
WINONA, MINN. [See Figure 79]
J. R. Watkins Med. Co., Plainview,
MN, was established by Joseph R. Wat-
kins in 1868; Watkins moved to
Winona in 1885 (Shimko 1969). The
firm was operating in 1986.
Clear; 5³/₈″ × 2¹/₄″ × 1⁵/₈″; 9n; 3b; 1ip;
v; ABM. See WATKINS (Liniment,
Miscellaneous, Trade Mark).

Fig. 79

[Script:] The J. R. Watkins Co./
REG. U.S. PAT OFF [Base: diamond]
Bottle manufactured by the Diamond
Glass Co. after 1924 (Toulouse 1972).
Clear; 7³/₄″ × 2⁷/₁₆″ × 1¹/₄″; 1n; 3b;
1ip; v, part script. See WATKINS
(Liniment, Miscellaneous, Trade Mark).

GERMAN BALSAM BITTERS/W. M.
WATSON & CO./SOLE AGENTS
FOR U.S.
See GERMAN (Bitters).

THE DR. H. F. WEIS MEDICINE
CO./GUARD ON THE RHINE/
STOMACH BITTERS/DAYTON,
OHIO [Base:] W. T. CO./U.S.A.
See GUARD ON THE RHINE (Bitters).

S. C. WELLS & CO//SHILOH//
LEROY, N.Y. [Base:] Est 1873
Aqua; 5³/₄″ × ? × ?; 11n; 6b; 4ip; v,
sfs. See PARK (Cure, Syrup), SHILOH
(Cure, Miscellaneous, Remedy).

S. C. WELLS/& CO/LEROY, N.Y.//
Dr SHILOH'S//CATARRH//
REMEDY
See SHILOH (Remedy).

S. C. WELLS & CO//DR. SHILOH'S/
SYSTEM/VITALIZER//LEROY, N.Y.
Introduced ca. 1876 (Wilson and
Wilson 1971). Adv. 1879, VSS & C;
1929–30, AD.
Aqua; 5¹/₄″ × ? × ?; 11n; 6b; 4ip; v,
sfs. See PARK (Cure, Syrup), SHILOH
(Cure, Miscellaneous, Remedy).

S. C. WELL'S & CO/LEROY, N.Y.//
ESTABLISHED//IN 1870//2 OZ
Label: *SHILOH FOR COUGHS, etc
. . . S. C. Well's & Co., Toronto, Can.,
LeRoy, N.Y.* Also a variant, same
dimens., in aqua, without 2 OZ:
*CARTER'S COMPOUND EXTRACT OF
SMART WEED, Alcohol 68%. For Rheu-
matic Pains, Toothache, Neuralgia, Sim-
ple Sore Throat, Bruises, Sprains, S. C.
Wells & Co., LeRoy, N.Y.* Shiloh adv.
1871, *WHS*; 1948, *AD*. The Carter's
Extract of Smart Weed, produced by
Brown Med. Co. relationship is
unknown.
Clear; 5¹/₄″ × 1³/₄″ × 1¹/₈″; 16n; 6b;
1ip, arched; v, fssb; ABM. See CARTER
(Cure, Extract), FENNER (Remedy),
PARK (Cure, Syrup), SHILOH (Cure,
Miscellaneous, Remedy).

THE WEST ELECTRIC CURE CO.//
ELECTRICITY IN A BOTTLE
See WEST ELECTRIC (Cure).

SEASIDE COLOGNE/WESTERN
PERFUMERY CO/
SAN FRANCISCO, CAL
Clear; 5″ × 1³/₈″ diameter; 9n; 20b;
1ip, oval; v.

TRADE/FERNANDINA/MARK/
FLORIDA WATER/THE S. H.
WETMORE COMPANY/NEW YORK
See FERNANDINA (Water).

HEBBLE WHITE/M'F'G./
COMPANY/GAINESVILLE, N.Y.
Possibly a shoe polish.
Aqua; 5³/₈″ × 2⁵/₈″ × 1⁷/₁₆″; 3n; 11b;
1ip; v.

EDWARD WILDER & CO/
WHOLESALE DRUGGIST//
MOTHER'S/WORM SYRUP
See MOTHER (Syrup).

WILDROOT/COMPANY INC./
BUFFALO, N. Y. [Base: I in diamond]
Bottle manufactured by the Illinois
Glass Co. between 1916 and 1929
(Toulouse 1972). Hair tonic, introduced
after 1912 (Devner 1970). Adv. 1916,
MB. A product of Colgate-Palmolive
Co., 300 Park Ave., New York City, in
1980–81, *AD*.
Clear; 7″ × 2³/₄″ diameter; 7n; 20b; pl;
v; tapered sides; ABM.

WILLIAMS'/BRILLANTINE/
THE J. B. WILLIAMS CO./
GLASTONBURY, CT., U.S.A.
[See Figure 80]

Fig. 80

Company established in 1840 (Devner 1970); was still operating in 1948, *AD*. Clear; 3⁹/₁₆″ × 1¹/₂″ × 1¹/₂″; 7n; 7b, modified, pressed design; v. See WILLIAMS (*Miscellaneous*).

DR. BOCK'S RESTORATIVE TONIC/
MANUFACTURED BY/
S. H. WINSTEAD MEDICINE CO.
See BOCK (*Tonic*).

FARRAR'S SARSAPARILLA/
MANUFACTURED BY WOOD
DRUG CO./BRISTOL, TENN.
See FARRAR (*Sarsaparilla*).

DR. J. L. WOODS/TASTELESS
CHILL CURE/WOOD DRUG CO/
BRISTOL, TENN.
See WOOD (*Cure*).

Dᴿ COOPER/SARSAPARILLA/
WOODARD, CLARKE & CO./
PORTLAND, ORE.
See COOPER (*Sarsaparilla*).

FRELIGH'S/LIVER MEDICINE/
I. O. WOODRUFF & CO
See FRELIGH (*Medicine*).

IOWNA/BRAIN & NERVE TONIC/
I. O. WOODRUFF & CO
See IOWNA (*Tonic*).

WOODWARD, CLARKE & CO/
CHEMISTS/PORTLAND, OR. [Base:]
W T & CO/3/U.S.A.
See WOODWARD (*Chemical*).

CLINTON E. WORDEN & CO./
MANUFACTURING
PHARMACISTS/SAN FRANCISCO,
CAL.
Extracts, pills, tablets, lozenges, elixirs, syrups, wines, adv. 1890 (Devner 1970). The National Pharmacy Co. succeeded the firm in 1902 (Shimko 1969).
Amber; 3⁵/₈″ × 1⁷/₁₆″ × ⁷/₈″; 9n; 17b, with round corners; pl; v.

WORLDS COLUMBIAN/
SARSAPARILLA CO.//

WORCESTER, MASS/WORLDS//
COLUMBIAN/SARSAPARILLA
See WORLD (*Sarsaparilla*).

P. T. WRIGHT & Cº/PHILADᴬ //
CARMINATIVE//BALSAM
See WRIGHT (*Balsam*).

WYETH CHEMICAL CO./18
See WYETH (*Chemical*).

REGSTD TRADE/MARK/
MENTHOLATUM/YUCCA CO/
WICHITA KAN
The Yucca Co. was founded by Albert Alexander Hyde, Wichita, KS, in 1889. Mentholatum was one of the company's first products. The name was changed and the Mentholatum Company was incorporated in 1906. Offices were established in Buffalo, NY, shortly thereafter. The Wichita office closed within a few years. Information provided by Arthur Hyde, Sec., Mentholatum Co., Buffalo, NY, (personal communication, 1983). Mentholatum was still on the market in 1986.
Milk glass; 1¹⁵/₁₆″ × 1⁵/₈″ diameter; 17n; 20b; pl; v. See MENTHOLATUM (Trade Mark).

J. H. ZEILIN & CO//SIMMONS/
LIVER/REGULATOR//
PHILADELPHIA//MACON, GA.
[See Figure 81]
An 1887 package wrapper states: "A Strickly Vegetable Faultless Family Medicine. Price $1.00." Although formulated by Dr. A. Simmons, his daughter and grandson, Miles A. Thedford, manufactured and distributed the product until selling to Smith & McKnight in 1877, who in turn sold to the Chattanooga Medicine Co. Another of Simmon's children also sold the Regulator to J. H. Zeilin & Co., of Macon, GA and Philadelphia in 1868. A court suit settled the dispute and the Chattanooga Med. Co. renamed their product "Black Draught." Both products were being sold in 1929–30, *AD*. The labeled M. A. Thedford & Co's Original and Only Genuine Black Draught Liver Medicine was said to have been introduced in 1840 (Wilson and Wilson 1971). Black Draught adv. 1986 according to Laveal Ashley, Chattem Labs, 1715 W. 38th St., Chattanooga, (personal communication, 1986).
Aqua; 9″ × 2⁷/₈″ × 1³/₄″; 3n; 3b, modified; 6ip, three on front; v, b; h, f; v, ss. See CHATTANOOGA (Company), SIMMONS (Compound).

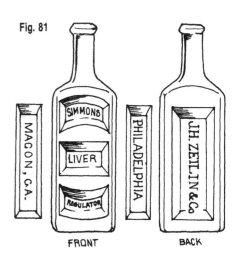

Fig. 81

FRONT BACK

THE ZEMMER CO./
MANUFACTURING CHEMISTS/
PITTSBURG, PA.
In Pittsburgh city directories from 1915 to 1960.
Clear; 4″ × 1¹/₂″ × ?; 3n; rect.; pl; v.

ZOA-PHORA COMPANY//ZOA-/
PHORA/WOMAN'S/FRIEND//
KALAMAZOO, MICH. U.S.A.
Liquid or tablet form, adv. 1889, *PVS & S*; 1929–30 by Syracuse Med. Co., Inc., 112 S. Clinton St., Syracuse, N.Y., *AD*.
Aqua; 7³/₈″ × 2³/₄″ × 2″; 9n; 3b; pl; v, s; h, f; v, s.

ZOELLER MEDICAL/MFG. CO./
PITTSBURGH, P.A., U.S.A.//
ZOELLER'S/KIDNEY REMEDY
[See Photo 21]
Label: *ZOELLERS KIDNEY REMEDY For The URINARY ORGANS, GRAVEL, CHRONIC CATARRH OF THE BLADDER, CHRONIC RHEUMATISM AND DROPSY. Prepared from Juniper Berries, Buchu Leaves & Other Valuable Diuretics. Guaranteed Under Food & Drugs Act, June 30, 1906. Serial No. 1059. Established 1870. MANUFACTURED BY THE ZOELLER MEDICAL MFG CO. INCORPORATED PITTSBURGH, PA. Adopted Jan. 1, 1907.* The only listing in Pittsburgh city directories was for William F. Zoeller, Liquors, 1905–1910.
Amber; 7″ × 2¹/₁₆″ × 2¹/₁₆″; 11n; 2b; pl; v, ss. See BLACK GIN (Miscellaneous).

THE ZOELLER/MEDICAL CO./
PITTSBURGH, PA.//
ZOELLER'S KIDNEY REMEDY
Label: *ZOELLERS KIDNEY REMEDY FOR THE URINARY ORGANS. . . .*
Amber; 9¹/₂″ × 2⁵/₈″ × 2⁵/₈″; 11n; 2b; pl; v, ss. See BLACK GIN (Miscellaneous).

AYER'S//COMPOUND EXT//
SARSAPARILLA//LOWELL/
MASS U.S.A.
See AYER *(Sarsaparilla).*

BACH'S//AMERICAN/
COMPOUND//AUBURN–N-Y
Originally the product of P. V. R.
Coventry & Co., Auburn, NY. (Baldwin
1973). Peter Coventry liquidated his
interests in the business ca. 1858; Fred
E. Smith, Rutland, VT, a general agent
for Bach's Compound for many years
may have purchased the business
(Wilson and Wilson 1971). Adv. 1851
(Baldwin 1973); 1910, *AD.*
Aqua; 7¼″ × 2⅞″ × ?; 10n; 3b; 3 or
4ip; v, sfs; p.

BACH'S//AMERICAN/
COMPOUND//AUBURN N.Y.
Light blue, aqua; 7¾″ × 3″ × 1⅞″;
1n; 3b; 3 or 4ip; v, sfs; p.

BAKER'S COMPOUND/BAMBOO
OWEGO/BRIAR TIOGA CO. N.Y.
Adv. 1900, *EBB.*
Aqua; 9″ × 2⅞″ × 1⅝″; 1n; rect.;
pl; v.

JOHN C. BAKER'S//COMPOUND//
FLUID EXTRACT OF//
SARSAPARILLA
See J. C. BAKER *(Sarsaparilla).*

[v] BEAVER/[h] &/[v] OIL/
COMPOUND
Dr. Jones' Beaver Oil, adv. 1887, *WHS;*
1912 by Morris Spiegal, Albany, NY
(Devner 1968).
Aqua; 5⅛″ × 1¹¹⁄₁₆″ × ⅞″; 1n; 3b;
3ip; v, h.

[v] BEAVER/[h] AND/[v] OIL/
COMPOUND
Aqua; 6¾″ × 2¼″ × 1¼″; 1n; 3b; ip,
arched front; v, h.

D̲R̲ BROWDER'S/COMPOUND
SYRUP/OF INDIAN TURNIP
See BROWDER *(Syrup).*

J. W. BULL'S//COMPOUND/
PECTORAL//BALTIMORE
See BULL *(Pectoral).*

BURRILLS COMPOUND/
CHERRY BALSAM
See BURRILL *(Balsam).*

J. CALEGARIS/COMPOUND
EXTRACT/SARSAPARILLA/
SAN FRANCISCO, CAL. [Base:]
W. T. & CO
See CALEGARIS *(Sarsaparilla).*

J. A. CALVINS//CELERY
COMPOUND
Cobalt; 9¾″ × 2½″ × 2½″; 2n; 2b;
4ip; v.

CARL'S/SARSAPARILLA AND/
CELERY COMP.//AURORA, ILL.//
AURORA, ILL
See CARL *(Sarsaparilla).*

CARTER'S/CASCARA COMPOUND
Cascara Sagrada, a laxative, adv. 1898;
1904 (Devner 1968).
Aqua; 7⅝″ × 2⅞″ × 1⅜″; 7n; 3b;
3ip; v.

D̲R̲ CARTER'S/COMPOUND/
PULMONARY/BALSAM
See CARTER *(Balsam).*

CHELF/CELERY-CAFFEIN/
COMP'D/CHELF CHEM. CO./
RICHMOND, VA. [Base:] 5
Adv. 1910, *AD;* 1929–30 by Chelf
Chem. Co., 105 S. 12th St., Rich-
mond, Va.; 1948 by Chelco Corp., 254
Sycamore St., Petersburg, Va., *AD.*
Cobalt; 4″ × 1⅝″ diameter; 3n; sp;
20b; pl; h; ABM.

CHELF'S/CELERY-CAFFEIN/
COMP'd/CHELF CHEM. CO/
RICHMOND, VA.
Blue; 2½″ × ?, also heights of 6¼″
and 7½″; 3n; 20b; pl; h.

[Script:] Otis Clapp & Sons/MALT
AND COD LIVER/OIL COMPOUND
See CLAPP *(Oil).*

JOSIAH COSBYS/VIRGINIA/
COMPOUND/VEGETABLE/
BITTERS/1834//B. R. LIPSCOMB,
AG ͭ//RICHMOND, V̲A̲
See COSBY *(Bitters).*

D̲R̲ DAVIS'S//COMPOUND//
SYRUP OF//WILD CHERRY//
AND TAR
See DAVIS *(Syrup).*

DRAKE'S//PALMETTO
WINE//COMPOUND//
CHICAGO ILLS
Label: *DRAKE'S PALMETTO COM-
POUND. Alcohol 15%. A Reliable Remedy
for Catarrh Manufactured for the
Drake Company, Wheeling, W. Va.
Guaranteed by The Drake Company under
the Food and Drugs Act, June 30, 1906.
Serial No. 618.* Adv. 1907, *PVS & S;*
1929–30, 1935 by Sterling Products
Inc., Wheeling, W. Va., *AD.*
Clear; 9¼″ × 2″ × 2″; 7n; sp; 2b; 4ip;
v, fsbs.

EGYPTIAN/VEGETABLE/
COMPOUND
Clear; 8¾″ × 3″ × 1¾″; 1n; 3 or 6b;
ip, oval front; v.

ENO'S FRUIT SALT -/DERIVATIVE/
COMPOUND
Light green; dimens. unk.; 7n, rect.;
pl; v. See ENO *(Miscellaneous).*

Eureka Pepsin/Celery Compound//
A Never Failing/Tonic
See EUREKA *(Pepsin).*

GARNETT'S/COMPOUND/
VEGETABLE BITTERS/
RICHMOND, VA.
See GARNETT *(Bitters).*

GAYS' COMPOUND//EXTRACT
OF/CANCHALAGUA//NEW YORK
1848 advertisement: "Gays' CAN-
CHALAGUA, A Californian Plant of
Rare Medical Virtues Unequalled in its
Eradiction of All Morbid Humors and
Impurities of the Blood." Directories
included Frederick A. Gay, New York
City, as proprietor of Gays' Canchalagua
from 1846–1850; Rushton, Clark &
Co., same city, became the general
agents in 1847 or 1848.
Aqua; 7″ × ? × ?; 11n; 3b; 3 or 4ip
arched; v, sfs; p. See RUSHTON *(Oil).*

[Script:] Gladstone's Celery/And
Pepsin Compound//Mastico
Medicine Co/Danville, Ills.
Amber; 7⅜″ × 4⅛″ × 2¼″; 12n; 6b;
pl; v, ss.

S. B. GOFFS//COMPOUND MAGIC/
OIL LINIMENT//CAMDEN N.J.
See GOFF *(Liniment).*

J. E. GOMBAULT'S/CAUSTIC
BALSAM/COMPOUND//THE
LAWRENCE WILLIAMS CO.//
THE LAWRENCE WILLIAMS CO.
See GOMBAULT *(Balsam).*

Graefenberg C<u>o</u>//SARSAPARILLA/
COMPOUND/NEW YORK
See GRAEFENBERG (Sarsaparilla).

DR. HARTER'S//IRON TONIC
COMPOUND
See HARTER (Tonic).

DR. HAYDEN'S [Base:] VIBURNUM/
COMPOUND
The 10 Sept. 1892 Medical Record
advertised: " 'H. V. C.' Hayden's Vibur-
num Compound as an unequaled
remedy of women's ailments and 'The
Only Reliable Remedy Known for Dys-
menorrhea and Menorrhagia.' The New
York Pharmaceutical Co., Bedford,
Mass." 4 oz., 10 oz. & 16 oz. sizes
available. Company established in
1870s in Bedford, MA (Wilson and Wil-
son 1971). Adv. 1877, McK & R; 1948
(same firm), AD.
Aqua; 7¼″ × 3″ diameter; 9n; 20b;
pl; h.

HIMALYA/THE KOLA/
COMPOUND/NATURES/
CURE FOR/ASTHMA/NEW YORK/
CINCINNATI
Also manufactured in London. Adv.
1895, PVS & S; 1915, SF & PD.
Light amber; 7½″ × 2½″ × 2½″; 7n;
1b; ip, arched front; h.

DR. SAMUEL HODGES//
COMPOUND SARSAPARILLA/
AND/IODIDE POTASH//
NASHVILLE, TENN.
See HODGES (Sarsaparilla).

THE HONDURAS CO'S//
COMPOUND EXTRACT//
SARSAPARILLA//ABRAMS &
CARROLL/SOLE AGENTS/S.F.
See HONDURAS (Sarsaparilla).

HOOD'S/COMPOUND/EXTRACT/
SARSA/PARILLA//C. I. HOOD &
C<u>o</u>//LOWELL, MASS.
See HOOD (Sarsaparilla).

DR. A. S. HOPKINS//COMPOUND
EXT//SARSAPARILLA
See HOPKINS (Sarsaparilla).

Dr HUNTINGTON.S//COMPOUND
RESTORATIVE/SYRUP//
TROY. N. Y.
See HUNTINGTON (Syrup).

THO<u>s</u>. A. HURLEY'S//COMPOUND
SYRUP/OF/SARSAPARILLA//
LOUISVILLE, K.Y.
See HURLÆY (Sarsaparilla).

KAY BROTHERS L<u>TD</u>/LINSEED/
COMPOUND/(TRADE MARK)//
STOCKPORT
Adv. 1897, EF; 1912 (British Medical
Association).
Aqua; 5⅛″ × 1¹¹/₁₆″ × 1¹/₁₆″; 1n; 3b;
4ip, oval; v, sfs.

DR. M. G. KERR/&/BERTOLET//
COMPOUND/ASIATIC BALSAM//
NORRISTOWN PA
See KERR (Balsam).

LIPPMAN'S//COMPOUND
EXTRACT//SARSAPARILLA/WITH
100 POTASS//SAVANNAH, GA.
See LIPPMAN (Sarsaparilla).

MASURY'S/SARSAPARILLA/
COMPOUND//J. & T. HAWKS//
ROCHESTER, NY.
See MASURY (Sarsaparilla).

CELERY COMPOUND/HAZEN
MORSE/TORONTO & NEW YORK
Adv. 1890, W & P; 1910, AD.
Clear, 4¾″ × ?; 9n; 21b; pl; v.

COMPOUND EXTRACT/OF/
MOUNTAIN ASH
Ulmer's Mountain Ash, adv. 1850
(Baldwin 1973).
Aqua; 7½″ × 3¼″ × 2″; 5n; 4b; pl;
v; p.

DR. NUNN'S/BLACK OIL/HEALING
COMPOUND
A smoothing, softening oil for horses,
cattle & sheep, introduced 1873 (Fike
1967); adv. 1974.
Clear; 5½″ × ?, also 7¼″ × 2⅞″; 7n;
20b; pl; v. Also earlier variant with
BALSAM rather than COMPOUND.
See NUNN (Balsam).

D<u>R</u>. B. OBER'S//COMPOUND
EXTRACT/OF/MOUNTAIN ASH
Green, aqua; 7½″ × 3¼″ × ?; 5n; 4b,
modified; pl; v, cf; p.

[Embossed swastika]/COMPOUND/
LAXATIVE SYRUP/MFGD BY T. S.
PAINE/WAYCROSS GA.
See PAINE (Syrup).

PAINE'S//CELERY COMPOUND
Label: PAINE'S CELERY COMPOUND,
A True Nerve Tonic, An Active Alterative,
A Reliable Laxative and Diuretic. It
Restores Strength, Renews Vitality, Purifies
the Blood, Regulates the Kidney's, Liver and
Bowels. PRICE $1.00. Prepared by
WELLS, RICHARDSON & CO., SOLE
PROPRIETORS, BURLINGTON, VT.
Introduced in 1882 by Milton K. Paine,
Windsor, VT. Wells, Richardson & Co.

became agents and owner in the late
1880s (Wilson and Wilson 1971).
Proprietorship transferred to the
predecessor of Sterling Drug Co. in the
1920s (Fritschel 1974). Adv. 1885 by
M. K. Paine, Windsor, Vt., in the New
Hampshire Register, Farmer's Almanac &
Business Directory; 1921, BD.
Amber, aqua, clear; 9¾″ × 2½″ ×
2½″; 2n; 2b; 4ip; v, fb. See
J. F. HENRY (Company).

PHOSPHO-CAFFEIN COMP./
ARLINGTON CHEMICAL CO./
YONKERS, N.Y.
See ARLINGTON (Chemical).

NUEVO COMPOUND VEGETAL/
DE PINKHAM
Label: Nuevo Compuesto Vegetal De Lydia
E. Pinkham, Sedante Uterino Fabricado
Por Laboratorios, Azteca, S.A.
Clear; 7⅞″ × 3⅜″ × 1⅞″; 16n; 13b;
pl; v. See PINKHAM (Medicine,
Purifier), also next entry.

LYDIA E. PINKHAM'S/
VEGETABLE COMPOUND
Lydia Estes Pinkham began bottling her
popular cure and compound for ladies'
complaints in Lynn, MA, in 1873
(Munsey 1970). After her death in
1883, the company became known as
Lydia E. Pinkham's Sons & Co.
(Wilson and Wilson 1971). Prior to the
1906 Act, the label did not mention
alcoholic content; after the Act, use of
the word Cure was dropped and the
alcoholic content became 18%. After
1918 it was reduced to 15%. Adv. 1983
by Coopervision Pharmaceuticals, Inc.,
San German, P.R., AD.
Aqua; 8¼″ × 3⅝″ × 1⅞″; 7n; 12b; pl;
v. See PINKHAM (Medicine, Purifier).

DR. J. W. POLAND'S/WHITE PINE/
COMPOUND
Label: . . . a Great New England
Remedy. A Cure for Sore Throats, Colds,
Coughs, Diptheria, Spitting of Blood and
as Remedy for Kidney Complaints, Dia-
betes, Difficulty of Voiding Urine. . . .
James W. Poland, Concord, NH, began
dispensing remedies on a limited basis
in the 1830s and moved to Manchester,
NH in the 1840s (Wilson and Wilson
1971). Poland had resigned as pastor of
a Baptist Church near Manchester in
1847, due to poor health. He studied
medicine to find remedies for his own
ills and found his remedies to be in
demand (Holcombe 1979). Dr. J. W.
Poland's Humor Doctor was introduced
in 1848 (Singer 1982); the White Pine
Compound was being advertised in

1855, but was previously called Dr. Poland's Cough Medicine (Holcombe 1979). Poland was listed in Goffstown Centre, NH, in 1855 and in Melrose, MA in 1863 (Singer 1982). George W. Swett and the New England Botanic Depot became proprietor of the afore-mentioned products ca. 1864. Poland continued to manufacture some family remedies but many formulas and rights were sold. Poland's remaining remedies were purchased by the firm of Littlefield & Hayes in 1872. There appears to be no record of G. W. Swett or of the Depot after 1872 (Holcombe 1979), and it is unclear who controlled and acquired the compound and Humor Doctor. Compound adv. 1910, *AD*.

Aqua; 5″ × 1¾″ × 1″; 1n; 13 or 15b; 1ip; v. See POLAND (Killer, Miscellaneous).

RIKER'S/COMPOUND/ SARSAPARILLA
See RIKER *(Sarsaparilla)*.

Dᴿ J. A. SHERMAN'S//RUPTURE/ CURATIVE/COMPOUND// NEW YORK
Amber; 8⅜″ × 3¼″ × 2″; 7n; 3b; 4ip; v, sfs.

Dᴿ SIMMONS/SQUAW VINE WINE COMPOUND
Aqua; 8⅞″ × 2¹³⁄₁₆″ × 1¾″; 11n; 3b; 4ip; v. See ZEILIN *(Company)*.

Dr. Slocum's/coltsfoote/compound/ Expectorant/TRADE MARK
See SLOCUM *(Expectorant)*.

SPOHN'S DISTEMPER COMP./ SPOHN MEDICAL COMPANY/ GOSHEN, INDIANA, U.S.A.
[Base: I in diamond]
Bottle manufactured by the Illinois Glass Co., Alton, IL, 1916 to 1929 (Toulouse 1972). Adv. as Spohn's Distemper Cough Remedy, 1907, *PVS & S*; 1935, *AD*.

Aqua; 5″ × 1³⁄₁₆″ × 1¹³⁄₁₆″; 1n, sp; rect.; 1ip; v; ABM. See SPOHN (Cure).

THOMPSONS/HERBAL/ COMPOUND
Label: *THOMPSON'S HERBAL COMPOUND Absolute Cure For Catarrh, Stomach & Kidney Trouble. The Thompson Remedy Co. New York. New Name August 1, 1902.*
Clear; 6¾″ × 2½″ × 1½″; 9n; 5b, round corners; pl; v.

THOMSON'S//COMPOUND/SYRUP OF TAR//FOR/CONSUMPTION// PHILADA
Product of Angney & Dickson, Philadelphia, 1845 (Baldwin 1973).
Aqua; 5¾″ × 2⅛″ × 1⅜″; 11n; 3b; 4ip; v, sfsb.

DR. THOMSON'S/COMPOUND EXTRACT/SARSAPARILLA
See THOMSON *(Sarsaparilla)*.

Dᴿ PHILIP THORPE'S/COMPOUND/ FRUIT JUICES/A DELICIOUS/ MORNING LAXATIVE
Clear; 4½″ × 1½″ × ⅝″; 11n, sp; 12b, inset; pl; h; picnic or pumpkin seed flask shape.

Dᴿ THRALLS//COMPOUND EXTRACT/COHOSH POND LILLY//NUNQUAH
Cure for female weakness, adv. 1853 (Baldwin 1973).
Aqua; 7½″ × 2¾″ × 1¾″; 11n; 3b; pl; v, sfs; p.

WAKEFIELD'S/BLACKBERRY/ BALSAM COMPOUND
See WAKEFIELD *(Balsam)*.

WAMPOLE'S/SYRUP HYPO. COMP./PHILADELPHIA
See WAMPOLE *(Syrup)*.

J. B. WHEATLEYˢ/COMPOUND SYRUP/DALLASBURGH, KY.
Bottle manufactured ca. 1857. Believed to have been bottled for country doctor, Jonathan B. Wheatley (Wilson and Wilson 1971).
Aqua; 6⅛″ × 2½″ diameter; 1n; 20b; pl; v; p.

Dᴿ. WILCOX/COMPOUND// EXTRACT OF/SARSAPARILLA
See WILCOX *(Sarsaparilla)*.

JOHN M. WINSLOW//COMPOUND/ BALSAM OF/HOARHOUND// COLDS COUGHS/AND/ CONSUMPTION
See WINSLOW *(Balsam)*.

DR. A ZABALDANO/COMPOUND SYRUP/OF EUCALYPTUS
See ZABALDANO *(Syrup)*.

1. DR. BAXTER'S//MANDRAKE BITTERS, from Vermont; advertised in 1881. Twelve-sided bottle.

2. DOYLE'S//HOP//BITTERS. ". . . For General Debility . . . Fever and Ague, Liver Complaint, Mental Depression and all Diseases of the Kidneys and Urinary Organs"; registered ca. 1872 .

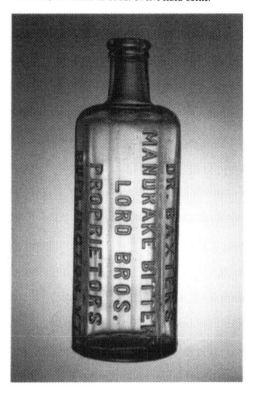

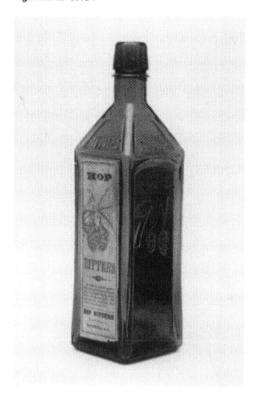

3. FERRO QUINA/STOMACH BITTERS, from San Francisco; introduced in 1895.

4. SAMPLE/LASH'S BITTERS. Product of John Spieker and Tito Lash, San Francisco, introduced in 1884.

5. Clark's Cordial label on bottles embossed LASH'S/ BITTERS CO.; produced ca. 1890 to 1910.

6. "Dr. B. F. Sherman's Compound Prickly Ash Bitters with Buchu, Button Snake, Senna, Sodium Acetate and Other Drugs was . . . recommended for constipation and flatulence, among other ailments." Bottle embossed PRICKLY ASH/BITTERS C⁰ . Advertised 1885 to 1935.

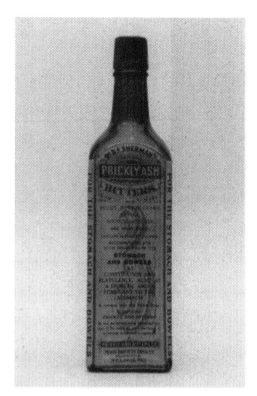

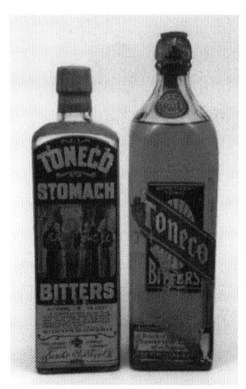

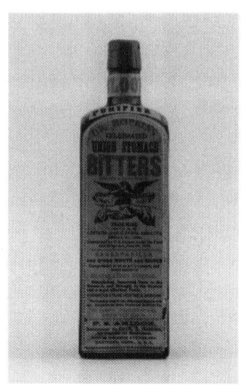

7. "Toneco Stomach Bitters" and "Toneco Appetizer Bitters" were products of the Lash's Bitters Co. of San Francisco. The bottles were embossed TONECO BITTERS early in the twentieth century.

8. DR. A. S. HOPKINS/UNION STOMACH BITTERS were composed of roots and barks and were for the "Purification of the Blood." Produced ca. 1900.

9. Bottle embossed WAIT'S/KIDNEY AND/LIVER BITTERS//CALIFORNIA'S OWN/TRUE LAXATIVE/AND BLOOD PURIFIER. "... A Purely Vegetable Compound For All Diseases Arising From a Disordered Condition of the Stomach, Liver or Bowels." Bottled ca. 1906 to ca. 1920.

10. Bottle embossing identical to Photo 9. A product of George Z. Wait of Sacramento for "... all Bronchial Affections." Bottled ca. 1906 to 1920.

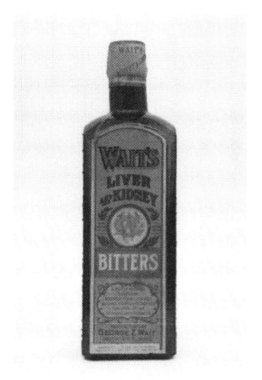

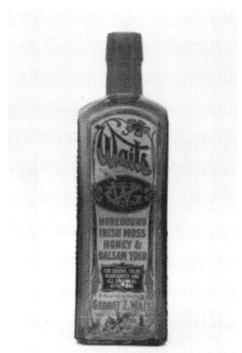

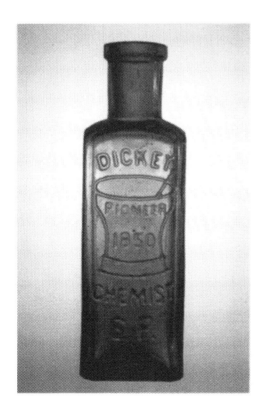

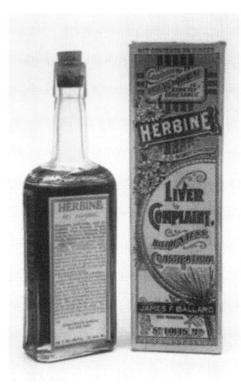

11. DICKEY/PIONEER/1850/CHEMIST/S. F. The product was a complexion cream advertised 1850 to 1923. Both cobalt and amber bottles were produced.

12. HERBINE was a 20 percent alcohol solution for "... Bilousness, Costiveness, Indigestion, Bloated Abdomen, Wind in the Bowels, Foul Breath"; produced ca. 1891 to ca. 1942.

13. Bottle was embossed in script: I. L. Lyons and Co./New Orleans, La.

14. The NATIONAL PHARMACY Co/ SAN FRANCISCO, CAL was still in existence in 1951.

15. THE/PISO COMPANY bottle contained Piso's Cure, a product of Hazeltine and Co. of Warren, PA. Product was introduced in 1864.

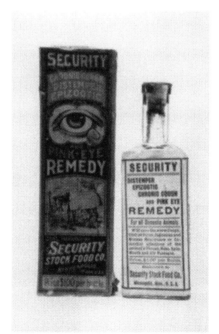

16. F. Aᵈ RICHTER & CO.//NEW YORK produced the Anchor Pain Expeller for "... Rheumatism, Gout, Influenza, Backache, Pain in the Side, Chest and Joints, Neuralgia, Sprains, etc...." Product was introduced in 1869.

17. This variant was not embossed. The Security Remedy Co. of Minneapolis, MN, was producing veterinarian products from the 1910s to the 1940s.

18. TWITCHELL CHAMPLIN & Co// NEURALGIC ANODYNE was introduced in 1883 as "A Valuable Remedy for the Cure of Neuralgia, Headache ... Diarrhoea, Sea Sickness"

19. VAPO-CRESOLENE was an effective vaporizing germicide produced from 1879 to 1983.

20. Embossed H.H. WARNER & CO.// TIPPECANOE. The product was first advertised as bitters. Later promotions stated: "After Once Using Our 'Tippecanoe,' You Will Use No Nostrums Nor Preparations Called Bitters." Production was around 1883 to 1910.

21. ZOELLER'S KIDNEY REMEDY was "Prepared from Juniper Berries, Buchu Leaves & Other Valuable Diuretics." The remedy was produced ca. 1870 to 1910.

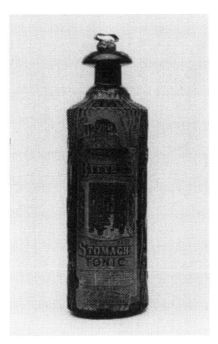

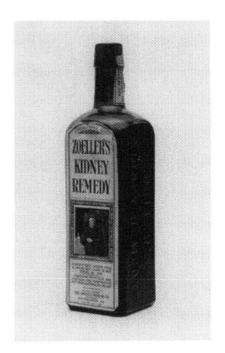

22. DR. KILMER'S/SWAMP ROOT/KIDNEY LIVER/AND BLADDER CURE was introduced in 1881. Later bottles were embossed REMEDY (See Photo 66).

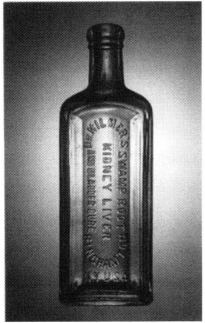

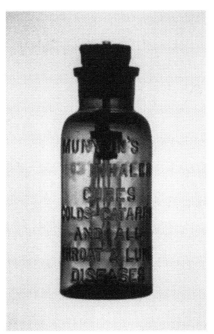

23. MUNYON'S INHALER, a product of Professor M. Munyon of Philadelphia, PA, was advertised 1907 to 1910.

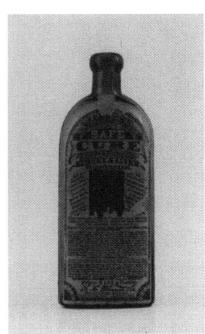

24. WARNER'S SAFE CURE was introduced by Hubert H. Warner of Rochester, NY, in 1879.

25. Embossed AMERICAN DRUG CO/NEW YORK, this universal container was produced after 1899.

26. The N. Y. DRUG CONCERN/NEW YORK sold a cold remedy advertised ca. 1917 to 1935.

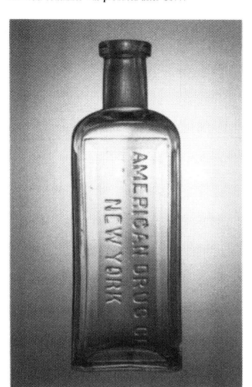

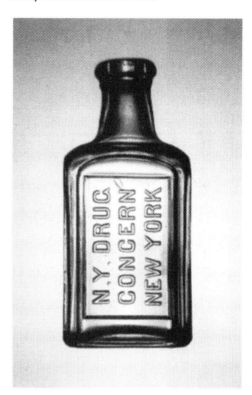

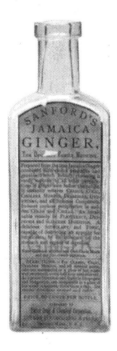

27. Embossed POTTER DRUG AND CHEMICAL CORP., this bottle contained SANFORD'S JAMAICA GINGER, "... A Delicious Family Medicine for Relief of Cramps, Colic, Cholera Morbus, Diarrhoea, Dysentary ...," registered in 1876.

28. AYER'S//HAIR VIGOR, introduced in 1867 by James C. Ayer of Lowell, MA, claimed use "For Restoring Gray Hair to its Natural Vitality and Color."

29. C. H. EDDY AND CO./JAMAICA/GINGER/
BRATTLEBORO, VT. contained an intoxicating beverage,
with some medicinal applications, which was used as a
substitute for hard liquor or beer.

30. TURNER'S/ESS OF/JAMAICA GINGER was a
product of the six Turner brothers of New York who
manufactured "... ginger wine, syrups, cordials, bitters,
native wines & c." from 1844 to 1865.

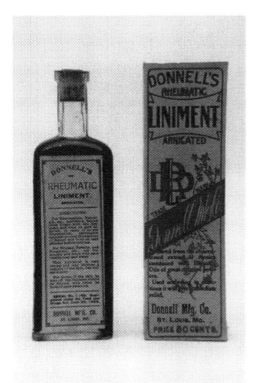

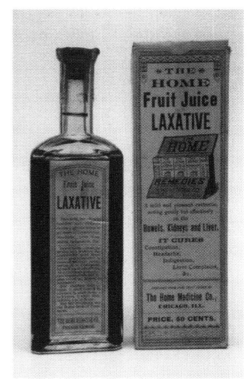

31. DONNELL'S/RHEUMATIC LINIMENT was introduced
in 1874 and was produced by John W. Donnell of
St. Louis, MO.

32. Bottles embossed HOME MEDICINE CO./CHICAGO
ILLS contained such products as the Home Fruit Juice
Laxative, advertised in 1894 as an ". .. effective laxative
and cathartic"

33. LORENZ MED. CO.//TRADE "TO-NI-TA" MARK. The vessel contained a bitters advertised as "An Invigorating and Stimulating Tonic" The alcohol level was 23 percent. The bitters were produced ca. 1890 to 1920.

34. Embossed A.D.S./514/24. A.D.S., Iron Tonic Bitters were advertised as ". . . Excellent as an Appetizer and General Tonic . . . ," alcohol content 20 percent. Production from ca. 1905 to 1935.

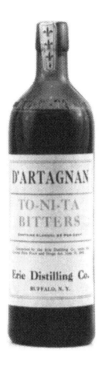

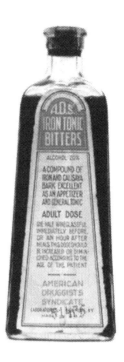

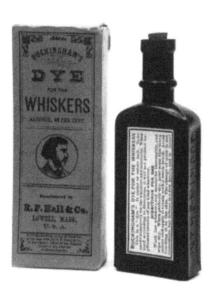

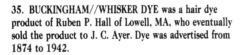

35. BUCKINGHAM//WHISKER DYE was a hair dye product of Ruben P. Hall of Lowell, MA, who eventually sold the product to J. C. Ayer. Dye was advertised from 1874 to 1942.

36. CARLSBAD was a Bohemian-imported laxative of sprudel salts introduced in 1863.

37. FERRO-CHINA-BISLERI/MILANO was manufactured by Joseph Personeni of New York ca. 1881 to 1910.

38. GLYCOZONE, introduced ca. 1885, was proclaimed to be the "Absolute Cure for Dyspepsia, Catarrh of the Stomach, Ulcer of the Stomach, Heart-Burn, etc. . . ."

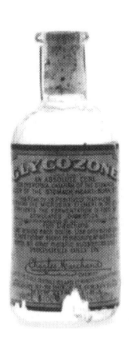

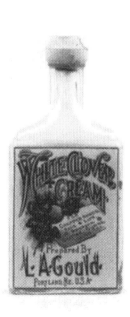

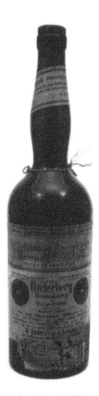

39. L. A. GOULD/PORTLAND, ME. manufactured White Clover Cream as the only effective treatment ". . . For Chapped Hands, Face, Lips, Chafing, Salt Rheum, Eczema and Sunburn. For Burns, Scalds, Cuts . . ."

40. This shapely bottle embossed HUA contained an aromatic bitters preparation ". . . of water, alcohol, roots, and herbs of the genus Gentiana . . ." which was introduced in 1846.

41. "Kickapoo Indian Sagwa," introduced in 1881, was embossed HEALY AND BIGELOW//INDIAN SAGWA. John Healy and Charles Bigelow, New Haven, CT, distributed their products via traveling medicine shows.

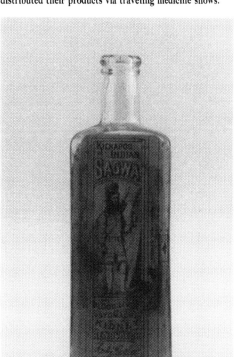

42. HUFELAND, introduced in 1851, claimed to be "... the first and the most healthful tonic ever introduced in the U.S."

43. HUMPHREY'S/MARVEL/OF WITCH HAZEL, known as a "Cure for Wounds, Bruises, Scalds, Toothache, Sunburns, Faceache . . . ," was a product of the Fred Humphrey Homeopathic Medicine Co., established in 1894.

44. INJECTION RICORD/PARIS was similar to another product, Ricord's Injection Brou, which was a French-imported cure for genital disease. Both products were advertised in 1843.

45. DR. D. JAYNE'S/ALTERATIVE/242 CHESṬ SṬ was manufactured by Dr. David Jayne of Philadelphia, PA, and was introduced in 1851.

46. DR. KILMER'S//SWAMP-ROOT was an herbal medicine introduced in 1881 by Andral and Jonas Kilmer of Binghampton, NY. Product claimed to be a "Diuretic to Kidneys and a Mild Laxative."

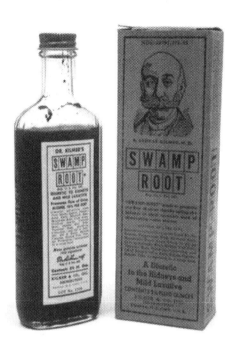

47. KUTNOW'S POWDER was advertised in 1898 as "...invaluable in diseases of the Stomach, Liver, Kidneys and Bladder."

48. LAXOL//A. J. WHITE//NEW YORK. The unique shape of a rounded back and a three-sided front makes this bottle easy to identify. Laxol was introduced by Albert J. White in 1894.

49. OZOMULSION was a "flesh forming food medicine for thin women, emaciated men, worn out mothers and thin children." Introduced in the 1880s.

50. PAGLIANO//GIROLAMO Curative Syrup was an Italian import containing **17.70** percent alcohol. Advertised in the United States in 1887.

51. Bottles embossed THE NAME/St. Joseph's/ASSURES/PURITY contained many products. St. Joseph's Witch Hazel was advertised in 1935.

52. Embossed DR. A. P. SAWYER/CHICAGO, the bottle contained Dr. Sawyer's Celebrated Cough Balsam. Alvin P. Sawyer established this Illinois-based business in the 1880s.

53. Embossed in script: W. F. Severa//Cedar Rapids, Iowa. Waclau Francis Severa advertised products in 1888. This vessel contained stomach bitters.

54. Products of JOS. TRINER//CHICAGO were advertised in 1901.

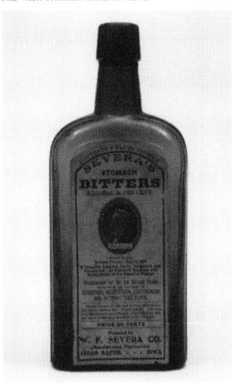

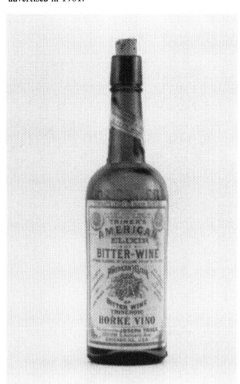

55. Embossed DR. VAN DYKE. Holland Bitters were patented in 1896.

56. VAR-NE-SIS, "For Rheumatism," was a product of the Var-Ne-Sis Company, Lynn, MA from 1916 to 1948.

57. Embossed TRIAL MARK/WATKINS. The firm of Joseph R. Watkins, Winona, MN, celebrated one hundred years in business in 1968.

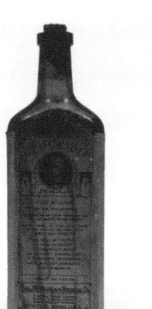

58. L.H. WITTE/HOMOEOPATHIC PHARMACY/ CLEVELAND O. was operating in the 1880s and 1890s.

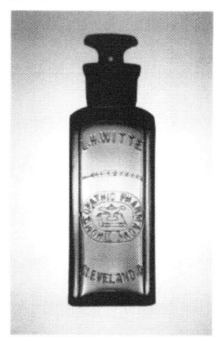

59. JOHN WYETH & BRO., of Philadelphia, PA, bottled effervescent salts around 1900 in this unique container with a dose cap.

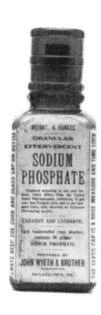

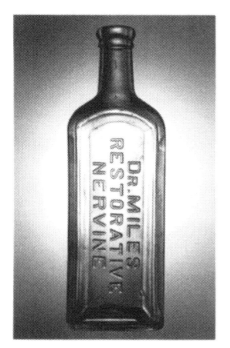

60. DR. MILES/RESTORATIVE/NERVINE was produced between 1881 and 1979.

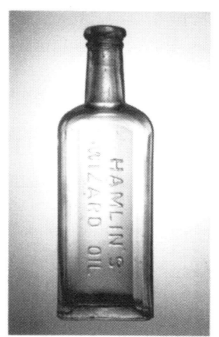

61. John A. Hamlin, Cincinnati, OH, introduced HAMLIN'S/WIZARD OIL in 1859. Advertisements stated it was "For Internal & External Use. Cures Rheumatism" Product was popularized by traveling medicine shows.

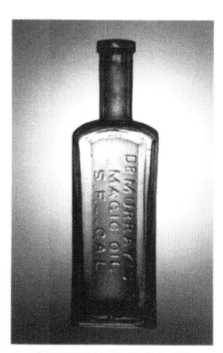

62. DᴿMURRAY'S/MAGIC OIL/S. F.–CAL. was advertised in 1896 as the "King of Pain, For External and Internal Aches or Pains."

63. SCOTT'S/EMULSION was an extremely popular cod liver oil introduced by Alfred Scott and Samuel Bowne of New York City in 1876.

64. ACKER REMEDY//FOR THROAT AND LUNGS//ACKER REMEDY CO./PROPRIETORS. Acker's Remedies claimed to "... stop a cough in one night ... check a cold in a day ... and prevent croup, relieve asthma and cure consumption if taken in time." Production was from the 1870s to the 1930s.

65. An 1848 advertisement stated: "Beware of Counterfeits ... Every Bottle has the words DR. P. HALL'S/COUGH REMEDY blown upon the glass" Later vessels substituted CATARRH for COUGH.

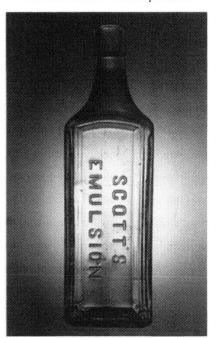

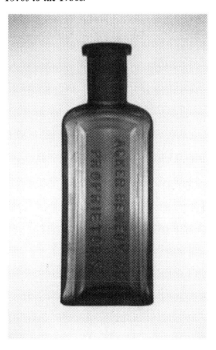

66. Note that DR. KILMER'S/SWAMP-/ROOT/ KIDNEY/LIVER &/BLADDER/REMEDY was embossed within an impressed kidney.

67. FARR'S/GRAY HAIR/RESTORER/BOSTON/ MASS was a popular turn-of-the-century dressing for restoring hair color.

68. THE/EDWIN W. JOY CO./SAN FRANCISCO produced as JOY'S SARSAPARILLA "A Fortunate Combination of the Most Effective Liver and Kidney Remedy, Blood Purifier, Stomach Regulator and Vegetable Laxative in Existence." Production ca. 1880s to 1915.

69. PERUVIAN SYRUP, introduced in 1854, claimed to be the sure remedy for "... Dyspepsia, Liver Complaint, Dropsy, Languor and Depression of Spirits, Piles, Carbuncles and Boils, Scurvy ... plus Diseases peculiar to Tropical Climates."

70. DR. PIERCE'S/ANURIC/TABLETS/FOR KIDNEYS/AND BACKACHE was a product of Dr. Ray Vaughn Pierce, Buffalo, NY.

71. CONGRESS SPRING CO./C/SARATOGA N.Y. Mineral waters were billed as very therapeutic, purifying and soothing in consumption. The Congress and Saratoga Springs in New York are among the most popular springs in the world.

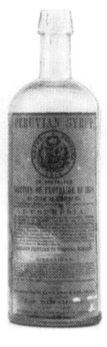
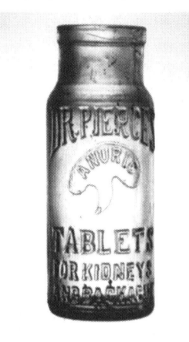
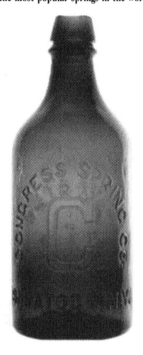

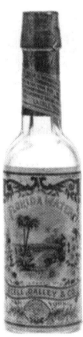
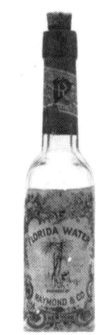

72. Bottle embossed FLORIDA WATER/LAZELL DALLEY & CO. Lewis T. Lazell and Henry Dalley produced this product from ca. 1887 to ca. 1914.

73. Bottle embossed FLORIDA WATER/ RAYMOND & CO./NEW YORK. This distinctive shape is exclusive to Florida waters and, to some extent, castor oils.

74. The Veronica Medicinal Springs Water Co. of Santa Barbara, CA, registered its VERONICA/ MINERAL WATER in 1893.

CORDIAL

**CLARK'S/CALIFORNIA/CHERRY/
CORDIAL**
Amber; 8¹/₈″ × 4¹/₄″ × 2¹/₄″; 12n; 6b;
pl; h, embossed within diamond. See
LASH (Bitters).

**DR CONVERS/INVIGORATING/
CORDIAL**
A Utica, NY product adv. 1845 (Bald-
win 1973).
Aqua; 6¹/₈″ × 3″ × ?; 11n; 12b; pl;
v; p.

**DR. FOORD'S//TONIC//
CORDIAL//CAZENOVIA,/N.Y.**
Adv. 1845 (Baldwin 1973); 1910, *AD*.
Aqua; 4¹/₄″ × 1¹/₂″ × 1¹/₈″; 5n; 3 or
6b; pl; v, fsbs. See FOORD (Syrup).

**DR. B. FOSGATE/AUBURN N.Y.//
PULMONIC/CORDIAL**
Adv. 1871, 1891, *WHS*.
Clear; 5³/₄″ × 2″ × 1¹/₂″; 1n; 3b; 3 or
4ip; v, fb; p.

**B. FOSGATES/ANODYNE/
CORDIAL**
Cure for teething and summer com-
plaint. Product of Blanchard Fosgate
(Baldwin 1973) and The Fosgate Lab.,
Auburn, NY, established in 1823
(Devner 1968). Cordial adv. 1823
(Baldwin 1973); 1923, *SF & PD*.
Aqua; 4³/₄″ × 1¹/₈″ diameter; 13n;
20b; pl; v; p; some variants without p.

**HAGEE'S CORDIAL//
KATHARMON CHEMICAL CO./
ST. LOUIS, MO.**
Label: *HAGEE'S ORIGINAL CORDIAL
COMPOUND, Alcohol 8% – Appetizer,
Stomachic, Stimulant to the Appetite
. . . .* Adv. 1895 as Hagee's Cordial of
Cod Liver Oil, *PVS & S*; 1941–42 by
Consolidated Drug Trade Products,
544 S. Wells St., Chicago, *AD*.
Clear; 8¹/₈″ × 3¹/₈″ × 2″; 10n; 11b; pl;
v, ss; ABM.

**DR. HILL'S//CARMINATIVE/
CORDIAL.//FARMER, N.Y.**
Adv. 1868 (Baldwin 1973).
Aqua; 8³/₄″ × 2⁵/₈″ × 1³/₈″; 1n; 3 or
6b; ip; v, sfs. See HILL (*Killer*, Syrup).

**Dᴿ HOOFLAND'S/BALSAMIC
CORDIAL//C. M. JACKSON/
PHILADELPHIA**
See HOOFLAND (*Balsam*).

**JACOB'S//CHOLERA &//
DYSENTERY//CORDIAL**
Advertisement, 1860: "10,000 negroes
saved yearly, Planters take notice,
Jacobs' cordial is the only sure and posi-
tive remedy in dysentery, diarrhoea, and
flux" (Baldwin 1973). It is uncertain who
was proprietor of this product: Dr. Wm.
W. Bliss & Co., Savannah, GA (*Bottle
Digest*, Jan 1974, Alabama Bottle
Collectors Society), or Stephen
Spencer, New Haven, CT (Wilson and
Wilson 1971). Adv. ca. 1845; 1916,
MB.
Aqua; 6³/₄″ × 1⁷/₈″ × 1⁷/₈″; 7n; 2b; 3ip;
v; p.

**MRS. E. KIDDER/DYSENTERY/
CORDIAL/BOSTON**
A formula of Elias Kidder, Boston, in
the 1830s, assumed by his wife after his
death in the 1840s (Wilson and Wilson
1971). Directories first establish Mrs.
Elias Kidder's medicinal depot in 1842,
products "Sold by Herself at Wholesale
and Retail, 88 altered to 100 Court
Street, Boston." Products for 1842
included Cholera, Dysentery &
Diarrhoea Cordial, Jaundice Bitters,
Purifying Vegetable Pills, Dalley's Pain
Extractor, Corn Extractor and Bristol's
Sarsaparilla. The last reference to the
business is 1858. Subsequent proprie-
tors are unknown. Cordial adv. 1910,
AD.
Aqua; 7¹/₈″ × 3³/₈″ diameter; 2n; 20b;
pl; v; p.

**DR McCABES/TONIC/CORDIAL/
Sᵀ LOUIS MO**
Label: *DR McCABES TONIC CORDIAL
Entered According to Act of Congress in
1872. Direct All Orders to Our Laboratory
Nos. 113 & 115 Morgan Street, St. Louis.*
Aqua; 9³/₄″ × 3³/₄″ × 1⁷/₈″; 1n; 12b; pl;
v.

**DR. J. H. McLEAN'S/
STRENGTHENING/CORDIAL/&/
BLOOD PURIFIER**
See MCLEAN (*Purifier*).

**Dᴿ. MORSE'S/INVIGORATING/
CORDIAL.**

"Dr. Morse's INVIGORATING COR-
DIAL . . . Prepared by M. Morse,
M.D., New York City . . . Sold by C.
H. Ring, Boston; Fetridge & Co and W.
V. Spencer, New York . . ." (*New York
Daily Times*, 8 Jan 1853). Adv. 1910,
AD.
Aqua; 7¹/₂″ × 2⁷/₈″ × ?; 11n; 12b; pl; v;
p. See MORSE (*Pills, Syrup*).

**PEYCHAUD'S/AMERICAN/
AROMATIC/BITTER/CORDIAL/
L. E. JUNG/SOLE PROPRIETOR/
29 CAMP &/116 COMMON STS./
NEW ORLEANS/LA.**
See PEYCHAUD (*Bitters*).

**PEYCHAUD'S/AMERICAN/
AROMATIC/BITTER/CORDIAL/
L. E. JUNG/SOLE PROPRIETOR/
NEW ORLEANS**
See PEYCHAUD (*Bitters*).

**SHAKER DIGESTIVE CORDIAL//
A. J. WHITE, NEW YORK**
Four sizes adv. 1895, *PVS & S*; 1910,
AD.
Aqua; 7″ × 2³/₈″ × 1⁷/₈″; 1n; 6b; pl; v,
ss. See LAXOL (Miscellaneous), SEIGEL
(*Syrup*), SHAKER (Pills), WHITE
(Miscellaneous, Syrup).

**Dᴿ WARREN'S//TONIC
CORDIAL//CINCINATTI & N.Y.**
Product of A. L. Scovill & Co., 65
Warren St., New York. Warren St. was
the company's first location in 1849,
and probably the source for the name.
Adv. 1870s (Devner 1968); 1910, *AD*.
Aqua; 9″ × 2¹¹/₁₆″ × 2¹¹/₁₆″; 11n; 2b;
3ip; v, fsb. See BAKER (Miscellane-
ous), BENNETT (Cure), HALL
(*Balsam*), J. HENRY (*Company*),
SCOVILL (*Company*, Syrup), WARREN
(Balsam, Remedy).

**WHITNEY'S//COUGH CORDIAL//
C. DYER JR.//PROV. R.I.**
Bottle manufactured ca. 1849. Produc-
tion ca. 1845 to 1853 (Wilson and
Wilson 1971).
Aqua; 4¹/₄″ × ?; 14n; 21b; pl; v.

**L. Q. C. WISHART'S//PINE TREE/
TAR CORDIAL/PHIA//[embossed
tree] PATENT/1859**
Adv. 1859 as: "DR. WISHART'S
PINE TREE TAR CORDIAL for
Consumption of the Lungs, Cough,
Sore Throat and Breast, Bronchitis,
Liver Complaint, Blind and Bleeding
Piles, Asthma, Whooping Cough and
Diptheria, &c." John W. Campion
apparently acquired the cordial from the
estate of Dr. Wishart in late 1874 or

1875 (Holcombe 1979). Adv. 1923, *SF & PD*.
Green; 8″ × 2¹/₁₆″ × 1⁵/₁₆″; 9n; 2b; pl; v, sf; h, s.

L. Q. C. WISHART'S//PINE TREE/ TAR CORDIAL/PHILᴬ//TRADE/ embossed tree]/MARK
Amber; 9³/₄″ × 2¹/₂″ × 2¹/₂″; 11n; 2b; pl; v, sf; h, s.

Dᴿ WOODRUFF'S//DYSENTERY/ CORDIAL//COLUMBUS Gᴬ
Adv. 1846 (Baldwin 1973).
Aqua; 9″ × ? × ?; 11n; 3b; 3 or 4ip; v, sfs; p.

ZOLLICKOFFERS// ANTIRHEUMATIC/CORDIAL// PHILAD.ᴬ
Zollickoffers Rheumatic Cordial, adv. 1872, *VHS*; Zollickoffers Anti-Rheumatic Cordial, adv. 1910, *AD*.
Olive; 6³/₈″ × 2³/₈″ × 1³/₈″; 11n; 3b; 4ip; v, sfs; p.

COUGH

ABIETINE/COUGH BALSAM
See ABIETINE *(Balsam)*.

DR. ADAMS COUGH CURE/ Prepared By/E. J. PARKER/ CORTLAND, N.Y.
See ADAMS *(Cure.)*

ANDERSON'S/POOR MANS/ COUGH CURE
See ANDERSON *(Cure)*.

DR. SETH ARNOLD'S// COUGH KILLER
Adv. 1865, *GG*; 1901 by Dr. Seth Arnold Med. Corp., Woonsocket, R.I. *HH & M*; 1923, *SF & PD*.
Aqua; 4³/₄″ × 1⁵/₈″ × ³/₄″; 7n; 3b; 3ip; v, ss; 3 or 4 sizes. See ARNOLD *(Balsam, Pills)*.

Dᴿ SETH ARNOLDS//COUGH KILLER
Aqua; 5¹/₂″ × 1³/₄″ × 1¹/₈″; 7n; 3b; 4ip; v, ss. See ARNOLD *(Balsam, Pills)*.

B & S/HOMEOPATHIC/COUGH & CROUP/SYRUP
See B & S *(Syrup)*.

TRY BAKERS 5 MINUTE/COUGH BALSAM 10 ᶜᴱᴺᵀˢ
See BAKER *(Balsam)*.

Dᴿ BAKER'S/PLANTATION/ COUGH SYRUP//S. F. BAKER & CO.//KEOKUK, IOWA
See BAKER *(Company)*.

BARTON'S//INFALLIBLE/ COUGH//CURE
See BARTON *(Cure)*.

BAUER'S/COUGH CURE
See BAUER *(Cure)*.

BAUER'S/INSTANT COUGH CURE/ MT. MORRIS, N.Y.
See BAUER *(Cure)*.

BEGGS'/CHERRY COUGH SYRUP
See BEGGS *(Syrup)*.

DR. BELL'S/PINE-TAR-HONEY/ FOR COUGHS AND COLDS
[Base: I in diamond]
Labeled in part: *Dr. Bell Med. Co., New York, St. Louis, successors to E. E. Sutherland, Philadelphia, Pa, Paducah, Ky.* Bottle manufactured by the Illinois Glass Co., 1916 to 1929 (Toulouse 1972). Adv. 1899 (Devner 1968); 1941–42 by Wm. R. Warner & Co., *AD*.
Light blue; 5⁵/₈″ × 1⁷/₈″ × ⁷/₈″; 1n; sp; 3n; 1ip; v; ABM. See SUTHERLAND (Company), WALKER (Tonic).

DR. BELL'S/PINE-TAR-HONEY/ FOR COUGHS AND COLDS// DR. BELL'S//PINE-TAR-HONEY
Clear; 8⁵/₈″ × 2⁷/₈″ × 1³/₄″; 11n; 3b; 3ip; v, fss. See SUTHERLAND (Company), WALKER (Tonic).

BINZ/BRONCHI-LYPTUS/FOR COUGH [Base:] E. G. BN
Introduced ca. 1908 (Devner 1968); adv. 1929–30, 1948 by Bronchi-Lyptus Labs., 732 Ceres Ave., Los Angeles, Ca., *AD*.
Amber; 4″ × 1³/₈″ × 1³/₈″; 9n; 2b; pl; v; ABM. See BINZ (Miscellaneous).

BINZ/BRONCHI-LYPTUS/FOR COUGH [Base:] E. G. BINZ
Amber; 7⁷/₈″ × 2⁷/₁₆″ × 2⁷/₁₆″; 9n; 2b; pl; v. See BINZ (Miscellaneous).

BRONKO/CURES COUGHS, COLDS/BRONCHITIS & c.
Possibly of British origin (McEwen 1977).
Blue; 5″ × 1³/₄″ × 1″; 9n; 3b; ip; v.

BRONSON'S//COUGH COLD AND/ CONSUMPTION/REMEDY// ALEXANDER, N.Y.
See BRONSON *(Remedy)*.

J. W. BULL'S//COUGH SYRUP// BALTIMORE
See BULL *(Syrup)*.

DR. J. W. BULL'S//COUGH SYRUP/A. C. MEYER & CO.// BALTIMORE, MD. USA
See BULL *(Syrup)*.

DR. J. W. BULLS COUGH SYRUP// A. C. MEYER & CO. BALTO. MD. U.S.A. [Base:] W
See BULL *(Syrup)*.

TAKE CARPENTER'S/GRIP/ AND STOP THAT COUGH
Product of Dr. A. H. Carpenter, Newark, NJ, adv. 1872 (Baldwin 1973).
Color and dimens. unk.; 7n; 3b; 1ip; v.

CARTER'S COUGH, AND/
CONSUMPTION CURE//THE
BROWN MEDICINE CO.//ERIE PA.
See CARTER (Cure).

GRACE CARY//AUSTRALIAN/
EUCALYPTUS/GLOBULOUS/
[embossed tree]/TRADE MARK/
GUM TREE/COUGH SYRUP//
SAN FRANCISCO//DIRECTIONS/
TAKE ONE TEASPOONFUL/EVERY
TWO HOURS/UNTIL RELIEVED/
PRICE 75CENTS
See CARY (Syrup).

CHAMBERLAIN'S/COUGH
REMEDY//CHAMBERLAIN MED.
CO.//DES MOINES, IA. U.S.A.
See CHAMBERLAIN (Remedy).

CHAMBERLAIN'S/COUGH
REMEDY//A. N. CHAMBERLAIN//
ELKHART, IND.
See CHAMBERLAIN (Remedy).

CIMONA/COUGH ASTHMA &
CROUP CURE/PREPARED BY
CIMONA MEDICINE CO./
INDIANAPOLIS, U.S.A.
See CIMONA (Cure).

CLASSES/COUGH SYRUP
See CLASSES (Syrup).

CLIFTON'S/BALSAMIC COUGH/
MIXTURE
See CLIFTON (Balsam).

CONGREVE'S//CELEBRATED/
BALSAMIC//ELIXIR//
FOR COUGH/& ASTHMA
See CONGREVE (Balsam).

COULSON'S//COUGH AND/
CONSUMPTION CURE//
BUFFALO N.Y.
See COULSON (Cure).

CRAFTS/DISTEMPER AND
COUGH/CURE
See CRAFT (Cure).

DR. CRAIG'S/COUGH
& CONSUMPTION/CURE
See CRAIG (Cure).

CRAMER'S/COUGH CURE
See CRAMER (Cure).

CUBEB/COUGH/CURE
See CUBEB (Cure).

W. H. CULMER'S/ROCKY
MOUNTAIN/COUGH SYRUP

[Base:] M⋴C
See CULMER (Syrup).

DR. DANIELS'/COUGH COLD
& FEVER DROPS/BOSTON,
MASS. U.S.A.
Adv. 1900, EBB; 1910, AD.
Clear; 4½″ × 1⅝″ × 1″; 7 or 9n; rect.;
pl; v. See DANIEL (Cure, Liniment,
Lotion, Miscellaneous).

DR. DENIG'S/COUGH BALSAM
See DENIG (Balsam).

M. DIMMITT/S�ᵀ. LOUIS//COUGH//
BALSAM
See DIMMITT (Balsam).

MRS. DINSMORE'S/COUGH
& CROUP/BALSAM
See DINSMORE (Balsam).

DUBBEL'S/COUGH & CROUP
CURE/WAYNESBORO, PA.
See DUBBEL (Cure).

G. DUTTON & SON//COUGH
& BRONCHITIS MIXTURE/OR/
SYRUP OF LINSEED &
LIQUORICE//CHEMISTS BOLTON
See DUTTON (Syrup).

EGYPTIAN/COUGH BALSAM
See EGYPTIAN (Balsam).

ETHEREAL/COUGH SYRUP//
THE HOLDEN DRUG CO//
STOCKTON CAL
See ETHEREAL (Syrup).

FIVE MINUTE/COUGH CURE/
PRICE 25 CENTS [Base:] WT &
CO/U.S.A.
See FIVE MINUTE (Cure).

GARLAND'S COUGH DROPS
Product of Milton H. Garland, San
Francisco, CA, ca. 1872–78 (Wilson
and Wilson 1971).
Light blue; 7½″ × ? × ?; 1n; 6b; 1ip,
arched indented panel; v.

GERMAN FIR COUGH CURE/
DILLARD REMEDY CO./
EAST BANGOR, PA. [Base:] 225A
See GERMAN (Cure).

Dᴿ GERMAN'S/COUGH
& CONSUMPTION/CURE//
S. A. WAKEMAN//UTICA. N.Y.
See GERMAN (Cure).

GILBERT'S/BREAST ANODYNE//
PHILADELPHIA//FOR COUGHS,
COLDS & C
Adv. 1887, McK & R; 1910, AD.
Aqua; 7¾″ × 2⅜″ × 1¾″; 1n; 3b; 3
or 4ip; v, fss.

S. B. GOFF'S//COUGH SYRUP//
CAMDEN, N.J.
See GOFF (Syrup).

S. B. GOFF'S//INDIAN
VEGETABLE/COUGH
SYRUP/& BLOOD PURIFIER//
CAMDEN N. J.
See GOFF (Syrup).

GRAY'S BALSAM/BEST COUGH
CURE//S. K. PIERSON//
LEROY, N.Y.
See GRAY (Balsam).

GRAY'S BALSAM/CURES
COUGHS//S.K. PIERSON//
LEROY, N.Y.
See GRAY (Balsam).

DR HALE'S/HOUSEHOLD/
COUGH CURE
See HALE (Cure).

HAMLIN'S/COUGH BALSAM//
CHICAGO//U.S.A.
See HAMLIN (Balsam).

HANSEE EUROPEAN/
COUGH SYRUP/R. H. HANSEE
Pʀᴏ/MONTICELLO N.Y.
See HANSEE (Syrup).

T. W. HARPER'S/COUGH/REMEDY
See HARPER (Remedy).

REV. W. HARRISON/ROME N.Y.//
COUGH//BALSAM
See HARRISON (Balsam).

[Script:] Valentine Hassmer's/LUNG
& COUGH SYRUP/PRICE PER
BOTTLE 1.25/5 BOTTLES TO THE
GALLON/P.O. BOX 1886
See HASSMER (Syrup).

HEALY & BIGELOW'S/KICKAPOO/
INDIAN COUGH CURE
See HEALY (Cure).

GUARANTEED CURE/HENRY'S/
RED GUM/COUGH/REMEDY
See HENRY (Remedy).

HENRY'S RED GUM/THE GREAT/
COUGH REMEDY
See HENRY (Remedy).

DR. HILLER'S/COUGH CURE
See HILLER (Cure).

HIRE'S//COUGH CURE//
PHILA. PA.
See HIRE (Cure).

HOLDEN'S/ETHEREAL COUGH
SYRUP//THE HOLDEN DRUG

CO//STOCKTON CAL.
See HOLDEN (Syrup).

HOLLAND/COUGH &/
CONSUMPTION/CURE
See HOLLAND (Cure).

DR. HOOKER'S/COUGH &
CROUP/SYRUP
See HOOKER (Syrup).

DR. HOUGH'S/COUGH &
LUNG/BALSAM//DR. H. G.
HOUGH//PROVIDENCE, R.I.
See HOUGH (Balsam).

HUNTER'S/PUL. BALSAM/
or COUGH SYRUP//J. CURTIS/
PROP.TR/BANGOR ME.
See HUNTER (Balsam).

HURD'S COUGH/BALSAM
See HURD (Balsam).

INDIAN COUGH SYRUP//
WARME SPRINGS OREGON
See INDIAN (Syrup).

JORDAN'S/COUGH SYRUP/
JORDAN MARSH DRUG CO./
COXSACKIE, N.Y.
See JORDAN (Syrup).

DR. KAISER'S//COUGH CURE
See KAISER (Cure).

KEMP'S BALSAM/FOR THAT
COUGH//KEMP'S BALSAM/
FOR THAT COUGH
[Base: O in a square]
See KEMP (Balsam).

KICKAPOO/COUGH SYRUP
See KICKAPOO (Syrup).

KIDD'S COUGH SYRUP
See KIDD (Syrup).

DR KILMER & CO//CATARRH/
[in indented lung:] DR KILMER'S/
COUGH-CURE/CONSUMPTION
OIL/[below lung:] SPECIFIC//
BINGHAMTON, N.Y.
See KILMER (Cure).

[h] DR. KILMERS/[v] INDIAN/
COUGH CURE/CONSUMPTION
OIL/[h] BINGHAMTON/N Y USA
See KILMER (Cure).

[h] DR. KILMER'S/[v] INDIAN/
COUGH REMEDY/CONSUMPTION
OIL/[h] BINGHAMTON/N.Y. U.S.A.
See KILMER (Remedy).

DR KING'S//CROUP/&/COUGH//
SYRUP
See KING (Syrup).

DR. KING'S/NEW DISCOVERY/
FOR COUGHS DUE TO COLDS
[Base: N in square]
See KING (Discovery).

DR KING'S/NEW DISCOVERY/
FOR COUGH'S AND COLDS//
H. E. BUCKLEN & CO.//
H. E. BUCKLEN & CO.
See KING (Discovery).

DR KING'S/NEW DISCOVERY/FOR
COUGHS AND COLDS//H. E.
BUCKLEN & CO.//CHICAGO, ILL.
See KING (Discovery).

KIRK'S IRISH MOSS/
COUGH BALSAM
See KIRK (Balsam).

JARABE DE LEONARDI/PARA LA
TOS CREOSOTADO/LEONARDIS
COUGH CURE CREOSOTED/
NEW YORK AND TAMPA, FLA
See LEONARDI (Cure).

LEWIS//COUGH//SYRUP//
ROCHESTER, N.Y.
See LEWIS (Syrup).

LIQUFRUTA//COUGH CURE
See LIQUFRUTA (Cure).

C. B. LITTLEFIELD'S/
CONSTITUTIONAL/COUGH
SYRUP/MANCHESTER, N.H.
See LITTLEFIELD (Syrup).

LOG CABIN//COUGH AND
CONSUMPTION//REMEDY [Base:]
SEPT. 6 1887
See LOG CABIN (Remedy).

LUNG SAVER/THE GOOD COUGH
SYRUP/THE LUNG SAVER CO.
PHILA. PA. U.S.A.
See LUNG SAVER (Company).

MARVINI'S//CHERRY COUGH
CURE
See MARVINI (Cure).

McANDREWS/COUGH BALSAM
See MCANDREW (Balsam).

MRS. Wᴹ MERRIAMS/COUGH
SYRUP//MERRIAM & FROST//
SPRINGFIELD MASS.
See MERRIAM (Syrup).

MINGAY'S/COUGH BALSAM
See MINGAY (Balsam).

MULLOCK'S/COUGH SYRUP/
WAVERLY N.Y.
See MULLOCK (Syrup).

[v] NATURE'S/COUGH SPECIFIC/
DR F. P. HOWLAND [h]
CORTLAND/N.Y.
See NATURE (Specific).

ONE MINUTE/COUGH CURE//
E. C. DEWITT & CO/CHICAGO,
U.S.A.
See ONE MINUTE (Cure).

ONE NIGHT COUGH CURE/
KOHLER M'F'G. CO./
BALTIMORE, MD.
See ONE NIGHT (Cure).

PAN-TINA/COUGH
& CONSUMPTION CURE/
E. SCHMIDT & CO. BALTO.
See PAN-TINA (Cure).

DR. PARKERS/COUGH CURE
See PARKER (Cure).

PARKS/COUGH/SYRUP//
FREE SAMPLE
See PARK (Syrup).

PARK'S/COUGH/SYRUP//F. O.
REDDISH//LEROY, N.Y.
See PARK (Syrup).

PARKS/COUGH/SYRUP//GEO. H.
WELLS//LEROY, N.Y.
See PARK (Syrup).

PECKHAM'S CROUP REMEDY/
THE CHILDREN'S COUGH CURE
See PECKHAM (Remedy).

PETTIT'S AMERICAN//
COUGH CURE
See PETTIT (Cure).

PETTIT'S AMERICAN//COUGH
CURE//HOWARD BROS
See PETTIT (Cure).

POLAR STAR/[embossed star]/
COUGH CURE
See POLAR (Cure).

PRIMLEYS/SPEEDY/CURE/
FOR/COUGHS/AND/COLDS//
JONES & PRIMLEY CO.//
ELKHART, IND.
See PRIMLEY (Cure).

"RED CHERRY COUGH CURE"/
FOR CONSUMPTION/
DR. PARKER'S SONS CO./
BATAVIA. N.Y.
See PARKER (Company).

REDSTAR [embossed star] COUGH
CURE//THE CHARLES A.
VOGELER CO. [Base:]
BALTIMORE/U.S.A.
See REDSTAR (Cure).

REID'S/GERMAN COUGH/&/
KIDNEY CURE//SYLVAN REMEDY
CO./PEORIA, ILL.//NO DANGER
FROM OVERDOSE//CONTAINS
NO POISON
See REID (Cure).

ROCHE'S//EMBROCATION/FOR
THE//HOOPING COUGH//
W. EDWARDS & SON
[See Figure 82]
English product patented by James
Roche, 1803 (Alpe 1888); imported by
E. Fougera. Adv. 1835 (Baldwin 1973);
1941–42, AD.
Clear; 5″ × 1¼″ × 1¼″; 7n; 2b; pl; v,
fsbs.

Fig. 82

ROCK'S/COUGH & COLD CURE/
CHA'SA DARBY N.Y.
See ROCK (Cure).

[h] 3¾ OZ/[v] RODERIC/WILD
CHERRY/COUGH BALSAM
See RODERIC (Balsam).

ROYAL/COUGH CURE//DILL
MEDICINE CO.//NORRISTOWN,
PA.
See DILL (Company).

DR. SAWEN'S//COUGH BALSAM
See SAWEN (Balsam).

DR. SCOTT'S ELECTRIC/COUGH
BALSAM/G. M. GROSSE, PROPᴿ
See SCOTT (Balsam).

SEABURY'S//COUGH BALSAM
See SEABURY (Balsam).

DR. SEELYE'S/MAGIC/COUGH
AND/CONSUMPTION/CURE//A. B.
SEELYE & CO.//ABILENE KANSAS
See SEELYE (Company).

SELLECK'S GINGER//
TOLU COUGH SYRUP//
CLAY, WHOLESALE & CO./
MFG PHARMACISTS/ELMIRA N.Y.
See CLAY (Company).

SHAWYER'S/SWINDON
EXPRESS/COUGH CURE
See SHAWYER (Cure).

SHEDD'S/COUGH SYRUP
See SHEDD (Syrup).

SHORT STOP/FOR COUGHS/
H. M. O'NEIL. N.Y.
Adv. 1890, W & P; 1910, AD.
Aqua; 4″ × 1½″ × 1½″; 9n; 1 or 2b?;
1ip; v.

SNOW & MASON/PROVIDENCE,
R. I./CROUP & COUGH/SYRUP
See SNOW & MASON (Syrup).

DR. STONE'S/OXFORD/DROPS,
FOR/COUGHS & C.
Bottle manufactured ca. 1854; product
of Andrew Stone, Troy, NY (Wilson
and Wilson 1971). Adv. 1852 (Baldwin
1973); 1870s.
Aqua; 5″ × 2″ × ?; 5n; 12b; pl; v; p.

G. W. STONE'S//COUGH/
ELIXIR//BOSTON MASS.
See STONE (Elixir).

STRICKLANDS/MELLIFLUOUS//
COUGH BALSAM
See STRICKLAND (Balsam).

[Embossed sun] SUN RISE/
COUGH BALSAM
See SUN RISE (Balsam).

TA-HA/COUGH CURE
See TA-HA (Cure).

TUS SANO/CURES/COUGHS/
AND/COLDS//C. I. HOOD & CO.//
LOWELL MASS [Base:] 4
See TUS (Cure).

UNIVERSAL/COUGH REMEDY//
J. L. HUNNEWELL/& CO./
BOSTON, MASS
See UNIVERSAL (Remedy).

UNIVERSAL//COUGH SYRUP//
EMRY DAVIS/SOLE PROPRIETOR/
NEW YORK//EMRY DAVIS
SUCCESSOR TO D. W. HATCH &
CO. JAMESTOWN, N.Y.
See UNIVERSAL (Syrup).

UNIVERSAL//COUGH SYRUP//
HATCH & DICKINSON/
JAMESTOWN NY
See UNIVERSAL (Syrup).

DR. VANDERPOOL'S S B/COUGH
& CONSUMPTION CURE
See VANDERPOOL (Cure).

VENO'S/LIGHTNING/COUGH/
CURE [Base: diamond]
See VENO (Cure).

VENO'S/LIGHTNING/COUGH/
CURE [Base: partial diamond with line
beneath]
See VENO (Cure).

WAIT'S/WHITE PINE COUGH
CURE/ONE BOTTLE CURES A
COUGH/GREENWICH, N.Y.
See WAIT (Cure).

DR. WARREN'S//BOTANIC/
COUGH BALSAM//S. F. CAL.
See WARREN (Balsam).

WHEELER'S//AMERICAN//
COUGH CURE
See WHEELER (Cure).

FAITH WHITCOMB'S/BALSAM//
CURES COUGHS AND COLDS//
CURES CONSUMPTION
See WHITCOMB (Balsam).

WHITE PINE COUGH SYRUP WITH
TAR/MANF'D BY/JORDAN BRO'S.
COXSACKIE, N.Y.
See WHITE PINE (Syrup).

WHITNEY'S//COUGH CORDIAL//
C. DYER JR.//PROV. R.I.
See WHITNEY (Cordial).

WILLSON'S/MONARCH/BALSAM/
FOR/COUGHS/AND/COLDS/
WILLSON BROS./EDGERTON/
WIS. U.S.A.
See WILLSON (Balsam).

DR. WILSON'S COUGH MIXTURE//
G. E. WEBB & BRO.//JACKSON,
MICH.
See WILSON (Mixture).

JOHN M. WINSLOW//COM-
POUND/BALSAM OF/
HOARHOUND//COLDS COUGHS/
AND/CONSUMPTION
See WINSLOW (Balsam).

WOODS/GREAT PEPPERMINT
CURE/FOR COUGHS & COLD
[Base:] AGM
See WOODS (Cure).

WOOD'S/GREAT PEPPERMINT
CURE/FOR COUGHS & COLD
See WOODS (Cure).

WRIGHT'S INDIAN/COUGH
BALSAM
See WRIGHT (Balsam).

DR YELLS/COUGH/MEDICINE
[Base:] W T & CO/U.S.A.
See YELLS (Medicine).

CREAM

ARNICATED/EUREKA CREAM
[See Figure 83]
Eureka Cream adv. 1921 in the *Salt Lake Tribune* (30 Jan 1921); Arnicated Eureka Cream adv. 1941–42 by S. T. Kostitch & Co., Denver Co., *AD*.
Clear; 5″ × 1¹⁵/₁₆″ × 1¹/₁₆″; 9n; 3b; 1ip; v.

Fig. 83

BARRY'S PEARL CREAM//CREAMA DE PERLAS DE BARRY
Adv. 1879, *VSS & C*; 1910, *AD*. Also producer of Barry's Tricopherous For The Hair.
Milk glass; 4″ × ? × ?; 7n; 4b; pl; v, ss. See BARRY (*Hair*, Miscellaneous), BRISTOL (Pills, Sarsaparilla), MURRAY & LANMAN (*Water*).

CREME DE CAMELIA/FOR THE COMPLEXION//THE BORADENT CO. INC./SAN FRANCISCO & NEW YORK
See BORADENT (*Company*).

CHEATHAM'S/PEARL ROSE CREAM/MADE IN RENO [Base:] WT & CO/U.S.A.
Bottle manufactured by Whitall-Tatum, Millville, NJ, 1857 to 1935 (Toulouse 1972). Reno directories show the (Thos. R.) Cheatham Drug Co. at 156 N. Virginia in 1906 and at 148 N. Virginia in 1907. The successor, in 1918 or 1919, was the V. F. Henry Drug Co., 148 N. Virginia. Verne Henry previously operated the McCullough Drug Co., McGill, NV.
Clear; 4½″ × 1⅞″ × 1¼″; 9n; 3b; pl; v.

De WITTS/TOILET CREAM
[See Figure 84]
Adv. 1907, *PVS & S*; 1916, *MB*.
Clear; 4⅝″ × 1⅝″ × 1¹/₁₆″; 7n; 5b; 1ip; v.

Fig. 84

ELY'S/CREAM/BALM/CO./OWEGO/N.Y.//HAY FEVER//CATARRH
See ELY (*Balm*).

ELY'S/CREAM/BALM/ELY BRO'S/NEW YORK//HAY FEVER/CATARRH
See ELY (*Balm*).

ELY'S/CREAM/BALM/ELY BROS./OWEGO/N.Y.//HAY FEVER//CATARRH
See ELY (*Balm*).

ELY'S/CREAM/BALM/LIQUID/ELY BRO'S/NEW YORK//HAY FEVER//CATARRH
See ELY (*Balm*).

ESPEY'S/FRAGRANT CREAM
Adv. 1879, *VSS & C*; 1901 by P. B. Keyes, 405 State, Chicago, *HH & M*; 1912, by J. E. Espey, Chicago (Devner 1968); 1929–30 and 1948 by J. E. Espey Co., Pasadena, Ca., *AD*.
Clear; 4½″ × 1⅝″ × 1¹/₁₆″; 7n; 5b; 1ip; v.

DR FUNK'S/CREAM OF ROSES
A Los Angeles product adv. 1895, 1907, *PVS & S*; 1911 according to Bob Toynton (personal communication, 1984).
Clear; 4⁹/₁₆″ × 1⅝″ × 1¹/₁₆″; 3n; 5b; 1ip; v.

[v] GOURAUD'S/ORIENTAL/CREAM/3⅜ FLD/[h] OZ
Introduced 1840s. Label dated 1914: *Oriental Cream or Magical Beautifier, an Elegant and Delicate Preparation for the Skin and Complexion, etc. . . . Prepared by Fred T. Hopkins & Sons, Successors to T. Felix Gouraud, 37 Great Jones St., New York*. Adv. 1948, *AD*.
Clear; 4¼″ × 2⅜″ × 1³/₁₆″; 9n; 3b; pl; v, h; ABM. See GOURAUD (Hair).

GOURAUD'S//ORIENTAL/CREAM//NEW YORK
Clear; 5⅛″ × 2¹³/₁₆″ × 1¹³/₁₆″; 9n; 3b; pl; v, sfs. See GOURAUD (Hair).

HASWELL'S/WITCH HAZEL CREAM [See Figure 85]
Adv. 1900, *EBB*.
Aqua; 5½″ × 2⅛″ × 1¼″; 9n; 4b; 1ip; v.

Fig. 85

HIND'S/HONEY &/ALMOND/CREAM/ALCOHOL 7%//A. S. HINDS CO/PORTLAND/MAINE/U.S.A.
Product of A. S. Hinds introduced in 1875 (Periodical Publishers Association, 1934); company absorbed by Lehn & Fink in 1907. Adv. 1948 by Lehn & Fink Products Corp., 194 Bloomfield Ave., Bloomfield, N.J., *AD*.
Clear; 2¹/₁₆″ × 1⅛″ × ⅝″; 3n; 3b; pl; h, fb.

HINDS/HONEY/AND/ALMOND/CREAM//IMPROVES THE/COMPLEXION//ALCOHOL 7%//A. S./HINDS CO/PORTLAND/MAINE/U.S.A.
Clear; 2½″ × 1¹/₁₆″ × ⅝″; 7n; 3b; 1ip; h, f; v, ss; h; b; several sizes.

INGRAMS MILK WEED CREAM
[Base:] **BOTTLE PATᴰ/Nº 481953**
"Nature's Skin Food for the Complexion." Milburn & Williamson, Detroit,

MI, was established in 1882 and changed to Frederick F. Ingram & Co., 23 May 1891. The company was incorporated in 1908 and purchased by Bristol Myers in 1928 (Blasi 1974). The Periodical Publishers Association (1934) references introduction of the cream in 1895 and a relationship to Ypsilanti, MI. Cream adv. 1948, *AD*.

Milk glass; $3^1/4'' \times 2^1/2''$ diameter, also $2^1/4'' \times 1^{13}/16''$; 17n; 20b; pl; h, shoulder embossed.

[Monogram in circle] **CREME/Luxor** [Base, script:] **Armour & Company/ CHICAGO/U.S.A.**
See ARMOUR *(Company)*.

M^c CONNON'S/FACE CREAM/ M^c CONON & COMPANY/ WINONA, MINN.
See McCONNON *(Company)*.

NADINOLA CREAM/ A COMPLEXION BEAUTIFIER/ NATIONAL TOILET CO/ PARIS TENN· U.S.A.
Adv. 1910, *AD*; 1980–81 by Chattem Labs., Chattanooga, TN, *AD*.
Milk glass; $1^1/8'' \times 3^1/4'' \times 2''$; 3n; 6b; 1ip; base.

NICHOLS/TOILET CREAM
Adv. 1887, *McK & R*; 1900, *EBB*.
Emerald green; $6^1/4'' \times 2'' \times 2''$; 9n; 2b; 1ip, arched; v.

[Script:] **Orange Flower Cream/THE CANN DRUG CO./RENO, NEV.** [Base:] **W. T. Co./U.S.A.**
Bottle manufactured by Whitall-Tatum, Millville, NJ, 1857 to 1935 (Toulouse 1972). The William Cann Drug Co. was located at 201 N. Virginia St. in 1906 and 1907, and at 205 N. Virginia in 1910. In 1926 or 1927 a merger with E. A. Kingston resulted in a name change to Kingston & Cann; the location remained the same.
Clear; $5^1/2'' \times 1^7/8'' \times 1^1/2''$; 9n; 3b; pl; v, part script.

DR. OSBORNE'S/CACTUS CREAM
Clear; $4^1/2'' \times 1^5/8'' \times 1^1/16''$; 7n; 5b; 1ip; v.

POMPEIAN/MASSAGE/CREAM
A Cleveland, OH product introduced in 1874 (Devner, 1970). Adv. 1929–30 by Colgate-Palmolive-Peet Co., 919 N. Michigan Ave., Chicago, Ill., *AD*; 1948 by Ritchie & Janvier, Inc., 60 Orange St., Bloomfield, N.J., *AD*.
Clear; $2^{11}/16'' \times 1^3/8''$ diameter; 7n, large salt mouth, with fluted stopper; 20b; pl; h; tapered body, ca. $1^3/4''$ at widest point.

RHINOL CREAM/CURES CATARRH
Morgan's Rhinol, adv. 1900, *EBB*. Assumed to be same product as Rhinol Cream.
Milk glass; $2^1/2'' \times 1^3/8''$ diameter; 17n; 20b; pl; v.

S & K/ITALIAN CREAM/LONDON
Light cobalt; $6'' \times 2^1/4'' \times 1^7/16''$; 11n; 3b; pl; v.

CREME/SIMON [Base:] **J S/35**
"IN ONE NIGHT, CHILBLAINS, CHAPS, and all light Cutaneous Affections are cured by LA CREME SIMON . . . SIMON, 36 Rue de Provence, Paris–London; V. Givry (late Melnotte), 23, Old Bondstreet, W." Adv. 1883 in *The Illustrated London News* (8 Dec.); 1929–30 by Fougera & Co., Inc., 41 Maiden Lane, New York City; 1948 by Maurry Biological Co., 6109 S. Western Ave., Los Angeles, Ca., *AD*.
Milk glass; $2^3/8'' \times 1^3/8''$ diameter; 15n; 20b; pl; h.

SWEET/LAVENDER/CREAM
Possibly related to Mme. Kenyon's Sweet Lavender Pills, adv. 1895, *PVS & S*; 1900, *EBB*.
Clear; $4^1/4'' \times 1^{15}/16'' \times 1^1/4''$; 7n; 1b; pl; v.

[Script:] **Velvetina/CREAM/ LOTION//GOODRICH DRUG CO./OMAHA, U.S.A.** [Base: diamond]
See GOODRICH *(Drug)*.

WATKINS FACE CREAM/ J. R. WATKINS MED. CO./ WINONA, MINN.
See WATKINS *(Company)*.

WHITES CREAM/VERMIFUGE
From *Lexington Progress*, Lexington, TN, (31 June 1901): "Mothers who would keep their children in good health should watch for the first symptons of worms and remove them with White's Cream Vermifuge." Adv. 1887, *WHS*; 1929–30 by James F. Ballard Inc., 500 Second St., St. Louis, Mo.; 1948 by Dr. W. B. Caldwell Inc., Div. Sterling Drug Inc., Monticello, Ill., *AD*.
Aqua; $5^1/2'' \times 1^{11}/16'' \times 7/8''$; 11n; 3b; 4ip; v.

WILLIAMS/BALSAMIC/ CREAM OF ROSES
See WILLIAMS *(Balsam)*.

WITCH/CREAM/PRICE/ DRUGGIST/SALEM/MASS
See PRICE *(Drug)*.

ABBOTT/BROS/[in circle, around monogram:] RHEUMATIC CURE/ESTD 1888/CHICAGO

Abbott Bros. was established in 1888, the firm operated as of 1986 as Abbott Labs, *RB*. Cure adv. 1889, *PVS & S*; 1910, *AD*. Also a remedy adv. 1910, *AD*; 1922, *RD*.

Amber; 5″ × 2¹/₈″ × 1³/₈″; 9n; 18b; pl; h.

ABBOTT/BROS/RHEUMATIC CURE//ESTD 1888/CHICAGO//ABBOTT BROS//RHEUMATIC CURE

Amber; 7¹/₂″ × 2¹/₄″ × 1¹/₈″; 11n; 3 or 6b; ip; h, fss.

DR. ADAMS COUGH CURE/Prepared By/E. J. PARKER/CORTLAND, N.Y.

Clear; 5³/₄″ × 1⁵/₈″ × 2³/₈″; 9n; rect.; pl; v.

Dᴿ AGNEW'S/CURE FOR THE HEART

Adv. 1898, *CHG*; 1910, *AD*.

Clear; 7³/₄″ × 2¹/₂″ × 1″; 7n; 3b; 3ip; v.

ALEXANDERS/SURE CURE FOR MALARIA/AKRON, O.//ALEXANDERS/LIVER & KIDNEY TONIC/AKRON, O.

See ALEXANDER *(Tonic)*.

THE ALMYR SYSTEM OF TREATMENT/FOR CATARRH/ALMYR CATARRH CURE [Base:] WT & CO/4/U.S.A.

Bottle manufactured by Whitall-Tatum, 1857 to 1935 (Toulouse 1972).

Aqua; 8¹/₈″ × 2¹/₂″ × 2¹/₂″; 9n; 2b; 1ip; v.

ANDERSON'S/POOR MANS/COUGH CURE

A Utica, NY product adv. 1883 (Baldwin 1973); 1910, *AD*.

Aqua; 5³/₄″ × 1¹³/₁₆″ × 1″; 7n; 3b; 3ip; v.

ANTI-APOPLECTINE//THE ONLY/APOPLEXY PREVENTIVE/AND/PARALYSIS CURE//DR. F. S. HUTCHINSON CO [Base:] ENOSBURGH FALLS/VT

See HUTCHINSON *(Company)*.

DR. R. A. ARMISTEAD'S//FAMOUS AGUE CURE

Ague Tonic adv. 1900, *EBB*; 1910, *AD*.

Clear; 6¹/₈″ × 1⁷/₈″ × 1⁷/₈″; 11n; 21b; pl; h, fb. See ARMISTEAD *(Tonic)*.

ARCTIC FROST/BITE CURE [Base:] W T & CO/U.S.A.

Label: *Arctic Frost Bite Cure — A Cure for Frost Bite, Chilblains, Sweaty Feet, Bunions, Pruritus, etc., Arctic Chem. Co., Chillicothe, Ohio.* Bottle manufactured by Whitall-Tatum, 1857 to 1935 (Toulouse 1972).

Aqua; 2¹/₂″ × ¹³/₁₆″ × ¹³/₁₆″; 9n; 2b; pl; v.

AYER'S//AGUE//CURE//LOWELL MASS

James Cook Ayer established his drug and medicine business in 1841. The first embossed containers date ca. 1847 (Wilson and Wilson 1971). Dates of introduction for Ayer's products: Cherry Pectoral, 1841 (Holcombe 1979); Cathartic Pills, 1843, in boxes, 1865 in bottles (Wilson and Wilson 1971), or ca. 1848 in oval wooden boxes for domestic trade and small glass bottles for export (Holcombe 1979); Sarsaparilla, 1848 (Holcombe 1979); Ague Cure and Hair Vigor, 1858 and 1867 respectively (Wilson and Wilson 1971). James Ayer died in 1878 and Frederick Ayer assumed the business, which he operated until early in the twentieth century. The descendents of Fred eventually purchased the interests of James. In 1937 the Ayer Company had branches on every continent in the world (Holcombe 1979). In 1938 the business was acquired by Sterling Products Inc. Ague Cure adv. 1921, *BD*; Ague Remedy, 1929–30 and 1941–42, *AD*.

Aqua; 7″ × 2¹/₂″ × 1³/₈″; 1n; 3b; 3ip; h, f; v, ssb, also with p. See AYER (Hair, Miscellaneous, Pectoral, Pills, Sarsaparilla).

H. A. BABCOCK'S/RHEUMATIC TINCTURE/BLOOD PURIFIER & CANCER CURE/BROOKFIELD, N.Y.

See BABCOCK *(Purifier)*.

BAKER'S/VEGETABLE/BLOOD & LIVER/CURE/[in panel:] LOOKOUT/MOUNTAIN/MEDICINE CO/MANUFACTURERS/&/

PROPRIETORS/[below panel:] GREENVILLE/TENN.

Amber; 9¹/₂″ × 3³/₄″ × 1³/₄″; 1n; 12b; 1ip; h.

BARTON'S//INFALLIBLE/COUGH//CURE

Product of Brookville, IN.

Aqua; 6¹/₂″ × 2¹/₄″ × 1¹/₄″; 1n; 3b; 3 or 4ip; v, sfs.

BAUER'S/COUGH CURE

Adv. 1910, *AD*.

Light aqua; 2⁷/₈″ × 1¹/₈″ × ³/₄″; 9n; 18b; pl; v.

BAUER'S/INSTANT COUGH CURE/MT. MORRIS, N.Y.

Aqua, clear; 7″ × 2¹/₄″ × 1¹/₈″; 11n; 3b; 3ip; v.

BEAN'S HERB CURE/FOR/DIARRHOEA & DYSENTERY

Clear; 6⁷/₈″ × 2¹/₄″ × 1¹/₄″; 7n; 3b; 3ip; v.

BECK'S/SPRUDEL VICHI/CURES/HEADACHE

Adv. 1900, *EBB*.

Clear; 2⁹/₁₆″ × 1¹/₁₆″ diameter; 7n; 20b; pl.

DR. BEEBE'S/CATARRH & ASTHMA CURE/OTTO L. HOFFMAN/MANUFACTURER, COLUMBUS, O.

Adv. 1889, *PVS & S*; 1910, *AD*.

Amber; 4³/₄″ × 1⁵/₈″ × 1⁵/₈″; 9n; 2b; 1ip; v.

BENNET'S/MAGIC CURE

Cobalt; 5¹/₈″ × 1⁵/₈″ × 1¹/₁₆″; 7n; 2b; 1ip; v.

Dᴿ BENNETT'S//QUICK CURE//A. L. SCOVILL & Cᵒ

Adv. 1872, *VHS*; 1910, *AD*. Other products included Fever & Ague Pills, Golden Liniment, etc.

Aqua; 4⁵/₈″ × 1³/₄″ × ⁷/₈″; 9n?; 4b; pl; v, sfs. See BAKER *(Miscellaneous)*, HALL *(Balsam)*, J. F. HENRY *(Company)*, SCOVILL *(Company,* Syrup*)*, WARREN (Cordial, Remedy).

BERRY'S/CANKERCURE//CUTLER BROS. & CO.//BOSTON

Berry's Authemeron Canker Cure was prepared by N. W. Berry, Roxbury, MA, with Thayer, Babson & Co., Boston, general agents, in 1861 (Singer 1982). Adv. 1910, *AD*.

Aqua; 5¹/₈″ × 1⁵/₈″ × 1″; 7n; 3b; 3ip; v, fss. See VEGETABLE *(Balsam)*.

BIRD'S LUNG CURE [Base:] WT & CO/U.S.A.

Bottle manufactured by Whitall-Tatum,

Millville, NJ, 1857 to 1935 (Toulouse 1972). Adv. 1900, *EBB*; 1910, *AD*. Aqua; 2⅞″ × 1¼″ × ¾″; 9n; 18b; 1ip; v.

BISHOP'S/GRANULAR CITRATE/ OF CAFFEINE//[front corner:] HEADACHES CURED//[alternate corner:] HEADACHES CURED
Of Australian origin. Adv. 1889, *PVS & S*; 1941–42 by E. Fougera & Co., *AD*. Blue; 4⅞″ × 1¾″ × 1¼″; 7n; 3b; pl; v, fcc.

BISHOP'S/GRANULAR CITRATE/ OF CAFFEINE//[front corner:] HEADACHES CURED//[alternate corner:] HEADACHES CURED [Base: W in rectangle]/II A
Bottle probably manufactured by Wood's Bottle Works, Portobello, Scotland, 1900–1920 (Toulouse 1972). Light blue; 6″ × 2¼″ × 1 7/16″; 7n; 3b; pl; v, fcc.

BOHEMIAN/CATARRH CURE/D. D. LUCAS CO./VINELAND N.J.
Clear; 3⅛″ × 1″ diameter; 9n; 20b; pl; v.

[d] BORTON CURE/[v] PLYMOUTH INSTITUTE CO./WARSAW, IND. U.S.A.
Clear; 8¼″ × 3″ × 2″; 9n; 3b; pl; d, v.

PROFESSOR BOUDROU/ MIRACULOUS CURE/ PHILADELPHIA [Base:] 324
Light aqua; 3½″ × 1½″ × 15/16″; 9n; 18b; pl; v.

BRADYCROTINE/A SURE CURE FOR ALL/HEADACHES
Adv. 1891, *WHS*; 1907, *PVS & S*. Clear; 4¼″ × 1 9/16″ × 1″; 9n; 18b; 1ip; v.

CERTAIN/CURE/PERMANENT/ BREWERS/LUNG/RESTORER
See BREWER *(Restorer)*.

CERTAIN/CURE/PERMANENT/ BREWER'S/LUNG/RESTORER// CURES BRONCHITIS// CURES CONSUMPTION
See BREWER *(Restorer)*.

M. A. BRIGGS/VALDOSTA GA.// TONIC PILLS//TRADE/NUNN BETTER/MARK//NEVER FAIL/ TO CURE
See TONIC *(Pills)*.

BRIGHTSBANE/THE GREAT/ KIDNEY AND STOMACH CURE
Amber; 8¾″ × 2 11/16″ × 2 11/16″; 11n; 2b; pl; v. Also variant with LIVER instead of STOMACH.

BRONKO/CURES COUGHS, COLDS/BRONCHITIS & c.
See BRONKO *(Cough)*.

BRONKURA
Possibly of British origin (McEwen 1977).
Dark aqua; 6″ × 2¼″ × 1″; 7n; 3 or 6b; ip; v.

BROWN'S/BLOOD CURE/ PHILADELPHIA [Base:] M.B.W./U.S.A.
Bottle manufactured by the Millville Bottle Works, Millville, NJ, 1903 to 1930 (Toulouse 1972). Adv. as H. W. Brown's Blood Cure until 1916, thereafter as Blood Treatment (Devner 1968). Adv. 1923, *SF & PD*. Emerald green, amber; 6⅛″ × 2″ × 2″; 9n; 1 or 2b; pl; v. See BROWN'S TREATMENT *(Miscellaneous)*.

DR. L. BURDICK'S/KIDNEY CURE
Adv. 1887 (Baldwin 1973); 1910, *AD*. Aqua; 7⅝″ × 2¼″ × 1¼″; 7n; 3b; 3 or 4ip, oval front; v.

Dᴿ L. BURDICK'S/KIDNEY CURE/ J. E. JACKSON SOL. PROP./ WOODBURY, N.J.
Label: *DR. L. BURDICK'S NEVER-FAILING KIDNEY CURE, The only medicine that is warranted to cure the BRIGHT'S DISEASE of the KIDNEYS . . . J. E. JACKSON & CO.; Proprietors, Woodbury, N.J. Registered in Patent Office.*
Aqua; 6⅞″ × 2¼″ × 1 5/16″; 7n; 3b; 4ip; v.

BURK'S MED. CO./NEW YORK/ & CHICAGO
See BURK *(Medicine)*.

[v] DR. BURNHAM'S/SAN JAK/ KIDNEY CURE/[h] CHICAGO
Clear; 7″ × 2½″ × 1½″; 9n; 6b; pl; v, h. See BURNHAM *(Miscellaneous)*, VAN SCHAACK *(Company)*.

MRS. BUSH//SPECIFIC CURE/ FOR/BURNS & SCALDS// WINDER, GA.
Clear; 5 1/16″ × 1 13/16″ × 1″; 1n; 3b; 4ip; v, sfs.

BUXTON'S/RHEUMATIC/CURE
Adv. 1900, *EBB*; 1910, *AD*. Aqua; 8 5/16″ × 2 13/16″ × 1 11/16″; 7n; 3b; 3ip; v.

[Script:] The Dr. D. M. Bye/Combination Oil Cure Co./316 N. ILLINOIS ST, INDIANAPOLIS, IND./THE ORIGINATOR (COPYRIGHTED)
Cancer cure adv. 1905 (Devner 1968).

Clear; 6⅞″ × 2½″ × 1½″, also 7½″ × 2½″ × 1⅝″; 9n; 18b; pl; v, part script.

CALVERT'S/DERBY CURE/FOR/ INFLUENZA & COLDS
A British product (McEwen 1977). Aqua; 5⅜″ × 2⅛″ × 1 5/16″; 7n; 12b; pl; v, graduated lines on front, right corner.

CANN'S KIDNEY CURE/ PHILADELPHIA/PA. U.S.A.
Label: *CANN'S KIDNEY CURE – Sure Cure for Diseases of the Kidneys, Urinary Organs and Liver – can be used with Perfect Safety. TAKE NO OTHER MEDICINE . . . PRICE $1 Per Bottle – 720 Venango Street, Philadelphia*. Adv. 1883 (Baldwin 1973); 1900, *EBB*.
Aqua; 6¼″ × 2″ × 1″; 7n; 3b; 3ip, oval front; v.

CARSON'S/AGUE CURE/ JAMESTOWN, N.Y.
Only advertisement found was for Carson's Herb Cure, 1900, *EBB*. Aqua; 7⅝″ × 2¾″ × 1¾″; 7n; 3b; 1ip; v.

CARTER'S COUGH, AND/ CONSUMPTION CURE// THE BROWN MEDICINE CO.// ERIE PA.
Adv. 1899 (Devner 1968); 1910, *AD*. Aqua; 5⅝″ × 1¾″ × 1 1/16″; 11n; 3b; 3ip; v, fss. See CARTER *(Bitters, Extract)*.

CAUCASIAN/DANDRUFF CURE/ SHELDON, IA. [Base:] PARIS
Bottle manufactured ca. 1910. Clear; 6½″ × 2½″ × 2″; 9n; 3b; pl; v.

CAVANAUGH BROS./WONDER/ COLIC CURE
Clear; 4 15/16″ × 1 13/16″ × 1¼″; 9n; 17b; v.

CENTURY//CATARRH CURE
Adv. as a remedy in 1907, *PVS & S*; as a cure, 1910, *AD*. Clear; 3⅜″ × 1½″ × 15/16″; 7n; 3b; pl; v, ss.

CHASE'S/DYSPEPSIA CURE/ NEWBURGH, N. Y.
Adv. 1910, *AD*. Aqua; 6¾″ × 2⅜″ × 1 7/16″; 1n; 3b; 3ip; v.

CILLS'/CATARRH/CURE
Clear; 3¼″ high, no flat base, the vessel will not stand; 15n; pl; v.

CIMONA/COUGH ASTHMA &
CROUP CURE/PREPARED BY
CIMONA MEDICINE CO./
INDIANAPOLIS, U.S.A.
Clear; 6¹/₈″ × 2″ × 1¹/₈″; 7n, sp; 3b;
1ip; v.

CLEM'S/SUMMERCURE//HOWES
& CO./PROPRIETORS
Aqua; 5″ × 1⁷/₈″ × 1″; 7n; 3b; pl; v, fb.

[embossed woman's head]/[d]
CLEWLEY'S/MIRACULOUS/
CURE FOR/RHEUMATISM//
SHAW PHARMACAL CO//
OFFICE 66 LIBERTY ST.
NEW YORK
Adv. 1891, WHS; 1910, AD.
Aqua; 6¹/₈″ × 2¹/₁₆″ × 1¹/₂″; 7n; 3b;
3ip; d, f; v, ss.

THE CLINIC/KIDNEY & LIVER
CURE//M'F'R'D BY FOLEY & CO./
STEUBENVILLE O. & CHICAGO
See FOLEY (Company).

COE'S/DYSPEPSIA CURE//
C. G. CLARK & C⁰//NEW
HAVEN C͟T
Product of the Coe Chemical Co.,
Cleveland, OH, in 1864 (Baldwin
1973); C. G. Clarke Co. in 1897 (Dev-
ner 1968). Adv. 1921, BD.
Aqua; 5¹⁵/₁₆″ × 2″ × 1³/₁₆″; 7n; 3b;
4ip; v, fss. See CLARK (Company).

COE'S/DYSPEPSIA/CURE//
THE C. G. CLARK CO.//
NEW HAVEN, CONN.
Aqua; 7¹/₂″ × 2¹/₂″ × 1³/₈″; 7n; 3b; 4ip;
v, fss. See CLARK (Company).

COKE/DANDRUFF/CURE
Adv. by A. R. Bremer, Chicago, in
1897 (Devner 1968); 1921, BD.
Clear; 6¹/₄″ × 3″ × 1⁷/₈″, also
5″ × 2¹/₂″ × 1¹/₂″; 9n; 6b; pl; base.

DR. COLE'S/CATARRH CURE
Adv. 1887, WHS; 1910, AD.
Clear; 2¹/₂″ × ³/₄″ diameter; 3n; 20b;
pl; v.

[Script:] The Original/Copper Cure
Amber; 7¹¹/₁₆″ × 2³/₄″ × 1⁵/₈″; 9n; 12b,
recessed above base; pl; d; script.

COULSON'S//COUGH AND/
CONSUMPTION CURE/
BUFFALO N.Y.
Directories listed John Coulson as a
druggist in 1877, and with William
Coulson in 1878. Coulson Drug Co.
was established prior to 1894 by C. H.
Webster and William Coulson. Between
1911 and 1917 the firm went out of
business. Cure adv. 1887, WHS.

Aqua; 5¹/₁₆″ × 1⁷/₈″ × 1³/₁₆″; 7n; 3b;
4ip; v, sfs.

"COX'S"//"CURE"
Clear; 4³/₈″ × 1⁹/₁₆″ × 1³/₁₆″; 7n; 3b;
3ip; v, ss.

CRAFTS/DISTEMPER AND
COUGH/CURE
Adv. 1900, EBB; 1915, SF & PD.
Amber; 5¹/₁₆″ × 1³/₄″ × 1¹/₄″; 7n; 3b;
1ip; v.

DR. CRAIG'S/COUGH
& CONSUMPTION/CURE
Adv. 1890, W & P.
Amber; 8″ × 3″ × 2″; 1n; 12b; pl, slug
plate panel¹; v. See CRAIG (Miscellane-
ous), WARNER (Cure).

THE ORIGINAL/D͟R CRAIG'S/
KIDNEY CURE/ROCHESTER, N.Y.
Dr. John A. Craig dispensed medicines
from Philadelphia and sold his rights to
the Kidney Cure For Diabetes to W. D.
Harris only months before meeting H.
H. Warner, in 1878. Warner then con-
vinced Craig to alter the formula which
became Warner's Safe Cure, thus two
similar kidney cures were on the mar-
ket. Richard D. Wood subsequently
bought the Craig Mfg. Co. from Harris
and continued to market products,
whether the cure was produced after
that is uncertain. Craig moved to Roch-
ester to develop compounds for Warner
(Wilson and Wilson 1971). Apparently
Craig did continue to market a variant
of the Kidney Cure since information on
the Craig Kidney Cure Co. was found
in the Boston city directory for 1885.
Craig's Kidney Cure, Craig Mfg. Co.,
New York, adv. 1878 and the Original
Kidney & Liver Cure, Craig Med. Co.,
Passaic, NJ, adv. 1887 (Baldwin 1973);
1910, AD.
Amber; 9¹/₂″ × 3¹/₂″ × 1³/₄″; 1n; 8b;
pl; h. See CRAIG (Miscellaneous),
WARNER (Cure).

DR. CRAIGS/[embossed kidneys]/
KIDNEY/CURE
Amber; 9³/₄″ × 3¹/₂″ × 1³/₄″; 1n; 12b;
pl; h. See CRAIG (Miscellaneous),
WARNER (Cure).

CRAIG'S KIDNEY/&/LIVER/
CURE/COMPANY
Amber; 9¹/₂″ × 3¹/₂″ × 1⁷/₈″; 1n; 12b;
pl; h. See CRAIG (Miscellaneous),
WARNER (Cure).

CRAMER'S/COUGH CURE
Aqua; 6¹/₄″ × 2″ × ⁷/₈″; 7n; 3b; ip,
front oval; v.

1. A plate with the company name which was inserted into
the mold so the glass manufacturer could use the same mold
for other firms.

FREE SAMPLE/CRAMER'S/
KIDNEY CURE/ALBANY N.Y.
Directories for 1912 and 1924 included
Cramer's Chem. Co., 228 Sherman,
Pat. Med. Mfgr.
Aqua; 4³/₁₆″ × 1″ diameter; 3n; 20b;
pl; v; occasionally found embossed
with backward Ns.

CRAMERS/KIDNEY & LIVER/
CURE
Aqua; 7″ × 2¹/₄″ × 1³/₈″, also 8⁷/₈″ ×
2⁷/₈″ × 1³/₄″; 7n; 3b; ip; v.

CRISWELL'S/BROMO-PEPSIN/
CURES HEADACHE AND
INDIGESTION
See CRISWELL (Pepsin).

CROSBY'S/5-MINUTE/CURE
Cure for headache, etc., adv. 1870s
(Devner 1968); 1901, HH & M.
Amber; 2¹/₂″ × ³/₄″ × ³/₄″; 9n; 2b; pl; v.

CROW'S/CHILL CURE
Produced in Jefferson, TX.
Aqua; 9¹/₈″ × 2¹/₂″ × 1³/₈″, also
7″ × 2¹/₈″ × 1¹/₄″; 11n; 3b; 3 or 4ip; v.

CRYSTALINA/THE MAGIC
SKIN CURE/A. S. HULL,
HINESBURGH, VT.
Adv. 1910, AD.
Clear; 5″ × 1¹⁵/₁₆″ × 1³/₁₆″; 9n; 18b;
pl; v.

CUBEB/COUGH/CURE
Introduced in 1886; adv. 1901 by the
Norman Lichty Mfg. Co., Des Moines,
Iowa, HH & M; 1910, AD.
Clear; 5¹/₈″ × 1⁵/₈″ × ⁷/₈″; 1n; 3b; ip; v.

THE CUTICURA SYSTEM/
OF CURING/CONSTITUTIONAL
HUMORS//ORIGINATED BY
WEEKS & POTTER BOSTON
Products for 1859 included Mrs. Gard-
ner's Indian Balsam, Low's Hair Dye
and Potter's Liniment. The firm was
also agent for Fetridge's Balm, Langley's
Bitters and Osgood's Cholagogue.
Andrew G. Weeks and Warren B. Pot-
ter formed Weeks & Potter in 1852 and
the firm operated until 1902, according
to Boston city directories. Cuticura was
trademarked in 1878 and the firm
introduced Sanford's Radical Cure in
1879. In 1883 the subsidiary firm of
Potter Drug & Chemical Co. was estab-
lished to produce the Cuticura prepa-
rations. Weeks & Potter marketed
other remedies and became Weeks &
Potter Co. in the late 1890s (Holcombe
1979). Directories don't list the Potter
Drug & Chemical Co. after 1961.
Cuticura preparations adv. 1948 by Pot-

ter Drug & Chemical Corp.; 1981 by Campana Corp., Division of Purex, Carson, Ca., *AD*.

Aqua; $9^{3}/_{16}$" × $2^{1}/_{2}$" × $2^{1}/_{2}$"; 11n; 2b; 4ip; v, fb. See FETRIDGE (Balm), GARDNER (Balsam), LANGLEY (*Bitters*), OSGOOD (*Miscellaneous*), POTTER (Drug), SANFORD (Cure, *Invigorator*).

THE CUTICURA SYSTEM/ OF CURING/CONSTITUTIONAL HUMORS//POTTER DRUG & CHEMICAL/CORPORATION/ BOSTON, MASS. U.S.A.

Aqua; 9" × $2^{1}/_{2}$" × $2^{1}/_{2}$"; 11n; 2b; 4ip; v, fb. See POTTER (Drug), SANFORD (Cure, *Invigorator*).

CUTICURA SYSTEM OF/BLOOD AND SKIN/PURIFICATION// POTTER DRUG & CHEMICAL/ CORPORATION/BOSTON, U.S.A.

Aqua; $9^{1}/_{2}$" × $2^{1}/_{2}$" × $2^{1}/_{2}$"; 11n; 2b; 4ip; v, fb. See POTTER (Drug), SANFORD (Cure, *Invigorator*).

CUTICURA TREATMENT/ FOR AFFECTIONS/OF THE SKIN// POTTER DRUG & CHEMICAL/ CORPORATION/BOSTON, U.S.A.

Aqua; $9^{1}/_{4}$" × $2^{1}/_{2}$" × $2^{1}/_{2}$"; 11n; 2b; 4ip; v, fb. See POTTER (Drug), SANFORD (Cure, *Invigorator*).

D. K. & B. CURE//BRO. MED. CO.

Dimmick's Kidney & Bladder Cure, adv. 1889, *PVS & S*; 1910, *AD*.

Aqua; $5^{3}/_{4}$" × $2^{3}/_{16}$" × $1^{1}/_{4}$"; 7n; 3b; 4ip; v, ss.

DACOSTA'S/RADICAL/CURE// SSS//MORRIS & HERITAGE// PHILADELPHIA

Aqua; $8^{3}/_{8}$" × $2^{5}/_{8}$" × $1^{5}/_{8}$"; 3n; 3b; 6ip; 3 on front; h, f; v, ss.

DACOSTAS/RADICAL/CURE// DR. MORRIS//SYRUP OF TAR

Cure for dyspepsia and problems of the kidneys and blood, adv. 1879, *VSS & C*; 1910, *AD*.

Aqua; $5^{3}/_{8}$" × $1^{7}/_{8}$" × 1"; 3n; 3b; 6ip, 3 on front; h, f; v, ss.

NO 1/DR DANIELS/VETERINARY/ COLIC/CURE

Adv. 1898, *CHG*; 1910, *AD*.

Clear; $3^{3}/_{8}$" × $1^{1}/_{16}$" × $1^{1}/_{16}$"; 7n; 2b; pl; h. Also variant, embossed NO 2. See DANIELS (Cough, *Liniment*, Lotion, Miscellaneous).

DR. DANIELS/WONDER WORKER LINIMENT/NATURES CURE FOR MEN OR BEAST/BOSTON, MASS, U.S.A.

See DANIELS (*Liniment*).

DATILMA/A RADICAL CURE/ FOR PAIN

Adv. 1900, *EBB*.

Clear; $4^{1}/_{4}$" × $1^{3}/_{4}$" × 1"; 7 or 9n; oval; pl; v.

DEAN'S/KIDNEY CURE/ THE LANGHAM MED. CO/ LEROY, N.Y.

Adv. as a remedy, 1907, *PVS & S*; as a cure, 1910, *AD*.

Aqua; $7^{1}/_{2}$" × $2^{1}/_{2}$" × $1^{1}/_{4}$"; 7n; 3 or 6b; ip; v.

DEERING & BERRY'S/GREAT KIDNEY CURE/SACO, ME.

Adv. 1900, *EBB*; 1910, *AD*.

Clear; 6" × 2" × 1"; 7n; sp; 3 or 6b; ip; v.

CHAS DENNIN//CERTAIN CURE/ FOR/RHEUMATISM//BROOKLYN

Dennin's Certain Cure adv. 1887, *WHS*; 1921, *BD*; Dennin's Rheumatic Remedy adv. 1935 by The Kells Co., Newburgh, N.Y., *AD*.

Aqua; $6^{3}/_{4}$" × $2^{1}/_{4}$" × $1^{5}/_{8}$"; 1n; 3b; 3ip; v, sfs.

DEWITTS/COLIC & CHOLERA CURE//E. C. DEWITT & CO.// CHICAGO, U.S.A.

Elden C. DeWitt and Charles W. Biggs were partners in Elk Point, SD, from 1884 until 1886 when Biggs left South Dakota and established his business in Chicago (Blasi 1974). Directories also locate E. C. DeWitt & Co. in Chicago by 1890. DeWitt's products were distributed by W. J. Parker ca. 1900 to 1915 (Devner 1968). Products adv. 1983 by DeWitt International Corp., Greenville, S.C., *RB*. The move from Chicago to Greenville was made after 1968. Colic & Cholera Cure adv. 1895 (Baldwin 1973); 1921, *BD*.

Aqua; $4^{7}/_{8}$" × $1^{3}/_{16}$" × $^{15}/_{16}$"; 11n; 3b; 4ip; v, fss. See DEWITT (Company, Sarsaparilla, Syrup), KODOL (Cure, Tonic), ONE MINUTE (Cure).

DR DEWITTS/ECLECTIC/CURE/ W J PARKER/& CO/ BALTIMORE/MD

Light green; $5^{5}/_{8}$" × $1^{5}/_{8}$" × $^{13}/_{16}$"; 11n; 3b; 3ip; h. See DEWITT (Company, Sarsaparilla, Syrup), KODOL (Cure, Tonic), ONE MINUTE (Cure).

DR DEWITTS LIVER BLOOD/ & KIDNEY CURE/W. J. PARKER & CO BALTO MD [Base:] WPG CO

Amber; $8^{5}/_{8}$" × 3" × 2"; 7n; 3b; pl; v. See DEWITT (Company, Sarsaparilla, Syrup), KODOL (Cure, Tonic), ONE MINUTE (Cure).

DUBBEL'S/COUGH & CROUP CURE/WAYNESBORO, PA.

Clear; $6^{3}/_{8}$" × $1^{7}/_{8}$" × 1"; 11n; 3b; 4ip; v. See DUBBEL (*Miscellaneous*), REDTHYME (Cure).

ELEPIZONE/A/CERTAIN CURE FOR/FITS &/EPILEPSY/DR H G ROOT/183 PEARL S^{T}/NEW YORK

New York City directories list Henry Root, Patent Medicines, from 1881 until 1913 or later. Cure adv. 1887, *WHS*; 1910, *AD*.

Clear; $8^{1}/_{2}$" × $3^{1}/_{4}$" × $1^{3}/_{4}$", also $5^{7}/_{8}$" × $2^{3}/_{8}$" × $1^{1}/_{8}$"; 9n; 6b; pl; h; also variants embossed LONDON.

"ELEPIZONE"/A/CERTAIN CURE FOR/FIT &/EPILEPSY/H. G. ROOT M.C./183 PEARL ST/NEW YORK

Aqua; $9^{3}/_{4}$" × $3^{3}/_{8}$" × $1^{5}/_{8}$"; 7n; 14b; pl; h.

DR. ELLIOT'S//SPEEDY CURE

Aqua; $7^{1}/_{8}$" × $2^{3}/_{4}$" × $1^{3}/_{4}$"; 7n; sp; 3b; 4ip; v, ss.

ELLIS'S/SPAVIN CURE

Adv. 1885, Boston city directory; 1910, *AD*.

Aqua; 8" × $2^{1}/_{2}$" × $1^{3}/_{8}$"; 7n; 3b; 3ip; v.

[h] A. D./ELMERS/[v] IT CURES/ LIKE/A CHARM// PAIN KILLING//BALM

See ELMER (*Balm*).

EMERSON'S/RHEUMATIC CURE/ EMERSON/PHARMACAL COMPANY/BALTIMORE MD

Adv. 1901, *HH & M*; 1917, *BD*.

Amber; 5" × 2" diameter; 3n; 20b; pl; h. See EMERSON (*Drug*, Sarsaparilla).

EMERSON'S SARSAPARILLA/ -3-BOTTLES GUARANTEED TO CURE -3-/CHICAGO, ILL. KANSAS CITY, MO.

See EMERSON (*Sarsaparilla*).

DR. FENNER'S/KIDNEY & BACKACHE/CURE

Adv. 1889, *PVS & S*; 1921, *BD*.

Amber; $10^{3}/_{8}$" × $3^{5}/_{8}$" × $1^{3}/_{4}$"; 11n; 12b; pl; h. See CAPITOL (Bitters), FENNER (Medicine, Miscellaneous, *Remedy*, Specific).

DR M. M. FENNER'S/PEOPLES REMEDIES/FREDONIA N.Y./ U.S.A./KIDNEY & BACKACHE/ CURE/1872–1898

See FENNER (*Remedy*).

FENNING'S/FEVER CURER

Product of Alfred Fennings, Hammersmith, England; firm founded ca. 1834.

The business eventually moved to Cowes, IOW; bottles were manufactured by the Garsten Bottle Co., Lancashire. The Fever Curer, when analyzed in 1909, was found to contain a weak solution of Nitric Acid, flavored with peppermint (McEwen 1977). Imported by E. Fougera & Co.

Clear; 6¼″ × 2½″ × 1½″; 7n; 6b; pl; v; ABM. Also without ABM; several sizes and colors.

THIS BOTTLE IS/LOANED BY THE/FITCH/DANDRUFF CURE CO.
See F. W. FITCH (Company).

F. W. FITCH'S//IDEAL/ DANDRUFF CURE CO
See F. W. FITCH (Company).

FITZGERALD'S/MEMBRANE CURE
Adv. 1900, *EBB*.
Aqua; 7⅛″ × 2½″ × 1½″; 7n; 3b; 3ip; v.

FIVE MINUTE/COUGH CURE/ PRICE 25 CENTS [Base:] WT & CO/U.S.A.
Bottle manufactured by Whitall-Tatum, 1857 to 1935 (Toulouse 1972).
Aqua; 5¾″ × 1¾″ × 1″; 11n; 3b; 3ip; v.

FLORAPLEXION/CURES/ DYSPEPSIA LIVER COMPLAINT/ AND CONSUMPTION//FRANKLIN HART//NEW YORK
Introduced in the 1870s (Devner 1968); adv. 1921, *BD*.
Aqua; 6″ × 2″ × 1⅛″; 1n; 3b; 3ip, oval front; v, fss; 2 sizes.

SAMPLE BOTTLE/FOLEY'S KIDNEY CURE./FOLEY & CO./ CHICAGO U.S.A.
See FOLEY (Company).

FOLEY'S KIDNEY/& BLADDER CURE//FOLEY & CO// CHICAGO, U.S.A.
See FOLEY (Company).

FOLEY'S KIDNEY & BLADDER CURE/MFD BY FOLEY & CO/ CHICAGO
See FOLEY (Company).

FOLEY'S/SAFE DIARRHOEA/& COLIC CURE//FOLEY & CO.// CHICAGO. U.S.A.
See FOLEY (Company).

FONTAINES CURE//FOR THROAT & LUNG DISEASES//FRANKLYN COIT/BROOKLYN/NEW YORK U.S.A.

Fontaine's Consumption Cure, adv. 1887, *WHS*; 1910, *AD*.
Aqua; 5⅝″ × 2″ × 1⅛″; 7n; 3b; 3ip; v, ssf.

FRAZIER'S DISTEMPER/CURE/ NAPPANEE, IND. [Base:] I
Adv. 1889, *PVS & S*; 1916, *MB*.
Clear; 4⅞″ × 1¹³⁄₁₆″ × 1³⁄₁₆″; 7n; 3b; 1ip, embossed; v.

FRENCH'S/TRADE/[embossed crown]**/MARK/KIDNEY & LIVER/&/DROPSY CURE CO/ PRICE 1.00**
Product of Robert T. French, Rochester, NY (Baldwin 1973). French established his business in 1876, renaming it R. T. French & Son in 1877; French, Jackson & French in 1880 and R. T. French Company in 1892. The company, famous for mustards and spices, was sold to J & J Colman, England, in 1926 (Zumwalt 1980). The manufacture of medicinals must have been only a brief venture.
Amber; 9½″ × 3¾″ × 1¾″; 1n; 6b; pl; h; TRADE MARK, reverse embossed.

FRUITCURA/WOMAN'S TONIC// MADAME M. YALE//CHICAGO & NEW YORK
See YALE (Tonic).

FULTON'S/RADICAL REMEDY// SURE KIDNEY, LIVER AND DYSPEPSIA CURE
Product of John J. Fulton, San Francisco, CA. Adv. 1897, *L & M*; 1905 (Devner 1968).
Amber; 9″ × 2⅝″ × 2⅝″; 11n; 2b; 2ip; v, fb.

GARGET CURE/C. T. WHIPPLE, PROP./PORTLAND, ME. [Base:] W. T. Co./U.S.A.
Bottle manufactured by Whitall-Tatum, Millville, NJ, 1857 to 1935 (Toulouse 1972).
Aqua; 5⅝″ × 2″ × 1″; 7n; 3b; 4ip; v.

GERMAN FIR COUGH CURE/ DILLARD REMEDY CO./ EAST BANGOR, PA. [Base:] 225A
Aqua; 6½″ × 2¼″ × 1⅛″; 7n, sp; 3b; 4ip; v.

Dᴿ GERMAN'S/COUGH & CONSUMPTION/CURE// S. A. WAKEMAN//UTICA. N.Y.
Aqua; 5¾″ × 2″ × 1¼″; 7n; 3b; 4ip; v, fss. See MARCHISI (Miscellaneous).

GLOBE/HAIR RESTORATIVE AND DANDRUFF CURE/GLOBE MFG.

CO, GRINNELL, IA
See GLOBE (Restorer).

GLOVER'S/IMPERIAL DISTEMPER CURE/H. CLAY GLOVER/ NEW YORK. [Base:] 412
Adv. 1887, *McK & R*; 1901, *HH & M*. The Distemper Cure was apparently changed to Remedy after passage of the 1906 Pure Food & Drug(s) Act and was adv. 1907, *PVS & S*; 1916, *MB*; and as Distemper Medicine, 1921, *BD*.
Amber; 5″ × 2″ × 1⅜″; 1n; 3b; pl; v. See GLOVER (Company, Medicine, Remedy).

GLOVER'S IMPERIAL MANGE CURE//H. CLAY GLOVER D.V.S.// NEW YORK
The Mange Cure was introduced in 1874 (Periodical Publishers Association, 1934) and the company was founded in 1876; ". . . eventually our products were also manufactured for human use in the treatment of dandruff and dandruff itch," according to Frank H. Glover, President, H. Clay Glover Co., Inc., Garden City, NY (personal communication, 1984). By 1900 the firm was the largest seller of bottled veterinarian products in the country. Product adv. as a Mange Remedy after passage of the 1906 Act; 1925, *BD*; as Mange Medicine in 1929–30, 1983, *AD*.
Amber; 6⅞″ × 2⅜″ × 1¾″; 1n; 3b; 4ip; v, fss. See GLOVER (Company, Medicine, Remedy).

DR GOERSS'/CHAULMOOGRA/ THE EAST INDIA CURE//[script:] **Franz C. A. Goerss. M.D.//Franz C. A. Goerss. M.D.**
Adv. 1895, *PVS & S*; 1910, *AD*.
Amber; 6″ × 2″ × 1⅛″; 7n; 3b; 3ip, arched front; v, fss, also script.

GOLD DANDRUFF CURE
Clear; 7⅜″ × 2½″ × 1⅞″; 3n; 6b; pl; v.

S. GROVER GRAHAM'S/ DYSPEPSIA CURE/ NEWBURGH, N.Y.
Remedy adv. 1900 (Devner 1968); 1929–30, *AD*. Grover Graham Preparations adv. 1948, *AD*.
Clear; 6⅝″ × 2⅜″ × 1⅜″, also 8¹⁄₁₆″ × 2⅞″ × 1¹⁵⁄₁₆″; 7n; 3b; pl; v. Also variants embossed: DYSPEPSIA REMEDY and MIXTURE.

DR. GRAVE'S/HEART REGULATOR/CURES HEART DISEASE
Adv. 1879, *VSS & C*; 1910, *AD*.

Aqua; 6¾″ × 2″ × 1⅛″, also
5⁹⁄₁₆″ × 2¹⁄₁₆″ × 1⅛″; 7n; 3b; 4ip; v.
See GRAVES (*Bitters*).

GRAY'S BALSAM/BEST COUGH CURE//S. K. PIERSON// LEROY, N.Y.
See GRAY (*Balsam*).

GRAY'S BALSAM/CURES COUGHS//S. K. PIERSON// LEROY, N.Y.
See GRAY (*Balsam*).

GREAT BLOOD & RHEUMATISM CURE/NO. 6088/MATT J. JOHNSON CO./ST. PAUL, MINN.
Adv. 1910, *AD*; 1929–30 and 1948 as
Matt Johnson's Remedy No. 6088 by
Matt J. Johnson Co., St. Paul, Minn.,
AD.
Aqua; 9″ × 2¹¹⁄₁₆″ × 1¾″; 1n; 3b; 3ip;
v. Also embossed with SUPERIOR,
WIS.

GUARANTEE/DANDRUFF/CURE/ THE/HOMER KIRK/CO [Base:] A.M.F. & CO.
Clear; 7¾″ × 2⁵⁄₁₆″ × 2⁵⁄₁₆″; 3n; 1b;
pl; h; distinctive shape.

DR. B. W. HAIR'S/ASTHMA CURE/ CINCINNATI, O. [Base:] WT & CO/U.S.A.
Bottle manufactured by Whitall-Tatum,
1857–1934 (Toulouse 1972). Cure adv.
1883 (Baldwin 1973); 1921, *BD*; Hair's
Asthma Formula adv. 1948 by Abbey
& Co., Richmond, Ind., *AD*. Cincinnati
directories indicate the business was
operating in the early 1880s; the last
listing was 1895 (Blasi 1974). The
history of the firm in Hamilton, OH (fol-
lowing entry) is unknown.
Aqua; 5⅞″ × 2³⁄₁₆″ × 1⅜″; 11n; 4b;
1ip; v. Also variants embossed
LONDON.

DR. B. W. HAIR'S/ASTHMA CURE/ HAMILTON, OHIO
Aqua; 8″ × 2⅝″ × 2⅝″; 11n; 2b; pl; v.

DR HALE'S/HOUSEHOLD/ COUGH CURE
Cure adv. 1895; Remedy adv. 1907,
PVS & S.
Clear; 6⅞″ × 2⅛″ × 1¼″; 24n; 6b;
3ip; v.

HALL'S/CATARRH/CURE
Bottle manufactured ca. 1900.
Produced as a gentian root tonic by F.
J. Cheney & Co., Toledo, OH ca.
1879. Label from newer variant: [Henry
S.] *HALL'S CATARRH CURE contains
about 14 per cent of grain alcohol, used only
as a solvent to prevent freezing. This valu-
able remedy has been thoroughly tried, and
proved itself a cure of catarrh. We offer it
to the public with full confidence of its
merits. Directions. . . . Price 75 cents.
Registered in U.S. Pat. Office, Oct. 23, 79.
Revised label Nov. 1st., 1906.* Hall's
Catarrh Cure adv. 1916, *MB*; Hall's
Catarrh Medicine, "formerly Catarrh
Cure," 1918 (Devner 1968), and
1929–30 by Cheney Med. Co., 1212
Adams St., Toledo, O., *AD*.
Aqua, clear; 4⅝″ × 1⅝″ diameter; 1,
3, 7 and 9n; 20b; pl; v. See HALL
(*Medicine*).

HAMILTON'S/DANDRUFF/CURE/ & HAIR/RESTORATIVE
See HAMILTON (*Restorer*).

HAMILTON'S/MEDICINES/CURE [within 7-point star]/AUBURN/NY
See HAMILTON (*Medicine*).

HANDYSIDE'S/CONSUMPTION, CURE
Products vary. George Handyside,
Newcastle, England, established his
business and introduced his "Cure for
Consumption" ca. 1858. Handyside
died May 1904 (McEwen 1977);
whether products were produced after
1904 is uncertain.
Dark green; 8⅜″ × 1¾″ × 1¾″; 2n;
2b; pl; v; container variations.

HANFORD'S/CELERY CURE/OR/ NERVE FOOD/CURES/ RHEUMATISM/NEURALGIA/ INSOMNIA/& C. & C.
Adv. 1890 by G. Hanford Mfg. Co.,
Syracuse, NY (Baldwin 1973); 1910,
AD.
Aqua; 7⅝″ × 2½″ × 1¾″; 1n; 3b; 4ip;
h; several sizes.

HART'S SWEDISH ASTHMA CURE/ BUFFALO, N.Y.
Adv. 1910, *AD*; 1921, *BD*.
Amber; 6½″ × 2⅝″ × 1½″; 9n; 3b;
pl; v. See HART (*Remedy*).

HART'S SWEDISH ASTHMA CURE CO/BUFFALO, N.Y.//4 FL. OZ.
Aqua, clear; 6″ × 2¼″ × 1½″; 7n; 3b;
pl; v, s; h, f. See HART (*Remedy*).

THE HAWKER MEDICINE Cº LTD/ HAWKER'S DYSPEPSIA CURE/ ST. JOHN. N.B.
See HAWKER (*Company*).

HEALY & BIGELOW'S/KICKAPOO/ INDIAN COUGH CURE
Bottle manufactured ca. 1889 (Wilson
and Wilson 1971).
Aqua; 6¼″ × 1½″ diameter; 7n; 20b;
1ip; v. See HEALY & BIGELOW (Oil,
Miscellaneous), KICKAPOO (*Oil*,
Miscellaneous, Syrup), SAGWA
(Miscellaneous).

GUARANTEED CURE/HENRY'S/ RED GUM/COUGH/REMEDY
See HENRY (*Remedy*).

FREE SAMPLE/HENTZ'S CURATIVE/BITTERS [Base:] 43
See HENTZ (*Bitters*).

HENTZ'S//CURATIVE/BITTERS// PHILADELPHIA
See HENTZ (*Bitters*).

HERMANU'S/GERMANYS INFALLIBLE/DYSPEPSIA CURE [Base:] 2
Amber; 2¹⁵⁄₁₆″ × 1¹⁄₁₆″ × ¾″; 3n; 3b;
1ip; v.

HERMANUS/GERMANY'S/ INFALLIBLE/DYSPEPSIA CURE// [embossed soldier standing over a dead bird]//PREPARED FOR THE U.S./ BY. L. AND N. ADLER MEDICINE CO./READING PA. U.S.A.
Amber; 8¾″ × 2¼″ × 2¼″; 12n; 2b;
3ip; v, f; h, s; v, b.

DR. HERNDON'S//GYPSEY'S GIFT//[monogram] /THAT IS/ MEDICINE/WHICH/CURES/ BALTº MD
Cure for rheumatism, adv. 1880 (Bald-
win 1973).
Clear, aqua; 6¾″ × 2″ × 1¼″; 7n; 3b;
3ip; v, ss; h, f.

HERNIA CURE CO.//WESTBROOK MAINE//RUPTURINE//CURES RUPTURE
See HERNIA (*Company*).

HERRICK'S HOREHOUND SYRUP/ CURES ALL THROAT/AND LUNG AFFECTIONS
Aqua; 6″ × 2⅛″ × 1⅛″; 7n, sp; 3 or
6b; ip; v, ssss.

HICK'S CAPUDINE/CURES HEADACHE
Amber; 3¼″ × 1⅜″ × ¹¹⁄₁₆″; 9n; 18b;
1ip; v. See CAPUDINE (Miscellaneous),
HICKS (*Miscellaneous*).

HILLEMAN'S AMERICAN/ CHICKEN CHOLERA CURE/ ARLINGTON MINN.
Bottle manufactured ca. 1903.
Cobalt; dimens., neck and base
finishes unk.; v.

DR. HILLER'S/COUGH CURE
Introduced ca. 1880, by F.J. Hiller, San Francisco who also produced Dr. Hartman's Cough & Croup Syrup and Hydrastine (Wilson and Wilson 1971). Adv. 1897, *L & M*.
Aqua; 7¼″ × ? × ?; 11n; 3b; 1ip; v.

HILLS/[H with arrow] TRADE/ MARK/DYS PEP CU/CURES/ CHRONIC/DYSPEPSIA/ INDIANA DRUG/SPECIALITY CO/ SᵀLOUIS &/INDIANAPOLIS
See INDIANA *(Company)*.

HIMALYA/THE KOLA/ COMPOUND/NATURES/CURE FOR/ASTHMA/NEW YORK/ CINCINNATI
See HIMALYA *(Compound)*.

HIRE'S//COUGH CURE// PHILA. PA.
Charles E. Hires, a Philadelphia druggist since ca. 1869 (Zumwalt 1980), began manufacturing extracts in 1876 (Devner 1970). Hires is particularly well known for his root beer extract. Hires died in 1937. Consolidated Foods purchased the company, today it's controlled by Crush International, Inc. (Zumwalt 1980). Cough Cure adv. 1891, *WHS*; 1907, *PVS & S*.
Aqua; 4½″ × 1½″ × 1½″; 7n; 2b; 3ip; v.

HITE'S PAIN CURE/FOR MAN AND ANIMALS/STAUNTON, VA.
Adv. 1891, *WHS*; 1929–30 and 1935, as Hite's Pain Remedy by S. P. Hite, Co., Inc., Roanoke, Va., *AD*.
Clear; 5¾″ × 1¹⁵⁄₁₆″ × 1³⁄₁₆″; 7n; 3b; 4ip, oval front; v. See HITE *(Remedy)*.

HOLLAND/COUGH &/ CONSUMPTION/CURE
Light green; 6³⁄₁₆″ × 2¹⁄₁₆″ × 1³⁄₁₆″; 7n, sp; 3b; 3ip; v.

HOLLENSWORTH'S/ RUPTURE CURE
Aqua; 6¼″ × 2⅛″ × 1¼″; 7n; 3 or 6b; ip; v.

HOLLOWAY'S/CORN CURE
Thomas Holloway, a London merchant, introduced an ointment in 1838, pills shortly after, and worm confections and an expectorant ca. 1868. Holloway appeared in New York City directories in 1855–56 through 1870. He apparently never lived there, the business was conducted by agents. Holloway died in Dec. 1883 (Holcombe 1979). The Toronto firm of Northrop & Lyman may have either procurred or borrowed Holloway's established name to affix to their own product (Sullivan 1983). Corn Cure adv. 1886, ca. 1909 (Sullivan 1983).
Aqua; 2¹¹⁄₁₆″ × ¹⁵⁄₁₆″ × ¹⁵⁄₁₆″; 9n; 2b; pl; v. See NORTHROP & LYMAN *(Discovery)*.

HOLMES' SURE CURE MOUTH WASH/PREPARED SOLELY BY/ DR. W. R. HOLMES/MACON, GA. [Base:] PAT. JAN 22 78
Adv. 1886 (Baldwin 1973).
Clear; 3⅝″ × 1⁷⁄₁₆″ × 1³⁄₁₆″; 9n; 18b, modified; pl; v.

HOOD'S PILLS/DOSE/2 to 6/ CURE LIVER ILLS
See HOOD *(Pills)*.

HOODS PILLS/DOSE/TO/CURE LIVER ILLS//C. I. HOOD & CO/ U.S.A/LOWELL MASS
See HOOD *(Pills)*.

C. B. HOWE//CURE
Label: *HOWE'S NEVER-FAILING AGUE CURE and TONIC BITTERS, A Permanent Cure For Chills, Ague and Fever, Intermittents, Dumb and Brow Agues, Liver Complaints, Biliousness, General Debility, Weakness, Irregularities, Sick Headache, Drowsiness, Dyspepsia, Neuralgia, Sciatica, Paralysis. All Atonic, Nervous and Periodic Diseases. Price: One Dollar Per Bottle. C. B. Howe, Sole Proprietor. Seneca Falls, N.Y.* Adv. 1868, 1878 (Ring 1980).
Aqua; 7″ × 2⅝″ × 1³⁄₈″; 7n; 3b; 4ip; v, ss.

STEWART D. HOWE'S/ARABIAN/ MILK-CURE//FOR CONSUMPTION//NEW YORK
Adv. 1876, *WHS*; 1910, *AD*.
Aqua; 7⅝″ × 2½″ × 1¾″; 7n; 3b; 3ip; v, fss. See CRISTADORO *(Hair)*, HOWE *(Sarsaparilla, Tonic)*.

DR. HOXSIE'S//CERTAIN/CROUP CURE//BUFFALO, N.Y.
Directories establish A. C. Hoxsie, MD, Homeopathist, in 1865. Adv. as a cure in 1872; as a remedy in 1900, *EBB*; as a syrup in 1907, *PVS & S*; again as a cure in 1910, *AD*; remedy in 1912 by Kells Co., Newburg, N.Y. (Devner 1968); cure 1916, *MB*.
Clear; 4½″ × 1¾″ × 1″; 7n; 3b; 3ip; v, sfs. See HOXSIE *(Remedy)*.

HOYT'S/POISONED BLOOD/CURE/ THE HOYT CHEMICAL/CO./ INDIANAPOLIS
See HOYT *(Company)*.

JAYNE'S/FOUNDER CURE/ JENNINGSVILLE, PA.
Aqua; 5⅛″ × 2⅛″ × 1⅜″; 9n; 18b; pl; v.

JOHNSONS CHILL & FEVER TONIC/GUARANTEED TO CURE/ A. B. GIRARDEAU SAV H.GA
See JOHNSON *(Tonic)*.

W. M. JOHNSON'S/PURE HERB TONIC/SURE CURE/FOR ALL MALARIAL DISEASES [Base:] 147/G
See JOHNSON *(Tonic)*.

JUNIPER BERRY GIN/ A DIURETIC/CURES KIDNEY TROUBLE//JUNIPER BERRY GIN/BOTTLED BY/QUININE WHISKEY CO./LOUISVILLE, KY.
See QUININE *(Company)*.

K. K./CURES/BRIGHT'S/DISEASE/ AND/CYSTITIS//K. K. MEDICINE CO//NEW JERSEY
See K. K. *(Company)*.

DR. KAISER'S//COUGH CURE
Clear; 6⅜″ × 2³⁄₁₆″ × 1″; 7n; 3b; 3ip; v, ss.

K.K.K./KAY'S/KENTUCKY KURE// OR/LINIMENT
Adv. 1900, *EBB*; 1910, *AD*.
Aqua; 3¾″ × 1½″ diameter; 7n; 20b; pl; v, fb.

DR. J. KAUFFMAN'S ANGELINE/ INTERNAL RHEUMATISM CURE/ HAMILTON OHIO.
Product of Jos. Schumaker & Co., Sole Proprietor, Trade Mark Registered, 12 Sept. 1882. Adv. 1913, *SN*.
Clear; 7⅝″ × 2⁷⁄₁₆″ × 2⁷⁄₁₆″; 9n; 2b; pl; v.

[h] D/L. E. K./THE Keeley/Cure/[d] DRUNKENNESS/[h] A/RELIABLE/ REMEDY/DISCOVERED BY/ DR. L. E. KEELEY/DWIGHT, ILL.// [shoulder:] K. C./[Script:] Leslie E. Keeley M. D.
Dr. Keeley, John Oughton, a chemist, and Mayor Curtis Judd, Dwight, IL, opened the Keeley Institute in 1879. Keeley died in Feb. 1900 and was succeeded by Oughton and Judd. Oughton operated the business, after the retirement of Judd, until his death in 1925. Oughton's son, James, continued until his death in 1935, family members thereafter until 1966. Labels indicate the distinctively shaped bottles were patented 15 March 1881. Approximately 30 different embossed bottles

were produced from ca. 1879 until the early 1920s (Hiller and Hiller 1973).
Clear; 5⅝″ × 3⅛″ × 1⅝″; 9n, with pour spout; unique, patented shape, inset base; pl; h, d, fb, with script. **Also variant DRUNKENNESS replaced with TOBACCO HABIT.** See KEELEY (Company, Remedy).

[h] Dr/L E KEELEY'S/DOUBLE/ CHLORIDE/OF/[d] GOLD CURE/ FOR/DRUNKENNESS/[h] A/ TESTED/AND/INFALLIBLE/ REMEDY/DISCOVERED BY/ DR. L. E. KEELEY/DWIGHT, ILL.//[shoulder:] K. C./[Script:] Leslie E. Keeley M. D.
Clear; 5½″ × 3⅛″ × 1⅝″; 9n, with pour spout; unique patented shape, inset base; pl; h, d, fb, with script. **Many variants including one with DRUNKENNESS replaced with NEUROTINE.** See KEELEY (Company, Remedy).

KELLEY'S/PERCURO/NEW-YORK
Aqua; 5¾″ × 2½″ × 1½″; 11n; 3b; 1ip. not embossed; v; p. See KELLEY *(Miscellaneous)*.

KELLUM'S/SURE CURE/FOR/ INDIGESTION/AND/DYSPEPSIA
Clear; 6¾″ × 2½″ × 1⅝″; 9n; 3b; pl; h.

KENDALL'S SPAVIN CURE [Base:] ENOSBURGH FALLS, VT.
Label: *KENDALL'S SPAVIN CURE. Alcohol 41%. We Recommend this Remedy for the removal of Spavins, Splints, Curbs, Ringbones, Callous, Galls, Swellings, Wounds, Sprains, Founder and unnatural enlargements of the joints or on any part of the body or limbs. No Blistering or Sores made by its use. Prepared By DR. B. J. KENDALL CO., ENOSBURG FALLS VT., U.S.A. Price, $1.00. Registered 1876 and 1907, by Dr. B. J. Kendall Co.*
Amber; 5½″ × 1⅞″ diameter; 7n; 21b, 12 sides; pl; h, around shoulder. **Also same with 10 sides, 2″ dia.** See KENDALL (Balsam, *Miscellaneous*).

KENDALL'S SPAVIN CURE// FOR HUMAN FLESH [Base:] KENDALL'S SPAVIN TREATMENT ENOSBURG FALLS, VT.
Amber; 5¼″ × 1⅜″ diameter; 7n; 21b, 10 sides; pl; v, ss. See KENDALL (Balsam, *Miscellaneous*).

DR KILMER & CO//CATARRH/[in indented lung:] DR KILMER'S/ COUGH-CURE/CONSUMPTION OIL/[below lung:] SPECIFIC// BINGHAMTON, N.Y.
A competitor is identified as T. J. Kilmer's Cough Cure, produced in Schoharie, NY.
Aqua; 8¾″ × 2¾″ × 1¾″; 1n; 3b; 5 or 6ip, 3 on the front; v, s; h, f; v, s. See KILMER (Extract, Miscellaneous, Ointment, *Remedy*).

[h] DR. KILMER'S/[v] INDIAN/ COUGH CURE/CONSUMPTION OIL/[h] BINGHAMTON/N Y USA
[See Figure 86]
Adv. 1887, *WHS*; 1912 as a remedy (Devner 1968); 1913, *SN*.
Aqua; 5¾″ × 2¹/₁₆″ × 1⅝″, also 7¼″ × 2⅜″ × 1⅜″; 1n; 3b; 4ip; h, v. **Also with REMEDY instead of CURE.** See KILMER (Extract, Miscellaneous, Ointment, *Remedy*).

Fig. 86

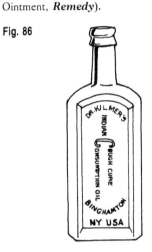

SAMPLE BOTTLE/DR. KILMER'S/ SWAMP-ROOT/KIDNEY CURE/ BINGHAMTON, N.Y.
Clear, aqua; 3⅛″ × 1″ diameter; 7n; 20b; pl; v. **Variant embossed LONDON. E.C.** See KILMER (Extract, Miscellaneous, Ointment, *Remedy*).

DR. KILMER & CO.//THE GREAT/[in indented kidney:] DR./ KILMER'S/SWAMP-/ROOT/ KIDNEY/LIVER &/BLADDER/ CURE/[below kidney:] SPECIFIC// BINGHAMTON, N.Y.
Aqua; 8⅜″ × 2⅞″ × 1¾″; 1n; 3b; 6ip, 3 on the front; v, s; h, f; v, s. **Also with LONDON. E.C.** See KILMER (Extract, Miscellaneous, Ointment, *Remedy*).

[h] DR KILMER'S/[v] SWAMP ROOT/KIDNEY LIVER/AND BLADDER CURE/[h] BINGHAMTON/N.Y. U.S.A.
[See Figure 87 and Photo 22]
Aqua; 7″ × 2⁷/₁₆″ × 1⅜″; 1n; 3b; 4ip; h, v. **Variant with LONDON. E.C.** See KILMER (Extract, Miscellaneous, Ointment, *Remedy*).

KODOL DYSPEPSIA/CURE//E. C. DEWITT & CO/CHICAGO, U.S.A.
Label: *KODOL DYSPEPSIA CURE, The New Digestant Combined with Pepsin, Pancreatine, Ptyalin and Other Effective Agents, as they exist in the Human Stomach. It Cures Bad Breath. Prepared only by the E. C. DeWitt & Co.*
Aqua; 4¼″ × 1¼″ × ⅝″; 7n; 3b; 4ip; v. See DEWITT (Company, *Cure*, Sarsaparilla, Syrup), KODOL *(Tonic)*, ONE MINUTE (Cure).

Fig. 87

KODOL DYSPEPSIA CURE// E. C. DEWITT & CO. CHICAGO
Aqua; 9″ × 2⅞″ × 1⅝″; 11n; 3b; 4ip; v, ss. See DEWITT (Company, *Cure*, Sarsaparilla, Syrup), KODOL *(Tonic)*, ONE MINUTE (Cure).

DR. LANE'S/CATARRH CURE/ FRED ᴷW. HALE, N. Y. PROP.
Also a London office (McEwen 1977). Adv. 1879, *VSS & C*; 1912, British Medical Association (Devner 1968).
Clear; 5⅛″ × 1⅝″ × 1⅝″; 9n; 2b; pl; v.

Dᴿ. LANE'S/CATARRH CURE// FREDᴷ. W. HALE//PROPRIETOR
Aqua; 6½″ × 2¼″ × 1⅜″; 7n; 3b; pl; v, fcc.

LANGENBACH'S/DYSENTERY CURE
Label: *Langenbach's Dysentery Cure— Manufactured by Langenbach Bitters Co., San Francisco. A Sure Cure For Dysentery, Diarrhoea, Colic, Cholera-Morbus, Cramps and all Choleroic Maladies.*
Amber; 5⅝″ × 2⅜″ diameter; 20 and 7n; 20b; pl; v.

DR. LAUBACH'S/WORM CURE
Adv. 1876, *WHS*; 1910, *AD*.
Aqua; 4⁵/₁₆″ × ⅞″ diameter; 7n; 20b; pl; v.

LAVARRE'S//SURE CURE/FOR NEURALGIA & C.//A CURE GUARANTEED
Adv. 1916, *MB*.
Clear; 6¼″ × 2″ × 1⅛″; 7n; 3b; 3ip; v, sfs.

LAWSON'S//CURATIVE
Adv. 1862 (Putnam 1968); 1901, *HH & M.*
Aqua; 9³/₈″ × 2³/₄″ × 1³/₄″; 11n; 3b; 4ip; v, ss.

LEINBACH'S/CORN CURE
Clear; 2¹/₈″ × ³/₄″ × ³/₄″; 9n; 2b; pl; v.

JARABE DE LEONARDI/PARA LA TOS CREOSOTADO/LEONARDIS COUGH CURE CREOSOTED/ NEW YORK AND TAMPA, FLA.
Light green; 5¹/₄″ × 1⁵/₈″ × 1″; 7n; 3b; 3ip; v. See LEONARDI (Lotion, Purifier).

LEONARDI'S//GOLDEN EYE LOTION/CURES WITHOUT PAIN// TAMPA FLA.
See LEONARDI (*Lotion*).

NO. 1/DR. LESURE'S/COLIC/CURE
[Base:] **447**
Adv. 1900, *EBB.*
Clear; 3³/₈″ × 1¹/₈″ × 1¹/₈″; 7n; 2b; pl; h. See LESURE (Liniment, Miscellaneous).

DR. LESURE'S/TOTAL ECLIPSE/ SPAVIN CURE/KEENE, N. H.
Label: *Lesure's Total Eclipse Spavin Cure and Family Liniment, The Most Wonderful Healer Known to Man! Dr. John G. Lesure, Keene, N.H.* Adv. 1900, *EBB.* The only information found was reference to the death of John G. Lesure, 11 Feb. 1901 noted in S. G. Griffin's, *History of the Town of Keene,* (Keene, NH: Sentinel Printing Co., 1904).
Clear; 5¹/₈″ × 2¹/₄″ × 1³/₈″; 9n; 18b; pl; v. See LESURE (Liniment, Miscellaneous).

LIEBIG'S FIT CURE/AN/ENGLISH REMEDY/DR. AB. MESSEROLE/ 96 JOHN ST. NEW YORK
Adv. 1884; 1910, *AD.*
Aqua; 5⁵/₈″ × 2¹/₈″ × 1¹/₂″; 9n; 3b; pl; v. See LIEBIG (*Invigorator,* Miscellaneous), MEDICATED (*Tablet*).

LIGHTNING KIDNEY AND LIVER CURE/NO RELIEF, NO PAY!// HERB MEDICINE CO// WESTON. W. VA
See HERB (*Medicine*).

LIGHTNING//OIL//SURE/CURE
See LIGHTNING (*Oil*).

LIQUFRUTA//COUGH CURE
A British product. Available 1909 (McEwen 1977).
Aqua; 5³/₁₆″ × 2″ × 1³/₁₆″; 24n; 6b; pl; v. Variations in color and size, also ABM.

LITTLE GIANT/CATARRH CURE// MF'D BY A. F. MANN// WARSAW, N.Y.
Amber; 3¹/₂″ × 1¹/₈″ × 1¹/₈″; 7n; 1 or 2b; 3 or 4ip; v, fsb.

LONG'S/STANDARD/MALARIA/ CURE Co/ROCHESTER/N.Y.
Amber; 7¹/₂″ × 3⁵/₈″ × 1³/₄″; 1n; 12 or 13b; pl; h.

DR. W. H. LONG'S/VEGETABLE/ PAIN CURE/25 CENTS [Base:] **3**
Aqua; 5³/₄″ × 1⁷/₈″ × 1″; 7n, sp; 3b; 3ip, arched embossed panel; v.

Dᴿ MACKENZIES/CATARRH CURE/SMELLING/BOTTLE
Adv. 1895, *PVS & S.*
Emerald green; 2¹¹/₁₆″ × 1⁹/₁₆″ diameter; 7n, large mouth, fancy stopper; 20b; pl; base; backwards Z or S in MACKENZIES.

MAGIC CURE/LINIMENT// E. I. BARNETT//EASTON, PA.
Label: *Our Doctor Liniment, Cure Everything from Toothache to Frostbite.*
Aqua; 6¹/₄″ × 2¹/₁₆″ × 1³/₁₆″; 11n; 3b; 4ip; v, fss.

SALLADE & CO./MAGIC MOSQUITO/BITE CURE/& INSECT/ DESTROYER/N.Y.
Adv. 1900 from 168 W. 23rd, *EBB;* 1913 from 122 Cedar, Trow's New York City directory; 1929–30 from 121 Leroy St.; 1941–42 by O. H. Simmons Inc., 67 Cortlandt St., New York City, *AD.*
Light cobalt; 7⁵/₈″ × 3¹/₈″ × 1⁹/₁₆″; 11n; 12b; pl; h; ABM.

SALLADE & CO/MAGIC MOSQUITO BITE CURE/ & INSECT/EXTERMINATOR/N.Y.
Aqua; 7³/₄″ × 3³/₁₆″ × 1⁵/₈″; 11n; 18b; pl; h.

MAGNETIC OIL/CURES RHEUMATISM/NEURALGIA AND// HEADACHE//Dᴿ. I. L. ST JOHNS
See ST. JOHNS (*Oil*).

DR. MALAKOFF'S/CONSUMPTION CURE//Mᶜ CONNON & Co./ WINONA, MINN.
See McCONNON (*Company*).

MARVINI'S//CHERRY COUGH CURE
Label: *Marvini's Cherry Cure For the Cure of All Throat & Lung Trouble. Prepared by the Corivitz Mfg. Co., Ashland, O.*
Clear; 6¹/₂″ × 2¹/₄″ × 1¹/₈″; 11n; 3b; 4ip; v, ss.

MAYERS' MAGNETIC/CATARRH CURE
Adv. 1910, *AD.*
Clear; 3⁵/₈″ × 1³/₈″ × ³/₄″; 9n; 6b; 1ip; v.

Mᶜ BURNEY'S/KIDNEY & BLADDER CURE/LOS ANGELES, CAL.
Product of W. F. McBurney, Los Angeles, adv. 1896 (Baldwin 1973); 1915, *SF & PD;* as Kidney & Bladder Medicine, 1917, *BD,* and 1941–42, *AD.*
Clear; 5″ × ? × ?; dimens. & neck finish unk.; rect.; ip; v. See McBURNEY (Purifier).

McCLURE & EATON//PAIN CURE OIL//READING Pᴬ
Label: *PAIN CURE OIL, A Positive and Permanent Cure as Warranted for Fever Sores, Rheumatism, Neuralgia, Erysipelas, Felons . . . Prepared only by McClure & Eaton, Reading, Pa. Entered According to Act of Congress in 1871.*
Aqua; 5⁹/₁₆″ × 2″ × 1¹/₈″; 11n; 3b; 4ip; v, sfs.

J. A. MELVIN'S/RHEUMATIC & DYSPEPSIA CURE
Adv. 1890, *W & P;* 1910, *AD.*
Clear;.6″ × 2³/₁₆″ × 1¹/₂″; 7n; 3b; 3ip, oval embossed panel; v.

METZGER'S AFRICAN/ CATARRH CURE
Products for 1900 included Metzger's African Catarrh Cure, Metzger's Catarrh Cure, Anglo Worm and Wormwood Liniment, Expectorant, and Hair Restorer, *EBB.* Metzger's Catarrh Remedy, probably a change due to the 1906 Act, adv. 1910, *AD;* Catarrh Prescription, 1929–30 and 1948 by Metzger Med. Mfg. Co., 215 E. Broad St., Bethlehem, Pa., *AD.*
Aqua; 7³/₁₆″ × 2¹/₄″ × 1¹/₈″; 7n; 3b; 4ip, oval embossed panel; v.

METZGER'S CATARRH CURE
Aqua; 6¹⁵/₁₆″ × 2¹/₄″ × 1¹/₈″; 7n; 3b; 4ip, oval embossed panel; v.

MEXICAN/CORN CURE/ (TRADE MARK)
Possibly a Trinidad, CO, product. Also could be Lambins Mexican Corn Killer, adv. 1895, *PVS & S.*
Clear 2³/₁₆″ × ¹⁵/₁₆″ × ³/₄″; 3n; 3b; pl; v.

FREE SAMPLE/DR. MILES/NEW HEART CURE [Base: M in circle]
Bottle manufactured by the Maryland Glass Co., Baltimore, MD, after 1916 (Toulouse 1972). Dr. Franklin L. Miles, an eye and ear specialist, began

bottling Dr. Miles Restorative Nervine in 1882 and founded the Miles Med. Co. in Elkhart, Indiana, in 1884. Various partnerships were fostered which were still in existence in 1985. Miles retired in 1904. Many of the product names have changed through the years. Miles Labs. currently manufacture many products including Alka-Seltzer, introduced in 1931. The New Heart Cure was introduced in 1888, became Heart Treatment, ca. 1920, then became Cactus Compound and was removed from the market in 1938. Information was provided by Donald N. Yates, Archivist, Miles Labs, Inc., Elkhart, IN. (personal communication, 1984). Devner (1968), indicates that the closures, shapes and embossing remained virtually the same until the 1920s.

Aqua; $3^7/_8'' \times 1''$ diameter; 1n; 20b; pl; v. See MILES (Medicine, Nervine, Purifier, Sarsaparilla, Tonic).

DR. MILES/NEW/HEART CURE
Aqua; $7^1/_2'' \times ? \times ?$; 7n; 3b; 3ip; v. See MILES (Medicine, Nervine, Purifier, Sarsaparilla, Tonic).

DR. MILES'/RESTORATIVE NERVINE//CURES ALL/NERVOUS TROUBLE/SEE WRAPPER
See MILES (Nervine).

[Script:] Mo Hair/Dandruff/Cure
Clear; $6^1/_2'' \times 2^1/_2'' \times 2''$; 9n; 3b; pl; h, script.

[h] NO. 2./[v] MORRISON'S/ VETERINARY/COLIC CURE
[Base:] 93
Clear; $3^5/_{16}'' \times 1^1/_8'' \times 1^1/_8''$; 7n; 2b; pl; h, v.

MUNYON'S/INHALER/CURES/ COLDS CATARRH/AND ALL/ THROAT & LUNG/DISEASES// PATENTED/FILL TO THE LINE
[See Figure 88 and Photo 23]
Adv. 1907, PVS & S; 1910, AD.
Green; $4^1/_8'' \times 1^3/_4''$ diameter; 9n; 20b; pl; h, fb. See MUNYON (Miscellaneous, Remedy).

MYSTERIOUS PAIN CURE/ A SCOTCH REMEDY [Base:] 325
Adv. 1910, AD.
Color unk.; $5^1/_4'' \times 2^1/_8'' \times 1^1/_4''$; 9n; 6b; pl; v.

MYSTIC CURE//FOR/ RHEUMATISM/AND/ NEURALGIA//MYSTIC CURE
Detchon's Mystic Cure, adv. 1895 (Baldwin 1973); 1901 by Dr. I. A. Det-

chon, Crawfordsville, Ind., HH & M; 1916, MB.
Clear; $6^1/_2'' \times 2^1/_8'' \times 1^1/_8''$; 7n; 3b; 3ip; v, sfs.

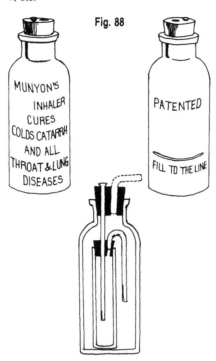

Fig. 88

NATIONAL/KIDNEY & LIVER/ CURE
Adv. 1901, HH & M; 1916, AD; apparently briefly as a remedy, 1907, PVS & S.
Amber; $9'' \times 2^9/_{16}'' \times 2^9/_{16}''$; 11n; 2b; pl; v.

NATIONAL PAIN CURE
Aqua; $6^1/_8'' \times 1^3/_8''$ diameter; 1n; 20b; pl; v.

[h] NAU'S/[d] DYSPEPSIA/[h] CURE
[See Figure 89]
Adv. 1917, 1921, BD.
Amber; $5'' \times 2'' \times 1^1/_4''$; 9n; 3b; pl; d. See NAU (Remedy).

Fig. 89

[Script:] Newbro's/Herpicide/THE DANDRUFF CURE
Clear; $6^7/_8'' \times 2^1/_8''$ diameter; 7n; 20b; pl; h, with script. See HERPICIDE (Hair), NEWBRO (Miscellaneous).

THE/GREAT/NIAGARA/ RHEUMATIC/AND/KIDNEY/CURE
Clear; $4^3/_{16}'' \times 1^5/_8'' \times 1^1/_8''$; 7n; 3b; pl; h.

NORTHROP & LYMAN'S// VEGE-TABLE'/DISCOVERY// AND DYSPEPTIC CURE
See NORTHROP & LYMAN (Discovery).

ONE MINUTE/COUGH CURE// E. C. DEWITT & CO/CHICAGO, U.S.A.
Introduced ca. 1894; adv. 1895, PVS & S. In 1906 the name was changed to DeWitt's Cough Syrup (formerly One Minute Cough Cure); however by 1913 the former name had returned, SN. Baby Cough Syrup adv. 1929–30, 1981, AD.
Aqua; $4^1/_8'' \times 1^1/_4'' \times 5/_8''$; 7n; 3b; 4ip; v, fb. See DEWITT (Company, Cure, Sarsaparilla, Syrup), KODOL (Cure, Tonic).

ONE MINUTE/COUGH CURE// E. C. DEWITT & CO// CHICAGO, U.S.A.
Newer label over old: DeWITTS' COUGH SYRUP, Formerly One Minute Cough Cure, Prepared only by E. C. DeWitt & Co., Chicago, U.S.A. Contains 2 per cent Pure Grain Alcohol, 3–10 Grain Opium and 3 Minims Chloroform per Fluid Ounce. If made and sold after Oct. 18, 1905, contains 2 per cent Alcohol, 3 Minims Chloroform per Fluid Ounce. Guaranteed Under Pure Food & Drugs Act, June 30, 1906.
Aqua; $5^1/_2'' \times 2'' \times {}^{15}/_{16}''$, also $6^1/_2'' \times 2^1/_2'' \times 1^1/_4''$; 11n; 3b; 4ip; v, fss. See DEWITT (Company, Cure, Sarsaparilla, Syrup), KODOL (Cure, Tonic).

ONE NIGHT COUGH CURE/ KOHLER M'F'G. CO./ BALTIMORE, MD.
Kohler's One Night Cough Cure, adv. 1891, WHS; 1921, BD.
Aqua; $5^1/_8'' \times 2^3/_{16}'' \times 1''$, also $3^1/_2'' \times 1^{11}/_{16}'' \times 7/_8''$; 7n; 15b; pl; v.

OTTO'S CURE/B. H. BACON/ ROCHESTER, N.Y.
Adv. 1898, CHG; 1929–30 by S. C. Wells & Co., Le Roy, N. Y. as Otto's Remedy, AD.
Clear; $2^3/_4'' \times 1^3/_{16}'' \times 5/_8''$; 9n; 11b; pl; v, fb.

OTTO'S CURE/FOR THE/THROAT AND LUNGS//B. H. BACON// ROCHESTER, N.Y.
Aqua; $6'' \times 2^1/_2'' \times 1''$, also $7^1/_8'' \times 2^1/_2'' \times 1^1/_4''$; 8n; 3b; 4ip, oval front; v, fss.

**T. S. PAGE/DEAFNESS CURE/NO 2
WEST 14th STREET/NEW YORK,
U.S.A.** [Base:] WT & Co
Bottle manufactured by Whitall-Tatum,
1857–1934 (Toulouse 1972).
Clear; $4^{1}/_{2}''$ × $1^{7}/_{8}''$ × $1^{1}/_{4}''$; 9n; 3b;
pl; v.

**PAN-TINA/COUGH &
CONSUMPTION CURE/E.
SCHMIDT & CO. BALTO.**
Adv. 1900, *EBB*; 1910, *AD*.
Clear; $5^{3}/_{4}''$ × $1^{15}/_{16}''$ × $1''$; 7n; 3b;
3ip; v.

DR. PARKERS/COUGH CURE
[See Figure 90]
John A. Weaver, Easton, PA,
copyrighted the Cough Cure in January
1876 and apparently distributed through
an agent in Philadelphia (Wilson and
Wilson 1971). Adv. 1897, *L & M*.
Aqua; $5^{3}/_{4}''$ × $2^{1}/_{16}''$ × $1^{3}/_{16}''$; 7n; 3b;
3ip; v.

Fig. 90

**DR PARKERS SONS/SURE CURE
FOR HEADACHE/
MANUFACTURED BY DR PARKER'S
SONS CO./BATAVIA, N.Y.** [Base:]
W. T. CO./U.S.A.
See PARKER (*Company*).

**PARKS/LIVER & KIDNEY/CURE//
FRANK O. REDDISH & CO//
LEROY, N.Y.**
Adv. 1894 (Baldwin 1973).
Amber; $9^{3}/_{4}''$ × $3''$ × $1^{3}/_{4}''$; 11n; 3 or
6b; 3 or 4ip; v, fss. See PARK (Syrup),
SHILOH (**Cure,** Miscellaneous, Remedy),
WELLS (Company).

**PATTON'S/FLORAL BALM/CURES/
CHAPPED/HANDS & C./
MᶜCLELLAN/AND/PATTON/
NEW YORK**
See PATTON (*Balm*).

**PECKHAM'S CROUP REMEDY/THE
CHILDREN'S COUGH CURE**
See PECKHAM (*Remedy*).

**PERUVIANA/NATURES KIDNEY
CURE/PERUVIANA HERBAL
REMEDY CO./CINCINNATI, OHIO.**
Adv. 1900, *EBB*. Directories listed the
Peruviana Herbal Remedy Co. at 517
Sycamore, home of John D. Park &
Sons, from 1896–1904.
Amber; $8''$ × $2^{1}/_{4}''$ × $2^{1}/_{4}''$; 11n; 2b; pl;
v. See GUYSOTT (*Sarsaparilla*).

**PETTIT'S AMERICAN//
COUGH CURE**
Adv. 1887, *WHS*; 1910, *AD*.
Aqua; $6^{5}/_{8}''$ × $2^{1}/_{4}''$ × $1^{1}/_{4}''$; 1n; 3b; 3
or 4ip; v, ss. See PETTIT (*Balsam*).

**PETTIT'S AMERICAN//COUGH
CURE//HOWARD BROS**
Aqua; $7^{1}/_{8}''$ × $2^{1}/_{4}''$ × $1^{5}/_{16}''$; 11n; 3b;
4ip; v, ssb. See PETTIT (*Balsam*).

**PINKSTONE'S/CURECHILINE/
CURES/CATTLE/DISEASES**
British origin (McEwen 1977).
Aqua; $7^{3}/_{8}''$ × $2^{3}/_{4}''$ × $1^{5}/_{8}''$; 12n; 4b;
pl; h.

**PISO'S CURE//FOR/
CONSUMPTION//HAZELTINE
& CO.** [See Figure 91]
Label: *PISO'S CURE For Consumption —
Price 25 cents. Prepared only by the Piso
Co., Warren, Pa., after a prescription of
Dr. M.C. Talbott* Piso's Cure was
introduced by Hazeltine & Co.,
Warren, PA, in 1864. In 1906 the name
was changed to Piso's for Coughs &
Colds (Holcombe 1979). A variant, in
an unembossed, threaded bottle stated:
New Carton & Label Adopted in 1939.
Adv. 1948, *AD*.
Aqua, olive; $5^{1}/_{16}''$ × $1^{15}/_{16}''$ × $1^{3}/_{16}''$;
7n; 3b; 4ip v, sfs. See PISO (Company).

Fig. 91

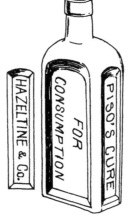

**PISO'S CURE//FOR/
CONSUMPTION//HAZELTINE
& CO.**
Aqua, $7^{1}/_{2}''$ × $3^{1}/_{2}''$ × $2^{5}/_{8}''$; 7n; 3b; 4ip;
v, sfs. See PISO (Company).

**DR. J. E. PLOUF'S/RHEUMATISM
CURE**
Clear; $6^{5}/_{8}''$ × $2^{5}/_{16}''$ × $1^{5}/_{8}''$; 9n; 3b;
pl; v.

**POLAR STAR/[embossed star]/
COUGH CURE**
Manufactured in Kennett Square, PA.
Aqua; $4''$ × $1^{7}/_{8}''$ × $3^{1}/_{4}''$, also
$5^{3}/_{4}''$ × $1^{7}/_{8}''$ × $1''$; 7n; 3b; 3ip; h.

**POLAR STAR/[embossed star]/
DIARRHEA CURE**
Aqua; $5''$ × $1^{3}/_{4}''$ × $1''$; 7n; 3b; 3ip,
embossed oval panel; v.

**PORTERS//CURE OF PAIN//
CLEV,D O'**
Aqua; $5''$ × $1^{5}/_{8}''$ × $1^{1}/_{8}''$; 1n; 3b; 4ip,
arched front panel; h, f; v, ss.

**PORTER'S//CURE OF PAIN//
CLEVELAND**
Clear; $6^{5}/_{8}''$ × $2^{1}/_{4}''$ × $1^{1}/_{2}''$; 1n; 3b; 4ip;
h, f; v, ss.

**PRATT'S/DISTEMPER AND/PINK
EYE CURE** [Base:] 488
Adv. 1916, *MB*.
Amber; $6^{3}/_{4}''$ × $2^{1}/_{4}''$ × $1^{1}/_{4}''$; 1n; 3b;
3ip; v.

**PRESTON'S/HED-AKE/CURES
YOU/"WHILE YOU WAIT"**
Product of Parker Blake Co., Ltd., New
Orleans, adv. 1910, *AD*; 1921, *BD*.
Clear; $4''$ × $1^{3}/_{8}''$ × $1^{3}/_{8}''$; 9n; 2b; 1ip;
v.

**PRIMLEYS/SPEEDY/CURE/
FOR/COUGHS/AND/COLDS//
JONES & PRIMLEY CO.//
ELKHART, IND.**
Adv. 1889, *PVS & S*; 1916, *MB*.
Aqua, clear; $6^{1}/_{2}''$ × $2^{1}/_{4}''$ × $1^{1}/_{8}''$; 7n;
3b; 4ip; h, fss. See PRIMLEY
(*Sarsaparilla, Tonic*).

PUS CURE
Clear; $1^{7}/_{8}''$ × $7^{1}/_{8}''$ diameter; 3n; 20b;
pl; v.

QUICK CURE
A remedial agent for Cholera, Cholera
Morbus and Colic.
Aqua; $4''$ × ? × ?; 7n; rect.; pl; v.

**GERM, BACTERIA OR/FUNGUS
DESTROYER/[within shield:]
Wᴹ RADAM'S/MICROBE KILLER/
[man clubbing skeleton]/
REGISTERED TRADE MARK
DEC. 13, 1887)/CURES/ALL/
DISEASES**
See RADAM (*Killer*).

**"RED CHERRY COUGH CURE"/
FOR CONSUMPTION/**

**DR. PARKER'S SONS CO./
BATAVIA. N.Y.**
See PARKER (Company).

REDSTAR [embossed star] **COUGH
CURE//THE CHARLES A.
VOGELER CO.** [Base:]
BALTIMORE/U.S.A.
A product of C. A. Vogeler & Co.,
introduced in 1884 (Holcombe 1979),
adv. 1910, AD.
Aqua; 7 1/8″ × 2″ × 1 3/16″; lln; 3b; 4ip;
v, ss. See BULL (Pectoral, *Syrup,*)
SALVATION (Oil), ST. JACOB (*Oil*).

**REDTHYME PAIN CURE/S. E.
DUBBEL/WAYNESBORO, PA.**
Aqua; 6″ × 2″ × 1″; 9n; 3b; 1ip,
indented oval panel; v. See DUBBEL
(Cure, *Miscellaneous*).

**J. L. REED'S/CHILL CURE/
CLARKSVILLE, TEX.**
Clear; 5 3/8″ × 2 1/4″ × 1 1/8″; 9n; 18b;
pl; v.

**REID'S/GERMAN COUGH/&/
KIDNEY CURE//SYLVAN REMEDY
CO./PEORIA, ILL.//NO DANGER
FROM OVERDOSE//CONTAINS
NO POISON**
Adv. 1891; 1910, AD.
Clear; 5 5/8″ × 1 7/8″ × 1″; 7n, sp; 3b;
4ip; v, fbss.

**RHINOL CREAM/CURES
CATARRH**
See RHINOL (*Cream*).

RHODES'//FEVER & AGUE CURE
Label: *Rhodes' Fever and Ague Cure or
Natures Infallible Specific, a certain
Remedy for Fever and Ague, Intermittent
and Remittent Fevers, Dumb Ague*
Adv. 1855 (Baldwin 1973); 1910, AD.
Aqua; 8 1/4″ × 2 3/4″ × 1 3/4″; lln; 3b; 2ip;
v, ss; p.

**RHODES'//ANTIDOTE/TO/
MALARIA//FEVER & AGUE CURE**
Aqua; 8 1/4″ × 2 7/8″ × 1 7/8″; lln; 3b; 2ip;
v, s; h, f; v, s. Later variant lacks front
embossing.

**RICKSECKER'S/SKIN SOAP/
HEALS/CURES**
Adv. 1889, *PVS & S*; 1901, *HH & M*.
Clear; 2 5/8″ × 3/4″ × 3/8″; 9n; 15b; pl; h;
flat, oval shaped body. See RICK-
SECKER (*Miscellaneous*).

THE RIVER SWAMP/CHILL AND
[embossed alligator]/**FEVER
CURE/AUGUSTA, GA.**
Amber; 7″ × 2 5/8″ × 1 3/4″, also 6″
height; 7n; 3b; pl; v.

**DR. C.C. ROC'S/LIVER
RHEUMATIC/AND NEURALGIC
CURE//CULLEN & NEWMAN//
KNOXVILLE TENN.**
Adv. 1895, *McK & R*; 1910, *AD*.
Aqua; 8″ × 2 7/8″ × 1 5/8″; 7n, sp; 3b;
4ip; v, fss.

**ROCK'S/COUGH & COLD CURE/
CHA'SA DARBY N.Y.**
Adv. 1887, 1891, *WHS*.
Aqua; 5 3/4″ × 2″ × 1″; 7n; 3b; 3ip; v.

**DR ROGERS//INDIAN FEVER//
CURE**
Adv. 1876, *WHS*; 1910, *AD*.
Aqua; 7 1/2″ × 2 1/2″ × 1 1/2″; lln; 3 or
6b; 3 or 4ip; v.

**ROSEWOOD/DANDRUFF CURE/
PREPARED BY/J. R. REEVES CO./
ANDERSON, IND.**
See REEVES (Company).

**ROYAL/COUGH CURE//
DILL MEDICINE CO.//
NORRISTOWN, PA.**
See DILL (Company).

**RUBY REMEDY/THAT CURES'/
TEASPOONFULS.**
See RUBY (*Remedy*).

S. B./CATARRH CURE [Base:]
**SMITH BROS/S. B. C. C./
FRESNO, CAL.**
Aqua; 7 3/4″ × 2 15/16″ diameter; 7n;
20b; pl; h.

**DR. I. L. ST JOHNS//MAGNETIC
OIL/CURES RHEUMATISM/
NEURALGIA AND//HEADACHE**
See ST. JOHNS (*Oil*).

SANFORD'S//RADICAL CURE
[Base:] **POTTER DRUG
& CHEMICAL CORPORATION
BOSTON MASS USA**
Introduced ca. 1871 (Wilson and
Wilson 1971), adv. 1879, *VSS & C*;
1901, *HH & M*.
Cobalt; 7 5/8″ × 2 5/8″ × 1 1/2″; 7n; 3b;
3ip; v, ss. See CUTICURA (*Cure*),
FETRIDGE (Balm), POTTER (Drug),
SANFORD (*Invigorator*).

SANFORD'S//RADICAL CURE
[Base:] **WEEKS & POTTER/
BOSTON USA**
Cobalt; 7 1/2″ × 2 1/2″ × 1 1/2″; 7n; 3b;
3ip; v, ss. See CUTICURA (*Cure*),
FETRIDGE (Balm), POTTER (Drug),
SANFORD (*Invigorator*).

**DR. A. P. SAWYER//FAMILY
CURE//CHICAGO**
Adv. 1900, *EBB*; 1910, *AD*.

Aqua; 7 3/4″ × 2 3/4″ × 1 1/2″; 1n; 3b; 3
or 4ip; v, sfs; **2 sizes**. See SAWYER
(Miscellaneous, *Sarsaparilla*), SUN RISE
(Balsam).

**SAVE-THE-HORSE/TRADE MARK/
SPAVIN CURE/TROY CHEMICAL
CO. TROY, N.Y.**
Product trademarked by Michael W.
Wilson, White Plains, NY, in 1885.
Apparently he sold the product to a firm
in Troy, NY, from where it was
distributed until their move to Bing-
hamton, NY, in 1887 (Wilson and Wil-
son 1971). Adv. as a Remedy, 1907,
PVS & S; as a Treatment, 1929–30,
AD; as Savoss, 1935, 1948 by Troy
Chemical Co., Binghamton, N.Y., *AD*.
Aqua; 6″ × 2 1/2″ × 1 1/2″; 3n; 11b;
1ip; v.

**SAVE-THE-HORSE/REGISTERED
TRADE MARK/SPAVIN CURE/
TROY CHEMICAL CO.
BINGHAMTON N.Y.**
Aqua; 6 1/2″ × 2 3/4″ × 1 5/8″; 3n; 11b;
1ip; v.

**SAYMAN'S/VEGET LINIMENT//
CURES CATARRH & COLDS//
RELIEVES ALL PAIN**
See SAYMAN (*Liniment*).

**DR. SEELYE'S/MAGIC/COUGH
AND/CONSUMPTION/CURE//
A. B. SEELYE & CO.//
ABILENE KANSAS**
See SEELYE (Company).

**SHAKER PAIN CURE//UNION
VILLAGE, O.**
Color unk.; 5″ × 1 3/4″ × 15/16″; 11n;
3b; 2ip, indented side panels; v, ss.

**SHAWYER'S/SWINDON EXPRESS/
COUGH CURE**
Product originating from Swindon in
Wiltshire, England (McEwen 1977).
Aqua; 4 1/4″ × 1 5/8″ × 15/16″; 5n; 4b;
pl; v.

**DR J. A. SHERMAN'S//RUPTURE/
CURATIVE/COMPOUND//
NEW YORK**
See SHERMAN (*Compound*).

SAMPLE/SHILOHS/CURE
[See Figure 92]
Schuyler C. Wells, LeRoy, NY, was
born 6 Feb. 1840. In 1866, Schuyler
and his brother-in-law, Dr. L. S.
Hooker, formed a partnership for the
sale of drugs. After three years he chose
to market a patent pail ear and
eavetrough and entered into business
with James P. Kneeland. In 1871 Wells

re-entered the field of drugs, alone, to develop and produce his formulas. "Shiloh's Family Remedies" were introduced soon after, either in 1872 or 1873. The firm became known as S. C. Wells & Co., either in 1877 with the building of a large plant on Church Street, or in 1882, when Schuyler sold one-third interest in the business to brother George. George retired in 1892. A stock company was formed in 1897 and apparently corporate leaders began the management of the company. Schuyler died 21 July 1897 according to *North's Description and Biographical Record of Genesee County, New York, 1899*. S. C. Wells & Co., LeRoy, NY, was in operation in 1948 as a division of Brown Mfg. Co, *AD*. Shiloh's Consumption was introduced ca. 1873, adv. 1900, *EBB*; 1907, as Shiloh's Consumption Remedy, *PVS & S*; 1910, *AD*, and 1916, *MB*, as Shiloh's Cure, the word Consumption removed; 1935, 1948, as Shiloh, *AD*.

Aqua; $2^7/_8'' \times 1^5/_{16}'' \times 1^{11}/_{16}''$; 7n; 6b; 4ip; v. See FENNER (Remedy), PARK (Cure, Syrup), SHILOH (Miscellaneous, Remedy), WELLS (Company).

Fig. 92

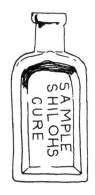

SHILOHS/CONSUMPTION/ CURE//S.C. WELLS//LEROY N.Y. [See Figure 93]

Fig. 93

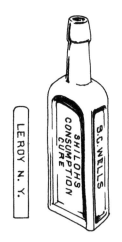

Clear, aqua; $6^3/_8'' \times 2^1/_{16}'' \times 1^1/_4''$, also $7^7/_8'' \times 2^5/_8'' \times 1^3/_8''$; 11n; 6b; 4ip; v, fss. See PARK (Cure, Syrup), SHILOH (Miscellaneous, Remedy), WELLS (Company).

CAPT. SIDDONS'/UNIVERSAL/ CATARRH CURE [Base:] WT & CO
Bottle manufactured by Whitall-Tatum, 1857 to 1935 (Toulouse 1972).
Amber; $3^3/_8'' \times 1^1/_4'' \times ^7/_8''$; 9n; 3b; pl; v.

SKABCURA/DIP CO./CHICAGO, ILL./U.S.A.
See SKABCURA (Company).

SLOAN'S SURE/COLIC CURE [Base:] S
Adv. 1895, *McK & R*; 1916, *MB*.
Clear; $3^3/_8'' \times 1^1/_8'' \times 1^1/_8''$, also $4^3/_4'' \times 1^1/_8'' \times 1^1/_8''$; 7n; 2b; pl; v. See SLOAN (Liniment, Miscellaneous, Ointment.)

H. K. SMITH/CURE ALL
The *Gazetteer & Business Directory of Onondaga Co. NY, 1868–69* has Hiram K. Smith, Syracuse, Cigar Mfgr.; the Syracuse city directory for 1878–79, and the 1900 *Era Blue Book* lists Smith as a Patent Medicine Manufacturer.
Aqua; $5'' \times 1^5/_8'' \times ^7/_8''$, also $4^1/_8'' \times 1^5/_{16}'' \times ^5/_8''$; 7n; 3b; 4ip; v.

[h] THE GREAT/SOUTH AMERICAN/NERVINE TONIC/[v] TRADE/ [monogram]/MARK/[h] AND/ STOMACH & LIVER CURE
Conqueror of St. Vitus Dance, adv. 1897 (Baldwin 1973); 1910, *AD*.
Clear; $9^7/_8'' \times 3^5/_8'' \times 1^7/_8''$; 1n; 12b; pl; h, v.

SPARKS'/KIDNEY & LIVER CURE/CAMDEN, N.J.
Amber, aqua; $4^1/_8'' \times 1^7/_8'' \times 1''$; 7n; 18b; pl; v. See SPARKS (Trade Mark).

THE/SPECIFIC/A NO 1/A SELF CURE/(TRADE MARK) [Base:] W T & CO USA
See SPECIFIC (Specific).

SPOHN'S DISTEMPER CURE/ SPOHN MEDICAL CO./ GOSHEN, IND.
Adv. 1907, as Remedy, *PVS & S*; 1910, as Cure, *AD* and 1921, as Cure, *BD*.
Aqua; $4^7/_8'' \times 1^{13}/_{16}'' \times 1^1/_4''$; 7n; 3b; 1ip; v. See SPOHN (Compound).

SURE/CURE//LIGHTNING//OIL
See LIGHTNING (Oil).

SWAMP/CHILL/AND/FEVER/ CURE//MORRIS-MORTON DRUG

CO.//FORT SMITH, ARK.
See MORRIS-MORTON (Company).

Dʀ SYKES'/SURE CURE/FOR/ CATARRH
Adv. 1873, *VSS & R*; 1916, *MB*. For a number of years beginning in 1873, Charles R. Sykes was a Chicago catarrh specialist; in 1891 the Cincinnati directory included a reference to Dr. Sykes Sure Cure Co. How this distant office was tied in is uncertain.
Aqua; $6^5/_8'' \times 2^5/_8''$ diameter; 7n; 20b; pl; h.

TA-HA/COUGH CURE
Aqua; $6'' \times 2'' \times 1''$; 7n; sp; 3b; ip; v.

TAYLOR'S//OPOCURA
Adv. 1855 (Baldwin 1973).
Aqua; $2^7/_8'' \times 1^3/_8'' \times 1^3/_8''$; 13n; 2b; pl; v, fb; p.

E. E. TAYLORS/[embossed star]/ CATARRH CURE
Adv. 1887, *WHS*; 1910, *AD*.
Clear; $2^3/_4'' \times ? \times ?$; 9n; 8b; pl; embossed in an oval.

3913/RHEUMATISM CURE
Clear; $5^3/_4'' \times 2^3/_8'' \times 1^1/_2''$; 9n; 3b; pl; v.

TIGER OIL/CURES PAIN
See TIGER (Oil).

DR. W. TOWNS/EPILEPSY/CURE/ FONDULAC/WISCONSIN/U.S.A.
Advertised as Towns Epilepsy Cure in 1900, *EBB*; 1910, *AD*. During implementation of the 1906 Pure Food & Drug Act, the name was briefly changed to Remedy, then to Treatment (Devner 1968). By 1906 the company had relocated in Milwaukee, WS (Devner 1968).
Amber, $7^1/_2'' \times 3^5/_8'' \times 1^1/_2''$; 7n; 3b; ip; h. See TOWNS (Miscellaneous).

TUS SANO/CURES/COUGHS/AND/ COLDS//C. I. HOOD & CO.// LOWELL MASS [Base:] 4
Adv. 1900, *EBB*; 1910, *AD*.
Aqua; $6^3/_4'' \times 2^1/_4'' \times 1^1/_{16}''$; 1n; 3b; 6ip, 3ip on front; h, f; v, ss. See HOOD (Company, Pills, *Sarsaparilla*).

UPHAM'S/FRESH MEAT CURE// PAT'N'D. FEB. 12 1867//PHILADᴬ
Upham's Fresh Meat Cure for Consumption adv. 1869 (Baldwin 1973); 1901, *HH & M*; Cure changed to Remedy, 1907, *PVS & S*. According to directories, S. C. Upham operated a periodical and stationery outlet in 1863 and a patent medicine business from 1865 to 1886. Johnston, Holloway &

Cowden, 602 Arch St., Philadelphia, appear to be proprietors of the Meat Cure by 1870 (Singer 1982).

Light blue; 6³/₈″ × 2¹/₄″ × 1³/₈″; 7n; 3b; 4ip; v.

DR. VANDERPOOL'S S B/COUGH & CONSUMPTION CURE

Aqua; 6¹/₈″ × 2¹/₁₆″ × 1³/₁₆″; 7n; 3b; 3ip; v.

VENO'S/LIGHTNING/COUGH/ CURE [Base: diamond]

Bottle manufactured by the Diamond Glass Co. after 1924 (Toulouse 1972). An international product adv. in the U.S. by the Veno Drug Co., Pittsburg, PA, 1909 (Devner 1968), 1910, *AD*; in England, 1909, 1912 by the Veno Drug Co. on Cedar Street in Manchester. When analyzed, under the English law of 1909, the product was found to contain Glycerine, Alcohol, Chloroform, Resin, Alkaline Ash and an Extract and coloring agent (British Medical Association, 1909, 1912; McEwen 1907).

Aqua; 5⁵/₁₆″ × 2″ × 1″; 7n; 3b; pl; h.

VENO'S/LIGHTNING/COUGH/ CURE [Base: partial diamond with line beneath]

Aqua; 7¹/₂″ × 2⁹/₁₆″ × 1⁵/₁₆″; 1n; 4b; pl; h; ABM; several colors and sizes.

WADLEIGH'S. RHEUMATIC CURE/ F. R. WADLEIGH. ALTON N. H. [Base:] 504

Adv. 1900, *EBB*; 1910, *AD*.

Aqua; 8¹/₂″ × 2⁷/₈″ × 1³/₄″; 7n; 3b; 3ip; v.

WAIT'S/WHITE PINE COUGH CURE/ONE BOTTLE CURES A COUGH/GREENWICH, N.Y.

Color & dimens. unk.; 7n; 3b; 3 or 4ip; v.

WAKEFIELD'S//MAGIC/PAIN CURE//BLOOMINGTON ILL.

Adv. 1892 (Blasi 1974); 1910, *AD*.

Aqua; 6⁷/₈″ × 1⁷/₈″ × 1¹/₈″; 7n; 3b; 3 or 4ip; v, sfs. See WAKEFIELD (*Balsam*, Liniment).

DR. WALKINSHAW'S//CURATIVE BITTERS//BATAVIA N. Y.

See WALKINSHAW (*Bitters*).

FREE SAMPLE/WARNER'S SAFE CURE CO./ROCHESTER, N.Y.

Hubert Harrington Warner, Rochester, NY, established his medicine business in 1878, having acquired the formulas of John A. Craig (Wilson and Wilson 1971). Warner's Safe Cure was introduced in 1879, the Bitters ca. 1880, Rheumatic Cure in 1883, and the

popular Log Cabin line in 1887. Offices with approximate dates are: Rochester, NY, 1879–1944; Toronto, Ont., 1882–1920s; London, England, 1883–1920s; Melbourne, Australia, 1887–1915; Frankfurt, Germany, 1887–1900; Kreuslingen, Switzerland, 1891–1900; Dunedin, New Zealand, 1891–1900; and Pressburg, Austro-Hungary, 1888–1890. The Log Cabin products were discontinued in 1892 when Warner sold his business to an English firm. The firm was unable to pay, due to the Panic of 1893 and the company reverted back to Warner, at which time the name was changed from H. H. Warner & Co. Ltd. to the Warner Safe Cure Company. An English syndicate purchased the business in 1900 and headquartered the firm in England until 1910 when it was acquired by J. J. Demay and S. R. Keaner. The two moved the firm back to Rochester and occupied the Duffy Malt Whiskey Warehouse. The new bottles were embossed WARNER'S/ SAFE/REMEDIES CO. and products were available, on a small scale, until 1944. Shortly after selling his business, Warner moved to Minneapolis and tried, in vain, to establish the Guaranteed Cure Co. He died there in 1923 (Seeliger 1974). Seeliger indicates the Remedies Co. was terminated in 1944, but products (relationship unk.), were adv. 1948 by Warner Remedies Co., Warren, Pa., *AD*.

Amber; 4¹/₄″ × 1¹/₁₆″ diameter; 7n; 20b; pl; v. See CRAIG (*Cure*, Miscellaneous), LOG CABIN (Extract, Remedy, Sarsaparilla), H. WARNER (Bitters, Company, Nervine, Remedy).

WARNER'S//SAFE CURE

Amber; 9¹/₂″ × 3³/₄″ × 1¹³/₁₆″; 1n; 12b; pl; h, fb, on shoulder. See LOG CABIN (Extract, Remedy, Sarsaparilla), H. WARNER (Bitters, Company, Nervine, Remedy).

WARNER'S SAFE CURE/ (CONCENTRATED)

Amber; 5¹/₂″ × 2¹/₁₆″ × 1¹/₄″; 3n; 10b; pl; v. See LOG CABIN (Extract, Remedy, Sarsaparilla), H. WARNER (Bitters, Company, Nervine, Remedy).

WARNER'S SAFE/CURE/TRADE/ MARK [on embossed safe]/ ROCHESTER, N.Y. [See Photo 24]

Amber, aqua, clear, emerald green; 7¹/₂″ × 2⁷/₈″ × 1¹/₂″; 20n; 12b; pl; h. Also LONDON and AUSTRALIA embossed variants, 11″ × 4¹/₂″ × 2³/₄″. See LOG CABIN (Extract, Remedy, Sarsaparilla), H. WARNER (Bitters, Company, Nervine, Remedy).

WARNER'S/SAFE/DIABETES/ CURE/TRADE/MARK [on embossed safe]/ROCHESTER, N.Y.

Adv. 1887, *McK & R*; 1915, *SF & PD*.

Amber; 9³/₄″ × 3¹/₂″ × 1⁵/₈″; 1n; 12b; pl; h. See LOG CABIN (Extract, Remedy, Sarsaparilla), H. WARNER (Bitters, Company, Nervine, Remedy).

WARNER'S/SAFE/KIDNEY & LIVER/CURE/TRADE/MARK [on embossed safe]/ROCHESTER, N.Y.

The most common of all variants.

Amber; 9⁵/₈″ × 3⁵/₈″ × 1¹³/₁₆″; 1n; 12b; pl; h. See LOG CABIN (Extract, Remedy, Sarsaparilla), H. WARNER (Bitters, Company, Nervine, Remedy).

WARNER'S/SAFE/RHEUMATIC/ CURE/TRADE/MARK [on embossed safe]/ROCHESTER, N.Y.

Introduced ca. 1880 (Holcombe 1979), 1883 (Seeliger 1974). Adv. 1887, *McK & R*; 1921, *BD*. The word Cure was briefly dropped and Remedy substituted, 1907, *PVS & S*. Adv. 1935 as Acute Rheumatic, *AD*.

Amber; 9¹/₄″ × 3⁵/₈″ × 1³/₄″; 1n; 12b; pl; h. See LOG CABIN (Extract, Remedy, Sarsaparilla), H. WARNER (Bitters, Company, Nervine, Remedy).

WEAKNESS CURE// ANCHOR MED. CO

See ANCHOR (*Company*).

ELECTRICITY IN A BOTTLE [Base:] THE WEST ELECTRIC CURE CO.

Chicago directories establish the West Electric Co. in 1887 with Heman Baldwin, Pres. and Henry H. West, Manager. Product adv. 1910, *AD*.

Amber, clear, cobalt, light blue; 2¹/₂″ × 1¹/₂″ diameter; 3n; 20b; pl; h, on shoulder.

WHALEN'S/HAIR/RESTORATIVE/ AND/DANDRUFF/CURE

Clear; 6¹/₄″ × 2⁷/₈″ × 1¹¹/₁₆″; 9n; 3b; pl; h.

WHEELER'S//AMERICAN// COUGH CURE

Aqua; 7¹/₈″ × 2¹/₄″ × 1⁵/₈″; 1n; 3b; 3ip; v, ssf.

FAITH WHITCOMB'S/BALSAM// CURES COUGHS AND COLDS// CURES CONSUMPTION

See WHITCOMB (*Balsam*).

A. J. WHITE//CURATIVE SYRUP

See WHITE (*Syrup*).

WHITE'S/NEURALGIA/CURE [Base:] McC

Bottle manufactured by Wm. McCully & Co., Pittsburgh, PA, 1832 to 1886

(Toulouse 1972). Product of E. B. White, location unk., adv. 1895, *PVS & S*; 1900, *EBB*.

Clear; $3^1/_8'' \times 1^1/_8''$ diameter; 9n; 20b; pl; v.

WHITE'S QUICK/HEALING CURE/ NORFOLK, VA.

Amber; $6^3/_4'' \times ? \times ?$; 7n; rect.; v.

[v] WINANS BROTHERS// INDIAN CURE/[h] WINANS BROS./ [woman's profile]/TRADE MARK/ INDIAN/CURE/FOR THE/BLOOD/ PRICE $1.00

Adv. 1889 (Baldwin 1973); 1890, *W & P*.

Aqua; $9^3/_{16}'' \times 3^3/_8'' \times 2^3/_{16}''$; 7n; 3b; 3ip; v, ss; h, f.

WINTERGREEN/GREAT RHEUMATIC CURE/J. L. FILKINS

Adv. 1900, *EBB*.

Aqua; $7^1/_8'' \times 2^7/_{16}'' \times 1^{11}/_{16}''$; 7n; 3b; 4ip; v. Also $6^1/_4'' \times 2'' \times 1^1/_4''$ with base embossed: W.T. & CO./6/U.S.A.

WOODS/GREAT PEPPERMINT CURE/FOR COUGHS & COLD

[Base:] AGM

Aqua; $5'' \times 1^7/_8'' \times 1^1/_{16}''$; 7n; 3b; 3ip; v; ABM. Also ABM, $6^7/_8'' \times 2^1/_4'' \times 4^1/_4''$.

WOOD'S/GREAT PEPPERMINT CURE/FOR COUGHS & COLDS

Aqua, clear; $5^1/_4'' \times 1^{15}/_{16}'' \times 1^1/_8''$; 3n; 3b; 3ip; v; ABM.

[v] WOOD'S/[d] RHEUMATISM/[v] CURE/S C BRADT & SON ALBANY NY

Adv. 1900, *EBB*; 1910, *AD*; briefly called Remedy, 1907, *PVS & S*. Information is sketchy, Samuel C. Bradt was listed as deceased by 1912. Son, Warren L. Wood operated the business until his death 4 March 1939, according to Albany city directories.

Clear; height and neck finish unk.; $2^9/_{16}'' \times 1^9/_{16}''$; 9b, with round corners, pl; v, d.

DR. J. L. WOODS/TASTELESS CHILL CURE/WOOD DRUG CO/ BRISTOL, TENN.

Aqua; $7^1/_4'' \times 2^1/_4'' \times 1^1/_4''$; 7n, sp; 3b; ip; v. See FARRAR (Sarsaparilla).

ZEMO CURES PIMPLES/AND ALL DISEASES OF THE/SKIN AND SCALP//ZEMO CURES ECZEMA/ E. W. ROSE MEDICINE CO./ ST. LOUIS

Zemo products for diseases of the skin and scalp were introduced ca. 1903 by the E. W. Rose Med. Co., Harrisburg, IL. The company moved to St. Louis in 1905 and Cleveland, OH, in 1915. The firm was acquired by Plough Inc., in 1956 (Devner 1968). Zemo adv. 1985 by Plough Sales Corp., Memphis, Tenn., *AD*.

Clear; $6^1/_4'' \times 2^1/_2'' \times 1^7/_8''$; 7n; 3b; pl; v, ss. See ZEMO *(Lotion)*.

ZEPP'S DANDRUFF CURE// T. NOONAN & CO. BOSTON

Directories establish T. (Timothy) Noonan & Co., hair dressers' supplies, in 1882; sometime during the twentieth century this firm became billed as T. Noonan & Sons. The last entry is 1973. Zepp's Hair Tonic adv. 1929–30 and 1941–42 by T. Noonan & Sons Co., 38 Portland St., Boston, Mass., *AD*.

Clear; $6^1/_2'' \times 2^1/_2'' \times 1^7/_{16}''$; 7n; 3b; 4ip; v, ss. See NOONAN (Company).

DISCOVERY

COOPER'S/NEW DISCOVERY
[See Figure 94]
Cure-all tonic adv. 1907, *PVS & S*;
1916 by Cooper Med. Co., Dayton, O.
(Devner 1970); 1935 by Benjamin
Rosenweig, 114 Lawrence St., Brooklyn, N.Y., *AD*.
Aqua; 9″ × 3″ × 1⅞″; 1n, sp; 3b;
3ip; v.

Fig. 94

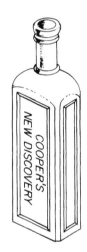

**Dʀ T. A. DUTTON/
NEW BRUNSWICK/N. J.//
VEGETABLE//DISCOVERY**
Adv. 1907, *PVS & S*; 1916, *MB*.
Light green; 6⅜″ × 2¼″ × 1¼″; 7n;
3b; 3 or 4ip; v, fss.

**FRANKLIN HOWES/MEDICAL
DISCOVERY/THE GREAT BLOOD
PURIFIER/NEW YORK/
REGISTERED**
Adv. 1891 (Baldwin 1973); 1910, *AD*.
Aqua; 9¼″ × 3½″ diameter; 9n; 20b;
pl; h.

**[h] D/L. E. K./THE Keeley/CURE/[d]
DRUNKENNESS/[h] A/RELIABLE/
REMEDY/DISCOVERED BY/
DR. L. E. KEELEY/DWIGHT, ILL.//**

[shoulder:] **K. C.**/[script:] **Leslie E.
Keeley M. D.**
See KEELEY *(Cure)*.

**[h] L. E. K./THE KEELEY/REMEDY/
[d] NEUROTINE/[h] DISCOVERED/
BY/DR. L. E. KEELEY/DWIGHT,
ILL.//[shoulder:] K. C./[script:]
Leslie E. Keeley**
See KEELEY *(Remedy)*.

**[h] Dr/L E KEELEY'S/DOUBLE/
CHLORIDE/OF/[d] GOLD CURE/
FOR/DRUNKENNESS/[h] A/
TESTED/AND/INFALLIBLE/
REMEDY/DISCOVERED BY/
DR. L. E. KEELEY/DWIGHT, ILL.//**
[shoulder:] **K. C.**/[script:] **Leslie E.
Keeley M.D.**
See KEELEY *(Cure)*.

**[h] L.E.K./THE Keeley/Remedy/[d]
TOBACCO HABIT/[h]
DISCOVERED/BY/DR. L. E.
KEELEY/DWIGHT, ILL.//**[shoulder:]
K. C./[script:] **Leslie E. Keeley M. D.**
See KEELEY *(Remedy)*.

**Dʀ KENNEDY'S//MEDICAL
DISCOVERY//ROXBURY MASS**
Remedy for ". . . Nursing Sore Mouths,
Scrofula, Pimples, Ringworm. . . ."
Product of Donald Kennedy, later son
George. Introduced in 1848, information from trade card advertising. Adv.
1879, *VSS & C*; 1916, *MB*.
Green; 8½″ × 3¼″ × 1⅞″; 11n; 3b;
3ip; v, sfs; p. Also an aqua variant, 9″
high, without p. See KENNEDY
(Liniment, Miscellaneous, Ointment).

**DR. KING'S/NEW DISCOVERY//
H. E. BUCKLEN & CO//
CHICAGO, ILL.**
Label ca. 1900: *DR. KING'S NEW
DISCOVERY For Coughs, Colds and all
Bronchial Affections of the Throat, Chest
and Lungs. 4% Alcohol. 50 Cents. . . .*
Bottle manufactured ca. 1898. Herbert
Bucklen obtained sole proprietorship of
Dr. Z. L. King's formulas in 1878
(Wilson and Wilson 1971). Adv. 1948
by Standard Labs, Inc., 113 W. 18th,
New York City, *AD*.
Clear; 4⅛″ × 1¼″ × ⅝″; 1n; 3b; 4ip;
v, fss. See ELECTRIC (Bitters), KING
(Pills, Syrup).

**DR. KING'S/NEW DISCOVERY/
FOR CONSUMPTION//H. E.
BUCKLEN & CO.//CHICAGO, ILL.**
Aqua; 6½″ × 2⅛″ × 1⅛″; 1n; 3b; 4ip;
v, fss. See ELECTRIC (Bitters), KING
(Pills, Syrup).

**DR. KING'S/NEW DISCOVERY/
FOR COUGHS DUE TO COLDS**
[Base: N in square]
Partial label: *DR. KING'S NEW DISCOVERY, Originated 1869, H. E.
BUCKLEN & CO., Offices—NEW
YORK, ST. LOUIS, Formerly Chicago.
Revision 1921.* Bottle manufactured by
the Obear-Nester Glass Co., East St.
Louis, IL, 1915 to at least 1972
(Toulouse 1972).
Clear; 6½″ × 2³⁄₁₆″ × 1⅛″; 16n; 3b;
pl; v; ABM. See ELECTRIC (Bitters),
KING (Pills, Syrup).

**DR KING'S/NEW DISCOVERY/
FOR COUGH'S AND COLDS//
H. E. BUCKLEN & CO.//
H. E. BUCKLEN & CO.**
Bottle manufactured ca. 1910 (Wilson
and Wilson 1971).
Aqua; 6¾″ × ? × ?; 1n; 3b; 2ip, on
sides; v, fss; ABM. See ELECTRIC
(Bitters), KING (Pills, Syrup).

**DR KING'S/NEW DISCOVERY/
FOR COUGHS AND COLDS//
H. E. BUCKLEN & CO.//
CHICAGO, ILL.**
Bottle manufactured ca. 1895 (Wilson
and Wilson 1971).
Aqua; 6¾″ × 2¼″ × 1⅛″, also
8″ × 2½″ × 1⅝″; 1n; 3b; 4ip; v, fss.
See ELECTRIC (Bitters), KING (Pills,
Syrup).

**MANNERS NEW DISCOVERY/
BINGHAMTON, N.Y.**
Label: *MANNER'S NEW DISCOVERY
—A Great Blood Purifier and Nerve Tonic.
HOSKINS MED. CO., BINGHAMTON,
N.Y.*
Aqua; 5½″ × 3″ × 1⅞″; also
8⅜″ × 3″ × 1¾″; 1n; 3b; 3ip; v. See
MANNERS *(Sarsaparilla)*.

**NATTHAN'S/CRYSTAL/
DISCOVERY/[embossed star]/
FOR THE HAIR**
Adv. 1876, *WHS*.
Cobalt; 7½″ × 2¾″ × 1½″; neck
finish unk.; 13b; pl; h.

**NORTHROP & LYMAN'S//VEGETABLE'/DISCOVERY//AND
DYSPEPTIC CURE** [See Figure 95]
Northrup & Lyman began as Tuttle,
Moses & Northrop of Newcastle,
Canada West, a branch of Tuttle &
Moses, Auburn, NY, established in
1854. By 1857 the company was billed
as Northrop & Moses, wholesale and
retail druggists and dealers in patent
medicines, etc. Between 1859 and 1862
John Lyman, with Henry Northrop,
purchased Tuttle & Moses and

renamed the firm Northrop & Lyman. In 1874 the pair relocated in Toronto. By 1914 Northrop & Lyman became a Howe family business; in 1951 it was controlled by T. A. McGillivray and by the mid 1960s renamed Northrop-McGillivray. By 1980 the company was out of business. The bottles of Northrop & Lyman were apparently embossed as early as the 1860s. In the 1920s the words, LIMITED were printed in the glass as part of the company name. Embossing ceased in the 1940s. Discovery adv. 1883–1909 (Sullivan 1983).

Aqua; 8¾″ × 3″ × ?; 11n; 3b; 4ip; v, sfs. See THOMAS *(Oil)*, HOLLOWAY *(Cure)*.

Fig. 95

DR PIERCE'S/GOLDEN/MEDICAL DISCOVERY//R.V. PIERCE, M. D.// BUFFALO, N.Y.
Dr. Ray Vaughn Pierce introduced his Favorite Prescription, Medical Discovery and Dr. Sage's Catarrh Remedy ca. 1870, the latter adv. 1869 (Baldwin 1973). Pierce established The World's Dispensary in 1873, died 4 Feb. 1914, and was succeeded by son V. Mott Pierce, MD (Holcombe 1979). The Pierce family operated the business until ca. 1960. Pierce's A-Nuric Tablets, Favorite Prescription, Golden Medical Discovery, Tablets, and Pleasant Pellets were on the market in 1982, products of Med-Tech, Inc., Cody, WY, according to Bill Weiss, Med-Tech, Inc. (personal communication, 1982). Medical Discovery adv. 1871, *VSS & R*; 1983, *RB*.

Aqua; 8⅜″ × 3″ × 1¾″; 1n; 3b; 4ip; v, fss. See ALLEN *(Medicine)*, PIERCE *(Extract*, Miscellaneous, Tablet), SAGE *(Remedy)*.

DR. SHELDON'S/NEW DISCOVERY//BOSTON, U.S.A.// SYDNEY, N.S.W.
Aqua; 5⅞″ × 1⅞″ × 1″; 11n; 3b; 3ip; v, fss. See SHELDON (Liniment).

AMERICAN DRUG CO/NEW YORK
[See Figure 96 and Photo 25]
The company postdates 1899 and was located at 2062 8th Ave., New York City, according to the 1913 and 1930 New York City directories.
Aqua; 6″ × 2⅛″ × 1¼″; 7n; 3b; 3ip; v.

Fig. 96

[Script:] **Meritol/AMERICAN DRUG & PRESS ASSN./DECORAH, IOWA, U.S.A.**
Label: *Meritol FAMILY LINIMENT, for Internal and External Use. For Rheumatism, Pleurisy, Quinsy, Chilblains, Sprains* Bottle manufactured ca. 1908 (Wilson and Wilson 1971). Adv. 1935 and 1941–42 as an ointment by Meritol Corp., Decorah, IA., *AD*.
Clear; 6⅜″ × ? × ?; 9n; rect.; pl; v, part script.

BIXBY'S SARSAPARILLA/BIXBY'S DRUG STORE/SANTA CRUZ CAL
[Base:] W.T. & Co.
See BIXBY *(Sarsaparilla)*.

H. BOWMAN/DRUGGIST// 262 J STREET//SACRAMENTO
Aqua; 7⅛″ × 2½″ × 1½″; 7n; 3b; 3ip; v, fss. See GOGINGS (Drug).

F. BROWN/Druggist/COR CHES' & 5ᵗʰ S/Philadᵃ
Aqua; 5½″ × 2″ × 1¼″; 5n; 12b; pl; v. See F. BROWN (*Jamaica Ginger*).

[Script:] **Orange Flower Cream/THE CANN DRUG CO./RENO, NEV.** [Base:] W.T. Co./U.S.A.
See ORANGE FLOWER (*Cream*).

W. W. CLARK/16 N 5ᵗʰ St/ PHILAD,A.//WHOLESALE// DRUGGIST
Clark was located at 16 N 5th St. from 1838 or 1839 until the early 1850s. Directories indicate he operated his business thereafter from various locations, including 1213 N. 3rd, until 1875.
Color unk.; 5³⁄₈″ × 1⁷⁄₈″ × 1¼″; 5n?; 3b; 3ip?; v, fss; p.

CRANE & BRIGHAM/WHOLESALE DRUGGISTS/SAN FRANCISCO
Bottle contained essence of Jamaica Ginger. The firm originated as Crowell, Crane & Brigham, which operated from 1856 to 1859; at this time Crowell & Crane separated from Brigham to form their own business. In 1861, Crowell sold his interests to Brigham, it thus became Crane & Brigham. The firm was dissolved in the 1880s (Shimko 1969; Wilson and Wilson 1971). This information was substantiated, in part, by city directories.
Aqua; 6″ × ? × ?; 11n; 12b; 1ip; v. See CRANE (*Miscellaneous*), YELLOW DOCK (*Sarsaparilla*).

CRESCENT DRUG CO.// NEWARK, N.J.//CRESCENT/ SARSAPARILLA//100 DOSES 50CENTS
See CRESCENT (*Sarsaparilla*).

DAVIS & MILLER//DRUGGISTS// BALTIMORE
Davis and Miller were druggists from ca. 1860s to ca. 1900.
Aqua; 3½″ × ? × ?; 7n; 3b; 4ip; v, fss. See DAVIS & MILLER (*Syrup*).

EATON DRUG CO. ATLANTA, GA.//ROYAL FOOT WASH
Listed in city directories from 1911 with W. J. Govan, Mgr., to 1914 or later.
Aqua; dimens. unk.; 7n; 3b; 3 or 4ip; v, ss.

BROMO-SELTZER/EMERSON/ DRUG CO./BALTIMORE, MD.
Isaac E. Emerson compounded and trademarked Bromo Seltzer in 1889. The bottles were manufactured by Hazel-Atlas until 1907, followed by the Maryland Glass Corp., using the ABM process. The letter M on the base dates from 1907 to ca. 1916; M in a circle, after 1916 (Toulouse 1972). Cork enclosures were in use until 1928 and early variants possessed small mouths. Bromo Seltzer was packaged in plastic bottles in 1986, the product of Warner-Lambert Co., Morris Plains, NJ.
Cobalt; 2½″ × 1⅛″ diameter; 3n; 20b; pl; h. Five sizes including height of 7¾″. See EMERSON (*Cure, Sarsaparilla*), W. WARNER (*Company*).

FORT BRAGG/HOSPITAL & DRUG CO. [Base:] WT & CO/USA
Bottle manufactured by Whitall-Tatum Glass Co., 1857–1935 (Toulouse 1972).
Aqua; 9½″ × 3¼″ × 1¹¹⁄₁₆″; 7n; 3b; 4ip, embossed oval panel; v.

R. E. GOGINGS/DRUGGIST// 262 J. Street//SACRAMENTO
Partial label from an unembossed, square, amber variant: *GOGING'S WILD CHERRY TONIC – Prepared by the R. E. GOGINGS DRUG CO., 904 J STREET, SACRAMENTO.* Directories for 1880–81 and 1884–85 listed Gogings at 904 J Street; information about the 262 J Street location wasn't available. Gogings Corn Cure adv. 1896–97, *Mack.*
Aqua; 7½″ × 2¼″ × 1⅝″; 1n; 3b; 3ip; v, fss. See BOWMAN (*Drug*).

GOODRICH DRUG CO.// ANOKA, MINN//HOFF'S GERMAN LINIMENT [Base: I in diamond]
See HOFF (*Liniment*).

RESORCIN/HAIR/TONIC/ GOODRICH/[embossed pyramid]/ QUALITY/TRADE MARK/ GOODRICH/DRUG CO./OMAHA
Tonic adv. 1916, *MB*, 1929–30 and 1941–42 by the Velvetina Co. Inc., Omaha, Neb., *AD*. The relationship to Goodrich Drug Co., Anoka, MN, is unk.
Clear; 7⅛″ × 2³⁄₁₆″ diameter; 3n; 20b; pl; h. Tapered body; GOODRICH, QUALITY and pyramid embossed within a double lined diamond. See HOFF (*Liniment*).

[Script:] **Velvetina/REG. U.S. PAT. OFF./RESORCIN/HAIR TONIC/ GOODRICH/DRUG CO. OMAHA** [Base: diamond]
Bottle manufactured by the Diamond Glass Co., Royersford, PA, after 1924 (Toulouse 1972).
Clear; 7¹⁄₁₆″ × 2¼″ diameter; 3n; 20b; pl; h, part script; ABM. Tapered body.

GOODRICH DRUG CO./OMAHA, U.S.A./[script:] Velvetina/CREAM/ LOTION [Base: diamond]
[See Figure 97]
Bottle manufactured by the Diamond Glass Co., Royersford, PA, after 1924 (Toulouse 1972).
Clear; 5⁵⁄₁₆″ × 2⁵⁄₁₆″ × 1⅜″; 9n, sp; 6b; 2ip; v, ss, part script; ABM.

Fig. 97

[Script:] **Velvetina/SKIN/[script:] Beautifier/GOODRICH/DRUG/ COMPANY/OMAHA U.S.A.**
[See Figure 98]
Label: *Velvetina Flesh Skin Beautifier, Contains 8% Alcohol. Goodrich Drug Co., Omaha, U.S.A.* Adv. ca. 1908 (Devner 1970); 1941–42 by Velvetina Co., Inc., Omaha, Neb., *AD*.
Milk glass; 5³⁄₁₆″ × 2³⁄₁₆″ × 1³⁄₁₆″; 9n; 4b; pl; h, part script.

Fig. 98

H. H. HAY/DRUGGIST/AND/ PHARMACEUTIST/PORTLAND ME
Directories and their advertisements show Henry H. Hay, Druggist, established his business in 1841, and incorporated in 1905. The directories listed this Portland, ME, firm until 1942 or later.
Aqua; 8½″ × ? × ?; 11n; 12b; pl; h. See HAY (*Miscellaneous*).

HEGEMAN & CO/CHEMISTS & DRUGGISTS/NEW YORK
See HEGEMAN *(Chemical)*.

THE HOLDEN DRUG CO// STOCKTON CAL//ETHEREAL/ COUGH SYRUP
See ETHEREAL *(Syrup)*.

THE HOLDEN DRUG CO// STOCKTON CAL.//HOLDEN'S/ ETHEREAL COUGH SYRUP
See HOLDEN *(Syrup)*.

HILLS/[embossed H with arrow] TRADE/MARK/DYS PEP CU/ CURES/CHRONIC/DYSPEPSIA/ INDIANA DRUG/SPECIALITY CO/Sᵀ. LOUIS &/INDIANAPOLIS
See INDIANA *(Company)*.

Dʳ H. W. JACKSON/DRUGGIST/ VEGETABLE/HOME SYRUP
Product of H. W. Jackson, Columbia, CT.
Olive; 5¹/₂″ × 2¹/₂″ diameter; 11n; 20b; pl; v; p.

JORDAN'S/COUGH SYRUP/ JORDAN MARSH DRUG CO./ COXSACKIE, N.Y.
See JORDAN *(Syrup)*.

KELLER-BOHMANSSON/DRUG CO.
[Base:] W.T. Co./U.S.A.
Bottle manufactured by Whitall-Tatum Glass Co., Millville, NJ, 1857–1934 (Toulouse 1972). Product of Eureka, CA, according to Bob Toynton (personal communication, 1984).
Clear; 5³/₄″ × 2″ × 1¹/₈″; 9n; 13b; pl; v.

F. W. KINSMAN & CO./ DRUGGISTS/AUGUSTA, ME./ AND/NEW YORK CITY
See KINSMAN *(Company)*.

G. LANGLEY//WHOLESALE DRUGGIST/SAN FRANCISCO// CALIFORNIA
There probably is a relationship to Langley & Michaels (Jamaica Ginger).
Clear; 4¹¹/₁₆″ × 1¹¹/₁₆″ × ¹⁵/₁₆″; 5n; sp; 6b; 4ip; v, sfs.

LAUGHLIN/AND/BUSHFIELD// WHOLESALE/DRUGGISTS// WHEELING, W. VA.
Aqua; dimens. unk.; 13n; 3b; pl; v, fss; p.

F. A. LEWIS/PURE DRUGS
[See Figure 99]
Clear; 5³/₈″ × 2¹/₄″ × 1¹/₄″; 4n; 17b; pl; v; vertically ribbed back.

Fig. 99

DR FLINT'S/REMEDY/MACK DRUG CO PROP'S/NEW YORK
See FLINT *(Remedy)*.

J. J. MACK & CO./WHOLESALE DRUGGISTS/SAN FRANCISCO, CAL.
See MACK *(Company)*.

MARINE DRUG STORE/ CLEVELAND, O.//U.S.A.// FENTON'S
Label: *Fenton's Compound Concentrated Extract Sarsaparilla or Matchless Liver & Blood Syrup. Fenton Manufacturing Co., No. 39 Academy St., Cleveland.* Sarsaparilla adv. 1879, *VSS & C*; 1900 from 122 Water St., Cleveland, O., *EBB*; 1910, *AD*. Carnot F. Fenton was listed in directories as a druggist in 1861, and in 1872–73; in 1878 as the Marine & R. R. Drug Store, C. F. Fenton & Co., Proprietors, and the Fenton Mfg. Co., T. C. Quick, F. H. Kelly & C. F. Fenton, Manufacturers of Fenton Family Medicines.
Aqua; 8¹/₂″ × 2³/₄″ × 1³/₄″; 1n; 3 or 6b; 3 or 4ip; v, fss.

MICHIGAN DRUG CO.//DETROIT, MICH.
Contained Johnston's Sarsaparilla. Adv. 1894 as having been on the market for 30 years (Shimko 1969); 1916, *MB*. An amalgamation of the drug firms of C. Penniman and Marshall Chapin created Williams, Davis, Brooks & Co. in 1891, which in 1898 became the Michigan Drug Co. The last entry occurs in the 1932–33 Detroit city directory (Shimko 1969).
Color unk.; 10¹/₄″ × 4″ × 2³/₈″; 12n; 3b; 2 or 3ip; v, ss.

MORRIS-MORTON DRUG CO.// FORT SMITH, ARK.//SWAMP/ CHILL/AND/FEVER/CURE
See MORRIS-MORTON *(Company)*.

FLORIDA WATER/MURRAY & LANMAN/DRUGGISTS/ NEW YORK
See MURRAY & LANMAN *(Water)*.

N.Y. DRUG/CONCERN/NEW YORK
[See Figure 100 and Photo 26]
Label: *HOMENTA – For Colds & Catarrh – New York Drug Concern, New York, N.Y.* Adv. 1921, *BD*; 1935, *AD*. Directories included the company in 1917 and 1930, Lawrence E. Cash, President.
Clear; 4¹/₄″ × 1¹⁵/₁₆″ × ⁷/₁₆″; 1n; 24b; 1ip; v. Variant embossed N-Y.

Fig. 100

[Script] **The Owl Drug Co**/[embossed owl on monogrammed mortar and pestle]/**TODCO//POISON**
See OWL *(Company)*.

THE OWL DRUG CO.// THE OWL DRUG CO.
See OWL *(Company)*.

PALMER DRUG CO/SANTA CRUZ, CAL. [Base:] WT CO/U.S.A.
Bottle manufactured by the Whitall-Tatum Glass Co., 1857 to 1935 (Toulouse 1972).
Amber; 4⁷/₈″ × 1⁷/₈″ × 1¹/₄″; 3n; 3b; ip; v.

POTTER DRUG & CHEMICAL/ CORPORATION/BOSTON, MASS. U.S.A.//THE CUTICURA SYSTEM/ OF CURING/CONSTITUTIONAL HUMORS
See CUTICURA *(Cure)*.

POTTER DRUG & CHEMICAL/ CORPORATION/BOSTON, U.S.A.// CUTICURA SYSTEM OF/BLOOD AND SKIN/PURIFICATION
See CUTICURA *(Cure)*.

POTTER DRUG & CHEMICAL/ CORPORATION/BOSTON, U.S.A.// CUTICURA TREATMENT/FOR AFFECTIONS/OF THE SKIN
See CUTICURA *(Cure)*.

POTTER DRUG & CHEM. CORP.//
BOSTON, MASS. U.S.A.//GENUINE
SANFORD'S GINGER/
A DELICIOUS COMBINATION OF/
GINGER FRENCH BRANDY AND/
CHOICE AROMATICS. REG'D 1876
Label: . . . *A Delicious Family Medicine
for Relief of Cramps, Colic, Cholera
Morbus, Diarrhoea, Dysentery. . . .
POTTER DRUG & CHEMICAL CO.,
135 & 137 Columbus Ave., BOSTON.
Registered 1876.* Adv. 1921, *BD.*
Aqua; 6½″ × ? × ?; 7n; 3b; 3ip; v, ssf.
See CUTICURA *(Cure)*, FETRIDGE
(Balm), SANFORD (Cure, *Invigorator*).

POTTER DRUG & CHEM. CORP.//
BOSTON, MASS. U.S.A.//
SANFORD'S JAMAICA GINGER/
THE QUINTESSENCE OF
JAMAICA/GINGER, CHOICE
AROMATICS &/FRENCH BRANDY,
REGISTERED 1876 [See Figure 101
and Photo 27]
Aqua; 6⅝″ × 2¼″ × 1⅛″; 7n; 3b; 3ip;
v, ssf. See CUTICURA *(Cure)*,
FETRIDGE (Balm), SANFORD (Cure,
Invigorator).

Fig. 101

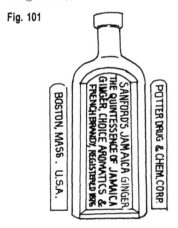

[Base:] POTTER DRUG &
CHEMICAL CORPORATION
BOSTON MASS USA [front:]
SANFORD'S RADICAL CURE
See SANFORD *(Cure)*.

WITCH/CREAM/PRICE/
DRUGGIST/SALEM/MASS
Adv. 1875; 1910, *AD.*
Color and dimens. unk., 15n; 3b; ip.

RANSOM & STEVENS//
DRUGGISTS BOSTON//
DANDELION & TOMATO/
PANACEA
Adv. 1844 (Baldwin 1973). C. R. Ran-
som and Benjamin Stevens, Jr., 325
Washington, Boston operated two
years, 1843–44, according to
directories.

Aqua; 8¾″ × 3¼″ × 1⅞″; 11n; 4b; pl;
v, ssf; p.

LA SANDORA/ROMERO DRUG CO.
See ROMERO *(Company)*.

J. B. SIBLEY//DRUGGIST//
RACINE, O [See Figure 102]
Aqua; 6½″ × 2³⁄₁₆″ × 1³⁄₁₆″; 7n, sp;
3b; 4ip; v.

Fig. 102

A. A. SOLOMONS & CO/
DRUGGIST/MARKET SQUARE/
SAVANNAH GA
Universal container. Abraham Solomon,
Savannah, GA, established his business
ca. 1840 (Watson 1965); the firm was
still operational in 1971 (Wilson and
Wilson 1971).
Aqua; 4¾″ × ?; 5n; 20b; pl; v. See
HOFFMAN (Mixture), SOLOMON
(Bitters).

[d] OPTIMUS/[v] STEWART &
HOLMES/DRUG CO/
SEATTLE, WASH.
See STEWART & HOLMES
(Company).

SULTAN/DRUG CO./ST. LOUIS
[See Figure 103]
St. Louis directories first included the
Sultan Drug Co. in 1890; the Peacock
Chemical Company was listed in 1893,
Frederick W. Sultan, President. Both
firms were located in the 1929–30
American Druggist, but were merged as

Fig. 103

the OD (Old) Peacock Sultan Co. in
1935 and 1948, *AD.*
Clear; 2¹⁄₁₆″ × ⅞″ × ½″; 7n; 3b; pl; h.
See O. P. S. *(Company)*.

SULTAN DRUG CO//ST. LOUIS
& LONDON
Label: *Seng, Stomachal Restorative*
Adv. 1895, *PVS & S*; 1929–30 by
Sultan Drug Co., 114 N. Second St.,
St. Louis; 1941–42 by OD Peacock
Sultan Co., 4500 Parkview Pl., St.
Louis, *AD.*
Amber; 7¼″ × 2¾″ × 1⅝″; 9n; 6b;
pl; v, ss. See O. P. S. *(Company)*.

SULTAN DRUG CO.//ST. LOUIS
& LONDON
Amber; 7½″ × 2¾″ × 1⅝″; 11n; 5b,
with round corners; pl; v, ss. See
O. P. S. *(Company)*.

SUTCLIFFE/McALLISTER/& Co//
DRUGGIST'S//LOUISVILLE
The partnership of Sutcliffe and
McAllister, which existed between 1851
and 1855, was terminated when Sut-
cliffe sold out to H. A. Hughes (Wilson
and Wilson 1971).
Aqua; 5½″ × ? × ?; 11n, crude; 24b;
pl; v, fss.

TARRANT & CO/DRUGGISTS/
NEW YORK [See Figure 104]
Clear; 5⅛″ × 2⁷⁄₁₆″ × 1½″; 7n; 3b; pl;
v. See TARRANT *(Chemical)*.

Fig. 104

TARRANT/DRUGGIST/NEW YORK
Aqua; 5″ × ? × ?; 3 or 7n, crude; 4b;
pl; v; p. See TARRANT *(Chemical)*.

THOMAS DRUG CO./THE REXALL
STORE/SAN JOSE, CAL. [Base:]
W T CO/U.S.A.
See THOMAS *(Company)*.

VANVLEET-MANSFIELD DRUG CO//MEMPHIS, TENN.
Wholesale druggists from 1882 until merger with McKesson & Robbins in 1929 (Shimko 1969).
Aqua; 7³/₈" × 2³/₈" × 1¹/₄"; 11n; 3b; 3ip; v, ss.

CITRATE· OF·MAGNESIA/H. P. WAKELEE/DRUGGIST
Cobalt; 7¹/₄" × 2⁵/₈" diameter; 20n; 20b; pl; v. See CAMELLINE (Miscellaneous), WAKELEE *(Miscellaneous)*.

EDWARD WILDER & CO/ WHOLESALE DRUGGIST// MOTHER'S/WORM SYRUP
See MOTHER *(Syrup)*.

B. O. & G. C. WILSON/BOTANIC DRUGGISTS/BOSTON
Benjamin Osgood and George Carlos Wilson apparently established their lucrative business in 1846; this firm was still operating in 1931, according to Boston city directories. A sarsaparilla produced by the company was distributed by Smith, Kline & Co., Philadelphia, an affiliate company, established in 1830 (Shimko 1969). The latter firm was operating in 1985, *AD*.
Aqua; 7¹/₂" × 3¹/₁₆" × 2"; 9n; 3b; pl; v; p. Three sizes including variant 4" high without p.

FARRAR'S SARSAPARILLA/ MANUFACTURED BY WOOD DRUG CO./BRISTOL, TENN.
See FARRAR *(Sarsaparilla)*.

DR. J. L. WOODS/TASTELESS CHILL CURE/WOOD DRUG CO/ BRISTOL, TENN.
See WOOD *(Cure)*.

ELIXIR

ACKERS ELIXIR//ACKERS ELIXIR//W. H. HOOKER & CO/ LONDON ENG/NEW YORK U.S.A.
See HOOKER *(Company)*.

BRUSH'S//ELIXIR PROPHYLACTIC//FOR/ PREVENTION/OF/SEA/SICKNESS
Adv. 1899 by the Brush Medicine Co., New York, NY (Devner 1968); 1910, *AD*.
Amber; 5³/₄" × 2¹/₄" × 1⁷/₁₆"; 7n; 3b; pl; v, ss; h. f.

CONGREVE'S//CELEBRATED/ BALSAMIC//ELIXIR// FOR COUGH/& ASTHMA
See CONGREVE *(Balsam)*.

REV. N. H. DOWNS'// VEGETABLE//BALSAMIC//ELIXIR
N. H. Downs Vegetable Balsamic Elixir contained 11¹/₂% Alcohol, 1 grain of opium and acted as a depressant for the central nervous system. Product of Henry, Johnson & Lord, Burlington, VT. A directory advertisement for 1882–83 states: ". . . is a sure cure for Coughs, Colds, Whooping-Cough and all Lung Diseases, when taken in season. People die of consumption simply because of neglect, when the timely use of this remedy would have cured them at once. Fifty-two years of constant use proves the fact that no cough remedy has stood the test like Down's Elixir." Adv. 1842 (Putnam 1968), but apparently available since ca. 1830; adv. 1929–30 and 1948 by Burlington Drug Co., Burlington, Vt., *AD*.
Aqua; 5³/₈" × 1³/₄" diameter; 1n; 21b; pl; v, ssss. Smaller variant with 7n. See BAXTER (Bitters), J. F. HENRY *(Company)*, SANDS *(Miscellaneous)*.

ELIXIR/[embossed bell with K within it]/OF/LIFE [Base:] T. C. W. & CO.
Bottle manufactured by the T. C.

Wheaton Co., Millville, NJ, after 1888 (Toulouse 1972).

Aqua; dimens. & neck finish unk.; rect.; sides & embossed order unk.

DR. HARTER'S/ELIXIR OF/ WILD CHERRY

Adv. 1877, 1918 (source unk.).

Aqua; 9½″ × ? × ?; 8n; 15b; pl; h. See HARTER (Balm, *Bitters,* Miscellaneous, Tonic), HOOD (Company).

DR STEPH. JEWETT'S// CELEBRATED/PULMONARY ELIXIR//RINDGE, N.H.

Adv. 1850 (Baldwin 1973).

Aqua; 5¼″ × 2⅛″ × 1¼″; 13n; 4b; pl; v; p. See JEWETT *(Bitters).*

LANGLEY'S/RED BOTTLE/ELIXIR/ OF LIFE

Aqua; 4¹⁵⁄₁₆″ × 2″ diameter; 9n; 20b; 1ip; h; p.

LEONARDI'S BLOOD ELIXIR/ THE GREAT BLOOD PURIFIER/ S. B. LEONARDI & CO./ NEW YORK & TAMPA, FLA.

See LEONARDI *(Purifier).*

LIGHTNING BLOOD ELIXIR/ NO RELIEF NO PAY// HERB MEDICINE CO// WESTON W. VA.

See HERB *(Medicine).*

LOUDEN & CO'S/FEMALE ELIXIR

Product of George Louden, Philadelphia, introduced ca. 1849; his son joined the business in 1858. The firm was apparently sold in the 1860s (Wilson and Wilson 1971). Products adv. 1901, *HH & M.*

Aqua; 4″ × ? × ?; 5n; 14b; pl; v; p. See LOUDEN (Balsam, Company).

DR. McMUNN'S/ELIXIR OF OPIUM

Introduced ca. 1842, later labeled as the *Pure and Essential Extract from the Native Drug . . . To Produce Sleep and Composure; to Relieve Pain and Irritation, Nervous Excitement and Morbid Irritability of Body and Mind; to Allay Convulsive and Spasmodic Actions, etc., etc. . . . The ELIXIR OF OPIUM is also greatly SUPERIOR TO MORPHINE-. . . E. Ferrett, Agent, 372 Pearl St., New York City.* Dr. Jonothan B. McMunn, New York, gave A. B. & D. Sands sole agency for this product ca. 1842. In 1875, Edmund Ferrett became agent; Ferrett was still in business ca. 1900 (Wilson and Wilson 1971). Eighty million bottles were being manufactured for this product annually by 1859 by the Folembray Glass Works, in France

(Putnam 1968). Adv. 1913, *SN.*

Aqua; 4¼″ × 1″ diameter; 5 and 7n; 20b; pl; v. Also variant embossed McMUMM (with pontil). See SANDS *(Miscellaneous,* Sarsaparilla).

[d] PHELPS/RHEUMATIC/ELIXIR/ [v] JOHN H. PHELPS PHARMACIST/SCRANTON, PA

Adv. 1887, *WHS*; 1948 by Kells Co., Newburgh, N.Y., *AD.*

Aqua; 5½″ × 2⅜″ × 1⅝″; 7n; 3b; pl; d, v.

SMITH'S/SPECIAL ELIXIR/U.S.A. [Base:] (C) CROWNFORD

Possibly a reproduction.

Light olive; 4⅜″ × 1¾″ × 1″; 9n; 3b; pl; h; ABM.

G. W. STONE'S//COUGH/ELIXIR// BOSTON MASS.

Adv. 1856, out of Lowell, MA (Baldwin 1973).

Aqua; 6″ × 2″ × 1⅝″; 1n; 6b; 3ip; v, sfs; p. See STONE (Miscellaneous, *Oil).*

DR. TRUE'S ELIXIR/ESTABLISHED 1851/DR. J. F. TRUE & CO. INC/ AUBURN, ME [See Figure 105]

Clear; 5½″ × 1⅞″ × ⅞″; 8n; 3b; pl; v; ABM.

Fig. 105

DR TRUE'S ELIXIR/ESTABLISHED 1851/DR. J. F. TRUE & CO/ AUBURN, MAINE//WORM EXPELLER//FAMILY LAXATIVE

Aqua; 6⅝″ × 2¼″ × 1⅛″; 7n; 3b; 3ip; v, fss.

TRUE'S PIN WORM ELIXIR/ ESTABLISHED 1851/DR. J. F. TRUE & CO/AUBURN MAINE [See Figure 106]

Apparently introduced in 1851, adv. 1948 by J. F. True & Co., Hanover, Mass., *AD.*

Aqua; 7¼″ × 2⅝″ × 1¾″; 7n; 3b; 4ip; v.

Fig. 106

TUTTLE'S ELIXIR CO.// BOSTON, MASS.

Product for Man or Beast. Directories indicate Samuel A. Tuttle was the operator of a stable in 1883 and proprietor of Tuttle's Elixir in 1885. The Tuttle Elixir Co., established in 1894, operated until 1968.

Clear; 6″ × 1¾″ diameter; 16n; 21b, 12 sides; pl; v; ABM. Also non ABM. See TUTTLE (Miscellaneous).

WAYNE'S/DIURETIC ELIXIR// F. E. SUIRE & Cᵒ/CINCINNATI

[See Figure 107]

Label: *Wayne's Diuretic & Alterative Elixir of Buchu, Juniper & Acetate Potash.* Cincinnati directories establish Suire, Eckstein & Co. with Francis E. Suire, Fred E. Eckstein and Andrew Merrian Wholesale and Retail Druggists in 1857; Isaac Taylor joined the business in 1859. In 1869, F. E. Suire & Co. was formed, with Suire, Taylor and James Prince. Edward S. Wayne replaced Prince in 1866, thus possibly the origin of Wayne's Elixir. Suire died in 1872 and the following year the firm became E. S. Wayne & Co.; in 1867 Taylor left the business; in 1874 Wayne was listed with J. S. Burdsal & Co., apparently established as Burdsal & Bro. in 1857. The fate of the elixir remains uncertain until 1891 and 1894 when references are found for the Wayne Elixir Co., coincidently at the same address as that of J. D. Park & Sons. It is presumed, however, that Wayne and the J. S. Burdsal & Co. manufactured the elixir; Wayne left this firm in 1878. Elixir adv. 1871 (Baldwin 1973); 1929–30 and 1941–42 by Kenton Pharmacal Co., Covington, Ky., *AD.*

Light green; 7½″ × 2¼″ × 2¼″; 11n; 2b; 2ip; v, fb. See ROBACK *(Purifier).*

Fig. 107

FRONT BACK

DR. J. S. WOODS/ELIXIR/
ALBANY NY
Labeled as Wood's Sarsaparilla Elixir
and adv. 1847 (Baldwin 1973).
Green; 8½" × 4" × 2⅛"; 11n; 4b; pl;
h; p. See WOOD (Cure).

ABRAMS & CARROLL'S/ESS OF/
JAMAICA GINGER/
SAN FRANCISCO
See ABRAM & CARROLL (*Jamaica
Ginger*).

ALLEN'S/ESSENCE OF/
JAMAICA GINGER
See ALLEN (*Jamaica Ginger*).

DR BARNES/ESS OF JAMAICA
GINGER/R. HALL & Co/
PROPRIETORS
See BARNES (*Jamaica Ginger*).

DR BARNES/ESS JAMAICA
GINGER/SHEPARDSON & GATES/
PROPRIETORS
See BARNES (*Jamaica Ginger*).

DR BARNES/ESS JAMAICA
GINGER/J. R. GATES & CO/
PROPRIETORS
See BARNES (*Jamaica Ginger*).

BOWER'S/GENUINE/ESSENCES
Aqua; 4¾" × 1¼" × ¾"; 14n; 6b; pl;
v; p.

DR COLLIS BROWN'S/ESS OF
JAMAICA GINGER/Nº 55
HAY MARKET/LONDON
See C. BROWN (*Jamaica Ginger*).

F. BROWN'S/ESS OF/JAMAICA
GINGER/PHILADA
See F. BROWN (*Jamaica Ginger*).

N. K. BROWN'S/AROMATIC
ESSENCE/JAMAICA GINGER/
MILWAUKEE, WIS.
See N. BROWN (*Jamaica Ginger*).

N K BROWN'S/AROMATIC
ESSENCE/JAMAICA GINGER/
BURLINGTON, V.T.
See N. BROWN (*Jamaica Ginger*).

ESSENCE OF//PEPPERMINT//
BY THE//KINGS PATENT

An effectual remedial agent for stomach disorders. A patent of John Juniper, England, in 1762; available in North America soon thereafter. The product soon lost all proprietorial association and was eventually distributed by a variety of producers, including Americans. The distinctive container was introduced prior to 1790 and was produced into the second decade of the twentieth century. The product was available in Canada in 1981 (Jones 1981). American advertisements, 1771, *JD*; 1983, Medi-Kay brand by L. T. York Co., 440 E. Helm, Brookfield, MO, *AD*.

Aqua; $2^{11/16}'' \times {}^{3/4}'' \times {}^{3/4}''$; 5n; 1b; pl; v, fsb; p. Also variants with several neck finishes, clear and light amber, without pontil.

FAIRCHILD BROS & FOSTER/ ESSENCE OF PEPSINE/NEW YORK
Clear; $5^{1/2}'' \times 2^{1/8}'' \times 1^{3/8}''$; 9n; 12b; pl; v. See PEPSENCIA *(Essence).*

FAIRCHILD BRO'S & FOSTER/ ESSENCE OF PEPSINE/NEW YORK
Clear; $6^{3/4}'' \times 2^{11/16}'' \times 1^{3/4}''$; 9n; 12b; pl; v. See PEPSENCIA *(Essence).*

J. A. FOLGER & CO/ESSENCE OF/ JAMAICA GINGER/ SAN FRANCISCO
See FOLGER *(Jamaica Ginger).*

GENUINE/ESSENCES
Aqua; $5'' \times 1^{1/16}'' \times {}^{5/8}''$; 13n; 24b; pl; v.

GILLETT'S/ESS JAMAICA/ GINGER/[monogram]/E. W. GILLETT/CHICAGO
See GILLETT *(Jamaica Ginger).*

GODBE & COs/ESS OF/JAMAICA GINGER/SALT LAKE CITY
See GODBE *(Company).*

HARVEY'S ESSENCE/ QUEENSLAND AGENTS/ TAYLOR & COLLEDGE LT\underline{D}/ BRISBANE
Aqua; $6^{1/8}'' \times 2''$ diameter; 7n; 20b; pl; v.

HOSTETTER'S/ESSENCE/ JAMAICA GINGER/PITTSBURGH
See HOSTETTER *(Jamaica Ginger).*

KNORR'S GENUINE/HIEN FONG ESSENCE/DETROIT, MICH. [Base: I in diamond]
Label: *Knorr's Genuine Hien Fong Green Drops.* Bottle manufactured by the Illinois Glass Co., 1916 to 1929 (Toulouse 1972). Adv. 1825 (source unk.); 1948, *AD*.

Aqua; $4^{1/8}'' \times 1^{1/2}'' \times 1^{1/2}''$; 9n; 2b; pl; v; ABM.

KNORR'S GENUINE/HIEN FONG ESSENCE/DETROIT, MICH.
Aqua; $4^{1/4}'' \times 1^{1/2}'' \times 1^{1/2}''$; 9n; 2b; 1ip; v.

LANGLEY & MICHAELS/ESS/ JAMAICA/GINGER/S.F.
See LANGLEY & MICHAELS *(Jamaica Ginger).*

LANGLEY'S/ESS/JAMAICA GINGER/SAN FRANCISCO
See LANGLEY *(Jamaica Ginger).*

E. G. LYONS & CO/ESS./JAMAICA GINGER/S. F.
See LYONS *(Jamaica Ginger).*

McMILLAN/&/KESTER'S/ESS = OF/ JAMAICA/GINGER/S. F.
See McMILLAN & KESTER *(Jamaica Ginger).*

PEPSENCIA/ESSENCE OF PEPSINE/ FAIRCHILD [Base: W T in triangle]
Label: *PEPSENCIA, Essence of Pepsine, Fairchild – An Extract of the Gastric Juice Prepared Directly From Fresh Peptic Glands. Alcohol by Volume 18.5%. Fairchild Brothers & Foster, New York.* Bottle manufactured by Whitall-Tatum, Millville, NJ, 1935 to 1938 (Toulouse 1972). Adv. 1882, *VSS & C*; 1929–30 by Fairchild Bros. & Foster, 76 Laight St., New York City; 1941–42, *AD*.

Clear; $7^{3/4}'' \times 3^{9/16}'' \times 2^{1/8}''$; 7n; 12b; pl; v; ABM. See FAIRCHILD (Essence).

REDINGTON & CO./ESS OF/ JAMAICA GINGER/ SAN FRANCISCO
See REDINGTON *(Jamaica Ginger).*

SANFORD'S JAMAICA GINGER/ THE QUINTESSENCE OF JAMAICA/ GINGER, CHOICE AROMATICS &/ FRENCH BRANDY, REGISTERED 1876//POTTER DRUG & CHEM. CORP.//BOSTON, MASS. U.S.A.
See SANFORD *(Drug).*

HENRY SNELL/ESSENCE OF JAMAGA GINGER/SALT LAKE/ UTAH
Note spelling of Jamaica. See SNELL *(Jamaica Ginger).*

TURNER'S/ESS OF/JAMAICA GINGER/NEW YORK
See TURNER *(Jamaica Ginger).*

VAN DUZER'S/ESSENCE/JAMAICA GINGER/NEW YORK
See VAN DUZER *(Jamaica Ginger).*

VANLOOSH'S/ESSENCE OF LINSEED/& HONEY
Light aqua; $5^{1/4}'' \times 1^{3/4}'' \times 1^{1/8}''$; 1n; 3b; 3ip, oval; v.

DR. DUNCAN'S//EXPECTORANT/ REMEDY

Philadelphia product adv. 1841 (Putnam 1968); 1843 (Baldwin 1973). **Light green; dimens. unk.; 7n; 4b; pl; v, fb.**

DR. D. JAYNE'S/EXPECTORANT

Label: *JAYNE'S EXPECTORANT – For Colds and Coughs . . . Non Narcotic. Alcohol 13% . . . DR. D. JAYNE & SON, 242 CHESTNUT ST., PHILA., PA.* Wilson and Wilson (1971) provide an approximate formula for 1880: Syrup squills, tincture of tolu, camphor and digitalis, opium, wine ipecac, antimon. & pot. tart. "DR. D. JAYNE'S EXPEC-TORANT. All who have used this invaluable medicine for Asthma, Coughs, Spitting of Blood, Whooping Cough, Croup or Hives, Consumption, Pleurisy, Inflammation of the Lungs or Chest, Hoarseness, Pain and Soreness of the Breast, Difficulty of Breathing, and every other disease of the Lungs and Breast, attest its usefulness" (Wilson and Wilson 1971).
Aqua; $6^{1}/_{2}'' \times 2^{5}/_{8}'' \times 1^{1}/_{2}''$; 10n; 4n; pl; v; ABM. See JAYNE (Balsam, Liniment, *Miscellaneous,* Tonic).

DR. D. JAYNE'S/EXPECTORANT// PHILADᴬ

Aqua; $6^{3}/_{4}'' \times 2^{5}/_{8}'' \times 1^{3}/_{4}''$; 11 and 7n; 4b; pl; v, fb. See JAYNE (Balsam, Liniment, *Miscellaneous,* Tonic).

DR. D. JAYNE'S/EXPECTORANT// PHILADᴬ

Bottle manufactured ca. 1880 (Wilson and Wilson 1971).
Aqua; $7'' \times 2^{1}/_{2}'' \times 1^{5}/_{8}''$; 1n; 4b; pl; v, fb. Also pontiled variant with 11 neck finish, $6^{1}/_{2}'' \times 2^{1}/_{2}'' \times 1^{3}/_{4}''$. See JAYNE (Balsam, Liniment, *Miscellaneous,* Tonic).

DR. D. JAYNE'S/EXPECTORANT/ PHILADELPHIA//HALF-SIZE// HALF DOLLAR

Bottle manufactured ca. 1895 (Wilson and Wilson 1971).
Aqua; $6^{1}/_{4}'' \times ? \times ?$; 7n; 6b; 1ip; v, fss. See JAYNE (Balsam, Liniment, *Miscellaneous,* Tonic).

DR. D. JAYNE'S/EXPECTORANT/ PHILADELPHIA//DR. D. JAYNE & SON//HALF SIZE

Aqua; dimens. unk.; 10n; 6b; 3ip; v, fss; ABM. See JAYNE (Balsam, Liniment, *Miscellaneous,* Tonic).

DR. D. JAYNE'S/EXPECTORANT// QUARTER SIZE//TWENTY FIVE CENTS

Aqua; $5^{1}/_{8}'' \times 1^{3}/_{4}'' \times {}^{15}/_{16}''$; 7n; 6b; 1ip; v, fss. See JAYNE (Balsam, Liniment, *Miscellaneous,* Tonic).

Dᴿ D. JAYNE'/INDIAN// EXPECTORANT/PHILADA

Aqua; $5'' \times 2^{1}/_{2}'' \times 1^{3}/_{4}''$; 5n; 4b; pl; v, fb. See JAYNE (Balsam, Liniment, *Miscellaneous,* Tonic).

Dr. Slocum's/coltsfoote/compound/ Expectorant/TRADE MARK

Adv. 1887, *WHS*; 1923, *SF & PD* .
Aqua; $6^{1}/_{8}'' \times 2^{3}/_{8}'' \times 1^{3}/_{8}''$; 9n; 6b; pl; v. Two sizes. See OZOMULSION *(Miscellaneous)*, PSYCHINE *(Miscellaneous)*, SLOCUM (Company, Oil).

Dᴿ SQUIRES//BALSAMIC/ EXPECTORANT// SPRINGFIELD, OHIO

See SQUIRES *(Balsam)*.

DR WARREN'S/EXPECTORANT// WHITE & HILL//NASHUA, NH.

Aqua; $6^{3}/_{8}'' \times 1^{7}/_{8}'' \times ?$; 1n; 3 or 6b; 3 or 4ip; v, fss; p.

EXTRACT

E. C. ALLEN/CONCENTRATED/
ELECTRIC PASTE/OR/ARABIAN
PAIN/EXTRACTOR//
LANCASTER/PA.
Dark aqua; 3¹/₁₆″ × 1¹/₂″ × 1¹/₂″; 13n;
2b; pl; v, fs; p.

AYER'S//COMPOUND EXT//
SARSAPARILLA//LOWELL/
MASS U.S.A.
See AYERS (Sarsaparilla).

JOHN C BAKER'S//COMPOUND//
FLUID EXTRACT OF//
SARSAPARILLA/
See J. C. BAKER (Sarsaparilla).

BRANT'S/PURIFYING EXTRACT//
M. T. WALLACE & C⁰/
PROPRIETORS//BROOKLYN. N.Y.
Adv. 1844 (Baldwin 1973); 1901 by H.
Planten & Son, New York City), HH
& M; 1910, AD.
Light aqua; 10″ × 3⁵/₈″ × 2⁵/₈″; 1n; 3b;
3ip; v, fss; p. See BRANT (Balm,
Balsam).

BRISTOL'S//EXTRACT OF/
SARSAPARILLA//BUFFALO
See BRISTOL (Sarsaparilla).

A. H. BULL//EXTRACT OF/
SARSAPARILLA//HARTFORD,
CONN.
See A. H. BULL (Sarsaparilla).

JOHN BULL//EXTRACT OF/
SARSAPARILLA//LOUISVILLE, KY.
See J. BULL (Sarsaparilla).

C. B. & I. EXTRACT CO/
S.F. CAL.//DR. HENLEY'S/
CELERY, BEEF AND IRON
See C. B. & I. (Company).

J. CALEGARIS/COMPOUND
EXTRACT/SARSAPARILLA/
SAN FRANCISCO, CAL. [Base:]
W. T. & CO
See CALEGARIS (Sarsaparilla).

CALIFORNIA EXTRACT OF FIG
CO/SAN FRANCISCO, CAL.//
CALIFORNIA/FIG/BITTERS
See CALIFORNIA (Bitters).

CARTER'S EXT/OF SMART/
WEED//BROWN MED. CO.//
ERIE, P.A.
Adv. 1871, WHS; 1929–30, AD.
Aqua; 7⁵/₈″ × ? × ?; 1n; 3b; ip; v, fss.
See CARTER (Bitters, Cure), WELLS
(Company).

DR. E. CHAMPLAIN/LIGNEOUS
EXTRACT/PATENTED
Aqua; 5¹/₄″ × 2³/₁₆″ × 1¹/₄″; ?n; 7b; v.

DR. CUMMINGS' CO/EXT. OF
SARSAPARILLA & DOCK/
PORTLAND, ME. [Base:] W.T. & CO.
See CUMMINGS (Sarsaparilla).

DAILY'S//PAIN/EXTRACTOR//
LOUISVILLE KY
William Daily's shingle, in Louisville,
read "Indian Doctor"; his office opened
in 1846; the last reference in directo-
ries appears to be 1857. Daily's Pain
Extractor adv. 1851–52 (Blasi 1974).
Aqua; 4⁵/₈″ × 1³/₄″ × 1″; 13n; 3b; 3ip;
v, sfs; p.

DR. FOWLER'S EXTRACT/OF/
WILD STRAWBERRY//FOSTER,
MILBURN & CO.//BUFFALO, N.Y.
Adv. 1890, 1904 (Devner 1968).
Aqua; 5¹/₈″ × 1⁵/₈″ × ⁷/₈″; 7n; 3b; 3 or
4ip; v, fss. See BURDOCK (Bitters),
FELLOW (Chemical, Syrup, Tablet),
THOMAS (Oil), WOOD (Syrup).

GAYS' COMPOUND//EXTRACT
OF/CANCHALAGUA//NEW YORK
See GAYS (Compound).

GOOCH'S//EXTRACT OF/
SARSAPARILLA//CINCINNATI, O
See GOOCH (Sarsaparilla).

Dᴿ GUILMETTE'S/EXTRACT OF
JUNIPER/BOSTON
Bottle manufactured ca. 1890s.
Products adv. 1901, HH & M; 1907,
PVS & S. Proprietor unk.; no informa-
tion could be found in Boston city
directories.
Light amber; 9³/₄″ × 2³/₄″ × 2³/₄″; 11n;
2b; pl; v.

H. T. HELMBOLD//GENUINE/
FLUID EXTRACTS//
PHILADELPHIA
Advertised as: "A Specific Remedy for
General Debility, Mental and Physical
Depression, Imbecility, Determination
of Blood to the Head, Confused Ideas,
Hysteria, etc., and All Diseases of the
Bladder and Kidneys Including
Spermatorrhoea, Rheumatism, Consti-
pation, Epilepsy, Paralysis, Spinal
Diseases, Female Complaints, etc. . . ."
Helmbold's Extract of Buchu, product
of Henry T. Helmbold, was formulated
and apparently introduced in 1850
(Young 1962). Helmbold also produced
a sarsaparilla extract and Catawba Grape
Pills. Helmbold died in 1892 (Young
1962). A. L. Helmbold was producing
the Extract of Buchu in 1897, L & M;
adv. 1941–42 by George Bayne,
Bayonne, N.J., AD.
Aqua; 6″ × ? × ?; 7n; 3b; 3 or 4ip;
v, sfs.

W. HENDERSON & C⁰//EXTRACT
OF/SARSAPARILLA//
PITTSBURGH
See HENDERSON (Sarsaparilla).

HIERAPICRA BITTERS/EXTRACT
OF FIGS//BOTANICAL SOCIETY//
CALIFORNIA [Base:] FIG
See HIERAPICRA (Bitters).

Dᴿ H. R. HIGGINS//PURE
EXTRACT OF//SARSAPARILLA//
ROMNEY Vᴬ
See HIGGINS (Sarsaparilla).

THE HONDURAS CO'S//
COMPOUND EXTRACT//
SARSAPARILLA//ABRAMS
& CARROLL/SOLE AGENTS/S.F.
See HONDURAS (Sarsaparilla).

HOOD'S/COMPOUND/EXTRACT/
SARSA/PARILLA//C. I. HOOD &
C⁰//LOWELL, MASS.
See HOOD (Sarsaparilla).

DR. A. S. HOPKINS//COMPOUND
EXT//SARSAPARILLA
See HOPKINS (Sarsaparilla).

DR H. A. INGHAM'S//NERVINE
PAIN EXTR.
See INGHAM (Nervine).

C. M. JOHNSON'S/EXTRACT/OF/
JAMAICA/GINGER
See JOHNSON (Jamaica Ginger).

S. H. KENNEDY'S//C. EXT. P C
Label: DARPIN IS THE EQUIVALENT
DISTINCTIVE NAME FOR RIO CHEM-
ICAL CO'S S. K. Kennedy's Dark Pinus
Canadensis Comp. Sole Manufacturers—
Rio Chemical Co., New York, U.S.A.
"GUARANTEED UNDER THE FOOD
AND DRUGS ACT—JUNE 30, 1906."—
OFFICIAL No. 110. A NON-
ALCOHOLIC preparation, possessing
superior astringent and tonic properties.

INDICATIONS – *Uterine Hemorrhage, and as an injection in Leucorrhea or Whites, Ulceration of Os Uteri and other Vaginal Diseases, Chronic Diarrhea and Dysentery, in Catarrh, Gleet, Excoriation, Obstinate Ulcers, and in all Cases requiring a powerful Astringent. DIRECTIONS FOR USE – As a internal remedy in Diarrhea, Dysentery, Night Sweats . . . For Piles, Fissures of the Anus, Sores . . . Gonorrhea or Gleet* Adv. 1876, *WHS*; 1941–42, *AD*. Also labeled: *ABICAN – Is the equivalent distinctive name for Rio Chemical Company's S. K. Kennedy's Light Pinus Canadensis Comp. INDICATIONS: To be used externally and locally only, as directed by the physician. NEW LABEL ADOPTED DECEMBER, 1915. RIO CHEMICAL CO. SOLE MANUFACTURERS NEW YORK U.S.A.* Adv. 1935, *AD*.

Clear; 6³/₄″ × 2³/₄″ diameter; 7n; 20b; pl; v, f; h, shoulder.

DR KILMERS//AUTUMN LEAF EXT/FOR/UTERINE INJECTION// BINGHAMTON, N.Y.
Adv. 1886 (Baldwin 1973); 1910, *AD*.
Aqua; 4¹/₂″ × 1⁹/₁₆″ × ⁷/₈″; 11n; 3b; 4ip; v, sfs. See KILMER (Cure, Miscellaneous, Ointment, **Remedy**).

DR KILMERS//HERBAL EXTRACT/ FOR/UTERINE INJECTION// BINGHAMTON, N.Y.
After 1910, DR. KILMERS AUTUMN LEAF, a vaginal douche, containing 86% alcohol, became Dr. Kilmers Herbal Extract. Adv. 1935, *AD*.
Aqua; 4¹/₂″ × 1¹/₂″ × ⁷/₈″; 11n; 3b; 3 or 4ip; v, sfs. See KILMER (Cure, Miscellaneous, Ointment, **Remedy**).

TRADE MARK/DR. KOCH'S/ REMEDIES/EXTRACTS & SPICES// DR KOCH VEG. TEA CO// WINONA, MINN.
See KOCH (**Remedy**).

DR LARDOR'S EXTRACT/OF LUNG WORT//C. J. ROOSEVELT & Cº/NEW YORK
See ROOSEVELT (*Company*).

LIPPMAN'S//COMPOUND EXTRACT//SARSAPARILLA/ WITH 100 POTASS// SAVANNAH, GA.
See LIPPMAN (*Sarsaparilla*).

LOG CABIN//EXTRACT// ROCHESTER, N.Y.
Amber; 8¹/₈″ × 2⁷/₈″ × 1¹/₂″; 20n; distinctive shape and base, flat back; 3ip, front; v. See LOG CABIN (Remedy,

Sarsaparilla), H. WARNER (Bitters, Company, **Cure**, Nervine, Remedy).

LOG CABIN//EXTRACT// ROCHESTER, N.Y. [Base:]
PATᴰ SEPT 1887
Label: *WARNER'S LOG CABIN EXTRACT. AN OLD FASHIONED LINIMENT – CORDIAL – PERFECTLY HARMLESS – RUB-IT-IN–TAKE-IT-IN. H. H. Warner & Co. Rochester N.Y.*
Amber; 6³/₈″ × 2³/₈″ × 1¹/₄″; 3n; 3-sided, flat back; 3ip; v. See LOG CABIN (Remedy, Sarsaparilla), H. WARNER (Bitters, Company, **Cure**, Nervine, Remedy).

[Script:] **Manners/DOUBLE/ EXTRACT/SARSAPARILLA/ BINGHAMTON, N.Y.**
See MANNERS (*Sarsaparilla*).

COMPOUND EXTRACT/OF/ MOUNTAIN ASH
See MOUNTAIN ASH (*Compound*).

DR. MYER'S//VEGETABLE EXTRACT/SARSAPARILLA/ WILD CHERRY/DANDELION// BUFFALO, N.Y.
See MYER (*Sarsaparilla*).

Dᴿ. B. OBER'S//COMPOUND EXTRACT/OF/MOUNTAIN ASH
See OBER (*Compound*).

PELLETIER'S//EXTRACT OF/ SARSAPARILLA//HARTFORD, CONN.
See PELLETIER (*Sarsaparilla*).

DOCTOR/PIERCE//EXTRACT OF/ SMART-WEED//R. V. PIERCE MD//BUFFALO. N.Y.
[See Figure 108]
Label: *. . . DR. PIERCE'S COMPOUND EXTRACT OF SMART WEED*

Fig. 108

FRONT BACK

or Water Pepper for External and Internal Use. Internally it cures Diarrhoea, Dysentery or Bloody-flux, Summer Complaint . . . Externally it cures Sprains and Bruises, Frost Bites, Chilblains, Felons Bottles were not embossed after 1915. Adv. 1876, *WHS*; 1941–42 by Pierce's Proprietories, Buffalo, N.Y., *AD*.
Aqua; 5¹/₄″ × 1³/₄″ × ⁷/₈″; 1n; 3b; 4ip; h, f; v, bss. Also variant, 7″ × 2¹/₄″ × 1¹/₄″ with base embossed: T. W. & Co. See PIERCE (**Discovery,** Miscellaneous), SAGE (Remedy).

POND'S EXTRACT
Adv. in Dec. 1872 *Overland Monthly*: "POND'S EXTRACT – Cures Burns, Bruises, Lameness, Soreness, Sore Throat, Sprains, Toothache . . . Bleeding of the Lungs . . . Humphrey's Specific Homeopathic Med. Co., 362 Broadway, New York." An advertisement for Jan. 1879 reads: "NO LADY'S BOUDOIR IS COMPLETE without POND'S EXTRACT . . . POND'S EXTRACT CO., 98 Maiden Lane [New York]." From *Harper's Weekly*, 23 July 1881: "POND'S EXTRACT – The Unrivalled Remedy . . . POND'S EXTRACT CO., 14 West 14th Street, New York." Theron Pond, Clinton, CT, formulated his preparation of witch hazel in 1846 (Devner 1970) and sold it to Fred Humphrey, New York. F. W. Hurt purchased the product in 1872, but Humphrey continued to market an identical medicine. When Hurt left the Pond's Extract Co. is unknown (*The Pacific Drug Review*, May 1907). Advertisements noted embossed containers in 1881. Adv. 1980 by Chesebrough–Pond's Inc., Greenwich, CT. Pond's creams were on the market in 1984–85, *AD*.
Clear; 5¹/₂″ × 2⁵/₈″ × 1⁷/₈″; 1n; 8b; pl; v. Also variant with pontil.

POND'S EXTRACT [Base:] **1846**
Aqua; 5¹/₂″ × 2¹/₂″ × 1⁷/₈″; 1n; 8b; pl; v.

RISLEY'S//EXTRACT/BUCHU// NEW YORK
Hubbell W. Risley opened a drug store in New York City ca. 1853; soon thereafter he began producing and marketing the Extract of Buchu. In 1859 Morgan & Risley was established, in 1881, Chas. F. Risley [son] & Co. (Devner 1970; Wilson and Wilson 1971). Adv. 1910, *AD*.
Aqua; 6″ × ? × ?; 1n; 3b; 3 or 4ip; v, sfs; p.

**SANFORD'S//EXTRACT OF//
HAMAMELIS/OR WITCH HAZEL**
Adv. 1879, *VSS & C*; 1907, *PVS & S*.
Cobalt; 7¼″ × 2⅜″ × 1⅝″; 7n; 3 or
6b; 3 or 4ip; v.

**SHAKER FLUID//EXTRACT/
VALERIAN**
Brown's Shaker Fluid Extract of Eng-
lish Valerian was concocted by the
Shakers in the 1830s. Edward Brinley
& Co., Boston, were distributors ca.
1840; Maynard & Noyes, Boston, ca.
1860; Weeks & Potter, Boston, ca.
1870; after 1875 the Shakers sold their
product through their own agent,
Nicholas A. Briggs (Wilson and Wilson
1971). Adv. 1923, *SF & PD*.
Aqua; 3¾″ × ?; 7n; 2b; 1 or 2ip; v, fb;
with and without p. See SHAKER
(Syrup).

**[v] SPECIAL BRAND EXTRACT/
JAMAICA GINGER/[h] 3½ OZS
[Base:] WT CO/USA**
See SPECIAL BRAND *(Jamaica
Ginger)*.

**DR. THOMSON'S/COMPOUND
EXTRACT/SARSAPARILLA**
See THOMSON *(Sarsaparilla)*.

**THOMPSON PHO'S CO.
CHICAGO//WILD CHERRY
PHOSPHATE// + //DIRECTIONS/
ONE TEASPOONFUL EXTRACT,
THREE OF SUGAR, ONE GLASS/
WATER, HOT OR COLD, DRINK
FREELY**
See THOMPSON *(Company)*.

**[h] THOMPSON'S/ORIGINAL/
-HYGEIA-/WILD/CHERRY/
PHOSPHATE/DIRECTIONS/USE
ONE TEASPOONFUL/EXTRACT
THREE OF/SUGAR ONE GLASS/
WATER USE HOT/OR COLD
DRINK FREELY/AS YOU WOULD/
LEMONADE/THOMPSON/
PHOSPHATE CO./CHICAGO//
THOMPSON'S/WILD CHERRY/[v]
HYGEIA PHOSPHATE CHICAGO**
See THOMPSON *(Company)*.

**DR THRALLS//COMPOUND
EXTRACT/COHOSH POND
LILLY//NUNQUAH**
See THRALL *(Compound)*.

**TROMMER/EXTRACT OF MALT
CO./FREMONT OHIO**
See TROMMER *(Company)*.

**DR VANBAUM'S//PAIN
EXTRACTOR//AND MAGIC//
RHEUMATIC LOTION**
See VANBAUM *(Lotion)*.

**DR. WILCOX/COMPOUND//
EXTRACT OF/SARSAPARILLA**
See WILCOX *(Sarsaparilla)*.

**DR. WILCOX'S//COMPOUND
EXTRACT//SARSAPARILLA**
See WILCOX *(Sarsaparilla)*.

**JNO. WYETH & BRO./
PHILADELPHIA/LIQ EXT. MALT**
[See Figure 109]
Label: . . . *A Pleasant & Valuable
Nutritive Tonic*. . . . Adv. 1870s
(Devner 1968); 1921, *BD*. John Wyeth,
born 1834, died 1907, graduated from
the Philadelphia College of Pharmacy in
1854 and began working for Henry C.
Blair; John became a full partner in
1858. In 1860, having sold his interests,
John with brother Frank, opened a drug-
store at 1410 Walnut. The firm of John
Wyeth & Bro. prospered during the
Civil War and Edward T. Dobbins
became a third partner. Fire destroyed
the Walnut St. store in 1889 and the
business was moved to 11th and
Washington, the retail store being sold
to Frank Morgan. In 1907, John
Wyeth's only son Stuart, became presi-
dent of the firm. When Stuart died in
1929, Harvard University inherited the
firm, and on 24 June 1931, American
Home Products, Inc., became owners.
As of 1977 Wyeth Laboratories
operated manufacturing facilities in
Pennsylvania, Illinois, Michigan, and
Idaho, and plants and sales offices in
thirty countries. In 1955 the home
offices were relocated in Radnor, PA
("The Wyeth Story, The History of a
Major American Pharmaceutical Firm,"
pamphlet published by Wyeth Labs.,
1977).
Amber; 9″ × ?; 12n; 20b; pl; v; tapered
body. See WYETH *(Chemical, Miscellane-
ous, Oil)*.

Fig. 109

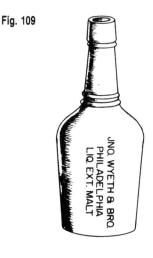

JNO. WYETH & BRO.
PHILADELPHIA
LIQ. EXT. MALT

HAIR

MRS S. A. ALLEN'S/WORLD'S
HAIR/BALSAM/355 BROOME St//
NEW YORK
See MRS. ALLEN (Balsam).

MRS S. A. ALLEN'S//WORLDS
HAIR/RESTORER//NEW YORK
[Base:] V D & R LONDON
See MRS. ALLEN (Restorer).

THE ALTENHEIM/MEDICAL
DISPENSARY//FOR THE HAIR//
CINCINNATTI, O. U.S.A. [Base: M
in circle]
See ALTENHEIM (Medicine).

"ASTOL"/HAIR/COLOUR/
RESTORER//EDWARDS
"HARLENE" LTD
Light amber; $5^3/4'' \times 2'' \times 1^1/4''$; 24n;
6b; 3ip; v, ss. See HARLENE (Hair).

[h: monogram]/[v] ATHENIAN/HAIR/
TONIC
See ATHENIAN (Tonic).

AYER'S//HAIR VIGOR [See Figure
110 and Photo 28]

Fig. 110

Cobalt; $6^1/4'' \times 1^{15}/16'' \times 1^3/4''$; 3n, sp;
6b, inset; pl; v, ss; ABM; distinctive
shape. Also non ABM variant in
peacock blue. See AYER (Cure,
Miscellaneous, Pectoral, Pills,
Sarsaparilla).

BALDPATE/HAIR TONIC/
BALDPATE CO./NEW YORK/
8 OZ. CONTENTS
See BALDPATE (Company).

BARRY'S//TRICOPHEROUS/FOR
THE SKIN/AND HAIR//NEW
YORK//DIRECTIONS/IN THE/
PAMPHLET
According to directories, Alexander C.
Barry, New York City, was first
affiliated with this hair restorative in
1851; labels and advertisements
introduced the product in 1801. Barclay
& Co., 44 Stone St., New York City,
assumed control in 1873, they later
merged with Lanman & Kemp
(Holcombe 1979). Adv. 1948 by
Lanman & Kemp-Barclay & Co., 135
Water St., New York City, AD. The
product was on the market in 1982.
Aqua; $6'' \times 2^1/8'' \times 1^1/4''$; 11n; 3b; pl;
v, sfsb. See BARCLAY (Balsam), BARRY
(Cream, Miscellaneous), BRISTOL
(Sarsaparilla), MURRAY & LANMAN
(Water).

BATCHELOR'S//LIQUID//HAIR
DYE//No1
The W. A. Batchelor Wig Factory, New
York, was established in 1837 (Devner
1970). Dye adv. 1850 (Putnam 1968);
1929–30 by Century National Chem.
Co., 86 Warren St., New York City;
1935 by Century National Chem. Co.,
Ward & Cross Sts., Paterson, N.J., AD.
Aqua; $2^7/8'' \times {}^{15}/16'' \times {}^{15}/16''$; 14n; 1b;
pl; v. fsbs; p. Variant embossed No 2.

BATCHELOR'S/HAIR DYE/No1
Clear; $4^1/4'' \times 1^{15}/16'' \times 1^{15}/16''$; 7n; 2b;
pl; v.

BOGLE'S/HYPERION/FLUID/
FOR THE HAIR
Product of William Bogle, a Boston,
MA, wig maker and perfumer, ca. early
1840s until late 1880s (Wilson and
Wilson 1971). Adv. 1846 (Putnam
1968); 1872, VHS.
Aqua; $5^1/2'' \times ? \times ?$; 5n; 12b; pl; v; 2
sizes.

D. CAMPBELL'S//HAIR/
INVIGORATOR//AURORA//
NEW YORK
Adv. 1860, CNT.
Aqua; $6^1/16'' \times 2^1/8'' \times 1^1/4''$; 1n; 3b;
3ip; v, sfsb; p.

CARBOLINE/FOR THE HAIR//
KENNEDY & Co. GEN'L AGENTS//
PITTSBURGH PA.
See KENNEDY (Company).

S. A. CHEVALIER'S//LIFE FOR
THE HAIR
Product of Sarah A. Chevalier, location
unk. Adv. 1864 (Putnam 1968); 1916,
MB.
Light blue; $7^1/4'' \times 2^3/4'' \times 1^3/8''$; 11n;
13b; pl; h, fb on shoulder.

CLIREHUGH'S//TRICOPHEROUS//
FOR/THE/SKIN/AND/HAIR//
NEW YORK
Adv. 1845 (Putnam 1968); 1865, GG.
Aqua; $6'' \times 1^7/8'' \times 1^1/4''$; 1n; 3b; 4ip;
v, sf; h, b; v, s; p.

COLLINS'/HAIR GROWER/
& DANDRUFF SPECIFIC/
W. R. COLLINS S. F.
See COLLINS (Specific).

CRANITONIC//HAIR FOOD
Adv. 1890s by Crani-Tonic Hair Food
Co., N.Y. (Devner 1968); 1900 by
Crani-Tonic Hair Food Co., 526 W.
Broadway, New York City, EBB; 1915,
The Kells Co., Newburgh, N.Y.
(Devner 1968); 1921, BD.
Aqua; $3^1/16'' \times 1^1/8''$ diameter; 3n; 21b,
12 sides; pl; v, ss.

J. CRISTADORO//LIQUID//HAIR
DYE/No 2
Joseph Cristadoro, New York City,
manufactured his own hair dye while
separately managing Kidder, Wetherill
& Co., New York; later called Wm. F.
Kidder & Co. The firm acquired a por-
tion of the Stewart D. Howe enterprises
in 1873. Cristadoro's factory was
located at 93 William St., New York
City in 1880. Kidder, Wetherill & Co.
operated from 1873, or before, until
1874 when it became Wm. F. Kidder
& Co.; the business was dissolved in
1877 (Holcombe 1979). Dye adv. 1853
(Putnam 1968); 1916, MB.
Aqua; $2^3/4'' \times {}^3/4'' \times {}^3/4''$; 7n; 1b; pl; v,
fsbs. See HOWE (Cure, Sarsaparilla,
Tonic).

CROW-HAIR-O//BEDFORD,
INDIANA
Milk glass; $6^1/2'' \times 2^5/8'' \times 1^1/2''$; 3n; 6b;
2ip; v, ss.

C. DAMSCHINSKY/LIQUID HAIR
DYE/NEW YORK
Adv. 1890, W & P; 1891 by Carl Dam-
schinsky, 226–228 E. 36th St., New
York City, WHS; 1929–30 from 142 E.
34th St.; 1935 from 117–119 E. 24th

St.; 1948 from 58 Roosevelt Ave., Woodside, N.Y., *AD.*
Aqua; 3³/₈″ × ? × ?; 7n; 3b; 1ip; v.

C. DAMSCHINSKY/LIQUID HAIR DYE/NEW YORK
Aqua; 3⁷/₁₆″ × 1⁵/₁₆″ × ¹⁵/₁₆″; 9n; 3b; 1ip; v.

TRADE [Script:] De Lacys MARK/ FRENCH/HAIR TONIC
See DE LACY *(Tonic).*

DIMMITT'S/CAPILLARIA/FOR THE HAIR. [See Figure 111]
Probably related to M. Dimmitt *(Balsam).*
Clear; 5¹/₂″ × 2³/₁₆″ × ¹⁵/₁₆″; 9n; 3b; pl; v.

Fig. 111

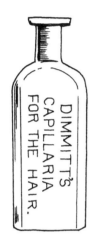

THE EMPIRE HAIR/ REGENERATOR//[embossed trade mark]//NEW YORK
Adv. 1910, 1941–42, *AD.*
Amber; 4¹/₄″ × 1⁵/₈″ × 1″; 3n; 3 or 6b; pl; v, sfs.

EXCELSIOR//HAIR TONIC// LOMBARD & CUNDALL/ SPRINGFIELD MASS
Aqua; 6¹/₂″ × 2¹/₄″ × ¹⁵/₁₆″; 1n; 3b; 4ip; v, ssf; p.

6OZ. FARR'S/GRAY HAIR/ RESTORER/BOSTON/MASS
See FARR *(Restorer).*

FECHTER'S FAMOUS/FAIRICON/ FOR THE HAIR
Three applications: No. 1 for baldness; No. 2 for dandruff; No. 3 for use as hair dressing. Adv. 1891, *WHS;* 1910, *AD.*
Aqua; 7⁷/₈″ × 2¹/₂″ × 1³/₈″; 7n; 3b; 3ip; v.

FISH'S/HAIR RESTORATIVE// B. F. FISH//SAN FRANCISCO
See FISH *(Restorer).*

THE/FOSO COMPANY//FOR THE HAIR AND SCALP//CINCINNATTI, O. U.S.A.
See FOSO *(Company).*

MADAME FOX'S//LIFE FOR THE HAIR
Amber; 7³/₄″ × 2¹¹/₁₆″ × 1³/₄″; 11n; 3b; 4ip; v, ss.

GALLAGHER'S//MAGICAL/ HAIR OIL//PHILAD.A
See GALLAGHER *(Oil).*

GEORGE'S//HAIR DYE//№ 1
Aqua; 3¹/₄″ × 1¹/₈″ × 1¹/₈″; 13n; 2b; pl; v, fsb; p.

GLOBE/HAIR RESTORATIVE AND DANDRUFF CURE/GLOBE MFG. CO. GRINNELL, IA
See GLOBE *(Restorer).*

D͟R F. FELIX/GOURAUD'S// POUDRES/SUBTILE//FOR/ UPROOTING/HAIR//NEW YORK
Adv. 1851–52 as "DR. F. FELIX GOURAUD'S POUDRES SUB-TILES—A Surprisingly Efficacious Depilatory for Uprooting Human Hair . . .," according to New York city directories; 1910, *AD.*
Clear; 3⁵/₈″ × 1⁵/₁₆″ × 1⁵/₁₆″; 5n; 1b; pl; v, fsbs. See GOURAUD *(Cream).*

GRANDJEAN'S//PATENT/ FOR THE//HAIR
Aqua; 5¹/₂″ × ?; 3n, crude; 2b; pl; v, sfs; p.

[h, shoulder:] AGRAN D'JEANS/ [v, sides:] COM//POS//IT//ION// FOR//THE//HAIR
Grandjean's Hair Composition, adv. 1841 (Putnam 1968); 1851, *JSH.*
Clear; dimens. & neck finish unk.; 21b; pl; h, v, 7 sides; p; not sure of embossing.

GREAT/REPUBLIC//HAIR// RESTORATIVE
See GREAT REPUBLIC *(Restorer).*

A. GRIMM'S//REJUVENATOR/FOR THE HAIR//SAN FRANCISCO
Product of Adam H. Grimm, San Francisco, adv. ca. 1871 to ca. 1900 (Wilson and Wilson 1971).
Aqua; 6³/₄″ × ? × ?; 7n; 3b; 3 or 4ip; v, sfs.

HAIR "BITTERS//HAIR "BITTERS// Beriault/LABORATORIES [Base:] PC
See HAIR *(Bitters).*

THE/HAIR RESTORER
See HAIR *(Restorer).*

DR. B. W. HAIR'S/ASTHMA CURE/ CINCINNATI, O. [Base:] WT & CO/U.S.A.
See HAIR *(Cure).*

DR. B. W. HAIR'S/ASTHMA CURE/ HAMILTON, OHIO
See HAIR *(Cure).*

HAMILTON'S/DANDRUFF/CURE/ & HAIR/RESTORATIVE
See HAMILTON *(Restorer).*

"HARLENE"/FOR/THE/HAIR// "HARLENE"/FOR/THE/HAIR// "HARLENE"/FOR/THE/HAIR
Edward's Harlene was an English preparation imported by E. Fougera & Co.; adv. 1896–97, *Mack;* 1935, *AD.*
Aqua, clear; 4¹/₂″ × 1⁵/₈″ × 1³/₁₆″; 7n; 3b; 3ip; h, fss. See ASTOL *(Hair).*

HARRISON'S/COLUMBIAN/HAIR DYE
Adv. 1897, *L & M.*
Clear; 3¹/₈″ × 1¹⁵/₁₆″ × ¹⁵/₁₆″; 13n; 4b, inset; pl; h; backward S in HARRISON.

HAY'S//HAIR HEALTH
According to Devner (1968), Hay's Hair Health was originally the product of the London Supply Co., New York City, followed by Philo Hay Speciality Co., Newark, NJ. Adv. 1891, *WHS;* 1935 by Wm. R. Warner & Co., 113 W. 18th St., New York City, *AD.*
Amber; 4¹¹/₁₆″ × 1⁷/₁₆″ × ¹¹/₁₆″; 1n; 3b; 3ip; v, ss.

HAY'S//HAIR HEALTH [See Figure 112]
Amber; 6⁵/₈″ × 2⁵/₁₆″ × 1¹/₈″; 1n; 3b; 4ip; v, ss.

Fig. 112

4 FL. OZ./Herpicide/Quality Products/FOR THE HAIR AND SCALP [Base: O over diamond]/ MADE IN U.S.A.

Label: *Herpicide for Scalp and Hair . . . Herpicide Company Distributor, New York City*. Bottle manufactured by the Owens-Illinois Glass Co., 1932 to 1943 (Toulouse 1972). Advertisement 29 Jan. 1921, *Salt Lake Tribune*: "Girls! For an abundance of soft, luxuriant hair, glistening with life and beauty. Use Newbro's Herpicide." Adv. 1890 (source unk.); 1929–30 by The Herpicide Co., Detroit, Mich.; 1948 by Jeris Sales Co., 805 E. 140th St., New York City, *AD*.
Clear; 6³/₁₆″ × 1³/₄″ diameter; 16n; 20b; 2ip; h; ABM. See NEWBRO (Cure, Miscellaneous).

HOVER'S//HAIR DYE//PHILAD.ᴬ
Aqua; 2³/₄″ × 1″ diameter; 13n; 21b; pl; v, sss, embossed on consecutive sides; p.

HURD'S//GOLDEN/GLOSS//FOR THE HAIR//NEW YORK
Adv. 1855 (Putman 1968). Probably the product of David W. Hurd, a New York City druggist from 1846–56, according to New York City directories.
Aqua; dimens. unk.; 1n; 3b; 4ip; v, h, sfsb; p.

IMPERIAL HAIR/REGENERATOR/CO./NEW YORK/PAT SEPT 16TH 1884 [Base:] W T & CO
See IMPERIAL (Company).

IMPERIAL HAIR/TRADE MARK/REGENERATOR//IMPERIAL/CHEMICAL MANUFACTURING CO.//NEW YORK
See IMPERIAL (Company).

IMPERIAL HAIR/TRADE/[embossed crest]/MARK/REGENERATOR//IMPERIAL/CHEMICAL MANUFACTURING CO//NEW YORK
See IMPERIAL (Company).

Dᴿ D JAYNE'S/HAIR TONIC//PHILADA
See JAYNE (Tonic).

Dᴿ D. JAYNE'S/HAIR TONIC/PHILADA//TONICO/DEL/Dᴿ D. JAYNE/PARAELPELO/PHILADA
See JAYNE (Tonic).

Dᴿ D. JAYNE'S//OLEAGINOUS/HAIR TONIC//PHILAᴰ
See JAYNE (Tonic).

T. JONES/CORAL//HAIR/RESTORATIVE
See JONES (Restorer).

KALOPEAN//HAIR DYE//NO 1
Adv. 1871, 1887, *WHS*.
Aqua; 3¹/₂″ × 1¹/₂″ × 1¹/₂″; 5n; 1b; pl; v, fsb; p.

KENDALL &/BANNISTER'S/AMBOLINE//FOR THE HAIR//NEW YORK
New York City newspapers and directories indicated that Edward Kendall and William H. Bannister were in business together in 1863–64 at 506 Broadway. Kendall was with George Dudley in 1865 and 1866 as Waring & Co., 35 Dey St. Kendall's Amboline adv. 1863, *New York Times*; 1910, *AD*, proprietors after 1866 are unknown.
Aqua; 7¹/₄″ × 2¹/₄″ × 1³/₈″; 3n; sp; 6b; 4ip; v, fss.

KENDALL'S/AMBOLINE/FOR THE HAIR//WARING & CO//NEW YORK
Aqua; 6⁵/₈″ × 2¹/₁₆″ × 1⁵/₁₆″; 7n; 6b; 4ip; v, fss.

KICKAPOO/SAGE/HAIR TONIC
Cobalt; 4³/₈″ × 2⁵/₁₆″ diameter; 3n, glass stopper; 20b; pl; h; tapered sides.

[v] KOKO [d] FOR/THE [v] HAIR//KOKO [d] FOR/THE [v] HAIR
An English preparation imported by E. Fougera; adv. 1897, *EF*; 1929–30, *AD*.
Clear; 4⁵/₈″ × 1⁵/₈″ × ⁷/₈″; 7n; 3b; pl; v, d, ss.

KROMER'S//HAIR DYE//№ 1
Label: *KROMER'S HAIR DYE. Manufactured by Johnston Holloway & Co., Philadelphia. 15% Alcohol—Black No. 1*. Adv. 1871, *VSS & R*; 1929–30, *AD*.
Clear; 3⁷/₁₆″ × 1¹/₄″ diameter; 7n; 20b; pl; v, sbs.

Dᴿ LEONS/ELECTRIC/HAIR RENEWER//ZIEGLER & SMITH//PHILADA.
(Henry S.) Ziegler & (Jacob H.) Smith were listed in 1876 and 1877 directories; between 1862 and 1876 the pair were associated with Henry Wampole (Drugs and Paints).
Black amethyst; 7″ × ? × ?; 7n; 3b; ip; v, fss. See WAMPOLE (Company).

LOCKYER'S/SULPHUR/HAIR RESTORER
See LOCKYER (Restorer).

LONDON/HAIR RESTORER
See LONDON (Restorer).

LYON'S//FOR/THE/HAIR//KATHAIRON//NEW YORK
Emanuel Thomas Lyons, New York, NY, introduced his products in 1848, and sold the controlling interests in his business to Barnes & Park, ca. 1858. Barnes and associates formed the Lyon Mfg. Co. in late 1871 or early 1872 to market many products including Lyons Kathairon (Holcombe 1979; Wilson and Wilson 1971). Lyon's Kathairon, hair restorative, adv. 1852, New York City directory; 1929–30 by Lyon Mfg. Co., 41 S. Fifth St., Brooklyn, N.Y., *AD*.
Aqua; 6³/₈″ × 2″ × 1¹/₄″; 11n; 3b; 4ip; h, fb; v, ss. Also variant, 6″ high with 1 neck finish. See DRAKE (Bitters), LYON (Jamaica Ginger, Miscellaneous), MEXICAN (Liniment), WYNKOOP (Pectoral, Sarsaparilla).

MACASSAR/OIL//FOR THE HAIR//REGENT Sᴵ//LONDON
See MACASSAR (Oil).

MASCARO TONIQUE/FOR THE HAIR/TRADE MARK/MARTHA MATILDA HARPER/ROCHESTER, N.Y. U.S.A. [Base:] 1250
See MASCARO (Tonic).

MAYOR WALNUT-OIL CO/KANSAS CITY, MO.//HAIR DYE//HAIR DYE//NONE BETTER
[Base: diamond]
See MAYOR (Oil).

DR. E. E. McLEAN'S/MEDICATED/HAIR TONICS/SAN FRANCISCO, CAL.
See E. E. McLEAN (Tonic).

THE MEXICAN//HAIR RENEWER
Product of the Anglo-American Drug Co., Ltd., London, England. Adv. 5 July 1884, *The Illustrated London News*; 1910, *AD*; 1912 (British Medical Association).
Cobalt; 7¹/₄″ × 2³/₄″ × 1¹/₂″; 22n; 10b; pl; v, ss.

[Script:] **Mo Hair/Dandruff/Cure**
See MO HAIR (Cure).

NATTHAN'S/CRYSTAL/DISCOVERY/[embossed star]/FOR THE HAIR
See NATTHAN (Discovery).

OLDRIDGES/BALM/OF COLUMBIA//FOR RESTORING/HAIR/PHILADELPHIA
See OLDRIDGE (Balm).

PARISIAN SAGE/A HAIR TONIC/GIROUX MFG. CO./BUFFALO. FORT ERIE
See PARISIAN (Tonic).

**PARKER'S//HAIR/BALSAM//
NEW YORK**
See PARKER *(Balsam).*

**PHALON & SON'S/CHEMICAL
HAIR/INVIGORATOR//
NEW YORK**
See PHALON *(Invigorator).*

[Script:] **Q = ban/for/the hair** [Base: I
in diamond]
Bottle manufactured by the Illinois
Glass Co., 1916 to 1929 (Toulouse
1972). Hair tonic adv. 1916, *MB;*
1929–30 by Hessig-Ellis Drug Co.,
South Front & McCall Ave., Memphis,
Tenn.; 1935 by McKesson-Van Vleet-
Ellis Corp., Memphis, Tenn.; 1948 by
Plough Sales Corp., Memphis, Tenn.,
AD.
**Amber; 6³/₄″ × 2¹/₂″ × 1¹/₂″; 7n; dis-
tinctive ribbed base, with flat back; pl;
script. Also ABM variant with
threaded cap.** See Q = BAN
(Miscellaneous).

**M. A. REAVES/GREAT ELECTRIC/
HAIR TONIC**
See REAVES *(Tonic).*

**REGENTS//MACASSAR/OIL//
FOR//THE HAIR**
See REGENTS *(Oil).*

**RESORCIN/HAIR/TONIC/
GOODRICH/[embossed
pyramid]/QUALITY/TRADE MARK/
GOODRICH/DRUG CO./OMAHA**
See GOODRICH *(Drug).*

**RHODES' HAIR/REJUVENATOR,/
LOWELL, MASS.**
Adv. 1910, 1935 by A. Rhodes Co.,
Lowell, Mass., *AD.*
Amber; 6¹/₂″ × ? × ?; 9n; 6b; pl; v.

**RHODES/ASTRINGENT HAIR
LOTION/LOWELL, MASS.**
Adv. 1910, 1929–30 by A. Rhodes
Co., Lowell, Mass., *AD;* Rhodes Hair
Tonic adv. 1948 from E. E. Cline,
Chicago, Ill., *AD.*
**Clear; 6″ × 2¹/₁₆″ × 1¹/₁₆″; 7n; 3b; 3ip;
oval embossed panel; v.**

**PROF-WM-/ROBERSON'S//HAIR//
RENEWER:**
**Black amethyst; 6³/₄″ × 2³/₈″ × 1⁵/₈″;
9n; 3b; 4ip; v, fss.**

**SAGE BRUSH/SAGE BRUSH/
TONIC CO. LTD/HAIR TONIC**
[Base:] **I. G. & CO.**
See SAGE BRUSH *(Tonic).*

Sᵀ CLAIR'S/HAIR LOTION
See ST. CLAIR *(Lotion).*

**SCHEFFLER'S/HAIR/COLORINE/
BEST IN/THE WORLD**
Adv. 1899 (Devner 1970); 1929–30 by
New York Hair Co., 832 Broadway,
New York City, *AD.*
**Clear; 4¹/₄″ × 1¹¹/₁₆″ × 1¹/₈″; 7n; 3b;
pl; h.**

**SIMPLES HAIR COLORING/
WILLIAM C. KORONY/
LOUISVILLE, KY**
Directories list William G. Korony, as
a "Manufacturing Chemist," 1911 to
1942. Korony Products Inc., Milton N.
Robenson, Pres., "Manufacturer of
Toilet Goods," was listed in 1946;
company was listed until 1953, later
information was unavailable.
Clear; 4³/₄″ × 2″ × ?; 10n; 19b; pl; v.

SKOOKUM ROOT//HAIR GROWER
Product of the Hillside Chemical Co.,
Newburgh, NY. Adv. 1895, *PVS & S;*
1935 by The Kells Co., Newburgh,
N.Y., *AD.*
**Cobalt; 6¹/₂″ × 2¹/₂″ × 1¹/₂″; 7n, sp;
3b; 4ip; v.**

**STEARN'S/HAIR REMOVER/$1.00/
DIRECTIONS/ON CARTON**
Milk glass; 2³/₄″ × ? × ?; 9n; ?b; pl.

**STERLING'S/AMBROSIA/FOR THE
HAIR//H. H. STERLING//
NEW YORK**
Carton of an unembossed variant reads:
*Sterlings Ambrosia For The Hair, New
Label adopted July 4th 1864. No. 1, used
at night, No. 2, used in the morning. An
Oily Extract from Roots, Barks & Herbs.
Prepared only by Sterlings Ambrosia Mfg.
Co., 121 Liberty St., New York* (Fike
1967). Adv. 1863 by Dr. H. H.
Sterling, Sole Proprietor, 493 Broad-
way, *New York Times;* 1910, *AD.*
**Light aqua; 6¹/₄″ × 2¹/₄″ × 1¹/₄″; 1n;
3b; 4ip; v.**

SUTHERLAND/SISTERS [embossed
over large 7]/**HAIR/GROWER/
NEW YORK//SUTHERLAND
SISTERS//NEW YORK**
[See Figure 113]
Fletcher Sutherland and his seven long-
haired daughters were vocalists and
instrumental performers when they
began promoting their famous hair
grower ca. 1882. Their business began
to prosper only when Henry Bailey, of
Barnum and Bailey circus fame, married
a daughter in 1885 and became their
business manager. Fletcher died in
1888. The business was declining by
1907; Grace the last surviving daugh-

ter died in 1946 (Munsey 1970).
Containing 30% alcohol, the hair
grower was still advertised in 1929–30
by Seven Sutherland Sisters, 242 Brad-
hurst Ave., New York City, *AD.*
**Clear; 5¹/₄″ × 2³/₈″ × 1⁵/₁₆″; 9n; 3b;
3ip; h, fss.** See SUTHERLAND (Trade
Mark).

Fig. 113

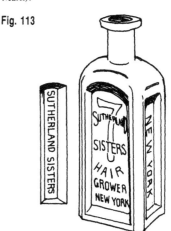

**DR. TEBBETS//PHYSIOLOGICAL/
HAIR//REGENERATOR**
James A. Tebbett, and son, Man-
chester, NH, began producing the
regenerator as a prescription, in the mid
1850s. The product was first bottled in
embossed containers ca. 1867 (Wilson
and Wilson 1971). Adv. 1864 (Putnam
1968); 1916, *MB.*
Puce; 3″ × ? × ?; 1n; 3b; 3ip; v, sfs.

**DR TEBBETTS'//PHYSIOLOGICAL/
HAIR/CAPACITY/6 OZS.//
REGENERATOR**
**Amber; 7³/₈″ × 2⁵/₁₆″ × 1⁵/₈″; 1n; 3b;
3ip; v, sfs.**

**PROF. J. R. TILTON//THE GREAT/
HAIR/PRODUCER//THE/
CROWN OF/SCIENCE//S. F. CAL.**
**Cobalt; 6³/₄″ × 2⁵/₈″ × 1¹/₂″; 7n; 3b;
2ip; v, s; h, fb; v, s.**

**TREGOR'S/E. R. B./HAIR
INVIGORATOR/A GERMICIDE/
M. TREGOR SONS/BALTIMORE,
MD./WASHINGTON, D.C.**
See TREGOR *(Invigorator).*

**VANS MEXICAN HAIR
RESTORATIVE/MANUFACTURED
ONLY BY THE/MEXICAN
MEDICINE CO./CHICAGO, U.S.A.**
See MEXICAN *(Company).*

[Script:] **Velvetina/REG. U.S. PAT.
OFF./RESORCIN/HAIR TONIC/
GOODRICH/DRUG CO. OMAHA**
[Base: diamond]
See GOODRICH *(Drug).*

**PAUL WESTPHAL/AUXILIATOR/
FOR/THE/HAIR/NEW YORK**
Adv. 1875 (Devner 1968); 1929–30
and 1935 by Paul Westphal, 209 W.
43rd St., New York City; 1948 from
653 11th Ave., *AD*.
Clear; $7^7/_8'' \times 3^1/_4'' \times 1^5/_8''$; 3n,
tapered; 24b; pl; h.

**WHALEN'S/HAIR/RESTORATIVE/
AND/DANDRUFF/CURE**
See WHALEN *(Cure)*.

**M<u>RS</u> H. E. WILSON'S//HAIR
DRESSING//MANCHESTER N. H.**
Adv. 1871, *VSS & R*.
Aqua; dimens. unk.; 1n; 3b; v, sfs; p.

**PROFESSOR WOOD'S/HAIR
RESTORATIVE.//DEPOT,
S^T LOUIS, MO//AND NEW YORK**
See WOOD *(Restorer)*.

**MADAM M. YALE'S/EXCELSIOR/
HAIR TONIC//MADAME
M. YALE'S/EXCELSIOR/
HAIR TONIC**
See YALE *(Tonic)*.

**MADAME YALE'S/EXCELSIOR
HAIR TONIC/PRICE 50¢//MFD
ONLY BY/MME. M. YALE/
NEW YORK & CHICAGO/U.S.A.**
See YALE *(Tonic)*.

INVIGORATOR

**D. CAMPBELL'S//HAIR/
INVIGORATOR//AURORA//
NEW YORK**
See CAMPBELL *(Hair)*.

**CLARKE'S//VEGETABLE TONIC/
AND/INVIGORATOR**
See CLARKE *(Tonic)*.

**DR CONVERS/INVIGORATING/
CORDIAL**
See CONVER *(Cordial)*.

**DAVIS'S KIDNEY AND/
LIVER BITTERS//
BEST INVIGORATOR/
AND CATHARTIC**
See DAVIS *(Bitters)*.

**DR. HAM'S/AROMATIC/
INVIGORATING SPIRIT/N.Y.**
Dr. Abner Ham, New York, introduced
his Invigorating Spirit in the early
1850s. After Abner's death the business
was operated by the family (Wilson and
Wilson 1971). Adv. 1856 (Putnam
1968); 1910, *AD*.
Amber; $7^1/_8'' \times 2^1/_2''$ diameter; 7n;
20b; pl; v.

**DR. HAM'S/AROMATIC/
INVIGORATING SPIRIT/N.Y.**
Label: . . . *Prepared by Dr. Darius
Ham. Put up & Sold by D. H. Ham 54
Broad St., Boston, Mass.* Bottle manufac-
tured ca. 1890 (Wilson and Wilson
1971). References have Darius Ham as
proprietor in 1866, with the general
depot located at 48 Water St., New
York City (Singer 1982).
Amber; $8^3/_4'' \times$?; 7 and 9n; 20b; pl; v.

**DR. LIEBIG'S/GERMAN
INVIGORATOR/400 GEARY
ST. S. F.**
Justus Von Liebig's Invigorator was
trademarked by A. C. Stoddart in 1883.
The Liebig Dispensary company bot-

tles are ca. 1890s; the firm went out of business ca. 1897 (Wilson and Wilson 1971). The *Arizona Silver Belt*, 16 Feb. 1884, stated: "DR. LEIBIG'S HEALTH INVIGORATOR, LOST MANHOOD RESTORED." Invigorator adv. 1897, *L & M*.

Amber; 6¾" × ?; 7n; 6b; 2ip; v, f. See LIEBIG (Cure, Miscellaneous), MEDICATED *(Tablet)*.

DR. LIEBIG'S/GERMAN INVIGORATOR/400 GEARY ST. S. F.

Amber; 8½" × 2⅞" × 1¾"; 7n; 6b; 2ip; v, f. See LIEBIG (Cure, Miscellaneous), MEDICATED *(Tablet)*.

Dᴿ LIEBIG'S WONDERFUL/ GERMAN INVIGORATOR Nº 1/400 GEARY ST. S.F. CAL.

Aqua; 7¾" × 2⁹⁄₁₆" × 1⁵⁄₁₆"; 7n; 3b; 3ip; v. See LIEBIG (Cure, Miscellaneous), MEDICATED *(Tablet)*.

Dᴿ. MORSE'S/INVIGORATING/ CORDIAL.

See MORSE *(Cordial)*.

PHALON & SON'S/CHEMICAL HAIR/INVIGORATOR// NEW YORK. [See Figure 114]

Adv. 1846 (Putnam 1968); 1910, *AD*.

Light green; 5⁵⁄₁₆" × 2⁷⁄₁₆" × 1¼"; 7n; 13b; pl; v, fb. See PHALON (Miscellaneous).

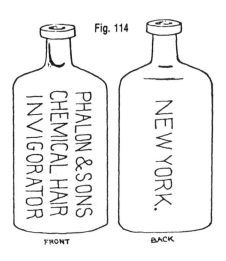

Fig. 114

FRONT BACK

DR SANFORD'S//INVIGORATOR/ OR/LIVER REMEDY

Dr. Samuel T. W. Sanford established his business in New York in the 1840s. About 1878 the Potter Drug & Chemical Co. became a subsidiary manufacturer of some of his products (Blasi 1974). Adv. as "Sanfords Liver Remedy" in 1840s (Wilson and Wilson 1971); as Liver Invigorator ". . . for

bilious attacks, headache or giddiness . . . Sanford & Company, New York," 1856 (Baldwin 1973; Putnam 1968); 1929–30, *AD*.

Aqua; 7⅜" × 2⅜" × 1½"; 11n; 3b; ip; v, sf; p. See CUTICURA *(Cure)*, POTTER (Drug), SANFORD *(Cure)*.

DR. SANFORD'S//LIVER/ INVIGORATOR//NEW YORK

Aqua; 7½" × 2⁷⁄₁₆" × 1⅜"; 11n; 3b; 4ip; v, sfs; also p. See CUTICURA *(Cure)*, POTTER (Drug), SANFORD *(Cure)*.

SOLOMON'S/STRENGTHENING &/INVIGORATING BITTERS// SAVANNAH/GEORGIA

See SOLOMON *(Bitters)*.

TREGOR'S/E. R. B./HAIR INVIGORATOR/A GERMICIDE/ M. TREGOR SONS/BALTIMORE, MD./WASHINGTON, D.C.

Marcus Tregor & Sons (John D., Harry A.), "Barber Supplies," were located in Baltimore in 1891 (home office) and in 1956. Washington, DC directories include the firm in 1891 and 1917. Marcus died in 1913.

Clear; 8" × ?; 9n; 1b; pl.

W. L. TUCKER/IMPROVED/IRON/ INVIGORATOR/WACO/TEX

Product of the Lion Drug Store, Waco, Texas, 1885–93.

Color unk.; 11" × ? × ?; ?n; rect.; ip; f, sides may also be embossed.

JAMAICA AND/OR GINGER

ABRAMS & CARROLL'S/ESS OF/ JAMAICA GINGER/ SAN FRANCISCO

Aqua; $5^{1/2}$" × ? × ?; 11n; 12b; pl; v. See HONDURAS *(Sarsaparilla)*.

ALLEN'S/ESSENCE OF/ JAMAICA GINGER

Product of William Allen, Fort Edwards, NY, formulated in the early 1860s and controlled by J. N. Harris (Wilson and Wilson 1971). Adv. 1910, *AD*.
Aqua; $5^{1/2}$" × $2^{1/4}$" × $1^{3/16}$"; 7n; 12b; pl; v. See ALLEN *(Balsam)*.

D<u>R</u> BARNES/E<u>SS</u> OF JAMAICA GINGER/R. HALL & C<u>O</u>/ PROPRIETORS

Bottle manufactured ca. 1861 (Wilson and Wilson 1971). Adv. 1877, *McK & R*; 1910, *AD*.
Aqua; $5^{1/4}$" × ? × ?; 11n; 12b; pl; v. See HALL *(Balsam, Sarsaparilla)*.

D<u>R</u> BARNES/E<u>SS</u> JAMAICA GINGER/SHEPARDSON & GATES/ PROPRIETORS

Bottle manufactured ca. 1868 (Wilson and Wilson 1971).
Aqua; $5^{3/4}$" × ? × ?; 1n; 12b; pl; v. See HALL *(Balsam, Sarsaparilla)*.

D<u>R</u> BARNES/E<u>SS</u> JAMAICA GINGER/J. R. GATES & CO/ PROPRIETORS

Bottle manufactured ca. 1880 (Wilson and Wilson 1971).
Aqua; $5^{3/8}$" × $2^{1/8}$" × $1^{1/8}$"; 7n; 12b; pl; v. See HALL *(Balsam, Sarsaparilla)*.

D<u>R</u> COLLIS BROWN'S/ESS OF JAMAICA GINGER/N<u>O</u> 5 HAY MARKET/LONDON

Imported beginning ca. 1862 (Wilson and Wilson 1971). Products of J. Collis Brown were adv. in 1883 in *The Illustrated London News*.
Light blue; $5^{1/2}$" × $2^{1/4}$" × $1^{1/4}$"; 7n; 12b; pl; v.

F. BROWN'S/ESS OF/JAMAICA GINGER/PHILADA

The *Langley & Michael* catalog for 1897 notes the introduction of Frederick Brown's Jamaica Ginger in 1822. Brown died in 1866 and control was assumed by his son Fred Jr. (Holcombe 1979). The Frederick Brown Company on the northeast corner of Fifth & Chestnut Sts., Philadelphia, PA, was incorporated in 1890, the 1897 *Langley & Michaels'* catalog states. The firm was located at 17 N 6th in 1913 and 1916, according to Boyd's Philadelphia city directory. Adv. 1921, *BD*. There is no apparent relationship to F. Brown Sarsaparilla Bitters.
Clear, aqua; 5" × $1^{7/8}$" × 1"; 7n; 12b; pl; v. See BROWN (Drug).

F. BROWN'S/ESS OF/JAMAICA GINGER/PHILAD<u>A</u>. [See Figure 115]

Aqua; $4^{7/8}$" × $1^{3/4}$" × 1", also $5^{1/2}$" × $2^{1/4}$" × $1^{1/4}$"; 11n; 12b; pl; v; also p. See BROWN (Drug).

Fig. 115

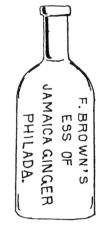

N K BROWN'S/AROMATIC ESSENCE/JAMAICA GINGER/ BURLINGTON, V.T.

Product of Nathaniel K. Brown, Burlington, VT. *The New Hampshire Register, Farmer's Almanac & Business Directory*, published by the Claremont Mfg. Co., Claremont, NH, provided the following advertisement for 1873: "N. K. Brown's Aromatic Essence of Jamaica Ginger – Only 50cents per bottle – Brown's Popular Medicines – N. K. Brown prop., Burlington, Vt." Jamaica Ginger adv. 1916, *MB*.
Aqua; $5^{3/4}$" × ? × ?, also height $4^{5/8}$"; 7n; 12b; pl; v.

N. K. BROWN'S/AROMATIC ESSENCE/JAMAICA GINGER/ MILWAUKEE, WIS.

Clear; $4^{1/2}$" × 2" × 1"; 7n; 12b; pl; v.

[arched:] C. H. EDDY & CO./[h] JAMAICA/GINGER/[arched:] BRATTLEBORO, VT.

[See Figure 116 and Photo 29]
Child's *Windham County Gazetteer, 1724–1884* lists Charles H. Eddy & George A. Eels (C. H. Eddy & Co.), "Bottling Works, Manufacturer of Ginger Ale & Soda, Birch and Tonic Beer." Also the Brattleboro city directory for 1930 has C. H. Eddy & Co., Henry M. Williams, Prop., "Bottlers, Carbonated Beverages and Flavoring Extracts, Wholesale Drugs & Barber Supplies."
Clear; $4^{7/16}$" × $1^{1/2}$" × $7/8$"; 7n; 12b; pl; h; picnic flask shape.

Fig. 116

J. A. FOLGER & CO/ESSENCE OF/ JAMAICA GINGER/ SAN FRANCISCO

James A. Folger, an employee of Wm. Bovee and the Pioneer Steam Coffee & Spice Mills, purchased the majority of Bovee's interests in 1859 and with Ira Marden established Marden & Folger. Folger purchased all interests and established J. A. Folger & Co. in 1866. August Schilling became a partner in 1878 and worked with Folger four years. Schilling eventually purchased the non-coffee portion of Folger's business ca. fifty years later. Folger died in 1889 and his son James II continued the business; incorporation took place in 1890 (Zumwalt 1980). The company manufactured a line of products with medicinal intent for a short time; the firm, as of 1986, was still in business.
Aqua; $5^{5/8}$" × $2^{1/4}$" × $1^{1/4}$"; 11n; 12b; pl; v.

GILLETT'S/ESS JAMAICA/ GINGER/[monogram]/ E. W. GILLETT/CHICAGO

Clear; $5^{1/4}$" × $2^{1/4}$" × $1^{1/4}$"; 7n; 12b; pl; h. See GILLET *(Miscellaneous)*, SHERER-GILLETT *(Company)*.

GODBE & COs**/ESS OF/JAMAICA GINGER/SALT LAKE CITY**
See GODBE (*Company*).

HOSTETTER'S/ESSENCE/JAMAICA GINGER/PITTSBURGH
Adv. 1980s (Denver 1968).
Amber; 5½″ × ?; 7n; 12b; pl; v. See HOSTETTER (*Bitters*).

C. M. JOHNSON'S/EXTRACT/OF/ JAMAICA/GINGER
Adv. 1900, *EBB*; 1910, *AD*.
Aqua; 6″ × 2½″ × 1¼″; 1n; 12b; pl; h.

[In circle:] CHARLES JOLY/ PHILADELPHIA/JAMAICA SARSAPARILLA
See JOLY (*Sarsaparilla*).

LANGLEY & MICHAELS/ESS/ JAMAICA/GINGER/S. F.
Aqua; 5⅞″ × 2⅜″ × 1¼″; 23n; 12b; pl; v. See following entry, LANGLEY (*Miscellaneous, Sarsaparilla*).

LANGLEY'S/ESS/JAMAICA GINGER/SAN FRANCISCO
Alfred John Langley, born 1820, died 1896, moved to San Francisco from New York in 1849. In April 1852, Langley entered a partnership with a Mr. Clerk; in 1855, Clerk was no longer listed in the directory and Alfred and his younger brother Charles, were billed as C. & A. J. Langley, importer of drugs & medicines. From 1862 to the 1880s, directories listed the business with just Charles Langley, except for a brief partnership with Eugene Crowell, 1866–1869. Around 1885 the firm became Langley & Michaels; in the 1930s, McKesson-Langley-Michaels (Shimko 1969). Apparently Henry Michaels was first affiliated with the business in 1871. Meanwhile, in 1858, Alfred Langley went to Victoria, B.C., and with brother James, established Langley Bros.; Alfred, however retained an association with the California business until 1862, or later (directories did not include him after 1862). James died in November 1893, Alfred on 9 April 1896. In 1896 the Victoria firm became Langley & Henderson Bros. and the retail sales were discontinued. In 1898 the business became Henderson Bros. (Shimko 1969).
Aqua; 5¾″ × 2¼″ × 1⅛″; 1n; 13b; pl; v. See previous entry, LANGLEY (*Miscellaneous, Sarsaparilla*).

E. G. LYONS & CO./ESS/JAMAICA GINGER/S. F. [See Figure 117]
Ernest G. Lyons acquired a San Fran-

cisco based bitters and cordial manufactury in 1865 and established E. G. Lyons & Co. In 1891 the firm was incorporated as E. G. Lyons Co. Lyons died in 1893 and within just a few years the name became E. G. Lyons & Raas Co. (Felton, et al. 1984).
Aqua; 5¾″ × 2⅛″ × 1⅛″; 11n; 12b; pl; v.

Fig. 117

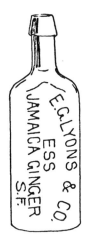

LYONS/JAMAICA/GINGER
Vessel probably contained "E. Thomas Lyons Pure Essence of Jamaica Ginger, For Dyspepsia, Gout, Rheumatism, Cramps, Cholera, Cholera Morbus, Cholic, Fever and Ague, &c." Adv. 1852 in the New York City directory.
Aqua; 6¼″ × 2″ × 1⅛″; 11n; 3b; 3ip, arched front; v. See LYON (*Hair*, Miscellaneous).

McMILLAN/&/KESTER'S/ESS = OF/ JAMAICA/GINGER/S. F.
[See Figure 118]
Bottle manufactured ca. 1875-1879 (Wilson and Wilson 1971). Donald McMillan and Levi Kester purchased this brand from Turner Bros. in 1865. Levi Kester died in 1881 and for another few years, McMillan operated

Fig. 118

the business under his own name. McMillan was succeeded by son Ronald who continued the business until 1906 (Felton, et al. 1984; Wilson and Wilson 1971).
Aqua; 5⅝″ × 2³/₁₆″ × 1⅛″; 11n; 12b; pl; h. See TURNER (*Jamaica Ginger*, Miscellaneous, Sarsaparilla), WONSER (*Bitters*).

McMILLAN & KESTER/ESS/ JAMAICA/S. F.
Bottle manufactured ca. 1872 (Wilson and Wilson 1971).
Aqua; 6″ × ? × ?; 11n; 12b; pl; v. See TURNER (*Jamaica Ginger*, Miscellaneous, Sarsaparilla), WONSER (*Bitters*).

PARKER'S//GINGER/TONIC// NEW YORK
See PARKER (*Tonic*).

REDINGTON & CO./ESS OF/ JAMAICA GINGER/ SAN FRANCISCO
Redington & Co.'s Jamaica Ginger adv. 1864, 1915. Adv. without a brand name until 1923 in Coffin-Redington Specialty lists, according to Peter Schultz (personal communication, 1985).
Aqua; 6″ × ? × ?; 11n; 12b; pl; v. See COFFIN-REDINGTON (Water), REDINGTON (*Company*).

PAUL RIEGER'S/JAMAICA GINGER/S. F. CAL
Paul Rieger and a partner established a drug business in San Francisco ca. 1873. Rieger was murdered in 1877 (Wilson and Wilson 1971) and the business continued as Paul Rieger & Co, "The California Perfumer, Paris, San Francisco, Extracts, and Perfumes." The firm was listed in 1916 (Devner 1970).
Aqua; 6″ × 2⅜″ × 1⅛″; 11n; 15b; pl; v.

GENUINE SANFORD'S GINGER/ A DELICIOUS COMBINATION OF/ GINGER FRENCH BRANDY AND/ CHOICE AROMATICS, REG'D 1876//POTTER DRUG & CHEM. CORP./ /BOSTON, MASS. U.S.A.
See POTTER (*Drug*).

SANFORD'S JAMAICA GINGER/ THE QUINTESSENCE OF JAMAICA/GINGER, CHOICE AROMATICS &/FRENCH BRANDY, REGISTERED 1876//POTTER DRUG & CHEM. CORP.// BOSTON, MASS. U.S.A.
See POTTER (*Drug*).

SELLECK'S GINGER//TOLU
COUGH SYRUP//CLAY,
WHOLESALE & CO./MFG
PHARMACISTS/ELMIRA N.Y.
See CLAY (Company).

HENRY SNELL/ESSENCE OF
JAMAGA GINGER/SALT LAKE/
UTAH
Little information could be found. The
Utah Gazetteer and Directory for 1884
includes a reference to Snell & Snell,
Salt Lake City, Manufacturing
Chemists.
Aqua; $5^{1}/_{2}'' \times 2^{1}/_{4}'' \times 1^{1}/_{8}''$; 7n; 12b; pl;
v; note spelling of Jamaica.

HENRY SNELL/ESSENCE JAMAGA
GINGER/SALT LAKE UTAH
Aqua; $6^{5}/_{8}'' \times 2^{1}/_{4}'' \times 1^{3}/_{16}''$; 7n; 12b;
pl; v; note spelling of Jamaica.

[v] SPECIAL BRAND EXTRACT/
JAMAICA GINGER/[h] $3^{1}/_{2}$ OZS
[Base:] WT CO/USA
Bottle manufactured by Whitall-Tatum,
from 1857 to 1935 (Toulouse 1972).
Aqua; $6^{3}/_{4}'' \times 2^{5}/_{16}'' \times 1^{1}/_{16}''$; 7n; 3b;
3ip; v, h.

TURNER'S/ESS OF/JAMAICA
GINGER/NEW YORK [See Photo 30]
The Turner brothers, Archibald,
George, James, Malcolm, Robert and
Thomas, "Manufacturers of ginger wine,
syrups, cordials, bitters, native wines &
c," had offices located in Buffalo, NY,
1844–1863; New York, NY, 1840s, or
early 1850s–1865; and San Francisco,
1852–1864. McMillan & Kester were
successors to the Turner products.
Aqua; $5^{3}/_{4}'' \times ? \times ?$; 11n; 12b; pl; v.
See AMERICAN (Balsam), McMILLAN &
KESTER (Jamaica Ginger), TURNER
(Miscellaneous, Sarsaparilla).

VAN DUZER'S/ESSENCE/JAMAICA
GINGER/NEW YORK
Directories list Selah R. Van Duzer,
198 Greenwich, New York City, in
1852; 85 Barclay & 40 Park Place in
1891; 37 Barclay & 42 Park Place in
1896. In 1900 the location was 42 Park
Place, EBB.
Aqua; $5^{7}/_{8}'' \times 2^{1}/_{4}'' \times 1^{5}/_{16}''$; 7n; 12b;
pl; v. See MRS. ALLEN (Balsam, Miscel-
laneous, Restorer), VAN DUZER (Mis-
cellaneous).

KILLER

DR. SETH ARNOLD'S//
COUGH KILLER
See ARNOLD (Cough).

BUMSTEAD'S/WORM/SYRUP/
ONE BOTTLE/HAS KILLED/
100WORMS/(CHILDREN/CRY FOR
MORE/JUST TRY IT/PHILADᵃ
See BUMSTEAD (Syrup).

CRAMP &/PAIN KILLER/CURTIS
& PERKINS/BANGOR Mᵉ
Killer, "Contains 51% Alcohol," adv.
1850–51 (Baldwin 1973); 1860 in the
New England Business Directory. After
1865 the product became Brown's
Household Panacea.
Aqua; $4^{1}/_{2}'' \times ?$; 5n; 20b; pl; v. Also
pontiled variant with slightly different
embossing, $4^{7}/_{8}'' \times 1^{5}/_{8}''$. See J.
BROWN (Liniment, Miscellaneous),
CURTIS (Miscellaneous), CURTIS &
PERKINS (Bitters), WINSLOW (Syrup).

CURTIS & PERKINS'/CRAMP
&/PAIN KILLER
Aqua; $5'' \times 1^{5}/_{8}''$ diameter; 13n; 20b;
pl; v; p. See J. BROWN (Liniment,
Miscellaneous), CURTIS (Miscellaneous),
CURTIS & PERKINS (Bitters), WINS-
LOW (Syrup).

DAVIS//VEGETABLE//
PAIN KILLER
Perry Davis (1791–1862) developed his
formula in Massachusetts in 1840 or
slightly earlier and moved to Provi-
dence, RI, in 1843. Bottles were first
embossed ca. 1854. In 1862, son
Edmund assumed the business and the
company expanded operations; agencies
were located in many countries.
Edmund died in 1880, and the company
was sold ca. 1895 to Davis & Lawrence
Co., Montreal and New York. Distri-
bution rights in the west belonged to
J. N. Harris & Co., manufacturers of
Allen's Lung Balsam. In 1967 the busi-
ness was sold to Canada Packers Ltd.,

Hamilton, Ontario (*History of Providence County Rhode Island, 1891;* Holcombe 1979; Sullivan 1984). Several sizes were available. Adv. 1984, in similar embossed, threaded, variants (Sullivan 1984). For a period of time after passage of the 1906 Act, the product was billed as a liniment.

Aqua; 4⅝″ × 1½″ × ¾″; 1n; 3b; 4ip; h, f; v, ss; with and without p. See SANDS *(Miscellaneous)*, WEAVER *(Syrup)*.

DAVIS//VEGETABLE// PAIN KILLER

Aqua; 6″ × 1⅞″ × 15/16″; 1n; 3b; 4ip; h, f; v, ss; many embossed variants. See SANDS *(Miscellaneous)*, WEAVER *(Syrup)*.

[h] A. D.//ELMERS/[v] IT CURES/ LIKE/A CHARM//PAIN KILLING// BALM

See ELMER *(Balm)*.

DR. HILL'S//PAIN KILLER// FARMER, N.Y.

Manufactured by C. H. Gardner, Candor, NY, in 1868 (Baldwin 1973). The relationship to Farmer, NY, now Interlaken, NY, is unknown.

Aqua; 5¼″ × 2½″ × 1½″; 7n; 3 or 6b; pl; v, sfs. See HILL (Cordial, Syrup).

DR W. S. LUNT'S//AGUE KILLER/ FINDLAY, O

Dark blue, aqua; 6¾″ × 2½″ × 1⅜″; 11n; 3b; pl; v; p.

J. W. POLAND'S/HEADACHE KILLER

Killer adv. 1855 in the *New England Business Directory*; 1865, *GG*.

Aqua; 7¼″ × ? × ?; 6n; 12b; pl. See POLAND (*Compound*, Miscellaneous).

GERM, BACTERIA OR/FUNGUS DESTROYER/[within shield:] W^M RADAM'S/MICROBE KILLER/ [man clubbing skeleton]/REGISTERED TRADE MARK DEC. 13, 1887/ CURES/ALL/DISEASES

Three strengths and three sizes including an English variant. Advertised as a "Fumigating Composition for Purification" as well as an "Absolute Cure for Consumption, Cancer, etc. . . ." William Radam, Austin, TX, introduced his mixture, composed of 99.381% water with a balance of sulphuric acid, hydrochloric acid and a coloring agent, in October 1886 (McEwen 1977; Young 1962). The composition was probably changed to meet standards set by the Pure Food & Drug(s) Act in 1906. Adv. 1935 by

Benjamin Rosenweig, 114 Lawrence St., New York City, *AD*.

Amber; 10″ × ?; 15n; 2b; pl; h, f.

WM. RADAMS/MICROBE KILLER

Tan; 11″ × ?; ?n; 20b; pl; h, shoulder embossed earthenware crockery, raised lettering.

KEEP JUG TIGHTLY CORKED/ WM. RADAM'S/MICROBE KILLER/ NO. 1

White; 11″ × ?; 15n; 20b; pl; h; earthenware crock, glaze paint lettering.

[h] RENNE'S [monogram], [v] IT WORKS/LIKE/A CHARM// PAIN KILLER//MAGIC OIL

See RENNE *(Oil)*.

RENNE'S/PAIN KILLING//MAGIC OIL//SAMPLE//TRY IT

See RENNE *(Oil)*.

[h] 6 OUNCE/[v] SLOAN'S LINIMENT/KILLS PAIN [Base:] O

See SLOAN *(Liniment)*.

[h] 18 FLUID/OZS/[v]/SLOAN'S LINIMENT/KILLS PAIN

See SLOAN *(Liniment)*.

LAXATIVE

CALIFORNIA'S OWN/TRUE
LAXATIVE/AND BLOOD
PURIFIER//WAIT'S/KIDNEY AND/
LIVER BITTERS [Base:] PCGW
See WAIT *(Bitters)*.

LAXATIVE/FELLOWS/TABLETS
See FELLOW *(Tablets)*.

LASH'S BITTERS//NATURAL/
TONIC LAXATIVE
See LASH *(Bitters)*.

LASH'S LIVER BITTERS//
NATURAL/TONIC LAXATIVE
See LASH *(Bitters)*.

LASH'S LIVER BITTERS//
NATURE'S/TONIC LAXATIVE
See LASH *(Bitters)*.

LAXAKOLA/THE GREAT/TONIC
LAXATIVE//LAXAKOLA CO.//
NEW YORK & CHICAGO
See LAXAKOLA *(Tonic)*.

MARSHALL'S BITTERS//THE BEST
LAXATIVE/AND BLOOD PURIFIER
See MARSHALL *(Bitters)*.

MULFORD'S/LAXATIVE SALTS OF
FRUIT
Label: *MULFORD'S BISMUTH FOR-
MIC IODIDE & SOMNOS, H. K.
Mulford Co., Phila., & Chicago. . . .*
Adv. 1900, *EBB*; 1929–30, *AD*.
Cobalt; $4^{1}/_{2}'' \times 1^{5}/_{8}''$ diameter; 7n;
20b; pl; v. See MULFORD *(Chemical)*.

NIBOL/KIDNEY AND LIVER/
BITTERS//THE BEST TONIC/
LAXATIVE & BLOOD PURIFIER
See NIBOL *(Bitters)*.

[Embossed swastika]/COMPOUND/
LAXATIVE SYRUP/MFGD BY T. S.
PAINE/WAYCROSS GA.
See PAINE *(Syrup)*.

POND'S/BITTERS//AN
UNEXCELLED/LAXATIVE [Base: I
in diamond]
See POND *(Bitters)*.

REX/KIDNEY/AND/LIVER/
BITTERS//THE BEST LAXATIVE/
AND BLOOD PURIFIER
See REX *(Bitters)*.

SANBORN'S/KIDNEY/AND/LIVER/
VEGETABLE/LAXATIVE/BITTERS
See SANBORN *(Bitters)*.

SUN/KIDNEY/AND/LIVER/
BITTERS//VEGETABLE
LAXATIVE/BOWEL REGULATOR/
AND BLOOD PURIFIER
See SUN *(Bitters)*.

DR PHILIP THORPE'S/
COMPOUND/FRUIT JUICES/
A DELICIOUS/MORNING
LAXATIVE
See THORPE *(Compound)*.

TILLINGHASTS/VEGETABLE/
LAXATIVE/WEST VALLEY NY
Aqua; $6^{3}/_{4}'' \times 2^{3}/_{8}'' \times 1^{1}/_{4}''$; 7n; 3 or
6b; ip; v.

TROPIC FRUIT/TROPIC FRUIT [in
embossed fruit]/LAXATIVE [embossed
across leaf]
Tropic-Fruit Laxative, "Prepared from
Tropical fruits and plants." Product of
John E. Hetherington, New York City,
introduced ca. 1879 (Holcombe 1979);
adv. 1901, *HH & M*.
Aqua; $4'' \times 2^{3}/_{4}'' \times 1^{1}/_{8}''$; 9n; 12b;
pl; h.

DR TRUE'S ELIXIR/ESTABLISHED
1851/DR. J. F. TRUE & CO/
AUBURN, MAINE//WORM
EXPELLER//FAMILY LAXATIVE
See TRUE *(Elixir)*.

LINIMENT

Fig. 119

ALLENS/NERVE & BONE//LINIMENT

Adv. 1854 (Baldwin 1973); 1935 by Williams Mfg. Co., 113 St. Clair Ave., N.E., Cleveland, Ohio, *AD*.

Aqua; $4'' \times 1^{7/16}''$ diameter; 7n; 20b; pl; v, fb.

ARNICA & OIL//LINIMENT

Henry & Johnson's Arnica & Oil Liniment, for man or beast, adv. 1879 (Baldwin 1973); 1891, *WHS*; Henry's Arnica & Oil Liniment, 1899 (Devner 1968); 1900, *EBB*; 1910, *AD*.

Aqua; $6^{1/2}'' \times ?$; ?n; 21b; pl; v, ss. See J. F. HENRY *(Company)*.

ATWATER'S//MAGIC//LINIMENT

Adv. 1858 (Baldwin 1973).

Aqua; $5^{5/8}'' \times 1^{3/8}'' \times 1^{3/4}''$; 11n; 3b; ip; h, v, sfs; p.

DR. BAKERS/TURKISH LINIMENT//S. F. BAKER & CO.//KEOKUK, IA.

Label: *DR. BAKER'S TURKISH LINIMENT for the Cure of the following diseases: Rheumatism, Swellings, Sprains, Bruises, Stiffness in the Joints, Pain in the Back or Limbs, Sore Throat, Humors, Headache, etc., Upon Mankind, Where an External Remedy is Required—Also Fistula, Poll Evil, Saddle or Harness Galls, Wind Galls, Sprains, Strains, Lumps or Swellings. Dr. S. F. BAKER & Co. KEOKUK, IOWA. PRICE 50 CENTS.* Adv. 1887, *MP*.

Aqua; $7^{3/4}'' \times 2^{1/2}'' \times 1^{5/16}''$; 7n; 3b; 4ip; v, fss. See BAKER *(Company)*.

BALLARD SNOW/LINIMENT CO./ST. LOUIS, MO. [See Figure 119]

Directories establish the Ballard Snow Liniment Co. in 1885. Liniment adv. 1889, *PVS & S*; 1941–42 by James F. Ballard Inc., St. Louis, *AD*.

Aqua; $4^{1/4}'' \times 1^{11/16}'' \times 1^{1/8}''$; 7n; 3b; 1ip; v. See BUCKEYE (Ointment), HERBINE (Company), SMITH'S BILE BEANS (Miscellaneous).

BALLARD SNOW/LINIMENT CO./ST. LOUIS, MO.

Aqua; $5^{7/8}'' \times 2^{1/8}'' \times 1^{3/16}''$; 7n; 3b; 1ip; v. See BUCKEYE (Ointment), HERBINE (Company), SMITH'S BILE BEANS (Miscellaneous).

DR. BARKMAN'S/NEVER FAILING/LINIMENT

Adv. ca. 1915.

Color & dimens. unk.; 11n; 3b; 3ip; v.

BARRELL'S//INDIAN//LINIMENT//H.G.O. CARY

"For Internal & External Pain." Product of H.G.O. Cary, Zanesville, OH, adv. 1856 (Baldwin 1973); 1941–42, *AD*.

Aqua; $4^{3/4}'' \times 1^{9/16}'' \times 1''$; 13n; 3b; 4ip; v, sfsb.

DR BENNETT'S/GOLDEN/LINIMENT

Label: *Bennett's Golden Liniment for Man or Beast.* Adv. 1856 (Devner 1968); 1910, *AD*. Possibly Bennett's Excellent Liniment is related, adv. 1929–30 by Shoemaker & Busch Inc., 511 Arch St., Philadelphia, *AD*.

Aqua; $4^{1/4}'' \times 1^{1/4}''$ diameter; 11n; 20b; pl; v.

BRAGG'S/ARCTIC/LINIMENT

Product of Bragg & Burrowes, St. Louis, MO, adv. 1858 (Baldwin 1973); 1910, *AD*.

Aqua; $7^{1/4}'' \times 2^{3/4}''$ diameter; 9n; 20b; pl; h; p; several sizes.

BROWN'S/HOUSEHOLD PANACEA/AND FAMILY LINIMENT//CURTIS & BROWN//MFG. CO. LD. NEW YORK

Adv. 1873 (Baldwin 1973); 1907, *PVS & S*.

Aqua; $5^{3/4}'' \times 1^{3/4}'' \times 7/8''$; 7n; 3b; 3 or 4ip; v, fss. See J. I. BROWN *(Miscellaneous)*, CURTIS (Miscellaneous), CURTIS & PERKINS (Bitters, Killer).

[v] E. A. BUCKHOUT'S/[h] DUTCH/[v] LINIMENT [embossed around standing man smoking pipe]//[v] PREPARED AT/MECHANICVILLE/SARATOGA CO N.Y.

Adv. 1852 (Baldwin 1973).

Light aqua; $4^{3/4}'' \times 2^{3/4}'' \times 1^{3/16}''$; 11n; 13b with square corners; pl; v, h, fb; p.

J. R. BURDSALL'S//ARNICA/LINIMENT//NEW YORK

Label: *BURDSALL'S CELEBRATED ARNICA LINIMENT. Sold by Druggists & Agents Throughout the United States & Canada. J. R. Burdsall, Copyright Secured 1849, New York.* Adv. 1923, *SF & PD*.

Aqua; $5^{1/2}'' \times 2^{3/8}'' \times 1''$; 11n; rect.; pl; v, sfs; p.

BURR'S/LINIMENT

Aqua; $6'' \times 2^{1/2}'' \times ?$; 11n; 12b; pl; v; p.

C. R./CANANDAIGUA/N.Y.//RINGBONE & SPAVIN//LINIMENT

Aqua; $6'' \times 2^{1/4}'' \times 1^{3/8}''$; 11n; 3b; ip; v, fss; p.

CENTAUR LINIMENT

Demas Barnes organized J. B. Rose & Co. in 1872 to produce the Centaur Liniment. The firm was incorporated as the Centaur Company in 1877. Charles H. Fletcher, an agent, had purchased Samuel Pitcher's Castoria and eventually assumed directorship of the Centaur Company. In 1923 the company was acquired by Household Products Inc. Stock of this firm was owned by Sterling Products who eventually became sole owner (Holcombe 1979). Adv. 1916, *MB*.

Aqua; $3^{1/2}'' \times 1^{3/16}''$ diameter; 7n; 20b; pl; h around shoulder. See FLETCHER *(Miscellaneous)*, PITCHER *(Miscellaneous)*.

CENTAUR LINIMENT

Adv. in 1873 as a cure for "Caked Breasts, Burns & Scalds . . . upon the Human Frame and Strains, Spavin, Ring-Bone, Wind-Galls, Scratchs, Sweeney, Stings, Bites on Horses and Animals and for Screw-worms on Sheep." White labels were for family use, yellow for animals.

Aqua; $4^{3/4}'' \times 1^{3/4}''$ diameter; 7n; 20b; pl; h around shoulder. See FLETCHER *(Miscellaneous)*, PITCHER *(Miscellaneous)*.

CHAMBERLAIN'S/LINIMENT//CHAMBERLAIN MEDICINE CO//DES MOINES, IA

Chamberlain's Antiseptic Liniment adv. 1910, 1935 by Wm. R. Warner & Co., New York, *AD*.

Aqua; 6³/₄″ × ? × ?; 11n; 3b; 4ip; v, fss. See CHAMBERLAIN (Balm, Lotion, Miscellaneous, *Remedy*), VON HOPF (Bitters), W. WARNER *(Company)*.

COLE BROS/PERFECTION LINIMENT//G. L. COLE PROP'R// BINGHAMTON N.Y.

Adv. 1888 (Baldwin 1973).

Aqua; 6³/₄″ × ? × ?; 1n; 3b; ip; v, fss.

DR DANIELS. OSTERCOCUS/ NERVE & MUSCLE LINIMENT/ RHEUMATISM/NEURALGIA LAMENESS

Adv. 1900, *EBB*; 1910, *AD*.

Clear; 5³/₄″ × 2″ × 1″; 8n; rect.; ip; embossed oval panel; v. See DANIEL (Cough, Cure, Lotion, Miscellaneous).

DR. DANIELS/WONDER WORKER LINIMENT/NATURES CURE FOR MEN OR BEAST/BOSTON, MASS, U.S.A.

Product of Albert C. Daniels, Boston, MA; directories listed the firm from 1888 to 1956.

Clear; 6³/₈″ × 2³/₈″ × 1⁵/₈″; 9n; 17b; pl; v. See DANIEL (Cough, Cure, Lotion, Miscellaneous).

L. P. DODGE//RHEUMATIC/ LINIMENT//NEWBURG

Adv. 1853 (Putnam 1968); 1857 (Baldwin 1973).

Green; 5″ × 1³/₄″ × 1″; 13n; 3b; pl; v, sfs; p.

DONNELL'S/RHEUMATIC LINIMENT//SPECIALTIES// ST. LOUIS, MO.

John Walter Donnell established his own business in St. Louis in 1872 and after several brief associations formed the Donnell Manufacturing Company in 1877. Donnell remained president until 1910 when he became manager of the White Rabbit Dye Co. (Blasi 1974). No reference for the company was found after 1910. Directories included John Tilden Donnell, a son and also a physician, as Secretary for the Donnell Mfg. Co. in 1900 and 1902.

Aqua; 5³/₄″ × 1⁷/₈″ × ⁷/₈″; 7n; 3b; 3 or 4ip; v, fss.

DONNELL'S/RHEUMATIC LINIMENT//J. T. DONNELL & CO.// ST. LOUIS, MO. [See Photo 31]

Label: . . . *Liniment for Rheumatism, Neuralgia, Bruises, Sprains, Eruptions & Burns. Guaranteed Under the Pure Food & Drug Act of 1906. Est. 1874.*

Aqua; 7¹/₄″ × 2³/₁₆″ × 1¹/₄″; 7n; 3b; 4ip; v, fss.

DURNO'S/THE/MOUNTAIN/ INDIAN/LINIMENT

Adv. by Dr. (Mrs.) Durno, Albany, NY, 1856–57 (Baldwin 1973); 1891, *WHS*.

Aqua; 5³/₄″ × 2³/₈″ diameter; 13n; 20b; pl; v; p.

ELECTRIC/LINIMENT// J. C. DONNELLY//EASTON PA

Adv. 1876, 1891, *WHS*.

Aqua; 6¹/₂″ × 2″ × 1¹/₈″; 11n; 3b; 3 or 4ip; v, fss.

ELECTRO-MAGNETIC LINIMENT/ J. WM. DANIEL, LOCUST HILL, VA./SOLE MANUFACTURER & PROPRIETOR

Aqua; 5³/₄″ × ? × ?; 7n; rect.; v.

EUREKA HORSE/LINIMENT//

[monogram, possibly S over W] [Base:] C & I

Bottle manufactured by Cunningham & Ihmsen, Pittsburgh, PA, from 1865 to 1879 (Toulouse 1972). Adv. 1891, *WHS*; 1910, *AD*.

Aqua; 6⁷/₈″ × 2³/₈″ × 1³/₈″; 1n; 3b; 4ip; v, fb.

FARMERS HEALING LINIMENT/ GRAHAM AND FISH/LODI, CALIFORNIA

Adv. 1896–97, *Mack*; 1923, *SF & PD*.

Aqua; 8³/₄″ × ? × ?; 7n; 3b; 3 or 4ip, oval front; v.

H. G. FARRELL'S/ARABIAN/ LINIMENT/PEORIA

Product of Hiram G. Farrell introduced in 1846 (Wilson and Wilson 1971); 1913, *SN*.

Aqua; 4¹/₂″ × 1³/₈″ diameter; 5n; 20b; pl; v; p, also without p.

J. H. FISHER'S//WILDFIRE/ RHEUMATIC/LINIMENT// FLEMINGTON, N.J.

Aqua; 6″ × 1³/₄″ × ?; 11n; 3b; 3 or 4ip; v, sfs; p.

FROST'S//LINIMENT

Adv. 1871, *VSS & R*; 1910, *AD*.

Light blue; 4⁷/₈″ × 1³/₄″ × ⁷/₈″; 1n; 3b; 4ip; v, ss; p.

J. D. GALLUPS//GOUT AND// RHEUMATIC//LINIMENT

Aqua; 4³/₄″ × 1³/₄″ × 1³/₄″; 5n; 21b, 8 sides; pl; v, fsbs; p.

GENESSEE//LINIMENT

Aqua; 5³/₈″ × 1⁵/₈″ × ?; 3n; crude; 3 or 6b; ip; v; p.

GIBB'S/BONE LINIMENT

Olive; 6¹/₂″ × 1⁷/₈″ diameter; 11n; 21b, 6 sides; pl; v; p.

GILES & CO/IODIDE AMMONIA/ LINIMENT

For Family and Animal, adv. 1875 (Baldwin 1973); White label for family, yellow for animal, 1890, *W & P*; 1910, *AD*.

Aqua; 3³/₄″ × ?; 7n; 20b; pl; v; Ns in Liniment are embossed backwards.

GILES/IODIDE AMMONIA/ LINIMENT

Light green; 6¹/₂″ × 2¹/₁₆″ × 2¹/₁₆″; 7n; 2b; pl.

GILES/LINIMENT//TRIAL SIZE// NEW YORK

Aqua; 4⁵/₈″ × 1⁵/₈″ × 1″; 7n; 3b; 3ip; v, fss.

S. B. GOFFS//COMPOUND MAGIC/ OIL LINIMENT//CAMDEN N.J.

Adv. 1887, *WHS*; 1935, *AD*.

Aqua; 4⁷/₈″ × 1⁵/₈″ × 1¹/₄″; 7n; 3b; ip; v, sfs. See GOFF (Bitters, Miscellaneous, Syrup), KEMP *(Balsam.)*

Dr. HAMILTON'S//INDIAN/ LINIMENT

Adv. 1872, *VHS*; 1877, *VSS & C*.

Aqua; 5″ × ? × ?; 7n; 12b; pl; v, fb; p.

HANNAS/ELECTRIC SILICON/ LINIMENT

Aqua; 6¹/₈″ × 3″ × 1¹/₈″; 7n, sp; oval; pl; v.

HARDY'S LINIMENT/E. A. BUCK PROP./BANGOR, ME

Edward A. Buck bought out Manly Hardy's products in the early 1880s (Wilson and Wilson 1971). Adv. 1910, *AD*.

Aqua; 4³/₄″ × ?; 3n; 20b; pl; v.

HINKLEY'S//BONE LINIMENT

James Hinkley's Bone Liniment was a product adv. by D. E. Prall & Co., Saginaw, MI, in 1856 (Devner 1968), also in 1899 (Baldwin 1973); and by the Hinkley Bone Liniment Co. 1900 (Devner 1968), 1941–42, *AD*.

Aqua, clear; 4⁷/₈″ × 1³/₄″ × 1¹/₁₆″; 7n; 3b; 4ip; v, ss; 3 sizes.

HOFF'S GERMAN LINIMENT// GOODRICH DRUG CO.//ANOKA, MINN. [Base: I in diamond]

Bottle manufactured by the Illinois Glass Co., Alton, IL, 1916 and 1929 (Toulouse 1972). Product of Goodrich & Jennings, Anoka, MN, prior to 1920, Goodrich Drug Co. in 1925 (Devner 1968). Adv. 1901, *HH & M*; 1929–30

by Goodrich Drug Co.; 1948 by Goodrich-Gamble Co., 1837 University Ave., St. Paul, Minn.; 1980–81 by Goodrich-Universal Inc., 500 N. Robert St., St. Paul, Minn., *AD*. Relationship to Goodrich Drug Co. *(Drug)*, Omaha, NE, is unknown.
Aqua; 5³/₈″ × 1¹¹/₁₆″ diameter; 3n; 21b, 12 sides; pl; v, fss; ABM.

HOFF'S GERMAN LINIMENT// GOODRICH & JENNINGS// ANOKA, MINN.
Clear; 6¹³/₁₆″ × 2¹/₄″ diameter; 3n; 21b, 12 sides; pl; v, fss.

DR. J. S. HUNT//THE/DOCTOR LINIMENT//EASTON, PA.
Label: *The "DOCTOR," a domestic remedy carefully prepared for the certain cure of Dysentery, Diarrhoea, Cholera Morbus, Pain in the Breast, Colic in Infants, Cough, Toothache, Burns, c & c, Earache, . . . Prepared by Dr. J. S. Hunt, Corner of Fourth and Northampton Sts., Easton, Pa. Price 50¢. Entered According to Act of Congress in the year 1870.*
Aqua; 6⁵/₈″ × 2³/₈″ × 1¹/₄″; 1n; 3b; 3 or 4ip; v, sfs.

HUNT'S/LINIMENT//PREPARED BY//G. E. STANTON// SING SING, N.Y.
Manufactured by George E. Stanton, Sing Sing, NY, now Ossining, NY, from 1842 to ca. 1900 (Wilson and Wilson 1971). Adv. 1845 (Putnam 1968); 1901, *HH & M*.
Aqua; 5″ × 2¹/₄″ × 1″; 11n; 4b; pl; v, fsbs; p. Also height of 4¹/₂″ with 6n, and 5¹/₄″ with 1n.

DR JACKSON'S/RHEUMATIC/ LINIMENT/PHILAD.
Light green; 5¹/₄″ × 2¹/₁₆″ × 1¹/₄″; 5n; 12b; pl; v; p.

T. H. JACKSON'S/Common-Sense/ LINIMENT/QUINCY-ILLS.
Adv. 1889, *PVS & S*; 1900 by T. H. Jackson & Co., Quincy, IL, *HH & M*; 1941–42 by T. H. Jackson & Co., 411 S. 5th St., Quincy, Ill., *AD*.
Light blue; 7⁷/₈″ × 2¹⁵/₁₆″ diameter; 7n; 20b; pl; v.

JADWIN'S/SUBDUING/ LINIMENT//C. C. JADWIN'S// HONESDALE PA.
Manufacturing facilities also in New York. Adv. 1871, *WHS*; 1929–30 by O. H. Jadwin & Sons Inc., 11 Vestry St., New York City; 1941–42 by Jadwin Pharmacy Inc., Honesdale, Pa., *AD*.
Aqua; 9″ × 2¹/₂″ × 2″; 7n; 3 or 6b; ip; v, fsbs; 3 sizes.

DR. D. JAYNE'/LINIMENT// COUNTER IRRITANT/PHILADᴬ
Bottle manufactured ca. 1867 (Wilson and Wilson 1971). Adv. 1929–30, *AD*.
Aqua; 5¹/₈″ × 1⁷/₈″ × 1¹/₄″; 5n; 4b; pl; v, fb; p. See JAYNE (Balsam, Expectorant, **Miscellaneous**, Tonic).

Dᴿ D JAYNE'/LINIMENT OR// COUNTER IRRITANT/PHILADA
Light green; 5″ × ? × ?; 5n; 3b; pl; v, fb. See JAYNE (Balsam, Expectorant, **Miscellaneous**, Tonic).

JEWETT'S//NERVE//LINIMENT
Aqua; 3″ × 1⁵/₈″ × 1¹/₄″; 13n; 3b; pl; v, fsb; p.

JOHNSON'S//AMERICAN// ANODYNE//LINIMENT
For external and internal pain. Advertised in 1891 as the product of Abner Johnson, Bangor, ME. Product was compounded in 1810 (1 Nov. *Pharmaceutical Era*); it was assumed by son Isaac in the 1830s. I. S. Johnson & Co. was apparently established in the early 1870s and had moved to Boston by 1881 (Holcombe 1979). Adv. 1941–42, *AD*.
Aqua; 4¹/₄″ × 1¹/₂″ diameter; 1n; 20b; pl; v, ssss.

DR. JONES'/[embossed beaver]/ LINIMENT
Label: *JONES' LINIMENT – It is beneficial for Muscular Soreness, Back Strains, Simple Neuralgia, and Headache, Toothache, Bruises, Sprains, Lameness and all bodily pains. Manuf. by M. Spiegel Med. Co., Albany, N.Y. . . .* Adv. 1890s; 1916, *MB*.
Aqua; 6³/₈″ × 2¹/₄″ × 1¹/₄″; 1n; 3b; 3ip; v.

K.K.K./KAY'S/KENTUCKY KURE/ OR/LINIMENT
See KAY *(Cure)*.

DR KENNEDY'S//RHEUMATIC/ LINIMENT//ROXBURY, MASS
Adv. 1865, *GG*; 1923, *SF & PD*.
Aqua; 6¹/₂″ × 2″ × 1¹/₄″; 11n; 3b; 3ip; v, sfs. See KENNEDY *(Discovery,* Miscellaneous, Ointment).

S. B. KITCHEL'S LINIMENT
A Coldwater, MI product adv. 1887, *WHS*; 1948 by S. B. Kitchel, 340 W. Chicago St., Coldwater, Mich., *AD*.
Aqua, clear; 8″ × 2¹/₂″ × 2¹/₂″, also 9¹/₄″ × 3¹/₈″ × 3¹/₈″; 9n; 2b; pl; v.

DR. LESURE'S/LINIMENT/ KEENE, N.H.
Adv. 1910, *AD*.

Clear; 6³/₈″ × 2³/₈″ × 1¹/₂″; 9n, sp; 17b; pl; v. See LESURE *(Cure,* Miscellaneous).

LISTERS//ANTISEPTIC LINIMENT//J. A. VAUGHAN// BROOKLYN, N.Y.
Adv. 1900, *EBB*; 1910, *AD*.
Aqua; 5″ × 1⁵/₈″ diameter; 7n; 21b, 12 sides; pl; v, ssss.

MACARTHUR'S//GENUINE YANKEE/LINIMENT// LIVERPOOL N.Y.
Aqua; 7″ × 2³/₄″ × 1⁵/₈″; 11n; 3b; pl; v, sfs; p.

MAGIC CURE/LINIMENT// E. I. BARNETT//EASTON, PA.
See MAGIC *(Cure)*.

R. MATCHETT'S//PURE & GENUINE/FOUR/FOLD// LINIMENT
Label: *FOUR-FOLD Liniment for External Use Only. Wounds, Burns, Sores, Sprains, Bruises, Swellings, Stings of Insects, Frost Bites, Ivy Poisoning, Toothaches, Corns and Bunions, Sore Muscles. Alcohol 9%. Manufactured by C. F. Simmons Med. Co., 502 N. Second St., St. Louis Mo.* Adv. by R. Matchett, Pittsburgh, 1858–59 (Baldwin 1973), 1929–30, *AD*.
Clear; 5¹/₈″ × 1¹⁵/₁₆″ × 1¹/₈″; 7n; 3b; 4ip; v, sfs; ABM.

A. MᶜECKRON'S/R. B. LINIMENT/ N.Y.
Adv. 1865, *GG*; 1876, *WHS*.
Aqua; 6″ × 2¹/₈″ diameter; 11n; 12b; pl; v; p.

MᶜLEAN'S//VOLCANIC//OIL// LINIMENT [Base:] M & C
See McLEAN *(Oil)*.

DR. J. H. MᶜLEAN'S//VOLCANIC// OIL//LINIMENT [Base: I in diamond]
See McLEAN *(Oil)*.

McNICOLS//RHEUMATIC/ LINIMENT//AUBURN, N.Y.
Product of James McNicol, Auburn, NY, adv. 1863 (Baldwin 1973).
Aqua; 5¹/₈″ × 1⁵/₈″ × 1″; 11n; 3 or 6b; 3 or 4ip; v, sfs.

MEXICAN/MUSTANG/LINIMENT
1900 advertisement: "For the Outward Ailments of Man or Beast: Scalds, Burns, Colds, Cuts, Bruises, Sprains, Strains, Sore Throat, Inflammation; Galls, Scratches, Sweeny, Spavins, Ringbone, Strains, Lameness, Shoe Boils, Harness Sores" (Fike 1966). Product of George W. Westbrook, St.

Louis, MO, introduced ca. 1825. Sole agents from 1850 to 1853 were A. G. Bragg and J. H. McLean. Westbrook moved to New York ca. 1856 and soon sold his business to Demas Barnes and John D. Park; Barnes bought out Park's interests in the New York firm in the 1860s; Park held many other interests, including that with John D. Park & Sons which went out of business in 1935. The liniment was manufactured by the Lyon Mfg. Co., New York, after 1871; later the firm moved to Brooklyn (Holcombe 1979; Wilson and Wilson 1971). Adv. 1948 by Lyon Mfg. Co., Brooklyn, N.Y., *AD*.

Aqua; 3¾" × 1½" diameter; 5n; **rolled lip; 20b; pl; v. See DRAKE** *(Bitters)*, J. F. HENRY *(Company)*, LYON *(Hair,* Jamaica Ginger, Miscellaneous), WYNKOOP *(Pectoral)*.

MEXICAN/MUSTANG/LINIMENT

Aqua; 3⅞" × 1⁷⁄₁₆" diameter; 13n; **20b; pl; v; p. See DRAKE** *(Bitters),* LYON *(Hair,* Miscellaneous),WYNKOOP *(Pectoral)*.

MEXICAN/MUSTANG/LINIMENT/ D. S. BARNES/NEW YORK

Aqua; 3¾" × ?; 5n; 20b; pl; v. See DRAKE *(Bitters),* LYON *(Hair,* Miscellaneous), WYNKOOP *(Pectoral)*.

MEXICAN/MUSTANG/LINIMENT/ LYON MFG CO/NEW YORK

Aqua; 4" × ?; 7n; 20b; pl; v. See DRAKE *(Bitters),* LYON *(Hair,* Miscellaneous), WYNKOOP *(Pectoral)*.

MEXICAN/MUSTANG/LINIMENT/ LYON MF'G CO/NEW YORK

Aqua; 5½" × 2" diameter; 7n; 20b; pl; v. See DRAKE *(Bitters),* LYON *(Hair,* Miscellaneous), WYNKOOP *(Pectoral)*.

MEXICAN/MUSTANG/LINIMENT/ LYON M'F'G, CO./BROOKLYN, N.Y.

Clear; 3⅞" × 1⅝" diameter; 1n; 20b; **pl; v; ABM. Also height of 5½", non ABM. See DRAKE** *(Bitters),* LYON *(Hair,* Miscellaneous), WYNKOOP *(Pectoral)*.

MINARD'S/LINIMENT

Adv. in 1 Nov. 1891 *Pharmaceutical Era:* "Minard's Liniment, 'King of Pain,' The King of All Liniments, For Man or Beast. Cures Diptheria, Rheumatism, Sore Throat, Frost Bites, Swelling, Bruises, Sprains, Burns, Headache, Neuralgia . . . Minard's Liniment Mfg. Co., W. J. Nelson, President, 273 Commercial St., Boston, successors to Nelson & Co., Boston." Product of Levi Minard. The last reference to the Minard Liniment Co. in Boston city

directories is 1907. In 1929–30 and 1941–42 the Minard Company was located in Framingham, MA; in 1948, Hyannis, MA. Adv. 1886 (Devner 1968); 1980 by Beecham Products, Pittsburgh, *AD*.

Clear; 4¾" × 1½" diameter; 7n; 21b, **8 sides on front, round back; pl; v; ABM.**

MINARD'S//LINIMENT//BOSTON

Light green; 5" × 1½" diameter; 7n; **21b, 8 sides on front, round back; pl; v, sss.**

MINARD'S//LINIMENT//So FRAMINGHAM MASS USA

Clear; 5" × 1⅝" diameter; 3n; 21b, 8 **sides on front, round back; pl; v, sss.**

DR MITCHELL/OX GALL/ ARNICA/LINIMENT

Aqua; 4½" × 1⅜" diameter; 5n; 20b; **pl; v; p.**

FATHER MORRISCY'S/LINIMENT

Clear; 5½" × 2" × 1⅛"; 3n; 18b; **1ip; v.**

MOTOR LINIMENT/MADE ONLY BY/DR. G.L.K. HICKMAN

Clear; 5¾" × 2" × 1"; 7n, sp; 3b; **4ip; v.**

NATIONAL/HORSE LINIMENT

Product of J. R. Williams, Stockton, CA, earlier affiliated with H. H. H. Horse Medicine (Wilson and Wilson 1971). Adv. 1915, 1923, *SF & PD*.

Aqua; 5¾" × ? × ?; 7n; 3b; 3 or 4ip; v. See H. H. H. *(Medicine),* WILLIAMS *(Balsam)*.

NERVE & BONE/LINIMENT

Barker's Nerve & Bone Liniment was introduced by Thomas Barker, Philadelphia, in 1859. The firm was assumed by Barker's son, Robert, Ben Mein, and John Moore in the 1860s. In 1893 Mein & Moore sold out to Robert, the business becoming Robert Barker & Co. (Wilson and Wilson 1971). Directories indicated the firm went out of business in 1916 or 1917. Liniment adv. 1916, *MB*. There was also H. W. Barker's Nerve & Bone Liniment, produced by the H. W. Barker Med. Co., Elbow Lake, MN, in 1899; this firm was located in Sparta, WS, in 1916 (Devner 1968).

Aqua; 4" × 1½" diameter; 3n; 20b; pl; **v; p. Several sizes: also without pontil.** See BARKER (Medicine).

ORIENTAL/LIFE/LINIMENT

Aqua; 3⅞" × 1⁵⁄₁₆" diameter; 13n; **20b; pl; v; p.**

"WYANOKE"/DR. PARKS INDIAN LINIMENT/A M FOLLETT, PROP. CONCORD, N.H.

Clear; 5⁵⁄₁₆" × 1⁷⁄₁₆" diameter; 9n, **tapered down; 20b; pl; v.**

PAYNE'S/GOLD DUST LINIMENT/ GOUVERNOUR, N.Y.

Adv. 1910, *AD*.

Aqua; 6" × 2" × 1⅛"; 7n, sp; 3 or 6b; **ip; v.**

PENETRENE/THE/PENETRATING LINIMENT [Base: I in diamond]

Bottle manufactured by the Illinois Glass Co., 1916–1928 (Toulouse 1972). Product of the Penetrene Corporation, Cleveland, OH. Adv. 1941–42 by Lawrence-Williams Co., 6545 Carnegie Ave., Cleveland, O., *AD*.

Clear; 5" × 1¾" × 1⅜"; 16n; 3b, inset **base; 1ip, arched; v; ABM; tapered body.**

DR PERRY'S/LAST CHANCE// LINIMENT

Aqua; 5¾" × 2" × 1"; 7n; 3b; 4ip; **v, fb.**

RICE'S [within figure of goose]/GOOSE GREASE LINIMENT/MANF'D ONLY BY THE/GOOSE GREASE LINIMENT CO./ GREENSBORO, N.C.

The Goose Grease Liniment Co. was operated by William H. Osborn, "Pres. & Mayor of Greensboro," & John B. Fariss, also proprietor of the Fariss Drug Store, according to the 1903–04 directory.

Aqua; 7" × 3¼" × ?; 7n; 3b; 4ip; h.

SAYMAN'S/VEGET LINIMENT// CURES CATARRH & COLDS// RELEIVES [sic] ALL PAIN

Manufactured by T. M. Sayman, St. Louis, MO, adv. 1899 (Devner 1968); 1948 by Saymans Products Co., St. Louis, *AD*.

Aqua; 6¾" × 2⅛" × 1⅛"; 11n, sp; **3b; 4ip, arched front; v, fss; note spelling error of RELEIVES.**

SCARLESS LINIMENT CO./ WINTERSET, IA.

Company established in 1900 by E. K. Cole and Isaac Ketman; the firm went out of business in 1952.

Clear, aqua; 9" × ? × ?; 9n; 13b; v. **Also embossed with REMEDY rather than LINIMENT. See SCARLESS** (Company).

R. SCHELLS ELECTRIC/LINIMENT, ILION N.Y.

Aqua; 5″ × 1¾″ × ⅞″; 7n; 3 or 6b; ip; v.

SCOTCH LINIMENT [Base:] **AMF & Co**

Bottle manufactured by Adelbert M. Foster & Co., Chicago, IL, Millgrove, Upland, and Marion, IN, ca. 1895–1910 (Toulouse 1972). Possibly Scotch Oil Liniment adv. 1900, *EBB*.

Light amber; 6½″ × 2″ × 1⅛″; 7n; 3b; 3ip, arched; v.

SCOTT S//RED OIL//LINIMENT// PHIL.A

Adv. 1872, *VHS*.

Light aqua; 4⅞″ × 2″ × 1⅛″; 13n; 3b; pl; v, fsbs; p.

SEAVERS/JOINT &//NERVE/ LINIMENT

Amber; 4″ × 1¾″ diameter; 5n; 20b; pl; v, fb; p. See HAYES *(Miscellaneous)*.

SELDENS/WIGWAM/ LINIMENT/N.Y.

Possibly a product of Charles W. Selden, a New York physician, in 1867–68.

Aqua; 7½″ × 3″ × 1½″; 11n; 12b; pl; v; several sizes.

DR. SHELDON'S/MAGNETIC LINIMENT//BOSTON, U.S.A.// SIDNEY, N.S.W.

Bottle manufactured ca. 1900. Possibly the product of Dr. Leonard L. Sheldon, a Boston physician in the 1870s (Wilson and Wilson 1971).

Green; 5¾″ × ? × ?; 12n, sp; 3b; 3 or 4ip, arched front; v, fss. See SHELDON (Discovery).

SILVER STATE/OVERLAND LINIMENT [See Figure 120]

Aqua; 7¼″ × 2⅝″ × 1¾″; 9n; 3b; 4ip; v.

Fig. 120

SLOAN'S LINIMENT/MADE IN U.S.A. [Base: O superimposed over diamond]

Label: *SLOAN'S LINIMENT . . . 113 W. 18th St. New York, N.Y. — Laboratories: New York, St. Louis.* Bottle manufactured by the Owens Illinois Glass Co., from 1929 to 1954 (Toulouse 1972). Adv. 1852 (Putnam 1968); 1902 by Earl S. Sloan, Boston; 1918 by Dr. Earl S. Sloan Inc., Philadelphia (Devner 1968); 1935 by Wm. R. Warner & Co., New York, *AD*; 1985 by Warner-Lambert Co., Morris Plains, NJ, (market shelf observation). Directories indicate Sloan operated an office in Boston from 1888 to 1914.

Aqua; 6⅞″ × 2⅜″ × 1⅜″; 16n; 3b; 1ip; v; ABM. See SLOAN (Cure, Miscellaneous, Ointment), W. WARNER *(Company)*.

SLOAN'S LINIMENT/FOR MAN OR BEAST/DR EARL S. SLOAN INC/ BOSTON USA LONDON ENG

Clear; 9½″ × 3¼″ × 2″; 7n; 3 or 6b; ip; v. See SLOAN (Cure, Miscellaneous, Ointment), W. WARNER *(Company)*.

[h] 6 OUNCE/[v] SLOAN'S LINIMENT/KILLS PAIN [Base:] **O**

Bottle maker unknown.

Clear; 6³⁄₁₆″ × 2⅜″ × 1⅜″; 7n; 4b; pl; h, v. See SLOAN (Cure, Miscellaneous, Ointment), W. WARNER *(Company)*.

[h] 18 FLUID/OZS/[v] SLOAN'S LINIMENT/KILLS PAIN

Clear; 9½″ × 3³⁄₁₆″ × 1¹⁵⁄₁₆″; 7n; 3b; 1ip, arched; h, v. See SLOAN (Cure, Miscellaneous, Ointment), W. WARNER *(Company)*.

SLOAN'S N & B LINIMENT/ DR E. S. SLOAN BOSTON

Sloan's Nerve & Bone Liniment adv. 1890, *W & P*; 1921, *BD*.

Aqua; 6⅛″ × 2⅜″ × 1⅜″; 7n; 3 or 6b; pl; v. See SLOAN (Cure, Miscellaneous, Ointment), W. WARNER *(Company)*.

DR SPEAR'S/LINIMENT//COOPER & MARSH//PORT JERVIS N.Y. [See Figure 121]

Label: *For Colic and Pain in the Bowels.*

Aqua; 6½″ × 2¼″ × 1⅜″; 7n; 3 or 6b; 3 or 4ip; v, fss.

CLARK STANLEY'S/SNAKE OIL LINIMENT//FOR RHEUMATISM/ AND NEURALGIA//BEST HORSE LINIMENT/IN THE WORLD

See STANLEY *(Oil)*.

SWEET'S//INFALLIBLE// LINIMENT

Fig. 121

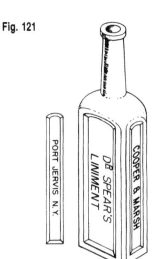

Sweet's Liniment was advertised as "THE GREAT EXTERNAL REMEDY, FOR RHEUMATISM, GOUT, NEURALGIA, LUMBAGO, STIFF NECK AND JOINTS, SPRAINS, BRUISES, CUTS AND WOUNDS, PILES, HEADACHE, AND ALL RHEUMATIC AND NERVOUS DISORDERS . . . RICHARDSON & CO., Sole Proprietors, Norwich, Ct." Product of Edmund B. Richardson, Norwich, VT, introduced ca. 1859 (Wilson and Wilson 1971). Possible relationship to A. E. Richardson, Burlington, VT, see HENRY (Company). Adv. 10 Dec. 1859 in *Harper's Weekly*; 1915, *SF & PD*.

Aqua; 5″ × 2⅛″ × 1″; 11n; rect.; pl; v, fss; p.

DR. I. S. SWEET'S/LINIMENT/ SO. EDMESTON, N.Y.

Aqua; 4″ × 1⅞″ × 1⅛″; 9n; 18b; pl; v.

STEPHEN//SWEET'S// INFALLIBLE//LINIMENT

Aqua; 5¼″ × 2¼″ × 1″; 11n; 4b; pl; v, sfsb; p. Also without pontil.

G. C. TAYLOR//LINIMENT OR/ OIL OF LIFE//FAIRPORT, N. Y.

Adv. 1887, *WHS*; 1895, *McK & R*.

Clear; 5¾″ × 1¾″ × 1″, also 7⅛″ × 2⅜″ × 1⅜″; 7n; 3b; 3ip; v, sfs.

DR TOBIAS/NEW YORK// VENETIAN/LINIMENT

Label: *. . . Unexcelled Liniment, Applied Externally for Rheumatism, Neuralgia, Pains in the Limbs, Back or Chest, Mumps, Sore Throat, Colds, Sprains, Bruises, Stings of Insects, Mosquito Bites. Taken Internally, it acts like a charm for Cholera Morbus, Diarrhoea, Dysentery, Colic . . . Prepared in New York City. . . .*

Samuel Tobias' Venetian Liniment was introduced ca. 1850 (Wilson and Wilson 1971); adv. 1853, New York City directory; 1929–30 by O. H. Jadwin & Sons, Inc., 11 Vestry St., New York City; 1935 by O. H. Simmons, 65 Cortlandt St., New York City, *AD*.
Aqua; 4″ × 2″ × 1″, also 4¼″ × 1⅞″ × 1″; 1 and 7n; 12b; pl; v, fb.

Dʳ TOBIAS//VENETIAN HORSE/ LINIMENT//NEW YORK
Adv. 1865, *GG*; 1907, *PVS & S*.
Aqua; 8¼″ × ? × ?; 11n; 3b; pl; v, sfs.

DR. TOLSTOIS/CAUCASIAN LINIMENT//McCONNON & CO.// WINONA, MINN.
See McCONNON *(Company)*.

TOMS.//RUSSIAN//LINIMENT
Adv. 1871, *WHS*; 1879, by Manhattan Med. Co., New York (Baldwin 1973); 1910, *AD*.
Aqua; 4½″ × 1½″ × 1½″; 11n; 1 or 2b; 3 or 4ip; v, fss. See ATWOOD'S JAUNDICE *(Bitters)*.

(V. P. D.)/TOWNSEND'S LINIMENT/ JNO. T. STEEL, PROP'R/ NEW YORK
For relief of pain, inflammation and swelling; adv. 1877 (Devner 1968); by the proprietor, John T. Steel, New York, 1894 (Baldwin 1973); by S. P. Townsend, Albany, NY, 1899 (Devner 1968); 1910, *AD*.
Aqua; 6¾″ × 2¾″ × 1¾″; 9n; 18b; pl; v. See S. P. TOWNSEND *(Sarsaparilla)*.

UNCLE SAMS/NERVE & BONE/ LINIMENT//EMMERT/ PROPRIETARY CO/CHICAGO ILL
For Man or Beast; adv. 1882 (Baldwin 1973); 1922, *RD*.
Aqua; 7¼″ × 2½″ × 1⅜″; 1n; 3b; pl; v, ss. See WINCHELL (Syrup).

VERMONT/LINIMENT// J. M. HENRY & SONS// WATERBURY, Vᵀ
Henry's Vermont Liniment, product of James M. Henry & Sons, adv. 1860, *New England Business Directory*; 1876, *WHS*.
Aqua; 5¼″ × 2″ × 1³⁄₁₆″; 9n; 3b; 4ip, arched; v, fss; p. See J. F. HENRY *(Company)*.

WAKEFIELD'S/NERVE & BONE/LINIMENT
Adv. 1871, *VSS & R*; 1921, *BD*.
Aqua; 3⅞″ × 1⁷⁄₁₆″ diameter; 7n; 20b; pl; v. See WAKEFIELD *(Balsam, Cure)*.

WATKINS/LINIMENT
Label: . . . *For Internal and External Use, For Man or Beast. Sold recently "For External Use Only"* . . . *Alcohol 47%*.
Color & dimens. unk.; 1n; 3b; ip; v. See WATKINS *(Company,* Miscellaneous, Trade Mark).

LOTION

BARTINE'S/LOTION

Advertisement: ". . . Remedy for Rheumatism, Sprains, Bruises, Man or Animal" Product of C. S. Bartine & Co., New York, adv. 1845 (Baldwin 1973); 1910, *AD*.

Aqua; 6¼" × 2¼" × 1½"; 11n; 3b; pl; v; p.

BARTINE'S/LOTION

Light green; 7³⁄₁₆" × 2¹¹⁄₁₆" × 2"; 11n, crude; 3b; pl; v; p.

CHAMBERLAIN'S/HAND LOTION/ALCOHOL 49% [Base: · O in square ·.] [See Figure 122]

Bottle manufactured by the Owens Bottle Co., 1911 to 1929 (Toulouse 1972).

Clear; 2³⁄₄" × ¹⁵⁄₁₆" × ¹³⁄₁₆"; 3n; 6b; pl; v; ABM; vertical ribs on side. See CHAMBERLAIN (Balm, Liniment, Miscellaneous, *Remedy*), VON HOPF (Bitters), W. WARNER (*Company*).

Fig. 122

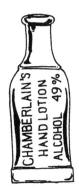

COLEMAN'S/LOTION/PHILᴬ

Aqua; 4³⁄₄" × 1³⁄₄" × ?; 3n, crude; 3b; ip; v; p.

DR A. C. DANIELS/WONDER LOTION/NATURES HEALER FOR MAN OR BEAST/BOSTON MASS. U.S.A.

Clear; 6½" × 2½" × 1³⁄₄"; 7 or 9n; 17 or 18b; pl; v. See DANIELS (Cough, Cure, *Liniment*, Miscellaneous).

FIELD'S LOTION//P & W

Adv. 1890, *W & P*; 1910, *AD*.

Milk glass; 4⁵⁄₈" × ?; 3n; ?b; pl; v; ss.

FROSTILLA//FRAGRANT LOTION//ELMIRA, NY. U.S.A.

[Base: obscure numbers on each side of O in square]

Bottle manufactured by the Owens Bottle Co., Toledo, OH, 1911 to 1929 (Toulouse 1972).

Clear; 4⁹⁄₁₆" × 1³⁄₄" × 1¹⁄₈"; 16n; 6b; 1ip, front; v, fss. See HOLMES (*Miscellaneous*, Trade Mark).

PROF. I. HUBERTS/MALVINA LOTION/TOLEDO, OHIO

[See Figure 123]

Label: *MALVINA LOTION, an addition to Malvina Cream. To cure freckles, pimples, moth patches, liver mole, ringworm and salt rheum.* Introduced and adv. 1874, *HH & M*; 1935 by Hubert Malvina Inc., 578 Madison Ave., New York City, *AD*.

Cobalt, milk glass; 4⁷⁄₈" × 1⁵⁄₈" × 1⁵⁄₈"; 9n; 2b; pl; v. Newer variants were cobalt.

Fig. 123

PROF. I. HUBERTS/MALVINA LOTION/TOLEDO, OHIO. [Base:] W.T. & CO./U.S.A.

Bottle manufactured by Whitall-Tatum Co., Millville, NJ, 1857 to 1935 (Toulouse 1972).

Milk glass; 5" × 1¹¹⁄₁₆" × 1¹¹⁄₁₆"; 9n; 2b; pl; v.

LEONARDI'S//GOLDEN EYE LOTION/CURES WITHOUT PAIN//TAMPA FLA.

Adv. 1891, *WHS*.

Aqua; 4¹⁄₈" × 1³⁄₈" × ¹¹⁄₁₆"; 7n; 6b; 4ip; v, sfs. See LEONARDI (Cure, Purifier).

MARSHALL'S/RING & TET'R WORM/LOTION

Apparently the product of Marshall's Drug Store, ". . . medicines for humans and animals," No. 312 Market St., Philadelphia, PA from 1835–1845 (Shimko 1969).

Aqua; 4³⁄₄" × 1" × ½"; 7n; 12 or 15b; pl; v.

PALMER'S LOTION

Adv. 1871, *VSS & R*; 1941–42 by Solon Palmer, 374 Pearl St., New York City, *AD*.

Clear; 3⁷⁄₈" × 1⁷⁄₈" × 1¹⁄₈"; 7n; 4b; pl; v; ABM. See PALMER (Miscellaneous, *Water*).

PALMER'S//VEGETABLE/COSMETIC//LOTION

Clear; 4" × 1¹³⁄₁₆" × 1¹⁄₁₆"; 7n; 4b; pl; v, sfs.

RHODES/ASTRINGENT HAIR LOTION/LOWELL, MASS.

See RHODES (*Hair*).

Sᵀ CLAIR'S/HAIR LOTION

Apparently manufactured in Sacramento, CA. Adv. 1896–97, *Mack*; 1897, *L & M*.

Cobalt; 7¼" × 2³⁄₄" × 1⁵⁄₈"; 7n; 3b; 1ip; v. Also in blue, 7⁵⁄₈" × 2⁹⁄₁₆" × 1⁷⁄₁₆".

SHAW'S/GLYCERINE/LOTION

Introduced in 1868 (Wilson and Wilson 1971), adv. 1897, *L & M*. Product of Henry Shaw, San Francisco, CA, who also introduced a pectoral syrup in 1872. By the mid-1890s, Shaw was affiliated with H. P. Wakelee (Wilson and Wilson, 1971). Shaw's Moth & Freckle Lotion adv. 1876, *WHS*; 1910, *AD*. Shaw's Lotion adv. 1915, 1923, *SF & PD*.

Aqua; dimens. unk.; 9n; 3b; 1ip; h.

Dᴿ VANBAUM'S//PAIN EXTRACTOR//AND MAGIC// RHEUMATIC LOTION

Adv. 1872, *VHS*.

Aqua; 6" × 2¹⁄₈" × 1½"; 11n; 3b; 4ip; v, sfsb; p.

[Script:] Velvetina/CREAM/ LOTION//GOODRICH DRUG CO./ OMAHA, U.S.A. [Base: diamond]

See GOODRICH (*Drug*).

ZEMO/ANTISEPTIC LOTION/ FOR SKIN & SCALP//ZEMO/MFG. BY E. W. ROSE CO./CLEVELAND, O. [Base: W over T in triangle]

Label: *ZEMOTONE, An Alterative and Tonic of Vegetable Origin, to be used with Zemo for the Treatment of Blood and Skin Affections. Alcohol 32%. Prepared for the E. W. Rose Co., Cleveland, O., Formerly*

St. Louis, Mo. Bottle manufactured by the Whitall-Tatum Co., Millville, NJ, 1935–1938; also a variant with an I in diamond, a product of the Illinois Glass Co., 1916 to 1929 (Toulouse 1972). Product manufactured in both an ointment and liquid form. Zemo eczema remedy adv. 1907, *PVS & S*, 1910 by Rose Med. Co.; Zemo Liquid adv. 1929–30 by The Musterole Co., 1748 E. 27th St., Cleveland, Ohio; 1948 by E. W. Rose Co., *AD*; 1984–85 by Plough Sales Corp., Memphis, Tenn., *AD*.

Clear; $6^{1}/_{16}'' \times 2^{1}/_{2}'' \times 1^{7}/_{8}''$; 9n; 3b; pl; v, ss; ABM. See MUSTEROLE (Miscellaneous), ZEMO *(Cure)*.

MAGNESIA

BISHOP'S/GRANULAR CITRATE/ OF MAGNESIA
Product of the Bishop Remedy Co., San Francisco (Devner 1968). Adv. 1876, *WHS*; 1915, *SF & PD*.
Light cobalt; $6^{1}/_{4}'' \times ? \times ?$; 11n; 4b; pl; h.

BISHOP'S//MAGNESALINE [Base: BH monogram]
Adv. 1935 and 1941–42 by E. Fougera & Co., New York City, *AD*.
Aqua; $6^{1}/_{8}'' \times 2^{1}/_{4}'' \times 1^{1}/_{4}''$; 11n; 4b; pl; v, ss.

BISURATED/MAGNESIA/BISMAG LTD/LONDON [Base:] MADE IN/R.B. LTD /ENGLAND
Adv. 1925, *BWD*; 1929–30 by International Druggists & Chemists Labs., Inc., 123 William St., New York City, *AD*.
Clear; $4^{3}/_{4}'' \times 1^{7}/_{8}''$ diameter; 7n, large mouth; 20b; pl; v.

CITRATE/MAGNESIA
[See Figure 124]
Universal container, numerous producers.
Clear; $8'' \times 2^{7}/_{8}''$ diameter; 11n; 20b; pl; h.

Fig. 124

CURLING'S/CITRATE OF MAGNESIA [See Figure 125]
Three strengths adv. 1896–97, *Mack*; 1915, *SF & PD*.
Cobalt; 6″ × 2¼″ × 1⁵/₁₆″; 8n, large mouth; 4b; pl; v.

Fig. 125

DINNEFORD'S/MAGNESIA
Label: *DINNEFORD'S MAGNESIA. The best remedy for Acidity of the Stomach, Heartburn, Headache, Gout, and Indigestion, and safest aperient for delicate constitutions, ladies, and children.* Adv. 1883 in *The Illustrated London News* (8 Dec.); 1913 "Approved by the Medical Profession for over seventy years . . .," *The Illustrated London News* (7 June). Adv. 1929–30 by Fougera & Co., New York City, *AD*.
Aqua; 6⅞″ × 2⅜″ × 1⁵/₁₆″; 1n; 12b; pl; v; flask shape, tapered body.

HENRY'S//CALCINED// MAGNESIA//MANCHESTER
This product, for the cure of acute indigestion, acid stomach, heartburn, dyspepsia, etc., was introduced by Thomas and William Henry, St. Peters, Manchester, England, in 1772; the *Jacob Scheiffelin* catalog shows its availability in the United States in 1804. Agents in U. S. included Thomas Dyott and Tarrant & Co. (Holcombe 1979; Wilson and Wilson 1971). W. H. Schieffelin owned or was agent for the product in 1891. Adv. 1921, *BD*.
Clear; 4¼″ × 1¼″ × 1¼″; 3n; 1b; pl; v, fsbs; p. Also without pontil. See HUSBAND *(Magnesia)*.

F. J. HILL & CO/CITRATE/OF/ MAGNESIA/SALT LAKE CITY
[Base:] WT & CO/USA
See HILL *(Company)*.

HUSBAND'S//CALCINED// MAGNESIA//PHILADᴬ
The high import duty on medicinal imports prompted Thomas J. Husband, a Philadelphia chemist, not only to copy the formula of Thomas and William Henry's Calcined Magnesia, but also the name; Husband introduced his product in the U.S. in 1844. Thomas Jr. joined the business ca. 1867. In 1928 the bottle was still unchanged, except it was manufactured by ABM (Holcombe 1979; Wilson and Wilson 1971). Adv. 1948 by Husbands Magnesia Co., Inc., 18th & Market Sts., Philadelphia, *AD*.
Clear; 4″ × 1¼″ × 1¼″; 15n; 2b; pl; v, fsbs. See HENRY *(Magnesia)*.

KRUSES/PRIZE MEDAL/ MAGNESIA [Base: monogram]
Aqua; 7⁷/₁₆″ × 2¾″ × 1½″; 20n; 12b; pl; v.

KRUSES/PRIZE MEDAL/ MAGNESIA//FELTON GRIMWADE & CO./MELBOURNE [Base:] K
Aqua; 7½″ × 2⅞″ × 1½″; 20n; 12b; pl; v, f, h, b.

FELIX KRUSE'S/FLUID MAGNESIA
Aqua; 7¾″ × 2⅝″ × 1⅝″; 20n; 6b; pl; v.

"MAGNOS"/OR/FAULDING'S FLUID MAGNESIA/[Base:] A
Aqua; 7½″ × 2⅞″ × 1¹³/₁₆″; 25n; 12b; ip; v.

SIR JAMES/MURRAY'S/SOLUTION OF/MAGNESIA
Bottle manufactured ca. 1861. Murray's Fluid Magnesia, of English origin, was introduced to the United States in the late 1830s (Wilson and Wilson 1971). Adv. 1840 (Putnam 1968); 1921, *BD*.
Aqua; 6″ × ? × ?; 1n; 12b; 1ip; v.

SIR JAMES/MURRAY'S/SOLUTION OF/MAGNESIA
Bottle manufactured ca. 1866 (Wilson and Wilson 1971).
Aqua; 8″ × ? × ?; 1n; 12b; pl; v.

PHILLIPS'/MILK OF/[in circle:] **TRADE MARK/MAGNESIA**
Aqua; 3¼″ × 1⁷/₁₆″ × 1¹/₁₆″; 3n; 8b; pl; h. See PHILLIPS *(Company,* Miscellaneous, Oil, Trade Mark).

PHILLIP'S/MILK OF/[in circle:] **TRADE MARK/MAGNESIA/ PATENTED/APRIL 29th & JULY 22nd 1873**
Aqua; dimens. unk.; 7n; 10b; pl; h. See PHILLIPS *(Company,* Miscellaneous, Oil, Trade Mark).

PHILLIP'S/MILK OF/[in circle:] **TRADE MARK/MAGNESIA/ REGISTERED**
Aqua; 6⅝″ × ?; 7n; 10b; pl; h. See PHILLIPS *(Company,* Miscellaneous, Oil, Trade Mark).

PHILLIP'S/MILK OF/[in circle:] **TRADE MARK/MAGNESIA/REG'D IN U.S. PAT. OFFICE/AUG. 21, 1906** [See Figure 126]
Light blue; 5″ × 2⅜″ × 1¾″; 7n; 10b; pl; h. See PHILLIPS *(Company,* Miscellaneous, Oil, Trade Mark).

Fig. 126

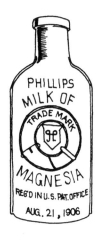

MILK OF/[in circle:] **TRADE MARK/ MAGNESIA/REG'D IN U.S. PATENT OFFICE/AUG. 21, 1906/ THE CHAS. H. PHILLIP'S/ CHEMICAL COMPANY/ GLENN BROOK, CONN.**
Cobalt; dimens. unk.; 7n; 10b; pl; h; ABM; 3 sizes: 3, 6, 12 oz.; also same with threaded variant, introduced ca. 1924. See PHILLIPS *(Company,* Miscellaneous, Oil, Trade Mark).

CITRATE·OF·MAGNESIA/ H. P. WAKELEE/DRUGGIST
See WAKELEE *(Drug)*.

MANUFACTURER

MRS. R. W. ALLEN/ESTABLISHED
1866/DETROIT, MICH.//
MANUFACTURER/OF FINE
COSMETICS/AND PERFUMERY
Amber; 5³/₄″ × 2⁵/₁₆″ × 1¹/₂″; 9n; 3b;
pl; v, ss.

ANDREWS MFG CO/BRISTOL,
TENN.
See ANDREWS (Company).

DR. M. HERMANCE'S/ASTHMA
MEDICINE/MFG'D. BY/CLAUDE
A. BELL/LOWELL, MASS.
[See Figure 127]
M. Hermance and Claude A. Bell estab-
lished their business shortly after the
Civil War. Hermance's widow operated
the firm after her husband's death;
Claude Bell took over after her death
(Shimko 1969). Hermance's Asthma
Cure adv. 1876 WHS; 1900, EBB; Her-
mance Asthma Medicine adv. 1905
(Devner 1968); 1948, AD.
Clear; 5⁵/₈″ × 2¹/₈″ × 1⁵/₁₆″; 7n; 11b;
pl; v. See BELL (Balsam).

Fig. 127

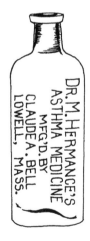

THE BELL MFG. COMPANY/
[monogram]/PERTH AMBOY, N.J.
See BELL (Company).

BOTHIN/M'F'G. CO./S. F.
See BOTHIN (Company).

RAMON'S PEPSIN CHILL TONIC/
MADE BY BROWN MF'G CO.//
GREENVILLE, TENN.//NEW YORK,
N. Y. [Base: diamond]
See RAMON (Tonic).

BROWN M'F'G CO. NEW YORK//
RAMON'S/SANTONINE/
WORM SYRUP
See RAMON (Syrup).

MANUF'G. BY/L. D. CAULK/
PHILADA, PA.//TRADE/MARK//
HALF/OUNCE/CAULK'S/20ᵀᴴ/
CENTURY/ALLOY//[v] CAULK'S/
FILLING/MATERIALS/[h] EST 1877
Clear; 1³/₄″ × ⁷/₈″ × ⁷/₈″; 16n; 1b; pl; v,
s; h, bf; v, h, s. See CAULK (Company,
Miscellaneous).

CHESEBROUGH MFG. CO./
VASELINE
See CHESEBROUGH (Company).

CLAY, WHOLESALE & CO./MFG
PHARMACISTS/ELMIRA N. Y.//
SELLECK'S GINGER//TOLU
COUGH SYRUP
See CLAY (Company).

CORONA DISTEMPER TONIC/
MANUFACTURED ONLY BY/
THE CORONA MFG. COMPANY/
KENTON, OHIO
See CORONA (Tonic).

CURTIS & BROWN//MFG. CO. LD.
NEW YORK//BROWN'S/
HOUSEHOLD PANACEA/
AND FAMILY LINIMENT
See BROWN (Liniment).

ELECTRO-MAGNETIC LINIMENT/
J. W̲M̲. DANIEL, LOCUST
HILL, VA./SOLE MANUFACTURER
& PROPRIETOR
See ELECTRO-MAGNETIC (Liniment).

ELLIMAN'S/ROYAL/
EMBROCATION/FOR HORSES/
MANUFACTORY/SLOUGH
Aqua; 7³/₈″ × 2¹/₂″ diameter; 19n,
modified; 20b; pl; h. See ELLIMAN
(Miscellaneous).

[Monogram]/ELYSIAN MFG. CO./
CHEMISTS PERFUMERS/
DETROIT, U.S.A.
See ELYSIAN (Company).

FOLEY'S SARSAPARILLA/
MFD. BY/FOLEY & CO.
CHICAGO.//FOLEY & CO//
CHICAGO USA.
See FOLEY (Company).

M'F'R'D BY FOLEY & CO./
STEUBENVILLE O. & CHICAGO//
THE CLINIC/BLOOD PURIFIER
See FOLEY (Company).

MEYER'S SARSAPARILLA/MANF'D
BY/GIANT MEDICINE CO./
HELENA. MONT.
See MEYER (Sarsaparilla).

PARISIAN SAGE/A HAIR TONIC/
GIROUX MFG. CO./BUFFALO
See PARISIAN (Tonic).

GIROUX. MFG. CO./BUFFALO.
FORT ERIE//PARISIAN SAGE/
A HAIR TONIC
See PARISIAN (Tonic).

GLOBE/HAIR RESTORATIVE AND
DANDRUFF CURE/GLOBE MFG.
CO, GRINNELL, IA
See GLOBE (Restorer).

FREAR'S AMBER OIL/MFG. BY/
GOLD MEDAL FOOD CO./
TUNKHANNOCK, PA.
See FREAR (Oil).

RICE'S [within figure of goose]/GOOSE
GREASE LINIMENT/MANF'D ONLY
BY THE/GOOSE GREASE
LINIMENT CO./
GREENSBORO, N.C.
See RICE (Liniment).

GUGGENHEIM MF'G CO/
ROCHESTER, N.Y. [Base:] FER & CO
See GUGGENHEIM (Company).

ALL TOILET PREPARATIONS/
MANUFACTURED BY/HARMONY
OF BOSTON/SOLD ONLY AT/
The Rexall Store
Clear; 3″ × 1³/₁₆″ × ³/₄″; 9n; 12b; pl; v.

MRS. NETTIE HARRISON/
AMERICA'S BEAUTY DOCTOR/
SAN-FRANCISCO, CAL.//
MANUFACTURER/OF FINE
COSMETICS/AND PERFUMERY
Universal container for cosmetics and
cures, products adv. 1900, EBB; 1910,
AD.
Amber; 5¹/₂″ × 2⁵/₁₆″ × 1⁹/₁₆″; 7n; 3b;
pl; v, ss.

MRS. NETTIE HARRISON/
DERMATOLOGIST/
SAN-FRANCISCO, CAL.//
MANUFACTURER/OF FINE
COSMETICS/AND PERFUMERY
Amber; 5⁵/₈″ × 2³/₈″ × 1⁵/₈″; 7n; 3b;
pl; v, ss.

[h] MANUF'R/[v] DAMIANA
BITTERS//[h] LEWIS HESS/
[v] BAJA CALIFORNIA
[Base: 8-point star]
See DAMIANA (Bitters).

DR. BEEBE'S/CATARRH &
ASTHMA CURE/OTTO L.
HOFFMAN/MANUFACTURER,
COLUMBUS, O.
See BEEBE (Cure).

[d] HOLMES/RHEUMACINE/
[v] MAN'F'DR/A. B. HOLMES/
CORNING, N. Y.
Adv. 1893 (Baldwin 1973).
Aqua; 7¼″ × 2½″ × 1¾″; 7n; 3 or
6b; ip; d, v.

UNIVERSE BITTERS/
MANUFACTURED BY/AUG.
HORSTMAN/SOLE AGENT/
F. J. SCHAEFER/231 MARKET ST./
NASHVILLE KY
See UNIVERSE (Bitters).

P. E. ILER/MANUFACTURER/
OMAHA NEB//[in circle:]
AMERICAN LIFE BITTERS//
[in circle:] AMERICAN LIFE BITTERS
See AMERICAN LIFE (Bitters).

IMPERIAL/CHEMICAL
MANUFACTURING CO.//
NEW YORK//IMPERIAL HAIR/
TRADE MARK/REGENERATOR
See IMPERIAL (Company).

C. E. JOHNSON/MFG/[embossed
shield inscribed:] VT/R/
SALT LAKE CITY
Aqua; 6⅛″ × 2″ × 1⁵⁄₁₆″; 11n; 9b with
square corners; pl; h. See VALLEY
TAN (Remedy).

JOHNSTON & LILLY/
MANUFACTURING
PHARMACISTS/INDIANAPOLIS
Dr. J. F. Johnston and Eli Lilly were
partners from 1873 to 1876 at which
time Eli Lilly established his own chem-
ical drug business. The firm never
manufactured patent medicines. Eli was
succeeded by sons and grandsons until
1953 when the presidency was assumed
by Eugene N. Beesley, a non-family
member. Company correspondence
notes vessels embossed EL & CO.,
which date ca. 1897–ca. 1907. Square
or rectangular bottles contained pills,
granules and tablets; round bottles held
fluid extracts and other liquids. Informa-
tion furnished by Eli Lilly & Co., Indi-
anapolis (personal communication,
1982).

Color unk.; 7⅜″ × ?; 7n; 1 or 2b;
1ip; v.

WHITE PINE COUGH SYRUP WITH
TAR/MANF'D BY/JORDAN BRO'S.
COXSACKIE, N.Y.
See WHITE PINE (Syrup).

ONE NIGHT COUGH CURE/
KOHLER M'F'G. CO./
BALTIMORE, MD.
See ONE NIGHT (Cure).

L.E.K./MANUFACTURED/BY/THE
LESLIE E. KEELEY CO./
LABORATORY/DWIGHT,
ILLINOIS/U.S.A.//[script:] Leslie E.
Keeley M.D.
See KEELEY (Company).

LEIS CHEMICAL MFG. CO./
LAWRENCE KAS.
See LEIS (Company).

LIQUOZONE/MANUFACTURED
ONLY BY/THE LIQUID OZONE Co/
CHICAGO USA
See LIQUOZONE (Company).

BAKER'S/VEGETABLE/BLOOD &
LIVER/CURE/LOOKOUT/
MOUNTAIN/MEDICINE CO/
MANUFACTURERS/&/
PROPRIETORS/GREENVILLE/
TENN.
See BAKER (Cure).

LORRIMER & CO./
MANUFACTURING CHEMISTS/
LABORATORY/BALTIMORE, MD.
See LORRIMER (Chemical).

LUCKY TIGER/MFG CO./K C MO
See LUCKY TIGER (Company).

LUNDIN & CO. SOLE
MANUFACTURERS CHICAGO, ILL.
U.S.A.//LUNDIN'S CONDENSED
JUNIPER-ADE//MAKES 5
GALLONS OF A HEALTHFUL
BEVERAGE//LUNDIN'S
KONDENSERADE ENBARS SIRIP
[Base:] A3
See LUNDIN (Company).

MEXICAN/MUSTANG/LINIMENT/
LYON MFG CO/NEW YORK
See MEXICAN (Liniment).

MEXICAN/MUSTANG/LINIMENT/
LYON M'F'G, CO./BROOKLYN, N.Y.
See MEXICAN (Liniment).

THE MALTINE MF'G CO/
NEW YORK
See MALTINE (Company).

THE/MALTINE/MF'G CO/
CHEMISTS/NEW YORK
See MALTINE (Company).

MF'D BY A. F. MANN//WARSAW,
N.Y./LITTLE GIANT/
CATARRH CURE
See LITTLE GIANT (Cure).

MARVIN BRO'S & BARTLETT/
COD LIVER OIL MANUF'D AT/
PORTSMOUTH N.H.
See MARVIN (Oil).

DR. BUCHARD'S/AUREOLINE/
M'F'D. BY JOHN ALEX
McCORMICK/SAN FRANCISCO,
CAL. [Base:] 319 [See Figure 128]
Adv. 1895, McK & R; 1910, AD.
Light aqua; 6½″ × 2¾″ × 1⁹⁄₁₆″; 7n;
6b; pl; v.

Fig. 128

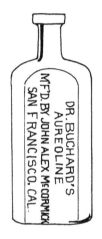

MERTEN MFG CO/S. F. CAL.
See MERTEN (Company).

VANS MEXICAN HAIR
RESTORATIVE/MANUFACTURED
ONLY BY THE/MEXICAN
MEDICINE CO./CHICAGO, U.S.A.
See MEXICAN (Company).

PAGEMATIC/TRADE MARK/FOR
THE RHEUMATIC/, Manufactured
by/The Pagematic/Co of Texas/
DALLAS, TEXAS
See PAGEMATIC (Company).

[Embossed swastika]/COMPOUND/
LAXATIVE SYRUP/MFGD BY T. S.
PAINE/WAYCROSS GA.
See PAINE (Syrup).

THE PALISADE/MFG CO./
YONKERS N.Y.//BOROLYPTOL//
BOROLYPTOL
Adv. 1895, McK & R; 1929–30 and
1941–42 by Arlington Chemical Co.,
Yonkers, N.Y., AD.
Clear; 4⅞″ × 1¹³⁄₁₆″ × 1⅛″; 9n; 6b;
2ip; base, v, ss; several sizes.

D℞ PARKER'S SONS/SURE CURE
FOR HEADACHE/
MANUFACTURED BY D℞ PARKER'S
SONS CO./BATAVIA, N.Y. [Base:]
W. T. CO./U.S.A.
See PARKER (Company).

E. M. PARMELEE//
MANUFACTURING/CHEMIST//
DANSVILLE N. Y.
Universal container; products included
Parmelee's Dyspepsia Compound adv.
1881 (Baldwin 1973), 1900, EBB;
Hamilton's Cough Balsam adv. 1887,
McK & R; 1910, AD; Parmelee's Hop,
Iron & Buchu Bitters adv. 1888, 1894
(Ring 1980).
Aqua; 5″ × 1¾″ × ⅞″; 7n; 3 or 6b; ip;
v, sfs; several sizes.

PEET BROS./MANFG. CO./
KANSAS CITY, U.S.A.
See PEET (Company).

CALDWELL'S SYRUP PEPSIN/
MF'D. BY/PEPSIN SYRUP
COMPANY/MONTICELLO,
ILLINOIS
See CALDWELL (Syrup).

FOR/EXTERNAL/USE ONLY/
PRESCRIPTION/REESE CHEM. CO.
[superimposed over 1000]/EXTERNAL/
USE 4TIMES DAILY/MFG. BY/
REESE CHEM. CO./CLEVELAND O.
See REESE (Chemical).

WILD CHERRY BITTERS/
MANUFACTURED BY/C. C.
RICHARDS & Co/YARMOUTH, N.S.
[Base:] L. G. Co. N.S.
See WILD CHERRY (Bitters).

ZEMO/MFG. BY E. W. ROSE CO./
CLEVELAND, O.//ZEMO/
ANTISEPTIC LOTION/FOR SKIN
& SCALP [Base: W over T in diamond]
See ZEMO (Lotion).

FERRO QUINA/STOMACH
BITTERS/BLOOD MAKER/
MNFG. BY/D. P. ROSSI/
SAN FRANCISCO/CAL.
See FERRO QUINA (Bitters).

SCHLOTTERBECK & FOSS CO./
MANUFACTURING CHEMISTS/
PORTLAND, ME.
See SCHLOTTERBECK (Company).

SCOVILL MFG. CO/NO 4/
BEEKMANS/NEW YORK
See SCOVILL (Company).

[In circle:] HOPE IS THE ANCHOR
OF THE SOUL/T. A. SLOCUM CO/

MANFG. CHEMISTS/NEW YORK–
LONDON//FOR CONSUMPTION
AND LUNG TROUBLES//PSYCHINE
See SLOCUM (Company).

G. S. STODDARD & CO./M'F'G.
CHEMISTS/NEW YORK//
G. S. STODDARD & CO./
M'F'G. CHEMISTS/NEW YORK
See STODDARD (Company).

THOMPSON MFG. CO.//
SAN FRANCISCO, CHICAGO
& N. Y.//HYGEIA/WILD [monogram]
TMCO CHERRY/PHOSPHATE
See THOMPSON (Company).

THOMPSON STEELE/AND PRICE/
MANUFACTURING. CO.//
CHICAGO//Sᵀ. LOUIS [Base:]
W. MᶜC & CO
See THOMPSON STEELE (Company).

HONDURAS/TONIC/W. E. TWISS
& Co/MFR.
See HONDURAS (Tonic).

WASHINGTON MANF'G CO/
SAN FRANCISCO//[monogram]
See WASHINGTON (Company).

HEBBLE WHITE/M' F' G./
COMPANY/GAINSVILLE, N.Y.
See WHITE (Company).

DR. BOCK'S RESTORATIVE TONIC/
MANUFACTURED BY/
S. H. WINSTEAD MEDICINE CO.
See BOCK (Tonic).

FARRAR'S SARSAPARILLA/
MANUFACTURED BY WOOD
DRUG CO./BRISTOL, TENN.
See FARRAR (Sarsaparilla).

CLINTON E. WORDEN & CO./
MANUFACTURING
PHARMACISTS/SAN FRANCISCO,
CAL.
See WORDEN (Company).

MFD ONLY BY/MME. M. YALE/
NEW YORK & CHICAGO/U.S.A.//
MADAME YALE'S/EXCELSIOR
HAIR TONIC/PRICE 50¢
See YALE (Tonic).

THE ZEMMER CO./
MANUFACTURING CHEMISTS/
PITTSBURG, PA.
See ZEMMER (Company).

ZOELLER MEDICAL/MFG. CO./
PITTSBURGH, P.A., U.S.A.//
ZOELLER'S/KIDNEY REMEDY
See ZOELLER (Company).

MEDICINE

ABIETINE MEDICAL CO//
OROVILLE, CAL. U.S.A.//GREEN'S
LUNG RESTORER/[d] SANTA/
[v] ABIE
See GREEN (*Restorer*).

ABIETINE MEDICAL CO//
OROVILLE, CAL. U.S.A.//
SANTA ABIE
See ABIETINE (*Company*).

PREPARED FOR THE U.S./BY. L.
AND N. ADLER MEDICINE CO./
READING, PA. U.S.A.//
HERMANUS/GERMANY'S
INFALLIBLE/DYSPEPSIA CURE//
[embossed soldier standing over a
dead bird]
See HERMANUS (*Cure*).

ALLAN'S/ANTI FAT//BOTANIC
MEDICINE//BUFFALO, N.Y.
A remedy for corpulency formulated by
J. C. Allan, Buffalo, NY. The product
was sold to R. V. Pierce in the spring
of 1874, who named his subsidiary com-
pany the Botanic Medicine Co.; Pierce
was still operating the firm after 1900
(Wilson and Wilson 1971). Adv. 1878
by Botanic Medicine Co., Buffalo, N.Y.,
Harpers Weekly (6 July); 1917, *BD*.
Aqua; 7³/₄″ × ? × ?; 11n; 3 or 6b; 3 or
4ip; v, fss. See PIERCE (*Discovery*).

THE ALTENHEIM/MEDICAL
DISPENSARY//FOR THE HAIR//
CINCINNATTI, O. U.S.A.
[Base: M in circle]
Bottle manufactured by the Maryland
Glass Co., Baltimore, MD, after 1916
(Toulouse 1972). Directories included
the Altenheim Medical Dispensary,
"Manufacturers of the Foso Hair Reme-
dies," 548, 550 Main, Cincinnati, O,
1894–1905; the Foso Company, same
address, 1905–1910. Products adv.
1922, *RD*.

Clear; 8¹/₁₆″ × 2¹³/₁₆″ × 1⁹/₁₆″; 1n, sp;
3b; 4ip; v, fss. See FOSO (*Company*).

ANCHOR MED. CO//
WEAKNESS CURE
See ANCHOR (*Company*).

ACM [monogram]/ATLAS MEDICINE
CO./HENDERSON, N.C. U.S.A.
Label: *ATLAS BABY SYRUP–*
Facilitates Teething, Regulates the Bowels
. . . Manufactured at the Laboratory of
Atlas Medicine Co., Main St., Henderson,
N.C. Branch Offices, Chicago, Baltimore,
Atlanta. Container held several products
including Atlas Aconic Oil, ". . . the
Greatest Cure on Earth for Pain . . .,"
and Vegetable Tonic Syrup.
Aqua; 5″ × 1⁹/₁₆″ × 1¹/₁₆″; 7n; 3b; 4ip,
oval front; v.

ACM [monogram]/ATLAS MEDICINE
CO./HENDERSON, N.C. U.S.A.
Label: *ATLAS CELERY PHOSPHATE*
VITALIZER.
Amber; 5³/₄″ × 2¹/₁₆″ × 1″; 7n; 3b; 4ip,
oval front; v.

ACM [monogram]/ATLAS MEDICINE
CO./HENDERSON. N.C. U.S.A.
Label: *ATLAS KIDNEY & LIVER*
CURE.
Amber; 9″ × 3³/₁₆″ × 1⁵/₈″; 7n; 3b; 4ip,
oval front; v.

THE BARKER/MOORE & MEIN/
MEDICINE COMPANY
Aqua; 6¹/₈″ × 2¹/₄″ × 1¹/₈″; 9n; 3b; 4ip,
arched front; v. See NERVE & BONE
(*Liniment*).

THE BARKER/MOORE & MEIN/
MEDICINE COMPANY
Aqua; 6¹/₄″ × 2¹/₄″ × 1¹/₈″; 7n; 3b; 4ip;
v. See NERVE & BONE (*Liniment*).

THE BARKER/MOORE & MEIN/
MEDICINE COMPANY//
PHILADELPHIA
Aqua; 6¹/₈″ × 2¹/₄″ × 1¹/₈″; 7n; 3b; 4ip,
arched front; v, fs. See NERVE &
BONE (*Liniment*).

DR: BELDING MEDICINE. CO//
MINNEAPOLIS, MINN.//
DR. BELDING'S/SKIN REMEDY
See BELDING (*Remedy*).

GUNN'S/ONION SYRUP/
DR. BOSANKO MED. CO/
PHILADA. P.A.
See BOSANKO (*Company*).

DR. GUNN'S/ONION SYRUP/
PREPARED BY/

THE DR. BOSANKO MED. CO/
PHILADELPHIA, PA.
See BOSANKO (*Company*).

BRO. MED. CO.//D. K. & B. CURE
See D. K. & B. (*Cure*).

BROWN MED. CO.//ERIE, P.A.//
CARTER'S EXT/OF SMART/WEED
See CARTER (*Extract*).

THE BROWN MEDICINE CO.//
ERIE PA.//CARTER'S COUGH,
AND/CONSUMPTION CURE
See CARTER (*Cure*).

DR. W. H. BULL'S/MEDICINE
BOTTLE [Base:] PATᴰ
OCT. 19, 1885
Product of W. H. Bull & Co., St. Louis,
MO, adv. 1900, *EBB*; 1916, *MB*.
Amber; 7³/₄″ × 3³/₈″ × 1³/₈″; 11n; 4b;
pl; h. The slug plate mold on this vari-
ant has obliterated DR. See
W. H. BULL (*Miscellaneous*).

BURK'S MED. CO./NEW YORK/
& CHICAGO
The Burk Med. Co. advertised many
products including Balm of Gilead Oint-
ment, Liniment, Red Clover
Sarsaparilla, Maple and White Pine
Balsams, Vegetable Liver Pills, etc.
Products adv. 1888, Chicago city direc-
tories; 1915, by W. P. Burk Co. (Blasi
1974).
Clear; 4¹/₂″ × 1⁷/₈″ × 1³/₁₆″; 3n; 3b;
1ip; v. See BURK (*Balsam*).

BURTON'S/FAMILY/MEDICINES//
BURTON'S MEDICINES
Products adv. 1900, *EBB*.
Aqua; 9¹/₂″ × 3¹/₄″ × 1³/₄″; 7n; 3b; 6ip,
1 round and 2 rectangular panels on
front; h, f; v, s.

DR BYRAMS//PURE BOTANIC/
MEDICINES//TRENTON, N.J.
Byram's Vegetable Worm Destroying
Syrup adv. 1883 (Baldwin 1973); 1910,
AD.
Aqua; 6¹/₄″ × 1¹³/₁₆″ × 1¹/₄″; 11n; 3b;
4ip, arched; v, sfs; p.

THE CAREY/G. E. S. S./MEDICINE
CO.//BINGHAMPTON N.Y.//
BINGHAMPTON N.Y.
See CAREY (*Company*).

DR. CAREY'S/MARSH ROOT//
CAREY MEDICAL CORPN.//
ELMIRA. N.Y.
Aqua; 7⁷/₁₆″ × 2⁷/₈″ × 1³/₈″, also
9¹/₂″ × 3″ × 1³/₄″; 1n; 3b; 3ip; v, fss.
Also ABM.

CHAMBERLAIN MED. CO.//
DES MOINES, IA. U.S.A.//
CHAMBERLAIN'S/COLIC/
CHOLERA/AND/
DIARRHOEA REMEDY
See CHAMBERLAIN (*Remedy*).

CHAMBERLAIN MED. CO.//
DES MOINES, IA. U.S.A.//
CHAMBERLAIN'S/COUGH
REMEDY
See CHAMBERLAIN (*Remedy*).

CHAMBERLAIN MEDICINE CO//
DES MOINES, IA//
CHAMBERLAIN'S/LINIMENT
See CHAMBERLAIN (*Liniment*).

CHAMBERLAIN MED. CO//
DES MOINES, IA. U.S.A.//
CHAMBERLAIN'S/PAIN-BALM
See CHAMBERLAIN (*Balm*).

CHATTANOOGA MEDICINE CO.//
CARDUI THE WOMAN'S TONIC
See CHATTANOOGA (*Company*).

THE CHATTANOOGA MEDICINE
CO//MᶜELREE'S CARDUI
[Base: C in circle]
See CHATTANOOGA (*Company*).

CHATTANOOGA MEDICINE CO.//
MᶜELREE'S WINE OF CARDUI
See CHATTANOOGA (*Company*).

CIMONA/COUGH ASTHMA &
CROUP CURE/PREPARED BY
CIMONA MEDICINE CO./
INDIANAPOLIS, U.S.A.
See CIMONA (*Cure*).

THE COLLINS/NEW YORK
MEDICAL INSTITUTE/140 WEST
34ᵀᴴ STREET/NEW YORK CITY,
N.Y. [Base:] WT & CO./U.S.A.
Bottle manufactured by the Whitall-
Tatum Glass Co., 1857 to 1935
(Toulouse 1972).
Clear; 6½″ × 2½″ × 1⁹/₁₆″; 9n; 18b,
also 17b with round corners; pl; v.

WM. CRAEMER MED. CO.//
ST. LOUIS, U.S.A.
See CRAEMER (*Company*).

DR. DAVIS'//FAMILY/
MEDICINES//SENECA FALLS, N.Y.
Products of Davis & Seaman, Seneca
Falls, NY, adv. 1898 (Baldwin 1973).
Aqua; 7¼″ × 2⅝″ × 1½″; 7n; 3b; ip;
v, sfs.

DE TREY'S/SYNTHETIC/
PORCELAIN/MED. [monogram] BY/
THE L. D. CAULK CO. [Base:] 89
See CAULK (*Company*).

THE DILL MEDICINE CO//
NORRISTOWN PA
See DILL (*Company*).

THE DILL MEDICINE CO.//
NORRISTOWN, PA.//DILL'S/
BALM OF LIFE
See DILL (*Company*).

DILL MEDICINE CO.//
NORRISTOWN, PA.//ROYAL/
COUGH CURE
See DILL ((*Company*).

J. C. DODSON MEDICINE CO./
STERLING PRODUCTS (INC)/
SUCESSOR/DODSON'S
Label: *DODSON'S LEVERTONE is an
Effective Laxative, Causes no Restriction of
Habit of Diet. Contains 23% Alcohol.
Wheeling, W. Va. Copyright 1912.* Pos-
sibly J. G. DODSON instead of J. C.
DODSON. The name was eventually
changed to Livertone. Adv. 1929–30
and 1948 by Sterling Products Inc.,
Wheeling, W. Va., *AD*.
Clear; 6⅞″ × 2¼″ × 1⁵/₁₆″; 8n; 3b;
1ip; v; ABM. See DODSON (Mis-
cellaneous).

DUFF/GORDON/SHERRY/
MEDICAL/DEPARTMENT/U.S.A.
Olive; 9⅞″ × 3⅜″ diameter; 2n; 20b;
pl; h.

[h] DR. EBELING'S/[v] HERB
MEDICINE/910 RACE Sᵀ PHILᴬ
Clear with smokey tinge; 6⅛″ × 2¾″
× 1⁷/₁₆″; 9n; 13b; pl; h, v, embossed
across top and along sides in front.

FARMERS//XXX//HORSE
MEDICINE/S. F. CAL.
[See Figure 129]
Aqua; 6¾″ × 2¼″ × 1⅜″; 7n; 3b; 4ip;
v, ssf.

Fig. 129

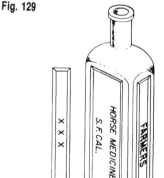

FARMERS//XXX//HORSE
MEDICINE/S. F. CAL
Light green; 8¼″ × 2¹¹/₁₆″ × 1⅝″; 6n;
3b; 4ip; v, ssf.

FATHER JOHN'S/MEDICINE/
LOWELL, MASS.
Father John O'Brien gave his prescrip-
tion to George H. Carleton and Charles
Hovey of Carleton & Hovey Drug
Store in the early 1850s. The pair gave
the medicine to local church patrons
and later bottled and distributed the
product through several agents (Wilson
and Wilson 1971). Adv. 1870s (Dev-
ner 1968); 1948 by Father John's Med.
Co., Inc., 73 Market St., Lowell,
Mass., *AD*; 1984–85, by Medtech, Inc.,
Cody, WY, *AD*.
Amber; 7¼″ × 2½″ × 1⅛″; 3n; 6b;
1ip; v; 3 known sizes.

FATHER JOHN'S/MEDICINE/
LOWELL, MASS.
Amber; 7½″ × 2½″ × 1¼″; 16n; 6b;
1ip; v; ABM.

FATHER JOHN'S/MEDICINE/
LOWELL, MASS.
Amber; 9¼″ × 3″ × 1¹³/₁₆″; 3n, large
mouth; 6b; 1ip; v.

DR. M. M. FENNER/FREDONIA,
N.Y./ST. VITUS DANCE/MEDICINE
Label: *This medicine contains of the best
C. P. Grain, Alcohol 35%.* Adv. 1889,
PVS & S; 1941–42 by S. C. Wells &
Co., Le Roy, N.Y., *AD*.
Aqua; 4½″ × 1⅝″ diameter; 9n; 20b;
pl; v; earlier variant substituted
SPECIFIC for MEDICINE. See
CAPITOL (Bitters), FENNER (Cure,
Miscellaneous, *Remedy*, Specific).

DR. M. M. FENNER/
ST. VITUS DANCE/MEDICINE
Aqua; 4½″ × 1⅝″ diameter; 7n; 20b;
pl; v. See CAPITOL (Bitters), FENNER
(Cure, Miscellaneous, *Remedy*, Specific).

FLAGON REDUIT/ECHANTILLON
MEDICAL [Base:] J T C/910
Clear; 4½″ × 1¹¹/₁₆″ × 1⁵/₁₆″; 7n; 12b;
pl; v.

FRELIGH'S/LIVER MEDICINE/I. O.
WOODRUFF & CO
Adv. 1900, *EBB*; 1929–30 by I. O.
Woodruff & Co., Inc., 66 Beekman St.,
New York City; 1948 by Leon, 311
Fifth Ave., New York City, *AD*.
Clear; 3½″ × 1½″ × ¾″; 7 or 9n; 17
or 18b; pl; v. See IOWNA (Tonic).

FRY'S FAMILY MEDICINES/
SALEM, OREGON
Aqua; 7″ × 2⁵/₁₆″ × 1⁵/₁₆″; 7n; 3b;
4ip; v.

**GERSTLE MEDICINE CO.//
CHATTANOOGA, TENN.//S J S/
FOR THE/BLOOD**
St. Joseph Sarsaparilla. The Gerstle Med. Co. was located at the corner of Chamberlain and Maple, Chattanooga, TN, from 1890 to 1920 (Shimko 1969). Sarsaparilla adv. 1900, *EBB*.
Amber; 8³/₄″ × ? × ?; 11n; rect.; 3 or 4ip; v, ss; h, f.

**MEYER'S SARSAPARILLA/MANF'D
BY/GIANT MEDICINE CO./
HELENA. MONT.**
See MEYER *(Sarsaparilla)*.

**THE GLESSNER MED. CO.//
FINDLAY, OHIO//DR. DRAKE'S/
GERMAN/CROUP REMEDY**
See DRAKE *(Remedy)*.

[h, shoulder:] 6¹/₂ FL. OZ/[v]
**GLOVERS IMPERIAL/
MANGE MEDICINE//H. CLAY
GLOVER CO//NEW YORK**
[Base: O in square]
Bottle manufactured by the Owens Bottle Co., 1911 to 1929 (Toulouse 1972).
Amber; 6¹³/₁₆″ × 2³/₈″ × 1⁵/₈″; 1n; 3b; 4ip; h, v, f; v, ss. See GLOVER (Company, *Cure*, Remedy).

**GRAFTON MEDICINE/
Co//Sᴛ LOUIS, Mᵒ//
MRS. WHITCOMBs//
SYRUP FOR CHILDREN**
See WHITCOMB *(Syrup)*.

**GREGORY MED. CO.//LITTLE
ROCK, ARK.//GREGORY'S/
ANTISEPTIC OIL**
See GREGORY *(Oil)*.

**H. H. H. HORSE/MEDICINE//
D. D. T. 1868**
Bottle manufactured ca. 1895. Daniel D. Tomlinson (D. D. T.), Stockton, CA, introduced his "Celebrated Indian Vegetable Pain Extractor for Horses" in 1868, John Williams and Henry H. Moore were sole agents. In 1880, Moore purchased the horse medicine and Tomlinson moved to Philadelphia (Wilson and Wilson 1971). Tomlinson apparently sold the formula, the same year, to L. L. Gifford, Philadelphia. Although Gifford resided in Philadelphia he was in the medicine business in Chicago between 1877 and 1880 with E. A. Sharpe; their firm was named Gifford & Sharpe. In 1880 Gifford moved to Chicago and from 1881–1885 the H. H. H. Medicine Co. and L. L. Gifford & Co., both located at 241 S. Water, Chicago, were listed in directo-

ries as proprietors of H. H. H. Medicine. From 1886–1901 the firm was listed as William Gifford & Co., 428 W. E. 12th, Chicago, proprietors of H. H. H. Medicine. Bottles in the 1920s were threaded and had bakelite caps. Gifford's H. H. H. Horse Medicine adv. 1907, *PVS & S*; Tomlinson's H. H. H. Liniment adv. 1948 by Aschenbach & Miller, Philadelphia, *AD*.
Amber, clear; 6¹/₄″ × ? × ?; 7n; 3b; 4ip, arched; v, fs. See GIFFORD (Medicine), MOORE (Remedy), NATIONAL (Liniment), WILLIAMS (Balsam).

**THE CELEBRATED/H. H. H.
HORSE/MEDICINE/D. D. T. 1868**
Aqua; 6¹/₂″ × 2¹/₈″ × 1³/₁₆″; 1n; 3b; 3ip, arched; v. See MOORE (Remedy), NATIONAL (Liniment), WILLIAMS (Balsam).

**THE CELEBRATED//H. H. H.//
HORSE MEDICINE//D. D. T. 1868**
Bottle manufactured ca. 1880 (Wilson and Wilson 1971).
Aqua; 6³/₄″ × ? × ?; 7n; 3b; 4ip; v, fbss. See MOORE (Remedy), NATIONAL (Liniment), WILLIAMS (Balsam).

**THE CELEBRATED/H. H. H.
HORSE/MEDICINE/D. D. T. 1868**
Bottle manufactured ca. 1898 (Wilson and Wilson 1971).
Aqua; 8¹/₄″ × ? × ?; 7n; 3b; 3 or 4ip, arched; v. See MOORE (Remedy), NATIONAL (Liniment), WILLIAMS (Balsam).

**THE CELEBRATED/H. H. H./
MEDICINE/D. D. T. 1868**
Label: *The Celebrated (D.D.T.) H. H. H. (1868) Liniment and Medicine (Contains 65¢ Ethyl Alcohol). The Reliable Remedy for those Ailments, both of MANKIND and of all Domestic Animals, for which it is recommended. Congestion in Chest from severe Colds and Coughs, Influenza . . . Bunions, Callous Lumps, Diarrhoea, Colic, Stomach-Cramps, Poisonous Bites and Stings, Toothache, Pain, Inflammation, etc., etc. Price 65 ¢ Per Bottle. See that the Trade Mark "H.H.H." is on every bottle, and the name H. H. Moore & Sons, Proprietors and Manufacturers, Stockton, California U.S.A.*
Clear; 8¹/₄″ × 2¹¹/₁₆″ × 1⁵/₈″; 8n; 3b; 3ip; v. See MOORE (Remedy), NATIONAL (Liniment), WILLIAMS (Balsam).

[h] GIFFORD/& CO./[v] H. H. H./
MEDICINE/[h] CHICAGO//THE
CELEBRATED//D. D. T. 1868
[See Figure 130]
Aqua; 6¹/₂″ × 2³/₁₆″ × 1³/₁₆″; 8n; 3b;

3ip; h, v, fss. See H.H.H. *(Medicine)*, MOORE (Remedy), NATIONAL (Liniment), WILLIAMS (Balsam).

Fig. 130

HALL'S/MEDICINE
Clear; 4¹/₂″ × 1⁵/₈″ diameter; 1n; 20b; pl; v; ABM. See HALL *(Cure)*.

HAMILTON'S/MEDICINES/CURE
[within a 7-point star]/AUBURN/NY
Bottle manufactured ca. 1890. Products of Albert H. Hamilton, Auburn, NY, included Hamilton's Bone Liniment, Corn Cure, Cough Mixture, Diarrhoea Cordial, Emulsion, and a Vegetable Lotion (Baldwin 1973). Products adv. 1879, *VSS & C*; 1907, *PVS & S*.
Aqua; 8³/₄″ × 2⁷/₈″ × 1¹/₂″; 7n; 3 or 6b; ip; h.

HAND MED. CO./PHILADELPHIA
[See Figure 131]
Clear; 5¹/₄″ × ? × ?; modified neck finish; 12b; 1ip; h, above and below ip. See HAND *(Miscellaneous)*.

Fig. 131

D. HARTSHORNS/MEDICINE
Bottle contained "Unadulterated Paragoric." Edward Hartshorn established his manufactury in Berlin, MA, in the 1850s (Lincoln 1973) and opened a Boston branch in 1867 (Shimko 1969).

The Berlin office was closed in 1895 when Edward sold the business to his son William H. (Lincoln 1973). Products adv. 1935 by E. Hartshorn & Son, Northampton, Mass., *AD*.
Color and dimens. unk.; 7n; 13b; pl; v. See BERLIN (Miscellaneous).

[v] D̠R̠ HARTSHORN'S/[h] FAMILY/ [v] MEDICINES/[embossed bull's-eye, center of vessel]
Aqua; 7¼″ × 2¾″ × 1⅜″; 11n; 12b; 2ip; v, h. See BERLIN (Miscellaneous).

[v] D̠R̠ HARTSHORN'S/[h] FAMILY/ [v] MEDICINES/[embossed bull's-eye, center of vessel]
Bottle manufactured ca. 1874 (Wilson and Wilson 1971).
Aqua; 9¼″ × ? × ?; 11 and 7n; 12b; 1ip; v, h. See BERLIN (Miscellaneous).

HASKIN MEDICINE CO.// BINGHAMPTON, N.Y.// HASKIN'S/NERVINE
See HASKINS (Nervine).

THE HAWKER MEDICINE C̠O̠ LTD/ HAWKER'S DYSPEPSIA CURE/ ST. JOHN. N.B.
See HAWKER (Company).

HERB MEDICINE CO.// SPRINGFIELD, OHIO//LIGHTNING HOT DROPS/NO RELIEF NO PAY
Cure for aches and pains, adv. 1900, *EBB*; 1948 by Herb Med. Co., 130 S. Limestone St., Springfield, O., *AD*; 1983 by Herb Med. Co., 915 Valley St., Dayton, O., *RB*.
Color & dimens. unk.; 1n; 3b; 3 or 4ip; v, ssf.

HERB MEDICINE CO//WESTON W. VA//LIGHTNING BLOOD ELIXIR/NO RELIEF NO PAY
Adv. 1900 by Herb Med. Co., Springfield, O., *EBB*; 1910, *AD*.
Aqua; 9½″ × ? × ?; ?n; 3b; pl; v, ssf.

HERB MEDICINE CO//WESTON W. VA//LIGHTNING KIDNEY AND LIVER CURE/NO RELIEF, NO PAY!
Adv. as Remedy, 1900, *EBB*; 1910, *AD*.
Aqua; 9¼″ × 2⅞″ × 1¹¹⁄₁₆″; 1n; 3b; 3ip; v, ssf.

DR. M. HERMANCE'S/ASTHMA MEDICINE/MFG'D. BY/CLAUDE A. BELL/LOWELL, MASS.
See BELL (Manufacturer).

DR HERNDON'S//GYPSEY'S GIFT// [monogram]/THAT IS/MEDICINE/ WHICH/CURES/BALT̠O̠ MD
See HERNDON (Cure).

HOBENSACK'S//MEDICATED/ WORM SYRUP/PHILAD̠A̠
See HOBENSACK (Syrup).

HOME MEDICINE CO./CHICAGO ILLS. [Base:] W.T. & Co/USA
[See Photo 32]
Label: *The HOME FRUIT JUICE LAXATIVE* – this mild, but effective Laxative and Cathartic exerts a specific action in all cases of Constipation, Headache, Liver Complaint, Indigestion, Etc. Directions . . . *THE HOME MEDICINE CO. CHICAGO, ILLINOIS*. Bottle manufactured by Whitall-Tatum, 1857 to 1935 (Toulouse 1972). Chicago directories included the firm in 1894 only.
Aqua; 7¼″ × 2⁵⁄₁₆″ × 1⅛″; 9n; 3b; 4ip; embossed oval panel, arched back panel; v.

HORSE SHOE MEDICINE CO/ [embossed running horse]/ COLLINSVILLE/ILLS//W/HORSE SHOE BITTERS [Base:] PATENT APPLIED FOR
See HORSE SHOE (Bitters).

FRANKLIN HOWES/MEDICAL DISCOVERY/THE GREAT BLOOD PURIFIER/NEW YORK/ REGISTERED
See HOWE (Discovery).

HUMPHREYS/HOMEO MED CO
[See Figure 132]
The Pharmaceutical Record, 8 Oct. 1891, showed the company at 111 & 113 William and 61, 63 & 65 John Streets, New York City. Products included Humphreys' Specifics, Veterinary Specifics, Special Prescriptions, Witch Hazel Oil and Marvel of Healing and Aconite 3.
Amber; 2½″ × ¾″ × ¾″; 3n; 2b; pl; v. See HUMPHREY (Miscellaneous, Specific).

Fig. 132

HUMPHREYS' MEDICINE CO/ [embossed horse in circle]/TRADE MARK/NEW YORK
Clear; 4½″ × 2¾″ × 2¾″; 7n, large mouth; 1b; pl; h. See HUMPHREY (Miscellaneous, Specific).

[h] JACKSON'S/ABORIGINAL/ [embossed Indian]/AMERICAN/ MEDICINES/[v along front sides:] J. D. GOLDBOROUGH/ SOLE PROPRIETOR
T. H. Jackson's cures, New York, adv. 1883, 1916.
Green; 9″ × ? × ?; 20n; 12b?; pl; h, v; p.

K. K. MEDICINE CO//NEW JERSEY//K. K./CURES/BRIGHT'S/ DISEASE/AND/CYSTITIS
See K. K. (Company).

KKK//KKK MEDICINE CO.// KEOKUK, IOWA
See KKK (Company).

[Embossed circle:] KASKARA/ MEDICINE CO./CHICAGO
See KASKARA (Company).

D̠R̠ KENNEDY'S//MEDICAL DISCOVERY//ROXBURY MASS
See KENNEDY (Discovery).

LANE'S MEDICINES ARE GOOD/ CHAS. E. LANE & CO./ ST. LOUIS, MO.
Medicinals included Lane's Catarrh Cure, Family Medicine, Malarial Cure, Smallpox Cure and Rheumatism Cure; products adv. 1887, *Harper's Weekly*; 1923, *SF & PD*.
Aqua; 5″ × 1¹⁵⁄₁₆″ × 1⅞″; 1n; 12b; pl; v.

DEAN'S/KIDNEY CURE/ THE LANGHAM MED. CO/ LEROY, N.Y.
See DEAN (Cure).

A. H. LEWIS MEDICINE CO./ ST. LOUIS, MO. [See Figure 133]
August Henry Lewis and James H. Howe moved to St. Louis, from Bolivar, MO, in 1901. When Lewis died in 1928 the firm employed 300 people (Blasi 1974). When Lewis and Howe established their business in Bolivar, MO is not known. Products included Nature's Remedy, adv. 1900, *EBB*; 1948 by Lewis-Howe Co., 4th & Spruce Sts., St. Louis, Mo., *AD*.
Clear; 5⅞″ × 1¹¹⁄₁₆″ × ⅞″; 8n, sp; 3b; 4ip; v.

Fig. 133

A.H.LEWIS MEDICINE CO.
ST. LOUIS, MO.

**BAKER'S/VEGETABLE/
BLOOD & LIVER/CURE/
LOOKOUT/MOUNTAIN/
MEDICINE CO/MANUFACTURERS/
&/PROPRIETORS/**[below panel:]
GREENEVILLE/TENN.
See BAKER *(Cure)*.

**LORENTZ MED. CO.//TRADE
"TO-NI-TA" MARK** [See Photo 33]
Label: *D'ARTAGNAN TO-NI-TA BIT-
TERS, Contains Alcohol 23 Per Cent.
Guaranteed by the Erie Distilling Co.,
under the National Pure Food & Drug Act,
June 30, 1906. ERIE DISTILLING CO.,
BUFFALO, N.Y. . . . An Invigorating
and Stimulating Tonic.* . . . Adv.
1897–1919 (Ring 1980).
Amber; 3³/₄″ × 1¹/₄″ diameter, also
9³/₄″ × 2¹³/₁₆″ diameter; 11n; 20b; pl;
h, bf on shoulder.

**MAGUIRE/MEDICINE COMPANY/
Sᵀ LOUIS. MO.**
Label: *J & C Maguire's Extract of Benne
Plant and Catechu Compound. Guaranteed
Under the Pure Food & Drug Act of 1906.
A Valuable Remedy For Diarrhoea, Dysen-
tery, Cholera Morbus, Summer Complaint,
etc. Same Formula Since 1846.* . . .
Extract adv. 1918 (Devner 1968).
Products also included Maguire's Cun-
durango Bitters and Expectorant Syrup.
The J & C Maguire Medicine Company
was established in 1841 by James and
Constantine Maguire (Blasi 1969).
Aqua; 5⁵/₈″ × 2¹/₄″ × 1¹/₄″; 11n; 3b;
pl; h.

**J & C MAGUIRE/MEDICINE C./
Sᵀ LOUIS.**
Light aqua; 5¹/₂″ × 2¹/₈″ × 1³/₁₆″; 11n;
3b; pl; v.

**J. & C. MAGUIRE'S/FAMILY
MEDICINES/MAGUIRE MEDICINE
CO./SOLE PROPRIETORS/
ST. LOUIS.**

Amber; 8³/₁₆″ × 2¹¹/₁₆″ × 1⁷/₈″; 11n;
3b; pl; v.

**4ᴼᶻ/MARCHAND'S/PEROXIDE/
OF/HYDROGEN/(MEDICINAL)
NEW YORK/U.S.A.**
Adv. 1897, *L & M*; 1948 by Charles
Marchand Co., 521 W. 23rd St., New
York City, *AD.*
Amber; 5¹/₂″ × 2¹/₈″ diameter; 3n;
20b; pl; h. See GLYCOZONE *(Miscel-
laneous)*, HYDROZONE (Miscellaneous).

**DR. MARKLEY'S//FAMILY/
MEDICINES,//LANCASTER, PA**
Aqua; 7¹/₈″ × 2¹/₈″ × ?; 1n; 3 or 6b; 3
or 4ip; v, sfs; p.

[Script:] **Mastico Medicine Co/
Danville, Ills.//Gladstone's Celery/
And Pepsin Compound**
See GLADSTONE *(Compound)*.

**Dᴿ J. M'CLINTOCK'S//FAMILY//
MEDICINES**
Labeled as Rheumatic Liniment, adv.
1854 (Baldwin 1973). Vessel also con-
tained other products.
Clear; 7¹/₄″ × 2³/₈″ × ?; 11n; 3b; 3 or
4ip; v, fss; p; several sizes.

**Dᴿ Jᴬˢ M'CLINTOCK'S//FAMILY//
MEDICINES**
Labeled as Pectoral Syrup, adv. 1854
(Baldwin 1973); 1871, *WHS.*
Clear; 8³/₈″ × 3¹/₁₆″ × 2″; 11n; 3b; 3ip;
v, fss; p.

[Script:] **McKesson & Robbins/
New York//Medicinal Solution/of
Pyrozone/3% H₂O₂/**
Pyrozone adv. 1895, *McK & R*; 1948,
AD.
Amber; 5¹/₈″ × 1¹¹/₁₆″ × 1¹¹/₁₆″; 7n;
2b; pl; v, fb, script. See McKESSON &
ROBBINS *(Miscellaneous)*.

**DR. E. E. McLEAN'S/MEDICATED/
HAIR TONICS/SAN FRANCISCO,
CAL.**
See E. E. McLEAN *(Tonic)*.

**NONE GENUINE/WITHOUT THE/
NAME/**[script:] **Liebigs/BEEF/WINE
& IRON/PREPARED BY/THE
MEDICATED TABLET CO./
CHICAGO, ILL.**
See MEDICATED *(Tablet)*.

TO-KA//BLOOD/TONIC [Base:]
MEX. MED. CO.
See MEX. *(Company)*.

**VANS MEXICAN HAIR
RESTORATIVE/MANUFACTURED
ONLY BY THE/MEXICAN
MEDICINE CO./CHICAGO, U.S.A.**
See MEXICAN *(Company)*.

DR. MILES/MEDICAL CO.
[Base: P in circle]
Label: *DR. MILES' CACTUS
COMPOUND—Contains 11 per cent
alcohol. Prepared at the Dr. Miles Medical
Co.'s Laboratory, Elkhart, Ind.* Adv.
1929–30, *AD.* This product was
removed from the market in 1938,
according to Donald N. Yates,
Archivist, Miles Laboratories, Inc.
(personal communication, 1984).
Aqua; 8¹/₄″ × 2¹¹/₁₆″ × 1³/₈″; 1n; sp;
3b; 1ip; v; ABM. See MILES *(Cure,
Nervine, Purifier, Sarsaparilla, Tonic)*.

[h] **Dᴿ MORGRIDGE'S/**[v]
VEGETABLE/[standing Indian]/
FAMILY/[h] **MEDICINES**
Aqua; 6¹/₂″ × 2³/₈″ × ?, also
7¹/₈″ × 2⁵/₈″ × ?; 7n; 12 or 13b; pl; h,
v; p.

N. Y. MEDICAL//UNIVERSITY
J. Walter Scott, an allopathic physician,
established his New York Medical
University ca. 1868; his widow, Jane,
assumed control in 1875 and subse-
quently called it the University Med.
Co. Products included Ethereal
Phosphorous for Nervous Debility,
5 Minute Pain Curer, and Amaranth for
the Hair (Wilson and Wilson 1971).
Cobalt; 7¹/₂″ × 2¹/₂″ × 1¹/₄″; 8n; 3b; pl;
v, ss. University embossed with back-
wards S.

[h] [Embossed bird]/**TRADE MARK/**
[v] **OZARK EYE/STRENGTHENER/
OZARK MED. CO./
SPRINGFIELD, MO.**
See OZARK *(Company)*.

**PACIFIC MEDICAL COMPANY/
SHELTON, NEB.** [See Figure 134]
Box label: *. . PACIFIC BLOOD PURI-
FIER, The Great Vegetable Remedy and
Purifier of the Blood and System. A Tonic,
Cleanser and Invigorator. $1.00 per bottle.*

Fig. 134

PACIFIC MEDICAL COMPANY.
SHELTON, NEB.

Corporate seal is dated 1897. Other products included Pacific Cough Tablets, Cough Cure, Fruit Syrup, Bone Liniment, Rheumatic Remover, Kidney Cure, Polar Pills, Catarrh Cure, Cholera Cure, Pain Cure Liniment, Household Liniment and Household Perfect Polish.

Aqua; $7^{1}/_{16}$″ × $2^{5}/_{16}$″ × $1^{1}/_{8}$″; 7n; 3b; 4ip, oval front; v.

GROVES TASTELESS/CHILL TONIC PREPARED BY/PARIS MEDICINE CO./ST. LOUIS.
See GROVE (Tonic).

PAWNEE BITTERS/PAWNEE/ INDIAN MEDICINE CO./S. F.
See PAWNEE (Bitters).

DR PIERCE'S/GOLDEN/MEDICAL DISCOVERY//R. V. PIERCE, M.D.// BUFFALO, N.Y.
See PIERCE (Discovery).

[h] $14^{1}/_{2}$ OZS./[v] LYDIA E. PINKHAM'S/MEDICINE [Base:] MADE IN U.S.A./[O over diamond]
Label: Lydia E. Pinkham's Vegetable Compound, Contains 15% Alcohol, Prepared by Lydia E. Pinkham Medicine Co., Lynn, Mass. U.S.A., "... in use for over 50 years." Bottle manufactured by the Owens Illinois Glass Co. after 1929 (Toulouse 1972). Label also recommends Lydia E. Pinkham's Pills and Vegetable Compound.
Clear; $8^{1}/_{8}$″ × $3^{5}/_{16}$″ × 2″; 16n; 13b; pl; h, v; ABM. See PINKHAM (Compound, Purifier).

PINUS MEDICINE CO.// MONTICELLO, ILL. U.S.A.// FRITOLA [Base: diamond]
See PINUS (Company).

PINUS MEDICINE CO// MONTICELLO, ILL. U.S.A.// TRAXO [Base: P in circle]
See PINUS (Company).

[Script:] Rawleigh's/TRADE MARK// W. T. RAWLEIGH MED CO// FREEPORT, ILL.
See RAWLEIGH (Trade Mark).

REAKIRT'S/MEDICATED// BREAST JULAP
Aqua; $5^{3}/_{16}$″ × $1^{7}/_{8}$″ × $1^{1}/_{4}$″; 11n; 4b; pl; v; fb; p.

ZEMO CURES ECZEMA/ E. W. ROSE MEDICINE CO./ ST. LOUIS//ZEMO CURES PIMPLES/AND ALL DISEASES OF THE/SKIN AND SCALP
See ZEMO (Cure).

DR. SALISBURY'S/ FAVORITE MEDICINE
Aqua; $6^{1}/_{4}$″ × 2″ × $1^{1}/_{4}$″; 9n; 3 or 6b; ip, oval front; v.

SCHROEDER'S MED. Co// WOODCOCK/PEPSIN BITTERS
See WOODCOCK (Bitters).

SEMINOLE INDIAN/MEDICINE CO./BOONE, IA.
See SEMINOLE (Company).

SEMINOLE INDIAN MED. CO./ LUNG BALM/BOONE, IOWA
See SEMINOLE (Company).

DR. SHOOP'S FAMILY MEDICINES//RACINE, WIS.
Numerous products included several cures, pills, salves, tablets and a panacea, restorative and sarsaparilla. Charles Irving Shoop started his business in the late 1880s (Wilson and Wilson 1971). The Dr. Shoop Family Med. Co. first appeared in the Racine, WS, city directories in 1892; by 1912 the company was listed as Dr. Shoop Laboratories, Inc. (Shimko 1969). Products adv. 1929–30 by Shoop Labs., Racine, Wis.; 1941–42 by McCullough Drug Co., Lawrenceburg, Ind., AD.
Aqua; $6^{3}/_{8}$″ × $2^{3}/_{16}$″ × $1^{1}/_{16}$″, also $5^{1}/_{2}$″ × $1^{7}/_{8}$″ × $7/_{8}$″; 7n; 3b; pl; v, ss. See SHOOP (Miscellaneous).

DR. SHOOP'S/FAMILY MEDICINES//RACINE, WIS.
Label: Dr. Shoop's Rheumatic Remedy, a Treatment for Rheumatism, Rheumatic and Neuralgic Pains, Swollen Joints. . . . Prior to 1905, this remedy was known simply as Shoop's Rheumatic Cure (Devner 1968). Remedy adv. 1921, BD.
Aqua; $6^{7}/_{8}$″ × $2^{3}/_{8}$″ × $2^{3}/_{8}$″; 7n; 2b; 4ip; v, fb. See SHOOP (Miscellaneous).

DR. SHOOP'S/FAMILY MEDICINES//RACINE, WIS.
Label: Dr. Shoop's Rheumatic Remedy. . . .
Aqua; 7″ × ?; 7n; 2b; 2ip; v, fb. See SHOOP (Miscellaneous).

SPOHN'S DISTEMPER COMP./ SPOHN MEDICAL COMPANY/ GOSHEN, INDIANA, U.S.A.
[Base: I in diamond]
See SPOHN (Compound).

SPOHN'S/DISTEMPER CURE/ SPOHN MEDICAL CO./ GOSHEN, IND.
See SPOHN (Cure).

THE E. E. SUTHERLAND/ MEDICINE CO./PADUCAH, KY.// DR. BELL'S//PINE, TAR, HONEY
See SUTHERLAND (Company).

SWAMP A. MED. CO//WASH. D.C.
Swamp Angel medicine was an Atlanta, GA, product in 1894 (Baldwin 1973); the affiliation with Washington, DC, is unknown. Swamp Angel Rheumatic Cure adv. 1895, PVS & S; Swamp Angel Liver Pills, 1900, EBB.
Aqua; $8^{1}/_{4}$″ × $2^{1}/_{2}$″ diameter; 7n; 21b, 10 sides; pl; h, fb on shoulder.

SYMPATHICK//LAPIERRE'S// GENUINE/MEDICINE
Aqua; 5″ × $1^{1}/_{2}$″ × $1^{1}/_{2}$″; 5n; 2b; pl; v, fsbs; p.

[h] 200 MILS/[v] MEDICAL/ DEPARTMENT/U. S. NAVY
Clear; 6″ × 2″ × 2″; 9n; 2b; pl; h, v.

UNITED STATES/MEDICINE CO/ NEW YORK
See UNITED STATES (Company).

UNIVERSITY OF/FREE MEDICINE/ PHILADA
Label: University's Remedy For Complaints Of The Lungs. The University of Free Medicine & Popular Knowledge Chartered in 1853. Adv. 1855 (Singer 1982). Numerous products adv. 1879, VSS & C.
Color unk.; 6″ × $2^{1}/_{8}$″ diameter; 5n; 21b, 6 sides; pl; v; p. See ROWLAND (Tonic).

[Script:] Vose's Celebrated Pile/ Dysentery & Cholera/ Vegetable Medicine/Albany N.Y.
Possibly related to a product of Dr. F. Vose & Co., Rochester, NY; adv. 1863–1864 (Baldwin 1973).
Aqua; $7^{1}/_{4}$″ × 3″ × ?; 7n; 12b; pl; v, script; p.

DR. WARD'S/MEDICAL COMPANY//5 OZ. FULL MEASURE//WINONA, MINN.
See WARD (Company).

WATKINS FACE CREAM/ J. R. WATKINS MED. CO./ WINONA, MINN.
See WATKINS (Company).

THE DR. H. F. WEIS MEDICINE CO./GUARD ON THE RHINE/ STOMACH BITTERS/DAYTON, OHIO [Base:] W.T. CO/U.S.A.
See GUARD ON THE RHINE (Bitters).

DR. BOCK'S RESTORATIVE TONIC/MANUFACTURED BY/ S. H. WINSTEAD MEDICINE CO.
See BOCK *(Tonic).*

DR YELLS/COUGH/MEDICINE
[Base:] **W T & CO/U.S.A.**
Bottle manufactured by Whitall-Tatum, 1857–1935 (Toulouse 1972).
Aqua; 5³/₄″ × 2¹/₁₆″ × 1³/₁₆″; **7n; 3b; 4ip; v.**

ZOELLER MEDICAL/MFG. CO./ PITTSBURGH, P.A., U.S.A.// ZOELLER'S/KIDNEY REMEDY
See ZOELLER *(Company).*

MISCELLANEOUS

[h] **A. D. S./514/[v] 24**
[See Photo 34]
Label: *A. D. S. IRON TONIC BITTERS—ALCOHOL 20%. A COMPOUND OF IRON AND CALISAYA BARK—EXCELLENT AS AN APPETIZER AND GENERAL TONIC . . . AMERICAN DRUGGISTS SYNDICATE, LABORATORIES, NEW YORK, N.Y.* Products adv. 1905, 1918: Shampoo, Toilet Water, Foot Tablets, Headache Wafers, Hair Reviver, Sarsaparilla (Devner 1968, 1970); 1935, *AD.*
Clear; 8¹/₄″ × 3″ × 2¹/₁₆″; **24n; 9b, tapered corners; pl; h, v, on base; tapered sides; ABM.**

ABSORBINE JR//4ᴱᴸ OUNCES
[Base:] **W. F. YOUNG P. D. F./ SPRINGFIELD, MASS./U.S.A.**
Absorbine, a cure all and product of W. F. Young, Meriden, CT, was introduced in 1892; operations were moved to Springfield, MA, ca. 1896. Absorbine Jr. was introduced ca. 1910, the bottles embossed until the 1930s. The same firm was marketing the product in 1984 according to Kenneth Alexander of W. F. Young (personal communication, 1984).
Clear; 5″ × 1⁷/₈″ diameter; **9n; 20b; pl; h, fb, on shoulder and base.**

ACEITE/MEXICANO
Bottle manufactured ca. 1910. This Mexican oil was a product of the Hausman Drug Company, Trinidad, CO. Adv. 1921, *BD.*
Light blue; dimens. unk.; **1n; 3b; ip; base.**

ALBOLENE/(REGISTERED)
[See Figure 135]
Adv. 1889, *PVS & S*; 1929–30 and 1948 by McKesson & Robbins, Bridgeport, Conn., *AD.*
Clear; 8″ × 2¹/₂″ × 2¹/₂″; **9n; 2b; pl; v.**

Fig. 135

ALEXANDER'S//TRICOBAPHE// R & G. A. WRIGHT//PHILADᴬ.

Product claimed to change hair color instantly. Adv. 1845 (Putnam 1968); 1871, *WHS*.

Aqua; 2½″ × ?; 13n; 21b, 6 sides; pl; v, sss; p. See R. & G. A. WRIGHT (*Miscellaneous,* Water).

MRS S. A. ALLEN'S//NEW YORK

[Base:] V. D. & R./LONDON

Amber; 7¼″ × ? × ?; 1n; 3b; 3ip; v, ss. See MRS. ALLEN (Balsam, *Restorer*).

ANDERSON'S/DERMADOR

Prof. H. Anderson's Dermador was promoted as ". . . one of the greatest triumphs of chemical science . . . a Liniment for Wounds, Sores, Bruises, Sprains, Burns, Rheumatic Pain, Muscular Lameness, Chillblains, External Inflammations, &c . . . No Blistering– No Grease–No Wood Alcohol. Price 25 and 50 cents." A testimonial by Homer Anderson said he would probably introduce the product to the public in 1848. D. Ransom had control by 1876, possibly earlier (Holcombe 1979). Adv. 1850 (Baldwin 1973); 1948 by D. Ransom, Buffalo, N.Y., *AD*.

Aqua; 5½″ × 2½″ diameter; 11n; 20b; pl; h; p. Several sizes and variants with and without p. See MILLER (Balm), RANSOM (*Company*), TRASK (*Ointment*).

Dᴿ N. ANGELL'S/RHEUMATIC GUN

Label: *ANGELL'S RHEUMATIC GUN –60% Alcohol. For Inflammatory Rheumatism, Sciatica, Chronic Rheumatism, Neuralgia & Nervous Rheumatism.* No address. Adv. 1877, *McK & R*; 1910, *AD*.

Clear; 6½″ × 2⁷/₁₆″ × 1⁷/₁₆″; 7n; 3b; 4ip; v.

Dr. N. ANGELL'S/RHEUMATIC GUN

Aqua, clear; 7″ × 2⅝″ × 1½″; 1n; 3b; 4ip; v.

ANGIER'S/PETROLEUM/ EMULSION

Label: . . . *a Remedy for the Throat and Lungs and Diseases of the Digestive Apparatus, Useful in General Debility and Wasting Diseases.* Adv. 1889, *PVS & S*; 1929–30 and 1941–42 by Angier Chemical Co., 244 Brighton Ave., Allston Station, Boston, Mass., *AD*. Directories last listed the firm in 1960.

Aqua; 7″ × 2½″ × 1⅜″; 3n; 12b; 1ip; base. See EMULS (Miscellaneous).

E. ANTHONY//501, BROADWAY/ NEW YORK

Bottles contained daguerreotype materials, not medicine. Edward Anthony, located at 205 Broadway until 1856, was joined by Henry T. Anthony and moved to 308 Broadway. In 1861 the pair was listed as photographic suppliers, relocated to 501 Broadway; in 1870, 591 Broadway. Directories last included the company in 1892.

Aqua; 5¾″ × 2¼″ × 2¼″; 1 and 5n; 2b; pl; v, fb.

E. ANTHONY/501/BROADWAY/ N.Y.

Aqua; 5¹¹/₁₆″ × 2″ diameter; 7n; 20b; pl; h.

E. ANTHONY/NEW YORK

Aqua; 6¼″ × 2¼″ × 2¼″; 1n; 2b; pl.

ANTI-URIC/NEW YORK SAN FRANCISCO/PEORIA

Label from 8-ounce bottle: *ANTI-URIC–Alcohol 19%–Valuable in Many Cases of Rheumatism, Gout, Sciatica, Lumbago and General Uric Acid Conditions–Price $1.50. ANTI-URIC COMPANY, 32 Front St., Cor. Pine, San Francisco, Cal.* Introduced ca. 1915 (White 1974); adv. 1916, *MB*; 1948 by Anti-Uric Co., 42 Second St., San Francisco, *AD*.

Color & dimens. unk.; 9n; 12 or 18b; pl; embossed order unk., SAN FRANCISCO in larger lettering.

ANYVO//MAKE UP

Adv. 1915, *SF & PD*.

Cobalt; 5″ × 1¹⁵/₁₆″ × 1¼″; 7n; 3b; 1ip; v, ss.

ERNEST L. ARP/[monogram in cross]/KIEL

Label: *Arp's STOMACH BITTERS, Alcohol 32%. World Exposition 1878, Kiel, Germany, Trade Mark issued 1884.* Adv. 1915, *C & C*.

Amber; 11¾″ × 3″ diameter; 1n; 20b; pl; v; distinctive shape. See ARP (Bitters).

ERNEST L. ARP/[monogram in cross]/ KIEL [See Figure 136]

Aqua; 12½″ × ?; 18n; 20b; pl; h within circle; distinctive shape. See ARP (Bitters).

Fig. 136

ASCHENBACH & MILLER/ PHILADA [See Figure 137]

Label: *BIRD BITTERS, Alcohol 20%. Add One Drop to Birds Water. The Result is a Very Cheery, Singing Bird. Philadelphia Bird Food Co., Aschenbach & Miller, 400 N. 3rd St., Philadelphia.* Also: *P. B. F. BIRD BITTERS . . . To impart new life and vitality to your bird and to bring out his song, put a few drops of Bird Bitters in his drinking water. This remedy is particularly valuable when your bird in languid and sings seldom and during the mouting season. Food For Song. Since 1882. Phila. Bird Food Co., 339–341 N. 4th St. Phila. Pa. Alcohol 26%, 20 minims ether to each fluid ounce.*

Adolph William Miller and Frederick Aschenbach each purchased an interest in a Philadelphia drugstore in 1862; by 1864 the pair controlled the firm calling it Aschenbach & Miller. Gradually the business was changed from retail to wholesale manufacturing and importing. "Today, 122 years later, our company remains one of the oldest family run drug manufacturing businesses in the area," Martie S. Helweg, Secretary, Aschenbach & Miller, Inc., Philadelphia, PA (personal communication, 1984). Bitters adv. 1901 by Aschenbach & Miller (The Bird Food Co., 400 N. 3rd), *HH & M*; 1929–30, by Aschenbach & Miller, Northwest Corner, 3rd & Callowhill St., also the Philadelphia Bird Food Co., 400 N.

3rd; 1941–42 and 1948 by Aschenbach & Miller and the Philadelphia Bird Food Co., both at 346 N. Orianna St., *AD*.
Clear; 4³/₄″ × 1⁹/₁₆″ × ³/₄″; 7n, sp; 3b; 4ip, embossed arched panel; v.

Fig. 137

ATHENSTAEDT & REDEKER/ HEMELINGEN b BREMEN
Label: *Athenstaedt's Formula Tincture of Iron, 16% Alcohol. An Efficient Tonic, Invigorating and Pleasant to Take. Lehn & Fink, New York.* Adv. 1887, *WHS*; 1921, *BD*.
Amber; 9¼″ × 3¼″ × 2¼″; 4n; 12b; pl; v.

[Script:] A-theuca-ine//DENVER POULTICE//DENVER POULTICE
Label: *A-theuca-ine, Burdick's Inflammation Special—For Internal & External Pain . . . The Liquid Poultice Medical Co., Inc., Denver, Colo. Guaranteed Under Food & Drug Act, June 30, 1906. Serial No. 8815.* Adv. 1917, *BD*; 1941–42 by Denver Mud Co., Inc., Denver, Colo., *AD*.
Aqua; 8¼″ × 2⁵/₈″ × 1¼″; 11n; 3b; 3ip; d, f; v, ss; some script.

ATHLOPHOROS//R. N. SEARLES
Label: *. . . for Muscular Aches & Pains due to Rheumatism, Simple Neuralgia, Simple Headache. E. Newton Searles, Prop., Pomfret Center, Conn.* Adv. 1887, *WHS*; 1901 by Athlophoros Co., New Haven, Conn., *HH & M*; 1929–30 and 1948 by Athlophoros Co., Pomfret Center, Conn., *AD*.
Aqua; 6³/₈″ × 2¼″ × 1¹/₈″; 1n; 3b; 2ip; v, ss; ABM.

DR. A. ATKINSON//NEW YORK
Bottles contained an Extract Stillingia & Potassium, various other products and purportedly a blood purifier. Dr. Asher Atkinson was an established botanic physician in 1835 and by 1860 was operating three clinics; Atkinson retired around 1870 (Wilson and Wilson 1971).
Aqua; 8″ × ? × ?; 11n; 3b; pl; v, ss; p.

AYER [See Figure 138]
This bottle was still being utilized in 1893 according to an illustration in the *Salt Lake Tribune*. The successor, distinctively shaped, in cobalt and peacock blue, was still in use in 1919 (Shimko 1969). An advertisement in the *New Hampshire Register, Farmer's Almanac & Business Directory, 1871* reads: "AYER'S HAIR VIGOR—For Restoring Gray Hair to its natural Vitality & Color. Prepared by Dr. J. C. Ayer & Co., Practical & Analytical Chemists, Lowell, Mass. $1.00." The Hair Vigor was introduced in 1867 (Wilson and Wilson 1971) and was advertised in 1929–30, *AD*.
Aqua; 7½″ × 3¹/₈″ × 1½″; 1n; 13b; pl; base. See AYER (*Cure,* Hair, Pectoral, Pills, Sarsaparilla).

Fig. 138

AYER'S//SENOPOS//SENOPOS// LOWELL/MASS, U.S.A.
Label: *SENOPOS Do Dr. AYER—For The Treatment of Constipation, Digestive Disorders*
Aqua; 5¹⁵/₁₆″ × 2″ × 1¹/₈″; 1n; 3b; 4ip; h, f; v, ssb. See AYER (*Cure,* Hair, Pectoral, Pills, Sarsaparilla).

B. B. B.//ATLANTA GA
Label: *Botanic Blood Balm For all Blood Humors. Mfg. by Blood Balm Co. Phila. & St. Louis.* From the *Lexington Progress*, Lexington, TN, 31 May 1901: "'Blood Balm kills or destroys the Syphilitic Poison in the Blood and expels it from the system, making a perfect cure. B. B. B. thoroughly tested for 30 years,' Blood Balm Co., Atlanta, Ga." Adv. 1887, *WHS*; 1935 by Wm. R. Warner, New York City, *AD*.
Amber; 8½″ × 3½″ × ?; 11n; 3b; 4ip; v, ss.

B. B. B./NEW YORK ST. LOUIS
Amber; dimens. unk.; 11n; 3b; 1ip; v; ABM.

BABY EASE
Adv. 1900, *EBB*; 1913, *SN*.
Aqua; 6⁷/₈″ × 2⁵/₁₆″ × 1¼″; 1n; 3b; 4ip; v.

Wᴹ A BACON/LUDLOW, VT.
Bottle contained Jamaica Ginger. William A. Bacon also produced Excelsior Hair Oil, both for a short while in late 1856–1857 (Wilson and Wilson 1971). Bacon was a newspaper man, entering that business in 1854. In 1874 he was still affiliated with the newspapers. It is presumed that the medicine business was a brief side venture. Information from *History of Windsor Co., Vt.*, by L. C. Aldrich & F. R. Holmes, 1891.
Aqua; 5¼″ × 2″ × 1″; 11n; 13b; pl; v; p.

BAER BROTHERS/NEW YORK
Trow's New York City directories indicated Abraham and Max Baer manufactured powders, including a Bronze Powder, 1892 to 1931 or later.
Clear; 4³/₄″ × 1³/₄″ × ⁷/₈″; 9n; 13b; 1ip; v.

DR. BAKER'S//PAIN/PANACEA
Product of Albert R. Baker, Cincinnati; Amon Scovill was sole agent. About 1855 Scovill made Baker a junior partner (Wilson and Wilson 1971). Adv. 1860, *CNT*; 1901 by H. Planten & Son, 224 William St., New York City, *HH & M*; 1929–30 by H. Planten & Son, 93 Henry St., Brooklyn, N.Y., *AD*. H. Planten & Son, "The Pioneer American Capsule House" was established in 1836, *HH & M*.
Aqua; 5″ × 1³/₄″ × 1¹/₈″; 1n; 3b; ip; h, fb; p. See BENNETT (*Cure*), BRANT (*Balsam*), HALL (*Balsam*), J. F. HENRY (*Company*), SCOVILL (*Company*, Syrup), WARREN (*Cordial*, Remedy).

BALDWIN'S/CELERY SODA
[See Figure 139]
Label: *. . . for Headache, Nervousness & Seasickness. Manufactured by Edward L. Baldwin Co., 8 Market St., San Francisco.* Adv. 1900, *EBB*; 1921, *BD*.
Amber; 3¹⁵/₁₆″ × 1⁹/₁₆″ diameter, also 5⁹/₁₆″ × 2¹/₈″ diameter; 3n; 20b; pl; v.

B//a//r//b//a//s//o//l. [Base:] D. PAT. NO: 81937/REG U.S. PAT. OFF./A [in circle]
Adv. 1923 (Periodical Publishers Association, 1934); 1948 by The Bar-

basol Co., Indianapolis, Ind., *AD*.
Clear; $2^1/2'' \times 2^3/4''$ diameter; 17n; 21b, 8 sides; h.

Fig. 139

BARBERS/EMBROCATION
Aqua; $6'' \times 2^3/8'' \times 1^3/8''$; 12n; 3b; pl; v; p.

DR. G. BARBER'S// INSTANTANEOUS/RELIEF// FROM PAIN
Product attributed to Dr. George Barber, New York. Barber's Rheumatic Diapent adv. 1854 (Baldwin 1973).
Aqua; $4^7/8'' \times 1^5/8'' \times {}^{15}/16''$; 11n; 3b; 3ip; v, sfs; p.

[h] REGISTERED/[v] WM JAY BARKER/HIRSUTUS/NEW YORK
Adv. 1887, *WHS*; 1948 by Wm. Jay Barker, 160 E. 127th St., New York City, *AD*.
Clear; $6^7/8'' \times 2^5/8'' \times 1^3/16''$; 7n; 5b, round corners; 1ip; h, v. Also 3b variant of unk. dimens.

BARNIZ [Base:] WT & CO
Bottle manufactured by Whitall-Tatum, Millville, NJ, 1857 to 1935 (Toulouse 1972). Adv. 1929–30 and 1948 by Hausman Drug Co., Inc., 122 W. First St., Trinidad, Colo., *AD*.
Milk glass; $4^5/8'' \times 2'' \times 1^1/4''$; 9n; 3b; pl; v.

BARRY'S/TRICOPHEROUS/ NEW YORK, U.S.A.
Aqua; $6^1/4'' \times 2^1/16'' \times 1^3/16''$; 11n; 3b; pl; v; ABM. Also non-ABM variant. See BARRY (Cream, *Hair*).

J. A. BAUER/S. F. CAL.
John Bauer products included Martinelli Liniment, manufactured ca. 1860–1890 (Wilson and Wilson 1971).
Lime green; $8^1/2'' \times ? \times ?$; 7n; 3 or 6b; 3 or 4ip; v.

X. BAZIN/PHILADA
Xavier Bazin, Perfumery, Philadelphia, PA, was established in the 1850s; sons Felix and Charles joined the firm in the early 1870s; the business was liquidated in 1887 (Wilson and Wilson 1971). Products were awarded medals at the London's Worlds Fair in 1851 (Fike 1965); others such as smelling salts adv. 1922, *RD*, producer unk.
Clear; $3^1/4'' \times ? \times ?$; 5n; 6b; pl; v.

X. BAZIN/PHILADA
Contained toilet water or cologne. X. Bazin Depilatory (H & R) adv. 1925, *BWD*.
Clear; $6'' \times ? \times ?$; 7n; 4b; pl; v.

BEEBE'S/WHITE PINE AND TAR
Clear; $7^3/4'' \times 2^1/8'' \times 1^1/8''$; 7n, sp; 3 or 6b; ip; v.

BEETHAM'S/GLYCERINE &/ CUCUMBER
Label: *BEETHAM'S GLYCERINE & CUCUMBER IS SUPERIOR TO EVERY OTHER PREPARATION FOR RENDERING THE SKIN, SOFT, SMOOTH, and WHITE . . . sole makers, M. BEETHAM and SON, Chemisto, Cheltenham.* Adv. 8 Dec. 1883, 16 Aug. 1913, *The Illustrated London News.*
Aqua; $4^3/8'' \times 1^5/8'' \times {}^7/8''$; 3n; 3b; pl; v.

BEETHAM'S/GLYCERINE & CUCUMBER [Base: 3-pronged spear]
Clear; $6'' \times 2^1/4'' \times 1^3/8''$; 9n; rect., pl; v.

BEN HUR
Clear; $5^1/8'' \times 1^5/8'' \times {}^7/8''$; 9n; 3b; 1ip, not embossed; v.

BENETOL [See Figure 140]
Label from unembossed, ABM, threaded variant: *BENETOL—Internal & External Germicide. Benetol Products Co., Minneapolis, Minn.* Adv. 1916, *MB*; 1929–30 and 1948 by Carel Labs., Benetol Bldg., Redondo, Ca., *AD*.
Amber; $4'' \times 1^{11}/16''$ diameter; 9n; 20b; pl; h, on shoulder; several sizes.

Fig. 140

BERLIN/[bull's-eye]/SERIES
Label: *Unadulterated Paregoric, Berlin.*
Aqua; $5^1/4'' \times 2^1/8'' \times 1^1/4''$; 5n; 12b; 1ip; h; p. See HARTSHORN (Medicine).

BETUL-OL/FOR EXTERNAL USE
Introduced in 1888; adv. 1929–30 as an ". . . External Analgesic and Counter-Irritant, for Relief of Muscular Pains and Aches," by Huxley Labs., Inc., 175 Varick St., New York, successors of the Anglo-American Pharmaceutical Corp. Adv. 1948 by Huxley Labs., 521 Fifth Ave., New York City, *AD*.
Clear; $4^1/8'' \times 1^5/8'' \times 1^1/8''$; 7n; 18b; 1ip; v; 4 sizes.

A. M. BICKFORD & SONS LTD/ BRISBANE
Aqua; $8^5/8'' \times 1^{15}/16'' \times 1^{15}/16''$; 21n; 2b; pl; v.

A. M. BICKFORD & SONS LTD/ BRISBANE//NOT TO BE TAKEN
Green; $7^1/2'' \times 3^1/4'' \times 2''$; 20n; 12b; pl; v, fb.

BINZ/BRONCHI-LYPTUS
[See Figure 141]
Amber; $3^7/8'' \times 1^5/16'' \times 1^5/16''$; 9n; 2b; pl; v. See BINZ (Cough).

Fig. 141

BIOKRENE//HUTCHINGS & HILLYER//NEW YORK
Label: *Biokrene of Life Rejuvenator, Cures Impotency, Debility, Weakness of Organs, & Mental Indolence. A Restorer of Wasted & Inert Functions.* The partnership of Jacob S. Hutchings and Edwin Hillyer is shown in New York city directories from 1864 to 1870 (Holcombe 1979); who later acquired Biokrene is unknown. Biokrene adv. 1864 (Baldwin 1973); 1910, *AD*.
Aqua; $7^1/4'' \times ? \times ?$; 11n; 3b; 3 or 4ip; v, fss.

DR. BIRNEY'S/CATARRHAL POWDER
Label: *Dr.* [Charles A.] *Birney's Catarrhal Powder, Relieves Instantly, Catarrh, Hay Fever, Headache, Deafness, Coldness*

in the Head, Tonsilitis, Sore Throat, and Quinsy, Birney Catarrhal Powder Co., Chicago, Ill. Adv. 1894, Chicago city directory; 1905 (Devner 1968).

Clear; $2^{1/2}" \times {}^{11/16}"$ diameter; 15n; 20b; pl; v.

C. P. BISSEY & SONS/FRENCHTOWN/N. J.
Color unk.; $5^{1/4}" \times 1^{3/4}" \times {}^{3/4}"$; 7n; sp; 3 or 6b; 4ip; v.

BLACK GIN/FOR THE KIDNEYS//WM. F. ZOELLER/PITTSBURGH, PA.
Amber; $9^{1/4}" \times 2^{3/4}" \times 2^{3/4}"$; 11n; 2b; pl; v, fb. See ZOELLER *(Company)*.

BLUSH OF ROSES/PAT. NOV 22, 1882//FLORA A. JONES/DETROIT; MICH.
Label: *. . . for the beautification of the complexion. Useful in eradication of freckles and pimples.* Adv. 1889, *PVS & S*; 1891 by Flora A. Jones, South Bend, Ind., *Pharmaceutical Era*; 1910, *AD*.

Clear; $5^{1/8}" \times 2^{3/16}" \times 1^{3/8}"$; 9n; 6b; pl; h, fb, on shoulder.

BOERICKE & RUNYON/HOMOEOPATHIC PHARMACIST'S/SAN FRANCISCO, CAL./PORTLAND, OR.
Bottle dates, 1891–1903. Directories listed Boericke & Runyon in San Francisco, CA, 1891–1956; Portland, OR, 1891–1903; and New York City, NY, 1894–1948, possibly later.

Clear; $3^{1/4}" \times 1^{1/16}" \times 1^{1/16}"$; 9n; 1b; pl; v. See BOERICKE & RUNYON (Company), BOERICKE & TAFEL *(Miscellaneous)*, C. C. C. (Tonic).

BOERICKE/& TAFEL
Boericke & Tafel was established by Francis E. Boericke and Adolph J. Tafel. Directories listed the firm in New York, NY, 1872–1930, possibly later; in Philadelphia, PA, 1873–1948 or later; in Portland, OR, 1903–1906, and in San Francisco, CA, managed by William Boericke, 1870–1886. From 1887 to 1890 the San Francisco firm was called Boericke & Schenck, "Successors to Boericke & Tafel, Proprietors of the Pioneer Homoeopathic Pharmacy," and Boericke & Runyon from 1891 to 1956.

Clear; $2" \times {}^{5/8}" \times {}^{5/8}"$; 9n; 2b; pl; v. See BOERICKE & RUNYON *(Miscellaneous)*.

BOERICKE & TAFEL
Clear; $3^{1/4}" \times {}^{11/16}" \times {}^{11/16}"$; 9n; 2b; pl; v.

BOERICKE & TAFFEL/NEW YORK
Amber; $2^{1/2}" \times {}^{13/16}" \times {}^{13/16}"$; 3n; 2b; pl; v; embossed error.

BONNINGTONS/IRISH MOSS/CHRISTCHURCH
Light green; $5^{1/4}" \times 1^{7/8}" \times 1^{1/8}"$; 9n; 3b; 3ip; v.

Little/Bo-Peep/AMMONIA [Base:] B
[See Figure 142]
Clear; $8^{11/16}" \times 3^{1/16}" \times 1^{1/2}"$; 3n; sp; oval; pl; h; ABM.

Fig. 142

J. BOSISTO/RICHMOND
Aqua; $5^{5/16}" \times 2" \times 1^{1/16}"$; 3n; 15b; 1ip; v; ABM.

BOSWELL & WARNER'S/COLORIFIC
Advertisement in May 1875 *Druggists' Circular and Chemical Gazette*: "COLORIFIC–Beautiful & Natural Brown or Black. NO PREVIOUS WASH. Boswell & Warner's Colorific for the Hair. All Druggists. Depot, 9 DEY STREET, NEW YORK." Adv. 1872, *VHS*; 1923, *SF & PD*.

Cobalt; $5^{1/2}" \times 2^{1/8}" \times 1^{5/16}"$; 7n; 7b; 4ip; v.

DR. BRIEN'S/IMMACULINE
Milk glass; $5" \times ?$; 9n; ?b; pl.

G. E. BRIGGS.
Label: *The Genuine Briggs Cosmetic, an application to the hair, to restore the hair or prevent falling out. . . .*
Citroen, cobalt; $6" \times 2^{7/8}" \times 1^{1/2}"$; 15n; 3b; pl; v, in arch. Also cobalt, pontiled variant.

MRS. BRISTOL'S/BABY SOOTHER
Aqua; $5" \times 1^{1/8}"$ diameter; 4n; 20b; pl; v.

BROMO/CAFFEINE [See Figure 143]
Label: *. . . an Effervescent Salt for "Brain Workers" with headaches caused from over taxed mental energy. . . .* Originally

called Broma, the product was introduced in 1881 by Keasbey & Mattison; in the 1890s the name was changed to Bromo (Wilson and Wilson 1971). Adv. 1929–30 by Keasbey & Mattison, Ambler, Pa.; 1948 by Alkalithia Co., 312 W. Lombard St., Baltimore, Md., *AD*.

Light blue; $3^{1/8}" \times 1^{1/4}"$ diameter; 3n; 20b; pl; v. See KEASBEY & MATTISON (*Chemical*, Company, Miscellaneous).

Fig. 143

J. I. BROWN & SONS/BOSTON
Contained Brown's Bronchial Troches; introduced in 1850, and trademarked in 1856 (Holcombe 1979). Date of introduction verified in advertisement, *Harper's Weekly*, 3 Jan. 1880. John Isaac Brown established his Boston apothecary ca. 1832; son Atherton T. was with the firm in 1851 and son G. Frank soon after, according to Boston city directories. A brief partnership with Jeremiah Curtis transpired in 1865, to market products other than the Bronchial Troches, i.e., Mrs. Winslow's Syrup. The Block Drug Co., Brooklyn, NY, acquired the Boston business in Dec. 1936 (Holcombe 1979). Troches adv. 1929–30 and 1935 by John I. Brown & Son, Inc., 596 Atlanta Ave., Boston; 1941–42 from 190 Baldwin Ave., Jersey City, N.J., *AD*. Possibly the latter firm was owned by the Block Drug Co., with retention of the Brown name.

Clear; $3" \times 2^{1/8}" \times 1^{1/2}"$; 7n, large mouth; 15b; pl; h. See BROWN (Liniment), CURTIS (Bitters, Killer, Miscellaneous), WINSLOW *(Syrup)*.

DR. O. BROWN/JERSEY CITY
Products included balms, powders, liquid medicinal extracts, Vervain and an herbal remedy. The manufacturer's statement in the 1901 *Hornick, Hess & More* catalog included the following: "The well known house of Standard Herbal Remedy fame, established in 1850 by Dr. O. Phelps Brown, is send-

ing out a unique, attractive 1901 Shakesperian Almanac. . . . J. Gibson Brown formerly Dr. O. Phelps Brown. Address the old firm at the old place, 47 Grand Street, Jersey City, N.J." J. Gibson Brown, in early years, was an agent and distributor for O. P. Brown (Blasi 1974). Products still available in 1923, *SF & PD*.

Clear; $3^{1}/_{4}''$ × $1^{7}/_{8}''$ × $1^{1}/_{2}''$; **3n, large mouth; 3b; pl; v.** See MALE FERN (Miscellaneous).

DR. O. P. BROWN/JERSEY CITY
Light aqua; $3^{3}/_{8}''$ × $1^{13}/_{16}''$ × $1^{1}/_{2}''$; **7n; 3b; pl; v.**

DR. O. PHELPS BROWN
Aqua; $6^{7}/_{8}''$ × $1^{7}/_{8}''$ × ?; **7n; 3b; 4ip; v.**

DR. O. PHELPS BROWN
[See Figure 144]
Label: *ACACIAN BALSAM. Trade Mark Reg. March 3, 1881. For the Instant Relief and Permanent Cure of Consumption, Bronchitis, Coughs, Colds. . . .* The medicine was purported to contain "11 percent alcohol, over 16 grams of acacia to each 100 cc, nitrate, licorice, meconic acid, tartrates, reducing sugar and sodium and potassium compounds" (Blasi 1974). Adv. 1873, *VSS & R*; 1923, *SF & PD*.
Aqua; $8''$ × $2^{5}/_{8}''$ × $1^{3}/_{4}''$; **9n; 3b; 4ip; v.**

Fig. 144

DR. O. PHELPS BROWN//JERSEY CITY/N. J. [See Figure 145]
Aqua; $3^{1}/_{4}''$ × $2^{5}/_{8}''$ × $2^{5}/_{8}''$; **3n; 2b; pl; v, fs.**

Fig. 145

R. J. BROWN/LEAVENWORTH/KAS.
Bottle contained Jamaica Ginger. The Brown Medicine & Manufacturing Co. was organized in 1876 with Geo. A. Eddy, president, R. J. Brown, superintendent, treasurer and supervisory chemist. The medicines were manufactured especially for the various diseases incident to the western states and territories (Shimko 1969). Products adv. 1900, *EBB*.
Aqua; $5^{1}/_{2}''$ × $2^{1}/_{4}''$ × $1^{1}/_{4}''$; **7n; 12b; pl; v.**

BROWN'S/BLOOD TREATMENT/PHILADELPHIA
Emerald green; $6^{1}/_{8}''$ × $2''$ × $2''$; **9n; 2b; pl; v.** See BROWN *(Cure)*.

BROWN'S/SALICYLINE/FOR RHEUMATISM/ELMIRA, N. Y.
Adv. 1887, *WHS*; 1910, *AD*.
Aqua; $5''$ × ?; **7 or 9n; 1 or 2b; pl; v.**

BRYANS/TASTELESS/VERMIFUGE
Advertised as a peerless worm remedy and mothers' favorite, 1858 (Baldwin 1973); 1910, *AD*.
Aqua; $4''$ × $1''$ diameter; **13n; 20b; pl; v; p.**

BUCKINGHAM//WHISKER DYE
[See Photo 35]
Ruben P. Hall, Lowell, MA, introduced his vegetable hair renewer in 1866 and later purchased the controlling interest in the dye, which he eventually sold to James C. Ayer (Wilson and Wilson 1971). Dye adv. 1874 by R. P. Hall & Co., Nashua, N. H. (Fike 1967); 1941–42 by The Ayer Co., Lowell, Mass., *AD*.
Amber; $4^{7}/_{8}''$ × $1^{3}/_{4}''$ × $15/_{16}''$; **7n, sp; 3b; 4ip; v, ss.**

DR. JOHN BULL'S/KING OF PAIN/LOUISVILLE. KY.
Adv. 1854 (Baldwin 1973); 1891, *WHS*.
Aqua; $4^{3}/_{4}''$ × $1^{13}/_{16}''$ × $15/_{16}''$; **13n; 12b; pl; v; p.** See J. BULL *(Sarsaparilla)*, J. SMITH (Miscellaneous).

DR. W. H. BULL'S/HERBS AND IRON [Base:] PAT'D OCT. 13TH '85
Patented in 1885, adv. 1941–42 by W. H. Bull Medicine Co., 1950 N. 11th St., St. Louis, Mo., *AD*.
Amber; $10''$ × $4^{3}/_{8}''$ × $1^{7}/_{8}''$; **11n; 4b; pl; h.** See BULL (Medicine).

Dr. BULLOCK'S//NEPHRETICUM//PROVIDENCE/R. I.
Label: *Dr. Bullock's Kidney Remedy Nephreticum, a Vegetable Compound for Diseases of the Kidneys and Urinary*

Organs. . . . Product of A. D. Bullock, introduced in 1868, apparently distributed by Geo. Pierce, Boston (Wilson and Wilson 1971). Adv. 1910, *AD*.
Aqua; $7''$ × ? × ?; **7n; 3b; 3 or 4ip; v, ssf.**

BURDELLS·ORIENTAL/TOOTH·WASH·/H·P WAKLEE·SOLE·AGENT
Galen Burdell's tooth wash was distributed by H. P. Wakelee, 1870 to 1871; by B. B. Thayer, ca. 1871; and then by Painter & Calvert (Wilson and Wilson 1971).
Blue; $6^{3}/_{4}''$ × ? × ?; **2n; 4b; pl; v;** note spelling of WAKELEE.

BURNETT//BOSTON
Bottle manufactured ca. 1864 (Wilson and Wilson 1971). Joseph Burnett opened an apothecary in 1845 according to the city directory of Boston; previously Burnett was in partnership with Theodore Metcalf & Co. Burnett introduced his Cocoaine For The Hair, Oriental Tooth Wash and Kalliston For The Skin soon after establishing his own business (Holcombe 1979). Directories establish Joseph Burnett & Co. in 1856. By 1937 the family-owned business was exclusively manufacturing flavoring extracts (Holcombe 1979).
Clear; $8^{15}/_{16}''$ × $1^{9}/_{16}''$ × $15/_{16}''$; **9n; 6b; 2ip; v.** See METCALF *(Company)*.

BURNETT//BOSTON
[See Figure 146]
Aqua; $6^{1}/_{2}''$ × $3''$ × $1^{1}/_{2}''$; **7n; 3b; pl; v, ss.** See METCALF *(Company)*.

Fig. 146

BURNETT/[monogram]/BOSTON
Aqua; $8''$ × $2^{1}/_{8}''$ diameter; **11n; 20b; pl; h.** See METCALF *(Company)*.

BURNETT'S/COCOAINE//
BURNETT//BOSTON
[See Figure 147]
Label: *BURNETT'S COCOAINE, A*
Perfect Hair Dressing, A Promoter of the
Growth of the Hair. A Preparation Free
From Irritating Matter. Alcohol 50%.
Cocoa-nut Oil. Entered According to Act of
Congress in 1857 by Joseph Burnett & Co.
Introduced 1847 (Holcombe 1979);
adv. 1923, *SF ;& PD.*
Aqua; 6³/₄″ × 2¹/₂″ × 1⁹/₁₆″, also
6¹/₁₆″ × 2³/₁₆″ × 1⁵/₁₆″; 6n; 4b; pl; v,
fss. See METCALF *(Company).*

Fig. 147

BURNHAM'S/BEEF [monogram]
WINE/& IRON [See Figure 148]
Adv. 1894, 1918 (Shimko 1969).
Products also included a clam bullion
and sarsaparilla (Wilson and Wilson
1971). Chicago directories show Edwin
Burnham and Charles G. Smith listed
as Burnham & Smith, and manufactur-
ing drugs and medicines in 1854.
Associations included Peter Van
Schaack and Henry T. West; also son
Edwin R. in 1859. By 1870 the com-
pany was called E. Burnham & Son,
"Successors to Burnham & Van
Schaack"; by 1900, E. S. Burnham Co.,
EBB; by 1929–30, E. Burnham

Fig. 148

Products Co.; 1948, E. Burnham
Laboratories. Offices, at some point,
included New York and London.
Aqua; 7¹/₂″ × 3″ × 1¹/₂″; 11n; oval; pl;
h; 3 sizes. See BURNHAM (Cure), VAN
SCHAACK *(Company).*

JEAN WALLACE BUTLER/BUENA/
TOILET PREPARATIONS/
CHICAGO, ILL.
Products adv. 1907, *PVS & S.*
Clear; 5⁷/₈″ × 2⁹/₁₆″ × 1⁹/₁₆″; 9n; 3b;
pl; v.

C. & B./S. F.
Crane & Brigham, San Francisco, CA.,
produced this Florida water.
Aqua; 6¹/₄″ × 1³/₄″ diameter; 11n;
20b; 1ip, slug plate; v. See CRANE &
BRIGHAM *(Drug,* Miscellaneous).

CABOT'S/Sulpho-Napthol
Adv. 1898, *GHG*; 1925, *BWD.*
Amber; 4³/₄″ × 1¹³/₁₆″ × 1¹/₄″; 9n; 17b;
pl; v.

CALDER'S/ALC [monogram]/
DENTINE [See Figure 149]
Calder's tooth powder, product of
Albert L. Calder, Providence, RI
(Wilson and Wilson 1971). Adv. 1865,
GG; 1948 by Albert L. Calder Co.,
Long Island, N.Y., *AD.*
Clear; 2⁷/₈″ × 1¹⁵/₁₆″ diameter; 3n,
large mouth; 20b; pl; h.

Fig. 149

CALIDAD SUPERIOR
Aqua; 5¹/₂″ × ?; 11n; 20b; pl; v. See
CALIDAD (Water).

PROF CALLAN'S/WORLD
RENOWNED/BRAZILLIAN [sic]
GUM [Base: diamond] [See Figure 150]
Bottle manufactured by the Diamond
Glass Co., Royersford, PA, after 1924
(Toulouse 1972). Product adv. 1891,
WHS.
Aqua, amber; 4¹/₄″ × 1¹/₂″ × 1¹/₂″; 7n;
2b; pl; v.

Fig. 150

[Monogram/Guarantee/Stamp/]/
CALVERT'S/EXTRA PURE/
CARBOLIC/ACID [Base:] YG/Cº
Label: *F. C. Calvert & Cos. Carbolic Acid*
for Internal Medicinal Use. F. C. Calvert
& Co., Bradford, Manchester. Medals
Awarded 1868, 1871, 1867, 1873. Adv.
1887, *WHS.*
Amber; 7⁷/₈″ × 3⁵/₁₆″ × 2¹/₄″; 7n; 12b;
pl; h.

CAMELLINE/FOR THE/
COMPLEXION
Amber; 2⁵/₁₆″ × 1¹/₈″ × ¹¹/₁₆″; 3n; 3b;
1ip; v. See WAKELEE (Drug, *Mis-*
cellaneous).

CAMELLINE/NET CONTENTS
4 FLD. OZS.
Newer variant of previous entry.
Amber; dimens. unk.; 7n; 3b; pl; v.
See WAKELEE (Drug, *Miscellaneous).*

[Script:] **Cantrell & Cochrane//**
Cantrell & Cochrane/PGC 8
Label: *CANTRELL & COCHRANE'S*
AERATED SARSAPARILLA As
Introduced by Cantrell & Cochrane A.D.
1856. Manufactured Under Same Formula
And Exactly As In Dublin & Belfast,
Ireland. Manufactured in U.S.A. 16 FL.
OZ. NET. Bottle manufactured by the
Portland Glass Co., Greenford, Middle-
sex, Eng., 1922 to 1956 (Toulouse
1972).
Light blue; 8⁷/₈″ × 2¹/₂″ diameter; 19n;
20b; pl; h, fb, just above base; script;
ABM.

CAPUDINE/FOR HEADACHE
Amber; 3¹/₄″ × 1⁵/₁₆″ × ³/₄″; 3n; 12b;
1ip; v; ABM. See HICKS (Cure, *Mis-*
cellaneous).

CAPUDINE/FOR HEADACHE
Amber; 5¹¹/₁₆″ × 2″ × ⁷/₈″; 10n; 3b;
1ip, oval and embossed; v; ABM. See
HICKS (Cure, *Miscellaneous).*

**DR. M. CARABALLO/TAMPA//
VERMICIDA**

Funeral parlor records in Tampa, FL, included signatures by Dr. M. Caraballo, June 1891 to April 1899. No other information was located.

Aqua; 4¹/₈″ × ¹³/₁₆″ diameter; 7n; 20b; pl; v, fb.

CARLO/ERBA/MILANO

Clear; 3⁵/₈″ × 1¹/₂″ × ³/₄″; 7n, crude; 6b; 3ip; h. See OLIO (Miscellaneous).

CARLSBAD [See Photo 36]

Advertisement: "Carlsbad Sprudel Salt is obtained from the Sprudel Spring (Bohemia) by evaporation–Aperient, Laxative, Diuretic. Accelerates Absorption, Stimulates Nutrition, Aids Digestion, Corrects Acidity. Eisner & Mendelson Co. Sole Agents For The U.S., 6 Barclay Street, New York City. Introduced in 1863." Adv. 1929–30 by Carlsbad Products Co., 120 W. 42nd St., 1948, *AD*.

Clear; 4¹/₈″ × 1¹³/₁₆″ diameter; 15n; 20b; pl; base.

**GEORGE W./CARPENTER/
PHILADELPHIA//GENUINE//
PREPARATIONS**

Products adv. 1831 (source unk.); 1852, *GC*; 1910, *AD*.

Aqua; dimens. unk.; 11n; 3 or 6b; 3 or 4ip, arched front; v, fss; p.

**FANNY BRIGGS CARR/FACE
PREPARATIONS/LOS ANGELES,
CAL.** [Base:] **REX**

Products adv. 1907, *PVS & S*.

Clear; 5³/₈″ × 2¹/₁₆″ × 1¹/₄″; 9n; 11b; pl; v; 2 known sizes.

**CAULK'S/CROWN-BRIDGE/AND/
GOLD INLAY/CEMENT**

[See Figure 151]

Bottle manufactured ca. 1900 to 1905. The Caulk Company, Philadelphia, was founded in 1877 and was in business in the 1980s as a division of Dentsply International Inc., according to David H. Geddes, D.D.S., Ogden, UT, (personal communication, 1982).

Clear; 1⁵/₈″ × 1¹/₁₆″ diameter; 3n, large mouth; 20b; 1ip, on back; h. See CAULK (Company, Manufacturer).

Fig. 151

**Dᴿ CAVANAUGHS/PILE SALVE/
Sᵀ LOUIS M.O.**

Adv. 1869 (Baldwin 1973); 1871, *WHS*.

Aqua; 2³/₈″ × 2¹/₈″ diameter; 3n; 20b; pl; h; p.

**TRUE/CEPHALICK/SNUFF/
BY THE KINGS/PATENT**

A cure for catarrh, introduced in 1700s (Wilson and Wilson 1971). Adv. 1891, *WHS*.

Aqua; 3³/₄″ × ?; 13n; 20b; pl; v.

CEREVISINE [Base:] **L. G./2302**

Label: *CEREVISINE, Pure Desicrated Yeast, Saccharomyces Cere-Visine For Treatment of Furunculosis, Boils, Acne, Urticaria and Certain Skin Affections. E. Fougera & Co., New York. Guaranteed Under 1906 Act.* Adv. 1910, *AD*; Chapoteaut's Cerevisine, 1921, *BD*.

Clear; 4³/₄″ × 1⁷/₈″ diameter; 7n; 20b; pl; v. See CHAPOTEAUT (Miscellaneous).

CHAMBERLAIN'S [Base:] **BOTTLE 8/
MADE IN U.S.A.**

Clear; 5⁵/₈″ × 1⁷/₈″ × 1″; 11n; 3b; 1ip; v; ABM. See CHAMBERLAIN (Balm, Liniment, Lotion, *Remedy*), VON HOPF (Bitters), W. WARNER *(Company)*.

CHAMPLIN'S/LIQUID PEARL

Available either in pink or white. Adv. 1879, *VSS & R*; 1901 by Champlin Manf'g Co., 17 Platt St., New York City, *HH & M*; 1929–30 by O. H. Jadwin & Sons Inc., 11 Vestry St., New York City; 1941–42 by O. H. Simmons Inc., 67 Cortlandt St., New York City, *AD*.

Milk glass; 5″ × ?; 7n; ?b; ip; h.

CHAPOTEAUT//PARIS

Label: *Morrhuol Creosote [Chapoteaut] Cod Liver Oil. Laboratoire de Pharmacologie, Inc., New York formerly Rigaud & Chapoteaut, Paris. E. Fougera & Co., 90–92 Beekman St., New York.* Adv. 1887, *WHS*; 1935 by Fougera & Co., *AD*. E. Fougera & Co. was founded in New York City in 1849 by Edmond Fougera, a native of Chaillon, France. Originally the firm imported French items exclusively, for retail sale only, to appeal to the French expatriot communities of New York. Later, the company was expanded to include distribution and wholesale sales. The company was sold after the Civil War; however the name was retained and English medicines were added to the merchandise line. The company was incorporated in 1912. The first address on record was 30 N. William St., in the 1890s. 90–92

Beekman St. was used in the early 1900s; 41 Maiden Lane ca. 1928, although shipping and production remained at the Beekman St. address. After 1930 both offices were combined and moved to 75 Varick St. In 1957 the company moved to Hicksville, NY and in 1963 was purchased by Byk-Gulden, GmbH of West Germany. As of 1984 the firm was located in Melville, NY, according to Burckhard K. Blob, Director of Personnel, Byk-Gulden, Inc. (personal communication, 1984).

Clear; 4¹/₄″ × 1¹/₂″ diameter; 3n; 21b; pl; v, ss. See CEREVISINE (Miscellaneous).

**DR J. CHEEVER'S/LIFE ROOT
MUCILAGE/CHARLESTOWN
MASS.**

Aqua; 8¹/₂″ × 3¹/₄″ × ?; 11n; 4b; pl; v; p.

CHRISTIES/MAGNETIC/FLUID

Used with early plaster casts. Adv. 1845 (Putnam 1968); ca. 1880 (Wilson and Wilson 1971).

Aqua; 5″ × 2¹/₈″ × 1¹/₄″; 9n; 3b; pl; v; p.

CIRCASSIAN BLOOM

Product for the hair formulated by Dr. Henry M. Davidson, Ogdensburg, NY; J. J. Mack & Co., San Francisco, were sole agents (Wilson and Wilson 1971). Adv. 1871, *WHS*.

Clear; 5″ × ? × ?; 9n; 12b; pl; h. See MACK *(Sarsaparilla)*.

OTIS CLAPP & SON

Otis Clapp, Boston, established his business in 1840. It was family owned until 1964 when the business was sold to a partnership, which by 1984 was solely owned by Donald Breen. "Originally there were hundreds of medicines primarily homeopathic, of different strengths and forms, composed of thousands of botanical ingredients." The company was still in business in 1984 according to Douglas Batchelder, Otis Clapp & Son, Inc., Cambridge, MA (personal communication, 1984).

Milk glass; 4″ × ?; 9n; ?b; pl. See CLAPP (Oil).

[Script:] **Otis Clapp & Son's/
CAMPHOR DISKOIDS/BOSTON**

Adv. 1910, 1941–42 from 439 Boylston St., Boston, Mass., *AD*.

Clear; 3¹/₄″ × 1³/₈″ × ⁷/₈″; 3n; 3b; pl; v, some script. See CLAPP (Oil).

CLARKE & WHITE/C/NEW YORK

Dark green; 7¹/₄″ × ?; 2n; 20b; pl; h, embossed in an oval. See CLARKE

(Company), CONGRESS *(Water)*, LYNCH (Miscellaneous).

JOHN CLARKE/NEW YORK

Directories showed John Clarke, Mineral Waters, at 10 Thames, New York City, 1833 to 1847.

Dark green; 7³/₈" × ?; 2n; 20b; pl; h. See CLARKE (Company), CONGRESS *(Water)*, LYNCH (Miscellaneous).

RUE DE LA CLOCHE/№ 477

[script:] a Cologne

Clear; 5" × 2" × 1³/₄"; 3n; 17b; pl; v, some script; distinctive shape.

COCA MARIANI/PARIS [Base:] COCA MARIANI PARIS FRANCE

Bottle manufactured ca. 1894 to 1900 (Wilson and Wilson 1971).

Dark green; 8³/₄" × ?; 2n; 20b; pl; h. See VIN MARIANI *(Miscellaneous)*.

COLCHI-SAL [Base:] A-1

A French preparation of Colchi-Sal Pearls, adv. 1897, *EF*; 1935 and 1948 by Huxley Pharmaceutical Inc., New York City, *AD*.

Clear; 3⁵/₈" × 1¹/₈" diameter; 7n; 21b, 12 sides; pl; v.

COMSTOCK'S/VERMIFUGE

Comstock's Tonic Vermifuge, product of Comstock & Co., New York, adv. 1848 (Baldwin 1973); 1921, *BD*.

Aqua; 3³/₄" × ⁷/₈" diameter; 13n; 20b; pl; v; p. See MORSE (Cordial, *Pills, Syrup*).

[Script:] Conway/Laboratories/ CHICAGO

Clear; 5³/₈" × 2⁵/₁₆" × 1⁵/₁₆"; 9n; 6b; pl; h, some script.

BY/A. A. COOLEY/ HARTFORD/CON.

Bottle contained several products. Abial A. Cooley was the son of Samuel, who produced medicinals such as Dr. Samuel Cooley's Vegetable Elixir, Pulmonary Balsam, Toothache Remedy, and Catarrh Snuff. He chose the lumber business until finally following in his father's footsteps in 1837 by entering the medicine business. Abial formulated several medicinals including Cooley's Anti-Dyspeptic Jaundice Bitters; he died in 1858 (Blasi 1974; Wilson and Wilson 1971).

Olive; 4¹/₂" × 2³/₈" × 1¹/₂"; 13n; 12b; pl; v; p.

L. COOLEY/BOSTON

Label: *Cooley's Celadon Green.*

Clear; 1⁷/₈" × ⁵/₈" × ⁵/₈"; 7n; 2b; pl; v.

COOLEY'S/34 NEWBURY ST./ BOSTON.

Label: *Cooley's Mother of Pearl No. 3.*

Clear; 3¹/₂" × 1¹/₂" × ¹³/₁₆"; 18n; 3b; pl; v.

CORBIN'S//SUMMER/ COMPLAINT/TINCTURE// SYRACUSE, N.Y.

Z. Corbin established his business in Liverpool, NY, and apparently relocated it to Syracuse, NY, as Z. Corbin & Pohle, Manufacturing Chemists, 1857–58 (Baldwin 1973).

Aqua; 4¹/₈" × 2³/₄" × ⁷/₈"; 7n; rect.; pl; v, sfs.

CORBIN'S//WORM DESTROYER// LIVERPOOL, N.Y.

Adv. 1864 (Baldwin 1973); 1910, *AD*.

Aqua; 5¹/₄" × 2" × 1¹/₈"; 11n; 3b; pl; v, sfs; p.

COULEY'S FOUNTAIN/OF HEALTH/№ [embossed fountain] 38/ BALTIMORE Sᵗ/BALTIMORE

Aqua; 9³/₄" × 3" diameter; 11n; 20b; pl; h; p.

DR CRAIGS/VITALIZED/OZONE FOR/INFLAMMATION/ ROCHESTER, N. Y.

Adv. 1886 (Baldwin 1973).

Aqua; 4¹/₂" × 1¹/₂" diameter; 7 or 9n; 20b; pl; v. See CRAIG *(Cure)*, WARNER *(Cure)*.

CRANE & BRIGHAM/ SAN FRANCISCO [See Figure 152]

Florida water.

Aqua; 9¹/₄" × 2³/₁₆" diameter; 11n; 20b; 1ip; v. See C & B (Miscellaneous), CRANE & BRIGHAM *(Drug)*.

Fig. 152

[Embossed tree] CRESCENTIAL [tree]//EDWARD FINLAY. M.D./ HAVANA

A bottle of Havana, Ohio.

Clear; 5⁷/₈" × 2⁹/₁₆" × 1³/₄"; 5n; 3b; pl; v, fb.

CHARLES CROCKER

Aqua; 7" × 2¹/₂" × 1¹/₂"; 11n; 3b; 3ip; v; p.

Dᴿ CROOK'S//WINE OF TAR

Label: *CROOK'S WINE OF TAR – The Well Known Remedy For Throat & Lung Diseases . . . Price One Dollar.* Oliver Crook, Dayton, OH, was already dispensing his wine of tar when he founded Oliver Crook & Co. in 1868. Around 1875 the firm was succeeded by S. N. Smith & Co., an affiliate of John D. Park (Holcombe 1979). Crook's Wine of Tar adv. 1923, *SF & PD*.

Blue; 8³/₄" × 2¹/₄" × 2¹/₄"; 11n; 2b; pl; v, fb.

Dᴿ CUMMING'S/VEGETINE

Dr. Cumming's Vegetine ". . . Nature's Remedy, the Great Blood Purifier," was introduced in 1851, the product of Henry R. Stevens, Boston, MA; Steven's association with Cummings is unknown. George Pierce & Co., Boston, succeeded H. R. Stevens, as the proprietor of Vegetine in 1885 (Holcombe 1979; Wilson and Wilson 1971). Directories associate Stevens with Vegetine until 1883 or 1884; soon thereafter, Stevens apparently began the manufacture of Familine. Vegetine adv. 1923, *SF & PD*.

Aqua; 9¹/₂" × 3³/₄" × 1¹⁵/₁₆"; 1n; 12b; pl; v. See INDIAN *(Bitters)*, STEVENS *(Balsam)*.

CUNDURANGO//CUNDURANGO

Label: *Dr. Place's Cundurango Bitters, composed of Pure California Brandy, Cundurango bark and other roots and herbs. Cure for Cancer . . . appetizer and stimulant, unequaled for family, hotel and medical use. Geo. W. Chesley & Co., Sacramento, Cal.* Produced ca. 1872 to 1880. George W. Chesley and partners, Sacramento, CA, established their wholesale liquor business in 1857; by 1866, Chesley was sole owner (Watson 1965; Wilson and Wilson 1969).

Light amber; 9" × 3" × 3"; 7n; 2b; pl; v.

DOCT. CURTIS'//INHALING/ HYGEAN VAPOR//NEW YORK

[See Figure 153]

Carton states: *DOCT CURTIS Hygeana or Inhaling Vapor and Cherry Syrup FOR THE CURE OF ASTHMA, CONSUMPTION, BRONCHITIS, COUGHS COLDS and all diseases of the LUNGS, AIR-PASSAGES, THROAT and HEART, By*

an entirely NEW METHOD of MEDICATED INHALATION . . . Price $1.00. Entered According to Act of Congress in the Year 1854 by Jeramiah Curtis. Adv. 1854 *New York Daily Times:* "Dr. Curtis' Hygeana or Medicated Inhalation . . . Product of Curtis & Perkins." Adv. 1874 (Devner 1968).

Clear; 7⅛″ × 2⅜″ × 1⅝″; 1n; 3b; 4ip; v, sfs; p. See CURTIS (Syrup), WINSLOW *(Syrup).*

Fig. 153

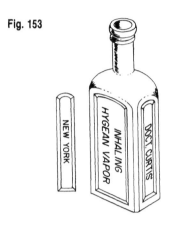

D. D. D.
Cream remedy adv. 1900 by D. D. D. Co., Galveston, Tx., *EBB;* 1929–30 and 1935 by D. D. D. Co., Batavia, Ill.; 1948 by Campara Sales Co., Batavia, Ill., *AD.*

Clear; 5⅝″ × 1¾″ × 1¾″; 9n; 2b; pl; v. Also ABM variant.

DABROOKS/[monogram]/**PERFUMES/DETROIT**
[See Figure 154]
Adv. 1901 by Michigan Drug Co. & Williams, Davis, Brooks & Co., Detroit, Mich., *HH & M;* 1914, *HD.*

Clear; 5⅞″ × 1⅝″ diameter; 7n; 20b; pl; h. See DABROOK (Water).

Fig. 154

DALBYS/CARMINATIVE
Twentieth century label: . . . *For Infants Afflicted With Wind, Watery Gripes, Fluxes and Other Disorders of the Stomach and Bowels.* Ingredients included opium. Product of J. Dalby, London, England, introduced, in England in the 1780s (Griffenhagen and Young 1959) and the United States in 1804, *JS.* Adv. 1929–30 by Fougera & Co., New York City, *AD.* "In one of the last actions under the 1906 law, a case concluded in 1940 . . .," Dalby's Carminative was charged by the government with misrepresentation for false and fraudulent claims. When settled the defending company was fined $100 for misbranding (Griffenhagen and Young 1959).

Aqua; 3⅝″ × 1⅝″ diameter, also height of 4½″; 3n; 20b, inset; pl; v; p.

NO. 1/Dᴿ DANIELS/VETERINARY/COLIC/DROPS
A Boston, MA product adv. 1900, *EBB;* 1910, *AD.*

Clear; 3⅝″ × 1⅛″ × 1⅛″; 7n; 2b; pl; v, h. See DANIEL (Cough, Cure, Liniment, Lotion).

DR DAVIS'S//DEPURATIVE//PHILA.
Dr. W. A. Davis' Depurative, a cure-all, adv. 1853–54 (Baldwin 1973).

Green; 9½″ × 2¹⁵⁄₁₆″ × 2¹⁵⁄₁₆″; 11n; 2b; pl; v, sfs; graphite p.

[Script:] **One/of the/Debeco/FORMULA**
Clear; 4⅜″ × 1⅞″ × 1¹⁄₁₆″; 7n; 8b, modified; pl; h, some script.

[Script:] **De Lacy's/CIN-KO-NA AND IRON//De Lacy's/CIN-KO-NA AND IRON**
Adv. 1907, *PVS & S;* 1929–30 by De Lacy Chem. Co., 4856 Lee Ave., St. Louis, Mo., *AD.*

Amber; 9½″ × 2⅝″ × 2⅝″; 12n; 2b; 4ip; v, ss, some script. See DE LACY (Tonic).

A. DEMONCO. M.D./SALT LAKE/UTAH.
Salt Lake city directories included Almo De Monco from 1892 to 1896.

Amber; 3¼″ × 1⅛″ × 1⅛″; 9n; 2b; pl; v.

[Script:] **Dioxygen**
A hydrogen peroxide adv. 1910, 1948 by Oakland Chemical Co., Inc., New York City, *AD.*

Amber; dimens. unk.; 7n; 20b; pl; h, script, just above base. See OAKLAND *(Chemical).*

Wᴹ. DOCKER'S/SUN BRAND
Possibly not a medicine.

Aqua; 5½″ × 2″ × 1¼″; 7n, large mouth; 3b; 3ip; v.

DODSON'S//LIVER-TONE
Light blue; 7¼″ × 2¼″ × 1¼″; 7n; 6b; 3ip; v, ss. See DODSON *(Medicine).*

DR. C. J. DOUGLAS/SALT LAKE CITY [Base:] WT & CO/U.S.A.
Charles J. Douglas, or Charles I. Douglas, depending on the directory year consulted, is listed as a Homeopathic Physician and Surgeon from 1888 until his death, at age 70, in 1938.

Amber; 2⅞″ × 1³⁄₁₆″ × ½″; 3n; 6b; pl; v.

Dᴿ J. DOUGHTYˢ/CELEBRATED/GRAVE ROBBER
Dark aqua; 8½″ × 3″ × ?; 11n; 3b; 2ip; h; p.

DUBBEL'S/MENTHANE/VERMIFUGE/WAYNESBORO, PA.
A product of Silas E. Dubbel, Waynesboro, PA. Dubbel was also a principal agent in the selling of Peter Fahrney's products. Vermifuge adv. 1910, *AD.*

Aqua; dimens. unk.; 11n; 3b; ip; v. Possibly variants embossed DUBBELL'S. See DUBBEL (Cure), REDTHYME (Cure).

CHLORAL BROMURE/DUBOIS
Dr. Dubois' Medicine for the Nervous System was French in origin. Products adv. 1900, *EBB;* 1907, *PVS & S.*

Aqua; 7½″ × 3″ × 1¾″; 7n; rect.; pl; v.

S. O. DUNBAR/TAUNTON/MASS.
Label: *Fluid Magnesia. An Aperient Anti-Acid. Prepared by S. O. Dunbar, Taunton, Mass.* Adv. 1871, *WHS;* 1910, *AD.* Other products adv. 1850 (Baldwin 1973).

Aqua; 5⅝″ × 2⅝″ diameter; 11n; 20b; pl; h.

DUNN & ROEBUCK/NEW YORK//BEVERAGES//BEVERAGES
New York City directories list Fred A. Dunn and Lillie A. Roebuck as manufacturers of waters in 1896, manufacturers of specialties in 1897, and manufacturers of supplies in 1898.

Aqua; 6″ × 2⅛″ × 1³⁄₁₆″; 7n; 3b; 4ip; v, fss.

DURFEE/ASPIRATING/BOTTLE//
[graduated markings 8 OZ to 56 OZ]
Contents were for mortuary use.

Clear; 8½" × 4⅝" × 4⅝"; 7n, large mouth; 2b; pl; h, fb. See DURFEE (Balm).

DYER'S/HEALING/EMBROCATION/PROVIDENCE R. I.

A product of C. Dyer Jr., who was succeeded by A. H. Field in 1856 (Singer 1982). Adv. 1847 (Baldwin 1973); 1910, *AD*.

Light aqua; 6⅛" × 2½" × 1¾"; 11n; 12b; pl; v; p.

T. W. DYOTT

In 1805 Thomas W. Dyott, Philadelphia, PA, was making and selling bootblacking. The Philadelphia city directory showed Dyott established a patent medicine warehouse by 1807. Dyott claimed to be the grandson of Dr. Robertson of Edinburg and bestowed upon himself the prefix of Dr.; he manufactured many medicinals, often prefaced with Dr. Robertson. By 1809 Dyott had his own mold, and bottles were embossed DR. ROBERTSONS/FAMILY MEDICINE/PREPARED/ONLY BY/T. W. DYOTT (Nielsen 1978; Wilson and Wilson 1971; Young 1962). Dyott also became a distributor for such products as Bears Oil, British Oil, Bateman's Drops, Turlington Balsam and Daffy's Elixir. Around 1822 Dyott bought an interest in the Kensington Glassworks and became the sole owner; ca. 1833 the name was changed to Dyottville Glass Works (Wilson and Wilson 1971). Dyott also established agencies in New Orleans, New York, Cincinnati and other cities, and was sued for fraudulent insolvency as a result of the financial disaster of 1837 in the U.S. Dyott died in 1861 at the age of 90 (Young 1962). His son, T. J. Dyott, Philadelphia, also established agencies to sell glassware and medicinals in the 1840s. His business was short-lived; part of his interests were transferred to relatives (Wilson and Wilson 1971).

Aqua; 3¾" × ?; 5n; 20b; pl; v.

PREPARED BY/DR. E. EASTERLY/ST. LOUIS

Dr. Ezra Easterly operated a medicine depot in St. Louis from 1845 until 1847, and Easterly & Co., "The Family Medicine Store," from 1847 until his death in 1874. Directories also included a reference to a Chicago store from 1863 to 1867, operated by Charles J. Easterly.

Aqua; 7¼" × 3" × 1¾"; 11n; 13b; pl; v. See BAKER (Specific).

DR./R. D. EATON'S/REMOVINE/MINNEAPOLIS/MINN.

Roderick D. Eaton, a veterinary surgeon, operated the Peerless Med. Co., 424 Kasota Bldg., Minneapolis, MN, from its establishment sometime between 1891 and 1898 until his death in 1917 according to Davison's Minneapolis city directories.

Light aqua; 7¼" × 2¼" × 1¹¹⁄₁₆"; 7n; 12b; pl; h.

ELLIMAN'S/EMBROCATION [Base:] 10834

Elliman's Royal Embrocation for animals and Universal Embrocation for humans adv. 1888 (Alpe 1888); 1891, *WHS*; 12 July 1913, *The Illustrated London News*, as a product of Elliman, Sons & Co., Slough, England; 1948 by Fougera & Co., New York City; 1980–81 by Consolidated Midland Corp., Brewster, NY, *AD*; and in 1983, as Elliman's Royal or Universal Liniment by Consolidated Midland Corp., *RB*.

Aqua; 5½" × 2" × 1⅛"; 10n, also sp; 4b; pl; v. See ELLIMAN (Manufacturer).

[Script:] **Empress** [Base: I in diamond] Bottle manufactured by the Illinois Glass Co., 1916 to 1929 (Toulouse 1972). Products included dental cream, face bleach, hair bleach and tonic, and tooth powder. Hair Color Restorer adv. 1912, 1914 (Devner 1970).

Amber; 3¾" × 1½" diameter; 3n; 20b; h, script; ABM.

EMULS/ANGIER

Label: *Angiers Emulsion, Petroleum with Hypophosphites. Boston.*

Aqua; 7" × ? × ?; 10n; 12b; 1ip; embossed on base. See ANGIER (*Miscellaneous*).

ENO'S/FRUIT SALT [Base:] WBI

The base monogram, either WBI or WBL, is possibly the symbol for Woods Bros., a glass house located in Barnsley, York, England. Eno's Fruit Salts, a derivative compound of fruit salts for upset stomach, infectious diseases and blood poisons, was the product of Jonothan E. Eno, London, England, introduced ca. 1880 (Wilson and Wilson 1971). Adv. 1922 by J. C. Enos, Ltd., Harold F. Ritchie & Co., Sole Agents, *RD*; as Eno Effervescent Salt, 1948 by Ritchie & Janvier, Inc., 60 Orange St., Bloomfield, N.J., *AD*; as Eno's Antacid, 1983 by Beecham Products, Pittsburgh, PA, *RB*.

Aqua; 6⅞" × 2½" × 1½"; large distinctive neck finish; 3b; pl; v. See ENO (Compound).

EXTERNAL USE ONLY//EXTERNAL USE ONLY

Label: *NYAL'S COMPOUND LARKSPUR LOTION. Alcohol 10%. Recommended as a convenient lotion for destroying Parasites which Infest the Hair. Nyal Company, Distributors, Detroit, Mich.* Frederick Stearns & Co. owned the Nyal Company in 1906 (Devner 1970). Larkspur Lotion adv. 1948 by Jamieson Pharmacal Co., 1962 Trombly Ave., Detroit, Mich., *AD*.

Amber; 6⁹⁄₁₆" × 2¹⁄₁₆" × 1¹⁄₁₆"; 1n, sp; 3b; 4ip; v, ss. See STEARNS (*Company*).

B. A./FAHNESTOCK'S//VERMIFUGE [See Figure 155]

Advertisement: "The Safest and Most Effective Remedy For Worms in children and adults, THAT HAS EVER BEEN DISCOVERED." Benjamin A. Fahnestock, Pittsburgh, PA, introduced this product in 1830. In 1852 B. A. Fahnestock & Co., druggists, and B. L. Fahnestock, wholesale druggists, were operating from the same location at 19 and 21 Wood, Pittsburgh. By 1854 directories showed B. A. Fahnestock & Co., as "Importers and Wholesale Dealers in DRUGS, PAINTS, OILS, DYE STUFFS, Patent Medicines, Glassware, &C." at the corner of Wood and First Streets, Pittsburgh. The New York City directory for 1854 included an office there with Aurelius B. Hull a member, and offices were located in Philadelphia from ca. 1858–1869 with B. A. Fahnestock's son, George W., in charge. By 1863–64 the firm was billed as B. A. Fahnestock, Son & Co., "druggists, cor. First and Wood." Benjamin A. Fahnestock passed away in the fall of 1868 and the patent medicine branch of the business became [J. E.] Schwartz & Haslett, same location. The success and demand for B. A. Fahnestock's vermifuge resulted in imitations, including one prepared by B. L. Fahnestock. About 1858 B. L. Fahnestock established B. L. Fahnestock & Co. with son B. S. at No. 60, corner of Wood and Fourth Streets, Pittsburgh; soon thereafter, they put their vermifuge on the market (Holcombe 1979). Bottles are found embossed with both B. A. and B. L. Fahnestock. B. A. Fahnestock's vermifuge introduced 1830, adv. 1948 by B. A. Fahnestock Co., St. James Rectory, Titusville, Pa., *AD*. B. L. Fahnestock's vermifuge adv. 1865, *GG*; in 1895 with other family medicines and

a Lung Syrup by B. S. Fahnestock, Pittsburgh, previously B. L. Fahnestock & Co., *McK & R*; 1910, *AD*.

Aqua; 3¾″ × ⅞″ diameter; 13n; 20b; pl; v, fb; p.

Fig. 155

FRONT BACK

Dᴿ. P. FAHRNEY'S//PANACEA

Adv. 1872, *F & F*; as a Blood Cleansing Panacea, 1910, *AD*.

Aqua; 9½″ × 3¼″ × 2″; 7n; 3b; 3ip; v, ss. See FAHRNEY *(Company)*, PETER (Miscellaneous).

J. M. FARINA/A COLOGNE

A toilet water, introduced in Germany as Kolnisches Wasser in 1749. Sometime later the French word, Eau-de-Cologne, was added. The product was introduced in the United States ca. 1843 (Devner 1970). Adv. 1853 (Putnam 1968); 1898, *CHG*. The firm was still in business ca. 1928.

Clear; 4¾″ × 1¹¹⁄₁₆″ diameter; 13n; 21b, 6 sides; pl; v; p. See FARINA (Water), NO. 4711 (Miscellaneous).

JEAN MARIE FARINA/PLACE JULIERS № 4/COLOGNE

Color & dimens. unk.; 13n; 21b, 6 sides; v. See FARINA (Water), NO. 4711 (Miscellaneous).

DR. M. M. FENNER/FREDONIA,/ N. Y. 1904

Amber, clear; 4¹⁵⁄₁₆″ × 1⁹⁄₁₆″ × ¹⁵⁄₁₆″; 7n; 12b; pl; v. See FENNER (Cure, Medicine, *Remedy*, Specific).

FERRO-CHINA [Base:] 385

Label: *PROMOTION FERRO-CHINA BITTERS, Alcohol 35% by Volume. Guaranteed and Manufactured by CERRUTI MERCANTILE CO., INC., DISTILLERS, SAN FRANCISCO, CAL. Under National Pure Food Law, June 30, 1906, Serial No. 9422.* Also labeled, *Manufactured by the PROMOTION WINE & LIQUOR CO. INC., SAN FRANCISCO, CAL.* The relationship to Ferro-China Excelsior Bitter Tonic is unknown.

Olive; 10¼″ × 3⁹⁄₁₆″ diameter; double ring lip finish starting ca.¼″ below top; 20b; pl; h, near shoulder. See EXCELSIOR (Chemical), FERRO QUINA (Bitters).

FERRO-CHINA-BISLERI/MILANO// 1¹³⁄₁₆ PTS./NEW YORK [Base:] 24

[See Photo 37]

Label: *BISLERI'S IRON-CINCHONA BITTERS, Alcohol 20%. DOSE: FOR ADULTS ONE TABLESPOONFUL BEFORE MEAL—FOR CHILDREN ONE TEASPOONFUL IN A LITTLE WATER. Manufactured by JOSEPH PERSONENI in NEW YORK with essential Ingredients prepared by FELICE BISLERI at MILAN, ITALY. Manufactured under the National Prohibition Act U. S. Permit N. Y. -H- 16082.* Established 1881 (source unk.). Adv. 1935 by J. Personeni, 496–498 W. Broadway, New York City, *AD*.

Emerald green; 9⅝″ × 3⅝″ diameter; 23n, with 3 rings; 20b; pl; h, fb, near shoulder and just above base; ABM. See EXCELSIOR (Chemical), FERRO QUINA (Bitters).

FERRO-CHINA-BISLERI// 1¹³⁄₁₆ PTS./NEW YORK [Base:] L754/15

Labeled same as previous entry except prepared . . . *under special secret formula of Felice Bisleri, Milano, Italy;* also no reference to prohibition.

Amber; 9⅝″ × 3⁹⁄₁₆″ diameter; 23n, with 3 rings; 20b; pl; h, fb, near shoulder and just above base; ABM. See EXCELSIOR (Chemical), FERRO QUINA (Bitters).

[Script:] **F. W. Fitch's//Ideal/ Dandruff Remover//4 OZ** [Base: I in diamond 2]

Pewter pour spout reads: "F. W. Fitch Co., Des Moines, Iowa." Bottle manufactured by the Illinois Glass Co., 1916 to 1929 (Toulouse 1972). Cardboard packing carton reads: *1 DOZEN, NO. 6 SIZE Fitch's Dandruff Remover Shampoo—Removes All Dandruff, Dirt, Grease, or Foreign Substance—F. W. Fitch Co., DES MOINES, IOWA, BAYONNE, N.J. U.S.A.* Adv. 1916, *SF & PD*; 1948, *AD*.

Clear; 5³⁄₁₆″ × 2⅝″ × 1³⁄₁₆″; 7n; 6b; 1ip; v, ss; h, f; some script; ABM. See FITCH *(Company)*.

DR. S. S. FITCH/707 B.WAY, N.Y.

Samuel Sheldon Fitch was a New York physician for consumption, and a manufacturer of proprietary medicines. Directories have the business located at 707 Broadway from 1847 through

1853, followed by 714 Broadway; the firm became S. S. Fitch & Son in 1873. Products included Fitch's Cherry Pulmonic Syrup, Anti-Bilious Mixture, Female Restorative, Cholera & Colic Specific, Catarrh Snuff, Pulmonary Expectorant, Hair Tonic, Uterine Catholicon, and Cathartic Pills; the latter advertised 1871, *VSS & R*, and 1907, *PVS & S*.

Aqua; 2¾″ × ?; 5n; 2b; pl; v; p.

DR. S. S. FITCH/707 B.WAY, N.Y.

Aqua; 6¼″ × 2½″ × 1¾″; 11n; 12b; pl; v; p.

Dᴿ S. S. FITCH//707 B.WAY, N.Y.

Aqua; 4¾″ × 2″ × ¾″; 5n; 3b; pl; v, ss; p.

Dʳ S. S. FITCH/714 BROADWAY/ N.Y.

Aqua; 5⅛″ × 2″ × 1¹⁄₁₆″; 9n; 12b; pl; v; p; many sizes and shapes.

Dʳ S. S. FITCH/714 BROADWAY/ N. Y.

Aqua; 6″ × 2⅜″ × 1¼″; 1n; 12b; pl; v; p.

Dᴱ S. S. FITCH/714 BROADWAY/ N. Y.

Aqua; 6⅜″ × 2⅜″ × 1″; 9n; 12b; pl; v; p.

FIVE DROPS//CHICAGO, U.S.A.

[Base:] 6

Advertisement in 1902: "SWANSON'S 5-DROPS, the Greatest Blood Purifier Ever Discovered, a Cure for Lumbago, Sciatica, Neuralgia & Kidney Trouble. Swanson Rheumatic Cure Co., 160 Lake St., Chicago" (Fike 1966). Adv. 1900, *EBB*; 1929–30 from 167 Dearborn St., Chicago, and Newark, O.; 1948 by Swanson Co., 68 E. Locust, Newark, O., *AD*.

Aqua; 5½″ × 1⅞″ × 1″; 1n; 3b; 3ip; v, ss; tapered body.

[Script:] **Chas. H. Fletcher's// CASTORIA** [See Figure 156]

Label: *. . . a vegetable preparation for assimulating the food and regulating stomach and bowels of infants and children.* Introduced in the early 1890s (Wilson and Wilson 1971); adv. 1981 by Glenbrook Labs., a Division of Sterling Drug Inc., New York City, *AD*; 1984–85 by Glenbrook Labs., 90 Park Ave., New York City, *AD*.

Aqua; 5¾″ × 1⅞″ × ¹⁵⁄₁₆″; 1n; 6b; 4ip; v, ss, some script. Also ABM. See CENTAUR *(Liniment)*, PITCHER *(Miscellaneous)*.

Fig. 156

FLOWERS/OF/PETROLEUM// W. E. JERVEY/PROPRIETOR/ NEW YORK [Base:] McᶜC

Bottle manufactured by McCully Glass Co., Pittsburgh, PA, 1832 to 1886 (Toulouse 1972). "Flowers of Petroleum" was registered in 1878 by W. E. Jervey as a "Preparation of the Hair. The only hope for the bald and gray" according to letters written to *Old Bottle Magazine*. Adv. 1910, *AD*.

Color & dimens. unk.; 7n?; base & sides unk.; v, fb.

DOCᵀ ROBᵀ B//FOLGER'S/ OLOSAONIAN//NEW-YORK

Folger's Olosaonian, or Lung Balsam, adv. 1845 (Putnam 1968); 1910, *AD*.

Aqua; 7³/₄" × 2¹/₂" × 1¹/₂"; 11n; 4b; pl; v, cfc; p; distinctive shape.

TERP-HEROIN./"FOSTER'S"

Label: *. . . a sedative and cough suppressant, a mixture of terpin hydrate and heroin.* Adv. 1929–30 by Foster Laboratory, 95 Roseville Ave., Newark, N.J., *AD*.

Aqua or clear; dimens. unk.; 5 or 9n; rect.; pl; v.

H. D. FOWLE/BOSTON

Henry D. Fowle's Pile & Humor Cure, ". . . a sure cure of leprosy, scrofula and salt rheum . . .," was advertised in the 1869 Boston city directory as having "No failures in over ten years." Cure adv. 1921, *BD*. Fowle's business operated from 1841 or 1842 until 1922.

Blue, aqua; 5³/₄" × 2³/₄" × 1³/₈"; 7n; 12b; pl; v.

FRANKLIN PRODUCTS 1845

[embossed star in circle]
Products adv. 1941–42 by O. M. Franklin Serum Co., location unk., *AD*.

Amber; 2¹/₂" × 1¹/₁₆" diameter; 7n; 20b; pl; h, around base; ABM; graduated lines.

FRATELLI BRANCA/MILANO

Only known embossed bottle using this distinctive two ring lip finish. Fernet-Branca Bitters was billed as an anticholera and tonic remedy, possessing a 78 proof herbal formula. Giuseppe, Luigi, and Stefano Branca, "Fratelli Branca e C." (Branca Brothers & Co.), Milan, Italy, introduced the bitters on a limited scale, in 1845; imports were first made to the United States ca. 1867. Luigi died in 1886, Giuseppe in 1888, and Stefano in 1891; family members and others managed the firm until Stefano's son, Bernardino, became the director in 1917; Bernardino died in 1937. A branch office was established in New York in 1921, and by 1936 branches were also located in Buenos Aires, St. Louis, and Chicago, and in Egypt and Europe (Holcombe 1979; Schulz, et al. 1980). Fernet-Branca, Italian Bitters is still produced by Fratelli Branca & Co., Inc., 12–14 Desbrosses St., New York City, according to Alba Tos, Ass't to Pres., Fratelli Branca & Co. (personal communication, 1984).

Green; 13¹/₄" × 3¹/₈" diameter; 18n, with two rings; 20b; pl; embossed shoulder seal; recessed base, turn mold.

FRENCH'S/FRECKLE REMOVER

Proprietor unknown, however an advertisement in the 1 Nov. 1891 *Pharmaceutical Era* included a reference to French, Cave & Co., Philadelphia, manufacturers of perfumes and cosmetics. Also there was a reference to a French's Ointment, adv. 1907, *PVS & S*.

Milk glass; dimens. unk.; 7n; 3b; pl; h.

E. FRESE/S. F.

Contained Jamaica Ginger. San Francisco directories included Emil Frese, Importer & Dealer, Drugs & Medicines, from at least 1860 to 1874.

Light green; 6³/₈" × 2" × 1¹/₁₆"; 11n; 12b; pl; v.

FREYS'//VERMIFUGE// BALTIMORE

Adv. 1871, *WHS*; 1913, *SN*.

Aqua; 4¹/₄" × 1¹/₄" × 1¹/₄"; 5n; 1b; pl; v, fsb; p.

G. P. O. B.//C. C. W.

Light green; 5¹/₁₆" × 2¹/₂" × 1¹/₂"; 3n, large mouth; 3b; 4ip; v?, ss; p.

Dᴿ GALVINS/CROUP TINCTURE// J. W. CARNEY//SCRANTON, PA.

Adv. 1887, *WHS*; 1910, *AD*.

Light green; 4¹⁵/₁₆" × 1¹¹/₁₆" × ³/₄"; 7n; 3b; 3ip; v, fss.

R. W. GARDNER NEW YORK

Robert W. Gardner products included Protected Solution of Ferrous Nitrate and Syrups of Hypophosphite of Lime, Soda, Iron and Potash; W. H. Schieffelin controlled the products in 1891. Medicinals adv. 1876 by R. W. Gardner, 158 Williams St., New York City), *WHS*; 1929–30 by the firm of R. W. Gardner, 372 Henry St., Orange, N.J., *AD*.

Clear; 6⁵/₈" × 2⁹/₁₆" diameter; 9n; 20b; pl; h, around shoulder; 3-piece mold.

Dᴿ S. M. GIDDING'S/ PREPARATIONS/N.Y.

New York City directories listed Senter M. Giddings, Manufacturers of Vegetable Family and Botanic Medicines, from 1852 until 1875.

Aqua; 7¹/₄" × 2⁵/₈" × ?; 11n; 13b; pl; v; p.

GILLET/CHICAGO [See Figure 157]

Gillett, McCulloch & Co., Chicago, IL, manufacturers of extracts, operated from 1880 to 1902, according to directories.

Clear; 2¹/₁₆" × ⁷/₈" diameter; 9n; 20b; pl; h; note spelling of GILLETT. See GILLETT (Jamaica Ginger), SHERER-GILLETT (Company).

Fig. 157

GLYCEROLE

Adv. 1887, *WHS*; 1929–30 by Sharp & Dohme, Baltimore, Md., *AD*.

Aqua; 4⁷/₈" × 1⁷/₈" × 1⁷/₈"; 7n; 2b; 1ip; v.

GLYCO-THYMOLINE

An inhalant, product of Kress & Owens, New York, adv. 1896–97, *Mack*; 1948, *AD*.

Clear; 2³/₈" × 1" diameter; 3n; 20b; pl; d; square sides. See KO (Company).

GLYCO-/THYMOLINE

Clear; 4¹/₈" × 2⁵/₁₆" × 2⁵/₁₆"; 3n; 1n; pl; d. See KO (Company).

GLYCOZONE/PREPARED ONLY BY/CH. MARCHAND/ NEW YORK/U.S.A. [See Photo 38]

Label: *GLYCOZONE, an Absolute Cure for Dyspepsia, Catarrh of the Stomach,*

Ulcer of the Stomach, Heart-Burn, . . . Charles Marchand, 57–59 Prince St., New York. Charles Marchand, New York City, established Marchand & Co. about 1885, the Marchand Institute shortly thereafter, and ca. 1890, the Drevet Manufacturing Co., Manufacturing Chemists. Associated with the business was Joseph B. and George (son) Rose. The Drevet Co. manufactured various preparations including Peroxide of Hydrogen, Glycozone and Hydrozone. Marchand was president of the firm until 1908 and the following year control was passed on to others. In 1915 Marchand moved to Brooklyn into "apparent oblivion." In 1918 George Rose and M. K. Ruby, both formerly connected with the Drevet firm, organized a new firm—The Charles Marchand Co., a Delaware corporation (Holcombe 1979). The firm was in business in 1980–81 as Marchand, Division of the Nestle LeMur Co., New York City, *AD*. No reference was found for the company in 1983, *RB*.

Clear; $4^{3}/4'' \times 1^{15}/16''$ diameter; 3n; 20b; pl; v. See HYDROZONE (Miscellaneous), MARCHAND (Medicine).

S. B. GOFF'S//CAMDEN, N. J.
Contained Goff's Bitters.

Clear; $5^{9}/16'' \times 2'' \times 1''$; 24n; 3b; 3ip; v, ss. ABM. See Goff (Bitters, Liniment, Syrup), KEMP *(Balsam)*.

[Script:] **Mary T. Goldman/St. Paul, Minn.** [Base: diamond]
Variant labeled: *Gray's Hair Restorer*, adv. 1865, *GG*; 1920 by Mary T. Goldman, 1654 Goldman Bldg., St. Paul, Minn., *Hearth & Home* (20 April 1920). The 1934 Periodical Publishers Association publication noted that the Goldman products were purchased by the Monroe Chemical Co. in 1929. Bottle manufactured by the Diamond Glass Co., Royersford, PA, after 1924 (Toulouse 1972).

Amber; $5^{1}/2'' \times 2^{3}/8'' \times 1^{1}/2''$; 3n; 3b; pl; d, script. Labeled variant, also embossed with base: MADE/IN/U.S.A.

C. F. GOODMAN/OMAHA, NEB.
[Base:] C & I
Label: *Celebrated Mountain Herb Bitters. C. F. Goodman, Omaha, Neb.* Bottle manufactured by Cunningham & Ihmsen, Pittsburgh, PA, from 1865 to 1879 (Toulouse 1972). The [Charles F.] Goodman Drug Co., was a wholesale and retail dealer in drugs and medicines from at least 1874 until Goodman died 11 Jan. 1895.

Amber; $9^{1}/8'' \times 2^{5}/8'' \times 2^{5}/8''$; 11n; 2b; pl; v.

DR. GORDACK'S//ICELAND JELLY
A cure for cankers and palpatation, prepared in Portland, ME, adv. 1841 (Baldwin 1873); 1843 (Putnam 1968).

Aqua; $6^{3}/4'' \times 2^{1}/2'' \times 1^{7}/8''$; 3n; crude; rect.; pl; v, fb; p.

L. A. GOULD/PORTLAND, ME.
[See Photo 39]
Label: *WHITE CLOVER CREAM, Prepared by L. A. GOULD, PORTLAND, Me. Trial Size For Chapped Hands, Face, Lips, Chafing, Salt Rheum, Eczema and Sunburn, For Burns, Scalds, Cuts. . . .*

Clear; $4^{5}/8'' \times 2^{1}/4'' \times 7/8''$; 7n; 6b; 1ip; v.

DR. J. C. GRAFT'S//RIGGSCIDE
Label: *. . . a medicated tooth powder, prepared by Terra-Plastica Mfg. Co., Newark, N.J.*

Clear; $4^{1}/8'' \times 1^{3}/8''$ diameter; 17n; 20b; pl; v, ss.

MRS. GRAHAM'S PREPARATIONS/ARE/PURE & HARMLESS//MRS. GERVAISE GRAHAM/BEAUTY DOCTOR/3425 STATE ST. CHICAGO
Preparations included Dandruff Cure, Face Bleach, Moth & Freckle Lotion, Quick Hair Restorer, Nail Polish, Vegetable Blood Syrup, Rose Bloom & Skin Tightener. Products adv. 1896–97, *Mack*; 1941–42, *AD*.

Clear; $5^{11}/16'' \times 2^{3}/8'' \times 1^{5}/8''$; 9n; 3b; pl; v, ss.

DR. T. W. GRAYDON/CINCINATTI, O./DISEASES OF THE LUNGS
Cincinnati city directories list Thomas W. Graydon as the manager of the American Dentaphone Co. in 1880, and as a physician from 1881 until his death in 1900. Proprietorship of the medicinals after 1900 may have been assumed by J. A. Graydon, manager of the estate. Products included an Andral Broca Method, and tuberculosis cure adv. 1905 (Devner 1968).

Amber; $7^{1}/4'' \times 2^{1}/4'' \times 2^{1}/4''$; 7n; 1 or 2b; ip; v.

GRECIAN/FANCHERONIAN/DROPS//J. S. FANCHER//NEW YORK
Label: *. . . a Cure of Any Case of Dyspepsia, Even the Most Obstinate. Will Positively Cure Cholera. . . .* Adv. 1851 (Baldwin 1873); 1854 by Jonathan S. Fancher, proprietor, in Trow's New York City directory. Fancher is listed as a broker in 1856; a lawyer in 1857.

Light aqua; $7^{1}/2'' \times 3^{5}/16'' \times 2''$; 11n; 3b; pl; v, fss; p.

G. G. GREEN. PROP.//AGUE CONQUEROR//WOODBURY, N. J.
Adv. 1878 (Baldwin 1973); 1923, *SF & PD*.

Clear, aqua; $6^{1}/4'' \times 2^{1}/4'' \times 1''$; 7n; 3b; 4ip; v, sfs. See BOSCHEE *(Syrup)*, L. M. GREEN (Miscellaneous).

L. M. GREEN. PROP.//WOODBURY, N.J.
Clear; $4^{3}/4'' \times 1^{3}/4'' \times 7/8''$; 7n; 6b; 4ip; v, ss. See BOSCHE *(Syrup)*, G. G. GREEN (Miscellaneous).

L. M. GREEN, PROP.//WOODBURY, N. J. [Base:] 3
Label: *Dr. A. BOSCHEE'S SYRUP OF TAR AND WILD CHERRY COMPOUND—For Coughs, Due to Colds. Soothes the Throat, Promotes Expectoration. G. G. Green, Inc., Sole Manufacturer, Woodbury, N. J., U.S.A. PROPRIETOR, L. M. GREEN, Woodbury, N. J.*

Clear; $7'' \times 2^{3}/8'' \times 1^{3}/8''$; 7n; 6b; 4ip; arched; v, ss; ABM. See BOSCHEE *(Syrup)*, G. G. GREEN (Miscellaneous).

L. M. GREEN, PROP.//WOODBURY, N.J.
Label: *GREEN'S DYSPEPTIC MEDICINE—August Flower, Contains $7^{1}/2$% Alcohol . . . Label Revised Jan. 1910. . . .* Adv. 1876, *WHS*; 1948, *AD*.

Clear; $5^{1}/4'' \times 1^{3}/4'' \times 1^{1}/16''$; 7n; 6b; 4ip; v, ss. See BOSCHEE *(Syrup)*, G. G. GREEN (Miscellaneous).

L. M. GREEN. PROP.//WOODBURY, N.J.
Aqua; $6^{7}/8'' \times 2^{3}/8'' \times 1^{3}/8''$; 7n; 3b; 4ip; v, ss. See BOSCHEE *(Syrup)*, G. G. GREEN (Miscellaneous).

T. T. GREEN/N.Y.
Bottle may have contained a toothache anodyne. New York City directories indicate that Thomas T. Green was a druggist, located at 399 Broadway, in 1837; from the 1840s until 1870 Green is listed as a Wholesaler and Manufacturer of Vegetable Family and Botanic Medicines.

Light green; $2^{3}/4'' \times$?; 5n; 20b; pl; h; p; tapered body.

DRS F.E. & J.A. GREENE//NEW YORK & BOSTON
Probably contained Dr. Green's Nervura, adv. 1889, *PVS &S*; 1925, *BWD*.

Aqua; $7^{3}/8'' \times 2^{11}/16'' \times 1^{11}/16''$; 7n; 3b; 4ip; v, ss. Also variant $9'' \times 3^{1}/4'' \times 1^{7}/8''$, with 1n.

GREENSILL'S/MONA BOUQUET
Clear; $4^{3}/8'' \times 1^{5}/8'' \times ^{7}/8''$; 23n; 3b; pl; v.

GRIGSBY'S//LIVER-LAX
Contained a laxative, maufactured by the Lebanon Cooperative Med. Co., Lebanon, TN.
Color unk.; $10'' \times ? \times ?$; 7n; 3 or 6b; 3 or 4ip; v, ss.

PREPARED/BY/A. G. GROBLEWSKI/PLYMOUTH, PA.
Label: *BEAVER DROPS Comp . . . The Proprietary or Patent Medicine Act, No. 8522, Alcohol 76%. . . .* Albert G. Groblewski was in business in 1892 (Ring 1980).
Clear; $4^{7}/8'' \times 1^{5}/8'' \times ^{3}/4''$; 7n; 3b; 4ip, embossed oval panel; v.

GUERLAIN/DEPOSE/PARIS
Pierre Guerlain, France, established his business, primarily devoted to colognes, in 1828. Agents in the United States included Park & Tilford, NY, and Fougera & Co. Products included Baume de la Fuerte, in addition to colognes. Products adv. 1884 (Denver 1970); 1986.
Clear; $3^{1}/4'' \times 1^{3}/4'' \times 1^{3}/4''$; 3n, salt mouth; 2b; pl; v, sfs. Also embossed with coat of arms.

GYPSY'S GIFT/FOR/RHEUMATISM
[Base:] L.G.W.
Bottle manufactured by the Louisville Glass Works, Louisville, KY, ca. 1870 to 1900 (Toulouse 1972). Adv. 1891, *WHS.*
Aqua; $5^{3}/4'' \times ? \times ?$; 7n; 3b; 3 or 4ip; v.

[monogram] HUA [See Photo 40]
Label: *Underberg Boonekamp of Maag-Bitter.* Ring (1980) states: "Underberg Bitters, sole manufacturers Hubert Underberg-Albrecht of Rheinberg, Germany, was first founded in 1846. This aromatic preparation of water, alcohol, roots, and herbs of the genus Gentiana, has been continuously manufactured for more than 125 years. The motto of the firm 'Semper idem,' means 'always the same quality. . . .'" After 1949 the product was packaged only in small .67 fl. oz. bottles. Competitors also used HUA monogrammed bottles. A round, base-embossed 1960s variant, $4''$ high, threaded plastic cap, is labeled: *A stimulant for the appetite and known as a dependable stomachic. It may be used as flavour in soda water, cocktails and other beverages.* A 1985 rectangular variant reads: *3 Tanner Boonekamp Magenbitter. R. Herr, Rastatt/Boden —*

Imported from West Germany by S. Younger & Sons, Los Angeles.
Amber; $12^{1}/4'' \times 3^{3}/16''$ diameter; 18n; 20b; pl; base monogram; distinctive lady's leg shape.

HALE'S/HONEY OF/HOREHOUND AND TAR//C. N. CRITTENTON// NEW YORK
Directories place Charles N. Crittenton as a New York City druggist in 1861. Crittenton established the Central Medicine Warehouse in 1876. Locations included No. 7 Sixth Ave., ca. 1876–1880; and 115 Fulton St., with expansion to 117 Fulton, ca. 1880–1905 (Holcombe 1979). In 1899 the company became the Charles Crittenton Co., according to the New York City directory; this firm was still in operation in 1905 (Holcombe 1979). Hale's Honey of Horehound adv. 1865, *GG;* 1929–30 by Century National Chemical Co., 86 Warren St., New York City; 1948 by Century National Chemical Co., 45 Ward St., Paterson, N.J., *AD.*
Aqua; $5^{3}/16'' \times 1^{3}/4'' \times ^{3}/4''$, also a $7''$ high variant and a variant $8^{1}/2'' \times 2^{5}/8'' \times 1^{5}/8''$; 7n; 3b; 3ip; v, fss. See COLDEN (Tonic), KIDDER (Miscellaneous).

HALSEY BROS/SUPERIOR/ TRITURATIONS/CHICAGO/AND/ DETROIT
Halsey products included Petro Calendula, Bronchial Syrup, Camphor Pills, Carbo-Peptine Wafers, Catarrh Tablets, Chestnut Pile Cerate, Elixir Hydnastis & Coca, Liver Tablets, Mentone Grape Juice and Homeo Family Medicines adv. 1895, 1907, *PVS & S.*
Amber; $5^{1}/2'' \times 1^{7}/8'' \times 1^{7}/8''$; 7n, large mouth; 2b; pl; h.

A. HAMBURGER & SONS/ DENTAFOAM/LOS ANGELES, CAL.
Clear; $4^{1}/4'' \times 2^{1}/4'' \times 1''$; ?n; 13b?; pl; h.

HAMPTON'S/V. TINCTURE/ MORTIMER/& MOWBRAY/BALT͟O
Label: *HAMPTON'S VEGETABLE TINCTURE, a certain cure for Dyspepsia, Scrofula, Liver Complaint, & c., and all diseases from impure blood. . . .* Adv. 1842 (Baldwin 1973); 1910, *AD.*
Olive; $6^{3}/8'' \times 2^{3}/4'' \times 1^{7}/16''$; 7n; 13b; pl; h; p.

SETH S. HANCE/INVENTOR/ BALTIMORE.
Seth S. Hance produced several medicinals including the Compound Syrup of Hoarhound for Coughs, Colds and Con-sumption adv. 1844 (Baldwin 1973); 1853 (Putnam 1968).
Aqua; $5^{1}/2'' \times 2'' \times 1^{1}/4''$; 9n; 12b; pl; v, p.

DR D. B. HAND/SCRANTON PA.
Probably contained Dr. Hand's Pleasant Physic. A partial label reads: *Mixture for Children, a Worm Elixir, for Colic, Diarrhoea, etc., Prepared by Hand Medicine Co., Philadelphia, Pa., Successor to D. B. Hand, M.D.* Hand's children's remedies adv. 1860s (Devner 1968); 1948 by Smith, Kline, & French Labs., Philadelphia, Pa., *AD.* Other products included a cough and croup remedy, a colic remedy, a diarrhoea mixture, general tonic, teething lotion and a worm elixir.
Aqua; $5^{5}/16'' \times 1^{7}/8'' \times ^{15}/16''$; 7n; 12b; 1ip; h, above and below ip. See HAND (Medicine).

HANSELL & BRO/MARKET S͟T/PHILAD͟A
Aqua; $5'' \times 2'' \times 1^{1}/16''$; 7n; 12b; 1ip; v.

HARPER'S CEPHALGINE/FOR HEADACHE/WASHINGTON, D.C.
Cephalgine adv. 1895, *PVS & S;* "Cephalgine, now called Cuforhedake," 1899 (Devner 1968); 1907, *PVS & S;* "Cephalgine, now named Harper's Headache Remedy," 1910, *AD;* Harper's Headache Medicine, 1925, *BD;* 1935 by Robert N. Harper & Co., Washington, D.C., *AD.*
Aqua; $5'' \times 1^{3}/4'' \times ^{1}/2''$; ?n; 3 or 6b; ip; v. See HARPER (Remedy).

HARPER'S CUFORHEDAKE/BRAIN FOOD/WASHINGTON, D.C.
"Cuforhedake Brane Fude," for headache and neuralgia (Devner 1968). Adv. 1899, 1912 (Devner 1968).
Clear, aqua; $5'' \times 1^{3}/4'' \times 1''$; 7n; 3b; 3ip; v. See HARPER (Remedy).

DR. HARTER'S/SOOTHING DROPS
Adv. 1873, *VSS & R;* 1916, *MB.*
Aqua; dimens. unk.; 7n; 20b; pl. See HARTER (Balm, *Bitters,* Elixir, Tonic), HOOD (Company).

D͟R HARVEY'S//RED PINE
Aqua; $5^{1}/4'' \times ? \times ?$; 7n, sp; 3 or 6b; 3 or 4ip; v, ss.

J. HAUEL/PHIL͟A
Aqua; $3^{1}/2'' \times ? \times ?$; 3n; 15b; 1ip; v; p. See HAUEL (Balm, *Company*).

D͟r. HAWK'S/UNIVERSAL/ STIMULANT
Cure for headaches, toothaches and other ills, adv. 1861 (Baldwin 1973); 1910, *AD.*

Aqua $3^{1}/_{2}"$ × $1^{1}/_{4}"$ diameter; 7n; 20b; pl; v.

Dr HAWKS/UNIVERSAL/ STIMULANT

Aqua $4^{5}/_{8}"$ × $1^{1}/_{2}"$ diameter; 7n; 20b; pl; v; with and without pontil.

H. H. HAY SOLE AGT. -L. F.- [Base:] L. F. ATWOOD/L F [monogram]

Label: *L. F. ATWOOD'S Improved Vegetable Physical Bilious Jaundice Bitters. Sold Wholesale & Retail by H. H. Hay, Portland, Me.* Label also warns consumers . . . *of a Bitter sent from Mass.*, label bearing the name of Moses Atwood, Georgetown. Reg. 1867. Adv. 1929–30 by Beavan Labs., 117 W. Taylor St., Syracuse, N.Y., *AD.*

Aqua $6^{7}/_{8}"$ × $2^{1}/_{4}"$ diameter; 7n; 20b; pl; h, round shoulder. See HAY *(Drug)*.

Dr Wm R. HAYDEN'S//PAINLESS FLUID/CATHARTIC & ALTERATIVE//BOSTON MASS.

The only directory reference is 1912: Mrs. W. R. Hayden, Proprietor of Hayden's Medicines.

Aqua; $6^{3}/_{8}"$ × $2"$ × $1^{1}/_{8}"$; 11n; 3 or 6b; 3 or 4ip; v, sfs; p; graduated markings on front panel.

HAYES/&/BRISTOL

Same bottle mold as Seaver's Joint & Nerve Liniment, slug plated out and converted.

Green; $3^{15}/_{16}"$ × $1^{3}/_{4}"$ diameter; 5n; 20b; pl; v; p. See SEAVER (Liniment).

HEALY & BIGELOW//INDIAN SAGWA//[embossed Indian head]
[See Photo 41]

Label: *KICKAPOO INDIAN SAGWA – Blood, Liver, Stomach, Kidney Renovator.* The Kickapoo Indian Medicine Company was established in New Haven, CT in 1881, by John Healy and Charles Bigelow; the primary outlet for distribution of products was the traveling medicine show (Fike 1967). Healy sold his interests to Bigelow in 1894 (Wilson and Wilson 1971). Adv. 1881 (Wilson and Wilson 1971); 1929–30, as Kickapoo Sagwa by Wm. R. Warner, New York City, *AD.*

Aqua; $8^{1}/_{2}"$ × $2^{15}/_{16}"$ × $1^{3}/_{4}"$; 1n; 3b; 3ip; v, ss; hf. See HEALY & BIGELOW (Cure, Oil), KICKAPOO *(Oil, Miscellaneous, Syrup)*, SAGWA (Miscellaneous).

R. E. HEMSLEY/PHARMACEUTIST/ NEW YORK

Products included R. E. Hemsley's Worm-Destroying Syrups, adv. by Hemsley & Beers, New York, 1846 (Baldwin 1973).

Aqua; $4^{3}/_{4}"$ × $1^{1}/_{2}"$ × $^{7}/_{8}"$; 5n; 12b; pl; v; p.

DOCTOR I. T./HENDERSONS// QUACHITA/VERMIFUGE

Possible Louisiana origin (Nielsen 1978).

Blue green; $5"$ × ? × ?; 1n?; 3b; p. Also a round, vile variant, $4"$ × $1"$ (Nielsen 1978).

DR. HENLEY'S/CELERY, BEEF AND IRON

Adv. 1885 (Baldwin 1973); 1923, *SF & PD.*

Amber; $11^{3}/_{4}"$ × ?; 18n; 20b; pl; h, around shoulder. See C. B. & I. (Company), HENLEY *(Bitters)*.

Dr HENLEY'S/REGULATOR

Adv. 1897, *L & M.*

Aqua; $8^{1}/_{2}"$ × ? × ?; 7n; 2b; 1ip; v. See C. B. & I. (Company), HENLEY *(Bitters)*.

Dr HENRY'S BOTANIC/ PREPARATIONS.

Aqua; $6^{1}/_{4}"$ × $2"$ × $1^{1}/_{8}"$; 7n; 3b; 4ip; v.

HERB/JUICE [Base: N in square]

Label: *MILLER'S HERB EXTRACT AND LAXATIVE COMPOUND. Alcohol 11%. An Agreeable Laxative prepared by a Combination of Herbs, Barks and Leaves. Distributed by Herb Juice Med. Co., Jackson, Tenn.* Bottle manufactured by the Obear-Nester Glass Co., East St. Louis, IL, 1915 to present (Toulouse 1972). Adv. 1929–30 from 109 Church St., Jackson, Tenn.; 1948 by Herb Juice-Penol Co., Inc., 421 Newton St., Danville, Va., *AD.*

Clear; $8^{3}/_{8}"$ × $2^{7}/_{8}"$ × $1^{3}/_{8}"$; 7n; sp; 3n; 1ip; d; ABM.

HERBA

Possibly Herba Soap adv. 1935 and 1941–42 by David Boghen, 1080 Park Ave., New York City, *AD.*

Aqua; $2^{1}/_{2}"$ × ?; 7n; 20b; pl; v.

HICK'S CAPUDINE/FOR ALL HEADACHES/COLDS, GRIPP, ETC.

Product of the Capudine Chemical Co., Raleigh, NC, adv. 1890s (Devner 1968); 1948 (same company), 1980–81 by Oakhurst Co., New York City, *AD;* 1984–85, as Capudine Liquid Headache Remover by Oakhurst Co., 1001 Franklin Ave., Garden City, N.Y., *AD.*

Amber; $2^{3}/_{4}"$ × $2^{1}/_{4}"$ × $1^{3}/_{4}"$; 7n; 3b; ip; v. See CAPUDINE (Miscellaneous), HICK (Cure).

HICK'S CAPUDINE/FOR ALL HEADACHES/COLDS, GRIPP, ETC.

Amber; $5^{5}/_{8}"$ × $2^{1}/_{8}"$ × $^{7}/_{8}"$; 7n, crude; 3b; 4ip, oval front; v. Also ABM variant, $5^{3}/_{4}"$ × $2^{1}/_{16}"$ × $1^{3}/_{16}"$. See CAPUDINE (Miscellaneous), HICK (Cure).

HIGINBOTHAM

Bottle manufactured ca. 1904.

Color unk.; ? × $1^{3}/_{4}"$ × $1^{3}/_{4}"$; 7 or 9n; 2b.

JOHANN HOFF

Johann Hoff's Malt Extract (Beer of Health) was introduced in 1847 and manufactured in Berlin and Hamburg, Germany. Advertisement: "THE GENUINE AND ONLY IMPORTED JOHANN HOFF'S MALT EXTRACT – Introduced into the United States by LEOPOLD HOFF in 1866, and sold from Hoff's Malt Extract Depot, 542 Broadway, N. Y., Leopold Hoff Proprietor. Agency transferred to JOSEPH S. PEDERSEN in 1868, Depot $2^{1}/_{2}$ Murray Street, N. Y.; TARRANT & COMPANY, Appointed SOLE AGENTS in 1869, 278, 280 and 282 GREENWICH STREET, New York" (Wilson and Wilson 1971). Adv. 1935 by Johann Hoff Co., 220 36th St., Brooklyn, N.Y., *AD.*

Olive green, amber; $7^{5}/_{8}"$ × $2^{15}/_{16}"$ diameter; 11n; 20b; pl; h, around shoulder; later variants amber. See JSP (Miscellaneous), TARRANT (Drug).

HOLMES' FRAGRANT// FROSTILLA//ELMIRA, N. Y., U.S.A.

Frostilla, the formula of Clay W. Holmes, was introduced in 1873 (Devner 1968); by 1900 the product was the best selling brand of its type (Wilson and Wilson 1971). Later variants are embossed: FOR THE SKIN. Frostilla adv. 1948 by Frostilla Co., Inc., Elmira, N.Y., *AD.*

Clear; $4^{3}/_{8}"$ × $1^{13}/_{16}"$ × $1^{1}/_{4}"$; 7n; 6b; 3ip; v, sfs. See HOLMES (Lotion, Trade Mark).

HOLMES' FRAGRANT// FROSTILLA//FOR THE TOILET

Clear; $4^{1}/_{2}"$ × ? × ?; 7n; 6b; 3ip; v, sfs. See HOLMES (Lotion, Trade Mark).

THE HON. BLE/LADY HILL

Light aqua; $3^{1}/_{2}"$ × $1^{1}/_{4}"$ diameter; 13n; 20b; pl; p.

HOPKINS'/CHALYBEATE/ BALTIMORE

Olive; $7^{1}/_{2}"$ × $3"$ diameter; 2n; 20b; pl; h; p.

DR JEROME HORN/MAGNETIC/ HEALING BATHS/808. 24TH ST/ NEAR MISSION/SAN FRANCISCO

Contained Galvanic Fluid, produced ca.

1883 to 1888 (Wilson and Wilson 1971).
Clear; 4″ × ? × ?; 9n; 8b; pl; h.

HOUCK'S/PATENT/PANACEA/BALTIMORE
Adv. 1836 (Putnam 1968); 1910, *AD*.
Aqua; 6⅞″ × 3″ diameter; 11n; 20b; pl; v; p.

HOYT'S/NICKEL/COLOGNE
Clear; 2½″ × ⅞″ diameter; 7n; 20b; 1ip; h. See HOYT *(Company)*.

J. HUCKEL Jᴿ/PHILADᴬ
Directories listed James H. Huckel, Jr., as a Commercial Merchant, 1215 Front St., Philadelphia, in 1860; as a Druggist, 617 Sears, in 1863, relocated to 443 Worth in 1864; as a Clerk by 1874.
Aqua; 4⅛″ × 2⅛″ × 1¼″; 13n; 12b; pl; v; p.

RICHARD/HUDNUT/NEW YORK//RH [monogram]//RH [monogram]
Richard Hudnut opened a drugstore, Broadway & 22nd. St., New York City, in 1888, and began manufacturing "a few select cosmetics at a time when use of such beauty aids by women was still considered daring." In 1914 Hudnut closed his retail store and devoted his full energies to manufacturing cosmetics; he sold the business to the Pfeiffer Chemical Co. in 1916. Richard Hudnut cosmetics were still being manufactured in 1982 by the Warner-Lambert Company. Information supplied by Thorn Kuhl, Warner-Lambert Co. (personal communication, 1982).
Clear; 5⅞″ × 1¾″ × 1⅜″; 3n; 6b; pl; h. See PHEIFFER *(Company)*, W. WARNER *(Company)*.

HUFELAND [See Photo 42]
Bottle manufactured ca. 1908 to 1918. Contained bitters introduced in 1851, according to an advertisement in the *Arizona Miner*, 16 March 1872: *The oldest and the best, Dr. Hufeland's Celebrated Swiss Stomach Bitters, the first and the most healthful tonic ever introduced in the U.S. These bitters have been in the San Francisco market for over 20 years. Taylor & Bendel, Sole Agents, 409 & 411 Clay St., S. F.* In earlier years the product belonged to J. G. Frisch, San Francisco, who also had temporary offices in Virginia City, NV. In 1864 the bitters were acquired by Thomas Taylor. When Taylor died in 1874 the San Francisco plant was closed and the headquarters were moved to Virginia City. The Hufeland brand was sold to

N. Van Bergen & Co. The bottles were not embossed until after 1900 (Wilson and Wilson 1969). Van Bergen controlled manufacture in 1915 but by 1917, Kuhls, Schwarke & Co., Inc. was sole manufacturer. The product was recommended for ". . . chronic constipation, indigestion, biliousness, dyspepsia and general disorders caused by the inactivity of the liver, bowels and digestive organs." Adv. 1921, *BD*.
Amber; 11⅞″ × 3⅛″ diameter; 18 and 25n; 20b; pl; h, just below shoulder; ABM. See ALPINE *(Bitters)*.

HUMPHREYS/NEW YORK/
[embossed circle with wings]
[See Figure 158]
Fred Humphrey established the Specific Homeopathic Med. Co. ca. 1844, in Auburn, NY. Humphrey's Homeopathic Med. Co., Inc., New York City was incorporated in 1854. In the 1940 the name was changed to Humphrey's Med. Co., Inc. In the 1960s the company relocated to Rutherford, NJ., and in 1968 the name became Humphrey's Pharmacal Inc. Products for human consumption were numbered; veterinary specifics, lettered (Humphrey 1972). The firm was in business in 1983, *RB*.
Clear; 2¼″ × 1½″ diameter; 7n, large mouth; 20b; pl; base. See HUMPHREY *(Medicine*, Specific).

Fig. 158

HUMPHREYS/GOLDEN/G. D./DOUCHE/NEW YORK [Base:] W. T. & CO. [See Figure 159]
Label: *HUMPHREYS' GOLDEN DOUCHE, (8.80% Alcohol). For the Prompt Relief of LEUCORRHEA, PRURITUS, ITCHING and UNHEALTHY DISCHARGES. Humphreys' Homeo. Med. Co., New York City.* Bottle manufactured by Whitall-Tatum, 1857 to 1935 (Toulouse 1972). Adv. 1907, *PVS & S*; 1941-42, *AD*.
Clear; 7¾″ × 2¹³⁄₁₆″ × 1⅞″; 9n; 18b, with round corners; pl; h. See HUMPHREY *(Medicine*, Specific).

Fig. 159

HUMPHREYS'/MARVEL/OF HEALING
Witch Hazel Oil, the Pile Ointment, adv. 1878 (Devner 1968); 1879, *VSS & C*; 1929-30 and 1941-42 from Lafayette & Prince Sts., New York City, *AD*.
Clear; dimens. unk.; 7n; 12b; pl; h, embossed within circle. See HUMPHREY *(Medicine*, Specific).

HUMPHREYS/MARVEL/WITCH HAZEL [See Photo 43]
Labeled for . . . *Wounds, Bruises, Scalds, Toothache, Sunburns, Faceache . . . Humphreys' Homeo. Med. Co., Corner William & Ann Streets, New York.*
Clear; 5⅜″ × 2⅜″ × 1¾″; 3n; 8b; pl; h; ABM. See HUMPHREY *(Medicine*, Specific).

HUNNEWELL'S/TOLU/ANODYNE
Promoted as a cure for relief of many menstruation problems, hysteria, neuralgia and tooth and earaches. Introduced ca. 1840 (Wilson and Wilson 1971); adv. 1859, John L. Hunnewell, proprietor, Boston, Mass. (Singer 1982); 1910, *AD*. Wilson and Wilson (1971), note the sale of Hunnewell brands to Gilman Bros., Boston, ca. 1870. Directories establish John L. Hunnewell & Co. ca. 1841, with Joseph W. Hunnewell a partner. The company primarily manufactured paint and oils. The firm eventually changed its name to J. W. Hunnewell & Co. and included a reference to the manufacture of drugs, 1906-20. 1920 was the last listing for the company.
Aqua; 4″ × 1⁹⁄₁₆″ × ¹⁵⁄₁₆″; 5n; 6b; 1ip; v. See UNIVERSAL (Remedy).

HYDROZONE/PREPARED ONLY BY/CHAS. MARCHAND
Advertisement: "Remedy for Dyspepsia, Stomach Catarrh & Yellow Fever." Adv. 1895, *PVS & S*; 1941-42, *AD*.

Amber; 4″ × 1″ diameter; 3n; 20b; pl; v. See GLYCOZONE *(Miscellaneous)*, MARCHAND (Medicine).

HYDROZONE/PREPARED ONLY/ BY/CHAS. MARCHAND/ NEW YORK/U.S.A.

Clear; 4⁵/₈″ × 1¹³/₁₆″ diameter; 7n; ; 20b; pl; h. See GLYCOZONE *(Miscellaneous)*, MARCHAND (Medicine).

HYOMEI

Product of R. T. Booth, Ithaca, NY, guaranteed to cure the common cold. Adv. Nov. 1896, *Western Druggist*; 1929–30 by Booth's Hyomei Co., 319 E. Seneca St., Ithaca, N.Y.; 1941–42 by same company, 2 Johnes St., Newburgh, N.Y., *AD*.

Clear; 3¹/₂″ × ⁷/₈″ diameter; 7n; 20b; pl; v.

INDAPO

Label: *"INDAPO" Take three Pellets at each meal before eating. Oriental Medical Co., Proprietors for the U.S., Chicago, Ill.* Adv. 1895, *PVS & S*; 1910, *AD*.

Clear; 2⁷/₈″ × ³/₄″ diameter; 13n; 20b; pl; base.

INJECTION BROU//102 RHU RICHELIEU//PARIS

Ricord's Injection Brou, cure for genital diseases, adv. 1843 (Wilson and Wilson 1971); 1948 by Fougera & Co., Inc., New York City, *AD*.

Clear; 7¹/₂″ × ? × ?; 7n; 23b; pl; v, fcc.

INJECTION BROU//192 BOULEVART MAGENTA//PARIS

Clear; 7¹/₈″ × 2¹³/₁₆″ × 1¹/₂″; 7n; 23b; pl; v, fcc.

INJECTION RICORD/PARIS

[See Photo 44]

Blue; 6″ × 2″ × 2″; 7n; 2b; pl; v.

JOHN IRVING/& SONS

Green; 4³/₄″ × 1¹/₂″ × 1¹/₈″; 7n; sp; 3b; 4ip; v.

[monogram] JSP

Label: *Leopold Hoff's Malt Extract, a dietectic healing remedy, Manufactured in Hamburg, Germany — Imported by Tarrant & Co.*

Green; 8³/₄″ × 2¹/₄″ diameter; 12n; 20b; pl; h, monogram; several colored variants. See HOFF *(Miscellaneous)*.

J a c i e l

Milk glass; 2¹/₂″ × 2″ diameter; 17n; 20b; pl; base; a cream jar with zinc cap embossed with butterfly and flowers.

Dᴿ JACKSON'S/PILE/ EMBROCATION/PHILᴬ

Ointment for itching piles, distributed by A. B. & D. Sands, New York, NY. First embossed bottles ca. 1844; adv. 1910, *AD*.

Aqua; 4″ × ?; 5n; 20b; pl; v. See A. B. & D. SANDS *(Miscellaneous)*.

JUDSONS JACOBUS/CHICAGO

[See Figure 160]

Directories listed the drug firm of Judson Jacobus from 1874 to at least 1902.

Clear; 2⁵/₈″ × ⁷/₈″ × ⁷/₈″; 9n; 2b; 1ip; v.

Fig. 160

[Script:] Jad//Jad

Label: *JAD BRAND SALTS Sparkling Effervescent Salts Combining fruit acids. Price 85 cents. Distributed by Wyeth Chem. Co., Inc., New York. N.Y.* Adv. 1925, *BWD*; 1948 by Whitehall Pharmacal Co., New York City, *AD*.

Clear; 6¹/₄″ × 2⁵/₈″ × 1³/₄″; 16n; 12b; pl; h, fb, script on shoulder; ABM.

JAFFE'S ELECTRIC//PAIN EXPELLER

Prepared and bottled by Moses L. Jaffe, San Jose, CA, 1893 to 1896 (Wilson and Wilson 1971). Adv. 1896–97, *Mack*; 1897, *L & M*.

Aqua; 7¹/₄″ × ? × ?; 7n, sp; 6b?; 3 or 4ip; v, ss.

DᴿR D JAYNE'S/ALTERATIVE/ 84 CHESᵀ Sᵀ PHILᴬ

Dr. David Jayne introduced his medicines in 1830. The first Jayne almanac was published in 1843 (Holcombe 1979). Jayne's business was located at 20 S. Third St., Philadelphia, in 1844 (Putnam 1968); 84 Chestnut St. in 1851. The building numbers were changed in 1857 and 84 became 242 (Holcombe 1979). Jayne's Liniment was introduced in 1839, the sarsaparilla in 1854 (Wilson and Wilson 1971), and the alterative in 1851 (Holcombe 1979); the latter adv. 1929–30, *AD*.

Aqua; 7″ × 2⁷/₈″ × 1³/₄″; 11n; 13b; pl; v; p. See JAYNE (Balsam, Expectorant, Liniment, Tonic).

Dᴿ D. JAYNE'S/ALTERATIVE/ 242 CHESᵀ Sᵀ PHILᴬ.

[See Photo 45]

Label: *JAYNE'S ALTERATIVE. This style Bottle & Package Adopted January 1, 1905. The Blood Purifier, For Scrofula, King's Evil, Goitre, Scrofulous and Indolent Tumors, White Swellings, Ulcers . . . and all Diseases Originating from a Deprived and Imperfect State of the Blood or other Fluids of the Body.*

Aqua; 6³/₄″ × 2⁵/₈″ × 1¹/₂″; 6n, modified; 4b; pl; v. See JAYNE (Balsam, Expectorant, Liniment, Tonic).

DR. D. JAYNE & SON, INC.// PHILADELPHIA U.S.A.

[Base: O over diamond]

Label: *JAYNE'S EXPECTORANT. Alcohol 1% [or 11%]. Dr. D. Jayne & Son Inc. Philadelphia.* Bottle manufactured by the Owens-Illinois Glass Co., after 1929 (Toulouse 1972). Adv. 1835 (Singer 1982); 1929–30, *AD*; as Jayne's For Coughs, 1948, *AD*.

Clear; 5¹/₄″ × 2³/₄″ × 1″; 3n; 6b; pl; v, ss; ABM. See JAYNE (Balsam, Expectorant, Liniment, Tonic).

DR. D. JAYNE & SON// PHILADELPHIA U.S.A. [Base: I in diamond]

Label: *JAYNE'S CARMINATIVE. Alcohol 25%. . . .* Bottle manufactured by the Illinois Glass Co., 1916 to 1929 (Toulouse 1972). Other products listed on label were Vermifuge, Sanative Pills, Expectorant, Jaynex, Liniment, and Tapeworm Remedy.

Clear; 6¹/₂″ × 2¹/₈″ × 1³/₈″; 10n; 3b; modified with concave sides; 2ip; v, ss; ABM. See JAYNE (Balsam, Expectorant, Liniment, Tonic).

JEWELETTE/LABORATORIES/ [embossed vertical diamond]/ PERFUMERS/CHICAGO

Clear; 7¹⁵/₁₆″ × 2¹⁵/₁₆″ × 1¹¹/₁₆″; 9n; 13b; pl; h.

JEWELETTE/LABORATORIES/ PERFUMERS/CHICAGO

Clear; 8¹/₈″ × 2⁷/₈″ × 1³/₄″; 9n; 13b; pl; h.

JONES//AMERICAN/ CHOLAGOGUE//NEW YORK

Advertised in 1848 as ". . . An Infallible Remedy For Fever and Ague, Bilious and Intermittent Fevers, and all diseases of a Malarious origin . . . C.C. Bristol, Wholesale and Retail Agency, 225 Main St., Buffalo" (Singer 1982). Adv. 1856 by Barnes & Park (Baldwin 1973).

Aqua; $6\frac{1}{2}'' \times 1\frac{3}{8}'' \times 1\frac{1}{2}''$; 13n; rect.; pl; v, sfs; p. See GUYSOTT (*Sarsaparilla*), WYNKOOP (*Pectoral*).

[h] JONES/[v] J. D. PARK/ CINCINATTI, O//AMERICAN// CHOLAGOGUE
Aqua; $6\frac{1}{2}'' \times 2\frac{1}{4}'' \times 1\frac{1}{2}''$; 1n; 3b; 3ip; h, v, fss; p. See GUYSOTT (*Sarsaparilla*), WYNKOOP (*Pectoral*).

[monogram] KKK [Base: diamond]
Label: *KKK Shampoo Liquid, KKK Medicine Co., Keokuk, Ia.* Bottle manufactured by the Illinois Glass Co., Alton, IL, 1916 to 1929 (Toulouse 1972). Adv. 1900, *EBB.*
Clear; $7\frac{3}{4}'' \times 2\frac{5}{8}'' \times 1\frac{1}{4}''$; 16n, sp; 6b; pl; v; ABM.

K.K.K.K.//K.K.K.K.//F. E. LAWRENCE/LEROY, N.Y.
Label: *Kenyon's Kough and Konsumption Kure.* Adv. 1900, *EBB.* Frank E. Lawrence was a "Dealer in Pat. Medicine & Lumber" in 1896.
Aqua; $6'' \times 1\frac{5}{8}'' \times 1''$; 11n; 1 or 2b; 3 or 4ip; v, fbs.

KYB//NIPPON
Clear; $2\frac{1}{2}'' \times 1\frac{3}{4}'' \times 1''$; 3n, sp; 12b; pl; h, fb, in triangle; distinctive shape.

KAMAME//KAMAME
Partial label: *BOBASKA, for the Toilet and Bath, Laundry.* . . .
Aqua; dimens. unk.; 7n; ?b; ip; v, ss.

[Arched:] HARTWIG KANTOROWICZ/[h] POSEN/ HAM = /BURG/PARIS
Label: *Litthauer Stomach Bitters, invented by Jos. Loewenthal, manufactured by H. Kantorowicz and assumed by S. Loewenthal, son of sole inventor.*
Milk glass; $9\frac{1}{2}'' \times 2\frac{3}{8}''$ diameter; 11n; 1b; pl; h; tapered body; many variations. See LITTHAUER (*Bitters*).

DR KAY'S//RENOVATOR
Label: *Dr. B. J. Kay's Renovator, Liquid or Tablet Form, Dr. B. J. Kay Medical Co., Saratoga Springs, N.Y.* The Dr. B. J. Kay Medical Co. was founded by B. J. Kendall, *HH & M.* Product adv. 1899 (Devner 1968); 1910, *AD.*
Amber; $10'' \times 2\frac{5}{8}'' \times 2\frac{5}{8}''$; 12n; 1 or 2b; ip; v, fb. See KENDALL (*Miscellaneous*).

KEASBEY & MATTISON [Base:] KEASBEY/&/MATTISON/PHILADA
Products included Magnesium Carbonate, Granular Effervescing Salts, and Effervescent Cafetonique.
Blue; $3\frac{1}{4}'' \times 1\frac{1}{4}''$ diameter; 3n; 20b; pl; h, around shoulder, base. See

KEASBEY & MATTISON (*Chemical,* Company), BROMO (Miscellaneous).

KEASBEY & MATTISON PHILADELPHIA
Blue; $6'' \times ?$; 3n; 20b; pl; h, around shoulder. See KEASBEY & MATTISON (*Chemical,* Company), BROMO (Miscellaneous).

Dr. J. CLAWSON KELLEY'S// ANTISEPTIC DETERGENT// NEW-YORK.
John Clawson Kelley had a variety of interests. Kelley was listed in directories from 1833 to 1836 as chemist; 1836 to 1841 as a printer; 1841 to 1854 as a physician. Clawson opened a drugstore in 1845 with his son John W., the latter was listed as a botanist in 1846. In 1848 Kelley & Son, Analytic Medical Institute, was established and operated until 1854. J. C. Kelley's Vegetable Rob for Chronic Diseases adv. 1839 (Baldwin 1973).
Dark green; $9\frac{1}{8}'' \times 3\frac{1}{4}'' \times 2\frac{1}{8}''$; 11n; 3b; pl; v, sfs; p. See KELLEY (*Cure*).

Dr. D. C. KELLINGER./N.Y.
Universal vessel for several products. DeWitt C. Kellinger began the manufacture of medicinals in 1850, according to Rhode's New York City directory. Kellinger's Infallible Liniment adv. 1852 (Baldwin, 1973); 1923, *SF & PD.* Other products included Kellinger's Great Discovery, Heave Remedy and Renovating Cordial.
Aqua; $6\frac{1}{8}'' \times 2\frac{1}{16}''$ diameter; 11n; 20b; pl; v; p. See KELLINGER (*Remedy*).

DR./KELLINGER'S//MAGIC FLUID//NEW YORK
Aqua; $3\frac{11}{16}'' \times 1\frac{13}{16}'' \times \frac{7}{8}''$, also $4\frac{7}{8}'' \times 2'' \times 1\frac{1}{8}''$; 13n; 3b; 3ip; v, fss; p. See KELLINGER (*Remedy*).

DR. B. J. KENDALLS/QUICK RELIEF
In 1891 Kendall products were being manufactured in Enosburgh Falls, VT, by three companies. 1. Benjamin J. Kendall introduced Kendall's Spavin Cure in 1876 (White 1974), established B. J. Kendall & Co. in 1879, and incorporated in 1883. Kendall left the business to managers in 1884 and sold the firm in 1889; Kendall also founded the Dr. Kay Medical Co., Saratoga Springs, NY. B. J. Kendall's Quick Relief adv. 1900, *EBB,* 1910 *HH & M.* 2. Daniel A. Harvey and Henry D. Kendall began producing the following medicinals in 1882: Kendall's Liver & Kidney Cure; Sarsaparilla and Iron; Elixir; Cordial;

Pain Cure; Pills; Soothing Syrup; Condition Powders and Healing Oil. Harvey eventually became the sole owner. 3. Hamilton Kimball & Co., successors to Hamilton, Best & Kimball, began manufacturing a line of Kendall's preparations and extracts in 1888 (*History of Franklin and Grand Isle Counties Vermont,* Syracuse, N.Y., 1891).
Aqua; $5'' \times 2'' \times 1''$; 7n; 3 or 6b; ip; v. See GILBERT (*Bitters*), HUTCHINSON (Company), KAY (Miscellaneous), KENDALL (Balsam, Cure).

KENDALL'S SPAVIN TREATMENT/ FOR HUMAN FLESH [Base:] ENOSBURG FALLS VT.
Kendall's Spavin Cure was introduced in 1876 (White 1974); adv. 1876, *New Hampshire Register, Farmers Almanac & Business Directory;* 1921, *BD;* as a treatment in 1929–30, *AD;* as liniments for human and veterinarian use in 1948, *AD.*
Aqua; $5\frac{3}{8}'' \times 1\frac{3}{8}''$ diameter; 7n; 21b; pl; v. See KENDALL (Balsam, Cure), HUTCHINSON (Company).

DR. KENNEDY'S//PRAIRIE WEED//ROXBURY, MASS.
A balsam and tonic for the cure of coughs and colds. Adv. 1876, *WHS;* 1907, *PVS & S.*
Aqua; $8\frac{1}{4}'' \times 3'' \times 2''$; 1n; 3b; pl; v, sfs. See KENNEDY (*Discovery,* Liniment, Ointment).

DR. KENNEDY'S//RHEUMATIC// DISSOLVENT//ROXBURY, MASS.
Adv. 1870 (Singer 1982); 1907, *PVS & S.*
Aqua; $9'' \times 3'' \times 2''$; 11n; 6b; 3ip; v. See KENNEDY (*Discovery,* Liniment, Ointment).

KERKOFF/[monogram]/PARIS/ FRANCE
Contained perfume. Products of Alfred H. Smith, Importer, adv. 1912 (Devner 1970); 1929–30, *AD.*
Clear; $5'' \times 2\frac{3}{8}'' \times 2\frac{3}{8}''$; 9n; 2b; pl; h; tapered with ribbed base.

KICKAPOO SAGWA STOMACH/ LIVER AND KIDNEY RENOVATOR
Color & dimens. unk.; 1n; 3b; pl; v. See HEALY & BIGELOW (Cure, *Miscellaneous,* Oil), KICKAPOO (Oil, Syrup), SAGWA (Miscellaneous).

WM F. KIDDER/NEW YORK
Labeled as *Hydroleine Digestive Nutritive, Charles N. Crittenton, New York.* Adv. 1887, *WHS;* 1948 by Century National Chemical Co., 45 Ward St., Patterson, N.J., *AD.* William F. Kidder was a New York merchant in 1871, prior to estab-

lishing his own drug firm, according to New York City directory.

Light green; 7½″ × 3⅛″ × 1¾″; 7n; 12b; pl; h. See COLDEN (Tonic), HALE *(Miscellaneous)*.

DR. KILMER'S//SWAMP-ROOT
[Base: P in circle] [See Photo 46]
Label: *DR. KILMER'S SWAMP ROOT—Diuretic to Kidneys and Mild Laxative. Kilmer & Co., Inc., Distributors, Plainview, N.Y. 11803.* Bottle manufactured by Pierce Glass Co., St. Marys, PA, 1905 to 1917 (Toulouse 1972).
Clear; 7″ × 2⅛″ × 1¼″; 16n; 12b, modified with strap sides; pl; v, ss; ABM. See KILMER (Cure, Extract, Ointment, *Remedy*).

[Shoulder:] **POISON**/[around side near base:] **KILNER BROS LTD MAKERS** [Base:] **MADE IN ENGLAND**
Kilner Bros., Glass Makers, England, was established in 1857.
Cobalt; dimens. unk.; 10n; 20b; h; vertical flutes.

C. S. KINTZING/Sᵀ. LOUIS Mᴼ
Bottle manufactured ca. 1864; probably contained bitters (Switzer 1974).
Dark green; 8⅞″ × 2¹³/₁₆″ × 2¹³/₁₆; 11n; 2b; pl; v.

KNOXIT
A cure for venereal disease. Adv. 1899 by C. W. Beggs & Sons Co., Chicago, IL (Devner 1968); 1935 by Beggs Mfg. Co., 1650 S. Ogden Ave., Chicago, *AD*.
Clear; 5″ × 2″ × 1⅜″; 7n; 6b; 1ip; v. See BEGGS (*Balsam*, Syrup).

KNOXIT/GLOBULES
Clear; 3⅜″ × 1⅜″ × ¹⁵/₁₆″; 7n; 3b; pl; v.

DR AUGUST KOENIGS/ HAMBURGER/TROPFEN
[See Figure 161]
The "Dr. Koenig" line of medicinals, usually advertised in German, were introduced by A. Vogeler & Co., Baltimore, MD, in 1871 (Holcombe 1979).

Fig. 161

Stomach drops adv. 1871 (Holcombe 1979); 1929–30, *AD*.

Aqua; 3¾″ × ⅞″ diameter; 7n; 20b; pl; v. See BULL *(Syrup)*, ST. JACOBS *(Oil)*.

KUTNOW'S POWDER [Base:] **KP**
[See Photo 47]
Label: *KUTNOW'S IMPROVED EFFERVESCENT POWDER . . . invaluable in diseases of the Stomach, Liver, Kidneys and Bladder.* A product of Gustav, John and Hermann Kutnow introduced ca. 1895 (Wilson and Wilson 1971). There were offices in New York and London. Adv. 1898, *CHG*; 1929–30 by S. Kutnow Co., Ltd., New York, *AD*; 1941–42 by Richie & Janvier Inc., Bloomfield, N.J., *AD*.
Clear, early variants aqua; 5″ × 2⅜″ × 1½″; 7n; 3b; pl; v.

L M & G
Clear; 3⅝″ × 1¾″ × 1¼″; 7n; 3b; pl; v.

LACTOPEPTINE/FOR [embossed Maltese cross] **ALL/DIGESTIVE AILMENTS**
The 1 Nov. 1891 *Pharmaceutical Era* advertised Lactopeptine as "The Most Important Remedial Agent ever Presented to the Profession for Dyspepsia, Vomiting in Pregnancy, Cholera Infantum, Constipation and All Diseases Arising from Imperfect Nutrition." The product and firm, The New York Pharmacal Association, was established by John Carnrick, New York City, in 1877. About 1887 the company was absorbed by Reed & Carnrick (Holcombe 1979). Product available in powder, tablet, syrup and elixir form in 1929–30. Adv. 1948 by Arlington Chemical Co., Yonkers, N.Y., *AD*.
Emerald green; 1⅞″ × 1¼″ × ¾″; 16n, ground; 12b; pl; h. Also cylindrical variant, shoulder embossed: RCA [Reed, Carnrick & Andrus] **NEW YORK**. See ARLINGTON (Chemical), LACTOPEPTINE (Remedy), PEPTENZYME (Miscellaneous), REED & CARNRICK *(Oil)*.

G. W. LAIRD/PERFUMER/ NEW YORK
Label: *Laird's Bloom of Youth or Liquid Pearl for Beautifying & Preserving the Complexion & Skin. Price 75¢. Prepared by Geo. W. Laird, Beware of Counterfeits.* Adv. 1864 (Putnam 1968); 1915, *SF & PD*.
Milk glass; 4⅞″ × 2¼″ × 1¼″; 7n; 3b; pl; v.

Dᴿ LALOR'S/PHOSPHODYNE// PRICE 4/61/LONDON//ENGLAND
Light blue; 6⅝″ × 2⅜″ × 1½″; 7n; 4b, back corners are tapered more than front corners; pl; v, fcc.

LANGLEY & MICHAELS/SAN FRANCISCO [Base:] **5 F**
[See Figure 162]
Florida water, adv. 1897, *L & M*.
Aqua; 8⅝″ × 2¼″ diameter; 11n; 20b; pl, slug plate; v. See LANGLEY & MICHAELS *(Jamaica Ginger)*, NICHOLS (Miscellaneous).

Fig. 162

W. F. LAWRENCE'S/EPPING, N.H.//GENUINE//PREPARATIONS
Aqua; 5½″ × ? × ?; 1n; 3b; 3ip; v, fss; p.

LAXOL//A. J. WHITE/ NEW YORK//LAXOL [Base:] **DESIGN PATENTED/APRIL 10/ 1894** [See Figure 163 and Photo 48]
A castor oil product of Albert J. White, New York, introduced in 1894 (Wilson and Wilson 1971). Adv. 1895, *PVS & S*; 1948 by A. J. White Ltd., 70 W. 40th St., New York City, *AD*.
Peacock blue, cobalt; 7″ × 2¼″ × 1⅝″; 3n; 27b; 3ip; v, cc; h, f. See SEIGEL *(Syrup)*, SHAKER (Cordial, Pill), WHITE (Miscellaneous, Syrup).

Fig. 163

LEAVEN'S/ENGLISH VERMIN/DESTROYER

Aqua; 5¹/₄″ × 2″ × 1¹/₁₆″; 11n; 13b; pl; v; p.

DR. LEPPER'S/ELECTRIC LIFE

Product for man or beast, internal or external use. Adv. 1880s; 1896–97, *Mack;* 1921, *BD.*

Aqua; 5³/₄″ × 2¹/₁₆″ × 1¹/₈″; 7n; 7b; 3ip; v. See LEPPER *(Oil).*

DR. LEPPER'S/MOUNTAIN/TEA

[Base:] **W.T. & CO.**

Bottle manufactured by Whitall-Tatum, Millville, NJ, 1857 to 1935 (Toulouse 1972). Adv. as "Natures Great Regulator of the Kidneys and Liver. . . ." 1896–97, *Mack;* 1917, *BD.*

Aqua; 8¹/₂″ × 2³/₄″ × 1¹/₁₆″; 7n; 3b; 3ip; v. See LEPPER *(Oil).*

DR. LESURE'S/COLIC/DROPS// NO. 2, 1 OZ/1 FL. OZ.

Bottle manufactured ca. 1900. Adv. 1910, *AD.*

Clear; 3³/₈″ × 1¹/₈″ × 1¹/₈″; 9n; 1b; pl; h, fb. See LESURE *(Cure,* Liniment).

DR LESURE'S/FEVER DROPS/ KEENE, N. H.

Clear; 4³/₈″ × 1³/₈″ × 1″; 9n; 17b; pl; v. See LESURE *(Cure,* Liniment).

DR LESURE'S/VETERINARY/ FEVER DROPS/KEENE N. H.

Clear; 4¹/₈″ × 1³/₄″ × 1¹/₈″; 9n; 18b; pl; h; distinctive shape. See LESURE *(Cure,* Liniment).

LEWIS & HOLT/ 152 CHATHAM'ST/N.Y.

In 1846 the firm was located at 186 and 188 Chatham St. No dates were available for the 152 Chatham St. location.

Aqua; 6″ × ?; 1n; 20b; pl; h.

LIEBIG DISPENSARY/ 400 GEARY ST/S. F.

Light green; 7³/₄″ × 2¹/₂″ × 1³/₈″; 7n; 3b; 4ip; v. See LIEBIG (Cure, *Invigorator),* MEDICATED *(Tablet).*

LIEBIG'S DISPENSARY/FOR DISEASES OF MEN/400 GEARY ST. S. F. CAL

Aqua; 8″ × ? × ?; 7n; 3b; 3 or 4ip; v. See LIEBIG (Cure, *Invigorator),* MEDICATED *(Tablet).*

LINDSEY'S//BLOOD +/ SEARCHER//HOLLIDAYSBURG

Ad in 1 Nov. 1891 *Pharmaceutical Era*: "DR. LINDSEY'S BLOOD SEARCHER, Makes a Lovely Complexion. Is a Splendid Tonic for Curing Boils, Pimples, Scrofula, Mercurial and All Diseases of the Blood. SELLERS

MEDICINE CO., PITTSBURGH, PA." Product of J. M. Lindsey assumed by Emory Sellers & Co., Pittsburgh (Wilson and Wilson 1971). Adv. 1872 (Baldwin 1973); 1918, by J. Gilmore Drug Co., Pittsburgh (Devner 1968).

Light blue; 8¹/₂″ × 4″ × 2⁵/₈″; 1n; 3b; 3ip; v, sfs.

LONDON/BLOOD PANACEA// S. A. FOUTZ//BALTIMORE. MD

Aqua; 8¹/₂″ × 2⁵/₈″ × 1⁵/₈″; 1n; 3b; 3ip; v, fss.

LONGLEY'S//PANACEA

Product of the Comstock family, New York City, ca. 1830s to 1870 (Wilson and Wilson 1971). Adv. 1846 (Putnam 1968).

Olive green; 6″ × ? × ?; 2n; 4b; pl; v, ss; p.

LONGLEY'S//PANACEA

Olive; 6³/₄″ × 3¹/₄″ × 2″; 2n; 3b; pl; v, ss; p.

LORDS/[man throwing away crutches]/ OPODELDOC

Opodeldoc is a 16th century word referring to medicated plasters. Advertising card: "LORDS OPO-DELDOC (Instant Opium). Made from Rare Celestial Aqueous Compounds. Aids Kleptomania."

Aqua; 5″ × 2¹/₈″ × 1¹/₈″; 7n; 12b; 1ip; h.

LUNDBORG/NEW YORK

Florida water.

Aqua; 4³/₄″ × ?; 11n; 20b; pl; v; ABM. See LUNDBORG *(Water).*

LUYTIES

Label: *Natrum mur. 6. Formula Pharmacopoea Homoeopathica Polyglottica. — PAGE III. For, intermitting fevers; headache; weak, confused sight; tettery eruption around the mouth, gastric derangement; constipation; frequent and urgent urination; excessive sore and ulcerated eyelids; children do not learn to talk; painful contraction of the hamstrings, hang nails; nettle rash. Dose. — Six Pellets or two drops of the tincture every two hours; for children half, for infants one-fourth that quantity. PREPARED BY Luyties Hom. Pharmacy Co., St. Louis.* Bottle variants were numerous and contained many products including syrups, cordials, powders, lotions, oils, and pills. A distributor of pharmaceuticals, Dr. Herman Luytie, St. Louis, established the Luytie Homoeopathic Co., in 1853. "His products were natural healing, would help the body heal themselves, they

were not miracle products but they worked." The company still manufactures homeopathic medicines, according to Forest Murphy, Luyties (personal communication, 1984).

Amber; 2⁵/₈″ × 1³/₁₆″ × 1³/₁₆″; 3n; 1b; v. See WISE *(Tablet).*

LUYTIES

Label: *LUYTIES COMBINATION TABLETS. Containing Pulsatilla, Viburn·Opul· & Caulophyullum, Indicated in Dysemorrhoeas, the Result of Structural Changes or Flexions of the Uterus. LUYTIES PHARMACY CO. ST. LOUIS.*

Amber; 6¹⁵/₁₆″ × 2¹/₄″ × 2¹/₄″; 3n; 2b; pl; v. See WISE *(Tablet).*

LUYTIES [Base:] **107** [See Figure 164]

Label: *COMBINATION TABLETS. No. 39. CONTAINING Arsen. Iod., Baryta Iod. Indicated in Laryngitis, Tonsilitis and Pharynitis. DOSE. — Three tablets every two hours dissolved in a little warm water. LUYTIES HOMOEOPATHIC PHARMACY CO, ST LOUIS — CHICAGO — NEW YORK.*

Amber; 4⁵/₈″ × 1⁵/₈″ × 1⁵/₈″; 3n; 2b; pl; v. See WISE *(Tablet).*

Fig. 164

[h in circle:] **JBL** [v] **DR. J. B. LYNAS & SON/LOGANSPORT, IND.**

Dr. J. B. Lynas, Logansport, IN, (1835–1901) began manufacturing remedies in his home after a successful medical career. The business soon became too large, and in 1874 he established a laboratory at 409 Fourth Street; later he moved to 210 Sixth Street. In 1904 the firm was incorporated under the name Dr. J. B. Lynas and Son [George H.]. In 1906 the company moved to 517 and 519 Market Street. In 1913 there were between 1400 and 1500 employees with the firm (*Powell's History of Cass County Indiana*, 1913). The city directory for 1921–22 located

the firm at 521–523 E. Market, as Medicine, Flavoring Extract and Toilet Article Manufacturers. The firm also produced Langtry Balm ca. 1906, after Lilly Langtry.

Clear; 5⅞" × 1¾" × 1"; 3n, sp; 12b; pl; h, v.

LYNCH & CLARK/NEW YORK
Contained mineral water; supposedly the first bottle produced for the water from Congress Spring, NY; bottle manufactured ca. 1833. Adv. 1835 (Putnam 1968).

Dark green; 7¼" × ?; 2n; 20b; pl; h; p. See CLARKE (Company, Miscellaneous), CONGRESS *(Water)*.

LYON'S/POWDER//B&P/N.Y.
[See Figure 165]
B&P were the initials for Demas Barnes and John D. Park, general agents. Adv. 1853, *New York Daily Times* (Jan. 1); 1910, *AD*.

Amber, other colors; 4¹/₁₆" × 1½" diameter; 7n; 20b; pl; h, fb, on shoulder. Also with pontil. See DRAKE *(Bitters)*, LYON *(Hair, Jamaica Ginger)*, MEXICAN *(Liniment)*, WYNKOOP *(Pectoral, Sarsaparilla)*.

Fig. 165

M. A. C./FOR DYSPEPSIA/AND CONSTIPATION/SMITH BROS./FRESNO, CAL.//FOR SEA-SICKNESS//FOR TRAIN-SICKNESS
Adv. 1917, *BD*; 1929–30 by Smith Bros., Oakland, Calif.; 1935 by Smith Bros., Berkeley, Calif., *AD*.

Clear; 8¾" × 3³/₁₆" × 1¾"; 24n; 6b; pl; v, fss; ABM.

MALE FERN VERMIFUGE//O. P. B.
[See Figure 166]
O. P. Brown's Male Fern Vermifuge, adv. 1873, *VSS & R*; 1910, *AD*.

Aqua; 4⅞" × 1⅝" × ⅞"; 7n; 15b; pl; v, fb. See O. P. BROWN *(Miscellaneous)*.

MANN'S/[monogram]/COLOGNE
Clear; 5⅜" × 1¾" diameter; 3n; 20b; 1ip; h.

Fig. 166

FRONT BACK

T. HILL MANSFIELD'S CAPILLARIS
-X- [Base: H on anchor]
Label: *Mansfield Capillaris-x- Registered 1882, 1909. Capillaris Manfg Co., Glen Ridge, N.J.* Bottle manufactured by Anchor-Hocking Glass Corp., Lancaster, OH, no known dates (Toulouse 1972). Adv. 1929–30, *AD*.

Clear; 3" × 2¹/₁₆" diameter; 17n; 20b; pl; h, on shoulder; ABM.

DR J. B. MARCHISI//UTICA, N.Y.
Label: *Dr. German's Cough & Consumption Cure, Howarth & Ballard, wholesale agents, Utica, N.Y.* . . . Adv. 1879 (Baldwin 1973); 1910, *AD*. Marchisi products date back to the 1840s (Baldwin 1973).

Aqua; 6" × 2" × 1¼"; 7n; 3b; 3 or 4ip; v, ss. See GERMAN (Cure).

MARINELLO
Milk glass; 3" × 1½" × 1½"; 17n; 2b; pl; d; ABM.

MARSH & BURKE/APOTHECARIES/PRINCETON, N. J.
Cobalt; 4" × ?; 9n; 2b; pl; h.

G. MARSH. S. W./PAIN/RELIEVER
Adv. 1854 (Baldwin 1973); 1891, *WHS*.
Aqua; 3⅞" × 1¾" × ¹³/₁₆"; 13n; 3b; pl; v; p.

DOCT./MARSHALL'S//CATARRH/SNUFF [See Figure 167]
Dr. Benjamin Marshall, New York, introduced his snuff in the early 1830s. Charles Bowen, Montpelier, VT, became the sole proprietor ca. 1840. Around 1870 Marshall sold the product to F. C. Kieth, Cleveland, OH. The product in the 1860s was labeled as a cure for *Nearly All the Common Diseases of the Head, Except Wrong-Headedness* (Wilson and Wilson 1971). Adv. 1929–30 and 1948 by Williams Mfg. Co., 118 St. Clair Ave., NE., Cleveland, O., *AD*.

Aqua; 3⅜" × 1¼" × ¹⁵/₁₆"; 3n; 3b; pl; v, ss.

Fig. 167

DOCT./MARSHALL'S//SNUFF
Aqua; 3" × ? × ?; 13n; 6b; pl; v, ss; p.

DR MC BRIDE//WORLD'S RELIEF//WORLD'S RELIEF
Adv. 1887, *MP*; 1897, *L & M*.
Aqua; 6⁷/₁₆" × 2" × 1⅛"; 7n; 3b; 4ip; v, fss.

DR J. J. Mᶜ BRIDE/KING OF PAIN
J. J. McBride, physician, San Francisco, introduced the product in 1869; apparently McBride sold the medicine to Charles DeGrath, Philadelphia, ca. 1875 (Wilson and Wilson 1971). King of Pain adv. 1872, *VHS*; 1897, *L & M*.
Aqua; 6¼" × 2" × 1³/₁₆"; 7n; 3b; 4ip; v, fb.

Mᶜ KESSON//& ROBBINS
[See Figure 168]
The pharmaceutical firm of McKesson & Robbins was established in 1833 (Devner 1970) or 1841 (Brand Names Foundation 1947). The firm was in business in 1981 as McKesson Laboratories, Fairfield, CT, *AD*; in 1984–85 they were located in Dublin, CA, *RB*.
Amber; 3" × 1½" × ¹³/₁₆"; 7n; 3b; pl; v, ss. See McKESSON & ROBBINS (Medicine).

Fig. 168

DR. J. H. McLEAN/ST. LOUIS, MO.
Amber; 2¼" × 1⅛" × ¾"; 3n; 6b; pl; ABM. See McLEAN *(Balm, Oil, Purifier, Sarsaparilla)*.

McLEAN'S/VOLCANIC
Color & dimens. unk.; 1n; 3b; ip; v. See McLEAN *(Balm, Oil, Purifier, Sarsaparilla)*.

W. J. McLEAN'S/TINCTURE OF LIFE/UTICA, N.Y.
Aqua; 7¹/₈″ × 2¹/₄″ × 1¹/₄″; 7n; 3 or 6b; ip, arched front; v.

MEADE & BAKER/CARBOLIC/ MOUTH WASH/[monogram]/ ANTISEPTIC/GARGLE
Adv. 1891, *WHS*; 1929–30 by Meade & Baker, 919 Main St., Richmond, Va.; 1935 by Wm. R. Warner & Co., New York City, *AD*.
Clear; 4⁵/₁₆″ × 2³/₈″ × 1¹/₁₆″; 3n; 10b; 1ip; h.

MEADE & BAKER/CARBOLIC/ MOUTH WASH/RICHMOND, VA.
[Base: monogram]
Clear; 3⁵/₈″ × 1³/₄″ diameter; 3n; 20b; pl; h.

MEADE & BAKER/CARBOLIC/ MOUTH WASH/[monogram]/ RICHMOND VA
Clear; 4⁵/₁₆″ × 2³/₈″ × 1″; 3n; 8b; 1ip; h; distinctive shape.

J. J. MELCHERS Wᶻ/// AROMATIC SCHNAPPS// SCHIEDAM
Label: *MELCHERS–AROMATICO SCHIEDAM SCHNAPPS–The Medicinal Schnapps is distilled with the Finest herbs in the solely established AROMATIC DIS-TILLERY, at Schiedam and is warranted genuine and pure.*
Olive green; 9¹/₄″ × 2⁷/₈″ × 2⁷/₈″; 11n; 2b; pl; v, fbs.

G. W. MERCHANT/LOCKPORT/ N.Y.
Blue green; 5¹/₁₆″ × 2″ × 1″; 11n; 6b; pl; v. See GARGLING (Oil), MERCHANT (Chemical).

G. W. MERCHANT/LOCKPORT. N.Y.
Bottle manufactured ca. 1862 (Wilson and Wilson 1971).
Blue; 5¹/₄″ × ? × ?; 11n; 3b; pl; v. See GARGLING (Oil), MERCHANT (Chemical).

G. W. MERCHANT/LOCKPORT/ N.Y.// +
Aqua, emerald green; 5″ × 2¹/₈″ × 1″, also 4³/₄″ × ? × ?; 11n; 3b; pl; v, fb; p. See GARGLING (Oil), MERCHANT (Chemical).

J. S. MERRELL
The Jacob S. Merrell Co., St. Louis, MO, was established in 1853. Jacob died in 1885 and the name was changed to the J. S. Merrell Drug Co. (Blasi 1974). Products included Ague Cure, Condition Powders, Cough Balsam,

Diarrhoea Syrup, Eye Syrup, Female Tonic, Fever & Ague Pills, Hair Restorative, Liver Pills, Medicated Cordial, Penetrating Oil, Rheumatic Syrup, Syrup Stillingia, and Worm Lozenges; many were still available in 1948, *AD*.
Light green; ? × 2″ × ?; 13n; 12b; pl; h.

MERRICK'S//VERMIFUGE// MILTON, PA
Product of Thomas B. Merrick, Milton, PA, adv. 1843 (Baldwin 1973).
Aqua; 3¹/₂″ × 1⁵/₈″ diameter; 5n; 21b, 12 sides; pl; v, sss; p.

METHYLETS//SHARP & DOHME
Adv. 1910, 1948, *AD*.
Clear; 4″ × 1¹/₈″ diameter; 3n; 21b, 6 sides; pl; v. See SHARP & DOHME (*Miscellaneous*).

MIDDLETOWN/HEALING/ SPRINGS/GRAYS & CLARK/ MIDDLETOWN VT.
Amber; 8³/₄″ × 3³/₄″ diameter; 2n; 20b; pl; h.

MILK'S EMULSION
Product of the Milk's Emulsion Co., Terre Haute, IN adv. 1907, *PVS & S*; 1948, *AD*.
Aqua, amber; dimens. unk.; 7n, large mouth; 20b; pl; h.

MINGAY'S/MAGIC RELIEF
Adv. 1887, *WHS*; as a balsam in 1900, *EBB*, and 1910, *AD*.
Aqua; 4¹/₂″ × 1⁷/₈″ × 1¹/₄″; 7 or 9n; 3 or 6b; ip; v. See MINGAY (Balsam).

DR. MINTIE'S//NEPHRETICUM// SAN FRANCISCO
Label: *DR. MINTIE'S NEPHRE-TICUM – The Great Kidney and Bladder Tonic For All Forms of Kidney Disease & Bladder Complaints, Diabetes, Brights Disease, Incontinence of Urine, Irritation, Mucus and Milky Discharges, Pain in the Back and Loins, Stoppage, Calculi, and All Forms of Acute or Chronic Inflammation of the Bladder & Kidneys. A. E. Mintie, M.D., Proprietor, San Francisco, Cal. Price $1.25.* Adv. 1877 (Wilson and Wilson 1971); 1897, *L & M*.
Aqua; 6¹/₂″ × ? × ?; 7n; 3b; 3 or 4ip, arched front; v, sfs.

MOROLINE//MOROLINE// MOROLINE//MOROLINE// MOROLINE [Base:] MOROLINE/ [O superimposed over diamond]/ MOROLINE
Bottle manufactured by Owens Illinois Glass Co. after 1929 (Toulouse 1972). Moroline Hair Tonic adv. 1935 and

1948 by Plough Sales Corp., Memphis, Tenn., *AD*.
Clear; 2³/₄″ × 1³/₄″ diameter; 17n; 20b; pl; v, sssss; ABM; 3-sided front.

JOB/MOSES//JOB/MOSES
[See Figure 169]
Contained Sir James Clarke's Female Pills, British in origin. Job and Oscar Moses, New York City, became agents for the brand ca. 1870 (Wilson and Wilson 1971). Adv. 1856 (Putnam 1968); 1923, *SF & PD*.
Aqua; 2³/₈″ × 1³/₈″ × 1¹/₈″; 5n, large mouth; 3b; pl; v, ss; also with pontil. See CLARKE (Pills).

Fig. 169
SIDE / FRONT BACK / SIDE

MOTHER'S/RELIEF
Contained Bartholick's Mother's Relief, adv. 1887, *McK & R*; 1910, *AD*.
Aqua; 8¹/₂″ × 3¹/₈″ diameter; 11n; 20b; pl; v.

MOTHER'S/SALVE/CHICAGO
Adv. 1887, *WHS*; 1948 by Mother's Remedies Co., 1160 W. 31st St., Chicago, Ill., *AD*.
Milk glass; 1¹/₄″ × 1⁹/₁₆″ diameter; 17n, with plain zinc cap; 20b; pl; base; ABM.

W. H. MOUNTFORT/NEW YORK
Directories included William H. Mountfort, New York City, Photographic Supplies and Varnish, 1864–1870. Possibly the bottle contained photographic chemicals.
Aqua; 5³/₄″ × 2¹/₈″ diameter; 7n; 20b; pl; v.

MOXIE/NERVE FOOD/LOWELL/ MASS./PATENTED
Dr. Augustine Thompson, Lisbon Falls, CT, and Lowell, MA, introduced his Nerve Food ca. 1885. Thompson claimed his product did not contain a drop of medicine, poison, stimulant or alcohol in its composition (Wilson and Wilson 1971). Directories showed offices in Chicago in 1888; Boston in 1900 and 1909, and New York City in 1900. A news article in Shimko (1969),

assumed to be from the 1890s, notes the proprietors as the Ingalls Bros., Portland, ME. Moxie was still being manufactured in 1984 in England under a different formula, and the formula has been revived in Lisbon Falls, CT, "Where it all started," (ABC News, July 1984).

Light green, amber; 9³/₄″ × 3¹/₈″ diameter; 3n; 20b; pl; h.

MOXIE/NERVE/FOOD/[near base:] **REGISTERED**//[near shoulder:] **MOXIE**

Clear; 10⁵/₈″ × ?; 3n; 20b; pl; h, fb.

MUNYON'S/GERMICIDE/ SOLUTION

Prof. J. M. Munyon, Philadelphia, advertised nearly 70 products in 1900, and was a leader in the manufacture of medicinal cures. Germicide adv. 1900, *EBB*; 1907, *PVS & S*.

Green; 3¹/₄″ × 1⁵/₁₆″ × ⁷/₈″; 9n; 3b; pl; v. See MUNYON (Cure, Remedy).

MUNYON'S//PAW-PAW

Paw-Paw Tonic ". . . is to the stomach what Paw-Paw Pills are to the liver and bowels." Paw-Paw was the product of the Munyon Homeopathic Home Remedy Company, Philadelphia (Fike 1966). Adv. 1907, *PVS & S*; 1923, *SF & PD*.

Amber; 3³/₁₆″ × 1¹/₄″ × 1″; 2n; 3b; 4ip; v, ss. See MUNYON (Cure, Remedy).

MUNYON'S/PAW-PAW [over embossed tree]//**MUNYON'S// PAW-PAW** [See Figure 170]

Amber; 10″ × 2⁷/₈″ × 2¹/₈″; 12n; 3b; 4ip, arched front; h, f; v, ss. See MUNYON (Cure, Remedy).

Fig. 170

MUSTEROLE/CLEVELAND

Label: *MUSTEROLE—More than a Mustard Plaster, A Counter-Irritant. Try it for colds, congestion . . . The Musterole Co., Cleveland, O.* Company established in 1906 (Periodical Publishers Association, 1934); product adv. 1907, *PVS & S*; 1948, *AD*.

Milk glass; 2″ × 1³/₄″ diameter; 17n; 20b; pl; base; ABM. See ZEMO (*Lotion*).

MYERS'//ROCK ROSE// NEW YORK

Product of William Franklin & Co., New Haven, CT, adv. 1852 as the ". . . new medicine for the cure of Scrofula, Dyspepsia, Erysipelas, Salt Rheum, Sick Headache, Nursing Sore Mouth . . ." (Singer 1982); 1910, *AD*.

Aqua; 9″ × 3³/₈″ × 2¹/₈″; 11n; 3b; 3 or 4ip; h, f; in small panel; v, ss; p.

[v] **NATOL**/[h] **NATOL** [See Figure 171]

Label: *NATOL, PINEAPPLE-PEPSIN COMPOUND. Prepared from the juice of fresh, ripe pineapple. FOR THE AGED AND THOSE FAILING HEALTH. For indigestion, weak stomach, inflammation of the stomach headache and nervousness arising from stomach troubles, sour stomach, vomiting, bloating, as an appetiser and to assist digestion and assimilation of food. Also excellent for expectant mothers and for morning sickness. NATIONAL DRUG CO., IOWA CITY, IOWA.* Adv. 1929–30 by Parke, Davis & Co., Atwater St., Detroit, Mich.; as Natola, 1948, *AD*.

Clear; 7¹/₂″ × 2¹/₄″ × 1⁷/₈″; 7n; 6b; pl; v, h, embossed within circle.

Fig. 171

4FL. OZ./NEWBRO'S/HERPICIDE/ FOR THE SCALP [Base: I in diamond]

Clear; 6″ × 1³/₄″ diameter, several sizes; 7n; 20b; pl; h. See HERPICIDE (*Hair*), NEWBRO (Cure).

[Script:] **Newbro's/Herpicide/KILLS THE/DANDRUFF GERM**

Clear; 6⁷/₈″ × 2¹/₄″ diameter; 7n; 20b; pl; h, some script. See HERPICIDE (*Hair*), NEWBRO (Cure).

NICHOLS'/INFALLIBLE/ INJECTION [See Figure 172]

Product owned or controlled by Langley & Michaels, San Francisco, adv. 1895, *L & M*; 1896–97, *Mack*.

Aqua; 7¹/₄″ × 2⁹/₁₆″ × 1¹¹/₁₆″; 7n; 6b; ¹/₂″ groove down side to within ³/₄″ of base, apparently served a functional purpose, possibly for an eye dropper; v, s; embossed dose cap. See LANGLEY & MICHAELS (Miscellaneous).

Fig. 172

NICHOL'S/INJECTION

Light blue; 7¹/₂″ × 2¹/₂″ × 1⁵/₈″; 7n; 6b; grooved, as previous entry; v, s; embossed dose cap. See LANGLEY & MICHAELS (Miscellaneous).

[Script:] **№ 4711**

Cologne, 4711 Bath Salts, Depilatory Powder and White Rose Soap adv. 1925, *BWD*. Product of J. M. Farina.

Clear; 5³/₈″ × 2¹/₄″ × 1⁹/₁₆″; 7n, large mouth; 3b; pl; h, script. See FARINA (*Miscellaneous*, Water).

DR NORTON'S TASTELESS// WORM/DESTROYER

Amber; 4¹/₈″ × 1⁵/₈″ × 1¹¹/₁₆″; 9n; 3b; pl; v, sf. Also variant with 3ip.

NORWOOD'S/TINCT. V. VIRIDE

Label: *Norwood's Tincture Veratrum Viride.* . . . Adv. 1863 (Baldwin 1973); 1923, *SF & PD*.

Clear; 5¹/₄″ × 2¹/₄″ × ?; 7n; 12 or 13b; pl, v; p.

ONDONTOLINE/LOCAL/ ANESTHETIC

Amber; 2¹/₂″ × 1¹/₂″ diameter; 7n, large mouth; 20b; pl; h.

OLIO/RICINO//CARLO/ERBA/MILANO
Clear; 4⅞″ × 1⅝″ × ⅞″; 8n; 6b; 2ip; h, fb. See CARLO (Miscellaneous).

ONDULINE/[embossed circle]/JEAN
[Base: O superimposed over diamond] Bottle manufactured by Owens Illinois Glass Co., after 1929 (Toulouse 1972). Clear; 3¹/₁₆″ × 1⅜″ diameter; 7n; 20b; pl; h; ABM.

LIQUID/OPODELDOC
The *John Tweedy* catalog, ca. 1760, included a penciled entry of the product. Also adv. 1834, *S & S*; 1907, *PVS & S*.
Aqua; 4½″ × 1¼″ diameter; 6n; 20b; pl; v; p.

OSGOOD'S//INDIA/CHOLAGOGUE//NEW YORK
A cathartic for the elimination of bile, introduced by Charles Osgood, Norwich, CT, ca. 1841. Osgood expanded to New York City in 1859. In the late 1870s, after Osgood's death, Murray & Lanman became sole agent (Wilson and Wilson 1971). Adv. 1844 (Putnam 1968); 1929–30 by Osgood's Indian Cholagogue, Inc., 45 Commerce St., Norwich, Conn., *AD*.
Aqua; 5¹/₁₆″ × 2⅜″ × 1⁷/₁₆″; 11n; 3b; pl; v; sfs; p. See CUTICURA (*Cure*).

OSGOOD'S//INDIA/CHOLAGOGUE//NORWICH, CONN./U.S.A.
Aqua; 5¼″ × 2⁷/₁₆″ × 1½″; 11n; 3b; pl; v; sfs. See CUTICURA (*Cure*).

E. B. OWEN
Possibly Owen's Extract of Buchu, adv. 1873, *VSS & R*; 1887, *MP*.
Aqua; 2½″ × ?; 1n; 21b; pl; v.

OZO/MULSION
Advertisement: "OZOMULSION is a Perfected Emulson of Pure Norwegian Cod Liver Oil. It is a product of Beechwood [Germany]. It destroys all poisonous bacteria in the blood, lungs, stomach and entire human organism. Increases the appetite, stimulates digestion and thus aids nature in producing pure, rich, red blood, strength and firm flesh. FOR: Lung troubles, coughs, asthma. . . . OZOMULSION is a flesh forming food medicine for thin women, emaciated men, worn out mothers and thin children. OZOMULSION is manufactured in New York, London, Paris, Karlsbad, Rome, Montreal, Madrid, Havana and City of Mexico" (Fike 1966). Ozomulsion, was formu-

lated by Thomas Slocum, New York City, in the early 1880s and became popular, ca. 1902, when promoted by Frank Richardson (Wilson and Wilson 1971). Adv. 1948 by T. A. Slocum Co., 548 Pearl St., New York City, *AD*.
Amber; 3¼″ × 1⁹/₁₆″ diameter; 7n; 20b; pl; base. See PSYCHINE (*Miscellaneous*), SLOCUM (Company, Compound, Oil).

OZOMULSION [See Figure 173 and Photo 49]
Amber; 5¼″ × 1⅞″ × 1⅛″; 7n; 11b; pl; v. See PSYCHINE (*Miscellaneous*), SLOCUM (Company, Compound, Oil).

Fig. 173

PACKER'S/CUTANEOUS/CHARM
Adv. 1876, *WHS*; 1929–30 by Packer Mfg. Co., 101 W. 31st. St., New York City; 1941–42 by Packers Tar Soap Inc., 10 Rockefeller Plaza, New York City; 1948 by Packers Tar Soap Inc., Mystic, Conn., *AD*. Random New York City directories included Packer's Mfg. Co. in 1878 as Soap Mfgr., Edward A. Olds, Proprietor, 146 Wall; in 1884 at 100 Fulton; in 1891–1896 at 81–83 Fulton. The company also manufactured a Florida water.
Aqua; 6½″ × 2⁹/₁₆″ × 1½″; 7n; 12b; 1ip; v.

PACKER'S/SHAMPOO 6 48
Label: *Packer's Shampoo with Olive Oil—Packer's Tar Soap, Inc., Mystic, Conn., U.S.A.* Adv. 1929–30 and 1935 by Packer Mfg. Co., 101 W. 31st. St., New York City; 1941–42 by Packers Tar Soap, Inc., 10 Rockefeller Plaza, New York City; 1948 by Packers Tar Soap, Inc., Mystic, Conn., *AD*. The basal mark 6 48 probably corresponds to a production date for the bottle.
Clear; 5¹⁵/₁₆″ × 2⅛″ × 1⁵/₁₆″; 16n; 3b; 8ip, 4 on each side; base; ABM.

PAGLIANO//GIROLAMO
[See Photo 50]
Label: *Girolamo Pagliano CURATIVE*

SYRUP—Alcohol 17.70%—Florence [Italy]. Adv. 1887, *WHS*; 1929–30 by Fougera & Co., New York, *AD*.
Clear; 4¼″ × 1⅜″ × 1³/₁₆″; 7n; 3b; pl; v, fb; p.

PAGLIANO//GIROLAMO
Bottle manufactured ca. 1860s.
Light green; 4¼″ × 1½″ × 1⁵/₁₆″; 14n; 3b; pl; v, fb, p.

[Script:] <u>Palmer</u> [See Figure 174]
Pale green; 4¾″ × 1⅛″ × 1″; 3n; 18b; pl; v, script. See PALMER (Lotion, *Water*).

Fig. 174

[Script:] <u>Palmer</u>
The Kelly green bottles are named for George A. Kelly, Pittsburgh, manufacturers of the Palmer bottles.
Palmer green, Kelly green; 5¼″ × 1⅞″ diameter, also 6¾″ × 2⅛″ diameter; 3n; 20b, slightly oval; pl; d, script. See PALMER (Lotion, *Water*).

PANOPEPTON/BREAD AND BEEF PEPTONE/FAIRCHILD [Base:] W T & CO/USA
Bottle manufactured by Whitall-Tatum, 1857 to 1935 (Toulouse 1972). Adv. 1897, *L & M*; 1941–42 by Fairchild Brothers & Foster, New York City, *AD*.
Amber; 5⅜″ × 1¾″ × 1¹/₁₆″; 9n; 6b; pl; b, inset.

PA-PÁY-ANS BELL [See Figure 175]
Amber; 2⅝″ × ⅞″ diameter; 3n; 20b; pl; v. See BELL (*Company*).

Fig. 175

PARFUMERIE/MONTE CRISTO/
[monogram] [See Figure 176]
Clear; 5¼″ × 2¼″ × 1¾″; 7n; 6b; pl; h.

Fig. 176

DR. PARKER'S SONS'/HEADACHE POWDER/AKRON, N.Y.
Adv. 1907, *PVS & S*; 1910, *AD*.
Clear; 4⅛″ × 1⅝″ × 1″; 3n; 3 or 6b; pl; v. See PARKER'S SONS' *(Company)*.

Dᴿ L. R. PARKS//EGYPTIAN// ANODYNE
Aqua; 5⅛″ × 1¹⁵⁄₁₆″ × 1¼″; 13n; 3b; 4ip; v, fss; p.

PARMINT/(DOUBLE STRENGTH)/ INTERNATIONAL/ LABORATORIES/BINGHAMTON, NEW YORK [See Figure 177]
Adv. 1916, *MB*; 1923, *SF & PD*.
Aqua; 3¼″ × 1⅛″ diameter; 9n; 20b; pl; v.

Fig. 177

[h] NET CONTENTS 8½ OZ./[v]
PAWNEE INDIAN/TOO-RE
Label: *PAWNEE TOO-RE, Alcohol 5%. Assists nature in the Cure of Blood, Stomach, Liver & Kidneys. C. A. Burgess & Co., 2476 Howard St., San Francisco, Cal.* Adv. ca. 1891; 1929–30 by Pawnee Indian Med. Co., 3542 Mission St., San Francisco, Cal., *AD*.
Aqua; 7⅜″ × 2¹¹⁄₁₆″ × 1⁹⁄₁₆″; 7n; 6b; pl; h, v. See PAWNEE *(Balm, Bitters)*.

PEARL'S/WHITE GLYCERINE
Labeled as . . . *a remover of all extraneous matter from the skin. V. R. Pearl, New Haven, Conn. Patented 1870. . . .* Adv. 1910, *AD*.
Cobalt; ? × 2½″ × 1⅛″; 11n; 3b; 1ip; v.

EBENEZER A PEARL'S/TINCTURE OF LIFE
Adv. 1888 (Baldwin 1973).
Aqua; 7¾″ × 2⅝″ × 1½″; 8n; 3 or 6b; ip; v.

DR. H. F. PEERY'S//DEAD SHOT// VERMIFUGE
Adv. 1846 (Putnam 1968); 1929–30 by Wright's Indian Vegetable Pill Co., 372 Pearl St., New York City, *AD*. Agents included A. & B. Sands, New York, and Edmund Ferret, New York City, proprietor of Wright's Indian Medicines (Wilson and Wilson 1971). The Wright's Indian Vegetable Pill Co., was incorporated in 1901 (Holcombe 1979).
Aqua; 4″ × ¾″ diameter; 7n; 20b; pl; v, sss; with and without pontil. See SANDS *(Miscellaneous)*.

[Script:] **Penslar**/14 OZ [Base:] P. 69
Hair tonic and product of the Penslar Co., Chemists, Kansas City, MO. The company dates from 1907 to 1965 (Devner 1970).
Clear; 7½″ × 3″ × 2¹⁄₁₆″; 3n; 3 or 6b; 2ip; d, script.

[Script:] **Penslar** [Base: 518 in diamond]
Bottle manufactured by the Diamond Glass Co., Royersford, PA, after 1924 (Toulouse 1972).
Clear; 4⅝″ × 2″ × 1⅛″; 3n; 3 or 6b; 2ip; d, script; ABM.

PEPTENZYME/REED & CARNRICK/ N.J. [See Figure 178]
Peptenzyme Elixir, Powder, Tablets and Granular Effervescence. Peptenzyme products adv. 1895, *PVS & S*; 1984–85, *AD*.
Cobalt; 2½″ × ? × ?; 16n; 12b; bottle will not stand; pl; v. See LACTOPEPTINE *(Miscellaneous,* Remedy*)*, REED & CARNRICK *(Oil)*.

Fig. 178

PEPTENZYME. [Base, in circle:] REED. CARNRICK JERSEY CITY
Cobalt; 3⅛″ × 1¾″ × 1½″; 3n; 6b; 1ip, arched front panel; d. See LACTOPEPTINE *(Miscellaneous,* Remedy*)*, REED & CARNRICK *(Oil)*.

PEPTENZYME//REED & CARNRICK/NEW YORK
Cobalt; 4¾″ × ? × ?; 3n; 1b; pl; d, fb. See LACTOPEPTINE *(Miscellaneous,* Remedy*)*, REED & CARNRICK *(Oil)*.

PEPTO-MANGAN (GUDE)/ CONTENTS 11 FLUID OUNCES
Label: *GUDE'S PEPTO-MANGAN, Neutral Organic Compound. Alcohol 16%. A Combination of the Peptonates of Iron and Manganese in Palatable, Easily Disgested Form. A Stimulant and Tonic. M. J. BREITENBACH CO., NEW YORK CITY. New Label Adopted 1900.* Introduced in 1891, adv. 1985, by Medtech Labs, Cody, WY, *AD*.
Clear; 7″ × 2⅜″ diameter; 8n; 21b, 6 sides; pl; v. See GUDE *(Company)*.

PEROXIDE OF HYDROGEN
Amber; 6¼″ × 2½″ diameter; 7n; 20b; pl.

Dᴿ PETER'S/KURIKO//MADE BY/ Dᴿ P. FAHRNEY/CHICAGO, ILL. U.S.A. [Base:] PAT. APPLIED FOR
Clear; 8⅞″ × 2¾″ × 2¾″; 7n; 2b; 2ip; v, fb. See FAHRNEY *(Company,* Miscellaneous*)*.

PETROLEUM//S. M. KIER// PITTSBURGH, Pᴬ
Label: *Kier's Rock Oil For Man or Beast . . . Samuel M. Kier, Pittsburgh* Adv. 1840s (Young 1962); 1860, *CNT*.
Aqua; 6⅛″ × 2⅛″ × 1⅜″; 11n; arched; 3b; 3 or 4ip; v, fss.

PHALON & SON//PERFUMERS, N. Y.
Label: *PHALON & SONS COCIN FOR THE HAIR, Prepared from Highly Purified Coconut Oil. . . .* Adv. 1859 *Harper's Weekly* (Dec. 10); 1860, *CNT*; as Hair Invigorator, 1901, *HH & M*. The firm was established in 1859 (Devner 1970).
Aqua; 6⁹⁄₁₆″ × 2⅜″ × 1⅜″; 9n; 3b; pl; v, ss; p. See PHALON (Invigorator).

PHELP'S//ARCANUM// WORCHESTER//MASS.
A cure-all adv. 1830 (Putnam 1968); 1841 (Turner 1953).
Olive; 9″ × 3½″ diameter; 2n; 20b; 8ip; v, ssss, on alternate indented panels; p.

30/PHENOLAX/WAFERS/UPJOHN
[Base: I in diamond 21]
Bottle manufactured by the Illinois Glass Co., 1916 to 1929 (Toulouse 1972). Adv. 1910, 1948 by Upjohn, Kalamazoo, Mich., *AD*.
Clear; 2⁹/₁₆" × 1⅛" diameter; 3 and 7n; 20b; pl; h; ABM.

PHENYLE/NOT TO BE TAKEN// POISONOUS/TAR DISTILLERS,
LIMITED [Base: monogram]
Labeled as *SMITH'S PHENYLE SOLU-TION, formerly Little's*. . . . Little's adv. 1887, *WHS*; 1900, *EBB*.
Amber; 7⅜" × 3" × 2"; 3n; diamond-shaped base; pl; v.

C. H. PHILLIPS/NEW YORK
Clear; 4¾" × 1½" × 1½"; 7n; 2b; pl; v. See PHILLIPS (*Company*, Magnesia, Oil, Trade Mark).

PHYSICIAN'S//PINEOLEUM// SAMPLE//PINEOLEUM
Light green; 2¼" × 4¹³/₁₆" × ?; 3n; 2 or 3b; pl; v, ssss; ABM. See PINEOLEUM (*Miscellaneous*).

PRESCRIBED/BY/R. V. PIERCE M. D./BUFFALO/N.Y. [See Figure 179]
Aqua; 7" × 2¾" × 1⅝", also height of 6¼"; 7n; 12b; pl, graduated horizontal lines on back; h. See PIERCE (*Discovery*, Extract, Tablet), SAGE (*Remedy*).

Fig. 179

Dʀ PIERCE'S/FAVORITE/ PRESCRIPTION//R. V. PIERCE, M.D.//BUFFALO, N.Y.
Advertised in 1888 as the only guaranteed cure for women, "A cure of those chronic weaknesses and complaints of females." Adv. 1873, *VSS & R*; 1982, by Medtech Labs. Inc., Cody, WY, according to Bill Weiss, Medtech Labs. Inc. (personal communication, 1982).
Aqua; 8¼" × 3" × 1½"; 1n; 3b; 1ip; v, fss. See PIERCE (*Discovery*, Extract, Tablet), SAGE (*Remedy*).

PINEOLEUM
Ad: "Pineoleum Liquid Ointment . . . for intranasal therapy as dropper, spray or inhalation medication – in coryza, all manifestations of rhinitis, sinusitis, pharyngitis, laryngitis, grippe, influenza and pollen allergy . . . ," 1941–42, *AD*. Adv. 1913, *SN*; 1942–41 by Pineoleum Co, New York City, *AD*.
Clear; 3¼" × 1⁵/₁₆" × ⅞"; 7n; 3b; 1ip; v. See PHYSICIAN (Miscellaneous).

PINEOLEUM
Clear; 5" × 1⅝" × 1⅝"; 9n; 2b; pl; v. See PHYSICIAN (Miscellaneous).

Dʀ PINKHAM'S/EMMENAGOGUE
Aqua; 5⅞" × 2¾" × 2¾"; 11n; 2b; pl; v; p.

PIPERAZINE/ EFFERVESCENTE/MIDY
Product for dissolving uric acid, adv. 1910, 1929–30 by Fougera & Co., New York City; 1948, *AD*.
Amber, dimens. unk.; 7n; rect.; 1ip; v.

PIPIFAX
"Famous Rosicrucian Elixir." Manufactured by Herrman Wolfgang, Berlin, Prussia (Ring 1980), Pipifax was shipped to the United States in barrels. Distributors included Walter & Shaeffer, San Francisco, 1870–73; James M. Gowey, San Francisco, 1874–75; and John Sroufe and Hugh McCrum, 1876–85 and later. The product was distributed in embossed bottles from 1877 to 1885 (Wilson and Wilson 1969). Adv. 1871 (Ring 1980); 1883 by Sroufe & McCrum, San Francisco city directory.
Light amber; dimens. unk.; 12n; 2b; pl; v.

PITCHER'S/CASTORIA
Patent No. 77,758 – Samuel Pitcher, Barnstable, Mass – Medicine-Mixture to be used as a cathartic. The castoria was advertised as an aid to constipation, especially in children. S. Pitcher & Co. advertisements for 1868 and 1869 testified that the product was ". . . a Pleasant and Complete Substitute for Castor Oil . . .," Boston city directories. Charles H. Fletcher, for Demas S. Barnes, acquired the formula ca. 1871 and then billed it as castoria, still retaining the Pitcher embossing. J. B. Rose & Co. was established in 1872 with C. H. Fletcher as a principal to produce the Castoria and Centaur Liniment. The Centaur Company was established in 1877. In 1888, following the death of Barnes, Fletcher assumed control.

Fletcher died in 1922 and in 1923 the business was assumed by Sterling Products (Holcombe 1979). Variants embossed FLETCHER were introduced in the early 1890s (Wilson and Wilson 1971). Pitcher's adv. 1948 by Juvito Products Co., 6 Stevenson St., Pittsburgh, Pa., *AD*.
Aqua; 6¼" × ? × ?; 1n; 3b; 3 or 4ip; v. See CENTAUR (*Liniment*), FLETCHER (*Miscellaneous*), WYNKOOP (*Pectoral*).

PITCHERS LIVURA/NASHVILLE, TENN.
Adv. 1895, *PVS & S*.
Aqua; 9" × 3" × 1¾"; 1n; 3b; ip; v. See CENTAUR (*Liniment*), FLETCHER (*Miscellaneous*).

DR. S. PITCHER'S//CASTORIA
[Base:] A 87 [See Figure 180]
Aqua; 5¹¹/₁₆" × 1⅞" × 1"; 1n; 3b; 4ip; v, ss. See CENTAUR (*Liniment*), FLETCHER (*Miscellaneous*).

Fig. 180

DR. S. PITCHER'S//CASTORIA/ BOSTON MASS//PATᴰ MAY 12 68
Aqua; 5½" × 2" × 1¹/₁₆"; 7n; 3b; 4ip; v, sfs. See CENTAUR (*Liniment*), FLETCHER (*Miscellaneous*).

Dʀ J. W. POLAND'S/ HUMOR DOCTOR
Introduced in 1848 (Singer 1982); adv. 1910, *AD*.
Aqua; 8¾" × 3½" × 1¹³/₁₆"; 1n; 12b; pl; v. See POLAND (*Compound*, Killer).

POLLINE
Aqua; 3½" × 1½" diameter; 7n, wide mouth; 20b; pl; h.

DR PORTER/NEW YORK
Label: *The Zadoc Porter Medicated Stomach Bitters. Alcohol 28½ per cent. Price 25 cents*. Adv. 1853, patented 30 Oct. 1858 (Ring 1980); adv. 1910, *AD*. Also labeled: *Madame [Zadoc] Porter's Cough*

Balsam – Hall & Ruckel, 218 Greenwich, N.Y., Proprietors, which included a testimonial dated 1838. Balsam adv. 1863 (Baldwin 1973); 1910, *AD*. Zadoc Porter pioneered efforts to improve medicinal taste and was among the first to manufacture sugar-coated pills (Blasi 1974).

Aqua; 5 9/16″ × 1⅞″ × 1 3/16″; 7n; 3b; lip; v.

PORTER'S//PAIN KING

Adv. 1910, 1948 by George H. Rundle Co., 419 Caldwell St., Piqua, Ohio, *AD*.

Clear; 6¾″ × 2¾″ × 1⅝″; 7n, sp; 3b; 4ip; v, ss.

PRATT'S/NEW LIFE

Adv. 1867 (Baldwin 1973); 1897, *L & M*.

Amber, aqua; 7¾″ × ? × ?; 11n; 3b; 3 or 4ip; v, See PRATT (*Oil*).

PREPARED ONLY BY/DR. J. PARKER PRAY/AMERICAS FIRST MANICURE/NEW YORK, U.S.A.

Toilet preparations introduced in 1808 (Devner 1970); adv. 1901, *HH & M*.

Clear; 4″ × 1⅝″ × 1⅝″; 9n; 1b, with curved sides; pl; v.

PRESCRIPTION C-2223// PRESCRIPTION C-2223 [Base: I in O over diamond]

Label: *St. Joseph's Prescription C-2223, A Treatment for Sub-Acute and Chronic Rheumatism, Gout . . . St. Joseph's Labs., New York, Memphis, San Francisco.* Bottle manufactured by the Owens-Illinois Glass Co., after 1929 (Toulouse 1972). Adv. 1921 by Plough Chemical Co., Memphis, Tenn., *BD*; 1941–42 (same company), *AD*.

Amber; 7⅞″ × 2⅜″ × 1¼″; 7n, sp; 3b; 4ip, oval back, arched front; v, ss; ABM. See ST. JOSEPH (Miscellaneous).

PRESTON & MERRILL//BOSTON

[Joshua P.] Preston & [Warren J.] Merrill, Boston, MA, operated from 1845 to ca. 1906 according to directories. Products included Rose Water, Lemon & Yeast Powders and flavoring extracts.

Clear; 4″ × 1 11/16″ × 15/16″; 7n; 6b; 3ip; v, ss; tapered body.

PRESTON & MERRILL/BOSTON

Amber; 10⅜″ × 2¼″ diameter; 11n; 20b; pl; v.

PROTONUCLEIN [Base:] R & C/N.Y. [See Figure 181]

Tablets or Powder for Gland Problems, product of Reed & Carnrick, adv. 1897,

L & M; 1948 by Reed & Carnrick, 155 Van Wagenen Ave., Jersey City, N.J., *AD*.

Amber; 3⅛″ × 1½″ × 1⅜″; 3n; 6b; pl; d. See REED & CARNRICK (*Oil*).

Fig. 181

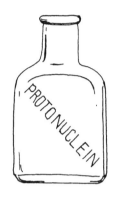

PSYCHINE

Psychine, for consumption and lung troubles, was introduced in the late 1870s by Thomas A. Slocum, New York; apparently embossed bottles were not utilized until the late 1880s (Wilson and Wilson 1971). Adv. 1887, *McK & R*; 1929–30 and 1948 by T. A. Slocum, 548 Pearl St., New York City, *AD*.

Aqua; 8¼″ × 2⅜″ × 1⅞″; 7n; 18b; 1ip; v; several sizes and shapes. See OZOMULSION (*Miscellaneous*), SLOCUM (Company, Compound, Oil).

PSYCHINE/FOR [superimposed over anchor]/CONSUMPTION/ T A SLOCUM M C./181 PEARL ST/ NEW YORK

Aqua; 5⅜″ × 1⅞″ × 1⅛″; 7n; rect., fss. See OZOMULSION (*Miscellaneous*), SLOCUM (Company, Compound, Oil).

PURE//FAMILY//NECTAR

Clear; 8¾″ × 3″ × 1¾″; 11n; 3b; 3 or 4ip; v, sfs; p; bold lettering.

DR. PUSHECK'S//PUSHKURO [Base:] CHICAGO, ILL. U.S.A.

Adv. 1910, *AD*; 1916, *MB*.

Amber; 9″ × 2¾″ diameter; 9n; 20b; pl; h, fb.

[Script:] **Q = ban** [Base: A93 in diamond]

Clear; 6¼″ × 2¼″ × 1⅝″; 7n; rect.; d; script; ABM; distinctive shape. See Q = BAN (*Hair*).

QUEEN/LAVENDER WITH MUSK [Base:] M

Clear; 4⅝″ × 2″ × 15/16″; 7n; 4b; pl; v.

RADEMACHER'S/ = GOLDGEIST/ G.M.S. № 75198

Amber; 5⅝″ × 2″ × 1″; 7n, fluted sides; 3b; 1ip; v.

RADIUM/RADIA

Labeled as *The World's Premier Conqueror of Pain . . . Radium Radia Co., Los Angeles, Ca., 13 W 26th St., New York City.*

Clear; 5⅜″ × 2″ × 1⅜″; 9n; 17b; pl; v.

JOHN B. REY/HOOPELAKA

Baldwin (1973) lists product as Dr. John B. Rey's Woopelaka, or Whooping Cough Remedy, adv. 1855.

Aqua; 5½″ × 1⅞″ × 1⅞″; 13n; 1b; pl; v; p.

DR. S. A. RICHMOND//SAINT JOSEPH, MO [Base:] McC

Bottle manufactured by Wm. McCully, Pittsburgh, PA, 1832 to 1886 (Toulouse 1972).

Aqua; 7⅛″ × 2 5/16″ × 1¼″; 11n; 3b; 4ip; v, ss. See SAMARITAN (*Nervine*).

[Embossed sun]/[Script:] **Ricksecker/ NEW YORK/U.S.A.//**[embossed flowers]//[flowers]//[flowers]

Theo. Ricksecker, Brooklyn, NY, was the manufacturer of skin soaps and face powders in 1881, perfumes by 1884 (Devner 1970). In 1891 offices were located at 58 Maiden Lane, New York City, *Pharmaceutical Record*; in 1900 at 22 Reade, *EBB*; there were also offices in Montreal and London. Offices were, at some time, located at 146 & 148 William St., New York City. Products adv. 1889, *PVS & S*; 1923, *SF & PD*.

Aqua; 6″ × 1 13/16″ × 1⅜″; 3n; 6b; pl; h, fssb, part script; tapered body. See RICKSECKER (*Cure*).

RICKSECKER/PERFUMERY

Clear; 4¾″ × 1¼″ diameter; 8n; 20b; 1ip; d. See RICKSECKER (*Cure*).

THE/RICKSECKERS/PERFUME/NY

Clear; 3¼″ × 1 1/16″ diameter; 3n; salt mouth; 20b; inset; pl; d. See RICKSECKER (*Cure*).

RIKER/NEW YORK

Possibly Riker's Expectorant, a product of Wm. B. Riker & Son, New York, adv. 1888 (Baldwin 1973). According to the 1 Nov. 1891 *Pharmaceutical Era*, ". . . new facilities were rapidly being completed for William B. Riker & Son on the corner of 22nd St., and Sixth Ave. . . ." Products adv. 1910, *AD*.

Clear; 4⅜″ × 1⅞″ diameter; 3n; 20b; pl; d. See RIKER (Sarsaparilla).

M. B. ROBERT'S//VEGETABLE// EMBROCATION

Adv. 1872, *VHS*; 1900, *EBB*.

Green; 5″ × 1½″ diameter; 11n; 20b; pl; v, p.

DR. A. ROGER'S/LIVERWORT TAR/& CANCHALAGUA// A. L. SCOVILL//CINCINATTI
Adv. 1847 (Singer 1982); 1913, *SN*.
Aqua; 8″ × 2⅞″ × 1¾″; 11n; 3 or 6b; ip; v, fss; p; also without pontil. See SCOVILL *(Company)*.

Dᴿ ROSE'S//PHILAD.ᴬ
Dr. Jacob S. Rose manufactured products such as Rose's Alterative Syrup or Blood Purifier and Buchu Compound adv. 1859; Carminative Balsam adv. 1855; Dyspepsia Compound, Expectorant or Cough Syrup adv. 1850 (Baldwin 1973); Antidyspeptic Vermifuge, Magic Liniment, Prophylactic Syrup (Nielsen 1978) and Sarsaparilla.
Green; 5¼″ × 2″ × 1¼″; 13n; 3b; pl; v, ss; p. See ROSE (Sarsaparilla).

ROWAND &/WALTON'S// PANACEA//PHILAD
John Rowand advertised a tonic mixture in 1832 (Putnam 1968), and his son Joseph T. and David G. Walton were listed as partners in 1847 (Singer 1982), also in 1850–51 (Wilson and Wilson 1971).
Aqua; 6½″ × ? × ?; 11n; 3b; pl; v, sfs. See ROWAND *(Tonic)*.

ROWS/EMBROCATION
Light green; 5⅜″ × 2¼″ × 2¼″; 7n; 2b; pl; v.

RUSH'S//BUCHU//AND IRON// A. H. FLANDERS, M. D./ NEW YORK
Adv. 1871, *WHS*; 1910, *AD*.
Aqua; 8⅞″ × 3″ × 1⅜″; 1n; 3b; 4ip; v, fssb. See RUSH (Balm, *Bitters*, Sarsaparilla).

SAGWA//SAGWA
Aqua; 7½″ × 2½″ × 1⁷⁄₁₆″; 7n; 3b; 3ip; v, ss. See HEALY & BIGELOW (Cure, *Miscellaneous*, Oil), KICKAPOO (Miscellaneous, *Oil*, Syrup).

THE NAME/St. Joseph's/ASSURES/ PURITY [See Figure 182 and Photo 51]
Label: *Genuine St. Joseph's Witch Hazel. A Product of the St. Joseph Co., New York, Memphis, San Francisco.* Also labeled: *St. Joseph's PURE SPIRITS OF TURPENTINE NET CONTENTS 1½ FLUID OUNCES BOTTLED ONLY BY the St. Joseph Company, Memphis, Tenn. and New York N.Y. U.S.A.* Two sizes adv. 1935 by Plough Sales Corp., Memphis, Tenn., *AD*. The carton for the bottle stated: *Women have used St. Joseph's G. F. P. For 50 years. It is a vegetable compound which contains such well known herbs*

as *Blessed Thistle, Blue Cohosh Root, Squaw Vine, Life Root Plant, Helonias Root, Star Grass, and Cramp Bark.*
Clear; 5⅜″ × 2⅛″ × ¹¹⁄₁₆″; 12n; 12b; pl; h; ABM; flask shape. See PRESCRIPTION (Miscellaneous).

Fig. 182

THE NAME/St. Joseph's/ASSURES PURITY [Base: O superimposed over diamond]
Bottle manufactured by Owens-Illinois Glass Co., after 1929 (Toulouse 1972).
Clear; 5⅜″ × 2″ × 1¼″; 3n; 6b, recessed sides at base; pl; v; ABM. See PRESCRIPTION (Miscellaneous).

THE NAME/St. Joseph's/ASSURES PURITY [Base: diamond]
Label: *St. Joseph's LAXATIVE SYRUP. Alcohol 15%. A Mild and Effective Compound for Relieving Constipation, Sour Stomach and Biliousness. Price 50¢ Prepared only by The St. Joseph's Lab., New York, Memphis and Monterey.* Bottle manufactured by the Diamond Glass Co. after 1924 (Toulouse 1972).
Clear; 6″ × 2″ × 1³⁄₁₆″; 3n, sp; 6b, recessed sides at base; 1ip; v; ABM; distinctive shape. See PRESCRIPTION (Miscellaneous).

SAL·CODEIA BELL
Pain killer and laxative adv. 1910, 1948 by Hollings-Smith Co., Orangeburg, N.Y., *AD*.
Green; dimens. unk.; 3n; 1b; pl; v.

SAL-MUSCATELLE
Adv. 1887, *WHS*; 1907, *PVS & S*.
Blue; 6⅝″ × 2⅝″ × 1⁹⁄₁₆″; n?, large mouth; 3b; pl; v.

A. B. & D. SANDS/NEW YORK
Abraham B. and David Sands established their business in New York City in 1836 (Holcombe 1979), and the firm is listed in *Longworth's American Almanac, New York Register*, and the city directory for 1837. The New York City

directory for 1842 and an advertisement for 1843, in Shimko (1969), listed the brothers at several locations as A. B. & D. Sands Druggists and David Sands & Co., both apparently retail outlets, and A. B. Sands & Co., wholesale/retail and export. By 1847 the inventory of proprietary medicines included Wistar's Balsam, McMunn's Elixir of Opium, Dr. Peery's Dead Shot Vermifuge, Davis' Pain Killer, Sand's Sarsaparilla and Down's Balsamic Elixir. David died in 1860, Abraham in 1862; by 1863 the firms were all merged as A. B. Sands & Co. (Holcombe 1979; Shimko 1969). Various family members managed the business until it was sold to W. H. Schieffelin & Co. in March 1875, *Druggists' Circular and Chemical Gazette* (May 1875). Information provided by Peter Schulz (personal communication, 1984).
Aqua; 4¼″ × ? × ?; 5n; 12b; pl; v; p. See DAVIS *(Killer)*, DOWN'S (Elixir), JACKSON (Miscellaneous), MCMUNN *(Elixir)*, SANDS (Sarsaparilla).

SANITOL//FOR THE TEETH
Product of Sharpe & Dohme, Baltimore, MD, adv. 1901, *HH & M*; 1935 by Wm. R. Warner & Co., New York City, *AD*.
Milk glass; 5″ × 2¼″ × ?; 3 and 15n; 4b; pl; v, ss. See SANITOL (Trade Mark), SHARPE & DOHME *(Miscellaneous)*.

SANTAL DE MIDY//PARIS
[See Figure 183]
Label: *Santal Midy Capsules, For Kidney & Bladder Troubles, Venereal Disease. Imported by E. Fougera, N.Y.* Adv. 1870s (Devner 1968); 1941–42, *AD*.
Clear; 4³⁄₁₆″ × 1¹⁄₁₆″ diameter; 7 and 9n; 21b, 10 sides; pl; v, ss, alternate panels.

Fig. 183

DR. A. P. SAWYER/CHICAGO
[See Photo 52]
Label: *DR. SAWYERS CELEBRATED COUGH BALSAM. Prepared by Dr. A. P. Sawyer Med. Co., 161 Colorado Ave., Chicago.*

Aqua; 6¹/₄″ × 2¹/₈″ × 1³/₁₆″; 7n; 3b; 4ip; v. See SAWYER, (Cure, *Sarsaparilla*), SUN RISE (Balsam).

[h] 4 FL. OZ./[v] VAL SCHMIDT'S/ INCORPORATION/ SAN FRANCISCO [Base: IPGCo within diamond]
Bottle manufactured by the Illinois Pacific Glass Co., San Francisco, 1902–1930 (Toulouse 1972). Valentine Schmidt, Druggist and Apothecary at 238 Kearny, first appeared in the directory in 1889. The firm was listed as Val Schmidt Incorporation in 1934 and 1940.
Amber; 5″ × 2¹/₈″ × 1³/₈″; 9n; 3b; pl; v.

J. H. SCHROEDER/28 WALL STREET/LOUISVILLE, KY.
Bottle manufactured ca. 1864.
Olive; 9¹⁵/₁₆″ × 3¹/₁₆″ × 3¹/₁₆″; 11n; 2b; pl; v. See SCHROEDER *(Bitters)*.

SCOTT & BOWNE
Emerald green; 4¹/₈″ × 1⁵/₈″ × ¹⁵/₁₆″; 1n; 12b; pl; v. See SCOTT & BOWNE *(Oil)*.

SCOTT & BOWNE//NEW YORK
Label: *BUCKTHORN, Scott & Bowne's Cordial. Made from True German Bark for constipation and indigestion.* . . . Adv. 1887, *WHS*; 1929–30 by Scott & Bowne, 60 Orange St., Bloomfield, N.J., *AD*.
Amber; 9¹/₂″ × 2″ base diameter; 11n; 20b, rect. sides, changes to round base; pl; v; distinctive shape. See SCOTT & BOWNE *(Oil)*.

SEABURY/PHARMACAL/ LABORATORIES
Products included Cough Balsam, Hive Syrup, Oleaginous Liniment, Rubefacient Liniment and Ague Tonic, adv. 1871–1910.
Amber; 3³/₄″ × 2¹/₄″ × 2¹/₄″; 17n; 1b; pl; circular embossing. See SEABURY (Balsam).

SECRET DE BEAUTE/[embossed cupid]/D'EUGENIE
A product to preserve the skin and remove wrinkles, adv. 1835, 1845 (Putnam 1968).
Milk glass; 4³/₄″ × ?; 3n; 21b; ip.

Seely's/Mag Queen
Label: *New Mown Hay.*
Clear; 8″ × 2⁵/₈″ diameter; 9n; 20b; pl; h, etched lettering.

Seely's/Marie Stuart
Label: *Moss Rose.*

Clear; 8″ × 2⁵/₈″ diameter; 9n; 20b; pl; h, etched lettering; distinctive hollow stopper.

Seely's/MOSS ROSE
Clear; 6¹/₄″ × 2³/₈″ diameter; 9n; 20b; pl; h, etched lettering.

SEIDLITZ/CH/CHANTEAUD/ 54 R DES FRANCS BOURGEOIS/ PARIS
Label: *Seidlitz's Chanteaud Sulphate of Magnesia.* . . . Seidlitz's Powdered Magnesia adv. 1828 by Mass. College of Pharmacy; 1901, *HH & M.* Imported by E. Fougera & Co.
Clear; 6″ × 2¹/₈″ diameter; 7n; 20b; pl; h; ABM.

[Script:] W. F. Severa//Cedar Rapids, Iowa [Base: I in diamond]
Bottle manufactured by the Illinois Glass Co., 1916 to 1929 (Toulouse 1972). Waclav Francis Severa opened a drugstore in Cedar Rapids, IA, in 1880. In 1901 the retail aspect of the business was sold and W. F. Severa & Co., Medicine Manufacturers, was established (Blasi 1974). Products adv. 1888 (Ring 1980); 1889, *PVS & S*; 1948, *AD*. Products for 1948 included Antisepsol, Arton Hair Tonic, Balzol Life Balsam, Blodal Blood Purifier, Catarrh Balm, Cough Balsam, Diarrhoea Remedy, Golden Eye Salve, Gothardol Hair Tonic, Laxative Vermifuge, Regulator, Rheumatic Compound, Stomach Bitters, and Headache Tablets.
Amber; 7¹/₂″ × ? × ?; 11n; 7b; pl; v, fb, script.

[Script:] W. F. Severa//Cedar Rapids, Iowa [Base: I in diamond]
[See Figure 184]
Label: *Severa's STOMACH BITTERS*

Fig. 184

FRONT BACK

. . . Adv. 1888 (Ring 1980); 1948, *AD*.
Amber; 9¹/₂″ × 2⁵/₈″ × 2⁵/₈″; 12n; 2b; pl; v, fb; ABM.

[Script:] W. F. Severa//Cedar Rapids Iowa [Base: 280 in diamond]
[See Photo 53]
Label: *Severa's STOMACH BITTERS, ALCOHOL 25 PERCENT. Revised Formula May 15, 1909. A Valuable Laxative, Tonic, Invigorant and Recuperant. An Excellent Appetizer and Strengthener of the Digestive Organs. Recommended for Old and Delicate People. Price 50¢ Prepared by W. F. Severa Co. Manufacturing Pharmacists CEDAR RAPIDS, –IOWA.*
Bottle manufactured by the Diamond Glass Co., Royersford, PA, after 1924 (Toulouse 1972).
Amber; 9¹/₂″ × 2⁵/₈″ × 2⁵/₈″; 12n; 2b; pl; v, fb; ABM.

SHARPE & DOHME//BALTIMORE
Label: *ERGOTOLO, 19% Alcohol. A Concentrated, Purified, Permanent Liquid Preparation of Prime Ergot of Rye.* A. P. Sharpe opened an apothecary in Baltimore in 1845 and formed his partnership with Louis Dohme in 1860. The firm became Merck, Sharp & Dohme in 1953 and as of 1981 was headquartered in Rahway, N.J., according to W. H. Helfand, Merck Co., Inc. (personal communication, 1981). Ergotolo adv. 1891, *WHS*; 1921, *BD*.
Cobalt; 2″ × ⁷/₈″ × ¹³/₁₆″; 7n; 27b; pl; v, ss. See METHYLET (Miscellaneous), SANITOL (Miscellaneous).

SHARP & DOHME//BALTIMORE
[See Figure 185]
Amber; 2¹/₂″ × 1″ diameter, also 4″ × 1⁵/₈″ diameter; 3n; 20 and 21b; pl; v, ss. See METHYLET (Miscellaneous), SANITOL (Miscellaneous).

Fig. 185

BALTIMORE SHARP & DOHME

DR. SHILOH'S/SYSTEM/ VITALIZER//S. C. WELLS// LEROY, N.Y.

Bottle carton reads: *DR. SHILOH'S SYSTEM VITALIZER, For The Cure of Dyspepsia, Inactive Liver, Habitual Constipation, Sour Stomach, Loss of Appetite, and General Languor and Debility of the System. Prepared only by S. C. WELLS, LEROY, N.Y. After a prescription of Dr. Brutus Shiloh. Price 75 Cents. Registered in Patent Office by S. C. Wells, 1877.* Adv. 1921, *BD*.

Aqua; 5¼" × ? × ?; 11n; 6b; 4ip; v, fss. See PARK (Cure, Syrup), SHILOH *(Cure,* Remedy), WELLS (Company).

DR. SHOOP LABORATORIES// RACINE WISCONSIN
Label: *SHOOP'S TONIC . . . Lawrenceburg, Ind.*

Clear; 7" × 2⅜" × 2⅜"; 15n; 1b; 2ip; v, ss; ABM. See SHOOP *(Medicine)*.

SHRINTER'S/VERMIFUGE
Aqua; 4½" × 1⅛" × ¾"; 7n; 3b; pl; v.

DR JGB SIEGERT & HIJOS [Base:] **DR JGB SIEGERT & HIJOS**
Angostura Bitters.

Green; 8" × 2¼" diameter, also 10⅜" × 2¹³/₁₆" diameter; 2n; 20b; pl; h, shoulder; 3-piece mold. See SIEGERT *(Bitters)*.

C. SINES//TAR WILD CHERRY/&/ HOARHOUND//PHILA Pᴬ
Sines' Celebrated Compound Syrup of Tar, Wild Cherry & Hoarhound, product of Charles Sines, Philadelphia, PA, adv. 1853–54 (Baldwin 1973); 1910, *AD*.

Aqua; 5" × 1½" × 1"; 3n, crude, folded; 3b; ip; v; sfs; p.

1. OZ. 5DR. SLADE//BUFFALO
Clear; 4⅜" × 1¹¹/₁₆" × 1¼"; 7n, sp; 3b; 4ip; v, ss. See SLADE *(Company)*.

SLOAN'S/ANTI-COLIC
Product of Dr. Earl S. Sloan, Boston, MA, adv. 1900, *EBB*; 1929–30 by Wm. R. Warner, New York City, *AD*.

Clear; 4⅞" × 1⅛" × 1⅛"; 7n; 2b; pl; v. See SLOAN (Cure, Liniment, Ointment).

SMITH & SHAKMAN/BALTIMORE
Bottle manufactured ca. 1900.

Color & dimens. unk.; 11n; rect.; ip; v.

E. A. SMITH M.D./BRANDON VT.
Bottle manufactured ca. 1882. Products included an herb bitters, with label dated 1882. E. A. Smith, was a Brandon, VT, physician from the mid 1870s until the 1890s who ". . . claimed to have extraordinary power of perception in determining ills and how to cure

them" (Wilson and Wilson 1971). Child's *Gazetteer & Business Directory of Rutland County, Vt., 1881-82* listed Ezra A. Smith, MD, Eclectic Physician & Surgeon.

Aqua; 9½" × ? × ?; 9n; 13b; pl; v.

JAMES P. SMITH/NEW YORK/ CHICAGO
Clear; 5¾" × 2" diameter; 3n; 20b; pl; h, within circle.

JOHN J. SMITH/LOUISVILLE, KY.
Label: *SMITH'S TONIC SYRUP, or Vegetable Febrifuge For The Speedy And Radical Cure of Fever And Ague, or Chills And Fever. Dr. John Bull's Principal Office, 831 West Main St., Louisville, Ky.* Tonic Syrup adv. 1871, *WHS*; 1907, *PVS & S*.

Aqua; 6½" × 2¼" diameter; 11n; 20b; pl; v. See J. BULL (Miscellaneous, *Sarsaparilla*).

SMITH'S/GREEN MOUNTAIN/ RENOVATOR
Light amber; 7½" × 2½" × 1½"; 1n; 3b; ip, oval embossed panel; v. See SMITH *(Remedy)*.

SMITH'S//GREEN MOUNTAIN// RENOVATOR//EAST GEORGIA VT.
Bottle manufactured ca. 1854–1860 (Fritschel 1976).

Olive amber; 7" × 3" × 2⅛"; 1n; 4b; pl; v, ccbs; p. See SMITH *(Remedy)*.

SMITH'S/GREEN MOUNTAIN/ RENOVATOR//EAST GEORGIA, VT.
Bottle manufactured ca. 1881–1897 (Fritschel 1976).

Aqua; 7¾" × ? × ?; 12n; 13b; pl; h, fb, SMITH and EAST GEORGIA, VT., arched. See SMITH *(Remedy)*.

S. SMITH'S/GREEN MOUNTAIN RENOVATOR
Light green; 7¾" × 3³/₁₆" × 1¹¹/₁₆"; 25n; 13b; pl; h, across shoulder. See SMITH *(Remedy)*.

S. SMITH/GREEN MOUNTAIN RENOVATOR/EAST GEORGIA VT.
Bottle manufactured ca. 1865–1882 (Fritschel 1976).

Aqua; 7¾" × ? × ?; 11n; 12b; pl; v. See SMITH *(Remedy)*.

SMITH'S BILE BEANS
[See Figure 186]
Bottle contained "Anti-bilious Pergative Pills," a product of James Ballard & Co., St. Louis, MO, introduced in 1879 (Wilson and Wilson 1971). Adv. 1941-42, *AD*.

Clear; 1⅞" high, no base, vessel will not stand; 3n; pl; circular embossed. See BALLARD *(Liniment)*.

Fig. 186

SMITH'S/CERTIFIED/ENAMEL
The Lee Smith Co., manufacturer of dental supplies, Pittsburgh, PA, was established in 1866; firm may still be in business.

Clear; dimens. unk.; 7 and 15n; 20b; ip on back, front embossed; h.

SODERGREN BROS.// MINNEAPOLIS, MINN
Contents unknown. Directories establish H. Alfred and Uno Sodergren, Manufacturing Chemists, in the 1890s; the firm was operating from the early 1900s to the 1940s as Sodergren & Co.

Aqua; 5⅝" × 1¾" × 1"; 1n, also 7n, sp; 3b; 4ip; v. See SODERGREN (Company).

SOZODONT//FOR THE TEETH/ AND BREATH//SOZODONT
Clear; 2½" × ⅞" × ⅝"; 3n, sp; 3b; 4ip; v, sfs. See VAN BUSKIRK *(Miscellaneous)*, STAFFORD *(Miscellaneous)*.

GENUINE/J. RUSSELL SPALDING/ BOSTON MASS.
Label: *Trial Size J. Russell Spalding's Celebrated Vegetable Compound of Rose Mary and Castor Oil, or Highest Premium Cytherean Hair Oil or Wash . . . J. Russell Spalding Chemist and Apothecary, Principal Depot at No. 27 Tremont Row, opposite Boston Museum, Boston, Mass. U.S.A.* Directories included the company from 1856 to 1862. Spaldings Rosemary for the Hair adv. 1859 (Devner, 1970); other products, 1890, *W & P*.

Aqua; 5" × 2" × 1³/₁₆"; 7 and 13n; 12b; 1ip; v; p. See SPALDING (Oil).

SPARKLENE [Base:] **REGISTERED**
Amber; 2⅜" × 1" diameter; ?n; 20b; pl; v.

A. SPIEHLER/PERFUMER/ ROCHESTER, N.Y.
Adv. 1929–30 and 1941–42 by Adolph Spiehler Inc., 202 Court St., Rochester, N.Y., *AD*.

Clear; $5^3/_4'' \times 2^9/_{16}''$ diameter; 9n; 20b; pl; circular embossing; shapely stopper.

E. R. SQUIBB
E. R. Squibb, New York, Pharmaceutical Laboratory, was established in 1857. Squibb invented and developed percolation, which allowed the introduction of fluid extracts (Devner 1970). As of 1986, E. R. Squibb & Sons, Inc., was operating in Princeton, NJ.

Aqua; $4^7/_8'' \times 1^7/_8''$ diameter; 9n; 20b; pl; h, on shoulder; variations in height and color.

J. R. STAFFORD//OLIVE TAR
William H. Hall and John H. Ruckel, New York, formed a partnership in 1848; products included the Olive Tar and Sozodont. The firm had several partnership changes and was still in operation in the late 1930s. Richard Van Buskirk, a principal of the firm, left the business in 1858 and by 1867 was competitively marketing Van Buskirk's Fragrant Sozodont (Holcombe 1979). This competitive product was probably soon sold to Hall & Ruckel. Olive Tar adv. 1860 (Putnam 1968); 1921, *BD*.

Aqua; $6'' \times 2^1/_4'' \times 1^1/_8''$; 1n; 3 or 6b; pl; v, ss; with and without pontil. See SOZODONT (Miscellaneous), VAN BUSKIRK (Miscellaneous).

STANDARD/PER'Y WORKS N. Y.
[Base:] B & R
Florida water. Directories locate the firm at 62 Vesey in 1884 and at 18 Merc. in 1891.

Amber; $9^3/_{16}'' \times 2^3/_{16}''$ diameter; 11n; 20b; pl; v. Also aqua and amber variants, $8^7/_8'' \times 1^7/_8''$.

STEARN'S/QUALITY
Clear; $5'' \times 2^1/_4'' \times 1^1/_4''$; 18n; 18b, with square corners; pl; h; ABM.

STEARN'S/ZEPYROL
Adv. 1921, *BD*; 1929–30 by Esbencott Chem. Labs., East 17th St., No. Portland, Ore.; 1941–42 by Santiseptic Co., 2014 N. E. Sandy Bl., Portland, Ore., *AD*.

Clear; $5^1/_4'' \times 2^1/_8''$ diameter; 7n; 20b; pl; h; ABM.

M. STEIN/SPIRIT GUM/ NEW YORK
Max Stein was a New York City druggist from 1878 to 1900; directories showed that in 1900 Stein established M. Stein, Drug & Cosmetic Co.; the firm was listed as M. Stein Cosmetic Co., Inc. in 1948, *AD*.

Aqua; $3'' \times 1^7/_{16}''$ diameter; 3n, large mouth; 20b; pl; h.

G. W. STONE'S//LIQUID CATHARTIC & FAMILY PHYSIC//LOWELL MASS
For aches and pains, adv. 1856 (Baldwin 1973).

Olive; $9'' \times 3^1/_8'' \times 2^3/_8''$; 11n; 3 or 6b; ip; v, sfs. See STONE (Elixir, *Oil*).

DR. S. F. STOWE'S/AMBROSIAL NECTAR/[embossed drinking glass in wreath]/PATENTED MAY 22, 1866.
Light green; $8'' \times 2^1/_2''$ diameter; 18n; 20b; pl; h.

STRATFORD/COOKSON
Stratford-Cookson Co., Yeadon, PA, dental suppliers, were still in business as of 1986.

Clear; dimens. unk.; 3n; 20b; 2ip.

STRONTIUM/PARAF-JAUAL
Strontium products adv. 1941–42, 1948, *AD*.

Aqua; $7^1/_2'' \times 3^1/_4'' \times 1^1/_2''$; 8n; 13b; pl; v.

JNO. SULLIVAN/PHARMACIST/ [monogram]/BOSTON
Milk glass; $5'' \times 2^1/_{16}'' \times 1^3/_8''$; 9n; 3b; pl; h.

SULPHOLINE
Contained either Pepper's Sulpholine Lotion adv. 1887, *McK & R*; 1900, *EBB*; or Hale's Sulpholine, adv. 1910, *AD*; 1917, *BD*; could be both with a proprietorial change.

Cobalt; $6'' \times 2^1/_4'' \times 1^3/_8''$; 7n; 3b; pl; ribbed.

SWAIM'S/PANACEA//GENUINE// PHILADA
Bottle introduced in 1823 (Wilson and Wilson 1971) or 1825 (Munsey 1970); discontinued ca. 1830 (Baldwin 1973). Promoted as "SWAIM'S PANACEA, For the Cure of Scrofula, Rheumatism, Ulcerous Sores, White Swelling, Diseases of the Skin, General Debility . . . and all Diseases Arising from Impurity of Blood." William Swaim's Panacea, primarily a syrup of sarsaparilla, was introduced in 1820. The panacea owed much of its success to a delicious flavor, a palatability others could not claim (Young 1962). W. H. Schieffelin & Co., New York, were general agents in 1862 (Holcombe 1979); also in 1891, *WHS*. James Ballard, St. Louis, became the sole agent ca. 1900; soon thereafter bottles were embossed with St. Louis rather than Philadelphia. Others were apparently also embossed New York (Wilson and Wilson 1971). Adv. 1900 by Swaim's

Laboratory, Clifton, Staten Island, New York, E. Battachon Swaim, Sole Owner; so also were Swaim's Pills, Vermifuge, Elixir, Ointment, and Febrifuge, *EBB*; 1929–30 by James Ballard, St. Louis, "Formerly Panacea" in 1935 and 1941–42 by James Ballard, *AD*.

Aqua; $7'' \times ? \times ?$; 11n; 3b; pl; v, fss; p. See SWAIM (Trade Mark).

SWAIM'S//PANACEA//PHILAD[A]
Bottle introduced 1828 (Wilson and Wilson 1971) or 1829 (Munsey 1970).

Olive green, apple green; $8'' \times 3^1/_2''$ diameter; 21n; 20b; ip, series of small, vertical panels; v, sss; p. See SWAIM (Trade Mark).

T & M//T & M
Bear Paw Made Hair Dressing or Bear Grease Pomade, product of Taylor & Moore, New York City, adv. 1837–1857 (Wilson and Wilson 1971).

Light blue, teal; $2^1/_8'' \times 1^3/_8'' \times 1''$; 3n; 6b; pl; v, ss; p.

DR. TAFT'S/ASTHMALENE/ NEW YORK
Product of Charles S. Taft, New York City, formulated in the early 1880s (Wilson and Wilson 1971). Adv. 1887, *WHS*; 1929–30 by B. S. McKean, 79 E. 130th St., New York City; 1948 by B. S. McKean, Inc., 180 E. Prospect Ave., Mamoroneck, N.Y., *AD*.

Aqua; $8'' \times 2^1/_2'' \times 1^3/_8''$; 1n; 3b; pl; v.

TANLAC
Label: *TANLAC – Net Weight 8 Ounces – 18% Alcohol by Volume – A Splendid Tonic and System Purifier – Manufactured and Distributed by International Proprietaries, Dayton, O., Atlanta, Ga. This Style Bottle Adopted April 5, 1922.* Dr. Will "Doc" Cooper, Dayton, OH, introduced Tanlac in the 1860s, a product of his medicine shows. Adv. 1935, *AD*.

Clear; dimens. unk.; 4n; 6b; ip; base; ABM.

TAYLOR'S/SWEET GUM & MULLEIN/ATLANTA, GA.
Aqua; $5'' \times ? \times ?$; 7n; 3b; pl; v. See TAYLOR *(Remedy)*.

TEMPLE/OF/HEALTH
Dr. J. W. Roberts Hesperian Tonic, Temple of Health Medicine Co., San Francisco. Adv. ca. 1895–1918 (Wilson and Wilson 1971).

Aqua; $9'' \times ? \times ?$; 7n; 3b; pl; v.

DR. TICHENOR'S//ANTISEPTIC
Light green; $5^3/_4'' \times 2^1/_8'' \times 1^1/_4''$; 7n; 17b; 1ip; v, ss.

DR. TICHENOR'S//ANTISEPTIC

[Base: O superimposed over diamond]
Label: *DR. G. H. TICHENOR'S ANTISEPTIC REFRIGERANT, 67% Alcohol. For Cuts, Bruises, Sprains, Superficial Burns, Sunburn and Mouth Wash. Dr. G. H. Tichenor Antiseptic Co., New Orleans, La. Registered in U. S. Patent Office 1883.* Bottle manufactured by Owens Illinois Glass Co., after 1929 (Toulouse 1972). Adv. 1948 from 214 Canal St., *AD.*
Clear; 5⅞" × ? × ?; 16n; 9b; pl; v; ss; ABM.

If it's Tillmann's it's good

Not a medicine. Frederick Tillman established a wholesale grocery in San Francisco in 1853. Products included teas, baking powders, oils, etc. The theme, "If it's Tillmann's it's good," was trademarked in 1897 (Zumwalt 1980).
Clear; 4¹³/₁₆" × ?; 17n; 20b; pl; h; ABM.

G. DE KONING TILLY

Tilly's Gold Medal Haarlem Oil, originally a diuretic and kidney stimulant was later billed as a product for clearing the skin and brightening the eyes. Formula originated by Dr. Hermaanus Boerhave and Claus Tilly of Holland, in 1696, given to G. de Koning Tilly, grandson of Claus, in 1740. The product was introduced in the United States in 1907 by the Genuine Haarlem Oil Mfg. Co., Holland and Jersey City, NJ (Devner 1968). Adv. 1941–42, *AD.*
Aqua; 3¾" × ¹¹/₁₆" diameter; 13n; 20b; pl; v.

GENUINE TILLY/HAARLAM HOLLAND

Aqua; 3¾" × ?; 13n; 20b; pl; v.

TONSILINE//TONSILINE//

[embossed giraffe] [Base: P in circle]
[See Figure 187]
Label: *TONSILINE, Alcohol 7½%. For Minor Irritations of the Throat and Mucous Membrane of the Mouth & Hoarseness Due to Colds. The Tonsiline Co., Canton, Ohio.* Also embossed screw-capped variant label: *TONSILINE, For Minor Irritations of the Throat and Mucous Membranes of the Mouth. . . .The Tonsiline Co., Canton, Ohio, Copyright 1963. Box Copyrighted 1961. Alcohol 3 to 4%. . . .* Bottle manufactured by the Pierce Glass Co., 1905-1916 (Toulouse 1972). Adv. 1899 (Devner 1968); 1984-85 by Oakhurst Co., 1001 Franklin Ave., Garden City, N.Y., *AD.*
Clear; 6¾" × 2¼" × 1¼"; 1n; sp; 3b; 4ip; v; ssf; ABM.

Fig. 187

TOWNS/EPILEPSY/TREATMENT/MILWAUKEE/WISCONSIN/U.S.A.

Amber; 7½" × 2¾" × ?; 7n; rect.; ip. See TOWN *(Cure).*

TRIACOL ALPERS

Label: *Alpers Triacol or Elixir . . . Guaicot Co., Prepared by the Alpers Chem. Co., 486 White St., N.Y.* Adv. 1907, *PVS & S*; 1921, *BD.*
Amber; 7⅜" × 2⁹/₁₆" × 1⁹/₁₆"; 9n; 17b; pl; v.

JOS. TRINER//CHICAGO

[See Photo 54]
Label: *TRINER'S AMERICAN ELIXIR OF BITTER-WINE . . . NEW FORMULA ADOPTED APRIL 26, 1910 . . . Manufactured by JOSEPH TRINER 1333-1339 Ashland Ave. Chicago, ILL., U.S.A.* First embossed ca. 1900. Products included Triner's American Elixir of Bitter Wine and Triner's Angelica Bitter Tonic, registered 4 Feb. 1902, and Angelica Bitter Wine. Elixir of Bitter Wine adv. 1901-02 (Ring 1980); 1920-30 by Jos. Triner Corp., 4053 W. Fillmore St., Chicago, Ill.; 1941-42 from 1335 S. Ashland Ave., Chicago, Ill. *AD.*
Amber; 10¾" × 3" diameter; 12n; 20b; h, fb, shoulder; several sizes. Also a variant 5¼" high; 1n; 21b; pl; v.

TRITURATION/FROM/ST. PAUL HOMEOPATHIC PHARMACY/ST. PAUL, MINN.

[Base:] W.T. & CO/A/U.S.A.
Bottle manufactured by Whitall-Tatum Glass Co., 1857 to 1935 (Toulouse 1972).
Clear; 9⅛" × 2⅞" × 2⅞"; 7n; 2b; pl; v.

DR. TULLEY'S//1180//PRESCRIPTION

Clear; 5¹⁵/₁₆" × 1¹⁵/₁₆" × ¹⁵/₁₆"; 11n; 3b; 1ip; v.

DR. TULLEY'S//1180//PRESCRIPTION

Clear; 7⅞" × 2½" × 1¼"; 11n; 3b; pl; v.

TURKISH/FOOT BATH//FOR TENDER FEET//GALLED ARMPITS & C.

Adv. 1895, 1907, *PVS & S.*
Aqua; dimens. unk.; 1n; 3b; 3ip; v, fss.

TURNER'S/LIVER REGULATOR/TURNER BROS/SAN FRANCISCO

Aqua; 7¾" × ? × ?; 7 or 13n; 11 or 18b; pl; v. See TURNER (*Jamaica Ginger,* Sarsaparilla).

DR. S. A. TUTTLE//BOSTON, MASS.

Tuttle's Family Elixir.
Aqua; 6" × 1⅞" diameter; 7n; 21b, 12 sides; pl; v, ss. See TUTTLE *(Elixir).*

DR. S. A. TUTTLE//BOSTON MASS

Aqua; 6½" × 2¾" × 1½"; 7n; 3b; 4ip; v, ss. See TUTTLE *(Elixir).*

U.S.A./HOSP./DEPT

Clear; 4⅞" × 1¾" diameter; 9n; 20b; pl; h, partially arched.

U.S.A./HOSP. DEP'T.

The embossed vessels were produced for the U. S. Army, in Pittsburgh, between 1860 and 1870 and contained such products as poisons, disinfectants, narcotics, acids and anesthetics, according to Pat and Clint Roger, Laramie, WY, (personal communication, 1967).
Aqua; 5¹³/₁₆" × 2⁷/₁₆" diameter; 7n; 20b; pl; h. Many variants and colors including amber, cobalt, green and olive.

U.S.A. HOSP DEPT

Aqua; 6½" × 2⅝" diameter; 3n; 20b; pl; h.

U S/MARINE/HOSPITAL/SERVICE/100 c.c.

Clear; 5" × 1⅝" × 1⅝"; 7n; 2b; pl; h.

DR. ULRICI/NEW YORK

New York City directories first reference Carlos J. Ulrici, Chemist, in 1899 at 136 Water St. After a brief partnership with Escalante as Ulrici & Escalante Med. Co., the Ulrici Medicine Co. was established. The firm was operating by the family in 1930 at 233 W. 14th.

Aqua; 8³/₈″ × 2¹/₂″ diameter; 7n; 20b; pl.

UMATILLA/INDIAN RELIEF
Adv. 1895, *PVS & S*; 1910, *AD*.
Aqua; 5″ × 1⁵/₈″ × 1¹³/₁₆″; 7n; 3b; 3ip; v.

URICEDIN/STROSCHEIN' [Base: V with embossed flags] E/J ST.
URICEDIN
Adv. 1910, *AD*; 1929–30 by Boediner & Schlesinger, Third Ave. & 10th St., New York City; 1948 by Barnes Chemical Co., Inc., Corona, N.Y., *AD*.
Cobalt; 5″ × 2¹/₄″ × 1¹/₂″; 16n, ground; 6b; pl; v.

Dᴿ V. P. F. P./M. W. M./ ALBANY, N. Y.
Aqua; 2¹/₄″ × 1¹/₁₆″ diameter; 7n; 20b; pl; v.

VAN BUSKIRK'S/FRAGRANT/ SOZODONT
Adv. 1865, *GG*; 1929–30 by Hall & Ruckel Inc., New York City, *AD*.
Clear; 5¹/₂″ × 1⁷/₈″ × 1″; 3n, sp, crude; 6b; 4ip; v. See SOZODONT (Miscellaneous), STAFFORD (*Miscellaneous*).

VAN BUSKIRK'S//FRAGRANT SOZODONT//FOR THE TEETH/ AND BREATH [See Figure 188]
Clear; 4⁵/₈″ × 1¹³/₁₆″ × 1″, also 6⁵/₁₆″ high; 3n, sp; 3b; 4ip; v, ssf. See SOZODONT (Miscellaneous), STAFFORD (*Miscellaneous*).

Fig. 188

VAN DUZER//NEW YORK
Clear; 5³/₈″ × 1¹⁵/₁₆″ × 1″; 8n, sp; 3b; 4ip; v, ss. See MRS. ALLEN (Balsam, *Restorer*), VAN DUZER (*Jamaica Ginger*).

DR. VAN DYKE//DR. VAN DYKE
[Base:] PATENTED/[diamond]/JUNE 2 ᴺᴰ 1896 [See Photo 55]
Label: *Dr. Van Dyke's HOLLAND BITTERS.* . . . Product of Van Dyke Bitters Co., St. Louis, MO. Adv. 1916, *MB*.

Clear; 9⁵/₈″ × 3³/₈″ × 2¹/₂″; 12n; 6b; 4ip; v, ss; tapered sides.

[Script:] **Vantine's**
Adv. 1914, *HD*; as Vantine's Liquid, 1948 by A. A. Vantine Products Corp., New York City, *AD*.
Clear; 2¹/₂″ × 1¹⁵/₁₆″ × 1″; 3n; 6b; pl; h, script.

[Script:] **Vantine's**
Clear; 2³/₄″ × ⁷/₈″ × 1¹¹/₁₆″; 3n; 6b; pl; d, script; ABM.

[Script:] **Vantines**
Green; 2¹/₂″ × ?; 17n; 20b; pl; d, script.

VAR-NE-SIS [See Photo 56]
Label: *VAR-NE-SIS For Rheumatism, Such as Sciatie, Lumbago, Muscular, Chronic Rheumatic Arthritis, Rheumatic Neuritis—Contains Not Over 15 Per Cent, Alcohol—Prepared by the VAR-NE-SIS COMPANY, Lynn, Mass., U.S.A. Revised August 11, 1916.* Adv. 1929–30 and 1948 by Var-Ne-Sis Co., 25 Hamilton Ave., Lynn, Mass., *AD*. Chemists from Connecticut in 1917 found the product to contain 18% alcohol, laxative drugs and cayenne pepper.
Aqua; 8¹/₂″ × 3¹/₂″ × 1⁷/₈″; 24n; 12b; pl; v; ABM.

VASELINE/CHESEBROUGH/ NEW-YORK [See Figure 189]
Clear; 2⁷/₈″ × 1⁵/₈″ diameter; 17n; 20b; pl; h. See CHESEBROUGH (*Company*).

Fig. 189

VASEROLE
Aqua; 2³/₄″ × 2¹/₈″ diameter; 3n; 20b; pl; h, on shoulder.

VASOGEN
Adv. 1916, *MB*, 1917, *BD*.
Amber; 3¹³/₁₆″ × 1″ diameter; 3n; 21b, 6 sides; pl; v.

[h, shoulder:] **BUCKINGHAM/ [v?] VENABLE & HEYMAN/ 152 CHAMBER ST. NEW YORK**
Florida water. Directories place George W. Venable and Moses J. Heyman, Wines, at 150 Chambers, New York City, in 1878; and at 24 Reade in 1891.
Amber; 6¹/₄″ × ?; 11n; 20b; pl; h, v?.

VICKS/VA-TRO-NOL/
[embossed triangle]
Label: *Vicks VA-TRO-NOL For Nose & Throat, Vicks Chemical C., Greensboro, N.C.* . . . Introduced with Vicks Medicated Cough Drops in 1931, product of the Vicks Chemical Co., according to Kathi Davis, Richardson-Vicks Inc., Wilton, CT, successors to Richardson-Merrell Inc. (personal communication, 1983). Adv. 1983, *RB*.
Cobalt; 2¹/₂″ × 1³/₈″ diameter; 16n; 20b; pl; embossed on base; ABM.

VIGOR OF LIFE
Cure for social diseases, adv. 1915, *SF & PD*; 1916, by Van Vleet-Mansfield Co., Memphis, TN (Devner 1968).
Aqua; 7¹³/₁₆″ × 2⁷/₁₆″ × 1⁷/₁₆″; 1n; 3b; 4ip; v.

VIN MARIANI/COCA/PHYSICIANS' SAMPLE/PARIS FRANCE
Vin Mariani or Mariani Coca Wine was a popular tonic and stimulant for the body, brain and nerves, composed of about 11 percent alcohol, two ounces of coca leaves and small portions of tannin, iron, salts and acids. The wine was consumed before or after meals or anytime as a cocktail or grog; it was purportedly useful in the prevention and treatment of contagious diseases, for influenza, nervousness, anemia, insomnia, impotence, melancholy and stomach, throat and lung problems. Vin Mariani was introduced in Paris, by Angelo Francois Mariani, in 1871 and officially listed in the French Pharmaceutical Codex in 1884. As a narcotic, its popularity is apparent, although early in the twentieth century substitutes were used. In 1954 the name became Tonique Mariani and it was still produced in 1963 (Helfand 1980). The first advertising found for the United States was 1889, *PVS & S*.
Clear; 5¹/₂″ × 2¹/₄″ × 1¹/₂″; 9n; 3b; pl; v. See COCA MARIANI (Miscellaneous).

DR D. B. VINCENTE//ANGEL OF LIFE/FOR THE BLOOD// SAN FRANCISCO
Aqua; 8¹/₈″ × 2¹/₂″ × 1¹/₂″; 1n; 3 or 6b; 3 or 4ip; v, sfs.

VINOL [Base:] Patented April 19, 1898/[O superimposed over diamond]
Label: *VINOL Alcohol 16%. Vinol Supplies Iron and Other Imported Elements Which the Body Needs. Particularly Beneficial for Convalescents, Delicate Children and Elderly People. An Aid in Stimulating the Appetite.* . . . Chester-Kent, Inc., Distributors, St. Paul, Minn.

Bottle manufactured by the Owens-Illinois Glass Co. after 1929 (Toulouse 1972).

Amber; 6³/₄″ × 3″ × 1¹/₂″; 16n; 12b; pl; h, shoulder, base; ABM; **distinctive shape, bulbous body, small base.**

VINOL [Base:] PRIVATE MOULD/ PATENTED APRIL 19–1898

Patented in 1898, adv. 1948 by Chester-Kent Inc., St. Paul, Minn., *AD.* Advertisement, ca. 1905: "Vinol–Our delicious Cod Liver preparation without oil. Better than old-fashioned cod liver oil and emulsions to restore health for old people, delicate children, weak run-down persons, and after sickness, colds, coughs, bronchitis and all throat and lung troubles. Try it on our guarantee."

Amber; 6³/₄″ × 3¹/₂″ × 2¹/₄″; 18n; 12b; pl; h, shoulder, base; **distinctive shape, bulbous body, small base, cross section ca. 4³/₄″ × 2³/₄″.**

W [See Figure 190]

A universal container manufactured ca. 1867. Contained products such as Wenzell's Jamaica Ginger. W. T. Wenzell, San Francisco, purchased the George S. Dickey drug concern about 1870 and apparently sold the business in 1893 when he became a professor of chemistry at the California College of Pharmacy, San Francisco (Wilson and Wilson 1971).

Blue green; 5³/₄″ × ? × ?; 11n; 12b; pl; **h, in oval.** See DICKEY *(Chemical),* WENZELL (Miscellaneous).

Fig. 190

[Script:] **Wakamoto** [Base:] **3/ NAGA//11.ģ.B**

Amber; 4⁵/₈″ × 1⁷/₈″ diameter; 3n; 20b; pl; **d, script, oriental lettering around neck;** ABM.

H. P. WAKELEE/SAN FRANCISCO

Henry Peck Wakelee, 1822–1882, established his drug business in Buffalo,

NY in 1857; within ten years he was manufacturing his own medicines in San Francisco. In 1882 Wakelee slipped on the ice while on a business trip to New York and suffered a fatal brain concussion; his daughter Kate Garrison Wakelee assumed the business. In the 1890s Kate married George Bromley, and ". . . the business was placed in the hands of two brothers [Kate's or Bromley's ?] with a solid drug background and the company continued to prosper" (Wilson and Wilson 1971).

Clear; 7¹/₈″ × 2⁷/₈″ diameter; 5n; 20b; pl; **v.** See CAMELLINE (Miscellaneous), WAKELEE (Drug).

WAKELEE'S/CAMELLINE

A lotion, comprised of 8% alcohol, for softening and beautifying the complexion. Adv. 1895, *PVS & S;* 1917, *BD.*

Cobalt; 4⁵/₈″ × ? × ?; 7n; 3b; pl; **v; later variant was amber.** See CAMELLINE (Miscellaneous), WAKELEE (Drug).

J. WALKER'S/V. B.

Joseph Walker patented his California Vegetable Renovating Vinegar Bitters in 1863 (Ring 1980), and by 1866 had located his business at the corner of American and Channel streets, Stockton, CA; Richard H. McDonald was sole agent. Other products included Walker's Vegetable Renovating Ginger Bitters, and J. Walker's Vinegar Bitters. About 1866, McDonald moved to San Francisco and soon thereafter began bottling and selling Walker's bitters. The product was described in an ad as a ". . . strictly medicinal preparation, manufactured from the Native Roots and Herbs of California, gathered when the juices are richest in their healing properties." About 1870 Walker and McDonald moved to New York. By 1877 Walker was no longer listed in directories; reportedly he died in a train accident. Although McDonald returned to San Francisco in 1879, R. H. McDonald & Co., New York City, continued to market the bitters, possibly only for a short while, and other proprietaries until 1890 (Schulz, et al. 1980). According to a San Francisco city directory, Redington & Co., were general agents in 1883. Adv. 1923, *SF & PD.*

Light blue, aqua; 8¹/₄″ × 2¹⁵/₁₆″ diameter; 3n, modified; 20b; pl; base.

WALNUTTA

Hair gloss adv. 1907, *PVS & S;* 1923, *SF & PD.*

Aqua; 4″ × 1¹/₂″ diameter; 9n; 20b; pl; **h, v, on shoulder.**

WARNER'S/BROMO/SODA/ PHILA–ST. LOUIS [See Figure 191]

Adv. 1887–88 (Alpe 1888); 1889, *PVS & S;* 1929–30 by Wm. R. Warner & Co., 113 W. 13th St., New York City, *AD.*

Cobalt; 2⁷/₈″ × 1³/₁₆″ diameter; 3n; sp; sp; 20b; pl; **v.** See W. WARNER *(Company).*

Fig. 191

WATKINS WINONA, MINN.

[Base: diamond]

Bottle manufactured by the Diamond Glass Co. after 1924 (Toulouse 1972). Products included Pain Oil, Lax-tone Liniment, Gen-De-Can-Dra, Cough Medicine and Skin Alterative Tonic.

Clear; 4″ × ?; 17n; 1b; 1ip; ABM. See WATKINS *(Company,* Liniment, Trade Mark).

[h] TRIAL MARK/[v] WATKINS

[Base:] **B** [See Photo 57]

Label: *WATKINS STOCK DIP FOR KILLING Lice, Ticks, Mites and Vermin. For Preventing and Curing Mange, Scab and Itch. For Disinfecting and Purifying Poultry Houses, Pig Sties, Cattle Sheds, Stables, Dwellings, Sick Rooms, Water Closets, Sinks, Sewers, Etc. . . . PRICE 25 CENTS THE J. R. WATKINS MEDICAL CO. Proprietors Watkins' Liniment, Watkins' Remedies, Extracts, Spices, Soaps and Perfumes. WINONA, MINN., U.S.A.*

Amber; 8¹/₂″ × 3″ × 1³/₄″; 7n; 3b; 1ip; **h, v.** See WATKINS *(Company,* Liniment, Trade Mark).

Dr. C. J. WEATHERBY'S/ LABORATORY/SALT LAKE CITY, UTAH [Base:] 4/W.T. & CO./U.S.A.

Bottle manufactured by Whitall-Tatum, 1857 to 1935 (Toulouse 1972).

Cobalt; 4¹/₁₆″ × 1³/₄″ × 1¹/₁₆″; 9n; 18b; pl; **v.**

WEAVERS PAIN EXPELLER// SHAMOKIN PA.

Aqua; 5⁵/₈″ × 1⁷/₈″ × ⁷/₈″; 7n, sp; 3b; 3 or 4ip; **v, ss.**

**WEED'S//CRINALGIA//
NEW YORK**

New York City directories included
John W. Weed, Physician, 1844–61.

Aqua; 6″ × 2⁷/₁₆″ × 1³/₁₆″; 5n; 24b;
2ip; v, sfs; p.

**WELCH'S/AGOPODIUM/
PREPARED/BY/W.G. WELCH,
M.D./NEW HAVEN/CONN.**

Adv. 1897, *L & M*.

Clear; 5¼″ × 2¼″ × 1¼″; 9n; 6b; pl;
h.

W. T. WENZELL/SAN FRANCISCO

[See Figure 192]

Bottle manufactured ca. 1874 (Wilson
and Wilson 1971).

Aqua; 5½″ × ? × ?; 7n; 12b; pl; v. See
DICKEY *(Chemical)*, W *(Miscellaneous)*.

Fig. 192

**WEST INDIAN//TOOTHWASH//
R. B. DACOSTA/PHILADA**

Product of R. B. DaCosta, Philadelphia,
PA, introduced ca. 1859 (Wilson and
Wilson 1971); adv. 1910, *AD*.

Aqua; 3³/₄″ × ? × ?; 13n; 6b; pl; v, ss;
h, f.

WHEELER'S/TISSUE PHOSPHATES

[Base: script monogram]

Adv. 1896–97, *Mack*; 1917, *BD*.

Aqua; 8⁷/₈″ × 2⁵/₈″ × 2⁵/₈″; 11n; 2b;
4ip; v.

A. J. WHITE//LONDON

Aqua; 5¹/₁₆″ × 1¹³/₁₆″ × ¹⁵/₁₆″; 7n; 3b;
2ip; v, ss. See LAXOL (Miscellaneous),
SEIGEL *(Syrup)*, SHAKER (Cordial,
Pills), WHITE (Syrup).

**A. J. WHITE, LTD.//A. J. WHITE,
LTD.**

Label: *Mother Seigel's Curative Syrup, A.
J. White Ltd., 168 Duane St., New York,
U.S.A.*

Aqua; 4⁵/₈″ × 1⁷/₈″ × 1¹/₈″; 7n; 3b; 2ip;
v, ss. See LAXOL (Miscellaneous),
SEIGEL *(Syrup)*, SHAKER (Cordial,
Pills), WHITE (Syrup).

WHITEHALL//WHITEHALL [Base: I
in circle]

Bottle manufactured by Owens Illinois
Glass Co. after 1954 (Toulouse 1972).

Amber; 3¹/₁₆″ × 1³/₈″ × 1″; 16n; 6b; pl;
v, ss; ABM.

WHITEHURST [Base: I in diamond]

Label: *JUNIPER-TAR COMPOUND, J.
Harrison Whitehurst Compound, Baltimore, Md. For Spasmodic Croup, Bronchitis, Ordinary Sore Throat, Colds. . . .*
Bottle manufactured by the Illinois
Glass Co., Alton, IL, 1916 to 1929
(Toulouse 1972). Baltimore directories
listed Mrs. A. L. Whitehurst as the
manufacturer of Juniper Tar in 1877. In
1920 five Whitehursts were affiliated
with the firm (Blasi 1974). Jesse Harrison Whitehurst apparently controlled
the business in the late 1920s. Juniper
Tar Compound adv. 1941–42 by J.
Harrison Whitehurst Co., 504 Pennyslvania Ave., Baltimore, Md., *AD*.

Clear; 3³/₈″ × 1³/₄″ × ¹³/₁₆″; 3n; 12b;
pl; ABM.

**WHITWELL'S/ORIGINAL/
OPODELDOC**

Adv. 1822, ". . . not to be confused
with 'Steers' worthless mixture 38
cents per bottle" (Putnam 1968); 1834,
S & S.

Aqua; 4½″ × 1½″ diameter; 5n; 20b;
pl; v; p.

WILLIAMS'/BRILLANTINE

[See Figure 193]

Adv. 1907, *PVS & S*; 1929–30 by J. B.
Williams & Co., Glastonbury, Conn.,
AD.

Clear; 3½″ × ?; 3n; 20b, recessed
sides at base; pl; h; tapered sides. See
WILLIAMS (Company).

Fig. 193

**WILLIAMS'/MAGNETIC RELIEF//
A. P. WILLIAMS//FRENCHTOWN,
N. J.**

Adv. 1899 (Devner 1968); 1910, *AD*.

Aqua; 6¹/₈″ × 2¼″ × 1¼″; 11n; 3 or
6b; 3 or 4ip; v, fss.

**WILLIAMS'/WHITE PINE HONEY/
AND TAR**

Aqua; 6³/₈″ × 2¹/₈″ × 1″; 7n; 3 or 6b;
ip; v.

[Script:] **Wil-low/OF BOSTON//
Wil-low/OF BOSTON**

Clear; 6½″ × 2¹/₁₆″ × 1⁵/₁₆″; 3n; sp;
3b; pl; v, ss, partial script.

**Dʳ WILSON'S/BLOOD RENEWER//
A. ACHESON//NEW YORK**

Adv. 1887, *WHS*; 1910, *AD*.

Aqua; 7³/₈″ × 2³/₄″ × 1½″; 1n; 3 or
6b; ip, arched front; v, fss.

[Script:] **Ar. Winarick/New York**
[Base:] **LOANED BY/AR. WINARICK**

Product unk., adv. 1929–30 by Ar.
Winarick, 799 E. 140th St., New York
City, *AD*.

Clear; 7¹/₈″ × 2³/₄″ × 1⁵/₈″; 7n; sp;
16b; pl; v, partial script; ABM.

**WINCHESTERS/HYPOPHOSPHITE/
OF MANGANESE//FOR LIVER
COMPLAINT/& C & C//
J. WINCHESTER/NEW YORK**

Adv. 1861 (Putnam 1968); in 1878 as
having 20 years' experience, Winchester's Co., Chemists, 36 John St.,
New York City, *Harper's Weekly* (28
Sept.); in 1935 by Winchester & Co.,
Mt. Vernon, New York, *AD*.

Aqua; 6⁷/₈″ × 2½″ × 1½″; 11n; 3 or
6b; ip; v, fss. See CHURCHILL
(Remedy).

**WINER'S//CANADIAN//
VERMIFUGE**

Product of J. Wright & Co., New
Orleans, LA, adv. 1846 (Baldwin
1973); 1910, *AD*.

Aqua; 4″ × ⁷/₈″ diameter; 7n; 20b; pl;
v, fsb.

WINSTEAD'S//LAX-FOS [Base:] N

Label: *WINSTEAD'S LAX-FOS with
Pepsin, Alcohol 15%. For Habitual Constipation. Formerly Manufactured by the
LAX-FOS COMPANY, Paducah, Ky.
Now Manufactured by Paris Medicine Company, St. Louis, Mo.* Adv. 1913, *SN*;
1929–30 by Paris Medicine Co., Pine
& Beaumont Sts., St. Louis, *AD*.

Amber; 7¼″ × 2³/₈″ × 1⁵/₁₆″; 1n; 3b;
3ip, arched front; v, ss; ABM.

WINTERSMITH/LOUISVILLE, KY.
[Base:] F W/5

Charles H. Wintersmith was listed as a
manufacturer of patent medicines in
1870, and the Wintersmith Chemical
Co. was listed in 1956. Wintersmith
was also affiliated with Arthur Peter &
Co., Wholesale Druggist, from 1879 to

1900, according to Louisville city directories.

Amber; 5¾" × 2⅜" × 1⅜"; 1n; 8b; pl; v; ABM.

WINTHROP'S D. & C. WKS

Label: *Winthrop's Neuralgia Tablets. Winthrop Drug & Chemical Works, Chicago.* Adv. 1907, *PVS & S.*

Clear; 2⅝" × 15/16" diameter; 3n; 20b; pl; v.

WISDOM'S/ROBERTINE

Label: *WISDOM'S ROBERTINE A Fluid Face Powder, Product of William Wisdom, Chicago. . . . Also: New Package WISDOM'S ROBERTINE – a Fluid Face Powder for the Complexion. . . . Prepared by Blumauer-Frank Drug Co., Portland, Ore.* Adv. ca. 1885 (Wilson and Wilson 1971); 1929–30, *AD.*

Cobalt; 4⅞" × 2⅛" × 15/16"; 9n; 3b; 1ip, arched; h. See BLUMAUER *(Company).*

L. H. WITTE/[in circle:]
HOMOEOPATHIC PHARMACY
[monogram]/CLEVELAND. O
[See Figure 194 and Photo 58]
Witte's Homoeopathic Pharmacy was in operation, 1869–1878.

Amber; 4½" × 1¹¹/16" × 1¹¹/16"; 7n, glass stopper; 2b; pl; h.

Fig. 194

UDOLPHO WOLFE'S//AROMATIC/
SCHNAPPS//SCHIEDAM

A medicinal gin tonic, diuretic, antidyspeptic and invigorating cordial introduced by Udolpho Wolfe, New York City, in 1848. In 1869, Udolpho Wolfe moved to New Orleans, leaving his brother, S. M. Wolfe, in charge of the New York operation. In 1881, Udolpho trademarked an Ameliorated Schiedam Holland Gin and in 1882, brother Joel B. Wolfe had the Aromatic Schnapps trademarked (Wilson and Wilson 1971). Adv. 1848, possibly

1821 (Putnam 1968); also 12 July 1913, *The Illustrated London News.*

Olive green; 8¼" × ?; 11 and 12n; 2b; pl; v, sfs.

DR WOOD'S//LIVER
REGULATOR//NEW YORK

Contents included Mandrake, Dandelion, Butternut, Black Root, Bitter Root, Calisaya Bark, Barberry Bark, Sweet Flag, Indian Hemp, Wa-a-hoo, Golden Seal, etc. Adv. 1876, *WHS*; 1910, *AD.*

Aqua; 6⁷/16" × 2" × 1¼"; 7n; 3b; 4ip; v, fss.

N. WOOD//PORTLAND, MAINE

Label: *DR. BUZZELL'S VEGETABLE BILIOUS BITTERS . . . sure Cure for the Loss of Appetite, Foulness of the Stomach, Headache, Costiveness . . . Eruptions on the Face and Neck and as a Purifier of the Blood. . . .* Adv. 1845, proprietor unk.; patented 1894, E. N. Bates, Portland, ME (Ring 1980). Adv. 1910, *AD.* Nathan Wood also apparently prepared and sold the product in the mid- or late-1890s. This vessel also contained a label for Atwell's Wild Cherry Bitters, adv. 1855 and 1868 (Watson 1968). Normally the latter label is found on an aqua, oval vessel, embossed C. W. ATWELL//PORTLAND/ME.

Aqua; 7½" × 3" × 2"; 7n; 12b; pl; v, fb. See ATWOOD'S GENUINE *(Bitters).*

R. E. WOODWARD'S//
VEGETABLE//TINCTURE//SOUTH
READING//MASS

Tincture, adv. 1865, *GG.*

Aqua; 5¾" × 2¾" × 1¾"; 11n; 4b; pl; v, scfcs; p.

R & G. A. WRIGHT/PHILADᴬ

Bottle manufactured ca. 1861–1880 was universal, one labeled as Alexander's Tricobaphe. Directories provide the following listings: 1859 – George A. Wright, Importers of Fancy Goods; 1860 – George A. Wright, Importer at 355 4th, Perfumer at 323 Union; 1861 – Richard & George A. Wright, Importers of Druggists Articles & Manufacturer of Perfumes at 624 Chestnut, factory at 323 Union; 1880 – George A. Wright & Co., 272 S. 3rd.

Clear; 2⅝" × 1¹¹/16" diameter; 3n, large mouth; 20b; pl. See ALEXANDER (Miscellaneous), WRIGHT (Water).

WRIGHT'S/INSTANT RELIEF

Wright's Rapid Relief adv. 1917, 1921, *BD.*

Aqua; 4⅞" × 1⅝" × ¾"; 7n, sp; 3 or 6b; ip; v.

Dᴿ L. B. WRIGHT'S//LIQUID
CATHARTIC/OR//FAMILY PHYSIC

For stomach and bowels, adv. 1855 (Baldwin 1973).

Aqua; 6¾" × 2¼" × ?; 11n; 3b; 3 or 4ip; v, sfs; p.

WULFING'S/FORMAMINT//
WULFING'S/FORMAMINT

Formamint Tablets adv. 1910, *AD*; 1925, *BWD*; possibly same product.

Aqua; 3⅝" × 1⅜" × 1"; 17n, ground; 13b, recessed sides at base; pl; v, ss; tapered sides.

WYETH & BRO/PHILA.

Label: *Compressed Pill, Gold & Sodium Chloride. Guaranteed Under 1906 Act. . . .*

Clear; 1¾" × ⅞" × 9/16"; ?n; 12b; pl; v. See WYETH (Chemical, *Extract,* Oil).

WYETH & BRO/PHILADA

Clear; 7⅝" × 3⅛" × 2½"; 9n; 8b; pl; circular embossing. See WYETH (Chemical, *Extract,* Oil).

WYETH & BRO/PHILAD'A

Label: *Elixir Bismuth.*

Clear; 7½" × 3¼" × 2⅝"; 9n; 10b; pl; circular embossing. See WYETH (Chemical, *Extract,* Oil).

WYETH & BRO/PHILAD'A

Amber, cobalt, aqua; 8⅜" × 2¹³/16" × 1⁹/16"; 9n; 18b?; pl; circular embossing. See WYETH (Chemical, *Extract,* Oil).

WYETH & BRO./PHILAD'A

Clear; 4¼" × 1¹⁵/16" × 1⁷/16"; 9n; 8b; pl; v. See WYETH (Chemical, *Extract,* Oil).

[Body:] JOHN WYETH & BRO./
[neck:] TAKE NEXT DOSE AT [Base:] PAT MAY 16ᵀᴴ 1899. [See Photo 59]
Label: *Granular Effervescent Sodium Phosphate, Laxative and Cathartic. The Glass Cap serves as a measure holding one adult dose, also as a time lock, changeable to any hour at which the next dose is to be taken. . . .* Adv. 1900, *EBB.* The product was popular around 1900.

Cobalt; 5¹³/16" × 2⅛" × 2⅛", also 4⅞" × 1¾" × 1¾"; 11n, dose cap embossed: THIS/CUP/HOLDS/A HEAPING DESSERT SPOONFUL; 1b; pl; v. See WYETH (Chemical, *Extract,* Oil).

JOHN WYETH & BRO/PHILA.

[See Figure 195]
Products included Warburg's Tincture.

Cobalt; 2¾" × 1½" × 1"; 7n; 12b; pl; v. See WYETH (Chemical, *Extract,* Oil).

187

Fig. 195

the Schaffners bought the business from Scott Elsea an associate of Glessner, and relocated the company to Grove City, OH. Associates include Ron, Doris and Ruth Johnson, Westerville, OH. Information courtesy of Don & Marie Schaffner, ZMO Company (personal communication, 1984).
Aqua; 4³⁄₈″ × 2³⁄₄″ × 1″; 4n; 3b; pl; v, ZMO in circle. See ZAEGEL (Oil).

Fig. 196

JOHN WYETH & BRO/PHILA.
Label: *Compressed Tablets. Lead Water and Laudanum. Manufactured by John Wyeth & Bro., Inc., Phila. . . .* An additional label, same vessel: *Guaranteed Under the Food & Drugs Act, June 30, 1906, Guaranty No 9.* Adv. 1892, *Pharmaceutical Record.*
Clear; 3⁵⁄₈″ × 1⁷⁄₈″ × 1¹⁄₄″; 3n; 12b; pl; v. See WYETH (Chemical, *Extract,* Oil).

JOHN WYETH & BRO./ PHILADELPHIA
Clear; 3″ × 1⁵⁄₈″ diameter; 7n; 20b; pl; v. See WYETH (Chemical, *Extract,* Oil).

JOHN WYETH & BRO/ PHILADELPHIA
Clear; 3⁵⁄₁₆″ × 1¹⁄₁₆″ × 1¹⁄₁₆″; 9n; 2b; pl; v. See WYETH (Chemical, *Extract,* Oil).

JOHN WYETH & BRO/ PHILADELPHIA
Amber; 5¹⁄₄″ × 1³⁄₄″ × 1³⁄₄″; 7n; 2b; pl; v. See WYETH (Chemical, *Extract,* Oil).

JOHN WYETH & BRO./ PHILADELPHIA
Label: *Compound Medicinal Lozenges, Sulphur Compound.*
Clear; 7¹⁄₂″ × 3″ diameter; 17n; 20b; pl; h, circular embossing. See WYETH (Chemical, *Extract,* Oil).

ZMO FOR PAIN Base:] W T CO/U.S.A. [See Figure 196]
Bottle manufactured by the Whitall-Tatum Glass Co., 1857 to 1935 (Toulouse 1972). Zaegel's Magnetic Oil, an all purpose healing oil for man or beast, was formulated by Max R. "Doc" Zaegel, Sheboygan, WS. "The first registration date was Oct. 10, 1899. The trade mark had been used since Oct. 27, 1897." After the death of "Doc" in 1934, the product was assumed by Mace Labs. Inc., Neenah, WS. Henry C. Glessner, Findlay, OH, purchased the formula in 1965 and formed the ZMO Company. In 1976

ZENDEJAS/TREATMENT/LOS ANGELES, CAL. [Base:] S in ?
Clear; 8³⁄₄″ × ?; neck, base and sides unk.; v; ABM.

MIXTURE

BREWSTER'S//CHOLERA// MIXTURE
Adv. 1872, *VHS*; 1910, *AD*.
Light green; 4³/₈" × 1³/₁₆" diameter; 13n; 21b, 8 sides; pl; v, sss.

CANTRELL'S/AGUE/MIXTURE// PHILADELPHIA
John A. Cantrell's Ague Mixture adv. 1844 (Putnam 1968); 1872, *VHS*.
Aqua; 6" × 2¹/₂" × 1¹/₂"; 12n; 4b; pl; v, fb; p.

CARTER'S/SPANISH/MIXTURE
Baldwin (1973) notes proprietorship with Bennett & Beers, Richmond, VA in 1854; Wilson and Wilson (1971) attribute the brand probably to John Carter, an Erie, PA, druggist, in the early 1850s. Differences may reflect a proprietorial change. Adv. 1891, *WHS*.
Olive; 8" × 3¹/₂" diameter; 2n; 20b; pl; h; p.

CLIFTON'S/BALSAMIC COUGH/MIXTURE
See CLIFTON *(Balsam)*.

DR CROSSMAN'S/SPECIFIC/ MIXTURE
See CROSSMAN *(Specific)*.

G. DUTTON & SON//COUGH & BRONCHITIS MIXTURE/ OR/SYRUP OF LINSEED & LIQUORICE//CHEMISTS BOLTON
See DUTTON *(Syrup)*.

DR. IRA HATCH'S/FEBRIFUGE MIXTURE
Adv. 1900, *EBB*; 1910, *AD*.
Aqua; 4¹/₂" × 1¹/₄" diameter; 7n; 20b; pl; v.

HOFFMAN'S MIXTURE/FOR/ GONORRHEA GLEET & C/ SOLOMONS & CO/SAVANNAH,
GEO. [Base:] 3°Z/[monogram]

Aqua; 4³/₄" × 2¹/₈" × 1¹/₈"; 9n; 18b; pl; v. See SOLOMON (Bitters, **Drug**).

DR . LEROY'S/MIXTURE
Leroy's Compound Mixture was a product of Dr. Leroy, Paris, France. Adv. 1845 by A. Donnaud, MD, U.S. Agent. Baldwin (1973) includes a reference from a New Orleans newpaper; Donnaud may have resided there.
Blue green; 7" × 2¹/₂" diameter; 18n; 20b; pl; v; p.

LOWERRE//& LYON// ASTRINGENT/MIXTURE
A product of Newark, NJ (Nielsen 1978).
Aqua; 5³/₈" × 2" × ?; 7n; 3b; 3 or 4ip; v, ssf; p.

MACKENZIE'S//AGUE & FEVER/ MIXTURE//CLEVELAND OHIO
Cleveland directories list C. S. Mackenzie & Co. from 1869 to at least 1873.
Aqua; 6¹/₂" × 2³/₄" × ?; 3n; rect.; pl; v, cfc; p.

ROWAND'S//TONIC//MIXTURE// VEGETABLE//FEBRIFUGE// PHILAD
See ROWAND *(Tonic)*.

DR. H. S. THACHER'S/CHOLERA MIXTURE/CHATTANOOGA, TENN.
Adv. 1899, 1911 (Devner 1968); 1916, *MB*.
Color unk.; 3³/₈" × 1¹/₁₆" × 1¹/₁₆"; 3n; 2b; pl; v. See THACHER (Syrup).

VAUGHN'S//VEGETABLE/ LITHONTRIPTIC/MIXTURE// BUFFALO
Product of G. C. Vaughn, 307 Main St., Buffalo, NY, adv. 1851 (Singer 1982); 1910, *AD*.
Aqua; 8" × 3¹/₈" × 3¹/₈", also 6" × 2³/₈" × 2³/₈"; 11n; 2b; 3ip, arched; v, fsb; several sizes and colors.

DR. WILSON'S COUGH MIXTURE// G. E. WEBB & BRO.//JACKSON, MICH.
Aqua; 5¹/₂" × ? × ?; 7n; 3b; 4ip; v, fss.

NERVINE

**ALLENS/NERVE &
BONE//LINIMENT**
See ALLEN *(Liniment)*.

**BAKER'S/HIGH/LIFE/BITTERS//
THE/GREAT/NERVE/TONIC**
See BAKER *(Bitters)*.

**DALTON'S SARSAPARILLA/
AND/NERVE TONIC//BELFAST//
MAINE U.S.A.**
See DALTON *(Sarsaparilla)*.

**DR DANIELS. OSTERCOCUS/
NERVE & MUSCLE LINIMENT/
RHEUMATISM/NEURALGIA
LAMENESS**
See DANIELS *(Liniment)*.

**DR. GUERTIN'S//NERVE
SYRUP//KALMUS CHEMICAL CO./
CINCINNATI.** [Base: I in diamond]
See GUERTIN *(Syrup)*.

**DR. GUERTIN'S//NERVE
SYRUP//KALMUS CHEMICAL CO./
CINCINNATI & NEW YORK**
See GUERTIN *(Syrup)*.

**HANFORD'S/CELERY CURE/
OR/NERVE FOOD/CURES/
RHEUMATISM/NEURALGIA/
INSOMNIA/& C. & C.**
See HANFORD *(Cure)*.

**HASKIN'S/NERVINE//HASKIN
MEDICINE CO.//BINGHAMPTON,
N.Y.**
Adv. 1910, *AD*.
Aqua; 8¹/₂″ × 3″ × 1³/₄″; 1n; 3 or 6b;
3 or 4ip; v, fss.

**DᴿH. A. INGHAM'S//
NERVINE PAINCURAL**
Henry A. Ingham, Vergennes, VT,
established H. A. Ingham & Co.
apparently ca. 1875; however, Ingham's
main product, Pain Killer, later called
Pain Extractor, was introduced ca.

1855. The company went out of
business ca. 1905 (Holcombe 1979).
Aqua; 5⁷/₈″ × 2″ × 1¹/₈″; 7n; 3b; 4ip;
v, ss.

**DR H. A. INGHAM'S//NERVINE
PAIN EXTR.**
Ingham's Vegetable Expectorant
Nervine Pain Extractor, for restless and
teething children, adv. ca. 1855
(Holcombe 1979); 1915, proprietor
unk. (Devner 1968).
Aqua; 4¹/₂″ × 1⁵/₈″ × ⁷/₈″; 13n; 3b; ip;
v, ss.

**IOWNA/BRAIN & NERVE
TONIC/I. O. WOODRUFF & CO**
See IOWNA *(Tonic)*.

JEWETT'S//NERVE//LINIMENT
See JEWETT *(Liniment)*.

**KENYON'S/BLOOD AND NERVE/
TONIC/J. C. KENYON/
OWEGO/N.Y.**
See KENYON *(Tonic)*.

**DR. KLINE'S GREAT//NERVE
RESTORER**
See KLINE *(Restorer)*.

KODOL/NERVE/TONIC
See KODOL *(Tonic)*.

KODOL//NERVE/TONIC [Base:]
E. C. DEWITT/& CO./CHICAGO
See KODOL *(Tonic)*.

**DᴿLOEW'S CELEBRATED/
STOMACH BITTERS & NERVE
TONIC//THE/LOEW & SONS CO./
CLEVELAND, O.**
See LOEW *(Bitters)*.

DR. MILES/NERVINE
Originally this product was introduced
as a Restorative Tonic, then it was
called Dr. Miles Restorative Nervine
and finally Dr. Miles Nervine. Produc-
tion dates were 1882–1979, according
to Donald N. Yates, Archivist, Miles
Laboratories, Inc., Elkhart, IN
(personal communication, 1983).
Aqua; 4¹/₄″ × ? × ?; 7n; 3 or 6b; 3ip;
arched front; v. Also larger variant,
ABM with 17n, sp. See MILES *(Cure,*
Medicine, Purifier, Sarsaparilla, Tonic).

**DR. MILES/RESTORATIVE/
NERVINE** [See Photo 60]
Light green, aqua; 8¹/₄″ × 2³/₄″ × 1¹/₂″;
1n; 3b; 3ip; v. See MILES *(Cure,*
Medicine, Purifier, Sarsaparilla, Tonic).

**DR. MILES'/RESTORATIVE
NERVINE//CURES ALL/NERVOUS
TROUBLE/SEE WRAPPER**
Aqua; 4¹/₄″ × 1⁵/₁₆″ × 1³/₄″; 7n; 3b;
4ip; v, fb. See MILES *(Cure,* Medicine,
Purifier, Sarsaparilla, Tonic).

**NER-VENA//A. B. SEELYE & CO.//
ABILENE, KANSAS**
See SEELYE *(Company)*.

NERVE & BONE/LINIMENT
See NERVE & BONE *(Liniment)*.

RENNE'S//NERVINE
Light blue; 6¹/₈″ × 2¹/₈″ × 1¹/₁₆″; 7n,
sp; 3b; ip; v, ss. See RENNE *(Oil)*.

SAMARITAN//NERVINE/[arched:]
S.A. RICHMOND. M.D./[d] **TRADE**
[embossed bearded man's head]/
MARK/[h] **ST. JOSEPH MO**
Label: *SAMARITAN NERVINE, Free
from Alcohol, An Effective Nerve Sedative,
Manufactured only by Richmond Remedies
Co., St. Joseph, Mo. Successors to
Dr. S. A. Richmond Nervine Co.,
Distributed by Zerbst Pharmacal Co.,
St. Joseph.* Adv. 1884 (Baldwin 1973);
1929–30 by Zerbst Pharmacal Co.,
St. Joseph, MO, *AD*.
Clear; 8″ × 3¹/₈″ × 1⁹/₁₆″; 11n; 3b; 4ip;
v, ss; h, d, f. See RICHMOND
(Miscellaneous).

**SEAVERS/JOINT &//
NERVE/LINIMENT**
See SEAVER *(Liniment)*.

[h] **THE GREAT/SOUTH AMERI-
CAN/NERVINE TONIC/**[v] **TRADE/**
[monogram]/**MARK/**[h] **AND/
STOMACH & LIVER CURE**
See SOUTH AMERICAN *(Cure)*.

**UNCLE SAMS/NERVE & BONE/
LINIMENT//EMMERT/
PROPRIETARY CO/CHICAGO ILL**
See UNCLE SAM *(Liniment)*.

**WAKEFIELD'S/NERVE &
BONE/LINIMENT**
See WAKEFIELD *(Liniment)*.

**WARNER'S/SAFE/NERVINE/
TRADE/MARK** [on embossed
safe]/**ROCHESTER, N.Y.**
[See Figure 197]
Product introduced ca. 1880 (Hol-
combe 1979); adv. 1935 by Warner's
Safe Remedies Co., Rochester, N.Y.,
AD.
Amber; 7¹/₄″ × 2⁷/₈″ × 1¹/₂″; 20n; 12b;
pl; h. Also variant 9″ high with 1n.
See LOG CABIN (Extract, Remedy, Sar-
saparilla), H. WARNER (Bitters, Com-
pany, *Cure,* Remedy).

Fig. 197

OIL

WHEELER'S//NERVE VITALIZER
Cure for the nervous system and a product of the J. W. Brant Co., Albion, MI, adv. 1899 (Devner 1968); 1921, *BD*.
Aqua; 7⅝″ × 2⅝″ × 1½″; 1n; 3b; 3ip, oval front; v, ss.

DR. WHEELER'S//NERVE VITALIZER
Aqua; 7¾″ × 2⅝″ × ?; 1n; 3b; 3ip; v, ss.

THE A & H/"TASTELESS"/ · CASTOR OIL ·
Cornelius Allen and Frederick J. Hanbury, London, Eng. introduced the "Tasteless" Castor Oil in 1880 (Wilson and Wilson 1971). Adv. 1929–30 by Allen Hanbury's Co., Ltd., Niagara Falls, N.Y., *AD*. The pair also marketed "Allenburys" Castor Oil. In 1891 all A & H products were controlled by W. H. Schieffelin.
Cobalt; 7″ × ?; 7n; 20b; pl; v.

[Script:] **The "Allenburys"/Castor Oil//ALLEN & HANBURYS L ᵀᴰ// ALLEN & HANBURYS Lᵀᴰ**
British origin. Label for Allenbury's Castor Oil stated the product was introduced in 1715. Adv. 1929–30 by Fougera & Co., New York City, *AD*.
Amber; 4⅞″ × 1⁹⁄₁₆″ × ⅞″; 7n; 3b; pl; v, fss, partial script.

AMERICAN/OIL//CUMBERLAND RIVER//KENTUCKY
Possibly American Medicinal Oil adv. 1860, *CNT*, or American Oil adv. 1865, *GG*.
Dark aqua; 6¾″ × 3″ × 1¾″; 7n, crude; 3b; pl; h, f; v, ss; embossed on side shoulder; p.

ARNICA & OIL//LINIMENT
See ARNICA *(Liniment)*.

BEARS/OIL
A hair oil adv. 1822 (Putnam 1968); 1835 in the Boston city directory. In later years, product might have been renamed Sand's Superior Scented Bear's Oil, adv. 1851, *JSH*; 1860; *HO*.
Aqua; 2¾″ × 1⁹⁄₁₆″ × 1″; 13n; 3b; pl; h; p.

[v] **BEAVER** [h] **AND** [v] **OIL/COMPOUND**
See BEAVER *(Compound)*.

BURNETT'S/COD LIVER OIL/BY/T. METCALF & CO/ BOSTON
See METCALF (Company).

[Script:] **The Dr. D. M. Bye/ Combination Oil Cure Co./ 316 N. Illinois St, INDIANAPOLIS, IND./THE ORIGINATOR (COPYRIGHTED)**
See BYE (Cure).

[Script:] **Otis Clapp & Sons/ MALT AND COD LIVER/OIL COMPOUND**
Adv. 1898, GHG; 1948, AD.
Amber; 7^1/$_8$" × 2^7/$_8$" × 1^7/$_8$"; 9n; 6b; pl; v, partial script. See CLAPP (Miscellaneous).

COD LIVER OIL//H. W. & CO. NEW YORK//WARRANTED PURE
See H. W. (Company).

PROF. DEAN'S//KING CACTUS OIL
Label: *PROF. DEAN'S KING CACTUS OIL COMPANY HEALING OIL LINIMENT. Apply freely two or three times a day to all open wounds. Use a syringe when necessary. For Burns, Swellings and Lameness apply freely or rub gently. In case of Rheumatism saturate a flannel cloth and lay on the affected parts – Manufactured by PROF. DEAN'S KING CACTUS OIL COMPANY – Clinton, Iowa – New Style Label Adopted Oct. 1, 1915.*
Clear; 5" × 1^3/$_4$" × 15/$_{16}$"; 7n; sp; 2b; 2ip; v, ss.

PROF. DEAN'S/KING CACTUS OIL/ THE GREAT/BARBED WIRE/ REMEDY/OLNEY & MCDAID/ TRADE MARK [embossed in pictoral wire display case]
The Cactus Oil was introduced by Olney in the 1860s; McDaid joined the business in the 1870s. Adv. 1935, AD.
Clear; 7^1/$_2$" × ?; 7n; 20b; pl; h. Several sizes including 4" and 6" variants.

PROF. DEAN'S/KING CACTUS OIL/ THE GREAT/BARBED WIRE/ REMEDY/CLINTON, IOWA/TRADE MARK [embossed in pictoral wire display case]
Clear; 9^1/$_2$" × 2^7/$_8$" diameter; 7n; 20b; pl; h.

PROF. DE GRATH'S// ELECTRIC OIL//PHILADA
Cure for stiff joints and piles, introduced in 1856 (Wilson and Wilson 1971); advertised in embossed containers in 1859 (Putnam 1968). Product of Lanman & Kemp in 1918 (Devner

1968); adv. 1929–30, AD.
Aqua; 4^1/$_2$" × ? × ?; 7n; 3 or 6b; 3 or 4ip, arched front; v, sfs.

DUDLEY'S/EMULSION// PURE COD LIVER OIL// PANCREATINE & LIME
Adv. 1882, VSS & C; 1910, AD.
Cobalt; 9^1/$_2$" × 2^1/$_2$" × 1^3/$_4$"; ?n; 3b; 3ip; v, fss.

EUCALYPTUS/OIL [Base:] **F.B.H.**
The oil distilled from the leaves of eucalyptus globules or the Australian gum tree was used as a stimulant, aphrodisiac, anti-spasmodic and antiseptic. It has been used in the treatment of septic fevers, diptheria, fetid breath, ulcers (including those of syphilitic origin), purulent catarrhal affections of bladder and vagina.
Aqua; 5^1/$_4$" × 2" × 1^1/$_8$"; 7n; 12b; 1ip; v. See V-O (Oil).

FINK'S/MAGIC OIL// PITTSBURGH, PA.
Product of H. G. G. Fink for rheumatism, neuralgia, sore throat, diarrhoea, colic scalds, cholera, etc. Adv. 1873, VSS & R; 1948 by Fink's H. G. G. Labs., 215 E. Pearl St., Cincinnati, O., AD. Pittsburgh city directories first include the Henry Fink Laboratory in 1856; offices in 1899 included Springdale, PA (Devner 1968).
Aqua; 5" × 1" × 7/$_8$"; 7n, sp; 3b; 4ip; v, fs.

Fornis/Heil-Oel//PREPARED BY/ DR PETER FAHRNEY & SONS Co/ CHICAGO, ILL. U.S.A. [Base:] **PAT APPLIED FOR**
See FAHRNEY (Company).

FREAR'S AMBER OIL/MFG. BY/GOLD MEDAL FOOD CO./ TUNKHANNOCK, PA.
Adv. 1929–30, 1935, AD.
Aqua; dimens. unk.; 7n; rect.; possibly ABM.

GALLAGHER'S//MAGICAL/ HAIR OIL//PHILAD.A
Adv. 1872, VHS.
Aqua; 4^1/$_2$" × 1^1/$_2$" × 11/$_{16}$"; 13n; 6b; 4ip; v, sfs; p.

GARGLING OIL/LOCKPORT, N.Y.
Label: *Gargling Oil, 44% Alcohol. Since 1833. Nearly 100 years an External Liniment for Family Use. Product of Merchant's Gargling Oil Company, Lockport, N.Y. . . .* Advertisement in Mack & Co. catalog, 1896–97: "CURES Burns and Scalds, Chilblains, Frost Bites,

Rheumatism, Chapped hands, Flesh Wounds, Lame Back, Piles, Corns, Cramps, Boils, Weakness of the Joints, Contractions of Muscles, Galls, Scratches, Sand Cracks, Sitfast, Ringbone, Poll Evil, Lameness, Distemper, Ulcers, Swellings, Sprains, Bruises, Foundered Feet, Spavins, Sweeney Curb, Fistula; Garget in Cows, Abcess of Udder; Foot Rot in Sheep Mange; Roup in Poultry · Yellow Wrapper For Animal; White For Human Flesh." Alcoholic content varied, i.e., 34, 35, & 44%. " 'The Oldest & Best Liniment in the U.S. . . .,' originated in 1833," commonly known as "Beast Oil" or Merchants Celebrated Gargling Oil, was named for George W. Merchant, and purported to be a successful liniment for man or beast. In 1855 all rights transferred to M. H. Tucker & Co. for $50,000; after 1865 control rested with John Hodge. About 1870 the bottles were altered to read as embossed. In 1928 fire destroyed the office and laboratory (Holcombe 1979). In 1933, Clay Parson's, 28 Market St., New York City, the owner and manufacturer of the oil, was a small, hand-operated business. Adv. 1948 by Merchant's Gargling Oil Co., Inc., 28 Market St., New York City, AD. This date was the last year of manufacture.
Cobalt; 5" × 1^3/$_4$" × 1^1/$_4$"; 7n; 6b; 1ip; arched; v; ABM. See MERCHANT (Chemical, Miscellaneous).

GARGLING OIL/LOCKPORT, N.Y.
Green; 5^1/$_4$" × 1^3/$_4$" × 1^1/$_8$", also 7^1/$_8$" × 3" × 2"; 11n; 6b; 4ip; arched front; v. Also blue green variant, 5^9/$_{16}$" × 2^1/$_4$" × 1^1/$_2$", and in cobalt ABM. Other sizes, colors and variants. See MERCHANT (Chemical, Miscellaneous).

S. B. GOFFS//COMPOUND MAGIC/ OIL LINIMENT//CAMDEN N.J.
See GOFF (Liniment).

GREGORY'S/ANTISEPTIC OIL// GREGORY MED CO.//LITTLE ROCK, ARK.
Label: *GREGORY'S ANTISEPTIC OIL, Relieves Pain Readily – A Reliable First Aid. Prevents Infection, Hastens Healing. Price 60¢. Prepared by the Gregory Medicine Co., C. J. Lincoln Co., Distributors, Little Rock, Ark.*
Clear; 7" × 2^5/$_{16}$" × 1^1/$_4$"; 7n; 3b; 4ip; v, fss.

HAMILTON'S//OLD ENGLISH// BLACK OIL
Adv. 1900, EBB; 1929–30 and 1948 by

Kimball Bros. & Co., Inc., Enosburg Falls, Vt., *AD*.
Aqua; 6½″ × 1¾″ diameter; 1 and 24n; 21b, 8 sides; pl; v, sss. See KENDALL (Balsam).

HAMLIN'S/WIZARD/OIL
John A. Hamlin, Cincinnati, OH, introduced his Wizard Oil in 1859; the product was popularized by the medicine shows. In the 1860s Hamlin moved to Chicago (Wilson and Wilson 1971; Young 1962). Other Hamlin products included Herb Tea, Wizard Liver Whips, Cold Tablets and Cough Cordial. Wizard Oil adv. 1929–30 by Hamlin Wizard Oil Co., 2616 N. Cicero Ave., Chicago; 1948 from 230 W. Huron St., *AD*; 1983 by Consolidated Royal Chemical Corp., 1450 N. Dayton St., Chicago, *RB*.
Aqua; 3¾″ × 1⅞″ × ¹⁵⁄₁₆″; 1n; 12b; pl; v. See HAMLIN (Balsam).

HAMLIN'S/WIZARD OIL
Label: *Hamlin's Wizard Oil For Internal & External Use. Cures Rheumatism, Lame Back, Headache, Neuralgia, Toothache, Earache, Sore Throat, Diptheria, Catarrh, Inflammation of the Kidneys and All Painful Affections.* Bottle manufactured ca. 1900 (Wilson and Wilson 1971).
Aqua; 6⅛″ × 2⅛″ × 1⅛″; 1n; 3b; 4ip; v. See HAMLIN (Balsam).

HAMLIN'S/WIZARD OIL
[See Photo 61]
Label: *Hamlin's Wizard Oil Liniment. 65% Alcohol, Soothing, Healing. A Superior Counter-Irritant, Strongly Antiseptic. Copyright 1902.*
Clear; 9⅛″ × 3″ × 1¾″; 1n; 3b; 1ip; v. See HAMLIN (Balsam).

HAMLIN'S//WIZARD OIL//CHICAGO
Aqua; 5¾″ × 1¾″ × 1″; 1n; 3b; 4ip; v, sfs. See HAMLIN (Balsam).

HAMLIN'S/WIZARD/OIL//CHICAGO/ILL.
Probably earliest Chicago variant.
Aqua; 3¹¹⁄₁₆″ × 1¹⁵⁄₁₆″ × ¹⁵⁄₁₆″; 5n; 12b; pl; v, fb. See HAMLIN (Balsam).

HAMLIN'S/WIZARD OIL//CHICAGO, ILL.//U.S.A.
Aqua; 6⅛″ × 2⅝″ × 1¼″, also 8¾″ × 2¾″ × 1¾″; 1n; 3b; 4ip; v, fss. See HAMLIN (Balsam).

HEALY & BIGELOW'S/KICKAPOO/INDIAN OIL [See Figure 198]
Aqua; 5½″ × 1³⁄₁₆″ diameter; 1n; 20b; pl; v. See HEALY & BIGELOW (Cure, *Miscellaneous*, Syrup), KICKAPOO (*Oil*, Miscellaneous, Syrup), SAGWA (Miscellaneous).

Fig. 198

HEALY & BIGELOW'S KICKAPOO INDIAN OIL

HEMLOCK OIL CO.,/DERRY, N.H.
See HEMLOCK (Company).

[h] U.S.A./[d] HIXONS/HIXONS/[v] RAY OIL/[h] SALINA KAN
[See Figure 199]
Clear; 6½″ × 2″ × 1³⁄₁₆″; 7n; 3b; 3ip; h, d, v.

Fig. 199

U.S.A. HIXONS HIXONS RAY OIL SALINA KAN

HOLTON'S/ELECTRIC OIL [See Figure 200]
Other Holton products adv. 1900, *EBB*; 1910, *AD*.
Clear; 3¼″ × 1¼″ diameter; 7n; 20b; pl; v.

Fig. 200

HOLTON'S ELECTRIC OIL

KICKAPOO OIL [See Figure 201]
Label: *KICKAPOO OIL for Relief from Aches & Pains. Price 25 cents, Kickapoo Ind. Med. Co., Inc., Phila & St. Louis.* Adv. 1889, *PVS & S*; 1900 by Kickapoo Indian Med. Co., Chapel & Hamilton, New Haven, Conn., *EBB*; Kickapoo Worm Oil adv. 1929–30 by Wm. R. Warner & Co., 113 W. 8th St., New York City, *AD*. The move to Philadelphia and St. Louis must have transpired after 1912 (Devner 1968).
Aqua; 5⅜″ × 1³⁄₁₆″ diameter; 1n; 20b; pl; v. See HEALY & BIGELOW (Cure, *Miscellaneous*), KICKAPOO (Miscellaneous, Syrup), SAGWA (Miscellaneous).

Fig. 201

KICKAPOO OIL

DR KILMER & CO//CATARRH/
[in indented lung:] DR KILMER'S/COUGH-CURE/CONSUMPTION OIL/[below lung:] SPECIFIC//BINGHAMTON, N.Y.
See KILMER (Cure).

[h] DR. KILMER'S/[v] INDIAN/COUGH CURE/CONSUMPTION OIL/[h] BINGHAMTON/N Y USA
See KILMER (Cure).

[h] DR. KILMER'S/[v] INDIAN/COUGH REMEDY/CONSUMPTION OIL/[h] BINGHAMTON/N.Y. U.S.A.
See KILMER (Remedy).

DR. LEPPER'S//OIL/OF/GLADNESS//JUSTIN GATES//SACRAMENTO
Dr. Andrew Lepper gave agent rights to his oil to Justin and James Gates, Sacramento, in 1865; the pair moved to San Francisco in 1881. Around 1890 Lepper changed agents to A. C. Tufts, a business associate of John Spieker, affiliated with Lash's Bitters. The Gates Brothers are not the Gates of "Shepardson & Gates" (Wilson and Wilson 1971). Gladness Oil adv. 1897, *L & M*.

Aqua; 5″ × 1 9/16″ × 7/8″; 7n; 3b; 4ip; v, sfsb; embossing order on back and sides unk.; 2 known sizes. See LEPPER (Miscellaneous).

LIGHTNING//OIL//SURE/CURE
Aqua; 5 1/2″ × 2″ × 1″; 7n; 3 or 6b; 3 or 4ip; v, ss; h, f.

MACASSAR/OIL//FOR THE HAIR//REGENT S^T//LONDON
Clear; 3 9/16″ × 1 1/8″ × 9/16″; 3n; 6b; pl; v, fsbs. See REGENTS (Oil), ROWLAND (Oil).

MARVIN BRO'S & BARTLETT/COD LIVER OIL MANUF^D AT/ PORTSMOUTH N. H.
Adv. 1872, *F & F*; 1907, *PVS & S*. Marvin Bro's & Bartlett, Cod Liver Oil manufacturers, was established in 1869 or 1870; became Marvin & Bartlett in 1887 and operated into the 1900s, according to the *New Hampshire Register, Farmers Almanac & Business Directory*. Clear, light green; 8 1/4″ × 2 1/2″ × 2 1/2″; 9n; 2b; pl; v.

MAYOR WALNUT-OIL CO/KANSAS CITY, MO.// HAIR DYE//HAIR DYE// NONE BETTER [Base: diamond]
Bottle manufactured by the Diamond Glass Co. after 1924 (Toulouse 1972). Product adv. 1907, *PVS & S*; 1948 by The Mayor Co., Kansas City, Mo., *AD*. Amber; 5″ × 1 13/16″ × 1 1/8″; 9n; 3b; pl; v, fssb.

M^C CLURE & EATON// PAIN CURE OIL//READING P^A
See McCLURE (*Cure*).

M^C LEAN'S//VOLCANIC//OIL// LINIMENT [Base:] M & C
Label stated this product was introduced in 1841. Adv. 1941–42 by Dr. J. H. McLean Med. Co., 3114 Franklin Ave., St. Louis, *AD*. Apparently this product was re-introduced in 1970s–80s.
Aqua; 3 5/16″ × 1 5/16″ × 1 5/16″; 1n; 2b; 4ip; v, fsbs. See McLEAN (*Balm*, Miscellaneous, Purifier, Sarsaparilla).

DR. J. H. M^C LEAN'S//VOLCANIC// OIL//LINIMENT [Base: I in diamond]
Label, in part: *Dr. J. H. McLean's Med. Co., 3114–20 Franklin Ave., St. Louis.* Bottle manufactured by the Illinois Glass Co., 1916 to 1929 (Toulouse 1972).
Aqua; 4 1/4″ × 1 5/16″ × 1 5/16″; 1n; 2b; pl; v, fsbs; ABM. See McLEAN (*Balm*, Miscellaneous, Purifier, Sarsaparilla).

DR. J. H. M^C LEAN'S/VOLCANIC// OIL//LINIMENT

Aqua; 6 1/2″ × ? × ?; 1n; 3b; ip; v, fss; ABM. See McLEAN (*Balm*, Miscellaneous, Purifier, Sarsaparilla).

MODOC INDIAN OIL
An elixir for "... Rheumatic Aches, Headache, Earache, Sprains, Toothache, Chilblains, Cuts, Bruises, Burns" Manufactured by the Oregon Indian Medicine Co., Corry, PA. Adv. 1887, *WHS*; 1918.
Clear; 6 1/4″ × 1 1/2″ diameter; 7n; 20b; pl; v. See INDIAN (Syrup), KA:TON:KA (*Remedy*).

MODOC OIL//PRICE 25CTS
Color unk.; 5 1/2″ × ? × ?; 7n; 3b; ip; v, ss; ABM. See INDIAN (Syrup), KA:TON:KA (*Remedy*).

MOONE'S EMERALD OIL// ROCHESTER, N.Y.
Label: *Moone's Emerald Oil, Antiseptic, Germicide, Deodorant ... International Labs., Rochester, N.Y. New Label Adopted Jan. 1925.* Adv. 1948 by International Laboratories Inc., 26 Forbes St., Rochester, N.Y., *AD*.
Emerald green; 5″ × 1 3/4″ × 7/8″; 3n; 6b; pl; v, ss, ABM. See CLEMENT (*Tonic*).

D^R MURRAY'S/MAGIC OIL/ S. F.--C A L. [See Figure 202 and Photo 62]
Label: *Murray's Improved Magic Oil! King of Pain, For External and Internal Aches or Pains. O. S. Murray & Co., Proprietors, San Francisco.* Adv. 1896–97, *Mack*; 1923, *SF & PD*.
Blue; 6″ × 1 3/16″ × 1 1/4″; 7n; 3b; 4ip, arched embossed panel; v.

Fig. 202

NOLEN//COD LIVER OIL// PHILADELPHIA
Advertised by Charles W. Nolen, Philadelphia, 1866 (Baldwin 1973); 1872, *VHS*.

Aqua; 10″ × 3 1/4″ × 1 1/4″; 11n; 3 or 6b; ip; h, f, v, ss; NOLEN within small indented panel.

PURE NORWEGIAN/COD LIVER OIL/IMPORTED BY ALFRED SWEDSBERG/DULUTH, MINN.
[Base:] W. T. CO./U.S.A.
Bottle manufactured by Whitall-Tatum Glass Co., 1857 to 1935 (Toulouse 1972). Adv. 1896–97, *Mack*.
Clear; 8″ × 2 7/16″ × 2 7/16″; 9n; 2b; 1ip, arched; v.

DR. NUNN'S/BLACK OIL/ HEALING BALSAM
See NUNN (*Balsam*).

DR. NUNN'S/BLACK OIL/ HEALING COMPOUND
See NUNN (*Compound*).

Omega Oil [See Figure 203]
Omega Oil was billed as a liniment, and was introduced in the 1890s (Wilson and Wilson 1971). Adv. 1929–30 by Omega Chemical Co., 576 Fifth Ave., New York City; 1948 from 190 Baldwin Ave., Jersey City, N.J., *AD*; 1983 by Block Drug Co., Jersey City, NJ, *AD*.
Clear; 3 1/2″ × 13/16″ diameter; 8n; 20b; pl; v; ABM; also non ABM.

Fig. 203

OMEGA/OIL/IT'S GREEN [all within embossed leaf]/TRADE MARK/ THE OMEGA/CHEMICAL CO./ NEW YORK
Clear; 5 7/8″ × 1 1/4″ diameter; 14n; 20b; pl; h.

PHILBRICK'S/WHITE MOUNTAIN/OIL
Product formulated by S. R. Philbrick, North Berwick, ME, in the 1850s; inherited by L. E. Philbrick, East Weare, NH. Product sold until ca. 1900 (Wilson and Wilson 1971).
Aqua; 5 1/4″ × ? × ?; 7n; 3b; 3 or 4ip; v.

PHILLIPS' EMULSION/COD-LIVER OIL/NEW YORK

Amber; 9¼″ × 2⅞″ × 1¹³/₁₆″; 11n, large mouth; 6b; 1ip; v. See PHILLIPS (*Company*, Magnesia, Miscellaneous, Trade Mark).

PHILLIPS' PALATABLE/ COD LIVER OIL

Adv. 1889, 1907, *PVS & S.*

Amber; 7⅜″ × 2½″ × 1³/₁₆″; 11n; 3b; 1ip; v. See PHILLIPS (*Company*, Magnesia, Miscellaneous, Trade Mark).

PRATT & BUTCHER/MAGIC OIL/ BROOKLYN, N. Y.

Adv. 1858 (Putnam 1968); 1887, *WHS.*

Aqua; 3¹³/₁₆″ × 1⅞″ × 1″; 13n; 12b; pl; v; p; 3 sizes.

PRATT'S/ABOLITION OIL

Product of James N. Pratt, San Francisco, introduced in the 1850s. After retiring, son Perry assumed the business, giving sole agency to Alexander McBoyle who soon became a partner (Wilson and Wilson 1971). Adv. 1867 (Baldwin 1973); 1921, *BD.*

Aqua; 8″ × 2½″ × 1½″; 11n; 3b; 4ip; v. See PRATT (Miscellaneous).

PRATT'S/ABOLITION OIL//FOR/ ABOLISHING PAIN [See Figure 204]

Aqua; 5⅞″ × 2″ × 1⅛″; 7n; 3b; 4ip; v, fb. Also variant with S backwards in ABOLISHING. See PRATT (Miscellaneous).

Fig. 204

FRONT BACK

REED & CARNRICK/NEW YORK// PEPTONIZED/COD LIVER OIL/ AND MILK

Label: *Peptonized Cod Liver Oil and Milk—Formula Contains 50 Per Cent of Pure Norwegian Cod Liver Oil. The Remaining Percentage is Composed of Milk, and Emulsion Formed with Irish Moss.* Adv. 1887, *McK & R*; 1901, *HH & M.* New York City directories list Reed, Carnrick & Andrus, Manufacturing Chemists, from 1868 to 1874; Reed,

Carnrick & Edwards, 1874 to 1876; Reed & Carnrick, 1876 to 1986. In 1899 the office was relocated in New Jersey where it was operating as of 1986. Nelson (1983) discusses three management eras: John Carnrick, 1860s to 1890s; The Sartorius family, 1890s to 1952, and the Block Drug Co. beginning in 1952. Carnrick also controlled Maltine and the Maltine Company, which he sold in the 1890s (Nelson 1983). Carnrick also established the New York Pharmacal Association in 1877 which was dissolved or absorbed by (David) Reed & Carnrick about 1887 (Holcombe 1979). John Andrus, affiliated with Reed and Carnrick in the 1860s and the Pharmacal Association ca. 1879, also established a succession of companies which led to the development of the Arlington Chemical Company, predecessor of the USV Corporation (Nelson 1983).

Amber; 7¼″ × 2¹/₁₆″ × 2¹/₁₆″; 7n; 1b; 2ip; v, ss. See ARLINGTON (Chemical), LACTOPEPTINE (*Miscellaneous*, Remedy), MALTINE (*Company*), PEPTENZYME (Miscellaneous), PROTONUCLEIN (Miscellaneous).

REGENTS//MACASSAR/OIL// FOR//THE HAIR

Product of Rowland & Son, London, adv. 1851, *JSH.*

Clear; 3½″ × ? × ?; 5n; 6b; pl; v, sfsb; p, order of embossing on back unk. See MACASSAR (Oil), ROWLAND (Oil).

[h] RENNE'S [monogram] [v] IT WORKS/LIKE/A CHARM// PAIN KILLER//MAGIC OIL

The *Biographical Review of Berkshire Co. Mass., 1899* provides a brief sketch: William Renne, Pittsfield, MA, born July 27, 1809, was for ". . . a number of years sole manufacturer of a proprietary medicine, Renne's Pain-Killing Magic Oil"; Renne sold his patent and plant in 1877. The application for trade mark in 1872 claimed the oil was introduced in 1855; the Herrick Medicine Co., New York City, who purchased the business in 1877, claimed introduction in 1840. The company was acquired by L. W. Warner, location unknown, around 1900 (Wilson and Wilson 1971), and was acquired by James Ballard, St. Louis, MO, prior to 1916 (Devner 1968). Oil adv. 1935 by James Ballard, St. Louis, *AD.*

Aqua; 6″ × 1⅞″ × 1″; 1n; 3b; 3 or 4ip; h, v, fss; other variants. See RENNE (Nervine).

RENNE'S/PAIN KILLING// MAGIC OIL//SAMPLE//TRY IT

Bottle manufactured ca. 1888 (Wilson and Wilson 1971).

Aqua; 2⅜″ × ⅞″ × ½″; 7n; 3b; 4ip; v, fbss; several sizes and shapes. See RENNE (Nervine).

ROWLANDS/MACASSAR//OIL// № 20 HATTAN/GARDEN/ LONDON//THE ORIGINAL/AND GENUINE

A hair preparation introduced in England ca. 1793, by Alexander Rowland; still available 1953 (Turner 1953); distributed 1929–30 by Fougera & Co., *AD.*

Aqua; 3½″ × ? × ?; 5n; 6b; pl; v, fsbs. Also pontiled, clear variant. See REGENT (Oil), MACASSAR (Oil).

RUSHTON'S//COD LIVER OIL// NEW YORK

Adv. 1850 (Putnam 1968); 1879, *VSS & C.*

Aqua; 10″ × ? × ?; 21n; 3b; 3ip; v, fss. See GAY (*Compound*).

ST. JACOBS OIL LTD./ BALTIMORE & LONDON// AECHTES/KLETTENWURZELOEL

Barns, fences and rocks were often painted with "St. Jacob's Oil Conquers Pain." Poetry, appeared in many instances:

"Seek you a cure, easy and sure
For aching sprains or hurts or pains,
 Of every sort, in any part.
Be of good cheer, the secret's here:
And if you heed what here you read,
 Your pains you'll end, your
 ailments foil;
For you will send for ST. JACOB'S
 OIL" (Holcombe 1979).

Augustus Vogeler, 1819–1908, a Baltimore drug manufacturer since 1845 (A. Vogeler & Co.), established a co-partnership with his oldest son Charles A. and John H. Winklemann in July 1873. In 1878 Charles A. Vogeler formed the Charles A. Vogeler Co., a separate firm, also with Augustus and J. Winkleman, and purchased the formula for Keller's Roman Liniment from Wilmer L. Keller, Baltimore. This firm began the manufacture and promotion of St. Jacobs Oil. With the death of Charles in 1882 the business was changed to include Charles' widow, Minnie, Christian Deveries, and Herman Umbstaetter. The company promoted a competitive product to A. C. Meyer & Co.'s Bull's Cough Syrup called Red Star Cough Cure. A. C.

Meyer & Co. retaliated with Salvation Oil. In conciliation the Red Star Cure was dropped and Salvation Oil was ". . . restricted to certain packaging and marketing." Apparently early in the 1900s St. Jacob's Oil was sold to an English syndicate for nearly $200,000 (Holcombe 1979). Sometime thereafter Wyeth Chemical Co. acquired the product. Adv. 8 March 1919 as St. Jacobs Liniment in the *Ridgway Sun*, a Colorado newspaper; as St. Jacobs Oil, 1929–30 and 1941–42 by Wyeth Chem. Co., *AD*.

Clear; 4 1/2" × 1 3/4" × 1 1/8"; 7n; 3b; pl; v, ss. See BULL (Pectoral, *Syrup*), REDSTAR (Cure), SALVATION (Oil), VOGELER (Company).

ST. JAKOBS OEL/ST. JACOBS OIL LTD./BALTIMORE, MD. U.S.A.
[See Figure 205]

Aqua; 5" × 1" diameter; 1n; 20b; pl; v. See BULL (Pectoral, *Syrup*), REDSTAR (Cure), SALVATION (Oil), VOGELER (Company).

Fig. 205

ST. JAKOBS OEL/THE CHARLES A VOGELER COMPANY/ BALTIMORE, MD. U.S.A.

Aqua; 6 3/8" × 1 3/8" diameter; 1n; 20b; pl; v. See BULL (Pectoral, *Syrup*), REDSTAR (Cure), SALVATION (Oil), VOGELER (Company).

DR. I. L. ST JOHNS// MAGNETIC OIL/CURES RHEUMATISM/NEURALGIA AND//HEADACHE

Adv. 1879, *VSS & C*; 1900, *EBB*. I. L. St. John & Co., Tiffin City, OH, advertised products in 1858 (Baldwin 1973).
Aqua; 5 1/2" × 2 3/4" × 1 1/8"; 8n; 3b; pl; v, sfs. Also 5 3/8" × 1 7/8" × 1 1/8", clear variant with 7n finish.

SALVATION/TRADE OIL MARK/ A. C. MEYER & CO/BALTIMORE, M.D. U.S.A.

Adolph Meyer, in trademark application, claimed this product to be ". . . the greatest cure on earth for pain associated with the gout, sciatica, lumbago, pleurisy, chilblains and weak ankles" (Wilson and Wilson 1971). Introduced 1882 (Devner 1968), 1883 (Wilson and Wilson 1971); adv. 1923, *SF & PD*.

Aqua; 6 1/2" × 2 1/4" × 1"; 1n; 15b; 1ip, arched; v. See BULL (Pectoral, *Syrup*), REDSTAR (Cure), ST. JACOB (*Oil*), VOGELER (Company).

SCOTT & BOWNE//PALATABLE/ CASTOR OIL//NEW YORK

Adv. 1879, *VSS & C*; 1901, *HH & M*.
Aqua; 6 3/8" × 2 1/4" × 1 1/4"; 11n; 3 or 6b; 3 or 4ip; v. See SCOTT & BOWNE (Miscellaneous).

SCOTT'S/EMULSION//COD LIVER OIL//WITH LIME & SODA [See Figure 206 and Photo 63]

Alfred Scott and Samuel Bowne, New York, established their business in 1871 and introduced the Cod Liver Oil in 1876. The logo, a man carrying a fish, was trademarked in 1886 and first embossed in glass about 1890; "WITH LIME & SODA," ca. 1899. The firm moved to Bloomfield, NJ, ca. 1900 (Periodical Publishers Association, 1934; Wilson and Wilson 1971). Adv. 1983 by Beecham Products, Pittsburgh, PA, *RB*.

Aqua; 7 1/2" × 2 3/8" × 1 1/2"; 11n; 3b; 3ip; v, fss. See SCOTT & BOWNE (Miscellaneous).

Fig. 206

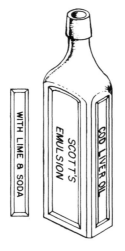

SCOTT'S/EMULSION//COD LIVER OIL//WITH LIME & SODA [Base: man carrying fish]

Aqua; 9 1/4" × 2 3/8" × 1 1/2", also 9 1/4" × 2 7/8" × 2"; 11n; 3b; 3ip; v, fss. See SCOTT & BOWNE (Miscellaneous).

[h] SCOTT'S/EMULSION/[v] TRADE [man carrying fish]/MARK/[h] COD LIVER OIL/WITH/LIME & SODA [Base: W over T in triangle] [See Figure 207]

Bottle manufactured by Whitall-Tatum, 1935 to 1938 (Toulouse 1972).
Aqua; 7 3/8" × 2 3/8" × 1 1/2"; 22n, modified; 12b; pl; h, v; ABM. See SCOTT & BOWNE (Miscellaneous).

Fig. 207

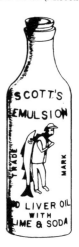

SCOTT S//RED OIL//LINIMENT// PHIL.A

See SCOTT (*Liniment*).

J. S. SEABURY'S// REFINED/CASTOR OIL// JAMAICA L.I.

Aqua; 5" × 1 7/8" × 1 1/8"; 13n; 3b; 3ip; arched; v, sfs; p.

SILVER PINE/HEALING OIL// INTERNATIONAL FOOD CO.// MINNEAPOLIS, MINN.

See INTERNATIONAL (*Company*).

SKERRETT'S OIL/B. WHEELER/ W. HENRIETTA/MON. CO. N.Y.

Green, amber; 7 1/4" × 3 1/8" diameter; 11n; 20b; pl; v.

SLOCUM'S//OXYGENIZED/ PURE CODLIVER OIL// NEW YORK CITY

Product of Dr. T. A. Slocum, adv. 1879 (Baldwin 1973); 1896–97, *Mack*.
Aqua; 7" × 2 1/4" × 1 3/8"; 7n; 3 or 6b; 3 or 4ip; v, sfs. See OZOMULSION (*Miscellaneous*), PSYCHINE (*Miscellaneous*), SLOCUM (Company, Expectorant).

DR. BARLOW J. SMITH'S// CALORIC VITA OIL

Label: *Dr. Barlow J. Smith's Caloric Vita Oil, Creator of Animal Heat, Promotor of Vital Action and the Blood's Circulation.* A San Francisco product introduced ca.

1880 (Wilson and Wilson 1971), adv. 1896–97, *Mack*; 1921, *BD*.
Aqua; 5³⁄₄″ × ? × ?; 7n, sp; 3b; 3 or 4ip; v, ss.

J. R. SPALDING'S/ROSEMARY &/ CASTOR OIL
Aqua; 5″ × 2″ × 1″; 13n; 12b; 1ip; v. See SPALDING *(Miscellaneous)*.

CLARK STANLEY'S/SNAKE OIL LINIMENT//FOR RHEUMATISM/ AND NEURALGIA//BEST HORSE LINIMENT/IN THE WORLD
Product of Clark Stanley, Providence, RI, adv. 1880s, 1899 (Devner 1968).
Clear; 6¹⁄₂″ × 1³⁄₈″ × 1³⁄₈″; 3n; 2b; pl; v, fsb.

STONE'S COD LIVER OIL/ TOURTEL & GERRISH/ PROPRIETORS/BOSTON, MASS.
Directories show Peter B. Tourtel as agent for Stone's Cod Liver Oil from 1877 to 1882; when Tourtel entered in partnership with C. F. Gerrish, the pair continued as agents for the cod liver oil. By 1890 the firm was listed only as manufacturers of washing compounds; the last business entry was in 1904. Adv. 1907, proprietor unk., *PVS & S*.
Clear; 8¹⁄₂″ × 3³⁄₈″ × 1⁷⁄₈″; 9n; 18b; pl; v. See STONE (Elixir, Miscellaneous).

W. C. SWEET'S/KING OF OILS// ROCHESTER, N.Y.
Adv. 1856 (Baldwin 1973).
Green; 4³⁄₄″ × 1³⁄₄″ × 1¹⁄₈″; 11n; 3b; pl; v, ss; p.

G. C. TAYLOR//LINIMENT OR/OIL OF LIFE//FAIRPORT, N.Y.
See TAYLOR *(Liniment)*.

THOMAS/ECLECTRIC OIL// INTERNAL & EXTERNAL// FOSTER, MILBURN & CO.
[See Figure 208]
Advertised in 1888 as: "The Greatest Household Remedy for Pain, a Cure for Painful Diseases." Two companies produced the Eclectric Oil, Northrop & Lyman and Foster Milburn. Orrin E. Foster and Thomas Milburn, Toronto, Canada, established a branch office in Buffalo, NY, in the late 1870s (Wilson and Wilson 1971). Although the fate of the Toronto office is unknown, the Buffalo office was still in operation in 1965, according to the Buffalo city directory. The Eclectric Oil was produced by Foster Milburn Co. in the late 1860s (Wilson and Wilson 1971), and in 1948, *AD*. Northrop & Lyman produced the same product, ca. 1871

to ca. 1980 (Sullivan 1983). Sullivan notes that the Northrop & Lyman Eclectic Oil bottles had the ". . . same form and general configuration from before the 1880s until a standard-shaped dispensing oval was adopted for the product some time around World War II." Sullivan states that the Dominion Glass Company's inventory of mould equipment in 1926 indicates that the firm was apparently still producing hand-finished Eclectric Oil bottles.
Aqua; 4¹⁄₄″ × 1¹⁄₂″ × 1″; 7n; 3b; 1ip; v, fss. Also clear and aqua, 5¹⁄₂″ × 2¹⁄₈″ × 1¹⁄₄″. Several sizes and variants, the clear vessels being the most recent. See BURDOCK (Bitters), FELLOW (Chemical, *Syrup*, Tablet), FOWLER (Extract), NORTHROP & LYMAN *(Discovery)*, WOOD (Syrup).

Fig. 208

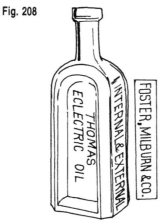

DR. S. N. THOMAS/ECLECTRIC OIL//INTERNAL//EXTERNAL// FOSTER, MILBURN & CO.
Aqua, clear; 5¹⁄₂″ × ? × ?; 1n; 3b; pl; v, fssb; back embossing and order unk. See BURDOCK (Bitters), FELLOW (Chemical, *Syrup*, Tablet), FOWLER (Extract), NORTHROP & LYMAN *(Discovery)*, WOOD (Syrup).

Dᴿ S. N. THOMAS/ECLECTRIC OIL//INTERNAL,//EXTERNAL,// NORTHROP &/LYMAN CO/TORONTO, ONT.
Bottle manufactured ca. 1895 (Wilson and Wilson 1971).
Aqua; 5¹⁄₂″ × 2″ × 1″; 1n; 3b; 1ip; v, fssb. See BURDOCK (Bitters), FELLOW (Chemical, *Syrup*, Tablet), FOWLER (Extract), NORTHROP & LYMAN *(Discovery)*, WOOD (Syrup).

DR. S. N. THOMAS'/OZONE OIL
Adv. 1887, 1895, *McK & R*.
Aqua; 4⁷⁄₈″ × 1³⁄₄″ × 1″; 7n; 3 or 6b; pl; v. See BURDOCK (Bitters), FELLOW (Chemical, *Syrup*, Tablet), FOWLER (Extract), NORTHROP & LYMAN *(Discovery)*, WOOD (Syrup).

TIGER OIL/CURES PAIN
Dr. Jno. Leeson's Tiger Oil, adv. 1889, *PVS & S*; 1929–30, 1935 by Dr. John Leeson, (Estate), Cadillac, Mich., *AD*.
Aqua, clear; 4³⁄₄″ × 1³⁄₄″ × ³⁄₄″; 7n, sp; 3b; 4ip; v.

V–O/EUCALYPTUS/OIL/THEO. NOEL Cᴼ/CHICAGO/U.S.A.
Introduced ca. 1891 (Wilson and Wilson 1971), adv. 1910, *AD*.
Aqua; 5″ × ?; 3n; 20b; pl; h. See EUCALYPTUS *(Oil)*.

WALKER'S EMULSION/OF NORWEGIAN COD LIVER OIL/ WITH BIBASIC PHOS. OF LIME
Adv. 1887, *WHS*; 1900, *EBB*.
Aqua; 9³⁄₈″ × 2³⁄₄″ × 1⁷⁄₈″; 11n; 3 or 6b; 1ip; v.

WYETH & BRO//LACTO PHOSPHATE/OF LIME AND// COD LIVER OIL
Adv. 1887, *WHS*; 1935, *AD*.
Cobalt; 8¹⁄₂″ × 2⁵⁄₈″ × 1⁷⁄₈″; 7 or 9n; 3b; 3 or 4ip; v, sfs. See WYETH (Chemical, *Extract*, Miscellaneous).

WYETH & BRO'//LACTO PHOSPHATE/OF LIME AND// COD LIVER OIL//PHILADᴬ
Light blue; 8³⁄₄″ × 2¹¹⁄₁₆″ × 1¹³⁄₁₆″; 1n; 3b; 3ip; v, sfsb. See WYETH (Chemical, *Extract*, Miscellaneous).

[In circle:] ZAEGEL'S/ZMO/ MAGNETIC OIL/[outside circle:] TRADE MARK/FOR PAIN
Aqua; 5¹⁄₄″ × 2¹⁄₈″ × 1¹⁄₄″; 9n; rect.; pl; v. See ZMO *(Miscellaneous)*.

OINTMENT

BUCKEYE/PILE OINTMENT
Label: *TABLER'S BUCKEYE PILE OINTMENT . . . Prepared by James F. Ballard, St. Louis, Mo.* Adv. 1887, *McK & R*; 1923, *SF & PD*.

Aqua; $2^{15}/_{16}'' \times 1^9/_{16}'' \times 1^1/_2''$; 7n, large mouth; 18b; pl; v. See BALLARD (*Liniment*).

KENNEDY'S/SALT RHEUM/ OINTMENT
Bottle manufactured ca. 1853 (Wilson and Wilson 1971). Advertisement: "Ointment cures Salt-Rheum, Erysipelas Sores, Scald Head, Shingles, Ringworms, Sore Eyes, Hot and Itching Humor, Burns and Scalds." Adv. 1860, *HDO*; 1923, *SF & PD*.

Aqua; $3^1/_2'' \times ?$; 3n, crude, folded out lip; 20b; pl; h; globular shape. See KENNEDY (*Discovery*, Liniment, Miscellaneous).

KENNEDY'S/SALT RHEUM/ OINTMENT
Bottle manufactured ca. 1900 (Wilson and Wilson 1971).

Clear; $3^1/_2'' \times ?$; 17n; 20b; pl; base. See KENNEDY (*Discovery*, Liniment, Miscellaneous).

KENNEDY'S/SALT RHEUM/ OINTMENT
Bottle manufactured ca. 1857 (Wilson and Wilson 1971).

Aqua; $3^3/_4'' \times ?$; 3n, infolded lip; 20b; pl; h; p. See KENNEDY (*Discovery*, Liniment, Miscellaneous).

DR. KILMER'S/U. & O. ANOINTMENT/BINGHAMTON, N.Y.
Label: *DR. KILMER'S UTERINE AND OVARIAN ANOINTMENT For External Application.* Bottle manufactured ca. 1891 (Wilson and Wilson 1971). A nerve oil adv. 1887, *McK & R*; 1941–42, *AD*.

Aqua; $1^3/_4'' \times 1^1/_4''$ diameter; 17n, ground lip; 20b; pl; h. Also clear variant, $2^7/_8'' \times 1^3/_8''$ diameter. See KILMER (Cure, Extract, Miscellaneous, *Remedy*).

SLOANS//OINTMENT
"Promotes perspiration"; adv. 1850 (Baldwin 1973); 1929–30 and 1941–42 by Wm. R. Warner & Co., New York City, *AD*.

Aqua; $2^5/_8'' \times 1^1/_4'' \times 1^1/_4''$; 3n; 2b; pl; v, fb; p. See SLOAN (Cure, *Liniment*, Miscellaneous), W. WARNER (*Company*).

TAYLOR[S]//INDIAN//OINTMENT
Adv. 1848 (Baldwin 1973); 1900, by Taylor Drug & Chem. Co., Trenton, NJ; 1900, 1918 (Devner 1968).

Aqua; $3^1/_8'' \times 1^1/_2''$ diameter; 13n; 21b, 6 sides; pl; v, sss, consecutive sides; p.

A. TRASK'S//MAGNETIC// OINTMENT
Advertised as "The Discovery of The Age, A remedy for internal and external pain, nervous headache, inflammation of the bowels, affections of the spine, in face or breast, burns, fever sores" Trask's Ointment was introduced by S. Bull, of New York State in 1846 (Wilson and Wilson 1971). David Ransom became the proprietor in 1864 according to Buffalo city directories. By 1886 Canadian agency rights belonged to Northrop & Lyman (Sullivan 1983). The ointment was produced in clear, cylindrical, and milk glass, threaded (screw cap) bottles after 1915. Adv. 1948 by D. Ransom, Buffalo, N.Y., *AD*.

Aqua; $2^1/_2'' \times 1^1/_4'' \times 1^1/_4''$; 7n; 2b; pl; v, fsb; p; 15 to 20 variants. See ANDERSON (Miscellaneous), MILLER (Balm), RANSOM (*Company*).

A. TRASK'S//OINTMENT
Clear; $2^5/_8'' \times 1^1/_4'' \times 1^1/_4''$; 3n; 2b; pl; v, fb; ABM. See ANDERSON (Miscellaneous), MILLER (Balm), RANSOM (*Company*).

WESTLAKE'S//VEGETABLE// OINTMENT
Product of William Westlake, Lima, NY, in the late 1850s (Wilson and Wilson 1971). Distribution in latter years was handled by Kemp & Lane, Inc., LeRoy, NY. Adv. 1929–30, *AD*.

Aqua; $3^1/_8'' \times 1^3/_8'' \times 1^3/_8''$; 7n; 2b; pl; v, fsb. See KEMP (*Balsam*).

WESTLAKE'S//VEGETABLE// OINTMENT//LIMA. N.Y.
Bottle manufactured ca. 1862 (Wilson and Wilson 1971).

Aqua; $3'' \times ?$; 3n; 2b; pl; v, fsbs; with and without p. See KEMP (*Balsam*).

DR. WILSON'S//MAGNETIC// VEGETABLE//OINTMENT
Adv. 1887, *McK & R*; 1929–30 by Gibson Snow Co., 216 W. Willow St., Syracuse, N.Y., *AD*.

Aqua; $4^3/_4'' \times 2^1/_2'' \times 2^1/_2''$; 7 or 9n; 1b; pl; v, fbss.

A. WRIGHT'S//AMERICAN// MAGNETIC//PILE/OINTMENT
Adv. 1895, 1907, *PVS & S*.

Aqua; $2^7/_8'' \times 1^1/_2'' \times 1^3/_8''$; 7 or 9n; 3b; pl; v, sbsf.

PECTORAL

AYER'S//CHERRY//PECTORAL//LOWELL/MASS

From an 1891 *Phoenix Weekly Herald*: "A dose of this medicine affords certain and speedy relief. To cure colds, coughs, sore throat, asthma, bronchitis, hoarseness and the various disorders of the breathing apparatus. Ayer's Cherry Pectoral has no equal." Introduced 1847; adv. 1948, *AD*.

Aqua; 6^1/$_8$″ × 2″ × 1^1/$_2$″, also 7^3/$_{16}$″ × 2^1/$_4$″ × 1^{11}/$_{16}$″; 1n; 3b; 4ip; v, fssb; with and without pontil. Also variant with U.S.A. See AYER (*Cure*, Hair, Miscellaneous, Pills, Sarsaparilla).

AYER'S PECTORAL//AYER'S PECTORAL [Base: A in circle]

Label: *AYER'S PECTORAL, Wild Cherry Flavor. An Especially Effective Medicine for Coughs and Bronchial Irritations Due to Cold . . . Alcohol 16^1/$_2$%. The Ayer Co., Inc., Distributors New York, N.Y. and Rahway, N.J.* Bottle manufactured either by the American Glass Works, Richmond, VA, and Paden City, WV, ca. 1908 to 1935; or the Armstrong Cork Co., Glass Division, Lancaster, PA (who purchased the Whitall-Tatum Glass Co., and Hart Glass Co. in 1938), 1938 to 1970. Kerr Glass Co. purchased the Armstrong company in 1968 (Toulouse 1972).

Clear; 6^5/$_8$″ × 2^1/$_4$″ × 1^1/$_4$″; 16n; 3b; pl; v, ss. See AYER (*Cure*, Hair, Miscellaneous, Pills, Sarsaparilla).

AYER'S//PECTORAL SYRUP//BROWNVILLE NY

See AYER (*Syrup*).

J. W. BULL'S//COMPOUND/PECTORAL//BALTIMORE

Adv. 1876, 1887, *WHS*.

Aqua; 5^1/$_2$″ × 1^3/$_4$″ × 13/$_{16}$″; 11n; 3b; 3ip; v, sfs; p. See BULL (*Syrup*), REDSTAR (Cure), SALVATION (*Oil*), ST. JACOB (*Oil*), VOGELER (Company).

DUCONGE'S//PECTORAL BALSAM SYRUP/NEW ORLEANS

See DUCONGE (*Balsam*).

DR. FOORD'S//PECTORAL/SYRUP//NEW YORK

See FOORD (*Syrup*).

LITTLE'S//PECTORAL/SYRUP//NEW YORK

See LITTLE (*Syrup*).

NOWILL'S. PECT/ORAL HONEY/OF LIVERWORT

Product for consumption produced by D. Nowill, New York. Adv. 1852 (Baldwin 1973); 1900, *EBB*.

Aqua; 5″ × 1^3/$_8$″ diameter; 5n; 20b; pl; v; p.

SKELTON'S//PECTORAL BALSAM/OF LIFE/FOR//LUNG DISEASES

See SKELTON (*Balsam*).

SMITH'S PECTORINE/LINCOLN

Light blue; 6^7/$_8$″ × 2^1/$_2$″ × 1^1/$_2$″; 3n; 3b; 3ip; v.

WYNKOOP'S/ICELAND PECTORAL/NEW YORK [See Figure 209]

"Wynkoop's Pectoral, 25¢, for ailments of the chest. . .," introduced ca. 1851. It was a product of Robert D. Wynkoop, who established a medicinal laboratory and sales outlet in New York City in the 1840s. Sometime in the 1850s, for certain in 1857, the firm was billed as Heath, Wynkoop & Co. Wynkoop also distributed Lyon's Powder and Kathairon until E. T. Lyon sold his products to Demas Barnes, and John Park ca. 1858. Around this time Wynkoop introduced his sarsaparilla and Barnes & Park became agents; proprietary rights for Wynkoop's products were acquired by the pair ca. 1862. John D. Park was no longer affiliated with Barnes after ca. 1868. Barnes and associates formed The Lyon Mfg. Co. in late 1871 or early 1872 to market their products including the Centaur and Pitcher brands and Iceland Pectoral (Holcombe 1979; Shimko 1969; Wilson and Wilson 1971). A pontiled toilet water bottle embossed HEATH WYNKOOP & CO./PERFUMERS/NEW YORK has also been found. Pectoral adv. 1853 (Singer 1982); 1912 (Shimko 1969); 1923, *SF & PD*.

Aqua; 5^1/$_4$″ × 2″ × 7/$_8$″; 11n; 3b; 1ip; v; with and without pontil; several variants. See BARNES (*Balsam*), DRAKE (*Bitters*), GUYSOTT

(*Sarsaparilla*), HAGAN (Balm), J. F.
HENRY *(Company)*, JONES
(Miscellaneous), LYON *(Hair,* Jamaica
Ginger, Miscellaneous), MEXICAN
(Liniment), WYNKOOP (Sarsaparilla).

Fig. 209

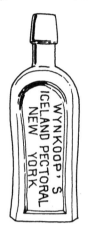

WYNKOOP'S
ICELAND PECTORAL
NEW YORK

PEPSIN

PEPSIN BITTERN/[monogram cross]/
E. L. ARP KEIL
See ARP *(Bitters).*

BALDWIN'S/CELERY PEPSIN/
AND/DANDELION TONIC
See BALDWIN *(Tonic).*

CALDWELL'S SYRUP PEPSIN/MF'D
BY/PEPSIN SYRUP COMPANY/
MONTICELLO, ILLINOIS
See CALDWELL *(Syrup).*

CALDWELLS SYRUP PEPSIN/MF'D
BY/PEPSIN SYRUP COMPANY/
MONTICELLO, ILLINOIS
See CALDWELL *(Syrup).*

DR. W. B. CALDWELL'S/SYRUP
PEPSIN//PEPSIN SYRUP
COMPANY//MONTICELLO,
ILLINOIS
See CALDWELL *(Syrup).*

CRISWELL'S/BROMO-PEPSIN/
CURES HEADACHE/AND
INDIGESTION
Bromo-Pepsin adv. 1895, *PVS & S*;
1900, *EBB*; Criswell's Bromo Pepsin,
1910, *AD*.
Amber; 4⅝" × 1⅝" diameter; 7n;
20b; pl; v.

CRISWELL'S/BROMO-PEPSIN/FOR
HEADACHE/AND INDIGESTION
Amber; 2½" × 1⅛" diameter; 7n;
20b; pl; v, also variant with
INDIGESTION deleted.

Eureka Pepsin/Celery Compound//
A Never Failing/Tonic
Amber; 7¼" × 4⅛" × 2¼"; 12n; 6b;
pl; v, ss.

FAIRCHILD BROS & FOSTER/
ESSENCE OF PEPSINE/NEW YORK
See FAIRCHILD *(Essence).*

[Script:] Gladstone's Celery/
And Pepsin Compound//

Mastico Medicine Co/Danville, Ills.
See GLADSTONE *(Compound)*.

**DR THOS HALL'S/CALIFORNIA/
PEPSIN WINE BITTERS**
See HALL *(Bitters)*.

DR. J. S./HOUGHTON'S/PEPSIN
Product of J. S. Houghton, Philadelphia,
formulated as a dry or liquid food
digestant ca. 1850 (Wilson and Wilson
1971). Adv. 1852 in the Woodward &
Rowland's Pittsburgh city directory;
1900 by E. F. Houghton & Co., 240
W. Somerset, Philadelphia, *EBB*; 1910,
AD.
Aqua; $5^3/4'' \times$?; 11n; 20b; pl; h; p.

**PEPSENCIA/ESSENCE OF
PEPSIN/FAIRCHILD** [Base: WT in
triangle]
See PEPSENCIA *(Essence)*.

**RAMON'S PEPSIN CHILL TONIC/
MADE BY BROWN MF'G CO.//
GREENVILLE, TENN.//NEW YORK,
N.Y.** [Base: embossed diamond]
See RAMON *(Tonic)*.

**WOODCOCK/PEPSIN BITTERS//
SCHROEDER'S MED. C°**
See WOODCOCK *(Bitters)*.

PILLS

**DR SETH ARNOLD//
VEGETABLE//ANTIBILIOUS//
PILLS**
Adv. 1865, *GG*; 1916, *MB*.
Aqua; $2^3/8'' \times 7/8''$ diameter; 7n; 21b,
12 sides; pl; v. See ARNOLD *(Balsam,
Cough)*.

AYER'S//PILLS//LOWELL/MASS
Ayer's Cathartic Pills; sources vary on
the date of introduction, possibly 1843
(Wilson and Wilson 1971), or ca. 1848
(Holcombe 1979). Adv. 1935, *AD*.
Aqua; $2'' \times 1'' \times 3/4''$; 3n; 3b; 3 or 4ip;
v, ssf. See AYER *(Cure,* Hair,
Miscellaneous, Pectoral, Sarsaparilla).

**DR. A. V. BANES/
9 OCLOCK PILLS**
Adv. 1889, *PVS & S*; 1916, *MB*.
Amber; $2^1/8'' \times {}^{13}/_{16}'' \times {}^{13}/_{16}''$; 7n; 2b;
pl; v.

**BRISTOL'S/PILLS//PILDORAS/
DE/BRISTOL//NEW YORK//
NEW YORK**
Adv. 1876, *WHS*; 1923, *SF & PD*.
Aqua; $1^5/8'' \times 1^1/2'' \times$?; 3n; crude; 3b;
pl; h, fb; v, ss; p. See BARRY *(Cream,
Hair,* Miscellaneous).

SIR J. CLARK'S//FEMALE PILLS
Aqua; $2^1/2'' \times 1^3/8'' \times 1^1/8''$; 7 or 9n;
2b; pl; v, fb. See MOSES *(Mis-
cellaneous)*.

**CLICKENER'S//SUGAR COATED/
VEGETABLE/PURGATIVE//PILLS**
Cornelius V. Clickener, 81 Barclay
Street, New York City, established his
business about 1843. Vegetable Purga-
tive Pills adv. 1845 (Sonnedecker and
Griffenhagen 1957); 1910, *AD*.
Aqua; $2'' \times 1^3/4'' \times 1^3/4''$; 13n; crude; 1
or 2b; v, sfs; p.

D. EVANS//CAMOMILE//PILLS
Dr. Evan's Camomile Pills, a laxative for
clearing up the skin and a tonic system
builder, was introduced by Dr. William

Evans, New York City, ca. 1820; William Evans Jr. relocated the business to Philadelphia in the late 1830s (Wilson and Wilson 1971). Adv. ca. 1930 (Devner 1968).

Aqua; 3¹/₈″ × 1″ × 1″; 5n; 1b; pl; v. See EVANS (Syrup).

FOLEY'S KIDNEY PILLS/FOLEY & CO., CHICAGO
See FOLEY *(Company)*.

HOOD'S PILLS/DOSE/1 to 4/ FOR LIVER ILLS
Adv. 1887, *McK & R*; 1929–30 by Wm. R. Warner & Co., New York City, *AD*.
Clear; 1³/₄″ × ? × ?; 16n; 12b; pl; h. See HOOD (Company, *Sarsaparilla*), TUS *(Cure)*.

HOOD'S PILLS/DOSE/2 TO 6/ CURE LIVER ILLS
Clear; 1³/₄″ × ? × ?; 3n; 12b; pl; h. See HOOD (Company, *Sarsaparilla*), TUS *(Cure)*.

HOODS PILLS/DOSE/TO/CURE LIVER ILLS//C. I. HOOD & CO/ U.S.A./LOWELL MASS [See Figure 210]
Clear; 1³/₄″ × ⁵/₈″ × ⁵/₁₆″; 3n; 12b, recessed sides at base; pl; h, fb. See HOOD (Company, *Sarsaparilla*,) TUS *(Cure)*.

Fig. 210

FRONT BACK

DR KING'S/NEW LIFE PILLS
Label: *Dr. KING'S NEW LIFE PILLS for Constipation & Biliousness. H. E. Bucklen & Co., Saint Louis & Philadelphia, Formerly Chicago.* Introduced in 1880 (Wilson and Wilson 1971). Adv. 1887, *WHS*; 1921, *BD*.
Clear; 2¹/₂″ × ⁷/₈″ × ⁷/₈″; 7n; 2b; pl; v; also ABM. See ELECTRIC (Bitters), KING *(Discovery)*.

DR. KING'S/NEW LIFE PILLS// H. E. BUCKLEN & CO.//CHICAGO, U.S.A. [See Figure 211]
Clear; 2¹/₂″ × ?; 7n; 1b; pl; v, fb; ABM. See ELECTRIC (Bitters), KING *(Discovery)*.

DR. KING'S/PILLS
Label: *Dr. KING'S PILLS Formerly called Dr. King's New Life Pills*. . . . Adv.

1925, *BWD*; 1948 by Wm. R. Warner & Co., New York City, *AD*.
Clear; 2⁵/₈″ × ⁷/₈″ × ⁷/₈″; 7n; 2b; pl; v; ABM. See ELECTRIC (Bitters), KING *(Discovery)*.

Fig. 211

FRONT BACK

MORSE'S INDIAN/ROOT PILLS// W. H. COMSTOCK//DOSE ¹/₂ TO 4
[Base:] AGM
". . . a general corrective for people who eat too much and drink too much." Morse's Indian Root Pills appear to have been originated ca. 1835 and packaged for some years in wooden boxes. William Howes Comstock, a native of London, England, moved to Morristown, NY, and established W. H. Comstock Co., Ltd. in the late 1870s. The company manufactured Morse's Indian Root Pills, Dr. Morse's Compound Syrup of Yellow Dock Root and Comstock's Dead Shot Worm Pellets; whether Comstock originally introduced the products is unknown. Offices were located in London, England; Brockville, Ontario, Canada; Sydney, New South Wales; Wellington, New Zealand and Hong Kong, China (Holcombe 1979). It is unknown when Comstock relinquished ownership of the business, however the firm and name were still in existence in Morristown, NY, in 1948, according to the *American Druggist* catalog. The pills were still being manufactured in the 1980s by the Benjamin Company who acquired the rights and formula from N. C. Polson & Co., Ltd., of Canada, and the W. H. Comstock Co., Pty., of Australia.
Amber; 2¹/₂″ × 1¹/₈″ × ³/₄″; 7n; 3b; 3ip; v, fss; ABM. See COMSTOCK (Miscellaneous), MORSE (Cordial, *Syrup*).

MORSES INDIAN/ROOT PILLS// W. H. COMSTOCK//DOSE 2 TO 4
Amber; 2⁵/₈″ × 1¹/₈″ × ³/₄″; 7n; 3b; 3ip; v, fss. See COMSTOCK (Miscellaneous), MORSE (Cordial, *Syrup*).

MORSES INDIAN/ROOT PILLS
[Base:] BOTTLE/MADE IN/JAPAN
Amber; 2¹/₂″ × 1¹/₈″ × ³/₄″; 7n; 3b; 3ip; v. See COMSTOCK (Miscellaneous), MORSE (Cordial, *Syrup*).

THE SHAKER/FAMILY PILLS/ DOSE 2 TO 4//A. J. WHITE
A cure for headaches, colds, bilious disorders and constipation. Adv. 1887, *McK & R*; 1923, *SF & PD*.
Aqua; 2¹/₈″ × 1¹/₁₆″ × ³/₄″; 15n; 3b; pl; v, fss. See LAXOL (Miscellaneous), SEIGEL *(Syrup)*, SHAKER (Cordial), WHITE (Miscellaneous, Syrup).

THE SHAKER/FAMILY PILLS// DOSE 2 TO 4//A. J. WHITE
Amber; 2¹/₄″ × 1″ × ³/₄″; 3n; 3b; 3 or 4ip; v, fss. See LAXOL (Miscellaneous), SEIGEL *(Syrup)*, SHAKER (Cordial), WHITE (Miscellaneous, Syrup).

TONIC PILLS//TRADE/NUNN BETTER/MARK//NEVER FAIL/ TO CURE//M.A. BRIGGS/ VALDOSTA GA.//
The History of Lowdnes County Georgia, 1825-1941, portrays Matt A. Briggs as an operator of a drugstore next door to his father's hardware store prior to his opening a clothing store in 1889 or 1890.
Aqua; 2⁹/₁₆″ × ¹⁵/₁₆″ × ¹⁵/₁₆″; 7n; 2b; pl; v, bssf.

DR. VELPAU'S/FRENCH PILLS
Velpau's Female Pills, adv. 1872, *VHS*; 1910, *AD*.
Aqua; 2³/₄″ × 1³/₈″ diameter; 7n; 20b; pl; v.

DR. H. WILLIAM'S//MOUNTAIN PILLS//GREENVILLE CAL.
Bottle manufactured ca. 1883. Harry Williams operated a drugstore in the community of Greenville, CA, from ca. 1882 to 1885 (Wilson and Wilson 1971).
Aqua; 2¹/₄″ × ? × ?; 3n; 3b; 3 or 4ip; v, fss.

PURIFIER

H. A. BABCOCK'S/RHEUMATIC TINCTURE/BLOOD PURIFIER & CANCER CURE/BROOKFIELD, N.Y.
Label: . . . *an Indian Remedy: For The Cure of Cancers and Rheumatism; An Excellent Remedy For Syphilatic and Cutaneous Diseases . . . "A Powerful Remedy In Case Of Female Obstructions."*
Clear, aqua; 8″ × ? × ?; 7n; 3b; ip; v; sides may be embossed.

E. L. BAILEY'S KIDNEY/AND LIVER BITTERS//BEST BLOOD PURIFIER
See BAILEY *(Bitters)*.

BRO. BENJAMIN'S/HERBALO BLOOD PURIFIER/STOMACH – LIVER & KIDNEY/RENOVATOR
[See Figure 212]
Label: *BRO. BENJAMIN'S HERBALO, Blood Purifier, Stomach, Liver And Kidney Cure. Benjamin Remedy Co., Cincinnati, O.* Adv. 1917, 1921, *BD.*
Aqua; 8³/₄″ × 2³/₄″ × 1³/₄″; 7n; 3b; 3ip, front arched; v.

Fig. 212

DR G. T. BLAKE'S//HORSE RENOVATOR/&/BLOOD PURIFIER//J. R. KLINE
Aqua; 9″ × 3³/₈″ × 1⁷/₈″; 7n; 3b; 3ip; v, sfs; p.

BRANT'S/PURIFYING EXTRACT//M. T. WALLACE & C⁰/PROPRIETORS//BROOKLYN. N.Y.
See BRANT *(Extract)*.

16 OZ./DR E. E. BURNSIDES/PURIFICO/P/THE PURIFICO CO/BUFFALO, N.Y.
See PURIFICO *(Company)*.

CALIFORNIA'S OWN/TRUE LAXATIVE/AND BLOOD PURIFIER//WAIT'S/KIDNEY AND/LIVER BITTERS [Base:] PCGW
See WAIT *(Bitters)*.

THE CLINIC/BLOOD PURIFIER//M'F'R'D BY FOLEY & CO./STEUBENVILLE O. & CHICAGO
See FOLEY *(Company)*.

CUTICURA SYSTEM OF/BLOOD AND SKIN/PURIFICATION//POTTER DRUG & CHEMICAL/CORPORATION/BOSTON, U.S.A.
See CUTICURA *(Cure)*.

DR DENNIS/SYSTEM RENOVATOR &/BLOOD PURIFYING SYRUP
See DENNIS *(Syrup)*.

DR. S. J. EMBREY'S/BLOOD PURIFIER/LEXINGTON TENN
Clear, aqua; 9³/₄″ × 4″ × 1⁷/₈″; 1n; 15b; pl; h.

GENUINE GERMAN/STYLE CATHARTIC/AND BLOOD PURIFIER//COLBURG/STOMACH BITTERS/FOR/LIVER, STOMACH & BOWELS
See COLBURG *(Bitters)*.

S. B. GOFF'S//INDIAN VEGETABLE/COUGH SYRUP/& BLOOD PURIFIER//CAMDEN N.J.
See GOFF *(Syrup)*.

GREENHALGH'S/BLOOD PURIFIER/PREPARED BY/GREENHALGH REMEDY CO./SALT LAKE CITY, UTAH
See GREENHALGH *(Remedy)*.

DR HATHAWAY'S//PURIFIER
Aqua; 7³/₄″ × 2³/₈″ × 1⁵/₈″; 11n; 4b; pl; v, ss; p.

HERBS OF LIFE/BLOOD PURIFIER//BLOOD PURIFIER/DENVER, COLO, U.S.A.
Adv. 1907, *PVS & S.*
Aqua; 9″ × 3⁷/₈″ × 1³/₄″; 1n; 3b; 3ip, arched front; v, ss.

FRANKLIN HOWES/MEDICAL DISCOVERY/THE GREAT BLOOD PURIFIER/NEW YORK/ REGISTERED
See HOWE *(Discovery)*.

STEWART D. HOWE'S//ARABIAN/ TONIC/BLOOD PURIFIER// NEW YORK
See HOWE *(Tonic)*.

LASH'S KIDNEY AND/LIVER BITTERS//THE BEST CATHARTIC/ AND BLOOD PURIFIER
See LASH *(Bitters)*.

LASH'S/KIDNEY [in arc]/AND/ LIVER [in arc]/BITTERS//THE BEST CATHARTIC/AND BLOOD PURIFIER
See LASH *(Bitters)*.

LEONARDI'S BLOOD ELIXIR/THE GREAT BLOOD PURIFIER/S. B. LEONARDI & CO/NEW YORK & TAMPA, FLA.
Products included Leonardi's Cough Cure, Tasteless Chill Cure, Iron Tonic, and Golden Eye Lotion. Elixir adv. 1910, *AD*.
Amber; 8¼" × 2⅞" × 2"; 9n; 4b; pl; v. See LEONARDI (Cure, Lotion).

MARSHALL'S BITTERS//THE BEST LAXATIVE/AND BLOOD PURIFIER
See MARSHALL *(Bitters)*.

TRADE MARK/McBURNEYS/ LIVER/REGULATOR/AND BLOOD/ PURIFIER/LOS ANGELES/CAL.
The 1900 *Era Blue Book* catalog listed W. F. McBurney at 418 S. Spring, Los Angeles, CA. Adv. 1916, *MB*, 1921, *BD*.
Clear; 8¾" × 1½" × ?; ?n; ?b; ip; h. See McBURNEY (Cure).

DR. J. H. McLEAN'S/ STRENGTHENING/CORDIAL/ &/BLOOD PURIFIER
A product to tone up and strengthen the system. Adv. 1865, *GG*; 1929–30 and 1948 by Dr. J. H. McLean Medicine Co., 3114 Franklin Ave., St. Louis; 1980–81 by Dr. J. H. McLean Medicine Co., 1 W. 37th St., New York City, *AD*.
Light blue; 8" × ? × ?; 1n; 14b; pl; h; also 9" high variant. See McLEAN (*Balm*, Miscellaneous, Oil, Sarsaparilla).

DR. MILES'/RESTORATIVE/ BLOOD PURIFIER
The blood purifier, later called Alterative Compound, was produced from 1885 to 1937, according to Donald N. Yates, Archivist, Miles Laboratories, Inc. (personal communication, 1984).
Light blue; 8⅛" × 2¾" × 1½"; 1n; 3b; 3ip; v. See MILES (*Cure*, Medicine, Nervine, Sarsaparilla, Tonic).

NIBOL/KIDNEY AND LIVER/ BITTERS//THE BEST TONIC/ LAXATIVE & BLOOD PURIFIER
See NIBOL *(Bitters)*.

P-P-P/PRICKLY ASH POKE ROOT POTASSIUM/THE GREAT BLOOD PURIFIER
Product advertised 1894, by Lippman Bros., Savannah, GA (Baldwin 1973); 1913, *SN*.
Amber; 8¾" × 3¼"; 7n; ?b; sides unk.; v. See LIPPMAN (Sarsaparilla).

LYDIA E. PINKHAM'S/BLOOD PURIFIER
Adv. 1882, *VSS & C*; 1929, as shown by an advertisement reproduced in Nov. 1983 *Good Old Days* magazine.
Aqua; 8⅜" × 3⅝" × 1⅞"; 7n; 12b; pl; v. See PINKHAM (*Compound*, Medicine).

PURIFIER/BY T. C. POMEROY, M.D.//BLOOD & LIVER
Product adv. 1871, by Dr. T. C. Pomeroy, Cortland, NY (Baldwin 1973).
Aqua; 8¾" × 3" × 2"; 7n; 3 or 6b; ip; v, fs.

QUAKER SARSAPARILLA/ BLOOD PURIFIER
See QUAKER *(Sarsaparilla)*.

REX/KIDNEY/AND/LIVER/ BITTERS//THE BEST LAXATIVE/ AND BLOOD PURIFIER
See REX *(Bitters)*.

DR C. W. ROBACK'S/ SCANDINAVIEN/BLOOD PURIFIER/CINCINNATI. O
Charles Roback, Cincinnati, OH, manufactured products such as Roback's Blood Pills, registered in 1855, and changed to Roback's Scandinavian (or Scandinavien) Blood Pills in 1857; Roback's Scandinavien Blood Purifier, introduced by 1857 (Holcombe 1979); and Roback's Unrivalled Stomach Bitters, patented in 1855 (Ring 1980). Although Roback sold his business to the United States Proprietary Medicine Company in 1866 the products remained the same except for the bitters, which were changed to Roback's Scandinavian Stomach Bitters. The U. S. Proprietary Medicine Co. was assumed by F. E. Suire & Co., either in 1870 or 1871; J. S. Burdsal & Co. bought out F. E. Suire & Co. in 1874. J. S. Burdsal & Co. manufactured Dr. Roback's Scandinavian Blood Pills but it is uncertain who acquired and sold the bitters and blood purifier. J. S. Burdsal & Co. was still operating in 1880 (Holcombe 1979). Purifier adv. 1857 (Holcombe 1979); 1910, *AD*.
Blue green; 7½" × 3" × ?; 7n; 12b; pl; v; p. See ROBACK (Bitters), WAYNE (*Elixir*).

DR C. W. ROBACK'S/ SCANDINAVIAN/BLOOD PURIFIER/PURELY VEGETABLE// DYSPEPSIA//LIVER COMPLAINT
Aqua; 8¾" × 3¼" × 1⅝"; 1n; 3b; 3 or 4ip; v, fss. See ROBACK (Bitters).

S & Co BLOOD//PURIFIER
A product of James G. Steele, San Francisco, CA, a manufacturer and dealer of drugs and patent medicines from the 1860s to 1899 (Wilson and Wilson 1971).
Blue green; 8½" × ? × ?; 7n; rect.; pl; v, ss.

SUN/KIDNEY/AND/LIVER/ BITTERS//VEGETABLE LAXATIVE/BOWEL REGULATOR/ AND BLOOD PURIFIER
See SUN *(Bitters)*.

SUPERIOR TONIC, CATHARTIC/ AND BLOOD PURIFIER// E. J. ROSE'S/MAGADOR BITTERS/ FOR STOMACH, KIDNEY & LIVER
See ROSE *(Bitters)*.

WEB'S/A N⁰ 1//CATHARTIC/ TONIC//THE LIVER, KIDNEY/ & BLOOD/PURIFIER
See WEB *(Tonic)*.

REMEDY

ACKER'S ENGLISH REMEDY// W. H. HOOKER & CO/SOLE AGENTS/NORTH & SOUTH AMERICA//FOR THE THROAT & LUNGS

William H. Hooker, New York, NY, obtained sole proprietorship to the Acker products in 1877; Walter Hooker assumed control in the 1880s (Wilson and Wilson 1971). An 1891 *Phoenix Weekly Herald* advertisement stated: "It will stop a cough in one night. It will check a cold in a day. It will prevent croup, relieve asthma and cure consumption if taken in time." Adv. 1935 by McCullough Drug Co., 30–34 E. High St., Lawrenceburg, Ind., *AD*. Cobalt; $4^{1}/_{2}'' \times ? \times ?$; 7n; 3b; 3ip; v, sfs. See ARTHUR (Company), HOOKER (Company).

ACKER'S ENGLISH REMEDY// FOR THE THROAT & LUNGS// W. H. HOOKER & CO./ PROPRIETORS/NEW YORK, U.S.A.

Cobalt; $5^{5}/_{8}'' \times 2'' \times 1^{1}/_{8}''$; 9n; 3b; 3ip; v, ssf. See ARTHUR (Company), HOOKER (Company).

ACKER'S ENGLISH REMEDY// FOR ALL THROAT & LUNG DISEASES//B. F. ARTHUR & CO/ SOLE AGENTS/NORTH & SOUTH AMERICA

Cobalt; $6^{3}/_{4}'' \times 2^{5}/_{8}'' \times 1^{7}/_{16}''$; 9n; 3b; 3ip; v, ssf. See ARTHUR (Company), HOOKER (Company).

ACKER REMEDY//FOR THROAT & LUNGS//ACKER REMEDY CO./PROPRIETORS [See Photo 64]

Cobalt; $5^{1}/_{2}'' \times 2'' \times 1^{1}/_{16}''$; 9n; 3b; 3ip; v, ssf. See ARTHUR (Company), HOOKER (Company).

THE AMERICAN REMEDY CO./ OGDEN, UTAH, U.S.A.

See AMERICAN *(Company)*.

DR. BELDING'S/SKIN REMEDY// DR: BELDING MEDICINE. CO// MINNEAPOLIS, MINN.

Adv. 1907, *PVS & S*; 1916, *MB*. Aqua; $7^{1}/_{2}'' \times 2^{3}/_{8}'' \times 1^{3}/_{8}''$; 1n; 3b; 3ip; v, fss. See BELDING (Sarsaparilla), INTERNATIONAL *(Company)*.

BONPLAND'S//FEVER & AGUE/ REMEDY//NEW YORK

Adv. 1849 (Baldwin 1973). Aqua; $5^{1}/_{8}'' \times 2^{3}/_{8}'' \times 1^{1}/_{2}''$; 11n; 3b; pl; v, sfs; p.

DR. BOSANKO'S/PILE/REMEDY

[See Figure 213]
Dr. Bosanko's Pile Remedy was introduced ca. 1884 (Wilson and Wilson 1971). Adv. 1929–30 and 1941–42 by United Medicine Co., Philadelphia, Pa., *AD*. The company, located in Piqua, Ohio, moved to Philadelphia in the 1890s. Aqua; $2^{1}/_{2}'' \times 1^{3}/_{8}''$ diameter; 7n, large mouth; 20b; pl; h. See BOSANKO *(Company)*, GUNN (Syrup).

Fig. 213

BRONSON'S//COUGH COLD AND/ CONSUMPTION/REMEDY// ALEXANDER, N.Y.

Adv. 1892 (Baldwin 1973). Clear; $5^{3}/_{4}'' \times ? \times ?$; 11n; rect.; 3 or 4ip; v, sfs.

Dr M CALDWELL'S/DYSPEPSIA/ REMEDY//LOCKPORT// NEW YORK

Adv. 1876, *WHS*; 1910, *AD*. Aqua; $6^{3}/_{4}'' \times 2^{1}/_{4}'' \times 1^{1}/_{4}''$; 7n, sp; 3b; 3 or 4ip; v, fss.

CHAMBERLAIN'S/COLIC/ CHOLERA/AND/DIARRHOEA REMEDY//CHAMBERLAIN MED. CO.//DES MOINES, IA. U.S.A.

[See Figure 1]
Label of unembossed ABM variant, dated 1931, with the same neck finish reads: *Chamberlain's Colic Remedy for Flatulent or Wind Colic*. . . . Product introduced ca. 1882 (Wilson and Wilson 1971). Brothers Davis and Lowell Chamberlain, established a proprietary

medicine business in Marion, Iowa in 1873 (*Des Moines Register*, 23 July 1945). In 1881, the pair moved to Des Moines and with sister Izanna established Chamberlain and Company. In 1892 the firm became the Chamberlain Medicine Company (thus the earliest date for embossed containers) and soon had expanded to Australia, Canada and South Africa (*Des Moines Register*, 15 March 1933). In 1930, the medicine branch of the firm was sold and became Pfeiffer Chemical Co. and Chamberlain Laboratories was formed to manufacture Chamberlain's Lotion, which was introduced after 1900, and other cosmetic specialities (*Arizona Republic*, 11 April 1934). Arizona newspapers reported the history because Davis held interests in Arizona banking. Davis died 14 March 1933. Although the proprietary medicine business was terminated in 1930 some products continued to be marketed for a short time. Deyet and Carl Weeks, nephews of Lowell, formed separate drug firms in Des Moines in the 1890s. A younger brother, Leo, joined Carl ca. 1910 and in 1935 the two firms merged to form the Weeks & Leo Company. In 1955 Weeks & Leo purchased the Chamberlain Lotion business (Chamberlain Company history notes courtesy of Weeks & Leo Co., Des Moines, IA, 1982.) Chamberlain's Pain Balm was available in 1880; Cough Remedy ca. 1881 and the Consumption Cure and Liniment later (Wilson and Wilson 1971). Products were also available in unembossed, ABM, screw-capped containers. Pfeiffer Chemical Co. apparently sold to Standard Labs., New York, NY, who advertised Chamberlain's Colic Remedy in 1948, *AD*.

Aqua; 4½″ × 1¾″ × ⅞″; 11n; 3b; 4ip; v, fss; 3 sizes. See CHAMBERLAIN (Balm, Liniment, Lotion, Miscellaneous), PFEIFFER (Company), VON HOPF (Bitters), W. WARNER (*Company*).

CHAMBERLAIN'S/COLIC AND/ DIARRHOEA REMEDY// CHAMBERLAIN//BOTTLE MADE IN U.S.A.

Aqua; 5⅜″ × 2¹/₁₆″ × 1⅛″; 11n; 3b; 4ip; v, fss. See CHAMBERLAIN (Balm, Liniment, Lotion, Miscellaneous), PFEIFFER (Company), VON HOPF (Bitters), W. WARNER (*Company*).

CHAMBERLAIN'S/COUGH REMEDY//CHAMBERLAIN MED. CO.//DES MOINES, IA. U.S.A.

[See Figure 214]

Carton label, illustrated in 1901 *Hornick, Hess & More* catalog: *Adopted in 1882.* Adv. 1935, *AD*.

Aqua; 5¾″ × 2″ × 1″; 11n; 3b; 3ip; v, fss. See CHAMBERLAIN (Balm, Liniment, Lotion, Miscellaneous), VON HOPF (Bitters), W. WARNER (*Company*).

Fig. 214

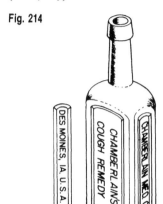

CHAMBERLAIN'S/COUGH REMEDY//CHAMBERLAIN MED. CO.//DES MOINES, IA. U.S.A.

Aqua; 7″ × 2⅜″ × 1¼″; 11n; 3b; 4ip; v, fss. See CHAMBERLAIN (Balm, Liniment, Lotion, Miscellaneous), VON HOPF (Bitters), W. WARNER (*Company*).

CHAMBERLAIN'S/COUGH REMEDY//A. N. CHAMBERLAIN// ELKHART, IND.

The A. N. Chamberlain Company was founded in 1850 (Devner 1968). Products included Green Mountain Salve, Immediate Relief, Restorative Pills, Cough Tablets and the Cough Remedy. Products adv. 1948 by A. N. Chamberlain Sales Co., South Bend, Ind., *AD*.

Aqua; 6″ × 2⅛″ × 1¼″; 1n; 3b; 3ip; v, fss; with and without pontil.

DR. J. F. CHURCHILL'S/SPECIFIC REMEDY/FOR CONSUMPTION// HYPOPHOSPHITES OF LIME AND SODA//J. WINCHESTER/ NEW YORK

Adv. 1858, a product of J. Winchester, New York (Baldwin 1973); 1900 by Winchester & Co., 46 Cliff, New York, N.Y., *EBB*.

Aqua; 7″ × 2⅜″ × 1½″; 11n; 3 or 6b; 3 or 4ip; v, fss; with and without pontil. See WINCHESTER (Miscellaneous).

DR. CLASSES//REMEDIES

Label: *Dr. E. CLASSES COUGH SYRUP for the Cure of Coughs, Colds, Croup, Whooping Cough, Hoarseness,*

Asthma and Consumption. W. P. DIGGS & CO., Sole Agents United States and Canada, ST. LOUIS, MO. Products adv. 1916, *MB*.

Clear; 5⁵/₁₆″ × 1⅞″ × ⅞″; 7n; 3b; 2ip; v, ss. See CLASSE (*Syrup*).

CLAYTON'S/DOG/REMEDIES/ CHICAGO

Adv. 1916, *MB*; 1948 by George W. Clayton Co., 1810 S. Wabash Ave., Chicago, Ill., *AD*.

Clear; 2⅛″ × 1³/₁₆″ diameter; 7n; 20b; pl; h.

D.R.V.G./DYSPEPSIA REMEDY

Product of Goetchius & Co., location unk. Adv. 1887, *McK & R*; 1910, *AD*.

Aqua; 6½″ × 2¼″ × 1¼″; 7n; rect.; ip; v.

DAVIS & MILLERS//AMERICAN// WORM SYRUP//A. CERTAIN// REMEDY//FOR WORMS

See DAVIS & MILLER (*Syrup*).

PROF. DEAN'S/KING CACTUS OIL/ THE GREAT/BARBED WIRE/ REMEDY/OLNEY & MCDAID/ TRADE MARK

See DEAN (*Oil*).

PROF. DEAN'S/KING CACTUS OIL/ THE GREAT/BARBED WIRE/ REMEDY/CLINTON, IOWA/ TRADE MARK

See DEAN (*Oil*).

DEBING'S/PILE REMEDY// PHILA. PA.

Adv. 1873, *VSS & R*; 1923, *SF & PD*.

Aqua; 4⅞″ × 1⁹/₁₆″ × ⅞″; 9n; 3b; 3ip; v, fs.

GERMAN FIR COUGH CURE/ DILLARD REMEDY CO./ EAST BANGOR, PA. [Base:] 225A

See GERMAN FIR (*Cure*).

DR. DRAKES//CROUP REMEDY

[Base: I in diamond]
Bottle manufactured by the Illinois Glass Co., 1916 to 1929 (Toulouse 1972).

Clear; 6⅜″ × 2″ × 1¹/₁₆″; 1n; sp; 3b; 2ip; v, ss; ABM. See next entry.

DR. DRAKE'S/GERMAN/CROUP REMEDY//THE GLESSNER MED. CO.//FINDLAY, OHIO

The Glessner Medicine Company, Findlay, OH, was established in 1889 by Lernard C. Glessner; the company went out of business in 1962 (Wilson and Wilson 1971). Croup Remedy adv. 1899 (Devner 1968); 1941–42, *AD*; Dr. Drake's For Children adv. 1948 by

Glessner Co., 230 E. Sandusky St., Findlay, O., *AD*; Dr. Drake's Children's Cough Syrup adv. 1983 by Alvin Last, Inc., Dobbs Ferry, NY, *RB*.

Aqua; 6³/₈″ × 2¹/₈″ × 1¹/₄″; 7n, sp; 3b; 4ip, arched front; v, fss.

DR. DUNCAN'S//EXPECTORANT/ REMEDY

See DUNCAN *(Expectorant)*.

F. E. C./KIDNEY REMEDY/ ROCHESTER, N.Y. U.S.A.

Adv. 1887, *WHS*; 1910, *AD*.

Clear; 8¹/₂″ × 3″ × 2¹/₈″; 7 or 9n; rect.; pl; v.

Dᴿ M. M. FENNERS/PEOPLES REMEDIES//FREDONIA, N.Y.// U.S.A. 1872-1898.

Milton M. Fenner established a medical practice in Fredonia, NY, in 1869 and introduced his "Remedies" ca. 1872. Milton died in 1905 and was succeeded by his son Jr. (Wilson and Wilson 1971). Sometime in the early 1910s or 1920s the Fenner formulas were acquired by S. C. Wells & Co., LeRoy, NY; the Wells bottles apparently retained the Fenner embossing but many were threaded or capped, and were ABM. Adv. 1948, *AD*.

Aqua, clear; 5³/₄″ × 1¹⁵/₁₆″ × ¹⁵/₁₆″, also 7³/₄″ × 2¹/₄″ × 1¹/₄″; 11n; 3b; 4ip; v, fss. See CAPITOL (Bitters), FENNER (Cure, Medicine, Miscellaneous, Specific), WELLS (Company).

Dᴿ M. M. FENNER'S/PEOPLES REMEDIES/FREDONIA N.Y./ U.S.A./KIDNEY & BACKACHE/ CURE/1872-1898

Amber; 8¹/₂″ × 2⁵/₁₆″ × ?, also 10″ × 3⁵/₈″ × 1⁷/₈″; 11n; 12b; pl; h. See CAPITOL (Bitters), FENNER (Cure, Medicine, Miscellaneous, Specific).

8 FL. OZ./Dᴿ M. M. FENNER'S/ PEOPLES REMEDIES/FREDONIA, N.Y./U.S.A./KIDNEY & BACKACHE/REMEDY/1872-1898

Label: *Dr. FENNER'S KIDNEY & BACKACHE MEDICINE, Alcohol 13%, Compounded by S. C. Wells & Co., LeRoy N.Y., Successors to M. M. Fenner Co.*

Amber, aqua, clear; 8⁵/₈″ × 2⁷/₈″ × 1¹/₂″, also 10″ high variant; 11n; 12n; pl; h. See CAPITOL (Bitters), FENNER (Cure, Medicine, Miscellaneous, Specific).

Dᴿ FITLER'S//RHEUMATIC/ REMEDY//PHILADᴬ

Joseph P. Fitler became a medical practitioner in Philadelphia, PA, about 1837; it is believed that his son, James P. Fitler, who joined his father in the 1850s, was responsible for the wide-

spread distribution of the medicinals (Wilson and Wilson 1971). Baldwin (1973) provides an 1873 reference to Fitler's Rheumatic Syrup as being a speciality for 39 years. Remedy adv. 1871, *WHS*, undoubtedly earlier; 1910, *AD*.

Aqua; 6⁵/₈″ × 2¹/₂″ × 1³/₈″; 1n; 3b; 3 or 4ip; v, sfs.

Dᴿ FITLER'S//RHEUMATIC/ REMEDY//PHILAD

Bottle manufactured ca. 1870 (Wilson and Wilson 1971).

Clear; 6³/₄″ × ? × ?; 7n; 3b; pl; v, sfs.

DR FLINT'S/REMEDY/ MACK DRUG CO PROP'S/ NEW YORK

Bottle manufactured ca. 1878. A product of Julius Mack, New York, NY, and San Francisco, CA, introduced in the late 1860s (Wilson and Wilson 1971). Adv. 1910, *AD*.

Amber; 7¹/₂″ × ? × ?; 7n; 6b; pl; v. See INDIAN *(Sarsaparilla)*, MACK (Company).

DR. A. E. FLINT'S/HEART REMEDY//J. J. MACK & CO., PROP'S/SAN FRANCISCO

Bottle manufactured ca. 1885 (Wilson and Wilson 1971).

Amber; 7¹/₂″ × 3″ × 1⁵/₈″; 9n; 6b; pl; v. See INDIAN *(Sarsaparilla)*, MACK (Company).

FULTON'S/RADICAL REMEDY// SURE KIDNEY, LIVER AND DYSPEPSIA CURE

See FULTON *(Cure)*.

GLOVER'S/IMPERIAL DISTEMPER REMEDY/H. CLAY GLOVER/ NEW YORK

Amber, teal; 5″ × 2″ × 1¹/₄″; 1n; 3b; pl; v. See GLOVER (Company, *Cure*, Medicine).

Dᴿ GOODALE'S//AMERICAN// CATARRH/REMEDY

R. Goodale, MD, had offices located in New York City and Boston in 1858. Adv. 22 June 1858, *Harper's Weekly*; 1910, *AD*.

Aqua; dimens. unk.; 11n; 3b; 3 or 4ip; v, ssf; p.

Greenhalgh Remedy Co./28 EAST FOURTH SOUTH/SALT LAKE CITY

The Greenhalgh Remedy Co., 28 E. Fourth South, Salt Lake City, UT, was established by Dr. Peter Greenhalgh, apparently in 1905. In 1921 the address was changed to 30 E. 4th So.; by 1940 the company was called Greenhalgh Remedies. Peter was succeeded, in the

1930s, by a series of presidents including his wife, Jeannette. The firm went out of business ca. 1948, according to R. L. Polk & Co's Salt Lake City directories.

Clear; 5¹/₄″ × 1⁵/₈″ × 1⁵/₈″; 3n; 2b; pl; v.

GREENHALGH'S/BLOOD PURIFIER/PREPARED BY/ GREENHALGH REMEDY CO./ SALT LAKE CITY, UTAH

Clear; 8″ × 3″ × 2″; 3n; 17b; pl; h.

GUARANTY/RHEUMATIC REMEDY/COMPANY

Adv. 1910, *AD*.

Amber; 7¹/₄″ × 2³/₄″ × 1¹/₄″; 7 or 9n; rect.; pl; v.

GUN WA'S/CHINESE REMEDY// WARRANTED/ENTIRELY VEGETABLE/AND HARMLESS

An herbal sage tea remedy out of Denver, CO, produced ca. 1890s (source unk.).

Amber; 7³/₄″ × 2³/₁₆″ × 2³/₁₆″; 12n; 2b; pl; v, fb. Also variants in smoky gray, brown and olive and other sizes.

DOCT. P. HALL'S/CATARRH REMEDY/ERIE. PENN.

[See Photo 65]

Advertisement, 1848: "BEWARE OF COUNTERFEITS AND BASE IMITATIONS–Every bottle has the words 'Dr. P. Hall's Cough Remedy' blown upon the glass . . . " (Singer 1982). Later vessels substituted CATARRH for COUGH. Adv. 1935 by Dr. P. Hall, Erie, Pa., *AD*.

Clear; 2¹/₂″ × 1³/₈″ × 1³/₈″; 7n; 2b; pl; v.

HARPER/HEADACHE REMEDY/ WASHINGTON D.C.

Clear; 4⁷/₈″ × 1³/₄″ × ⁷/₈″, also 6¹/₄″ × 2″ × 1³/₁₆″; 7n; 3b; 3ip, oval front; v. See HARPER *(Miscellaneous)*.

T. W. HARPER'S/COUGH/REMEDY

Adv. 1834 (Putnam 1968); 1891, *WHS*.

Aqua; 4″ × ?; 5n; 20b; pl; v; p.

DR HARTS//RHEUMATIC/ REMEDY//BUFFALO N.Y.

Directories establish Gilbert W. Klock as a manufacturer of patent medicines by 1885; by 1894 Klock was listed as the manager of Hart's Rheumatic Remedy; the 1917 directory mentioned Klock as a manufacturer of medicines. Adv. 1891, *WHS*; 1910, *AD*.

Aqua; 7″ × 2⁵/₈″ × 1¹/₂″; 7n, sp; 3 or 6b; 3 or 4ip; v, sfs. See HART (Cure).

GUARANTEED CURE/HENRY'S/ RED GUM/COUGH/REMEDY
Clear; 5½" × 2⅛" × 1⅜"; 9n; 10b; pl; v.

HENRY'S RED GUM/THE GREAT/ COUGH REMEDY
Clear; 5¼" × 2¼" × 1¼"; 7n; 3 or 6b; ip; v.

REV. T. HILL'S/VEGETABLE/ REMEDY
Green; dimens. unk.; 11n; 12b; pl; v; p.

HILMER'S/POPULAR REMEDY/ SAN FRANCISCO
San Francisco directories included Louis Hilmer in the apothecary, drug and chemical business from 1872 to 1876.
Aqua; 7¼" × ? × ?; 7n; 3b; 3 or 4ip; v.

HITE'S PAIN REMEDY/FOR MAN AND ANIMALS/ROANOKE, VA.
Label: *HITE'S PAIN REMEDY, Alcohol 65%. Can be used for Pains, Summer Complaint, Head & Toothache, Cramps, Coughs, Colds, Bronchitis, Sore Throat, Neuralgia, and Similar Ailments, Also for Cuts, Burns, and Sprains on Man and Animal; Colic in People, Horses and Cattle, Gape's and Cholera in Fowls. Prepared by S. P. HITE CO., Inc., ROANOKE, Va.* Hite also manufactured a pain cure, blood purifier, kidney pills and a liver regulator. The company was located in Staunton, VA, and moved after 1900 to Roanoke, VA. Hite's Pain Remedy adv. 1929–30 and 1935, *AD*; Hite's Household Remedy, 1941–42, *AD*.
Clear; 5¾" × 2" × 1"; 8n; 3b; 4ip, oval embossed panel; v. See HITE *(Cure).*

W. E. HOUCK REMEDY CO.// SEDALIA MO.//DR. F. A. WOOD'S/ SARSAPARILLA
See F. WOOD *(Sarsaparilla).*

DR. HOXSIE'S//CERTAIN CROUP REMEDY//BUFFALO, N.Y.
Clear; 4¼" × 1¾" × 1"; 9n; 3b; 3ip; v, sfs. See HOXSIE *(Cure).*

HUNT'S REMEDY// WM E. CLARKE/PHARMACIST/ PROVIDENCE. R.I.// HUNT'S REMEDY
Label: *HUNTS REMEDY for Dropsy and All Diseases of the Kidneys, Bladder and Urinary Organs. William E. Clarke, Sole Prop., Providence, R. I., U.S.A.* William E. Clarke acquired the formula from Dr. David Hosack, a noted New York physician in 1872, the medicine suppos-

edly saved the life of Clarke. After Clarke's death either in late 1880 or early 1881, the business was named the Hunt's Remedy Company (Holcombe 1979). Adv. 1923, *SF & PD.*
Aqua; 7¼" × 2¾" × 1¾"; 7n; 3b; 3 or 4ip; v, sfs.

KA:TON:KA//THE GREAT INDIAN REMEDY
From a trade card advertisement: "KA-TON-KA, the Great Indian Medicine for the Blood, Liver, Kidneys and Stomach. Cures all diseases of the Stomach, Liver, Bowels, Skin and Blood. KA-TON-KA is a Remedy of the Pacific Coast . . . composed of Roots, Herbs, and Barks Gathered and Prepared by the Warm Spring Indians of Oregon. OREGON INDIAN MEDICINE CO., Corry, Pa." Augustus Edwards established the company in Pittsburgh, PA, in 1876 and moved to Corry, PA, in 1883. Ka:Ton:Ka was introduced in 1876 (Greenfield 1975); adv. 1918 (Devner 1968).
Clear; 8¾" × 2⅞" × 1⅝"; 11n; 3b; ip; v, ss. See INDIAN (Syrup), MODOC (Oil).

[h] D/L.E.K./THE Keeley/Cure/[d] DRUNKENESS/[h] A/RELIABLE/ REMEDY/DISCOVERED BY/ DR. L.E. KEELEY/DWIGHT, ILL.// [shoulder:] K. C. [script:] Leslie E. Keeley M. D.
See KEELEY *(Cure).*

[h]L.E.K./THE KEELEY/REMEDY/ [d] NEUROTINE/[h] DISCOVERED/ BY/DR. L. E. KEELEY/DWIGHT, ILL.// [shoulder:] K. C. [script:] Leslie E. Keeley
Clear; 5⅝" × 3⅛" × 1⅞"; 7n, with pour spout; unique patented shape; pl; h, d, fb, some script, embossed N on shoulder. See KEELEY (Company, *Cure).*

[h] Dr/L E KEELEY'S/DOUBLE/ CHLORIDE/OF/[d] GOLD CURE/ FOR/DRUNKENNESS/[h] A/ TESTED/AND/INFALLIBLE/ REMEDY/DISCOVERED BY/ DR. L. E. KEELEY/DWIGHT, ILL.// [shoulder:] K. C. [script:] Leslie E. Keeley M. D.
See KEELEY *(Cure).*

[h] L.E.K./THE Keeley/Remedy/[d] TOBACCO HABIT/[h] DISCOVERED/BY/DR. L. E. KEELEY/DWIGHT, ILL.//[shoulder:] K. C. [script:] Leslie E. Keeley M. D.

Clear; 5¾" × 2¹³⁄₁₆" × 1⁷⁄₁₆"; 9n, with pour spout; unique patented shape; pl; h, d, fb, some script. See KEELEY (Company, *Cure).*

D͟R D. C. KELLINGER'S// REMEDIES//NEW YORK
Remedies adv. 1854, 1855 (Baldwin 1973).
Aqua; 7" × 2³⁄₁₆" × 2³⁄₁₆"; 11n; 1b; 3ip; v, fss, p. See KELLINGER *(Miscellaneous).*

DR. D. KENNEDY'S/FAVORITE REMEDY/KINGSTON N.Y. U.S.A.
David Kennedy of Kingston/Rondout Village (absorbed by Kingston), was listed in Child's *1871–72 Gazetteer & Business Directory of Ulster County, N.Y.,* as an Allo. Physician; in 1879 as a manufacturer of medicines, *VSS & C;* also in 1917 (Blasi 1974). Favorite Remedy adv. 1879, *VSS & C;* 1929–30 and 1935 by Troy Chemical Co., Binghamton, N.Y.; 1948 by The R. F. Clements Co., 507 E. Main St., Little Falls, N.Y., *AD.*
Clear, aqua; 7⅛" × 2½" × 1½", also 8½" × 2¾" × 1¾"; 1n; 3b; 3ip; v. See KENNEDY (Balsam).

DR. KILMER'S/FEMALE/ REMEDY/BINGHAMTON NY
Label: *Dr. KILMER'S FEMALE REMEDY, The Great Blood Purifier and System Regulator. The Only Herbal Alterative and Depurative Ever Discovered. Specially Adapted to Female Constitutions. . . .* Bottle manufactured ca. 1895 (Wilson and Wilson 1971). Adv. late 1870s (Holcombe 1971); 1923, *SF & PD.* Dr. Andral Kilmer established his manufactury in Binghamton, NY, in the mid 1870s (Holcombe 1979; Wilson and Wilson 1979). Andral was joined by his brother Jonas in 1878; Jonas became an equal partner in 1881. The Swamp-Root, the most popular and famous of the Kilmer medicines, was distributed locally until Willis Sharpe Kilmer, Jonas's son, began extensive promotion in 1888 (Holcombe 1979). By 1892, Jonas had purchased Andral's interests in the company (Wilson and Wilson 1971). In 1895 the company was manufacturing 18 different herbal medicines plus their own bottles and corks. Willis became president in 1924 (Bernardin 1975). With the death of Willis, date unknown, the company's assets were sold to Diebold Products Inc., Stamford, CT (McEwen 1977).
Aqua; 8⅝" × 2¾" × 1⅝"; 1n; 3b; 3ip, arched embossed panel; v. See KILMER (Cure, Extract, Miscellaneous, Ointment).

SAMPLE BOTTLE/DR. KILMER'S/ SWAMP-ROOT KIDNEY/REMEDY/ BINGHAMTON, N.Y.
Introduced in 1881 (Holcombe 1979). Adv. 1985 by Medtech Labs., Cody, WY.
Aqua; 4¼″ × 1″ diameter; 7n; 20b; pl; v. See KILMER (Cure, Extract, Miscellaneous, Ointment).

THE GREAT/[in indented kidney:] DR./KILMER'S/SWAMP-/ROOT/ KIDNEY/LIVER &/BLADDER/ REMEDY//BINGHAMTON, N.Y.
[See Photo 66]
Aqua; 8″ × 2⅞″ × 1¹³⁄₁₆″; 1n; 3b; 6ip, 2ip on front, plus indented kidney; h, f; v, s. See KILMER (Cure, Extract, Miscellaneous, Ointment).

DR. KILMER & CO//THE BLOOD/ [in indented heart:] DR. KILMER'S/ OCEAN WEED/HEART/REMEDY/ [below heart in panel:] SPECIFIC// BINGHAMTON, N.Y.
Adv. 1887, WHS; 1921, BD; as a medicine rather than remedy in 1925, BWD.
Aqua; 8½″ × 2⅞″ × 1¾″; 1n; 3b; 6ip, 2ip on front, plus indented heart; v, s; h, f; v, s. See KILMER (Cure, Extract, Miscellaneous, Ointment).

[h, arched:] DR. KILMER'S/[v] OCEAN-WEED/HEART REMEDY/ [h, arched:] BINGHAMTON/[h] N.Y. U.S.A.
Aqua; 7⅛″ × 2⅜″ × 1⅜″; 1n; 3b; 4ip; h, v. See KILMER (Cure, Extract, Miscellaneous, Ointment).

TRADE MARK/DR. KOCH'S/ REMEDIES/EXTRACTS & SPICES// DR KOCH VEG. TEA CO// WINONA, MINN.
Bottle manufactured ca. 1900. Products adv. 1900, EBB; 1907, PVS & S.
Clear; 9″ × ? × ?; 7n; 3b; ip; v, fss.

DR. KOCHS/TRADE MARK/ REMEDIES/PURELY VEGETABLE// DR. KOCH VEGETABLE TEA CO.// WINONA, MINN.
Clear; 9¾″ × 3¼″ × 1⅝″; 7n; 3b; ip; front oval; v, fss.

LACTOPEPTINE//THE BEST/ REMEDIAL AGENT IN ALL/ DIGESTIVE DISORDERS//THE NEW YORK PHARMACAL ASSOCIATION
Cobalt; 8″ × 2¾″ × 2¾″; 7n; 1b; 3 or 4ip; v, sfs. See ARLINGTON (Chemical), LACTOPEPTINE (Miscellaneous), PEPTENZYME (Miscellaneous), REED & CARNRICK (Oil).

TRIAL BOTTLE/LE GRANDE'S/ ARABIAN/CATARRH REMEDY// J. A. LAWRENCE//NEW YORK
Aqua; 6½″ × 2½″ × 1½″; 1n; 6b; 3ip, front oval; v, fss.

LIEBIG'S FIT CURE/AN/ENGLISH REMEDY/DR. AB. MESEROLE/ 96 JOHN ST. NEW YORK
See LIEBIG (Cure).

LOCHER'S RENOWNED/ RHEUMATIC REMEDY/ LANCASTER, P.A.
Product of Locher & Wenger Co., Lancaster, PA, adv. 1900, EBB; 1901 by Locher's Drug Store, Lincoln I. Wenger, Mngr. in the Lancaster city directory; 1916 (Devner 1968).
Aqua; 4″ × 1⅜″ × ⅞″; 7n; 3 or 6b; ip; v.

LOG CABIN//COUGH AND CONSUMPTION//REMEDY [Base:] SEPT. 6 1887
Adv. 1889, PVS & S; 1897, L & M.
Amber; 9″ × 3⅛″ × 1½″; 20n; unique patented shape, flat back with 3ip on front; v, cfc, base. See LOG CABIN (Extract, Sarsaparilla), H. WARNER (Bitters, Company, Cure, Nervine, Remedy).

LOG CABIN//HOPS AND BUCHU// REMEDY/ [Base:] SEPT 6, 1887
Adv. 1889, PVS & S; 1896–97, Mack.
Amber; 10″ × 3½″ × 1⅞″; 20n; unique patented shape, flat back with 3ip on front; v, cfc, base. See LOG CABIN (Extract, Sarsaparilla), H. WARNER (Bitters, Company, Cure, Nervine, Remedy).

LUCKY TIGER/REMEDY CO./ KANSAS CITY, MO.//LUCKY TIGER/FOR SCALP/ECZEMA & DANDRUFF [Base: N in square]
See LUCKY TIGER (Company).

MATHEWSON'S//HORSE// REMEDY//PRICE 50 CTS
Aqua; 6⅝″ × 2¼″ × 1⅜″; 1n; 3b; 4ip; v, fsbs. Also 8¼″ high variant with PRICE 1 DOLLAR.

MAYR'S WONDERFUL/REMEDY/ CHICAGO, U.S.A. [Base: I in diamond]
Label: *MAYR'S WONDERFUL REMEDY for Ailments such as Gastric Dyspepsia and Resulting Indigestion. . . .* Bottle manufactured by the Illinois Glass Co. 1916 to 1929 (Toulouse 1972). Adv. 1880s (Devner 1968); 1929–30 by O. H. Jadwin & Sons Inc., New York City; as Mayr's, 1948 by Berosol Products, Rockaway Beach, L.I., N.Y., AD.
Clear; 6¼″ × 2″ × 1⅛″; 7n; 6b; 1ip; v.

MAYRS WONDERFUL/ STOMACH REMEDY/CHICAGO
Clear; 6¼″ × 2¹⁄₁₆″ × 1⁹⁄₁₆″; 7n; 6b; 1ip; v.

MOORE'S/REVEALED [shield and monogram] /REMEDY
Products of H. H. Moore, Stockton, CA, included Arkansas Liver & Kidney Remedy, Syrup, Essence of Life and Red Skin Liniment. Remedy adv. 1895, PVS & S; 1923, SF & PD.
Amber; 9″ × ? × ?; 7n; 8b; pl; h. See H. H. H. (Medicine), WILLIAMS (Balsam).

MUNYON'S/HOMOEOPATHIC/ HOME REMEDIES
Munyon's Remedies adv. 1895, McK & R. Munyon's Homoeopathic Remedies adv. 1896–97, Mack; 1929–30 by Munyon Remedy Co., 1821 No. Main St., Scranton, Pa., AD. Munyon's Preparations adv. 1941–42, AD.
Clear; 3½″ × 1½″ × ¾″; 3n; 18b; pl; v. See MUNYON (Cure, Miscellaneous).

MURINE EYE REMEDY/CHICAGO, U.S.A. [Base:] H [See Figure 215]
Adv. 1892 (Devner 1968); 1985 by Abbott Labs., Chicago, Ill.
Clear; 3⅝″ × ¹³⁄₁₆″ diameter; 7n; 20b; pl; v.

Fig. 215

MURINE/EYE REMEDY/ CO. CHICAGO. [Base:] P
Clear; 3⁷⁄₁₆″ × ¹³⁄₁₆″ diameter; 7n; 20b; pl; v.

MURINE EYE REMEDY CO./ CHICAGO [Base:] WT & CO./U.S.A.
Bottle manufactured by the Whitall-Tatum Glass Co., 1857 to 1935 (Toulouse 1972).
Milk glass; 3⅛″ × 1⅜″ × ¹⁵⁄₁₆″; 9n; 3b; pl;.v; ABM.

MURINE/EYE/REMEDY CO./ CHICAGO, U.S.A.
Clear; 3¾″ × ?; 7n; 20b; pl; v; ABM.

MYSTERIOUS PAIN CURE/ A SCOTCH REMEDY [Base:] 325
See MYSTERIOUS (Cure).

NATIONAL REMEDY/COMPANY/ NEW YORK [See Figure 216]
Label: *EN-AR-CO (Formerly Japanese Oil). A Cure For Man or Beast. For Bunions, Lock Jaw, Snake Bite. . . . National Remedy Co., New York.* Bottle manufactured ca. 1910. The National Remedy Co., Inc., New York, NY, was established in 1884, according to a *Western Druggist* circular, January 1904. Old Reliable Japanese Oil adv. ca. 1884, 1890s. En-Ar-Co adv. 1904, *Western Druggist*, Jan. 1904; 1974, product of Universal Drug Products, Ridgefield, NJ (White 1974).
Aqua; 5³/₈″ × 5⁷/₁₆″ × ¹⁵/₁₆″; 8n; 3b; 3ip; v. Also ABM variant with 16n.

Fig. 216

[h] NAU'S/[d] DYSPEPSIA/[h] REMEDY
Adv. 1915, 1923, *SF & PD*.
Amber; 5″ × 2¹/₁₆″ × 1⁵/₁₆″; 9n; 3b; pl; h, d. See NAU'S (Cure).

NELATION REMEDY CO./ BALTIMORE, MD.
See NELATION (*Company*).

THE NU-TO-NA REMEDY CO// BINGHAMTON, N.Y.//NU/TO/NA/ THE GREAT/SYSTEM/BUILDER
Adv. 1910, *AD*.
Aqua; 8¹/₂″ × 3″ × 1³/₄″; 1n; 3 or 6b; 3 or 4ip; v, ss; h, f.

OSAGE INDIAN REMEDY./ MAKES SICK PEOPLE WELL/ MAKES WEAK PEOPLE STRONG.
Product of the Osage Indian Medicine Co., Lyons, NY, 1890s.
Clear; 8¹/₄″ × 3¹/₄″ × 1¹/₂″; 3n; 11 or 13b; pl; v.

PACKARDS//SCROFULA/ REMEDY//ROME, N.Y.
Label: *. . . Cures everything, the best Tonic ever offered to the public.* Giles C. Packard, established his business in

Rome, NY, in 1867 (Baldwin 1973); by 1878–79 directories for Syracuse, NY, included the firm; in 1900, Juliet B. Packard, Syracuse, NY, was listed as the manufacturer, *EBB*. Adv. 1871 (Baldwin 1973); 1910, *AD*.
Aqua; 9″ × 3¹/₂″ × 2″; 7n; 3b; 3 or 4ip; v, sfs.

PARDEE'S//RHEUMATIC REMEDY
A product of the Pardee Medicine Co., Rochester, NY. Adv. 1887, *WHS*; 1921, *BD*.
Aqua; 8¹/₂″ × 2³/₄″ × 1³/₄″; 1n; 3b; 3 or 4ip; v, ss.

DR. PAREIRA'S//ITALIAN/ REMEDY
Bottle manufactured ca. 1858. Jonothan Pereira was a European physician who settled in England and wrote several books on materia medica in the 1850s; he died in 1860. Apparently a New York medicinal formulator marketed some of Pareira's products including this one for venereal disease (Wilson and Wilson 1971). Adv. 1855 (Baldwin 1973).
Aqua; 5³/₈″ × 2¹/₈″ × 1¹/₄″; 11n; 3b; pl; v, fb; p.

PECKHAM'S CROUP REMEDY/ THE CHILDREN'S COUGH CURE
A product of H. C. Peckham, Freeport, MI. Adv. 1889, *PVS & S*; 1948 by Peckham Remedy Co., 1328 South Jefferson St., Hastings, Mich., *AD*. Other products adv. 1870s (Devner 1968).
Clear; 6¹/₄″ × 2″ × 1¹/₈″; 11n; 6b; 3ip; v.

PECKHAM'S/REMEDIES
Label: *PECKHAM'S REMEDY—Alcohol Two Per Cent. A Medicine for Children's Coughs and Colds. Formerly Called Peckham's Croup Remedy. Prepared Only By Peckham Remedy Co., Freeport, Mich., U.S.A.*
Clear; 6″ × 2″ × 1″; 11n; 3b; 3ip; v.

PROF. W. H. PEEKE'S/REMEDY/ NEW YORK
Remedy for fits and epilepsy, introduced in the 1890s; name changed to Infallible Remedy after 1900 (Wilson and Wilson 1971). Prof. W. H. Peeke's Remedy adv. 1893 (Devner 1968); Infallible Remedy adv. 1912, 1916 (Devner 1968).
Amber; 8″ × 2¹/₂″ × 2¹/₂″; 7n; 2b; pl; v.

PERUVIANA/NATURES KIDNEY CURE/PERUVIANA HERBAL

REMEDY CO./CINCINNATI, OHIO.
See PERUVIANA (*Cure*).

DR. RICHAUS/GOLDEN REMEDIES//D. B. RICHARDS// SOLE PROPRIETOR
Universal container for products such as Dr. Richau's Golden Elixir. Adv. 1870 (Baldwin 1973), and 1900, *EBB*. Other products were Golden Antidote and a Balsam, Nos. 1 and 2.
Aqua; 6³/₈″ × 2³/₈″ × 1¹/₄″; 6n, modified; 3b; 4ip; v, fss.

ROSEWOOD/DANDRUFF REMEDY/THE J R REEVES CO./ ANDERSON, IND.
See REEVES (*Company*).

JOHN STERLING/ROYAL REMEDY CO./KANSAS CITY, MO. [Base:] W.T. & Co.
Label: *Sterling's Royal Remedy. . . .* Bottle manufactured by Whitall-Tatum, 1857 to 1935 (Toulouse 1972). Adv. 1889, *PVS & S*; 1921, *BD*.
Clear; 6¹/₄″ × 2⁵/₈″ × 1¹¹/₁₆″; 9n; 3b; pl; v.

RUBY REMEDY/THAT CURES/ TEASPOONFULS.
Clear; 4⁷/₈″ × 1″ diameter; 7n; 20b; recessed sides at base; pl; v; sides with 11 graduated lines.

Dᴿ SAGE'S//CATARRH/REMEDY// Dᴿ PIERCE/PROPR//BUFFALO
Product of Dr. R. V. Pierce, Buffalo, NY. Adv. 1869 (Baldwin 1973); 1941–42 by Pierce's Proprietaries, Inc., Buffalo, N.Y., *AD*.
Clear; 2¹/₄″ × 1³/₈″ × ⁷/₈″; 7n; 3b; 4ip; v, sfbs. See PIERCE (*Discovery, Extract*, Miscellaneous, *Tablet*).

DR SANFORD'S//INVIGORATOR/ OR/LIVER REMEDY
See SANFORD (*Invigorator*).

SCARLESS REMEDY CO./ WINTERSET, IA.
See SCARLESS (*Company*).

SECURITY REMEDY CO./ MINNEAPOLIS, MINN.// ANTISEPTIC HEALER 50 CENTS// ANTISEPTIC HEALER 50 CENTS [Base:] B 96
See SECURITY (*Company*).

Dr SHILOH'S//CATARRH// REMEDY//S. C. WELLS/& CO/ LEROY, N.Y.
Adv. 1879, *VSS & C*; 1929–30, *AD*.
Aqua; 2¹/₈″ × 1¹/₄″ × 1¹/₄″; 7n; 2b; pl; v, fsbs. See PARK (Cure, Syrup), SHILOH (*Cure*, Miscellaneous), WELLS (Company).

SMITH'S/GREEN MOUNTAIN/ RENOVATOR//REMEDY COMPANY//ST. ALBANS, VT.
Label: . . . *a vegetable preparation and sure cure for Scrofula, Erysipelas, Tumors, Fever Sores, White Swelling, Heart Disease, Syphilis and all Ulcerous, Cutaneous and Cancerous Affections and Diseases Arising from Impure Blood.* . . . Bottle manufactured ca. 1898–1905. Silas Smith, East Georgia, VT, began the manufacture of the renovator ca. 1854. Ransom J. Smith succeeded his father in 1881. The firm was moved to St. Albans in 1897 and the formula sold to the St. Albans Remedy Company in 1898; the latter firm went out of business in 1905 (Fritschel 1976). The successor is unknown but the product was being sold in 1910, *AD*.
Amber; $8^{3}/_{4}'' \times 3'' \times 1^{7}/_{8}''$, also $7^{1}/_{2}''$ height; 1n; 3b; 4ip, arched front; v, fss. See S. SMITH (*Miscellaneous*).

DR. SOUTHWORTH'S/BLOOD & KIDNEY REMEDY/ LEONARDSVILLE, NY
Aqua; $8^{3}/_{4}'' \times 2^{3}/_{4}'' \times 1^{3}/_{4}''$; 7n; 3 or 6b; ip; v.

THE SPEEDWAY REMEDY CO// SHELBY, OHIO [See Figure 217]
Clear; $6^{3}/_{4}'' \times 2^{1}/_{4}'' \times 1^{1}/_{4}''$; 1n; 3b; 2ip; v, ss.

Fig. 217

SYLVAN REMEDY CO./PEORIA, ILL.//REID'S/GERMAN COUGH/ &/KIDNEY CURE//NO DANGER FROM OVERDOSE//CONTAINS NO POISON
See REID (*Cure*).

TAYLORS CHEROKEE REMEDY/ OF/SWEET GUM & MULLEIN
A cough remedy, the product of Walter A. Taylor, Atlanta, GA. Adv. 1884 (Baldwin 1973); 1948 by R. G. Dunwody & Sons, 235 Forsythe St., Atlanta, Ga., *AD*.

Aqua; $4^{7}/_{8}'' \times 1^{3}/_{4}'' \times 7/_{8}''$; 7n, sp; 3b; ip, front oval; v. Also variant $5''$ high with 7n, no sp. See TAYLOR (*Miscellaneous*).

DR. THOMSON'S/COMPOUND EXTRACT/SARSAPARILLA
See THOMSON (*Sarsaparilla*).

DR. THOMSON'S/SARSAPARILLA/ GREAT ENGLISH REMEDY// ST. STEPHEN, N.B.//CALAIS, ME. U.S.A.
See THOMSON (*Sarsaparilla*).

UNIVERSAL/COUGH REMEDY// J. L. HUNNEWELL/& CO./ BOSTON, MASS
Introduced in 1840s (Wilson and Wilson 1971). Adv. 1910, *AD*.
Aqua; $4^{1}/_{8}'' \times 1^{3}/_{4}'' \times 1''$, also height of $6^{1}/_{4}''$; 5n; 3 or 6b; 2ip; v, fb. See HUNNEWELL (*Miscellaneous*).

[Embossed shield with:] **VT/R/ VALLEY/TAN/REMEDIES// C. E. JOHNSON//SALT LAKE CITY**
[Base:] MCC
Label: *KOL-KURA For Summer Complaints, Wind, Colic.* . . . Bottle manufactured by Wm. McCully, Pittsburgh, PA., 1832 to ca. 1886 (Toulouse 1972). Adv. 1900 by The Johnson Company, Salt Lake City, Ut., *EBB*; 1910, *AD*. The *Utah Gazetteer and Directory* for 1884 included the following reference: Valley Tan Remedies, Agent, Zion Cooperative Mercantile Institution.
Aqua; $6^{1}/_{4}'' \times 2^{1}/_{16}'' \times 1^{1}/_{4}''$; 1n; 3b; 4ip; h, f; v, ss. See JOHNSON (*Manufacturer*).

8OZ/WARNER'S/SAFE/REMEDY/ TRADE/MARK [on embossed safe]/ **ROCHESTER, N.Y.** [Base:] A
In 1906 the word REMEDY replaced CURE whenever used, the result of the Pure Food & Drug(s) Act (Holcombe 1979). By 1910 the word CURE returned, *AD*.
Amber; $7^{1}/_{4}'' \times 3'' \times 1^{1}/_{2}''$; 20n; 12b; pl; h. See LOG CABIN (Extract, Remedy, Sarsaparilla), H. WARNER (Bitters, Company, *Cure*, Nervine).

12½ FL. OZ./WARNER'S/SAFE/ REMEDIES CO./TRADE/MARK [on embossed safe]/**ROCHESTER, N.Y. U.S.A.** [Base:] 488
Amber, clear; $8^{15}/_{16}'' \times 3^{1}/_{4}'' \times 1^{5}/_{8}''$; 11n; 12b; pl; h. Clear variant has 489 on base. See LOG CABIN (Extract, Remedy, Sarsaparilla), H. WARNER (Bitters, Company, *Cure*, Nervine).

DR WARREN'S/PILE REMEDY// A. L. SCOVILL & CO/CINTI. & N.Y.
Adv. 1900, *EBB*; 1910, *AD*.
Aqua; $2^{1}/_{2}'' \times 2^{3}/_{4}''$ diameter; 6n; 20b; pl; v. See BAKER (*Miscellaneous*), BENNETT (Cure), HALL (*Balsam*), J. F. HENRY (*Company*), SCOVILL (*Company*, Syrup), WARREN (Cordial).

WILLSON'S/MONARCH/ REMEDIES/WILLSON BROS/ EDGERTON/WIS. U.S.A.
Products of Charles and Dexter Willson. Adv. 1882 (source unk.); 1968 (Wilson and Wilson 1971).
Aqua; $7^{1}/_{2}'' \times ? \times ?$; 1n; sp; 3 or 6b; 3ip; h. See WILLSON (Balsam).

WOLFSTIRN'S/RHEUMATIC & GOUT REMEDY/HOBOKEN, N.J.
[Base:] W.T. Co. U.S.A.
Bottle manufactured by Whitall-Tatum, 1857 to 1935 (Toulouse 1972). Adv. 1900, *EBB*; 1929–30 by Dr. L. Wolfstirn Estate, Hoboken, N.J.; 1941–42 by Mrs. J. Wolfstirn, 100 47th St., Union City, N.J., *AD*.
Aqua; dimens. unk.; 7n; 3b; ip; v.

ZOELLER'S/KIDNEY REMEDY// ZOELLER MEDICAL/MFG. CO./ PITTSBURGH, P.A., U.S.A.
See ZOELLER (*Company*).)

ZOELLER'S KIDNEY REMEDY// THE ZOELLER/MEDICAL CO./ PITTSBURGH, PA.
See ZOELLER (*Company*).

M^{RS} S. A. ALLEN'S//
WORLDS HAIR/RESTORER//
NEW YORK [Base:] V D & R
LONDON
Mrs. S. A. Allen's Worlds Hair Color Restorer, often confused with Zylo-Balsamum, was introduced ca. 1840 and adv. 1942 by Fougera & Co., New York (Holcombe 1979); Selah H. VanDuzer & Co. were general agents by 1860 and proprietors in 1861. In the mid 1870s, VanDuzer formed a subsidiary partnership with Reeve & Co., London, and by the 1890s they merged, VanDuzer in control. Bottles were first embossed ca. 1855; by 1890s were embossed: V. D. LONDON or V D & R LONDON (Holcombe 1979; Wilson and Wilson 1971).
Amber; 7¼″ × 2¾″ × 1⅞″; 1n; 3b; 3ip; v, sfs; 5 color variants. See MRS. ALLEN (Balsam, Miscellaneous), VAN DUZER (Jamaica Ginger).

"ASTOL"/HAIR/COLOUR/
RESTORER//EDWARDS
"HARLENE" L^{TD}
See ASTOL (Hair).

DR. BOCK'S RESTORATIVE
TONIC/MANUFACTURED BY/
S. H. WINSTEAD MEDICINE CO.
See BOCK (Tonic).

CERTAIN/CURE/PERMANENT/
BREWERS/LUNG/RESTORER
Adv. 1887, McK & R; 1900, EBB.
Amber; 7″ × ? × ?; ?n; rect.; h.

CERTAIN/CURE/PERMANENT/
BREWER'S/LUNG/RESTORER//
CURES BRONCHITIS//
CURES CONSUMPTION
Amber; 9¼″ × 3″ × 1½″; 1n; 3b; 3 or 4ip; h, f; v, ss.

C. BRINCKERHOFFS//HEALTH
RESTORATIVE//NEW YORK//
PRICE $1.00

Cornelius Brinkerhoff, New York, NY, established the Health Restorative Depot in 1840, and retired ca. 1850. Brinckerhoff's formulas were in use until the 1890s (Wilson and Wilson 1971); whether his restorative survived is unknown. Restorative adv. 1844 (Baldwin 1973); 1847 (Putnam 1968).
Olive; 7¼″ × 3⅛″ × 2″; 11n; 4b; pl; v, fssb, front and back embossing arched; p.

DR FAHRNEY'S/HEALTH/
RESTORER/HAGERSTOWN/MD
A cousin to Peter Fahrney, Daniel began marketing a Teething Syrup in 1872 and was producing eight to ten products by 1900; shortly thereafter the business was sold to the Victor Remedies Company (Wilson and Wilson 1971). Restorer adv. 1891, WHS; 1900, EBB.
Amber; 7⅛″ × 3½″ × 2⅜″; 7n; 11b, with square corners; pl; h. See FAHRNEY (Company).

6OZ. FARR'S/GRAY HAIR/
RESTORER/BOSTON/MASS
[See Photo 67]
Ingredients varied by bottle depending upon the color of hair desired. Adv. 1910, 1941–42 by Brookline Chemical Co., Boston, Mass., AD.
Amber; 5½″ × 2⁵⁄₁₆″ × 1½″; 9n; 3b; pl; d.

FISH'S/HAIR RESTORATIVE//
B. F. FISH//SAN FRANCISCO
Directories listed N. Mills, in 1861, as the manufacturer of Fish's Hair Restorative. In 1862 Norman S. Coon was the Perfumery and Agent for Fish's Hair Restorative, B. F. Fish was shown as operating Black Hawk Livery Stable. There were no references to the restorative after 1862.
Aqua; 7¼″ × 2¼″ × 1¾″; 7n; 3b; 4ip, arched; v, fss.

GLOBE/HAIR RESTORATIVE
AND DANDRUFF CURE/GLOBE
MFG. CO, GRINNELL, IA
Adv. 1907, PVS & S; 1910, AD.
Clear; 8″ × 2⅜″ × 1⅜″; 7n, sp; 3b; 4ip; v.

GREAT/REPUBLIC//HAIR//
RESTORATIVE
Aqua; 7⅝″ × 2½″ × 1⅜″; 11n; 3b; 3ip; v, fss.

[v] GREEN'S LUNG RESTORER/[d]
SANTA/[v] ABIE//ABIETINE
MEDICAL CO//OROVILLE,
CAL. U.S.A.

Green's Lung Restorer or Santa Abie adv. 1896–97, Mack; 1921, BD.
Aqua; 6″ × 2⅛″ × 1³⁄₁₆″; 1n; 3b; 3ip; v, d, fss. See ABIETINE (Balsam, Company).

THE/HAIR RESTORER
A Hair Restorative was adv. 1907, PVS & S; this may not be the same product as Hair Restorer.
Cobalt; 6⅞″ × 2⁷⁄₁₆″ × 1½″; 7n; 3b; 3ip; v.

HAMILTON'S/DANDRUFF/CURE/
& HAIR/RESTORATIVE
Clear; 9″ × 3¼″ × 1¹⁵⁄₁₆″; 24n; 10b; pl; h.

HOLMAN'S/NATURES GRAND/
RESTORATIVE//J. B. HOLMAN
PROP.//BOSTON MASS.
Two advertisements, 1850 and 1858, refer to a J. [Joshua] F. Holman; the initial B, on the embossing, may be a mistake. In 1858 the product claims to have been on the market for thirty years. "The sale has been immense, and without advertising in the papers" (Singer 1982). Directories included references from 1847 to 1859. The proprietors prior to 1847 are unknown.
Aqua; 7¼″ × 3¼″ × ?; 5 and 7n; 4b; pl; v, fss.

Dr HUNTINGTON.S//
COMPOUND RESTORATIVE/
SYRUP//TROY. N.Y.
See HUNTINGTON (Syrup).

INDIAN/RESTORATIVE/
BITTERS//D<u>R</u> GEO. PIERCE'S//
LOWELL, MASS.
See INDIAN (Bitters).

J. S. JENKINS//RESTAURATEUR//
PHILAD.^A
Aqua; 3⅝″ × 1¼″ × ¾″, also height of 4¾″; 5n; 3b; 1ip; v, sfs; p.

D^R STEPHEN JEWETT'S//
CELEBRATED HEALTH/
RESTORING BITTERS//
RINDGE, N.H.
See JEWETT (Bitters).

T. JONES/CORAL//HAIR/
RESTORATIVE
Product of T. Jones, 164 Washington St., San Francisco, CA. Adv. ca. 1856.
Aqua; 5″ × 2¹⁄₁₆″ × 1⅜″; 11n; 3b; pl; v, fb; p.

DR. KLINE'S GREAT//NERVE
RESTORER
Partial label: KLINE'S GREAT NERVE RESTORER – The Great Nerve Tonic and Sedative – Robert H. Kline, M.D., 931

Arch St., Philadelphia – $2.00 per bottle.
Kline also manufactured an Aromatic Cordial, Sarsaparilla, Solvent, Embrocation and Blood Purifier. Directories locate the Robert H. Kline Co., at 931 Arch St., Philadelphia, PA, in 1897, established from the estate of Robert H. Kline, a physician located at the same address. Kline was producing the restorer as early as 1880 (Baldwin 1973). The company was located in Philadelphia, 1897–1909; in New York City, 1890–1948; in Redbank, NJ, 1912–1935. Nerve Restorer adv. 1880 (Baldwin 1973), 1921, *BD*. Nerve & Epileptic Remedy adv. 1929–30, 1941–42, *AD*. Nerve Medicine adv. 1948, *AD*.
Aqua; 8¾″ × 3″ × 1¾″; 7n; 3b; 2ip; v, ss.

LOCKYER'S/SULPHUR/
HAIR RESTORER

An English preparation imported by E. Fougera. Adv. 1896–97, *Mack*; 1912, British Medical Association.
Aqua; 7½″ × 3³/₁₆″ × 1¾″; 11n; 15b; pl; v.

LONDON/HAIR RESTORER

Swayne's London Hair Color Restorer, adv. 1871, *WHS*; 1929–30 by James F. Ballard, Inc., 500 N. Second St., St. Louis, Mo., *AD*.
Aqua; 7³/₁₆″ × 2½″ × 1⁵/₁₆″; 7n; 23b; pl; v; sloping side shoulders.

DR. MILES'/RESTORATIVE/
BLOOD PURIFIER

See MILES *(Purifier)*.

DR. MILES'/RESTORATIVE/
NERVINE

See MILES *(Nervine)*.

DR. MILES'/RESTORATIVE
NERVINE//CURES ALL/NERVOUS
TROUBLE/SEE WRAPPER

See MILES *(Nervine)*.

DR. MILES/RESTORATIVE/TONIC

See MILES *(Tonic)*.

OLDRIDGES/BALM/
OF COLUMBIA//FOR RESTORING/
HAIR/PHILADELPHIA

See OLDRIDGE *(Balm)*.

OLDRIDGE'S/BALM/
OF COLUMBIA//FOR RESTORING/
HAIR/PHILADELPHIA/
ENLARG'D/1826

See OLDRIDGE *(Balm)*.

VAN'S MEXICAN HAIR
RESTORATIVE/MANUFACTURED

ONLY BY THE/MEXICAN
MEDICINE CO./CHICAGO, U.S.A.

See MEXICAN *(Company)*.

WHALEN'S/HAIR/RESTORATIVE/
AND/DANDRUFF/CURE

See WHALEN *(Cure)*.

PROFESSOR WOODS//
HAIR RESTORATIVE/DEPOTS//
Sᵀ LOUIS & NEW YORK

Product of Orlando J. Wood, St. Louis, MO, introduced ca. 1854; about the same time a branch office was located in New York City (Wilson and Wilson 1971). Products included a Restorative Cordial, Blood Purifier, and Oriental Sanative Liniment. Hair Restorative adv. 1862 (Putnam 1968); 1901, *HH & M*.
Aqua; 6¾″ × 2½″ × 1½″; 11n; 3b; 3ip; v, sfs; p. At least 3 pontiled variants.

PROFESSOR WOOD'S/
HAIR RESTORATIVE.//DEPOT,/
Sᵀ LOUIS, MO//AND NEW YORK

Aqua; 9¼″ × 3¾″ × 2¾″; 11n; 3b; pl; v, fss; p.

SARSAPARILLA

ADAMUR/GREEN PLANT/ SARSAPARILLA
Aqua; $8^3/4'' \times 3^1/8'' \times 1^3/4''$; 1n; 3 or 6b; 4ip, arched front; v.

AIMAR'S//SARSAPARILLA/&/ QUEEN'S DELIGHT// CHARLESTON S.C.
Label: *AIMAR'S SARRACENIA or Fly Trap Bitters. Prepared only by G. W. AIMAR & Co., Druggists & Apothecaries, Corner King & Vanderhorst Streets, Charleston, S.C.* George W. Aimar opened his drugstore in Charleston, SC, in 1852; the family was still operating the facility in 1969 (Shimko 1969). Sarsaparilla adv. 1857 (Ring 1980).
Aqua; $9^1/2'' \times 2^3/4'' \times 1^3/4''$; 1n; 3b; 3ip; v, sfs.

SARSAPARILLA & STILLINGIA/ GEO W. ALBERS/KNOXVILLE, TENN
Aqua; $8^1/8'' \times 3'' \times 1^5/8''$; 7n; rect.; 3ip, oval front; v.

ALBRIGHTS SARSAPARILLA/ PREPARED BY/C. W. ALBRIGHT. GRADUATE IN PHARMACY/ CENTRAL AVE & KOSSUTH ST. CAMDEN, N.J./100 DOSES– 50 CENTS
Aqua; $8'' \times 3'' \times 2''$; 7n; 3 or 6b; 4ip, arched front; v.

THE ALLEN/SARSAPARILLA CO//WOODFORDS//MAINE
Directories included The Allen Sarsaparilla Co., Woodfords, ME, manufacturers of patent medicines and sarsaparilla, in 1893–94 and 1895 with Herbert J. Allen, manager.
Aqua; $7^5/8'' \times 2^1/2'' \times 1^1/2''$, also $9^1/2'' \times 3^1/4'' \times 2''$; 1n; 3b; 3ip; v, ss.

ALLEN'S/SARSAPARILLA
Adv. 1899 (Shimko 1969); 1900 by Allen S. Olmstead, LeRoy, N.Y., *EBB*;

1910, *AD.* Other products were Brain Food, Bilious Physic, Chap Healer, Coca Iron Pills, Foot Ease, Lung Balsam, Root Beer, Soap Bark and Wormwood Ointment.
Aqua; $8^3/8'' \times 3^3/16'' \times 2^1/16''$; 7n; 18b; pl; v.

AYER'S//SARSAPARILLA
Label: *AYER'S SARSAPARILLA Contains the Medicinal Properties of Sarsaparilla Root, Yellow Dock Root, Licorice Root, Cinchona Bark, Buckthorn Bark, Burdock Root, Senna Leaves, Iodide, Potassium and other Valuable ingredients. Alcohol 18 per cent. The AYER COMPANY, Lowell, Mass., U.S.A.* Also 1860s label: *AYER'S Compound Concentrated Extract of SARSAPARILLA, For the Cure of Scrofula, or King's Evil, and all Scrofulas Affections, Eruptive and Cutaneous Diseases, such as St. Anthony's Fire, Rose, etc. An Alterative, for the Renovation of the Blood, and for Restoration of the Tone and Strength to the System debilitated by disease; hence it affords great protection from attacks that originate in changes of the Season, of Climate, and of Life. Prepared by Dr. J. C. AYER & CO., LOWELL, MASS. U.S.A. PRICE $1.00.* After 1906 the product was advertised as non-alcoholic. Sarsaparilla introduced in 1848; adv. 1941–42 by Ayer Co., Lowell, Mass., *AD.*
Aqua; $8^1/2'' \times 2^3/4'' \times 1^5/8''$; 1n; 3b; 4ip; v, ss; ABM. See AYER (*Cure,* Hair, Miscellaneous, Pectoral, Pills).

AYER'S//COMPOUND EXT// SARSAPARILLA//LOWELL/ MASS U.S.A.
Aqua; $8^1/2'' \times 2^{11}/16'' \times 1^{11}/16''$; 1n; 3b; 4ip; v, fssb. See AYER (*Cure,* Hair, Miscellaneous, Pectoral, Pills).

DR BAILY'S/SARSAPARILLA
Light green; $9'' \times 3'' \times 3''$; 11n; 2b; pl; v.

DR. IRA BAKER'S/HONDURAS/ SARSAPARILLA
Label: *Dr. Ira Baker's Compound Extract of Honduras Sarsaparilla For Purifying the Blood . . . Sole Manufacturers, The Owl Drug Co., 1128 Market St., San Francisco.* Another product was Dr. Ira Baker's Tar & Wild Cherry Cough Balsam. The Owl Drug Co. was established in 1892 (Shimko 1969). The 1128 Market St. location was destroyed by the 1906 earthquake and fire (Shimko 1969).
Aqua, green, clear, the clear was the most recent; $10^1/2'' \times 3^1/2'' \times 2''$; 7n; 3b; 4ip, front oval; v. See OWL (*Company*).

JOHN C. BAKER'S//COMPOUND// FLUID EXTRACT OF// SARSAPARILLA
Aqua; $6^3/4'' \times 2'' \times 2''$; 9n; 2b; 4ip; v, ssss. See BAKER (*Company*).

BALDWIN'S/SARSAPARILLA/ WEST STOCKBRIDGE, MASS.
Aqua; $9'' \times 2^1/8'' \times 1^3/4''$; 1n; 3b; 3ip, arched front; v.

DR. BELDING'S/SARSAPARILLA/ WILD CHERRY/MINNEAPOLIS, MINN.
Adv. 1916, *MB.*
Clear; $9'' \times ? \times ?$; 7n; 3 or 6b; ip; v. See BELDING (Remedy,) INTERNATIONAL (*Company*).

BELLS SARSAPARILLA/ A. M. ROBINSON. JR/ BANGOR, ME
Product of Alexander M. Robinson, Bangor, ME, introduced in 1885 (Wilson and Wilson 1971). Adv. 1910, *AD.* Robinson died in 1910 (Shimko 1969).
Aqua; $9^1/4'' \times 3'' \times 1^1/2''$; 1n; 3b; 3ip; v.

BIXBY'S SARSAPARILLA/BIXBY'S DRUG STORE/SANTA CRUZ CAL
[Base:] W.T. & Co.
Bottle manufactured by Whitall-Tatum, Millville, NJ, 1857 to 1935 (Toulouse 1972).
Aqua; dimens. unk.; 7n; 3 or 6b; ip; v.

BRISTOL'S//EXTRACT OF/ SARSAPARILLA//BUFFALO
A trade card showed the product was introduced ca. 1832. Adv. 1844 by Cyrenius C. Bristol, in the Buffalo city directory; 1918 by Lanman & Kemp, NY, Mfgrs. & Props. (Shimko 1969); 1935 by Lanman & Kemp, Barclay & Co., Inc., New York City, *AD.*
Aqua; $5^5/8'' \times 2^1/16'' \times 1^1/4''$; 11n; 3b; 3ip; v, sfs; p. See BARRY (*Hair*), MURRAY & LANMAN (*Water*).

BRISTOL'S//GENUINE/ SARSAPARILLA//NEW YORK
Aqua; $10^1/2'' \times 3^{13}/16'' \times 2^1/4''$; 11n; 3b; 3ip; v, sfs.

F BROWN BOSTON/ SARSAPARILLA/& TOMATO BITTERS
See F. BROWN (*Bitters*).

BROWN'S/SARSA/PARILLA//FOR THE KIDNEYS/LIVER AND BLOOD
Product of Ara Warren, Bangor, ME, trademarked, 1884 (Shimko 1969). Adv. 1910, *AD.*
Aqua; $9'' \times 3'' \times 1^3/4''$; 1n; 3b; 4ip, 3 on front; h, f; v, b.

A. H. BULL//EXTRACT OF/ SARSAPARILLA// HARTFORD, CONN.

Directories listed Albert H. Bull, Druggist, at 88 & 90 State St., Hartford, CT, from 1843 to 1851 (Shimko 1969). Sarsaparilla adv. 1865, *GG*; 1910, *AD*, proprietors unk.

Aqua; 7" × 2¼" × 1½"; 1n; 3 or 6b; 3ip, arched front; v, sfs; p. See PELLETIER *(Sarsaparilla)*.

JOHN BULL//EXTRACT OF/ SARSAPARILLA//LOUISVILLE, KY.

John Bull, a Louisville, KY, druggist in 1838, established various partnerships throughout the years. By 1876 the John Bull proprietories were under the management of the John Bull estate; in 1887 the business was sold to John D. Park (Shimko 1969; Wilson and Wilson 1971). Sarsaparilla adv. 1851 in the Louisville city directory; 1935 by John D. Park & Sons Co., Ltd., Cincinnati, O., *AD*.

Light blue; 9" × 3¾" × 2⅜"; 11n; 3b; 3ip; v, sfs. See J. BULL (Miscellaneous), GUYSOTT *(Sarsaparilla)*, J. SMITH (Miscellaneous).

BUSH'S/,S'MILAX/SARSAPARILLA

Possibly related to H. V. Bush, New York, NY; products included Magic Cream Liniment adv. 1852, and possibly Bush's Specific, for gonorrhoea, adv. 1848 (Baldwin 1973).

Aqua; 9¾" × 3¾" × 2½"; 14n, modified; 3b; ip, arched front; v; p.

BUTLER'S/SARSAPARILLA/ LOWELL, MASS

Aqua; 9" × 3½" × 2"; 1n; 12b; pl; v.

J. CALEGARIS/COMPOUND EXTRACT/SARSAPARILLA/ SAN FRANCISCO, CAL. [Base:] W. T. & CO

Bottle manufactured by Whitall-Tatum, Millville, NJ, 1857 to 1935 (Toulouse 1972).

Aqua; 8¾" × 2¾" × 1¹¹⁄₁₆"; 11n; 3b; 4ip; v.

CARL'S/SARSAPARILLA AND/ CELERY COMP.//AURORA, ILL// AURORA, ILL

Amber; 9" × 3⅛" × 1¾"; 1n; 3b; 3ip; v, fss.

CHAMPLIN'S/SARSAPARILLA
[Base:] W. T. & CO

Bottle manufactured by Whitall-Tatum, 1857 to 1935 (Toulouse 1972).

Aqua; 9" × 3" × 1¾"; 1n; 3b; 3ip; v.

DR.CHANNING'S//SARSAPARILLA

Aqua; 10" × 3⅜" × 1¾"; 11n; 3 or 6b; ip; v, ss.

E. R. CLARKE'S//SARSAPARILLA/ BITTERS//SHARON, MASS.
See CLARKE *(Bitters)*.

Dᴿ COOPER/SARSAPARILLA/ WOODARD, CLARKE & CO./PORTLAND, ORE.

Portland newspapers advertised the sarsaparilla from 1909 to 1911. Charles H. Woodard established a retail drugstore in 1865; with the addition of Lewis G. Clarke in 1880, the firm became Woodard, Clarke & Co.; when the wholesale aspects of the business were established is unknown. W. F. Woodward began working in the store in 1884 and became a partner in 1896. C. H. Woodard retired in 1904 and the retail and wholesale divisions of the Clarke-Woodward Drug Co. were separated; Clarke, President and General Manager of the wholesale store, Woodward in charge of the retail store. At the peak of production over 700 specialties were being manufactured. Directories did not include the wholesale store in 1924 and it was the last year for the retail business (Shimko 1969).

Aqua; 10½" × 3¾" × 2⅛"; 11n; rect.; 4ip; h. See WOODARD (Chemical).

CORNELL & FOLSOM./WAHOO & SARSAPARILLA/N.Y.

Probably a product of John F. Cornell and Sewell Folsom, both physicians in New York City in the 1840s, Cornell, 1841–1846; Folsom, 1841–1842. Their association was unlisted in directories.

Aqua; 9⅝" × 3⅜" × 2½"; 11n; 3b; p v.

CORWITZ//SARSAPARILLA

Aqua; 9½" × 3" × 1¾"; 11n; 3 or 6b; 3ip; v, ss.

CRESCENT/SARSAPARILLA/ 100 DOSES 50CENTS// CRESENT DRUG CO.// NEWARK, N.J.

Directories and newspapers listed the Crescent Drug Co. from 1855 to 1900. The firm moved from 120 Market St., its original location, ca. 1888, to 627–629 Broad St.; in 1900 the business was moved to 593 Broad St. (Shimko 1969). The year the sarsaparilla was introduced is unknown. Adv. 1900, *EBB*; 1910, *AD*.

Aqua; 8¾" × 2⅞" × 1¾"; 7n; 3 or 6b; 3ip, arched front; v, fss.

DR. CUMMINGS' CO/EXT. OF SARSAPARILLA & DOCK/ PORTLAND, ME. [Base:] W.T. & CO.

Bottle manufactured by Whitall-Tatum, Millville, NJ, 1857 to 1935 (Toulouse 1972). In 1855 and 1860 H. T. Cummings was a druggist in Portland, ME, according to the Adams, Sampson & Co. New England business directories. Sarsaparilla adv. 1887, *McK & R*; 1910, *AD*.

Aqua; 7½" × 3" × 1¾"; 7n; 12 or 13b; pl; v.

DALTON'S SARSAPARILLA/AND/ NERVE TONIC//BELFAST// MAINE U.S.A. [See Figure 218]

Carton: . . . *Price $1.00. It Permanently Cures All Blood Diseases, from which arise Scrofula, White Swellings, Enlarged Glands, Tuberculosis, Erysipelas, Goitre, Tumors, Cancer, Syphilitic Taints and Sores. It Positively Cures All Diseases of the Stomach, Liver and Kidneys, Constipation and Piles. It is without rival in Relief of Nervous Diseases, Paralysis, Painful and Irregular Menstruation . . . Prepared by the Dalton Sarsaparilla Co., Belfast, Me. . . .* The Dalton Sarsaparilla Co., was incorporated 31 Dec. 1892 by Elmer Small, MD (Shimko 1969). Adv. 1910, *AD*.

Aqua; 9³⁄₁₆" × 3⅛" × 1⅝"; 1n; 3b; 4ip; v, fss.

Fig. 218

DANA'S/SARSAPARILLA

The Dana Sarsaparilla Co. was established in Belfast, ME, in 1888, by Dr. Gustavus Clark Kilgore. In 1894, management changes resulted in a move to Boston. Although the *History of Belfast* published in 1913 notes the firm suspended business in 1895 (Shimko 1969), trade catalogs advertised the sarsaparilla in 1910, *AD*. Additionally the 1900 *Era Blue Book* catalog included a reference to the Dana

Sarsaparilla Co., located at 99 Broadway, Boston.

Aqua; $8^{13}/_{16}'' \times 2^{15}/_{16}'' \times 1^3/_4''$; 1n; 3b; 4ip; v; also variant embossed on sides: BELFAST//MAINE.

DR. DANA'S SARSAPARILLA/ L. N. KEMPTON & CO./ CLAREMONT, N.H.

No Claremont, NH, city directories were located by Shimko (1969) with L. N. Kempton as the manufacturer of medicines or sarsaparilla. The 1881–82 directory citation read: "Leonard N. Kempton, Agt., Toy Cart, Sled and Express Wagon Mfgr., Elm, n. Main h. Pleasant below Summer"; in 1887–1888, just the address "Pleasant below Summer" is listed, in 1893 "Blacksmith h. 73 Pleasant St."; 1896–1897: "Machinist 73 Pleasant St."; 1899: "Retired" (Shimko 1969).

Aqua; $7^5/_8'' \times 2^1/_2'' \times 1^1/_2''$; 7n; rect.; ip; v.

DEWITTS/SARSAPARILLA/ CHICAGO

Label: *DEWITTS SARSAPARILLA. A Compound Concentrated Extract of the Best Blood Purifying Ingredients Known to Medicine. Cure for Scrofula, Erysipelas, Ring-Worm, Venereal Disease. . . .* Label #6,514 was registered 28 April 1891 (Shimko 1969). Adv. 1907, *PVS & S.*

Aqua; $8^3/_4'' \times 3^3/_{16}'' \times 1^{11}/_{16}''$; 7n; 3b; 4ip; v. See DEWITT (Company, *Cure,* Syrup).

EHRLICHER'S/SARSAPARILLA

Clear; $8^7/_8'' \times 3'' \times 1^1/_4''$; 1n; 3 or 6b; ip; v.

EMERSON'S SARSAPARILLA/ -3- BOTTLES GUARANTEED TO CURE -3-/CHICAGO, ILL. KANSAS CITY, MO.

Label registered 20 April 1897. Adv. 1910, *AD.*

Clear; dimens. unk.; 1n; 12 or 13b; pl; v. Also variant embossed CHICAGO, ILL. blocked out (slug plate), $8^1/_2'' \times 3^1/_4'' \times 2^1/_4''$ with 7n. See EMERSON (Cure, *Drug*).

EMMERT & BURRELL/ SARSAPARILLA/FREEPORT, ILLS.

[Base:] W. T. & CO./U.S.A.
Bottle manufactured by Whitall-Tatum, 1857 to 1935 (Toulouse 1972).
Clear; $7^1/_4'' \times 2^3/_4'' \times 1^5/_8''$; 9n; rect.; v.

FARRAR'S SARSAPARILLA/ MANUFACTURED BY WOOD DRUG CO./BRISTOL, TENN.

Adv. 1900, *EBB.*

Aqua; $9'' \times 2^7/_8'' \times 1^5/_8''$; 1n; 3 or 6b; 3ip, arched panels; v. See J. L. WOOD (Cure).

FOLEY'S SARSAPARILLA/MFD. BY/FOLEY & CO. CHICAGO.// FOLEY & CO//CHICAGO USA.

See FOLEY (*Company*).

GILBERT'S//SARSAPARILLA// BITTERS//N. A. GILBERT & CO.// ENOSBURGH FALLS VT.

See GILBERT (*Bitters*).

GOLD MEDAL//SARSA/ PARILLA//J. V. BABCOCK

Product of J. V. Babcock, Montpelier, VT (Shimko 1969).

Amber; $9'' \times 2^7/_8'' \times 1^3/_4''$; 1n; 3b; 4ip, 2 on front; v, s; h, f; v, s.

GOOCH'S//EXTRACT OF/ SARSAPARILLA//CINCINNATI, O

Calendar for 1879: "GOOCH'S SARSAPARILLA Is Endorsed by the Best Physicians and Chemists in the United States. It is put up in a larger bottle, is more highly concentrated, contains more real value and merit than any other Blood preparation and is a positive cure for all diseases arising from an impure state of the Blood, viz., Scrofula, King's Evil, Cancers, Tumors, Eruptions, Erysipelas, Boils, Pimples, Ring Worm, Tetter, Scald Head, Rheumatism, Old and Stubborn Ulcers, Syphilas [sic], Lumbago, Salt Rheum, and all diseases arising from an injudicious use of Mercury. . . ." D. Linn Gooch was listed as the salesman for Gooch's Sarsaparilla, in Ironton, OH, 1879–ca. 1882, when the company was apparently relocated to Cincinnati as the Cincinnati Drug and Chemical Co., D. Linn Gooch, President. Directories last included the company in 1912, Chas. F. Furber, President (Shimko 1969). Adv. 1910, *AD.*

Aqua, clear; $9^1/_2'' \times 4'' \times 2^1/_2''$; 11n; 3 or 6b; 3 or 4ip; v, sfs.

Graefenberg C̱o̱//SARSAPARILLA/ COMPOUND//NEW YORK

Adv. 1848 (Putnam 1968); 1910, *AD.*

Aqua, clear; $6^7/_8'' \times 2^1/_8'' \times 1^7/_{16}''$; 11n; 3b; 3ip; v, sfs; p. See GRAEFENBERG (Company, *Syrup*).

GRANT'S SARSAPARILLA// FREMONT, NEB.

Adv. 1901, *HH & M.*

Aqua; $9^1/_4'' \times 3'' \times 1^3/_4''$; 1n; 3 or 6b; 3ip; v, ss.

DR. GREENE'S//SARSAPARILLA

Product of the Dr. F. R. Greene Med.

Co., New York, Boston and Chicago. Chicago locations included 115 Lake Street in 1902 and 18 E. Lake St. in 1913 (Shimko 1969). Adv. 20 April 1920, *Hearth & Home Magazine.*

Aqua; $9'' \times 2^{15}/_{16}'' \times 1^3/_4''$; 1n; 3b; 3ip; v, ss.

DᴿGUYSOTT'S//YELLOW DOCK/ &/SARSAPARILLA//B. & P. NEW YORK

John D. Park, Cincinnati, OH, purchased Dr. Guysott's Yellow Dock & Sarsaparilla 19 Nov. 1849. Benjamin Sanford and John D. Park (Sanford & Park), patent medicine dealers, established their business in Cincinnati, OH in 1841. With the departure of Sanford in 1850, the firm became John D. Park. Park had many business interests including an association with Demas Barnes, New York (Barnes & Park) from 1855 to 1868 and a Mr. White, in San Francisco (Park & White), ca. 1856–1868. In 1876 Park formed a co-partnership with his sons, Ambro R. and Godfrey F. Park. John Park died in 1894 of a paralytic stroke. John D. Park & Sons went out of business in 1935 (Blasi 1974; Shimko 1969). Apparently the company purchased many firms which continued to operate under their original names, i. e., the John Bull Medicine Company, as listed in the 1896 Cincinnati city directory. The sarsaparilla was first bottled in square, taper-sided, gin-style bottles. The rectangular shape was introduced ca. 1857, the oval style later. Guysott's Sarsaparilla adv. 1935 by John D. Park & Sons Co., Ltd., 515 Sycamore St., Cincinnati, O., *AD.*

Aqua; $8^3/_4'' \times 3'' \times 2''$; 11n; 3b; 3 or 4ip; v, sfs; p. Numerous variants and sizes. See J. BULL (*Sarsaparilla*), WISTAR (Balsam), WYNKOOP (*Pectoral*).

DᴿGUYSOTTˢ/YELLOWDOCK &/ SARSAPARILLA/JOHN D. PARK/ CINCINNATI, O.

Aqua; $9^1/_4'' \times 4^1/_{16}'' \times 2^1/_{16}''$; 11n; 12b; pl; v. See J. BULL (*Sarsaparilla*), WISTAR (Balsam), WYNKOOP (*Pectoral*).

HALL'S/SARSAPARILLA//J. R. GATES & CO.//PROPRIETORS, S.F.

Advertisement, 1891: "HALL'S SARSAPARILLA YELLOW DOCK AND IODIDE OF POTASS–The Best Spring Medicine and Beautifier of the Complexion in use. Cures Pimples, Boils, Blotches, Neuralgia, Scrofula, Gout. . . J. R. GATES & CO., Propr'

417 Sansome St., San Francisco." Richard Hall, San Francisco, CA, established a wholesale and retail drug business about 1855; in 1863 Hall hired a clerk, James R. Gates, who soon became owner. In 1867, Gates acquired a partner, Hart F. Shepardson (Shepardson & Gates), by 1869 or 1870, directories listed Gates alone. Locations included 143 and 145 Clay St. in 1859, Northwest corner of Sansome and Commercial in 1867, and 417 Sansome St., 1870–1891. In 1901 the firm was incorporated as the Gates Drug Co.; the last listing in directories was 1907, the address was 113–115 Davis Street, Fernand Vautier, president; Gates apparently died about 1901 (Blasi 1974; Shimko 1969; Wilson and Wilson 1971). Sarsaparilla adv. 1859 (Shimko 1969); 1910, *AD*.

Aqua; $9^3/8'' \times 2^3/4'' \times 1^3/4''$; 11n; 3b; 3 or 4ip; v, fss. See BARNES (Jamaica Ginger), HALL *(Balsam)*.

HALL'S/SARSAPARILLA// SHEPARDSON & GATES// PROPRIETORS. S.F.

The bottles date from 1867 to ca. 1869. See prior entry.

Aqua, blue; $9^1/4'' \times 2^3/4'' \times 1^3/4''$; 11n; 3b; 3 or 4ip; v, fss. See BARNES (Jamaica Ginger), HALL *(Balsam)*.

THE/CORPORATION OF/ HEGEMAN & CO./CHEMISTS/ SARSAPARILLA/(ARTHUR BRAND)/200 BROADWAY/ NEW YORK

See HEGEMAN *(Chemical)*.

W. HENDERSON & Cọ// EXTRACT OF/SARSAPARILLA// PITTSBURGH

Product of William Henderson, Pittsburgh, PA, 1839–1902 (Shimko 1969).

Light blue; $8^3/4'' \times 4'' \times 2^5/8''$; 11n; 3b; pl; v, sfs; p.

Dʀ HENRY'S/SARSAPARILLA

Adv. 1915, *SF & PD*.

Aqua; $9^3/8'' \times 2^3/4'' \times 1^3/4''$; 7n; 3b; 4ip; v.

Dʀ H. R. HIGGINS//PURE EXTRACT OF//SARSAPARILLA// ROMNEY Vᴬ

Adv. 1836 (Putnam 1968).

Clear, with gray tint; $10'' \times ? \times ?$; 11n; 2b; pl; v, fsbs; p.

DR. SAMUEL HODGES// COMPOUND SARSAPARILLA/ AND/IODIDE POTASH// NASHVILLE, TENN.

Label: *Dr. Sam'l Hodges' After-Five*

Compound Sarsaparilla with Iodide Potash. Campbell Bros., Nashville, Tenn. Application filed April 21, 1887 William C. and John A. Campbell were included as druggists in Nashville directories first in 1887 (Shimko 1969). Adv. 1900 by Rangum Root Medicine Co., Nashville, Tenn., *EBB*; 1922 (Shimko 1969).

Aqua; $9^1/4'' \times 3^1/4'' \times 2''$; 11n; 3 or 6b; 3ip; v, sfs. Also variant embossed: DR HODGES SARSAPARILLA/AND/ IODIDE POTASH//RANGUM ROOT MEDICINE CO.//NASHVILLE, TENN.

THE HONDURAS CO'S// COMPOUND EXTRACT// SARSAPARILLA//ABRAMS & CARROLL/SOLE AGENTS/S.F.

Directories listed Abrams & Carroll, Wholesale Druggists and Importers, from 1874 to 1889.

Aqua; $9^5/8'' \times 2^3/4'' \times 1^3/4''$; 1n; 3b; 4ip; v, bssf. See ABRAMS (Jamaica Ginger).

HOOD'S/COMPOUND/EXTRACT/ SARSA/PARILLA//C. I. HOOD & Cọ//LOWELL, MASS.

[See Figure 219]

Carton for 11 Fluid Ounce bottle: *HOOD'S COMPOUND EXTRACT SARSAPARILLA—Contains $16^1/2$ Per Cent, Alcohol. This Preparation combines in an agreeable form the medicinal properties of Sarsaparilla, Mandrake, Gentian, Dock, Dandelion, With Other Approved Alterative And Tonic Substances. Prepared Only By C. I. HOOD CO., Manufacturing Pharmacists, Lowell, Mass., U.S.A. Price, $1.25.* Charles I. Hood, (1845–1922), entered business as a pharmacist's apprentice, including a tenure with Theodore Metcalf & Co., Boston, MA. In 1870 Hood established his own drugstore with a friend in Lowell, MA; six years later Hood became sole proprietor and began formulating his own medicinals (Shimko

Fig. 219

1969). Sarsaparilla adv. 1887, *McK & R*; 1929–30 by Wm. R. Warner & Co., 113 W. 18th St., New York City; 1948 by Standard Labs. Inc., 113 W. 18th St., New York City, *AD*.

Aqua; $8^3/4'' \times 2^7/8'' \times 1^3/4''$; 1n; 3b; 7ip, 3 on front; h, f; v, ss; ABM. See HOOD (Company, Pills), TUS *(Cure)*, W. WARNER *(Company)*.

HOOD'S/SARSA/PARILLA// C. I. HOOD & Cọ//LOWELL, MASS.

Aqua; $8^3/4'' \times 2^7/8'' \times 1^3/4''$; 1n; 3b; 7ip, 3 on front; h, f; v, ss. See HOOD (Company, Pills), TUS *(Cure)*, W. WARNER *(Company)*.

DR. J. C. HOOD// SARSAPARILLA//LOUISVILLE, KY.

John C. Hood was a physician from 1890 to 1906, and directories referred to the Dr. J. C. Hood Laboratory, under proprietary medicines, in 1900. The *1918 Thomas Register of American Mfgrs.* listed Hood as the proprietor of Honduras Sarsaparilla (Shimko 1969).

Aqua; $8^7/8'' \times 3'' \times 1^3/4''$; 1n; 3b; 3ip; v, sfs.

DR. A. S. HOPKINS// COMPOUND EXT//SARSAPARILLA

Aqua; $8^3/4'' \times 2^3/4'' \times 1^3/4''$; 1n; 3b; 3ip; v, sfs. See UNION *(Bitters)*.

Dʀ HOWE'S//SHAKER/ SARSAPARILLA//NEW YORK

Advertisements as early as 1849 emphasized embossed bottles. Stewart D. Howe started his business in Cincinnati, OH, about 1848 and established shipping and storage facilities in New York. The business continued until ca. 1900 (Holcombe 1979; Shimko 1969; Wilson and Wilson 1971). Sarsaparilla adv. 1849, 1899 (Shimko 1969).

Aqua; $9'' \times 3'' \times 2^1/2''$; 3n; 3 or 6b; 3ip; v, sfs. See CRISTADORO *(Hair)*, HOWE (Cure, Tonic).

HURD'S/SARSAPARILLA

Possibly the product of Richard Hurd, North Berwick, ME.

Light green; $9^1/2'' \times 3'' \times 2^1/2''$; 11n; rect.; 1ip, arched; v; p. See BAKER (Specific).

THOˢ. A. HURLEY'S// COMPOUND SYRUP/OF/ SARSAPARILLA//LOUISVILLE, K.Y.

According to directories, Thomas A. Hurley was a Louisville druggist in 1838. Proprietors of Hurley's Sarsaparilla included Hurley in 1855; James Ruddle & Co. in 1870; J. W. Seaton & Co. in 1876 (Shimko 1969).

Sarsaparilla adv. 1855 (Shimko 1969); 1913, *SN*.
Aqua; 9½" × 3½" × 2¼"; 1n; 3b; 3ip; v, sfs.

HUSTED'S/SARSAPARILLA/WITH CELERY [Base:] W. T. CO. U.S.A.
Bottle manufactured by Whitall-Tatum, Millville, NJ, 1857 to 1935 (Toulouse 1972).
Aqua; 9½" × 3" × 1¾"; 7n; 3 or 4b; 3ip; v.

INDIAN/SARSAPARILLA/ A. F. DESAUTELS
Amber; 8¾" × 3" × 1¾"; 1n; rect.; 3ip; v.

INDIAN/SARSAPARILLA// J. J. MACK & CO.// SAN FRANCISCO, CAL.//
[embossed Indian]
J. J. Mack & Co., Visalia, CA, was established in Dec. 1877, and moved to San Francisco in March 1878. The company remained in business until the 1906 earthquake and fire. In 1907 Mack became president of the City Electric Company (Shimko 1969). Sarsaparilla adv. 1896–97, *Mack*.
Aqua; 9³⁄₁₆" × 2¾" × 1¾"; 1n; 3b; 4ip; v, fss; h, b. See CIRCASSIAN (Miscellaneous), FLINT (Remedy), MACK (Company).

IXL SARSAPARILLA/&/IODIDE POTASSIUM//R. COTTER & CO// HOUSTON TEXAS
IXL Sarsaparilla was introduced in the 1870s. The Houston Drug Company was affiliated with the product in 1902 (Shimko 1969) and in 1929–30 according to the *American Druggist* catalog. Adv. 1941–42 by Southwestern Drug Corp., Houston, Tex., *AD*.
Aqua, clear; 8¾" × ? × ?; 11n; 3b; 3ip; v, fss.

[In circle:] **CHARLES JOLY/ PHILADELPHIA/JAMAICA SARSAPARILLA**
An advertisement in the Philadelphia city directory for the sarsaparilla indicates establishment of the business in 1848 (Shimko 1969). Charles Joly, Wine, Spirit and Mineral Water Merchant, was located at No. 9 N. 7th St., Philadelphia, 1882–1907, and 1122 McClellan St., 1908–1909.
Aqua; 10" × 2½" diameter; 19n; 20b; pl; h.

JOY'S//SARSAPARILLA//THE/ EDWIN W. JOY CO./ SAN FRANCISCO [See Photo 68]
Label: *JOY'S VEGETABLE – THE*

CALIFORNIA REMEDY SARSA-PARILLA, A Fortunate Combination Of The Most Effective Liver and Kidney Remedy, Blood Purifier, Stomach Regulator and Vegetable Laxative In Existence. A compound of the juices of Vegetable Alterative Indigenous to California. PREPARED ONLY BY THE EDWIN W. JOY COMPANY, CHEMISTS, SAN FRANCISCO, CALIFORNIA. Edwin Joy formed a partnership with Charles Bayly, a druggist in San Francisco, in 1874; within the year Joy opened his own store. Sarsaparilla label registered 30 Oct. 1888 (Shimko 1969). Adv. 1915, *SF & PD*.
Aqua; 8⅝" × 2⅞" × 2"; 7n; 3b; 4ip; v, ssf.

KEMP'S/SARSAPARILLA//O. F. WOODWARD//LEROY, N. Y.
Adv. 1889, *PVS & S*; 1910, *AD*.
Aqua; 9½" × 2¾" × 1¾"; 1n; 3b; 3ip; v, fss. See KEMP *(Balsam)*, GOFF (Bitters, Miscellaneous, Syrup).

DR. KING'S/SARSAPARILLA
Product of the Koening Medicine Co., Chicago, IL. Adv. ca. 1889–1917 (Shimko 1969).
Aqua; 9¼" × 3⅛" × 1¾"; 7n; 3 or 6b; 3ip; v.

GENUINE//LANGLEY'S/ SARSAPARILLA//VICTORIA, V. I.
Adv. ca. 1858–1898 (Shimko 1969).
Aqua; 9½" × 3½" × 2½"; 7n; 3b; 3 or 4ip; v, sfs. See LANGLEY *(Jamaica Ginger)*.

E. N. LIGHTNER & CO/ DETROIT, MICH.// SARSAPARILLA//& STILLINGIA
Directories establish the Edwin N. Lightner & Co., Detroit, MI, in 1882. In 1900 Lightner & Co. was manufacturing "Perfumes & Toilet Articles," *EBB*; the firm became Lightner-Seeley Co. in 1906 (Devner 1970).
Aqua; 8½" × 2¾" × 1¾"; 3n; 3 or 6b; 4ip; v, fss.

LIPPMAN'S//COMPOUND EXTRACT//SARSAPARILLA/WITH 100 POTASS//SAVANNAH, GA.
Lippman Bros., Wholesale and Proprietary Medicines, Savannah, GA, operated from 1871 to 1905; F. V. Lippman Co., Wholesale Druggist, from 1905 to 1920 (Shimko 1969).
Aqua; 8¼" × 2⅝" × 1¾"; 7n; 3 or 6b; 4ip; v, sbfs. See P-P-P (Purifier).

LOG CABIN//SARSAPARILLA// ROCHESTER, N. Y. [Base:] Pat. SEPT. 6 87

Label: *WARNER'S LOG CABIN SARSAPARILLA – An Old Fashioned Roots & Herbs preparation of Sterling Value For All Blood Disorders. An Alterative Tonic Blood Purifier – The Great System Strengthener. Price $1.00 A Bottle, Six Bottles For Price of Five – H. H. WARNER Co., Rochester, N.Y.* Introduced ca. 1887; adv. 1909 (Shimko 1969).
Amber; 9" × 3⅛" × 1½"; 20n; distinctive shape with flat back and 3 front panels; 3ip; v. See LOG CABIN (Extract, Remedy), H. WARNER (Bitters, Company, *Cure*, Nervine, Remedy).

LOGAN'S//SARSAPARILLA AND// CELERY. OMAHA. NEB.
Aqua; 9" × 3" × 1¾"; 1n; 3 or 6b; 3ip; v, fss.

[Script:] **Manners/DOUBLE/ EXTRACT/SARSAPARILLA/ BINGHAMTON, N.Y.**
The Manners Sarsaparilla Co. was listed in the Binghamton city directory 1892–1902, or later; Sarsaparilla Trade Mark issued 28 March 1893 (Shimko 1969). Adv. 1910, *AD*.
Aqua; 7½" × 2½" × 1½"; 7n; 3 or 6b; 1ip; v; part script. See MANNERS (Discovery).

MASURY'S/SARSAPARILLA/ CATHARTIC
Aqua; 8¼" × 4¼" × 2"; 9n; 4b; pl; v; p.

MASURY'S/SARSAPARILLA/ COMPOUND//J. & T. HAWKS// ROCHESTER, NY.
Louisville directories listed J. and T. Hawks, Druggists, 1849–1851. Several brothers or relatives were also in the business between 1834 and 1854 (Shimko 1969).
Aqua; 11" × 4¼" × 2½"; 11n; rect.; 3ip; v, fss.

McLEAN'S//SARSAPARILLA// ST. LOUIS, MO.
Adv. 1891 (Shimko 1969); 1941–42, *AD*.
Aqua; 9¼" × 2¾" × 1½"; 1n; 3b; 3ip; v, sfs. See McLEAN *(Balm*, Miscellaneous, Oil, Purifier).

MEAD'S//SARSAPARILLA//M. T. MEAD & CO./APOTHECARIES/ FAIRHAVEN VERMONT
See MEAD *(Company)*.

MEYER'S SARSAPARILLA/MANF'D BY/GIANT MEDICINE CO./ HELENA. MONT.
Aqua; 9¼" × 3" × 1¾"; 1n; 3b; 3ip; v.

DR. MILES/WINE OF SARSAPARILLA

Label registered 23 Jan. 1900 (Shimko 1969). Adv. 1907, *PVS & S*.

Aqua; 9″ × 3″ × 1¾″; 1n; 3b; 3ip; v. See MILES (*Cure*, Medicine, Nervine, Purifier, Tonic).

Dᴿ MORLEY'S//SARSAPARILLA/ AND/100 POTASS//ST. LOUIS

Label: *MORLEY'S, Formerly M. Jarman's Sarsaparilla with the Iodides of Potash & Iron . . . St. Louis, Mo.* (Shimko 1969). Adv. 1900 by Morley Bros., 214 S. Main, St. Louis, *EBB*; 1916, *MB*.

Aqua; 9½″ × 3½″ × 2¼″; 7n; 3b; 3ip; v, sfs.

I. C. MORRISON'S/ SARSAPARILLA// 188 GREENWICH ST./ NEW YORK//188 GREENWICH ST./NEW YORK

I. C. Morrison is possibly an embossing error. Directories listed John C. Morrison, Druggist, 188 Greenwich, New York, NY, 1822–1851.

Aqua, cobalt; 9¼″ × 3¾″ × 2¾″; 11n; 3b; 3ip; v, fss; graphite p.

DR. MYER'S//VEGETABLE EXTRACT/SARSAPARILLA/WILD CHERRY/DANDELION//BUFFALO, N. Y.

Dr. H. B. Myer's Extract of Dandelion, Myer & Price, Proprietors, Buffalo, NY, adv. 1851 (Baldwin 1973).

Aqua; 9¾″ × 3¾″ × 2½″; 11n; 3b; 3ip; v, sfs; p.

PELLETIER'S//EXTRACT OF/ SARSAPARILLA//HARTFORD, CONN.

Product of C. L. Covell and George M. Welch, Hartford, CT, adv. 1847 (Shimko 1969). Welch was the successor in 1844 to the business of Isaac D. Bull, father of A. H. Bull. Welch sold the store in 1854, according to *Trumbull's Memorial History of Hartford County Connecticut, 1633–1884.*

Light green; 10½″ × 3½″ × 2¾″; 1n; 3b; 3ip; v, sfs; p. See BULL (*Sarsaparilla*).

KIRK G. PHILLIPS/ SARSAPARILLA/DEADWOOD, SO. DAK. [Base:] W.T. & CO./U.S.A.

Bottle manufactured by Whitall-Tatum, Millville, NJ, 1857 to 1935 (Toulouse 1972).

Aqua; 9⅛″ × 3″ × 1¾″; 1n; 3b; 3ip; v.

PHOENIX/SARSAPARILLA// GENUINE//LOUISVILLE KY

Aqua; 9¼″ × 3¾″ × 2¾″; 11n; 3 or 6b; 3ip; v, fss; p.

DR. C. POPE'S/SARSAPARILLA

Product of C. Pope, Waterville, Oneida Co., NY (Shimko 1969).

Aqua; 6½″ × 2⅞″ × 1¾″; 11n; 4b; pl; v; p.

PORTER'S SARSAPARILLA/ PREPARED BY/HIRAM POND/ HOLLISTER, CAL. [Base:] W.T. CO. U.S.A.

Bottle manufactured by Whitall-Tatum, Millville, NJ, 1857 to 1935 (Toulouse 1972). 1899 and 1903 news articles discussed improvements to Pond's new store (Shimko 1969). Sarsaparilla adv. 1907, *PVS & S*.

Aqua; 8⅛″ × 3″ × 2″; 7n; rect.; 4ip; v.

PRIMLEY'S/SARSAPARILLA// SHERMAN PRIMLEY//ELKHART, INDIANA

Seth A. Jones, Grand Rapids, MI, and Jonathan P. Primley, Elkhart, IN, were both druggists when they began manufacturing patent medicines in 1883. Sherman Primley purchased his brother Jonathan's drugstore so Jonathan could open a sales outlet for the wholesale business. As the business grew Sherman sold the drugstore and joined his brother. Jonathan retired in the late 1890s, and Sherman bought out Seth Jones and continued the business after 1900 (Wilson and Wilson 1971). Adv. 1889, *PVS & S*; 1918 (Shimko 1969).

Aqua; 9¼″ × 3½″ × 1⅞″; 7n; 3b; 4ip, oval front; v, fss. Also other variants, i.e., JONES & PRIMLEY CO.// ELKHART INDIANA; SHERMAN PRIMLEY//MILWAUKEE WISC. See PRIMLEY (Cure, *Tonic*).

QUAKER SARSAPARILLA/ BLOOD PURIFIER

A product of the Quaker Medical Association, St. Paul, MN. Adv. 1892 (Shimko 1969); 1910, *AD*.

Clear; 7¾″ × 2⅝″ × ?; 7n; 3 or 6b; ip; v.

RACKLEY'S/SARSA/PARILLA// B. F. RACKLEY//APOTHECARY// DOVER, N.H.

Benjamin F. Rackley, Dover, NH, advertised Rackley's Sarsaparilla in 1867, and continued his business until his death in 1890 (Shimko 1969). Referenced also in the *New Hampshire Register, Farmers Almanac & Business Directory, 1891.*

Aqua; 9¼″ × 3″ × 1¾″; 1n; 3b; 6ip, 3 on the front; h, f; v, sbs.

RADWAY'S//SARSAPARILLIAN/ RESOLVENT//R. R. R.// ENTᴰ ACCORᴰ/TO ACT OF/ CONGRESS

Introduced in 1857 and trademarked 11 Oct. 1887 (Shimko 1969). Adv. 1929–30 by Radway & Co., Inc., 208 Center St., New York City, *AD*. Other locations included 23 John St., New York in 1861; 87 Maiden St. in 1871; 32 Warren St. in 1873, 1888; and 55 Elm St. in 1902 (Shimko 1969).

Aqua; 7½″ × 2⁷⁄₁₆″ × 1½″; 1n; 3b; 4ip; v, sfsb. See RADWAY *(Company)*.

RECAMIER//SARSAPARILLA

Product of Harriet Hubbard Ayers, New York, NY, principally of cosmetic fame. Adv. 1888, 1902 (Shimko 1969).

Amber; 9⅜″ × 3″ × 1¾″; 1n; 3b; 4ip; v, ss.

RIKER'S/COMPOUND/ SARSAPARILLA

Product of J. L. and D. S. Riker, New York, NY, in 1899; of Riker Laboratories, New York and Boston in 1907 (Shimko 1969). Possible relationship to RIKER (Miscellaneous). Adv. 1891, *WHS*; 1910, *AD*.

Clear; 10″ × 3½″ × 2″; 7n; 3b; 3ip; v.

DR. J. S. ROSE'S// SARSAPARILLA//PHILADELPHIA

Aqua; 9½″ × 3″ × 3″; 11n; 1 or 2b; pl; v, fss; p. See ROSE (Miscellaneous).

DR. RUSH'S//SARSAPARILLA// MOBILE, ALA.

Aqua; 7½″ × 2⅞″ × 1⅞″; 11n; 3b; 3 or 4ip; v, sfs; p.

RUSH'S//SARSAPARILLA//AND IRON//A. H. FLANDERS. M.D./ NEW YORK

Boston directories listed A. H. Flanders, "Proprietor of Rush's Medicines," 50 School Ave., in 1866–1867 only. Adv. 1865, *GG*; 1912 (Shimko 1969).

Aqua; 8⁹⁄₁₆″ × 2¹⁵⁄₁₆″ × 1¹³⁄₁₆″; 1n; 3b; 4ip; v, fssb. Also early BOSTON, MASS. variant. See RUSH (Balm, *Bitters*, Miscellaneous).

DR. RUSSELL'S/BALSAM OF HOREHOUND/AND/ SARSAPARILLA

Directories located the Dr. Russell Medicine Co. at 200 Kinzie Ave., Chicago, IL from 1890 to 1901; from 1901 until 1909 the location is unknown; from 1909 to 1914, the location was 913 Eddy St., Providence, RI (Shimko 1969).

Aqua; 9¼″ × 3½″ × 2″; 11n; 3 or 4b; pl; v; p.

SAND'S/SARSAPARILLA/ NEW YORK

Early variant manufactured ca. 1840s. From the *A. B. & D. Sands Family Recipe & Medical Almanac*, 1853: the product ". . . has now borne the test of over fourteen years' experience. . . ." Adv. 1843 (Putnam 1968; Singer 1982); 1865, *GG*.

Aqua; 6″ × 2″ × 1¼″; 11n; 4b; pl; v, cfc; p. See McMUNN (Elixir), A. B. & D. SANDS (*Miscellaneous*).

SAND'S/SARSAPARILLA// GENUINE//NEW YORK

This embossed variant was depicted in advertising illustrations in 1848 and 1858, according to Peter Schulz (personal communication, 1984).

Aqua; 10⅛″ × 3¾″ × 2½″; 1n; 3b; 3ip; v, fss; p. See McMUNN (Elixir), A. B. & D. SANDS (*Miscellaneous*).

SARSAPARIPHERE// LACOUR'S BITTERS

See LACOUR (*Bitters*).

[v] Dr. A. P. SAWYER'S//[h] [embossed sun]/[eclipse]/[v] ECLIPSE//SARSAPARILLA

Bottle manufactured ca. 1899–1912 (Shimko 1969). Alvin P. Sawyer, Physician & Manufacturer of Medicine, located his business at 161 Colorado, Chicago, IL, in 1889; 875 Warren Ave., 1890–1896; and finally 194 Clinton, the new home of the Dr. A. P. Sawyer Med. Co. The office location of 161 Colorado was Sawyer's home for many years, according to Lakeside Chicago city directories. Blasi (1974) includes an illustration for the company with a location of 69–81 Sacramento, Chicago, date unk. Products were adv. 1910, *AD*.

Aqua; 9″ × 3″ × 1¾″; 1n; 3 or 6b; 4ip; v, s; h, v, f; v, s. See SAWYER (Cure, Miscellaneous), SUN RISE (Balsam).

SCHEERER'S/SARSAPARILLA

Aqua; 9″ × 3″ × 1¾″; 1n; 3 or 6b; 3ip; v. Also variant embossed: SHEERER'S/SARSAPARILLA.

STEVEN'S SARSAPARILLA// LOWELL MASS, U.S.A.

Aqua; 8¼″ × 3″ × 1¾″; 1n; 3b; 3ip, arched; v, ss.

TAYLOR'S/SARSAPARILLA ROOT BEER/TRENTON, N.J.

Adv. 1900, *EBB*; 1910, *AD*.

Aqua; 4¾″ × 2″ × 2″; 7n; 2b; pl; v.

DR. THOMSON'S/COMPOUND EXTRACT/SARSAPARILLA

Aqua; 8¼″ × 2¾″ × 1¾″; 1n; 3 or 6b; 3ip; v.

DR. THOMSON'S/SARSAPARILLA/ GREAT ENGLISH REMEDY// ST. STEPHEN, N. B.//CALAIS, M. E. U.S.A.

Trademark issued 24 April 1894 (Shimko 1969). Adv. 1910, *AD*.

Aqua; 9″ × 3″ × 1¾″; 1n; 3b; 4ip; v, fss.

DR TOWNSEND'S// SARSAPARILLA//ALBANY/N.Y.

1886 advertisement: "DR. S. P. TOWNSEND'S COMPOUND EXTRACT OF SARSAPARILLA. Wonder and Blessing of the Age. The most Extraordinary Medicine in the World. This Extract is put up in Quart Bottles; it is six times cheaper, pleasanter, and warranted superior to any sold. It cures without vomiting, purging, sickening, or debilitating the Patient . . . RASCALITY AND DECEPTION! There is a Sarsaparilla for sale called old Dr. Jacob Townsend's Sarsaparilla. It is advertised as the original, &c. This is a notorious falsehood. . . . None genuine unless signed S. P. Townsend, and put up in Steel plate Wrappers. . . ." Of about 20 variants, the one with Albany is the earliest. Samuel P. Townsend, Albany, NY, introduced his sarsaparilla in 1839 and moved to New York City in 1846, where he patented the brand. In 1851 proprietary rights belonged to John C. Bach and Foster Nostrand, Nostrand & Bach, "successors to Clapp & Townsend, and sole proprietors of Dr. S. P. Townsend's Sarsaparilla, Office, 82 Nassau St., New York"; Clapp's full involvement is unknown. Townsend died in the late 1880s. Foster Nostrand retired in the 1860s and his son, Elbert, became a partner with John Bach; Bach died in 1886. Elbert Nostrand continued the business for a year or so. When he liquidated the business and retired, the location was still 82 Nassau St. Embossed bottles were discontinued in the 1870s (Shimko 1969; Wilson and Wilson 1971). Adv. 1910, AD, proprietor unknown.

Emerald green, aqua; 9¼″ × 3″ × 3″; 11n; 2b; pl; v, fsb. See TOWNSEND (Liniment).

OLD DR/J. TOWNSEND's// SARSAPARILLA//NEW YORK

1886 advertisement: "'CLEANSE

THE BLOOD' OLD DR. JACOB TOWNSEND'S SARSAPARILLA Is the most Effective Remedy for Skin and Blood Diseases, Pimples, Blotches, &c. Specially recommended for Ladies and Children . . . Chief Depot: DEAN, STEEL & Co., 131 Fleet St., London." Product of Jacob S. Townsend, New York, NY, introduced in 1849. Bottles are nearly identical to those of his competitor, S. P. Townsend. Sold by several agents (Wilson and Wilson 1971). Adv. 1849 (Singer 1982); 1923, *SF & PD*.

Blue; 9⅞″ × 3″ × 3″; 11n; 2b; pl; v, fsb; with and without p. Several colors and variants.

TURNER'S/SARSAPARILLA/ BUFFALO N.Y.

Adv. 1857 (Shimko 1969).

Aqua; 12¼″ × 5¾″ × 3″; 11n; rect.; v. See McMILLAN & KESTER (*Jamaica Ginger*), TURNER (*Jamaica Ginger*, Miscellaneous).

DR TUTT'S//SARSAPARILLA/&/ QUEENS DELIGHT//AUGUSTA, GA.

William H. Tutt, 1823–1898, Augusta, GA, entered the drug business prior to 1850 and retired in the mid 1890s; the Tutt Mfg. Co. survived until 1918. Tutt also had offices in New York City (Ring 1980; Shimko 1969). Sarsaparilla adv. 1876, *WHS*; 1910, *AD*.

Aqua; 7½″ × 2⅜″ × 1⅝″; 1 and 3n; 3b; 3ip; v, sfs. Also variant embossed NEW YORK.

VICKERY'S/SARSAPARILLA/ DOVER, N.H. [Base:] W.T. & Co.

Bottle manufactured by Whitall-Tatum, Millville, NJ, 1857 to 1935 (Toulouse 1972). The *1891 New Hampshire Register, Farmers Almanac & Business Directory* includes W. H. Vickery, Drugs & Medicines, from 1870–1891. Shimko (1969) provides a 1901 reference for a J. E. Vickery, Dover, NH. The relationship to W. H. Vickery is unknown.

Aqua; 9½″ × 2⅞″ × 1¾″; 7n; rect.; ip; v.

C. M. WALKER'S/SARSAPARILLA/ BENTON HARBOR, MICH.

Aqua; 9″ × 3″ × 1¾″; 1n; 3 or 6b; ip; v.

WEST'S SARSAPARILLA// BAINBRIDGE, N.Y.

Aqua; 8¾″ × 2¾″ × 1¾″; 7n; 3 or 6b; 3ip; v.

WETHERELL'S/SARSAPARILLA// EXETER, N.H.

The *1891 New Hampshire Register, Farmers Almanac & Business Directory* included Albert S. Wetherell, Drugs & Medicines, from 1874 to 1891. Shimko (1969) indicates Wetherell operated his business well into the 1900s.

Aqua; $8^{7/8}'' \times 2'' \times 1^{11/16}''$; 1n; 3b; 3ip; v, sfs; measurements above recessed base are $2^{7/8}'' \times 1^{11/16}''$. Also variant embossed on shoulder: A. S. W.//1881.

WHIPPLE'S/SARSAPARILLA/PORTLAND, ME.

Directories establish W. W. Whipple & Co., Portland, ME, in 1851. The Maine Register last included the business in 1893–1894. Sarsaparilla adv. 1851, 1894, Portland city directories.

Aqua; $9^{1/8}'' \times 2^{7/8}'' \times 1^{3/4}''$; 1n; 3b; 3ip; v.

DR. WILCOX/COMPOUND//EXTRACT OF/SARSAPARILLA

Olive amber; $8^{7/8}'' \times 4''$ diameter; 11n; 21b; pl; v, ss; p.

DR. WILCOX'S//COMPOUND EXTRACT//SARSAPARILLA

Blue green; $9'' \times 3'' \times 3''$; 11n; 2b; pl; v, fsb; p.

DR. F. A. WOOD'S/SARSAPARILLA

Product of the Houck Remedy Co., Sedalia, MO. Adv. 1900, *EBB*; 1929–30 by Van Fleet Mansfield Drug Co., 105 S. Second St., Memphis, Tenn., *AD*.

Aqua, clear; $9'' \times 3'' \times 1^{1/2}''$; 1n; 3b; 3ip; v.

DR. F. A. WOOD'S/SARSAPARILLA//W. E. HOUCK REMEDY CO.//SEDALIA MO.

Clear; $9'' \times 3'' \times 1^{1/2}''$; 1n; 3b; 3ip; v, fss; ABM.

DR WOOD'S//SARSAPARILLA/&/WILD CHERRY//BITTERS

See WOOD *(Bitters)*.

Dr WOODWORTH'S/SARSAPARILLA//BIRMINGHAM, CT.

Product of Dr. M. Woodworth, adv. 1854 as "The Great Connecticut Remedy" (Shimko 1969).

Aqua; $10'' \times 3^{3/4}'' \times 2^{1/2}''$; 11n; 4b; pl; v, fb; p.

WORLDS//COLUMBIAN/SARSAPARILLA//WORLDS COLUMBIAN/SARSAPARILLA CO.//WORCESTER, MASS

Light green; $8^{3/4}'' \times 3'' \times 1^{5/8}''$; 1n; rect.; 4ip; v, sfbs.

WRIGHT'S/SARSAPARILLA/BUFFALO, N.Y.

Wright's Sarsaparilla adv. 1910, *AD*, proprietor unknown. There was also a Wright's Sarsaparilla with Iodides, manufactured by Charles Wright Medicine Co., Detroit, MI, advertised 1 Nov. 1891, *Pharmaceutical Era*.

Aqua; $7^{1/2}'' \times 2^{1/2}'' \times 1^{1/4}''$; 7n; 3b; 4ip; v.

DR WYNKOOP'S/KATHARISMIC SARSAPARILLA//NEW YORK

Adv. 1896 (Shimko 1969).

Cobalt; $9^{7/8}'' \times 3^{3/4}'' \times 2^{3/8}''$; 11n; 3b; ip; v, fs; p. See DRAKE *(Bitters)*, LYON *(Hair*, Jamaica Ginger, Miscellaneous), WYNKOOP *(Pectoral)*.

WYNKOOP'S/KATHARISMIC/SARSAPARILLA//NEW YORK

Blue; $9^{1/2}'' \times 3^{1/2}'' \times 2^{1/2}''$; 11n; 3b; 3ip; v, fs; p. See DRAKE *(Bitters)*, LYON *(Hair*, Jamaica Ginger, Miscellaneous), WYNKOOP *(Pectoral)*.

YAGER'S/SARSAPARILLA

Product of Gilbert Bros. & Co., Baltimore, MD. The firm was located at 9–13 Howard from 1896–1900 at 308 W. Lombard in 1912; and at 308–310 W. Lombard from 1913–1930 (Shimko 1969).

Amber; $8^{1/2}'' \times 3'' \times 2''$; 7n; 3b; 3ip; v.

YELLOW DOCK//SARSAPARILLA//CROWELL CRANE & BRIGHAM [Base:] W.T. & CO.

Bottle manufactured by Whitall-Tatum, Millville, NJ, 1857 to 1935 (Toulouse 1972). Crowell, Crane & Brigham, 131 Commercial St., San Francisco, CA, operated from 1856 to 1858 (Shimko 1969).

Dark aqua; $7^{1/2}'' \times 3^{1/4}'' \times 2''$; 9n; 3b; 3 or 4ip, arched; v, ssf; p. See CRANE & BRIGHAM *(Drug)*.

SPECIFIC

[Embossed figure of Uncle Sam]/
BAKER'S/SPECIFIC/R. H. HURD PROP/NO BERWICK ME U.S.A.
1860 advertisement: "DR. BAKER'S SPECIFIC will cure Gonorrhea, Gleet Stricture, Seminal Weakness and All Diseases of the Genital Organs. Reader, have you a private disease? Do not neglect it. Delay is dangerous. . . . Dr. Easterly, corner of Third and Chestnut streets St. Louis Mo.; sole proprietor. . . ." Purportedly a product of Charles Baker, Jr., New York, NY, introduced ca. 1850; Ezra Easterly became agent. Baker died in the 1880s and the product was assumed by Richard H. Hurd, North Berwick, ME (Wilson and Wilson 1971). Richard Hurd operated a drugstore in North Berwick, ME, from 1878 to 1937 (Shimko 1969). Baker's Great American Specific adv. 1895, *McK & R*.
Clear; 4¼" × ? × ?; 7n; 3 or 6b; pl; h. See EASTERLY (Miscellaneous), HURD (Sarsaparilla).

MRS. BUSH//SPECIFIC CURE/ FOR/BURNS & SCALDS// WINDER, GA.
See BUSH *(Cure).*

DR J. F. CHURCHILL'S/SPECIFIC REMEDY/FOR CONSUMPTION// HYPOPHOSPHITES OF LIME AND SODA//J. WINCHESTER/ NEW YORK
See CHURCHILL *(Remedy).*

COLLINS'/HAIR GROWER/ & DANDRUFF SPECIFIC/ W. R. COLLINS S. F.
William R. Collins operated a barber shop in San Francisco, CA, from 1892 to 1899; directories refer to the manufacture of the hair grower only in 1897. Adv. 1896–97, *Mack.*
Aqua; 7¼" × ? × ?; 7n; 3b; 3 or 4ip; v.

DR. J. C. COOPER'S/BLOOD & LIVER/SPECIFIC
Aqua; 9" × 2¾" × 1¾"; 7n; 3b; 3ip, arched front; v.

Dᴿ CROSSMAN'S/SPECIFIC/ MIXTURE
Adv. 1855 (Putnam 1968); 1897 by F. Ferrett, New York City, *L & M*; 1923, *SF & PD*.
Aqua; 3⅝" × 1⅝" diameter; 7n; 20b; pl; v.

DR. M. M. FENNER/FREDONIA, N.Y./ST. VITUS DANCE/SPECIFIC
Aqua; 5" × ?; 9n, wide, flared mouth; 20b; pl; v. See CAPITOL (Bitters), FENNER (Cure, Medicine, Miscellaneous, *Remedy).*

GREAT ENGLISH/SWEENY// SPECIFIC//CAREY & CO.
See CAREY *(Company).*

HANKINS'/SPECIFIC/ BORDENTOWN, N.J.// FOR RHEUMATISM// GOUT AND LUMBAGO
Adv. 1887, *McK & R*; 1923, *SF & PD*. Color unk.; 6½" × 2⁵⁄₁₆" × 1⁵⁄₁₆"; 7n; 3b; 3ip; v, fss.

HUMPHREYS'/HOMEOPATHIC/ [embossed horse in circle] TRADE MARK/VETERINARY/SPECIFICS
Clear; dimens. unk.; 3n; 15b; pl; h. See HUMPHREY *(Medicine, Miscellaneous).*

DR./HUMPHREYS'/SPECIFICS/ NEW YORK
Clear; dimens. unk.; 16n; 13b; pl. See HUMPHREY *(Medicine, Miscellaneous).*

DR KILMER & CO//CATARRH/ [in indented lung:] DR KILMER'S/ COUGH-CURE/CONSUMPTION OIL/[below lung:] SPECIFIC// BINGHAMTON, N.Y.
See KILMER *(Cure).*

DR. KILMER & CO//THE BLOOD/ [in indented heart:] DR. KILMER'S/ OCEAN WEED/HEART/REMEDY/ [below heart:] SPECIFIC// BINGHAMTON, N.Y.
See KILMER *(Remedy).*

DR. KILMER & CO.//THE GREAT/ [in indented kidney:] DR.//KILMER'S/ SWAMP-/ROOT/KIDNEY/LIVER &/ BLADDER/CURE/[below kidney:] SPECIFIC//BINGHAMTON, N.Y.
See KILMER *(Cure).*

H. LAKE'S/INDIAN/SPECIFIC
Herbert W. Lake operated a drugstore in Waterbury, CT, from ca. 1871 until his death ca. 1920 (Blasi 1974).
Aqua; 8¼" × 3⁷⁄₁₆" × 1⅝"; 3n, sp; 24b; 2ip; v, p.

DOCTOR/C. McLANE'S// AMERICAN WORM/SPECIFIC
Product of Dr. C. McLane, Pittsburgh, PA, introduced in 1844. When McLane died in 1855, John and Cochrane Flemming of Flemming Bros., Pittsburgh, became ". . . prop's of McLane's medicines, 24 Wood." Products in 1863–64 included Dr. C. McLane's Celebrated American Worm Specific or Vermifuge, Liver Pills, Crudoform, Mikado Cologne, and Kidd's Cough Syrup (Holcombe 1979). Kidd's Cough Syrup may have been named for J. Kidd Flemming affiliated with the business in later years, ca. 1880 (Holcombe 1979). Specific adv. 1844 (Holcombe 1979); 1910, *AD*.
Clear; 3⅞" × 1³⁄₁₆" diameter; 3n; 20b; pl; v, fb. Also variant with 13n and pontil. See KIDD (Syrup).

[v] NATURE'S/COUGH SPECIFIC/ DR F. P. HOWLAND [h] CORTLAND/N. Y.
Aqua; 5⅝" × 2" × 1⅛"; 7n; 3 or 6b; ip; v, h.

REYNOLDS//GOUT//SPECIFIC// ENFIELD
An Enfield, England product introduced ca. 1830. Agents included E. Fougera & Co., New York (Wilson and Wilson 1971). Adv. 1897, *EF*; 1923, *SF & PD*.
Clear; 3½" × ?; 5n; 1b; pl; v, fsbs.

SEARS/PULMONARY/SPECIFIC
Aqua; 6" × 2⅜" × 1"; 11n, crude; 3b; pl; v; p; distinctive shape.

THE/SPECIFIC/A NO 1/A SELF CURE/(TRADE MARK) [Base:] W T & CO USA [See Figure 220]
Bottle manufactured by Whitall-Tatum,

Fig. 220

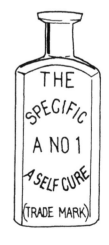

1857 to 1935 (Toulouse 1972). Cure for gonorrhoea and gleet introduced in 1884 by Augustus Schoenheit Sr., San Jose, CA; Augustus Jr. became the manager of the business in 1893 (Wilson and Wilson 1971). Adv. 1916, *MB*.
Aqua; 5¹/₈″ × 2¹/₁₆″ × 1³/₈″; 9n; 3b; pl; h.

NATHAN TUCKER, M.D./[embossed star and shield]/SPECIFIC/FOR ASTHMA, HAY FEVER/AND ALL CATARRHAL/DISEASES OF THE RES/PIRATORY ORGANS
Clear; 3¹/₄″ × 1³/₁₆″ diameter; 5n; 20b; pl.

ARTHURS//RENOVATING// SYRUP A & A
Green; 9¹/₄″ × 3″ × 3″; 11n; 2b; pl; v, fss; p. Also rectangular variant, 7⁷/₈″ × 2³/₄″ × 2¹/₄″.

D̲R̲ ATHERTON'S/WILD CHERRY SYRUP//E. W. HALL/ WHITEHALL, N.Y.
Adv. 1871, *WHS*; 1910, *AD*.
Aqua; 5¹/₈″ × 2″ × ?; 7n; 13b; pl; v, fb; p.

AYER'S//PECTORAL SYRUP// BROWNVILLE NY
Apparently an unsuccessful competitor of J. C. Ayer (Baldwin 1973).
Aqua; 7³/₈″ × 2¹/₄″ × 1⁵/₈″; 1n; 3b; 3 or 4ip; v, ssf; p.

B & S/HOMEOPATHIC/COUGH & CROUP/SYRUP
Adv. 1923, *SF & PD*; 1929–30 and 1940–41 by Eopa Co., 880 Folsom St., San Francisco, CA, *AD*.
Clear; 3⁵/₁₆″ × 1¹/₁₆″ × 1¹/₁₆″; 3n; 1b; pl; v.

MOTHER BAILEY'S/QUIETING SYRUP
Quieting syrup for teething children, product of A. Richards, New London, CT in 1868 (Singer 1982). Adv. 1910, *AD*.
Aqua; 5″ × 1¹/₄″ diameter; 7n; 20b; pl; v.

D̲R̲ BAKER'S/PLANTATION/ COUGH SYRUP//S. F. BAKER & CO.//KEOKUK, IOWA
See BAKER *(Company)*.

BEGGS'/CHERRY COUGH SYRUP
Label: *BEGGS' CHERRY COUGH SYRUP for Coughs, Colds, Hoarseness, Bronchitis, Sore Throat, Weak Lungs and Consumption. Prepared only by Begg's Mfg. Co., Chicago.* Adv. 1884 (Devner 1968); 1910, *AD*.

Aqua; 8⅛″ × 2¾″ × 1½″; 7n; 3b; 3ip; v. See BEGGS *(Balsam)*, KNOXIT (Miscellaneous).

BICKNELL/DYSENTERY SYRUP// E. SUTTON'S//PROV, R. I.
Adv. 1866 (Baldwin 1973); 1910, *AD*.
Aqua; 6⅜″ × 2″ × 1¼″; 1n; 3b; 3 or 4ip; v, fss.

Dᴿ A. BOSCHEE'S/ GERMAN SYRUP//L. M. GREEN// PROPRIETOR [See Figure 221]
Lewis M. Green, Baltimore, MD, established a wholesale drug business in 1866 and a manufactury in Woodbury, NJ, in 1870 or 1871 (Holcombe 1979); Lewis's son George G. became manager and sole agent in 1872. Boschee's German Syrup was introduced in 1872, Green's August Flower in the late 1860s, and Green's Aque Conqueror ca. 1880 (Wilson and Wilson 1971). Wilson and Wilson note the transition from a 7 neck finish to a 1 neck finish ca. 1897 for the bottle. However, variants containing the syrup and embossed L. M. GREEN in the 1930s–1940s, possessed a 7 neck finish, were clear, ABM, and were labeled: *New Revised Label, April, 1939 . . . G. G. Green, Woodbury, N.J.*
Aqua; 6¼″ to 6¾″ × 2¼″ × 1¼″; 1 and 7n; 3b; 4ip; v, fss. See G. G. GREEN (Miscellaneous), L. M. GREEN (Miscellaneous).

Fig. 221

DR. BROGAS/BLOOD AND LIVER SYRUP/59 R. R. ST. ONEIDA, N. Y.
Kinsman D. Broga, born in 1830, began his medical practice as a eclectic physician in Durhamville, NY in 1861 and eventually moved to Oneida, NY. A branch office was also located in Camden, NY. Broga was still in business in 1894 according to the 1894 edition of the *Biographical Review of Madison County New York.*

Clear; 8¼″ × 3″ × 2⅛″; 9n; rect.; pl; v.

Dᴿ BROWDER'S/COMPOUND SYRUP/OF INDIAN TURNIP
Aqua; 7″ × 2¾″ × 1¾″; 11n; 4b; pl; v; p.

J. W. BULL'S//COUGH SYRUP// BALTIMORE
"The Peoples Remedy"; introduced in 1852. There is no relationship to John Bull's Sarsaparilla. August Vogeler, who began manufacturing drugs and chemicals in Baltimore, MD, in 1845, acquired the preparations of Rev. Dr. John W. Bull in 1873, and formed a partnership with Adolph C. Meyer. The company was known under several names and eventually became A. C. Meyer & Co. after Meyer purchased all interests of the partners in 1883. The company promoted Dr. Bull's Family Medicines. Another branch of the business produced and promoted the Dr. Koenig preparations: A. Vogeler & Co., 1873–1882; Vogeler, Winklemann & Co., 1882–ca. 1885; and then two smaller branches, John H. Winklemann & Co., and Vogeler, Son & Co. St. Jacobs Oil was produced by yet another division (Holcombe 1979). Cough syrup introduced in 1852. Adv. 1941–42 by A. C. Meyer & Co., Baltimore, Md., *AD*.
Aqua; 5¾″ × 1¾″ × 1″; 11n; 3b; 3 or 4ip; v, sfs. See BULL (Pectoral), REDSTAR (Cure), SALVATION (Oil), ST. JACOB *(Oil)*, VOGELER (Company).

DR. J. W. BULL'S//COUGH SYRUP/A. C. MEYER & CO.// BALTIMORE, MD. U.S.A.
Aqua; 5¾″ × 1¾″ × ⅞″; 11n; 3b; 3ip; v, sfs. See BULL (Pectoral), REDSTAR (Cure), SALVATION (Oil), ST. JACOB *(Oil)*, VOGELER (Company).

DR. J. W. BULLS COUGH SYRUP// A. C. MEYER & CO. BALTO. MD. U.S.A. [Base:] W
Aqua; 6⅜″ × 2″ × 1³⁄₁₆″; 11n; 3b; 4ip; v, ss. See BULL (Pectoral), REDSTAR (Cure), SALVATION (Oil), ST. JACOB *(Oil)*, VOGELER (Company).

Dᴿ J. W. BULL'S/VEGETABLE/ BABY SYRUP/TRADE MARK
Bottle manufactured ca. 1886 (Wilson and Wilson 1971). Adv. 1878 (Devner 1968); 1879, *VSS & C*; 1921, *BD*.
Aqua; 5″ × ?; 1n; 20b; pl; v. See BULL (Pectoral), REDSTAR (Cure), SALVATION (Oil), ST. JACOB *(Oil)*, VOGELER (Company).

BUMSTEAD'S/WORM/SYRUP/ONE BOTTLE/HAS KILLED/ 100 WORMS/(CHILDREN/CRY FOR MORE/JUST TRY IT/PHILADᴬ
Adv. 1876, *WHS*; 1929–30 by Dr. C. A. Voorhees Estate, 426 W. Chelten, Philadelphia); 1948 by The Dr. C. A. Voorhees Co., 34 W. Lancaster Ave., Ardmore, Pa., *AD*.
Aqua; 4½″ × 1¼″ diameter; 7n; 20b; pl; h.

BURRINGTON'S/VEGETABLE CROUP SYRUP/PROVIDENCE R.I.
Product of Henry H. Burrington, Providence, RI, introduced ca. 1840s. His son, Charles, continued the business after Henry's death in 1885 (Wilson and Wilson 1971). Adv. 1898, *CHG*.
Aqua; 5¼″ × ?; 13n; 20b; pl; v; p.

CALDWELL'S SYRUP PEPSIN/ MF'D. BY/PEPSIN SYRUP COMPANY/MONTICELLO, ILLINOIS [See Figure 222]
Dr. William Burr Caldwell introduced his Syrup Pepsin ca. 1889. The product was purchased by Allen Moore in 1899; Moore sold out to Household Production in 1924. Embossed bottles date ca. 1895–1962; the cork enclosure became a threaded cap in 1942. For many years the bottles were manufactured by the Pierce Glass Co., Port Allegany, PA (Whitaker 1973). A 1979 label: *DR. CALDWELL'S SENNA LAXATIVE,* was on a product of Glenbrook Labs., 90 Park Ave., New York City, *RB*.
Aqua; 3″ × 1³⁄₁₆″ × ¾″; 3n; 6b; pl; v. Also ABM variants.

Fig. 222

CALDWELLS SYRUP PEPSIN/MF'D BY/PEPSIN SYRUP COMPANY/ MONTICELLO, ILLINOIS
Aqua; 7″ × 2⁵⁄₁₆″ × 1⁵⁄₁₆″; 1n; 6b; pl; v.

DR. W. B. CALDWELL'S/SYRUP PEPSIN//PEPSIN SYRUP COMPANY//MONTICELLO, ILLINOIS
Light blue; 9″ × 2⅞″ × 1¹¹⁄₁₆″; 1n; 3b; 3ip; v, fss; ABM.

CALIFORNIA FIG SYRUP CO/CALIFIG/STERLING PRODUCTS (INC.)/SUCCESSOR
Label: *CA LI FIG Elixir of Senna Combined in Palatable Syrup of Figs – Active Ingredients: Alcohol 6%, Senna, Cassia, Peppermint, Clove Combined in Palatable Fig Syrup Gentle and Effective Relief For Temporary Constipation. The Sterling Products Division, Wheeling W. Va., Successor to California Fig Syrup Co.* Product was introduced by W. Penninger and R. Queen ca. 1878. In the 1880s the business was relocated to San Francisco, CA, and the name Ca Li Fig was adopted (White 1974); an office remained in or included Reno until 1907 according to Reno city directories. In 1897 offices were located in San Francisco, Louisville, and New York, according to the *Langley & Michaels* catalog. Fig syrup was manufactured until the 1970s by Sterling Drug Inc., Wheeling, WV.
Clear; dimens. unk.; 7n; 3b; 3ip; v, ABM. See SYRUP (Syrup).

CALIFORNIA/FIG SYRUP CO/ SAN FRANCISCO, CAL
Clear; 7″ × 2¼″ × 1⅜″; 7n; 3b; ip; v. See SYRUP (Syrup).

CALIFORNIA FIG SYRUP CO/ SAN FRANCISCO, CAL// SYRUP OF FIGS//SYRUP OF FIGS
[See Figure 223]
Clear; 7⅛″ × 2³⁄₁₆″ × 1⅜″; 7n; 3b; 3ip; v, fss. See SYRUP (Syrup).

Fig. 223

CALIFORNIA/FIG SYRUP CO.// WHEELING, W. VA.
Clear; 6⅞″ × 2³⁄₁₆″ × 1⅜″; 8n; 3b; 3ip; v, fs; ABM. See SYRUP (Syrup).

GRACE CARY//AUSTRALIAN/ EUCALYPTUS/GLOBULOUS/ [embossed tree]/TRADE MARK/ GUM TREE/COUGH SYRUP// SAN FRANCISCO//DIRECTIONS/ TAKE ONE TEASPOONFUL/EVERY TWO HOURS/UNTIL RELIEVED/ PRICE 75 CENTS
Adv. 1896-97, *Mack*; 1929-30 by H.G.O. Cary Med. Co., 524 Main St., Zanesville, O., *AD*.
Clear; 6⁵⁄₁₆″ × 2⁵⁄₁₆″ × 1⁵⁄₁₆″; 7n, sp; 3b; 4ip; v, s; h, f; v, sb. See EUCALYPTUS (Oil).

CHAPMAN'S/CHOLERA SYRUP/ 4 SALEM ST.
Dr. Chapman's Cholera & Dysentery Syrup was advertised in 1859 as "'Prepared from the Original Recipe' by Dr. C. W. C. Grant, Successor to the late Dr. J. W. Chapman, No 160 Hanover, corner of Salem Street, Great Falls, N.H."; also in 1861 and 1880 as prepared by George Moore, Great Falls, NH ". . . who was in the employ of Dr. J. W. Chapman for six years, and received the recipe directly from him." The advertisement for 1861 warns of imitators and states, ". . . the bottle has the name of the Proprietor blown in the glass" (Singer 1982).
Aqua; 6½″ × 2¾″ × 1½″; 11n; 12 or 13b; pl; v; p.

CLARK'S/SYRUP
Cure for sexual incapacities. Possibly a product of Joseph Clark, Albany, NY. Adv. 1859 (Baldwin 1973); 1860 (Putnam 1968). The relationship to Clark's Peruvian Syrup is unknown.
Green; 9½″ × 2¾″ × 2¾″; 1n; 2b; pl; v. See PERUVIAN (Syrup).

CLASSES/COUGH SYRUP
Label: *CLASSE'S COUGH SYRUP – Alcohol 8 per cent – For the Relief of Coughs, Colds, Croup . . . Prepared only by W. P. DIGGS & CO., ST. LOUIS, MO.* Adv. 1900, *EBB*; 1935 by James F. Ballard, Inc., St. Louis, Mo., *AD*.
Clear; 7″ × 2³⁄₁₆″ × 1⅛″; 7n; 3b; 3ip; v. See CLASSE (Remedy).

CLIMAX SYRUP//OWEGO, N.Y.
Aqua; 4⅝″ × 1½″ diameter; 5n; 21b, 12 sides; pl; v, ss, on alternate panels; p.

W. H. CULMER'S/ROCKY MOUNTAIN/COUGH SYRUP

Bottle manufactured by Wm. McCully, Pittsburgh, PA, 1832 to ca. 1886 (Toulouse 1972).
Clear; 4⅞″ × 1⅝″ × 1″; 7n; 3b; 1ip, arched; v.

DOCT. CURTIS'//CHERRY/SYRUP// NEW YORK [See Figure 224]
Adv. 1865, 1874 (Denver 1968).
Clear; 7¼″ × 2½″ × 1⅝″; 1n; 3b; 3ip; v, sfs; p. See CURTIS (Miscellaneous), WINSLOW (Syrup).

Fig. 224

DAVIS & MILLERS//AMERICAN// WORM SYRUP//A. CERTAIN// REMEDY//FOR WORMS
Adv. 1872, *VHS*.
Aqua; 4⅝″ × 1⅝″ diameter; 5n; 21b, 6 sides; pl; v, sssss; p. See DAVIS & MILLER (Drug).

Dᴿ DAVIS'S//COMPOUND// SYRUP OF//WILD CHERRY// AND TAR
Consumption medicine adv. 1847 (Baldwin 1973).
Light aqua; 6⅞″ × 2⁵⁄₁₆″ diameter; 11n; 21b, 8 sides; 5ip; v, sssss; p.

Dᴿ DENNIS/SYSTEM RENOVATOR &/BLOOD PURIFYING SYRUP
Adv. 1895, *McK & R*; 1910, *AD*.
Clear; 4⅛″ × 1⅝″ × 1⅜″; 7 or 9n; rect.; pl; v.

DEWITTS SOOTHING SYRUP/ CHICAGO
Advertised as ". . . an unfailing remedy for children during nursing and teething period. . . ." Adv. 1899 (Devner 1968); 1910, *AD*.
Clear; 5″ × ¹³⁄₁₆″ diameter; 7n; 20b; pl; v. See DEWITT (Company, Cure, Sarsaparilla).

DUCONGE'S/PECTORAL BALSAM SYRUP/NEW ORLEANS
See DUCONGE (Balsam).

G. DUTTON & SON//COUGH & BRONCHITIS MIXTURE//OR/

**SYRUP OF LINSEED &
LIQUORICE//CHEMISTS BOLTON**

Aqua; 5½″ × 2″ × 1⅛″; 7n; 6b; pl; v,
sfs; tapered body.

**ETHEREAL/COUGH SYRUP//
THE HOLDEN DRUG CO//
STOCKTON CAL**

Aqua; 5⅞″ × 1⅞″ × 1⅜″; 1n; 3b; 3ip;
v, fss. See HOLDEN *(Syrup)*.

DR/W. EVANS/TEETHING SYRUP

Product of Dr. William Evans, New
York, adv. 1840 (Baldwin 1973).

Aqua; 2⅜″ × ⅞″ diameter; 5n; 20b;
pl; v. See EVANS *(Pills)*.

**FELLOWS/SYRUP OF/
HYPOPHOSPHITES**

There are American and Canadian
variants. "Fellows' Compound Syrup of
Hypo-phos-phites – 'The Promoter and
Perfector of Assimilation – The
Reformer and Vitalizer of the Blood –
The Producer and Invigorator of Nerve
and Muscle – The Builder and Supporter
of Brain Power' . . . Curtis & Brown
Mfg. Co., Nos. 215 & 217 Fulton
Street, New York." James I. Fellows,
St. John, New Brunswick, followed his
father's line of work (Israel Fellows and
Donald James had established a chem-
ical drug manufactury in 1849). James
primarily formulated medicinals and let
larger wholesalers market the products.
James I. Fellows & Co. also was in a
partnership with Perry Davis & Son,
Taunton, MA. The syrup was
introduced ca. 1872, agents included
Curtis & Brown (Holcombe 1979;
Wilson and Wilson 1971). Adv. 1876
by Perry Davis & Son and Lawrence
& James I. Fellows, Canada (Devner
1968); 1900 by Fellows Medical Mfg.
Co., 48 Vessey, New York City, *EBB*;
1929–30 and 1948 by Fellows Med.
Mfg. Co., Inc., 26 Christopher St.,
New York City, *AD*; 1980 by O'Neal,
Jones & Feldman Inc., 2510 Metro
Blvd., Maryland Heights, MO., *RB*.

Aqua; 7¾″ × 3½″ × 2¼″; 7n; 13b; ip;
v. See BURDOCK (Bitters), FELLOW
(Chemical, Tablet), FOWLER (Extract),
THOMAS *(Oil)*, WOOD (Syrup).

**DR. FOORD'S//PECTORAL/
SYRUP//NEW YORK**

Adv. 1846 (Putnam 1968); 1910, *AD*.

Aqua; 7½″ × 2½″ × 1¾″; 9 and 11n;
3b; 3 or 4ip; v, sfs; with and without
p; 2 sizes. See FOORD *(Cordial)*.

**GALLUPS//SYRUP OF/
BRIER ROOT//ALBANY, N.Y.**

Product of S. T. and A. Smith. Adv.
1852 (Baldwin 1973); 1887, *WHS*.

Clear; 6¼″ × 2⅛″ × 1⅛″; 1n; rect.;
ip; v, sfs.

GARFIELD-TEA//SYRUP

Label: *GARFIELD-TEA SYRUP. A Mild
Pleasant Laxative. Babies Like It, It Cures
Them. Healthful, Agreeable, Unequalled.
GARFIELD TEA CO., 41st St. & 3rd
Ave., Brooklyn, N.Y.* Slogan: "Flush your
Bowels with Garfield Tea." Adv. 1881
(Devner 1968); 1948 by Garfield Tea
Co., 313 41st St., Brooklyn, N.Y., *AD*;
1984–85 by Medtech Laboratories,
Inc., Cody, WY, *AD*.

Clear; 4⅝″ × 1⅝″ × 1³⁄₁₆″; 1n; 3b;
2ip; v, ss.

GAUVIN'S SYRUP FOR BABIES

Product of J. A. Gauvin, Lowell, MA.
Adv. 1912 (Devner 1968).

Aqua; 4¹¹⁄₁₆″ × 2⅜″ diameter; 7n;
20b; pl; v.

GIBSON'S/SYRUP

Adv. 1858 (Baldwin 1973); 1910, *AD*.

Green; 9¾″ × 2¾″ × 2¾″; 1n; 1 or
2b; pl; v.

**S. B. GOFF'S//COUGH SYRUP//
CAMDEN, N. J.**

Adv. 1890, *W & P*; 1935 by S. B. Goff
& Sons Co., LeRoy, N.Y.; 1948 by
Kemp & Lane Inc., LeRoy, N.Y., *AD*.

Aqua; 5¾″ × ? × ?; 8n; 3b; 3ip; v, sfs.
See GOFF (*Bitters*, Liniment,
Miscellaneous), KEMP *(Balsam)*.

**S. B. GOFF'S//INDIAN
VEGETABLE/COUGH SYRUP/
& BLOOD PURIFIER//CAMDEN N.J.**

Aqua; 8″ × 2″ × 1⅛″; 7n; 3b; 3ip; v,
sfs. See GOFF (*Bitters*, Liniment,
Miscellaneous), KEMP *(Balsam)*.

**GRAEFENBERG CO//DYSENTERY/
SYRUP//NEW YORK**

Several investors including Joshua A.
Bridge, established the business ca.
1847; Bridge eventually acquired full
control (Wilson and Wilson 1971).
Products included Sarsaparilla,
Consumptive Balm, Fever & Ague
Remedy, Eye Lotion, Health Bitters,
Uterine Catholicon and Pile Remedy.
Products adv. 1848 (Singer 1982);
1935, *AD*. Syrup adv. 1858 (Baldwin
1973); 1923, *SF & PD*.

Aqua; 4¾″ × ? × ?; 13n; 3b; 3ip,
arched; v, sfs. See GRAEFENBERG
(Company, Sarsaparilla).

**Graefenberg Co//DYSENTERY/
SYRUP//NEW YORK**

Aqua; 5¾″ × 1⅞″ × 1⅜″; 1n; 3b; 3ip;
v, sfs; p. See GRAEFENBERG
(Company, Sarsaparilla).

**WM. H. GREGG M.D./NEW
YORK//CONSTITUTION//
LIFE SYRUP**

Labeled as a family remedy for diseases
of the blood. Introduced 1859 (Wilson
and Wilson 1971). Adv. 1865, *GG*;
1910, *AD*.

Aqua; 8¾″ × ? × ?; 3 and 9n; 3b; 3 or
4ip, gothic; v, fss. See GREGG (Water).

SIROP IODE/DE/GRIMAULT & Cⁱᵉ

French preparation, Grimault's Iodized
Syrup of Horseradish, adv. 1891, *WHS*;
1935 by E. Fougera, New York City,
AD.

Aqua; 8″ × 2⅞″ × 1¹¹⁄₁₆″; 7n, sp; 10b;
pl; h, tapered body.

**DR. GUERTIN'S//NERVE SYRUP//
KALMUS CHEMICAL CO./
CINCINNATI.** [Base: I in diamond]

Label: *Dr. GUERTIN'S NERVE
SYRUP, For Epilepsy, Hysterical, Infantile
and Puerperal Convulsions, Nervous
Excitement or Unrest. KALMUS CHEM.
CO., CINCINNATI, OHIO.* Bottle
manufactured by the Illinois Glass Com-
pany, 1916 to 1929 (Toulouse 1972).
Adv. 1910, *AD*; 1929–30 by P. D. Q.
Speciality Co., 214 Main St.,
Cincinnati, O; the same address for
Kalmus Chem. Co., *AD*; 1948 by
Kalmus Chem. Co., 215 E. Pearl St.,
Cincinnati, O., *AD*. Directories estab-
lish the Kalmus Chemical Company,
Wholesale Druggists, in 1908. The
proprietor, Otto Kalmus, was also
associated with the Epileptic Institute.
Kalmus apparently acquired the formula
from Alfred L. Guertin, a Cincinnati
physician.

Clear; 8¼″ × 2¹³⁄₁₆″ × 1½″; 1n; 3b;
3ip; v, ssf; ABM.

**DR. GUERTIN'S//NERVE SYRUP//
KALMUS CHEMICAL CO./
CINCINNATI & NEW YORK**

Clear; 8½″ × 2¾″ × 1¾″; 1n; 3b; 3ip;
v, ssf.

**GUNN'S/ONION SYRUP/
DR. BOSANKO MED CO/
PHILADA. P.A.**

See BOSANKO *(Company)*.

**DR. GUNN'S/ONION SYRUP/
PREPARED BY/
THE DR. BOSANKO MED. CO/
PHILADELPHIA, PA.**

See BOSANKO *(Company)*.

**DR. GUNN'S/ONION SYRUP/
SAMPLE SIZE**

Aqua; 2⁹⁄₁₆″ × 1⁵⁄₁₆″ × 1³⁄₁₆″; 7n; 3b;
pl; v. See BOSANKO *(Company,
Remedy)*.

HADLOCKS//VEGETABLE//SYRUP
Adv. 1836 (Baldwin 1973); 1910, *AD*.
Aqua; 6½″ × 2½″ × 2½″; 11n; 21b, 6 sides; 3ip; v, sss, on alternate panels; p.

HANSEE EUROPEAN/COUGH SYRUP/R. H. HANSEE PRO/MONTICELLO N.Y.
Adv. 1910, *AD*; 1929–30 by Harris Chemical Co., Honesdale, Pa., *AD*.
Light green; 5⅝″ × 1⅞″ × 1⅛″; 7n; 3b; 3ip; v.

[Script:] **Valentine Hassmer's/LUNG & COUGH SYRUP/PRICE PER BOTTLE 1.25/5 BOTTLES TO THE GALLON/P.O. BOX 1886**
Label: *VALENTINE HASSMER'S LUNG & COUGH SYRUP For All Diseases Of The Throat & Lungs—Catarrh—Fevers IT WILL CURE CONSUMPTION Price Per Bottle $1.25 933 Washington St., Cor. Powell, San Francisco.* Distribution ca. 1880–1900 (Wilson and Wilson 1971). Adv. 1896–97, *Mack*.
Amber; 12″ × ?; 12n; 20b; pl; h, partial script.

DR HASTING'S//NAPTHA/SYRUP//LONDON
Product for bronchitis, spitting of blood, etc. Adv. 1848 (Baldwin 1973); 1910, *AD*.
Aqua; 6½″ × 2½″ × 1½″; 1n; 3 or 6b; pl; v, sfs.

DR. E. D. HAYES//VEGETABLE/HUMOR SYRUP//HAYES & NASH/LAWRENCE MASS
Adv. 1857 (Baldwin 1973); 1865, *GG*.
Aqua; 7¼″ × 2¼″ × ?; 11n; 3b; 3 or 4ip; v, ssf; p.

HERRICK'S HOREHOUND SYRUP/CURES ALL THROAT/AND LUNG AFFECTIONS
Aqua; 6″ × 2⅛″ × 1⅛″; 7n; sp; 3 or 6b; ip; v.

DR. HILL'S//PULMONARY SYRUP//FARMER, N.Y.
Aqua; 7⅜″ × 3″ × 1⅞″; 1n; 3 or 6b; ip; v, sfs. See HILL (Cordial, *Killer*).

HOBENSACK'S//MEDICATED/WORM SYRUP//PHILADᴬ
John N. Hobensack was a Philadelphia druggist who went into business ca. 1842; his brother George joined him a few years later and by 1850 the company was one of the largest in the city. John practiced as an MD in the 1850s leaving the chores of the business largely to George; both retired in the 1860s (Wilson and Wilson 1971). There were no listings in directories after 1864. Worm Syrup adv. 1855, *New England Business Directory* (Boston: Adams, Sampson & Co., 1855); 1895, *McK & R*. The proprietors following Hobensack are unknown.
Aqua; 4¾″ × ? × ?; 5n; 3b; 3 or 4ip, arched; v, sfs; p.

HOLDEN'S/ETHEREAL COUGH SYRUP//THE HOLDEN DRUG CO//STOCKTON CAL.
E. S. Holden, druggist, Stockton, CA, began manufacturing medicines, perfumes and extracts in 1850. The firm was still in business in 1906 (Zumwalt 1980). Cough Syrup adv. 1897, *L & M*; 1923, *SF & PD*.
Aqua; 4⅞″ × 1¹¹⁄₁₆″ × 1″; 23n; 3b; 3ip; v, fss. See ETHEREAL (Syrup).

DR. HOOKER'S/COUGH & CROUP/SYRUP
Adv. 1867 by C. D. Lee, Proprietor, Springfield, MA (Singer 1982); 1891 by Charles B. Kingsley, 140 Main St., Northampton, Mass. in *Pharmaceutical Era*; 1929–30 by Kingsley Labs., 140 Main St., Northampton, Mass.; 1941–42 at 138 Main St., *AD*.
Aqua; 5⅝″ × 1⅝″ diameter; 1n; 20b; 1ip; v.

HUNTER'S/PUL. BALSAM/or COUGH SYRUP//J. CURTIS/PROP.TR/BANGOR ME.
See HUNTER (*Balsam*).

Dr HUNTINGTON.S//COMPOUND RESTORATIVE/SYRUP//TROY. N.Y.
Bottle manufactured ca. 1849. Elon Huntington sold medicines in Troy, NY, in the 1850s and operated a grocery in the 1860s. It's possible that Elon inherited the product from Matthew L. Huntington, relationship unknown, a Troy merchant from the 1830s to early 1850s (Wilson and Wilson 1971).
Aqua, light green; 9″ × ?; 11n; 2b; pl; v; S in HUNTINGTON'S is backwards.

THOˢ. A. HURLEY'S//COMPOUND SYRUP/OF/SARSAPARILLA//LOUISVILLE, K.Y.
See HURLEY (*Sarsaparilla*).

INDIAN COUGH SYRUP//WARME SPRINGS OREGON
Product of the Oregon Indian Medicine Co., Corry, PA.

Clear; 7″ × 2¼″ × 1⅛″; 11n; 3b; ip; v, ss. See KA:TON:KA (*Remedy*), MODOC (Oil).

Dr H. W. JACKSON/DRUGGIST/VEGETABLE/HOME SYRUP
See JACKSON (*Drug*).

DR. JAMES/CHERRY TAR SYRUP//PITTSBURGH//PENNA, U.S.A.
Adv. 1907, *PVS & S*; 1910, *AD*.
Aqua; 5¾″ × 1⅞″ × 1″; 1n; 3 or 6b; 3 or 4ip; v, fss.

JORDAN'S/COUGH SYRUP/JORDAN MARSH DRUG CO./COXSACKIE, N. Y.
Clear; 5″ × 1⅞″ × 1⅛″; 7n; rect.; pl; v. See WHITE PINE (*Syrup*).

KELLY'S/RHEUMATIC/SYRUP
Adv. 1915, *SF & PD*; 1921, *BD*.
Aqua; 5⁵⁄₁₆″ × 2³⁄₁₆″ × 1¼″; 9n; 4b; 1ip; v.

KELLY'S/RHEUMATIC/SYRUP
[Base:] **480/H**
Adv. 1923, *SF & PD*.
Aqua; 5¼″ × 2⅛″ × 1¼″; 9n; 4b; 1ip; v.

KICKAPOO/COUGH SYRUP
Introduced in 1881 (Fike 1967). Adv. 1935 by Wm. R. Warner Co., New York City, *AD*.
Aqua; 6¼″ × 1¼″ diameter; 7n; 20b; 1ip; v. See HEALY & BIGELOW (Cure, *Miscellaneous*, Oil), KICKAPOO (Miscellaneous, *Oil*), SAGWA (Miscellaneous).

KIDD'S COUGH SYRUP
Adv. 1863 (Holcombe 1979); 1910, *AD*.
Amber; 6″ × 2″ × 1⅛″; 7n; 3b; 1ip, arched; v. See McLANE (*Specific*).

Dᴿ KING'S//CROUP/&/COUGH//SYRUP
Product may have been acquired by H. E. Bucklen. Adv. 1910, *AD*.
Aqua; 5″ × ? × ?; 1n; 3b; 3ip; v, sfs; p. See KING (*Discovery*).

Dᴿ LAROOKAH'S//INDIAN/VEGETABLE//PULMONIC SYRUP
Product of Severy & Howe, Melrose, MA, 1855; Severy & Ingalls, Melrose, MA, 1856 (Singer 1982). Adv. 1910, *AD*.
Aqua; 8¼″ × ? × ?; 11n; 3b; ip; v, sfs.

REV. J. W. LAWTON'S/INDIAN BLOOD SYRUP
Aqua; 8″ × 3¼″ × 2″; 7n; 3 or 6b; ip; v.

Dᴿ LEATHE'S/YELLOW DOCK SYRUP/NEW YORK

Adv. 1860 (Singer 1982); 1891, *WHS*.
**Aqua; 9¼″ × 4½″ × 2½″; 11n; 13b;
pl; v.**

LEVING'S//HOARHOUND/AND/ ELECAMPANE//SYRUP

Product of Obadiah Leving, San Francisco, CA, 1892–1894. Leving also manufactured a sarsaparilla (Wilson and Wilson 1971).

**Blue aqua; 7¼″ × ? × ?; 7n; 3 or 6b; 3
or 4ip, arched; v, sfs.**

LEWIS//COUGH//SYRUP// ROCHESTER, N.Y.

**Olive; 6″ × 2⅝″ diameter; 11n; 21b, 8
sides; pl; v; p.**

LITTLE'S//PECTORAL/SYRUP// NEW YORK

Dr. J. Delmonico Little's Syrup Pectoral, Anderson & Howell, Sole Proprietors, 400 Canal St., New York. Adv. 1870 (Singer 1982).

**Aqua; 7¼″ × 2⅜″ × 1¼″; 7n; 3 or
6b; 3 or 4ip; v, sfs.**

C. B. LITTLEFIELD'S/ CONSTITUTIONAL/COUGH SYRUP/MANCHESTER, N. H.

Adv. 1890, *W & P*. The business of C. B. Littlefield, Manchester, NH, operated from ca. 1879 to 1892, or later, according to the *New Hampshire Register, Farmers Almanac & Business Directory, 1891*.

**Aqua; 4½″ × 2³⁄₁₆″ × 1⅛″; 9n; 18b;
pl; v.**

LUNDIN'S CONDENSED/ JUNIPER-ADE//LUNDIN'S KONDENSERADE/ENBARS SIRUP//MAKES 5 GALLONS OF A/ HEALTHFUL BEVERAGE//LUNDIN & CO./SOLE MANUFACTURERS/ CHICAGO, ILL. U.S.A. [Base:] A3

See LUNDIN *(Company)*.

LUNG SAVER/THE GOOD COUGH SYRUP/THE LUNG SAVER CO. PHILA. PA. U.S.A.

See LUNG SAVER *(Company)*.

DR MARSHALL'S/LUNG SYRUP

Charles H. Marshall, Fond Du Lac, WS, established the Mary W. Marshall Co., in honor of his wife, in 1879 (Blasi 1974); Devner (1968) says 1878. Charles died in 1901, Mary in 1903, and son Frank assumed management. Frank, a physician, gradually relinquished his interest in the company and died in 1928 (Blasi 1974). The company was in Decatur, IN, in 1900, *EBB*; Red Granite, WS, in 1920 (Devner

1968) and 1935, *AD*. Lung Syrup adv. 1878 (Devner 1968); 1929–30, *AD*; adv. as Marshall's Cough Syrup in 1935, *AD*.

**Aqua; 4¹¹⁄₁₆″ × 1¹¹⁄₁₆″ × ¹³⁄₁₆″; 7n; 3b;
3ip; v.**

DR. J. A. McARTHUR'S//SYRUP OF/ HYPOPHOSPHITES// CHEMICALLY/PURE

Label: *McARTHUR'S SYRUP OF THE HYPOPHOSPHITES OF LIME & SODA. Formula of Dr. J. A. McArthur, Lynn, Mass. Prepared by The McArthur Hypophosphite Co., Ansonia, Conn.* Adv. 1887, *McK & R*; 1897 by Potter Drug & Chemical Co., Boston, Mass., *L & M*; 1900 by McArthur Hypophosphite Co., Ansonia, Conn., *EBB*; 1935 (same address), *AD*.

**Clear; 6⁹⁄₁₆″ × 2⁹⁄₁₆″ × 2⁹⁄₁₆″; 2n; 9b;
4ip; v, fsb. See CUTICURA *(Cure)*.**

MRS Wᴹ MERRIAMS/ COUGH SYRUP//MERRIAM & FROST//SPRINGFIELD MASS.

Adv. 1875 (Baldwin 1973).

**Aqua; 6⅜″ × 2″ × 1¼″; 1n; 3 or 6b;
3 or 4ip; v, fss.**

Dʀ MITCHEL'S//IPECAC SYRUP// PERRY N.Y.

Adv. 1849 (Baldwin 1973); 1907, *PVS & S*.

**Aqua; 5⅛″ × 1½″ × 1¼″; 11n; 3 or
6b; 3 or 4ip; v, sfs; p.**

DR. MORRIS//SYRUP OF TAR// DACOSTAS/RADICAL/CURE

See DACOSTA *(Cure)*.

MORSE'S/CELEBRATED SYRUP/ PROV. R. I.

1853 advertisement: "MORSE'S COMPOUND SYRUP OF YELLOW DOCK ROOT Occupies the first rank among the proprietary medicines of this country for completely curing Cancer, Salt Rheum, Erysipelas, and all other diseases arising from an IMPURE STATE OF THE BLOOD. . . ." Adv. 1850 by C. Morse & Co., Providence, RI (Baldwin 1973), 1910, *AD*. The product was manufactured for a number of years by the W. H. Comstock Co., Ltd., Morristown, NY (Holcombe 1979).

**Aqua; 9½″ × 4¼″ × 2¾″; 11n; 12b;
pl; v; p. See COMSTOCK (Miscellaneous), MORSE (Cordial, *Pills*).**

MOTHER'S/WORM SYRUP// EDWARD WILDER & CO/ WHOLESALE DRUGGIST

Product of Wilder & Co., Louisville, KY. Adv. 1869 (Baldwin 1973); 1891,

WHS. Apparently Edward Wilder began manufacturing medicinals in 1859. Wilder terminated his drug business ca. 1876 and established a wholesale liquor distributorship; he died in 1890 (Shimko 1969). Other products included Wilder's Chill Tonic, Extract of Wild Cherry, Stomach Bitters, Sarsaparilla and Mother's Syrup.

**Clear; 4¾″ × 1¼″ × 1¼″; 12n; 1 or
2b; ip; v, fb.**

MULLOCK'S/COUGH SYRUP/ WAVERLY N.Y.

**Aqua; 6¼″ × 1³⁄₁₆″ × 2³⁄₁₆″; 7n; sp;
6b; ip; v.**

NEWELL'S//PULMONARY/ SYRUP//REDINGTON & Cᵒ

A product of William Andrew Newell, San Francisco, CA, Newell's Pulmonary Cough Syrup was available in 1860 or earlier, according to directories. By the early 1890s the product was being distributed by Redington, who also may have been the owner. Syrup adv. 1897, *L & M*.

**Aqua; 7⅝″ × 2⁵⁄₁₆″ × 1¾″; 1n; 3b;
3ip; v, sfs. See COFFIN-REDINGTON (Company), REDINGTON *(Company)*.**

PAGE'S/VEGETABLE SYRUP/ FOR FEMALES

Label: *PAGE'S VEGETABLE SYRUP, The Safest and Most Effectual Remedy for Lessening the Pains and Sufferings Attendant of Parturient Women that has ever been discovered. Prepared by Gilman Brothers, 109 Milk Street, Boston. Entered According to Act of Congress in the Year 1863.* Adv. 1891, *WHS*.

**Aqua; 8½″ × 3¼″ diameter; 2n; 20b;
pl; v. See ARNOLD *(Balsam)*.**

[Embossed swastika]/COMPOUND/ LAXATIVE SYRUP/MFGD BY T. S. PAINE/WAYCROSS GA.

In Laura Singleton Walker's *History of Ware County* (Macon, GA: J. W. Burke Co., 1934), Dr. Thomas Spaulding Paine was recalled as a Civil War veteran and First Lieutenant in the Ochlochnee Light Infantry. He was given special recognition for his veterans service, and presented an award in 1894. No other information was found.

**Aqua; 5¾″ × 2⅛″ × 1⅛″; 8n; 3 or
6b; ip; v.**

PROF. PARKER'S/PLEASANT/ WORM SYRUP

Adv. 1876 (Baldwin 1973); 1916, *MB*.

**Aqua; 4½″ × 1″ diameter; 7n; 20b;
pl; v.**

**PARKS/COUGH/SYRUP//
FREE SAMPLE**

Aqua; 3″ × 1¼″ × ¾″; 7n; 3 or 6b; ip;
v, fb. See PARK (Cure), SHILOH (*Cure*,
Miscellaneous, Remedy), WELLS
(Company).

**PARK'S/COUGH/SYRUP//
F. O. REDDISH//LEROY, N. Y.**

George H. Wells, LeRoy, NY, was
born 12 June 1848. After 1876, George
worked with ". . . his brother S. C.
(Schuyler) in the manufacture and sale
of the celebrated 'Shiloh's Remedies,'
having charge of the correspondence."
In 1882 Schuyler sold one-third interest
in his business to George, according to
North's *Description & Biographical Rec-
ord of Genesee Co., N.Y., 1899.* Aside
from his associations with Schuyler,
George was managing his own firm, G.
H. Wells & Co., proprietors of Park's
Sure Cure products in 1889 (Shimko
1969) and 1894, as listed in the LeRoy
city directory. Contrary to Wilson and
Wilson (1971), there is no evidence of
George establishing this business in the
early 1870s. George died ca. 1897.

Frank O. Reddish, LeRoy, NY, was
born 13 Nov. 1853. Reddish manufac-
tured carriages until July 1879 when he
became general agent for S. C. Wells
& Co. Reddish resigned when Schuyler
died in July 1898 and ". . . purchased
a three-fourths interest in a competing
line formerly manufactured by George
H. Wells & Co. On October 1, 1897,
Mr. Reddish began the manufacture of
pharmaceutical and proprietary medi-
cines as follows: Park's Tea for Consti-
pation, Park's Sure Cure for Kidney and
Liver Trouble, Park's Cough Syrup and
Park's Kidney and Liver Plasters,"
North's *Description & Biographical Record
of Genesee Co., N.Y., 1899.* Reddish
apparently assumed George's business
shortly after George's death but prior to
purchasing controlling interest. The
firm was operating in 1900, *EBB*; how
long Reddish controlled the business is
unknown. Park's Cough Syrup adv.
1895, *McK & R*; 1907, *PVS & S.*

Aqua; 6⅜″ × 2³⁄₁₆″ × 1⅛″; 11n; 3b;
4ip; v, fss. See PARK (Cure), SHILOH
(*Cure*, Miscellaneous, Remedy), WELLS
(Company).

**PARKS/COUGH/SYRUP//GEO. H.
WELLS//LEROY N.Y.**

Aqua; 6¾″ × ? × ?; 11n; 3b; 4ip; v,
fss. See PARK (Cure), SHILOH (*Cure*,
Miscellaneous, Remedy), WELLS
(Company).

**PERUVIAN//SYRUP//
N. L. CLARK & CO.**

Label: *PERUVIAN SYRUP or, protected
Solution of Protoxide of Iron, For the Cure
of Dyspepsia, Affections of the Liver,
Dropsy, Neuralgia, Bronchitis Consumptive
Tendencies, Boils, Scurvy, Cutaneous Com-
plaints, General Debility and all Diseases
which require a Tonic and alterative medi-
cine. Sold by N. L. CLARK & CO.,
Proprietors, No. 5 Water St. Boston.*
Introduced in the 1850s (Wilson and
Wilson 1971). Adv. 1856 (Putnam
1968); 1910, *AD.*

Aqua; 8³⁄₁₆″ × 2½″ × 1⅝″; 11n; 3b;
3ip; v, ssf.

PERUVIAN SYRUP [See Photo 69]

Labeled as a remedy for . . . *Dyspep-
sia, Liver Complaint, Dropsy, Languor
and Depression of Spirits, Piles, Carbun-
cles and Boils, Scurvy . . . plus Diseases
Peculiar to Tropical Climates. Since 1854.
Prepared by N. L. CLARK & CO.,
BOSTON Exclusively For J. P. Dinsmore,
New York. Entered, according to Act of
Congress, In the Year 1860 by S. A. Clark.*

Aqua; 9⅞″ × 3″ diameter; 11n; 20b;
pl; v.

**PIKE & OSGOOD BOSTON MASS.//
ALTERATIVE SYRUP**

The Boston city directory for 1857
listed two separate entries: Marshall S.
Pike, Apothecary, and James H.
Osgood, Druggist; their association is
unknown.

Olive; 8⅝″ × 3⅜″ × 2¼″; 11n; 3b; pl;
v, ss; p.

**RAMON'S/SANTONINE/
WORM SYRUP//BROWN M'F'G
CO. NEW YORK**

Adv. ca. 1883 (source unk.); 1910, *AD.*

Aqua; 5″ × ? × ?; 1n; 3b; 3 or 4ip; v,
fs; unknown if other side is embossed.
See RAMON (Tonic).

**RANSOMS//HIVE//SYRUP &//
TOLU**

Cure for the common cold introduced
in 1859 by David Ransom, Buffalo, NY
(Holcombe 1979). Adv. 1935 by D.
Ransom Son & Co., 137 Main St.,
Buffalo, N.Y., *AD.* Ransoms Com-
pound Syrup adv. 1948 by D. Ransom
Son & Co., 18 Quay St., Buffalo, N.Y.,
AD.

Blue; 3½″ × 1½″ × 1½″; 3n; 2b; pl;
v, fsbs. Also unembossed, ABM,
threaded variant. See RANSOM
(*Company*).

**REUTER'S//LIFE/SYRUP//
NEW YORK**

"Certain Cure for Every Sick Person."

Adv. 1878 (Baldwin 1973); 1910, *AD.*

Aqua; 9⅜″ × 3″ × 1⅝″; 11n; 3 or 6b;
3 or 4ip; v, sfs.

**RHEUMATIC/[embossed tree]/
TRADE MARK/SYRUP/1882//
R. S. CO ROCHESTER, N.Y.**

Product of the Rheumatic Syrup Co.,
Rochester, NY, adv. 1884 (Baldwin
1973); 1910, *AD.*

Amber; 9⅝″ × 2⅝″ × 2⅝″; 11n; 1 or
2b; ip; h, fb; order of back embossing
unknown.

**ROGERS//VEGETABLE/
WORM SYRUP//CINCINATTI**

Product of A. L. Scovill & Co., Cincin-
nati, OH. Adv. 1863 (Baldwin 1973);
1923, *SF & PD.*

Aqua; 5″ × 1¾″ × ⅞″; 11n; 3b; 3ip;
v, sfs. See SCOVILL (*Company*, Syrup).

**DR. ROGER'S//VEGI-MEDICA//
SYRUP**

Adv. 1890, *W & P.*

Aqua; dimens. unk.; 11n; 3b; 3ip; v,
sfs.

**SCHENCK'S//PULMONIC//
SYRUP//PHILAD.ᴬ**

Joseph H. Schenck introduced Dr.
Schenck's Mandrake Pills Compound
and Pulmonic Syrup in 1836, and soon
thereafter, his Sea-Weed Tonic. By
1872 the company was known as J. H.
Schenck & Son (Holcombe 1979).
Syrup adv. 1942 by J. H. Schenck &
Son, Philadelphia; 1948 by Plough Sales
Corp., Memphis, Tenn., *AD.*

Aqua; 7¼″ × 2¾″ diameter; 11n;
21b, 8 sides; pl; v, ssss, on alternate
panels. See SCHENCK (Tonic).

**SCOVILL'S//BLOOD &/
LIVER SYRUP//CINCINATTI, O.**

Bottle manufactured ca. 1877 (Wilson
and Wilson 1971). Adv. 1840 (Devner
1968); 1860 (Putnam 1968); 1916, *MB.*

Aqua; 9½″ × 2⅞″ × 1⅝″; 11n; 3 or
6b; 3 or 4ip; v, sfs. See BAKER
(*Miscellaneous*), BENNETT (Cure),
HALL (*Balsam*), J. F. HENRY
(*Company*), SCOVILL (*Company*),
WARREN (Cordial, Remedy).

**SCOVILL'S//BLOOD &/LIVER
SYRUP//CIN'TI & N.Y.**

Bottle manufactured ca. 1880 (Wilson
and Wilson 1971).

Aqua; 10″ × 3″ × 1¾″; 11n; 3 or 6b;
3 or 4ip; v, sfs. See BAKER
(*Miscellaneous*), BENNETT (Cure),
HALL (*Balsam*), J. F. HENRY
(*Company*), SCOVILL (*Company*),
WARREN (Cordial, Remedy).

**THE MOTHER SEIGEL'S//
SYRUP CO**

Andrew Judson White, New York, NY, purchased the formula from the Shakers and began distribution ca. 1856. In 1875, his son Albert J., assumed the business. Albert introduced Laxol in 1894 (Wilson and Wilson 1971). Syrup adv. 1935 by A. J. White Ltd., 70 W. 40th St., New York City, *AD*.
Aqua; 4³/₄″ × 1¹³/₁₆″ × 1¹/₈″; 7n; 4b; 2ip; v, ss. See LAXOL (Miscellaneous), SHAKER (Cordial, Pills), WHITE (Miscellaneous, Syrup).

SELLECK'S GINGER//TOLU COUGH SYRUP// CLAY, WHOLESALE & CO./ MFG PHARMACISTS/ELMIRA N.Y.
See CLAY *(Company)*.

SHAKER SYRUP/№ 1// CANTERBURY, N.H.
Bottle contained Corbett's Shaker Compound Concentrated Syrup or Sarsaparilla. The product was formulated by Dr. Thomas Corbett in the 1820s and given to the Shaker Society. In 1880 the brand had been on the market over 50 years (Singer 1982). Adv. 1910, *AD*.
Aqua; 8″ × 2¹/₂″ × 1¹/₂″, also height of 7¹/₄″; 11n; 3b; 2ip; v, ss; with and without p.

SHEDD'S/COUGH SYRUP
Adv. 1884 as "Shedd's Excelsior Cough Syrup, a Cure for the Irritation of Throat & Lungs" (Baldwin 1973). Adv. 1910, *AD*.
Aqua; 6″ × 2¹/₄″ × 1″; 7n; 3 or 6b; ip, oval embossed panel; v.

Sirop/dé sève de Pin/LAGASSE/ Phᵉⁿ/á BORDEAUX
A French preparation adv. 1887, *WHS*; 1923, *SF & PD*.
Aqua; 7⁷/₈″ × 3″ × 1¹/₂″; 7n; 6b; with concave front panels; pl; h.

SNOW & MASON/PROVIDENCE, R.I./CROUP & COUGH/SYRUP
Product advertised by C. A. P. Mason, Providence, RI, 1856–57 (Baldwin 1973); 1910, *AD*.
Color unk.; 5³/₈″ × ?; ?n; 20b; pl; v.

Dᴿ STANLEYS/ROOT & HERB/ LUNG SYRUP
Product of Stoddard & Hare, Georgetown, NY, for throat and lung diseases. Adv. 1878 (Baldwin 1973).
Light blue; 7″ × 2³/₈″ × 1³/₈″; 7n; 3b; 4ip; v.

DR. STEELLING'S//PULMONARY/ SYRUP//BRIDGETON, N.J.
Adv. 1845 (Baldwin 1973).

Aqua; 6″ × 2″ × ?; 11n; 3b; 3 or 4ip; v, sfs; p.

SYRUP OF FIGS//SYRUP OF FIGS
Bottle manufactured ca. 1884 (Wilson and Wilson 1971).
Aqua; 6³/₄″ × ? × ?; 7n; 3b; 3 or 4ip; v, ss. See CALIFORNIA *(Syrup)*.

DR. THACHER'S/LIVER & BLOOD SYRUP//SAMPLE// CHATTANOOGA, TENN.
[Base: C in diamond]
Adv. 1900, *EBB*; 1917 (Devner 1968).
Amber; 3⁵/₁₆″ × 1⁵/₁₆″ × ³/₄″; 3n; 6b; pl; v, fss. See THACHER (Mixture).

DR THACHER'S/LIVER AND BLOOD SYRUP/ CHATTANOOGA, TENN
Amber; 7¹/₄″ × 2¹/₂″ × 1¹/₂″, also height of 8″; 7n; 3b; 4ip; v. See THACHER (Mixture).

DR. THACHER'S/LIVER AND BLOOD SYRUP/ CHATTANOOGA, TENN.
Label: *DR. THACHERS LIVER & BLOOD SYRUP, 8% Alcohol. Recommended as helpful in the Treatment of Torpid Liver, Biliousness, Constipation, Indigestion, Loss of Appetite, Skin Eruptions, and Blood Impurities. . . .*
Aqua; 7⁷/₈″ × 2¹/₂″ × 1³/₈″; 3n; 3b; 3ip; v; ABM. See THACHER (Mixture).

THOMSON'S//COMPOUND/SYRUP OF TAR//FOR/CONSUMPTION// PHILADA
See THOMSON *(Compound)*.

Dᴿ TOPPING'S//ALTERATIVE &/ CATHARTIC SYRUP//J. J. LORD & CO./SPRINGFIELD ILL
Adv. 1872, *F & F*; 1910, *AD*.
Aqua; 8″ × 2¹/₂″ × 2¹/₂″; 1n; 2b; pl; v, fb.

UNIVERSAL//COUGH SYRUP// EMRY DAVIS/SOLE PROPRIETOR/ NEW YORK//EMRY DAVIS SUCCESSOR TO D. W. HATCH & CO. JAMESTOWN, N. Y.
Hatch's Universal Cough Syrup adv. 1876, *WHS*; 1910, *AD*.
Aqua; 5³/₈″ × 2⁷/₈″ × 1″; 1n; 3 or 6b; ip; v, ssfb, order of back embossing unk.

UNIVERSAL//COUGH SYRUP// HATCH & DICKINSON/ JAMESTOWN NY
Aqua; 8⁷/₈″ × 2³/₄″ × 1³/₄″; 1n; 3 or 6b; 3 or 4ip; v, ssf. Also variant with slightly different embossing, 6¹/₂″ high.

WAMPOLE'S/SYRUP HYPO. COMP./PHILADELPHIA
Adv. 1887, *WHS*; 1941–42, *AD*.
Aqua; 7³/₄″ × 3¹/₂″ × 2¹/₄″; 7n; 12b; pl; v. See WAMPOLE *(Company)*.

WARNER'S//WHITE WINE/AND TAR SYRUP//COLDWATER, MICH.
Product of C. D. Warner, Coldwater, MI. Adv. 1879, *VSS & C*; 1948 by C. D. Warner Co., Coldwater, Mich., *AD*.
Aqua; 7″ × 2⁷/₈″ × 1⁵/₁₆″; 1n; 3b; 4ip; v, sfs; p.

DR. J. WATSON'S//CANCER & SCROFULA/SYRUP//FULTON, N.Y.
Aqua; 9¹/₄″ × 2⁷/₈″ × 1³/₄″; 7n; 3 or 6b; ip; v, sfs.

Dᴿ S A WEAVER'S/CANKER &/ SALT RHEUM/SYRUP
Salton A. Weaver, New London, CT, inherited his father's syrup and cordial business ca. 1850 (Wilson and Wilson 1971). A booklet entitled *Veni! Vidi! Vici!*, (New London, CT: S. A. Weaver & Co., 1856) provided testimonials for Dr. Weaver's Canker and Salt Rheum Syrup, and Cerate in 1851 and 1855 plus: "Notice to our Agents in the Western and Southern States, Owing to the large and increasing demand for our Canker and Salt Rheum Syrup, CANKER CURE, AND CERATE, For the convenience of ourselves and the better accommodation of our customers in the West and South, we have transferred to J. N. HARRIS & CO., OF CINCINNATI, OHIO, (AGENTS FOR DAVIS' PAIN KILLER,) The agency for our Medicines, and they will attend to all orders from those sections. J. N. H. & CO. will hereafter act as our authorized agents, and supply you with our Medicines at our prices." J. N. Harris, with offices in New London, CT, manufactured the syrup in 1860 according to Adam's Sampson & Co's New England business directory. Syrup adv. 1921, *BD*.
Aqua; 9″ × 4¹/₄″ × 2¹/₂″; 7 and 9n; 12b; pl; v; with and without p. See DAVIS *(Killer)*.

B. WHEATLEYˢ/COMPOUND SYRUP/DALLASBURGH, KY.
See WHEATLEY *(Compound)*.

MRS. WHITCOMBs//SYRUP FOR CHILDREN//GRAFTON MEDICINE/Co//Sᵀ LOUIS, Mᵒ
Probably Whitcombs Soothing Syrup adv. 1872, *F & F*; 1901, *HH & M*. Directories show the Grafton Medicine Company, St. Louis, MO, from 1867

to 1877. Presidents included Henry B. Butts, 1867–1875; Isaac L. Downs in 1876; and S. B. Dugger in 1877; subsequent proprietors of the syrup are unknown.

Aqua; 5″ × 1³/₁₆″ diameter; 7n; 20b; pl; v, ssss.

WHITE PINE COUGH SYRUP WITH TAR/MANF'D BY/JORDAN BRO'S. COXSACKIE, N.Y.

Label: *JORDAN'S Cough Syrup, White Pine, Wild Cherry and Tar, The Great Cure for Coughs, Colds, Hoarseness, Loss of Voice, Dryness of the Throat. Made by Jordan Brothers, Props. of the Excelsior Remedies, Coxsackie, N.Y.* Syrup adv. 1887, 1891, *WHS*.

Clear; 5″ × 1⅞″ × 1¼″; 5n; 17b; pl; v. See JORDAN (Syrup).

A. J. WHITE//CURATIVE SYRUP

Bottle manufactured ca. 1882. Product later became Mother Seigel's Syrup (Wilson and Wilson 1971).

Aqua; 5¼″ × 2¾″ × 1⅛″; 7n; 3b; 4ip; v, ss. See LAXOL (Miscellaneous), SEIGEL *(Syrup)*, SHAKER (Cordial, Pills), WHITE (Miscellaneous).

WHITTEMORE//VEGETABLE SYRUP/FOR DIARRHOEA// ESSEX, CONN.

Adv. 1854 (Baldwin 1973); 1910, *AD*.

Aqua; 5″ × 1⅝″ × 1″; 11n; 3b; pl; v, fss; p. See WHITTEMORE (Water).

DR WINCHELL'S/TEETHING SYRUP/EMMERT/PROPRIETARY CO/CHICAGO, ILLS'

". . . not only for all disorders of teething infants, but cures coughs, croups, sore throat, colic and cramps of older children." Adv. 1871, *WHS*; 1923, *SF & PD*.

Clear; 5¼″ × 1¼″ diameter; 7n; 20b; pl; v. See UNCLE SAM (Liniment).

WINDSOR/SOOTHING SYRUP// WINDSOR/SOOTHING SYRUP

Adv. 1889, *PVS & S*; 1910, *AD*.

Light blue; 4¾″ × 1¼″ diameter; 7n; 20b; pl; v, fb.

MRS WINSLOW'S/SOOTHING SYRUP/CURTIS & PERKINS/ PROPRIETORS

Bottled as a treatment for problems of teething babies. Product was attributed to Mrs. Charlotte N. Winslow who tended and treated children for many years. Charlotte formulated the product in 1835 and her son-in-law, Jeremiah Curtis, and a partner, Benjamin A. Perkins, are credited with the first distribution, probably in 1849. Curtis &

Perkins registered the brand in Maine in 1852 and by 1854 were located in New York City (Holcombe 1979; White 1974; Wilson and Wilson 1971). Curtis & Perkins were advertising the product in 1859 (Singer 1982); Jeremiah Curtis & Son (George) in 1860, apparently to 1880 when the business became the Anglo-American Drug Company. In 1865 Curtis entered a limited co-partnership with John I. Brown to market products other than the syrup. After passage of the 1906 Act the formula was revised and the word "Soothing" removed (Holcombe 1979). It is uncertain how long the words Curtis & Perkins were retained and embossed in the glass. Syrup adv. 1948 by Lafayette Drug Co., Jersey City, N.J., *AD*.

Aqua; 5″ × 1³/₁₆″ diameter; 13n; 20b; pl; v; also with p. See J. BROWN (Liniment, *Miscellaneous*), CURTIS (Bitters, Killer, Miscellaneous), HUNTER *(Balsam)*.

MRS. WINSLOW'S/SOOTHING SYRUP/JEREMIAH CURTIS & SON/SUCCESSORS TO/CURTIS & PERKINS/PROPRIETORS

Aqua; 5¹/₁₆″ × 1³/₁₆″ diameter; 13n; 20b; pl; v. See J. BROWN (Liniment, *Miscellaneous*), CURTIS (Bitters, Killer, Miscellaneous), HUNTER *(Balsam)*.

WOOD'S NORWAY/PINE SYRUP// FOSTER MILBURN & CO// BUFFALO, N.Y.

Adv. 1877, *McK & R*; 1916, *MB*.

Aqua; 6¾″ × 2″ × 1⅛″; 1n; 3 or 6b; 3 or 4ip; v, fss. See BURDOCK (Bitters), FELLOW (Chemical, *Syrup*, Tablet), FOWLER (Extract), THOMAS *(Oil)*.

WOOD'S//NORWAY PINE/ SYRUP//TORONTO ONT

Aqua; 5½″ × ? × ?; 1n; 3 or 6b; 3 or 4ip; v, sfs; ABM. See BURDOCK (Bitters), FELLOW (Chemical, *Syrup*, Tablet), FOWLER (Extract), THOMAS *(Oil)*.

DR. A ZABALDANO/COMPOUND SYRUP/OF EUCALYPTUS

Product of Alexander Zabaldano, San Francisco, CA, from ca. 1875 to 1899 (Wilson and Wilson 1971). Adv. 1897, *L & M*; 1923, *SF & PD*.

Aqua, clear; 6¾″ × ? × ?; 3n; 13b; pl; v.

TABLET

Light green; $3^1/_{16}" \times 1^3/_{16}"$ diameter; 7n; 20b; pl; h. See PIERCE (*Discovery, Extract,* Miscellaneous), SAGE (Remedy).

Fig. 225

ACKER'S/DYSPEPSIA/TABLETS// W. H. HOOKER/& CO./BUFFALO/ N. Y.
See HOOKER *(Company)*.

LAXATIVE/FELLOWS/TABLETS
Adv. 1907, *PVS & S*; 1929–30 by Fellows Medicine Mfg. Co. Inc., 26 Christopher St., New York City, *AD*.
Clear; $2^3/_4" \times ? \times ?$; 7n; 3b; pl; h. See BURDOCK (Bitters), FELLOW (Chemical, *Syrup*), THOMAS *(Oil)*.

NONE GENUINE/WITHOUT THE/ NAME/[script:] **Liebigs/BEEF/ WINE & IRON/PREPARED BY/ THE MEDICATED TABLET CO./ CHICAGO, ILL.**
The Medicated Tablet Co., Otto C. Jarmuth, proprietor, operated in Chicago, IL, from 1892 to 1895, according to the Lakeside city directories of Chicago. Liebig's Extract of Beef, Wine & Iron and other similar products were the property of the Liebig Extract of Meat Co. (LEMCO), London, England, and were originated by Baron Liebig in 1865 (Turner 1953). The Medicated Tablet Co. was apparently an American producer of the product. Earliest American advertising date found was 1889, *PVS & S*; adv. 1921, *BD*.
Aqua; $8" \times 3^3/_8" \times 1^3/_4"$; 7n; 13b; pl; h, some script and arched embossing. See LIEBIG (Cure, *Invigorator,* Miscellaneous).

PEPSI KOLA/TABLETS
Adv. 1907, *PVS & S*; 1913, *SN*.
Amber; $2^1/_8" \times ?$; 3n?; 20b?; pl.

DR. PIERCE'S/ANURIC [in kidney]/ **TABLETS/FOR KIDNEYS/ AND BACKACHE** [See Figure 225 and Photo 70]
Adv. 1917, *BD*; 1941–42 by Pierce's Proprietories, Inc., Buffalo, N.Y., *AD*.

WARNER & COS/TABLETS/ PHILADA
See WARNER *(Company)*.

WISE'S/TRITURATIONS/AND/ MACHINE MADE/TABLET/ TRITURATES/KANSAS CITY MO.
Dr. Bev. L. Wise, a customer of Herman Luytie, St. Louis, saw an opportunity to capture the northern migratory routes to the West and established a retail and commercial market for homeopathic products in Kansas City ca. 1880. The western pioneer trails split in Missouri; the central and southwest travel through St. Louis was the Luytie market, and the northern and northwest travel through Kansas City was the Wise market. Luyties purchased the Wise company ca. 1961 and moved the firm to St. Louis. The Wise products were still being integrated with Luyties products and the Wise name still remained on many products as of 1984, according to Forest Murphy, Luyties (personal communication, 1984).
Amber; $8^5/_8" \times 2^5/_8" \times 2^5/_8"$; 3n; 2b; pl. See LUYTIES *(Miscellaneous)*.

ALEXANDERS/LIVER & KIDNEY TONIC/AKRON, O.// ALEXANDERS/SURE CURE FOR MALARIA/AKRON, O.

Front label: *ALEXANDER'S RHEU- MATIC AND MALARIAL REMEDY.* Back: *ALEXANDER'S LIVER AND KIDNEY TONIC, a Cure or Tonic for Rheumatic or Neuralgic Pains, Liver Com- plaint, Kidney Affections, Giddiness, Female Complaints . . . Guaranteed Under the Pure Food & Drugs Act of 1906. Prepared Only by W. W. Alexander & Co., Chemists, Akron, Ohio.* William Alexander introduced the tonic in 1887 and the cure in the early 1890s (Wilson and Wilson 1971). Rheumatic Remedy adv. 1910, *AD*; Liver & Kidney Tonic adv. 1910, *AD*.
Amber, aqua; 7³/₄″ × 2⁵/₈″ × 1¹/₂″; 7n; sp; 3b; 2ip; v, ss.

DR. R. A. ARMISTEAD//FAMOUS AGUE TONIC [Base: N in square]
Label: *ARMISTEAD AGUE TONIC, 5¹/₂% Alcohol – 1864, W. M. AKIN MED. CO. EVANSVILLE, IND.* Bottle manufactured by Obear-Nester Glass Co., East St. Louis, IL, after 1915 (Toulouse 1972). Adv. 1900 by W. M. Akin & Son, Second & Goodsell, Evansville, Ind., *EBB*; 1916, *MB*.
Clear; 7¹/₈″ × 2¹/₄″ diameter; 16n; 21b; pl; h, fb, on shoulder; ABM. See ARMISTEAD (Cure).

[h: monogram]/[v] ATHENIAN/ HAIR/TONIC
Clear; 6³/₈″ × 2⁵/₈″ × 1⁵/₈″; 9n; 18b; pl; h, v.

BAKER'S/HIGH/LIFE/BITTERS// THE/GREAT/NERVE/TONIC
See BAKER (*Bitters*).

BALDPATE/HAIR TONIC/ BALDPATE CO./NEW YORK/ 8 OZ. CONTENTS
See BALDPATE (*Company*).

BALDWIN'S/CELERY PEPSIN/ AND/DANDELION TONIC
Label: *. . . delightful appetizer – a morn- ing bracer which acts as a mild stimulant and strengthens the generative organs. . . .* Claimed relief for *. . . nervous exhaustion, loss of brain power, restlessness, indigestion and loss of physical power.* Product of John J. Spieker, introduced in the 1890s by the Baldwin Medicine Company, San Francisco, Cincinnati, and London, a subsidiary of the Lash's Bitters Company (Wilson and Wilson 1971).
Amber; 8″ × ?; 12n; 1b; 1ip; h. See LASH (Bitters).

BLUD-LIFE/THE GREAT/ ANTI-TOXIC/THE KING/ OF TONICS/MADE IN U.S.A.
[See Figure 226]
Blud-Life adv. ca. 1930 (source unk.); 1935 and 1941–42 by B-L Co., Atlanta, Ga., *AD*.
Clear; 8¹/₄″ × 2⁷/₈″ × 1¹/₂″; 10n; 6b; pl; h; ABM.

Fig. 226

DR. BOCK'S RESTORATIVE TONIC/ MANUFACTURED BY/S. H. WINSTEAD MEDICINE CO.
Color unk.; 9¹/₂″ × 3″ × ?; 7n; 3 or 6b; ip; v.

DR BOYCE'S//TONIC BITTERS// HENRY & CO//PROPRIETORS
See BOYCE (*Bitters*).

M. A. BRIGGS/VALDOSTA GA.// TONIC PILLS//TRADE/ NUNN BETTER/MARK// NEVER FAIL/TO CURE
See TONIC (*Pills*).

BROWNLOW & RAYMOND// FEDERAL TONIC
Cobalt; 9¹/₈″ × 3¹/₈″ × 1³/₄″; 11n; 3b; 3ip; v, ss.

C C C/TONIC/BOERICKE & RUNYON/NEW YORK
Adv. as C. C. C. Simmons Pile Remedy, 1900, *EBB*; as C. C. C., 1929–30 by Boericke & Runyon, 200 Sixth Ave., New York City; as C. C. C. Tonic, 1935 by Boericke & Tafel, Philadelphia, *AD*.
Clear; 8″ × 3″ × 1³/₄″; 9n; rect.; pl; v. See BOERICKE & RUNYON (Company, *Miscellaneous*).

CARDUI THE WOMAN'S TONIC// CHATTANOOGA MEDICINE CO.
See CHATTANOOGA (*Company*).

CLARKE'S//VEGETABLE TONIC/ AND/INVIGORATOR
Adv. 1870 (Baldwin 1973).
Aqua; 8¹/₂″ × 3″ × 1³/₄″; 7n; rect.; ip; v, sf.

CLEMENTS TONIC
Product of Frederick W. Clements, founder of International Laboratories, Rochester, NY. Directories included the firm in 1916 and 1972. Early or later dates are uncertain. Tonic adv. 1935, 1948, *AD*.
Amber; 8″ × 3¹/₂″ × 2″; also 6³/₄″ × 2¹/₄″ × 1¹/₄″; 3n; 4b; pl; v. See MOONE (Oil).

THIS BOTTLE ALWAYS REMAINS/ THE PROPERTY OF/CLEMENTS TONIC/LIMITED [Base:] G. B. W. L.
Amber; 6³/₄″ × 2¹/₂″ × 1³/₈″; 7n; 4b; pl; v. See MOONE (Oil).

COLDEN'S/LIQUID BEEF TONIC/ PHYSICIAN'S SAMPLE
10 Sept. 1892 *Medical Record* advertised the tonic as ". . . invaluable in all forms of Wasting Disease and in case of convalescence from severe Illness." Also for the cure of ". . . nervous weak- ness, malarial fever . . . The Charles N. Crittenton Co., General Agents Nos. 115 and 119 Fulton Street, New York." Adv. 1887, *MP*; 1929–30 by Century National Chemical Co., 86 Warren St., New York City; 1935 by Century National Chemical Co., Ward and Cross Sts., Paterson, N.J., *AD*.
Clear; 4³/₄″ × 2⁵/₈″ × 1¹/₈″; 9n; rect.; pl; v; several sizes. See HALE (*Miscel- laneous*), KIDDER (Miscellaneous).

CORONA DISTEMPER TONIC/ MANUFACTURED ONLY BY/ THE CORONA MFG. COMPANY/ KENTON, OHIO
Label: *CORONA TONIC (For Livestock Only) For Distemper . . . The CORONA MFG. CO., Kenton, O.*
Clear; 5¹/₂″ × 2¹/₄″ × 1¹/₄″; 3n; 6b; 1ip; v.

CRANITONIC//HAIR FOOD
See CRANITONIC *(Hair)*.

CY-CO TONIC
Label: *CY-CO Medicinal Stomach Regulator and Tonic. . . .* Adv. after 1906 (source unk.).
Amber; 9″ × ?; 11n; ?b; pl.

DALTON'S SARSAPARILLA/AND/ NERVE TONIC//BELFAST// MAINE U.S.A.
See DALTON *(Sarsaparilla)*.

TRADE [script:] De Lacys **MARK/FRENCH/HAIR TONIC**
Adv. 1907, *PVS & S*; 1929–30 by De Lacy Chemical Co., 4856 Lee Ave., St. Louis, Mo., *AD*.
Amber; 6¼″ × 2″ × 2″; 9n; 1b; pl; v, **some script.** See DE LACY *(Miscellaneous)*.

Eureka Pepsin/Celery Compound// A Never Failing/Tonic
See EUREKA *(Pepsin)*.

EXCELSIOR//HAIR TONIC// LOMBARD & CUNDALL/ SPRINGFIELD MASS
See EXCELSIOR *(Hair)*.

DR. FOORD'S//TONIC// CORDIAL//CAZENOVIA,/N.Y.
See FOORD *(Cordial)*.

DR. JAS. GRAVES// TONIC BITTERS//LOUISVILLE KY.
See GRAVES *(Bitters)*.

GROVES TASTELESS/CHILL TONIC PREPARED BY/PARIS MEDICINE CO./ST. LOUIS.
Bottle manufactured ca. 1900. Chill Tonic introduced in 1878. Adv. 1948 (Blasi 1974). E. W. Grove established the Paris Medicine Company in Paris, TN in 1889; in 1891 the company moved to St. Louis. E. W. Grove died in 1927 and the business was assumed by E. W. Grove, Jr., the latter Grove died in 1934, the year the firm became Grove Laboratories (Blasi 1974).
Clear; 5¾″ × ? × ?; 3n; 13b; pl; v. **Also an ABM variant.**

GROVES TASTELESS/CHILL TONIC PREPARED BY/PARIS MEDICINE CO./ST. LOUIS.
[Base: embossed diamond]
Bottle manufactured by the Diamond Glass Co., Royersford, PA, after 1924 (Toulouse 1972).
Light aqua; 5⅞″ × 2½″ × 1⅜″; 3n; 18b; pl; v; ABM.

DR. HARTER'S//IRON TONIC
Label: *HARTER'S, the only True Iron Tonic. HARTER MEDICINE CO., ST. LOUIS.* Adv. 1872, *F & F*; 1935 by Wm. R. Warner & Co., 113 W. 18th St., New York City, *AD*.
Amber; 9¼″ × 3″ × 2″; 11n; 3b; 3ip; v, ss. See HARTER (Balm, *Bitters*, Elixir, Miscellaneous), HOOD (Company).

DR. HARTER'S//IRON TONIC COMPOUND
Label: *DR. HARTER'S IRON TONIC COMPOUND, Stimulant to the Appetite. Alcohol 17%. C. I. Hood & Company, Inc., New York and St. Louis. Successors to the Dr. Harter Med. Co.*
Amber; 9″ × ? × ?; 11n; 3b; 3ip; v, ss. See HARTER (Balm, *Bitters*, Elixir, Miscellaneous), HOOD (Company).

HONDURAS/TONIC/W. E. TWISS & CO/MFR.
Bottle manufactured ca. 1900.
Amber; 9″ × 3½″ × 1½″; 7n; 13b; pl; h.

DR HOOFLAND'S//GERMAN// TONIC
Adv. 1871, *VSS & R*; 1910, *AD*.
Aqua; 9¾″ × 2½″ × 2½″; 12n; 1 or 2b; pl; v, fsb. See HOOFLAND (Balsam, *Bitters*).

STEWART D. HOWE'S//ARABIAN/ TONIC/BLOOD PURIFIER// NEW YORK
Introduced ca. 1848. Manufactured in Cincinnati with sales from New York City (Wilson and Wilson 1971). Adv. 1910, *AD*.
Aqua; 9½″ × 3¼″ × 2″; 7n; 3b; 3 or 4ip; v, sfs. See CRISTADORO *(Hair)*, HOWE (Cure, *Sarsaparilla*).

INDIAN/CLEMENS TONIC/ PREPARED BY/GEO. W. HOUSE
[over embossed standing Indian]
A cure for fever and ague. A product of Geo. W. House, Nashville, TN, adv. 1846 (Baldwin 1973).
Aqua; 5½″ × 2⅜″ × 1⅜″; 18n; 12b; pl; h.

IOWNA/BRAIN & NERVE TONIC/ I. O. WOODRUFF & CO
Adv. 1929–30 by I. O. Woodruff & Co., Inc., 66 Beekman St., New York City; 1948 by Leon, 311 5th Ave., New York City, *AD*.
Clear; 3½″ × 1½″ × 1″; 9n; 18b; pl; v. See FRELIGH (Medicine).

DR D JAYNE'S/HAIR TONIC// PHILADA
Label: *Jayne's Hair Tonic. Before applying the Tonic, let the head be well brushed,*

with a good, fine, but stiff hair brush, until the scalp is considerably excited by the friction, and all dirt and dandruff removed from the head. This will expose the pores of the skin and surface vessels of the scalp to the direct action of the Tonic. Then (with a small round brush, such as are used by painters,) apply the Tonic to various parts of the scalp, more especially on bald places, and where the hair is thin, or shows disposition to fall off. Then brush the head freely until every part of the head and scalp is moistened with the Tonic. . . .* Adv. 1838 (Singer 1982); 1920 (Devner 1968).
Aqua; 4½″ × 2¹⁄₁₆″ × 1″; 5n; 13b; pl; v, fb; p. See JAYNE (Balsam, Expectorant, Liniment, *Miscellaneous*).

Dᴿ D. JAYNE'S/HAIR TONIC/ PHILADA//TONICO/DEL/ Dᴿ D. JAYNE/PARAELPELO/ PHILADA
Clear; 4⅞″ × 1⅝″ × 1⅝″; 9n; 1b; pl; h, fb. See JAYNE (Balsam, Expectorant, Liniment, *Miscellaneous*).

Dᴿ D. JAYNE'S//OLEAGINOUS/ HAIR TONIC//PHILAᴰ
Bottle manufactured ca. 1851 (Wilson and Wilson 1971).
Aqua; 4½″ × ? × ?; 5n; 3b; pl; v, sfs. See JAYNE (Balsam, Expectorant, Liniment, *Miscellaneous*).

DR. D. JAYNE'S/TONIC VERMIFUGE/84 CHESᵀ Sᵀ PHILᴬ
Adv. 1840 (Singer 1982); 1941–42, *AD*.
Aqua; 4⅜″ × ? × ?; 5n; 12b; 1ip; v; p. See JAYNE (Balsam, Expectorant, Liniment, *Miscellaneous*).

Dᴿ D. JAYNE'S//TONIC// VERMIFUGE//PHILADᴬ
Aqua; 4⅞″ × 1¼″ × 1¼″; 5n; 2b; 4ip; v, fsbs; p. See JAYNE (Balsam, Expectorant, Liniment, *Miscellaneous*).

DR. D. JAYNE'S//TONIC/ VERMIFUGE//PHILADELPHIA
Bottle manufactured ca. 1894 (Wilson and Wilson 1971).
Aqua; 6¾″ × ? × ?; 7n; rect.; ip; v, sfs. See JAYNE (Balsam, Expectorant, Liniment, *Miscellaneous*).

DR. D. JAYNE'S//TONIC/ VERMIFUGE//PHILADELPHIA// THE STRENGTH-GIVER
Aqua; 6⅝″ × 2¼″ × 1⁷⁄₁₆″; unusual neck finish, a reverse 6; 6b; 4ip; v, sfsb. See JAYNE (Balsam, Expectorant, Liniment, *Miscellaneous*).

DR. D. JAYNE'S/TONIC VERMIFUGE/242 CHESᵀ Sᵀ PHILᴬ

Bottle manufactured ca. 1868 (Wilson and Wilson 1971).

Aqua; 5¼″ × ? × ?; crude 1n; 13b; 1ip; v. See JAYNE (Balsam, Expectorant, Liniment, *Miscellaneous*).

DR. D. JAYNE'S/TONIC VERMIFUGE/242 CHESᵀ Sᵀ/PHILA

Aqua; 5¾″ × ? × ?; 7n; rect.; pl; v; longer neck than those described previously. See JAYNE (Balsam, Expectorant, Liniment, *Miscellaneous*).

DR. D. JAYNE'S/TONIC VERMIFUGE/242 CHESᵀ Sᵀ PHILA

Aqua; 5⅜″ × 1¹⁵⁄₁₆″ × 1″; 7n, tapered lip; 3b; pl; v. See JAYNE (Balsam, Expectorant, Liniment, *Miscellaneous*).

DR. D. JAYNE'S/TONIC VERMIFUGE/242 CHESᵀ Sᵀ PHILA//THE STRENGTH-GIVER

[See Figure 227]
Bottle manufactured ca. 1900 (Wilson and Wilson 1971).

Aqua; 5¾″ × 2¹⁄₁₆″ × 1⅛″; 7n; 12b; 1ip; v, fb. See JAYNE (Balsam, Expectorant, Liniment, *Miscellaneous*).

Fig. 227

FRONT — DR. D. JAYNE'S TONIC VERMIFUGE 242 CHEST Sᵀ PHILA

BACK — THE STRENGTH-GIVER

DR. D. JAYNE'S/TONIC VERMIFUGE/242 CHESᵀ

Sᵀ PHILA [Base: O in square]
Bottle manufactured by Owens Bottle Co. 1911 to 1929 (Toulouse 1972).

Aqua; 5⁷⁄₁₆″ × 1¹⁵⁄₁₆″ × 1¹⁄₁₆″; 10n, tapered lip; 3b; pl; v; ABM. See JAYNE (Balsam, Expectorant, Liniment, *Miscellaneous*).

JOHNSON'S CHILL/AND FEVER TONIC

Adv. 1891, *WHS*; 1941–42 by James F. Ballard Inc., 500 N. Second St., St. Louis, Mo., *AD*.

Clear; 6″ × 2″ × 2″; 1n; 2b; v.

JOHNSONS CHILL & FEVER TONIC/GUARANTEED TO CURE/ A. B. GIRARDEAU SAV H. GA

Light green; 5⅞″ × 1¹³⁄₁₆″ × 1¹³⁄₁₆″; 7n; 2b; 1ip; v.

W. M. JOHNSON'S/PURE HERB TONIC/SURE CURE/FOR ALL MALARIAL DISEASES [Base:] 147/G

Label: *JOHNSON'S PURE HERB TONIC. A positive Cure for the Stomach, Liver and Kidneys, Chills and Fevers, Malaria, Sick Headache, Constipation, Biliousness, Indigestion . . . Fainting Spells . . .* Trademark was issued to W. D. Kenyon and W. M. Johnson, Marysville, CA, on 26 April 1901. (White 1974).

Amber; 8¾″ × 2⅝″ × 2⅝″; 11n; 2b; pl; v.

DR JONE'S/RED/CLOVER/TONIC

[embossed clover]//GRIGGS & CO OTTAWA, ILLS.
Adv. 1870s (Devner 1968); 1883 (Baldwin 1973); 1916, *AD*.

Amber; 9″ × ?; other attributes unk., except embossed fb; back order of embossing unk.

KENYON'S/BLOOD AND NERVE/ TONIC/J. C. KENYON/OWEGO/N.Y.

Directories listed Joel C. Kenyon, Druggist, 5 Lake St., Owego, NY, in 1888 and 1930.

Clear; 8¼″ × 3¼″ × 2″; 5n; 13b; pl; h.

KICKAPOO/SAGE/HAIR TONIC

See KICKAPOO (*Hair*).

KODOL/NERVE/TONIC

Product of E. C. DeWitt & Co., Chicago, IL. Adv. prior to 1904 (Devner 1968); 1907, *PVS & S*; 1948 by E. C. DeWitt & Co., Inc., 2835 Sheffield Ave., Chicago, *AD*.

Aqua; 3⅝″ × 1⅛″ diameter; 11n; 20b; pl; v. See DEWITT (*Cure*, Sarsaparilla, Syrup), KODOL (*Cure*).

KODOL/NERVE/TONIC [Base:] E. C. DEWITT/& CO./CHICAGO

Clear; 3⅝″ × 1⅛″ diameter; 11n; 20b; pl; v. See DEWITT (*Cure*, Sarsaparilla, Syrup), KODOL (*Cure*).

KODOL/NERVE/TONIC//FREE SAMPLE [Base:] E. C. DEWITT/ & CO./CHICAGO

Aqua; 3¾″ × 1⅛″ diameter; 11n; 20b; pl; v, fb. See DEWITT (*Cure*, Sarsaparilla, Syrup), KODOL (*Cure*).

LASH'S LIVER BITTERS// NATURAL/TONIC LAXATIVE

See LASH (*Bitters*).

LAXAKOLA/THE GREAT/TONIC LAXATIVE//LAXAKOLA CO.// NEW YORK & CHICAGO

Adv. 1907, *PVS & S*; 1913, *SN*.

Aqua; 7½″ × 2¼″ × 1¼″; 7n; 3 or 6b; 3 or 4ip; h, fss.

LILLYBECK'S/TWOBIT/CHILL TONIC

Label: *LILLYBECK'S CHILL & FEVER TONIC, The Southern Cure. Oscar Lillybeck, Wholesale Druggist, Meridian, Miss.* Adv. 1910, *AD*.

Clear; 6½″ × 2¼″ × 1¼″; 7n, sp; 3b; 4ip; v.

Dᴿ LOEW'S CELEBRATED/ STOMACH BITTERS & NERVE TONIC//THE/LOEW & SONS CO./ CLEVELAND, O.

See LOEW (*Bitters*).

MALTO IRON TONIC CO./ [monogram]/BALTO. & LOUISVILLE [Base:] G. L. ? CO.

See MALTO (*Company*).

MASCARO TONIQUE/FOR THE HAIR/TRADE MARK/MARTHA MATILDA HARPER/ROCHESTER, N. Y. U.S.A. [Base:] 1250

Adv. 1910, 1941–42, *AD*. When Martha Matilda Harper established her toilet preparation and hair dressing business is unknown, but Rochester directories listed the firm in 1916 and 1972.

Clear; 6¼″ × 2¾″ × 1⅝″; 9n; 12b; pl; v.

MASC·ARO TONIQUE/ TRADE MARK/MARTHA M/ HARPER/ROCHESTER/N.Y.

Clear; 6⅜″ × 2⅝″ × 1⅝″; 9n; 12b; pl; v.

DR MᶜCABES/TONIC/CORDIAL/ Sᵀ LOUIS MO

See McCABE (*Cordial*).

DR. E. E. MᶜLEAN'S/MEDICATED/ HAIR TONICS/SAN FRANCISCO, CAL.

Directories for 1899 and 1900 listed Dr. E. E. McLean at 201–215 Claus Bldg., San Francisco; in 1899 McLean was listed as a Physician for the Hair, in 1900, manager of the Family Prescription Pharmacy; the 1892 directory lacked any reference to McLean.

Clear; 6⅛″ × 2⅝″ × 1⅝″; 9n; 3b; pl; v.

DR. MILES/RESTORATIVE/TONIC

"Product to excite in a moderate degree the energies of all parts of the body without causing any deviation of healthy functions." Tonic was introduced in 1882; Restorative Tonic became Restorative Nervine in 1938, according to Donald N. Yates, Archivist, Miles Laboratories, Inc. (personal communication, 1983). Containers with labels dated 1939 were clear, corked and possibly embossed.

Aqua; 8¹/₄″ × 2³/₄″ × 1¹/₂″; 1n, sp; 3b; 3ip; v. See MILES (*Cure*, Medicine, Nervine, Purifier, Sarsaparilla).

DR. MOTT'S/WILD, CHERRY TONIC/A. H. POWERS & CO

Bottle manufactured ca. 1879. Product introduced by A. H. Powers, Sacramento, CA, ca. 1878. Powers probably soon sold the product to John Spruance and Samuel Stanley, San Francisco (Wilson and Wilson 1971).

Amber; 9¹/₂″ × ?; 11n; 2b; pl; v. See AFRICAN (*Bitters*), CATAWBA (*Bitters*).

DR. MOTT'S/WILD CHERRY TONIC/SPRUANCE STANLEY & CO

Bottle manufactured ca. 1881 (Wilson and Wilson 1971).

Amber; 9¹/₂″ × ?; 11n; 2b; pl; v. See AFRICAN (*Bitters*), CATAWBA (*Bitters*).

MULL'S GRAPE TONIC/ ROCK ISLAND, ILL.

Bottle manufactured ca. 1889 (Wilson and Wilson 1971). Adv. 1917, *BD*.

Amber, cobalt; 7³/₈″ × 3¹/₄″ × 1¹/₂″; 11n; 7b; pl; v.

NAYEAU TONIC CO/TRADE/ MARK/CHICAGO, ILL. USA

See NAYEAU (*Company*).

NIBOL/KIDNEY AND LIVER/ BITTERS//THE BEST TONIC/ LAXATIVE & BLOOD PURIFIER

See NIBOL (*Bitters*).

HULL/OWBRIDGE'S//LUNG TONIC

Product of W. T. Owbridge, England, adv. 1874 (Devner 1968); 1912 (British Medical Association).

Aqua; 5¹/₁₆″ × 1¹¹/₁₆″ × 1¹/₁₆″; 3n; 3b; 3ip, oval; v, ssf.

HULL//OWBRIDGE'S//LUNG TONIC

Light blue; 5¹/₈″ × 1⁵/₈″ × 1¹/₈″; 7n; 3b; 3ip, oval; v, ssf.

PARISIAN SAGE/A HAIR TONIC/ GIROUX MFG. CO./BUFFALO

Adv. 1912 (Devner 1970); 1935, *AD*. Directories included the Giroux Mfg. Co., in 1911, its business unknown; in 1917 as a manufacturer of Hair Tonic; in 1938 and 1941, as a manufacturer of Toilet Preparations.

Clear; 6³/₄″ × 2⁷/₁₆″ × 1³/₁₆″; 7n; 3b; 1ip; v.

PARISIAN SAGE//A HAIR TONIC//GIROUX. MFG. CO./ BUFFALO. FORT ERIE

Color unk.; 7″ × ? × ?; 7n; 3 or 6b; 3 or 4ip; v, ssf.

PARKER'S//GINGER/TONIC// NEW YORK

Product introduced by Hiscox & Co., Chemists, New York, NY, in 1876 (Wilson and Wilson 1971). Adv. 1879, *VSS & C*; 1910 as "A Perfect and Superlative Health Restorative," *AD*; 1923, *SF & PD*.

Aqua; 6¹/₂″ × 2¹/₈″ × 1¹/₈″; 1n; 3b; 4ip; arched; v, sfs. See PARKER (*Balsam*).

PRIMLEY'S/IRON &/WAHOO/ TONIC//JONES & PRIMLEY CO./ ELKHART, IND.

Label: *PRIMLEY'S IRON WAHOO TONIC. THE BEST APPETIZER, THE BEST LIVER AND KIDNEY MEDICINE. The Best Remedy for Dyspepsia and all Stomach Troubles. The Best Blood Purifier in the World. It acts like a charm for Indigestion, Want of Appetite, Loss of Strength, Loss of Energy, etc. MANUFACTURED BY JONES & PRIMLEY CO. ELKHART, INDIANA. PRICE ONE DOLLAR.* Adv. 1883 (Devner 1968); 1916, *MB*.

Amber; 9¹/₄″ × 2⁹/₁₆″ × 2⁹/₁₆″; 12n; 2b; 4ip; h, f; v, b. Variants with base embossed: F. G. MFG. CO. See PRIMLEY (Cure, *Sarsaparilla*).

QUININE/TONIC//ATWOOD'S// BITTERS

See ATWOOD (*Bitters*).

RAMON'S PEPSIN CHILL TONIC/ MADE BY BROWN MF'G CO.// GREENVILLE, TENN.// NEW YORK, N.Y. [Base: diamond]

Label: *RAMON'S PEPSIN CHILL TONIC. A Perfect Cure For Chills and Fever and all Malarial and Billious Troubles. BROWN MF'G. CO. N.Y. & GREENVILLE, TENN.* Bottle manufactured by the Diamond Glass Co., Royersford, PA, after 1924 (Toulouse 1972). Adv. 1900, *EBB*; 1916, *MB*.

Clear; 7¹/₁₆″ × 2³/₈″ × 1¹/₂″; 1n; 3b; 4ip; v, fss. See RAMON (Syrup).

M. A. REAVES'/GREAT ELECTRIC/ HAIR TONIC

Adv. 1896–97, *Mack*; 1897, *L & M*.

Aqua; 6¹/₂″ × 2¹/₂″ × 1¹/₂″; 7n; 18b; pl; v.

REED'S/GILT/EDGE/1878/TONIC

Product of George W. M. Reed, New Haven, CT (Wilson and Wilson 1971). Adv. 1910, *AD*.

Amber; 9″ × 2³/₄″ × 2³/₄″; 11n; 2b; pl; v. Possibly related to REED (Bitters).

RESORCIN/HAIR/TONIC/ GOODRICH/[embossed pyramid]/ QUALITY/TRADE MARK/ GOODRICH/DRUG CO./OMAHA

See GOODRICH (*Drug*).

ROCKY MOUNTAIN//TONIC BITTERS//1840 TRY ME 1870

See ROCKY MOUNTAIN (*Bitters*).

ROWAND'S//TONIC//MIXTURE// VEGETABLE//FEBRIFUGE// PHILAD

Embossed containers were depicted in 1830s advertisements. The product was purchased by the University of Free Medicine and Popular Knowledge between 1853 and 1855 (Singer 1982). Adv. 1832 (Putnam 1968); 1910, *AD*.

Aqua; 5³/₄″ × ?; 11n; 21b, 6 sides; pl; v, sssss; p. See ROWAND & WALTON (*Miscellaneous*), UNIVERSITY (Medicine).

SAGE BRUSH/SAGE BRUSH/ TONIC CO. LTD/HAIR TONIC [Base:] I. G. & CO.

Bottle manufactured by the Illinois Glass Co., ca. 1880 to 1900 (Toulouse 1972).

Clear; 4³/₈″ × ?, also 7¹/₂″ high; 9n; 2b; pl; several sizes. Also variant embossed SHAMPOO instead of TONIC.

SCHENCK'S//SEAWEED//TONIC

The oval indented panel held a small box of pills. Product introduced in the 1830s (Holcombe 1979). Adv. 1929–30, *AD*.

Aqua; 8³/₈″ × 2⁷/₈″ × 2⁷/₈″; 11n; 2b; 1ip; v, fss. See SCHENCK (*Syrup*).

DR. SMITH'S/COLUMBO TONIC

Labeled as a bitters, *Guaranteed Under Food and Drugs Act, June 30, 1906. Serial No. 19671. Established 1880, Inc. 1908. 20% Alcohol by volume. Manufactured by Smith's Columbo Tonic Co. Inc. 521 Linden ST. (Opp. Court House) Scranton Pa. Recommended for Dyspepsia, Kidney and Liver Complaint . . .* (Watson 1968).

Amber; 9¹/₂″ × 2³/₄″ × 2³/₄″; 11n; 1 or 2b; 1ip; v.

[h] THE GREAT/SOUTH
AMERICAN/NERVINE TONIC/[v]
TRADE/[monogram]/MARK/[h]
AND/STOMACH & LIVER CURE
See SOUTH AMERICAN *(Cure).*

SPILLMAN'S//ALTERATIVE//
AGUE//TONIC
Product of Dr. William Spillman,
Columbus, MS, ca. 1850s–1860s
(Wilson and Wilson 1971).
Aqua; 7¹/₂″ × ? × ?; 1n; 3b; 4ip; v,
sfsb; with and without p.

SUPERIOR TONIC, CATHARTIC/
AND BLOOD PURIFIER//
E. J. ROSE'S/MAGADOR BITTERS/
FOR STOMACH, KIDNEY & LIVER
See ROSE *(Bitters).*

SWAMP/CHILL/AND/FEVER/
TONIC//SWAMP & DIXIE LABS.
INC.//FORT SMITH, ARK.
Adv. 1916, *MB*; 1929–30 by Morris-
Morton Drug Co., Ft. Smith, Ark.;
1948 by Swamp & Dixie Labs, Inc.,
Fort Smith, Ark., *AD.*
Clear; 6⁵/₈″ × 2³/₁₆″ × 1³/₁₆″; 11n; 3b;
pl; h, f; v, ss; ABM. See MORRIS-
MORTON *(Company).*

THORN'S/HOP & BURDOCK/
TONIC/BRATTLEBORO, VT.
Advertised early 1870s–ca. 1900
(Wilson and Wilson 1971). Isaac Thorn
established his drug trade in Brattleboro,
VT, in 1858. After the Civil War the
firm became I. N. Thorn & Co., and
in 1878, I. N. Thorn & Son (Edwin C.).
In 1884 the business was sold to C. M.
Colburn & Co. (Shimko 1969); subse-
quent producers of the tonic are
unknown.
Amber; 8¹/₄″ × 2¹/₂″ × 2¹/₂″; 7n; 2b;
pl; v.

TO-KA//BLOOD/TONIC [Base:]
MEX. MED. CO.
See MEX. *(Company).*

TONECO/STOMACH BITTERS//
APPETIZER & TONIC
See TONECO *(Bitters).*

[Script:] Velvetina/REG. U.S. PAT.
OFF./RESORCIN/HAIR TONIC/
GOODRICH/DRUG CO. OMAHA
[Base: diamond]
See GOODRICH *(Drug).*

VER = MUTH/STOMACH/
BITTERS//TONIC/AND/
APPETIZER [Base: F in circle]
See VER = MUTH *(Bitters).*

[h] VIN VITALIA/[v] A TONIC WINE
Emerald green; 9¹/₄″ × 2⁷/₈″ diameter;
23n, modified; 22b; pl; h, v.

WAIT'S WILD CHERRY TONIC//
THE GREAT TONIC [Base:] 147/G
Label from unembossed variant:
*WAIT'S WILD CHERRY TONIC COM-
POUND A Highly Recommended Alterative
And Digestive. As A Remedy For Coughs
And Colds It Has No Equal. Contains In
Small Percentages Kola, Iron, Pepsin,
Manganese, Peruvian Bark And A Large
Proportion Of Wild Cherry Bark. Is
Artificially Flavored And Colored And Con-
tains One Per Cent Alcohol—Guaranteed
Under The Food And Drugs Act, June 30,
1906 . . . MANUFACTURED ONLY
BY THE GEO. Z. WAIT CO.
MANUFACTURING PHARMACISTS
SACRAMENTO, CAL.*
Amber; 8¹/₂″ × 2³/₄″ × 2³/₄″; 11n; 2b;
pl; v, fb. See WAIT *(Bitters).*

WALKER'S/TONIC/FREE/SAMPLE
Adv. 1907, *PVS & S*; 1913 by Suther-
land Medicine Co., *SN.*
Clear; 3³/₈″ × 1¹/₄″ diameter; 7n; 20b;
pl; v. See BELL *(Cough,)* SUTHER-
LAND *(Company).*

Dᴿ WARREN'S//TONIC CORDIAL//
CINCINATTI & N.Y.
See WARREN *(Cordial).*

WEB'S/A № !//CATHARTIC/
TONIC//THE BEST/LIVER,
KIDNEY/& BLOOD/PURIFIER
Adv. 1897, *L & M*; 1923, *SF & PD.*
Amber; 9¹/₄″ × 2⁹/₁₆″ × 2⁹/₁₆″; 11n; 1b;
pl; v, fb.

MADAME M. YALE'S/EXCELSIOR/
HAIR TONIC//MADAME M.
YALE'S/EXCELSIOR/HAIR TONIC
Adv. 1899 (Devner 1968); 1929–30 by
Mme. M. Yale Inc., 8 E. 12th St., New
York City, *AD.*
Clear; 5³/₄″ × 1¹³/₁₆″ × 1¹³/₁₆″; 9n; 2b;
pl; v, fb.

MADAME YALE'S/EXCELSIOR
HAIR TONIC/PRICE 50¢//MFD
ONLY BY/MME. M. YALE/
NEW YORK & CHICAGO/U.S.A.
Clear; 5¹/₂″ × 1³/₄″ × 1³/₄″; 7n; 1b; pl;
v, fb. Also a 25¢, 3⁷/₈″ high variant.

MADAME M. YALE//FRUITCURA/
WOMAN'S TONIC//CHICAGO &
NEW YORK
Adv. 1895, *PVS & S*; 1912 (Devner
1968).
Clear; 8¹/₂″ × 2⁷/₈″ × 1³/₄″; 1n; 3b; 4ip;
v, sfs.

B [embossed leaf] W/BLACK WEED/
TRADE MARK
Amber; 7⅞″ × 2¾″ diameter; 9n;
20b; pl; h, embossed in circle; ABM.

BABY BRAND (TRADE MARK)/
CASTORIA//BABY BRAND//
BABY BRAND
Possibly Baby's Own Castoria adv.
1941–42 by Baby's Own Laboratories,
Belmont, Mass., *AD*.
Clear; 6¹/₁₆″ × 2¹/₁₆″ × 1¹/₁₆″; 1n; 3b;
3ip; v, fss.

C. R. BAILEY'S/CELEBRATED/
REXOLEUM/TRADE MARK/
NEW YORK
Cream adv. 1910 (source unk.).
Directories listed Charles R. Bailey,
Perfumer, at 20 Cedar St., New York
City, in 1891 and at 256 Church in
1913.
Color & dimens. unk.; 17n; 20b; h,
ABM.

BEAR LITHIA WATER/[embossed
bear] BEAR/LITHIA WATER/
TRADE MARK/NEAR/ELKTON, VA.
See BEAR LITHIA (*Water*).

BOWDEN/LITHIA WATER/
[embossed building]/LITHIA
SPRINGS, GA./TRADE MARK REG.
See BOWDEN (*Water*).

M. A. BRIGGS/VALDOSTA GA.//
TONIC PILLS//TRADE/NUNN
BETTER/MARK//NEVER FAIL/
TO CURE
See TONIC (*Pills*).

BUFFALO/LITHIA/SPRINGS/
WATER/[seated woman]/NATURES/
MATERIA/MEDICA/TRADE MARK
See BUFFALO (*Water*).

Dᴿ J. W. BULL'S/VEGETABLE/
BABY SYRUP/TRADE MARK
See BULL (*Syrup*).

TRADE MARK/[monogram]/
THIS BOTTLE/IS NOT SOLD/
BUT REMAINS/PROPERTY OF/
SIR ROBT. BURNETT/& Cᵒ/
LONDON/ENGLAND
See BURNETT (*Company*).

GRACE CARY//AUSTRALIAN/
EUCALYPTUS/GLOBULOUS/
[embossed tree]/TRADE MARK/
GUM TREE/COUGH SYRUP//
SAN FRANCISCO//DIRECTIONS/
TAKE ONE TEASPOONFUL/EVERY
TWO HOURS/UNTIL RELIEVED/
PRICE 75CENTS
See CARY (*Syrup*).

HALF/OUNCE/CAULK'S/20ᵀᴴ/
CENTURY/ALLOY//TRADE
MARK//[v] CAULK'S/FILLING/
MATERIALS/[h] EST 1877//
MANUF'G BY/L. D. CAULK/
PHILADA, PA.
See CAULK (*Manufacturer*).

COLGATE & CO./TRADE C & C
[monogram] MARK/NEW YORK
See COLGATE (*Company*).

REGISTERED/COSMOLINE
[embossed over globe]/TRADE MARK
[See Figure 228]
Label: *NATURES SOVEREIGN HEAL-
ING OINTMENT, PHILADELPHIA*. In
1865, Edwin F. Houghton began con-
verting oil into commercially usable
products. In 1869, with the help of
Aaron F. Carpenter, E. F. Houghton &
Co., Philadelphia, was founded and
Cosmoline introduced. Products
included an ointment, a pomade for the
hair, carbolized cosmoline, for antisep-
tic and disinfectant purposes; Veterinary
Cosmoline; and rust preventives. The
latter were ". . . on duty in the Spanish-
American War, both World Wars, the
Korean conflict, and now in Vietnam."
In the 1960s apparently only industrial
rust prohibitives, called Cosmoline and
Rust Veto, were being produced; infor-

Fig. 228

mation courtesy of an E. F. Houghton
& Co. pamphlet, dated post-1964,
Philadelphia, PA. Houghton's Cosmo-
line was advertised in 1910, in the forms
of Plain, Camphorated, Carbolized,
Fluid, Pomade, Veterinary and White,
AD.
Clear; 3″ × 1⅞″ diameter; 3n; 20b;
pl; h.

[v] CRAB ORCHARD/[d] GENUINE
[embossed crabapple & leaves]
GENUINE/[v] TRADE MARK/
SALTS/BOTTLED BY/CRAB
ORCHARD WATER CO./
LOUISVILLE, KY.
See CRAB ORCHARD (*Water*).

[h] NONE GENUINE/WITHOUT
OUR/[v] TRADE/[embossed bottle]/
MARK/[h] DAMONIA/M. M. CO./
CHICAGO, ILL.
Remedy produced by the Damonia
Magnetic Mineral Co., Chicago, IL.
Adv. 1884, Chicago city directory;
1907, *PVS & S*.
Clear; 6¼″ × 2″ × 2″; 9n; sp; 2b; pl;
h, v.

PROF. DEAN'S/KING CACTUS OIL/
THE GREAT/BARBED WIRE/
REMEDY/OLNEY & MCDAID/
TRADE MARK
See DEAN (*Oil*).

PROF. DEAN'S/KING CACTUS
OIL/THE GREAT/BARBED WIRE/
REMEDY/CLINTON, IOWA/
TRADE MARK
See DEAN (*Oil*).

TRADE [script:] De Lacys MARK/
FRENCH/HAIR TONIC
See DE LACY (*Tonic*).

THE EMPIRE HAIR/
REGENERATOR//[embossed trade
mark]//NEW YORK
See EMPIRE (*Hair*).

TRADE/FERNANDINA/MARK/
FLORIDA WATER/
THE S. H. WETMORE COMPANY/
NEW YORK
See FERNANDINA (*Water*).

FRENCH'S/TRADE/[embossed crown]/
MARK/KIDNEY & LIVER/&/
DROPSY CURE CO/PRICE 1.00
See FRENCH (*Cure*).

GEORGIA/BROMINE LITHIA/
[embossed building]/LITHIA
SPRINGS, GA/TRADE MARK REG.
Aqua; dimens. unk.; 7n?; 20b; pl; h;
one gallon size.

[Shoulder:] GLYCERINE//
COD LIVER/[body:] TRADE MARK/
COD LIVER/GLYCERINE
Label: . . . *a Reconstructive, Digestive,
Alterative. Strongest Tissue Builder Known.
Manufactured only by Cod Liver Glycerine
Company, St. Louis and New York.* Adv.
1896–97, *Mack*; 1910, *AD*.
Amber; 6″ × 2¼″ diameter; 9n; 20b;
pl; h, fb.

RESORCIN/HAIR/TONIC/
GOODRICH/[embossed pyramid]/
QUALITY/TRADE MARK/
GOODRICH/DRUG CO./OMAHA
See GOODRICH *(Drug)*.

PEPTO-MANGAN "GUDE" [Base:]
DR. A GUDE & CO TRADE/[raised
heart with:] ME/P/MARK/G & CO.
See GUDE *(Company)*.

HILLS/[embossed H with arrow]
TRADE/MARK/DYS PEP CU/
CURES/CHRONIC/DYSPEPSIA/
INDIANA DRUG/SPECIALITY CO/
S[T]. LOUIS &/INDIANAPOLIS
See INDIANA *(Company)*.

[h] HOLMES/FRAGRANT/
[d] TRADE/FROSTILLA/MARK/[h]
ELMIRA/N. Y.//[v] FOR CHAPPED
HANDS//SALT RHEUM ETC. [See
Figure 229]
Probably the newest variant.
Clear; 4½″ × 1¹³⁄₁₆″ × 1⁵⁄₁₆″; 9n; 3b;
3ip; h, d, f; v, ss. See HOLMES (Lotion,
Miscellaneous).

Fig. 229

HOPS/&/MALT/BITTERS/HOPS &
MALT/TRADE-MARK/BITTERS//
HOPS/&/MALT BITTERS//
HOPS/&/MALT BITTERS//
HOPS/&/MALT BITTERS
See HOPS *(Bitters)*.

HUMPHREYS'/HOMEOPATHIC/
[embossed horse in circle] TRADE
MARK/VETERINARY/SPECIFICS
See HUMPHREY *(Specific)*.

HUMPHREYS' MEDICINE CO/
[embossed horse in circle]/TRADE
MARK/NEW YORK
See HUMPHREY *(Medicine)*.

IMPERIAL/CHEMICAL
MANUFACTURING CO.//
NEW YORK//IMPERIAL HAIR/
TRADE MARK//REGENERATOR
See IMPERIAL *(Company)*.

KAY BROTHERS L[TD]//LINSEED/
COMPOUND/(TRADE MARK)//
STOCKPORT
See KAY *(Compound)*.

TRADE MARK/DR. KOCH'S/
REMEDIES/EXTRACTS & SPICES//
DR KOCH VEG. TEA CO//
WINONA, MINN.
See KOCH *(Remedy)*.

DR. KOCHS/TRADE MARK/
REMEDIES/PURELY VEGETABLE//
DR. KOCH VEGETABLE TEA CO.//
WINONA, MINN.
See KOCH *(Remedy)*.

LAGNO/TRADE MARK/THE
SCIENTIFIC/MOUTH WASH/AND/
ANTISEPTIC
Clear; 5⁷⁄₁₆″ × 2⁵⁄₁₆″ × 1¾″; 9n, with
collar; 5b; pl; h.

[h] TRADE MARK/[v, script:] Lange/
DE PERE, WIS.
The 1931 De Pere, WS, directory listed
the Lange Co., Roy C. French, Pres.,
Medicines, as incorporated in 1902; also
A. J. Hilbert & Co., Roy C. French,
Pres., Toilet Preparations, as being
incorporated in 1898; both firms were
located at 202 S. Broadway.
Clear; 8¹³⁄₁₆″ × 2¹⁵⁄₁₆″ × 1¾″; 1n, sp;
3b; h, v, part script.

LUNDBORG'S/CALIFORNIA/
WATER/TRADE MARK/
REGISTERED
See LUNDBORG *(Water)*.

MASCARO TONIQUE/FOR THE
HAIR/TRADE MARK/MARTHA
MATILDA HARPER/ROCHESTER,
N.Y. U.S.A. [Base:] 1250
See MASCARO *(Tonic)*.

MASC·ARO TONIQUE/TRADE
MARK/MARTHA M/HARPER/
ROCHESTER/N.Y.
See MASCARO *(Tonic)*.

MENTHOLATUM/REG/
TRADE/MARK
Milk glass; 2⅝″ × 2⅜″ diameter; 17n;
20b; pl; base. See YUCCA *(Company)*.

MENTHOLATUM/TRADE MARK/
MENTHOLATUMCO/BUFFALO
N. Y./WICHITA KAN
Milk glass; 2″ × 1⁹⁄₁₆″ diameter; 17n;
20b; pl; v. See YUCCA *(Company)*.

REGSTD TRADE/MARK/
MENTHOLATUM/YUCCA CO/
WICHITA KAN
See YUCCA *(Company)*.

MEXICAN/CORN CURE/
(TRADE MARK)
See MEXICAN *(Cure)*.

[v] A. L. MURDOCK//
LIQUID FOOD//BOSTON, U.S.A.//
12½ PERCENT SOLUBLE
ALEUMEN [h] TRADE/MARK
Albert L. Murdock began distribution
of his liquid food, a remedial and health
stimuli, in 1880 or 1881; eventually
Albert E. Murdock became the
manager; the last reference in directo-
ries was in 1926.
Amber; 5¾″ × 1¹⁵⁄₁₆″ diameter; 7n;
21b, 12 sides; pl; v, on consecutive
panels; 2 known sizes.

NAYEAU TONIC CO/TRADE/
MARK/CHICAGO, ILL. USA
See NAYEAU *(Company)*.

TRADE/[embossed head]/MARK/
NUBIAN/TEA/FOR THE LIVER
Adv. 1913, *SN*.
Amber; 8″ × ? × ?; 11n; rect.; v.

OMEGA/OIL/IT'S GREEN/
TRADE MARK/THE OMEGA/
CHEMICAL CO./NEW YORK
See OMEGA *(Oil)*.

[h: embossed bird]/TRADE MARK/[v]
OZARK EYE STRENGTHENER/
OZARK MED. CO./
SPRINGFIELD, MO.
See OZARK *(Company)*.

PAGEMATIC/TRADE MARK/
FOR THE RHEUMATIC/
, Manufactured by/The Pagematic/
Co of Texas/DALLAS, TEXAS
See PAGEMATIC *(Company)*.

PHILLIPS'/MILK OF/[in circle:]
TRADE MARK/MAGNESIA
See PHILLIPS *(Magnesia)*.

PHILLIP'S/MILK OF/[in circle:]
TRADE MARK/MAGNESIA/
PATENTED/APRIL 29th
& JULY 22nd 1873
See PHILLIPS *(Magnesia)*.

PHILLIP'S/MILK OF/[in circle:]
TRADE MARK/MAGNESIA/
REGISTERED
See PHILLIPS (Magnesia).

PHILLIP'S/MILK OF/[in circle:]
TRADE MARK/MAGNESIA/
REG'D IN U.S. PAT. OFFICE/
AUG. 21, 1906
See PHILLIPS (Magnesia).

C. H. PHILLIPS/[in circle:] TRADE
MARK/NEW YORK/PATENTED/
APRIL 29th & JULY 22nd/1873
Aqua; 6¼" × 2½" × 1¹³/₁₆"; 9n; 8b;
pl; h. See PHILLIPS (Company, Oil,
Magnesia, Miscellaneous).

MILK OF/[in circle:] TRADE MARK/
MAGNESIA/REG'D IN U.S.
PATENT OFFICE/AUG. 21, 1906/
THE CHAS. H. PHILLIP'S/
CHEMICAL COMPANY/
GLENN BROOK, CONN.
See PHILLIPS (Magnesia).

[Script:] Pinex/TRADE MARK
Label: Pinex, Trade Mark—22 Minims
Chloroform, 17% Alcohol per fluid ounce
and other valuable ingredients. Makes 1
Pint Of Very Effectual Cough Remedy—
The Pinex Co., Fort Wayne, Ind. A prod-
uct of William Noll, Fort Wayne, IN,
introduced in 1906; a Toronto office
was established in 1914. The family
operated the business until ca. 1960
(White 1974). Adv. 1980 by Belmar
Products Division, 575 Madison Ave.,
New York City, and 1983 by Alvin
Last, Inc., Dobbs Ferry, N.Y., RB.
Aqua; 5¾" × 1⅞" × 1"; 1n; 3b; 1ip;
v, part script; ABM. Also clear vari-
ant, 6" high.

TRADE-PISO'S-MARK//
THE/PISO COMPANY//
HAZELTINE & CO.
See PISO (Company).

TRADE PISO'S MARK//PISO CO.
WARREN, PA. U.S.A.
See PISO (Company).

[Script:] Purola/TRADE MARK REG
Label: Purola Sizz For Headache &
Neuralgia—Guaranteed By Blumauer-
Frank Drug Co. Under Food and Drugs Act
June 30, 1906—Prepared by Blumauer-
Frank Drug Co., Portland, Oregon. Adv.
1935, AD.
Blue; dimens. unk.; 16n, threaded
jigger cap; 2b; pl; v, part script; ABM.
See BLUMAUER (Company).

GERM, BACTERIA OR/
FUNGUS DESTROYER/[within shield:]

WᴹRADAM'S/MICROBE KILLER/
[man clubbing skeleton]/REGISTERED
TRADE MARK DEC. 13, 1887/
CURES/ALL/DISEASES
See RADAM (Killer).

[Script:] Rawleigh's/TRADE MARK
W. T. Rawleigh, Freeport, IL, began
manufacturing medicines in 1889. Cork
enclosures were in use until ca. 1933
(Fike 1965). In 1917, 140 products
were being sold (Shimko 1969). About
1970, the family-owned business
became a subsidiary of an eastern
investment company (Zumwalt 1980).
Products manufactured in 1985.
Clear; 6½" × 2¼" × 1⅛"; 1n, sp; 3b;
1ip; v, part script; ABM.

[v, Script:] Rawleigh's/TRADE
MARK/[h] BOTTLE MADE IN
U.S.A.
Clear; 8¼" × ? × ?; 16n; 3b; 1ip; h, v,
part script; ABM.

[Script:] Rawleigh's/TRADE MARK//
W. T. RAWLEIGH CO//
FREEPORT, ILL.
Aqua, clear; 7⅝" × 2⅝" × 1⅜", also
6⅛" × 2¼" × 1³/₁₆"; 1n; 3b; 4ip; v,
fss, part script.

[Script:] Rawleigh's/TRADE MARK//
W. T. RAWLEIGH MED CO//
FREEPORT, ILL.
Clear; 6⅛" × 2¼" × 1³/₁₆"; 1n; 3b;
4ip; v, fss; part script.

[v, Script:] Rawleigh's/TRADE
MARK/[h] BOTTLE MADE IN
U.S.A. [Base: I in diamond]
[See Figure 230]
Label: Rawleigh's RU-MEX-OL COM-
POUND, Alcohol 18%. Useful as a Tonic
and Alterative. Manufactured by the W.
T. RAWLEIGH COMPANY,
FREEPORT, ILL., U.S.A., MEMPHIS,
MONTREAL.

Fig. 230

Amber; 8⅜" × 3" × 1⁹/₁₆"; 1 and 16n;
3b; 1ip, arched; v, h, part script;
ABM. Some variants embossed REG.
U.S. PAT. OFF.

RHEUMATIC/[embossed tree]/
TRADE MARK/SYRUP/1882//
R. S. CO ROCHESTER, N.Y.
See RHEUMATIC (Syrup).

S. A. RICHMOND. M.D./[d] TRADE
[embossed bearded man's head]/MARK/
[h] ST. JOSEPH MO/[v]
SAMARITAN//NERVINE
See SAMARITAN (Nervine).

SALVATION/TRADE OIL MARK/
A. C. MEYER & CO/BALTIMORE,
M.D. U.S.A.
See SALVATION (Oil).

SANITOL/TRADE MARK/BEST
FOR THE TEETH [See Figure 231]
Clear; 4" × 1⅞" diameter; 3n; 20b; pl;
d. See SANITOL (Miscellaneous).

Fig. 231

SAVE-THE-HORSE/TRADE MARK/
SPAVIN CURE/TROY CHEMICAL
CO. TROY, N.Y.
See SAVE-THE-HORSE (Cure).

SAVE-THE-HORSE/REGISTERED
TRADE MARK/SPAVIN CURE/
TROY CHEMICAL CO.
BINGHAMPTON N.Y.
See SAVE-THE-HORSE (Cure).

[h]SCOTT'S/EMULSION [v] TRADE/
[man with fish]/MARK/[h] COD
LIVER OIL/WITH/LIME & SODA
[Base: W over T in triangle]
See SCOTT (Oil).

SLADE'S AMMONIA/PEAR/TRADE
MARK//CHARLES F. SLADE CO/
10 OZ./BUFFALO, N.Y.
See SLADE (Company).

Dr. Slocum's/coltsfoote/compound/
Expectorant/TRADE MARK
See SLOCUM (Expectorant).

THE GREAT/SOUTH AMERICAN/
NERVINE TONIC/TRADE/
[monogram]/MARK/AND/STOMACH
& LIVER CURE
See SOUTH AMERICAN *(Cure)*.

[d] TRADE/MARK/[h] SPARKS/
PERFECT HEALTH/[embossed man]/
FOR/KIDNEY & LIVER/DISEASES/
CAMDEN, N.J.
Adv. 1891, *WHS*; 1910, *AD*.
Amber; $9^3/_8'' \times 3^1/_2'' \times 1^3/_4''$; 11n; 4b;
pl; d, h. See SPARKS (Cure).

THE/SPECIFIC/A NO 1/A SELF
CURE/(TRADE MARK) [Base:] W T
& CO USA
See SPECIFIC *(Specific)*.

SUTHERLAND 7 SISTERS/TRADE
COLORATOR MARK
Bottle manufactured ca. 1900.
Adv. 1917, *BD*.
Color unk.; $9'' \times ? \times ?$; 9n; rect.; 1ip;
v. See SUTHERLAND *(Hair)*.

TRADE/SWAIM'S/MARK//
PANACEA//ESTABLISHED//
1820//PHILAD^A
Bottle introduced in 1875 (Wilson and
Wilson 1971), or 1879 (Munsey 1970).
Aqua; dimens. unk.; 12n; 20b; ip; v,
sssss. See SWAIM *(Miscellaneous)*.

[v in circle:] ESTABLISHED 1873/
TRADE/MARK [superimposed on
elephant]/REGISTERED [d] THE [v]
U. P. T. Co./N.Y.
See U. P. T. *(Company)*.

TRADE "TO-NI-TA" MARK//
LORENTZ MED. CO.
See LORENTZ *(Medicine)*.

WARNER'S/SAFE/BITTERS/
TRADE/MARK [on embossed
safe]/ROCHESTER, N.Y.
See WARNER *(Bitters)*.

WARNER'S SAFE/CURE/TRADE/
MARK [on embossed safe]/
ROCHESTER, N.Y.
See WARNER *(Cure)*.

WARNER'S/SAFE/DIABETES/
CURE/TRADE/MARK [on embossed
safe]/ROCHESTER, N.Y.
See WARNER *(Cure)*.

WARNER'S/SAFE/KIDNEY &
LIVER/CURE/TRADE/MARK
[on embossed safe]/ROCHESTER,
N.Y.
See WARNER *(Cure)*.

WARNER'S/SAFE/NERVINE/
TRADE/MARK [on embossed
safe]/ROCHESTER, N.Y.
See WARNER *(Nervine)*.

8 OZ/WARNER'S/SAFE/REMEDY/
TRADE/MARK [on embossed safe]/
ROCHESTER, N.Y. [Base:] A
See WARNER *(Remedy)*.

$12^1/_2$ FL. OZ./WARNER'S/SAFE/
REMEDIES CO./TRADE/MARK
[on embossed safe]/ROCHESTER,
N.Y. U.S.A. [Base:] 488
See WARNER *(Remedy)*.

WARNER'S/SAFE/RHEUMATIC/
CURE/TRADE/MARK [on embossed
safe]/ROCHESTER, N.Y.
See WARNER *(Cure)*.

[h] TRADE MARK/[v] WATKINS
Clear; $8^7/_{16}'' \times 3'' \times 1^5/_8''$; 1n; 3b; 1ip;
h, v. See WATKINS *(Company*, Lini-
ment, Miscellaneous).

[v] WINANS BROTHERS/INDIAN
CURE/[h] WINANS BROS/[woman's
profile]/TRADE MARK/INDIAN/
CURE/FOR THE/BLOOD/
PRICE $1.00
See WINAN *(Cure)*.

L. Q. C. WISHART'S//PINE TREE/
TAR CORDIAL/PHILA^A//TRADE/
[embossed pine tree]/MARK
See WISHART *(Cordial)*.

ZAEGEL'S/ZMO/MAGNETIC
OIL/TRADE MARK/FOR PAIN
See ZAEGEL *(Oil)*.

WATER

Fig. 232

AGUA DE RUBINAT/CONDAL
[See Figure 232]
Label: *NATURAL APERIENT MINERAL WATER OF RUBINAT CONDAL SPRING SPAIN — The Only Rubinat Water Declared In Spain To Be Of Public Utility . . . RUBINAT COMPANY SOLE AGENTS FOR UNITED STATES and CANADA . . . 60 BROAD ST., NEW YORK Recommended By All The Principal Medical Authorities In Europe And America.* Adv. 1889, *PVS & S;* 1929–30 by Hahn & Wessel, 103 W. 52nd St., New York City, *AD.*
Aqua; 10¾″ × 2⅝″; 8n; 20b; pl; h.

ROCK-BRIDGE/VIRGINIA,/ALUM-WATER.
Adv. 1895, *McK & R;* 1916, *MB.*
Emerald green; 9¼″ × 4⅝″ diameter; 7n; 20b; pl; h.

BAKER'S/FLORIDA WATER/PORTLAND.
Directories indicated that the Baker Extract Co., 249½ Commercial, Portland, ME, were manufacturing extracts and perfumes in 1895 and 1912, with Will H. MacDonald, manager.
Light green; 6⅞″ × 1¾″ diameter; 11n; 20b; pl; v.

BARRY'S/FLORIDA WATER/DOUBLE STRENGTH/NEW YORK
Probably related to Barry, (see Hair).
Adv. 1889, *PVS & S.*
Aqua; 9″ × ?; 11n; 20b; pl.

FLORIDA WATER/BAZIN & SARGENT/NEW YORK
[See Figure 233]
Bazin & Sargent were perfumers in New York City from 1888 to 1898; directories listed Felix A. Bazin, Perfumer, alone in 1899.
Aqua; 5¾″ × 1⅜″ diameter, also 9⅝″ × ?; 11n; 20b; pl; d.

Fig. 233

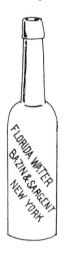

BEAR LITHIA WATER/[embossed bear]/BEAR/LITHIA WATER/TRADE MARK/NEAR/ELKTON, VA.
Ceramic stopper embossed: Pat'd Feb. 2, 1883 [or 1893]. Adv. 1910, *AD.*
Aqua; 10¼″ × ?; 20n; 20b; pl; h.

BERKSHIRE SPRING WATER/FROM THE/BERKSHIRE HILLS/[monogram]/BERKSHIRE SPRINGS CO./579 & 581 E 133 ST NEW YORK/THIS BOTTLE NOT SOLD
See BERKSHIRE SPRINGS *(Company).*

BLOUNT SPRING/NATURAL/SULPHUR WATER
Production ca. 1870s to ca. 1914 (source unk.).
Blue; dimens. unk.; ?n; 20b; pl; 2 sizes.

BLUE LICK/[embossed deer]/WATER//JOHN T. FLEMING/PROPRIETOR/MAYSVILLE, KY.
Adv. 1851 (Putnam 1968); 1910, *AD.*
Dark amber; 9½″ × ?; 11n; 20b; pl; h, fb.

BOWDEN/LITHIA WATER/[embossed building]/LITHIA SPRINGS, GA./TRADE MARK REG.
Adv. 1880s–ca. 1912 (source unk.).
Aqua; dimens. unk.; 20n; 20b; pl; h; pint, quart and gallon sizes.

BOYD & BEARD/MINERAL WATER/B/THIS BOTTLE/IS NEVER SOLD
Bottle manufactured ca. 1870 (source unk.).
Emerald green; 6¾″ × 2½″ diameter; 11n; 20b; pl; h, fb; p.

BUFFALO/LITHIA/SPRINGS/WATER/[seated woman]/NATURES/MATERIA/MEDICA/TRADE MARK
Advertised in 1890 as ". . . Useful in Eliminating Kidney Stones, Uric Acid and Valuable in use of gouty Diabetes and Brights Disease. Thomas F. Goode, Buffalo Spring, Va." Advertisement, Dec. 1900, *Century Magazine:* "MINERAL SPRINGS BUFFALO LITHIA WATER. In Uric Acid Diathesis, Gouty Rheumatic Conditions, Albuminuria of Bright's Disease and Pregnancy. Solvent and Eliminator of Renal Calculi, and also Preventive of the Calculous formation. Proprietor, Buffalo Lithia Springs, Virginia." Adv. 1878 (Devner 1968); 1923, *SF & PD.*
Aqua; 10½″ × 4⅝″ diameter; 7n; 20b; pl; h.

PROFESSOR BYRNE'S/=GENUINE=/FLORIDA WATER/PREPARED FOR/H. K. & F. B. THURBER & CO/NEW YORK
Adv. 1891, *WHS;* 1900, *EBB.* New York directories found Horace K. Thurber, Grocers, in 1871, and H. [Horace] K. and F. [Francis] B. Thurber & Co. in 1878; also George J. Byrne, Perfumer, 122 Liberty, in 1891, and at 107 Liberty, in 1896.
Aqua; 9¼″ × ?; 11n; 20b; pl; v.

GENUINE/FLORIDA WATER/PROF. GEO. J. BYRNE/NEW YORK
Aqua; 7″ × ?, also 9″ × ?; 11n; 20b; pl; v.

BYTHINIA WATER
Label: *BYTHINIA, Santa Barbara's Famous Water. Santa Barbara Mineral Water Co. San Francisco, Ca.* Adv. 1897, *L & M;* 1923, *SF & PD.*
Amber; 9⅞″ × 3¼″ diameter; 11n; 20b; pl; h, on shoulder.

AGUA DE FLORIDA/CALIDAD SUPERIOR
Aqua; 5¼″ × ?, also 8¾″ × ?; 11n; 20b; pl; v. See CALIDAD (Miscellaneous).

CALNON & CRONK/MINERAL WATER/DETROIT//BOTTLES RETURNED

Dark aqua; 7³/₁₆″ × 2¹¹/₁₆″ diameter; 11n; 20b; pl; h, fb; p; early soda water shape.

CASTALIAN//CAL. NAT. MIN. WATER

Product of J. P. Forbes Co., San Francisco, CA, adv. 1895, *McK & R*; 1923, *SF & PD*.

Amber; 7¹/₂″ × 3″ diameter; 9n; 20b; pl; h, fb, near shoulder.

FLORIDA WATER/COFFIN-REDINGTON CO./SAN FRANCISCO

Adv. 1913–1942, according to Peter Schulz (personal communication, 1985).

Aqua; 8³/₄″ × 2¹/₄″ diameter; 11n; 20b; pl; v. See REDINGTON *(Company*, Jamaica Ginger).

CONGRESS/WATER//CONGRESS SPRING CO./C/SARATOGA, N.Y.

[See Figure 234 and Photo 71]
The Saratoga and Congress Springs were discovered in 1792 by a congressman named Gilman from New Hampshire, and named in his honor (Putnam 1968). John Clarke and Thomas Lynch established the Congress Springs Co. in 1823. Lynch died in 1833 and Clarke made William White a full partner. After the death of White and Clarke, Chauncy Kilmer, president of the Empire Spring Co., purchased the Spring and Mineral Water business in 1864. Until 1874 the vessels were embossed The Congress and Empire Spring Co. The embossing on bottles from both springs are the same except Empire Water bottles have an E embossed on them, while Congress Water bottles have a C. Prior to 1867 the bottles were dark olive green, after 1867, emerald green. When the Hotch-

Fig. 234

kiss family acquired the company in 1879 the name Hotchkiss Sons was added to embossing. In 1884 the Congress and Empire relationship was dissolved and the two were operated separately. In 1889 the shape was changed to a blob top variant embossed only on the base, CONGRESS SPRING CO. S. S. N. Y. (source unk.) Adv. 1921, *BD*.

Dark green; 7⁵/₈″ × 3″ diameter; 2n; 20b; pl; h, bf. See CLARKE (Company, Miscellaneous), EMPIRE (Water), LYNCH (Miscellaneous).

[v] CRAB ORCHARD/[d] GENUINE

[embossed crabapple & leaves]
GENUINE/[v] TRADE MARK/SALTS/BOTTLED BY/CRAB ORCHARD WATER CO./LOUISVILLE, KY.

Adv. 1887, *WHS*; 1917, *BD*.

Amber; 4⁵/₁₆″ × 1¹⁵/₁₆″ diameter; 3n, large mouth; 20b; pl; v, d.

DABROOKS'/FLORIDA WATER/DETROIT

Label: *DABROOKS' FLORIDA WATER – PREPARED BY Dabrooks' Perfume Co., DETROIT – NEW YORK.*

Clear; 6″ × 1¹/₂″ diameter; 11n; 20b; pl; v. See DABROOK (Miscellaneous).

DE LEON'S/FLORIDA WATER

Adv. 1900, *EBB*; 1910, *AD*.

Aqua; 6³/₈″ × ?, also 9″ × ?; 11n; 20b; pl; v.

W.E. ELMENDORF'S/CAPITAL CITY/FLORIDA WATER/ALBANY N.Y.

Label: *CAPITAL CITY AQUA DE FLORIDA. PREPARED ONLY BY WILLARD E. MASTEN, ALBANY, N.Y.*

Aqua; 9″ × 2³/₁₆″ diameter, also 5³/₄″ × ?; 11n; 20b; pl; v. See MASTEN *(Balsam*, Water).

EMPIRE/WATER//CONGRESS & EMPIRE SPRING CO/E/SARATOGA N.Y. [Base: 4-point star]

Dark green; 7¹/₄″ × ?; 2n; 20b; pl; h, v, fb. See CLARKE (Company, Miscellaneous), CONGRESS *(Water)*, LYNCH (Miscellaneous).

FLORIDA WATER/J. MARIA FARINA/№ 4711/COLOGNE

Aqua; 9″ × ?; 11n; 20b; pl; v. See FARINA *(Miscellaneous)*, NO 4711, (Miscellaneous).

TRADE/FERNANDINA/MARK/FLORIDA WATER/THE S. H. WETMORE COMPANY/NEW YORK

[See Figure 235]

Adv. 1899 (Devner 1970).

Aqua; 5⁷/₈″ × 1⁷/₁₆″ diameter; 11n; 20b; pl; v.

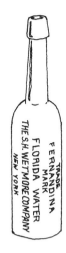

Fig. 235

FLORIDA WATER

Clear, aqua, amber; 6³/₄″ × 1⁵/₈″ diameter, also 9¹/₈″ × ?; 11n; 20b; pl; v.

QUEEN FLORIDA WATER/FRENCH RICHARDS & CO/PHILADELPHIA

Directories listed the firm as Wholesale Druggists, 1883–1891; prior to 1883 they were a manufacturer of plasters.

Aqua; 6⁵/₈″ × 1⁹/₁₆″ diameter; 11n; 20b; pl; v.

GARWOOD'S/FLORIDA WATER/PHILADELPHIA

Label: *GARWOOD'S FLORIDA WATER, SCHANDEIN & LIND PERFUMERS PHILADELPHIA.*

Aqua; 6⁵/₈″ × 1⁵/₈″ diameter; 11n; 20b; pl; v.

Wᴹ GOLDSTEIN'S/IXL/FLORIDA WATER

Aqua; 9¹/₈″ × 2³/₁₆″ diameter; 11n; 20b; pl; v.

Dᴿ W. H. GREGG//CONSTITUTION WATER//NEW YORK

Introduced ca. 1859. Adv. 1865, *GG*; 1921, *BD*.

Aqua; 6³/₈″ × 2³/₈″ × 1³/₈″; 7n; 3b; 3ip; v, sfs. See GREGG (Syrup).

HOT SPRINGS/MINERAL WATER/SALT LAKE CITY/UTAH/JOHN BECK

Prior to being proprietor of the Hot Springs from ca. 1896 to ca. 1898, John Beck was owner of the French Steam and Hand Laundry, according to R. L. Polk & Co's Salt Lake City directories.

Aqua; 9¹/₂″ × 2⁵/₈″ diameter; 20n; 20b; pl; h.

JORDAN/WATER//PAN AM/1901
Aqua; dimens. unk.; 13n; 20b; pl; v, fb.

"LAIT"/TOILET WATER// SAMPEI. HIRAO
Clear; 5¼″ × 2″ × 1⁷⁄₁₆″; 7n; 3b; pl; v, ss.

FLORIDA WATER/LAZELL DALLEY & CO./NEW YORK
[See Photo 72]
Label indicates a new label was adopted 1 Sept. 1887. Henry Dalley, Jr. succeeded his father in business in 1852. In 1887, Dalley teamed with Lewis T. Lazell and formed Lazell, Dalley & Co. The company was dissolved in 1890 and the product names were continued under other owners (Devner 1970; Holcombe 1979). Adv. 1914, *HD*.
Aqua; 5½″ × ?; 11n; 20b; pl; v.

FLORIDA WATER/LAZELL, MARSH,/&/GARDINER/ NEW-YORK
Lewis T. Lazell was with Lazell, Marsh & Gardiner from 1864 at 10 Gold St. to 1887, when he joined Henry Dalley, as listed in the New York City directories.
Aqua; 9″ × 2⅛″ diameter; 11n; 20b; pl; v.

LUNDBORG'S/CALIFORNIA/ WATER/TRADE MARK/ REGISTERED
Product of John M. Lundborg, Perfumer, New York, NY. Directories located the firm at 22 Vesey in 1878, and at 24 Barclay in 1891 and 1896. The firm was still in business in 1899 (Devner 1970).
Aqua; 9″ × ?; 11n; 20b; pl; v. See LUNDBORG (Miscellaneous).

MACK'S/FLORIDA WATER
[See Figure 236]

Fig. 236

Product of Mack & Co., wholesale drugs dealer, San Francisco, CA. Adv. 1896–97, *Mack*.
Aqua; 5⅞″ × 1⅝″ diameter; 11n; 20b; pl; v. See MACK (Company).

W. E. MASTEN'S/CAPITAL CITY// FLORIDA WATER/ALBANY N.Y.
Aqua; 6¾″ × 1⅜″ diameter; 11n; 20b; pl; v. See MASTEN (*Balsam*), ELMENDORF (Water).

FLORIDA WATER/MERTEN MOFFITT & CO/SAN FRANCISCO
See MERTEN (*Company*).

FLORIDA WATER/MIANNAY & ALLEN/NEW YORK
Bottle manufactured ca. 1900. Edward Miannay was not found in the 1891 New York City directory; in 1896 Miannay was a boxmaker.
Aqua; 8¾″ × ?; 11n; 20b; pl; v.

MINNEQUA WATER/BRADFORD Cº/P∆
Product produced ca. 1910 (source unk.).
Color & dimens. unk.; 2n, modified; 20b; pl; h.

FLORIDA WATER/MURRAY & LANMAN/DRUGGISTS/NEW YORK
[See Figure 237]
David T. Lanman, located at 69 Water St., New York City in 1836, formed a partnership with Lindley Murray in 1842. Murray left the business in 1854 and George Kemp, a senior clerk, became a silent partner. In 1858 the firm became D. T. Lanman & Kemp, in 1861, Lanman & Kemp. The pair produced many products including the Florida Water, retaining its original name; they also produced Bristol's Sarsaparilla. Lanman died in 1864; in 1871 the firm relocated from 69 Water St. to 68 and 70 William St. In 1901 Lanman & Kemp merged with Barclay & Co. (Holcombe 1979; Wilson and Wilson 1971). Florida Water adv. 1948 by Lanman & Kemp-Barclay & Co., Inc., New York City, *AD*. The product may have been temporarily suspended but was on the market in 1982 in an unembossed, threaded variant labeled: *LANMAN & KEMP-BARCLAY & CO., INC., WESTWOOD, N.J.*
Aqua; 5¾″ × 1⅜″ diameter; 11n; 20b; pl; v. See BARRY (Cream, *Hair*, Miscellaneous), BRISTOL (Sarsaparilla).

Fig. 237

FLORIDA WATER/MURRAY & LANMAN/DRUGGISTS/NEW-YORK
Aqua, apple green; 9″ × 2³⁄₁₆″ diameter; 11n; 20b; pl; v. See BARRY (*Hair*), BRISTOL (Sarsaparilla).

FLORIDA WATER/MURRAY & LANMAN/NO 69 WATER ST./ NEW-YORK
Earliest variant.
Aqua; 9″ × 2³⁄₁₆″ diameter; 11n; 20b; pl; v. See BARRY (*Hair*), BRISTOL (Sarsaparilla).

FLORIDA WATER/THE OAKLEY SOAP & PERFUMERY CO N. Y.
Random New York City directories included the firm in 1871 as soap manufacturers, with Eli B. Oakley, proprietor; in 1891 and 1896, with John A. Oakley, President, located at 43 Leonard & 122 Duane.
Aqua; 9¼″ × ?; 11n; 20b; pl; v.

OLYMPIA WATER CO./MINERAL WELLS/TEX.
Color & dimens. unk.; 20n; 20b; pl.

SOLON PALMER'S/FLORIDA WATER/NEW YORK
[See Figure 238]

Fig. 238

Solon Palmer opened a small cosmetic store in Cincinnati, OH, in 1847. In 1871 his expanding business was moved to New York City (Devner 1970). Solon's son Eddy entered the firm either in 1892 or 1903 (source unk.). The business was family operated until the 1960s or 1970s.

Aqua; 8¾" × 2³⁄₁₆" diameter; 11n; 20b; pl; v; several sizes. See PALMER (Lotion, Miscellaneous).

PERFECTION/FLORIDA WATER/ L. DI N.S.F. [See Figure 239]

Aqua; 9" × 2⅛" diameter; 11n; 20b; pl; v.

Fig. 239

POCAHONTAS/SPRING/WATER/ THIS BOTTLE LOANED/ NOT SOLD/SIX PINTS

Aqua; 11¾" × 5¼" diameter; 3n; 20b; pl; h.

FLORIDA WATER/RAYMOND & Co/NEW YORK [Base:] J/11 [See Photo 73]

Label: *FLORIDA WATER – Prepared by RAYMOND & Co. NEW YORK.*

Aqua; 6¼" × 1½" diameter, also 8⅞" × ?; 11n; 20b; pl; v.

FLORIDA WATER/REDINGTON & CO/SAN FRANCISCO

See REDINGTON *(Company)*.

POOR RICHARD'S/EYE WATER// MRS M. G. BROWN//PHILA U.S.A.

Adv. 1863 by Mrs. M. G. Brown, 410 Arch St., Philadelphia, according to McElroy's Philadelphia directory; 1935 by Mrs. M. G. Brown, Bethlehem, Pa., *AD*.

Clear; 4¼" × 1½" × 1"; 9n, sp; 3 or 6b; ip; v, fss.

ST. CATHARINES/MINERAL WATER/G. L. MATHER AGENT/ ASTOR HOUSE/NEW YORK

Label: *ST. CATHERINE MINERAL WATER. From the famous Artesian Well in Canada West; a sovereign remedy for Rheumatism, Gout, Erysipelas, Liver and Kidney complaints, &c. . . .* Adv. 1858, 1866, G. L. Mather as agent (Singer 1982); 1887, *McK & R*.

Olive; 11" × 2⅞" diameter; 12n; 20b; pl; v.

STANDARD/MINERAL WATERS/ BRINTON & BROSIUS/ PHILADELPHIA [Base:] B & D

Philadelphia directories included firm from 1888 to 1908.

Clear; 8½" × ?; Codd patent stopper; 20b; pl.

AGUA DE FLORIDA/J. STEINERT/ NEW YORK

Directories locate George J. Steinert, physician, at 148 E. 39th, New York, NY in 1878.

Aqua; 9⅛" × ?; 11n; 20b; pl; v; embossing order uncertain.

AGUA DE FLORIDA/FELIX B. STROUSE/PERFUMER/NEW YORK

Directories establish Felix B. Strouse, Perfumer, New York, between 1865 and 1867, and ceased listing the firm between 1872 and 1877.

Aqua; 9³⁄₁₆" × ?; 11n; 20b; pl; v.

TELLERS/MINERAL/WATER/ DETROIT

Pierre Teller, Detroit, MI, bottled waters from 1845 to 1958 (source unk.).

Cobalt; 7⅝" × 2⅝" diameter; 11n; 20b; pl; h; p; early soda water shape.

TELLERS/MINERAL/WATER/ DETROIT//THE BOTTLE MUST BE RETURNED

Cobalt; green; dimens. unk.; 11n; 20b; pl; with and without p; various shapes.

DR THOMPSON'S//EYE WATER// BRIDGEPORT//CONNT

A product of the 1850s supposedly developed from the original formula by a relative or descendant of Dr. Isaac Thompson (see next entry). The competition with Isaac's Eye Water was settled by a financial arrangement (Holcombe 1979).

Aqua; 3⅞" × 1" diameter; 13n; 20b; pl; v, fsbs; p.

DR THOMPSON'S/EYE WATER/ NEW LONDON/CONNT

Dr. Isaac Thompson's Celebrated Eye Water was introduced in 1795. Isaac's daughter Mary married John L. Thompson, Troy, NY, who was also in the medicine business. John purchased Isaac's product in 1830, and the bottles continued to be embossed New London (Holcombe 1979). Eye Water adv. 1941–42 by John L. Thompson Sons & Co., 161 River St., Troy, N.Y., *AD*.

Light green, aqua; 3¾" × ?; 7n, crude; 20b; pl; v; with and without p.

UTE CHIEF/MINERAL/ WATER CO./MANITOU, COLO.// THIS BOTTLE/NEVER SOLD

[Base:] U. C.

Clear; 8¼" × 2½" diameter; 19n; 20b; pl; h, fb.

FLORIDA WATER/VENNARD & COMPANY/NEW YORK

Label: *VENNARD'S NON-PAREIL FLORIDA WATER. Manufactured by Vennard & Co., New York.* Product of William L. Vennard adv. 1887, 1895, *McK & R.* Directories located the New York business at 91 Foulton in 1891.

Aqua; 8⅞" × ?, also 5⅞" × ?; 11n; 20b; pl; v.

VERONICA//MINERAL WATER [See Photo 74]

Label from variant 10⅝" high: *VERONICA – SANTA BARBARA California's Natural Medicinal Spring Water – Veronica Medicinal Springs Water Co., Santa Barbara, California . . . The Veronica Springs are situated in a beautiful valley about four miles west from the city of Santa Barbara, California. . . .* The product was registered July 1893 (Schulz, et al. 1980). Adv. 1929–30 by Hahn & Wessel, 103 W. 52nd St., New York City; 1948 by Veronica Sales Co., Santa Barbara, Cal., *AD*.

Amber; 8" × 2½" × 2½"; 7n; 1b; pl; h, fb, on shoulder.

D. J. WHELAN/[monogram]/TROY, N.Y./1881//MINERAL/WATERS

A 1914 directory listed D. J. Whelan, Estate Bottlers.

Light green; 7¼" × 2⅜" diameter; 20n; 20b, recessed at base to 1½" diameter; pl; h, fb; fluted shoulders.

WHITTEMORE'S/EYE WATER/ ESSEX CONN.

Product of A. F. Whittemore, Essex, CT. Adv. 1851 (Baldwin 1973).

Aqua; 4" × 1¼" × ?; 5n; 12b; pl; v; p. See WHITTEMORE (Syrup).

WITTER/SPRING/WATER [Base:] W.M.S.CO./SAN FRANCISCO

Adv. 1915, 1923, *SF & PD*.

Amber; 9" × 3³⁄₁₆" diameter; 11n; 20b; pl; h, on shoulder.

**AGUA DE FLORIDA/R & G. A.
WRIGHT/FILADELFIA**
Aqua; 9″ × ?; 11n; 20b; pl; v. See
ALEXANDER (Miscellaneous), R. & G.
A. WRIGHT *(Miscellaneous)*.

**YPSILANTI/MINERAL/WATER/
SALTS/T.C./OWEN/YPSILANTI/
MICH**
Aqua; light blue; 5¾″ × 2¼″
diameter; 7n; 20b; pl; h.

BIBLIOGRAPHY

JOURNALS AND SUPPLY HOUSE CATALOGS CITED

In citing a journal or catalog in the reference section of this book, abbreviations have generally been used. Works frequently cited are listed here and their abbreviations precede the entry. As an aid to the researcher, the author's source of information has been included in this section, as many of these journals and catalogs are rare and not commonly found. In addition, note that some of the bibliographical information may be incomplete, due to length or the incomplete nature of the original document.

AD *American Druggist and Pharmaceutical Record* 56 (1910). Philadelphia. Source: California State Library, Sacramento, CA.

American Druggist Blue Book. Products and Prices. 1941–42. New York. Source: Philadelphia College of Pharmacy and Science, Philadelphia, PA.

_____. 1948. Source: same.

_____. 1980–81. Source: author's personal collection.

_____. 1984–85. Source: same.

American Druggist Price Book. 7th ed. 1935. New York. Source: California State Library, Sacramento, CA, and Philadelphia College of Pharmacy and Science, Philadelphia, PA.

The American Druggist Year Book and Price List. 2d ed. 1929–30. New York. Source: California State Library, Sacramento, CA.

BWD Bankers Wholesale Drug Co. 1925. *Bankers' Drug List.* Brooklyn. Source: private collection of William H. Helfand, New York City, NY.

BD Brunswig Drug Co. 1917. Price List of Drugs, Chemicals, Etc. *The California Druggist* 16 (Sept.–Oct.). Source: California State Library, Sacramento, CA.

_____. 30 (Jan.–Feb. 1921). Source: same.

TB Bohannan, Thos. & Co. 1834. *Prices Current of Drugs . . .* Louisville, KY. Source: Lloyd Library, Cincinnati, OH.

GC Carpenter, Geo. W. 1831. *Essays on Some of the Most Important Articles of the Materia Medica . . . A Catalogue of Medicines, Surgical Instruments . . .* Philadelphia. Source: National Library of Medicine, Bethseda, MD.

_____. 1852. *Wholesale Drug and Chemical Warehouse.* Philadelphia: T.K. and P.G. Collins. Source: Pennsylvania State Historical Society, Philadelphia, PA.

_____. 1854. Source: Pennsylvania State Historical Society, Philadelphia, PA.

Ch & C Charles & Co. 1915. *Catalogue (Annual Issue).* New York. Source: Library, University of California, Santa Barbara, CA.

C & C Comstock and Co. 1842. *The General Family Directory . . .* New York. Source: Francis A. Countway Library of Medicine, Boston, MA.

JD Day, John and Co. 1771. *Catalogue of Drugs, Chymical and Galenical Preparations . . .* Philadelphia: John Dunlap. Source: American Philosophical Society, Philadelphia, PA.

_____. 1790. *Price Book. Catalogue of Drugs, Chymical and Galencial Preparations . . .* Philadelphia. Source: American Philosophical Society, Philadelphia, PA.

TWD Dyott, T. W. 1820. *Catalogue of Drugs and Medicines . . .* Philadelphia. Source: See Putnam (1968), annotated bibliography.

EBB *The Era Blue Book, A Universal Price List and Directory of Manufacturers for Drug Trade Buyers.* 1900. Issued annually by *The Pharmaceutical Era.* New York: D. O. Haynes & Co. Source: Library, University of California, Santa Barbara, CA.

EF Fougera, E. & Co. 1897. *Price List of French and English Medicinal Preparations* . . . New York. Source: Byk-Gulden, Inc., Melville, NY.

_____. 1900. Source: Library, University of California, Santa Barbara, CA.

FF *Fuller & Fuller's Price Current.* 1892. Chicago. Source: National Museum of American History, Smithsonian Institution, Washington, D.C.

CHG Goldthwaite, C. H. 1898. *Goldthwaite's Cut Price List.* Brockton, MA, and Taunton, NJ. Source: Library, University of California, Santa Barbara, CA.

GG Goodwin, Geo. C. & Co. 1885. *Catalogue . . . Current Prices.* Boston. Source: copy in private collection of Carlyn Ring, Portsmouth, NH.

Goodwin, Geo. C. & Co. 1865. *Catalogue of Patent Medicines, Perfumery, Toilet Articles* . . . Boston. Source: Massachusett's College of Pharmacy, Boston, MA.

JH Henshaw, John. 1835. *Prices Current* . . . Boston. Source: Lloyd Library, Cincinnati, OH.

HH & M Hornick, Hess & More. 1901. *Prices Current of Drugs and Chemicals, Proprietary Medicines* . . . Sioux City, IA. Source: private collection of William H. Helfand, New York City, NY.

JHS Houghton, J. S. 1851. *Magasin de Sante. Depot for the Sale of Genuine Popular Medicines, Cosmetics, Perfumery.* Boston: George Coolidge. Source: Francis A. Countway Library of Medicine, Boston, MA.

HD *Houston Drug Company, Wholesale Druggists and Importers.* 1914. Houston. Source: author's personal collection.

L & M Langley and Michaels Co. 1897. *Prices Current of Drugs, Chemicals, Proprietary Medicines, Pharmaceutical Preparations* . . . San Francisco. Source: California State Historical Society, San Francisco, CA.

Mack *Mack & Co's General Prices Current.* 1896–97. San Francisco. Source: Nevada Historical Society, Reno, NV.

MASS Mass. College of Pharmacy. 1828. *Catalogue of the Materia Medica, and of the Pharmaceutical Preparations* . . . Boston: Jonathan Howe. Source: Massachusetts College of Pharmacy, Boston, MA.

McK & R McKesson & Robbins. 1877. *Prices Current of Drugs and Druggists' Articles, Chemical and Pharmaceutical Preparations* . . . New York: Tritchener & Glastaeter. Source: Library, University of California, Santa Barbara, CA.

_____. 1887. *Prices Current of Drugs, Chemical and Pharmaceutical Preparations* . . . New York. Source: Library, University of California, Santa Barbara, CA.

_____. 1895. Source: same.

MB *Meyer Brothers Druggist.* 37 (June 1916). St. Louis. Source: private collection of Peter Schulz, Sacramento, CA.

MP *Morrisson, Plummer & Co.'s Prices—Current.* 1887. Chicago. Source: copy in private collection of Carlyn Ring, Portsmouth, NH.

HO O'Neill, Howard D. 1860. *Wholesale Druggist* . . . Baltimore. Source: Winterthur Museum, Winterthur, DE.

SSP Pierce, S. S. 1886–87. *Importers and Grocers.* . . . Boston. Source: Baker Library, Harvard University, Cambridge, MA.

RB *Redbook. The Pharmacist's Guide to Products and Prices.* 1979. Oradell, NJ: Litton Ind. Inc. Source: author's personal collection.

_____. 1980. Source: same.

_____. 1983. Source: same.

RD Royal Drug Co. 1922. *Catalogue & Net Price List.* Chicago. Source: author's personal collection.

S & S Sands & Shaw. 1834. *Catalogue of Genuine Drugs, Medicines* . . . Albany, NY: Packard & Van Benthuyser. Source: Lloyd Library, Cincinnati, OH.

SF & PD *San Francisco and Pacific Druggist* 19 (1915). San Francisco: Coffin Redington Co. Source: Medical School Library, University of California, San Fransisco.

_____. 28 (1923). Source: same.

JS Scheiffelin, Jacob. 1804. *Catalogue of Drugs, Medicines & Chemicals.* New

York: William A. Davis. Source: Lloyd Library, Cincinnati, OH.

WHS Schieffelin, W. H. & Co. 1876. *General Prices Current of Foreign and Domestic Drugs, Medicines, Chemicals . . .* New York: Holt Brothers Press. Source: private collection of William Helfand, New York City, NY.

 _____. 1887. Source: same.

 _____. 1891. Source: copy in author's personal collection.

 _____. 1871. *Jobbers' Catalogue and Price List.* New York. Source: National Museum of American History, Smithsonian Institution, Washington, D.C.

VHS Smith, Valentine H. & Co. 1872. *Wholesale Druggists . . .* 1. Philadelphia. Source: Philadelphia College of Pharmacy and Science, Philadelphia, PA.

SN Spurlock-Neal. 1913. *General Catalogue, Drugs, Chemicals . . .* Nashville. Source: private collection of William H. Helfand, New York City, NY.

CNT Tuttle, C. N. 1860. *Cash Prices Current.* Auburn, NY. Source: National Museum of American History, Smithsonian Institution, Washington, D.C.

JT Tweedy, John. 1760. *A Catalogue of Druggs, and of Chymical and Galenical Medicines.* Newport, RI. Source: National Library of Medicine, Bethesda, MD.

PVS & S Van Schaack, Peter & Sons. 1889. *Annual Price Current, Drugs, Chemicals, Medicines* 19. Chicago. Source: Pharmaceutical Library, University of Wisconsin, Madison, WI.

 _____. 25 (1895). Source: same.

 _____. 37 (1907). Source: same.

VSS & C Van Schaack, Stevenson & Co. 1879. *Annual Price Current, Drugs, Chemicals, Medicines . . .* 9. Chicago. Source: Pharmaceutical Library, University of Wisconsin, Madison, WI.

 _____. 12 (1882). Chicago. Source: author's personal collection.

VSS & R Van Schaack, Stevenson & Reid. 1871. *Prices Current – Drugs, Chemicals,*

Medicines . . . Chicago. Source: Lloyd Library, Cincinnati, OH.

 _____. 1873. Source: same.

W & P Weeks & Potter. 1890. *Revised Catalogue of Foreign and Domestic Drugs . . .* Boston: Cashman, Keating & Co. Source: Library, University of California, Santa Barbara, CA.

REFERENCES CITED

Individual citations of early gazetteers, county histories, magazines, city and business directories occur only with the bottle descriptive histories.

Agee, Bill. 1973. *Collecting All Cures*. Waco, TX: Texian Press. Illustrated, descriptive guide to collecting "cure" bottles.

Alpe, E. N. 1888. *Handy Book of Medicine Stamp Duty with Statutes and Appendices*. London, Eng.: Offices of the Chemist and Druggist. History of medicinal taxation in England; includes current (1888), affected and exempt products, and patent dates.

Baldwin, Joseph K. 1973. *A Collector's Guide to Patent and Proprietary Medicine Bottles of the Nineteenth Century*. Nashville, TN: Thomas Nelson Inc. Comprehensive listing of several thousand patent and proprietary medicines. Included are numerous illustrations, attributes and early cited dates of advertisement.

Berge, Dale L. 1980. *Simpson Springs Station — Historical Archaeology in Western Utah*. Cultural Resource Series 6. Salt Lake City, UT: Bureau of Land Management. Materials found at Simpson Springs, Utah, site of 1860–1861 Pony Express Station, were subjected to analysis and provided the basis for expansion of this analysis to include a more comprehensive discussion of chronologies, characteristics, and technological variation of many classes of artifacts, including bottles.

Bernardin, Claude. 1975. Dr. Kilmer's. *Antique Bottle World* 2 (July). History of S. Andral Kilmer and the Kilmer family medicine empire.

Blasi, Betty. 1974. *A Bit about Balsams*. Waco, TX: Texian Press. An excellent, comprehensive reference to balsam bottles; includes illustrations and documented histories.

Brand Names Foundation. 1947. *43,000 Years of Public Service*. New York, NY: Brand Names Foundation, Inc. "A roster of product-identifying names used by the American public for over 50 consecutive years or more"; includes the years of origin for many products and their companies and addresses.

British Medical Association. 1909. *Secret Remedies, What They Cost and What They Contain*. London, Eng.: British Medical Association. Presents the results of analyses performed on popular English proprietary medicines for the British Medical Association, in an attempt to educate the public and end extravagant and fraudulent medicinal cure claims.

_____. 1912. *More Secret Remedies, What They Cost and What They Contain*. London, Eng.: British Medical Association. Continuation of above.

Carson, Gerald. 1961. *One for a Man, Two for a Horse*. Garden City, NY: Doubleday and Co., Inc. A pictorial history of medicine, predominantly comprised of colorful advertising.

Cumberland Glass Manufacturing Company. n.d. *Illustrated Catalogue and Price List of Bottles, Fruit and Battery Jars*. Reprint of 1911 catalog.

Davis, Pearce. 1970. *The Development of the American Glass Industry*. New York, NY: Russell and Russell. A definitive study of 300 years of American glassmaking, including the historic and economic evolution, change and progress.

DeGrafft, John. 1980. *American Sarsaparilla Bottles*. North Attleboro, MA. Thorough listing of sarsaparillas, with illustrations and physical descriptions. Dates and histories are not provided.

Deiss, Ronald W. 1981. *The Development and Application of a Chronology for American Glass*. Norman, IL: Midwestern Archaeological Research Center, Illinois State University. Discussions include the "origins, developments, and industrial changes in glass technology and stylistic changes" in the United States, complimented with a chronology of glass found in several midwestern excavations.

Devner, Kay. 1968. *Patent Medicine Picture*. Tucson, AZ. Comprehensive list of medicines including dates of advertisement. Data sources include newspaper advertisements, magazines, trade cards, and supply house catalogs.

_____. 1970. *At the Sign of the Mortar*. Tucson, AZ. Provides a brief history of American drugstores with lists of early supply houses, their merchandise and medicine.

Dominion Glass Company Limited n.d. (post 1913). *Druggists Glassware Catalog* 12. Montreal, Que.

Felton, David L., Frank Lortie and Peter D. Schulz. 1984. The Chinese Laundry on Second Street: Papers on Archaeology at the Woodland Opera House Site. *California Archaeological Reports* No. 24. Sacramento, CA: State of

California, Dept. of Parks and Recreation. Details the results of historical and archaeological investigations at the site of the Woodland Opera House; includes descriptions and analysis of artifacts.

Fike, Richard E. 1965. *Handbook for the Bottleologist*. Ogden, UT. Listing and brief description of over 1000 alcoholic, non-alcoholic, medicinal, cosmetic and household bottles.

_____. 1966. *Guide to Old Bottles, Contents & Prices* 1. Ogden, UT. Illustrations and advertisements to over 250 historic bottles.

_____. 1967. *Guide to Old Bottles, Contents & Prices* 2. Ogden, UT. An appendum to Volume 1, with more illustrations and advertising.

Fritschel, Don. 1974. Butter Color, Diamond Dye and Kidney-Wort. *Old Bottle Magazine* 7 (September). History of Wells, Richardson & Company, Burlington, VT, its predecessors and products.

_____. 1976. Silas Smith and his Green Mountain Renovator. *Old Bottle Magazine* 9 (December). History of Silas and Ransom Smith and the Green Mountain Renovator bottles.

Greenfield, Samuel F. 1975. Ka-Ton-Ka the Great Indian Medicine. *Old Bottle Magazine* 8 (October). History of Ka-Ton-Ka, Augustus Edwards and the Oregon Indian Medicine Co., Corry, PA.

Griffenhagen, George B. and Lawrence B. Romaine. 1959. Early U. S. Pharmaceutical Catalogues. *The American Journal of Pharmacy* 131 (January). Compilation of known pharmaceutical manufacturers' and wholesalers' catalogs through 1890 with a guide to their curatorial location.

Griffenhagen, George B. and James Harvey Young. 1959. Old English Patent Medicines in America. *Contributions from the Museum of History and Technology, United States National Museum Bulletin* No. 218. Washington, D.C.: Smithsonian Institution. Well-documented discussion of the migration, evolution and compositional history of several early English patent medicines.

Hechtlinger, Adelaide. 1970. *The Great Patent Medicine Era*. New York, NY: Galahad Books. Illustrated story of American folk medicine from the Civil War until 1906, and passage of the Pure Food and Drugs Act.

Helfand, William H. 1980. Vin Mariani. *Pharmacy in History* 22. The history of Vin Mariani, or Mariani Wine, and Angelo Francois Mariani.

Hiller, Sam and Kate Hiller. 1973. Have You Dug a Keeley Bottle? *Old Bottle Magazine* 6 (May). The Keeley Institute, its founders, evolution and containers.

Holcombe, Henry W. 1979. *Patent Medicine Tax Stamps*. Lawrence, MS: Quarterman Publications, Inc. Histories of firms employing use of proprietary tax stamps. This volume originates from a series of articles prepared by Holcombe between 1936 and the early 1940s for philatelic journals. Partially updated in the 1950s, the articles have been consolidated and reprinted, the discussions of tax stamps are correlated to the histories of leading medicinal corporations and their products.

Humphrey, Walt. 1972. Humphreys' Homeopathic Specifics. *Old Bottle Magazine* 5 (December). History of the Humphrey Homeopathic Medicine Company, its origins, products, and empire.

James, D. 1967. *Drug, Perfume and Chemical Bottles 1902*. Signal Mountain, TN. Edited reprint of Whitall-Tatum's 1902 catalog.

Jefferys, James B. 1954. *Retail Trading in Britain 1850–1950*. Cambridge, Eng.: Cambridge University Press. "A study of trends in retailing with special reference to the development of co-operative, multiple shop and department store methods of trading."

Jones, Olive R. 1981. Essence of Peppermint, A History of the Medicine and Its Bottle. *Historical Archaeology* 15. Comprehensive study of Essence of Peppermint, the history of "production, marketing and distribution."

Kebler, Lyman F. 1909. Drug Legislation in the United States. U. S. Department of Agriculture. *Bureau of Chemistry Bulletin* No. 98 (Revised), Part 1. Washington, D.C.: Government Printing Office. Provides all laws and legislation pertaining to the sale of drugs current to July 15, 1908.

Kendrick, Grace. 1971. *The Antique Bottle Collector*. New York, NY: Harcourt Brace Jovanovich. An abbreviated history of glassmaking with descriptions and illustrations of technological change; a guide for collectors to dating and estimating value.

Lief, Alfred. 1965. *A Close-up of Closures: History and Progress*. New York, NY: Glass Manufacturer's Institute, Inc. The technological evolution of bottle closures, their characteristics and chronologies.

Lincoln, Gerald. 1973. Hartshorn Medicines. *National Bottle Gazette* 2 (June/July). History of Edward Hartshorn and the Hartshorn medicines.

Lohmann, Watson M. 1972. *1904 Whitney Glass Works Illustrated Catalogue and Price List with Historical Notes 1900–1918*. Pitman, NJ.

McEwen, Alan. 1977. *Collecting "Quack Cure."* West Yorkshire, Eng.: Keighley. "A compendium of

Victorian medicine bottles embossed with the word "Cure" or variations thereof to be found in Great Britain." Brief histories, dates and ingredients are included.

McKearin, Helen and Kenneth M. Wilson. 1978. *American Bottles & Flasks and Their Ancestry*. New York, NY: Crown Publishers, Inc.

Miller, George L., and Catherine Sullivan. 1981. Machine-Made Containers and the End of Production for Mouth-Blown Bottles. *Research Bulletin* No. 171. Ottawa, Ont.: Parks Canada. Discussion of the glassmaking industry in the late nineteenth and early twentieth centuries. Includes production figures and technological comparisons between semi-automatic and automatic bottle machines. Reprinted in *Historical Archaeology* 18 (1984).

Moore, N. Hudson. 1924. *Old Glass, European and American*. New York, NY: Frederick A. Stoles Co. The technological evolution of glassmaking in Europe and the United States.

Morgan, Roy. 1979. The Benign Blue Coffin Part II. *Old Bottle Magazine* 12 (September). A comprehensive study of poison bottle containers including the legislation affecting marketing and distribution.

Munsey, Cecil. 1970. *The Illustrated Guide to Collecting Bottles*. New York, NY: Hawthorne Books Inc. "In sixty-two chapters and more than one thousand illustrations, [this book] covers the hobby's history, glass production, old and even ancient bottles, unusual bottles, new bottles, bottle collecting, and collateral articles."

Nelson, Gary L. 1983. *Pharmaceutical Companies Histories*, vol. 1. Bismarck, ND: Woodbine Publishing. A history of thirteen successful U. S. pharmaceutical companies including Eli Lilly, Miles Laboratories, Merck Sharp & Dohme and Reed & Carnrick.

Nielsen, R. Frederick. 1978. *Great American Pontiled Medicines*. Cherry Hill, NJ: Cortech Corporation. Listing of several hundred pontiled medicines. No dates or detailed information are provided.

Noël Hume, Ivor. 1969. Glass in Colonial Williamsburg's Archaeological Collections. *Colonial Williamsburg Archaeological Series* No. 1. Williamsburg, VA: Colonial Williamsburg Foundation. "A survey of glass history as it relates to drinking glasses, bottles, and other glass artifacts found in Williamsburg excavations."

Periodical Publishers Association. 1934. *Nationally Established Trade-Marks*. New York, NY: Periodical Publishers Association. Nationally established trademarks in use in 1934; includes brief company histories.

Putnam, H. E. 1965. *Bottle Identification*. Jamestown, CA. Includes partial reprint of the 1911 Illinois Glass Company catalog.

_____. 1968. *Bottled Before 1865*. Fontana, CA. From newspaper and magazine advertisements, the author provides a list of commercial products for the years 1708 to 1865. Product applications, ingredients and company locations are included and a brief history of glassmaking in the colonial states. A copy of the 1820 T. W. Dyott, Catalog of Drugs and Medicines, Philadelphia, is reprinted.

Riley, John J. 1958. *A History of the American Soft Drink Industry*. Washington, D.C.: American Bottlers of Carbonated Beverages. A study of soft drink containers, the technological and chronological evolution.

Richardson, Charles G. 1977. Federal Drug Law and its Effect on Labeling. *Old Bottle Magazine* 10 or 12 (September). History of the Pure Food & Drugs Act of 1906.

Ring, Carlyn. 1980. *For Bitters Only*. Boston, MA. Comprehensive reference to bitters bottles; includes advertising and marketing dates. Information is well researched and reliable.

Schulz, Peter D., Betty J. Rivers, Mark M. Hales, Charles A. Litzinger and Elizabeth A. McKee. 1980. The Bottles of Old Sacramento, A Study of Nineteenth-Century Glass and Ceramic Retail Containers – Part 1. *California Archaeological Reports* No. 20. Sacramento, CA: State of California, Dept. of Parks and Recreation. Detailed study of bottles retrieved from archaeological excavations in Old Sacramento. Part 1 examines corporate histories and chronologies for liquors, bitters, wines and soda and mineral water bottles.

Seeliger, Michael W. 1974. *H. H. Warner His Company and His Bottles*. Madison, WS. History of Hubert H. Warner, the Warner products and companies associated therewith.

Shimko, Phyllis. 1969. *Sarsaparilla Bottle Encyclopedia*. Aurora, OR. An illustrated, descriptive guide to sarsaparilla bottles. Includes well-documented chronologies and company histories.

Singer, David. 1982. *Perspectives In Newspaper Advertisements: Glass Containers and their Contents*. Historical Monograph Series 1. Cambridge, MA: Data Publishing Co. Documented 1840s–1880s advertisements, primarily medicinal in nature. Personal communications with the author found the ads to be from Boston Newspapers (90%), Providence, RI, and Philadelphia, PA.

Smith, Elmer L. 1975. *Patent Medicine the Golden Days of Quackery*. Lebanon, PA: Applied Arts

Publishers. Selected advertising, descriptions and histories of patent medicines.

Sonnedecker, Glenn and George Griffenhagen. 1957. A History of Sugar Coated Pills and Tablets. *Journal of American Pharmaceutical Association* (Practical Pharmacy Edition) 18. Paper presented to the Section on Historical Pharmacy, May 3, 1957 with highlights of the era of invention and acceptance of sugar-coated pills and tablets.

Sullivan, Catherine. 1983. The Bottles of Northrop & Lyman, A Canadian Drug Firm. *Material History Bulletin* Fall 1983. Ottawa, Ont.: National Museum of Man. "This study is an initial examination of Northrop & Lyman bottles, with company history, marketing, and product advertising included as background and context for the containers."

_____. 1984. Perry Davis–Pain Killer, King of the Wild Frontier. *Canadian Collector* 19 (March/April). Perry Davis Pain Killer bottles, their place in Canadian archaeology; includes the evolution of the container and history of the product.

Switzer, Ronald R. 1974. *The Bertrand Bottles—A Study of 19th-Century Glass and Ceramic Containers.* Washington, D.C.: U. S. Park Service. A study of the bottles salvaged from the Missouri River excavations of the steamer Bertrand.

Texaco Inc. 1962. Blown Glass. *Lubrication* 48 (September). Descriptive history of blown glass, its composition and technological progress.

Toulouse, Julian H. 1967. When Did Hand Bottle Blowing Stop? *Western Collector* 5 (August). Summary of the evolution and the transition from the manufacture of hand-finished bottles to fully automatic production.

_____. 1969a. A Primer on Mold Seams Part 1. *Western Collector* 7 (November). Comprehensive discussion of the manufacture of glass bottles, mold changes and identifying characteristics through time; includes illustrations.

_____. 1969b. A Primer on Mold Seams Part 2. *Western Collector* 7 (December). Continuation of Part 1.

_____. 1972. *Bottle Makers and their Marks.* New York, NY: Thomas Nelson, Inc. Dictionary of bottle makers, their symbols and identification marks; includes individual symbol chronologies; an excellent reference.

Turner, E. S. 1953. *The Shocking History of Advertising.* New York, NY: E. P. Dutton & Co., Inc. A study of commercial advertising in America and Great Britain from the 17th century to the present.

United States Patent Office. n.d. Annual Index of Patents: Washington, DC. Dates of registration of brands, trademarks, etc.

Watson, Richard. 1965. *Bitters Bottles.* New York, NY: Thomas Nelson & Sons. A guide, for collectors, of several hundred embossed, and labeled only, bitters bottles. Numerous illustrations aid in identification. Little information, other than that provided by the labels, or embossing, provided.

_____. 1968. *Supplement to Bitters Bottles.* Camden NJ: Thomas Nelson & Sons. A continuation of the volume above.

Whitall-Tatum & Co. 1880. *Glass Manufacturer.* (Catalog) Druggists', Chemists' and Perfumers' Glassware and Druggists' Sundries. Philadelphia, PA: Whitall-Tatum & Co.

Wilson, Bill, and Betty Wilson [Zumwalt]. 1969. *Western Bitters.* Santa Rosa, CA: Northwestern Printing Co. Histories and photographs of individual bitters bottles from the western United States. No citations are provided.

_____. 1971. *19th Century Medicine in Glass.* Amador City, CA: 19th Century Hobby & Publishing Co. Histories and photographs of individual patent and proprietary medicines. A useful reference, however no material references were included.

Whitaker, June. 1973. Dr. Caldwell's Syrup Pepsin. *Bottle News* 2 (October). History of William Burr Caldwell and his Syrup Pepsin.

White, James Seeley. 1974. *The Hedden's Store, Handbook of Proprietary Medicines.* Portland, OR: Durham and Downey. Histories of medicines found in the historic Hedden's Store, Scottsburg, Oregon; references are not provided.

Young, James Harvey. 1962. *The Toadstool Millionaires.* A Social History of Patent Medicines in America before Federal Regulation. Princeton, NJ: Princeton University Press. Quackery within proprietary medicine from the early eighteenth century until regulatory law in the twentieth century is placed in meaningful perspective. Case studies of some of the biggest offenders are presented.

Zumwalt, Betty. 1980. *Ketchup, Pickles, Sauces, 19th Century Food in Glass.* Fulton, CA: Mark West Publishers. Thorough coverage of food products in glass, histories of the individuals and companies affiliated with the products; includes photographs, advertisements and patents.

Place Name Index

An additional source for identification of glass sherds is the Place Name Index. Towns, cities, states and their abbreviations, are shown here exactly as they are embossed in the glass. Base profile numbers (See Figure 3) also provide the user with a means for scrutinizing sherds.

PLACE NAME	BASE • PRIMARY NAME • CHAPTER
ABILENE KANSAS	3 • Seely • Company
ABILENE, KANSAS	2 • A. B. Seely • Company
AKRON, N.Y.	3 or 6 • Parker • Miscellaneous
AKRON, O.	3 • Alexander • Tonic
ALBANY NY	4 • J. S. Wood • Elixir
ALBANY NY	9 • Wood • Cure
ALBANY N.Y.	12 • Vose • Medicine
ALBANY N.Y.	20 • Crammer • Cure
ALBANY N.Y.	21 • Filkens • Balsam
ALBANY N.Y.	20 • Elmendorf • Water
ALBANY N.Y.	20 • W. E. Masten • Water
ALBANY, N.Y.	rect. • Gallup • Syrup
ALBANY, N.Y.	3 or 6 • Masten • Balsam
ALBANY, N.Y.	20 • V.P.F.P. • Miscellaneous
ALBANY/N.Y.	2 • Townsend • Sarsaparilla
ALBION, MICH.	3 or 6 • Brant • Balsam
ALEXANDER, N.Y.	rect. • Bronson • Remedy
ALTON N. H.	3 • Wadleigh • Cure
AMBLER PA	20 • Keasbey & Mattison • Company
AMBLER, PA.	3 • Keasbey & Mattison • Chemical
ANDERSON, IND.	6 • Reeves • Company
ANOKA, MINN.	21 • Hoff • Liniment
ARLINGTON MINN.	? • Hilleman • Cure
ATLANTA GA	3 • B. B. B. • Miscellaneous
ATLANTA. GA.	3 • Bradfield • Company
ATLANTA, GA.	3 • Bradfield • Company
ATLANTA, GA.	3 • Eaton • Drug
ATLANTA, GA.	3 • Taylor • Miscellaneous
ATTICA, IND.	1 • Crumpton • Balsam
AUBURN MAINE	3 • True • Elixir
AUBURN, MAINE	3 • True • Elixir
AUBURN, ME	3 • True • Elixir
AUBURN N.Y.	3 • Bach • Compound
AUBURN, N.Y.	3 • B. Fosgate • Cordial
AUBURN, N.Y.	3 or 6 • McNicol • Liniment
AUBURN/NY	3 or 6 • Hamilton • Medicine
AUBURN–N-Y	3 • Bach • Compound
AUGUSTA, GA.	3 • River Swamp • Cure
AUGUSTA, GA.	3 • Tutt • Sarsaparilla
AUGUSTA, ME.	8 • F. W. Kinsman • Company
AURORA, ILL	3 • Carl's • Sarsaparilla
AURORA//NEW YORK	3 • Campbell • Hair
BAJA CALIFORNIA	20 • Damiana • Bitters
BAINBRIDGE, N.Y.	3 or 6 • West • Sarsaparilla
BALTIMORE	20 • Abbott • Company
BALTIMORE	3 • J. W. Bull • Syrup, Ointment
BALTIMORE	20 • Couley • Miscellaneous
BALTIMORE	3 • Davis & Miller • Drug
BALTIMORE	1 • Frey • Miscellaneous
BALTIMORE	2 • Granger • Bitters

PLACE NAME	BASE • PRIMARY NAME • CHAPTER
BALTIMORE	20 • Hopkins • Miscellaneous
BALTIMORE	20 • Houck • Miscellaneous
BALTIMORE	20, 21, 27 • Sharp & Dohme • Miscellaneous
BALTIMORE	rect. • Smith & Shakman • Miscellaneous
BALTIMORE.	12 • S. S. Hance • Miscellaneous
BALTIMORE & LONDON	3 • St. Jacobs • Oil
BALTIMORE MD	20 • Emerson • Cure, Drug
BALTIMORE. MD	3 • London • Miscellaneous
BALTIMORE, MD.	20 • Bromo Seltzer • Drug
BALTIMORE, MD.	6 • Gilbert Bros. • Company
BALTIMORE, MD.	9 • Lorrimer • Chemical
BALTIMORE, MD.	2 • Nelation • Company
BALTIMORE, MD.	15 • One Night • Cure
BALTIMORE/MD	3 • Dewitt • Cure
BALTIMORE, MD. U.S.A.	3 • J. W. Bull • Syrup
BALTIMORE, MD. U.S.A.	20 • St. Jacobs • Oil
BALTIMORE, M.D. U.S.A.	15 • Salvation • Oil
BALTIMORE/U.S.A.	3 • Red Star • Cure
BALTIMORE, MD./ WASHINGTON D.C.	1 • Tregor • Invigorator
BALT°	13 • Hampton • Miscellaneous
BALTO.	3 • Pan-tina • Cure
BALTO. & LOUISVILLE	18 • Malto Iron • Company
BALTO MD	3 • Dewitt • Cure
BALT° MD	3 • Herndon • Cure
BALT'O MD	20 • Resinol • Company
BALTO. MD. U.S.A.	3 • J. W. Bull • Syrup
BANGOR M^E	20 • Curtis • Killer
BANGOR ME.	4 • Hunter • Balsam
BANGOR, ME	3 • Bell • Sarsaparilla
BANGOR, ME	20 • Hardy • Liniment
BATAVIA N.Y.	2 • Walkinshaw • Bitters
BATAVIA, N.Y.	3 • Parker • Company
BATAVIA. N.Y.	3 • Parker • Company
BEDFORD, INDIANA	6 • Crow • Hair
BELFAST//MAINE U.S.A.	3 • Dalton • Sarsaparilla
BENTON HARBOR, MICH.	3 or 6 • Walker • Sarsaparilla
Berlin	1 • Litthauer • Bitters
BINGHAMPTON N.Y.	3 or 6 • Carey • Company
BINGHAMPTON, N.Y.	3 or 6 • Haskin • Nervine
BINGHAMTON N.Y.	3 • Cole Bros. • Liniment
BINGHAMTON N.Y.	3 • Kilmer • Remedy
BINGHAMTON N.Y.	11 • Save-The-Horse • Cure
BINGHAMTON, N.Y.	3 • Kilmer • Extract
BINGHAMTON, N.Y.	3, 20 • Kilmer • Cure, Ointment, Remedy
BINGHAMTON, N.Y.	3 • Manner • Discovery
BINGHAMTON, N.Y.	3 or 6 • Manner • Sarsaparilla
BINGHAMTON, N.Y.	3 or 6 • Nu-To-Na • Remedy
BINGHAMTON/N.Y.	3 • Kilmer • Cure
BINGHAMTON/N Y USA	3 • Kilmer • Cure
BINGHAMTON N.Y. U.S.A	3 • Kilmer • Cure
BINGHAMTON/N.Y. U.S.A.	3 • Kilmer • Remedy
BINGHAMTON, NEW YORK	20 • Parmint • Miscellaneous
BIRMINGHAM, CT.	4 • Woodworth • Sarsaparilla
BLAIR, NEBR.	3 • Haller • Company
BLOOMINGTON ILL.	3 • Wakefield • Cure

PLACE NAME	BASE • PRIMARY NAME • CHAPTER
BOLTON	6 • Dutton • Syrup
Boone, IA.	20 • F. W. Fitch • Company
BOONE, IA.	3 • Seminole • Company
BOONE, IOWA	rect. • Seminole • Company
BORDEAUX	20 • Arousseau • Chemical
BORDEAUX	6 • Sirop • Syrup
BORDENTOWN, N.J.	3 • Hankin • Specific
BOSTON	3 • Arnold • Balsam
BOSTON	3 • Berry • Cure
BOSTON	3 • Billings Clapp • Company
BOSTON	12 • F. Brown • Bitters
BOSTON	15 • J. I. Brown • Miscellaneous
BOSTON	3, 4, 6, 20 • Burnett • Miscellaneous
BOSTON	1 • Otis Clapp • Miscellaneous
BOSTON	2 • L. Cooley • Miscellaneous
BOSTON	2 • Cuticura • Cure
BOSTON	20 • Doliber-Goodale • Company
BOSTON	12 • H. D. Fowle • Miscellaneous
BOSTON	3 • Greene • Miscellaneous
BOSTON	2 • Guilmette • Extract
BOSTON	12 • Harmony • Manufacturer
BOSTON	20 • Kidder • Cordial
BOSTON	20 • Langley • Bitters
BOSTON	12 • Metcalf • Company
BOSTON	21 • Minard • Liniment
BOSTON	3 • Nichols • Chemical
BOSTON	3 • Paxton • Company
BOSTON	6, 20 • Preston & Merrill • Miscellaneous
BOSTON	4 • Ransom & Stevens • Drug
BOSTON	3 or 6 • Sloan • Liniment
BOSTON	3 • Jno. Sullivan • Miscellaneous
BOSTON	? • O. Tompkins • Chemical
BOSTON	4 • Whitwell • Bitters
BOSTON	3 • Will-low • Miscellaneous
BOSTON	3 • Wilson • Drug
BOSTON	2, 21 • Wistar • Balsam
BOSTON	3 • Zepp • Cure
BOSTON.	3 • Cooley • Miscellaneous
BOSTON MASS	3 • S. Pitcher • Miscellaneous
BOSTON MASS	2 • C. A. Richard • Company
BOSTON MASS	3 • Tuttle • Miscellaneous
BOSTON MASS	3 • Vegetable • Balsam
BOSTON MASS.	2 • J. Dingley • Company
BOSTON MASS.	3 or 6 • W. R. Hayden • Miscellaneous
BOSTON MASS.	4 • Holman • Restorer
BOSTON MASS.	3 • Pike & Osgood • Syrup
BOSTON MASS.	12 • J. R. Spalding • Miscellaneous
BOSTON MASS.	6 • Stone • Elixir
BOSTON, MASS	3 • Rush • Sarsaparilla
BOSTON, MASS	3 or 6 • Universal • Remedy
BOSTON, MASS.	1 • Carpenter-Morton • Company
BOSTON, MASS.	? • Metcalf • Company
BOSTON, MASS.	3 or 6 • Steven • Balsam
BOSTON, MASS.	18 • Stone • Oil
BOSTON, MASS.	21 • Tuttle • Elixir, Miscellaneous
BOSTON/MASS	3 • Farr • Restorer

PLACE NAME	BASE • PRIMARY NAME • CHAPTER
CHICAGO/U.S.A.	20 • V-O • Oil
CHICAGO//U.S.A.	6 • Hamlin • Balsam
CHRISTCHURCH	3 • Bonnington • Miscellaneous
CINCINATTI	3 • Allen • Balsam
CINCINATTI	3, 6 • Roger • Syrup, Miscellaneous
CINCINATTI & N. Y.	2 • Warren • Cordial
CINCINATTI, O	3 • Jones • Miscellaneous
CINCINATTI, O.	1 or 2 • T. W. Graydon • Miscellaneous
CINCINATTI, O.	3 or 6 • Scovill • Syrup
CINCINNATI	1 • Himalya • Compound
CINCINNATI	2 • Wayne • Elixir
CINCINNATI	3 • Guertin • Syrup
CINCINNATI & NEW YORK	3 • Guertin • Syrup
CINCINNATI, O	3 or 6 • Gooch • Sarsaparilla
CINCINNATI, O.	4 • B. W. Hair • Cure
CINCINNATI, O.	12 • Guysott • Sarsaparilla
CINCINNATI. O,	12, 20 • Roback • Bitters, Purifier
CINCINNATI, O/U.S.A.	18 • Evans • Company
CINCINNATI, OHIO	21 • Wistar • Balsam
CINCINNATI, OHIO.	2 • Peruviana • Cure
CINCINNATI, OHIO.	3 or 4 • Potter • Company
CINCINNATI/OHIO/ U.S.A.	18 • Evans • Company
CINCINNATTI, O. U.S.A.	3 • Altenheim • Medicine
CINCINNATTI, O. U.S.A.	3 • Foso • Company
CIN'TI & N. Y.	6 • Scovill • Company
CIN'TI & N.Y.	3 or 6 • Scovill • Syrup
CIN'TI & N.Y.	20 • Warren • Remedy
CLAREMONT, N.H.	rect. • Dana • Sarsaparilla
CLARKSVILLE, TEX.	18 • Reed • Cure
CLEV, D O'	3 • Porter • Cure
CLEVELAND	20 • Musterole • Miscellaneous
CLEVELAND	3 • Porter • Cure
CLEVELAND/O.	17 • Reese • Chemical
CLEVELAND, O.	3 or 6 • Marine • Drug
CLEVELAND, O.	1 • Loew • Bitters
CLEVELAND, O.	3 • Zemo • Lotion
CLEVELAND. O	2 • L. H. Witte • Miscellaneous
CLEVELAND, O.//U.S.A.	3 or 6 • Marine • Drug
CLEVELAND OHIO	rect. • Mackenzie • Mixture
CLINTON, IOWA	20 • Dean • Oil
COLDWATER, MICH	3 • Warner • Syrup
COLLINSVILLE/ILLS	rect. • Horse Shoe • Bitters
COLUMBUS G.ᴬ	3 • Woodruff • Cordial
COLUMBUS, O.	2 • Beebe • Cure
COLUMBUS OHIO	4 • Converse • Company
CONCORD, N.H.	20 • Park • Liniment
CORNING, N.Y.	3 or 6 • Holmes • Manufacturer
CORTLAND, N.Y.	rect. • Adam • Cure
CORTLAND/N.Y.	3 or 6 • Nature • Specific
COVINGTON, KY.	20 • Kenton • Company
COXSACKIE, N.Y.	rect. • Jordan • Syrup
COXSACKIE, N.Y.	17 • White Pine • Syrup
CUMBERLAND RIVER// KENTUCKY	3 • American • Oil
CURACAO	20 • White • Bitters
DALLAS, TEXAS	7 • Pagematic • Company
DALLASBURGH, KY.	20 • J. B. Wheatley • Compound
DANSVILLE N.Y.	3 or 6 • E. M. Parmelee • Manufacturer
DANVILLE, ILLS.	6 • Gladstone • Compound
DARBY N.Y.	3 • Rock • Cure
DAYTON, O.	6 • Harter • Bitters
DAYTON, OHIO	5 • Empress Josephine • Company
DAYTON, OHIO	2 • Guard • Bitters
DAYTON, OHIO	20 • Pretzinger • Balm
DE PERE, WIS.	3 • Lange • Trade Mark
DEADWOOD, SO. DAK.	3 • Phillips • Sarsaparilla
DECORAH, IOWA, U.S.A.	rect. • American • Drug
DEER LODGE, MONTANA	2 • Eastman • Company
DENVER, COLO.	3 • Morey • Company
DENVER, COLO, U.S.A.	3 • Herbs of Life • Purifier
DERRY, N.H.	1 • Hemlock • Company
DES MOINES, IA	3 • Chamberlain • Liniment
DES MOINES, IA. U.S.A.	3 • Chamberlain • Balm, Remedy
DES MOINES, IOWA	3 • Chamberlain • Company
DES MOINES/IOWA	2 • Von Hoff • Bitters
DETROIT	20 • Calnon & Cronk • Water
DETROIT	20 • Dabrook • Miscellaneous, Water
DETROIT	2 • Halsey Bros. • Miscellaneous
DETROIT	2 • Parke-Davis • Company
DETROIT	20 • Teller • Water
DETROIT/MICH.	2 • Diamond • Bitters
DETROIT, MICH.	3 • R. W. Allen • Manufacturer
DETROIT, MICH.	2 • Knorr • Essence
DETROIT, MICH.	3 • Michigan • Drug
DETROIT, MICH.	triangle • F. Stearns • Company
DETROIT, MICH-	3 or 6 • Lightner • Sarsaparilla
DETROIT; MICH.	6 • Blush of Roses • Miscellaneous
DETROIT, MICH. U.S.A.	20 • Stearns • Company
DETROIT, U.S.A.	3 • Elysian • Company
DOGLIANI ITALIA	1 • Ferro Quina • Bitters
DOGLIANI/ITALIA &/ S.F. CAL.	1 • Ferro Quina • Bitters
DOVER, N.H.	3 • Rackley • Sarsaparilla
DOVER, N.H.	rect. • Vickery • Sarsaparilla
DULUTH, MINN.	2 • Norwegian • Oil
DWIGHT, ILL.	rect. • Keeley • Cure, Remedy
DWIGHT, ILLINOIS/ U.S.A.	rect. • Keeley • Company
EAST BANGOR, PA.	3 • German • Cure
EAST GEORGIA VT.	4, 12 • S. Smith • Miscellaneous
EAST GEORGIA, VT.	13 • Smith • Miscellaneous
EASTON PA	3 • Electric • Liniment
EASTON, PA.	3 • J. S. Hunt • Liniment
EASTON, PA.	3 • Magic • Cure
EDGERTON/WIS. U.S.A.	3 or 6 • Willson • Balsam, Remedy
EDMESTON, N.Y.	18 • I. S. Sweet • Liniment
ELKHART, IND.	3 • Chamberlain • Remedy
ELKHART, IND.	3 • Primley • Cure, Tonic
ELKHART, INDIANA	3 • Primley • Sarsaparilla
ELKTON, VA.	20 • Bear Lithia • Water
ELMIRA N.Y.	3 • Clay • Company
ELMIRA, N.Y.	1 or 2 • Brown's Salicyline • Miscellaneous
ELMIRA. N.Y.	3 • Carey • Medicine
ELMIRA/N.Y.	3 • Holmes • Trade Mark
ELMIRA, NY. U.S.A.	6 • Frostilla • Lotion
ELMIRA, N.Y., U.S.A.	6 • Holmes • Miscellaneous
ENFIELD	1 • Reynolds • Specific
ENGLAND	20 • Bisurated • Magnesia
ENGLAND	4 • Lalor • Miscellaneous
ENOSBURG FALLS VT.	21 • Kendall • Miscellaneous
ENOSBURG FALLS, VT.	21 • Kendall • Cure
ENOSBURGH FALLS VT.	21 • Gilbert • Bitters
ENOSBURGH FALLS, VT.	21 • Kendall • Cure
ENOSBURGH FALLS/VT.	3 • Hutchinson • Company
EPPING, N.H.	3 • W. F. Lawrence • Miscellaneous
ERIE PA.	3 • Carter • Cure
ERIE, P.A.	3 • Carter • Extract
ERIE. PENN.	2 • P. Hall • Remedy
ESSEX, CONN.	3 • Whittemore • Syrup, Water
EVANSVILLE, IND.	3 • J. C. Mendenhall • Company
EXETER, N.H.	3 • Wetherell • Sarsaparilla
FAIRCHILD	6 • Panopepton • Miscellaneous
FAIRHAVEN VERMONT	3 • Mead • Company
FAIRPORT, N.Y.	3 • G. C. Taylor • Liniment
FARMER, N.Y.	3 or 6 • Hill • Cordial, Killer, Syrup
FAYWOOD, HOT SPRINGS/N MEX	20 • McDermott • Company
FILADELFIA	20 • Wright • Water
FINDLAY, O	3 • Lunt • Killer
FINDLAY, OHIO	3 • Drake • Remedy
FLATBUSH, L. I.	5 • Dettmer • Chemical
FLEMINGTON, N.J.	3 • Fisher • Liniment
FONDULAC/ WISCONSIN/U.S.A.	3 • Town • Cure
FORT ERIE	3 or 6 • Parisian • Tonic
FORT SMITH, ARK.	3 • Morris-Morton • Company
FORT SMITH, ARK.	3 • Swamp • Tonic
FT. WAYNE, IND. U.S.A.	12 • Father • Balsam
FREDONIA, N.Y.	3 • Capitol • Bitters
FREDONIA, N.Y.	20 • Fenner • Medicine
FREDONIA,/N.Y.	12 • Fenner • Miscellaneous
FREDONIA N.Y./U.S.A	12 • Fenner • Remedy
FREDONIA, N.Y./U.S.A.	3 • Fenner • Cure
FREDONIA, N.Y.//U.S.A.	3 • Fenner • Remedy
FREEPORT, ILL.	3 • Furst-McNess • Company
FREEPORT, ILL.	3 • Rawleigh • Company
FREEPORT, ILLS.	rect. • Emmert & Burrell • Sarsaparilla
FREMONT, NEB.	3 or 6 • Grant • Sarsaparilla
FREMONT OHIO	15 • Trommer • Company
FRENCHTOWN/N.J.	3 or 6 • C. P. Bissey • Miscellaneous
FRENCHTOWN, N.J.	3 or 6 • A. P. Williams • Miscellaneous
FRESNO, CAL.	6 • M. A. C. • Miscellaneous
FRESNO, CAL.	20 • S. B. • Cure
FULTON, N.Y.	3 or 6 • J. Watson • Syrup
GAINESVILLE, N.Y.	11 • Hebble White • Company
GALION, OHIO	3 or 6 • Mann • Balsam
GEORGETOWN//MASS.	21 • Atwood • Bitters
GLASTONBURY, CT, U.S.A.	7 • J. B. Williams • Company
GLENN BROOK, CONN.	10 • C. H. Phillips • Magnesia

262

PLACE NAME	BASE • PRIMARY NAME • CHAPTER	PLACE NAME	BASE • PRIMARY NAME • CHAPTER	PLACE NAME	BASE • PRIMARY NAME • CHAPTER
NEWBURG	3 • L. P. Dodge • Liniment	PERRY N.Y.	3 or 6 • Mitchel • Syrup	PHILAD.A	3 • J. C. Baker • Company
NEWBURGH, N.Y.	3 • Chase • Cure	PERTH AMBOY, N.J.	8 • Bell • Company	PHILAD.A	6 • Gallagher • Oil
NEWBURGH, N.Y.	3 • S. G. Graham • Cure	PHIA	2 • Wishart • Cordial	PHILAD.A	12 • Louden • Company
NEWPORT	1 • Omnia • Chemical	PHIL.A	3 • Scott • Liniment	PHILAD. ^	21 • Hover • Hair
NO BERWICK ME U.S.A.	3 or 6 • Baker • Specific	PHIL ^	3 • Coleman • Lotion	PHILAD. ^	3 • Jenkin • Restorer
NORFOLK, VA.	rect. • White • Cure	PHIL ^	13 • D. Jayne • Miscellaneous, Tonic	PHILAD. ^	3 • Rose • Miscellaneous
NORRISTOWN PA	3 • Dill • Company			PHILAD. ^	21 • Schenck • Syrup
NORRISTOWN PA	3 • M. G. Kerr • Balsam	PHIL ^	12 • D. Jayne • Tonic	PHILAD. ^	3 • Zollickoffer • Cordial
NORRISTOWN, PA.	3 • Dill • Company	PHILA	13 • Ebeling • Medicine	PHILAD.^	20 • Louden • Balsam
NORTH & SOUTH AMERICA	3 • Acker • Remedy	PHILA	20 • C. Ellis • Company	PHILAD'A	8, 10, 18 • Wyeth & Bro. • Miscellaneous
		PHILA	15 • J. Hauel • Miscellaneous		
NORTH & SOUTH AMERICA	3 • Arthur • Company	PHILA	3 • D. Jayne • Tonic	PHILAD,A.	3 • W. W. Clark • Drug
		PHILA	2 • Wishart • Cordial	PHILADA.	3 • Leon • Hair
NORWICH, CONN./U.S.A.	3 • Osgood • Miscellaneous	PHILA	20 • Jackson • Miscellaneous	PHILADA.	20 • L. • Company
NOTTINGHAM	10, 15 • Woodward • Chemical	PHILA.	4 • D. Jayne • Miscellaneous	PHILADA.	20 • H. K. Wampole • Company
OGDEN, UTAH, U.S.A.	2 • American • Company	PHILA.	2 • Davis • Miscellaneous	PHILADA.	20 • W. R. Warner • Company
OGDENSBURGH NY	3 • Persian • Balm	PHILA.	12 • Wyeth & Bro. • Miscellaneous	PHILAD^.	12 • F. Brown • Jamaica Ginger
OMAHA	20 • Goodrich • Drug			PHILAD^.	21 • Alexander • Miscellaneous
OMAHA NEB	6 • American • Bitters	PHILAD	3 • D. Jayne • Tonic	PHILADA/NEW YORK/ CHICAGO	1 • W. R. Warner • Company
OMAHA, NEB.	2 • C. F. Goodman • Miscellaneous	PHILAD	3 • Fitler • Remedy		
		PHILAD	21 • Rowand • Tonic	PHILA. PA.	3 • Debing • Remedy
OMAHA, NEB.	2 • Kennedy • Bitters	PHILAD	3 • Rowand & Walton • Miscellaneous	PHILA. PA.	2 • Hire's • Cure
OMAHA. NEB.	3 or 6 • Logan • Sarsaparilla			PHILA^ P^	3 • Sine • Miscellaneous
OMAHA, U.S.A.	4, 6 • Goodrich • Drug	PHILAD.	12 • Jackson • Liniment	PHILAD, PA.	1 • Caulk • Manufacturer
ONEIDA, N.Y.	rect. • Broga • Syrup	PHILADA	4, 6 • Bazin • Miscellaneous	PHILAD^ PA.	3 • Clark • Bitters
ORANGEBURG/NEW YORK USA	11 • Bell • Company	PHILADA	12 • F. Brown • Jamaica Ginger	PHILADA. P.A.	20 • Bosanko • Company
		PHILADA	3 or 6 • De Grath • Oil	PHILA. PA. U.S.A.	rect. • Lung Saver • Company
OROVILLE, CAL. U.S.A.	3 • Abietine • Company	PHILADA	4 • D. Jayne • Expectorant	PHILA-ST. LOUIS	20 • Warner • Miscellaneous
OROVILLE, CAL. U.S.A.	3 • Green • Restorer	PHILADA	3 • D. Jayne • Liniment	PHILA U.S.A.	3 or 6 • Poor Richard • Water
OTTOWA, ILLS.	? • Jone • Tonic	PHILADA	1, 13 • D. Jayne • Tonic	PHILADELPHIA	3 • Barker • Medicine
OWEGO, N.Y.	21 • Climax • Syrup	PHILADA	20 • Keasbey & Mattison • Miscellaneous	PHILADELPHIA	18 • Boudrou • Cure
OWEGO/N.Y.	3 • Ely • Balm			PHILADELPHIA	1 or 2 • Brown • Cure
OWEGO/N.Y.	13 • Kenyon • Tonic	PHILADA	3 • Swaim • Miscellaneous	PHILADELPHIA	2 • Brown • Miscellaneous
PADUCAH, KY	3 • Sutherland • Company	PHILADA	3 • Thomson • Compound	PHILADELPHIA	4 • Cantrell • Mixture
PADUCAH, KY.	3 • Sutherland • Company	PHILADA	1 • W. R. Warner • Company	PHILADELPHIA	3 or 6 • G. W. Carpenter • Miscellaneous
PARIS	3 • Caucasian • Cure	PHILADA	8 • Wyeth & Bro. • Miscellaneous		
PARIS	21 • Chapoteaut • Miscellaneous	PHILAD^	12 • F. Brown • Drug	PHILADELPHIA	3 • Dacosta • Cure
PARIS	20 • Coca Mariani • Miscellaneous	PHILAD ^	3 • J. Hauel • Company	PHILADELPHIA	20 • French • Water
		PHILAD ^	3 • Hobensack • Syrup	PHILADELPHIA	20 • Garwood • Water
PARIS	2 • Guerlain • Miscellaneous	PHILAD ^	20 • Swaim • Miscellaneous, Trade Mark	PHILADELPHIA	3 • Gilbert • Cough
PARIS	23 • Injection Brou • Miscellaneous			PHILADELPHIA	12 • Hand • Medicine
		PHILAD ^	21 • University • Medicine	PHILADELPHIA	3 • H. T. Helmbold • Extract
PARIS	2 • Injection Ricord • Miscellaneous	PHILAD ^	21 • Wistar • Balsam	PHILADELPHIA	2 • Hentz • Bitters
		PHILAD ^	3 • Wyeth • Oil	PHILADELPHIA	3 • Hoofland • Balsam, Bitters
PARIS	1 • Kantorowicz • Miscellaneous	PHILAD^	3 • Fitler • Remedy	PHILADELPHIA	6 • D. Jayne • Expectorant, Tonic
PARIS	25 • Pinaud • Company	PHILAD^	12 • Hansell • Miscellaneous		
PARIS	21 • Santal De Midy • Miscellaneous	PHILAD^	4 • Hauel • Balm, Company	PHILADELPHIA	20 • C. Joly • Sarsaparilla
		PHILAD^	2 • Husband • Magnesia	PHILADELPHIA	2 • Keasbey & Mattison • Chemical
PARIS	20 • Sedlitz • Miscellaneous	PHILAD^	20 • Jayne • Balsam		
PARIS	3 • C. A. Vogeler • Company	PHILAD^	4 • Jayne • Expectorant, Liniment	PHILADELPHIA	20 • Keasbey & Mattison • Miscellaneous
PARIS FRANCE	20 • Coca Mariani • Miscellaneous			PHILADELPHIA	1 • H. K. Mulford • Chemical
		PHILAD^	2 • Jayne • Tonic	PHILADELPHIA	3 or 6 • Nolen • Oil
PARIS FRANCE	3 • Vin Mariani • Miscellaneous	PHILAD^	3 • Upham • Cure	PHILADELPHIA	23 • Oldridge • Balm
PARIS/FRANCE	2 • Kerkoff • Miscellaneous	PHILAD^	20 • R. & G. A. Wright • Miscellaneous	PHILADELPHIA	20 • Pillow Inhaler • Company
PARIS TENN·U.S.A.	6 • Nadinola • Cream			PHILADELPHIA	1 or 2 • Rose • Sarsaparilla
PENNA, U.S.A.	3 or 6 • James • Syrup	PHILADA	3 • Aschenbach & Miller • Miscellaneous	PHILADELPHIA	20 • Standard • Water
PEORIA	12 or 18 • Anti-Uric • Miscellaneous			PHILADELPHIA	3, 6 • Wampole • Company
		PHILADA	6 • West Indian • Miscellaneous	PHILADELPHIA	12 • Wampole • Syrup
PEORIA	20 • H. G. Farrell • Liniment	PHILADA	12 • J. Huckel • Miscellaneous	PHILADELPHIA	1, 20 • Warner • Company
PEORIA, ILL.	2, 6 • Allaire, Woodward • Company	PHILAD^	21 • Wistar • Balsam	PHILADELPHIA	20 • J. Wyeth & Bro. • Extract
		PHILAD^	3 • P. T. Wright • Balsam		
PEORIA, ILL.	25 • Mexican Amole • Company	PHILAD^	20 • Bumstead • Syrup		
PEORIA, ILL.	3 • Reid • Cure				

267

Secondary Name Index

This index lists alternate product names, agents, product or formula originators, proprietors and other key names as they are embossed in the glass, and refers the user to the primary name and chapter where that vessel may be found. Where the words "COMPANY," "CHEMICAL," or "MANUFACTURER," or their variations, accompany the secondary name the bottle can be located under that chapter.

SECONDARY NAME	PRIMARY NAME • CHAPTER	SECONDARY NAME	PRIMARY NAME • CHAPTER	SECONDARY NAME	PRIMARY NAME • CHAPTER
L. E. JUNG	Columbo • Bitters	CHAS. MARCHAND	Hydrozone • Miscellaneous	P & W	Field • Lotion
L. E. JUNG	Peychaud • Bitters	MARSH ROOT	Carey • Medicine	PAIN KING	Porter • Miscellaneous
JUNIPER-ADE	Lundin • Company	MRS. K. S. MASON	Paxton • Company	PALMOLIVE SHAMPOO	Johnson • Company
JUNIPER BERRY GIN	Quinine • Company	MASSAGE/CREAM	Pompeian • Cream	PALMETTO WINE	Drake • Compound
KATHARISMIC	Wynkoop • Sarsaparilla	G. L. MATHER AGENT	St. Catharine • Water	PAN AM	Jordan • Water
KATHAIRON	Lyon • Hair	H. B. MATTHEWS	Hunkidori • Bitters	PA·PÁ·ANS/BELL	Bell • Company
S. M. KIER	Petroleum • Miscellaneous	McCLELLAN/AND/		J. D. PARK	Jones • Miscellaneous
KING CACTUS	Dean • Oil	PATTON	Patton • Balm	JOHN D. PARK	Guysott • Sarsaparilla
KING OF PAIN	Bull • Miscellaneous	M cELREE'S CARDUI	Chattanooga • Company	JOHN. D. PARK	Wistar • Balsam
KING OF PAIN	McBride • Miscellaneous	MELLIFLUOUS	Strickland • Balsam	E. J. PARKER	Adams • Cure
KING/OF THE BLOOD	D. Ransom • Company	MELLIN'S INFANT FOOD	Doliber-Goodale • Company	PASTEURINE	Milliken • Company
J. R. KLINE	Blake • Purifier	MENTHO-LAXENE	B. P. • Company	PAW-PAW	Munyon • Miscellaneous
KOEHLER & HINRICH	Red Star • Bitters	MENTHOLATUM	Yucca • Company	PEARL ROSE	Cheatham • Cream
THE KOLA	Himalya • Compound	Meritol	American • Drug	PECTORINE	Smith • Pectoral
KONDENSERADE	Lundin • Company	DR. AB. MESSEROLE	Liebig • Cure	PEOPLES	Fenner • Remedy
WILLIAM G. KORONY	Simple • Hair	METTE & KANNE PROs	St. Gotthard • Bitters	PEPPERMINT	Essence • Essence
KURAKOFF	C. A. Lewis • Company	MEXICAN BITTERS	Ayala • Bitters	PEPSIN BITTERN	Arp • Bitters
KURIKO	Peter • Miscellaneous	JOHN MOFFAT	Phoenix • Bitters	PEPTO-MANGAN	
LACTO PHOSPHATE	Wyeth • Oil	MONA BOUQUET	Grigsby • Miscellaneous	"GUDE"	Gude • Company
LACTOSAL	Milliken • Company	MONARCH/BALSAM	Willson • Balsam	PEPTONIZED COD	
LADIES STAR	Pacific • Company	MOORE & MEIN	Barker • Medicine	LIVER OIL	Reed & Carnrick • Oil
LADY HILL	Hon. Ble • Miscellaneous	E. MORGAN & SONS	Haynes • Balsam	PEPTONOIDS	Arlington • Chemical
LAGASSE	Sirop • Syrup	MORRIS & HERITAGE	Dacosta • Cure	PERCURO	Kelley • Cure
LAPIERRE	Sympathick • Medicine	MORTIMER/&		PERSIAN BALM	Blodgett • Balm
LAST CHANCE	Perry • Liniment	MOWBRAY	Hampton • Miscellaneous	DR. PETER'S/OLEOID	Fahrney • Company
F. E. LAWRENCE	K. K. K. K. • Miscellaneous	MOSS ROSE	Seely • Miscellaneous	N. B. PHELPS	Norwegian • Balm
J. A. LAWRENCE	Le Grande • Remedy	THE MOTHER'S/FRIEND	Bradfield • Company	PHOSPHODYNE	Lalor • Miscellaneous
LAX-FOS	Winstead • Miscellaneous	MOUNTAIN ASH	Ober • Compound	DR PIERCE	Sage • Remedy
LESOEN OF ORME	Arousseau • Chemical	MOUNTAIN INDIAN	Durno • Liniment	GEo PIERCE'S	Indian Restorative • Bitters
LIFE ROOT MUCILAGE	Cheever • Miscellaneous	MOUNTAIN PILLS	Williams • Pills	S. K. PIERSON	Gray • Balsam
LIGHTNING HOT		MOUNTAIN TEA	Lepper • Miscellaneous	ED. PINAUD	Klotz • Company
DROPS	Herb • Medicine	W. H. MULLER	Bismarck • Bitters	PINE-TAR-HONEY	Bell • Cough
LINSEED	Kay • Compound	NAJOUTER FOIQUALA		PINE-TAR-HONEY	Sutherland • Company
B. R. LIPSCOMB, AG T	Josiah Cosby • Bitters	SIGNATURE	Klotz • Company	PINE TREE	Gaylord • Balsam
LIQUID FOOD	Murdock • Trade Mark	NEPHRETICUM	Bullock • Miscellaneous	PINE TREE	Wishart • Cordial
LIQUID PEARL	Champlin • Miscellaneous	NEPHRETICUM	Mintie • Miscellaneous	PINEOLEUM	Physician • Miscellaneous
LISTERINE	Lambert • Company	NER-VENA	Seelye • Company	JACOB PINKERTON	Wahoo • Bitters
DR. LISTER'S	Roger • Chemical	NEURALGIC ANODYNE	Twitchell • Company	PLANTATION/COUGH	Baker • Company
LIVER-LAX	Grigsby • Miscellaneous	NEW YORK PHARMACAL		PLANTATION/X/	
LIVERTONE	Dodson • Miscellaneous	ASSOCIATION	Lactopeptine • Remedy	BITTERS	Drake • Bitters
LIVURA	Pitcher • Miscellaneous	9 OCLOCK	Banes • Pills	HIRAM POND	Porter • Sarsaparilla
LITHRONTRIPTIC	Vaughn • Mixture	NIPPON	KYB • Miscellaneous	PORT WINE	Stockton • Bitters
Josef Loewenthal	Litthauer • Bitters	NORWAY/PINE	Wood • Syrup	POUDRES SUBTILE	Gouraud • Hair
LOMBARD & CUNDALL	Excelsior • Tonic	NUNN BETTER	Tonic • Pills	PRAIRIE WEED	Kennedy • Miscellaneous
LORD BROS	Baxter • Bitters	OCEAN-WEED	Kilmer • Remedy	PUSHKURO	Pusheck • Miscellaneous
Luxor	Armour • Company	OLD CABIN	Kelly • Bitters	PSYCHINE	Slocum • Company
Lycosine	L. Co. • Company	OLD ENGLISH	Hamilton • Oil	QUACHITA	Henderson • Miscellaneous
M. W. M.	V. P. F. D. • Miscellaneous	OLD ENGLISH	Paxton • Company	QUAKER BALM	Bogle • Balm
MACASSAR	Regents • Oil	OLEAGINOUS	Jayne • Tonic	QUEENS DELIGHT	Tutt • Sarsaparilla
Mag Queen	Seely • Miscellaneous	OLIVE TAR	Stafford • Miscellaneous	QUININE BITTERS	Evans • Bitters
MAGADOR	Rose • Bitters	OLNEY & McDAID	Dean • Oil	R & C	Protonuclein • Miscellaneous
MAGIC RELIEF	Mingay • Miscellaneous	OLOSAONIAN	Folger • Miscellaneous	RED BOTTLE	Langley • Elixir
MAGICAL	Gallagher • Oil	H. M. O'NEIL	Short Stop • Cough	RED/CLOVER	Jones • Tonic
MAGNETIC	Halsted • Company	OPOCURA	Taylor • Cure	RED GUM	Henry • Remedy
MAGNETIC	Miller • Balm	OPODELDOC	Lords • Miscellaneous	RED OIL	Scott • Liniment
MAGNETIC	St. Johns • Oil	OPTIMUS	Stewart • Company	RED PINE	Harvey • Miscellaneous
MAGNETIC/HEALING		ORAL HONEY	Nowill • Pectoral	RED SEA	A. D. Ashley • Balsam
BATHS	Horn • Miscellaneous	ORANGE GROVE	Baker • Bitters	F. O. REDDISH	Park • Syrup
MAGNETIC RELIEF	Williams • Miscellaneous	ORIENTAL	Gourand • Cream	REED & CARNRICK	Peptenzyme • Miscellaneous
MANDRAKE BITTERS	Baxter • Bitters	OSTERCOCUS	Daniels • Liniment	REGD LHR	Branica • Company
CH. MARCHAND	Glycozone • Miscellaneous	T. C. OWEN	Ypsilanti • Water	REMOVINE	Eaton • Miscellaneous

GENERAL INDEX

This index includes the primary names embossed on each bottle, some product names essential to the identification of certain vessels, and the page where each bottle is located. Variants may not be listed. Check the other indexes and errata if you are unable to locate your container in this index.

● Indicates the information for this container is updated in the errata.

277

279

290

ERRATA to the 2006 Printing

New information includes: histories, dates, and physical descriptions. A few unresearched new bottles have been added, plus several variations. In many cases, to save confusion, the total entry has been rewritten; false or superfluous information has been removed. New or corrected information is provided in bold type. Physical descriptions are not provided unless they are new entries or corrections. Citations are provided herein and not in the Bibliography.

BALM

[h] DR McLEAN'S/[d] LIVER/&/KIDNEY/[h] BALM/ST LOUIS Page 20
 Add: Products were still being manufactured **in 2005.**

New entry: SYLVAN'S BALM OF LILY'S/DISTILLED BY/ SYLVAN TOILET CO./ PORT HURON, MICH. Insert on page 21
 Not researched. **Clear; 5" x 2 1/16" x 1 3/8"; 9n; 3b1ip; v.**

BALSAM

CONGREVE'S//CELEBRATED/BALSAMIC//ELIXIR//FOR COUGH/& ASTHMA Page 23
 [George T.] Congreve's elixir for Consumption, of English origin, was imported by E. Fougera & Co.; adv. **Jan. 31, 1878, Lawrenceburgh (Indiana) Press**; 1900, *EBB;* 1935. *AD.*

WAKEFIELD'S/BLACK BERRY/BALSAM Page 28
 Add: **Adv. 2004 by Oakhurst Co., Levittown, NY,** *RB.*

BITTERS

ALPINE/HERB BITTERS//TT & C. [monogram] Page 29
 Embossed bottle manufactured only in 1888. Thomas Taylor (note monogram) of San Francisco established a wholesale liquor company in 1864 after acquiring the business of J. G. Frisch. Frisch and Taylor were also both producers of Hufeland Bitters. After Taylor's death in 1874, the business was moved to Virginia City, NV, and was operated by Bertha Taylor. In 1883 a move was made back to San Francisco (Wilson and Wilson 1969). **Trade Mark 56,907, Reg. 23 Oct. 1906, Filed 8 May 1905, Wichman, Lutgen & Co., San Francisco, CA (Gwen Hurst, personal communication 1987).**

N. WOOD SOLE PROPRIETOR [Base:] ATWOOD'S GENUINE BITTERS Page 30
 Nathan Wood purchased the recipe from Moses F. Atwood (son of Moses Atwood) in 1861 and the bottle and label rights from L. F. Atwood (another son of Moses Atwood) in May 1864 (Gwen Hurst, personal communication 1987; information obtained from the Official Gazette, Vol. 14, No. 15, October 8 1878 Circuit Court of the United States/District of Maine, The Manhattan Medicine Co. vs. Nathan Wood el al, Infringement of Trademark). Nathan Wood & Son, Portland, Me. is also found on bottles embossed Atwood's Jaundice Bitters, Formerly Made By Moses Atwood, Georgetown, Mass. Genuine Bitters adv. 1845 (Wilson and Wilson 1971); 1910, *AD.*

FREE SAMPLE//ATWOOD'S//JAUNDICE//BITTERS Page 30
 Alcohol content 25.6%. Moses Atwood, Georgetown, MA. **Information obtained from the Official Gazette of patent records, Vol. 14, No. 15, October 8 1878 Circuit Court of the United States/District of Maine, The Manhattan Medicine Co. vs. Nathan Wood el al, Infringement of Trademark.**

 Moses Atwood, along with L. H. Bateman first put up the Jaundice and Vegetable Jaundice Bitters in 1838 in cylindrical bottles without panels or embossing. On Jan. 1, 1848, Moses Carter was given the

right by Moses Atwood to sell the bitters in certain named places in Massachusetts, Rhode Island, Connecticut, and New York. On Feb. 2, 1852, Carter formed a partnership with Ben. S. Dodge and took in a third partner, C. L. Carter (son of Moses Carter). In 1855, Carter, Dodge & Co. was dissolved. The firm became known as Carter & Son. From 1855-1860, Dodge sold Atwood's Bitters. During the same period Carter & Son sold the product under two labels: "Carters are the only Genuine", directions, followed by, "Manufactured by M. Carter & Son, Successors to Moses Atwood, Georgetown, Mass, Caution – Observe that our Name is Blown in the Bottle and on the Revenue Stamp. None Others are Genuine Atwood's Vegetable Jaundice Bitters". Sold for $27.00 per gross. The second label was slightly different and the product somewhat inferior; it sold for $15.00 per gross. In 1860, Moses F. Atwood, son of Moses Atwood, and the original proprietor, Bateman, were using a fluted bottle embossed with the name, Moses Atwood and Georgetown, Mass. In 1861, Moses F. Atwood sold the recipe to Nathan Wood. In 1864, Nathan Wood purchased the bottle and label rights from L. F. Atwood (another of Moses Atwood's sons). Also in 1864, L. F. Atwood also sold rights to H. H. Hay of Portland, ME. On Jan. 1, 1875, the Manhattan Med. Co. obtained by assignment, rights belonging to heirs and representatives of L. H. Bateman. On March 18, 1875, the Manhattan Med. Co. obtained rights of Noyes and Manning. On March 30, 1875, the Manhattan Med. Co. obtained rights of Benjamin Dodge and William Dorman. On April 12 & 19, 1875, the Manhattan Med. Co. obtained rights of Carter's and the Manhattan Med. Co. using a 12-paneled bottle with yellow label, embossed Atwood's Genuine Physical Jaundice Bitters, Georgetown, Mass. The court found that Carter and Dodge never acquired from Moses Atwood the right to use labels of Atwood in the State of Maine outside of three towns. Therefore, the Manhattan Med. Co. had no exclusive right to put up or sell the medicine in the State of Maine. The Manhattan Med. Co. had no label rights. Nathan Wood was sole owner of the recipe (not protected by patent) and the label rights. The complaint of the Manhattan Med. Co. was dismissed with costs (Gwen Hurst, personal communication 1987). Adv. 1900 by Manhattan Medicine Co., *EBB*; 1929-30 by O. H. Jadwin & Sons, New York City, sole agents for the Manhattan Medicine Co., *AD*. About 1940, Jaundice was apparently changed to Jannaice, and the product was sold by the Wyeth Chemical Company, successors to the Manhattan Medicine Co. (Holcombe 1979). Adv. 1948 as Atwood's Jannaice Laxative Bitters by Whitehall Pharmacal Co., 22 E. 40th St., New York City, *AD*.

BROWN'S IRON BITTERS//BROWN CHEMICAL CO. Page 32

Label: *BROWN'S IRON BITTERS. A True Tonic, A Sure Appetizer-A Complete Strengthener, A Valuable Family Medicine. Not a substitute for whiskey, Not sold as a beverage, Not composed mostly of spirits, Not sold in bar-rooms. Registered May 21, 1878 by the Brown Chemical Co., Baltimore, Md.* **Trade Mark 12,479, Reg. 29 June 1886. Used since Oct. 1879 (Gwen Hurst, personal communication 1987).** Adv. 1900 by Brown's Iron Bitters Co., 306 Water, Baltimore, MD, *EBB*; 1935 by James F. Ballard Inc., 500 N. Second St., St. Louis, Mo., *AD*.

CLIMAX BITTERS//SAN FRANCISCO CAL. Page 32

Bottle manufactured ca. 1887 to 1890 (Wilson and Wilson 1969). Product of Justin Gates Jr., and Alonzo Van Alstine, introduced in 1884. Justin died in 1888 and, **according to Wilson and Wilson 1969**, the firm was dissolved in 1890. **According to the Official Gazette of Patent Records, Trade Mark 17,727 was Reg. April 1, 1890 and acquired by Leavitt & Van Alstine, San Francisco, CA. Included was a reference of use since Jan. 1888 (Gwen Hurst, personal communication 1987).** Adv. 1896-97, *Mack*, 1897, *L. & M.*

COLUMBO/PEPTIC BITTERS//L. E. JUNG/NEW ORLEANS, LA. [Base:] S. B. & G. CO. Page 33

Label: *COLUMBO PEPTIC BITTERS, L. E. JUNG, SOLE PROPRIETOR and MANUFACTURER, 317 AND 319 Magazine St., New Orleans. Awarded Gold Medal at Louisiana Purchase Exposition, St. Louis, 1904, also the Lewis & Clark Exposition, Portland, Oregon, 1905. Trade Mark No. 28,712 filed May 8, 1896 and Registered August 4, 1896.* Bottle manufactured by Streator Bottle & Glass Co., Streator, IL, **1898 to 1905 (Gwen Hurst, personal communication 1987).**

[Shoulder; h] MANUF'R/[v] DAMIANA BITTERS//[Shoulder; h]LEWIS HESS/[v]BAJA CALIFORNIA [Base: 8-point star] [See Figure22] Page 33

> Bottle manufactured ca. 1877 to 1885; shoulder embossing was terminated between 1886 and 1890. Henry Weyl (location unknown) produced the bitters for three years before selling the brand to Lewis Hess in 1876. Offices were located at 317 Broadway, New York, and in San Francisco. Hess sold the firm to Naber, Alfs and Brune of San Francisco in 1890 (Ring 1980; Wilson and Wilson 1969). **Trade Mark 3,713, Reg. May 23, 1876 to Winder and Shearer, San Francisco (Gwen Hurst, personal communication 1987).** Adv. 1917, *BD*.

"ELECTRIC" BRAND/BITTERS//H. E. BUCKLEN & CO./CHICAGO, ILL. [See Figure 23] Page 33

> Label: *"Electric" Brand Bitters, 18% alcohol. The Great Family Remedy For all Diseases of the Stomach, Liver and Kidneys. Guaranteed under the Pure Food and Drug Act of 1906* . . . Introduced in 1880 (Wilson and Wilson 1971; **Trade Mark 7,938, Reg. June 8, 1880 (Gwen Hurst, personal communication 1987).** An 1888 advertisement states "Mr. D. I. Wiscoxson, of Horse Cave, Ky., adds a testimonial saying he positively believes he would have died had it not been for Electric Bitters." Adv. 1923, *SF & PD*.

DOCTOR GREGORYS/SCOTCH BITTERS [Base:] IGCO Page 34

> Bottle manufactured by the Ihmsen Glass Co., Pittsburgh, **1885-1895 (Gwen Hurst, personal communication 1987).** Producers or dealers included Spink & Co. and Young Patterson & Co., Minneapolis, MN. Product adv. 1875-1885 (Ring 1980).

SAMPLE/LASH'S BITTERS [See Figure 25 and Photo 4] Page 37

> Bottle manufactured ca. 1890s. John Spieker and Tito Lash **formed the T. M. Lash & Co. in 1884 in Sacramento (not San Francisco) and** began the manufacture of proprietary medicines, **such as** Homer's Ginger Brandy and various bitters, **including Lash's Bitters. A dissolution of partnership in 1889 led Tito Lash to sell all rights to the manufacture and selling of Lash's Bitters to John Spieker. Spieker than formed the Lash's Bitter's Company and latter offices were located in San Francisco and New York. Spieker also** produced Dr. Webb's and Webb's Stag Bitters until prohibition. Spieker died in **1916 instead of 1914** and was succeeded by his wife. **The company name was changed to Lash's Products Co. in 1920 (Gwen Hurst, personal communication 1987, Ring 1980; Wilson and Wilson 1969). Cork enclosures were replaced by the screw cap ca 1924.** Lash's Bitters adv. 1935 by Hahn & Wessel, 316-324 E. 21st. Street, N. Y., *AD*.

MARSHALL'S BITTERS//THE BEST LAXATIVE//AND BLOOD PURIFIER Page 38

> Embossed 1902-1908, (Wilson and Wilson 1969). **See Label wording on pg. 38.** Product of Harry Kirk and William Geary, Sacramento, CA (Wilson and Wilson 1969, 1971). The *Era Blue Book* lists the company in 1900. **Trade Mark 40,990, Reg. Aug. 25, 1903 (Gwen Hurst, personal communication 1987).** Adv. 1888 (Ring 1980)

MISHLER'S HERB BITTERS//DR S. B. HARTMAN & CO//TABLESPOON GRADUATION/ [graduation marks embossed] [Base:] PAT FEB 6 66 Page 38

> In addition to other information add: **Trade Mark 52,768, Reg. May 15, 1906, Ashenbach & Miller, Philadelphia, PA (Gwen Hurst, personal communication 1987).**

OREGON/GRAPE ROOT/BITTERS Page 39

> Product of George and August Wolters of Wolters Bros. & Co., San Francisco, CA, manufactured in 1885 only (Wilson and Wilson 1969), **however the official Gazette of patent records trademarks the product in 1886 by J. B. Eastman & Co., Deer Lodge, MT. Could Wolters Brothers be an agent or distributor - Gwen Hurst, personal communication 1987.**

GARRY. OWEN/STRENGTHENING/BITTERS//BALL & LYONS/NEW ORLEANS. LA.//SOLE PROPRIETORS [Base:] W. McC & CO. PITTS. Page 39

> Only change: **Bottle manufactured by Wm. McCully & Co., Pittsburgh, PA 1842-1886 (Gwen Hurst, personal communication 1987).**

PARKERS/CELEBRATED/JCP [monogram in circle]/STOMACH/BITTERS [Base:] I G Co Page 39
Bottle manufactured **by Ihmsen Glass Co., Pittsburgh, PA 1855 to 1895 (Gwen Hurst, personal communication 1987).** Product of John C. Parker, St. Louis, Copyright No. 2300, June 1880. Adv. 1887 (Ring 1980).

POND'S/BITTERS//AN UNEXCELLED/LAXATIVE [Base: I in diamond] Page 40
See Label wording on pg. 40. Bottle manufactured by the Illinois Glass **Co.,** Alton, IL, **1915-**1929 **(Gwen Hurst, personal communication 1987).**

ST. GOTTHARD HERB BITTERS/METTE & KANNE PROS/ST LOUIS, MO [Base:] MGC CO Page 41
Bottle manufactured by the Modes Glass Co., Cicero, IN, **1887** to 1904. **Trade Mark 7,340 Reg. May 20, 1879, Mette & Kanne, St. Louis, MO (Gwen Hurst, personal communication 1987).** Adv. 1895 (Ring 1980).

SAXLEHNER/HUNYADI/JANOS/BITTERQUELLE Page 41
See label information on page 41. A "Natural Aperient Water" with gentle laxative properties, named Hunyadi Janos after a Hungarian national hero of the fourteenth or fifteenth century. The bottle was in use after 1863 (Toulouse 1972). Adv. **1928 by Charles & Co., New York, Wholesalers, (information from catalog in possession of Jon Horn, Montrose, CO.** Bottles were also used by others …

DR JGB SIEGERT & SONS [Base:] ANGOSTURA BITTERS Page 42
Add to existing information: **By 1872, Siegert & Hijos Angostura Bitters was available in United States grocery stores and food seasoning sections (US Patent Office Official Gazette records).**

[h] 1 PT. 3OZ./[d] Toneco/[h] BITTERS [Base:] FGW Page 42
Label documentation on page 42. Bottle manufactured by Fairmount Glass Works, Indianapolis, IN, 1898-**1933 (Gwen Hurst, personal communication 1987).** Produced 1908-1917 (Wilson and Wilson 1969).

WARNER'S/SAFE/BITTERS/TRADE/MARK [on embossed safe]/ROCHESTER, N.Y. Page 43
Trade Mark 7,467, Reg. July 1, 1879; Bottle Design No. 11,067, Reg. March 2, 1880 (Gwen Hurst, personal communication 1987).

WEST INDIA/STOMACH BITTERS//ST. LOUIS MO. [Base:] WIMCo Page 43
The West India Manufacturing Company was established in 1876 and succeeded Moody, Michel & Co., Wholesale Grocers, Wines, Liquors & Cigars (Holcombe 1979). **Trade Mark 3,405, Reg. Feb. 8, 1876, Joshua C. Michels, St. Louis (Gwen Hurst, personal communication 1987).** Adv. 1882, *VSS & C*; 1916, *MB*.

WILD CHERRY BITTERS/MANUFACTURED BY/C. C. RICHARDS & Co/YARMOUTH, N.S. [Base:] L.G. Co. N.S. Page 43
Bottle manufactured by the Lamont Glass Co., Trenton & New Glasgow, Nova Scotia, 1893-1897 (Gwen Hurst, personal communication 1987).

WINTER'S/STOMACH BITTERS [Base:] S B & Co [See Figure 33] Page 44
Bottle manufactured by the Streator Bottle & Glass Co., Streater, IL between **1898** and 1905 **(Gwen Hurst, personal communication 1987).**

CHEMICAL

New entry: PFEIFFER CHEMICAL CO./PHILADELPHIA/& ST. LOUIS Insert on page 47
See PFEIFFER (Company).

[h]W/[v]RUMFORD/CHEMICAL WORKS [Base:] PATENTED MARCH 10 1868 [See Figure 38] Page 48
Label: *Horsford's Acid Phosphate Tonic & Nerve Food.* See 1880 advertisement in text on page 48. Adv. 1884 (Baldwin 1973); 1935, *AD.* Eben N. Horsford, appointed professor at Harvard University by Benjain Count Rumford, established the business with George Wilson in Providence, RI in **1854. Their principal product, baking powder, was first on the market in 1854.** The firm was incorporated as Rumford Chemical Works in 1857 **(Eighty Years of Baking Powder History, Rumford Chemical Works, Rumford, RI 1939).** In 1966 the company was purchased by the Essex Corporation; in 1975 the firm was closed (Holcombe 1979; Zumwalt 1980).

SULPHUME CHEMICAL CO.//NEW YORK Page 48
>Label: ...*The Great Cure, Skin & Blood Purifier*...**Contents enough for 10 sulphur baths. Also taken internally. Located in Boston by 1911.** Adv. 1897, *L & M*; 1921, *BD.*

COMPANY

New entry: Monogram: BR CO Insert on page 51
>Label: ***Blough's Catarrh Balm for Cold in the Head, Nasal Catarrh, Catarrhal Sore Throat-A Superior Remedy for Nasal Catarrh, Cold in the Head, Hay Fever, Cold in the Chest or Throat, Croup, Cold Sores, Bruises, Insect Bites and all Catarrhal Affections. Blough Remedy Co., Wadsworth, Ohio.* Milk Glass; 2" x 1 ¾" x 1 ¾"; 17n; 1b; pl; h.**

New entry: S. F. BAKER & CO.//KEOKUK, IOWA. Insert on page 51
>Label: ***Baker's Pain Relief, For the Relief of Colic, Indigestion, Vomiting, Flatulence, Diarrhoea and Summer Complaint. Prepared only by S. F. Baker & Co., Keokuk, Iowa-PRICE $1.10.* Aqua; 8 ½" x 2 13/16" x 1 5/8"; 16n; 3b; 1ip; v, ss; ABM. See BAKER (Company, Liniment).**

BRADFIELD REG'L CO.//ATLANTA. GA.//THE MOTHER'S FRIEND [See Figure 42] Page 53
>Add: **Adv. 2003, S.S.S. Company [Pfeiffer Pharmaceuticals, Inc., Atlanta, GA],** *RB*

New entry: [Script:] W. H. BULL MED. CO./ST. LOUIS, U.S.A. Insert on page 53
>**See Bull (Medicine).**

California/Perfume Co./FRUIT/FLAVORS Page 54
>David H. McConnell, **New York, NY (not San Francisco)**, established the California Fruit Company in 1886, now known as the Avon Corporation located in New York City. **Products included: White Rose, Lily of the Valley, Hyacinth, and Heliotrope.** The first **sales person** was Mrs. P.F.E. Albee, and the product was Little Dot Perfume. **In 1895 the company moved to Suffern, NY; there was a branch established in Kansas City ca 1903. The line was known as Avon by 1929; the California Perfume Co., name was dropped by 1939 (Gaspar 1987).**

CHATTANOOGA MEDICINE CO.//CARDUI THE WOMAN'S TONIC Page 55
>Rev. R. I. McElree learned of an herbal concoction used by Indian women to relieve menstrual pain. McElree introduced his Cardui in 1879 and sold the product to the Chattanooga Medicine Company, now Chattem Labs, in 1882. Chattem Labs discontinued the product around 1982. L. D. Ward purchased the trademark in 1984, reformulated the product using drugs rather than herbs, and began shipping it in plastic bottles in August 1985 (Dave Ward, L. D. Ward, Chattanooga, TN, personal communication, 1986). **Originally the product contained whiskey and due to its high alcohol content (20%) it was not allowed to be sold on Indian reservations; later alcohol was substituted for whiskey. Prohibition lowered the alcohol content to 10%. The U. S. Patent Office states that the trademark "The Chattanooga Medicine Company" and "Cardui" were first used in 1880 on medicines for female diseases (Jon Horn, personal communication, 2004).**

COLGATE & CO/PERFUMERS/NEW YORK Page 56
>Label information on page 56. Colgate & Co. was established in 1806 **by William Colgate, New York City,** as a soap and candle factory and merged with B. J. Johnson & Palmolive Peet in 1928 (Devner 1970). **The Company became Colgate-Palmolive Co. in 1953. Toothpaste in collapsible tubes was introduced in 1896.**

J. D. EASTMAN & CO./DEER LODGE, MONTANA [Base:] I. G. CO Page 58
>**Bottle manufactured by Ihmsen Glass Co., Pittsburgh, PA, 1855-1895 (Gwen Hurst, personal communication 1987).** Products included Eastman's Oregon Grape Root Tonic and the Great Pacific Coast Remedy. Adv. 1887 (Ring 1980). **Grape Root Bitters, Label # 4,737, was Reg. Feb. 23, 1886 (Gwen Hurst, personal communication 1987).**

New entry: THE LAXAKOLA CO.//NEW YORK & CHICAGO Insert on page 68
>Box Label: *LAXAKOLA – The Great Tonic Laxative for the Prevention and Cure of Habitual Constipation and all Conditions Resulting from Derangement and Inactivity of the Stomach, Liver, Kidney's and Bowels*, etc. Aqua; 6 ¼" x 1 3/16" x 1"; 7n; 3b; 3ip; v. See LAXAKOLA (Tonic).

THE MOREY/MERCANTILE CO./DENVER, COLO. Page 71
Add: **The C. S. Morey Mercantile Co. was incorporated in 1884.**

New entry: PFEIFFER CHEMICAL CO./PHILADELPHIA/& ST. LOUIS Insert on page 73
Label: *DR. HOBSON'S COMPOUND, Prickly Ash, Poke Root and Stillingia with Potassium Iodide, Iron and Aromatics. A combination having laxative and tonic properties. For the treatment of digestive disturbances which tend to cause skin eruptions, as Tetter, Acne, Pimples, Blackheads and other minor skin disorders. PFEIFFER CHEMICAL COMPANY OFFICES, NEW YORK ST. LOUIS "REVISION 1918a".* Clear; 9 1/8" x 2 7/8" x 1 5/8"; 1n; 3b; 3ip; v. See HUDNUT (Miscellaneous), W. WARNER (Company).

New entry: SYLVAN'S BALM OF LILY'S/DISTILLED BY/ SYLVAN TOILET CO./ PORT HURON, MICH. Insert on page 78
See SYLVAN Balm).

New entry: 12 ½ FL. OZ/WARNER'S/SAFE/REMEDIES CO./TRADE/MARK [on embossed safe]/ROCHESTER, N.Y. U.S.A. [Base 89] Insert on page 81
See H. WARNER (Remedy).

REGSTD TRADE/MARK/MENTHOLATUM/YUCCA CO/WICHITA KAN Page 83
The Yucca Co. was founded by Albert Alexander Hyde, Wichita, KS, in 1889 **to produce soap and shaving cream.** Mentholatum was one of the company's first products **and was introduced in December 1894.** The name was changed and the Mentholatum Company was incorporated in 1906. Offices were established in Buffalo, NY, **in 1919.** The Wichita office was closed within a few years. Information provided by Arthur Hyde, Sec., Mentholatum Co., Buffalo, NY, (personal communication 1983). Mentholatum **is still on the market in polystyrene containers (introduced in 1959). Metal caps with "Mentholatum" embossed on them were used until after World War I. Convex, white painted, metal lids were introduced in the 1920s. Flat lids with printed lettering were introduced in the 1930s. White milk glass jars were used until January 1955. From 1955-1959, the jars were emerald green glass. In 1959, green, polystyrene jars were introduced (Jon Horn, Montrose, CO, PC, 2004). Adv. 2004, The Mentholatum Co., Orchard Park, NY, *RB*.**

COMPOUND

LYDIA E. PINKHAM'S/VEGETABLE COMPOUND Page 85
Add: **Blend of True Unicorn, False Unicorn, Pleurisy Root, Life Root, Fenugreek Seed, Black Cohosh, and prior to the 1906 act, alcohol 20%. The Compound was sold by the family until 1916, when it was purchased by Cooper Laboratories. Recently the alcohol content was listed at 13%. Discontinued, ca 2002.**

THE CUTICURA SYSTEM/OF CURING/CONSTITUTIONAL HUMORS//ORIGINATED BY WEEKS & POTTER BOSTON Page 96
Add: **Cuticura cures were designed to provide relief for skin afflictions including syphilis.**

CURE

MYSTIC CURE//FOR/RHEUMATISM/AND/NEURALGIA//MYSTIC CURE Page 103
Detchon's Mystic Cure, adv. 1895 (Baldwin 1973); 1901 by Dr. I. A. Detchon, Crawfordsville, Ind., *HH & M*; 1916, *MB*. **Dr. E. Detchon's Compound Kidney & Liver Cure; Unfailing Cure, and Whooping Cough Specific Cure, adv. By C. E. Ferris, Druggist, Lawrenceburgh, Ind., January 1877.**

New entry: [Script] Newbro's/Herpicide/angle THE DANDRUFF CURE Insert on page 103
Label: NEWBRO'S HERPICIDE, The Only Remedy Known that Positively Stops the Hair Falling Out. A New Scientific Discovery, Cures: Dandruff, Baldness and All Diseases of the Scalp by Destroying the Microbe or Parasite to Which All Scalp Diseases are Due. THE HERPICIDE

COMPANY, 6 WEST BROADWAY, NEW YORK. Clear; 7" x 2 1/8" diameter; 7n; 20b; pl; h, with script. See HERPICIDE (Hair), NEWBRO (Miscellaneous).

DISCOVERY

DR. PIERCE'S/GOLDEN/MEDICAL DISCOVERY//R.V. PIERCE, M.D.//BUFFALO, N.Y. Page 110
Dr. Ray Vaughn Pierce introduced his Favorite Prescription, Medical Discovery and Dr. Sage's Catarrh Remedy ca 1870, the latter adv. 1869 (Baldwin 1973). Pierce established The World's Dispensary in 1873, died 4 Feb. 1914, and was succeeded by son V. Mott Pierce, MD (Holcombe 1979). **By the time V. Mott Pierce died in 1942, the successors had been consolidated as Pierce's Proprietaries, Inc.** The Pierce family operated the business until ca. 1960. Pierce's A-Nuric Tablets, Favorite Prescription, Golden Medical Discovery, Tablets, and Pleasant Pellets were on the market in 1982, products of Med-Tech, Inc., Cody, WY, according to Bill Weiss, Med-Tech, Inc. (personal communication, 1982). Medical Discovery adv. 1871, *VSS & R*; **2004, through the Catalpa Trading Co., Berlin, OH,** *RB*.

DRUG

[Script:]Meritol/AMERICAN DRUG & PRESS ASSN./DECORAH, IOWA, U.S.A. Page 110
Label information available on page 110. Bottle manufactured ca. 1908 Wilson and Wilson 1971). Adv. **1916, Oleary's Drug Store, Gunnison, CO**; 1935 and 1941-42 as an ointment by Meritol Corp., Decorah, IA, *AD*.

BROMO-SELTZER/EMERSON/DRUG CO./BALTIMORE, MD. Page 111
The Bromo Seltzer brand name was in use in 1887 (Brand Names Foundation 1947) and trademarked in 1889. The Emerson Drug Co. was also established in 1889. According to the U.S. Patent Office, the product was used in 1889 as a granular effervescent salt for the cure of headache, nervousness, nervous headache, neuralgia, brain fatigue, sleeplessness, over brain-work, depression, and mental exhaustion. The bottles were manufactured by Hazel-Atlas until 1907, followed by the Maryland Glass Corp., using the ABM process. The letter M on the base dates from 1907 to ca 1916; M in a circle, after 1916 (Toulouse 1972). Cork enclosures were used until 1928 and early variants possessed small mouths. Bromo Seltzer was packaged in plastic bottles starting in 1986, the product of Warner-Lambert Co., Morris Plains, NJ. **The Maryland Glass Corp. was a subsidiary of the Emerson Drug Co. until 1956 when the product was passed onto the Warner-Lambert Co. Available 2005.**

ELIXIR

New entry: GAUSS (Vertical lines through G and S's)//ELIXIR Insert on page 115
Amber, 8" x 2 ½" x 1 3/8"; 7n; rect. with rounded corners and concave sides; v ss.

New entry: RIKER'S EXPECTORANT/MADE BY WM B. RIKER & SON CO./NEW YORK AND BROOKLYN Insert on page 118
Label: *Riker's Expectorant, Alcohol 5%, Guaranteed by Wm. B. Riker & Son Co. Under the Food and Drugs Act, June 30, 1906. Serial NO. 274. "A Pleasant, Swift and Certain Remedy For Coughs, Colds, etc. Prepared Only by Wm. B. Riker & Son Co, Laboratory 109 West 27th St., New York.* Clear; 6 ½" x 2 5/8" x 1 9/16"; 9n; 3b; pl; v. See RIKER (Miscellaneous).

EXTRACT

New entry: DOCTOR/PIERCE//EXTRACT OF SMART-WEED//R.V. PIERCE, M.D.//BUFFALO, N.Y.
Insert on page 120
Clear; 5" x 1 ¾" x 7/8"; 1n; 3b; 4ip; h, f; v, bss. See PIERCE (Discovery, Miscellaneous), SAGE (Remedy).

LINIMENT

New entry: T. H. JACKSON'S/ COMMON-SENSE LINIMENT/QUINCY – ILL. Insert on page 135
 Clear; 5" x 1 ¾" x 1 ¾"; 9n; 1b; pl; v, diagonal. See JACKSON (Liniment).

NERVE & BONE/LINIMENT Page 136
 Barker's Nerve & Bone Liniment was introduced by Thomas Barker, Philadelphia, in 1859. The firm was assumed by Barker's son, Robert, Ben Mein, and John Moore in the 1860s. In 1893 Mein & Moore sold out to Robert, the business becoming Robert Barker & Co. (Wilson and Wilson 1971). Directories indicated the firm went out of business in 1916 or 1917. **Further research is necessary as embossed Nerve & Bone Liniment bottles were recovered from the riverboat, "Arabia" which sank on the Missouri River in 1856.** Liniment adv. 1916, *MB*. There was also H. W. Barker's Nerve & Bone Liniment, produced by the H. W. Barker Med. Co., Elbow Lake, MN, in 1899; this firm was located in Sparta, WS, in 1916 (Devner 1968).

SLOAN'S LINIMENT/MADE IN U.S.A. [Base: O superimposed over diamond] Page 137
 Add: **Adv. 2003, Lee Pharmaceuticals, South El Monte, CA, *RB***

DR TOBIAS/NEW YORK//VENETIAN/LINIMENT Page 137
 See label information on page 137. Samuel Tobias' Venetian Liniment was introduced **in 1848, Lawrenceburgh (Indiana) Press, Jan. 31, 1878;** adv. 1853, New York City directory; 1929-30 by O. H. Jadwin & Sons, Inc., 11 Vestry St., New York City; 1935 by O. H. Simmons, 65 Cortlandt St., New York City, *AD*.

MEDICINE

New entry: [Script:] W. H. BULL MED. CO./ST. LOUIS, U.S.A. Insert on page 145
 Label: *Dr. Bull's Herbs and Iron, An Iron Tonic, Stomachic and Appetizer. Alcohol 16%. Box label states, sold since 1879.* Amber; 8 ½" x 3 ¼" x 1 ½"; 16n, 3b with rounded corners; pl; v; ABM. See **Bull (Miscellaneous).**

FATHER JOHN'S/MEDICINE/LOWELL, MASS. Page 146
 Add: **Adv. 2003, Oakhurst Co., Levittown, NY, *RB*.**

New entry: HARPER'S/HEADACHE MEDICINE/WASHINGTON, D.C. Insert on page 147
 Label: HARPER'S HEADACHE MEDICINE – For Headache, Neuralgia, etc. Alcohol 32%. Manufactured by THE ROBT. N. HARPER CO., 467 C ST., N.W., WASHINGTON, D.C. Clear; 5" x 1 7/8" x 7/8", 7n; 3b; 3ip; oval front, v. See HARPER (Miscellaneous, Remedy).
MAGUIRE/MEDICINE COMPANY/ST LOUIS, MO. Page 149
 Add: **The "Arabia" riverboat that sank in the Missouri River in 1856 had embossed variants, MAGUIRE/DRUGGIST/ST LOUIS MO.; aqua, dimensions unknown, 11n; 4b**

New entry: 4 O<u>Z</u>/MARCHAND'S/PEROXIDE OF/HYDROGEN/(MEDICINAL)/NEW YORK Insert on page 149
 Blue; 7 ¾" x 2" dia.; 7n; 20 base; pl; h, v. See Marchand (Medicine).

MISCELLANEOUS

ABSORBINE JR//4FL OUNCES [Base:] W. F. YOUNG P. D. F./SPRINGFIELD, MASS./U.S.A. Page 151
 Add: **Adv. 2003, W. F. Young, Inc., East Long Meadow, MA, *RB***

New entry: [Script:] A-theuca-ine//DENVER POULTICE//DENVER POULTICE Insert on page 153
 Label: *Denver's Liquid Antiphlogistic Poultice, Absolutely Harmless and the Latest and Best for All Cases of Inflammation with Pain and Soreness. Distributed by the A-Theuca-Ine Sales Co., Lincoln, Neb. Guaranteed Under Pure Food and Drug Act, June 30, 1906. Serial NO 8815. Box states: Manufactured*

only by the A-Theuca-Ine Co., Denver, Colo. Aqua; 6" x 2 1/16" x 1 1/16"; 11n; 3b; 3ip; d, f; v, ss; some script. See A-THEUCA-INE (Miscellaneous).

New entry: BON-OPTO/FOR/THE EYES//embossed eye cup BON-OPTO Insert on page 155
　　　Label: BON-OPTO Solution (collyrium, nasal douche, mouth wash, gargle). Valmas Drug Co., Inc., Rochester, N.Y. Clear; 3 1/8" x 1 ½" x 1 ½"; 7n; 2b; pl; h.

J. I. BROWN & SONS/BOSTON Page 155
　　　Contained Brown's Bronchial Troches. Add: **In 1931, the Federal Food & Drug Administration required the word bronchial be dropped. The firm was acquired by the Block Drug Co. in 1936, with retention of the Brown name.**

New entry: CHAMBERLAIN'S [Base:] BOTTLE 6/MADE IN U.S.A. Insert on page 158
　　　Label: *Chamberlain's Cough Syrup, Chamberlain Medicine Co., Inc. Offices: New York & St. Louis.* Clear; 5 5/8" x 1 7/8" x 15/16"; 16n; 3b; 1ip; v, ABM. See CHAMBERLAIN (Balm, Liniment, Lotion, Remedy), VON HOPF (Bitters), W. WARNER (Company).

Correction: [Script:] Dioxygen to **Dioxogen**　Page 160

[Script:] Chas. H. Fletcher's//CASTORIA [See Figure 156] Page 162 – Also see PITCHER'S/CASTORIA Page 177
　　　Add: **The Fletcher's script letters were introduced ca 1897 (American Medical Association 1912).**

New entry: [Script:] **Chas. H. Fletcher//CASTORIA** Insert on page 163
　　　Label: *CASTORIA-A Vegetable Preparation for Assimilating the Food by Regulating Stomachs and Bowels of Infants and Growing Children-No. 4079-The Centaur Company Limited-Windsor, Ontario.* Aqua; 5 ¼" x 1 7/8" x 7/8"; 16n; 6b; 4ip; v, ss, some script, ABM. See CENTAUR (Liniment), PITCHER (Miscellaneous).

Correction: GLYCO-/THYMOLINE Page 163
　　　Clear; 4 1/8" x 2 5/16" x 2 5/16"; 3n; 1**b**; pl; d. See KO (Company).

HICK'S CAPUDINE/FOR ALL HEADACHES/COLDS, GRIPP, ETC. Page 166
　　　Add: **Adv. 2003,** *RB.*

DR D JAYNES/ALTERATIVE/84 CHEST ST PHILA Page 168
　　　Add: **The Jayne company operated until 1911 at which time it was sold.**

New entry: KINA//LAROCHE Insert on page 170
　　　Label: *Quina Laroche Tonic Wine and Strengthening Febrifuge. Sole Agents for the United States, E. Fougera & Co., 90-92 Beekman St., New York.* Dates advertised include 1811, 1883, 1885, & 1906. Aqua; 9 1/4" x 2 5/8"; 18n; 20b, h.

DR. MINTIE'S//NEPHRETICUM//SAN FRANCISCO Page 173
　　　See label information on page 173. Adv. 1877 (Wilson and Wilson 1971; **1882 Denver Tribune June 6**; 1897, *L & M.*

PITCHER'S/CASTORIA Page 177
　　　Add: Variants embossed FLETCHER **(in script)** were introduced **ca 1897 (American Medical Association 1912).** See CENTAUR (Liniment), FLETCHER (Miscellaneous).

New entry: THE NAME/St. Joseph's/ASSURES PURITY [Base: O superimposed over diamond] Insert on page 179
　　　Label: *Genuine St. Joseph's G. F. P. Alcohol 20%-"A Vegetable Compound which is a Splendid Tonic for Conditions it is Intended to Help." It has been used for more than fifty years. To help the action of G. F. P. be sure to keep the bowels open. Use St. Joseph's Laxative Syrup. A Product of the St. Joseph's Laboratories, New York, Memphis.* Bottle manufactured by Owens-Illinois Glass Co., after 1929

(Toulouse 1972). Clear, 8 1/8" x 2 ¾" x 1 ½"; 3n, sp; 6b; recessed sides at base; 1ip; v; ABM. See **PRESCRIPTION (Miscellaneous).**

TONSILINE//TONSILINE//[embossed giraffe] [Base: P in circle} [See Figure 187] Page 183]
Add: **Adv. 2003, Oakhurst Co., Levittown, NY, *RB*.**

VICKS/VA-TROL-NOL/[embossed triangle] Page 184
Add: **The Vick Chemical Company of New York was established in 1885 or 1894. According to the U. S. Patent Office, the word VICKS was first used as a trademark for medicinal salves for colds and cough drops in 1894.**

New entry: **DR. WHITE'S//DANDELION/ALTERATIVE//INDIANAPOLIS, IND** Insert on page 186
White's Dandelion Alterative "As a blood purifier and renovator, it is positively unequaled", Bloomington (IL) Daily Pantagraph, Oct. 3, 1881 (Baldwin 1973). Aqua, 9 ¼" x 3" x 1 3/4"; 11n; 3b; v, fss.

OIL

HAMLIN'S/WIZARD/OIL Page 193
Add: **First embossed in the early 1890s, front panel only, later sides also. Contained 55% alcohol, tincture camphor, aqua ammicon, oil of sassafras, turpentine, chloroform, and oil of cloves. See HAMLIN (Balsam).**

REMEDY

DR. KILMER'S/FEMALE/REMEDY/BINGHAMTON NY Page 208
Add to last sentence: ...assets were sold to Diebold Products Inc., Stamford, CT **in 1958.**

SAMPLE BOTTLE/DR. KILMER'S/SWMP-ROOT KIDNEY/REMEDY/BINGHAMTON, N.Y. Page 209
Introduced in 1881 (Holcombe 1979). **Remedy was changed to cure in 1918 (Jim Rock, personal communication). Adv. 2004, Catalpa Trading Co., Berlin, Ohio, *RB*.**

MAYR'S WONDERFUL/REMEDY/CHICAGO, U.S.A. [Base: I in diamond] Page 209
Label information available on page 209. Bottle manufactured by the Illinois Glass Co. 1916 to 1929 (Toulouse 1972). Adv. 1880s (Devner 1968); **1911, George H. Mayr, Chicago (Cramp 1912);** 1929-30 by O. H. Jadwin & Sons Inc., New York City; as Mayr's 1948 by Berosol Products, Rockaway Beach, L.I., N.Y., *AD*.

NATIONAL REMEDY/COMPANY/NEW YORK [See Figure 216] Page 210
Correction: Aqua; 53/8" x 2 7/16" x 15/16"; 8n; 3b; 3ip; v. Also ABM variant with 16n.

New entry: **12 ½ FL. OZ/WARNER'S/SAFE/REMEDIES CO./TRADE/MARK [on embossed safe]/ROCHESTER, N.Y. U.S.A. [Base 89]** Insert on page 211
Aqua; 9 3/16" x 3 ¼" x 1 5/8"; 8n; 12b; pl; h.; ABM. Clear variant has 489 on base. See LOG CABIN (Extract, Remedy, Sarsaparilla), H. Warner (Bitters, Company, Cure, Nervine).

SARSAPARILLA

YAGER'S/SARSAPARILLA Page 221
Label: *YAGER'S COMPOUND EXTRACT SARSAPARILLA WITH CELERY – A Wonderful Nerve Tonic Alterative and Blood Purifier – It Restores Strength, Renews Vitality, Purifies the Blood, Regulates the Kidneys, Liver & Bowels. Price 50 Cents. Prepared by Gilbert Bros. & Co. Manufacturing Chemists, Baltimore, MD.* Product of Gilbert Bros. & Co., Baltimore, MD. The firm was located at 9-13 Howard from 1896-1900, at 308 W. Lombard in 1912; and at 308-310 W. Lombard from 1913-1930 (Shimko 1969). Amber; 81/2" x 3" x 2"; 7n; 3b; 3ip; v.

SPECIFIC

NATHAN TUCKER, M.D./[embossed star and shield]/SPECIFIC/FOR ASTHMA, HAY FEVER/AND ALL CATARRHAL/DISEASES OF THE RES/PIRATORY ORGANS Page 223
> Product of N. Tucker, Mount Gilead, Ohio – "Applied Locally by Atomizer, Comes with 4 Ounce Bottle of "Cure". … contains cocaine". Advertised in 1903 and 1911, source unknown.

SYRUP

New entry: GRODER'S/BOTANIC/DYSPEPSIA/SYRUP//WATERVILLE, ME.//U.S.A. Insert on page 226
> Not researched. Aqua; 9" x 2 15/16" x 1 ¾"; 1n; 3b; 7ip (4 on front).

CALIFORNIA FIG SYRUP CO/CALIFIG/STERLING PRODUCTS (INC.)/SUCCESSOR Page 225
> Add: According to the U. S. Patent Office, the Califig trademark was first used in 1900; the California Fig Syrup Company of San Francisco, California registered the product in 1906.

TONIC

New entry: B-L/THE KING/OF TONICS/MADE IN U.S.A. [Base: O in square] Insert on page 233
> Bottle manufactured by Owens Bottle Co., 1911-1929 (Toulouse 1972) Label: *B-L Formerly called Blud-Life the Medicine that has met the Test. Valuable Aid in the Treatment of Constipation. It has Wonderful Tonic Properties for a Simple Anemic condition of the Blood. An Appetizer, A Bowel Activator, and A Pleasant Flush – Price $1.25. Blud-Life Company, Atlanta, Georgia.* Clear; 8 3/8 x 2 7/8 x 1 ½; 10n; 6b; pl; h; ABM. See BLUD-LIFE (Tonic).

LAXAKOLA//THE GREAT/TONIC LAXATIVE//LAXAKOLA CO.//NEW YORK & CHICAGO page 235
> See LAXAKOLA (COMPANY).

TRADE MARK

[Script:] Rawleigh's/TRADE MARK Page 240
> W. T. Rawleigh, Freeport, Il, began manufacturing medicines **and flavoring extracts** in 1889. **Incorporated in 1898 the company had begun manufacture of its own bottles by 1926.** Cork enclosures were in use until ca. 1933 (Fike 1965). In 1917, 140 products were being sold (Shimko 1969). About 1970, the family-owned business became a subsidiary of an eastern investment company (Zumwalt 1980). Products advertised in **2005.**

[v, Script:] Rawleigh's/TRADE MARK/[h] BOTTLE MADE IN U.S.A. [Base: 4] Page 240
> Clear; 8 ¼" x 1 ¾" x 3"; 1n; 3b; 1ip; h, v, part script; ABM.

WATER

FLORIDA WATER/MURRAY 7 LANMAN/DRUGGISTS/NEW YORK [See Figure 237] Page 244
> Add: New York City Directories list Murray & Lanman, Druggists at 69 Water Street from 1835 to 1849; David T. Lanman, Druggist at 69 Water Street from 1836 to 1857; and Lanman & Kemp at 69 Water Street from 1858 to 1870 when they relocated to William Street. The distinctive shape was probably registered in 1857.

9 781932 846157